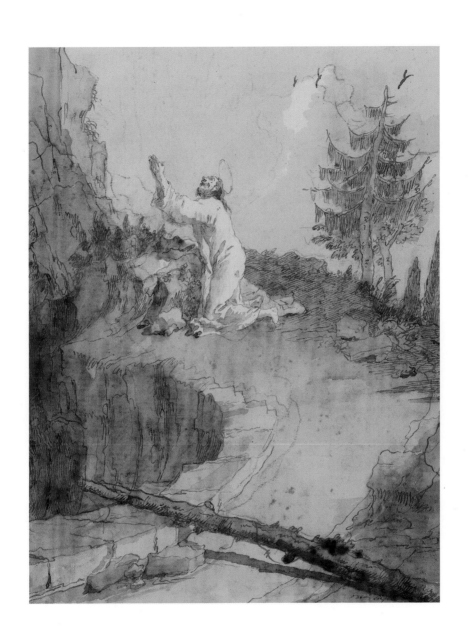

DOMENICO TIEPOLO
A New Testament

DOMENICO TIEPOLO
❧ *A New Testament* ☙

ADELHEID M. GEALT & GEORGE KNOX

INDIANA UNIVERSITY ART MUSEUM
IN ASSOCIATION WITH
INDIANA UNIVERSITY PRESS
BLOOMINGTON & INDIANAPOLIS

This publication was made possible through generous funding from the Samuel H. Kress Foundation; the John Simon Guggenheim Memorial Foundation; Furthermore: a program of the J.M. Kaplan Fund; the Indiana University Foundation; an Indiana University New Frontiers Grant; and Philip Morris and the National Endowment for the Arts.

PhilipMorrisUSA

40th
ANNIVERSARY

NATIONAL
ENDOWMENT
FOR THE ARTS
Established 1965

This book is a publication of

Indiana University Press
601 North Morton Street
Bloomington, Indiana 47404-3797 USA

http://iupress.indiana.edu

Telephone orders 800-842-6796
Fax orders 812-855-7931
Orders by e-mail iuporder@indiana.edu

The paper used in this publication meets the minimum requirements of American National Standard for Information Sciences—Permanence of Paper for Printed Library Materials, ANSI Z39.48-1984.

Manufactured in Canada

Cataloging information is available from the Library of Congress.

ISBN-13: 978-0-253-34809-8 (cl.)

ISBN-10: 0-253-34809-9 (cl.)

1 2 3 4 5 11 10 09 08 07 06

Dedicated to Thomas T. Solley, whose infallible eye first brought Domenico Tiepolo's drawings

to the Indiana University Art Museum, and to

Anthony J. Moravec, whose generous heart is expanding Domenico's presence here.

Contents

Foreword

The Venetian master Domenico Tiepolo is justly famous for his spirited, worldly drawings of the theatrical character Punchinello and his scenes of Venetian daily life, made for his own pleasure in his later years. An exhibition of the Punchinello drawings, organized by Adelheid Gealt, was held at The Frick Collection in the winter of 1980, in collaboration with the Indiana University Art Museum and the Stanford University Art Museum. With this publication of the 313 drawings from Domenico's lesser-known New Testament cycle—reunited here for the first time—Adelheid Gealt and George Knox now bring to light another side of the artist: his deep piety and profound engagement in textual study of the Bible.

The Frick Collection is proud to collaborate again with the authors and the Indiana University Art Museum on the occasion of this monumental achievement. The idea for an exhibition in New York emerged from discussions between Adelheid Gealt, and Colin B. Bailey and Susan Galassi at The Frick Collection. All three have been tireless advocates for the project, and have collaborated to secure significant loans and funding for both the exhibition and the publication of the *catalogue raisonné* of Tiepolo's religious drawings. From October 24, 2006, through January 7, 2007, the Frick will present sixty of the finest examples of Domenico's drawings from the New Testament series. I would like to express my deep gratitude to Adelheid Gealt, guest curator of the exhibition, and to George Knox for sharing their extensive scholarship with us through the exhibition. I am grateful as well to the staff of the Indiana University Art Museum for their collaboration with members of the Frick staff in making available to the public these deeply moving virtuoso drawings.

Principal funding for *Domenico Tiepolo: A New Testament* has been provided by The Peter Jay Sharp Foundation, with major support from Homeland Foundation. Additional generous support has been provided by Lawrence and Julie Salander, the Samuel H. Kress Foundation, the Arthur Ross Foundation, The Helen Clay Frick Foundation, and the Fellows of The Frick Collection. This project is also supported, in part, by an award from the National Endowment for the Arts, which believes that a great nation deserves great art. We are deeply grateful to them all.

Anne Poulet
Director, The Frick Collection

Preface and Acknowledgments

This volume brings together for the first time the 313 drawings by the Venetian master Domenico Tiepolo (1727–1804) that make up the series we have entitled *A New Testament*. Though not recorded in his lifetime, the drawings were well known to connoisseurs in France in the nineteenth century. The first important published note on them is found in a chapter on Domenico Tiepolo in Henri de Chennevières, *Les Tiepolo* (Paris 1898). Fifty of the drawings were reproduced in the fine volume by Henri Guerlain of Tours (1867–1922), *Domenico Tiepolo: au temps du Christ* (Tours 1921), the product of Alfred Mame et fils, a publishing house of Tours, which had already presented the first edition of Gustave Doré's *La Sainte Bible selon la Vulgate* (1866), the study by Charles Rohault de Fleury, *L'Évangile: études iconographiques et archéologiques* (1874), and the late religious drawings of James Tissot, *La vie de notre Sauveur Jesus Christ,* 2 vols. (1896–1897), after drawings now in the Brooklyn Museum. As will be seen, it is not impossible that Doré himself may have gained some inspiration from Domenico's work. The series also forms the subject of two pages in the first comprehensive study of Domenico as a draughtsman, James Byam Shaw's *The Drawings of Domenico Tiepolo* (1962). The drawings have also regularly attracted the attention of exhibition organizers since 1938, when ten of them were shown at Chicago; since then we have seen eight in New York in 1971, twelve in New York in 1973, and twenty-six in Udine in 1996. It was the exploratory work involved in the latter exhibition that inspired the present more comprehensive study.

In January 2000, when this work was far advanced, we learned of the doctoral dissertation of Christofer Conrad, *Die grossformatigen religiösen Zeichnungen Giovanni Domenico Tiepolos* (Heidelberg University, 1996), with a full *catalogue raisonné* of the drawings. We have tried to give proper credit to the data we have drawn from this source.

The 313 drawings that constitute Domenico's *New Testament* were divided into two groups, no doubt at some point in the early nineteenth century, in a somewhat arbitrary fashion. One group, which we call the *Recueil Fayet,* remains intact today in the form of an album with 138 drawings preserved in the Louvre. The essential problem here was to identify the subjects of the drawings and arrange them in an acceptable chronological order. The second group, which we call the *Recueil Luzarche,* was dispersed; this comprises all the other drawings of the series that are known. Here the essential problem was to trace the drawings, of indeterminate number, wherever possible. So far we have traced records of 175, of which we have illustrations of 168. In this we have received much help from the Witt Library, the Frick Art Reference Library, and the Service de Documentation au Musée du Louvre. We have also had much help from Messrs. Sotheby's and Christie's, Jean-Luc Baroni of Colnaghi's, M. and Mme. Bruno de Bayser, Marianne Roland Michel, M. and Mme. Prouté in Paris, and many others. These drawings also had to be identified and arranged in a logical sequence.

The identification of the drawings and the sources of the subjects often presented considerable problems, which are discussed in chapter 3. Apart from a careful reading of the Gospels and the Acts of

the Apostles, the investigation raised intricate questions regarding the Apocryphal New Testament and other pious literature as it could have been known to Domenico and his contemporaries. In this area we have received much valuable advice from Monsignor Antonio Niero of the Basilica di San Marco, P. Sergio Tellan, Librarian of the Redentore, Don Gianni Bernardi of the Biblioteca del Seminario, Marino Zorzi of the Biblioteca Marciana, Rosella Zorzi, and again many others.

In the matter of tracing the visual sources used by Domenico in this project, discussed in chapter 2, we have again received much help, especially from the following: Hugo Chapman of the British Museum Print Room; Elizabeth McGrath and Ruth Rubinstein of the Warburg Institute; Jacopo Scarpa; the Iconclass project, led by H. van der Waal; M. Pierre Robert of the Centre de Recherche et de Documentation of the Oratoire Saint-Joseph at Montreal; M. Henri Loyrette; Carel van Tuyll van Serooskerken; M. Christine André; M. Pierre Rosenberg, Mme. Françoise Viatte, and M. Stéphane Loire of the Musée du Louvre; Colum Hourihane, Adelaide Bennet, and Lois Drewer of the Index of Christian Art at Princeton; and Alice-Mary Talbot and Natalie Teteniatrikov of Dumbarton Oaks.

We must further record the kind assistance and forbearance of all the private collectors and museum officials who have responded so generously to our innumerable requests for information and assistance: Mme. Marie Hélène Lavallée, Musée des Beaux-Arts de Besançon; Mme. Nicole Garnier of the Musée Condé, Chantilly; Philippe le Leyzour, Musée des Beaux-Arts de Tours; William L. Barcham; Jean-Luc Baroni; Mme. Anisabelle Bérès; Mme. Annette Bühler; Alexis Kugel; Arturo Cuellar; Bruno Meissner; Yves Mikaeloff; Peter Nathan; Albrecht Neuhaus; John O'Brien; Hubert and Michèle Prouté; Adolphe Stein; Patricia Tang; E. V. Thaw; Monsieur la comte and Mme. la comtesse de Selancy; Gerard Stora; William O'Reilly; Francis Ford; Mark Brady and Laura Bennett; Hans Buijs; Christian Michel; Stephen Ongpin; Suzanne McCullagh; David Levanthal; Barbara Covello; Marilyn Palmeri; and Jan de Maere. Sophie Bostock, and Barbara Thompson of the Witt Library, have our enduring thanks for their assistance.

Deepest thanks to our project consultants Andrea Ciccarelli, Betty Jo Irvine, Massimo Ossi, Diane Reilly, Massimo Scalabrini, Lawrence Cunningham, Colum Hourihane, Luba Eleen, William Barcham, David Morgan, John O'Malley, David Rosand, and Erik Middelfort; and to Indiana University Art Museum staff whose dedication made this book possible: Carol Dell, Elizabeth Larsen, Richard W. Herendeen, Sean Dudley, Linda Baden, Brian Garvey, Jeremy Hatch, David Tanner, Heather Hales, Michael Cavanagh, and Kevin Montague. Warmest thanks must go to William Carmichael, without whom key sponsorship would not have been found, and to Lisa Ackerman of the Kress Foundation, who believed in this project from the start. At Indiana University, profound thanks are extended to Curt Simic, Michael McRobbie, and Kenneth R. R. Gros Louis for their friendship and encouragement. At Indiana University Press, Janet Rabinowitch, Bernadette Zoss, and Miki Bird deserve much thanks, as does Melanie Hunter. To our friends at The Frick Collection we acknowledge a great debt of gratitude, especially to Anne Poulet, Colin Bailey, Susan Galassi, Diane Farynyk, Joanna Sheers, and Amy Busam. We also extend affectionate thanks to Patricia Knox and Barry Gealt, as well as to Tony Moravec, who has done so much in support of this project.

Finally, we must offer our thanks to the John Simon Guggenheim Memorial Foundation and the Samuel H. Kress Foundation for their support of our research and their further support of the publication. We also extend our sincere gratitude to the additional sponsors who generously supported this publication: Indiana University New Frontiers grant, Philip Morris; furthermore, a program of the J. M. Kaplan Fund, the Indiana University Foundation, and the National Endowment for the Arts.

An Introductory Note on Domenico Tiepolo (1727–1804)

The extent of Domenico's New Testament cycle, published here for the first time, allows little room for even a brief biography. However, some information about Domenico may help the reader's understanding of the artist and place *A New Testament* in a clearer context.

Domenico is inevitably described as the eldest son and principal assistant to the great Giambattista Tiepolo (1696–1770), universally celebrated as the presiding genius of eighteenth-century Italian painting. Giambattista's reputation was such that invitations to decorate grand palaces came from all over Europe, from Saint Petersburg to Madrid, where, in fact, Giambattista died with Domenico at his side. Though overshadowed by the genius of his father, Domenico succeeded in establishing a clearly independent style as a painter,[1] draughtsman,[2] and printmaker,[3] and enjoyed a successful and distinguished career.

A salient aspect of Domenico involves his love of large, finished drawings. In fact, his reputation as a master in his own right rests largely on the hundreds of sheets of full-sized, handmade paper that he transformed into brilliant drawings, most of which still survive. None of the series to which many of these drawings once belonged remain intact, but serial narratives were Domenico's peculiar specialty, one in which his accomplishments are peerless. His pictorial biography of Punchinello, which unfolds over 104 sheets introduced by the title page, *Divertimento per li Regazzi,* is his most celebrated series (Gealt 1986). However, besides making charming drawings of satyrs and centaurs and other fabled creatures, we know that Domenico spent nearly as much time making drawings that portray ordinary life among residents of Venice and the Veneto (see Gealt and Knox 2005). If the sheer volume of what he produced is any indication, then none of his series can compare to Domenico's special passion for sacred narrative.

Domenico's career was launched by the creation of a sacred picture cycle, the first of its kind in Venice. In 1747, the 20-year-old painter received a commission to paint the *Fourteen Stations of the Cross* for the Venetian church of San Polo. Besides being the first such devotional cycle in Venice, the commission developed Domenico's interest in biblical serial narrative, something that would only be truly fulfilled in old age. Nearly forty years later, around 1785, comfortable with the wealth accumulated from a successful career as a painter and free to do as he pleased, Domenico recalled his youthful experience with sacred serial narrative and turned to it again.[4] In that effort he might have been encouraged by his younger brother, Giuseppe Maria Tiepolo (born 1729), who was a priest in the Order of the Somaschi, which was dedicated to the care of orphans.

1. For the basic study, see Adriano Mariuz, *Giandomenico Tiepolo* (Venice 1971).
2. James Byam Shaw, *The Drawings of Domenico Tiepolo* (London 1962); *Domenico Tiepolo, Master Draughtsman* (Udine/Bloomington 1996).
3. Aldo Rizzi, *The Etchings of the Tiepolos* (London 1971).
4. Domenico had another occasion to produce a sacred serial; in 1753 he produced a 24-plate etched series illustrating the *Flight into Egypt,* which he dedicated to his father's patron in Würzburg, the Prince-Bishop; see Exhibitions, Washington, 1972.

By 1785 Domenico had settled in the family villa at Zianigo near Mirano in the Veneto. This is when the drawn serial narratives for which he is so justly famous were begun. His first project—undertaken, so far as we know, solely to explore his own interests—was the present sacred cycle. It included the *Fourteen Stations,* but folded them into a broader context, one that rehearsed in great detail the epic history of early Christianity. Beginning with Joachim and Anna, the grandparents of Jesus, Domenico detailed the lives of Mary and Joseph, gave an extensive pictorial biography of John the Baptist, and spent considerable time over the infancy and ministry of Jesus. Christ's Passion is followed with those same events recast as the formal devotional cycle of the *Fourteen Stations.* Domenico considered the acts of Saints Peter and Paul, the founders of the early Church, and then added in some later saintly lore for good measure. The result was a series three times longer than any other drawing cycle by Domenico (or by anyone else, to our knowledge). How many years he labored at this massive project remains speculative. We imagine it must have taken at least five years, or even longer; perhaps he worked on it until he died. What prompted Domenico to undertake something of this magnitude with no known patron to spur him on? We still do not know. It appears to be a remarkable case of deep personal piety. The Venetian connections to Domenico's spiritual heritage are strong, suggesting a sense of patriotism as well. We also discovered an unusual accent on St. Peter and the papacy, causing us to speculate that he might have wanted to appeal to Pius VI. But Napoleon's incursion into Venice and Italy in 1797 brought that all to naught.

What caused the dismemberment of the drawings? Again, we do not know precisely, but it is significant, as the first chapter describes, that the first collectors were French and purchased the drawings after Domenico's death in 1804. The French love affair with Italian drawings goes back to the sixteenth century, and certainly during the Napoleonic occupation French collectors must have been particularly prevalent in Venice. Hence, historic events (Pius died in exile in 1799) altered what may have been the intended destiny of these drawings, while collectors over many generations preserved selections of them. Yet as a cycle the series was lost. If anyone besides Domenico knew what he had accomplished, that knowledge was lost as well. Two hundred years after Domenico's death, his forgotten masterpiece has finally been reassembled with the hope that his greatest accomplishment as a draughtsman can at last be more fully appreciated.

We would like to offer a few more comments to the users of this book, which we hope will include the interested general reader and those who love drawing and sacred stories, students and scholars alike. A great deal of information, perhaps a superfluity, is packed inside these pages. Besides providing a history of the drawings and a discussion of the literary and pictorial traditions from which Domenico worked, we have tried to consider the complexities of Domenico's narrative approach.

For those who desire a synopsis of the stories Domenico tells, these are summarized at the beginning of each of the "chapters" into which the story is divided, starting with that of Joachim and Anna. The description of each drawing begins with a quotation from a textual source that Domenico might have used. For the Bible, we cite the King James version, which seems sufficiently similar in its accounts to the Latin or Italian Vulgate that Domenico might have had to hand. There follows a general commentary on issues related to that drawing. A reference section provides further information on traditions and sources. Finally, we offer a list of subjects illustrated, which also notes those standard subjects Domenico appears to have omitted.

The Bible is a text that engages the reader for a lifetime. Domenico's drawings, inspired by a text of such spiritual and narrative complexity, also merit prolonged and, we hope, repeated contemplation. We believe this is a book to linger over. The drawings as much as the text are deeply moving and reveal themselves over time. We have devoted a decade to this material, and we remain continually inspired by Domenico's work. If the results give our readers any part of the pleasure we have had in reassembling this series, our ambitions will have been fulfilled.

AMG, GK, 2006

Domenico Tiepolo
❧ *A New Testament* ❦

CHAPTER I.

The History of the Material 🖋

G EORGE K NOX

Domenico Tiepolo (1727–1804) apparently spent most of the year 1785 in Genoa painting the ceiling of the Salone del Maggior Consiglio in the Palazzo Ducale. This, his most ambitious work as a painter, was lost in the nineteenth century, but the design survives in the *modello* in the Metropolitan Museum of Art.[1] Domenico went to Genoa on March 3, 1785, and the work was unveiled on November 14. After this the artist seems to have largely retired from painting to devote the remaining eighteen years of his life to drawing.

Thus, at around the age of 60 and during the years 1786–1790, so far as we can estimate the date, Domenico embarked on his most extensive and perhaps his most remarkable work as a draughtsman. Although he had produced drawings in long series before that time, this series of large religious drawings—essentially illustrating the events of early Christianity from the story of Joachim and Anna to the martyrdom of Peter and Paul—represents a new departure, quite unlike anything that had gone before, or indeed since, both in scale and elaboration.

For this new enterprise we have adopted, not without some hesitation, the title *Domenico Tiepolo: A New Testament.* The artist himself has given no indication of his purpose nor suggested a title for his work. Through the ages the actual New Testament has presented a somewhat arbitrary and contradictory account of the beginnings of Christianity, so much so that in the eighteenth century we find first the Deists in England and then, in Domenico's own time, certain Protestant theologians in Germany beginning to analyze the texts of the four Gospels in a somewhat destructive way.[2] We do not know whether any rumors of this activity had reached Venice, but in any case Domenico took a very different line. His approach was to ignore the limitations of the material offered in the New Testament and to restore, for the first and only time since the Reformation, the full amplitude of the narrative as it had been known in the Middle Ages, thereby creating a New Testament. In so doing he may have been responding to Venetian tradition, associated with the name of Paolo Sarpi (1552–1623), which regretted the schisms of the West, exacerbated by the Council of Trent and the Papacy of the time. At the time of the Interdict, Venice supported a more open and sympathetic relationship with the Greek Church—and even the Anglican Church—as well as a regard for traditions descending from the Middle Ages. Domenico also may have been responding to the antiquarian interests of his own time; he may even have encountered in Genoa some tradition of interest in its celebrated bishop, Jacopo da Varagine (or Jacobus de Voragine), and his immortal work *The Golden Legend.* Moreover, during those long months in Liguria, he may have found an opportunity to travel, perhaps even as far as Rome, to see the ancient and early Christian monuments and the new papal museums of Pius VI. Much of the inspiration for his project can evidently be found, as we shall see, in early Venetian monuments, especially in the mosaics of San Marco. But some aspects, not least his concern with the stories of Peter and Paul, down to their martyrdom in Rome, suggest an impetus from that quarter.

It may be appropriate at this point to consider briefly the question of the piety of the Tiepolo family.[3] Giambattista was closely associated with several Venetian religious foundations. In his early years, and again in

1. Mariuz (1971: [322]); Zeri and Gardner (1973: 67–69, [82, 83]); Udine (1996: 48, [rep.]). The competition was won in August 1784; see also "A Domenico Tiepolo Chronology" in Knox (1980: 337–339).

2. In 1776, Adam Weishaupt formed the Order of the Perfectibilists, later known as the *Illuminati.* In 1774–1778, Lessing published extracts of the work of Reimarus—see Schweitzer (1906: ch. 2).

3. For a full study, see Barcham (1989).

1743–1745, he carried out important work for the Discalced Carmelites of the Scalzi, and in the early 1740s he worked in the Scuola dei Carmini, of which he was said to be a member. At the same time he was associated with the Dominicans of the Gesuati. Around 1750, his young son Giuseppe Maria entered the Somasco Order of St. Girolamo Emiliani, in which he remained for the rest of his life, so far as we know. In 1757 the chapel of the Villa Tiepolo at Zianigo was dedicated to St. Girolamo, and Domenico decorated it with scenes from the life of the saint.

Domenico showed an early interest in religious iconography in *The Stations of the Cross* and the related canvases of the Oratorio del Crocefisso of San Polo. He followed these with the series of 22 etchings of the *Idee Pittoresche sopra Fugga in Egitto,* with the title page dated 1753. After this he carried out a number of projects in parish churches, but he does not seem to have been allied with any religious movement other than the Somaschi. This was essentially a teaching order, and it is an attractive idea that his large religious drawings may be seen as *Devozioni per li regazzi,* parallel to the later Punchinello drawings, the *Divertimento per li regazzi.*

Background

Like those of his father, Domenico's drawings are divided into two types: those in pen and wash on white paper, some 1,500 in all, and those in black or red chalk on blue paper, of which about 400 can be counted. Of the latter, all are essentially studies for paintings.[4] Of the pen and wash drawings, 500 are large elaborate drawings of the later part of his career: first, *A New Testament,* a series of 300 drawings disposed vertically, followed later by *The Scenes of Contemporary Life* and the *Divertimento per li regazzi,* about 100 each, disposed horizontally. Together, these elaborate drawings represent one-third of his entire output as a draughtsman, and *A New Testament* one-fifth of the whole.[5]

Of the remaining 1,000 pen drawings, about 100 are loose compositional studies of somewhat miscellaneous character, varied in size but broadly related to his activities as a painter.[6] The rest run in long sets of uniform character, generally quarto size: animals, including horses and horsemen; centaurs and satyrs; gods and heroes; and religious subjects of various kinds. Details of many of these are reused in the design of the three later series of large drawings.

As a draughtsman in pen and wash, Domenico was a very systematic worker. Each drawing was clearly conceived beforehand and then carried to completion, with a signature generally added. Unfinished drawings are virtually unknown,[7] as are failures, though such items may well have been discarded. In this pattern the large religious drawings of *A New Testament* stand apart; the scale and character were clearly planned prior to the beginning of the work, and once carried through to completion were never used for anything else later. One important element in this was the use of the vertical format, which immediately suggests a book illustration, with the disadvantage that a design with numerous figures seems to tend inevitably to a band of figures across the lower part of the composition and a relative vacancy above them.[8] Only one drawing, *The Last Supper* [fig. 1], can be cited as a possible precursor.[9] This resembles the style of the New Testament series in the careful, even pattern of penmanship and in the application of wash. The essential difference is that it is on a sheet of paper measuring 235 x 370—exactly one-half the regular size (470 x 370) of the later series—and is disposed horizontally, like the later *Scenes of Contemporary Life* and the *Divertimento per li Regazzi.* This drawing is closely related to Domenico's painting of 1775, now in the Maddalena in Venice.[10] It is quite unlike his normal compositional

4. Byam Shaw (1962: passim); Knox (1980: passim); Knox in Udine (1996: 39–59).

5. Udine (1996: [88–113, 135–176]), checklists: 240–253.

6. Udine (1996: [6–87]).

7. For an exception to this rule, one may note the important and interesting example of an unfinished drawing at Oxford (Udine 1996: [170]).

8. This pattern may derive from the large Dürer woodcuts and the Jesuit books of Nadal and Ricci—see below.

9. Udine (1996: [56]).

10. Knox (1980: [311–314]) [fig. 204].

studies for paintings, and it appears to be either a *modello* for presentation to a patron or a later *ricordo* of the picture. In either case it must be dated ca. 1775, and it may suggest that some of the New Testament illustrations may possibly be earlier than the date in the mid-1780s, when Domenico seems to have essentially retired from painting to devote himself to drawing.

Figure 1. Domenico Tiepolo, *The Last Supper* (drawing, private collection)

Some Comparable Contemporary Projects

We have no indication as to why Domenico embarked on this project. If there was some idea of engraving the designs, we know nothing of it. Apart from the case of the Beauchamp Album,[11] he seems to have had little interest in finding a market for drawings, though several albums of drawings by his father, Giambattista, were sold to Antonio Canova by his widow shortly after his death.[12] However, it may be worth noting some comparable projects of various kinds in eighteenth-century Venice. Perhaps most important is the series of large reproductive etchings made by Pietro Monaco in the years 1739–1745 and published in their final form in 1763 under the title *Centododici stampe di storie sacre.* These are predominantly from the Old Testament, but about one-third are New Testament subjects, reproducing the work of a number of Venetian masters down to Giambattista Tiepolo. Domenico had been marginally involved with this project some 40 years earlier, during the years of his apprenticeship.[13]

Among other immediate predecessors one may notice the large group of drawings on similar subjects by Giambattista himself, found mainly in the Orloff Album;[14] the series of 59 large drawings recording paintings of Venetian history by Antonio Guardi—*I fasti di Venezia*—in the Fondazione Giorgio Cini;[15] the album of 28 large finished drawings on religious subjects in the Correr Museum by Francesco Fontebasso;[16] the series of marble reliefs of 1730 by leading Venetian sculptors illustrating the New Testament in the chancel of the Chapel of the Rosary in Sts. Giovanni e Paolo; and Domenico's own series of etchings of 1753, *Idée Pittoresche sopra la Fugga in Egitto.*[17] Religious requirements also created a need for series such as the *Fourteen Stations of the Cross,* of which those painted by Domenico at the beginning of his career are a conspicuous example,[18] and the fifteen *Mysteries of the Rosary.* Though not Venetian, Domenico may also have known something of the twenty drawings depicting *The Life of the Virgin* by Jacques Stella, which were engraved in Rome by Francesco (Felice) Polanzani, published first in 1756 and reissued in 1783.[19] On the secular side, one may recall some long series of book illustrations such as those by Piazzetta and Novelli for Tasso,[20] and by Fragonard for Ariosto, soon to be followed by those of Flaxman for Homer and Dante.

None of the above examples, however, can be compared to Domenico's project for originality, inventiveness, and broadness of conception. He does not simply illustrate one text or follow one decorative tradition, but

11. Christie's, June 15, 1965 [1–167]; see Knox in Udine (1996: 49).

12. Pavanello (1996). For the history of the albums of chalk drawings and the Bossi Beyerlen drawings, see Knox (1980).

13. See Knox (1965) and Knox (1999) for further details about Monaco's *Raccolta* and the links with Giambattista and Domenico Tiepolo. The corpus has now been fully published; see Apolloni (2000).

14. See Knox (1961) for an account of the Orloff Album.

15. Morassi (1973: [57–121]).

16. Pignatti (1981: 165–178, [447–474]).

17. Rizzi (1971: [67–96]).

18. Knox (1980: ch. 7, 31–38).

19. Eleven of these drawings were sold, Christie's, Dec. 3, 1986 [122–132].

20. Knox (1978: 32, note 9).

creates—from all the texts available to him, and all the resources of Venetian art with which he was familiar—a complete account of the Christian story from the parentage of the Virgin Mary to the martyrdom of Peter and Paul. To this he adds an epilogue of a dozen drawings that seem to offer a brief account of Venetian piety in the subsequent ages.

The History of the Drawings

Domenico Tiepolo's *New Testament* has come down to us in two main groups. The album of 138 drawings in the Louvre, known as the *Recueil Fayet,* was bought in a shop in Piazza San Marco in 1833 by Jean Fayet Durand (1806–1889), a businessman and amateur of art,[21] on a tip from his friend Camille Rogier.[22] According to Henri de Chennevières, our source for this information, he bequeathed it to the Louvre, again at the suggestion of Rogier, in June 1889.[23] A second large accumulation of these drawings is said to have been purchased "in Italy," presumably at around the same time, by M. Victor Luzarche (1803–1869), citizen and, for a time, mayor of Tours,[24] which here goes under the name of the *Recueil Luzarche.* It did not go into his sale in 1868 but passed at his death to a kinsman who, according to Henri Guerlain (1867–1922), also of Tours,[25] who published 50 of these drawings in a handsome volume in 1921), in turn passed it to Camille Rogier (1805–1893), named as still the *heureux possesseur* of the collection.[26] This second reference to Camille Rogier may be a mistake, but if it is not, then it provides a link between Jean Fayet and Victor Luzarche; on the other hand, Rogier appears to have died in 1893. Finally, in 1921, a parcel of 82 drawings from the same source, including most of those published by Guerlain, appeared in the Paris sale room as the property of Roger Cormier of Tours. One must suppose that from this, or a closely related source, also came the numerous drawings that appeared in the collections of French art lovers and collectors prior to 1921, among them Jean-François Gigoux (1806–1894), Léon Bonnat (1833–1922), Jules Hédou (1833–1905), P. D. E. F. Lamy (1855–1919), Théodor de Wyzewa (1862–1917), and Vladimir Argoutinsky-Dolgoroukoff (1875–1941). To these should be added Charles Fairfax Murray (1849–1919). At present we have some record of the appearance of 169 drawings from the *Recueil Luzarche,* and a further six are recorded without illustrations, for a total of 175 items. Together with 138 items in the *Recueil Fayet,* we have at present a total of 313 items.

The Recueil Fayet *in the Louvre*

The drawings of the *Recueil Fayet* are mounted in an album—RF 1713bis—with a blue binding of the nineteenth century, and the title in gold—DOMENICO TIEPOLO 1760—on the front and the spine. The drawings are numbered consecutively from 1 to 138. Henri de Chennevières affirms that the album was prepared after the acquisition of the drawings by M. Fayet, and it is generally agreed that the date should be disregarded.[27]

21. In the same year, 1833, he purchased a Michelangelo drawing from the lawyer Savelli of Senigallia, which is also in the Louvre. His will is dated June 9, 1873. So far we have been unable to find more information about M. Fayet; however, one wonders whether there may be some link between him and M. Gustave Fayet of Béziers (1865–1925), "the first and greatest of all Gauguin collectors" and a supporter of Matisse at Collioure in 1906.

22. De Chennevières (1898: 140): *"M. Fayet ne manquaient guère de passer une quinzaine à Venise ou l'avait connu M. Camille Rogier. . . . Un jour, en 1833, il questionnait M. Camille Rogier: 'Ma foi, lui dit l'artiste, voyez donc un étalagiste sous les Procuraties; j'ai aperçu hier toute une liasse de dessins de Tiepolo le fils . . . ça doit être dans les quarante sous pièce. . . .'"* For a note on Camille Rogier and Tiepolo, see Knox (1960: 8, note 12).

23. De Chennevières (1898: 140): *"A distance d'années, M. Rogier, revoyant M. Fayet, lui reparlait de ces dessins: 'Vous savez, c'est une vraie collection, c'est une suite pour musée, faites-en donc bénéficier le Louvre un jour. . . .'";* Two of the series, illustrated by de Chennevières, are also listed by Sack (1910: 322, nos. 188, 129).

24. For a portrait and many details about Victor Luzarche, see Moreau (1999: [40]).

25. For a portrait and many details about Henri Guerlain, see Moreau (1999: [247]).

26. Guerlain (1921).

27. De Chennevières (1898: 140): *"M. Fayet avait fait un album relié, de sa série de dessins";* Byam Shaw (1962: 36).

The arrangement of the drawings in the album seems fairly arbitrary, but it may be noted that in certain cases a logical sequence is preserved. Thus, a series on the Flight into Egypt (pls. 47–72) includes folios 52–59 of the Louvre Album; a series on the story of John the Baptist (pls. 82–102) includes folios 11–19; a series on the Passion of Christ (pls. 170–204) includes folios 79–88 of the Louvre Album, but essentially in the reverse order. On the other hand, *The Stations of the Cross* (pls. 213–227) appear as folios 20–34. Folios 1–106 in the Louvre Album have on the verso a brief indication of the subject of the drawing in ink and in French. These were evidently added after the album was made up and, though often well-founded, are occasionally misleading. Henri de Chennevières suggests that Domenico Tiepolo was responsible for the numbering of the drawings and the inscriptions on the verso, but this again may be disregarded.[28]

By keeping together 138 of the drawings, the Louvre Album also makes it a simple matter to consider the question of the size of the paper used, as well as the size of the drawings. It seems that in general the drawings are on a full sheet of paper, as manufactured, but slightly trimmed. Only one sheet shows signs of having been trimmed to a drawn pen line. These sheets are not absolutely regular in size but appear to have averaged 485 x 380 mm. Domenico's image invariably leaves a margin of about 10 mm on each side, so that the image has an average size of 463 x 360 mm However, the height measurements range from 454 to 473 mm, and the width from 350 to 370 mm, always leaving the margin of 10 mm

One may note that the other two series of large drawings by Domenico, the *Scenes of Contemporary Life*[29] and the *Divertimento per li Regazzi*,[30] are drawn on similar sheets of paper, with a maximum paper size, trimmed, of about 375 x 465 mm, disposed horizontally rather than vertically. However, the image size allows a margin of about 30 mm on each side. The image size also varies slightly for an average of about 290 x 420 mm.

The Question of Style

An examination of the Louvre Album also makes it possible to come to some conclusions about variations in style and consequently to some tentative and broad conclusions about the chronological sequence of the drawings. Thus, some seem to be much later than others, such as *The Death of Anna* (pl. 21) among the drawings illustrating the story of Joachim and Anna, and *The Crucifixion* (pl. 200) among the scenes of the Passion. A pen outline of clouds or distant mountains suggests a relatively early dating; a very heavy underdrawing appears to be an indication of lateness (*The Flight into Egypt on a Mountain Road,* pl. 49) and thus is an unusual degree of looseness (*Jesus and the Dragons,* pl. 55). The drawings often seem to go in pairs, and sometimes one of the pair seems to be much later than the other. It is possible that with further study new factors will be noticed that will suggest a fairly convincing sequence for the execution of the drawings.

As regards Domenico's approach to drawing, it may be observed that after a very rudimentary underdrawing in black chalk, he proceeded at once to a pen outline, executing the important figures in the foreground first and the background last. To take *The Parting of Peter and Paul* (pl. 296) as an example, the figures of Peter and Paul were done first, followed, somewhat unusually, by the soldier to the left, who clearly overlaps them. The crowd and their weapons were drawn before the townscape and the platform, and the wash was added last. As in this example, the outline of distant mountains is often indicated in black chalk only. One must further note the very effective use of the white paper in details and the overall use of bistre to give a rich golden effect, not unlike the gold background of a medieval mosaic.

28. De Chennevières (1898: 140): *"car, la plupart étaient numerotés par l'artiste lui-même, et légendés de sa main, au verso, comme les feuilles d'un recueil primitivement classé."*

29. Byam Shaw (1962: ch. 5); Udine (1996: [135–154]). A checklist of the series is given in Udine (1996: 240–243). One further example has since come to light (Gealt and Knox 2005 [26]).

30. Byam Shaw (1962: ch. 6); Gealt (1986); Udine (1996: [155–176]). A checklist of the series in the sequence indicated by Domenico himself is given in Udine (1996: 244–247).

The wash is laid on in perhaps five or six overlapping layers, working from light to dark, with even darker details being added last of all. Thus, the first light wash would leave only the white highlights untouched, and subsequent layers of wash would leave parts of the previous wash untouched.

The thickness and absorbency of the paper seems to vary extensively. In most cases the verso shows a clean surface with no sign of penetration, but in other cases the penetration is extensive. The pen work never seems to penetrate the paper, even when the wash does. In some odd cases the pen work seems to inhibit the penetration of the wash; for example, a squared pavement may clearly show the wash penetrating to the verso, while the pen lines of the pavement show as white. It has been suggested that this penetration shows the corrosion of iron-gall ink, but it may be simply due to the application of more liquid in the form of washes. In some cases, especially in *Joachim in the Wilderness* (pl. 5), there appears to be a colorless underdrawing in some waxy or greasy material that inhibits the regular flow of the wash when it is laid over these passages. No satisfactory explanation for this phenomenon has so far emerged.

The signatures also vary widely in character and location. In the *Recueil Fayet,* some nineteen items—about 14 percent—are not signed. Several are signed on columns, and the rest are generally placed either low left or low right, unless design factors suggest a more central location on the bottom edge of the design. One drawing, *The Chief Priests in the Palace of Caiaphas* (pl. 177), is signed twice.

The Division of the Drawings

The division of the drawings between the two major groups seems at first to have been fairly arbitrary, but there is some indication that the drawings of the *Recueil Fayet* were selected from the entire collection, leaving the remainder to form the *Recueil Luzarche.* While this is speculative, it seems possible that M. Fayet may have bought the entire collection in 1833 and made his selections, then passed the rest to M. Luzarche. It is worth noting that they were almost exact contemporaries, Fayet being 27 (as was Jean-François Gigoux) and Luzarche 30 in that year. Since one must assume that the drawings were all initially loose, some sorting out of categories seems to have taken place before selection, so that a reasonable balance of the material was maintained between the two groups. Of course, we do not know the full extent of the series as planned, or how far the plan was completed. Nor do we know whether the division between the two groups was necessarily unequal, though it now stands as 44 percent to the *Recueil Fayet* and 56 percent to the *Recueil Luzarche.* One has only to suppose that fifteen drawings of the latter may have at one time belonged to the former group to bring the two groups into balance. However, taking the present numbers as they stand, when the two groups together are divided into fourteen sections, Sections 1–2, 3–4, and 5, separately and together, divide the drawings in the ratio of 2:3. Sections 6 and 7–8 together observe a ratio of 4:5. Sections 9, 10–11, and 12–13, separately and together, are nearly equal. This represents a degree of control that can hardly be accidental.

We should perhaps note that a small number of familiar scenes are not found among the extant drawings: among them *The Nativity of the Virgin, The Annunciation, The Wedding at Cana,* and *The Washing of the Feet.* It seems unlikely that Domenico omitted them deliberately, and if we are right in our suggestions about the division of the drawings into two comparable groups, it could well be that such subjects might have been retained by Fayet but that some of them failed to find a place in the Louvre Album. The disappearance of these drawings may account for the disparity in numbers between the *Recueil Fayet* and the *Recueil Luzarche;* on the other hand, this raises the possibility that some of the drawings listed under the latter may once have belonged to Fayet.

It may be noted that in many cases a subject is treated in a pair of drawings. Sometimes the division of the drawings separates a pair—for example, *Joachim's Offering Refused* and *Joachim Turns from the Temple in Despair* (pls. 2–3), or *Jesus Among the Doctors* and *Jesus Leaves the Doctors* (pls. 78–79)—and sometimes not—for example, *The Seven Virgins Draw Lots* and *The Young Mary Accepts the Scarlet and the Pure Purple* (pls. 18–19), or *Joseph Taking Leave of Mary* and *Joseph Scolding Mary* (pls. 30–31).

In a few cases we find a subject treated in three drawings, such as the story of Zacchaeus (pls. 166–168) or the story of Eutychus (pls. 289–291). In general, these sets are very similar in style and evidently were made at much the same time; this is also the case with the fourteen Stations of the Cross (pls. 213–227). However, in the case of

nos. 18–19, it would seem that *The Young Mary Accepts the Scarlet and the Pure Purple* is substantially earlier than *The Seven Virgins Draw Lots.*

The sequence of the drawings as they are presented here seems to reveal a clear underlying plan. Although we do not know how many drawings are missing, we believe that the main narrative may have been planned to number some 300 drawings, with an epilogue of some twenty items, for a total of about 320. The main group of 300 is divided into three roughly equal parts: the first third comprises five sections with some twenty drawings in each, taking the story up to *The Funeral of John the Baptist* (pl. 102); the second third comprises the ministry of Jesus (pls. 103–168) divided into four sections, as well as the Passion and the Resurrection (pls. 169–212), totaling 110 items; the third part includes the Stations of the Cross as well as the stories of Peter and Paul and a few beyond that, for a total of 101 items. *The Transfiguration* (pls. 139–141) seems to stand as a turning point in the middle of the whole design.

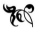

CHAPTER II.

The Visual Sources

GEORGE KNOX

We must suppose that, in the course of preparing some 300 elaborate compositions, Domenico drew upon the visual experiences of a lifetime. We must believe that his visual memory could recall a vast array of images of every kind, even if only a very small part of this material found its way into these drawings. Even so, it is of some interest to try to trace, as far as possible, the sources of the visual material he may have used, and to consider the basis for his choices. Biblical studies have blossomed since Domenico's day, and in an iconographical survey of this kind one must have constant recourse to the work of André Pigler and Louis Réau, itself the product of two centuries of intense activity. For a wider view one must refer to them, but here one must focus on works that could or should have been familiar to Domenico himself.

The Mosaics of San Marco

In developing the thematic material for *A New Testament,* Domenico may be said to have had recourse to certain main sources of visual inspiration, representing the tradition of New Testament illustration as it might have been known in Venice from the twelfth to the eighteenth centuries. Perhaps the most important and extraordinary aspect of this work is his revival of interest in a tradition that had been largely destroyed in the age of the Reformation and the Counter-Reformation and had then been largely forgotten for the subsequent 200 years. One may say that Domenico offers an extended New Testament that goes far beyond the familiar biblical text and tells the stories of early Christianity from the parentage and birth of the Virgin Mary down to the martyrdom of Peter and Paul. It adds much material that fills in the narrative before the Four Gospels and after the Acts of the Apostles, but omits the Epistles, which do not lend themselves to visual treatment, and, more significantly, ignores the Revelation, which has its own rich tradition of illustration.

No single text covers this material, but an equivalent visual account of it is presented by the mosaics of San Marco. These give an abundant account of the parentage and infancy of Christ, the Gospels, and a few scenes from the Acts of the Apostles, and the authority conferred by their antiquity and centrality to the artistic heritage of Venice is overwhelming. No fewer than 85 of them are related to Domenico's project, which open at the same point as he does, with *Joachim's Offer Refused,* and carry the story through to the martyrdom of Peter and Paul.

The sequence of the narrative scenes in San Marco, which cover all the vaults and walls below the transcendental images in the cupolas and their pendentives, appears somewhat baffling, but an order can be discerned. The stories of Joachim and Anna, down to Jesus in the Temple, begin in the western arch and wall of the south transept and continue in the corresponding western arch and wall of the north transept, with twelve scenes altogether.[1] Four scenes of the *Life of the Virgin* are found in the adjacent Capella dei Mascoli, and though they are of the fourteenth century, they may represent earlier work in the same location.

The north and east vaults and walls of the north transept, the east and south vaults and walls of the south transept, and the north vault of the crossing are ornamented with scenes of the ministry of Jesus. The east, south, and west vaults of the crossing tell the story of Christ from *The Annunciation* to *Noli Me Tangere* in a fairly accurate sequence. The south and north vaults and walls of the nave show the martyrdom of the twelve Apostles,

1. The anomalies here are *The Rediscovery of the Body of Mark* in the west wall of the south transept and *The Story of Susanna* on the west wall of the north transept.

including Paul. The anomaly here is the very large and handsome mosaic showing the *Agony in the Garden* on the south wall, and perhaps *The Paradise* on the north wall. The north wall also carries *The Fall of Simon Magus* and *Peter and Paul Before Nero,* as well as the martyrdom of Peter and Paul, bringing the story down to the foundation of the Church in Rome. The baptistery, as one might expect, also offers a full series of mosaics of the fourteenth century depicting the life of the Baptist, together with four scenes showing the story of the Magi that are not shown elsewhere. Thus, the scheme entirely omits the Acts of the Apostles; indeed, the only reference to the Acts is found in two mosaics of the Chapel of Peter, showing *Peter Before Herod* and *Peter in Prison.* The rest of the chapel is decorated with scenes from the life of Mark.

Recent publications cover the mosaics of San Marco in great detail, but not always in ways that make the narrative sequences entirely clear. Otto Demus is mostly concerned with style and chronology,[2] while Antonio Niero deals rather summarily with the parentage and infancy of Mary.[3]

San Marco is the great central monument of Venice, and its mosaics have been constantly accessible down the ages. Venetian antiquarians of the eighteenth century showed great interest in the basilica; Antonio Visentini had published his *Iconografia della Ducal Basilica dell'Evangelista S. Marco,* a complete visual record in 1726, in eleven large plates engraved by Vincenzo Mariotti,[4] which were republished in a sumptuous edition by Antonio Zatta in 1761, *L'Augusta Ducale Basilica dell'Evangelista San Marco,* with much additional material.[5] In 1749, Flaminio Corner gave a documentary account in vol. 10 of his *Ecclesiae Venetae,* with an Italian edition following in 1758, while in 1753 Francesco Meschinello published his *La Chiesa Ducale di S. Marco colle notizie* in three volumes.[6] However, it seems that none of these sources provide a succinct and detailed visual account of the mosaics of San Marco in the form of engravings, no doubt in part because of the vast quantity and variety of the material. An even more direct link between Domenico and the basilica may be indicated by his long acquaintance with Pietro Monaco, who was responsible for the mosaics from 1758 until his death in 1772, when he was replaced by his "relative and successor, Giacomo Monaco."[7] This may well have given Domenico access not only to the mosaics themselves but to the workshops that carried out restoration work and their archives, which contained record drawings of twelfth-century work that had been replaced in the sixteenth and seventeenth centuries. The abundance of New Testament illustration may often make it difficult to assign a specific source for a given motif; nevertheless, it appears very likely that certain groups of drawings do in fact descend from prototypes in San Marco. One may cite the conspicuous mosaics depicting the Temptations of Jesus (pls. 104–110), Jesus and the Woman of Samaria (pls. 131–132), and the Agony in the Garden (pls. 185–188).

Beyond this, however, we claim that the mosaics of San Marco are the primary inspiration for Domenico's whole project. He seems to have adopted quite deliberately the simple draperies and rather static attitudes of the old mosaics, ignoring the later replacements of the sixteenth and seventeenth centuries. His simple backgrounds and settings also relate to the early mosaics, as does the golden hue of his bistre washes.

2. Demus (1984: passim).

3. Antonio Niero, "La soluzione liturgica," in *San Marco* (1990: 153–154).

4. Dario Succi in Exh. Gorizia 1986 (141–146).

5. Zatta (1761) provides a long verbal description of the mosaics and gives all the inscriptions, but the engravings do not offer any proper visual account of the mosaics of San Marco.

6. This is a complete guide book that provides all the inscriptions and lists all the relics. Vol. 3 gives a history of the fabric under each Doge, with lists of the Procurators, etc.

7. Demus (1984: 15): "His relative and successor Giacomo Monaco, who worked on the façade, the Muscoli Chapel, and in 1806 proposed to the Procuratori a replacement of 1460 square feet of mosaic & the consolidation of 2,600 square feet—a proposal that, fortunately, was turned down."

The Four Columns of the Ciborium in San Marco

It is a little difficult to estimate the extent to which Domenico took account of the second great iconographic resource of New Testament imagery in San Marco, the four columns of the ciborium over the high altar. The columns are 3.01 m high, each with nine horizontal bands of relief sculpture about 28 cm high and an inscription in Latin above on a band about 5.5 cm high. Each of these 36 bands of sculpture, consisting of figures in nine niches—324 niches in all—display some three or four subjects, with figures from two or three niches combining to form a single subject: Column A, to the rear on the left, starts once again with the story of Joachim and Anna and continues down to the *Sposalizio;* Column B, to the front on the left, takes the story from The Annunciation to Jesus and the Canaanite Woman; Column C, to the rear on the right, continues the story of the ministry of Christ; Column D, to the front on the right, takes the story from The Entry of Jesus into Jerusalem to The Ascension.

The subject matter of the columns is not easy to decipher; indeed, the columns do not represent a very convenient way to convey information. In each band one has to follow the story line around the column, and only the central bands can be read conveniently; the high ones require standing on a chair, and the lower ones oblige the viewer to kneel or crawl on the floor. The Latin inscriptions are certainly a help, but in the case of Column A, telling the pre-Gospel story, it has been noted that the sculptures are based on the Greek *Book of James* of the second century whereas the inscriptions derive from the Latin *Liber de Infantia* of the mid-ninth century, which creates some discrepancies, and these must date from after the arrival of the columns in Venice in the early thirteenth century.

The origin of the columns is obscure. Sansovino noted in 1581 that they were *"cosa di gran magistero & di spesa, & fatta per quello che si puo giudicare, nella Grecia";* this represents the prevailing view down to the end of the nineteenth century,[8] and is essentially the view of Hans von der Gabelentz, who proposed in 1903 that they were Eastern work of the late fifth century. However, in 1901 Venturi proposed that they were Italian work of the first half of the sixth century. The matter has been disputed throughout the entire twentieth century, with Otto Demus in the forefront of the battle arguing for an early thirteenth-century date and a Venetian provenance. We here adopt the position of Thomas Weigel (1997), holding that they were made in Constantinople in the early years of the sixth century, possibly for the church of St. Anastasis, were brought to Venice as spoils following the fall of Constantinople in 1204, and were installed shortly thereafter in their present position in San Marco, their Latin inscriptions being added at that time. For Domenico and his contemporaries their origin was lost in the mists of antiquity, but their status as an extraordinary, precious, unparalleled, and very early compendium of New Testament illustration must have been evident. How far he was able to make use of them as a source is less clear.

The Mosaics of Monreale

No scenes illustrating the Acts of the Apostles find a place on the columns of the ciborium, and relatively few among the mosaics of San Marco. On the other hand, the important cycles of Norman Sicily in the Cappella Palatina at Palermo and at Monreale deal fully with the stories of Peter and Paul. Although it is hardly likely that Domenico knew these monuments firsthand, there seems no question that he could very well have had access to the publications that describe them: in the case of the Cappella Palatina, Tortoreto (1630), Pirri (1716), and Carafa (1749; no illustrations); in the case of Monreale, Lello (1596; no illustrations), and Lello and del Giudice (1702). In fact, one wonders whether Visentini's 1726 account of San Marco may not have been inspired in some degree by these publications. Much restoration work was done on the Cappella Palatina in the eighteenth century. Some work was done in 1719 by Leopoldo da Pozzo and interrupted in 1720, when "Pozzo was once again in

8. Zatta (1761) records all the Latin inscriptions on the columns, but does not express any opinion on the date or origin of the work.

Venice."⁹ Later, under Charles III, work was resumed in 1753 under Mattia Moretti. No comparable work was done in the eighteenth century at Monreale. In view of all this, one can hardly assume that Domenico knew little or nothing of the great Sicilian cycles. One could argue, in fact, that in presenting the material from the Acts of the Apostles and later, he was following the tradition of treating the stories of Peter and Paul as separate narratives.

The publication of del Giudice (1702) offers eight double-page plates with 86 images of the individual mosaics in the choir of Monreale, as follows: XVIII, *The Annunciation to Zacharias* to *Jesus Among the Doctors* (sixteen scenes); XIX, *The Feast at Cana* to *The Healing of the Man With the Dropsy* (fourteen scenes); XX, *The Feeding of the Multitude* to *The Transfiguration* (eleven scenes); XXI, *The Raising of Lazarus* to *The Betrayal of Jesus* (nine scenes); XXII, *Jesus Before Pilate* to *Noli Me Tangere* (nine scenes); XXIIII, *The Road to Emmaus* to *Pentecost* (nine scenes); XXIV, *The Life of Peter* (nine scenes); and XXV, *The Life of Paul* (nine scenes). It may now be proposed that these engravings may well have been the major source of Domenico's images from the Annunciation to Zacharias to the crucifixion of Peter.

Even so, the eighteen mosaics of Monreale illustrating the lives of Peter and Paul hardly compare with the 70 drawings illustrating these scenes in Domenico's *New Testament.* The most extensive display of wall paintings on such themes was to be found until 1823 in Rome on the walls of San Paolo fuori le Mura—a series of 42 scenes, although these were recorded in the seventeenth century in the Barberini Codex,¹⁰ together with the lost mosaics of Old St. Peter's, and were never engraved.

How well Domenico might have been familiar with the early Christian monuments of Rome is still not clear; we have suggested that he might have had an opportunity to visit Rome while he was in Genoa in 1785. In Giovanni Giustino Ciampini's great publications of 1690–1699 he would have found an account of the basilicas of Constantine and a record of many of the Roman mosaics, including those of Sta. Maria Maggiore and even of Sant' Apollinare Nuovo at Ravenna, but none that were relevant to his project, save a small engraving of the mosaics in the Chapel of John VII in Old St. Peter's (Tav. XXIII) depicting scenes from *The Annunciation* to *The Crucifixion.* Ciampini himself (1633–1698) had contacts with antiquarians throughout Europe, and although he was a full generation older than Scipio Maffei (1675–1755) and Lodovico Antonio Muratori (1672–1750), they certainly would have been aware of his works, which were handsomely republished in 1747.¹¹

The Paduan Frescoes of Giotto and Giusto de Menabuoi

We have no documentary proof that Domenico was familiar with the frescoes of Giotto in the Arena Chapel in nearby Padua. Verbal descriptions were freely available from Vasari onwards, but they do not appear to have been engraved. However, the series again opens at the same point as the Venetian cycles, with the story of Joachim and Anna, and whereas none of the drawings may be said to be direct transcriptions of any of the 38 frescoes, it is evident that fairly close parallels in the treatment of scenes indicate that Domenico studied the frescoes, perhaps making a special effort for this purpose during his recorded visits to Padua in 1777 and 1778. Domenico may also have been familiar with the cycle of frescoes by Spinello Aretino, then thought to be by Giotto depicting the life of the Baptist, in the choir of the Carmini in Florence, through the series of aquatints by Thomas Patch (1725–1782), issued in 1772 after the 1769 fire in the church.

Domenico also must have had some awareness of the important series of New Testament frescoes by Giusto de Menabuoi (1376–1378) in the baptistery of the Cathedral at Padua.¹² This includes eighteen scenes illustrating the life of Christ, starting with *The Presentation of the Virgin in the Temple,* on three walls, and nine scenes illustrating the story of John the Baptist on the fourth wall, starting with *The Annunciation to Zacharias.*

9. Demus (1949: 34, 35).

10. Vatican Barberini lat. 4406; Waetzoldt (1964: 58–61, [366–407]).

11. The problem of early illustrations for the Acts is the theme of a paper by Luba Eleen (1977) in *Dumbarton Oaks Papers.* Her principal examples are cited in the catalogue entries, but an appendix provides a full list of all the examples known to her in all the various sources she cites.

12. For a contemporary account see Rossetti (1765: 144–149); for a full modern account, see Spiazzi (1989).

The decorations of the baptistery also include a polyptych by Giusto over the altar, with a further twelve scenes illustrating the story of the Baptist, also starting with *The Annunciation to Zacharias.*

Thus, looking at the resources of illustration of the early Christian story in the Veneto from the early twelfth century to the late fourteenth century, as they would have been available to Domenico Tiepolo in the late 1700s, we find that there are no fewer than four cycles, all clearly interrelated, three of them starting with the story of Joachim and Anna deriving from the apocryphal New Testament, and none of them touching seriously upon the Acts of the Apostles, although this is an essential part of Domenico's panorama. Such a concentration of material is without parallel in the Mediterranean world.

The Byzantine Tradition

Apart from the absolutely unique case of the columns of the ciborium, which arrived in Venice too late to play any role in the development of the earlier mosaic cycles of San Marco, upon which the others must be supposed to depend, one must postulate for the latter a derivation from Byzantine sources. The most recent and widely accepted suggestion regarding the origins of the general design and the mosaics of San Marco points out the close relationship with the church of the Apostoleon in Constantinople, a building of the age of Justinian that was destroyed in 1475. This had five domes, as at San Marco, and the cupola over the nave likewise represented the Pentecost. On the north side the mosaics represented the early life of Christ, and on the south the later life of Christ, while the choir was devoted to scenes of the Passion.

When one turns to Byzantine manuscript illumination, it is not possible to cite a specific useful example that might have been accessible to Domenico. As a general model, though one that could scarcely have been known to him,[13] we have taken *The Rockefeller McCormick New Testament* in Chicago, an imperial manuscript of ca. 1265, published in 1932, which contains more than 90 miniatures; the series begins with *The Nativity* and continues to *Paul at Lystra,* Acts 14:8–11. The earlier stories are thus omitted, but the manuscript does go on to about halfway through the Acts. Only rarely can we cite a drawing that appears to depend directly on a source of this kind (*Jesus Ascends the High Mountain with Peter, James, and John,* pl. 139). Harold R. Willoughby points out that "fifteen *Rockefeller-McCormick* miniatures—one out of every six—are plainly unique. No other renditions of these themes are recorded for East Christian art. More than half of these singular miniatures are found in Acts."[14] Domenico illustrates 58 texts from the Acts of the Apostles, of which twelve are found in *Rockefeller McCormick,* and only three of these are recorded subsequently elsewhere; for the remaining 29, no early prototype has yet been traced.

Here one must mention a second Byzantine source that offers numerous "prototypes" for Domenico's designs. He could hardly have known anything directly about the celebrated church of Saint Saviour in the Chora,[15] the Kariye Djami, a miraculous survivor amid the wholesale destruction of Byzantine art, decorated with mosaics and frescoes ca. 1310–1320, largely brought to light in the course of restoration work between 1951 and 1958, and published by Paul Underwood in 1966. However, one must conjecture that some knowledge of the artistic tradition of which it is the most conspicuous and marvelous surviving example must somehow have filtered down to the Greek community of eighteenth-century Venice. The cycles of the Chora are closely related to two Serbian cycles at Decani (in Kosovo) and Ohred (in Macedonia). One is perhaps driven to the conclusion that in working out his scenes relating to Joachim and Anna and the early life of Mary, Domenico was advised by someone who was deeply versed in Serbian and Greek traditions.[16]

13. However, its whereabouts in the seventeenth and eighteenth centuries is completely obscure.

14. *The Rockefeller McCormick New Testament* (1932: III, xii).

15. It is curious, however, that the identification of the Chora was established as early as 1785 by Jean-Baptiste Lechevalier, working under the direction of the French ambassador, the comte de Choiseul-Gouffier; Ebersolt (1919: 194–196).

16. For a full discussion of such works, see Lafontaine-Dosogne in Underwood IV (1975: 163–194), as well as those at Curtea-de-Arges and Kalenic: "whose decoration, so far as the cycle of Christ is concerned, is greatly influenced by that of the Kariye Djami" (Underwood IV 1975: 207). See also Millet (1969).

The mosaics of the Chora begin once again with the story of Joachim and Anna and end, for our purposes, with a series on the miracles of Christ. We refer to them frequently, for in a number of cases they seem to be the most relevant prototypes we have.

Northern Europe in the Later Middle Ages

Figure 2. *Jesus Cursing the Barren Fig Tree* (miniature, Deutsche Bildebibel, fol. 24, Freiburg, University Library)

The decorations of Saint Saviour in the Chora do not help us with the drawings illustrating the Acts of the Apostles. Here, apart from the *Rockefeller McCormick New Testament,* the only substantial early source of prototypes is found in English medieval manuscripts, such as the twelfth-century *Bible Moralized* (British Museum, Harley 1526–1527) and the *Holkham Bible Picture Book* of about 1325[17]—sources that can hardly have been known to Domenico. On the other hand, it may be noted that Domenico's series of etchings, the *Idee pittoresche sopra la Fugga in Egitto,* is entirely a work of the Würzburg years and may well derive from a study of late-medieval sources in Northern Europe. Certainly they stand completely apart from any Italian tradition.[18]

A further possible source for inspiration may have been popular later-medieval New Testament manuscript illustration in Germany. As a specific example we cite a manuscript, possibly made in or near Strasbourg ca. 1420, now divided between New York, the Pierpont Morgan Library, and Freiburg in Breisgau. It contains no separate text but some 166 New Testament scenes and was published in 1960 under the title *Deutsche Bilderbibel aus dem später Mittelalter.* It too starts with the story of Joachim and Anna and continues through to Pentecost. Some of these miniatures do indicate a link with Domenico's drawings, such as *The Disciples Find the Ass and Her Colt* (pl. 169), but the most interesting of them are two images representing

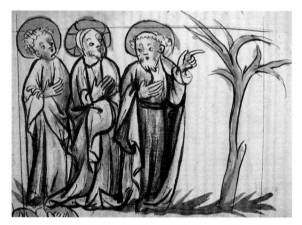

Figure 3. *The Fig Tree Withered* (miniature, *Deutsche Bildebibel,* fol. 24 verso, Freiburg, University Library)

the scene of Jesus cursing the barren fig tree [figs. 2 and 3], a very rare subject that appears in an overdoor[19] certainly designed by Giambattista and probably painted by Domenico for Veitshöchheim in 1752 [fig. 4]; this was probably by way of a woodcut by Urs Graf[20] [fig. 5], who also created an interesting series of 78 small Gospel scenes.[21] However, it is noteworthy that this scene does not appear in Domenico's *New Testament.*

17. Hassall (1954). However, in this context one should perhaps mention the Italian fourteenth-century manuscript of the *Meditationes vitae Christi* (Paris, BN, Ms. Ital. 115), perhaps Tuscan in origin, with 193 miniatures illustrating the life of Christ, but of course none relating to the Acts of the Apostles—admirably published by Ragusa and Green (1961) as *Meditations on the Life of Christ.*

18. *The Flight into Egypt* is studied by Hermann Voss (1957), Sheila Schwarz (1975), Schoole Mostafawy (1998), and the Stuttgart catalogue (1999).

19. Vancouver cat. (1980: [10]).

20. *The Illustrated Bartsch 13* (1978: 53).

21. *The Illustrated Bartsch 13* (1978: 76–88).

Sixteenth-century Printmaking

With the name of Urs Graf we enter the vast field of sixteenth-century printmaking, an art that was certainly familiar to Domenico and of which he owned a number of interesting examples. The Tiepolo sale of 1845 indicates that Domenico himself had a complete set of the celebrated series of twenty woodcuts by Albrecht Dürer representing *The Life of the Virgin,* and 37 woodcuts from *The Large Passion* and *The Small Passion.*[22] Only rarely can one point to a direct use of any element from these prints, but the general similarity displayed by a number of drawings suggests that Domenico studied Dürer's work most carefully. Moreover, *The Life of the Virgin* starts at exactly the same point as Domenico's series, with the story of Joachim and Anna. While this may perhaps reflect some inspiration from Dürer's experience of Venice, it also may well have provided some additional authority for Domenico's approach to the material of the apocryphal New Testament.

Among much else, Domenico owned a copy of a book described as follows: *Retratos o tablas de las historias del Testamento Viejo,* Lion (Lyons) 1543, *attribuées a Holbein.* So far we have not been able to lay hands on a copy of this volume, but it suggests some familiarity with the vast field of sixteenth-century Bible illustration, of which Lyons was a conspicuous center.[23] Until the middle of the century, bibles from Lyons and many other centers in Germany and Switzerland were decorated with woodcuts deriving from the designs of the young Hans Holbein.[24] An early Latin Bible (Lyons, 1522) displays 24 woodcuts, 58 x 38 mm, that illustrate the Gospels but not the Acts of the Apostles. The *Biblia Insigneum Historium simulacre* (Lyons, 1542) displays 50 woodcuts, 67 x 43 mm, 44 of them illustrating the Gospels and 6 the Acts.[25]

Figure 4. Giambattista Tiepolo, *Jesus Cursing the Barren Fig Tree* (drawing, Stuttgart, Staatsgalerie, 1418)

Figure 5. Urs Graf, *Jesus Cursing the Barren Fig Tree* (woodcut, Coburg)

22. Paris, Hotel des Ventes, November 10–12, 1845. Among this material are the following:
 89. *Retratos o tablas de las historias del Testamento Viejo* (Lyons, 1543), *attribuées a Holbein*
 93. Dürer. *La Passion,* 37 pieces
 94. Dürer, *La vie de la Vierge,* 20 pieces
 104. Lucas van Leyden
 107. Jacques Matham, after Dürer, *Calvary*
 135. Blecker, *Paul e Barnaba a Listre,* 1638
 137. Heemskerck, F. Floris, Stradan, M. de Vos, Breughel
 180. Sebastien Bourdon, *Flight into Egypt,* 4 items; Loir, *La Sainte Famille,* 6 items; *La Hire;* Simon Vouet
 252. *Considerazioni sopra tutta la vita di NS Giesu Christo di R.P.B. Riccium* (Rome, 1610)
 256. *La manière de se bien préparer à la mort* (Antwerp, 1700)
23. Baudrier (1896–1921: v, 191); copy recorded at Lyons, A 32 1167, with 94 woodcuts.
24. Manfred Kästner, *Die Icones Hans Holbeins des Jüngeren* (Heidelberg, 1985).
25. One may also note that *The Vision of St. Peter (Recueil Luzarche 14)* is one of the subjects by Holbein illustrating *Das Neuw Testament* (Basel, 1522; Hollstein XIVa [1988: 48i]).

After the middle of the century, woodcuts by Bernard Salomon become dominant in Lyons. Sometimes these are published separately, without a text. An example is *Il Nuovo ed Eterno Testamento di Giesu Christo* (Lyons, 1556), with 49 cuts, 59 x 47 mm, 39 illustrating the Gospels and 10 the Acts. A French edition followed, *Figures du Nouveau Testament* (Lyons, 1558), with 67 cuts of excellent quality, about 60 x 50 mm, 56 cuts illustrating the Gospels and 11 the Acts. Next came a similar Italian edition, *Figure del Nuovo Testamento* (Lyons, 1559). A Latin edition, *Icones Historicae Veteris et Novi Testamenti* (Geneva, 1680), containing 358 cuts altogether (with twelve illustrating the Acts), identifies the artist as "SALOMON BERNARD, *dit autrement* LE PETIT BERNARD."

The *Biblia Sacra,* 8vo (Lyons, 1588), carries 118 cuts, about 75 x 100 mm, attributed to Bernard Salomon, as follows: Matthew, 30; Mark, 9; Luke, 19; John, 15; and Acts, 45. The cuts, which adopt the familiar pattern of matching the full width of the letterpress, offer the largest series of illustrations of the Acts that I have come across, prior to Domenico's series of 58 items.[26] The same format is used in the *Biblia Sacra* (Venice Pezzana, 1727), with 57 cuts illustrating the Gospels but only four illustrating the Acts.

A similar publication without a text that offers some parallel to Domenico's enterprise is Virgil Solis's *Biblische Figuren des Neüwen Testaments* (Frankfurt, 1565),[27] which offers 116 illustrations but, like the Bible, omits the early apocryphal stories. This series skips the Acts of the Apostles but includes a number of illustrations for Revelation. Some of these designs are so close (pls. 117, 123, 139, 146, 159) that one feels Domenico must have used this volume, or some later copies deriving from it.[28]

Finally, as a well-informed person highly familiar with the art of the past, Domenico cannot have been ignorant of that great monument of Netherlandish art and early sixteenth-century illumination, *The Grimani Breviary,* then preserved in the Treasury of San Marco. Although there are no exact parallels between the miniatures and Domenico's inventions, there are a number of broad similarities, so that celebrated volume may well have suggested to him the vision of a superb illustrated book.

The Antwerp Engravers, 1575–1600

Item 137 of the 1845 sale refers to engravings, unspecified in number, linked with Heemskerck, Frans Floris, Stradanus, Maarten de Vos, and Breughel. This must focus our attention on the vast number of prints illustrating the New Testament by the Antwerp engravers of the last quarter of the sixteenth century, generally 4to in size, 200 x 300 mm. Of special interest is the *Acta Apostolorum,* first published in 1575 by Philip Galle (1537–1612) with a title page, and 17 prints by him after Marten van Heemskerck (1498–1574), some dated as early as 1558, and seventeen after Stradanus (1523–1605).[29] This volume passed through six editions between 1575 and 1655 and was by far the most elaborate series of compositions on the theme of the Acts of the Apostles of the sixteenth century. It appears to be the grand prototype of Domenico's 58 drawings on this theme, although he does not appear to have followed any of them exactly. Nothing appears to equal them in the seventeenth century and they are rivaled only by the set of engravings after Thornhill's decoration of the dome of St. Paul's in the 1720s.

Like Heemskerck, Maarten de Vos (1531–1603) supplied an enormous number of designs for the engravers. Here, the primary publication for our purposes is the *Vita, Passio et Resurrectio Iesu Christi,* a set of 51 plates, 182 x 222 mm, after Maarten de Vos by Adrien Collaert (ca. 1550–1618), published in Antwerp by Ioan Galle at an uncertain date, but no doubt ca. 1580.[30] These and many other designs of the same character were republished in the *Theatrum Biblicum* of 1639.[31] Once again, these designs provide effective prototypes for many of Domenico's drawings, though he never follows any detail exactly.

26. Baudrier cites the *Biblia Sacra,* published by Rouillé (Lyon, 1562), with 269 vignettes, 61 x 84 mm, by Pierre Vase, British Museum Print Room 334. 6. 9, with further editions in 1563, 1566, 1567, 1569, 1581—Baudrier ix, 281, 304, 311, 316, 320, 381.

27. *The Illustrated Bartsch 19* (1978: 336–393). An earlier edition, dated 1562, is in the British Museum Print Room. The *St. Mark* is also used, with the same border in the *Bishop's Bible* (London, 1568).

28. However, a consultation of Rosier (1997) does not suggest that a search among other illustrated Bibles may be fruitful.

29. *Illustrated Bartsch 56,* 147–179.

30. *The New Hollstein 44,* 1996 [275–325].

31. Editions were published in 1639, 1643, and 1674.

A specific point of contact may be mentioned here, however. Several drawings by Giambattista, together with several etchings and one drawing by Domenico (*The Holy Family Crosses the River*, pl. 53) relate to a tradition that can be traced back to the engraving by Johan Sadeler[32] after Maarten de Vos of 1582 [fig. 6] and the related drawing at Ottawa.[33]

Also of special interest is the *Vitae Deiparae Virginis Mariae*, containing a title page and 30 engravings designed, cut, and published by Hieronymus Wierix (1548/53–1619) at an unknown date, perhaps ca. 1580. One may note the engraving showing *The Holy Family Sailing a Boat* [fig. 7], which appears to be not only one of the first designs of this type of subject but also a direct model for several of Domenico's boats on the Sea of Galilee.

The Jesuit Tradition

The last phase of this great surge of activity in Antwerp in the closing years of the sixteenth century is represented by the series of 153 handsome engravings made by the brothers Wierix after Bernardino Passeri and Maarten de Vos under the title *Evangelicae Historiae Imagines* (Antwerp, 1593) for the Jesuit devotional book by Hieronymo Natali (Jérôme Nadal, 1507–1580), *Adnotationes et Mediatationes in Evangelia* (Antwerp, 1593). Arranged according to the calendar of the Catholic year,[34] these designs are disposed vertically, in 4to, 230 x145 mm, with the figures grouped in the lower part of the composition—the arrangement adopted by Domenico. The similar profusely illustrated Jesuit publication by Bartolomeo Ricci, *Consideratione sopra tutta la vita di N.S. Gesu Christo* (Rome, 1607; 2nd ed. 1610), is especially relevant since Domenico possessed a copy of the 1607 edition, with woodcuts. This is very similar to Nadal: 160 engravings with a full page of text facing, loosely arranged according to the feasts of the Church. However, once again these do not appear to have been used directly by Domenico for his designs.[35] This was no doubt something of a modern version of the Medieval *Meditationes vitae Christi*, still then attributed to Bonaventura, which (as will be seen below) was still current, a fine edition being published in Venice in 1761.

While the blockmakers and engravers of the sixteenth century were so energetically reviving the traditions of New Testament illustration, in particular creating an iconography for the Acts of the Apostles, many of the scenes depicted in the early Venetian

Figure 6. Johan Sadeler after Maarten de Vos, *The Holy Family Crossing the River* (engraving, 1582)

Figure 7. Hieronymus Wierix, *The Holy Family Sailing a Boat* (engraving, *Vitae Deiparae Virginis Mariae*, ca. 1580 [17])

32. *Illustrated Bartsch*, vol. 70 (183); *The New Holstein 44*, 1996, [266].

33. Popham and Fenwick (1965: [130]).

34. A similar publication, the *Exercices de Piété*, by the Jesuit Jean Croiset appeared in at least three Venetian editions in the eighteenth century, the latest in 1762–1763.

35. It may be noted that Domenico devoted about 140 drawings to the material covered by Nadal in 153 and by Ricci in 160 images.

sources of the years 1100–1400, particularly those deriving from apocryphal sources, dropped out of the repertory of Western art in the age of the Reformation and the Counter-Reformation, as did *The Golden Legend* and the other manuscripts and printed sources to which they relate. Much of the fascination of *Domenico Tiepolo: A New Testament* is that it manages to rediscover and give a new currency to this forgotten material.

The Imagery of the Tiepolo Studio

These old and important traditional collections of imagery, though they may well have provided the stimulus and the intellectual justification for Domenico's *New Testament,* only represent a part, though perhaps the most important part, of his sources of inspiration. Foremost in his visual memory was the repertoire of his own work. Among the designs that are based on or that quote from paintings by Domenico himself one may cite plates 84, 133, 137, 143, 152, 170, 181, 190, 197, 272, 273, 312, and 313; a number of others are closely related to the S. Polo *Via Crucis* (pls. 213–227), though here it seems likely that he used his set of etchings rather than the paintings. For the numerous scenes on the theme of the Flight into Egypt, he again had some recourse to his series of etchings (pls. 47–74), but all in all, relatively few of the compositions can be traced back directly to these earlier sources. Domenico also used one of his own pen drawings for the composition of *St. Anthony and the Christ Child* (pl. 305). Some drawings are used repeatedly; a remarkable instance is a drawing at Edinburgh[36] showing three figures, two girls and an old woman, standing in a landscape. The girl on the left appears in plates 90 and 119 and in *Contemporary Life* 50 and 63, the latter reversed; the girl in the center appears in plates 65 and 90 and in *Contemporary Life* 58; the old woman on the right appears in plates 2, 35, 65 (reversed), and 214 and in *Contemporary Life* 2 and 59. One area in which Domenico had frequent recourse to his own drawings was in the matter of horses. Thus, plates 90 and 221 use a drawing now in the Huntington Library and Art Gallery; plates 216 and 309 use a drawing in the Hermitage; plates 62 and 217 use a drawing at Besançon. Three drawings use the horse and groom deriving from Giambattista's sketch in the Petit Palais, *Alexander and Bucephalus* (pls. 10, 200, and 306); likewise *Contemporary Life* 23.

This raises the question of Domenico's use of his father's work. Three compositions are based on pen drawings by Giambattista from the Orloff Album: *The Holy Family Crosses the River* (pl. 53) is based on a drawing now in the collection of Mrs. Vincent Astor, which was also etched by Domenico; the essential parts of *John the Baptist Lying on the Ground, with Angels* (pl. 89) derive from a drawing in the Fogg Art Museum; and *Peter Released by the Angel* (pl. 249) is also based on a drawing from the Orloff Album, now at Williamstown. In a substantial number of cases Domenico adapted earlier landscape drawings by Giambattista for his settings: one may cite plates 68, 69, 88, 106, 153, 158, 250, 264, 281, and 292. While on the subject of backgrounds, one may also note here three references to the etchings of Domenico's slightly older contemporary Giambattista Piranesi (1720–1778) in plates 174, 249, and 262.

As for single figures, these are perhaps too numerous to mention. In two cases (pls. 27, 68), Domenico used drawings from the album *Sole figure vestite* in the Victoria & Albert Museum.[37] Some are of interest because they are evidently associated with red chalk drawings by Giambattista of the Würzburg period[38] (pls. 135 and 190) and a red chalk drawing at Stuttgart[39] is used on two occasions (pls. 41 and 232) as well as in *Divertimento 3.* Other curiosities may be noted, such as the seated figure from Amigoni's *Anzia and Abricone* (pl. 91).

A rather different case is Domenico's use of compositions by Giambattista as wall decorations. Thus we find Giambattista's *Rinaldo and Armida in the Garden* from Berlin on the wall of plate 18 and *The Death of Dido* from Moscow on the wall of plate 281. Domenico seems to have felt there was no incongruity in using "modern

36. Udine (1996: [41]); [fig. 115], *cf.* cat. no. 65.
37. Knox (1960/1975: [133, 158]).
38. Knox (1980: M. 347, 355).
39. Knox (1980: M. 350).

paintings" in a New Testament setting, and indeed they fit very comfortably into their surroundings. In fact, he offers an ideal neoclassical setting for such works and reminds us that Giambattista's frescoes are nothing if not a modern version of antique notions of wall decoration.

Domenico's incorporation of details from his own work and that of his father, found in more than one-third of the drawings in *A New Testament,* is similar to that later employed in *The Scenes of Contemporary Life* and the *Divertimento per li regazzi.* These three great series of drawings, which together occupied him in the last twenty years of his life, numbering some 500 sheets, represent about one-third of his entire output as a draughtsman. Even though the material in the three sets of drawings frequently overlaps, this phenomenon should not permit us to forget the inventiveness and creativity that is the overwhelming characteristic of these drawings.

Motifs Drawn from Other Modern Sources

Domenico's direct borrowings from Venetian paintings of the Renaissance are again fairly rare. One can point to two compositions after Titian: one, *The Sacrifice of Abraham* (pl. 1) after the ceiling from Santo Spirito in Isola, now in the sacristy of the Salute; and the other (pl. 194) after *The Crowning with Thorns* from Sta. Maria delle Grazie in Milan, now in the Louvre. However, in both cases it can be shown that Domenico worked after reproductive engravings by Valentin Lefebre. Very often one can find broad prototypes in Venetian painting from

1450 to 1750; Veronese is particularly rich in New Testament subjects, and in the eighteenth century the enthusiasm for Veronese, particularly in the work of Ricci, produces further examples, though these are rarely very close to Domenico's designs. Only one, plate 41, derives directly from Veronese's *Presentation of the Christ Child* in San Sebastiano, again by way of an engraving by Valentin Lefebre. One design is based on an engraving in the *Raccolta di Storie Sacre* of Pietro Monaco, *The Miracle of the Bitter Waters Turned Sweet,* after Castiglione (pl. 5). A particularly striking example, noted by Conrad (1996), is plate 286, based on Gregorio Lazzarini's *S. Lorenzo Giustiniani Gives Alms to the Poor* in San Pietro di Castello.

Figure 8. Cornelius Bloemart, *Pastorale* (etching)

Although one can only estimate the extent of Domenico's awareness of the art of the past, especially in the vast field of printmaking, one nevertheless has many clues, the earliest being details borrowed from Mantegna (pl. 227) and Giulio Romano (pl. 222). In his fundamental study of Domenico as a draughtsman, Byam Shaw pointed out the numerous examples of his making copies of the etchings of Stefano della Bella, Callot, Castiglione, and Ridinger.[40] To these Conrad has added the name of Salvator Rosa, with a number of interesting examples, such as plates 178, 195, and 200. Byam Shaw also pointed out the importance of Domenico's own collection of engraved material, as it is recorded in the sale catalogue of 1845.[41] As noted above, this provides ample evidence of Domenico's interest in Northern European printmaking from Dürer onwards.[42] An excellent and specific example of this is cited by Lorenz

Figure 9. Domenico Tiepolo, *A Reclining Peasant* (drawing, formerly Heygate Lambert)

40. Byam Shaw (1962: 61).

41. Byam Shaw (1962: 18, note 8).

42. Some of these leads are explored in the Stuttgart catalogue (1999), which among a number of other examples of *The Flight into Egypt,* drawn from the collections of the Staatsgalerie, reproduces the set of six etchings by Sebastien Bourdon [17.1–6], four of which are recorded in the Domenico sale, Paris, 1845, lot 180.

Eitner: an etching, the figure of a reclining peasant from Cornelius Bloemart's *Pastorale* [fig. 8],[43] is copied by Domenico [fig. 9].[44] This in turn is combined in a drawing at Stanford [fig. 10],[45] a peasant girl with a distaff that derives from an etching by Nicolaes Berchem (1620–1683) of 1652 [fig. 11].[46] The reclining peasant is then used later for plates 8 and 249 and in *Divertimento* 42 and 92, while the girl appears in *Scenes of Contemporary Life* 2. Further examples of Domenico using a design of Berchem as a source are found in plates 74 and 170, drawing upon a drawing in the Pierpont Morgan Library of 1657 that was also etched.[47]

To these examples one may add the drawing of two dogs with curly tails in the Heinemann collection [fig. 12].[48] Both these animals are copied from an engraving by Nicolaes de Bruyn (1571–1656), *The Fall of Man*, of 1600 [fig. 13].[49] One of them is featured in the two drawings of Jesus and the doctors (pls. 78–79). Curiously, *The Fall of Man* is reworked, showing one dog only, to form plate 1 of an extraordinary compendium of large engravings, measuring about 405 x 505 mm, illustrating the Bible from notable Netherlandish works of the seventeenth century, published by Nicolai Visscher (1587–1679) under the title *Historiae Sacrae Veteris et Novi Testamento* (Amsterdam, n.d. [ca.1670?]), representing a remarkable forerunner of Pietro Monaco's *Raccolta*.

Notwithstanding these numerous references to the art of the three centuries before his time, it is clear that Domenico essentially rejected the art of the Renaissance and Baroque periods in favor of an earlier and more austere narrative tradition. His style and imagery prefer the simple storytelling of the mosaics of San Marco, avoiding violent emotion and violent movement. Upright figures move in spaces that dissipate tension and focus attention on the lasting significance of the story as it unfolds. Thus, Domenico not only revives ancient traditions of New Testament illustration in Venice, but also brings that tradition, after seven centuries, to a close.

Subsequent Developments

After Domenico's time, we find in France two remarkable exercises in Bible illustration. The first is Gustave Doré (1833–1883), *La Sainte Bible selon la Vulgate,* first published in Tours in 1866, with 228 illustrations. Some of his designs offer compelling references to Domenico's, perhaps most notably *Burning the Books of Magic Arts at Ephesus* (pl. 287), a subject of extraordinary rarity, in which the layout of the design follows the Domenico drawing quite closely.[50] The Doré Bible of 1866, together

Figure 10. Domenico Tiepolo, *A Girl with a Distaff and a Reclining Peasant* (drawing, Stanford University, 1652)

Figure 11. Nicolaes Berchem, *A Pastorale* (etching)

43. Hollstein II (1996: 65, 27–42; not illustrated); Roethlisberger (1992: [1–4]) reproduces four of the *Leisure* series, but not this one, which may be the title page.

44. Heygate Lambert sale, Sotheby's, Apr. 21, 1926, lot 31c.

45. Sotheby's, June 27, 1928 [6]; Berkeley (1996/97: [38]).

46. *The Illustrated Bartsch* (1978: 7, 53).

47. New York, 1977, [101]; a specimen of the etching is in London, Witt Print Collection.

48. New York, 1973, [119].

49. 465 x 660 mm (Le Blanc 1854: [1]; Hollstein 1988: [11]).

50. For a further comparison, see *The Crucifixion* (pl. 200).

with the publication of Erneste Renan, *La Vie de Jésus* of 1863, and the new translation of Ludolf of Saxony, *La Grande Vie de Jésus,* by Dom M-P Augustin of 1864, represent a remarkable flowering of Catholic energy in France in the 1860s. Second are James Tissot's 365 compositions relating to the life of Christ, published in Tours in 1896–1897 and republished in an American edition as *The Life of Our Savior Jesus Christ* (New York 1903, 3 vols.), with a dedication to Mr. Gladstone.

The most thorough attempt in this period to survey the traditions of early New Testament illustration were the sumptuous two volumes of Charles Rohault de Fleury's *L'Évangile,* published in Tours in 1874, which falls about 90 years later than our drawings and some 46 years earlier than Guerlain's *Domenico Tiepolo: au temps du Christ,* published by the same firm as the others (Alfred Mame et fils, Tours, 1921). This was one of the last works to be published before the invention of the half-tone block. Rohault is constrained by confining himself to the four Gospels; thus he ignores most of the early stories illustrated here and all the material illustrating the flight into Egypt. He cites a remarkable range of monuments of Early Christian art and gives numerous examples of some subjects, but he is apparently unable to cite a single example of many of the subjects he addresses. In his preface he discusses the numerous attempts, deriving from the *Diatessaron* of Tatian, to reduce the four Gospels to a single coherent narrative, of which he regards "*L'Harmonie* de P. Lamy" as the most successful.

Perhaps it is appropriate to close this survey with a note on *The Kitto Bible* in the Huntington Library at San Marino, an extra illustrated Bible formed in the middle decades of the nineteenth century by J. Gibbs. This offers a remarkable survey of Bible illustration with some 30,000 engravings on 1,200 leaves in 60 volumes. In the preparation of this study it has offered some valuable insights, as well as some reassurance that nothing of major significance in the history of European printmaking has been neglected.

Figure 12. Domenico Tiepolo, *Two Dogs* (drawing, New York, Pierpont Morgan Library, Heinemann Collection)

Figure 13. Nicolaes de Bruyn, *The Fall of Man* (engraving)

CHAPTER III.

The Literary Sources 🌿

GEORGE KNOX

Domenico's *New Testament,* as we have noted, presents a coherent account of the early Christian story from the parentage and infancy of the Virgin Mary to the martyrdom of Peter and Paul. No single text offers a narrative source for this material, and the only general prototype for the project is found in the mosaic decorations of San Marco, though even there the Acts of the Apostles finds no place. This, then, is the first and only attempt since the end of the eleventh century to retell this story. It is a noble and remarkable enterprise.

In some cases these subjects are part of the visual traditions of Venetian art, so Domenico's use of them does not necessitate any reference to recondite literary sources. But in many cases the subjects are untraceable in earlier art, as Domenico might have known it. They are not imaginative exercises like his 22 earlier etchings, *Idée pittoresche sopra la Fugga in Egitto,* and they appear to demonstrate a firsthand knowledge of some highly inaccessible literature.

The New Testament

We must believe that although Domenico makes full use of the four Gospels and the Acts of the Apostles where appropriate, his plan was from the beginning in no way constrained by the familiar text of the New Testament, which since the sixteenth century had entirely dominated modern Christianity.

The four Gospels have presented down the centuries the problem of how to reconcile their differences in order to produce a single harmonious sequence of the various episodes in the ministry and passion of Christ. This was first attempted by Tatian of Alexandria of the second century in his *Diatessaron,* which has given birth to a vast literature.[1] Since Domenico must have been acutely aware of the problem, it is quite likely that he consulted one or more of these *Harmonies,* possibly the *Adunatione de quattro Evangelisti* of Natalino Amalio, printed in Venice in 1556.[2] In fact, *A New Testament* may be regarded as a great visual *Harmony* of the early Christian narrative. No printed *Harmony* has this scope. As regards the ministry and passion of Christ, it appears that Domenico seems to have considered Mark his primary source, perhaps regarding it as an eyewitness account deriving from Peter himself. The Acts of the Apostles presents a clear sequence of events,[3] but even here it seems likely that Domenico's main intention, rather than to simply follow the Acts, was to provide a full account of the work of Peter and Paul, down to the end of their lives. He follows this with an epilogue introducing some of the most celebrated saints, as they were revered in Venice, but strangely neglecting Mark and the other Apostles, whose deeds and martyrdoms are well represented in the mosaics of San Marco.

1. The Catalogue of Printed Books of the British Library, under *Bibles/Gospels/Harmonies,* lists some 300 items, mostly in English, and mostly of the nineteenth century. In our own day this has been attempted by H. van der Waal in *Iconclass 7,* with sequences that did not seem entirely happy for our purposes.

2. The latest Italian publication of this kind seems to be *Il Diatessaron in volgare italiano* (Vatican, 1938).

3. Broadly speaking, apart from the *Harmonies,* Catholic sources arrange this material in two ways. The first is chronological; this is the guiding principle of Eusebius, Jerome, Vincent of Beauvais, Cardinal Cesare Baronio, and Fleury. The second is according to the Catholic calendar—the guiding principle of Jacobus de Voragine, Nadal, the Bollandistes, and all hagiographers down to Alban Butler. There is no evidence that Domenico followed this path.

The Apocryphal Gospels

Clearly Domenico was fascinated, as had been the mosaicists of San Marco 700 years earlier, by the apocryphal stories surrounding the birth and upbringing of the Virgin Mary and the story of the Flight into Egypt. These stories derive in large part from the *Book of James,* a Greek text of no later than the second century, which became known in the sixteenth century as *The Protevangelium of James,* and which takes the story up to the Massacre of the Innocents.[4] The *Liber de Infantia,* a Latin text of the mid-ninth century, later known as *The Pseudo-Matthew,* continues the story down to the return of the Holy Family from Egypt.[5] Thus, in Venice, as we have noted above, the *Book of James* is the source of the images on column A of the ciborium of San Marco, ca. 500, while the thirteenth-century Latin texts on the column derive from the *Liber de Infantia.* These sound like very recondite sources today, but any Venetian library of the eighteenth century, and particularly that of the Padri Somaschi at Santa Maria della Salute, with which the Tiepolo family was linked through Domenico's brother Giuseppe Maria, could very well know such works. The great libraries of the Venetian religious houses were all systematically junked in the Napoleonic period, though in some cases the great interiors that housed them have survived, those at San Giorgio Maggiore and the Salute being cases in point. Manuscripts and older printed books were to some extent transferred to the Biblioteca Marciana, which still holds four manuscripts of the *Book of James* in the original Greek.[6] In fact, this process began as early as 1789 as a result of the scandalous sale of miniatures from the library of Sts. Giovanni e Paolo.[7]

A third text, *The Arabic Gospel,* which we shall also find useful, begins with the Nativity, said to take place in a cave, with an old midwife in attendance, later miraculously cured. It offers a very summary account of the Flight into Egypt, with much new material on the sojourn in Egypt, and continues the story down to Christ's dispute with the doctors.[8] The antiquity of this text is not clear, but some of the legends, found only here, make their way into the traditions of Christian illustration. The story of the single falling idol (pl. 64), the story of the robbers (pls. 66–69), and the story of the fountain of Matarea (pl. 70) derive from this source. It is said to have been first published by Henry Sike, Professor of Oriental Languages at Cambridge, in 1697, but it was widely known before that time. The fountain of Matarea is cited in various Medieval accounts of the Middle East: first by Burchard of Mount Sion in his *Locorum Terrae Sanctae,* ca. 1260;[9] second by Marino Sanuto the elder, in his *Secrets for True Crusaders,* presented to Pope John XXI on September 24, 1321;[10] third by Ludolph von Suchem in his *Description of the Holy Land, XXX—Of the Garden of Balsam,* ca. 1350.[11] Burchard and Sanuto were certainly familiar to Venetians.

From time to time, Domenico introduces into his story episodes from rare sources that continue to defy explanation as to how he might have known them. Thus, while the story of the robbers (pls. 66–69) finds a place

4. We have preferred the English text as offered by Montague James (Oxford, 1924: 38–49). It is also to be found in *The Lost Books of the Bible* (New York, 1979: 24–37). This essentially reprints William Hone, *The Apocryphal New Testament* (London, 1820). Of this work, James comments: "Hone's book has long held the field: it is constantly being reprinted, and it has enjoyed a popularity which is in truth far beyond its deserts. For it is a misleading and an unoriginal book." —and much more. On the other hand, it has given a wide currency to the texts of Jeremiah Jones; indeed, as James points out, it has provided an initial impulse for his own work.

5. James (1924: 70–79). Up to ch. 17, this follows the *Book of James.* Chapters 18–24 provide important details about the Flight into Egypt—the dragons, the palm tree, the falling idols of Sotinen, and the story of Affrodosius. James (1924: 79) comments: "The real importance of *Pseudo-Matthew* lies not so much in the stories which it preserves, as in the fact that it was the principal vehicle by which they were known to the Middle Ages and the principal source of inspiration to the artists and poets of the centuries from the twelfth to the fifteenth."

6. These are apparently without illustrations. Jameson (1864/1890: i, 260) refers to a Greek ms. in Paris with illustrations. This may refer to the *Homilies of Gregory Nazianus,* Paris, Bib. nat. (gr. 510).

7. New York, 1998 [1, 2].

8. James (1924: 80–82) gives a summary. *The Lost Books of the Bible* (1979: 38–59) provides a full text under the title *The First Gospel of the Infancy of Jesus Christ.*

9. Burchard of Mount Sion, *A Description of the Holy Land,* trans. Aubrey Stewart (London, 1896: 62).

10. Marino Sanuto, *Secrets for True Crusaders,* trans. Aubrey Stewart (London, 1896: 58–59).

11. Ludolph von Suchem, *Description of the Holy Land,* trans. Aubrey Stewart (London, 1896: ch. 30, *Of the Garden of Balsam,* 68–71).

in *The Arabic Gospel,* certain aspects of it, such as the story of the Holy Family visiting the robbers' farm (pls. 68–69) appear to be first known from certain texts of the *Gospel of Nicodemus,* otherwise known as *The Acts of Pilate.*[12] This story then reappears in the medieval German poem of Konrad von Fussesbrunnen, *Die Kindheit Jesu* of about 1220,[13] and is also told in the *Irish Infancy Gospel* (Arundel 404) in the British Museum.[14] It is assumed that it derives from an extended version of the *Liber de Infantia* that is lost; how Domenico came to know of it remains a mystery.

Apart from this, the publication of the books of the apocryphal New Testament proceeded very slowly, from the publication of Neander (Basel 1564) to the comprehensive work of Iohann Albert Fabricius (Hamburg 1703), which also includes *The Arabic Gospel* of Henry Sike,[15] and the curious work of Jeremiah Jones (Oxford 1726).[16] Italy seems to have played little part in this process. The *Liber de Infantia,* which contains some but not all of the scenes illustrated by Domenico in the section on the Flight into Egypt, is said to have been first published by J. C. Thilo (Leipzig 1832). Thus it is clear that much of this material was available only in the original Greek or Latin, and more than likely in manuscript form. The apocryphal gospels are wholly dismissed by the serious writers of the seventeenth and eighteenth centuries, such as by Calmet (1720–1721)[17] and Baillet (1739, I, *Discours,* ch. 3), though they are noticed by the Bollandistes—and this indicates the remarkable originality of Domenico's approach to this material.

Even so, there is always a question of the extent to which Domenico may have found it necessary to consult the original apocryphal material, for much of it is cited in later sources. Certainly it seems that we must go back to the *Book of James* for the basic text of *The Preparation for the Drawing of Lots, The Seven Virgins Draw Lots,* and *The Young Mary Accepts the Scarlet and the Pure Purple* (nos. 17–19), although Domenico places these scenes before and not after the betrothal of Mary to Joseph. He shows Mary as a girl of 12 or so, as the text requires (pls. 18–19), but in the betrothal scenes she is already a grown young woman (pls. 26–29); thus, he reverses the order.

The Golden Legend

In the thirteenth century, when the legends of the apocryphal sources were still broadly acceptable despite the canonical New Testament of Jerome, they reappeared in new texts, most conspicuously in *The Golden Legend* of Jacobus de Voragine (1228–1298), ca. 1260, which drew in turn from the *Speculum historiale* of Vincent of Beauvais of 1244. It is claimed that Giotto himself seemed to have access to this newly written work, which summarizes these earlier legends to some extent and which remained extremely popular in the later Middle Ages. In the early decades of the printed book it became a best-seller, with numerous editions and translations, among them the celebrated and most engaging translation of William Caxton into English. However, with the Reformation and the Counter-Reformation, *The Golden Legend* fell out of favor. The last Venetian edition in Latin appeared in 1519. There was no English edition between 1527 and 1878, no French edition between 1511 and 1843, and no Italian edition between 1613 and 1849. On the other hand, old copies were certainly available to an eighteenth-century specialist, and Domenico may have used it quite extensively, particularly for the events following those described in the Acts of the Apostles. *The Golden Legend* follows the calendar of the Church and

12. It is not clear whether this could have been known to Domenico. "The first part of the book, containing the story of the Passion and the Resurrection, is not earlier than the fourth century" (James 1923: 94). Montague James notes that there the story of the robbers is inserted in an extended account of the way to Calvary, which includes details, including the leprous child of Dysmas, "who is always crying, and is healed by the water in which Jesus is washed" (117).

13. Fussesbrunnen (1973, 1977). I am grateful to Christopher Conrad for drawing this poem to my attention.

14. James (1927: 122–126); see also Chaplin (1967).

15. Fabricius (1719: 1, 30, 166, resp.) gives the *Evangelium de Nativitate Mariae,* the *Protevangelium Jacopi,* and the *Evangelium Infantiae ex Arabica translatum Henrico Sikio interprete.*

16. This includes *The Protevangelium of James* and *The Nativity of Mary,* reprinted, as noted above, by William Hone in 1820 and subsequently in *The Lost Books of the Bible.*

17. However, a full account of Anna from the *Book of James* is given by Calmet VI (1722: 79), under Anne.

its feasts, so the account of the parentage and infancy of the Virgin, given under *The Nativity of Our Lady,* omits many of the scenes that Domenico depicts. And although there is a full account of The Massacre of the Innocents, only ten lines are devoted to The Flight into Egypt, of which the *Liber de Infantia* is such an important source for new legends, and which Domenico illustrates so abundantly. Adrien Baillet (1739: I, *Discours,* chs. 32–33) discusses *The Golden Legend* and indicates the low estimation in which it was held by serious writers in the eighteenth century. This in turn demonstrates how completely Domenico was going against the grain of the serious theology of the age in making use of it.

In this he may also have been responding to a tradition of hagiography in Venice itself, going back to the fourteenth century. The *Legendae dei sanctis,* ca. 1330, of Pietro Calo of Chioggia (d. 1345) remains essentially unpublished, though it relates the lives of 862 saints.[18] However, Petrus de Natalibus Venetus, Bishop of Jesolo (d. ca. 1400), used it extensively as he compiled his *Catalogus Sanctorum* in 1369–1372. This work was first printed in Vicenza in 1493, and a fine illustrated edition was published in Lyons by Jacques Giunta in 1542, with numerous woodcuts, 55 x 78 mm.[19] It is the foundation of all later hagiographies, although it is the only one illustrated, down to the magnificent work by Romualdo Gentilucci, *Il perfetto leggendario* (1848), which boasts one full-page illustration by Wenzel after Biglioli for each day of the year. The *Catalogus Sanctorum* was followed by the *De Vitis Sanctorum* of Luigi Lippomano, bishop of Verona and later Bergamo, of which a handsome edition in six volumes was published in Venice in 1581.

The Meditationes vitae Christi

The Golden Legend and the hagiographical tradition that descends from it hardly provide an adequate and coherent guide to Domenico's treatment of the parentage and infancy of Christ. For this we must turn first to the *Meditationes vitae Christi,* which is roughly contemporary with the great work of Jacobus de Voragine. Until the nineteenth century it was regarded as a work of the great Bonaventura (1221–1274); now it is assigned, somewhat inconclusively, to "the pseudo-Bonaventura." Certainly of Franciscan origin, it offers an immensely moving account of the life of Christ, which became extremely popular throughout the Middle Ages and does not seem to have suffered any diminution in esteem in the sixteenth century, unlike *The Golden Legend.* It was reissued in a handsome new edition of the *Opere* of Bonaventura in Venice in 1761. Domenico seems to be clearly following the text of the *Meditationes* in his treatment of several sequences of drawings, such as those dealing with the Visitation (pls. 32–33) and the Temptations of Jesus (pls. 104–110). He may even have been familiar with one of the illustrated manuscripts. Certainly those of the Paris, Ms. Ital 115, made available by Ragusa and Green (1961), have been extremely useful to us. The *Meditationes* uses only apocryphal material to a modest extent, and justifies it as follows:

> It is possible to contemplate, explain, and understand the Holy Scriptures in as many ways as we consider necessary, in such a manner as not to contradict the truth of life and justice and not to oppose faith and morality. Thus when you find it said here, "This was said and done by the Lord Jesus," and by others of whom we read, if it cannot be demonstrated by the Scriptures, you must consider it only as a requirement of devout contemplation. Take it as if I had said, "Suppose that this is what the Lord Jesus said and did," and also for similar things.[20]

Conrad has shown that certain episodes such as the Holy Family meeting with the infant John the Baptist before the Flight into Egypt (pls. 44–46) and a similar meeting on the return from Egypt (pl. 76) also appear to derive from this source.

18. See Poncelet (1910); there are three manuscript copies extant, one of them in the Marciana, three books in six vols., ms. IX, 15–20.

19. Baudrier cites nine editions published in Lyons between 1504 and 1545, and illustrates the title page of the edition by Etienne Gueynard of 1512, and that of the edition of Jacques Giunta of 1545.

20. Ragusa and Green (1961: 5); see also Bodenstedt (1944: 47).

The Vita Christi *of Ludolf of Saxony*

The fairly modest account of the life of Christ given in the *Meditationes* was followed by a fourteenth-century Latin text of German origin, the *Vita Christi* of Ludolf von Sachsen (1300–1378), who entered the Charterhouse at Strasbourg in 1340, possibly at the age of 50, and died in 1377.[21] This work, a vast compendium of medieval sources, was later printed throughout Europe, and a number of times in Venice.[22] In the sixteenth century it profoundly influenced both Ignatius Loyola and Teresa of Avila. Ultimately it appeared in an Italian translation by Francesco Sansovino, *La Vita di Giesu Christi Nostro Redentore,* first published in 1570, with a dedication to Pope Paul V, which went through no less than eight editions.[23] However, Ludolf of Saxony ignores most of the old stories drawn from the *Liber de Infantia* and *The Arabic Gospel,* and is of little assistance as a Venetian printed source of apocryphal material. For example, his ch. 13, a lengthy essay on the Flight into Egypt and the Massacre of the Innocents, gives only a brief account of the robbers and a very general account of the fallen idols. There is no mention of the miraculous palm tree or the fountain of Matarea. The *Vita Christi* may well have appealed to sixteenth-century mentalities, but it can have been of little use to Domenico.[24]

The Mística Ciudad de Dios *of Maria de Agreda*

We now come to the last great work of sacred biography that Domenico may be presumed to have known, also obviously inspired by Ludolf of Saxony: the *Mística ciudad de Dios . . . y vida de la Virgen* by the Spanish nun Maria de Jesus de Agreda (1602–1665), first published in Madrid in 1670 and again in Lisbon in 1685, in three volumes in small folio.[25] Her works, which also included a series of published letters to Philip IV, could well have become known to Domenico during his years in Spain, and he would have had no trouble reading Spanish. She appears to be the prime source for *The Death of Joachim, The Death of Anna, The Burial of Anna,* and *The Death of Joseph* (pls. 20–22, 80). However, at critical points where precise checking is possible he departs radically from her prescriptions. By and large, then, it seems uncertain that he used this book as a source of inspiration and authority, even though the author appears to have had the assistance of the Virgin herself in the compilation of this detailed and pious work.[26] Two Italian editions were printed in Trento in 1712 and 1713, and this remains an important modern source for much of the material Domenico presents. One may note that the recorded subject of one still missing drawing, *The Baptism of the Virgin* (pl. 114), may be traced to this work, which has lately enjoyed a wide distribution over the past 100 years, especially in the United States. On the other hand, one must also note that this work was condemned by the Inquisition in Rome in 1681 and by the Sorbonne in 1696; Bossuet denounced it as "an impious impertinence, and a trick of the devil"[27]—all this presumably on account of the inclusion of apocryphal material. Spain has always supported it, but it still appears to be somewhat under a cloud.

21. Approved by the Council of Basel in 1439. For an account of the importance and knowledge of this work throughout Europe, see Bodenstedt (1944: 95): "The mere reading of the *Vita,* equivalent in bulk to about six octavo volumes of some 500 pages, requires weeks." It has never been fully translated into English.

22. The Venetian edition runs to some 500 pages in small folio with double columns; the French edition of 1865, in 8vo, runs to some 3,000 pages.

23. I am grateful to dott. Susy Marcon of the Biblioteca Marciana for this reference.

24. Bodenstedt (1944: 47) points out that Ludolf's justification for the inclusion of apocryphal material follows that of the *Meditationes.*

25. First noted in this context by Christofer Conrad, it remains the most detailed and voluminous account of the life of the Virgin. The English translation by Fiscar Marison runs to four volumes in 8vo, with some 2,676 pages; thus, in length and scope it can only be compared with the *Vita Christi.*

26. At a much earlier time, St. Brigid of Sweden (1304–1373) is also said to have had interviews with the Virgin.

27. *The Catholic Encyclopedia* (1907, i), under Maria de Agreda.

Modern Texts

Of course, one may assume that for assistance Domenico had access to the vast religious literature of the sixteenth to eighteenth centuries, both erudite and popular. Of the former, one may note that when Cardinal Cesare Baronio (1538–1607) wrote and published his majestic *Annales ecclesiastici,* the standard Catholic work on Church history, at the end of the sixteenth century, stories from dubious apocryphal sources were ignored. The *Annales* continued to be republished in Italy throughout the seventeenth and eighteenth centuries, and an Italian edition, which might have been easier for Domenico to use, was published in Lucca in 1738. By that time other similar works had appeared. The *Memoires* of Lenain de Tillemont (1637–1698), representing the traditions of Port-Royal and presenting the material as a series of biographical notes, again dismissed the apocryphal tradition. The *Histoire ecclésiastique* of the Abbé Claude Fleury opens with the events immediately following the Ascension of Christ; an Italian translation by Gasparo Gozzi was published in Venice in 1766–1777. This would have been well known to Domenico, who nonetheless ignored this official approach to Church history and deliberately went back to the apocryphal tradition.

For the basic account of the lives of the saints we are indebted to the Jesuit Pedro Ribadeneira (1526–1611). His *Flos sanctorum* was written in Spanish, but an Italian edition was published in Venice in 1656/1660 in two handsome quarto volumes, which again would have been easily accessible to Domenico. A French edition, *Les nouvelles fleurs des vies des saints,* was published in Paris in 1657. By this time the monumental *Acta Sanctorum* of Jean Bolland (1596–1665) and the Bollandistes was well under way. The first two volumes, dealing with the saints of the month of January, appeared in 1643. By 1762, the number of great folios had risen to 44 and the saints extended to the end of August. This exhaustive treatment of the material takes account of the apocryphal gospels where appropriate.

Meanwhile, François Giry, "le Père Giry" (1635–1688), had published a more manageable two volumes based on the work of the Bollandistes, in 1684–1685; these led to further editions, culminating in a seventh, *Le Petit Bollandiste,* in seventeen volumes of 1878. Some of the stories of Joachim and Anna are included, but by no means all. Similarly, Adrien Baillet (1649–1706) had published *Les vies des saints* in twelve volumes in Paris (1701). In the later part of the first volume he presents a *Discours sur l'histoire de la vie des saints,* a detailed account of the history of hagiography up to his time. The more heavily rational account of *The Lives of the Saints* by Alban Butler first appeared in its original form in English as *The Lives of the Fathers* (London 1756–1759).

On the other hand, there was a mass of more or less popular pious publications touching on these matters.[28] One may cite, as a somewhat surprising example, *La vita di Maria Vergine* by Pietro Aretino (Venice 1539). Although it runs to 600 pages, it betrays only a very sketchy knowledge of the apocryphal tradition, padding out the story with long allocutions from angels annunciated in the manner of a Roman general addressing his troops.[29] Far more popular than the Aretino effusion is the *Legendario delle santissime vergini,* which appeared in Venice alone in at least five editions from 1532 to 1731; for our purposes, however, this only relates the story of Saint Agatha (pl. 302) without illustrations. Also in this period numerous printed accounts of the life of Joseph were available in Venice, such as that of Antonio Maria dalla Pergola, *Vita di San Giuseppe* (Treviso 1713). This is a biography with much detail but no apocryphal material. It is more useful than that of Giuseppe Antonio Patrignani (1659–1723), which is simply a devotional book.[30]

For the life of Christ we have already referred to the profusely illustrated books of Hieronymus Nadal and Bartolomeo Ricci. In the eighteenth century the former was perhaps superseded by the *Exercices de Piété* of another Jesuit writer, Jean Croiset (1656–1738), of which Venetian editions in Italian were published in 1725, 1755, and 1762/63, though without illustrations. Of special importance is Patrignani's *La santa Infantia del*

28. Niero (1993: 145), following Infelice, indicates that about half the titles published in Venice in the first half of the eighteenth century were works of this nature. Infelice (1980: 149) shows that 59.6 percent of the titles published by the Remondini of Bassano between 1751–1775 were religious and theological.

29. I am grateful to Monsignor Antonio Niero for drawing my attention to this little-regarded work.

30. See also Morigia (1599), Patrignani (1705), Verri (1971, 1991).

figliuol di Dio (1715–1722). Meanwhile, the traditional *Meditationes vitae Christi,* still at that time given to Bonaventura, appeared in a handsome new edition in Venice in 1761. Venetian publishers were also at this time printing magnificent editions of standard religious works, the most celebrated being the Albrizzi edition of the *Oeuvres de Bossuet,* 1736–1757, in ten volumes, followed by the Albrizzi edition of *Sancti Bonaventurae . . . Opere,* of 1751–1756, in fourteen volumes,[31] and the *Histoire ecclésiastique* of Claude Fleury of 1766–1777, in 26 volumes.

Topographical Accounts of Jerusalem and the Holy Land

Finally, we must note another class of literature that Domenico, in his search for useful information to assist his work, must surely have taken into account: topographical descriptions of Jerusalem and the Holy Land. We have already mentioned some medieval texts such as Burchard of Mount Sion and Marino Sanudo for the support they give to *The Arabic Gospel* and the story of Matarea. There is also the celebrated *Travels of Sir John Mandeville,* said to have been undertaken in 1322, which is much wider in scope. In the sixteenth century, however, a number of more detailed studies followed, the most important of which is the work of Christiaan van Adrichem (1523–1585), *Jerusalem sicut Christi tempore floruit* of 1584.[32] Not only does it give a full description of the Temple, with such notable features as the Golden Gate and the Beautiful Gate—some 268 sites altogether—but it also describes the *Via Crucis* in twelve stations, these being the first of the Fourteen Stations of the final series as it was later established. A similar work in Italian was published by Giovanni Zuallardo, *Il devotissimo viaggio in Gerusalemme* (Rome 1587).

Venetian Antiquarianism

From all this, it is clear that Domenico was living in a period in which there was plenty of material to draw upon, especially with the help of learned friends. However, none of these texts provides a comprehensive source for the full scope of subjects he presents; for that the mosaics of San Marco and Monreale offer more effective coverage, though even those are far from complete. Meanwhile, one gets the impression that a project to illustrate the New Testament from the story of Joachim and Anna down to the martyrdom of Peter and Paul in a religious culture that did not exactly encourage the reading of the Bible by the lay public, let alone apocryphal material, has a slightly subversive aspect. Beneath the massive weight of Catholic doctrine, one becomes aware of an individual enjoying the exploration of unfamiliar and possibly forbidden territory.

In fact, the more one reads the theological literature of the seventeenth and eighteenth centuries, the more clear it becomes that Domenico has little part in it. He is reaching back beyond it to the ancient traditions of New Testament illustration, embracing its legendary sources in defiance of the critical attitudes that had condemned them since the sixteenth century. He takes the stance of an antiquarian, loving the old tales for their own sake and defying any suggestion that they are unworthy of consideration.

This enlightened attitude may be said to place Domenico at the beginning of what Albert Schweitzer (1906, 1910) called "the quest of the historical Jesus," but for him the enterprise did not begin with the analysis of the text of the New Testament in search of historical data that could be relied upon. That was a task for the nineteenth century, which still goes on today.[33] Clearly for him too, the New Testament was not enough; to repair its deficiencies he took up the study of ancient stories that had flourished in Christendom for a thousand years and more and fashioned them into a compelling and unified visual sequence.

31. This includes the *Meditationes Vitae Christi XII* (1756: 379–526), but of course without illustrations.

32. It was translated and republished widely. An Italian edition was published in Verona in 1590, and an English edition in London in 1595. The latter, trans. Thomas Thynne, gives an impressive list at the back of the authorities cited. Among these is "A topographicall description of the City of Jerusalem by Fabian Licinius, a Venetian: printed at Venice in the yeare 1560." One may note two further English editions, London 1654 and York 1666. The latter is used here for citations and references.

33. Jenkins (2001).

It is not out of the question that much of this "research" may have been done by Domenico himself. His activity from the beginning displays an interest in religious iconography, and he was ready to address the problem of representing a newly canonized saint, St. Peter Regalatus, as early as 1747, when he was 19 years old.[34] Similarly, the *Fourteen Stations of the Cross* and the six additional paintings in the Cappella del Crocefisso in San Polo again represent an important determination to tackle new subject matter.[35] One might also say that an interest in considering new subjects was something he would have learned from his father, and from an awareness of other Venetian contemporaries.

Such a project must have occupied him for at least five years, during which time he could have done much study on his own account. But one must also suppose that he was able to draw on the knowledge and advice of others. First among these, no doubt, was his brother Giuseppe, a priest in the Somasco Order, and other clerics of his acquaintance. Indeed, it is not out of the question that his project might have been inspired by the educational work of the Order. A further possibility is that he sought help from Flaminio Corner (1693–1778) and his associates. Corner was the outstanding antiquary of his time in Venice, with a particular interest in Church history, and he mentioned Domenico's work in San Polo in respectful terms in his great work in fourteen folio volumes, the *Ecclesiae venetae . . .* (Venice 1749: ii, 314). More than anyone in Venice, he was familiar with Venetian church archives of the time as well as the holdings of the great conventual libraries and their librarians. Moreover, he had an abiding interest in saints, and later in life he published his *Hagiologium italicum* (Bassano 1773). However, these two volumes never allow more than one page to a saint, and as befits a friend of Benedict XIV, the writer avoids apocryphal material and indeed most miracles, though sources are indicated for each entry.[36]

Domenico too had links with the Papacy. In the years after his return from Madrid he dedicated the two volumes of the *Raccolta di Teste* to the Cavaliere Alvise Tiepolo, Venetian ambassador to Pope Clement XIV Ganganelli (1769–1774), presumably before the Pope's death.[37] In 1775 he dedicated the full volume of the family etchings to Clement XIV's successor, Pius VI Braschi (1775–1795), with a fine frontispiece showing the arts giving homage to the Papacy—by no means inappropriate since the new Pope and his predecessor created the Museo Pio-Clementino.[38] While we have no evidence that Domenico ever went to Rome, it is by no means impossible that he could have visited the city, possibly at the time of his eight-month visit to Genoa in April–November 1785. It may be significant that his labors on *A New Testament* appear to have begun immediately after his visit to Genoa, and his emphasis on the lives of Peter and Paul, culminating in their martyrdom at Rome, may suggest a link with the Papacy.

In the summer of 1779, Seroux d'Agincourt (1730–1814) spent some months in Venice, meeting l'Abbé Morelli (1745–1819), *"savant bibliothècaire"* of San Marco, and the young Leopoldo Cicognara (1767–1834). Though only at the beginning of his long residence in Italy, which lasted until he died, he was already beginning to commission images of Venetian art history, which ultimately appeared in the *Histoire de l'art par les monuments.*[39]

Apart from this, the comprehensive study of such material begins with Anna Jameson's *Sacred and Legendary Art,* the first book that examined it from an iconographical standpoint. This was mostly written in the 1840s, some 60 years after Domenico's drawings, and it is interesting to note that Jameson (I 1883: viii) cites as her most important sources *The Golden Legend, Il perfetto leggendario, Leggendario delle santissime vergini,* Ribadeniera,

34. Knox (1980: [72, 73]); Udine (1996: [5]).

35. Knox (1980: 31–38, [76–119]).

36. For Flaminio Corner, see also "Atti del Seminario di Studi su Flaminio Corner," *Ateneo Veneto,* 18 (1980: 9–121).

37. Knox, *Raccolta di Teste.* Udine, 1971.

38. Rizzi (1971: [157, 158]). Mimi Cazort pointed out to me 25 years ago that in this etching the Tables of the Law are to be found beneath the figure of Faith, and that these, examined by Y. S. Brownstone, prove to be legibly inscribed in Hebrew with the Ten Commandments, as given in the Torah.

39. Dumesnil (1858: iii, 1–58).

Baillet, and Butler. All these, with the exception of *Il perfetto leggendario,* could have been available to Domenico. In fact, one may say that Anna Jameson's voyage of discovery, at least in its literary aspects, appears to have followed much the same path as that of Domenico. Even so, she does not appear to have had access to some of his sources: the *Meditationes Vitae Christi* and Ludolf of Saxony, or, somewhat more understandably, Maria de Agreda.

CHAPTER IV.

Drawn from the Text:
Domenico Tiepolo as Narrator of the New Testament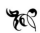

ADELHEID M. GEALT

Domenico Tiepolo's epic reexamination of the New Testament is, without doubt, his grandest and most extensive drawn serial narrative.[1] His retelling of the ancient story of early Christianity is remarkably exhaustive, beginning with Jesus's ancestors, Joachim and Anna [fig. 14] and ending with his successors, Saints Peter and Paul.[2] Moreover, Domenico did not simply recapitulate standard texts and visual formulas, as interesting as such an exercise might have been. Instead, he set himself far more ambitious goals. Using the old, established patterns as "fixed points," he moved in new directions, motivated, it seems, by asking himself some fundamental questions about what happened, how the texts described the event, and who witnessed it. His answers, shaped in part by his own inclinations as a visual narrator, took him into new, often uncharted visual territory, which, as we shall see, yielded groundbreaking conclusions about the roles of certain characters, notably Peter, and the authority of certain Gospel texts, namely, Mark and Luke.

With deceptively simple materials—pen, ink, and paper—Domenico created something both profound and complex. His evocative drawings established intricate connections not only from one scene to another but also between past and present, text and image, action and onlooker, speech and sight. He created a story that reached new conclusions about what the written sources related and about how those texts could be presented in visual terms.

As chapters 2 and 3 have shown, Domenico traced much of his narrative to its very roots in terms of sources and visual traditions. He translated his conclusions about textual authority into pictorial form in subtle ways, often adding details unique to specific texts. By accenting the issue of witnesses to the events portrayed, he created a dynamic "conversation" between written accounts, their origins among eyewitnesses, and the act of visual re-creation.

A similarly layered and nuanced approach inflected his treatment of time and its many dimensions. Besides fixing his story in its historic context (adding inscriptions, busts of ancient rulers, and the like), he linked it to his own time and place, using, among other devices, the familiar formula of giving some characters modern dress and some scenes contemporary settings.

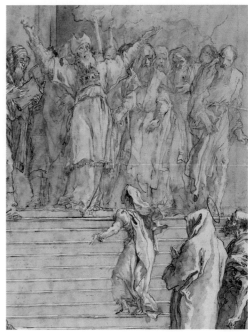

Figure 14. Detail of pl. 16, *The Presentation of Mary in the Temple*

As he moved his story forward through the generations, he considered the passing of centuries, months, weeks, days, even brief moments. He structured his narrative to form introduction, main events, and conclusions. As he did so, he experimented with diverse kinds of "cinematic" timing, from split-second freeze frames to fluid

1. Storytelling over multiple frames was Domenico's specialty. His most famous cycle is the 104-page biography of the theater character Punchinello; see Bloomington, 1979 exh.; Byam Shaw (1962); Gealt (1986, 2004); Udine (1996).

2. The question of completion is addressed later on in this chapter. We suspect there are still a few unlocated examples, including one *Flight into Egypt by Starlight* and another, an unidentified subject, according to our sources.

unfolding sequences, playing out short episodes over multiple frames, or collapsing great stretches of time into successive frames, depending on his inclination.

Honoring the sacred traditions of Venice, Domenico tinted his drawings with golden tones of sepia, thereby conjuring up the ancient grandeur of San Marco's glowing mosaics. His characters, delineated on a much smaller scale than those found in San Marco's monumental scenes, retained their dignity while manifesting greater vivacity than their Byzantine progenitors. What his drawings lack in size, they make up for in quantity, with Domenico determined to give a fuller visual account of all his characters than had been previously offered.

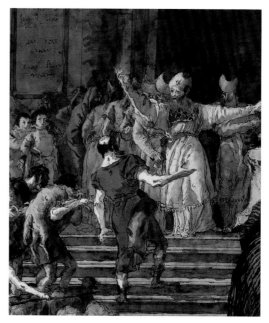

Figure 15. Detail of pl. 2, *Joachim's Offering Refused*

He linked his story to his beloved Venice in other ways as well, placing an accent on its Venetian dimensions and subtly sprinkling references to the notable relics and art of his native city into his scenes. Besides his homage to San Marco's mosaics, he honored the relics of Zacharias in San Zacharia, as well as the Venetian Duomo, San Pietro di Castello, which boasted the chair of St. Peter from Antioch. We also find him rethinking ancient events in the context of contemporary issues, which shaped his emphasis on certain themes, including exorcisms and money.

Domenico tied his scenes to the Gospels by presenting many characters in the act of speaking, as though sacred dialogue were flowing from their lips. Delineated in his characteristic trembling outline, his characters were set into perpetual motion so that momentous events continually unfold. In these events, a complex interplay between those who initiate action and those who respond to what they see engage the viewer in a continual judgment of what is presented [see fig. 15].

Domenico must have been attracted to the New Testament precisely because it was the acknowledged wellspring of supreme drama which offered nearly unlimited opportunities for drawn serial narrative. He knew he was not confronting a simple linear story with a beginning, middle, and end. Here was a story in which every episode was saturated with layers of meaning, rich with portents, symbols, and hallowed references. Beyond the rudimentary framework of Christ's birth, temptation, transfiguration, death, and resurrection, a single sequence of events, particularly of Christ's ministry, was virtually impossible

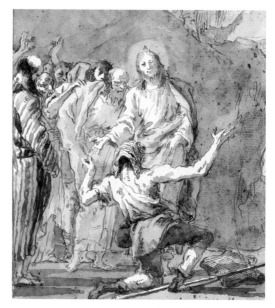

Figure 16. Detail of pl. 116, *Jesus Healing the Leper*

to construct from divergent Gospel accounts, which vary so much in their sequence and description of events.[3] There was a long (and often fairly rigid) set of pictorial conventions for depicting sacred scenes and characters from which artists rarely deviated over the centuries. Given his scope, Domenico confronted challenges far beyond those traditionally associated with narrative, as he entered the knotty realm of texts with their issues of precise wording, conflicting accounts, and doctrinal and devotional implications on the one hand, and more

3. John 19:26–27, for example, is the source for the presence of the Virgin and John the Evangelist at the foot of the Cross, which became the standard convention for painters. They are not singled out in the other three Gospels. In an example from *Jesus Healing the Leper* (pl. 116), only Mark 1:40 specifies that the leper knelt before Jesus; Matthew 8:3 says he "worshipped" Jesus; Luke 5:2 says the leper fell on his face. Of these distinctions, Domenico chose Mark's kneeling leper [fig. 16].

simple questions of timing, sequence, and interpretation on the other. These were generally reserved for biblical scholars, not for artists.

The son and pupil of one of Europe's most sophisticated painters and the brother of a priest, Domenico himself had launched his career with his celebrated *Fourteen Stations* for San Polo in 1747. Thus, he was uniquely qualified for his New Testament, which aligned itself so beautifully with his predilection for pictorial serial narrative and sacred stories. It is not difficult to imagine Domenico working at a fairly large table, with an abundance of large, uncut sheets of thick paper to hand, inks, chalks, and pen at the ready, and a vast amount of visual and textual knowledge in his head.

Invenzione

Domenico framed his approach by exploiting the dynamic tension inherent in theme and variation, the use of contrast, and the juxtaposition of opposites. All were aspects of the eighteenth-century idea of *invenzione,* which valued an artist's ability to invent new compositions out of fixed elements, and was deeply imbedded in Domenico's consciousness. Having created hundreds of diverse compositions on single subjects such as the Trinity, the Baptism, and Anthony of Padua, for example, Domenico must have approached the innumerable events of the New Testament with particular enthusiasm. Framed by the concept of *invenzione,* his project became the artistic equivalent of a dam being broken, unleashing a creative torrent.[4]

Invenzione encouraged Domenico's respect for visual traditions while challenging him to invent new interpretations, perhaps accounting for his remarkable scrutiny of the Gospels to visualize and raise points of textual difference that centuries of pictorial convention had glossed over.[5] Coupled with his consciousness of his place in art history, *invenzione* must have fueled Domenico's determination to pay homage to art historical precedents, while his awareness of current events, most notably the rapid secularization of society, doubtless encouraged a documentation of the history of his faith as well as the visualization of its most sacred devotional aspects.

In this undertaking, Domenico played a number of roles simultaneously: biblical scholar, archeologist, art historian, draughtsman, impresario. He consulted his texts, selected his subjects, assembled his troupe, cast his leads, designed his sets, and collected his props. Looking back on a thousand years of sacred imagery, he retold for the last time in his century the great holy story that made up his faith, and he gave it a justifiably expansive final salute. In so doing, he anticipated the future, presenting his epic with cinematic power. Through it all, Domenico hid the supple and fluid nature of his inventive mind behind a deliberate façade of clumsiness, as if daring the viewer to discover the secrets of his multilayered approach to storytelling. Thus, he was also something of a magician, whose sleights of hand are, at least in part, revealed in this essay.

Scope and Basic Pattern

At 313 sheets, *A New Testament* is longer than any sacred cycle by a single artist known to us.[6] The drawings themselves lack numbers, titles, or other clues to indicate Domenico's precise plan, but as our task of organizing them progressed, something of the artist's intentions began to emerge. Three hundred drawings cover the basic narrative.

4. Byam Shaw (1962: 31*ff*); Udine (1996: nos. 80–87). We know Domenico's experiments with the Trinity, the Baptism, and Anthony of Padua each originally numbered over 100.

5. The whole issue of why Domenico made such a deliberate effort to search out divergences in texts, as well as to seek out diverse texts in his interpretation of the New Testament story, may have several motivations. Given his evident interest in alternating between the established and the unconventional, one underlying motivation based on *invenzione* is not impossible.

6. To our knowledge, no comparable body of work by a single artist survives. Lavishly illustrated bibles, such as those discussed by B. A. Rosier (1997), yielded as many as 344 plates and involved several artists. Extensive mural and sculpted cycles were, by necessity of scale, much shorter or, if they covered many walls, were executed by numerous masters over many decades, as was the case with the San Marco mosaics.

Plates 1–81 carry us from the beginning of the story through the Holy Family's return from Egypt and the death of Joseph. Plates 82–102 relate the story of John the Baptist so that the first third of the narrative covers Jesus's ancestry, childhood, and coming of age. The central third of the narrative, plates 103–204, tells of Christ's adulthood, detailing his ministry and Passion. Within it, *The Transfiguration* [fig. 17], a watershed moment in Christ's ministry, comes not quite halfway into the story (pls. 139–142).[7] The final third of the narrative has three parts. There is a transitional series of scenes taking us from the Resurrection to the Ascension, followed by a repetition of Christ's Passion in its devotional form, the *Fourteen Stations of the Cross.* Next comes the Acts of Peter (35 drawings) and the Acts of Paul (32 drawings), after which Domenico added a short epilogue involving feast days, visions, and later Church history. Domenico was clearly aware of each chapter's function—Joachim and Anna's story formed a prelude, while Peter and Paul's acts were a conclusion to the central events of Christ's birth, life, and death. Much of how Domenico treated his narrative was framed with those larger issues in mind. Through it all, Domenico breathed such fresh life into his characters and events that we feel justified in titling his results *A New Testament.*

Domenico's preference for balance guided him throughout. Within Christ's ministry, 36 scenes lead up to a central turning point, *The Transfiguration,* and an equal number come after it, taking us to another turning point, *The Institution of the Eucharist* [fig. 18]. Eight temptation scenes frame the beginning of Christ's Ministry (pls. 103–110) and eight scenes of Christ's sufferings in the Garden of Gethsemane (pls. 182–189) frame its end. Jesus meets a woman of Samaria, raises someone from the dead (the son of the Widow of Nain), and feasts in a house where his feet are wiped with ointment before his Transfiguration. He likewise meets a fallen woman (taken in adultery), raises someone else from the dead (Lazarus), and feasts in a house where his feet are wiped with ointment *after* the Transfiguration. Any number of other balances between events before and after the Transfiguration can also be noted, some of which help differentiate these stages in Christ's ministry.

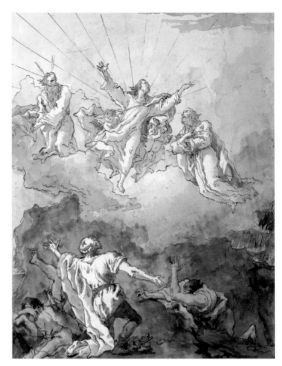

Figure 17. *The Transfiguration,* pl. 141

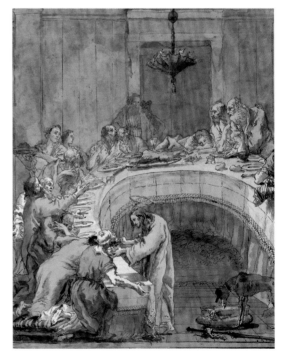

Figure 18. *The Institution of the Eucharist,* pl. 181

Omissions, Substitutions, and Missing Scenes

As this dismembered series was reconstructed it became obvious that Domenico had established a core narrative based on standard stories and visual traditions, around which he built his own original expanded epic. He adjusted his interpretation, sometimes omitting key scenes and making substitutions of his own. For example, not a single

7. This proportional relation in the sequence of events comes from the Gospels of Mark, Luke, and John. In Matthew alone, the Transfiguration falls more closely to midway in the story.

birth scene has been found. No birth of the Virgin or John the Baptist has surfaced, despite their established place in pictorial cycles. *The Birth of the Virgin* was evidently replaced by the unusual scene of *Anna Returns to Her House* (pl. 15). The traditional birth and naming of John the Baptist was reconfigured into a scene of John receiving his name at his circumcision, an event rarely portrayed and never associated (to our knowledge) with the naming episode (pl. 83). John's circumcision was clearly invented to parallel (and balance) the subsequent more traditional scene of *The Circumcision of Jesus* (pl. 39).[8] The fairly standard Nativity, which Domenico had ample reason to include for its traditional importance and because he faced no space limitations, is likewise absent, although the less common *Adoration of the Shepherds* is present (pl. 38). The absence of birth scenes reveals something of Domenico's narrative plans. His epic places an accent on the theme of death, which helps the central theme, Christ's sacrifice, fall into high relief. Death, in fact, is a key theme and receives fuller discussion later on.[9]

Given the number of Annunciations Domenico included in his story, the omission of the standard *Annunciation to the Virgin* is either a revolutionary choice (perhaps to make it stand out by its absence) or it remains to be found. Certainly Domenico relished the opportunity to portray lesser-known Annunciation scenes, including *The Annunciation to the High Priest Zacharias* (pl. 23).

Several of Christ's most famous miracles are missing, notably his transformation of water into wine during the Wedding at Cana (especially popular in his native Venice, as Veronese's famous examples indicate).[10] The Wedding at Cana is, I believe, a deliberate omission, the key to which can be found in Domenico's choice of two feast scenes noted earlier (in the homes of two different Simons, the Pharisee and the Leper). Each scene comes after Jesus raised someone from the dead: the son of the Widow of Nain in the first instance (pls. 120–121) and Lazarus in the second (pls. 164, 165). These parallel events flank the central Transfiguration scenes (pls. 139–142), thus inserting messages about Christ's power over death and his own imminent sacrifice before and after his transfiguration. This pairing lends a special symmetry to his overall presentation. Domenico must have felt that other resurrections, such as the raising of Jairus's daughter, or other banquets, such as the Wedding at Cana, would have disrupted his carefully constructed visual and narrative balance. He also appears to have avoided the traditional Last Supper, preferring instead its most important moment, *The Institution of the Eucharist,* another allusion to his sacrificial death and the subsequent devotions that death inspired within the Church (pl. 181).[11]

This does not, however, account for all of Domenico's choices. The iconic image of Christ praying in the Garden of Gethsemane (the prayer in which the angel delivers the cup) is missing. This omission begins to reveal Domenico's sensitivity to differences in textual sources, which is such a remarkable aspect to his whole approach. Matthew and Mark's Gospels do not describe the angel and only briefly note the third prayer as a repetition of the second. Luke (22:43–45) describes a lengthy prayer during which the angel appeared, which became the standard way the Gethsemane scene is portrayed. The absence of the angel is one of several instances in which Domenico returned to his sources and bypassed the standard image to present instead images based on details they supplied. Figure 19 shows Domenico taking to

Figure 19. *Jesus in the Garden of Gethsemane: The First Prayer,* pl. 185

8. Domenico needed look no further than the baptistery of San Marco to find the traditional treatment of this subject showing Zacharias writing his name on a tablet at his birth, by the seventeenth-century mosaicist Francesco Turresio; see *San Marco* (1991: 190).

9. In this respect, the almost "heavy-handed" transformation of Christ's crib into a cross in plate 38, thus alluding to death and sacrifice, makes sense.

10. Giotto included the episode in his cycle, and it is present in the north vault of the Dome of the Ascension in San Marco.

11. His version, interestingly, comes close to the most noted early interpretation of this subject, that of Justus of Ghent, now in Ducal Palace of Urbino (ca. 1475).

heart Mark's words that Jesus "fell on the ground." Plate 187 shows Domenico considering Luke's description of Jesus "praying more fervently."

In almost every chapter, Domenico skipped over standard subjects and substituted lesser-known events, thereby rendering his interpretation distinctive and original. Two of the most iconic post-Resurrection episodes, *Noli Me Tangere* and *Doubting Thomas,* have not been found, but two very rare scenes of Christ appearing to multiple disciples are present (pls. 207, 208). None of the traditional scenes of Mary's death and assumption and her subsequent coronation as Queen of Heaven—so vital to medieval iconography—are portrayed, although Mary makes many appearances throughout the narrative, including two most unusual ascents and descents to and from heaven (pls. 300–301). Given the trouble Domenico took to draw a title page or frontispiece for his chapter on the Fourteen Stations (pl. 213), and the fact that other narratives, such as his Punchinello drawings, have title pages, we can assume that a title page to the whole series was intended, or remains to be found. Although some missing scenes might still be located, in many instances the artist made substitutions of other, often more unusual subjects. Even if additional images are unearthed, Domenico's predilection for unusual subjects remains evident. His distinctive interpretation reflects his own understanding of the Gospel story's overall structure and thematic development.[12]

At least one drawing, Salome bringing the head of John the Baptist to Herod in *The Banquet of Herod,* is unfinished (pl. 101). The rather odd series of Roman episodes in the sequel seems incomplete (pls. 306–310). This, together with evidence of a stylistic shift within the drawings, hints that Domenico might have been preoccupied with this series until his death.[13] Thus, although we believe the series is essentially intact, tantalizing options for its completion remain.

Principal Characters

Domenico defined his characters on much the same principles that shaped his entire narrative, using them, like everything else, to carry the story forward on more than one level. Besides endowing them with individualizing characteristics, Domenico gave key characters selected qualities that became part of a visual pedigree, wherein a distinctive aspect was passed down to a significant descendant. This becomes evident in the first scene involving Abraham's sacrifice (pl. 1, [fig. 20]). Abraham's virile, muscular form, his beard, and his heroic stance establish him as the patriarch of the tribe of Israel, which over many generations would split into two groups, the larger Jewish community and that smaller but select band that would ultimately found the new Church: Joachim, Zacharias, and John the Baptist, but also Christ himself and, of course, his disciples.

Figure 20. Detail of Abraham from *The Sacrifice of Abraham,* pl. 1

Abraham's upraised arm is typical of the kind of device Domenico selectively carried forward. It reappears in the next scene, in which his priestly descendant uses a similar gesture to block poor Joachim (at that moment a less fortunate descendant of Abraham's) from entry (pl. 2). The upraised arm is John the Baptist's most prevalent gesture. Given Domenico's proclivity to reuse gestures to give his narrative an extra layer of meaning, we should not be surprised to find Abraham's gesture combined with the angel given a significant echo in the life of a key founder of the new Church, St. Peter. He too looks up and has his arm grasped by an angel in a similar (though

12. For a full account of omitted standard scenes, see the Combined Subject Index.

13. The clearest evidence of a stylistic change is found in the three drawings of Zacchaeus (pls. 166–168). The first scene, with its loose brushwork and hasty style, we assume to be a later date.

Figure 21. Detail of Peter and Angel from *The Apostles Delivered from Prison,* pl. 237

Figure 22. Detail of Peter from *The Denial of Peter,* pl. 191

not identical) fashion, as he is released from prison (pl. 237, [fig. 21]). Both Abraham and Peter were released—Abraham from his promise to God to sacrifice his son, Peter from prison. Both were founders: Abraham founded the tribe of Israel and Peter founded the new Church.[14]

Domenico strategically encoded significance into his characterizations throughout his narrative. Joachim's shame-faced departure from the temple (pl. 3) is echoed in the way his son-in-law Joseph reacts when he finds out that his new wife, the Virgin Mary, is inexplicably pregnant (pl. 31). The gesture is reused again—twice more, in fact, by St. Peter, whose function as heir to the legacy established by Joachim and Joseph is thereby strengthened. Peter registers this gesture of dismay as he hears the cock crow after his final denial (just as Christ had predicted) and uses it again in a most unusual scene as he witnesses Christ's crucifixion (pls. 191, 200, [figs. 22, 23]).

Stock elements enhanced with distinctive yet consistent qualities of Domenico's invention define all the principal characters. Anna, as was traditional, is old, and Domenico consistently reveals her face, in contrast with Joachim, who is generally seen from the back and whose face is rarely revealed. Anna is frail, Joachim virile. Their daughter Mary and her spouse Joseph inherit Anna's and Joachim's basic gestures and attitudes, although Mary is young whereas Joseph is older and more frail than Joachim. Mary rarely alters her dignified reserve, yet Domenico manages to convey changes in her mood or attitude, as well as her steadfast loyalty to her son. Joseph, like Joachim, is more emotional. Zacharias and Mary's cousin Elizabeth echo Joachim and Anna. They too are elderly beneficiaries of another miraculous child (John the Baptist) and Domenico lingers lovingly on the friendship between the two families in two separate visits using six scenes (pls. 33–35 and 44–46).

Some characters were based on Byzantine or medieval conventions, to which were added details of Domenico's invention. Satan, for example (pl. 104), resumes the bat-winged, cloven-hoofed appearance he had in Byzantine mosaics, perhaps to endow him with a sense of great antiquity. Domenico, who clearly enjoyed Satan, embellished his wings with circles found in the wings of moths to affirm his dark,

Figure 23. Detail of Peter from *The Crucifixion,* pl. 200

14. Domenico most likely invented this connection between Abraham and Peter, but there were precedents that helped him. The Chapel of St. Leonard in San Marco features the *Sacrifice of Isaac* and at the same time illustrates three miracles that feature Peter quite prominently, including the healing of Peter's mother-in-law, the feeding of the five thousand, and the curing of the Gadarene lunatic; see *San Marco* (1991: 91–93). Moreover, the introductory description of St. Peter in *The Golden Legend* states that Peter was particularly obedient, a quality that God was testing with Abraham.

nocturnal aspect. All the demons whom Jesus and his disciples conquer are clearly part of Satan's spawn (e.g., pl. 143).[15] Combining historical sophistication with childlike earnestness, Domenico defined evil in primordial if slightly comical terms. Though an archetype, Satan is a richly conceived character whose poses and attitudes shift dramatically (pls. 104–108). By contrast, Mary Magdalene, who makes frequent appearances in different parts of the story, retains her one-dimensional stock posture of groveling piety, helping us identify her in various episodes, including *The Feast in the House of Simon, I* (pl. 122), which introduces her.

Jesus Christ

Traditionally the ultimate archetype, Jesus develops more fully as a character in Domenico's epic and undergoes changes as his story develops, turning on the central point of the Transfiguration. Domenico begins with the newly baptized Jesus, who enters the stage boldly to launch his tests in the desert. Striding confidently into the wilderness, Jesus next assumes a seated "teaching position" as he prepares, first and foremost, to teach Satan a lesson (pls. 104, 107). His sermons and miracles are performed while standing and pointing, and he continues to teach or reveal great truths sitting down. After *The Transfiguration* (pl. 141), Jesus sits less often and becomes more emotional; his actions and gestures are more varied, culminating in his deeply felt struggles in the Garden of Gethsemane. His other mode is resigned pathos, an attitude first revealed as he inaugurates the Eucharist (pl. 181) and again when he is condemned to death and endures his torment (with occasional heroic overtones). Finally, as Jesus is affixed to the cross, he assumes the profile of the paschal lamb, which had prefigured his fate (pls. 181, 200).

The Disciples

All of Christ's disciples are thoughtfully characterized. Their origins, primarily as fishermen, are reflected in their rough-hewn bodies, awkward gestures, and often unkempt hair and beards. Their unself-conscious devotion to Jesus is never better expressed than in the two scenes of Christ's *Ascension* (pls. 211, 212). Although certain disciples can be identified—such as Andrew with his dark robe and drooping boots, and John, the youngest, deeply beloved disciple who looks almost like Jesus, and of course, Judas Iscariot—other disciples are less clearly defined [fig. 24]. Nevertheless, Domenico was fairly consistent, giving one fairly old disciple (perhaps Simon Zelotes) a gaunt, bare-chested presence (pl. 129). The most important disciple was Peter, but before turning to him it is worth considering Paul, who, though not a disciple, was, together with Peter, the cofounder of the Church.

Paul. In Domenico's interpretation, besides being transformed (as was traditional) from a persecutor to the great proselytizer, Paul also became a much beloved friend among the fledgling Christian communities he helped establish. In a significant detail about Paul, Domenico made him one of the few characters (besides Joachim and Jesus) at whom others point, a device first introduced in Joachim's story to underscore his shame at his expulsion (pl. 3). The device is repeated when Jesus is nailed to the cross (pl. 199). Perhaps it is the importance of Paul's ministry that inspired Domenico to endow him with this subtle distinction, linking the great preacher (whose story concludes the history of the early Church and his account of Acts) to the source of his beliefs and his power over death (pl. 291). A notable aspect

Figure 24. Detail of disciples from *The Ascension of Jesus, II,* pl. 212

15. Later traditions modernized Satan, making him an old monk (see Veronese) or a hermaphroditic seductress (Tintoretto).

of Paul's characterization is Domenico's very deliberate alternation between periods in which he has a full head of hair, such as when he baptizes Dionysius, and those in which he is clearly bald, as when he raises Eutychus (pls. 281, 291). This may be Domenico's response to the statement in Acts 18:18, which notes that Paul shaved his head in a vow. Butler amplifies our understanding, noting that "he shaved his head and made the religious vow of the Nazarites . . . [who] let their hair grow til a limited time, when they again cut it, and offered certain sacrifices. . . . By his conforming to this Jewish rite, St. Paul made himself a Jew with the Jews to gain them to Christ."[16]

Peter. As founder of the Church, first Pope, and lead disciple, Peter has generally received special attention from artists. Domenico, however, went far beyond tradition with his interest in this saint, using his characteristics to offer new insights into the Gospel accounts. His development of Peter's story is one of Domenico's most original contributions to this epic. Such an interest in St. Peter cannot be explained easily. After all, Domenico was a Venetian artist working far from Rome. Still, it should be remembered that the Venetian cathedral was, until 1807, not San Marco but San Pietro di Castello, which boasted the relic of Peter's throne from Antioch; thus, a Venetian association with the saint probably sparked Domenico's imagination. As we shall soon see, Domenico had other motives as well.

Like all Domenico's characters, Peter is given distinctive qualities. When he meets Jesus for the first time, he is given a prominent, central position and a crossed-arms posture of pious submission (pl. 111, [fig. 25]). During Jesus's ministry, Peter, his most constant companion, is visually and hierarchically "below" Jesus, intensely observing his cures, beginning with the leper and ending with the blind man (pls. 116, 162–163).[17]

Domenico's emphasis on Peter as Christ's leading disciple is reflected in the many times he stands out visually.[18] The only disciple to be given an independent scene featuring him without Jesus during his ministry, Peter is shown triumphantly retrieving the coin from the fish's mouth (pl. 145). He earns his leadership by struggling and failing as Jesus predicted, but ultimately remaining steadfast and faithful. Thus, Peter is the subject of five different scenes of warning and rebuke by Jesus during his sufferings in Gethsemane (pls. 182–184, 186, 188), after which he is seen running out of the picture in Domenico's dramatic and original interpretation of Jesus's arrest (pl. 189, [fig. 26]).

Figure 25. Detail of Peter from *The Calling of Peter and Andrew*, pl. 111

Figure 26. Detail of Peter from *Jesus Arrested in the Garden of Gethsemane*, pl. 189

16. Butler (1880: 879).

17. Peter is not the man behind Jesus during his raising of Lazarus (pl. 164), since the Gospel of John does not mention Peter's presence, and Peter's characteristic forelock and short beard are missing. The scene is unusual, most notably due to the absence of Mary and Martha, who are nearly always present.

18. Stationed right next to Jesus in the boat after the storm and as he delivers a sermon (pls. 124, 129), Peter listens with rapt attention as Jesus instructs Nicodemus, while being unaccountably (in terms of text and tradition) present in both scenes involving Jesus's discussions with the Woman of Samaria (pls. 131–132). The most prominent figure in *Jesus Blessing the Loaves and Fishes* (pl. 135), Peter is similarly (and traditionally) so stationed during the Transfiguration (pl. 141).

Peter's own ministry is interpreted far beyond the scope of a single text or picture cycle. Selecting stories from various commentaries beyond those found in *The Golden Legend*, Domenico has presented a visual exegesis on Peter's official role in the development of the early Church and as the first Pope. Though contrived from many sources, this has the authority of an eyewitness account, thus offering yet another and significant dimension to Domenico's essay on seeing that so informs this narrative.[19] Peter's many roles included leader of the disciples, spiritual, moral, and ecclesiastical authority, miracle worker, receiver of divine messages and intervention, and martyr, each of which is distinguished through his gestures and expressions. During his own ministry he manifests a new persona, one of dignity and calm authority, but when confronted by divine visitations he returns to the "subsidiary" postures he had while Christ was alive.

Peter as Witness and Textual Authority

Within the exceptionally extensive biography of Peter that Domenico took pains to create, he played up Peter's role of witness in a manner for which no visual traditions prepare us. Why that role should interest Domenico may be partly explained by his partiality for the Gospel of St. Mark, Venice's patron saint. As the series demonstrates, Domenico used every opportunity to underscore Peter's constant presence. Yet the standard episode that establishes Peter's primacy among the disciples, that of receiving the keys from Christ, is absent from Domenico's series. Only Matthew mentions the episode. Its omission suggests that Domenico was guided by several conflated motives. He wanted to emphasize Mark's text as his source, and likely preferred establishing Peter's authority through the more natural process of "trial and error" that Mark stresses. Peter's "errors" are clearly highlighted in Domenico's series and gain more resonance with the absence of Christ giving Peter the keys. When Domenico turned to the story of Christ's Passion, he continued to emphasize Peter using selected episodes from Mark as well as Luke. He portrayed a rare scene of Jesus warning Peter (pl. 182) that only Luke describes, followed by three (a fairly exceptional number) scenes of Peter being upbraided (pls. 183, 184, 186). These follow Mark and Matthew's description of Peter's assertion of loyalty and Jesus's warning, and the well-known episodes of Peter sleeping during Jesus's prayers.[20]

As the Passion series now stands (assuming no further drawings are found), it is clear that Domenico inflected his story with Mark's account. The angel bearing the cup to Jesus during his prayer (mentioned only by Luke) is bypassed, as is the traditional Kiss of Judas, although it is described by Matthew, Luke, and even Mark. With no divine intervention, the human drama is heightened. Emotions reach a higher pitch in Domenico's substitution for the Kiss of Judas, which plays up Peter preparing to defend Jesus with clenched fists as Judas approaches (pl. 188) and bursts into a crescendo in the relatively rare sequel (exclusive to Mark's account), showing Christ being led away after the infamous kiss (pl. 189).[21] That scene also portrays the youth, whom tradition has long identified as Mark himself, so frightened that he abandons his clothes in his haste to escape [fig. 27].[22] Peter, most unusually in terms of visual tradition, flees the scene as well. Again, this reflects Mark's account most closely, which concludes the story of the arrest with a separate stark verse: "And they all forsook him and fled" (Mark 14:50).

19. Domenico placed particular emphasis on Peter's presence and burial in Rome, a matter that had been debated for centuries and continued through the eighteenth century; see Cullmann (1962: 72).

20. At least 42 of the 74 scenes of Christ's ministry include Peter. Nine of the fifteen scenes that take us from the Last Supper to Jesus before Pilate also involve Peter.

21. Interestingly, Peter does not have the sword in his hand that John 18:10 assigns him; hence, his bravado has limited backing. In fact, Domenico makes him flee.

22. This is one of several instances in which Domenico omits a "standard" scene and supplants it with precursors or sequels that are less well known. His treatment of the miracle at *The Pool of Bethesda* (pl. 133) shows an unusual sequel, as does *The Woman Taken in Adultery* and *"Go, and sin no more"* (pls. 160–161).

Figure 27. Detail from *Jesus Arrested in the Garden of Gethsemane*, pl. 189

Despite the length of his narrative, Domenico reduced Christ's many trials to the single episode of his condemnation by Pilate (pl. 192), omitting other stages that generally had a fairly extensive visual pedigree.[23] Instead, Domenico elected a rare subject showing Peter shadowing Jesus as he goes to trial (pl. 190), followed by a scene of Peter's repentance when the cock crows as he descends a grand "porch" (pl. 191), which Mark's 14:68 account makes a focus in the story of his repentance. The latter scene centers strategically on Peter.[24] His appearance (cloaked against the cold) and attitude (weeping with remorse) make it impossible not to recognize his next and most unorthodox appearance at Christ's Crucifixion (pl. 200), which is unique, as far as we can determine, in the visual tradition [figs. 22, 23].[25]

Domenico's consistent characterization of Peter enables us to discover him in another radical departure from pictorial tradition as he places the saint in the scene of Christ's condemnation in the recapitulation of the *Fourteen Stations* (pl. 214), both Lamentation scenes (pls. 202, 226), and one burial scene (pl. 227). Jesus's appearances after his Resurrection likewise stress Peter, including Christ's appearance to two pilgrims who recognize him on the road to Emmaus (pl. 209) in an interpretation that again stresses Mark, who does not mention the much more pictorially famous Supper at Emmaus (an event Domenico omits).

Peter's appearance in untraditional locations encourages us to consider Domenico's sources. By stressing Mark's text as he turned to the most critical stage of Christ's life, Domenico could simultaneously honor Venice's patron saint (Mark) *and* establish Mark's factual authority as the product of Peter's dictation (an event Domenico later illustrates in pl. 253). Thus, in addition to his standard role as representing the first vicar of the new Church, Peter, in Domenico's hands, becomes the participant in and *witness to* the majority not just of Christ's ministry (as was traditional) but also his Passion (as was far less traditional), his Resurrection, and of course his Ascension. Using reason and logic, Domenico has not only inferred but stressed Peter's presence as principal witness, thereby underscoring the authenticity of Peter's dictation to Mark.[26]

Domenico gives the interplay between the image and the authority of text a dynamic new relationship. He very clearly honors the importance of text, taking pains to visually reference textual differences on the one hand while, on the other, tracing the validity of written words to their origins, namely, the act of seeing—hence the importance of witnesses in his images.[27] In this great visual summary, which one could argue as a defense of his faith and of the Papacy, Domenico once more gives the act of seeing ultimate authority, endowing the art of visualization with special power. At the same time, he gives St. Peter a potent new role, art historically speaking—that of authenticator of the prime Gospel (St. Mark's), an aspect that was not stressed, certainly to

23. Matthew (26:57) states that Jesus is first tried by a priestly tribunal (Caiaphas); Luke (23:1–11) adds a trial before Herod, who returns Jesus to Pilate; John 18:13 relates that Christ went before Annas, Caiaphas's son-in-law, first. Duccio's *Maestá*, Siena, Museo del Opera del' Duomo, shows many stages of the trial.

24. Matthew 26:58–75 has Peter moving to the porch (v. 71) and the cock crowing three verses later. Mark 14:68 states he "went out into the porch and the cock crew"; in v. 72, the cock crows again and Peter weeps.

25. Peter is rarely if ever present at the Crucifixion—we have found no examples. The Gospel of Mark is notable for his numerous accounts of Peter being rebuked by Jesus, an aspect commented on by Butler (1880: 497).

26. Using the internal logic of his own narrative, Domenico addresses the serious matter of Peter's principal symbol (the keys) by remembering an earlier chapter in the story, namely, *The Holy Family Beneath the Great Palm* (pl. 57), which shows the origin of the martyr's palm. He has Peter receive such a palm from heaven (together with his symbolic keys) at his crucifixion (pl. 261).

27. Here, Domenico anticipates the documentary power of photography—one aspect of his "cinematic" approach to the narrative. By stressing the act of witnessing (both in its literary dimensions as well as the tradition of portraying eyewitnesses), Domenico also honors a long-standing Venetian artistic tradition, which is well documented by Brown (1988).

this degree, in other picture cycles. It is also no accident that only Peter's chapter consistently employs lengthy inscriptions within many scenes, adding yet another dimension to the resonance between text and image. This complex, nuanced, and original approach to narrative is a revolutionary visual interpretation of the New Testament and represents one exceptional aspect of Domenico's accomplishment in this series. Moreover, it places Domenico in ground-breaking territory in terms of the history of theology. After all, by the early nineteenth century assertions had begun among theologians that Mark, not Matthew, was the "Ur" text. This was a revolutionary shift. Was Domenico at the forefront of this debate? Or did he simply intuit something that was soon to be (or perhaps already was) the most important debate among scholars? By his painstaking reference to verbal distinctions, was Domenico participating in the new critical approach to the biblical texts that developed in the eighteenth century? At this point it is impossible to say for certain. We can say, however, that in looking so carefully at texts and historical sources and actions, Domenico broke with iconographic traditions and brought his historicizing account very much up to date in terms of current issues.[28]

Unifying Presences: Angels

Domenico found new uses for other key actors as well. Angels are the only beings who appear from the beginning to the end of his epic. Their traditional role as divine intermediaries is adjusted to differentiate each episode and chapter. Domenico's habit of repeating and reusing certain poses is, in the case of his angels, selective. When noted, it deepens our understanding of the whole epic. Most striking is the angel who drops down from the sky (almost as though dangling from a rope, thus hinting at theatrical experiences Domenico might have had or wished to conjure up). An obvious paean to his father's work, notably the angel who delivers the martyr's palm to St. John, Bishop of Bergamo, Domenico adapts the angel to become a visual "icon" whose selective presence establishes a chain of connections among the scenes in which he appears.[29]

Figure 28. Detail of the angel in *The Sacrifice of Abraham*, pl. 1

This angel first drops in to stop Abraham from cutting Isaac's throat (pl. 1, [fig. 28]). Not named in the Old Testament, he assumes the pose Domenico later assigns to the archangel Gabriel, who, according to tradition, told Zacharias of Elizabeth's conception of John the Baptist (pl. 82). An angel descending like the one in *The Sacrifice of Isaac* frequently shows up (with minor adjustments of pose) to give instructions and mark some endings and other beginnings throughout the narrative until we come to Christ's ministry. Such an angel heralds Anna as she prepares to dismount from her donkey at the temple entrance (pl. 11). He makes several more appearances and later joins the company of angels that mourn her death and burial (pls. 21, 22). After his visit as Gabriel to give Zacharias the news of the birth of John (pl. 82), this angel leaves the cast, not appearing again until Peter goes to his death, whereupon we find him delivering the martyr's palm (pl. 261, [fig. 29]), blessing the martyrdom of Stephen (pl. 263), and reappearing among the angels who alone mourn and venerate Christ's death on the cross (pl. 298) and Domenico's marvelous visualization of the Feast of Corpus Christi (pl. 299). The angel's inclusion in the latter gives this

28. Though begun in the seventeenth century, textual criticism of the Bible flowered in the eighteenth, with numerous ramifications. These included the development of a debate over the "historical" Jesus launched by such notable scholars as Herman Samuel Reimarus (d. 1768), whose ideas on this subject were published in fragmentary form by Lessing in *Zur Geschichte und Literatur* (1774, 1778). My thanks to Professor John O'Malley for his advice on the topic of the history of theology related to Domenico's work.

29. Morassi (1962: [130]).

scene special meaning as the ultimate fulfillment of the epic narrative, which the Sacrifice of Abraham foretells so many drawings before.

Other angels have different duties. In the first chapter, they signify Anna's sanctified condition. In fact, once angels visit her, they never leave Anna throughout the story; they assemble en masse to mourn her death, and they alone bury her (pls. 21, 22). Besides paying reverential attendance upon Joachim, along with Mary, at his death, angels also assist his infant soul to heaven (pl. 20).[30] Angels do not appear in scenes of Mary's childhood until her betrothal; even more unusual, as the series exists now, they do not bring God's celebrated message to the Virgin about her destiny. However, angels attend Mary and her child with devotion. They are present in nearly half the Flight into Egypt scenes—urging departure, serving meals, acting as guardians, taking care of the donkey, and generally worrying over the Holy Family. Their fervent emotions and energetic attention make them nearly human foils to Mary's more dignified and divine demeanor, as seen in plate 50, *The Rest on the Flight into Egypt.*

Figure 29. Detail of the angel in *The Crucifixion of Peter,* pl. 261

Angels are conspicuously absent in Christ's ministry, save for the traditional angel who constantly stirs the waters at *The Pool of Bethesda* (pl. 133). They do crop up (unusually) in the central scene of *The Transfiguration* (pl. 141), establishing a visual parallel with his triumph after his Temptations (pl. 110). A few angels can be seen in Christ's radiating celestial light as he rises during his Resurrection (pl. 205), making this the third key episode that stresses Christ's divinity. They are strikingly absent during his Agony in the Garden. Bypassing centuries of tradition that portray Christ's Agony with the angel delivering the cup, Domenico renders Christ's lonely agony more profound (pls. 185, 187).[31] They are also omitted from Domenico's interpretation of Christ's Passion, despite traditions that place them at the cross and at scenes of lamentation.[32] Angels only return to venerate Jesus during his burial (pl. 204).[33] In his version of Christ's burial from the *Fourteen Stations* (pl. 227), Domenico amplifies the angels, adding an incense-bearing angel hovering above the tomb. Incense (last seen at the foot of Anna's bier in pl. 21) is also carried by an angel celebrating Christ's Resurrection (pl. 205).[34] Thus, Domenico gives Christ's earthly activities a more prosaic inflection by limiting angels, while letting their presence in the burial, Resurrection, and Ascension scenes amplify the divine radiance of these episodes.

30. That angels assisted the soul into heaven was often noted by early Church fathers and became part of the Mass of the Dead; see Daniélou (1976: ch. 9). He quotes, among others, St. Ephrem, who saw angels "taking up the soul (after it has left the body) and carrying it through the upper air" (p. 97).

31. While it is true that Domenico was motivated by the San Marco mosaics, which also portray the two earlier prayers, he bypassed the overwhelming popularity of the angel delivering the cup as the standard element of the Agony in the Garden scene. Also, as our reconstruction now stands, the third and final prayer in the Garden is absent. Even the San Marco mosaics show the angel in that scene.

32. Grieving angels are movingly portrayed in Giotto's Arena Chapel frescoes; they are likewise present in the Crucifixion scene found in the west vault of the Dome of the Ascension, San Marco. However, a later interpretation of the Crucifixion found in the "Well" lunette, executed in 1549, omits them, as did many later artists.

33. Later versions of the Entombment omitted angels as well; see the Entombment in the "Well" of San Marco. Titian's two versions in the Prado also omit them. Thus, modernizing his narratives by omitting angels clearly was not Domenico's motivation; instead, he linked Christ to his ancestors Anna, Joachim, and Joseph by placing angels among the attendants in all their funeral scenes.

34. Because incenses made of frankincense and myrrh were often used in oblations related to the hopes of reviving the dead, and because the Magi offered these as gifts, such references to angels with incense in these parallel scenes are important. The fourth-century Church evidently began the use of incense during the Eucharist, thus underscoring the importance of Domenico's reference.

Domenico stresses angels in his chapter on Peter (thus underscoring his closer connection to Christ) while excluding them from his chapter on Paul (perhaps to remind us of Paul's more earthly ministry). Instead of the worshipful role they had with Jesus, angels perform more pragmatic duties for Peter, acting as divine messengers and agents. They deliver Peter from prison twice (pls. 237, 249), and their final tasks are to deliver Peter's keys during his execution and his papal insignia during his funeral (pls. 261, 262).

Present in the scenes bridging Peter and Paul's story, angels attend Stephen's martyrdom (pl. 263) and the Eunuch's conversion (pl. 265), after which they disappear from Domenico's narrative until the epilogue. They return to venerate Jesus on the cross and the altar, as mentioned earlier. Finally, they attend three saintly visions: they carry Anthony of Padua aloft (pl. 305) and escort the Virgin and Christ as they appear to Philip Neri (pl. 312) and Jerome Emiliani (pl. 313). Divine agents of prayer and sanctity, angels hold Domenico's epic together, distinguishing one character from another and maintaining a link between the most ancient of sacred episodes and the more contemporary scenes of worship.

The Supporting Cast

Domenico assembled a huge supporting cast in this series. Running the gamut from the obligatory temple priests and Roman soldiers to shepherds and holy women, Domenico's characters include several types of demons, all of the ancient dragon type, and a large number of animals, most ubiquitous, of course, being the donkey and the dog, who plays a variety of roles, ranging from household pet to emblem of faithfulness, as well as representative of animal nature. Each chapter is distinguished by some exceptional characters. Thus, Joachim's groom is particularly long-suffering in the first chapter, while the eager converts who so unself-consciously disrobe, exposing their bottoms, add a note of levity to Christ's Baptism (pls. 93, 94). Domenico spanned the generations, giving nearly as many roles to children as to elders, while also presenting a broad cross-section of the social scale as servants, peasants, robbers, and cripples appear alongside potentates, priests, saints, and rulers.

Witnesses

Domenico's extensive cast places a strong emphasis on the fact of witnessing and engages us as observers, not only of the principal action but also to judge the reactions of the onlookers. The most ubiquitous observers were Jewish patriarchs and young boys, who therefore deserve special mention.

Jewish Patriarchs. Introduced in the first chapter as they witness Joachim's disgrace (pls. 2, 3) Jewish patriarchs or temple elders, shown bearded, turbaned, and cloaked, often with their backs to us, represent the patriarchal authority of biblical times. They are the race from which Joachim, Joseph, Zacharias, some disciples, Nicodemus, Joseph of Arimathea, Zacchaeus, Paul, and Jesus himself sprang. Sometimes representing the Scribes, Sadducees, and Pharisees mentioned in the Gospels, these men stand, generally in the foreground, acting as intercessors or barriers between our world and that of the story. The elders observe everything, from Joachim's disgrace to Paul's execution. It is no accident that they point at Joachim (pl. 3) and later his grandson Jesus (pl. 198) as both endure great shame. Notably absent during the sojourn into Egypt, the presence of one elder signals the Holy Family's return to Nazareth (pl. 76). Elders make up a prominent part of John the Baptist's audience, while two stand as witnesses to his beheading (pls. 91, 99). Key observers during Christ's most important early miracle, his resurrection of the son of the Widow of Nain (pls. 120–121), they are occasional witnesses throughout his ministry. Domenico gives them greater prominence during the latter part of Christ's ministry, particularly those events involving the Temple. Hence, Jesus and the adulteress, the healing of the blind man, and the resurrection of Lazarus involve more numerous elders, while an even bigger crowd shows up when Jesus teaches in the Temple after his triumphal entry and during his dispute over taxes (pls. 160–165, 174–175).

Domenico makes the elders the foremost witnesses of Christ's Passion, having them watching as he is disrobed (pl. 198), is nailed to the cross (no. 199), and lies dead (pl. 202). Elders are absent from Christ's burial scenes, reappearing when Jesus reveals himself to a large crowd (pls. 207, 208). Witnesses to Peter's ministry (pl. 238), elders observe Simon Magus plunging to his death and are present when Peter is arrested as well as martyred, though at

least one elder ranks among the converts Peter baptized in prison (pls. 255–256, 259, 260, 261).

Appropriately, Domenico would cast Paul (the early persecutor of Christians) as a nascent elder, as the youth, holding Stephen's garments, observes the Stoning of Stephen (pl. 263, [fig. 30]). Domenico indicated Paul's travels into realms beyond the borders of Jerusalem by diminishing the number of patriarchal witnesses in his ministry. They do observe key events, however. A single elder watches Paul and Silas thrown into prison at Philippi and later released, just as an elder witnesses Peter cast into his cell (pls. 275, 279, 259). The people of Malta who benefit from Paul's healing powers, as well as the crowds in Rome who gather to witness Paul's execution (pl. 297), include a good number of turbaned elders, although it is unclear whether these are Paul's followers or his persecutors.

Despite their lack of individuality, these elders (whom Domenico used in other picture cycles) lend much meaning to the story. The varying degrees of their emotional response or neutrality provides an opportunity to judge them while offering a way to gauge the diverse reactions of others.[35] Often the most authoritative among the Jewish populace that the Gospels blame for Jesus's persecution, these elders witness the unfolding of all key events from the story's beginning, endowing Joachim, Joseph, John the Baptist, and the disciples with a sense of context. Some join Jesus; others observe his violation of Jewish law, plot his demise, and finally call for and witness his execution. Not the hateful brutes who actually carry out Pilate's orders, these elders, in Domenico's interpretation, lend historical authenticity to each episode.

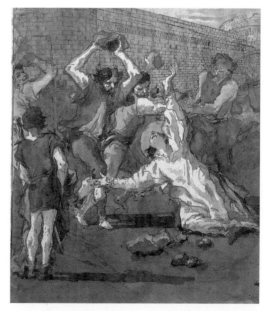

Figure 30. Detail of Paul in *The Stoning of Stephen,* pl. 263

The Gospel of Luke and the Role of Eyewitnesses

Besides Mark's Gospel, which led Domenico to posit St. Peter as a crucial eyewitness, the artist also placed an emphasis on the Gospel of St. Luke, beginning with Christ's Temptation, where differences between Matthew's and Luke's sequences of those temptations are noted. An accent on Luke appears in critical parts of Christ's ministry, such as the Transfiguration episodes, as well as in Domenico's emphasis on events described only by Luke, which get extra attention. Domenico made two scenes for the resurrection of the son of the Widow of Nain (pls. 120–121) and three scenes of meeting Zacchaeus (pls. 166–168, [fig. 31]), which only Luke relates. Domenico's partiality to Luke is harder to understand than his interest in Mark. After all, Mark was Venice's patron saint. Still, Luke was the patron saint of artists, which could have endeared him to Domenico. Moreover, Luke's body is preserved nearby, contained at Padua's St. Justina since AD 800. Domenico, who had executed commissions in Padua, was doubtless familiar with this fact.[36]

Domenico may have found Luke fundamentally interesting because his Gospel begins with its famous assertion about being based on those who "from the beginning were eyewitnesses, and ministers of the word" (Luke 1:2).[37] Not surprisingly, Domenico placed a strong accent on the reaction of witnesses to the episodes of

35. This neutrality traces its origins to Giambattista, as noted by Whistler (1996: 189). The presence of such characters in Venetian painting goes back for centuries and can be found among the works of Gentile Bellini, among others. Venice, a trading partner with Turkey, Greece, and the Middle East, makes this unsurprising. Bernard Lewis (2002: 36) notes that many emissaries from Islamic countries to cities like Venice tended to be Jews, Armenian Christians, and the like. Thus, Domenico's characterization of his Jewish patriarchs as Oriental pashas may be based on observation.

36. Domenico produced three altarpieces for churches in Padua, S. Agnese, and the Duomo between 1777 and 1778.

37. Even Butler's *Lives* stresses this important point.

Figure 31. Detail of Christ and Zacchaeus from *The Meeting of Jesus and Zacchaeus,* pl. 168

Christ's ministry based on Luke's account. For example, in the second (and rare) scene involving the Centurion's servant (pl. 118), Domenico inserts a turbaned man in striped clothing who points to Jesus beyond the picture frame, responding to Luke's words [fig. 32].[38] Witnesses crowd into the two episodes portraying the Widow of Nain's son (pls. 120–121), and details such as Jesus grasping the bier are based directly on Luke's words. The astonished reaction among the witnesses when the Widow's son is restored is masterful. The Zacchaeus episodes, which center on the fact that Zacchaeus climbed a tree to see Jesus, are likewise crowded with witnesses, as Luke relates (pls. 166–168).

Besides masses of eyewitnesses, Domenico fairly consistently inserts a man in a striped costume into many scenes that uses Luke as one of the sources for the story. Luke, as we know, related the story of the Centurion together with Matthew, and in the first image (pl. 118) a partly visible onlooker has a striped costume. He reappears quite often, such as in the story of the man sick with palsy, which Luke and Mark both describe (pl. 126).[39] This graphic device is not limited to scenes based on Luke, yet Domenico clearly went to some trouble to single out this man in striped costume as witness in connection to Luke's account, perhaps to underscore the eyewitness authority that Luke asserts. Equally significant, since Luke was the acknowledged author of Acts and the celebrated friend of St. Paul, is Domenico's rather consistent placement of a lone figure with a striped costume in just a few of Peter's episodes but in many of Paul's. Interestingly, a man in a striped costume observes Peter's activities in two notable scenes, one mentioned in Acts and one not: plate 240, in which Peter heals the palsied man, and plate 259, which shows Peter thrust into prison (not mentioned in Acts).

Paul's many adventures are witnessed by men in striped clothing, including his preaching in Damascus (pl. 269) and his stoning at Lystra (pls. 272–273). Such a man observes his imprisonment in Philippi (pl. 275, [fig. 33]) (a trip taken with Luke, during which Luke managed to avoid arrest), his subsequent encounter with the magistrates (pl. 279), and later his preaching at Athens (pl. 280). The man observes Paul expelling demons (pl. 284), rejoices at Eutychus's restoration to life (pl. 291), and stands among the crowd observing Paul's headless body being lowered from the scaffold (pl. 297). Scholars assert that Luke accompanied Paul to Rome and that Luke never deserted Paul, even through his execution.[40] The consistent presence of this witness, among other onlookers diversely characterized, suggests that Domenico probably had Luke in mind when he added this highly original dimension of his interpretation of Acts, demonstrating yet

Figure 32. Detail of turbaned man in *Jesus Heals the Centurion's Servant,* pl. 118

38. Luke 7:3: "And when he heard of Jesus, he sent unto him the elders of the Jews, beseeching him that he would come and heal his servant"—only Luke mentions that an elder was sent. Domenico shows him pointing toward an unseen Jesus.

39. Luke 5:18–25 (it is also described in Matthew 9:2–7). Luke's ample description of Jesus receiving the disciples of John (pl. 128) also features the man in striped clothes, as does Domenico's detailed account of Christ preaching at the Lake of Gennesaret (pl. 129), the unclean spirit (pls. 144–145), the house of Mary and Martha (pl. 147), prayer (pl. 148), the healing of the woman bent double (pl. 149), the ten lepers (pl. 154), the blind man (pls. 162–163), and the three Zacchaeus episodes (pls. 166–168).

40. Butler (1880: 553).

Figure 33. Detail of standing observer in
*Paul and Silas Beaten and Imprisoned at
Philippi,* pl. 275

another connection Domenico forged between the words of the New
Testament and their eyewitness source.[41]

Young Boys/Lads

Domenico's most popular supporting cast members, after the elders,
are boys aged about six to sixteen. Often standing with elders
to witness events, these lads also act as assistants of one kind or
another—helping priests, carrying dishes, gathering sticks or ropes.
Future beneficiaries of the ritual of baptism inaugurated by John,
they respectfully lead his funeral (pl. 102, [fig. 34]). They play an
especially prominent role during Christ's passion, beating out the
death march and carrying the sign that will be affixed to the cross.
Boys benefited from Christ's miracles; the Widow of Nain's son
and the lunatic son were raised and cured by Christ (pls. 120–121,
143–144). Boys were also
the focus of his teaching.
Jesus reminded his disciples
that they must be like
children, whom Domenico
characterized as sons. The sons of Zebedee (the Apostles James and
John) were portrayed as lads when their mother made her strange
request to have them sit at Christ's right and left in heaven (pl. 158).
Domenico's portrayal of Christ's ministry also includes parables
involving young men. The Prodigal Son is shown as a youthful lad,
as is the Master in the Vineyard (pls. 151–152, 157). Boys witness
Christ's reappearance, as well as Philip Neri's and Jerome Emiliani's
visions (pls. 207–208, 312–313). Except for his depiction as a corpse
on the ground, the unfortunate Eutychus who fell asleep during
Paul's lengthy sermon is a lad (pls. 289–291). Children throughout
the narrative are generally portrayed as boys. Emblems of eager
curiosity and pupils of their elders, they are unwittingly complicit in
many scenes while representing the ideal spiritual state: innocent and
willingly submissive to God.

Figure 34. Detail of boys leading funeral in
The Funeral of John the Baptist, pl. 102

Why would Domenico choose to emphasize boys? Several answers
can be proposed, none of them mutually exclusive. Certainly by limiting the number of girls, Domenico set the
Virgin's childhood into higher relief. Moreover, he may have considered that boys were likely favored and more
socially prominent and active in antiquity, as they certainly were in his own day. Girls, we know, had less social
freedom and were less likely to be found outside the home than boys—hence the presence of a little servant girl
standing by in several interior scenes signals her domestic status.[42] When Peter's mother-in-law is cured, a girl
offers Jesus a chair; when the Holy Family leaves the robbers and when they encounter the gypsies,
a little girl stands by (pls. 119, 69, 65).

41. Luke, a Syrian, could justifiably be portrayed as one of Domenico's Middle Eastern males. We know of no other artist who paid
such close attention to Luke's Gospel, or who imbedded such a clue as to his source in his interpretation.

42. Domenico's *Scenes of Contemporary Life* in Venice includes two visits to the convent where young girls were kept sheltered until
their marriage; see Gealt and Knox (2005).

Finally, it is possible that one audience for Domenico's sacred epic may have been orphan boys in his brother's care, since the Order of the Somaschi ran an orphanage, in which case the inclusion of so many boys in the larger narrative might have given them the means to identify with many parts of the story.

Themes and Related Narrative Devices

The New Testament offers numerous established themes, including miracles, martyrdoms, conversions, and visions, that one expects to—and *does*—find Domenico developing. More interesting are the themes and devices that, although suggested by his texts, especially appealed to Domenico and which he exploited independent of tradition to inflect each story with something of his own voice.

Fathers and Sons, Mothers and Sons

Introduced in the first scene of Abraham sacrificing Isaac (pl. 1), which of course foreshadowed God's central sacrifice of his only son, Jesus, on behalf of humanity, the theme of father and son echoes throughout Domenico's narrative. In retelling John the Baptist's story, Domenico stressed Zacharias, thereby placing an accent on both father and son in that chapter, while later on Domenico retold the story of the Prodigal Son, whose return to his father culminates a three-episode segment. Paul's chapter also dotes on Paul's resurrection of Eutychus using three drawings, and sprinkled throughout the narrative are vignettes of fathers standing protectively and affectionately by their sons, notably in the Sermon on the Mount. Yet another leitmotif is mothers and sons, which centers on the Virgin Mary and Jesus, but includes Elizabeth and John as well as the Widow of Nain, whose son Jesus restores to life. This likewise carries forward in vignettes of mothers and their sons observing the unfolding of sacred events.

Greetings and Partings, Exits and Entrances

Of all the devices bearing Domenico's imprint, greetings and partings (especially among friends and family) give his New Testament its distinctive, poignant flavor, enriching it with associative emotions from his first to his final chapter. In his story of Christ's grandparents Joachim and Anna, Domenico deliberately invented a scene of their parting after Joachim's rejection at the temple (pl. 4, [fig. 35]). This parting heightens our logical anticipation of their more famous reunion scenes over which Domenico positively reveled, using many frames. Once more, Domenico adds his own interpretation, avoiding their traditional embrace (pls. 10–14).

Domenico had any number of ways in which he could have told the story of Joseph and Mary, and he probably took up the apocryphal version of Joseph's discovery of the Virgin's condition because it involved the device of parting and return. Motivated by his love of unusual stories as well as his interest in revealing a more intimate side to Mary and Joseph's relationship, Domenico established a parallel between Joseph and his father-in-law by

Figure 35. Detail of Joachim and Anna in *Joachim Withdraws to the Wilderness,* pl. 4

showing Joseph, like Joachim, parting from his wife (pls. 4, 30). In contrast to Joachim's joy when he reunites with Anna, Joseph is dismayed upon his return to find his new young wife inexplicably pregnant (pl. 31)—alluding to the theme of chastity, which will be discussed more fully later on. Domenico plays up an estrangement between the couple as they make their way to Elizabeth and Zacharias (the traditional Visitation), recounted over four

frames (pls. 33–36). Here Mary's sanctified condition is celebrated in scenes of warmhearted greetings and concluded by a tenderhearted scene of parting. Joseph hugs Zacharias most affectionately, as if confirming their solidarity regarding their blessed wives. Domenico indulges in another episode of meetings and partings as he shows the Holy Family visiting Zacharias and Elizabeth again after the children are born, after which they part as they flee to Egypt (pls. 44–47).

Given Domenico's predisposition toward greetings, it is less surprising to find him creating, in his chapter on Christ's ministry, the dramatic scene of the Widow of Nain wildly embracing her resurrected son, which is again outside general pictorial traditions (pl. 121). It also helps us to understand Domenico's inclusion of the relatively rare subject of Christ bidding farewell to his mother, which he makes especially emotional (although they never touch),[43] then follows with a unique and heartbreaking scene of departure from her house in which everyone weeps (pls. 179, 180). Jesus bids his disciples farewell shortly thereafter and warns them of his death (pl. 182).

Domenico interprets Christ's arrest in such a manner as to stress unusual departures. He uses Mark's text, which relates that all his disciples abandoned him temporarily, and shows Peter departing (that is, running) out of the scene (pl. 189, [fig. 26]). By contrast, he underscores the constancy of Jesus's mother by showing them meeting, though unable to greet each other, several times as he carries his cross to Golgotha—and, of course, she never departs (pls. 197, 217, 218, [fig. 36]). Pitching his emotional range particularly high, when it comes to the bonds between Jesus and his disciples Domenico expands their final parting into two Ascension scenes (pls. 211, 212). He concludes his chapter on Peter and Paul by stressing their strong bonds, using the device of parting (pls. 292, 296).[44] All of these moments of parting and greeting transform what were archetypes into human beings with deep emotions whose passions are no longer remote but shared with the present through the depiction of a universal human experience. Interestingly, the tender aspects of an embrace are generally eschewed by the story's most spiritually elevated characters: Anna, Mary, Jesus, and Peter.[45]

Besides greetings and partings, Domenico exploited exits and entrances. Evoking or adapting the experience of theater and opera, he portrayed 30 such scenes and judiciously used doorways and portals in his sacred drama to add meaning, lend immediacy to individual scenes, change tempo, establish parallel relationships among scenes, or advance the sequence. The limited scenes of exits despite the prevalence of doors in Peter's story and Domenico's accent on exits in Paul's chapter contribute to

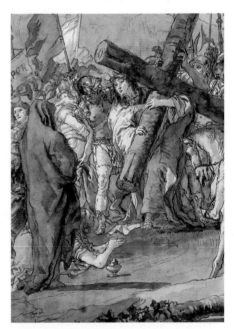

Figure 36. Detail of Jesus and Mary in *Station IV: Jesus Meets His Mother,* pl. 217

their distinctive flavors. His exploitation of exits and entrances, together with the tall brick-lined boxy rooms, similarly conceived doorways, and carefully considered portals with which these scenes are staged, suggest the inspiration of a medieval mystery play, reminiscent of Giotto's Padua frescoes, which present a similar sense of staging.

The whole story begins with a dramatic aborted entry as Joachim is refused access to the temple (pl. 2), marked by a grand doorway. The angel's annunciation to Anna takes place before a portal [fig. 37], signifying not only the transition of her life from barren to fruitful but also that Anna is the first of three "portals" through which the incarnation of Christian faith flows (pl. 7).[46] The Flight into Egypt begins with the Holy Family's exit

43. The Virgin only touches Jesus again, as she cradles his body on her lap in the Lamentation scenes.

44. Here Domenico adapted the traditional greeting scene and made it a touching farewell episode.

45. Anna never embraces Joachim; Mary never embraces Joseph; Jesus does not embrace Peter; and even his traditional embrace of John at the Last Supper is implied but not shown. Except for Paul, to whom he extends a farewell embrace, Peter embraces no one. By contrast, Paul's tender human nature is stressed by showing him hugging friends, while Jesus, who is portrayed being held by Satan during his second Temptation (pl. 105), is not shown in the more traditional embrace of Judas.

46. The others are the Gate of Jerusalem and the Holy Door (see below).

from a house (pl. 47). Their travels include three entrances and three exits through various city gates, after which Christ's encounter with the Temple doctors is characterized as an entry and departure as well (pls. 60, 63, 68–69, 72, 74, 78–79).

Christ's ministry also begins with the rare and powerful scene of his entry into the desert to do battle with Satan, after which Domenico, though often showing Jesus near doorways or gateways, does not show him actually passing *through* them until his triumphal entry into Jerusalem—thus throwing that important traditional event into higher narrative relief (pls. 103, 170–171).[47] Domenico stresses Christ's entry into that city by staging it over two frames, showing Jesus rapidly approaching and then halting as he actually passes into the gate [fig. 38], thus playing up the narrative importance of this transformative scene. Once Jesus enters Jerusalem he will leave only once more: to go to his death, which involves his exit through that same portal carrying his cross (pl. 196). Domenico augmented our anticipation of Christ's entry into Jerusalem by placing doorways or gateways into the great majority of scenes depicting Christ's ministry between the Transfiguration and the Triumphal Entry, culminating with a three-part prelude involving Zacchaeus, who climbed a tree in order to see Jesus as he went through Jericho (pls. 166–168). Staged before a massive wall, the story stresses Jesus' spreading fame (for having resurrected Lazarus) and gives an expanded account of the character whom visual tradition places in a tree in the background of so many Triumphal Entry scenes.

Domenico later enriches the drama of Christ's Passion not only with the farewell scenes noted above but also with exit scenes. Standing on the threshold of the Temple, Jesus (having bested the Pharisees again) prepares his final exit from that sacred spot and later departs from his mother's house (pls. 174, 180). After instituting the Eucharist, he bids his disciples goodbye (pl. 182), and once he leaves that door he passes through no other, despite his many movements from one place to another. This puts Jesus's final exit through the gate into Jerusalem into higher relief, while many exits and departures lend the protracted sense of ending to this stage of his Passion. As Jesus prepares to leave the Garden of Gethsemane, his followers, notably Peter, are shown abandoning him by exiting rapidly from the scene of his arrest (pls. 188–189). Then Jesus, now tentatively followed by the regretful Peter, exits one palace on his way to another trial, an atypical scene in Christ's Passion (pl. 190). Later, in an unusual episode, Peter, ruefully repentant, is shown exiting the palace (in a scene in which Christ's trial is implied but not shown) (pl. 191). As is traditional, Jesus leaves the city gate of Jerusalem as he starts his way to Golgotha (pl. 196), but then, in a fairly rare addition to the Passion cycle, Domenico shows Jesus's body carried away from Golgotha on its way to burial (pl. 203).

Figure 37. Detail of the portal in *The Annunciation to Anna,* pl. 7

Figure 38. Detail of Christ and the gateway in *The Entry of Jesus into Jerusalem, I,* pl. 170

47. Jesus is shown inside two key spaces—he enters Peter's house and cures his mother-in-law, and he later enters Matthew's counting house and recruits him (pls. 119, 127). Each scene features a doorway.

The Holy Door

A sacred doorway, the sanctity of which is sometimes further emphasized by a cloud of glory, plays a special role in Domenico's narrative and rests on the metaphor of Jesus as the doorway to salvation, which is noted by John 10:9: "I am the door: by me if any man enter in, he shall be saved. . . ." Domenico inserts the sacred portal into appropriate scenes, beginning with *The Circumcision of Jesus* (pl. 39) and culminating in Domenico's visualization of *The Institution of the Eucharist* (pl. 181, [fig. 39]). This sacred portal reappears in *Pentecost* (pl. 230) and is echoed by the staging of several key episodes of Peter's ministry, most particularly the central episode of *Peter Dictating the Gospel to Mark* (pl. 253).

Figure 39. Detail of the holy door in *The Institution of the Eucharist,* pl. 181

As far as can be determined, Domenico's visualization of the Holy Door is unique to his narrative, although it also had a tradition within the Church. Beginning in the fifteenth century, seven churches in Rome, including St. Peter's, had Holy Doors, which were sealed with brick and opened only during special Holy Years. In Domenico's lifetime, Pope Pius VI, who later visited Venice in 1782, opened the Holy Door of St. Peter's during the Jubilee year of 1775.[48]

Peter's story makes limited use of exits and entrances, with several exceptions, each of which mark divine intervention or divinely given powers. The drama surrounding Peter's first miracle is framed by exits and entrances. The lame man whom Peter cures by the Temple's grand portal (pl. 231) subsequently enters the Temple (pl. 232). Later, Peter, together with John, leaves prison through a door, miraculously guided by an angel (pl. 237). Two of the three scenes of Peter confronting Ananias and Sapphira show a body or spectator exiting the scene. Doors also take on spiritual significance in Peter's chapter; in plates 251–253 his church appears to be built around the sacred doorway that anchored Domenico's *Institution of the Eucharist.* The chapter reaches its final stage with Peter's only actual entrance as he is shoved through a prison doorway (pl. 259). The rest of the time Peter is already "there," while the moment portrayed is rich with implied arrivals and departures, exits and entrances around his fixed, enduring presence.

In Domenico's interpretation, Paul's story is distinguished from Peter's by its more commonplace doors and Paul's numerous exits. Paul's first appearance is protracted, played out over two scenes showing his approach and conversion near Damascus. His entrance into the city's portal (which Domenico places far in the distance) is aborted by God's sudden and shocking appearance (pls. 266, 267). Converted, Paul is transformed from persecutor to persecuted and makes his first of many exits by escaping from Damascus at night (pl. 270, [fig. 40]). We never see Paul enter Lystra, although Domenico considers his expulsion from that city over two frames that show him stoned and left for dead outside Lystra's walls—a rare subject at best and certainly not the subject of two images in any known cycle (pls. 272–273). Paul's second entrance is ignominious, as he and Silas are beaten and driven into prison at Philippi (pl. 275). Domenico then meditates at length on an unusual (in terms of visual tradition) episode, namely, Paul's *refusal to exit* the prison. The artist plays up its mammoth doors, which frame Paul's defiant rebuke of the soldiers and elders (pls. 278–279). Collapsing the story of Paul's further peregrinations, he inserts a scene of the apostle as he prepares to exit Ephesus by ship, which he follows with the aftermath of his storm-driven entrance on the shores of Malta (pls. 292, 294). No entrance to Rome is described,

48. See Piero Marini, Master of Papal Liturgical Celebrations, http://www.vatican.va./news-services-litergy/documents (accessed 1/31/2005).

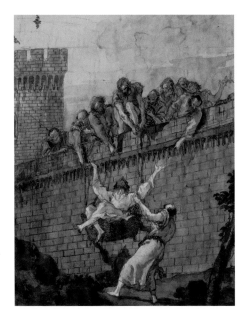

Figure 40. *Paul Lowered in a Basket from the Walls of Damascus*, pl. 270

described, although Domenico, true to characterizing Paul's life in terms of exits, elects to portray Paul's final exit from the scaffold upon which he was martyred, as his body is lowered down (pl. 297, [fig. 41]).

Deaths and Funerals

Domenico's thematic approach eschews birth scenes (as noted earlier) while concentrating on deaths and funerals. Almost every principal character dies, regardless of whether or not this was a standard part of the visual tradition or had a basis in text; many have funerals. Domenico portrays deaths to establish parallels between some characters (Joachim, Joseph, John, and Zacharias) and to distinguish others (Anna, Paul). But most important, he established a narrative context for his epic's central death, that of Christ.

Jesus's ancestors Joachim, Anna, and Elizabeth all die peacefully. In the epitome of a "just death," Joachim expires in his house, attended by Mary and mourned by Anna (pl. 20, [fig. 42]). Joseph's death parallels that of his father-in-law Joachim's and is followed by a distinctive assumption scene (pls. 80–81). Anna, singular in so many other ways, has an especially unusual demise. She lies in her home, mourned and venerated solely by the angels who had attended her in life, who go on to bury her in the desert. Only John the Baptist witnesses her burial, which is contrary to all known texts and traditions (pls. 21–22). Elizabeth, paralleling Anna, dies peacefully in the wilderness as well, mourned by her son John (pl. 96).

Herod launches the first murders of this epic, ordering *The Massacre of the Innocents,* which Domenico has described with terrifying brutality (pl. 43). Zacharias is next to die at Herod's command, stabbed to death in the

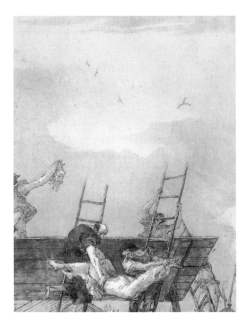

Figure 41. Detail of Paul's body in *The Beheading of Paul,* pl. 297

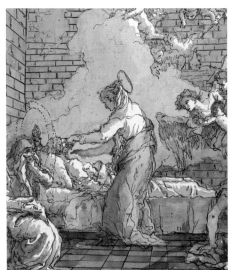

Figure 42. *The Death of Joachim,* pl. 20

temple (pl. 86) for refusing to divulge John's whereabouts. Despite texts that maintain his body could not be found, Domenico gives Zacharias a stately funeral that honors his relics in San Zacharia and anticipates as well as parallels that of his son John (pls. 87, 102). John's death (at the behest of Herod Antipas) takes place as text and tradition established—in prison, his severed head shown to two witnesses (pl. 99).

Jesus's death and burial, a core Christian event, is detailed over eight frames in two different chapters, the Passion and the *Fourteen Stations of the Cross* (pls. 200–204, 225–227). Within the context of the many deaths Domenico describes, Christ's is the most violent, public, and cruel, representing the greatest suffering and, of course, the ultimate sacrifice. Moreover, Domenico considered the Crucifixion two different ways in his Passion cycle (pls. 200–201). He also made

the Lamentation over Christ's body (pls. 202, 226) stand out in his narrative by considering it twice.

Joachim, Anna, Elizabeth, and Joseph all have deaths at which mourners preside, affirming through those strong emotional ties as the link between these ancestors of Jesus and Jesus himself, whose death prompts that grand theme, the Lamentation (or Pietà). Moreover, Zacharias, John the Baptist, and Peter are the only three characters besides Jesus to have funerals, the most opulent of which is Peter's [fig. 43]. All were killed unjustly, and all form links in the chain of priestly connections to the Temple and then the Church, indicating that even details such as funerals have narrative consequences in Domenico's plans (pls. 87, 102, 203, 262). Here again, Jesus's funeral stands out as the most important and the least ritualistic, consisting of the simple transport of his body.

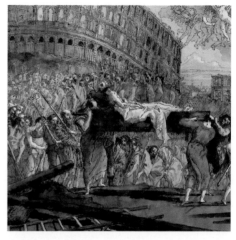

Figure 43. *The Funeral of Peter,* pl. 262

Only two people are actually buried in Domenico's epic, Jesus and his grandmother Anna, thus establishing another link between them. Jesus's burial is a canonical event, as affirmed by the Gospels and visual tradition, whereas Anna's is neither. Clearly, Domenico, who had established other parallels between these characters (notably their attitudes of prayer), invented a most unusual scene of Anna's burial. Both Jesus and Anna have angels present at their burials, forging yet another connection between them (pls. 22, 204, 227).[49]

Stephen, the first traditional martyr, reaches up to heaven as he is stoned to death, with Paul standing by (pl. 263).[50] Peter, founder of the Church, stretches down to earth as he dies upon his inverted cross, wishing, in his humility, not to die in the same manner as Jesus (pl. 261). Afterwards the parishioners of his thriving Church accord him the most stately funeral procession of the entire narrative in a scene that simultaneously affirms Peter's importance and locates his body in Rome by using that city's most famous landmark as the setting (pl. 262).[51] Paul, the last saint to die in Domenico's story, was beheaded "off-stage." Domenico reminds us of the execution as the swordsman holds up Paul's severed head (paralleling the presentation of John's head to witnesses) in a scene that anticipates Paul's funeral. His body is already being lowered toward a small group assembling for the procession (pl. 297). As Domenico's series stands now, no separate funeral scene was drawn, though traditions included it. In this and many other ways, Domenico differentiated Paul from Peter, consistently according Paul less glory.

Conscious of death's importance not only as the common fate of all humanity but also as the central point around which Christianity turns, Domenico gave mortality the strongest possible accent in his narrative, using distinctions between murders, executions, and martyrdoms, expressions of grief, and the types of funerals and burials to distinguish his characters. Perhaps it was his own advancing age and personal familiarity with death that inspired Domenico, or perhaps it was the long popularity of death scenes in the eighteenth century that shaped his decision.[52] Regardless of his reason, the artist's scenes of death are among his most sensitive inventions. Details such as Mary closing her father's eyes as Anna turns away, too absorbed in her own grief to notice, or Jesus comforting

49. This bit of internal logic amplifies Domenico's understanding of the Immaculate Conception, which of course implies that Jesus could not have inherited any traits from his earthly grandfather or father, but certainly, as the fruit of Mary's womb, could have inherited traits from his earthly grandmother, Anna.

50. St. Stephen's martyrdom (the first such after Christ's death) is a standard subject in Christian iconography. Domenico may have had reasons besides visual tradition, however, to portray the subject. According to some accounts, Doge Ordelafo Falier brought the body of St. Stephen back with him from a crusade that began in 1109 and deposited it, together with a part of the true cross, in the Venetian church of Santa Maria Maggiore. That church was deconsecrated by Napoleon and its contents scattered.

51. The Gospels do not mention that Peter was actually martyred and buried in Rome, which was still debated into the nineteenth century. For a summary of evidence, see Foakes Jackson (1957: 40*ff*).

52. Deathbed and last communion scenes had already gained popularity in the seventeenth century, as indicated by seminal images by A. Carracci, *The Last Communion of St. Jerome,* ca. 1591, Bologna, Pinacoteca Nazionale, and Domenichino, same subject, 1614, Rome, Vatican Collections. During the eighteenth century, death scenes expanded to contemporary histories, as Benjamin West's *Death of Wolf,*

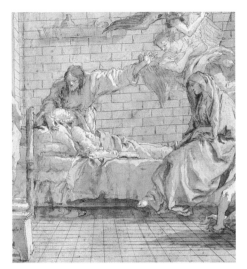

Figure 44. *The Death of Joseph,* pl. 80

Joseph by pointing to the heavenly host arriving to take him home [fig. 44], or Martha tenderly touching Christ's cheek as he lies dead across Mary's lap—all reflect Domenico's inspired interpretations.[53]

Prayer, Veneration, and Ritual

Given the sacred focus of the subject, scenes devoted to prayer, adoration, and veneration, as well as rituals, are not surprising. Here again, Domenico establishes similarities or distinctions among his characters regarding who prayed and how in order to reveal higher truths regarding his subject. Moreover, in placing such a strong accent on ritual, he builds up to his concluding scenes, which visualize the mystical aspect of the Mass and later believers partaking of the Mass, giving us a chain of events that links this ritual to its origins.

A very limited cast of characters actually pray. Joachim, Anna, and John the Baptist are the devout precursors to Jesus, an aspect Domenico stresses by showing each of them absorbed in prayer. Joachim and John the Baptist each pray in a similar fashion before makeshift altars (pls. 6, 88, [fig. 45]). Joachim joins Anna to pray in the temple, a rare set of scenes (pls. 13, 14). Anna, who alone has the strength to confront the Holy of Holies, stands in the prayerful posture that Jesus later assumes. Among the striking ways that Domenico distinguishes Jesus is the fact that he is shown praying more often than any other character (perhaps to remind us that he was closest to God).[54] Domenico offers the unusual subject of Christ's prayerful ascent up Mount Tabor as the prelude to his Transfiguration, which is derived from Luke (9:28–36), who says that his fervent prayer actually transfigures him (pl. 139, [fig. 46]). Jesus later leads his disciples in the Lord's Prayer, another rarely depicted scene, which offers a visual summary of the diverse attitudes one can assume in prayer (pl. 148). Jesus is then shown praying for deliverance in Gethsemane twice, also unusual (pls. 185, 187). Shown in profile with his hands clasped before him, much like his grandmother Anna, Jesus, not surprisingly, demonstrates more dignity, sanctity, and fervor as he prays than any other character.

Figure 45. Detail of John the Baptist in *John in the Wilderness,* pl. 88

Seen from behind, kneeling to the floor, their bare feet exposed, Joachim and John assume the attitude of prayer or reverence most often adopted by others (including angels), an aspect that links them in a fundamental way to the viewer.[55] Domenico also follows the long-standing convention that portrayed all the disciples and the Virgin at prayer during Pentecost (pl. 230). He expands on the idea by showing the disciples inspired by prayer as they formulate

1770, Ottawa, National Gallery, demonstrates. Deaths of sacred figures were often portrayed. Notable examples include Jean Restout's *Death of St. Scholastica,* 1730, Tours, Musée des Beaux-Arts; and Marco Benefial's *Blessed Giacinta Marescotti on her Deathbed,* 1736, Rome, Alaleoni Chapel, S. Lorenzo in Lucinda.

53. It should be noted that Rembrandt's *Lamentation,* which Domenico took as his model, did not have this detail, nor did it include so many mourners, among them Peter. None of the above-mentioned details are borrowed from other sources, so far as we know.

54. This is another highly original dimension of Domenico's interpretation. While the subject of Christ praying is a basic tenet of the Gospels, no artist besides Domenico (so far as we can determine) placed so much emphasis on it.

55. Note the prostrate figure in *The Lord's Prayer* (pl. 148). He can often be found in later scenes, such as *A Miracle of Sta. Agatha: The Sacred Heart* (pl. 302).

their Creed under the direction of St. Peter (pl. 254). Besides these principal characters, later congregations and saints (Anthony of Padua, Jerome Emiliani, and Philip Neri) experience miraculous visions as they kneel in prayer (pls. 302, 303, 305, 312, 313). Thus, prayer becomes the common thread, the sacred ritual that connects us to the holy characters in this drama.

Within his larger narrative, Domenico has defined and constructed the context for sacred rituals connected with Christ's death. He has shown us the rites of extreme unction (pl. 118); he portrays the ancient rite of circumcision (pl. 39) and the origins (in detail) of the modern rite of baptism (pls. 92–95); he shows the origins of the Eucharist and its later manifestation as the Feast of Corpus Christi (pls. 181, 299). That emphasis, coupled with his other scenes stressing acts of worship at altars, clearly connects episodes of Christ's life to their fulfillment in Catholic ritual (pls. 302, 303, 312, 313).

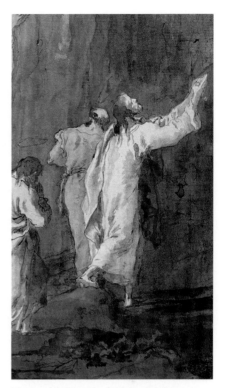

Figure 46. Detail of Christ in *Jesus Ascends the High Mountain with Peter, James, and John,* pl. 139

Chastity

Domenico was interested in the theme of chastity, and introduced it in Joachim and Anna's story. By never showing his characters in a traditional kiss, he doubtless meant to stress the concept of the Immaculate Conception of the Virgin herself, an aspect of her birth supported by the Franciscans since the twelfth and thirteenth centuries. Domenico's device allowed him to establish a visual characterization that carried forward in Mary and Joseph's story. He underscored Mary's inviolate condition at the time of her marriage by stressing her confinement within the Temple "conservatorio" (pl. 24). He added a surprising and unconventional scene in which Mary reveals her condition to the dismayed Joseph (pls. 30, 31, [fig. 47]).

Chastity threads its way through the story of John and on into Christ's ministry. John's death, of course, relates to the theme of chastity by suggesting its opposite: lust. After all, John reproved Herod and Herodias for living in sin (pl. 98). Herod, who did not want to kill John despite his wife's wishes, gave in because of his lust. Already ensnared by his wife, he was beguiled by her daughter's sensual dance at his birthday. Desirous of seeing Salomé dance again, he agreed to fulfill any wish, which Herodias made sure was John's head on a platter (pl. 101). Interestingly, these traditionally seductive characters, Herodias and her daughter Salomé, are characterized as being rather modest, so here has Domenico slightly subverted tradition by de-emphasizing their sensuality.

Domenico depicted every story involving a woman whose chastity was compromised in his treatment of Christ's ministry, giving the subject more prominence than it generally had within the limited space of individual picture cycles—especially since he used two frames in each case.[56] Conscious of the evolution within his narrative, he placed a stronger accent on the topic in scenes after the Transfiguration. In his section on Christ's early ministry, Domenico portrayed the encounter

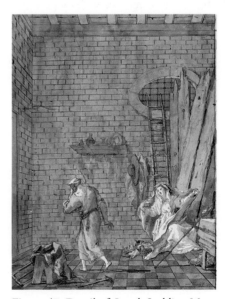

Figure 47. Detail of *Joseph Scolding Mary,* pl. 31

56. The sprawling network of chapels in San Marco includes many of these stories, but they are not linked along a single narrative thread. For example, *Christ and the Woman of Samaria* is a twofold story related in the Chapel of Saint Leonard; a single scene of *The Woman Taken in Adultery* is found in a single scene related in the Chapel of Saint John.

with the Woman of Samaria, a noted seductress (pls. 131–132). He also introduced the first of two episodes involving the reformed harlot, Mary Magdalene, washing Jesus's feet and anointing them with rare unguents in a portent of his death (pl. 122, [fig. 48]).[57]

After the Transfiguration, Jesus defends Mary Magdalene to Martha (pl. 147). He relates the parable of the Prodigal Son, who wasted his money on loose living, a story that unfolds over three scenes (pls. 150–152). Interestingly, the Prodigal's sensuality is implied, not described, while his repentance and his father's forgiveness, the core subject, is emphasized. Jesus later defends the adulteress who has been brought to the Temple (pls. 160–161). He also attends a feast in honor of Lazarus, where Mary Magdalene again anoints his feet with unguents and her hair (pl. 165). His last disputes in the Temple included several issues, among which was the question of the widow seven times over (an implied adulteress in heaven since the question centers on whose wife she would be in the afterlife). This debate is conjured up by the setting, gestures, and Jesus's pose in one drawing (pl. 174), which echoes his earlier defense of the adulteress [fig. 49].[58]

Although the number of subjects involving morally compromised women increases after the Transfiguration, their characterization as seductresses diminishes. Only the Woman of Samaria (whose story comes before the Transfiguration) is portrayed as mildly seductive, while the Magdalene, with her flowing tresses, is devoutly passionate. The adulteress makes a surprisingly modest appearance after the Transfiguration. Hence, sensuality is not Domenico's emphasis, other issues are: first, Jesus's associations with social outcasts (including, most notably, prostitutes and tax collectors); second, repentance—all of these characters repented and changed their conduct (in contrast to Herodias and Salomé, who did not).

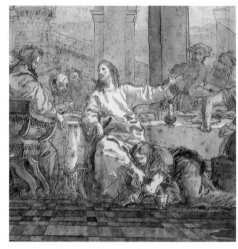

Figure 48. Detail of Mary Magdalene in *The Feast in the House of Simon, I*, pl. 122,

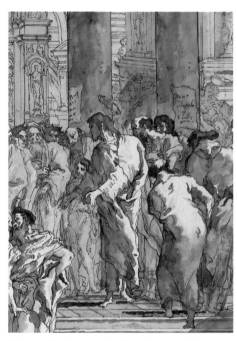

Figure 49. *Jesus in the Temple*, pl. 174

Money

Whereas Domenico used the theme of chastity to connect Christ's ministry to the story of his predecessors and precursors, he used the theme of money to connect the story of Christ and his principal follower, Peter and, to a lesser extent, Paul. Again, Domenico did not invent new subjects, but in selecting the stories to illustrate he stressed this theme.

Besides "fallen women," the other social outcasts with whom Jesus regularly interacted were tax collectors. In fact, he recruited one of them, Matthew, as a disciple (pl. 127). Domenico took special pains to show piles of money heaped on Matthew's table and a huge metal money vault in the background [fig. 50]. The artist wove the topic of money into his narrative, placing a greater emphasis on it after The Transfiguration. He lavished special attention on Jesus's encounter with Zacchaeus, the diminutive tax collector who so admired him and

57. Interestingly, this is a topic evidently not treated among the San Marco mosaics.

58. Domenico also connected a miraculous raising of the dead with a scene of the Magdalene anointing Jesus's feet in each section of Christ's ministry—the two scenes of the Widow of Nain's Son (pls. 120–121) and the *Feast in the House of Simon, I* (pl. 122) before the Transfiguration; *The Raising of Lazarus* (pl. 164) and the *Feast in the House of Simon, II* (pl. 165) after the Transfiguration. So far as we know, Domenico's epic is the only visual narrative to create these parallel situations.

Figure 50. Detail of Matthew in *The Calling of Matthew*, pl. 127

Figure 51. Detail of *The Tribute Money*, pl. 175

was famously charitable, making three drawings (pl. 166–168). He devoted an independent scene to the unusual subject of Peter finding the coin in the fish's mouth (pl. 145). Generally a detail in a larger scene (if shown at all), this independent scene places special emphasis on, and establishes an early connection between, the first Pope and money.

Domenico also connected compassion to money in his choice of parables: *The Good Samaritan; Lazarus at the Gate; the Master in the Vineyard;* and of course, the story of the Prodigal Son (pls. 146, 153, 157, 150–152). Jesus is twice shown cleansing the Temple of money lenders (pls. 172–173). Judas makes his pact for thirty pieces of silver, the bag of money dangling from his hands (pl. 178). Finally, one of Domenico's concluding episodes before Jesus's Passion begins centers on the payment of taxes, *The Tribute Money* (pl. 175). In it the coin is held up for all to consider [fig. 51] before Jesus makes his famous pronouncement: "Render unto Caesar," a subject that was well known but not a standard fixture in New Testament cycles.

Peter deals with money several times during his own ministry. He is so angry with Ananias and Sapphira for withholding money from the Church and lying about it that his public condemnation causes them to die before his eyes. Generally the subject of a single scene, Domenico placed special emphasis on the topic, giving it three drawings (pls. 234–236). He also included the rare subject of Peter refusing Simon Magus's offer of money to reveal the source of his power (pl. 239). Later, over two frames, Domenico shows Simon plunging to his death, thus placing unusual emphasis not only on Peter's power over Simon's false magic but on Simon's venal attempt to gain Peter's secrets (pls. 255–256).

Money also resonates briefly in Paul's story. Domenico shows Paul being punished and imprisoned for having cured a woman whose divining powers provided riches to the men who exploited her (pl. 275). We also have records but have not located an image of Paul being attacked and stoned by the makers of idols whose business slackened after Paul converted so many followers at Ephesus (pl. 288). These rare and unusual subjects further expand Domenico's meditations on the role of money in the motivations of the characters in his sacred drama. Ranging from simple greed to the civic duty of paying taxes to the virtue of charity, Domenico's treatment thus relates to the Church itself. Perhaps his accent on this theme extends beyond a focus on the traditional values of charity and social responsibility to include debates about Church authority and property, which were circulating in his own day.[59]

Exorcism

Of all Christ's miracles, his exorcism of numerous demons has received relatively little attention in terms of visual tradition. True, the story of the Gadarene Swine sometimes appears and does so in San Marco, but compared

59. The Jansenists, Febronianism, and other related movements were challenging the Pope's temporal authority through much of the eighteenth century, not to mention that when Napoleon conquered Venice (and other parts of Italy) in 1797, he closed countless convents and monasteries.

Figure 52. *The Gadarene Swine,* pl. 125

Figure 53. Detail of the crib in *The Adoration of the Shepherds,* pl. 38

with the many times Jesus expelled demons in the Gospels, the number of pictorial examples is strikingly paltry.[60] Therefore, Domenico's emphasis on Christ's powers of exorcism is remarkable. He shows no fewer than four scenes of such events, including *The Gadarene Swine* (pl. 125, [fig. 52]) and the rarely portrayed scene of Jesus receiving John's disciples (pl. 128). These are shown as events before his Transfiguration, and, true to Domenico's love of balance, two more exorcisms are included afterward. In fact, they are devoted to Christ's first post-Transfiguration miracle, the expulsion of an unclean spirit (pls. 143–144). Although Peter is not shown following Christ's example by expelling demons, Paul, in contrast, does. He is found expelling some particularly nasty demons in the wilder outback, including some who fight back, as he spreads Christ's ministry (pls. 284–285). Why would a product of the Enlightenment place such a heavy accent on a topic riddled with ideas of superstition, magic, and the irrational? The answer may lie in the notorious activities of an eighteenth-century German priest, Johann Joseph Gassner (1727–1779), whose thousands of exorcisms created a sensation.[61]

Symbols and Portents

Just as Domenico employed themes that unify his narrative, he exploited obvious symbols, subtle props, a number of witnesses, and key events to knit his disparate story together. Even the simplest of his props carries the story forward, foreshadows the future, or recalls events of the past. The cross, for example, encapsulates the essence of Christ's story. Cognizant of the old tradition of incorporating portents of death in scenes of Jesus's infancy, Domenico transformed his manger crib into an emphatic cross in *The Adoration of the Shepherds* (pl. 38, [fig. 53]), while a tomb slab lies beside Mary as the Magi visit (pl. 40). Domenico much more subtly encoded the cross into Jesus's and Peter's shared destinies by exploiting the window (itself a frequent metaphor for spiritual enlightenment). For instance, he deliberately and uniquely made the window brace into a cross in the scene of *Jesus Curing Peter's Mother-in-Law* (pl. 119, [fig. 54]); situated just above their heads, this cross becomes a portent not only of their future deaths upon crosses but of the Church founded on Christ's sacrifice. A cross-shaped window brace is not used again in Domenico's narrative until Peter assumes leadership of the Church, whereupon the sanctified light of the nascent church beams through its form (pls. 251, 253–254, [fig. 55]). To further underscore how they were linked through the cross, Domenico places Peter (where he is otherwise never found) beneath the cross, looking up at Jesus in *Station I* (pl. 214).

Figure 54. Detail of the window in *Jesus Curing Peter's Mother-in-Law,* pl. 119

60. The episode can be found in the cupola of St. Leonard, south transept of San Marco, based on cartoons by the seventeenth-century master Fumiani; see *San Marco* (1991: 93).

61. Midelfort (2005); Knox (1960/1975: 21) notes that themes relating to magic and witchcraft increased sharply in Venice with the appearance of Girolamo Tartarotti, *Congresso notturno delle lammie* (Pasquale, 1749), which was an attempt to analyze and demolish all witch-hunting literature since the *Malleus Maleficarum.* There were also essays by Scipione Maffei, *Arte magica dilguata* (Verona, 1759) and A. Lujato, *Osservazione sopra l'opuscolo che ha per titolo, l'arte magica dileguata* (Venice, 1750).

Figure 55. Detail of the window in *Peter in Cathedra, Blessing—January 18, AD 43,* pl. 251

Other props have meaning as well, enriching our understanding with selected details. Lion's heads (symbols of Venice and of the Resurrection) are inserted into the parallel scenes of the Samaritan Woman and the Adulteress; pomegranates (symbol of authority as well as the Resurrection) routinely decorate the cloaks, altars, thrones, and walls of appropriate scenes. Domenico also uses evergreens to great effect, strategically emphasizing them in scenes where Jesus is present, where they stand as affirmations of his power over death. John the Baptist and Peter are the only two saints into whose scenes Domenico added the detail of a stork. Ungainly in its upward flight, it stands out and begs to be interpreted; it may, in fact, ask us to meditate on the concept of filial piety that it may represent (pls. 75, 145).[62] After all, John and Peter are Christ's two principal followers. John preached his coming and obeyed his command to baptize him; Peter obeyed Jesus too and became the founder of his Church.

Busts of the Roman emperor Tiberias appear only in scenes that take place after the Transfiguration, becoming more frequent in episodes just before Christ's Passion and reaching a crescendo during its early stages. These busts not only establish a historical context for Christ's sufferings, but their appearance warns that the drama is reaching its climax [fig. 56].[63]

Domenico added other portents as well. A clock in the tower [fig. 57] hints at time running out as Jesus discusses the Kingdom of Heaven with the mother of Zebedee's children (pl. 158)— a detail that crops up again when the disciples gather the ass and colt a few scenes later (pl. 169). A lad rushes into the scene as Jesus calls Zacchaeus, anticipating the boy who runs

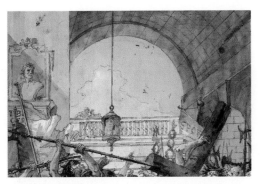

Figure 56. Detail of the bust of Tiberius in *Station II: Jesus Takes the Cross on His Shoulder,* pl. 215

in later to bring the rope that binds Jesus after Pilate finally condemns him (pls. 166, 192).

The number three is prominent in Domenico's interpretation. Symbol of the Trinity (which is visualized twice), it forges another link between Jesus and Peter. Peter slept three times as Jesus prayed in the garden, then denied Jesus three times before the cock crowed. Three stands in Peter's ministry. Domenico shows three different imprisonments for Peter (bypassing the visual canon, which generally featured one); Peter caused three deaths (Ananias, Sapphira, and Simon Magus) and performed three healing miracles (the cripple, the palsied man, and the raising of Tabitha). *The Golden Legend* made much of this number in relation to Peter in its discussion of the Feast of the Chair of St. Peter on February 22, noting that there are three feasts the Church celebrates to "honor the glorious successor of Christ," and that these celebrations are justified because he was above the other Apostles in three

Figure 57. Detail of the clock in *Jesus and the Mother of Zebedee's Children,* pl. 158

62. See Hall (1979) and Ripa (1976), who suggest such a meaning.

63. We find it as *Jesus Demonstrates the Power of Faith* (pl. 144); the bust looks down after the Temple has been cleared of accusers in *"Go, and sin no more"* (pl. 161); it crops up in *The Raising of Lazarus* (pl. 164), *The Entry of Jesus into Jerusalem, II* (pl. 171), *Jesus Before Pilate* (pl. 192), and *The Crowning with Thorns* (pl. 194), as well as *Station II* (pl. 215).

ways: authority, love of Christ, and the power to work miracles. Peter ruled three parts of the world: Asia, Africa, and Europe. And Peter delivered the faithful from three forms of sin: thought, word, and deed.[64] It is noteworthy that the papal tiara has three crowns.

Pairings and Parallels

Guided by his interest in balance, Domenico, as noted earlier in this essay, exploited the use of pairs and parallels to add order, meaning, and distinctive flavors of timing to his overall narrative. Pairs of images are evident from the start, though they are used differently in various chapters. For Joachim and Anna's story, pairs offer moments of sequential significance. Thus, two moments in time show us Joachim's expulsion from the temple (pls. 2, 3), while several subsequent pairs reveal their vindication. In fact, the first chapter offers a distinctive and thoughtful essay on pairings, perhaps to underscore the importance of the union for this sacred married pair.[65] In other chapters, pairs of drawings connect different moments in time. For example, Joseph's departure and return six months later are depicted in two clearly related drawings (pls. 30–31). A pair of scenes of John the Baptist preaching (pls. 90–91) establishes a fluid sequence of events leading up to the central theme of baptism. Only single scenes follow, deliberately differentiated, many of them focused on death.[66] For Christ's ministry, Domenico adopted yet another use of pairs, often showing a miracle and its aftermath before the Transfiguration while, after that, using pairs of scenes of closely sequenced events to build toward the final stages of the Passion.[67]

Related compositions often underscore a parallel relationship between one stage of the narrative and another. Such parallels exist throughout the story, with the first chapter offering a number of significant "preludes" that echo through the larger narrative. Joachim's expulsion (pls. 2–3) is a carefully orchestrated public humiliation, which in a very real sense echoes in his grandson's even more public humiliation and execution (pls. 195–204).[68] *The Presentation of Mary in the Temple* (pl. 16) also deliberately parallels *Joachim's Offering Refused* (pl. 2), based on the obvious contrast between accusation and exoneration. *Jesus and the Centurion* and its sequel (pls. 117–118) balance very neatly and appropriately with the later description of *Peter and the Centurion Cornelius* (pl. 246). Likewise, the scene of Jesus teaching *The Lord's Prayer* (pl. 148) parallels perfectly with *Pentecost* (pl. 230). In a more subtle parallel, Domenico shows *The Prodigal Son Taking His Journey into a Far Country* in a manner that resembles *Paul on the Road to Damascus* (pls. 150, 266), which links a secular and a sacred "prodigal" together.[69] In other respects, Paul's chapter is distinctive for its lack of parallels to earlier material, which distinguishes it from Peter in yet another important way.

Thus, the presence or absence of sequential episodes, the creation or absence of pairs, and parallels allowed Domenico to control the flavor, meaning, and impact of his larger narrative while varying his overall pacing and choreography. The resulting epic flows like a piece of music, with various preludes, crescendos, and postludes, played out differently in each chapter.

64. Jacobus de Voragine (1969: 169–170).

65. The couple's separation is paired with two reunions. Their separate departures (Joachim's for the wilderness, Anna's from home) are concluded by their joint return home.

66. In our reconstruction, plates 96, 99, and 102 all deal with death (Elizabeth, John the Baptist, his funeral).

67. *The Resurrection of the Widow's Son,* plates 120–121, among many others, exemplify the first point, while the two scenes of *The Woman Taken in Adultery,* plates 161–162, or *Entry into Jerusalem,* plates 171–172, exemplify the use of pairs after *The Transfiguration.*

68. The visual tradition for Joachim's expulsion does not demand a large audience; see, e.g., Giotto's version in the Arena Chapel, which has virtually no audience. Given the long-standing Venetian interest in onlookers, exemplified by Gentili Bellini's narrative cycles (see Brown 1988), Domenico's use of large audiences is not surprising, but his selective employment of those audiences for narrative purposes is clearly evident in this example and can be strikingly contrasted with Peter's silent and more private humiliation (pl. 191), where he is ignored by everyone in the scene.

69. It is doubtless no accident that the Prodigal Son story and the Acts of Paul are both authored by Luke.

Critical Narrative Devices

Cutoffs

Domenico was a master at using framing and cropping to suggest space and time beyond the picture frame. On key occasions, he also cut a character off along the picture's edge to reflect his status in the story. For example, when Domenico portrayed the miracle of the palm bending to offer its fruit during the Holy Family's journey into Egypt, Joseph is at the picture's edge, partly cut off by it, while Mary and the angel take command of the gleanings (pl. 56). Though loyal and devoted, Joseph is wholly human, outside (both literally and figuratively) the realm of the miraculous. Something of Joseph's human helplessness is again conveyed when they confront the robbers (pl. 66, [fig. 58]). Flailing his arms, he is again cut off at the right of the picture. Mary is the one who calms the robbers down and befriends them.

Judas is even more emphatically "marginalized" in Domenico's very striking interpretation of *The Institution of the Eucharist* (pl. 181, [fig. 59]). He is truncated a second time by the picture frame in his arrival at Gethsemane, where he points out Jesus in a scene in which he is, appropriately enough, also below him (pl. 188). Later it is Peter's turn to be diminished as he is cut off by the picture plane when, giving vent to his cowardice, he abandons Jesus, just as predicted (pl. 189, [fig. 60]). Later, Peter, hesitant and fearful, returns to follow Jesus and is found creeping back into the picture from the left in two unusual scenes. The first shows him deep in the crowd, watching Jesus go from one trial to another, while the First Station of the Cross shows him leaning in from the left and signaling up to Jesus, who looks down at him (pls. 190, 214).[70] The patriarchs who crowd into Pilate's audience chamber to demand Jesus's condemnation are also, to some extent, cut off by the picture (pl. 192).

Little Dramas or Subplots

Domenico evidently enjoyed inventing little dramas that carry through several frames in certain parts of his story. Perhaps one of the most charming is his dramatization of the Virgin's marriage. Joseph's stunned surprise that he is chosen and Mary's modest submission are two of the key elements of their betrothal scene, while her modesty and his continued amazement at this turn of fortune characterizes their departure from the temple (pls. 26, 28). His dismay at finding her pregnant is dramatically indicated in a subsequent scene, while their estrangement continues as they make

Figure 58. Detail of Joseph in *The Holy Family Meets the Robbers,* pl. 66

Figure 59. Detail of Judas in *The Institution of the Eucharist,* pl. 181

70. This is a device Domenico clearly learned from Giotto, who uses the picture's edge with equal sensitivity in the Arena Chapel. Joseph, for example, demonstrates his hesitation to marry the Virgin by hugging the edge of the picture.

Figure 60. Detail of Peter in *Jesus Arrested in the Garden of Gethsemane,* pl. 189

their way to visit Elizabeth (pls. 31, 32, [fig. 61]). Here the angel seems deep in conversation with Joseph, as if setting him straight, while in the following scene, Joseph, having recognized the error of his thinking, kneels before the Virgin (pl. 33). Their reconciliation is most lovingly characterized in one of their early rests during their flight into Egypt, in which Joseph tenderly plays with the infant Jesus and receives the baby's kiss while Mary gently urges him to take refreshments offered by the angels (pl. 50). Though based on tradition, this particular interpretation of events is Domenico's own invention. Charmingly and earnestly presented, the little drama enlivens these stock characters with an endearing sense of humanity. Mary's attitude undergoes subtle changes, but Joseph, labile in action and pose, is profoundly altered, changing facial expression, gestures, and overall demeanor as the story unfolds.

Such little subplots can be found throughout the story. Domenico cares enough about the blind man whom Jesus cures that he first introduces him and his companion in the Temple as Jesus deals with the case of the adulterous woman, and later underscores his restored sight by pointedly placing him in the foreground, observing Lazarus's resurrection (pls. 160, 163, 164). Perhaps Domenico's most surprising anecdotal tale was created by the simple reuse of a stock figure in different parts of his remarkable reconsideration of the Fourteen Stations. The sympathetic lad who catches Jesus in his arms as he falls the first time is distinctive (pl. 216, [fig. 62]). He forms an ironic foil to a much earlier scene in which Jesus, having resurrected the Widow of Nain's son, restores him to her (pl. 121). The son and mother are reunited in a similar pose, giving these two scenes an ironic contrast. The lad who caught Jesus is found again, posed in reverse with head facing away, holding Jesus as he is nailed to the cross in *Station XI* (pl. 224). The lad can be last seen disappearing among the crowd as Jesus dies (pl. 225, [fig. 63]). We cannot read the boy's

Figure 61. Detail of Joseph and the angel in *Mary and Joseph Set Out to Visit Elizabeth,* pl. 32

thoughts because his face is not visible, yet his presence makes us ponder him, and his actions offer a host of possible interpretations. His gentleness in holding Jesus twice may indicate a sympathetic nature, rendering it impossible for him to watch Jesus die; thus, he can be seen as leaving in deep sadness. It might also be possible that the boy is simply doing his job, and now that it is finished he leaves, indifferent to the pain his actions have inflicted on Jesus. Among all the others in the story, this lad registers the most ambiguous emotion and compels us to use our imaginations to "fill in the blanks."

Figure 62. Detail of the lad holding Jesus in *Station III: Jesus Falls Under the Cross the First Time,* pl. 216

Figure 63. Detail of *Station XII: The Crucifixion*, pl. 225

Conclusion

Domenico Tiepolo's interpretation of the New Testament offers nearly as many possibilities of study and learning as the texts that inspired it. Various stories, themes, characters, and lessons can be extracted, and numerous truths are revealed by a prolonged contemplation of his many images. Interested in both explicit and implicit meaning, he has anchored his story in the bedrock of textual authority, amplified and authenticated by the interaction of characters and witnesses, prime among them St. Peter. Clearly a realist, Domenico was also much more. He reinforced his reality with the authority of dogma, refreshed history by giving it the appearance of eyewitness reportage, yet paradoxically often filtered it through the lens of earlier art work, or presented it through the artifice of theater. He offers us, in fact, a distillation of many realities, rendering what we see more powerful by its concentration into elemental truths. Conveyed by actors whose limited vocabulary of movements communicate a surprising range of meaning and emotion, Domenico presented an old and venerable history with immediacy as well as distance.

Conscious of the many levels at which the human mind and heart operate, Domenico produced a powerfully engaging work. *A New Testament* appeals to our imagination, our reason, our emotions, our spirituality, our senses, and our common human experience. A marvelous blend of sophistication and simplicity, the series is fundamentally accessible. A basic human understanding courses through its many episodes, enlivening his sacred characters while giving his secular bystanders a palpably human dimension [fig. 64]. Domenico also dwelt on many events to which we can still relate today, including warmhearted greetings and tearful farewells. He consistently engaged our empathy and compassion while presenting a broad emotional range—moments of joy, fear, doubt, pain, sorrow, pleasure, anger, repentance, pride, indifference, horror, surprise, shock. The many states of mind he considered include the wisdom of God and the innocence of dogs and children. He likewise traveled down the scale of the senses, appealing to our touch, smell, taste, sight, and sound, as dialogue is shouted or whispered, trumpets blare, drums beat, or armor clangs [fig. 65].

Aside from engaging our emotions, Domenico clearly intended to challenge our intellect, rewarding us for our knowledge of the Bible, historical texts, sacred history, art history, and literature. The product of an encyclopedic era, he collected a vast assembly of moments that, true to his inventive nature, he manipulated and embellished, adding in many rare events while eliminating numerous traditional ones. He likewise tested our visual memory and rewarded any thoughtful study of his series with numerous surprises as our discoveries of the connections he forged between images and texts are recognized. Nearly every scene also calls on our judgment, asking us not only to bear witness but also to assess the reactions of others who witness the events placed before us, judging their levels of innocence or complicity. Moreover, it asks us

Figure 64. *Paul and Aquila as Tentmakers*, pl. 282

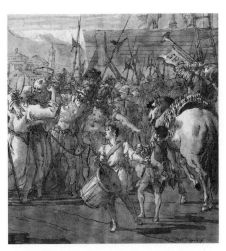

Figure 65. *The Parting of Peter and Paul*, pl. 296

to seek and find the larger sacred meanings imbedded in its many pages. Never forgetting this as a sacred drama, Domenico engages our feelings of awe and reverence without neglecting our sense of humor, offering us one spiritually uplifting moment after another while mitigating some serious moments with light touches of farce, uninhibited humanity, or comically crude inferences.

Given its universal approach, Domenico's series speaks to nearly everyone, from the simplest child to the most sophisticated connoisseur. Its emphasis on Peter [fig. 66] has directed us toward Pope Pius VI (1717–1799) as a possible patron. Given Domenico's connection to Pius, to whom he had dedicated a suite of prints, it is possible he had this Pope in mind as he made his drawings.[71] Since Pius died in exile two years after

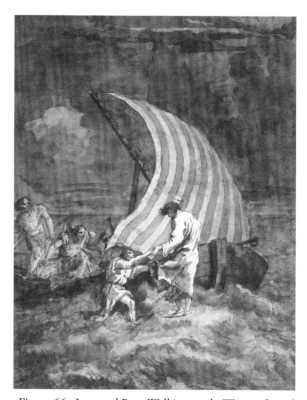

Napoleon's invasion of Italy in 1797, such hopes for papal patronage or approval, if indeed Domenico had any, were not fulfilled. Given the fate of this series, left behind in Domenico's studio upon his death, we cannot be certain he had any audience in mind besides himself. If that is so, then he explored his own beliefs with such depth that he revealed the universal dimensions of faith. He understood his basic childlike nature, as well as the elemental qualities of his beliefs that lay beneath his sophistication as an artist and creator.

In a very real sense, Domenico produced a summing up, culling from a lifetime's experience and knowledge not only of the Bible and its history but also of theater, opera, the Church, people, and the making of art. He was doubtless conscious that the world around him was changing, and that what he was creating would not only be unique but would be the last sympathetic look at the great sacred, historical, and visual heritage from which he had descended. Given the diminution of the Church and the threat to Venetian independence, which ended in 1797, one can imagine that Domenico wished to document a history that was threatening to fade away. No artist after him took the past so deeply to heart, nor would sacred events ever again be couched in terms that were so personal yet so steeped

Figure 66. *Jesus and Peter Walking on the Waters*, pl. 136

in tradition. Certainly Domenico's New Testament has hints of nostalgia, glowing in the reflected light of San Marco's ancient gold mosaics. However, the power of these drawings transcends their significance as an artifact of a bygone era by an important artist. Having explored with such depth the elements of his own beliefs and tied them to such universal aspects of his own humanity, Domenico genuinely transcended the limits of his century, making *A New Testament* as lasting and timeless as the source from which it sprang.

71. Domenico published his edition of the etchings in 1775 with a dedication to Pius VI, who made a famous visit to Venice in 1782; see Rizzi (1971: [158]) and Knox (1970: 1). Conrad also notes the connection to the Papacy. My profoundest thanks to Professor Knox for this and many other fundamental insights that have immeasurably aided my work.

CHAPTER V.

The Drawings

CHAPTER SUMMARIES AND COMMENTARY
BY ADELHEID M. GEALT

ENTRIES BY GEORGE KNOX

ALL MEASUREMENTS ARE IN MILLIMETERS,
WITH HEIGHT PRECEDING WIDTH

The Story of Joachim and Anna and the Infancy of Mary, Plates 1–22

The Gospels make no mention of Mary's parents, but early apocryphal legends passed down to medieval texts, notably *The Golden Legend,* relate their story. Pious and charitable, Joachim and Anna were, like Abraham and Sarah, childless. Their barren state was considered God's punishment and resulted in Joachim's famous banishment from the Temple at Jerusalem when he arrived to offer his annual sacrifice at the feast of the Dedication. Abashed, Joachim retreated to the desert to fast and pray, whereupon the couple separately received news from angels of God's divine intervention and joyously reunited at the Golden Gate.[1] In fulfillment of Anna's promise to God, three years after her birth Mary was delivered to the Temple where she ascended its thirteen steps unaided. Venerated as saints from the second century on, Joachim and Anna's feast day is July 26. Their stories form the essential prelude to the lives of the Virgin and Christ in picture cycles. Giotto's eight scenes in his Arena chapel frescoes done for the Scrovegni family in Padua, ca. 1305, are a celebrated example.[2]

Domenico's approach to Joachim and Anna's story serves as a fitting introduction to his larger epic in both conventional and more idiosyncratic ways. Besides elaborating on well-known aspects of the story by spreading them out over more than one frame, Domenico launches his idea of expanding his narrative by adding untraditional episodes. Thus, Joachim's expulsion unfolds over two drawings instead of the traditional single scene. Domenico has added an unusual scene of Joachim's farewell to Anna before moving on to Joachim's obligatory retreat to the desert. After Anna and Joachim are visited by angels, Domenico adds another rare episode, showing a frail Anna (attended by an abundance of angels) setting out to meet Joachim. Joachim and Anna's subsequent reunion and vindication inspired Domenico, who lingered over this part of the story with five more drawings. Instead of ending his story with the couple's traditional embrace, he reunites them at two distinct locations (the Temple's exterior gate, marking Jerusalem's entrance, and the porch to the Temple proper). This establishes an archeological awareness ignored by earlier artists. Domenico also

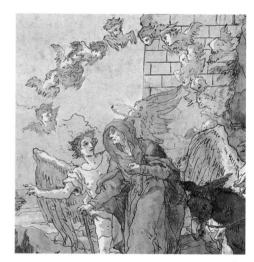

The angels and Anna, from plate 9, *Angels Leading Anna Away from Her House*

takes Joachim and Anna into the Temple's interior, showing them as the Holy of Holies is finally revealed at the high altar—another unusual experience. Joachim and Anna's return home, as well as their deaths, are further distinctive embellishments. Challenging our powers of recall, Domenico omits some standard scenes, implying but not describing them. Joachim and Anna never embrace, but we can envision it; the Virgin's birth is implied

1. Exactly where the couple were reunited varies according to the sources. The *Book of James* (1926: 27, in *Lost Books of the Bible*) simply says a "gate"; the *Liber de Infantia (Pseudo-Matthew)* specifies the Golden Gate of the Temple (James 1924, 73); *The Golden Legend* (523) specifies the Golden Gate of Jerusalem.

2. The west vault of the south transept of San Marco (Venice) also portrayed episodes of Joachim and Anna's story, including one rather rare episode: Joachim and Anna Read the Holy Scriptures.

but missing. The conventional scene of Anna teaching Mary to read is supplanted by the rarely portrayed legend of the casting of lots for the colors to be used in temple curtains. This unfolds over three scenes and is woven into the Virgin's childhood before her marriage.[3]

Besides offering us a much fuller visual introduction to Joachim and Anna than was traditional, Domenico took care to distinguish his characters with aspects that would establish their connections to key descendants. Anna's dress, her occasional shrouded appearance, and her employment of a donkey link her to her adult daughter, the Virgin Mary, while her grandson Jesus "inherits" her attitude of prayer. Joachim and Joseph are both more emotional than their wives and share similar gestures of despair, but Joachim is far more virile than his future son-in-law, Joseph.

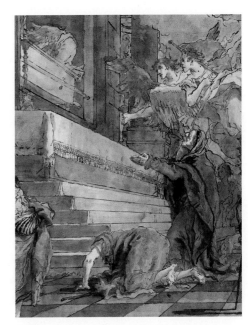

Anna praying while Joachim is prostrate before Holy of Holies, detail of plate 14, *Joachim and Anna Praying in the Temple, II*

3. Both the *Book of James* and the *Liber de Infantia* place this episode in Mary's adulthood just after her marriage to Joseph.

1. *The Sacrifice of Abraham*

And he said, Take now thy son, thine only son Isaac, whom thou lovest, and get thee into the land of Moriah; and offer him there for a burnt offering upon one of the mountains which I will tell thee of. (Gen. 22:2)

And they came to the place which God had told him of; and Abraham built an altar there, and laid the wood in order, and bound Isaac his son, and laid him on the altar upon the wood. And Abraham stretched forth his hand, and took the knife to slay his son. Then the angel of the Lord called unto him out of heaven, and said, Abraham, Abraham; and he said, Here am I. And he said, Lay not thy hand upon the lad, neither do thou any thing unto him: for now I know that thou fearest God, seeing thou hast not withheld thy son, thine only son from me. (Gen. 22:9–14)

> Pen and wash, over black chalk, 464 x 352
> Signed low left center: Dom.o Tiepolo f
> Provenance: Jean Fayet Durand (1806–1889)
> Literature: Byam Shaw 1962 [28]; Pedrocco 1990 [22]; Conrad 1996 [283]
> Reference: Christiaan van Adrichem 1584 Site 52

Paris, Musée du Louvre, Département des Arts Graphiques, RF 1713bis [8]

Abraham's sacrifice of Isaac foreshadowed God's sacrifice of Christ and established the central parallel between the Old and New Testaments. With this dramatic opening scene, Domenico anchored his epic within ancient interpretive traditions, while his recognizable quotation from a famous Titian signals his intention to encode a sweeping artistic history into his visual tribute. The angel, a deliberate departure from Titian's model, will make strategic reappearances to mark significant moments throughout Domenico's epic. 🖌

Domenico's story is dominated by two settings, the wilderness and the temple, both of them impregnated by the spirit and presence of God. The reality of the wilderness is established in this first drawing, *The Sacrifice of Abraham* (pl. 1), which acts as a prologue, introducing the theme of sacrifice that culminates in *The Crucifixion* (pl. 200) and the martyrdom of Peter and Paul (pls. 261, 297). However, the site of the Sacrifice of Abraham in "the land of Moriah" is also, by tradition, the site of the Temple: "Then Solomon began to build the house of the Lord at Jerusalem in Mount Moriah, where the Lord appeared unto David his father, in the place that David had prepared in the threshing floor of Ornan the Jebusite" (II Chron. 3:1). Under Genesis 22:2, the 1748 Venetian edition of the Vulgate gives a note reading "quo in loco templum postea fuit exstructum"; see also Christiaan van Adrichem (1584), Site 52. The wilderness also resonates throughout the detailed account of The Flight into Egypt (chs. 3–4), the story of John the Baptist (ch. 5), the Temptations of Christ, and *The Transfiguration* (pl. 141), as well as the Agony in the Garden and Golgotha. ⚜

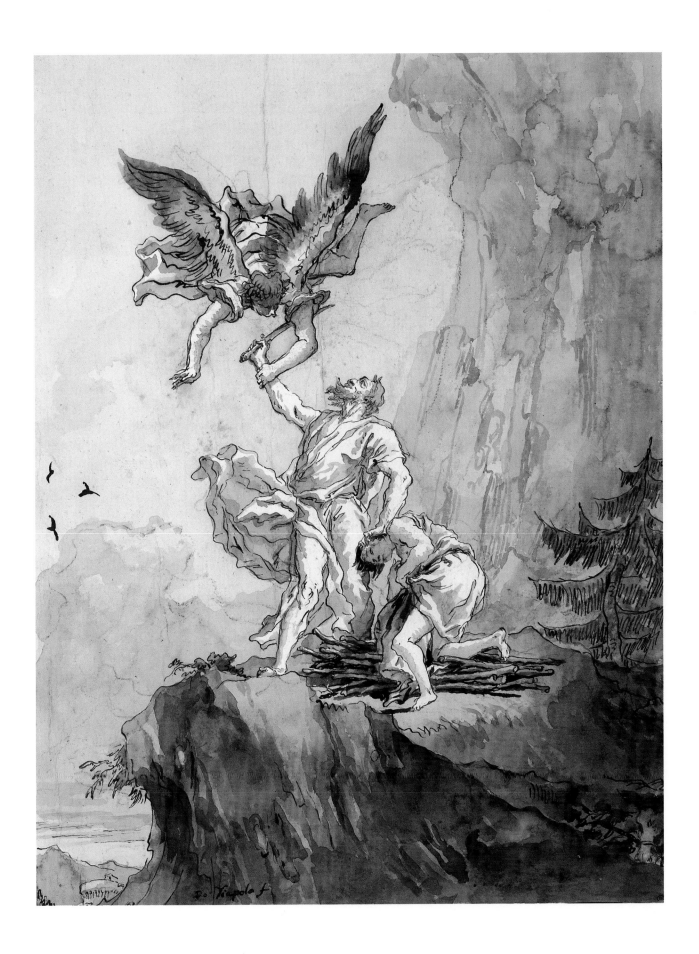

2. *Joachim's Offering Refused*

In the histories of the twelve tribes of Israel it is written that there was one Ioacim, exceeding rich: and he offered his gifts twofold, saying: That which is of my superfluity shall be for the whole people, and that which is for my forgiveness shall be for the Lord, for a propitiation unto me. Now the great day of the Lord drew nigh and the children of Israel offered their gifts. And Reuben stood over against him saying, it is not lawful for thee to offer thy gifts first, forasmuch as thou hast gotten no seed in Israel. (Book of James 1:1–2)

Pen and wash, over black chalk, 460 x 350
Signed top left: Dom.o Tiepolo f
Provenance: Jean Fayet Durand (1806–1889)
Literature: Conrad 1996 [1]; Gealt in Udine 1996, 81
Reference: Christiaan van Adrichem 1584, Site 74; *The Golden Legend* 1900 *v*, 99, under September 8; Ribadeneira 1656 i, 73; Maria de Agreda 1685 i, XII; Gentilucci 1841 iii, 179, under March 20; James 1924, 39; Lafontaine-Dosogne 1975

Paris, Musée du Louvre, Département des Arts Graphiques, RF 1713bis [135]

His upraised arms echoing Abraham's gesture (linking this episode to the previous scene), the high priest Reuben guards the Temple's sanctuary as he publicly denounces Joachim. As a youth at the right brings an armful of sticks to feed the sacrificial fire, several smug lads (doubtless the favored "seed of Israel") stare down at Joachim from the left. His ascent arrested, Joachim leans back in shock as his shepherds bend forward to listen. An older patriarch, Domenico's favorite onlooker, coolly observes the proceedings. An old peasant woman (the egg seller?) appears annoyed by all the noise and commotion. 🍃

Domenico now turns from the wilderness to the temple itself. For a thousand years, cycles of images representing the parentage and infancy of Mary followed the tale told in the Greek *Book of James* of about AD 200 and began with the story of Joachim and Anna, telling how Joachim's offering was refused because he was childless. Maria de Agreda offers a lengthy account, including the twenty years during which the couple remained childless. Apart from the Bollandists, this appears to be the only modern account of these events. For a full description of the temple, see Christiaan van Adrichem (1584: Site 74). ⚜

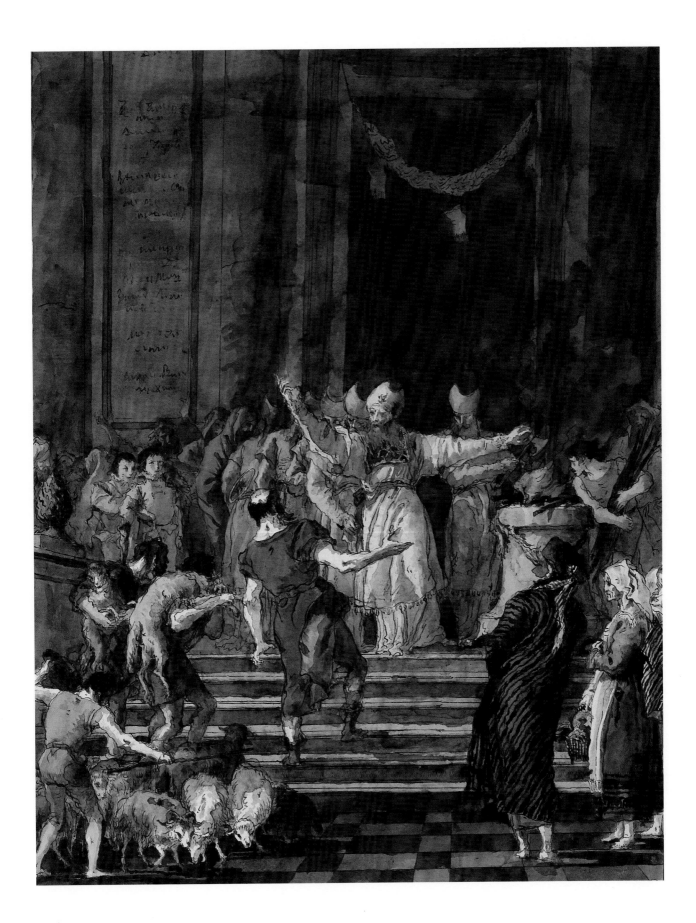

3. *Joachim Turns from the Temple in Despair*

And Joachim was sore grieved, and went into the record of the twelve tribes of the people, saying: I will look upon the record of the twelve tribes of Israel, whether I only have not gotten seed in Israel. And he searched, and found concerning all the righteous that they had raised up seed in Israel. And he remembered the patriarch Abraham, how in the last days God gave him a son, even Isaac. (Book of James 1:3)

> Pen and wash, over black chalk, 457 x 354, trimmed to the borderline
> Signed on the tablet, upper left: Domenico Tiepolo f
> Provenance: Charles Fairfax Murray, said to have been acquired in 1905; J. Pierpont Morgan 1910
> Exhibition: New York 1971 [252]; Udine 1996 [88]
> Literature: Fairfax Murray 1912 [IV.145]; Benesch 1947 [fig. 1]; Conrad 1996 [2]
> Reference: *The Golden Legend* 1900 v, 99, under *The Nativity of Mary,* September 8; Ribadeneira 1656: *i,* 73, under March 20; Maria de Agreda 1685: i, XII; James 1924, 39

New York, The Pierpont Morgan Library, Fairfax Murray Collection, IV.145

A disgraced Joachim descends the Temple steps as a patriarch points him out to a newly arrived companion. One hand hiding his head in shame, the other flung out in dismay, Joachim epitomizes despair. His back now turned, Reuben ushers some elect into the inner sanctum while the sacrificial fires burn brightly on the altar. Domenico is exceptional for adding a sequel to the standard single episode of Joachim's expulsion. ❦

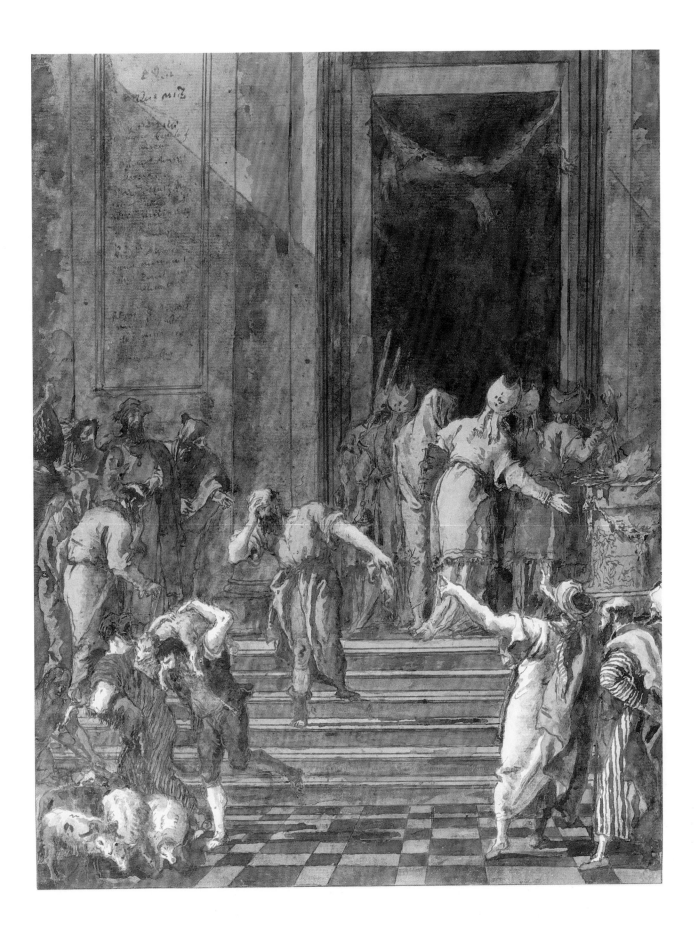

4. *Joachim Withdraws to the Wilderness*

And Joachim was sore grieved, and showed not himself to his wife, but betook himself unto the wilderness, and pitched his tent there and fasted forty days and forty nights, saying within himself: I will go down neither for meat or for drink until the Lord my God visit me, and my prayer shall be unto me meat and drink. (Book of James 1:4)

Pen and wash, over black chalk, 465 x 360
Signed low left: Dom.o Tiepolo f
Provenance: Jean Fayet Durand (1806–1889)
Literature: Conrad 1996 [7]
Reference: *The Golden Legend,* 1900, v, 100, under September 8; Maria de Agreda 1685, i, XII; James 1924, 39

Paris, Musée du Louvre, Département des Arts Graphiques, RF 1713bis [125]

Here Domenico indulged in one of his favorite themes, scenes of parting. Preparing to leave for the wilderness, Joachim bids farewell to his disconsolate wife. Perched rather feebly upon her donkey, Anna gazes down at her husband as her servants wait to escort her home. Last seen as the setting for Abraham's sacrifice, the cliff top establishes another connection between Joachim and Anna's story to that of Abraham and Sarah, here becoming the site of Joachim and Anna's house. This demonstrates Domenico's use of settings to convey meaning. Domenico ignores the text, which says that he "showed not himself to his wife." Joachim, quite a vigorous figure, is waving to Anna, represented as an old woman with a crutch. Thus Anna is introduced into the narrative with her clear characterization and, once introduced, she continues to play a leading role in it. �

Procopius records a great church dedicated to Anna by Justinian in Constantinople ca. 550. Her body is said to have been discovered and transferred thither by St Helena. Veneration of Anna was established in Venice, with the foundation of the *Fratres Eremitaorum de S. Anna de Castello* in 1284 (Corner 1749: iv, 254; Zorzi 1977: 488–489). The church still stands, though secularized, on the Rio di Sant'Anna. Her feast was established by Gregory XIII in 1584. Anna's cult flourished in seventeenth-century France, promoted by Anne d'Autriche, queen of Louis XIII. It led to the dedication of the great church of Sainte-Anne-la-Royale, built by Guarino Guarini on the present site of the École des Beaux-Arts, and the large chapel attached to the Cathedral at Apt, which contains her relics. Legend relates that her body was hidden in the crypt at Apt in the fourth century, and was miraculously rediscovered in the presence of Charlemagne in 801 (see also *The Burial of Anna,* pl. 22).

The veneration of Joachim is also found in Venice in close proximity to that of Anna. If one follows the Fondamenta di Sant'Anna along the canal for one hundred meters to the west of the church, one comes to the Ponte di S. Gioacchino. Beyond is the Fondamenta di S. Gioacchino, facing that of Sant'Anna, and the Calle di S. Gioacchino, leading to the church, now incorporated in the ancient Ospedale di SS. Pietro e Paolo di Castello (Zorzi, 1977: 540). ⚜

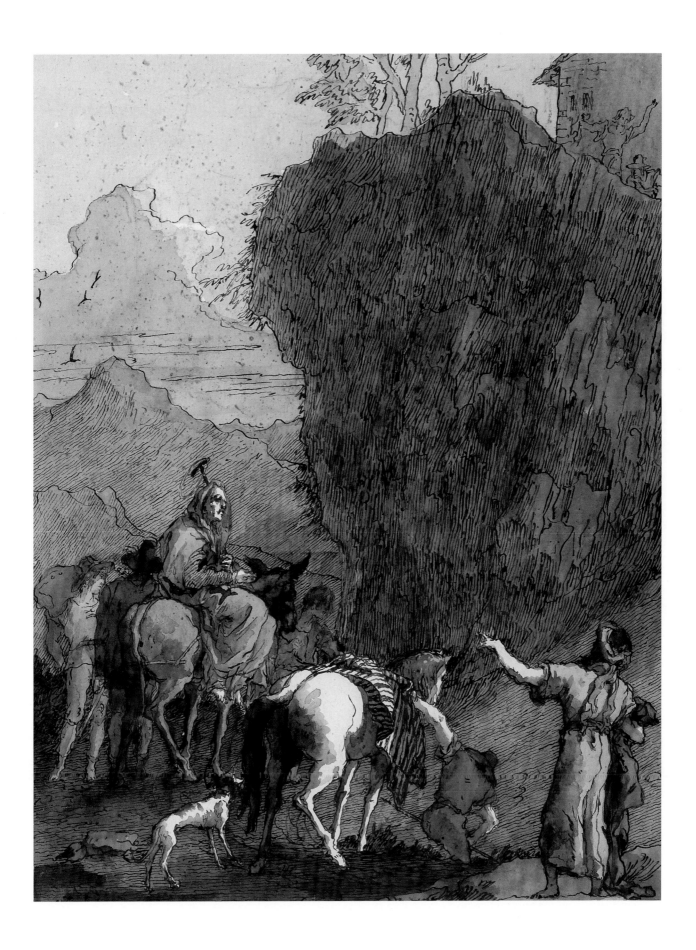

5. *Joachim in the Wilderness*

And Joachim was sore grieved, and showed not himself to his wife, but betook himself unto the wilderness, and pitched his tent there and fasted forty days and forty nights, saying within himself: I will go down neither for meat or for drink until the Lord my God visit me, and my prayer shall be unto me meat and drink. (Book of James 1:4)

Pen and wash, over black chalk, 460 x 360
Signed low right: Dom.o Tiepolo f
Provenance: Jean Fayet Durand (1806–1889)
Literature: Conrad 1996 [282]

Paris, Musée du Louvre, Département des Arts Graphiques, RF 1713bis [124]

The mood now shifts to one of determination in a scene filled with portents of fecundity. Still pointing and seen from behind (Domenico's favorite pose for Mary's father), Joachim strides purposefully toward the site of his lengthy exile from Anna. As he does so, he approaches an expansive (and therefore fruitful) flock, while he is the epitome of virility. The tall evergreen (a symbol of eternal life) just behind him, hints at the miraculous child (Mary) with whom he and Anna will soon be blessed. ❦

It seems possible that this is an early experimental drawing. There appears to be some extensive underdrawing in a waxy material that prevents the wash from taking to the surface of the paper evenly. The pen outline on cloud and mountain may also be taken as an indication of a relatively early date. ⚜

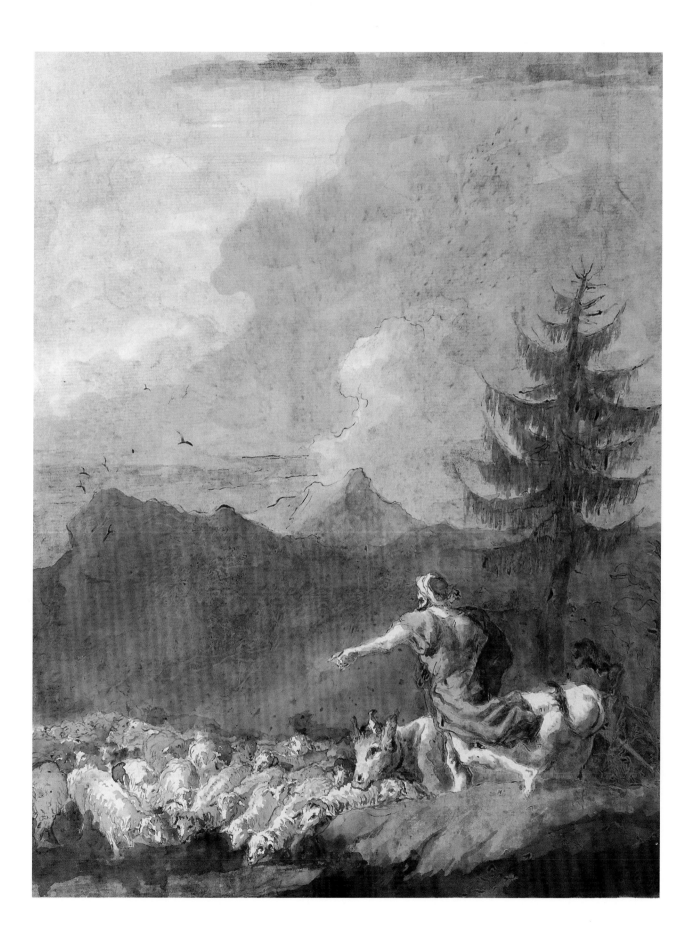

6. *Joachim Praying in the Wilderness*

And Joachim was sore grieved, and showed not himself to his wife, but betook himself unto the wilderness, and pitched his tent there and fasted forty days and forty nights, saying within himself: I will go down neither for meat or for drink until the Lord my God visit me, and my prayer shall be unto me meat and drink. (Book of James 1:4)

Pen and wash, over traces of black chalk, 460 x 353
Signed low right: Dom.o Tiepolo f
Provenance: Jean Fayet Durand (1806–1889)
Literature: Conrad 1996 [3]
Reference: Ribadeneira 1656, i, 73; Maria de Agreda 1685, i, XII; James 1924, 39

Paris, Musée du Louvre, Département des Arts Graphiques, RF 1713bis [128]

Kneeling before a makeshift altar inside a shed, Joachim, assuming the dress of a monk, prays fervently. In this episode Domenico evidently amplified the apocryphal Book of James with descriptions from the seventeenth-century Spanish writer Maria de Agreda, who specified that Joachim went "to a farm or storehouse . . . in solitude called upon the Lord for some days praying." Joachim's act of piety is humorously compared to a more prosaic function of kneeling—that is, milking the cow, seen in the background. ❦

Conrad proposes that the drawing should be associated with the story of Joachim. The costume of Joachim is consistent with plates 2, 3, and 13, but not with later representations such as plates 11, 12, and 15. The *Book of James* does not offer any text that supports this scene very directly. The setting suggests a farmyard in the Veneto rather than a howling wilderness. ⚜

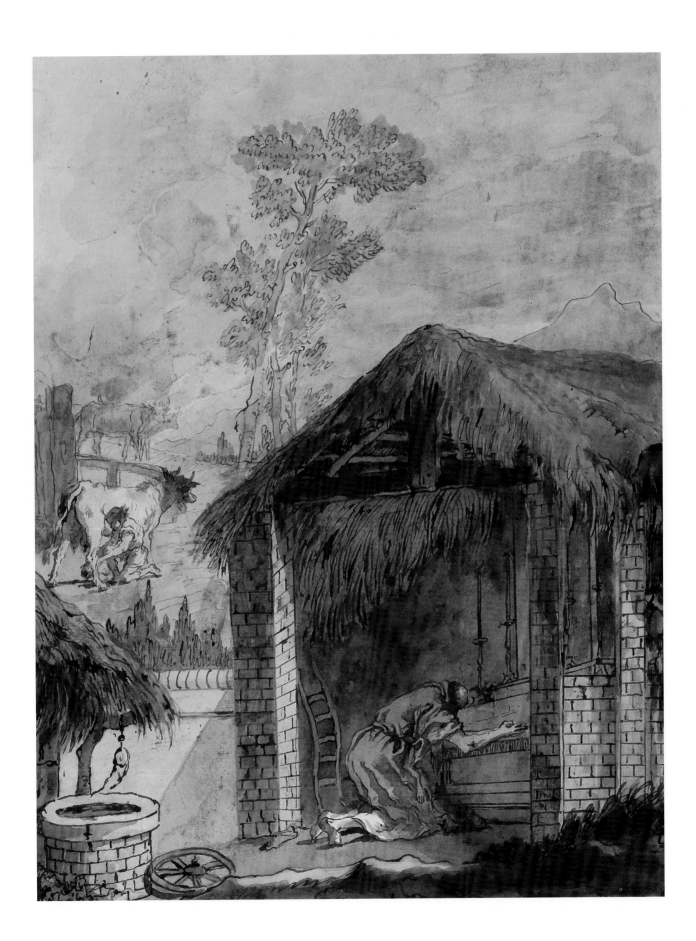

7. *The Annunciation to Anna*

And looking up to heaven she espied a nest of sparrows in the laurel tree, and made a lamentation within herself, saying: Woe is me, who begat me? . . . (Book of James 3:1)

And behold an angel of the Lord appeared, saying unto her: "Anna, Anna, the Lord hath hearkened unto thy prayer, and thou shalt conceive and bear, and thy seed shall be spoken of in the whole world. . . ." (Book of James 4:1)

Pen and wash, over slight black chalk, 459 x 350
Signed low left: Dom.o Tiepolo f
Provenance: Jean Fayet Durand (1806–1889)
Literature: Conrad 1996 [5]; Gealt in Udine 1996, 75
Reference: *The Golden Legend,* 1900, v, 101, under September 8; Maria de Agreda 1685, i, XII; James 1924, 40; Réau 1957, 158; Lafontaine-Dosogne 1964, 68–76

Paris, Musée du Louvre, Département des Arts Graphiques, RF 1713bis [62]

Alone in her walled garden, Anna has a vision just by its gateway (one of Domenico's favorite devices when staging a transition). Having mourned her barren fate, Anna still faces the nesting sparrows she envied as she sinks to her knees at the sight of the angel. Her divine messenger gracefully descends on a cloud of glory to deliver his joyful news while her spaniel barks excitedly. To amplify the story's meaning about Anna's impending fruitfulness, Domenico places verdant trees next to barren ones. 🖑

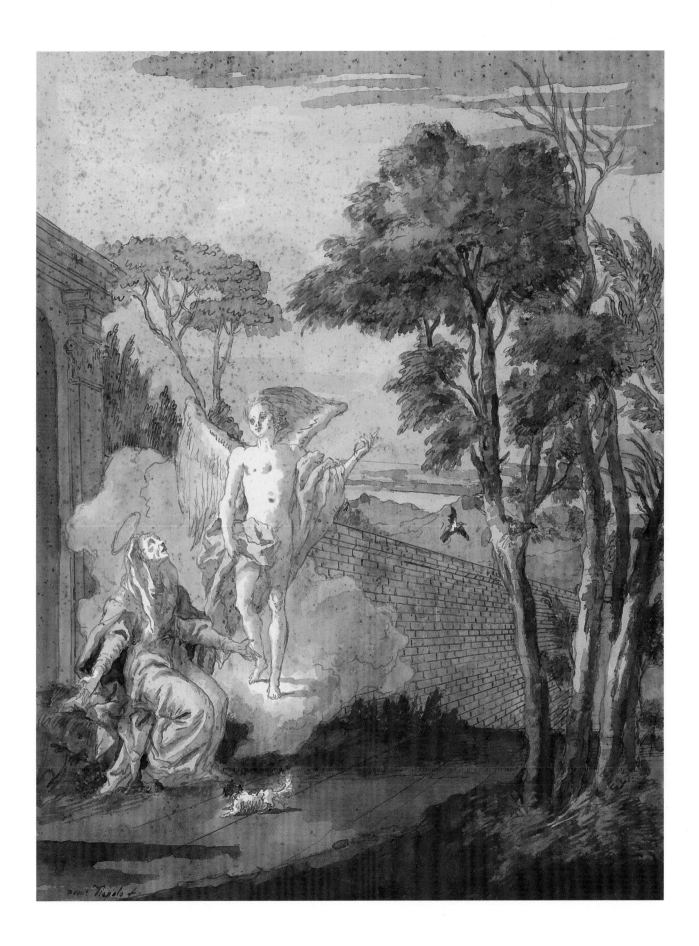

8. *The Annunciation to Joachim*

And behold there came two messengers saying unto her: Behold Ioachim thy husband cometh with his flocks: for an angel of the Lord came down to him saying: Ioachim, Ioachim, the Lord God hath hearkened unto thy prayer. Get thee down hence, for behold thy wife Anna hath conceived. (Book of James 4:2)

> Pen and wash, over extensive black chalk, 465 x 360
> Signed low right: Dom.o Tiepolo f
> Provenance: Jean Fayet Durand (1806–1889)
> Literature: Conrad 1996 [4]
> Reference: *The Golden Legend*, 1900, v, 100, under September 8; Ribadeneira 1656, i, 73; Maria de Agreda 1685, i, XIII; James 1924, 40; Réau 1957, 157; Lafontaine-Dosogne 1964, 76–82

Paris, Musée du Louvre, Département des Arts Graphiques, RF 1713bis [118]

Less dignified than Anna's angel, Joachim's messenger is also more frantic as he urges Joachim to wake up and meet Anna. Now dressed in striped sleeves and short pants, Joachim responds slowly, still rubbing sleep from his eyes. Except for the angel's urgency, the whole mood is placid: the cows rest peacefully on the hillock, and Joachim's dog is distracted by a flea. Only the bull in the foreground introduces a note of virility, but he too takes the angel's appearance quite calmly, as do his minders, although they seem to regard the angel with some caution. ❦

Again Domenico avoids anything suggesting a wilderness and sets the scene in the Venetian countryside, with trees, buildings, cattle, a herdsman, and a dog grooming itself. ⚜

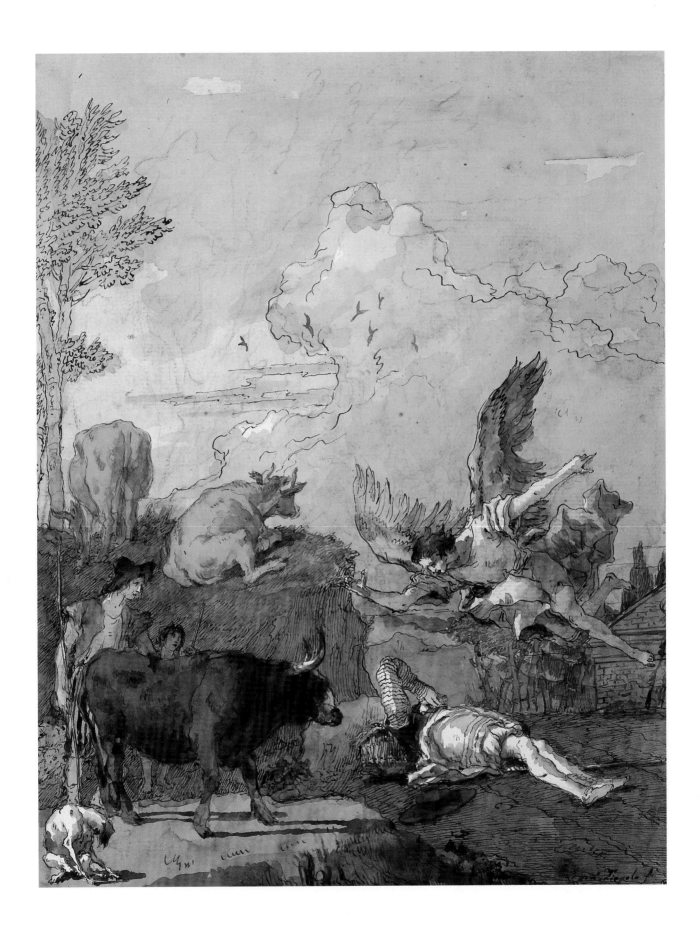

9. *Angels Leading Anna Away from Her House*

And behold there came two messengers saying unto her: Behold Ioacim thy husband cometh with his flocks. . . . (Book of James 4:2)

And as when Anne wept bitterly and wist not whither her husband had gone, the same angel appeared to her, and said all that he had said to her husband, and gave to her for a sign that she should go into Jerusalem, to the golden gate, and there she should meet with her husband which was returned. (The Golden Legend)

Pen and wash, over a light underdrawing in black chalk, 481 x 379 (paper); 465 x 360 (image)
Signed low left: Dom.o Tiepolo f
Provenance: Jean Fribourg, NYC; Sotheby's, Mar. 28, 1968 [52]; H. Pilantz; Colnaghi 1970; Christie's, Apr. 20, 1993 [36], Sotheby's, NYC, Jan. 10, 1995 [36], Colnaghi 1996; France, pc, 1998
Exhibition: Chicago 1938, pl. 94; London, Colnaghi 1969 [26]; London Colnaghi 1970, cat. 63 [xviii]; New York, Colnaghi 1996 [35]
Literature: Conrad 1996 [6]
Reference: Christiaan van Adrichem 1584, Site 37; *The Golden Legend* 1900, v. 101; Gentilucci 1848, vii, under July 26, refers to Baronius and the Bollandistes

New York, Colnaghi

In one of Domenico's most charming inventions, we find Anna leaving home to meet Joachim, a counterpoint to their earlier separation scene. Domenico introduces another favorite theme, that of a journey's beginning.[4] Deep in conversation with one of her angelic visitors, who explains where they are going, Anna gingerly starts off for the Golden Gate, aided by her walking stick. A second angel regards her reverently as he manages her donkey, while Joachim's dog hastily scratches an itch as he prepares to lead the way. They all ignore the bower of seraphim (marking Anna's blessed state) hovering joyfully overhead. In the distance a farm hand retrieves Joachim's horse. In a neat parallel to the dramatic close-up of the Temple, which marked the story's beginning, Domenico here provides a close-up (though still partially obscure) view of Anna's house. ❧

The drawing appeared in the Cormier sale with the title *La Vierge Marie entourée d'anges,* but the old lady in black with a crutch is more satisfactorily identified as Anna. For a note on Anna, see plate 4 above. The *Book of James* does not describe the scene exactly in these terms, and we turn to *The Golden Legend* for a text. The House of Saint Anne in Jerusalem is listed by Christiaan van Adrichem (1584: Site 37). ⚜

4. It is significant that Domenico chose to depict Anna starting a journey. This moment links her to her daughter and grandson, each of whom are also shown at the start of journeys, beginning with the Flight into Egypt sequence that begins with *The Holy Family Leaves the House* (pl. 47). Jesus is later shown starting his journey into the desert to begin his Temptations (pl. 103), and on the start of his journey to Calvary (pls. 196, 215—Station II). Thus, in terms of events (travel), modes of travel (donkey), and attitudes of prayer, Anna establishes strong precedents for her daughter and her grandson.

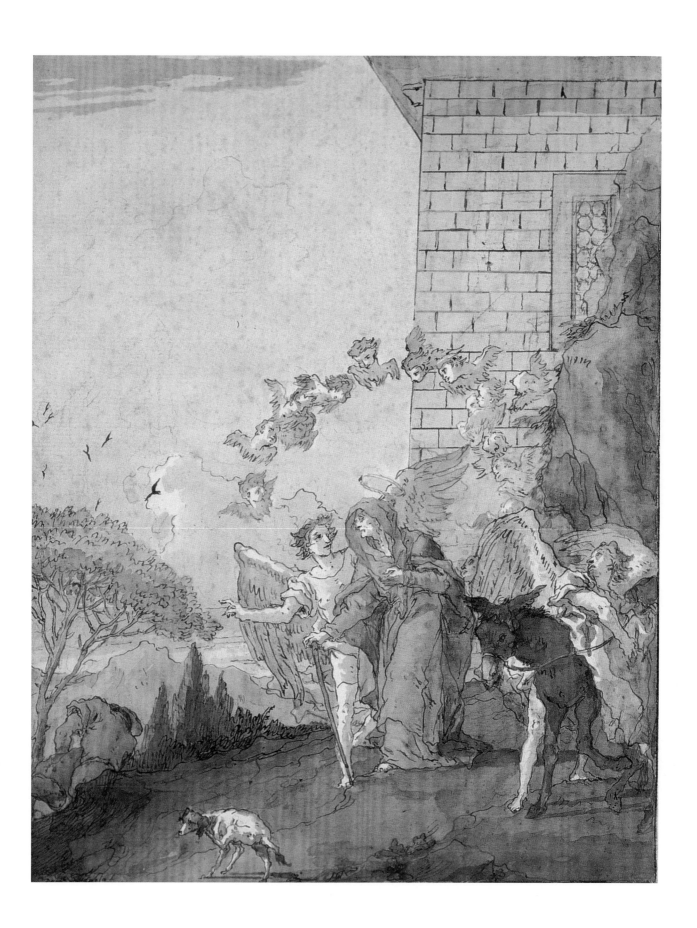

10. *Anna Meets Joachim at the Golden Gate*

And as when Anne wept bitterly and wist not whither her husband had gone, the same angel appeared to her, and said all that he had said to her husband, and gave to her for a sign that she should go into Jerusalem, to the golden gate, and there she should meet with her husband which was returned. (The Golden Legend)

Pen and wash, over black chalk, 480 x 375 (paper?)
Signed on the wall, left: Dom.o Tiepolo f
Provenance: Paris, Nouveau Drouot, June 24, 1985 [9]; Literature: Conrad 1996 [10]; Paris, Anisabelle Bèrés
Exhibition : Paris, Eric Coatelem, 2004
Reference: Christiaan van Adrichem 1584, Site 155; *The Golden Legend* 1900, v, 101, under *The Nativity of Mary;* Maria de Agreda 1685, i, XIII

Indiana, private collection, on loan to the Indiana University Art Museum

In the first of three scenes Domenico devoted to their reunion, Joachim and Anna meet at the busy entrance to Jerusalem. Joachim's groom has brought his stallion, greeted with much excitement by her spaniel. The hubbub is ignored by the egg seller, while a note of triumph is introduced. Anna's angels have left her side to hover overhead, and one has found two banners (emblems of victory that, significantly, reappear at Christ's Resurrection). The angel over Anna echoes the one who spoke to Abraham. Implying but not presenting the traditional embrace, Domenico introduced a note of chastity that will resonate in Mary and Joseph's story. ❦

The Golden Gate is both a city gate and the eastern entrance to the temple precincts in Jerusalem. It is described by Christiaan van Adrichem (1584: Site 155): "By this gate Christ came riding upon an Asse into the City of *Jerusalem,* at what time men cut down Palmes & strowed them in his way, crying *Hosanna* before him." The incident of Joachim and Anna meeting at the Golden Gate derives from the Latin *Liber de Infantia* of the mid-ninth century. In the *Book of James* they meet at their house, and here Domenico has them meeting at the foot of a flight of steps leading up to a great triple entrance with a wall stretching away to the right. Moreover, the woman with the basket of eggs, a familiar element in *The Presentation of Mary in the Temple* (pl. 16) does indicate the temple. A second version, arranged more frontally, is found in No. 11, in which they are clearly shown meeting at the entrance to the temple itself. In neither case are they kissing, which in both the Greek and the Latin tradition indicates the immaculate conception of Mary. Unlike other representations, Domenico shows Joachim's horse and groom on the left, but Anna's donkey, which appears prominently in No. 11, is not shown here. ⚜

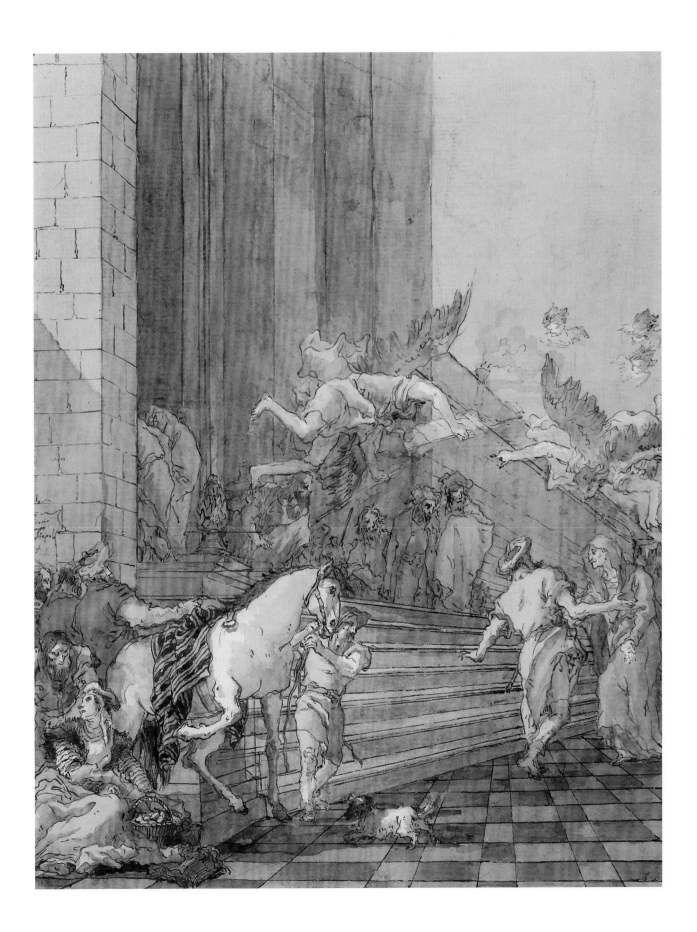

11. *Anna Meets Joachim Before the Temple*

And on the morrow he offered his gifts, saying in himself: if the Lord God be reconciled unto me, the plate that is upon the forehead of the priest will make it manifest unto me. . . . (Book of James 5:1)

Pen and wash, over black chalk, 464 x 360
Signed on column, left: Dom.o Tiepolo f
Provenance: Jean Fayet Durand (1806–1889)
Literature: Conrad 1996 [9]
Reference: *The Golden Legend,* 1900, v, 101, under September 8; Maria de Agreda 1685, i, XIII; James 1924, 73

Paris, Musée du Louvre, Département des Arts Graphiques, RF 1713bis [114]

Despite the brief account in sourcebooks, Domenico further elaborates on the reunion. The mood becomes even more celebratory here as Anna, having resumed the services of her donkey, arrives with Joachim at the steps to the Temple's inner sanctum. Assisted by several lads and a respectful elder, Anna gingerly dismounts onto a hastily provided chair. Joachim greets her with outstretched arms, though, as before, Domenico eschews the traditional embrace. Anna's angels now soar excitedly overhead, the higher one waving his banners triumphantly. The angel nearer Anna, still echoing Abraham's angel (pl. 1), urges the couple to enter as the doorway to the Temple is unobstructed. 🌿

The incident of Joachim and Anna meeting at the Golden Gate derives from the Latin *Liber de Infantia* of the mid-ninth century. In the *Book of James,* they meet at their house and go to the Temple the following day to make their offering. Here it seems that Domenico has them meeting at the foot of the steps leading up to the Temple, on an even grander scale than in the earlier drawings showing Joachim making his offering—which show only six steps. Here we can count eleven, still short of the required fifteen (pl. 16). Nor are they kissing, which in both the Greek and the Latin tradition leads to the Immaculate Conception of Mary.

This design is quite distinct from all other representations of the scene (pls. 10 and 12) in that it shows the donkey that conveys Anna to the rendezvous as well as the horse that has brought Joachim. ⚜

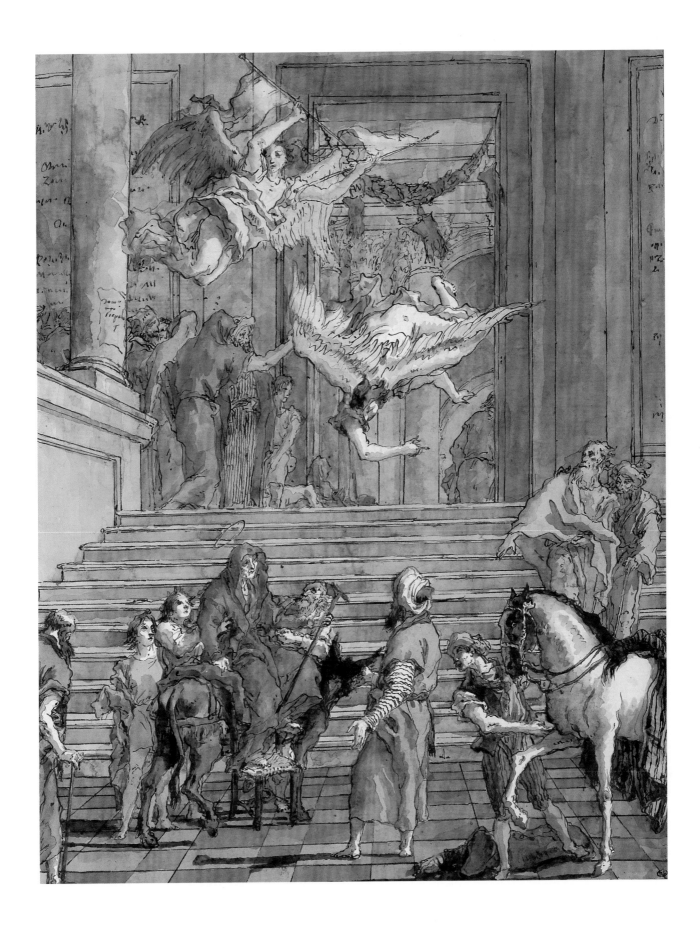

12. *Joachim and Anna on the Temple Steps*

Immediately arising she hastened to the temple of Jerusalem, and there found saint Joachim, as the angel had foretold to them both. Together they gave thanks to the Almighty for this wonderful blessing and offered special gifts and sacrifices. (Maria de Agreda 1971: i, 157)

> Pen and wash, over black chalk, 465 x 360
> Signed on column, left: Dom.o Tiepolo
> Provenance: Jean Fayet Durand (1806–1889)
> Literature: Conrad 1996 [11]; Gealt in Udine 1996, 82
> Reference: Maria de Agreda 1685, i, XIII; James 1924, 40

Paris, Musée du Louvre, Département des Arts Graphiques, RF 1713bis [113]

Not satisfied with the traditional reunion scene as the conclusion to Joachim and Anna's story, Domenico follows the pair into the Temple itself. As Joachim's groom manages his steed in a pose last seen at the couple's parting (pl. 4), and the patriarchs assume their familiar vigil in the scene's lower right, the reunited couple ascend the Temple steps. A "cloud of glory" lends a mystical flavor to a scene that considers more practical issues. How would an elderly Anna manage all those steps? Anna totters slightly and leans on Joachim's arm. A concerned elder (perhaps the one who assisted her as she dismounted) and an angel monitor her progress. His companion points not only to the Temple's gaily fluttering banners, but upwards to heaven, hinting at the divine intervention that has taken place and the favor that has been found. ❧

This seems to be an original invention of Domenico, since it does not seem to relate very clearly to the *Book of James,* nor it is described exactly by Maria de Agreda: "Encuentranse Joachim y Anna en el Tempio." The setting is almost identical to that of the preceding drawing, but Anna's donkey is not shown. Domenico devotes three sheets to the meeting. No. 10 shows the couple meeting at the Golden Gate, the traditional entrance to the temple precincts with steps leading up to it. No. 11 seems to show them clearly approaching the entrance to the temple itself, and is a pair with No. 12. In this he appears to follow Maria de Agreda, who, after mentioning the Golden Gate, goes on: "Immediately arising she hastened to the temple of Jerusalem, and there found saint Joachim, as the angel had foretold to them both." ⚜

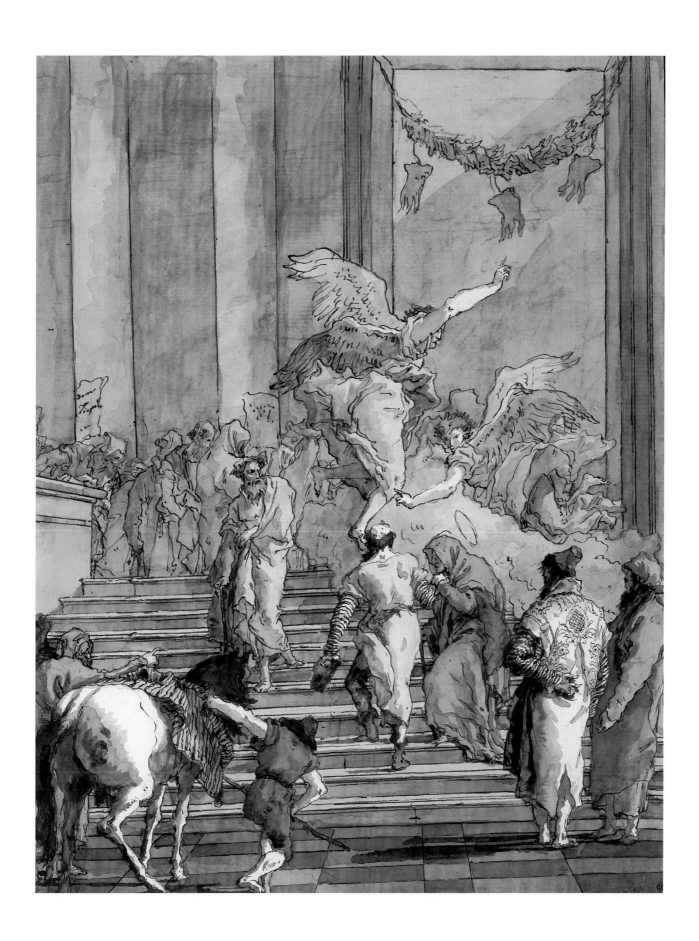

13. *Joachim and Anna Praying in the Temple, I*

. . . And Ioacim offered his gifts and looked earnestly upon the plate of the priest when he went up unto the altar of the Lord, and he saw no sin in himself. And Ioacim said: Now know I that the Lord is become propitious unto me and hath forgiven all my sins. . . . (Book of James 5:1)

Pen and wash, over a light underdrawing in black chalk, 467 x 362, trimmed to just without the border line
Signed on the step, left, and on the column, right: Dom.o Tiepolo f
Provenance: Roger Cormier, Tours, his sale, Paris, Georges Petit, Apr. 30, 1921, no. 12, as *The Meeting of Simeon and Anna before the Temple;* Paris, Broglio; Tomas Harris; Dr. Rudolf J. Heinemann, New York
Exhibition: London, Arts Council 1955, pl. 33; New York 1973 [100]
Literature: Conrad 1996 [13]
Reference: Christiaan van Adrichem 1584, Site 75; James 1924, 40; Réau 1957, 161, citing the Quentin Matsys *Triptych*

New York, The Pierpont Morgan Library, Gift of Mrs. Rudolf J. Heinemann in memory of
Dr. Rudolf J. Heinemann, 1996.102

In the first of two unusual scenes of the couple giving thanks, Domenico shows Joachim and Anna attended by angels. As the altar's curtain parts, Joachim's angel acts as intercessor and points to his kneeling form, while Anna's angel merely floats behind her as she stands confidently addressing her prayer directly at the Holy of Holies. Behind them two hooded priests recite incantations from their sacred books. The bust of a Roman ruler affixed to the wall hints at Jerusalem's status as a Roman possession in Anna and Joachim's day. Its presence anticipates later scenes of Christ's life, especially his Passion, where it again appears. ❦

Domenico interprets the entrance to the Holy of Holies as a conventional altar, disregarding the full description of Christiaan van Adrichem (1584: Sites 74–76). Here the veil of the Ark of the Covenant is drawn, but the Ark cannot be seen. Meanwhile, black smoke issues forth from the sanctuary, indicating the presence of the Almighty. Here the seven-branched candelabrum is more prominent but the Roman bust seems out of place. In the Cormier sale the scene is identified as *La recontre de Simeon et d'Anna la prophetesse devant le temple*—Luke 2:25–38—but this would require the presence of the Virgin and Child. ⚜

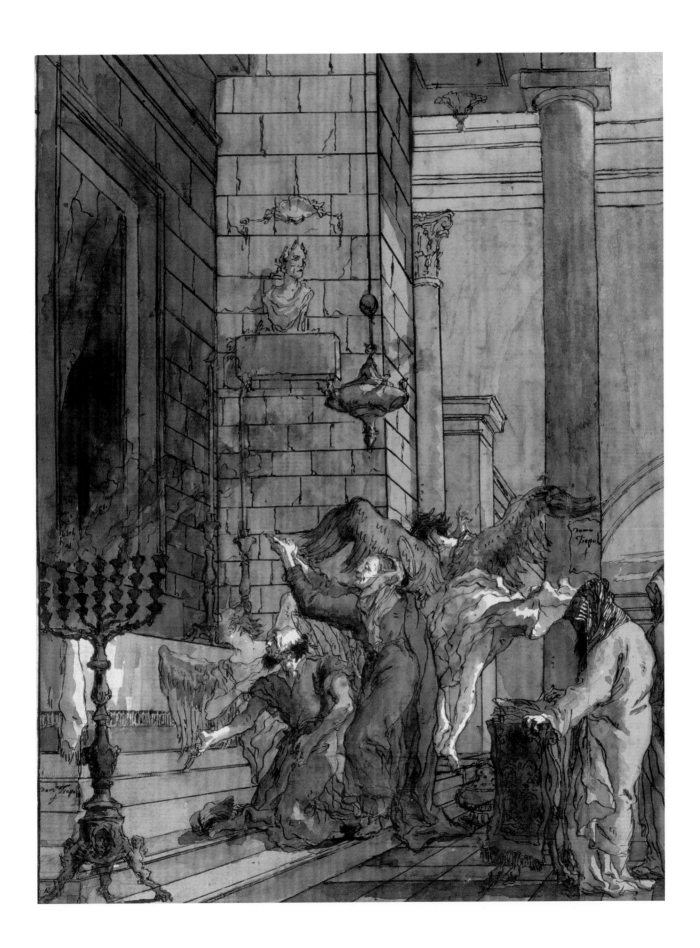

14. *Joachim and Anna Praying in the Temple, II*

. . . And Ioacim offered his gifts and looked earnestly upon the plate of the priest when he went up unto the altar of the Lord, and he saw no sin in himself. And Joachim said: now know I that the Lord is become propitious unto me and hath forgiven all my sins. . . . (Book of James 5:1)

> Pen and wash, over slight black chalk, 463 x 355
> Not signed
> Provenance: Jean Fayet Durand (1806–1889)
> Literature: Conrad 1996 [12]
> Reference: Christiaan van Adrichem 1584, Site 77; Maria de Agreda 1685, i, XIII; James 1924, 40; Réau 1957, 161, citing the Quentin Matsys *Triptych*

Paris, Musée du Louvre, Département des Arts Graphiques, RF 1713bis [132]

The altar curtain has fully parted and the smoke has cleared, revealing the Ark of the Covenant complete with its traditional cherubim. With both angels and a seraph fluttering above them (one again holds the banners of triumph), Joachim prostrates himself before the Ark while Anna, still standing, raises her eyes toward it, maintaining an attitude of prayer her grandson Jesus will later adopt. A cripple (whose prayers will remain unanswered until her grandson's healing powers mature) hobbles past them, as well as the three elders who had observed the couple enter the Temple (pl. 12). ❧

Christiaan van Adrichem (1584: Site 77): "The two Cherubim are like unto young boys, made of the wood of the olive-tree. Ten cubits high and covered with plates of gold, and shining with angelicall brightness, stood at each end of the Arke with wings spread." Joachim is prostrated. Neither follows the text from the *Book of James* closely, but they are described by Maria de Agreda: *"Hazen voto de nuevo de ofrecir la hija al Tempio."* Domenico's emphasis in his description of these scenes, together with the scene *Anna Returns to Her House* (pl. 15) is powerful evidence that here at least he is following Maria de Agreda. ⚜

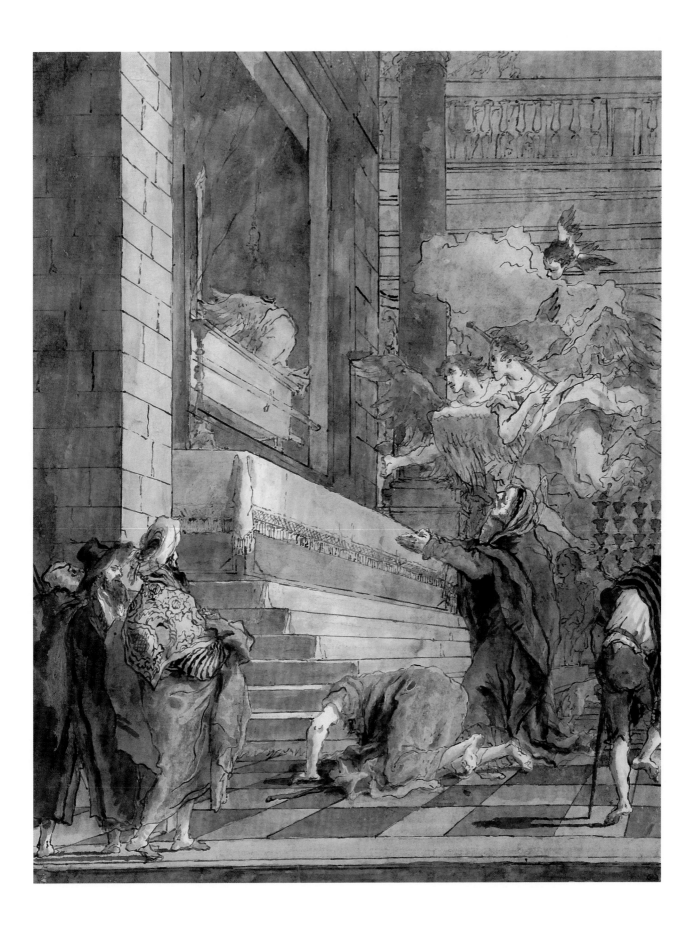

15. *Anna Returns to Her House*

. . . And Joachim said: Now know I that the Lord is become propitious unto me and hath forgiven all my sins. And he went down from the temple of the Lord justified, and went unto his house. (Book of James 5:1)

Pen and wash, over light black chalk, 481 x 381
Signed low left: Dom.o Tiepolo f
Provenance: Robert Lehman 1961; not in bequest to the Lehman Collection
Exhibition: New York 1971 [254]
Literature: Conrad 1996 [8]
Reference: Christiaan van Adrichem 1584, Site 37; *The Golden Legend,* 1900, v, 96–111; James 1924, 40; Byam Shaw and Knox 1987, 136

New York, Robert Lehman, on loan to the Lehman Collection, Metropolitan Museum of Art

One arm wrapped protectively around her, Anna's angel escorts her home as the bower of seraphim, now seen from behind, eagerly lead the way. The celebratory mood continues as Joachim, finally astride his great stallion, gallops up behind Anna, pointing to her with pride and joy, his hound leaping beside him. Ignoring the excitement, their long-suffering groom heads to the stable with another laborer, while above several servants prepare to welcome their master and mistress home. ❦

Domenico goes out of his way to illustrate these obscure events, for which no prototype has been noted. This demonstrates his own fascination for departures and arrivals, which he clearly felt lent logic and order to his interpretation of the story. On the other hand, a standard subject, *The Nativity of the Virgin* is omitted (or lost), and the story proceeds directly to *The Presentation of Mary in the Temple* (pl. 16). Domenico again shows us a much more vigorous Joachim than the aged and decrepit Anna, with her crutch; this would indicate his new confidence, now that he has repaired his relationship with the Almighty. On the other hand, it is Anna who has her glory of angels. *The House of Saint Anne* in Jerusalem is listed by Christiaan van Adrichem (1584: Site 37). ⚜

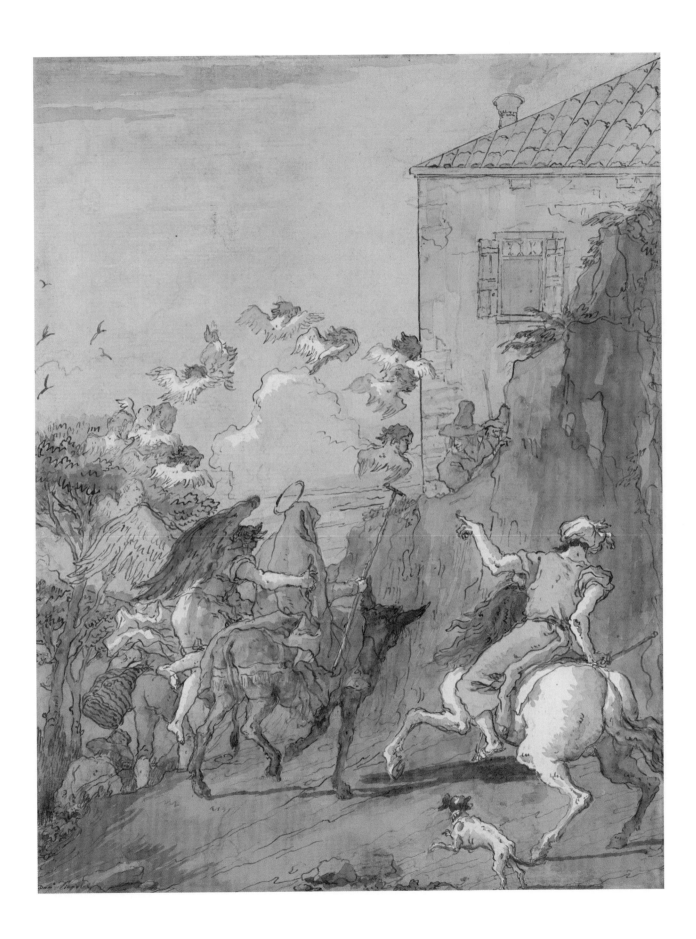

16. *The Presentation of Mary in the Temple*

And then when she had accomplished the time of three years, and had left sucking, they brought her to the temple with offerings. And there was about the temple, after the fifteen psalms of degrees, fifteen steps or grees to ascend up to the temple because the temple was high set. And nobody might go to the altar of sacrifices that was without, but by the degrees. And then our lady was set on the lowest step, and mounted up without any help as she had been of perfect age, and when they had performed their offering, they left their daughter in the temple with the other virgins, and they returned into their place. (The Golden Legend)

> Pen and wash, 475 x 365
> Not Signed
> Provenance: Richard Owen, Paris ; Paris, Léon Suzor; Katrin Bellinger 2004
> Exhibition: Paris, Cailleux 1952, pl. 54, with a full description
> Reference: *The Golden Legend* 1900, v, 101–102; Ribadeneira 1656, i, 73; Maria de Agreda 1685, ii, I, para. 412–423; James 1924, 73

Indiana, private collection, on loan to the Indiana University Art Museum

Fulfilling their promise, Anna and Joachim dedicate Mary to God. She precociously ascends the Temple's fifteen steps unaided, where the high priest appears ready to embrace the new protégé. Giving the scene the climactic quality it deserves, Domenico has assembled a huge crowd and most of his secondary cast, including his by now familiar watchful patriarchs and the egg seller at the left. Anna, shrouded by her gown as Mary would be later, strikes a somber note as her beloved child departs. ❦

Once again we return to the familiar setting of the entrance to the temple, but this time Reuben offers a warm welcome to the child Mary, so different from the brutal rejection he had offered to her father. The event, which took place when Mary was three years old, is mentioned briefly in the *Book of James* (7), without any mention of the fifteen steps; these are referred to in the *Liber de Infantia* and are fully described in *The Golden Legend*, v, 96–111, under *The Nativity of the Virgin Mary*, September 8. This event is celebrated on November 21. Domenico shows Mary as an exceptionally well-grown three-year-old. ❧

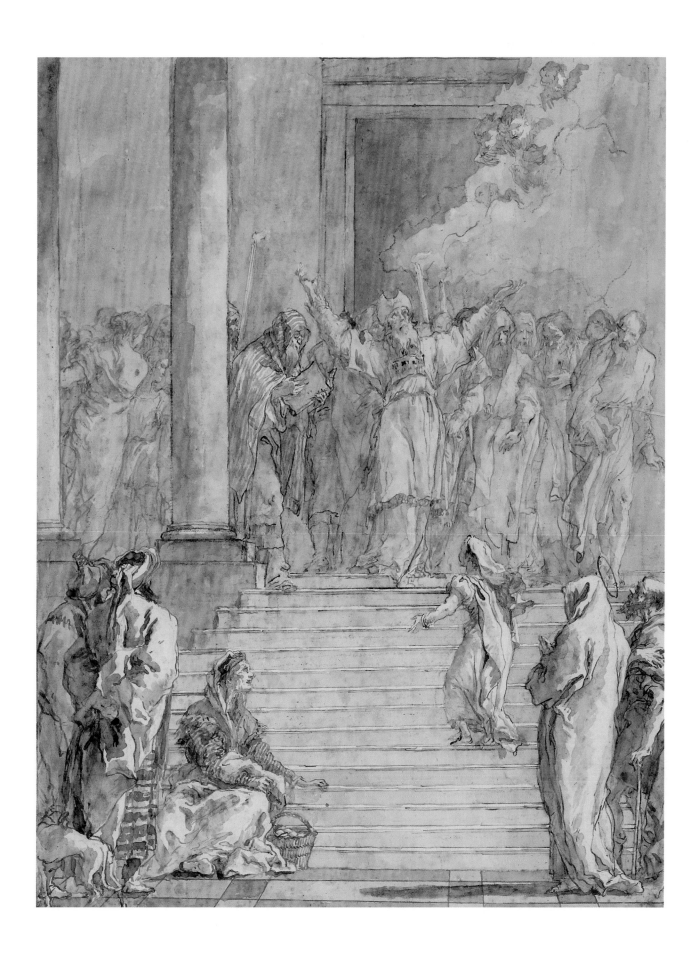

17. The Preparation for the Drawing of Lots

There took place a council of the priests, saying, "Let us make a veil for the Temple of the Lord." The priest said, "Call the undefiled virgins from the tribe of David." The attendants went out and sought them, and they found seven. Then the priest remembered the child Mary, that she was of the tribe of David and was pure before God; and the attendants went forth and brought her. They brought them into the Temple of the Lord, and the priest said, "Assign by lot for me here someone who will spin the gold thread and the white and the linen and the hyacinth blue and the scarlet and the pure purple. . . ." (Book of James 10:1)

Pen and wash, over black chalk, 461 x 361, trimmed to the image
Signed low right: Dom.o Tiepolo f
Provenance: Jean-François Gigoux (1806–1894), his bequest, 1894
Literature: Gernsheim 8143; Conrad 1996 [276]
Reference: Christiaan van Adrichem 1584, Site 85; James 1924, 41

Besançon. Musée des Beaux-Arts et d'Archéologie, 2230

Domenico selected a rare story from Mary's childhood, ignoring the more traditional subject of Mary learning to read at Anna's knee. Instead, Mary stands by observing the Temple elders preparing lots to select those who will weave the new Temple curtains. Presented in quasi-eighteenth-century dress, this scene introduces a device Domenico reuses in other childhood episodes, not only for Mary, but later for Jesus. 🌿

Mary appears on the left as a child, accompanied by two finely dressed young women who may be identified as "daughters of the Hebrews." The central figure bends over the table attending to something on a large plate. A little black box and inkwells also rest on the table. A man seated on the right in a fine chair looks upwards. A vast black cloud of smoke issues from the door at the back, indicating the presence of the Almighty: out of the cloud fly three bolts of lightning, and perhaps a fourth. We suggest here that this is the first of the three scenes depicting the drawing of the lots. In the second scene, *The Seven Virgins Draw Lots* (pl. 18), Anna is holding the little black box. In the third scene, showing *The Young Mary Accepts the Scarlet and the Pure Purple* (pl. 19), the large dish and the little black box can be seen once again lying on the table. The dark girl in the foreground is outlined in wax. In the *Book of James,* the episode of the drawing of the lots follows the betrothal of Mary to Joseph, but Domenico here clearly shows her as a child, not as a grown girl, and we follow the order that he indicates. The veil of the temple is described by Christiaan van Adrichem (1584: Site 85). ⚜

18. *The Seven Virgins Draw Lots*

There took place a council of the priests, saying, "Let us make a veil for the Temple of the Lord." The priest said, "Call the undefiled virgins from the tribe of David." The attendants went out and sought them, and they found seven. Then the priest remembered the child Mary, that she was of the tribe of David and was pure before God; and the attendants went forth and brought her. They brought them into the Temple of the Lord, and the priest said, "Assign by lot for me here someone who will spin the gold thread and the white and the linen and the hyacinth blue and the scarlet and the pure purple. . . ." (Book of James 10:1)

> Pen and wash, over light black chalk, 475 x 365
> Signed low right: Dom.o Tiepolo f
> Provenance: Paris, Didier Aaron; London, Hazlitt, Gooden & Fox
> Exhibition: Paris, Didier Aaron, Nov. 1976 [36]; Venice 1980 [104]; Brussels 1983 [52];
> London, Hazlitt, Gooden and Fox 1991–1992 [23]
> Literature: Conrad 1996 [274]
> Reference: James 1924, 43

London, private collection

The room has become more opulent and oddly secular, while the Virgin, tiny and vulnerable, stands out through her diminutive size as she prepares to draw lots. Several older patriarchs look on, one splendidly arrayed in a mantle decorated with the pomegranate motif first seen in plate 12. ❦

Jameson (1899: 154) notes that in pictures this subject usually precedes her marriage. Maria de Agreda does not refer to the story. The drawing, and plate 19 that follows, may be identified as a further stage in the episode from the *Book of James* (10:1), in which a veil was required "for the Temple of the Lord." For the weaving, seven virgins were required, among them "the child Mary," and they "cast lots to see who shall weave the gold, the amiantus, the linen, the silk, the hyacinth-blue, the scarlet and the pure purple." The old lady in black is Anna, whose presence here and in the following drawing may well be an invention of Domenico: she invites a young woman in white to draw her lot. The child Mary stands by her side. The other virgins may be counted among the crowd, and a boy in the lower left corner carries in a tray with coffee. ✤

19. *The Young Mary Accepts the Scarlet and the Pure Purple*

. . . And the lot of the true purple and the scarlet fell unto Mary, and she took them and went unto her house.
(Book of James 10:1)

Pen and wash, over black chalk, 460 x 360
Signed low right: Dom.o Tiepolo f
Provenance: Roger Cormier, Tours, his sale, Paris, Georges Petit, Apr. 30, 1921, no. 49
Exhibition: Udine 1996 [89]
Literature: Havercamp-Begemann 1964, cat. 62 [56]; Cailleux 1974 [8]; Conrad 1996 [275]
Reference: James 1924, 43

Williamstown, Massachusetts, The Sterling and Francine Clark Art Institute, 1463

Having crowded round the table to witness the drawing of the lots, the elders and women react with astonishment as the Virgin is awarded the most important colors of the Temple curtains, the scarlet and pure purple. These colors not only allude to Mary's favored status, but also Christ's future Passion and her future suffering. ✺

The setting is rather more simple than in the preceding drawing, though essentially the same, except that the large Tiepolo painting on the wall shows *A Centaur Hunting With A Bow,* which recalls the later decorations of the *Camerino dei centauri* of the Villa Tiepolo at Zianigo. Jean Cailleux does not find a direct source for this composition among Domenico's numerous drawings on this theme. ✤

20. *The Death of Joachim*

I say that Joachim, having presented his daughter at the Temple, as he had promised, soon after he died and went to his fathers. (Pietro Dorlando, cap. vii)

Man of God, may your eternal health be most high and omnipotent, and your holy place be necessary and suitable to your soul. Our daughter Mary sends to assist you at this time in which you pay your creator the debt of natural death. (Maria de Agreda)

> Pen and wash, 476 x 360
> Not signed
> Provenance: Christie's, Apr. 15, 1980 [122]; photo 942237; David Tunick, July 7, 1982; Stuart Denenburg; Mia Wiener 1985
> Literature: Conrad 1996 [14]
> Reference: Maria de Agreda 1685, ii, XVI

New York, private collection

Now fully grown, the Virgin performs a last filial duty, closing Joachim's eyes as he lies on his death bed. A vast cloud of glory emanates from his body as Anna, seated by her husband, weeps into her kerchief, oblivious to the host of angels gathering round Joachim. Behind Mary (significantly enough) one angel adopts the posture of veneration that Joachim assumed when he gave thanks for her imminent birth at the altar (pl. 14). Masses of angels gather to mourn and honor Joachim, while two receive his soul (here shown as an infant) and will escort it to heaven. Domenico likely invented this scene as a parallel to his later death of Joseph (pl. 80). ❦

The scene closely parallels, and indeed forms a pair with, *The Death of Joseph* (pl. 80), taking place in the same simple room with brick walls, a Venetian ceiling, and a window opposite the bed. The two angels gathering up the soul of the deceased in the form of a small child is a detail that is also found in the later drawing. The feast of Joachim and Anna is celebrated in the Greek church on September 9. In Venice the church of San Gioacchino, attached to the ancient Ospedale di San Pietro e Paolo, still exists about 100 meters west of the church of Sant'Anna. In the eighteenth century is boasted four paintings by Giuseppe Angeli. The Fondamenta di San Gioacchino faces that of Sant'Anna across the Rio di Sant'Anna in the vicinity of San Pietro di Castello (Lorenzetti 1926: 313; Zorzi 1972: 540). Maria de Agreda is very clear that Joachim died at the age of 69½, six months after Mary entered the temple at the age of 3. She calculates that he married Anna at 46, remained childless for 20 years, and died when Mary was 3½. Others suggest it occurred *"poco tempo dopo la solenne offerta fatta della figlia a Tempio."* In this she follows Dorlando (1570: cap. 7). However, Emile Rey (1942) suggests that the death of Joachim occurred in AD 5: *"La morte prématurée, c'est a dire, avant cette date, de saint Joachim et de sainte Anne est une legende: Tout, en effet, prouve le contraire."* Here the Virgin is shown more or less grown up, while Anna sits weeping on the left, which seems to argue against the possibility that Domenico depended on Maria de Agreda. His *The Death of Anna* (pl. 21) likewise does not follow her description. The setting is repeated, with a few changes, not only for *The Death of Joseph* (pl. 80) but also for *Jesus Curing Peter's Mother-in-Law* (pl. 119). ⚜

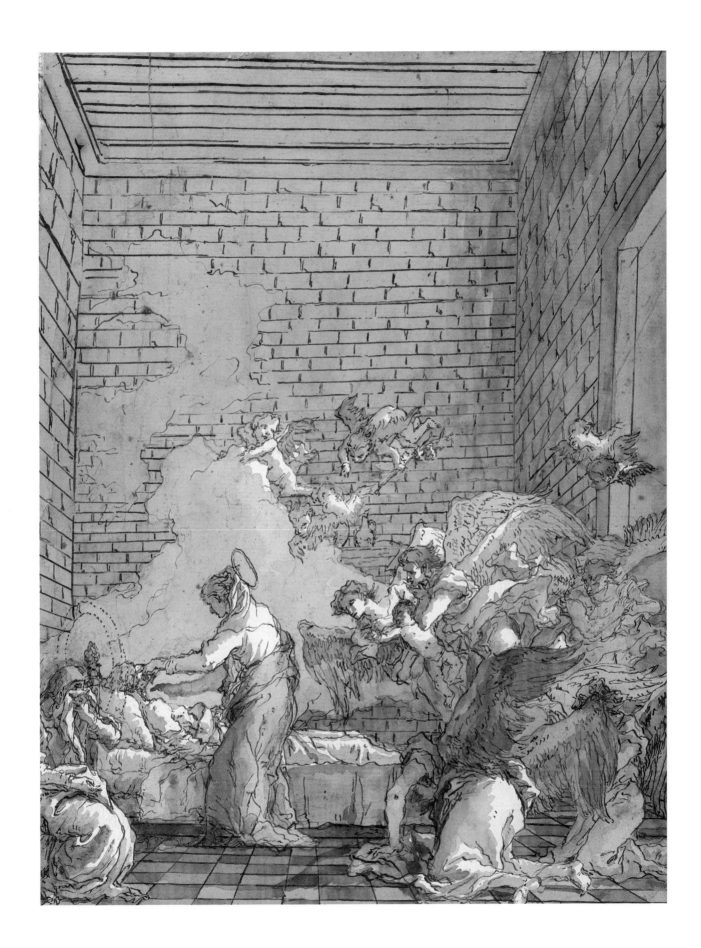

21. *The Death of Anna*

Some say that she died after the birth of Jesus Christ our Saviour on 26 July. (Ribadeneira)

Pen and wash, over extensive black chalk, 462 x 353
Signed low right: Dom.o Tiepolo
Provenance: Jean Fayet Durand (1806–1889)
Literature: Conrad 1996 [15]; Gealt in Udine 1996, 82
Reference: *The Golden Legend,* 1900, v, 97, under September 8; Ribadeneira 1656, i, 492; Maria de Agreda 1685, ii, XIX

Paris, Musée du Louvre, Département des Arts Graphiques, RF 1713bis [43]

Closing his chapter on Mary's parents, Domenico shows Anna lying on her bier attended only by her devoted angels. Amidst the hovering throng, the central angel links her back to the story of Abraham (pl. 1) with his familiar pose. A cloud of glory fills the room, mingling with the incense given off by the censer at the foot of the bier (a funereal detail repeated only in Domenico's scenes of Christ's burial). Why Mary is not present, as was traditional, remains mysterious but helps explain Domenico's insertion of a (rarely used) inscription. ◖

The death of Anna in the arms of her daughter Mary is described at length by Maria de Agreda. However, this is evidently not the tradition followed here, as Anna lies alone upon a pallet, surrounded by six angels but with Mary conspicuously absent. Maria de Agreda also relates that Anna died at the age of 56, while Mary was still in the temple. She calculates as follows: marriage to Joachim at 24; remaining childless for 20 years; Mary born when Anna was 44; remaining three years at home and nine in the temple, making 56. She also discounts the tradition, related in *The Golden Legend* and repeated by Ludolph of Saxony, cap. ii, and Pietro Dorlando, cap. vii, that after Joachim's death Anna remarried twice and had five more children, four of whom became Apostles. Domenico ignores this too, consistently showing Anna as a decrepit old woman with a crutch. Her feast was established by Gregory XIII in 1584. It is celebrated on 26 July. ⚜

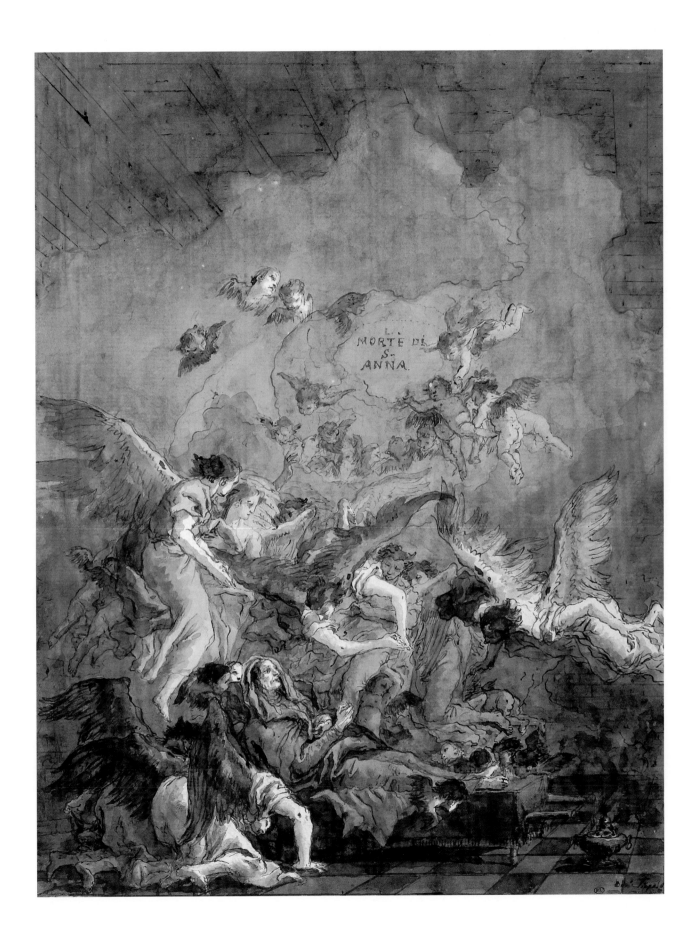

22. *The Burial of Anna*

Anna "fu seppellito presso il suo sposo S. Gioacchino, dal qual luogo ebbero poscia i Fedeli la cura di trasportare la sua sagra spoglia nella Chiesa del Sepolcro di nostra Signore nella valle di Giosafat, dove si vede anche a' giorni nostri il suo sepolcro in una Cappella." (Pietro Dorlando, vii)

After five years the pious and blessed old mother Elizabeth passed away, and the holy John sat weeping over her, as he did not know how to shroud the body and bury her, because on the day of her death he was only seven years and six months old. (The Life of John, according to Serapion)

> Pen and wash, over traces of black chalk, 479 x 377
> Signed low right: Dom.o Tiepolo f
> Provenance: Roger Cormier, Tours, his sale, Paris, Georges Petit, Apr. 30, 1921, no. 38; Knoedler; Clarke 1921
> Exhibition: Udine 1996 [91]
> Literature: Havercamp-Begemann 1964 [53]; Conrad 1996 [70], as *The Burial of Elizabeth*
> Reference: Christiaan van Adrichem 1584, Site 202; *The Golden Legend* 1900, v, 97–88; Maria de Agreda 1685, ii, XIX; Grandis 1761–1763; Hennecke 1963, 414–415

Williamstown, Massachusetts, The Sterling and Francine Clark Art Institute, 1457

In a daring invention, Domenico shows angels, guided by the familiar central being, reverently lowering Anna's body into her grave. Strangely, John the Baptist is the only mourner. Legend says John was Anna's nephew. His presence may place Anna's burial in the context of John's wilderness years. Serapion's account of Elizabeth's burial says that Jesus sent two angels, Michael and Gabriel, to bury her. Consistent with Domenico's emphasis on Anna's importance, *four* angels attend her, together with a sad remnant of her bower of seraphim. ❧

Domenico's series of eleven drawings illustrating the story of Anna is without parallel in the history of art. This one pairs (to establish a thematic connection) with *The Death of Elizabeth* (pl. 96). The burial of Anna in the Vale of Jehoshaphat at the age of 79 is recorded by Grandis. For Anna's cult in Venice, see plate 4 above. Pietro Dorlando tells us that her body was first buried by that of Joachim and later removed to the Church of the Holy Sepulcre in the Vale of Jehoshaphat, "where it may still be seen." Christiaan van Adrichem (1584, Site 202) describes the Valley of Jehoshaphat as a wide and deep valley between Jerusalem and Mount Olivet on the east side of the city. "This Valley was the common place of burial for the whole City, where all the common sort of people were buried." Legend holds that her body was discovered by St. Helena and transferred to Constantinople, where a great church was dedicated to her. Another legend records that her remains were later brought to Provence by Lazarus and the three Maries, and ultimately hidden in the lower crypt of the cathedral at Apt, later miraculously rediscovered in the presence of Charlemagne in 801. In 1584, Gregory XIII set the Feast of St. Anne on July 26. Her cult at Apt was revived in the early seventeenth century by Anne of Austria, queen of Louis XIII, who had built the fine chapel for her relics (for a full account, see Rey 1942; Baillet is skeptical). Anna's death is noted by Maria de Agreda, but she does not follow *The Golden Legend,* which claims that after the death of Joachim, Anna had two more husbands and five children, four of whom became Apostles. ⚜

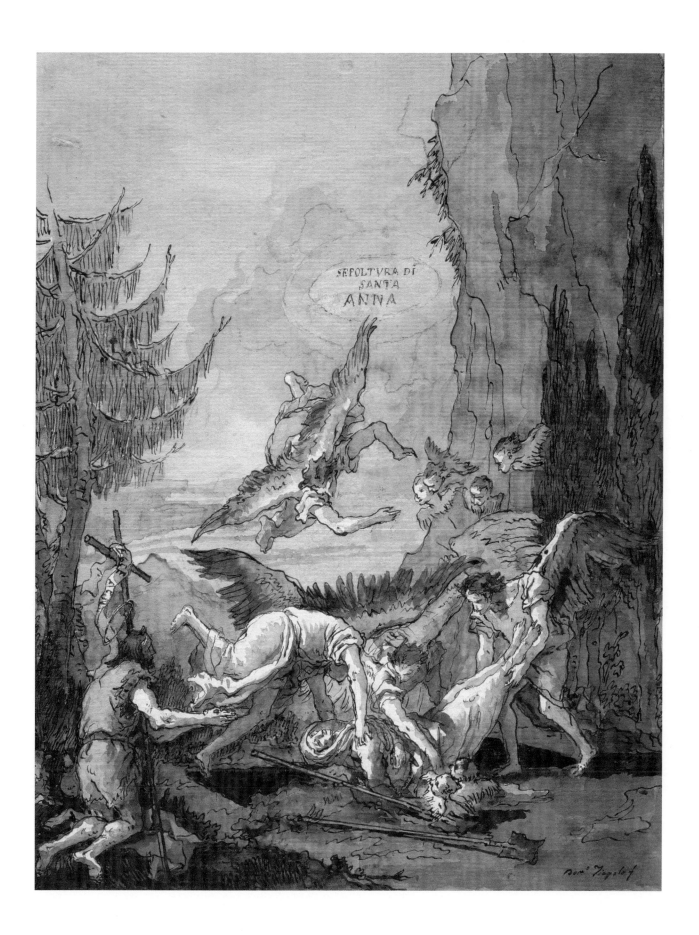

SEPOLTVRA DÍ
SANTA
ANNA

Mary and Joseph and the Infant Jesus, Plates 23–41

The Gospels barely touch on Joseph and Mary's marriage, with only Matthew and Luke offering brief accounts. Matthew spends most of his seventeen verses in chapter 1 linking Joseph to Abraham through fourteen generations.[5] Both Matthew and Luke agree on a central point: that Mary miraculously conceived Jesus while still a virgin. Matthew 1:18 tersely notes: "When as his mother Mary was espoused to Joseph, before they came together, she was found with child of the Holy Ghost." Luke 1:27–28 is the only Gospel that mentions how Mary found out her destiny through an angel's visit known as The Annunciation. He says that the angel Gabriel went "to a virgin espoused to a man whose name was Joseph, of the house of David" in Nazareth, and that he (the angel) said, "Blessed art thou among women." These rather sparse, yet portentous words, are followed by a lengthy explanation (ten more verses) to Mary of her destiny.

Apocryphal sources once again supply further details. When Mary (still within the Temple sanctum) reached marriageable age (12 to 14, depending on the source), the high priest Zacharias asked God for direction regarding her future. An angel instructed Zacharias to assemble all widowers (or eligible men) and ask them to submit a rod. God's selection would be manifested by the rod that flowered (or upon which a dove would settle). Joseph, a humble carpenter and elderly widower, reluctantly joined the suitors, was chosen, and obediently wed the Virgin.

The apocryphal *Book of James* presents a down-to-earth account of how Joseph discovered Mary's pregnancy. Having left Mary secluded immediately after their betrothal, Joseph returned six months later to find her pregnant. Matthew 1:19 touches on Joseph's dilemma, noting that Joseph prepared to put her away, until an angel revealed the truth in a dream. But *James* recounts Joseph's dismay with Mary more fully, followed by confrontations with the Temple priests (episodes that never entered the pictorial tradition). Luke 1:36–56 is the source for the story of Mary's visit to Elizabeth during her pregnancy (the Visitation). Luke is also the standard source (2:1–20) for most of the Christmas story: Jesus's birth in a manger, his adoration by shepherds, his circumcision in the Temple, and his veneration by the prophet Simeon and

The Virgin confronting the House, detail of plate 29, *Mary and Joseph Return to the House*

the prophetess Anna at his presentation there. Matthew 2:1 is the source for the story of the three Magi (whom second and third century sources, notably Tertullian, transformed into Kings), who came from the east to worship the new King.

5. *The Golden Legend* notes this (see Sept. 8, Nativity of the Virgin), and thus justifies filling in the gaps (p. 519).

Building on numerous traditional artistic subjects that sprang from these accounts, Domenico constructed an expansive and highly personal interpretation of the story, mingling ritual pageantry with deeply felt human emotion. Incorporating apocryphal sources, Domenico expanded his narrative far beyond visual tradition, playing out the story of Joseph and Mary's union over nine drawings in a series that evidently bypassed the traditional Annunciation while adding much unusual material. Joseph's surprise at being chosen, his dismay at finding the Virgin pregnant, and the resulting estrangement between the couple as they go to visit Elizabeth are strikingly new elements in Domenico's distinctive interpretation. So is the artist's development of the next part of the story, in which he shows Joseph's growing reverence as Mary's divine status dawns on him. These details are among the richest aspects of Domenico's

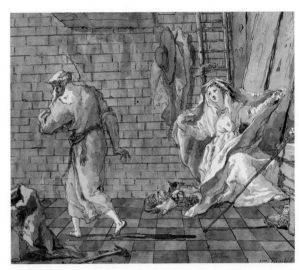

Joseph dismayed, detail of plate 31, *Joseph Scolding Mary*

highly original interpretation of this story. Though relying primarily on Gospel texts, Domenico returned to the *Book of James* for the scenes of Joseph's departure and return, while his own imagination supplied rich details such as the angel setting Joseph straight during their journey to Elizabeth and Zacharias.

Domenico's scenes of Christ's birth, visits from the shepherds, the Magi, and the purification of the Virgin are all traditional enough; to them Domenico added subsequent visits with John and Elizabeth that go beyond any traditional pictorial cycle.

23. The Annunciation to the High Priest Zacharias

And the high priest took the vestment with the twelve bells and went in unto the Holy of Holies and prayed concerning her. And lo an angel of the Lord appeared saying unto him: Zacharias, Zacharias, go forth and assemble them that are widowers of the people, and let them bring every man a rod, and so whomsoever the Lord shall show a sign, his wife shall she be. . . . (Book of James 8:3)

When Mary was fourteen years old, the priest Zacharias inquired of the Lord concerning her, what was right to be done; and an angel came to him and said, Go forth and call together all the widowers among the people, and let each bring his rod in his hand, and he to whom the Lord shall show a sign, let him be the husband of Mary. (The History of Joseph the Carpenter)

Pen and wash, traces of black chalk, 459 x 360, trimmed to the borderline
Signed low left: Dom.o Tiepolo f
Provenance: Roger Cormier, Tours, his sale, Paris, Georges Petit, Apr. 30, 1921, no. 13; Paris, Hôtel Drouot, May 20, 1935 [181]; Tomas Harris; Dr. Rudolf J. Heinemann, New York
Exhibition: London, Arts Council 1955, pl. 34; New York 1973 [101]
Literature: Conrad 1996 [263]; Gealt in Udine 1996, 73
References: *The Golden Legend,* 1900, v, 103; Anna Jameson, *Legends of the Madonna,* 1899, 159; James 1924, 42

New York, The Pierpont Morgan Library, Heinemann Collection, 1996.103

Marking yet another important "introductory" episode, an angel posed like Abraham's in the first scene and Anna's in subsequent episodes has flown through the open window to instruct the high priest Zacharias about arranging Mary's wedding. The Book of James states that Zacharias had been struck dumb by the Virgin's drawing of lots, so the presence of a hound (a "dumb" animal), besides being an emblem of faith and loyalty, may allude to his speechless condition. 🖋

According to the *Book of James,* the annunciation to the High Priest is said to have taken place in the Holy of Holies, not in a bedroom, with Zacharias snoozing in a comfortable chair; however, *The History of Joseph the Carpenter* is not specific on this point, nor is *The Golden Legend.* Zacharias, the high priest of the Apocrypha, must be distinguished from Zacharias, the father of John the Baptist. According to Luke 1:5–64, the latter was "a certain priest" whose "lot was to burn incense when he went into the temple of the Lord" (pls. 82, 85–87), and who is shown with his censer. A censer is also shown here, and the theme is identified in the Heinemann catalogue as *The Announcement of the Birth of St. John to Zacharias,* a scene illustrated in plate 82 as taking place in the Temple, as required by the text. However, the *Book of James* 10:1 also mentions after the drawing of lots (pls. 17–19): "And at that season Zacharias became dumb . . . ," clearly confusing the High Priest with the father of John the Baptist. ⚜

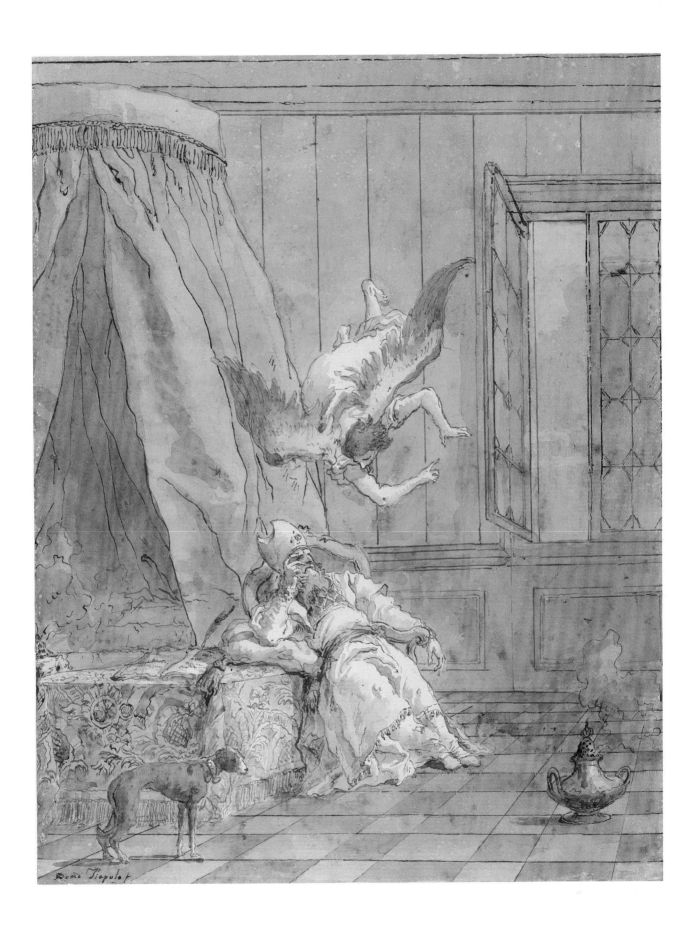

24. "CONSERVATORIO"

And when she was twelve years old, there was a council of the priests, saying: Behold Mary is become twelve years old in the temple of the Lord. What shall we do with her? lest she pollute the sanctuary of the Lord. And they said unto the High Priest: Thou standest over the altar of the Lord. Enter in and pray concerning her: And whatsoever the Lord shall reveal unto thee, that let us do. (Book of James 8:2)

Pen and wash, over traces of black chalk, 485 x 383
Signed on the column: Dom.o Tiepolo f
Provenance: Roger Cormier, Tours, his sale, Paris, Georges Petit, Apr. 30, 1921, no. 47; Duc de Trévise, his sale, Hôtel Drouot, Dec. 8, 1947, no. 38
Exhibition: Udine 1996 [99]
Literature: Guerlain 1921, 95; *Revue du Louvre* 1995, 2 [24]; Conrad 1996 [18]
Reference: *The Golden Legend* 1900, v, 102; James 1924, 42

Paris, Musée du Louvre, Département des Arts Graphiques, RF 44309

Following the angel's instructions, Zacharias presides over the Virgin's procession from her "Conservatorio" to the Temple proper, as an assembly of patriarchs look on. The barred windows and fortress-like walls all underscore the impregnable confines of Mary's sanctum to emphasize her purity. We suggest that this drawing represents Mary leaving for the temple on the occasion of her marriage, an event for which there is no text. Thus, the design makes an effective sequence with the following drawings, *The Suitors Present Their Rods* and *The Betrothal of Mary*. The text cited above indicates the circumstances, but properly precedes the previous drawing. ❧

A large group of women, one among them with a halo, appear to be coming out of a large building on the left marked *CONSERVATORIO*—meaning, in this context, a pious retreat. It refers to "the sanctuary of the Lord," which Mary at puberty must leave "lest she pollute" it. Alone with a halo, she is surrounded by her companions, perhaps the seven virgins of the earlier story of the drawing of lots, and faces the commanding figure of the High Priest in the center, evidently declaiming among a group of men. The light is beautifully controlled, so that the male element on the right is dark and heavy and the female group on the left is light and ethereal. The serious difficulty is that Mary here appears to be well over twelve years old, as the text insists. An alternative might be that it represents *The Purification of Our Lady,* celebrated on February 2 (see *The Golden Legend III,* 19–27), but this fails to account for any of the elements in the composition. Domenico gives this drawing a separate pair: *Jesus Leaves His Mother's House* (pl. 180), representing a very comparable event. ✤

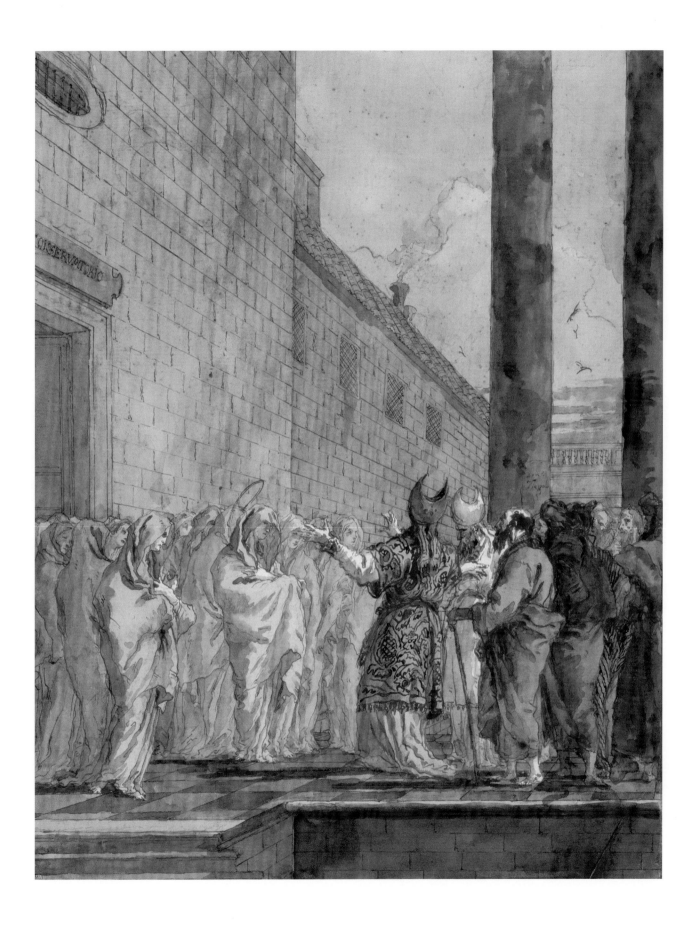

25. *The Suitors Present Their Rods*

And Joseph cast down his adze and ran to meet them, and when they were gathered together they went to the high priest and took their rods with them. And he took the rods of them all and went into the temple and prayed. . . .
(Book of James 9:1)

> Pen and wash over extensive black chalk, 462 x 364
> Signed low left: Dom.o Tiepolo f
> Provenance: Jean Fayet Durand (1806–1889)
> Literature: Conrad 1996 [16]
> Reference: *The Golden Legend,* 1900, v, 103, under September 8; James 1924, 42

Paris, Musée du Louvre, Département des Arts Graphiques, RF 1713bis [127]

Zacharias has instructed all eligible bachelors, including Joseph, to make their way into the Temple bearing their rods, or sticks, and this has drawn a huge crowd of applicants. The four lads bringing up the rear have a curiously eighteenth century air. Joseph's bald head and massive back can be picked out at the top of the stairs, aided by the lad at the bottom whose stick directs our eyes. Some elders observe the proceedings from the base of the Temple, as our young straggler with the long stick rushes past them toward the stairs. ❦

Once again Domenico returns to his familiar location, the entrance to the Temple. The drawing may be said to be relatively late in date. The columns and the doorway in the background are indicated in black chalk only. ⚜

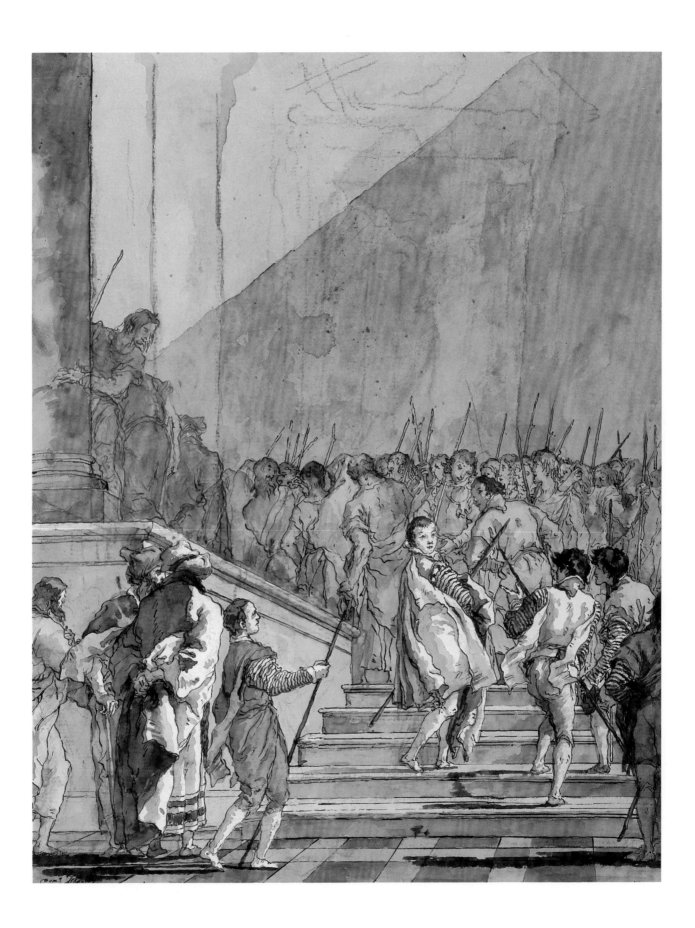

26. The Betrothal of Mary

And when he had finished the prayer he took the rods and went forth and took them back to them: and there was no sign upon them. But Joseph received the last rod: and lo, a dove came forth of the rod and flew upon the head of Joseph. And the priest said unto Joseph: unto thee hath it fallen to take the virgin of the Lord and keep her for thyself.
(Book of James 9:1)

And then Joseph by commandment of the bishop brought forth his rod, and anon it flowered, and a dove descended from heaven thereupon, so that it was clearly the advice of everyman that he should have the virgin. And then he espoused the Virgin Mary. . . . (The Golden Legend)

> Pen and wash, over black chalk, 483 x 386
> Signed on the column: Dom.o Tiepolo f
> Provenance: Luzarche, Tours; Roger Cormier, Tours, his sale, Paris, Georges Petit, Apr. 30, 1921, no. 44; Adrien Fauchier
> Magnan, his sale, Sotheby's Dec. 4, 1935, pl. 61, bt. Houthakker; Robert Lehman 1961
> Exhibition: New York 1971 [253]; Birmingham 1978 [131]; New York 1981 [128]
> Literature: Guerlain 1921, 93; Santifaller 1976 [17]; Byam Shaw and Knox 1987 [112]; Conrad 1996 [17]
> Reference: *The Golden Legend* 1900, v, 103; James 1924, 42

New York, The Metropolitan Museum of Art, Robert Lehman Collection, 1975.1.514

Pop-eyed in surprise as his rod flowers and the dove signals his election, Joseph is betrothed to the Virgin. Her head turned modestly away, Mary gives her hand to Joseph. Zacharias, accompanied by several other priests, declares that God's will is fulfilled by pointing heavenward. Suitors stand dejectedly at the left, while elders and some shrouded women attend this sober gathering at the right. ❦

Both the *Book of James* and *The Golden Legend* seem clear that the event described was at least a betrothal, if not a marriage, notwithstanding that it was acknowledged that Mary was a virgin dedicated to the Lord. However, the *Book of James* subsequently describes Joseph's distress when it became clear that she was six months pregnant (*Joseph Scolding Mary*, pl. 31). The drawing shows Mary as a grown woman, and for this reason we reverse the order of the *Book of James* and place the scene later than *The Seven Virgins Draw Lots* and *The Child Mary Accepts the Scarlet* and *The Pure Purple* (pls. 17, 18, 19). The setting is strangely unspecific, suggesting an open-air scene, but the seven-branched candlestick establishes the Temple location. ⚜

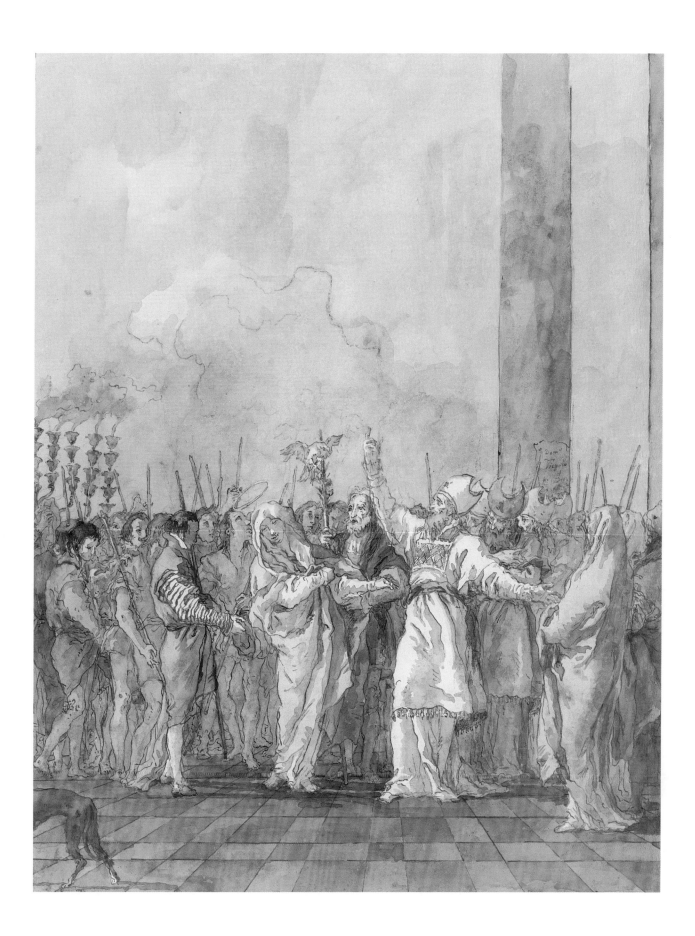

27. The Marriage of Mary and Joseph

Now the birth of Jesus Christ was on this wise: When as his mother Mary was espoused to Joseph, before they came together, she was found with child by the Holy Ghost. (Matt. 1:18)

And then he espoused the Virgin Mary. (The Golden Legend)

Pen and wash over black chalk
Signed low left: Dom.o Tiepolo f
Provenance: Jean-François Gigoux, his sale, 1882, pl. 176; Richard Owen; Dr. Rudolf J. Heinemann
Reference: *The Golden Legend* 1900, v, 103; Pigler 1956, i, 237–240; Réau 1957, 171; Verri 1991, 771–772

New York, The Pierpont Morgan Library, Heinemann Collection, 1997.56

Having regained his composure, an earnest Joseph gazes intently at the Virgin as Zacharias recites the marriage vows. A massive cloud of glory mingles with the smoke of incense, burning lamps, and candles. Cherubim and seraphim hover joyously overhead, bearing the nuptial wreath. A few disappointed suitors attend the ceremony, while an exceptionally portly elder looks on from the right. ✤

Matthew and Luke make it clear that Joseph was "espoused" to Mary, implying marriage, though it does not describe the ceremony. The Feast of the Marriage of the Virgin, celebrated on January 23, is discussed by Anna Jameson, *Legends of the Madonna* (1899, 157–162). Here the setting is unequivocally the interior of the Temple. ⚜

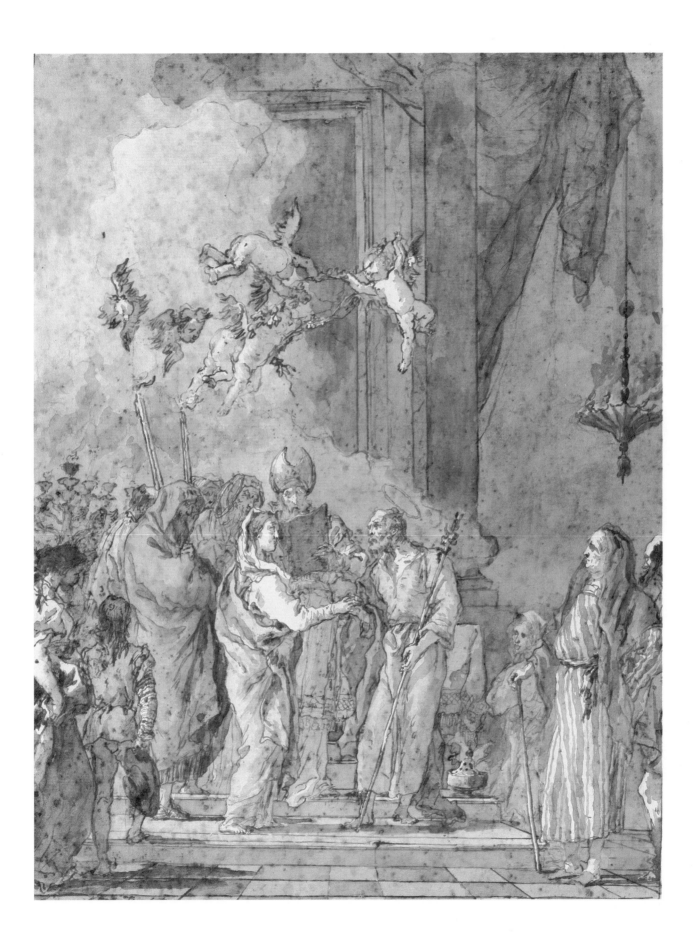

28. *Mary and Joseph Leave the Temple*

She took leave of the temple not without great grief on account of the sacrifice of her inclinations and desires.
(Maria de Agreda, ii, 578)

Pen and wash, over traces of black chalk, 475 x 365
Signed center, on the column: Dom.o Tiepolo f
Provenance: Paris, Leon Suzor
Exhibition: Paris 1952, pl. 55 [34]
Literature: Conrad 1996 [19]

Paris, Leon Suzor (formerly)

Consistent with his interest in departures, Domenico presents his idea of how the holy couple left the Temple, using a setting deliberately reminiscent of Joachim's earlier rejection, thus balancing plate 25, which shows the suitors entering the Temple. As priests and elders look on, Joseph escorts his bride down the steps, followed by some unsuccessful suitors who grumble to each other about the selected groom. Their intimate gossip contrasts with the holy couple's formality. Though Joseph turns solicitously toward Mary, she leans chastely away from him. ❦

This event is not really described in any of the texts, and may be regarded as an invention of Domenico himself. He once again sets the scene on the temple steps. Mary and Joseph are seen at the foot of the steps, on the right, with the unsuccessful suitors in attendance, still holding their rods. The setting should be compared with the other scenes illustrating the earlier trials and triumphs of Joachim and Anna in approaching the Temple (pls. 2, 3, 11, 12) and it makes a particularly effective comparison with *The Presentation of the Child Mary in the Temple* (pl. 16). ❦

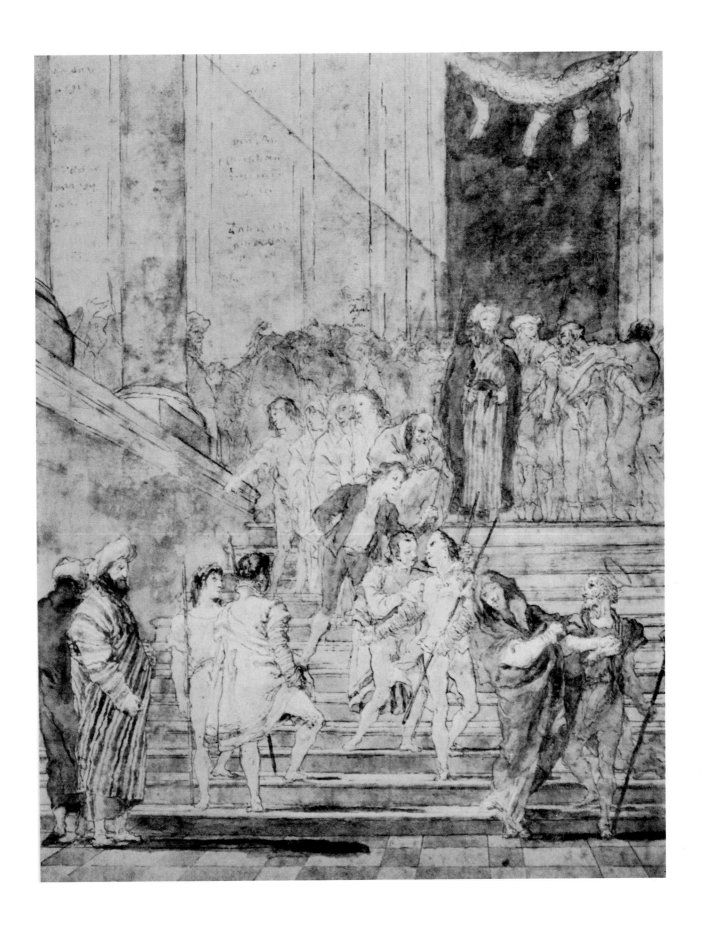

29. *Mary and Joseph Return to the House*

And the Virgin Mary returned unto the house of her father with seven virgins, her fellows of her age, which had seen the demonstration of the miracle. (The Golden Legend)

Having arrived at their home in Nazareth, where the Princess of heaven had inherited the possessions and estates of her blessed parents, they were welcomed and visited by their friends and relatives with the joyful congratulations customary on such occasions. (Maria de Agreda, ii, 548)

Pen and wash, over slight black chalk, 463 x 365, trimmed to the image
Signed low left, on the stone: Dom.o Tiepolo f
Provenance: Jean-François Gigoux (1806–1894), his bequest, 1894
Literature: Conrad 1996 [20]
Reference: *The Golden Legend* 1900, v, 103; James 1924, 42; Réau 1957, 173

Besançon, Musée des Beaux-Arts et d'Archéologie, 2233

Joseph now urges Mary to enter his house in a scene reminiscent of Joachim and Anna's earlier homecoming. But the mood here is mixed. At least one disappointed suitor has followed the party. Oblivious to the dancing celebrants, Mary, shrouded by her cloak, appears solemn and reluctant as she faces the darkened passage of her new home. Joseph seems anxious to remove her from all these young men and his emphatic instruction shocks the young servant girl standing at the door. Mary is lost in thought, clearly anticipating her upcoming trials with Joseph. 🌿

The seven virgins mentioned in *The Golden Legend,* apparently a reference back to the story of the drawing of the lots, may be the shrouded women in the back. ⚜

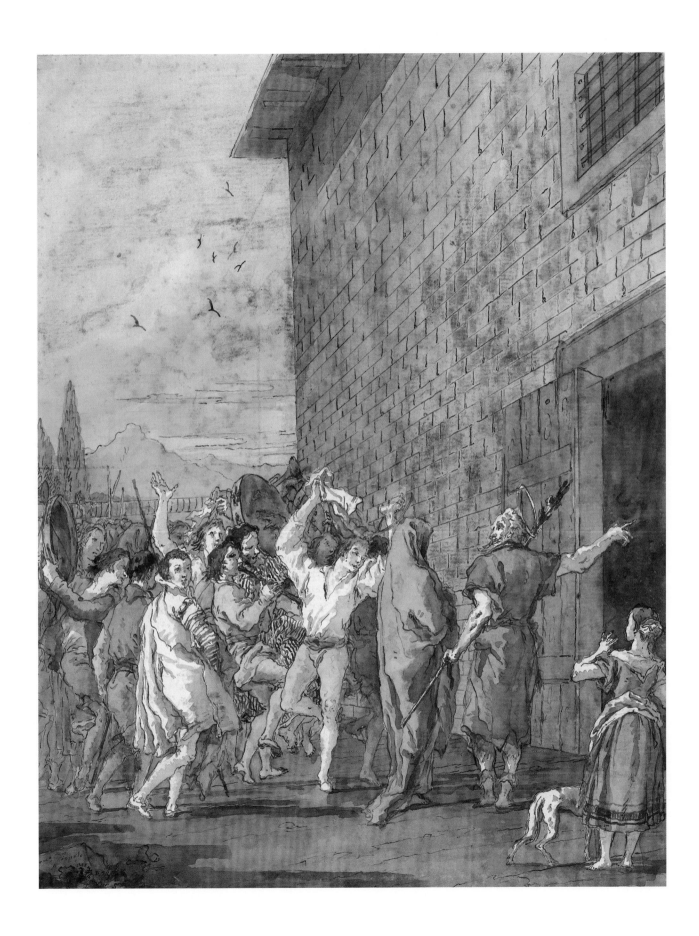

30. *Joseph Taking Leave of Mary*

. . . And Joseph said unto Mary: Lo, I have received thee out of the temple of the Lord: and now do I leave thee in my house, and I go away to build my buildings and will come again unto thee. The Lord shall watch over thee.
(Book of James 9:2)

Pen and wash, 460 x 360
Signed low left: Dom.o Tiepolo f
Provenance: Roger Cormier, Tours, his sale, Paris, Georges Petit, Apr. 30, 1921, no. 52
Literature: Guerlain 1921 [94]; Conrad 1996 [21]
Reference: James 1924, 42; Réau 1957, 206

In this and the following drawing the simple interior of Joseph's house is established by the planks of wood stacked against the wall on the right. Quietly seated inside her husband's simple but well-stocked carpentry shop, Mary bids a regretful farewell to her new husband. Joseph, having put on his cloak, holds his hat in one hand and a flowering staff in the other as he takes his leave, giving Mary some final instructions about his several months' absence. The family cat (an emblem of domesticity as well as feline wiles) lies curled up near Joseph's discarded hammer in the foreground, adding a pleasant domestic touch. ❦

In the mosaics of San Marco, the *Sposalizio* is followed by *The Annunciation* (omitted by Domenico), then the *Giving of the Purple, The Visitation,* and *Joseph Scolding Mary.* The present subject is omitted. It seems that Domenico adopted a rather more logical sequence in which *The Giving of the Purple* precedes the *Sposalizio* and *Joseph Taking Leave,* whereas *Joseph Scolding Mary* precedes *The Visitation.* ⚜

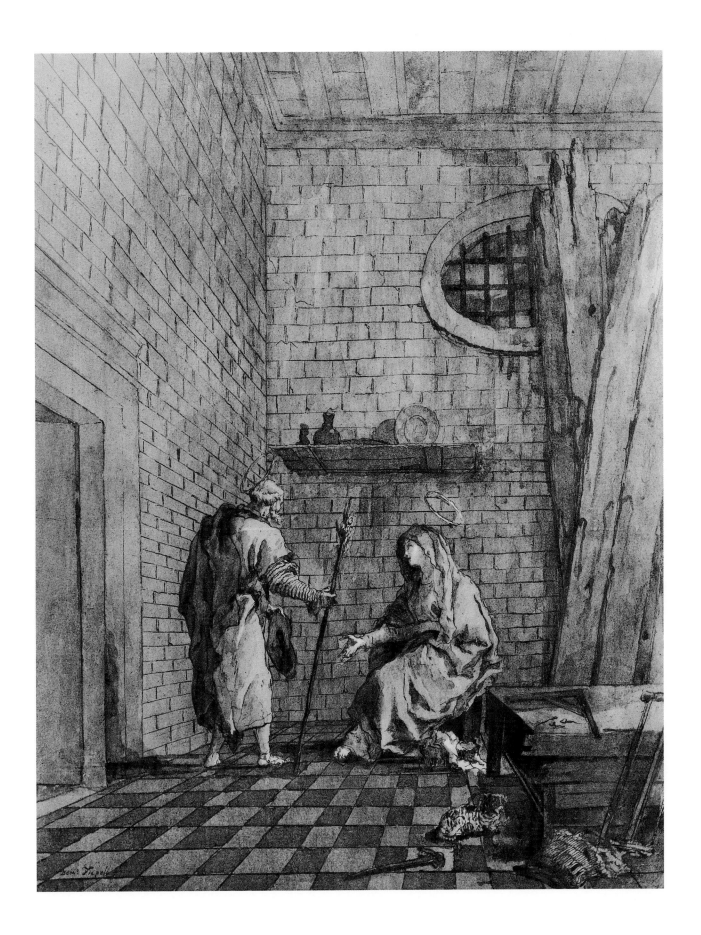

31. *Joseph Scolding Mary*

Now it was the sixth month with her, and behold Joseph came from his building, and he entered into his house and found her great with child. And he smote his face, and cast himself down upon the ground on sackcloth and wept bitterly, saying: With what countenance shall I look unto the Lord my God? and what prayer shall I make concerning this maiden? for I received her out of the temple of the Lord my God a virgin, and have not kept her safe. . . . (Book of James 13:1)

Then Joseph her husband, being a just man, and not willing to make her a public example, was minded to put her away privily. But while he thought on these things, behold, the angel of the Lord appeared unto him, saying, Joseph, thou son of David, fear not to take unto thee Mary thy wife: for that which conceived in her is of the Holy Ghost. (Matt. 1:19–20)

Pen and wash, over traces of black chalk, 465 x 360, image, not trimmed
Signed low right: Dom.o Tiepolo f
Provenance: Tomas Harris; Dr. Rudolf J. Heinemann, New York
Exhibition: London, Arts Council 1955, pl. 35; New York 1973 [103]
Literature: Santifaller 1976 [18]; Brussels 1983 [fig. 38]; Conrad 1996 [22]
Reference: Maria de Agreda 1685, iv, I–III; James 1924, 44

New York, The Pierpont Morgan Library, Gift of Mrs. Rudolf J. Heinemann, in memory of
Dr. Rudolf J. Heinemann 1996.104

Having just had time to hang up his hat and cloak upon his return, Joseph receives Mary's news. Still seated as before, she reveals her condition to her dismayed husband. A ladder leaning against the barred window provides a crude affirmation of Mary's impregnable condition, while Joseph's stunned gesture at learning of Mary's pregnancy ironically echoes Joachim's gesture of despair at being childless. Mary's cat, now curled up cozily beside her, ignores the hubbub. 🐾

Once again one may note how Domenico devotes two drawings to subjects barely known since the Middle Ages, while ignoring *The Annunciation,* one of the most popular themes of all time, which we owe to Luke. It seems, according to this scenario, that Mary also neglected to mention to Joseph the visit of the Holy Ghost, and consequently her husband had no warning of her interesting condition. Another angelic visitation (which Domenico also omits in its traditional form) was necessary to set his mind at rest. The outline underdrawing in black chalk indicates that the setting was at first planned to be even closer to the preceding drawing than was finally the case. Joseph in his despair has now cast aside his flowering rod. It is treated at length by Maria de Agreda, who also places this episode after *The Visitation,* an event (according to her) in which Joseph took no part. ✤

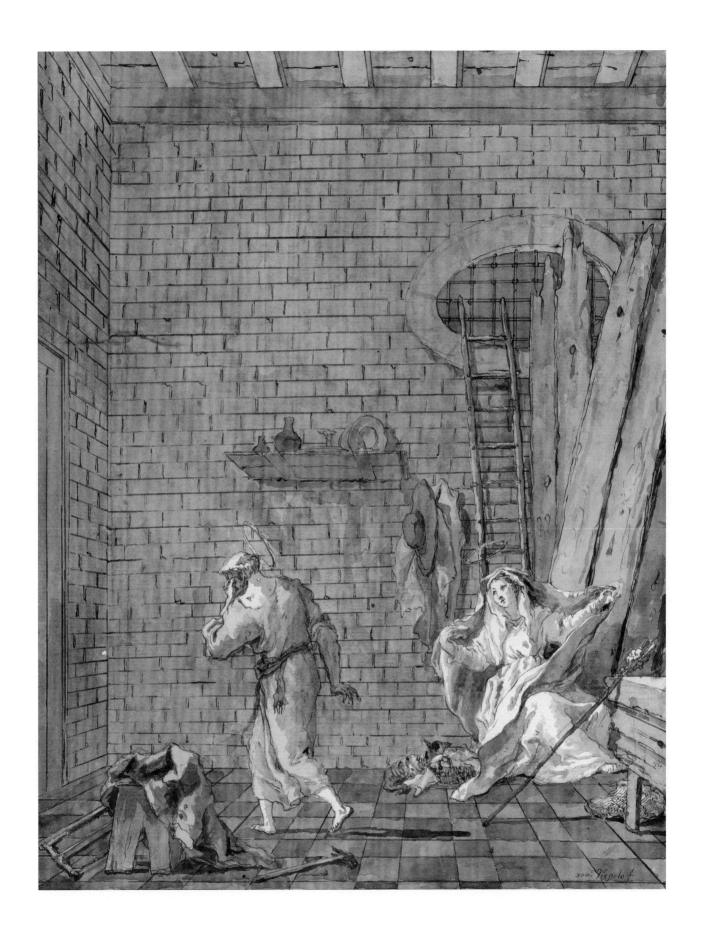

32. *Mary and Joseph Set Out to Visit Elizabeth*

When our Lady recalled the words of the angel about her cousin Elizabeth, she decided to visit her, that she might rejoice with her and serve her. Therefore she went, alone with her husband, from Nazareth to her house, a distance of 74 or 75 (14 or 15) miles from Jerusalem. The roughness and length of the road did not delay her; instead she walked rapidly because she did not want to be long in the public view. (Meditationes vitae Christi)

> Pen and wash, over extensive black chalk, 465 x 361
> Signed low right: Dom.o Tiepolo f
> Provenance: Jean Fayet Durand (1806–1889)
> Literature: Conrad 1996 [23]; Eagusa and Green 1961, 21–22 [15]; Maria de Agreda 1971, ii, 516–582

Paris, Musée du Louvre, Département des Arts Graphiques, RF 1713bis [54]

As Joseph and Mary set out to visit Elizabeth and Zacharias, a bower of seraphim (like Anna's earlier one) honors her blessed state, while angels escort the Virgin, just as they had accompanied her mother. Joseph, still estranged from Mary, appears to be getting an earful from one angel, who, pointing to Mary, clarifies once and for all her divine favor. This is a charming invention on Domenico's part, neatly solving the problem of how to show the angelic visitation that swept away Joseph's doubts. ☙

While at first sight this drawing appears to represent The Flight into Egypt—and indeed it does derive from one of Domenico's etchings on that theme—a strong case can be made for the suggestion that it may represent Mary and Joseph on the way to visit Elizabeth. The *Meditationes vitae Christi* describes the story of The Visitation at length, including in it *The Nativity* and *Circumcision of the Baptist,* with five miniatures. The first of these shows Mary and Joseph on the road, with Mary walking boldly along in the countryside, as here (Ragusa and Green 1961 [15]). Domenico's etching shows her holding the infant Jesus, but here she is clearly without the child. The glory of angels establishes a link with the earlier *Angels Leading Anna Away from Her House* (pl. 9). ❧

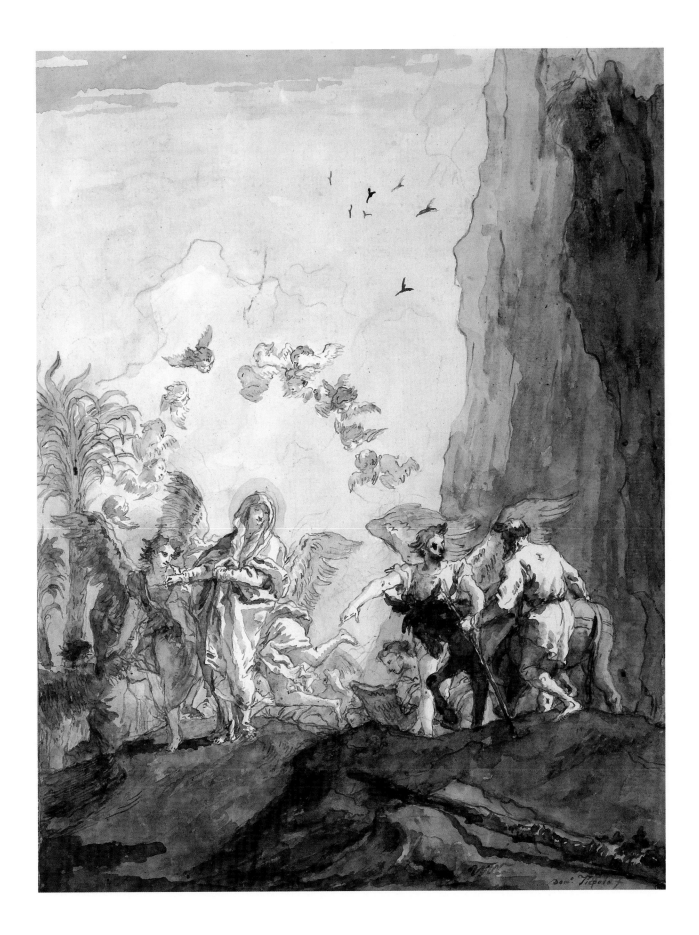

33. *The Visitation*

And it came to pass, that, when Elizabeth heard the salutation of Mary, the babe leapt in her womb; and Elizabeth was filled with the Holy Ghost: and she spake out with a loud voice, and said, Blessed art thou among women, and blessed is the fruit of thy womb. (Luke 1:41–42)

Pen and wash, over traces of black chalk, 483 x 394 / 465 x 360
Signed low left: Dom Tiepolo f
Provenance: Jean-François Gigoux, his sale, 1882, lot 178; M. Hector Brame, 68, blvd. Malsherbes, Paris 8.e; Topsfield, Mass.,
Mr. William A. Coolidge
Exhibition: Birmingham 1978, 142 [123]
Literature: Ragusa and Green 1961 [16]; Conrad 1996 [30]
Reference: Réau 1957, 195–204; Ragusa and Green 1961, 21–26; Verri 1991, 781

Boston, Museum of Fine Arts, Bequest of William A. Coolidge, 1993.30

Elizabeth has left her house and greets Mary warmly, while Zacharias peers from the door to see who has arrived. Joseph, who has begun to understand the situation, now sinks to his knees in homage before the holy women. ❧

The Feast of the Visitation is celebrated on July 2. In Luke 1:39–40 and *The Book of James* (12), the story of The Visitation does not include Joseph, whom Domenico always features. The design here is also unusual in that it presents the scene as an interior, rather than Mary meeting Elizabeth at the door of the house of Zacharias. Joseph is shown with the donkey on the left, and his presence seems to derive from the long account of the scene in *The Meditations on the Life of Christ.* ⚜

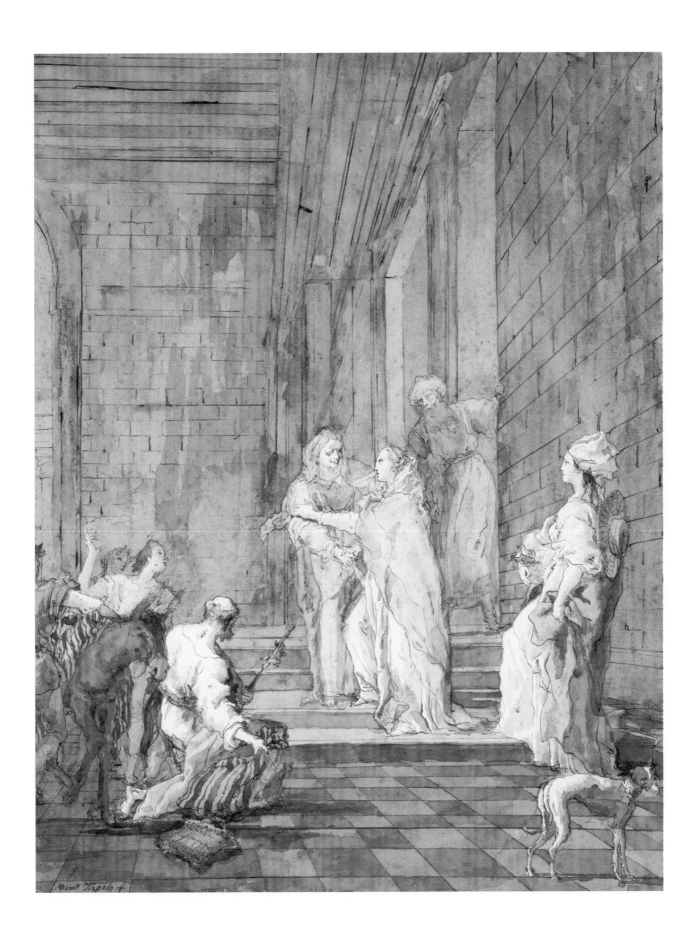

34. The Magnificat

And Mary said, My soul doth magnify the Lord, and my spirit hath rejoiced in God my Saviour, for he hath regarded the low estate of his handmaiden: for, behold, from henceforth all generations shall call me blessed. For he that is mighty hath done great things; and holy is his name. (Luke 1:46–49)

Pen and wash, over black chalk, 467 x 364
Signed low left, on the step: Dom.o Tiepolo f
Provenance: Léon Bonnat [1833–1922]
Literature: Bean 1960 [166]; Conrad 1996 [32]
Reference: Réau 1957, 206; Ragusa and Green 1951 [16]; Girardon LA 94452

Bayonne, Musée Bonnat, 1310

As Joseph and Zacharias embrace, Elizabeth venerates Mary, and angels swarm about in spiritual ecstasy, accompanied by a dazzling cloud of glory. This is all too much for the family dog, who barks excitedly at the assembly. 🌿

The absence of the Christ child suggests that this is a second scene on the theme of *The Visitation,* the setting being also quite similar to the preceding drawing but distinguished by the cloud of glory coming in at the window. It is here taken to represent the song of Mary (Luke 1:46–55). Joseph is not included in this story; here he embraces Zacharias fervently. *The Book of James* places *The Visitation* after *The Seven Virgins Drawing Lots* and *Mary Accepting the Scarlet and the Pure Purple* (pls. 18–19) and before *Joseph Taking Leave of Mary* and *Joseph Scolding Mary* (pls. 30–31). ⚜

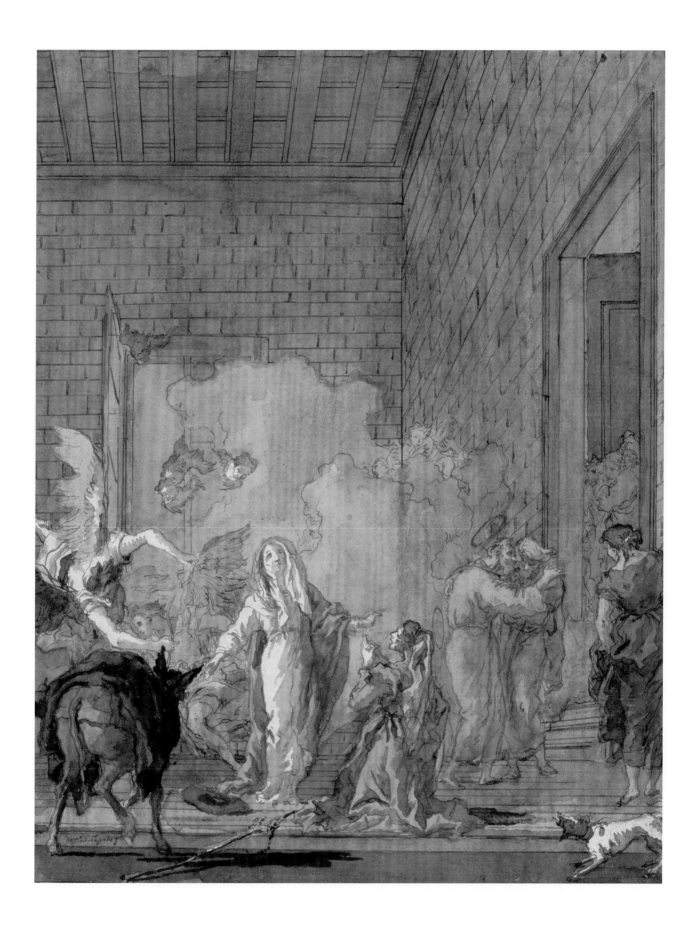

35. *Mary and Joseph Take Leave of Zacharias and Elizabeth*

And Mary abode with her about three months, and returned to her own house. (Luke 1:56)

Pen and wash, over slight black chalk, 467 x 360
Signed low left: Dom.o Tiepolo f
Provenance: Jean Fayet Durand (1806–1889)
Literature: Conrad 1996 [31]; Gealt in Udine 1996, 80
Reference: Réau 1957, 206; Maria de Agreda 1971, ii, 223; Ragusa and Green 1961 [16]

Paris, Musée du Louvre, Département des Arts Graphiques, RF 1713bis [45]

Domenico indulges his love of parting scenes by inventing this scene. Having spent three months with Elizabeth and Zacharias, Mary is now close to her confinement as she and Joseph prepare to depart. Tender embraces are exchanged among the friends as they bid each other farewell, with various servants and household members standing by respectfully. Elizabeth's lap dog barks at the proceedings, while Zacharias's hound seems profoundly saddened by the imminent parting. �ï
🌱

The scene, taking place outside the house, appears to precede or follow *The Visitation* and *The Magnificat* (pls. 33, 34). It is here taken to represent the departure of Joseph and Mary from the house of Zacharias and Elizabeth. According to Maria de Agreda, Joseph does not accompany Mary on the visit to Zacharias and Elizabeth, but he does come to fetch her when it is time to return home. ⚜

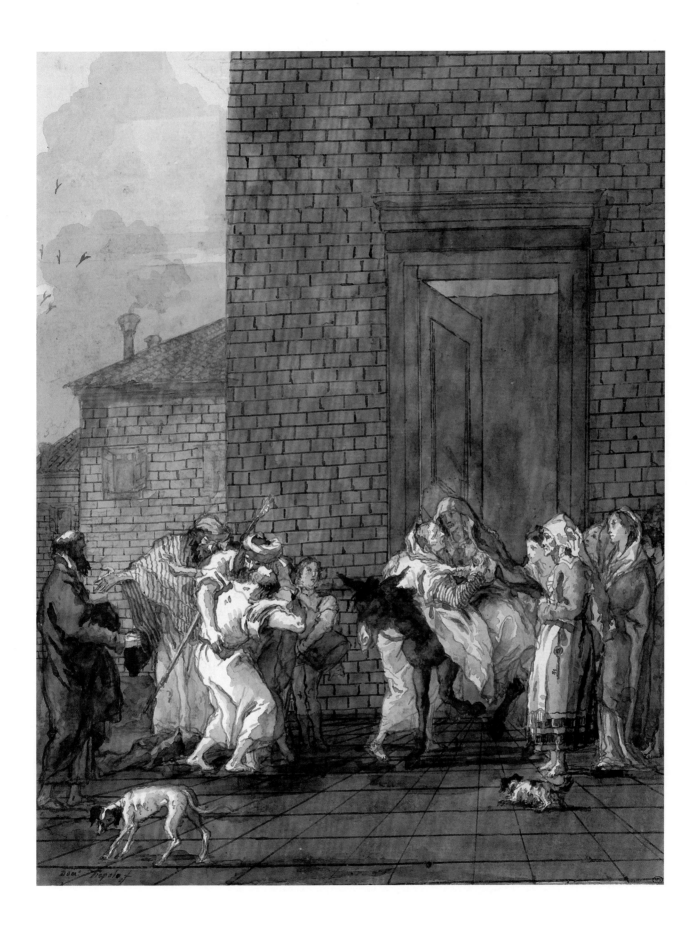

36. *The Return to Nazareth*

And Mary abode with her about three months, and returned to her own house. (Luke 1:56)

Pen and wash, over extensive black chalk, 464 x 362
Signed low left: Dom.o Tiepolo f
Literature: Conrad 1996 [28]
Reference: *The Golden Legend* 1900, v, 103; Réau 1957, 216; Ragusa and Green 1961 [20]; Maria de Agreda 1971, ii, XXIV, XXV

Paris, Musée du Louvre, Département des Arts Graphiques, RF 1713bis [44]

Domenico continues to linger over the parting of the two holy families. Here Zacharias accompanies Mary and Joseph as they start out on their journey. Mary, true to Domenico's conception, continues to lean modestly away from the now solicitous Joseph, here perhaps giving Zacharias a final message for Elizabeth. A groom leads a horse away, a familiar element in Domenico's scenes of parting or arrival in this part of his story, while the family donkey confidently trots on ahead. ❦

Alternatively it might be interpreted as Mary and Joseph setting out on the journey to Bethlehem, prior to the nativity of Christ (Luke 2:4). Maria de Agreda holds that Mary stayed with Elizabeth until after the birth and circumcision of John, following the *Meditationes vitae Christi.* ⚜

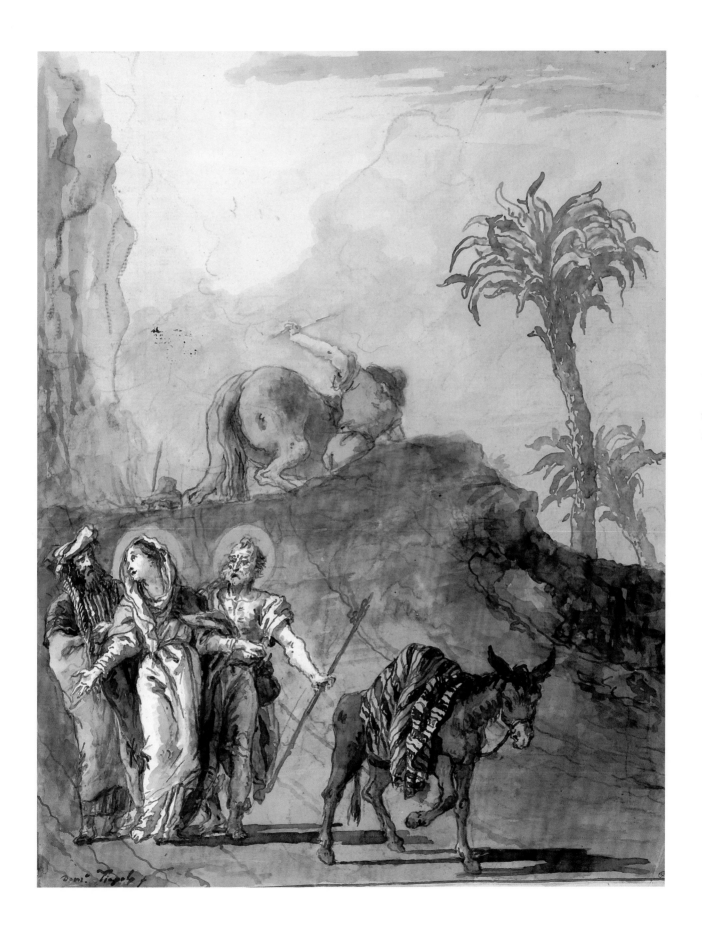

37. "*IN ECELCIS DEO*"—*The Annunciation to the Shepherds*

And, lo, the angel of the Lord came upon them, and the glory of the Lord shone round about them: and they were sore afraid. (Luke 2:9)

Pen and wash, 476 x 374
Signed low left: Dom.o Tiepolo f
Provenance: Roger Cormier, Tours, his sale, Paris, Georges Petit, Apr. 30, 1921, no. 1; Paris, Wildenstein; Christie's, New York, July 7, 1998 [150]
Exhibition: Baltimore 1978 [55]
Literature: Guerlain 1921, 41; Conrad 1996 [34]
Reference: *The Golden Legend* 1900, i, 25–28; Patrignani 1715–1722

Less interested in Mary and Joseph's journey to Bethlehem than he had been in their departure from Zacharias and Elizabeth, Domenico ignores that journey and begins Christ's nativity with a celebratory scene. A pair of banner-wielding angels delivers the joyous news to a group of poor and ragged shepherds gathered round their cottage with its neatly thatched roof. A vast flock of sheep are in the distance and a flourishing tree alludes to birth and fecundity. With their striped hose and patched coats, Domenico's peasants have a distinctly eighteenth-century appearance. They respond to the angels with unself-conscious reverence rather than fear. ❦

A relatively rare subject in Italy compared with *The Adoration of the Shepherds,* which is essentially a Nativity (pl. 38), Domenico expands what is often a background scene into a full-fledged independent episode. For a full account of The Nativity of our Lord, see *The Golden Legend* and Patrignani (1715–1722). The strange man with his back turned to the right foreground seems an unlikely shepherd. ✣

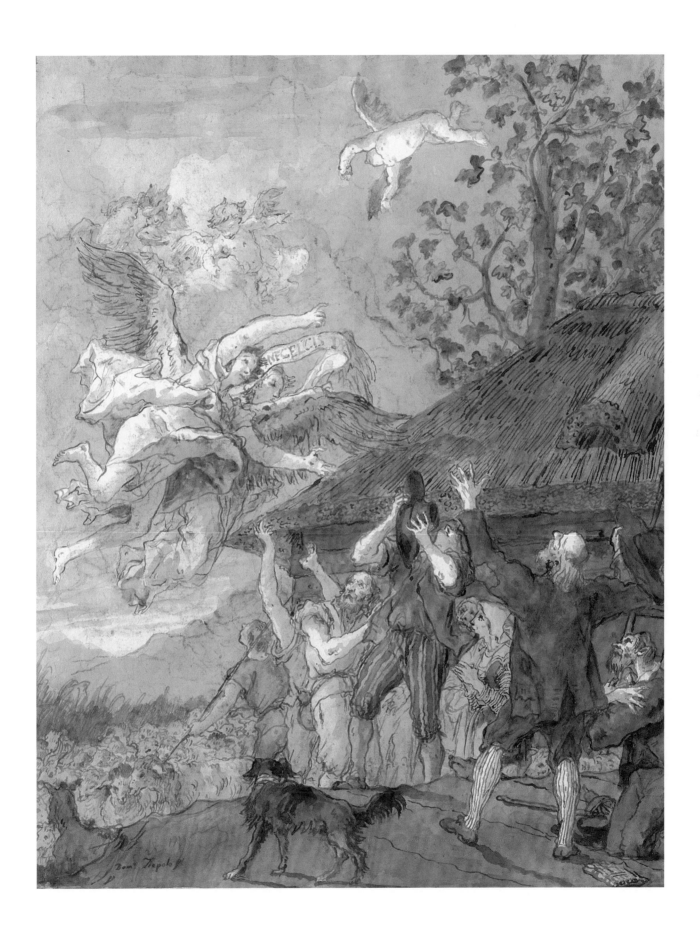

38. *The Adoration of the Shepherds*

And they came with haste, and found Mary, and Joseph, and their babe lying in a manger. And when they had seen it, they made known abroad the saying which was told them concerning this child. (Luke 2:6–18)

Pen and wash, over black chalk, 467 x 353
Signed low right: Dom.o Tiepolo f
Provenance: Jean Fayet Durand (1806–1889)
Literature: Conrad 1996 [35]
Reference: Maria de Agreda 1685, iv, XI; Réau 1957, iii, 233; Verri 1991, 763–788

Paris, Musée du Louvre, Département des Arts Graphiques, RF 1713bis [49]

The number of angels dwindles down to a few cherubim as the mood shifts from celebration to veneration. Crowded round the stable, shepherds bring offerings and kneel humbly before the Holy Family. Mary holds the infant up for them to see. His crib is emphatically shaped like a cross, which introduces the idea of Christ's ultimately sacrificial role. ✔

Domenico treats the scene in a somewhat unusual way. First, the setting appears to be an exterior, not the semi-interior that is usually suggested, and the sky is so lit with glory that it is barely recognizable as a night scene. On the other hand, the lighting of the figures apparently emanates from the infant Jesus, as is usual. The figures form a richly varied group, with a shepherd carrying a lamb and a woman with a basket of eggs. It is instructive to compare this treatment to early works of Domenico, especially the drawing in Milan (Udine 1996: [14]) and the painting at Stockholm (Mariuz 1971: [63]). ❧

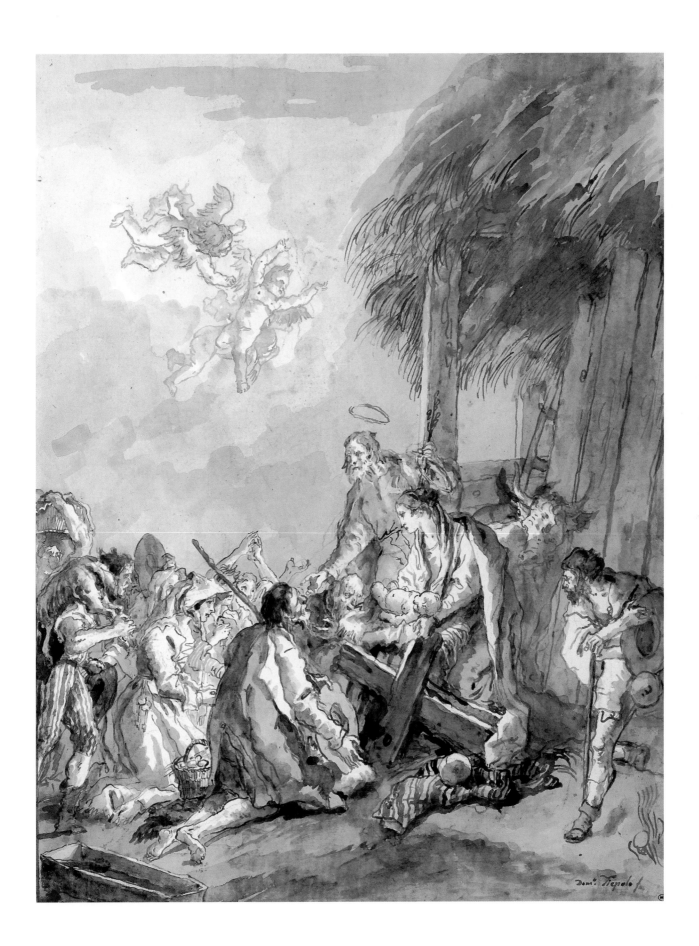

39. *The Circumcision of Jesus*

And when the eight days were accomplished for the circumcising of the child, his name was called JESUS, which was so named of the angel before he was conceived in the womb. (Luke 2:21)

Pen and wash, over heavy black chalk, 465 x 355
Signed low right: Dom.o Tiepolo f
Provenance: Léon Suzor, his sale, Paris, Hôtel Drouot, March 16, 1996 [63]
Exhibition: Udine, 1996, [98]; Tübingen, 2005 [30] (in memory of owners' grandfather and father)
Reference: *The Golden Legend* 1900, i, 28–41; Lippomani 1581, i, 1; Réau 1957, 256–260; Verri 1991, 784

Zürich, private collection

The sacrificial theme continues as Mary, watching her infant son's "first shedding of blood," stands in somber silhouette as she should later appear when confronting Christ's mature sufferings. Her attention is riveted on her son, whom the priest, holding a dangerous-looking knife, prepares to circumcise. Joseph, at some distance from her, turns solicitously toward Mary, offering words of comfort as the ceremony proceeds. Placed before a noble doorway crowned by curtains, this ritual takes on a mystical air of transformation. ❦

The Feast of the Circumcision is celebrated on January 1. The scene, which is mentioned only by Luke, is not found in the earlier visual sources, but a full account is given in *The Golden Legend,* and in the *Vita Christi* of Ludolph of Saxony (cap. X). The subject is often barely distinguishable from *The Presentation in the Temple,* also described only in Luke 2:22 (pl. 41), which followed on the fortieth day after the Nativity. The cloud of smoke indicates the presence of the Almighty. ⚜

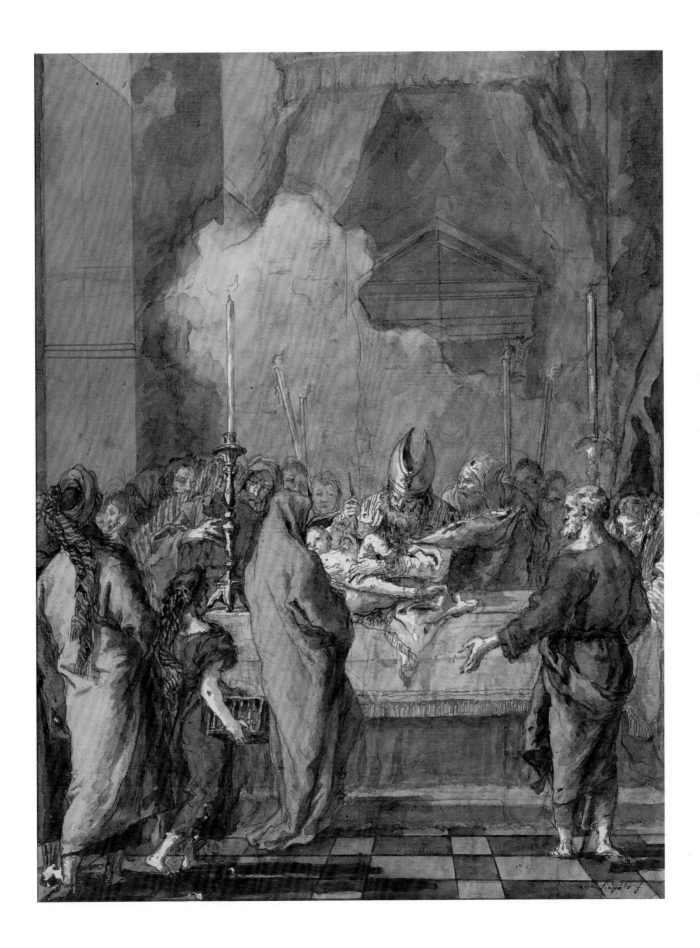

40. *The Adoration of the Kings*

And when they were come into the house, they saw the young child with Mary his mother, and fell down, and worshipped him; and when they had opened their treasures, they presented unto him gifts: gold, and frankincense, and myrrh. (Matt. 2:11)

The Feast of the Epiphany of our Lord is adorned of four miracles, and after them it hath four names, On this day the kings worshipped Jesu Christ, and S. John Baptist baptized him. And Jesu Christ changed this day water into wine, and he fed five thousand men with five loaves of bread. (The Golden Legend)

> Pen and wash, over extensive black chalk, 466 x 360
> Not signed
> Provenance: Jean Fayet Durand (1806–1889)
> Literature: Conrad 1996 [37]
> Reference: Maria de Agreda 1685, iv, XV–XVI; *The Golden Legend* 1900, i, 41–52, under Epiphany; Réau 1957, iii, 246–252; Verri 1991, 783

Paris, Musée du Louvre, Département des Arts Graphiques, RF 1713bis [51]

Still residing at the stable (the roof of which has now been more neatly thatched), Mary presents her infant son to the three Magi. The star they have followed radiates down upon them, accompanied by a larger group of festive cherubim and seraphim. Nearly always shown kneeling, the kings still stand here. Their reverence toward the infant is evident nonetheless as they gaze with clasped hands upon the Christ child. His swaddled appearance (often a reference to his burial cloths) and the discarded tomb slab near Mary continue the somber portents of the future. ✺

Epiphany is celebrated on January 6, after Twelfth Night. It is described at length in *The Golden Legend,* in the *Vita Christi* (cap. xi), and by Maria de Agreda. The arrangement of the space here is unusually confused, with a large crowd flowing in on the right and a walled building giving way to a landscape. ⚜

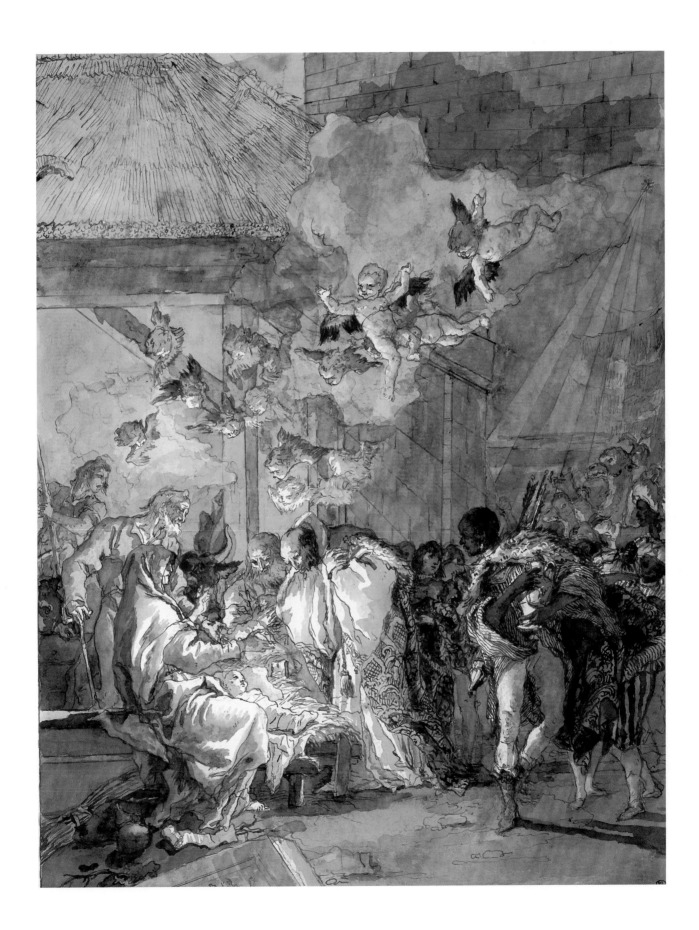

41. *The Presentation of Jesus in the Temple*

And when the days of her purification according to the law of Moses were accomplished, they brought him to Jerusalem, to present him to the Lord. (Luke 2:22)

Pen and wash, over black chalk, 491 x 385, sheet; 470 x 363, image
Signed low right: Dom. Tiepolo f
Provenance: M.L.T.; Paris, Hôtel Drouot, June 26, 1913 [110]; Paris, Henri Goudechaux; Thomas le Claire, 1987 [40]
Exhibition: Hamburg 1987, IV [40]; Vaduz 1995 [42]; New York 1996 [42]
Literature: Conrad 1996 [38]
Reference: *The Golden Legend* 1900, i, 28–41, under February 2; Verri 1991, 784–785

Vaduz, Wolfgang Ratjen Foundation, Inc., no. R930

Having returned to the temple for her purification, the Virgin presents her child to the priest in the manner of an "offering," giving this scene a sacrificial overtone as well. The aged priest Simeon spreads his arms in awe, as he recognizes God's instrument of salvation—"a light for the revelation to the Gentiles and the Glory to thy people of Israel" (Luke 2:29–32). That mixed populace stands in the foreground, represented by the dark cloaked figure and the Jewish patriarch. ❦

The Purification of the Blessed Virgin Mary, which is told only by Luke, is celebrated on February 2, the fortieth day after the birth of Christ. Luke follows with the meeting with Simeon, the song of Simeon, and the meeting with Anna the prophetess. The story is told at length in *The Golden Legend* and in the *Vita Christi* (cap. xi). Sometimes Simeon is identified as the high priest, and here the standing woman on the left may be Anna. Very unusually, in this case the design is left unfinished. ⚜

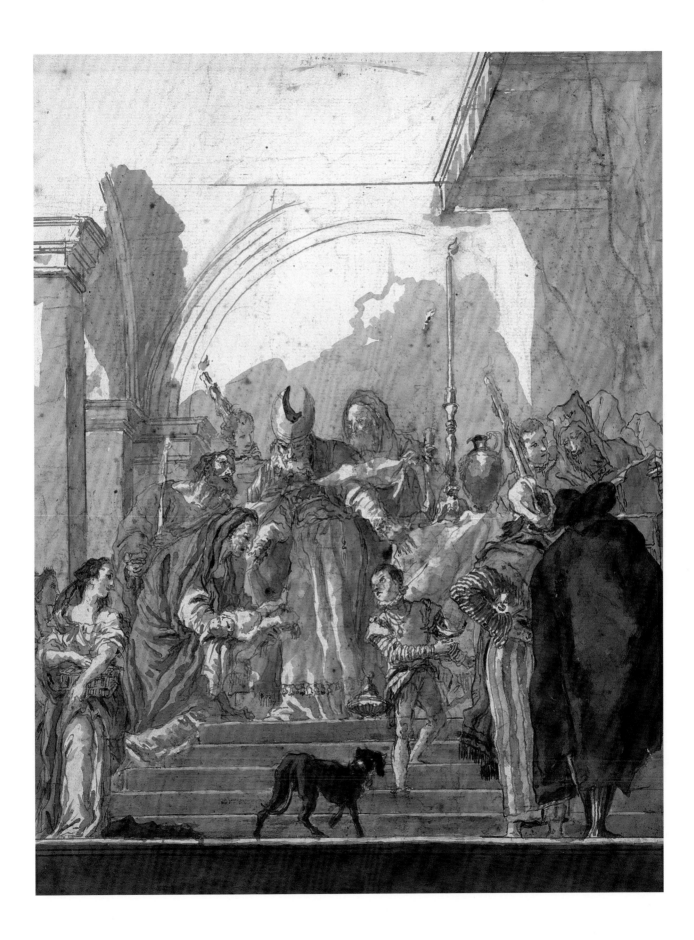

✿ Part III

The Massacre of the Innocents and the Flight and Sojourn into Egypt;
The Return from Egypt up to Joseph's Death, Plates 42–81

This stage of Christ's infancy receives limited discussion in the Gospels. Only Matthew tells the story of Herod's slaughter of the innocents, and does so in three brief verses. Matthew 2:1–18 relates that King Herod, having realized the Eastern Magi had not returned to tell him where the "new king" was, ordered all the children under two to be slaughtered, to protect his own power. Forewarned by an angel in a dream to flee to Egypt, the Holy Family escaped. Apocryphal sources—notably, the *Book of James,* the *Liber de Infantia,* and the *Arabic Gospel*—offer additional details. Each source describes different adventures for the Holy Family, ranging from falling idols to dragons in caves. Very few of these episodes have entered the visual canon.

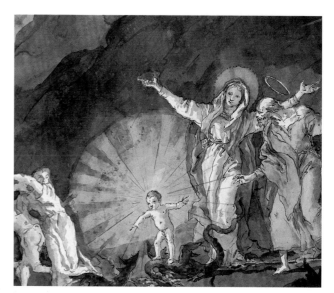

Detail of Jesus astride a dragon from plate 55, *Jesus and the Dragons*

The Massacre of the Innocents and the Flight into Egypt became fairly standard subjects, but generally took up no more than one or at most two frames in mural cycles. The Holy Family resting became an immensely popular subject for painters, who over the centuries sometimes included references to the miraculously bending palm tree. Domenico uniquely expanded this part of Christ's infancy into 34 drawings, culling no fewer than nineteen miraculous encounters from arcane sources. Besides depicting the famous palm tree bending to refresh the Holy Family with its fruits, Domenico illustrated far more rare episodes

154

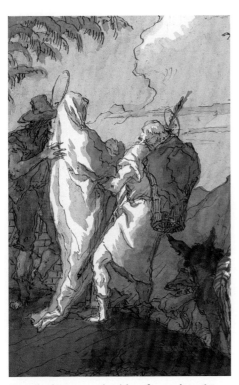

Detail of Mary and robber from plate 67,
The Holy Family Goes with the Robbers

involving tame beasts, defeated dragons, obsequious trees, and miraculous springs. Most remarkable is his fascination with the story of the robbers (the future good and bad thieves at Christ's Crucifixion), which transpires over four scenes. Knitting these disparate adventures together with drawings of entrances and exits, Domenico ends his chapter on Christ's infancy with a fairly traditional scene of a partially grown Jesus guiding his parents home, followed by a more unusual episode of the youthful Jesus leading his parents to Jerusalem. Domenico concludes Christ's childhood with Jesus in the Temple, wherein Jesus, Mary, and Joseph are transformed into eighteenth-century peasants. He ends this section with touching scenes of Joseph's death and ascent into heaven, which rarely, if ever, became standard parts of picture cycles.

42. *Herod Consults with the Wise Men and the Priests*

And when he had gathered all the chief priests and scribes of the people together, he demanded of them where the Christ should be born. (Matt. 2:1–8)

Pen and wash, over black chalk, 462 x 365
Signed low left: Dom. Tiepolo f
Provenance: Roger Cormier, Tours, his sale, Paris, Georges Petit, Apr. 30, 1921, no. 9
Exhibition: Williamstown 1961 [ix]
Literature: Havercamp-Begemann 1964, cat. 64 [59]; Conrad 1996 [36]
Reference: Patrignani 1715–1722; Rohault 1874 [XVI] cites Santa Maria Maggiore; Pigler 1956, i, 248; Réau 1957, 245

Williamstown, Massachusetts, The Sterling and Francine Clark Art Institute, 1460

As Herod discourses with the three Magi seated upon his raised dais, a group of priests attempt to answer his questions regarding the new king's whereabouts. At the right, one elder eagerly consults his texts, while to the left, in the background, Herod's soldiers have gathered, their pikes signaling their readiness for action. ❦

In his *New Testament,* Domenico devotes 40 drawings to the story of the Flight into Egypt. These are here divided into two sections: the first dealing with events up to the arrival in Egypt (18 items) and the second dealing with the events in Egypt and the return journey to Judaea, down to the death and apotheosis of Joseph (22 items). The story of the Massacre of the Innocents and the Flight into Egypt is told very briefly in Matthew 2, and omitted entirely in the other Gospels. Domenico had already created an imaginative series of etchings on this theme, the *Idee pittoresche sopra la Fugga in Egitto,* published in 1753, and he draws heavily on that material in many of these drawings, for which we can often find no related text. However, we now find in addition numerous scenes drawn from the *Liber de Infantia* and *The Arabic Gospels,* most of which disappeared from the repertory of Western art at the end of the Middle Ages. ❧

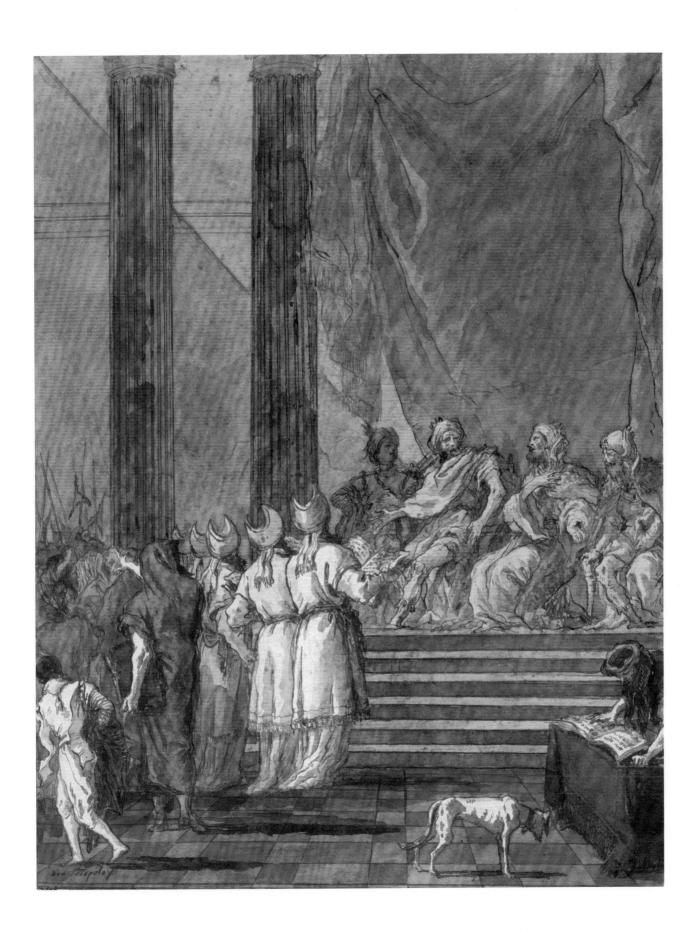

43. *The Massacre of the Innocents*

And Herod, when he saw that he was mocked of the wise men, was exceeding wroth, and sent forth, and slew all the children that were in Bethlehem, and in all the coasts thereof, from two years old and under, according to the time which he had diligently inquired of the wise men. (Matt. 2:16)

Pen and wash over black chalk, 468 x 362, trimmed to the border line
Signed low right: Dom.o Tiepolo f
Provenance: Charles Fairfax Murray, said to have been acquired in 1905; J. Pierpont Morgan 1910
Exhibition: Chicago 1938, pl. 88
Literature: Fairfax Murray 1912 [IV.149]; Conrad 1996 [41]
Reference: *The Golden Legend* 1900, ii, 176–182; Pigler 1956, i, 251–258; Réau 1957, 267–272

New York, The Pierpont Morgan Library, Fairfax Murray Collection, IV.149

As lifeless infants lie strewn in the foreground, the soldiers continue their bloody rampage. One hapless woman flails helplessly at the soldier, who prepares a fatal thrust. A tangle of arms and legs and torsos bespeak of an ongoing massacre, which continues off stage. The only note of calm is the horse, which has turned his back on this inhuman brutality. ❦

The Massacre of the Innocents has an extensive visual history. There are a number of especially powerful examples by Sienese masters, including Matteo di Giovanni. There is a full account of The History of the Innocents in *The Golden Legend*. It is curious that Anna Jameson, in her long account of the event (Jameson 1890, i, 259–272) suggests that the subject only became frequent after the establishment of the *Ospedale degli Innocenti* in Florence in 1444, but she cites a formidable array of depictions of the sixteenth and seventeenth centuries. The cult of the innocents traces back to the early Church, where they were regarded as the first martyrs. ⚜

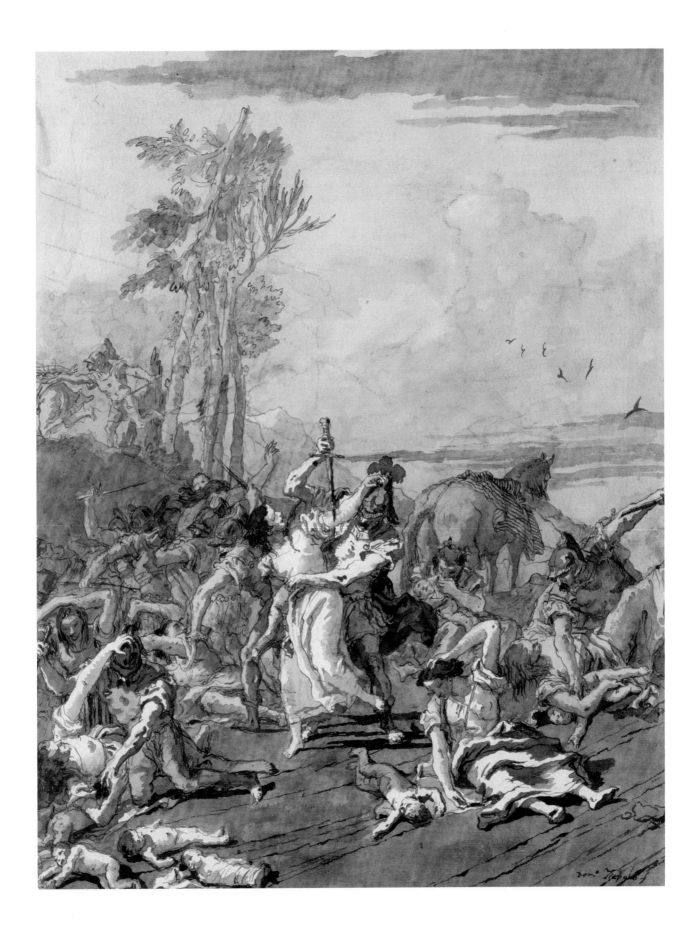

44. *The Holy Family with the Young John the Baptist and Angels*

Then the Blessed Virgin departed from Jerusalem and went to Elizabeth, wishing to see John before departing that region. Go always with her wherever she goes and help to carry Jesus. When they arrived there was great festivity, especially about their children. . . . When they had stayed a few days in that district, they left, wishing to return to Nazareth. (Meditations on the Life of Christ, 64–65)

> Pen and wash, over black chalk, 460 x 354
> Signed low left: Dom.o Tiepolo f
> Provenance: Jean Fayet Durand (1806–1889)
> Literature: Ragusa and Green 1961, 64, 65; Conrad 1996 [63]

Paris, Musée du Louvre, Département des Arts Graphiques, RF 1713bis [48]

Before considering the Flight and Sojourn into Egypt, Domenico developed three scenes of Mary, Joseph, and the baby with John the Baptist and, later, his parents. A story line can be developed among the three. In this scene, here taken to be the first, Joseph tends the donkey as Mary dandles Jesus and John rushes up to hug the child. As four angels kneel in reverent adoration, another angel bursts into the scene, perhaps to deliver urgent news about the imminent danger of Herod and his soldiers. ✹

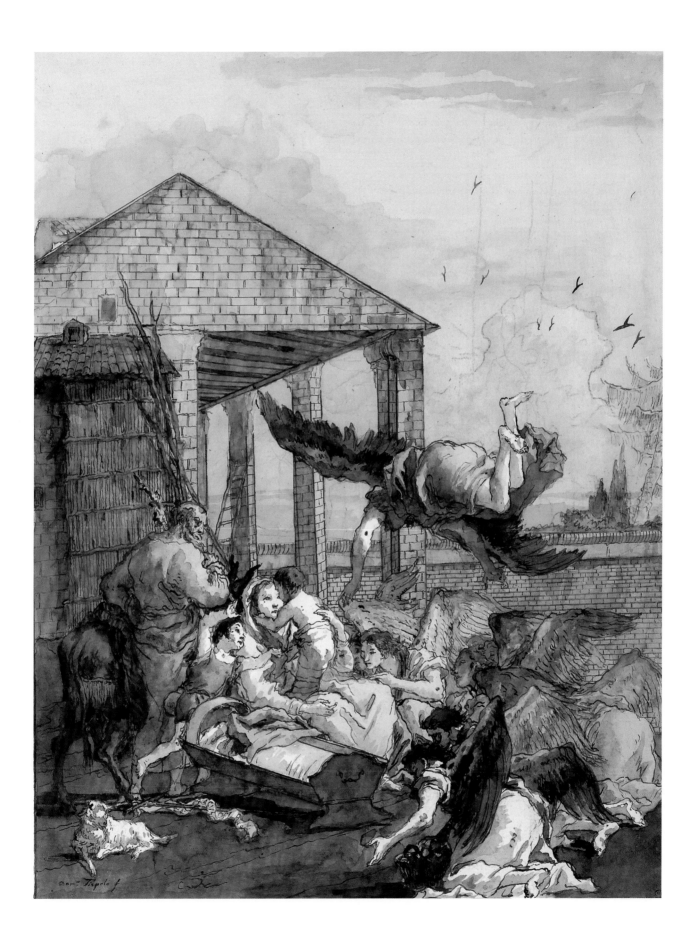

45. *The Holy Family Visits Zacharias, Elizabeth, and the Young John*

Then the Blessed Virgin departed from Jerusalem and went to Elizabeth, wishing to see John before departing that region. Go always with her wherever she goes and help to carry Jesus. When they arrived there was great festivity, especially about the children . . . When they had stayed a few days in that district, they left, wishing to return to Nazareth. (Meditations on the Life of Christ, 64–65)

Pen, bistre, Indian ink and brown washes, over black chalk, 459 x 361
Signed low left: Dom.o Tiepolo f
Provenance: Jean Fayet Durand (1806–1889)
Literature: Ragusa and Green 1961, 64, 65; Conrad 1996 [39]

Paris, Musée du Louvre, Département des Arts Graphiques, RF 1713bis [52]

Here the two families gather in a state of mystical rapture that, once again, hints of imminent dangers as well as future martyrdoms. Several angels continue their veneration of the group, while the flying angel (now assuming the familiar pose he had when stopping Abraham's sacrifice) delivers a martyr's wreath. As the Holy Ghost sends his blessing, Joseph lifts the swaddled Christ child toward this angel, and Elizabeth and Mary kneel in adoration. John the Baptist clutches at Joseph's robes and Zacharias raises his hands in prayerful veneration. Possibly a product of Domenico's imagination, the scene might also illustrate an as yet unidentified legend or prayer. ❧

The story of the visit of the Holy Family to the young John the Baptist and his parents before the Flight into Egypt is told in the *Meditationes vitae Christi* (Ragusa and Green 1961: [54]) between The Presentation in the Temple and The Flight into Egypt. The scene might also be interpreted as The Infant Jesus Acknowledged by Simeon and Anna (Luke 2:25–38), though this scene should take place in the Temple and not in the presence of the young John the Baptist. On the other hand, the main tradition holds that Zacharias was murdered when John was an infant. See also the previous drawing, which includes the young John but not his parents (pl. 44). This drawing is noteworthy for the presence of the angel with the crown of martyrdom and the Holy Spirit. ✣

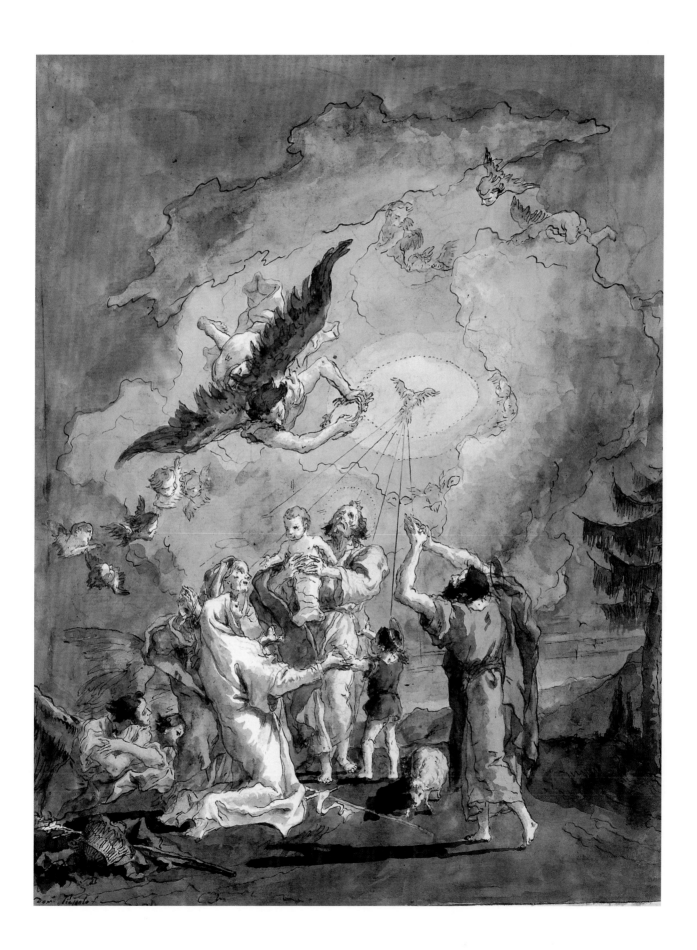

46. *The Holy Family with Elizabeth, Zacharias, and the Young John*

Then the Blessed Virgin departed from Jerusalem and went to Elizabeth, wishing to see John before departing that region. Go always with her wherever she goes and help to carry Jesus. When they arrived there was great festivity, especially about the children. . . . When they had stayed a few days in that district, they left, wishing to return to Nazareth. (Meditations on the Life of Christ, 64–65)

> Pen and wash, over slight black chalk, 468 x 362, trimmed close to the image
> Not signed
> Provenance: Jean-François Gigoux (1806–1894), his bequest, 1894
> Literature: Conrad 1996 [40]
> Reference: Patrignani 1715–1722; Pigler 1956, i, 250–251; Réau 1957, 273–274; Ragusa and Green 1961, 64–65; Verri 1991, 772–773

Besançon, Musée des Beaux-Arts et d'Archéologie, 2234

The two families are now inside the home of Zacharias and Elizabeth, and one can assume that this and the previous scene show them just before both must flee before Herod's wrath. Here Mary watches Elizabeth holding the infant Jesus toward John the Baptist. The flurry of angels surrounds them in a cloud of glory and their agitation adds a sense of urgency. Joseph gestures toward the door, indicating that one of the angels has delivered the message he traditionally receives in his sleep. Their departure begins in the next episode (pl. 47). ✺

The *Pseudo-Bonaventura* relates that before the Holy Family set out on the Flight into Egypt, they turned aside to visit Zacharias, Elizabeth, and the young John the Baptist once again. Here the setting is similar to *The Visitation* and *The Magnificat* (pls. 33–34). Another version is found in plate 45, though that is set in the open air. On the return from Egypt they once again encounter the young John on the edge of the desert (see pl. 75), when both the children are shown much older. The present scene appears to represent the first of these occasions, showing a miraculous scene in a Venetian interior, with Elizabeth seated holding the child and Zacharias standing beside her, surrounded by a glory of angels that illuminates the rather dark interior. The young John stands before Jesus, holding a symbolic cross in his left hand, but he already appears to be some two or three years old. Domenico shows a special interest in these rare scenes, as may also be noted in plate 84, which shows Elizabeth and the infant John fleeing into the wilderness. The story of Zacharias, Elizabeth, and the infant John the Baptist is perforce somewhat scattered here; some scenes are associated with *The Visitation* (pls. 32–36); some are placed before and after *The Flight into Egypt* (pls. 44–46); and some with *The Story of John the Baptist* (pls. 82–102). ⚜

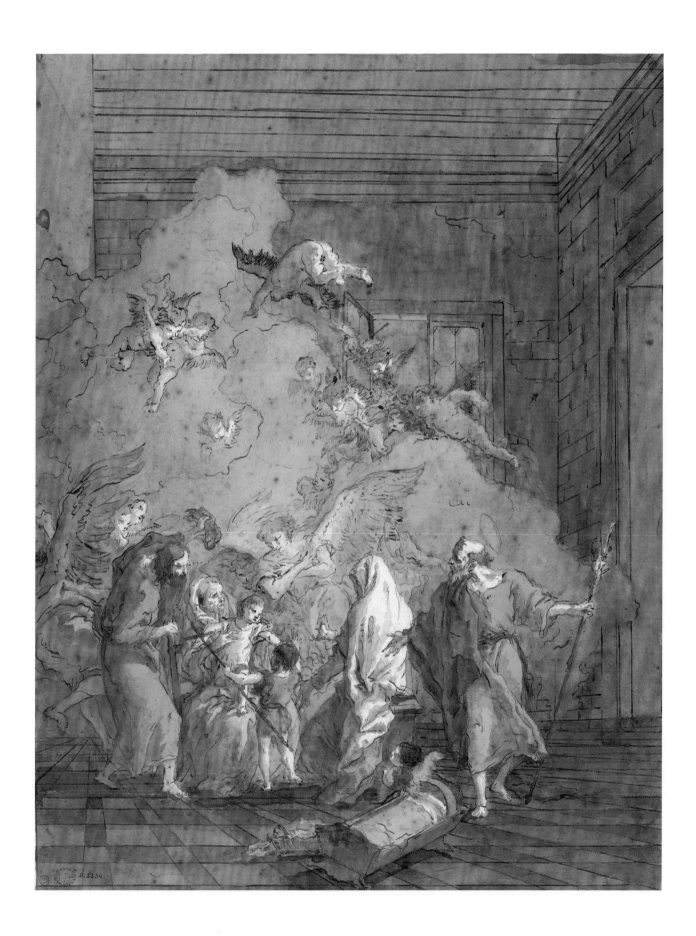

47. *The Holy Family Leaves the House*

When he arose, he took the young child and his mother by night, and departed into Egypt. (Matt. 2:14)

Pen and wash, over heavy black chalk, 455 x 355
Signed lower left: Dom.o Tiepolo f
Provenance: Roger Cormier, Tours, his sale, Paris, Georges Petit, Apr. 30, 1921, no. 48; Paris, Galerie Kraus, 1978; Miss Lovice
Ullein-Reviczky, Zürich; Christie's, New York, January 30, 1997 [83]
Literature: Byam Shaw and Knox 1987, 138, note 1; Verri 1991, 773–775; Gealt in Udine 1996, 79

Paris, private collection

Stopping briefly to bid farewell to some assembled peasants, Mary, having donned a pilgrim's hat, prepares to depart. The cloud of glory that had built up in the previous scene now bursts out of the doorway, although Elizabeth and Zacharias are nowhere to be seen. Joseph, ever solicitous, politely urges Mary to hurry. As several angels stand inside the doorway, another hovers anxiously at the right, holding the donkey's reins at the ready and adding to the sense of urgency. 🖋

The Flight into Egypt, which is mentioned only briefly in the Gospels in Matthew 2, is described fully in the Latin *Liber de Infantia* of the mid-ninth century, later dubbed the *Pseudo-Matthew* (James 1924, 70–79). We will refer to this material because it may be associated with individual drawings. This specimen is clearly one of the later creations of the series. It is conceived as a night scene, and the dark cloud billowing out of the doorway may be taken to indicate the presence of the Almighty. ⚜

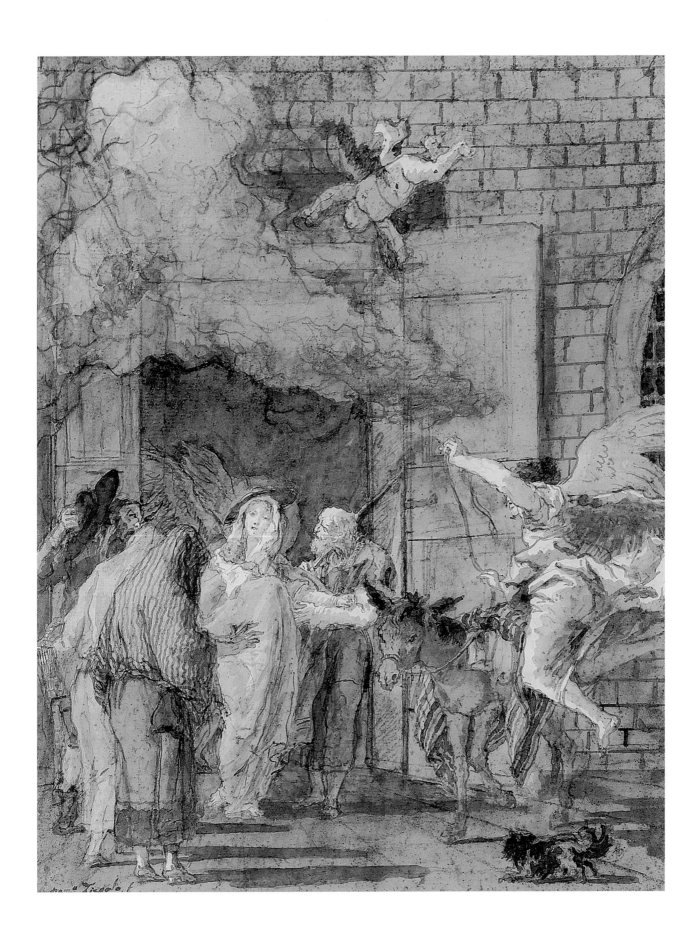

48. *The Flight into Egypt with the Almighty*

In order to save the life of thy Son and raise him up, Thou must leave thy home and thy country, fly with him and thy spouse Joseph into Egypt, where thou art to remain until I shall ordain otherwise: for Herod is seeking the life of the Child. The journey is long, most laborious and most fatiguing; do thou suffer it all for my sake; for I am, and always will be, with Thee. (Maria de Agreda, iv, 519)

Pen and wash, over traces of black chalk, 460 x 355, trimmed to the borderline
Signed low right: Dom.o Tiepolo f
Provenance: Charles Fairfax Murray; J. Pierpont Morgan, 1910
Exhibition: Chicago 1938, pl. 87; New York 1938 [72]; Udine 1996 [92]
Literature: Fairfax Murray 1912 [IV.148]; Conrad 1996 [50]
Reference: Réau 1957, 273–288

New York, The Pierpont Morgan Library, Fairfax Murray Collection, IV.148

The angel that first flew in to warn of their danger (pl. 44) now leads the way as the Holy Family's journey gets underway, under the protection of angels and watched over by God the Father and the Holy Ghost. Their presence marks a confluence of the earthly and heavenly Trinity. Soberly confronting her future, the Virgin has the shrouded silhouette we saw earlier, while the lead angel points heavenward, indicating God's presence. ❦

We here suppose that Domenico wished to associate the Almighty with *The Flight into Egypt* from the very beginning, as did Maria de Agreda: the figure is drawn from the etching, *Flight into Egypt 8,* but not perhaps with the same urgency as here. This is a further specimen of the group of eight sheets published by Charles Fairfax Murray in 1912. He apparently acquired them in 1905, from an unknown source, so they are independent of the Cormier group, although we suppose that they derive from the *Recueil Luzarche*. Some nineteen sheets of the present series, and sixteen in the *Recueil Fayet,* illustrate the theme of *The Flight into Egypt,* no doubt deriving essentially from Domenico's early set of 22 etchings published in 1753. ⚜

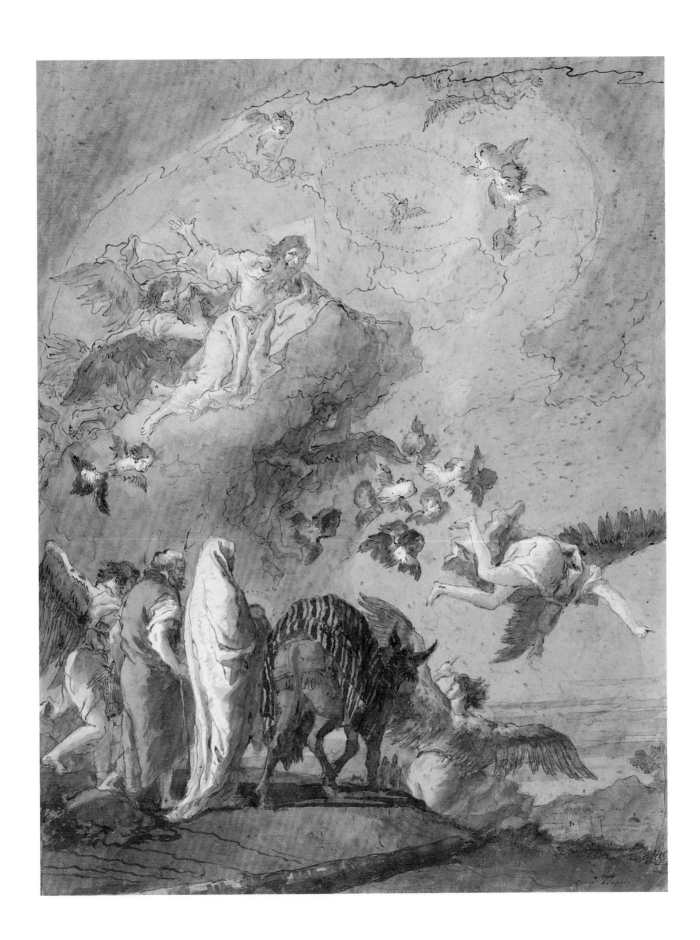

49. *The Flight into Egypt on a Mountain Road*

He was carried to Egypt by the very young and tender mother and by the aged, saintly Joseph, along wild roads, obscure, rocky and difficult, through woods and uninhabited places—a very long journey. (Meditations on the Life of Christ)

Pen and wash, over extensive black chalk, 466 x 360
Signed low right: Dom.o Tiepolo f
Provenance: Jean Fayet Durand (1806–1889)
Literature: Ragusa and Green 1961, 68; Maria de Agreda 1971, ii, 552; Conrad 1996 [52]

Paris, Musée du Louvre, Département des Arts Graphiques, RF 1713bis [55]

Two angels and a cherub hover protectively as Mary and the Christ child negotiate a mountainous precipice. One angel appears to urge Mary to move nearer the cliff, but her expression here is mild and unperturbed as she views what must be a steep drop below her. Joseph looks back most anxiously as he leads the way along this difficult terrain. Domenico developed this feeling of danger beyond any traditional images known to us.

Domenico here devises an extremely dramatic setting: a mountain road with crags to the right and a precipice on the left. Something of the passion behind the drawing is suggested by the vigorous underdrawing in black chalk, and one might suppose that it enshrines a memory of Domenico's own travels through the Alps. Certainly it is the wilderness as established in *The Sacrifice of Abraham* (pl. 1). ❧

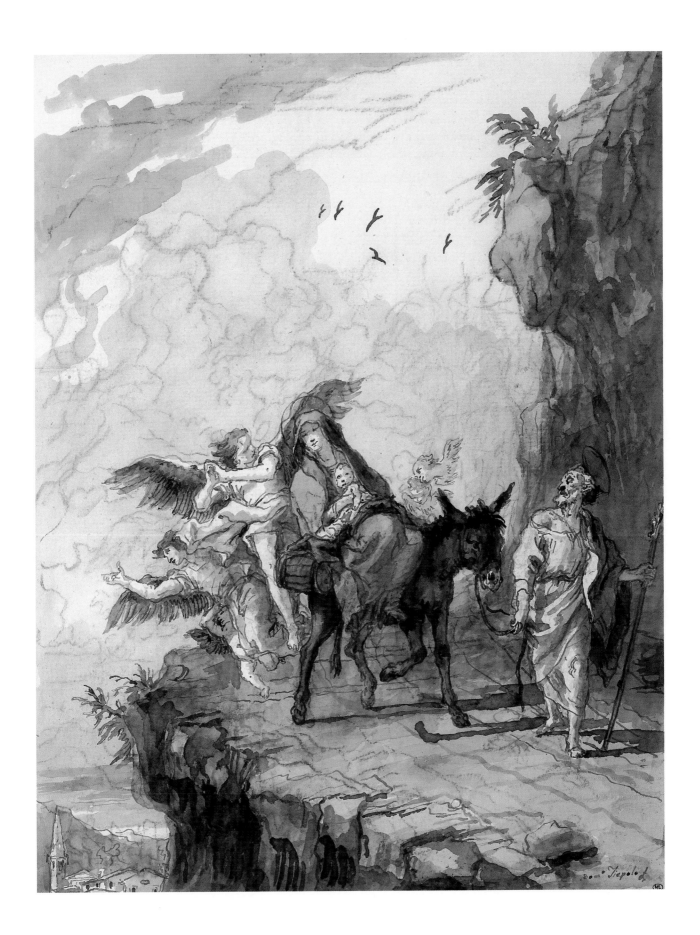

50. *The Rest on the Flight into Egypt*

During all this journey of sixty leagues through the desert they had no other night-shelter than the sky and open air. . . .
During that night the ten thousand angels who, full of marvel, assisted these earthly Pilgrims in visible human shapes,
formed a guard around their King and Queen. (Maria de Agreda 1971, ii, 540)

Pen and brown and gray Indian ink wash, over black chalk, 460 x 364
Signed low left: Dom.o Tiepolo f
Provenance: Jean Fayet Durand (1806–1889)
Literature: Maria de Agreda 1971, ii, 540; Conrad 1996 [55]

Paris, Musée du Louvre, Département des Arts Graphiques, RF 1713bis [57]

Still within the dangerous mountain terrain, the Holy Family stops at a fairly inhospitable location to take its first
rest. Undaunted, their mood is cheerful. Joseph, now a doting father, dandles the Christ Child, who kisses his
cheek. Mary, so enchanted by this tender exchange, ignores the prostrate angel kissing her feet and offers Joseph
refreshment from the basket the angels hold. Meanwhile, a tiny cherubim decides to play with the donkey. Too
tired to respond, the donkey ignores him. ❦

Here Domenico creates a masterly grouping, starting with the donkey low on the left and rising steadily to the
great winged angel on the right. Maria de Agreda seems to be a valuable literary source for the angels surrounding
the Holy Family on the Flight into Egypt, which are so prominent in this design and in others. Still deep in the
wilderness, the scene is one of relaxation; even the donkey is caressed by an angel. ⚜

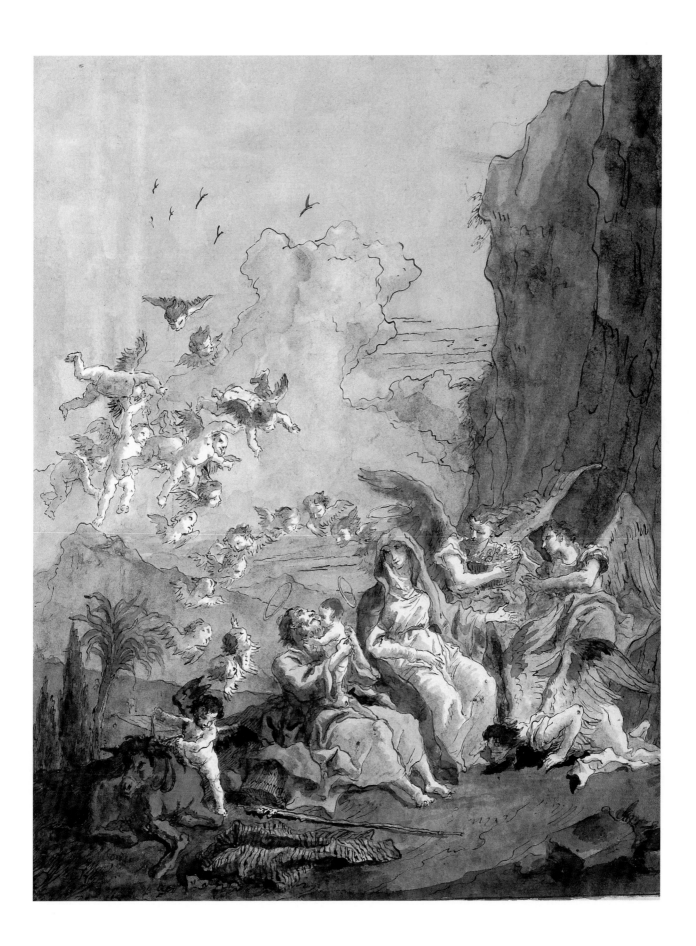

51. *The Flight into Egypt, after Castiglione*

In like manner lions and leopards adored him and accompanied them, showed them the way, and bowed their heads to Jesus. At first Mary was afraid, but Jesus smiled on her and reassured her. The lions never injured their oxen and asses or the sheep that they had brought from Judaea. (Pseudo-Matthew, 19)

Pen and wash over black chalk, 465 x 360, trimmed to the borderline
Signed low left: Dom.o Tiepolo f
Provenance: Charles Fairfax Murray; J. Pierpont Morgan, 1910
Exhibition: New York 1971 [256]; Birmingham 1978 [105]
Literature: Fairfax Murray 1912 [IV, 147]; Conrad 1996 [54]
Reference: James 1924, 75

New York, The Pierpont Morgan Library, Fairfax Murray Collection, IV.147

As Joseph confides some information to Mary about their progress, a little shepherd manages the flock they have acquired along the way. The mountains have been left behind, and the first palm trees and a truncated pyramid suggest their arrival in foreign parts. ❦

The text cited above, which might suggest a later placement during the sojourn in Egypt, between plates 55 and 56, is the only one that suggests that the Holy Family brought with them a flock of sheep from Judaea. This might have inspired Castiglione, who in turn seems to have inspired Domenico. The pyramid and building on the left and the palm trees on the right may be taken as indications that the arrival in Egypt is imminent. ⚜

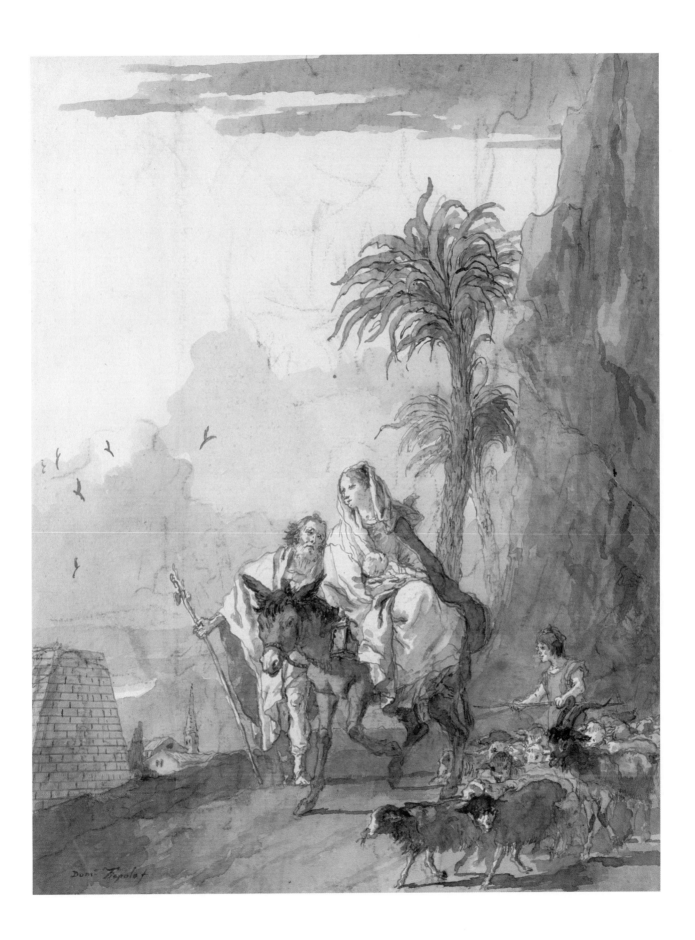

52. *The Flight into Egypt with Angels*

Nevertheless they were in want of food, and they were destitute of other things unprovidable by their own mere human effort. But the Lord allowed them to fall into this need in order that, listening to the acceptable prayer of his Spouse, He might make provision also for this by the hands of his angels. They brought them delicious bread and well-seasoned fruits, and moreover a most delicious drink; all of which they administered and served with their own hands. (Maria de Agreda)

Pen and wash, over black chalk, 467 x 362
Signed low left: Dom.o Tiepolo f
Provenance: Theodor de Wyzewa sale, Paris, Drouot, February 21–22, 1919 [251]
Literature: Maria de Agreda, ov, 542; Conrad 1996 [24]

Mary, having dismounted, is worshiped by several angels, while Joseph looks on attentively. Aloof to these attentions, Mary is focused on the heavens. This scene, set in such a lonely landscape, may portray the Holy Family on their way to Bethlehem, since the Christ child is not visible. ❦

The Christ child cannot be discerned, which leads Conrad to suggest an earlier journey of Joseph and Mary. One may note that the great art historian and biographer of Mozart, Theodor de Wyzewa (1862–1917), was also the translator of the French edition of *La légende dorée,* published in Paris in 1902. ⚜

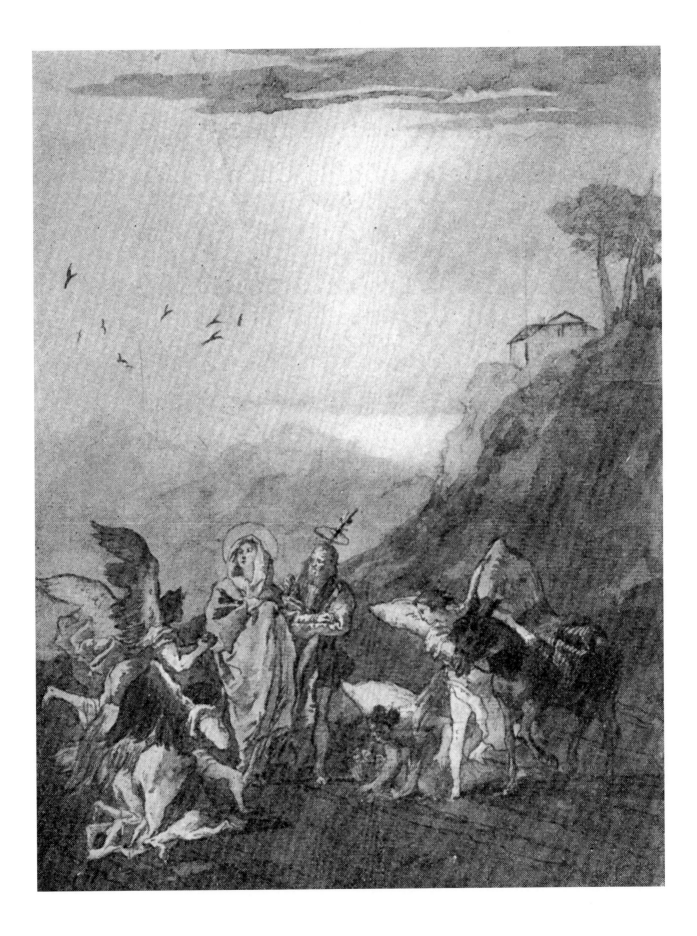

53. *The Holy Family Crosses the River*

Gaza, which lies a little less than twenty hours from Jerusalem, on the river Bezor, and on the road from Palestine to Egypt, not far from the Mediterranean Sea. (Maria de Agreda)

Pen and wash, over black chalk, 480 x 383
Not signed: it appears that a signature low right has been removed
Provenance: Paris, Hôtel Drouot, Mar. 11, 1994 [233]
Exhibition: Udine, 1996 [97]; Tübingen, 2005 [31] (in memory of owners' grandfather and father)
Literature: Conrad 1996 [51]
Reference: Maria de Agreda iv, 533; Réau 1957, 283, cites Domenico's etchings

Zürich, private collection

Nestled safely in a large if rustic boat, the Holy Family is conveyed across a vast body of water. The flying angel first introduced in plate 1, here delivers instructions (or offers protection) from his overhead station, while another angel looks to him as he maneuvers the oars that guide the vessel to its destination. Her baby cradled safely in her arms, Mary appears contented and is watched by Joseph. Meanwhile, the donkey catches a well-deserved nap at the back. ❦

In the lengthy accounts of The Flight into Egypt, given in the *Liber de Infantia* (18–25) and by Maria de Agreda, there is only one mention of a river, but even there no crossing of it. Nevertheless, there is a strong pictorial tradition of such a theme, both in Venice and the Low Countries. ⚜

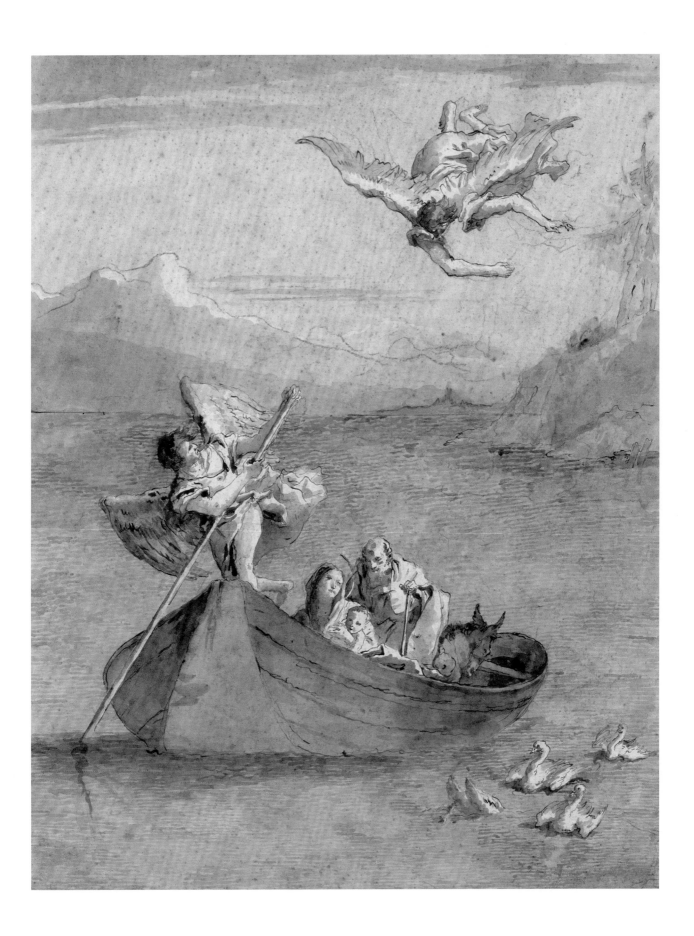

54. *The Holy Family with a Man Digging*

He who digs in earth which conceals gold does not at once snatch whatever the ragged trench may throw up: but before the stroke of the iron he wields brings up the shining mass, he ever and anon pauses in turning over the turfs, and feeds himself with hope, while as yet he is not enriched with gain. (Liber de Infantia, introductory letter)

Pen and wash, over extensive black chalk, 469 x 363
Not signed
Provenance: Jean Fayet Durand (1806–1889)
Literature: James 1924, 71; Conrad 1996 [27]
Reference: Jameson 1890 [31, 42]

Paris, Musée du Louvre, Département des Arts Graphiques, RF 1713bis [58]

As Joseph inquires about what the laborer is digging, the Holy Family's angelic escorts have disappeared and the mood is very somber. The older patriarch protectively guards his son, leaving one to speculate that a burial (perhaps one of Herod's victims?) is taking place. ❦

A number of scenes in *A New Testament* (pls. 54–63) derive from the *Liber de Infantia*. It is obviously not at all certain that this drawing relates to the text cited. A rather different light upon digging is offered by the inadequate servant who buried his single talent in Matthew 25:18. ❖

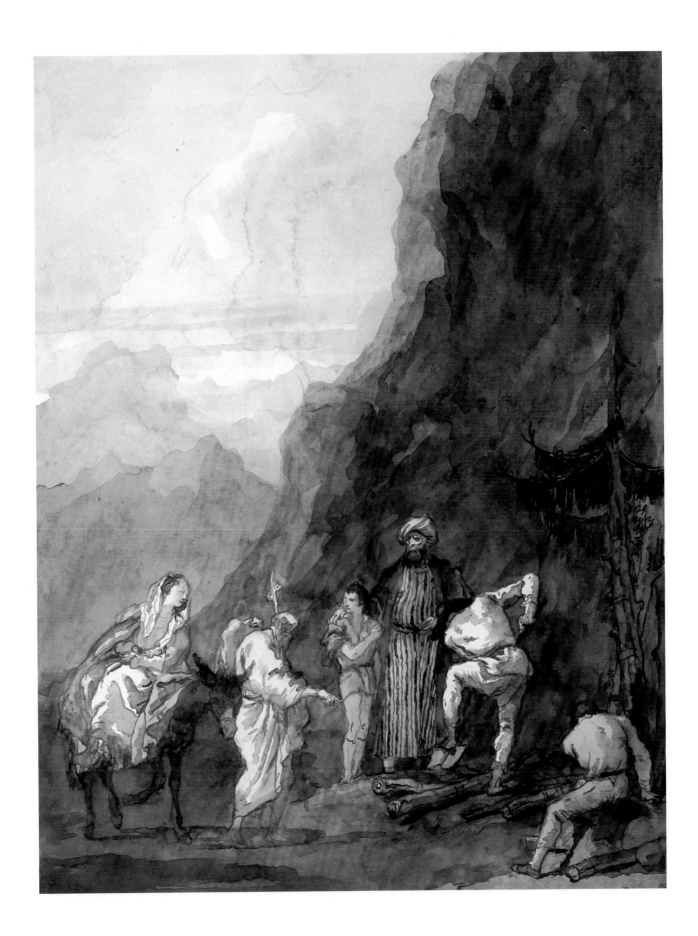

55. *Jesus and the Dragons*

*When they came to a cave and wished to rest in it, holy Mary dismounted and sat down with the child Jesus in her lap.
And on the journey there were with Joseph three boys and with Mary some maidens. And behold, suddenly many dragons
came out of the cave. When the boys saw them they cried out in terror. The Jesus got down from his mother's lap, and stood
on his feet before the dragons; thereupon they worshipped Jesus and then went back from them.* (Liber de Infantia, 18)

Pen and wash over extensive black chalk, 462 x 355
Signed low left: Dom.o Tiepolo f
Provenance: Jean Fayet Durand (1806–1889)
Literature: James 1924, 74–75; Conrad 1996 [42]; Stuttgart 1999 [fig. 5]
Reference: dalla Pergola 1713, ch. 24, 128–129; Réau 1957, 278, cites a relief on the façade of the cathedral at Orvieto;
Henneke 1963, 410

Paris, Musée du Louvre, Département des Arts Graphiques, RF 1713bis [46]

In the first of eight scenes closely connected to legends from the *Liber di Infantia,* Domenico stresses triumph.
Here the infant Jesus tames the dragons that frightened the children in a cave. Departing from the text, Domenico
shows Christ (radiating a massive circle of light) standing on one of the dragons (like a little Hercules) as his parents
react with wonder. Only one dragon actually worships Jesus, while another scampers away, perhaps to terrorize the
fleeing children. Nestled in the corner, fast asleep, the tired donkey is oblivious to all the commotion. ❦

The apocryphal stories of the *Liber de Infantia* and *The Arabic Gospel* contain many fantastic and miraculous
episodes. Some of them are mentioned by Antonio Maria dalla Pergola, *Vita di San Giuseppe* (Treviso, 1713: 129):
"i Leoni, i Cervi, i Leopardi, gli Orsi, i Dragoni ed altre belve di simil sorte." Apart from the much better known
stories of the bending palm, the leopards (etc.), and the falling idols, this is the only one that finds its way into
Domenico's account of the Flight into Egypt. ⚜

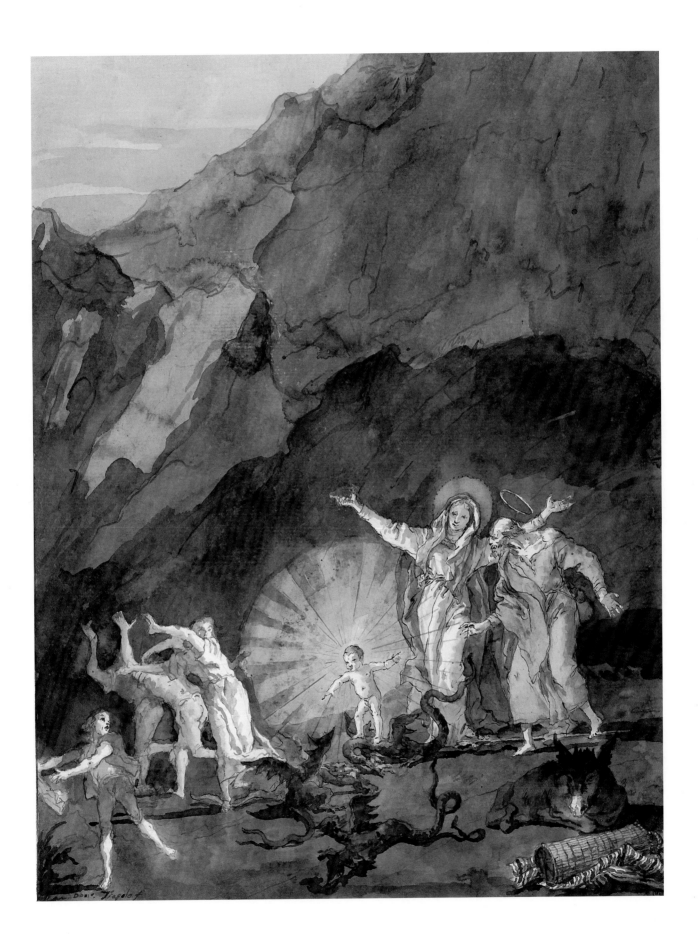

56. *The Holy Family with the Bending Palm*

On the third day Mary saw a palm and wished to rest under it. When she was seated there she saw fruit on it, and said to Joseph that she would like to have some. Joseph said that he was surprised she should say that because the tree was so high: he himself was thinking more about water, of which they had very little left. Jesus sitting in Mary's lap with a joyful countenance bade the palm to give his mother of its fruit. The tree bent as low as her feet and she gathered what she would. He bade it rise again, and give them of the water concealed below its roots. A spring came forth and all rejoiced and drank of it. (Liber de Infantia, 20)

Pen and wash, 470 x 360
Signed low right: Dom.o Tiepolo f
Provenance: Roger Cormier, Tours, his sale, Paris, Georges Petit, Apr. 30, 1921 [45]
Literature: Guerlain 1921, 45; Conrad 1996 [43]
Reference: *The Golden Legend,* 1900, ii, 181–182; James 1924, 75; Réau 1957, 278–280

As Mary and Joseph avail themselves of the fruits of the obliging palm tree, an angel has returned to assist and searches unself-consciously among its branches. Mary reaches up with grace and dignity, while Joseph and the angel take on the work in earnest. Contentedly chewing on some hay, the donkey ignores the lions and other wild beasts, which, we are told, piously adored Christ, though here they simply loiter about in the foreground. ✹

The story of the great palm tree is one of the favorite tales among the apocryphal material, and Domenico devotes two drawings to it. Here the foliage of the tree cascades about the Holy Family as Joseph and Mary pick the dates, assisted by an angel. Not content with this, he also introduces lions and leopards into the foreground. These are also described in *Liber de Infantia* 19, cited under plate 51; hence, the drawing appears to conflate the two stories. ⚜

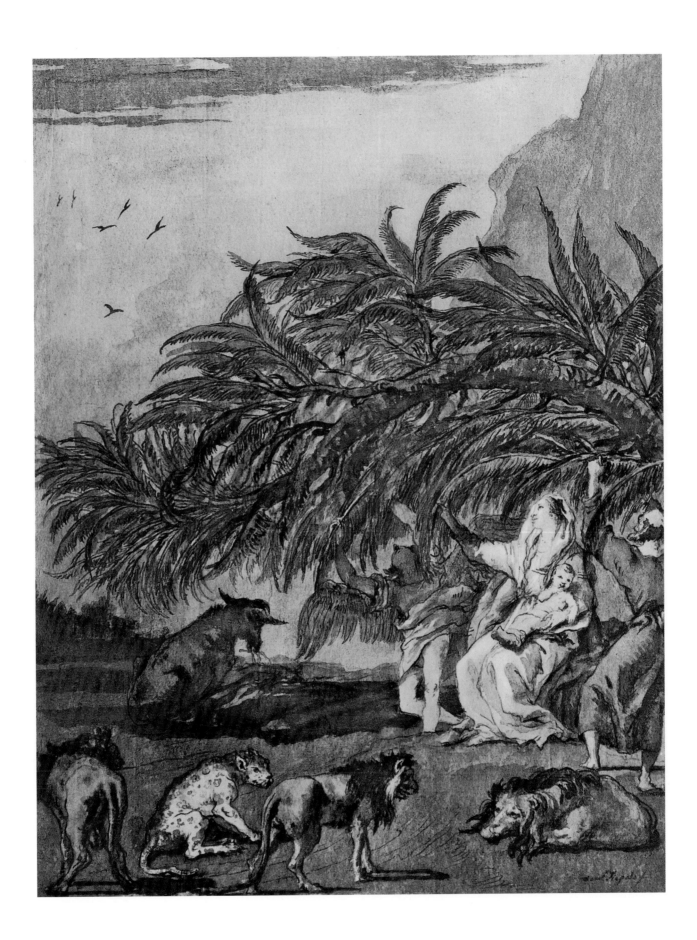

57. *The Holy Family Beneath the Great Palm*

And the day after, when they were setting out from there, and at the hour in which they began their journey, Jesus turned to the palm and said, "This privilege I give you, O palm tree, that one of your branches be carried away by angels, and planted in the paradise of my Father, And this blessing I will confer upon you, that it shall be said by all who shall be victorious in any contest, 'You have attained the palm of victory.'" And while he was speaking, behold, an angel of the Lord appeared, and stood upon the palm tree and, taking off one of its branches, flew to heaven with the branch in his hand. (Liber de Infantia, 21)

Pen and wash, over traces of black chalk, 470 x 379
Signed low left: Dom.o Tiepolo f
Provenance: Luzarche, Tours; Roger Cormier, Tours, his sale, Paris, Georges Petit, Apr. 30, 1921, no. 54; Tomas Harris 1950; Robert Lehman
Exhibition: London 1955; New York 1971 [257]; New York 1981 [127]; Würzburg 1996 [126]
Literature: Byam Shaw and Knox 1987 [113]; Conrad 1996 [44]
Reference: James 1924, 75, a shortened version

New York, The Metropolitan Museum of Art, Robert Lehman Collection, 1975.1.474

Here the tree has straightened itself and the refreshing fountain continues to gush forth from the base of its roots at the left, as mentioned in the previous episode. Joseph, his basket now filled with fruits, eyes the Christ child, who reaches for his mother's breast in order to nurse. While the Holy Family rests, more angels have arrived and have much to do. One busily selects the best palm fronds, another bears them heavenward, while the third prepares the donkey to resume their journey. ❦

This design appears to show the great palm-tree after it has returned to its natural state, assisted by an angel that holds its leaves. One may note the detail of the angel, upper right, flying off to heaven with a branch of the tree, to be a symbol for the Holy Martyrs. The invention of the palm-tree and the pyramid finds an interesting parallel in the small painting by Boucher at Copenhagen (Voss 1957: [36]) and one may speculate on the possibility of a common source. ⚜

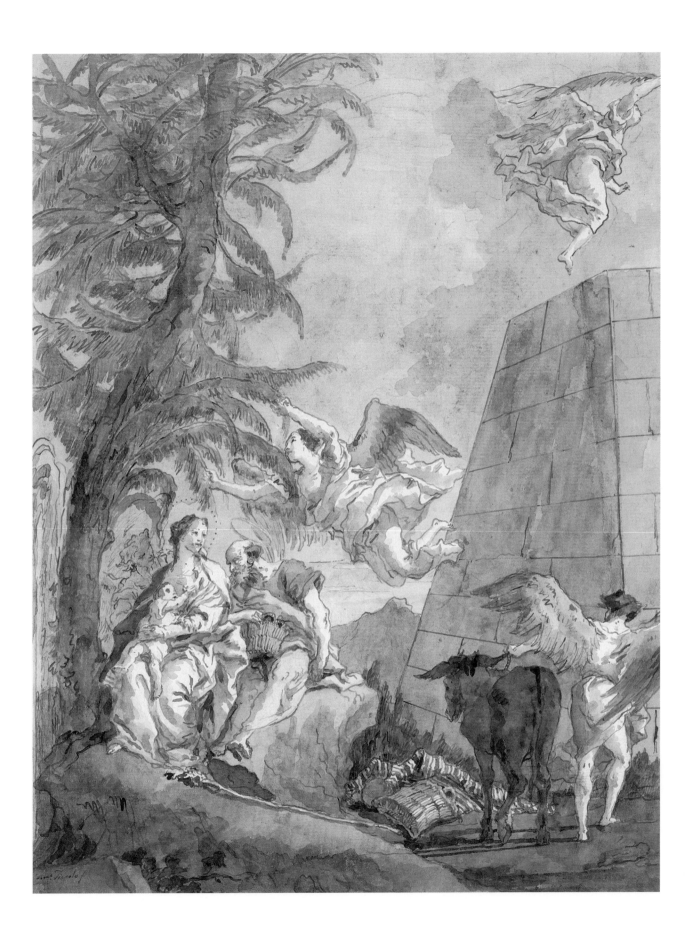

58. *The Holy Family Arrives Within Sight of a City*

After this, while they were going on their journey, Joseph said to Jesus, "Lord, the heat is roasting us; if it please you, let us go by the sea-shore that we may be able to rest in the cities on the coast." Jesus said to him, "Fear not, Joseph, I will shorten the way for you, so that what you would have taken thirty days to traverse you shall accomplish in this one day." And while they were speaking, behold, they looked ahead and began to see the mountains and cities of Egypt.
(Liber de Infantia, 22)

Pen and wash, 470 x 360
Not signed
Provenance: Roger Cormier, Tours, his sale, Paris, Georges Petit, Apr. 30, 1921, no. 37;
Duc de Trévise, his sale, Paris, Hôtel Drouot, Dec. 8, 1947, no. 35
Exhibition: Chicago 1938, pl. 86
Literature: Guerlain 1921, 44b; Conrad 1996 [26]
Reference: James 1924, 75, gives a shortened version

Once more traveling unescorted, Joseph leads the way and descends down the other side of a low rise in the road, approaching a small village in the distance. According to legend, these were the cities and mountains of Egypt, although Domenico has made them look like Italian mountain towns. ✺

The subject appears to be a variant of the following design. In both we see the Holy Family from behind, as they go forward to their journey's end, and in both the vastness of Egypt seems to loom in front of them. The Christ child cannot be discerned, which leads Conrad to suggest an earlier journey of Joseph and Mary. ⚜

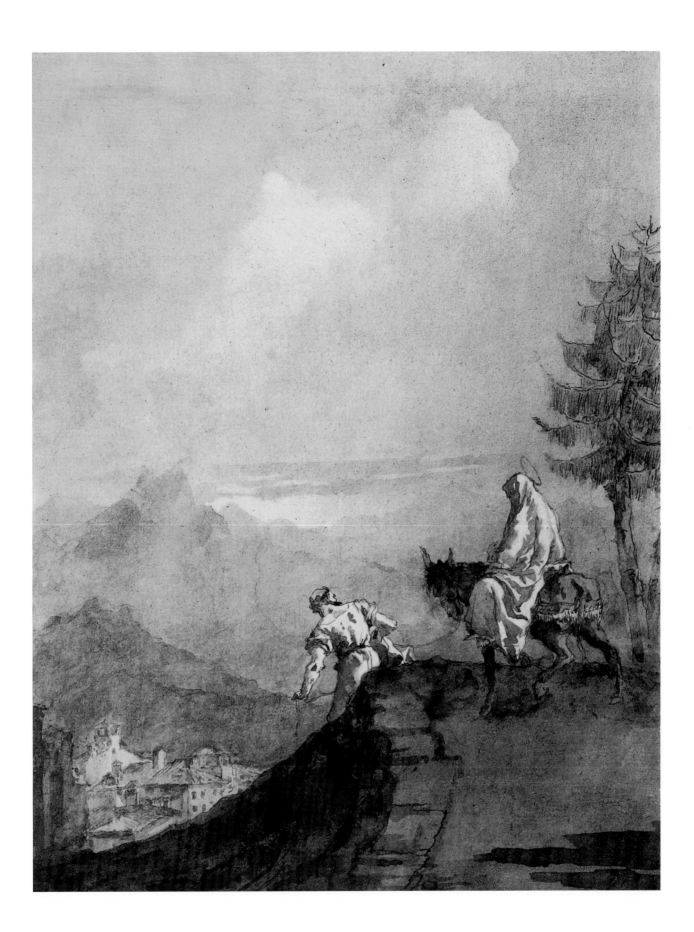

59. *The Holy Family Beholds the Mountains and Cities of Egypt*

After this, while they were going on their journey, Joseph said to Jesus, "Lord, the heat is roasting us; if it please you, let us go by the sea-shore that we may be able to rest in the cities on the coast." Jesus said to him, "Fear not, Joseph, I will shorten the way for you, so that what you would have taken thirty days to traverse you shall accomplish in this one day." And while they were speaking, behold, they looked ahead and began to see the mountains and cities of Egypt.
(Liber de Infantia, 22)

> Pen and wash, over traces of black chalk, 492 x 390
> Signed low left: Dom.o Tiepolo f
> Provenance: Paul Henri Charles Cosson, 1926 bequest
> Exhibition: Udine 1996 [95]
> Literature: Conrad 1996 [25]
> Reference: James 1924, 75, a shortened version

Paris, Musée du Louvre, Département des Arts Graphiques, RF 6944

In the second stage of this miracle, the Holy Family comes closer to its destination. As evening casts long shadows beside them, Joseph appears astonished at the sudden truncation of the trip. Gesturing emphatically with his staff, he tells Mary excitedly about the miracle. ❦

The Holy Family approaches the bank of a wide river with a city on the far bank, somewhat reminiscent of Udine (Knox 1984: [54]), and mountains in the distance. There is a large tower on the left. The Christ child cannot be discerned, which leads Conrad to suggest an earlier journey of Joseph and Mary. ⚜

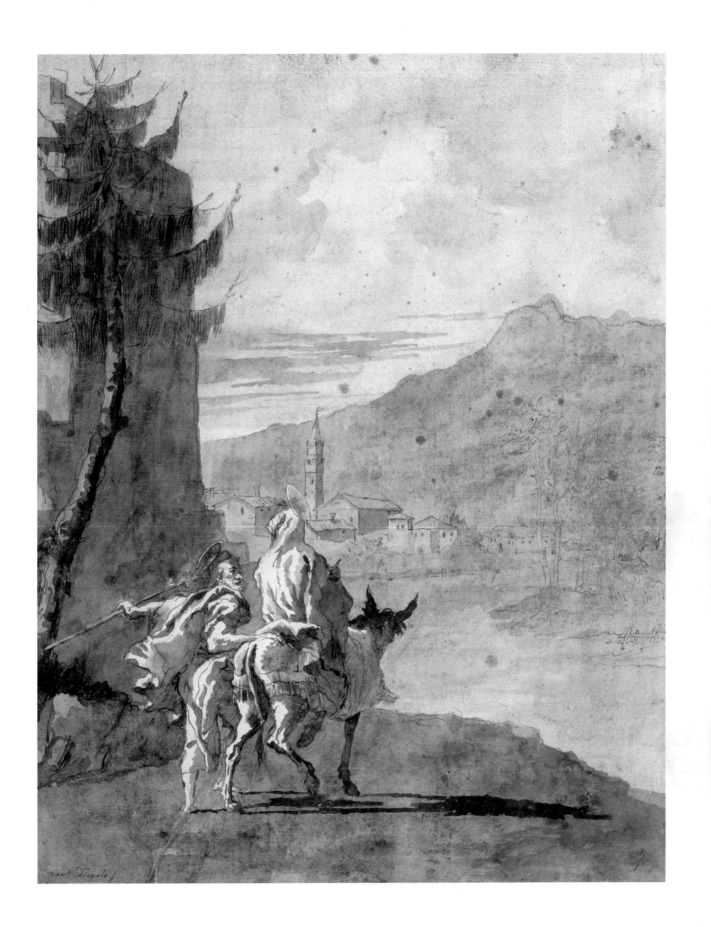

60. *The Holy Family Enters Sotinen*

Rejoicing and exulting they came to the region of Hermopolis, and went into one of the Egyptian cities called Sotinen. Since they knew no one in it from whom they could ask hospitality, they went into the temple which was called the Capitolium of Egypt. (Liber de Infantia, 22)

When they entered Egypt all the idols of that province fell and broke, as was prophesied by Isaiah. (Meditationes vitae Christi, 68)

Pen and wash, over extensive black chalk, 467 x 360
Signed low right: Dom.o Tiepolo
Provenance: Jean Fayet Durand (1806–1889)
Literature: dalla Pergola 1713, 135; James 1924, 75; Ragusa and Green 1961, 68; Conrad 1996 [59]; Gealt in Udine 1996, 80

Paris, Musée du Louvre, Département des Arts Graphiques, RF 1713bis [64]

Having reached the region of Hermopolis, Mary and Joseph follow a group of peasants into Sotinen's gate. The fragmented columns and walls distinguish it as an ancient and perhaps Roman protectorate, while the peasants and laborers look vaguely Venetian. They ignore the holy travelers behind them, who here make the first of four entrances into Egyptian cities. ❦

Two pairs of drawings show the Holy Family entering and leaving by a city gate, presumably in Egypt. This drawing and plate 63 describe a rather more modest gate, with a rounded bridge in front of it, here identified as the gate of Sotinen, a city that plays a considerable role in the story as told in the *Liber de Infantia*. There is no welcoming committee. The second pair suggest a more important city (pls. 72, 74) that is here identified as Memphis. Anton Maria dalla Pergola also mentions the arrival at Heliopolis and the falling idols, as well as Afrodisio. The man carrying a burden on his head is found again reversed in *The Pedlars-Divertimento 49* (Gealt 1986: [47]). ⚜

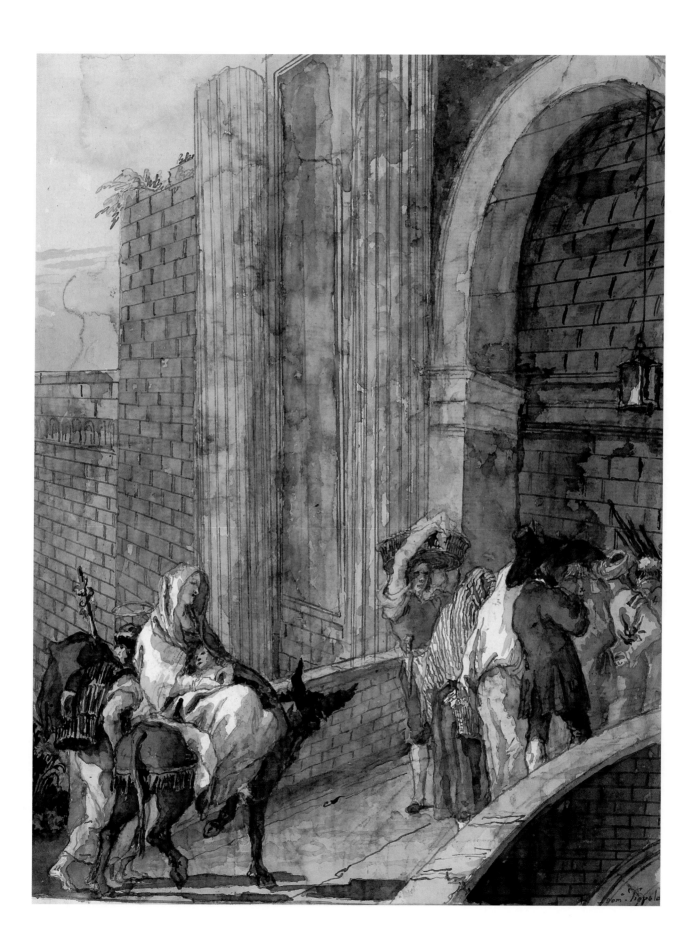

61. *The Broken Statues of Sotinen*

Rejoicing and exulting they came to the region of Hermopolis, and went into one of the Egyptian cities called Sotinen. Since they knew no one in it from whom they could ask hospitality, they went into the temple which was called the Capitolium of Egypt. There had been placed in this temple three hundred and sixty-five idols, to which, on appointed days, divine honour was given in sacrilegious ceremonies. It happened that, when the most blessed Mary, with her child, had entered the temple, all the idols were thrown to the ground, so that they all lay flat, convulsed and with their faces shattered. Thus they revealed openly that they were nothing. (Liber de Infantia, 23)

And after the prophesy of Isaiah, at the entering of our Lord into Egypt, the idols fell down, for like as at departing of the children out of Egypt, in every house the eldest son of the Egyptians lay one dead, in like wise at the coming of our Lord lay down the idols in the temples. (The Golden Legend)

Pen and wash, over black chalk, 457 x 350
Signed on the step, left: Dom.o Tiepolo f
Provenance: Jean Fayet Durand (1806–1889)
Literature: Conrad 1996 [47]; Gealt in Udine 1996, 79
Reference: *The Golden Legend* 1900, ii, 181; Maria de Agreda 1971, iv, XXIV; dalla Pergola 1713, 135; Réau 1957, 280

Paris, Musée du Louvre, Département des Arts Graphiques, RF 1713bis [115]

Joseph and Mary stand huddled together as the last of the idols of Sotinen's temple crash down around them. The cawing blackbird over head has distracted Mary, while Joseph tries to call her attention to the fallen idols behind him. Temporarily relieved of his burden, their donkey is led away by an angel who has reappeared to help. ❧

Against the wall are shown a row of empty plinths and niches, the latter seemingly inscribed with the names of the fallen idols. *The Golden Legend* treats The Flight into Egypt very briefly indeed, mentioning only this episode and the tree that "bowed down and worshipped Jesu Christ" (pl. 56). Anton Maria dalla Pergola also mentions the arrival at Heliopolis and the falling idols, as well as Afrodisio. ⚜

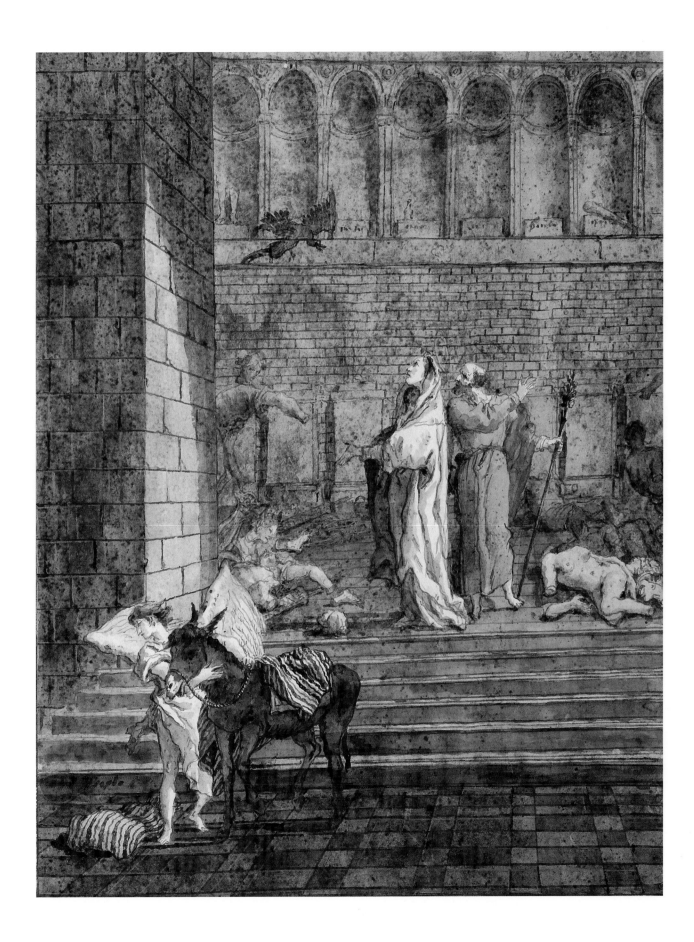

62. *Affrodosius Kneels Before the Holy Family*

Affrodosius, governor of the city, went to the temple with his whole army. And when the priests of the temple saw Affrodosius coming into the temple with his army, they thought they would see him take vengeance on those who had caused the gods to fall down. But when he came into the temple and saw all the gods lying prostrate on their faces, he went up to Mary, who was carrying the Lord in her bosom, and worshipped him. Then all the people of the city believed in the Lord God through Jesus Christ. (Liber de Infantia, 24)

> Pen and wash, over black chalk, 487 x 383
> Signed low right, on the step: Dom.o Tiepolo f
> Provenance: Paul Henri Charles Cosson, his bequest, 1926
> Exhibition: Udine 1996 [94]
> Literature: Conrad 1996 [48]
> Reference: James 1924, 75, a somewhat different text

Paris, Musée du Louvre, Département des Arts Graphiques, RF 6943

The angel has repacked the donkey and looks anxiously over his shoulder, preparing for flight, as the mighty Affrodosius arrives with his army to investigate. Kneeling before the Holy Family in recognition of Christ's power, his actions subdue the dangerous-looking archer behind him. His soldiers assess the damage, as a lad dressed in white enters stage left. ❦

This scene is drawn from the *Liber de Infantia* 24, and it also appears in the *Biblia Pauperum* VI.2. When the Holy Family arrived in the Egyptian city of Sotinen and entered the Temple, 365 idols fell and shattered. This is shown in the preceding drawing in the Louvre (pl. 61). The setting here is virtually the same. The angel there leading the donkey on the left is here found reversed on the right, and is replaced with a horse and Turkish rider, based roughly on a drawing at Besançon [fig. 113]. This element is also used in reverse in *Via Crucis* 4 (pl. 217). ✤

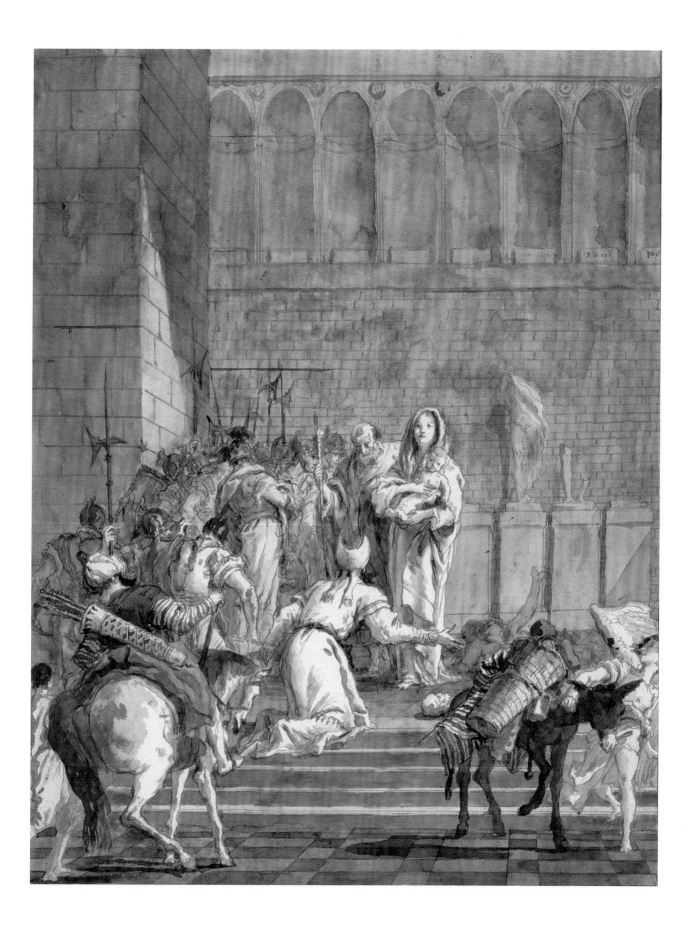

63. *The Holy Family Leaves Sotinen*

No text yet found.

Pen and wash, over black chalk, 470 x 360
Signed low left: Dom.o Tiepolo f
Provenance: Roger Cormier, Tours, his sale, Paris, Georges Petit, Apr. 30, 1921 [51]; Duc de Trévise, his sale, Paris, Hôtel Drouot, Dec. 8, 1947, no. 40; Christie's, July 5, 2005 [104]
Literature: Guerlain 1921, 44a; Conrad 1996 [61]

As the Holy Family leaves Sotinen's city gate, the lad dressed in white last seen at the temple and here somewhat smaller, points back to them, perhaps telling the woman what he saw as Affrodosius knelt before Mary and Joseph. The woman looks back at Mary and Joseph, but the rest of the people generally appear ignorant of what happened and go about their business. ❦

The present drawing is clearly paired with plate 60, since both show a bridge before the city gate. This pair is taken here to represent the Holy Family arriving and leaving Sotinen, and the Christ child is still clearly an infant. The second pair (pls. 72, 74) is taken here to represent the Holy Family arriving and leaving the larger city of Memphis, as described in *The Arabic Gospel* 8. Here, however, although the Virgin is apparently still carrying an infant, a grown boy seems to be leading the procession. If this figure is identified as the Christ child, it would seem that the scene must show the Holy Family leaving Egypt. Neither relates to the etching *The Flight into Egypt 7* [fig. 58], which also shows the Holy Family leaving by a city gate. The drawing shows a man in the center foreground wearing a short black garment and consulting a book. Perhaps he is a writer recording the scene, which we have not found in any literary source. ⚜

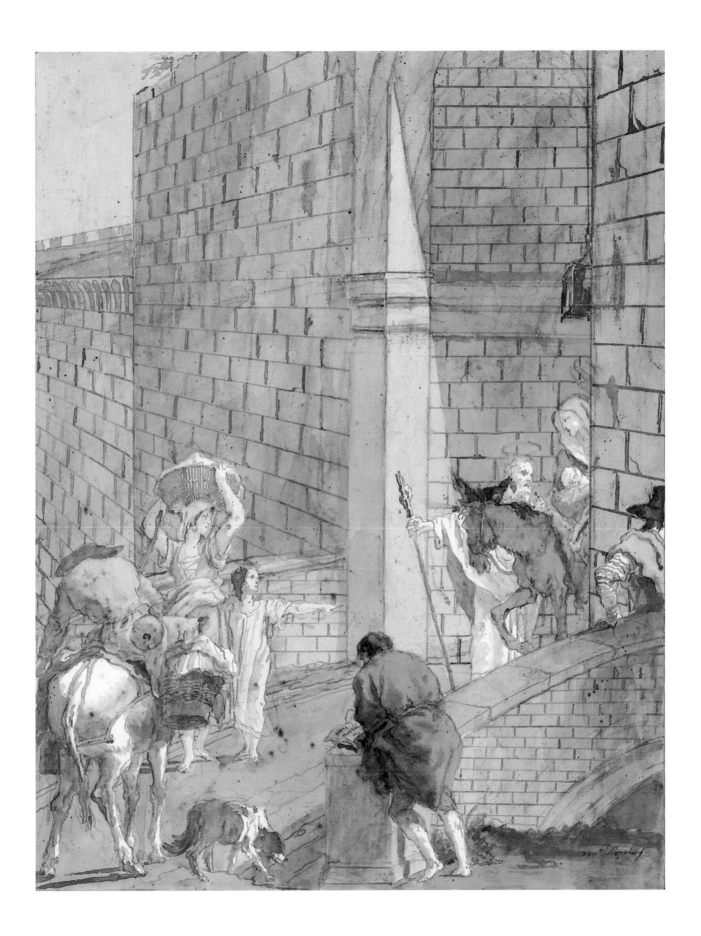

64. *The Holy Family Passes the Falling Idol*

And all the magistrates and priests of the idols assembled before that idol, and made enquiry there, saying, What means all this consternation, and dread, which has fallen upon all our country? The idol answered them, The unknown God is come hither, who is truly God; nor is there anyone besides him, who is worthy of divine worship; for he is truly the Son of God. At the fame of him this country trembled, and at his coming it is under the present commotion and consternation; and we ourselves are affrighted by the greatness of his power. And at that instant this idol fell down, and at his fall all the inhabitants of Egypt, besides others, ran together. (The Arabic Gospel 4:10–13)

Pen and wash, over extensive black chalk, 469 x 363
Signed low left: Dom.o Tiepolo f
Provenance: Jean Fayet Durand (1806–1889)
Literature: Byam Shaw 1962 [29]; Würzburg 1966, 182 [Abb. 2]; Conrad 1996 [45]; Gealt in Udine, 1996, 78
Reference: James 1924, 80–82; *Lost Books of the Bible* 1926, 38–59

Paris, Musée du Louvre, Département des Arts Graphiques, RF 1713bis [56]

Turning to legends from the *Arabic Infancy Gospels,* Domenico interprets this source more loosely. Here the Egyptian idol simply loses its head as the Holy Family passes by. Momentarily distracted by the angel who relates something to Joseph, this signal event goes unnoticed by those who caused it. Domenico elects not to show the inhabitants of Egypt panicking as the source describes. This is the second (but not the last) confrontation between a member of Christ's family and an ancient bust (most often of Roman rulers), and here, as in other such scenes, Christ's triumph is mixed with portents of danger. ❦

Eight drawings of *A New Testament* (pls. 64–67, 70, 72–74) derive from *The Arabic Gospel.* This offers a very different account of the Flight into Egypt from that of the *Liber de Infantia.* In fact, there the journey to Egypt takes no time at all, recording only that "in the length of the journey the girts of the saddle broke." And then immediately we are dealing with the arrival in Egypt and the story of the broken idol, which is told at great length. ⚜

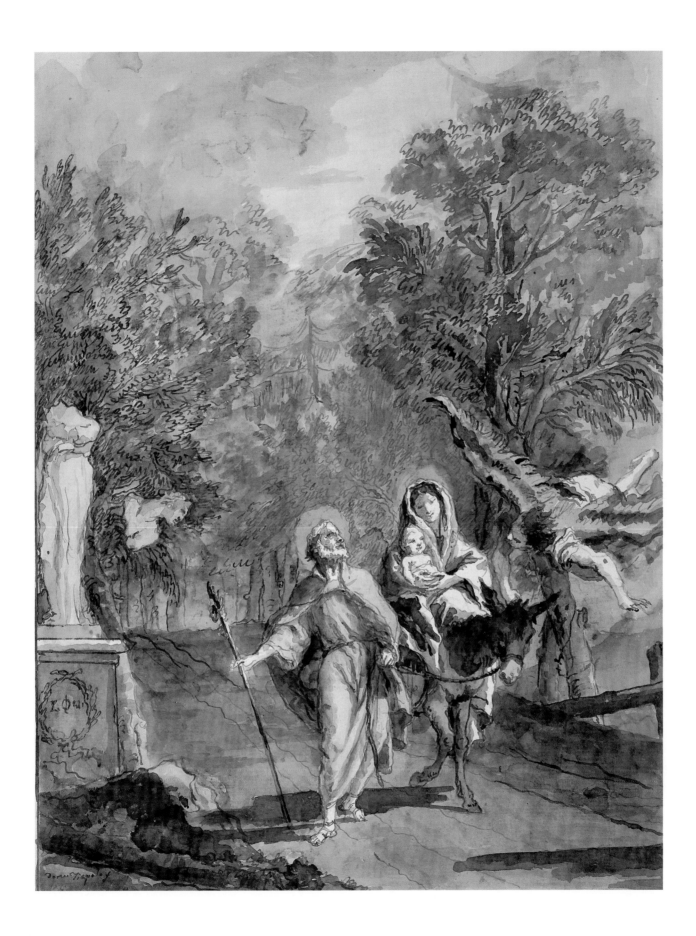

65. *The Holy Family Encounters a Group of Gypsies*

After this Joseph and Mary tarried there ten days, then went away, having received great respect from those people, who, when they took leave of them, and returned home, cried, but especially the girl. (The Arabic Gospel 7:33–35)

Pen and wash, over extensive black chalk, 466 x 361
Signed low left: Dom.o Tiepolo f
Provenance: Jean Fayet Durand (1806–1889)
Literature: Conrad 1996 [56]; Gealt in Udine 1996, 80
Reference: Maria de Agreda 1685, iv, 644; Jameson 1899, 242; *Lost Books* 1926, 46

Paris, Musée du Louvre, Département des Arts Graphiques, RF 1713bis [63]

Joseph, hat in hand, exchanges civilities with a group of peasants here presented as gypsies. As one man lifts his hands in respect, an older gypsy woman offers her thanks, perhaps for the miraculous cure of the girl, whose basket holds a proffered gift. Huddled in her robe, the Virgin is accompanied by their angel who, cut off by the picture, implies action and movement. ❧

The text here cited comes at the end of a long story about a girl suffering from leprosy, cured by water in which the infant Jesus had been washed (*The Arabic Gospel* 6:16 to 7:35). It may also be the source of a friendly meeting, described by Maria de Agreda, with a group of Egyptians, calling them, perfectly correctly, *gitanos*. This may explain the origin of Anna Jameson's poetic legend of Mary encountering a gypsy who "fortells all the wonderful and terrible things which, as the Redeemer of mankind, Jesus was destined to perform and endure upon earth." Gypsies were thought to be Egyptians. ⚜

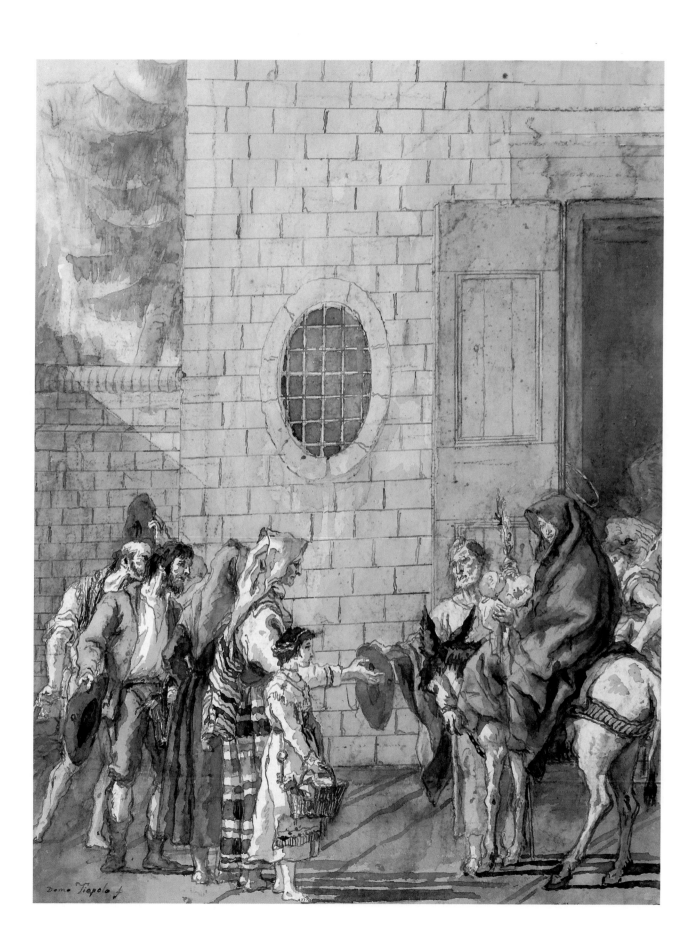

66. *The Holy Family Meets the Robbers*

In their journey from hence they came into a desert country, and were told it was invested with robbers; so Joseph and Mary prepared to pass through it in the night. And as they were going along, behold, they saw two robbers asleep in the road, and with them a great number of robbers, who were their confederates, also asleep. The names of these two were Titus and Dumachus; and Titus said to Dumachus, I beseech thee let those persons go along quietly, that our company may not perceive anything of them: but Dumachus refusing, Titus said again, I will give thee forty groats, and as a pledge take my girdle, which he gave him before he had done speaking, that he might not open his mouth, or make a noise, When the Lady St. Mary saw the kindness which this robber did show them, she said to him, The Lord God will receive thee to his right hand, and grant thee pardon for thy sins. Then the Lord Jesus answered, and said to his mother, When thirty years are expired, O mother, the Jews will crucify me at Jerusalem; and these two thieves shall be with me at the same time upon the cross, Titus on my right hand, and Dumachus on my left, and from that time Titus shall go before me into paradise. (The Arabic Gospel 8:1–7)

> Pen and wash, over black chalk, 465 x 365
> Signed low left: Dom.o Tiepolo
> Literature: Conrad 1996 [46]
> Provenance: Jean Fayet Durand (1806–1889)
> Reference: dalla Pergola 1713, 131–132; James 1924, 81; *Lost Books* 1926, 46–47; Réau 1957, 277; Henneke 1963, 409; Konrad von Fussesbrunnen 1973, vv. 1503–2530

Paris, Musée du Louvre, Département des Arts Graphiques, RF 1713bis [59]

On the road once more, the Holy Family is accosted by robbers. Speaking calmly, the Virgin manages to subdue them while Joseph, flailing his arms in fear, is helpless. For the first time during its many adventures, the donkey reacts, cocking his ears forward in a friendly manner as he comes nose to nose with an assailant. 🖋

The Arabic Gospel relates two encounters with robbers: the first cited at 5:1–6, and the second as cited here. Anton Maria dalla Pergola also mentions the story of the robbers and the good thief. Domenico illustrates this in two drawings, of which this appears to be the first, showing the robbers accosting the Holy Family, with Joseph on the right showing his distress. The following drawing (pl. 67) shows the Holy Family coming to a more amicable agreement with the robbers. It is here suggested that both tell the second story, which immediately precedes the story of Matarea (pl. 70). They are supplemented by two drawings showing the Holy Family in the company of the robbers arriving at the robber's farm (pl. 68) and again with the robbers leaving the farm (pl. 69). This episode is mentioned for the first time in some texts of the *Gospel of Nicodemus* of the fourth century and next seen in a German poem, *Die Kindheit Jesu*, by Konrad von Fussesbrunnen (1190–1220). It is also mentioned in the *Irish Infancy Gospel*, British Museum, Arundel 404 (James 1927, 120–126). We are unable to suggest how Domenico can have encountered this rare tradition. ⚜

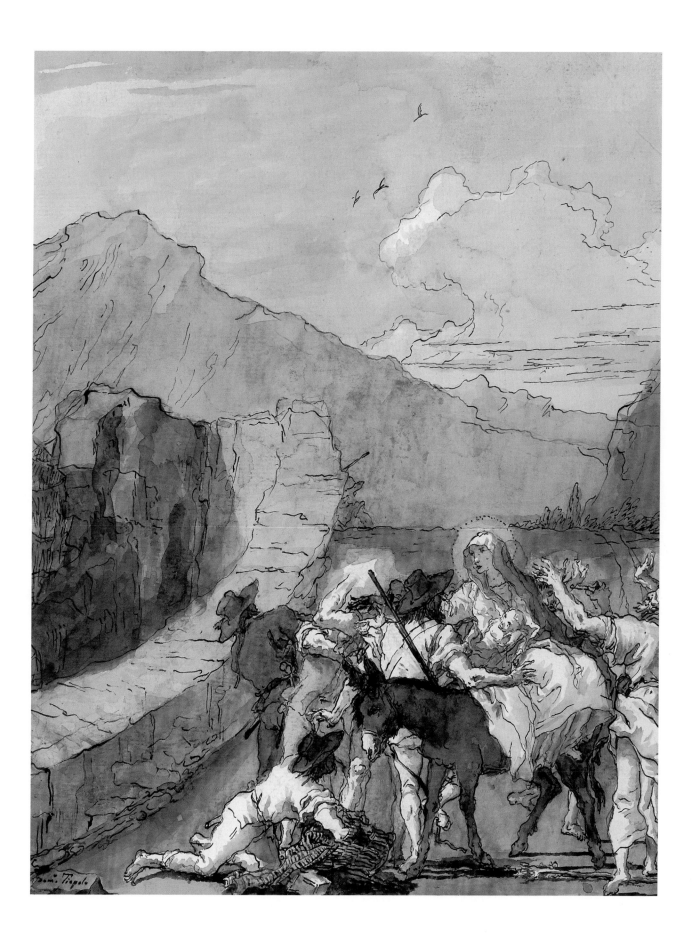

67. The Holy Family Goes with the Robbers

In their journey from hence they came into a desert country, and were told it was invested with robbers; so Joseph and Mary prepared to pass through it in the night. And as they were going along, behold, they saw two robbers asleep in the road, and with them a great number of robbers, who were their confederates, also asleep. The names of these two were Titus and Dumachus; and Titus said to Dumachus, I beseech thee let those persons go along quietly, that our company may not perceive anything of them: but Dumachus refusing, Titus said again, I will give thee forty groats, and as a pledge take my girdle, which he gave him before he had done speaking, that he might not open his mouth, or make a noise, When the Lady St. Mary saw the kindness which this robber did show them, she said to him, The Lord God will receive thee to his right hand, and grant thee pardon for thy sins. Then the Lord Jesus answered, and said to his mother, When thirty years are expired, O mother, the Jews will crucify me at Jerusalem; and these two thieves shall be with me at the same time upon the cross, Titus on my right hand, and Dumachus on my left, and from that time Titus shall go before me into paradise. (The Arabic Gospel 8:1–7)

Pen and wash, over slight black chalk, 490 x 380 / 455 x 359
Signed low left: Dom.o Tiepolo f
in pencil, top left, in the margin: 11 at right: 64
Provenance: private collection, France
Reference: Jameson 1852, 234; James 1924, 81; *Lost Books* 1926, 46–47; Réau iii, 1957, 277; Henneke 1963, 409; Chaplin 1967, 88–95; Konrad von Fussesbrunnen 1973, 3–9

Paris, Alexis Kugel

Having befriended the robbers, the Holy Family goes home with them. Only the Virgin's silhouetted form hints at fear or danger. As a palm tree leans protectively toward her (echoing the benefits provided by its relative earlier), the robbers lead the donkey off in the distance. ❦

Four scenes of *A New Testament* tell the story of The Holy Family and the robbers. The first two (pls. 66, 67) derive from *The Arabic Gospel*, "a late compilation," according to Montague James, which is best known from "a single Arabic manuscript, now lost, which was first published by Henry Sike in 1697." Even so, the story of the robbers was quite well known in the Middle Ages and was further embellished with additional details, including the visit to the robbers' house, which Domenico illustrates in plates 68 and 69. Here the clouds and mountains are outlined in ink, indicating a relatively early date. Since all the figures in this drawing are calm, this must represent the second part of the episode, when the robbers are no longer threatening. ⚜

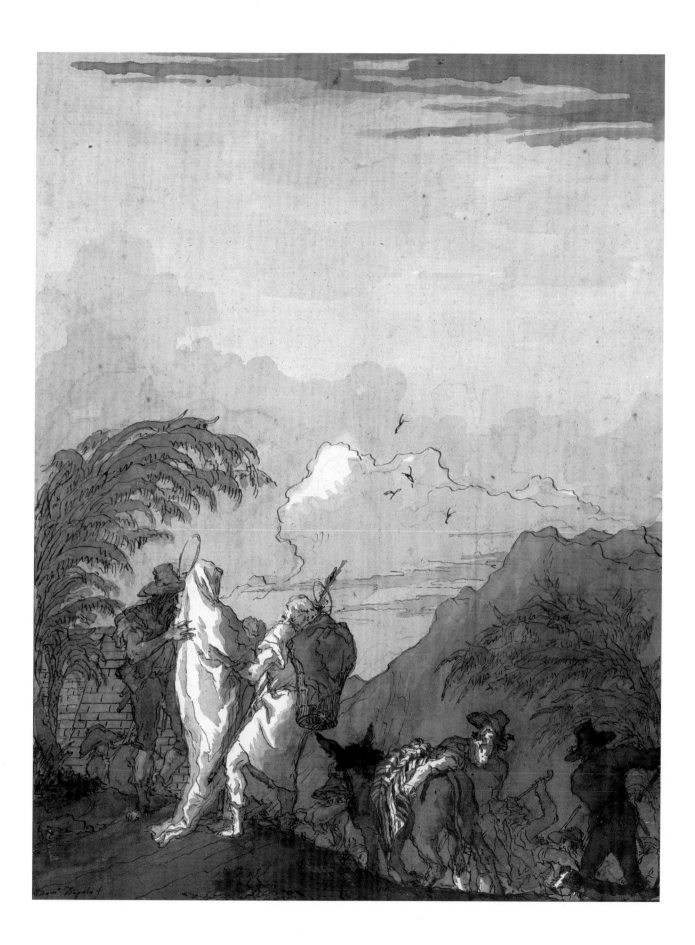

68. *The Holy Family Arrives at the Robbers' Farm*

Then the Holy Family meets Dymas, who is struck with the beauty of Mary and of the child in her arms, adores them, and says, "If God had a mother, I would have said that thou are she." He receives them into his house and when he goes out hunting commends them to his wife's care. He has a leprous child who is always crying and is healed by the water in which Jesus was washed. (James 1924, 117, from the Gospel of Nicodemus)

> Pen and wash, over traces of black chalk, 468 x 362, trimmed to the borderline
> Signed low left: Dom.o Tiepolo f
> Provenance: Charles Fairfax Murray; J. Pierpont Morgan
> Exhibition: New York 1971 [255]; Udine 1996 [96]
> Literature: Fairfax Murray 1912 [IV, 146]; James 1927, 122–126; Conrad 1996 [57]
> Reference: James 1927, 122–126; Chaplin 1967, 88–95; Konrad von Fussesbrunnen 1973, 3–9

New York, The Pierpont Morgan Library, Fairfax Murray Collection, IV.146

Now astride her donkey again, the Virgin arrives with Joseph at the farm house and prepares to enter yet another gateway, albeit a modest, rural one. As a girl holds the doorway open, one robber leads the party in. Joseph, bent with age, burdens, and concern, is diminished by the virile power of the aggressive robbers who surround him. 🕊

Montague James notes that the episode shown here is found for the first time in some texts of the fourth-century *Gospel of Nicodemus,* which relates the story of the meeting with the good thief Dyamas in Egypt on the way to Calvary. It is told at length in the early thirteenth-century German poem of Konrad von Fussesbrunnen, *Die Kindheit Jesu,* where the story of the robbers takes up a third of a text of some 3,000 verses. The poem relates that after meeting the robbers, the Holy Family followed the good thief to his home and stayed with him, and even visited him a second time on the way back from Egypt. We are grateful to Christofer Conrad for drawing our attention to this source. Since the rest of the poem follows the *Liber de Infantia,* it is probable that it derives from a longer version thereof, such as is recorded in the *Irish Infancy Gospel,* British Museum, Arundel 404 (James 1927, 122–126; Konrad von Fussesbrunnen 1973, 5–9). Margaret Chaplin discusses a fourteenth-century Spanish poem, *Lo libre dels tres reys dorient,* containing similar material, but it remains unclear how Domenico came to know the story. ⚜

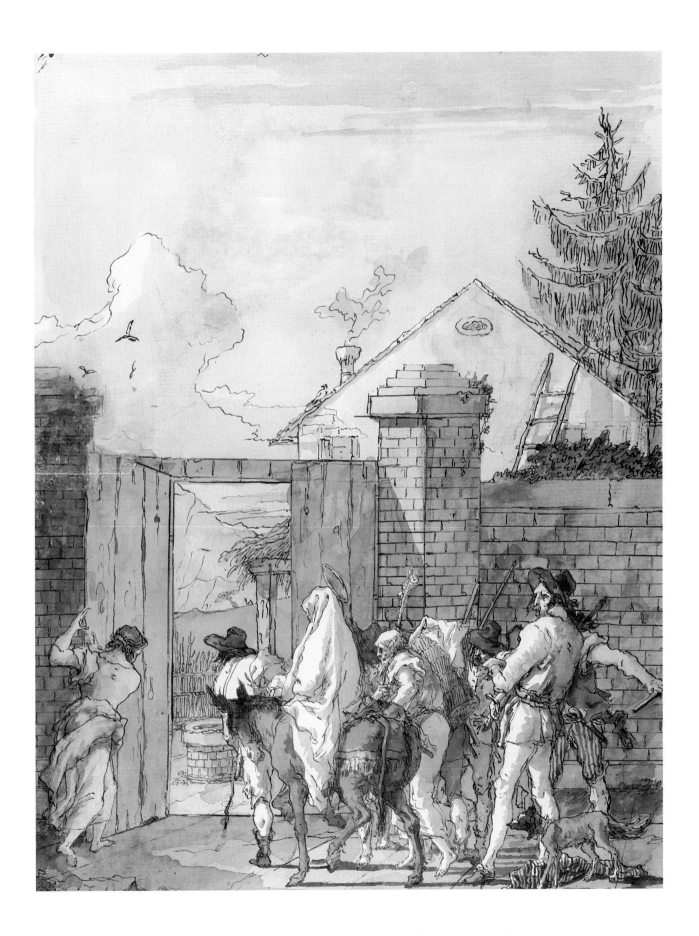

69. The Holy Family Leaves the Robbers' Farm

He has a leprous child who is always crying and is healed by the water in which Jesus was washed. (James 1924, 117, from the Gospel of Nicodemus)

> Pen and wash, over traces of black chalk, 474 x 373, trimmed close to the image
> Signed low left: Dom.o Tiepolo f
> Provenance: Jean-François Gigoux [1806–1894], his bequest, 1894
> Exhibition: Venice 1951, no. 115; Paris 1971 [298]; Udine 1996 [93]
> Literature: Byam Shaw 1962, 36; Conrad 1996 [58]
> Reference: James 1927, 122–126; Chaplin 1967, 88–95; Konrad von Fussesbrunnen 1973, 3–9

Besançon, Musée des Beaux-Arts et d'Archéologie, D.2232

Their visit over, the Holy Family bursts out of the farmyard gate, their donkey led by an energetic robber who will later help escort Jesus's donkey to the gates of Jerusalem (which may have been Domenico's way of placing him in that city to be arrested and crucified along with Jesus as the good thief). As several gypsies stand by respectfully, the party heads out. One eager robber has already passed partially from view, lending a sense of immediacy to this "snapshot" of the Holy Family's travels. The young girl who stands by is likely the leprous child healed by the water in which Jesus was washed. ✤

This scene showing the Holy Family leaving by a farm gate in company with the robbers and its companion showing them arriving at the same gate (pl. 68) are quite different from all the other scenes illustrating the Flight into Egypt. They are here associated with the visit of the Holy Family to the robbers' farm, an event that is mentioned in the fourth-century *Gospel of Nicodemus,* described in Konrad von Fussesbrunnen's poem, *Die Kindheit Jesu.* Since the rest of the poem follows the *Liber de Infantia,* it is suggested that this episode derives from a longer version of the text, such as is recorded in the *Irish Infancy Gospel,* British Museum, Arundel 404 (James 1927, 122–126). Margaret Chaplin discusses a fourteenth-century Spanish poem, *Lo libre dels tres reys dorient,* containing similar material, but it remains unclear how Domenico came to know the story. ✤

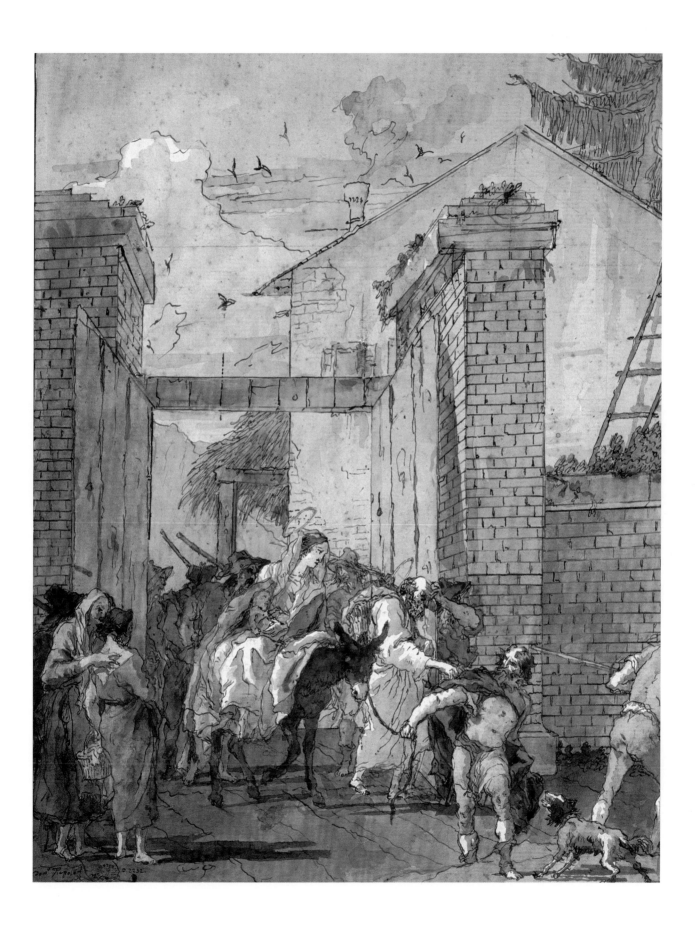

70. *The Holy Family at Matarea*

From there they went to that sycamore tree which today is called Matarea, and the Lord Jesus made to gush forth in Matarea a spring, in which the lady Mary washed his shirt. And from that sweat of the Lord Jesus which she wrang out there, balsam appeared in that place. (The Arabic Gospel 8:9–11)

Pen and wash, over slight black chalk, 462 x 355
Signed low right: Dom.o Tiepolo f
Provenance: Jean Fayet Durand (1806–1889)
Literature: Patrignani 1705; Conrad 1996 [49]
Reference: dalla Pergola 1713, 137; James 1924, 81; *Lost Books* 1926, 47; Pigler 1956, I, 258; Henneke 1963, 409; Maria de Agreda 1971, ii, 553.

Paris, Musée du Louvre, Département des Arts Graphiques, RF 1713bis [47]

In a cozy, restful scene, a row of small sycamore trees enclose a garden-like space by the fountain of Matarea. Here it miraculously provides a changing table as well. Angels have returned to offer assistance, aiding Mary with the washing and helping Joseph entertain the baby. As Mary lays out a piece of linen, her attention is fixed on Joseph and her son. They in turn are distracted by the cherub who clearly wants to play. The whole scene has the flavor of a moment caught in time, with the fountain gushing forth at the left, and Joseph's staff, hat, and cloak temporarily discarded. ❦

Apart from being the first source of the story of the fountain of Matarea, *The Arabic Gospel* relates numerous miracles relating to the washed garments of the infant Jesus and to the water in which they were washed (see chs. 5, 6, 9, 12, and 13), both before and after Matarea. Medieval travelers to the Holy Land also record the story: Burchard of Mount Sion, *Locorum Terrae Sanctae,* ca. 1280; Marino Sanuto Torcellus, *Secrets for True Crusaders,* 1321; and Ludolph von Suchem, *A Description of the Holy Land, XXX—Of the Garden of Balsam,* 1350. The latter describes the plantation and how the balsam is gathered and its medicinal properties, as well as the story of Mary in the garden. This is said to come verbatim from John of Hildesheim, *History of the Three Kings.* Anton Maria della Pergola mentions the arrival at Matarea and the fountain in the "Orto di Balsamo": *"Nell'acqua di questo fonte lavava la Vergine i panicelli dell'Umano Signore,"* citing Brocardo (i.e., Burchard of Mount Sion). Anna Jameson also describes the Garden of Balsam at Matarea in Egypt, with the fountain in which the Virgin washed their linen. The sweet fragrance that resulted gave the balsam its perfume (Jameson 1852, ed. 1899, 239–240). Conrad points out that similar details are related by Maria de Agreda in 1670. ⚜

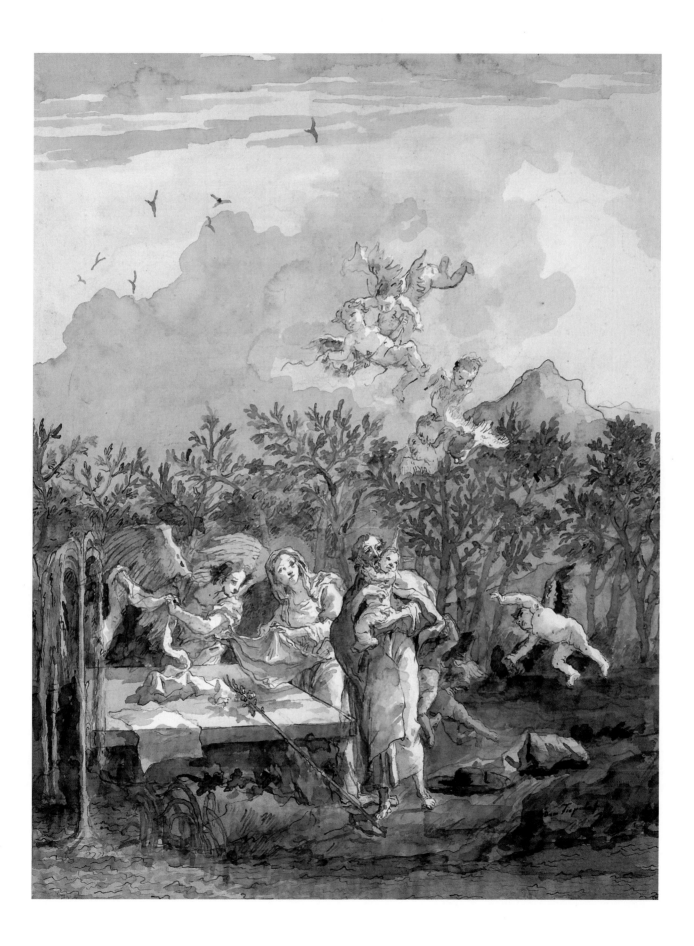

71. *The Holy Family at Hermopolis with Bowing Trees*

Cassiodorus saith in the History tripartite, in Hermopolin of Thebaid there was a tree called Persidia, which is medicinal for all sicknesses, for if the leaf or the rind of that tree be bound unto the neck of the sick person, it healeth him anon, and as the blessed Virgin Mary fled with her son, that tree bowed down and worshipped Jesu Christ.
(The Golden Legend)

As the Holy Family entered this forest, all the trees bowed down in reverence to the Infant God; only the aspen, in her exceeding pride and arrogance, refused to acknowledge him, and stood upright. Then the infant Christ pronounced a curse against her, as he afterwards cursed the barren fig-tree; and at the sound of his words, the aspen began to tremble through all her leaves, and has not ceased to tremble even to this day. (Jameson, Legends of the Madonna)

> Pen and wash, over extensive black chalk, 465 x 362
> Not signed
> Provenance: Jean Fayet Durand (1806–1889)
> Literature: Conrad 1996 [53]
> Reference: *The Golden Legend* 1900, ii, 182, citing Cassiodorus: Maria de Agreda 1971, ii, 553; Jameson 1899, 234

Paris, Musée du Louvre, Département des Arts Graphiques, RF 1713bis [53]

Having set out once more, the Holy Family is accompanied by an unusually large crowd of angels as trees on both sides of their path bow down in homage. Joseph has turned back to check on Mary and the baby, who may be explaining to him this latest wonder. With this episode, Domenico brings to eleven the number of scenes in which the Holy Family receives homage, thus stressing the theme of triumph and veneration. ❦

The legend that *The Golden Legend* derives from Cassiodorus does not seem to be mentioned elsewhere. The event is located at Hermopolis, a city located on the Nile, about halfway between Memphis and Thebes, and is something of a variant on the story of the bending palm, though quite distinct in all details. ❖

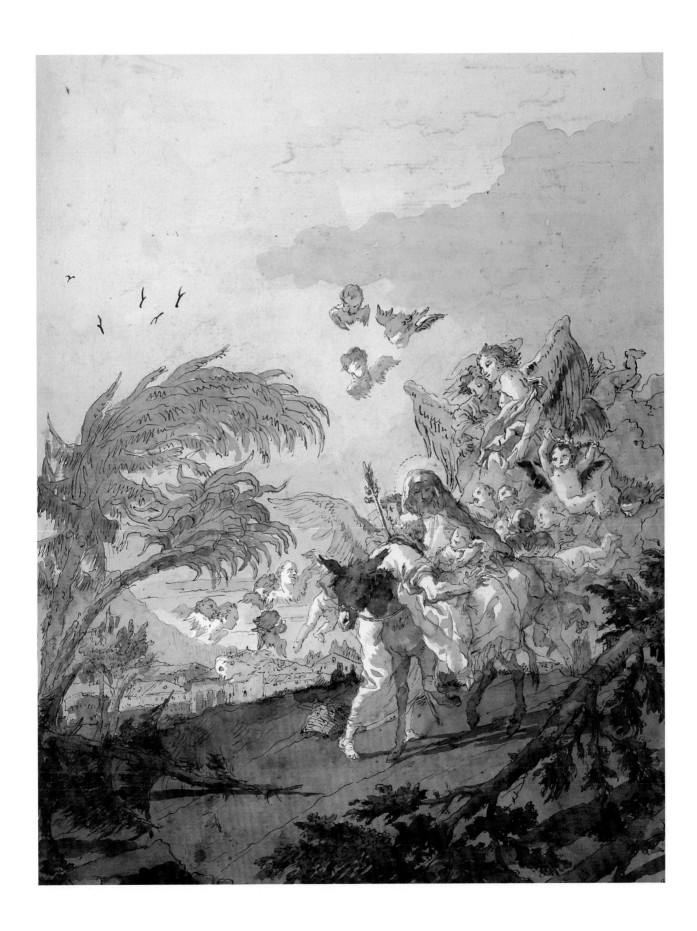

72. *The Holy Family Enters Memphis*

Thence they proceeded to Memphis, and saw Pharaoh, and abode three years in Egypt. (The Arabic Gospel 8:12)

Pen and wash, over black chalk, 460 x 360
Signed low left: Dom.o Tiepolo f
Provenance: Paris . . . , June 17, 1966 [56]; Paris, Hôtel Drouot, May 30, 1968 [56]; Paris, Hôtel Drouot, June 17, 1969 [planche IX]
Literature: Conrad 1996 [60]
Reference: *Lost Books* 1926, 47; Ragusa and Green 1961, 68

In yet another entrance scene, Mary and Joseph are now shown passing through a gate. Once again they are strangers, as the peasants who follow behind them fail to recognize their divine status. ❦

This and plate 74 represent a second pair of drawings showing the Holy Family entering and leaving a city gate. The first pair, distinguished by a bridge before the city gate (pls. 60 and 63), are here taken to show the Holy Family arriving and leaving Sotinen. The second pair are taken to show the Holy Family arriving and leaving Memphis. Here the Holy Family is unquestionable entering a large city, which is rather less the case with plate 60 and the etching *The Flight into Egypt 27,* which is the last of that series (Rizzi 1971, [93]), but both of these are quite different. Conrad notes that the three figures carrying burdens are found again in *The Pedlars—Divertimento 49* (Gealt 1986 [47]). ⚜

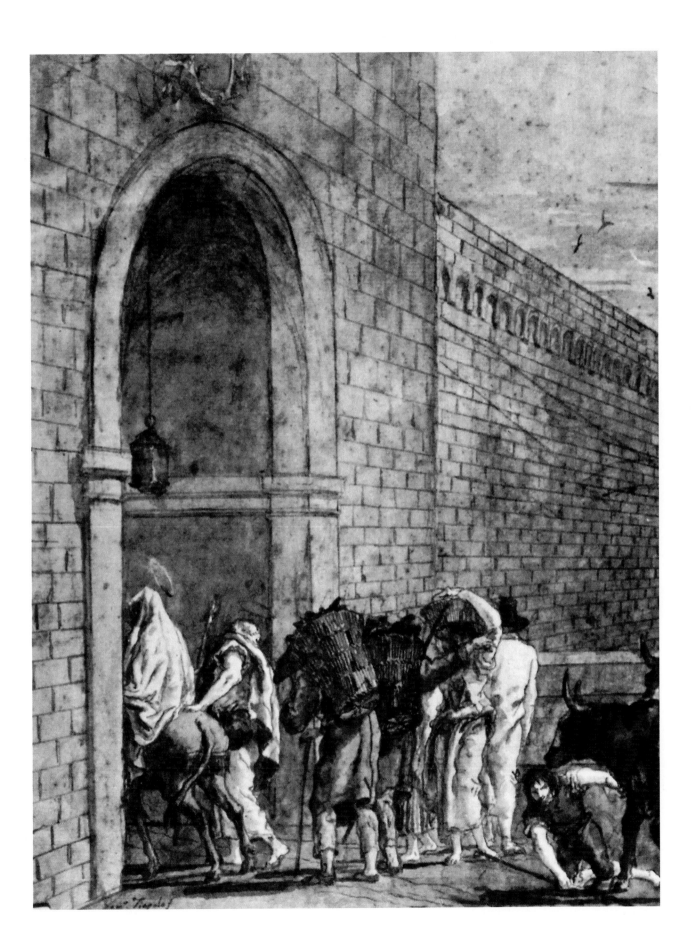

73. *The Dream of Joseph in Egypt*

But when Herod was dead, behold, an angel of the Lord appeareth in a dream to Joseph in Egypt, saying, Arise and take the young child and his mother, and go into the land of Israel: for they are dead which sought the young child's life. And he arose, and took the young child and his mother, and came into the land of Israel. (Matt. 2:19–21)

When the seven years of the Lord's peregrination in Egypt were over, the angel appeared to Joseph in his sleep, saying, "Take the Child and His mother and go to the land of Israel, for those are dead, who sought the life of the Child." (Meditationes vitae Christi)

> Pen and wash, over black chalk, 468 x 362
> Not signed
> Provenance: Jean Fayet Durand (1806–1889)
> Literature: Conrad 1996 [65]
> Reference: Lost Books 1926, 47; Ragusa and Green 1961, 77 [65]; Réau 1957, 286

Paris, Musée du Louvre, Département des Arts Graphiques, RF 1713bis [98]

Still asleep (as tradition required) Joseph receives instructions from a by-now familiar angel, as the donkey stands patiently by. Mixing exotic with domestic architecture, Domenico again shows an Italian village in the background. ❦

The Dream of Joseph in Egypt is also mentioned in *The Arabic Gospel* 8:16. It is interesting to note that in the *Meditations on the Life of Christ*, the sojourn in Egypt is declared to have lasted seven years. The composition echoes *The Annunciation to Joachim* (pl. 8). ⚜

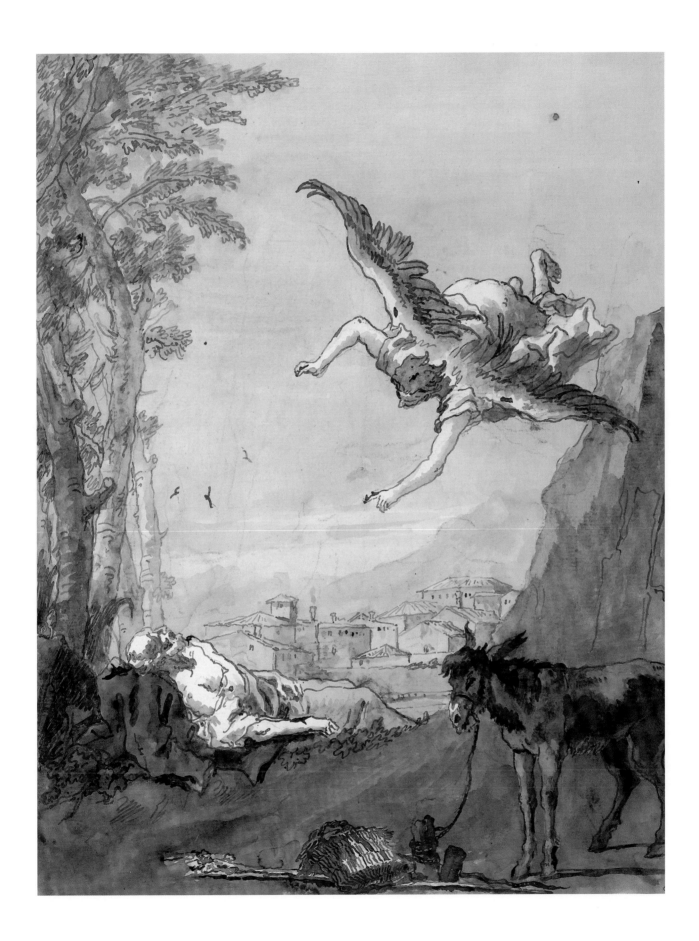

74. The Holy Family Leaves Memphis

Early the following morning you will see a few good women of the neighbourhood, and also men, come to accompany them to the outside of the city gate, to enjoy their pleasing, holy conversation. They had made their departure known to the neighbours a few days earlier, for it was not seemly to leave furtively, since they did not have to fear the death of the Boy as when they came to Egypt. Thus they departed, the men ahead with Joseph holding the Boy by the hand, followed by the mother and the women. The Child walked in front of her, for she would not have let Him go behind.
(Meditationes vitae Christi)

> Pen and wash, over black chalk, 470 x 370
> Signed low right: Dom.o Tiepolo f
> Provenance: Paris, Palais Galliera, June 20, 1970 [2]; Adolphe Stein
> Literature: Conrad 1996 [62]
> Reference: *Lost Books,* 1926, 47; Ragusa and Green 1961, 78 [66]
> Exhibition: London, Stein, n.d.

As the Holy Family leaves Memphis (or Egypt), angels (though less numerous as was sometimes the case earlier) have joined them and a peasant boy looks back at them, perhaps remembering them for some earlier miracle. In constructing a more extensive visual portrayal of the Holy Family's adventures in Egypt than was customary, Domenico faced the challenge of linking disparate events taken from diverse sources. The motif of exits and entrances was one of his favorite devices, and this exit scene may in fact not have been intended as the final one. ✺

As noted in plate 63 above, the Virgin apparently still carries an infant, which is, perhaps, an oversight. The city gate now appears to have two openings, unlike plate 72. ⚜

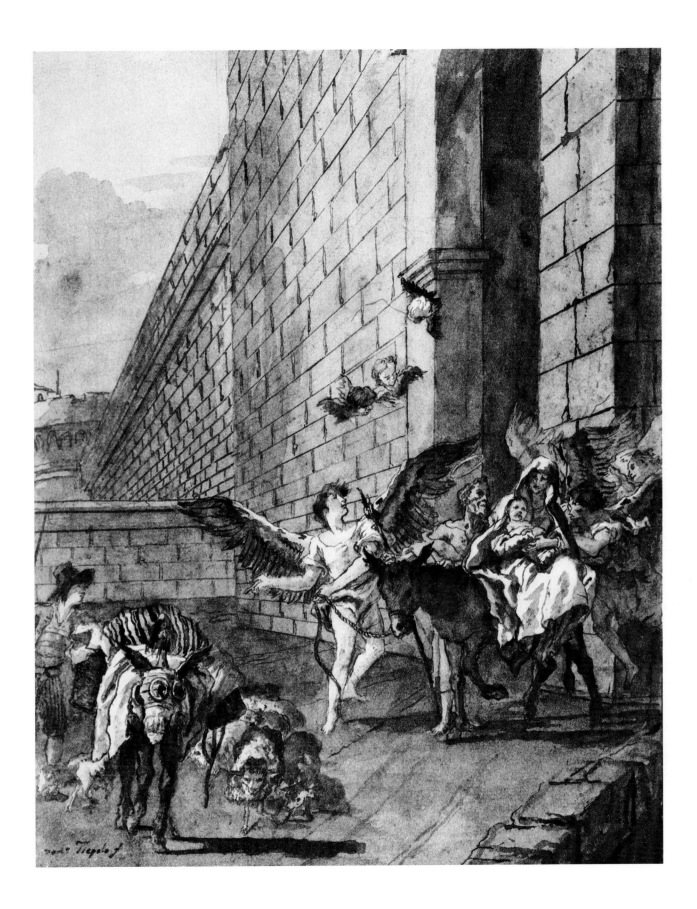

75. *The Holy Family Meets the Young John the Baptist*

When they came to the edge of the desert they found John the Baptist, who had already begun to do penance there, although he had not committed any sin. (Meditationes vitae Christi, 81, 82)

> Pen and wash, over slight black chalk, 462 x 358
> Signed low left: Dom.o Tiepolo f
> Provenance: Jean Fayet Durand (1806–1889)
> Literature: Conrad 1996 [64]
> Reference: Ragusa and Green 1961, 81, 82; Réau 1956, ii/i, 448

Paris, Musée du Louvre, Département des Arts Graphiques, RF 1713bis [12]

In his interpretation of a rare subject, Domenico deftly blends prosaic and mystical elements. Resting temporarily along their journey, the party is diversely occupied. Joseph, deeply absorbed in some text, could be taken as a traveler consulting a map. The two children greet one another with a mixture of shyness and interest. Jesus, wearing his boy's tunic (made by his mother), reaches toward John, whose tousled hair and hairshirt reflect his hermit's existence. Besides his traditional emblems, the cross and lamb, John holds a martyr's palm. The adoring angel at the right kneels in the pose John himself will assume as an adult later when he worships at his makeshift altar (see pl. 88). Above them a heron (symbolizing the dutiful son) flies away. ❦

As noted above (pls. 45 and 46), Bonaventura—or as nineteenth-century pedantry insists, the Pseudo-Bonaventura—is the source for the encounters between the infant Jesus and John the Baptist, both immediately before the Flight into Egypt and on the return of the Holy Family to Judaea. Here both the children are grown boys. The minimal use of chalk and the pen outline on the mountains indicate an early date for the drawing. ⚜

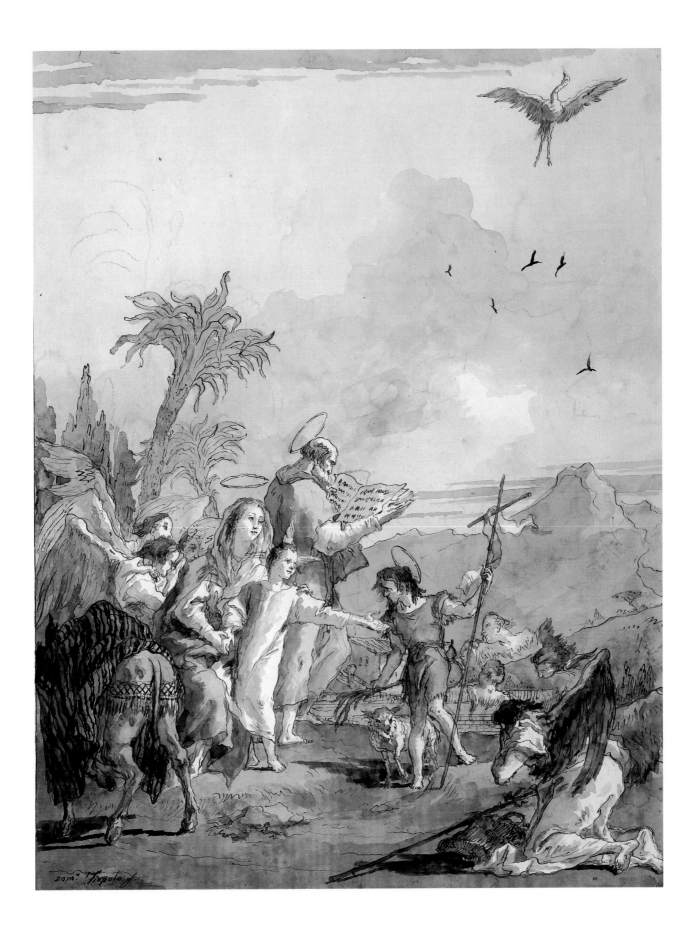

76. *The Holy Family Returns to Nazareth*

And he came and dwelt in a city called Nazareth: that it might be fulfilled which was spoken by the prophets, He shall be called a Nazarene. (Matt. 2:23)

Pen and wash, over black chalk, 470 x 361 (paper, 481 x 376)
Signed?
Provenance: M.L. Joly sale, Hôtel Drouot, Jan. 26, 1911 [174—front cover]; Jacques Guérin, his sale, Paris, Hôtel Drouot, Dec. 20–21, 1922 [63]; Tours, Hotel des Ventes, May 7, 1979 [11]; Paris, Hôtel Drouot, Dec. 2, 1987 [22]
Exhibition: Paris, Paul Prouté 1980 [58]
Literature: Conrad 1996 [66]

Now confidently leading his parents, Jesus, a shining presence in this lovely drawing, gives Joseph some directions or advice, while Mary, escorted by a pair of angels, smiles gently. An elder patriarch, entirely absent during their long sojourn in Egypt, looks on from the right, taking up the post he occupied during so many scenes in the earlier chapters of this story. This is a strong indication that the family is nearly home. ❧

There is little doubt that the Holy Family is on the return from Egypt. Once again they pass a pyramid on the left and a palm tree at the right, a spot familiar from an earlier episode of their journey (pl. 51). ⚜

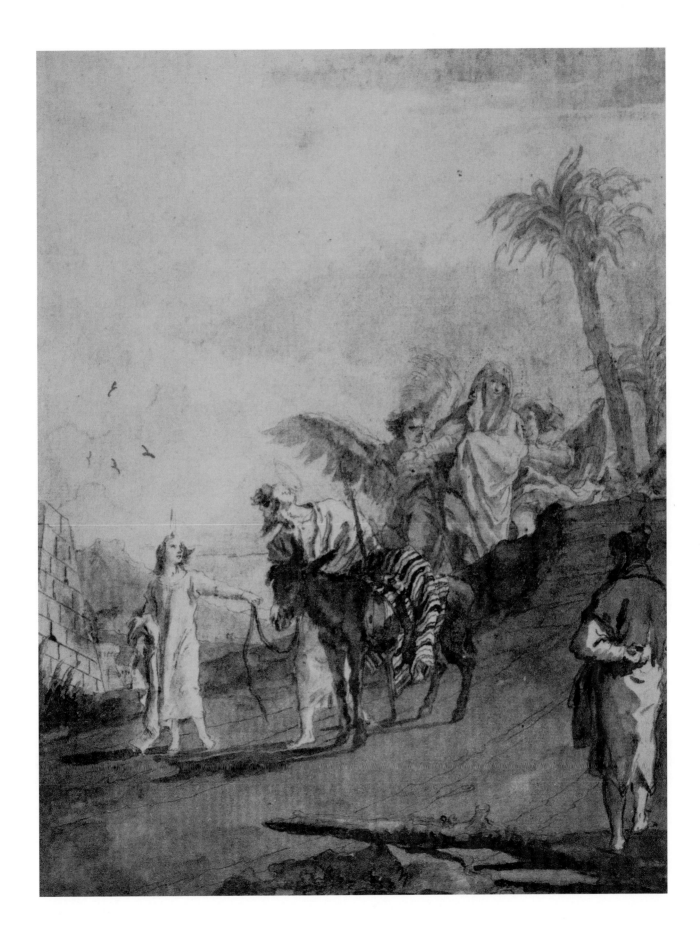

77. The Young Jesus Leads His Parents to Jerusalem

And when he was twelve years old, they went up to Jerusalem after the custom of the feast. (Luke 2:42)

Pen and wash, over heavy black chalk, 470x 360
Signed low right: Dom.o Tiepolo f
Provenance: Roger Cormier, Tours, his sale, Paris, Georges Petit, Apr. 30, 1921 [58]; Duc de Trévise, his sale, Paris, Hôtel Drouot, Dec. 8, 1947, no. 42
Literature: Guerlain 1921, 49; Guerlain 1921+, 229; Conrad 1996 [67]

Here Jesus is even taller and clearly older, and again he leads the way. Joseph manfully tries to keep pace and Mary's cloak flaps wildly, reflecting her effort to keep up with her energetic son. Peasants bearing baskets full of produce for the markets in Jerusalem can be seen just over the rise in the road. ❦

Once again Jesus confidently leads his parents, but now they are going away from us, up a road that curves away, presumably in the direction of Jerusalem. As is his custom, Domenico has no difficulty indicating whether a scene represents "going toward a place" or "coming away from it." Mary is no longer assisted by angels. ❦

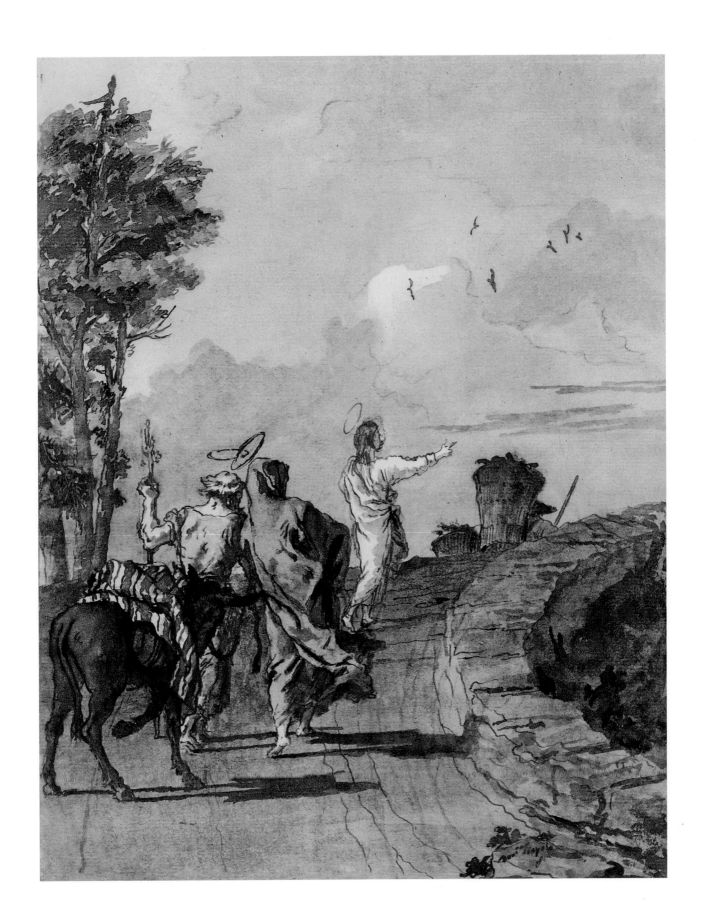

78. *Jesus Among the Doctors*

And it came to pass, that after three days they found him in the temple, sitting in the midst of the doctors, both hearing them, and asking them questions. (Luke 2:46)

Pen and wash, over black chalk, 462 x 355
Signed on the column: Dom.o Tiepolo f
Provenance: Jean Fayet Durand (1806–1889)
Literature: Conrad 1996 [272]
Reference: Virgil Solis 1565 [110]; Pigler 1956, i, 260–266; Bartsch X [91]; Réau 1957, 289–292; Verri 1991, 785–786

Paris, Musée du Louvre, Département des Arts Graphiques, RF 1713bis [109]

Staging this episode of Christ's childhood in a secular mode, as he did his mother's life in the Temple, Domenico characterizes Jesus among the doctors using a mixture of high and low, eighteenth-century and "historical" contexts. Jesus, a peasant (in contrast to his mother's childhood elegance), has just been found by Mary and Joseph, both dressed in rough country clothes. This may reflect the constant stress on the Holy Family's poverty by such tracts as *The Meditations on the Life of Christ*. By contrast, the Temple elders and patriarchs wear their traditional turbans while the two central elders seated beneath the elegantly curved and sculpted architecture wear more noble robes. ✴

The treatment here is very unusual: Joseph in knee-breeches and holding a large hat, Mary in a striped skirt. They seem to have already found the young Christ, who continues to address the doctors. This drawing is followed by plate 79, with the same setting. There, Jesus is leaving accompanied by Joseph and Mary, with the leading doctor in consternation; this again is very unusual. The underdrawing of architecture follows the same pattern, later abandoned, in both drawings. ⚜

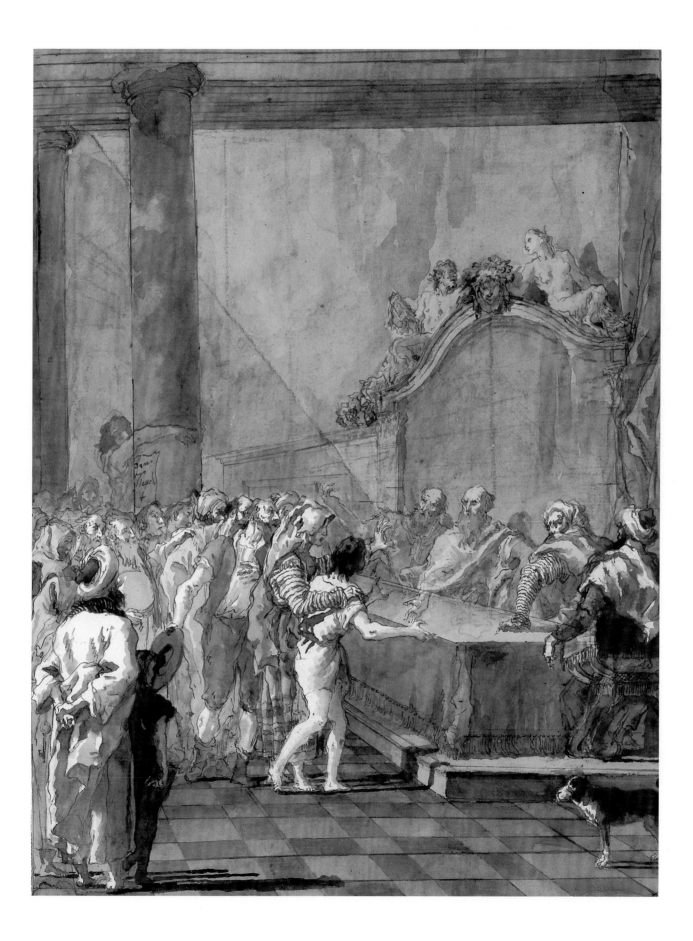

79. *Jesus Leaves the Doctors*

And when they saw him, they were amazed: and his mother said unto him, Son, why hast thou thus dealt with us?
behold, thy father and I have sought thee sorrowing. And he said unto them, How is it that ye sought me? wist ye not that
I must be about my Father's business? (Luke 2:46)

Pen and wash, over heavy black chalk, 464 x 356
Not signed
Provenance: Sir Henry Oppenheimer, F.S.A. (1859–1932), his sale, Christie's, Jul. 10–14, 1936 [193], bt. Brinsley Ford,
50 guineas
Exhibited: Exeter 1946 [138]
Literature: "The Ford Collection," *The Walpole Society*, XL 1998, RFB 117 [33], as "Tobit, Anna, Tobias and their dog being
turned out of the Court of Sennacherib"
Literature: Conrad 1996 [273]
Reference: Pigler 1956, i, 260–266

London, The Brinsley Ford Collection

Taking their son home, Mary and Joseph are undeterred as the elders register protest and amazement. The crowd
is unmoved and still includes the eager youth, who has climbed a column in order to better see and hear. ❦

A much longer and more detailed account of the discussions of Jesus with the doctors is given in the concluding
section of *The Arabic Gospel* 21–22. The scene follows plate 78, which displays the same setting and the same
figures at the table, but with the central figure seated calmly. However, the underdrawing seen in the central part
of the screen suggests that this drawing may have precedence. ✿

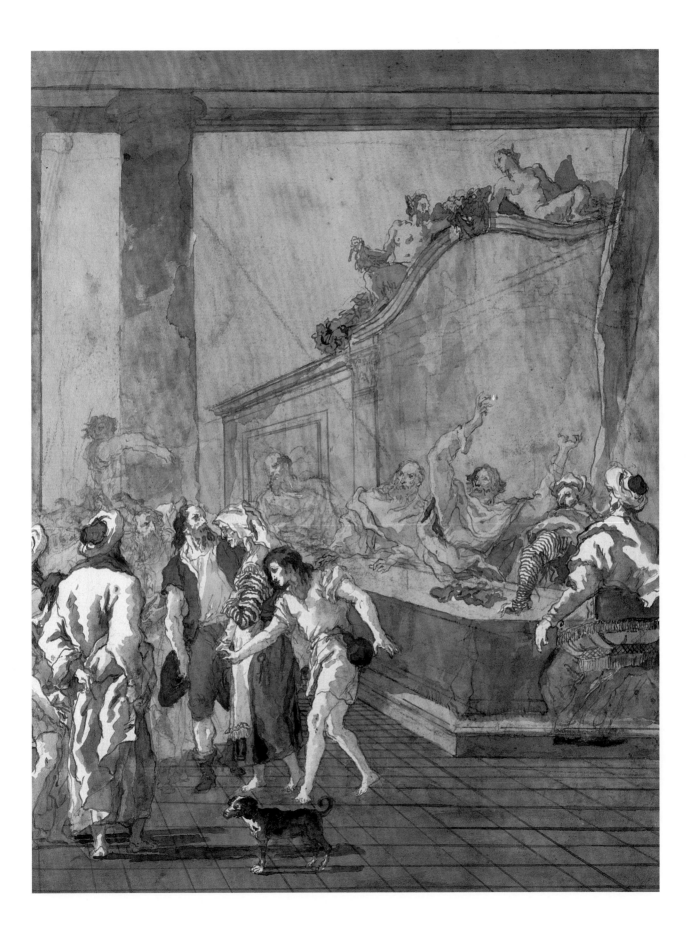

80. *The Death of Joseph*

I wept. My mother asked if Joseph must die, and I told her that it must be so. I sat at his head, Mary at his feet. I felt his heart and found that the soul was in his throat. . . . Death seeing me dared not enter. I arose and went outside and bade him go in and do his appointed work. Then Abbaton went in and took his soul, at sunrise on 26th Epep. Michael and Gabriel put the soul into a precious silken napkin and the angels took it away, singing. I sat down by the body and closed the eyes and mouth: and comforted Mary and the rest. (History of Joseph the Carpenter, 19–24)

Pen and wash, over traces of black chalk, 464 x 362
Signed on the stool, low left: Dom.o Tiepolo f
Provenance: Roger Cormier, Tours, his sale, Paris, Georges Petit, Apr. 30, 1921, no. 68; Sir Henry Oppenheimer, his sale, Sotheby's, July 10, 1936, lot 192, bt. Agnew's, 50 guineas; Dr. Rudolf J. Heinemann, New York
Exhibition: New York 1971 [258]; New York 1973 [110]
Literature: Santifaller 1976 [19]; Conrad 1996 [75]
Reference: Lippomano 1581, iiii, 87; Maria de Agreda 1685, v, 873–879; Patrignani 1709, i, cap. xii; della Pergola 1713, xlvi, 235; Gentilucci 1848, iii, 169; Jameson, *Legends of the Madonna*, 1899, 274; James 1924, 85–86; Verri 1991, 776–780

New York, The Pierpont Morgan Library, Gift of Mrs. Rudolf J. Heinemann, in memory of Dr. Rudolf J. Heinemann, 1997.58

In one of Domenico's most moving images, the pathos of death is enriched by prosaic reality blended with deep mysticism. Jesus, his arm tenderly cradling Joseph's head, comforts his earthly father and points to the angels who have come to escort him heavenward. Mary, regarding him sweetly, is surrounded by angels. The one who had prostrated himself behind her at her father's demise (pl. 20) returns to do similar honors here. Homier details are found nearer Joseph. The slippers neatly stored by the bedside bear mute testimony to his final steps, while his discarded carpenter's coat hangs at the left, in a respectful attitude. ❧

Maria de Agreda places *The Death of Joseph* after the childhood of Jesus but before the start of his ministry, in the early part of his manhood; *The History of Joseph the Carpenter* indicates a later date. The scene closely parallels *The Death of Joachim* (pl. 20), taking place in the same simple room with brick walls, a Venetian ceiling, and a window opposite the bed. An angel bears away the soul of the deceased in the form of a small child who waves farewell as he departs through the window. A similar detail is found in plate 20. The scene is described by della Pergola (1713): *Della Beata Morte di San Giuseppe fra le braccie di Gesù e di Maria.* Patrignani (1709) devotes a chapter to Joseph as the patron of *la buona morte.*

Joseph is venerated in Venice, principally in the church and monastery of San Giuseppe in Castello, founded in 1512 (Corner 1749: iv, 276). The festival of Joseph is celebrated on March 19 and his death on July 20. This was the source of a vigorous and widespread cult in Venice, incorporating the idea of *la buona morte* (Niero 1993: 140). St. Teresa of Avila chose him as the chief patron of her order. The most magnificent monument to his cult today is perhaps the vast Oratoire Saint-Joseph in Montreal. ⚜

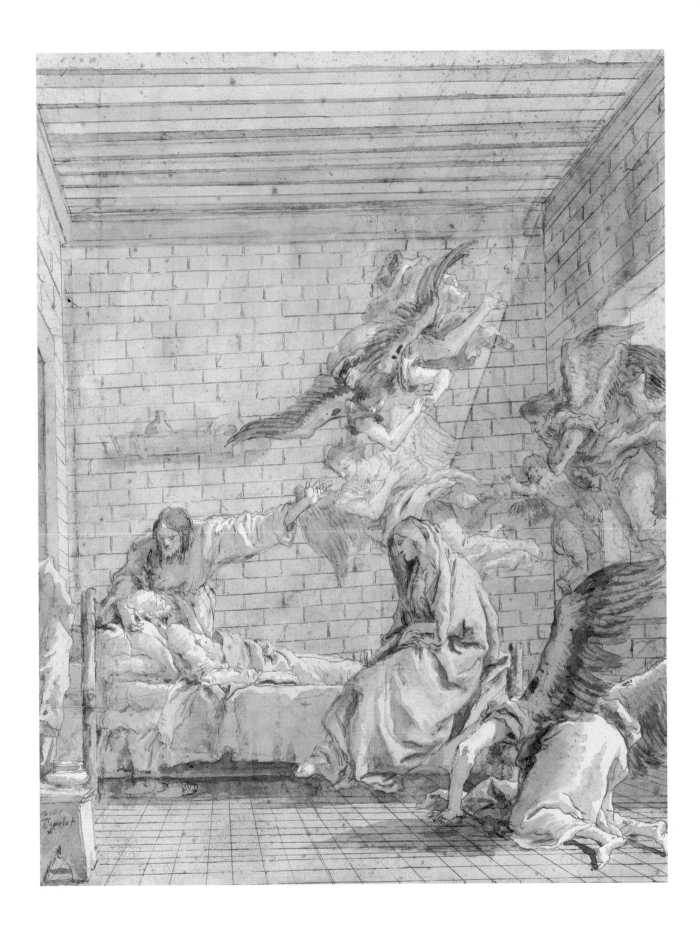

81. *The Assumption of Joseph*

By command of the Lord they carried his most holy soul to the gathering-place of the Patriarchs and Prophets, where it was immediately recognised by all as clothed in the splendors of incomparable grace, as the putative father and the intimate friend of the Redeemer, worthy of highest veneration. (Maria de Agreda iii, 153)

Cite: della Pergola 1713, xlvii
Pen and wash, 457 x 355
Signed low right: Dom.o Tiepolo f
Inscribed: *Anima Glorioso di S. Giuseppe*
Provenance: Jean-François Gigoux, his sale 1882, lot 179; P.D.E.F. Lamy (1855–1919), his sale, Paris, Hôtel Drouot, Nov. 25–26, 1912 [184]; New York, Seligman & Co; Zürich, Marianne Feilschenfeldt, 1959
Literature: Winslow Ames, *Italian Drawings,* New York 1963 [90]; Conrad 1996 [76]
Reference: Patrignani 1709; della Pergola 1713, xlvii, 243; Verri 1991, 780; photo: JBS archives

Bradford, Pennsylvania, T. Edward Hanley (formerly)

Ascending to heaven, Joseph passes by limbo, where, Maria de Agreda states, he gave the joyful news of redemption to the prophets and saints. His frail nude body is recognized by them as clothed in the "splendors of incomparable grace" by virtue of his devotion to Mary and Jesus. ✺

The Assumption of Joseph is not described in *The History of Joseph the Carpenter,* but it is depicted in the ceiling of San Giuseppe in Venice and elsewhere. Here the composition is somewhat reminiscent of many of Domenico's ceilings, especially *The Apotheosis of San Lio* in the church of San Lio of 1783 (Mariuz, 1971, [318]) and *The Trinity* for Casale sul Sile of 1781—note the fine drawing in the Scholz collection (Cambridge, 1970, [100]). The scene is described by della Pergola: *Della Sepoltura del Corpo di San Giuseppe e del passagio al Limbo della di lui anima,* and in xlviii: *San Giuseppe, come di molti è opinione risucito con Christo, ed alla Beata Vergine comparve.* ⚜

The Story of John the Baptist, Plates 82–102

Sometimes called the last prophet, or the first of the saints, John the Baptist, the messenger who preached of Christ in the desert, inaugurated the essential rite of Baptism, famously baptizing Jesus himself in the Jordan River. Importantly, both Mark (1) and John (1) skip the story of Christ's birth and focus on his adult life, beginning their narratives with accounts of his Baptism. Luke (1:1–80), who offered the most detailed account of Jesus's infancy, is also our principal source for John's birth. John's parents, the priest Zacharias (not to be confused with the Zacharias who conducted Mary and Joseph's marriage) and Elizabeth (Mary's cousin), were, like Abraham and Sarah as well as Joachim and Anna, old and childless. As Zacharias burned incense in the Temple, an angel delivered the news of Elizabeth's pregnancy. Struck dumb for his disbelief, Zacharias regained his voice only after writing John's name (chosen by Elizabeth) on a tablet on his son's naming day. Apocryphal sources added rarely depicted details about how John survived Herod's wroth. Zacharias was murdered in the Temple for refusing to divulge his location, while Elizabeth and John were hidden in a mountain that miraculously split into two and offered refuge from Herod's rampaging soldiers. John's destiny as a wilderness prophet is declared in Luke 1:80, while his life in the desert, concluding with his baptism of Jesus, occupies ch. 3. Mark 1:6 is the source for our knowledge of what he ate: honey and locusts. John 1:36 is the source for the words found on John the Baptist's banner, "Ecce Agnus Dei," referring to the words John uttered when he saw Jesus, "Behold the lamb of God." Matthew 3:1–14 offers a detailed account of Christ's baptism as well. Luke briefly notes John's imprisonment by Herod (3:19–20) while Matthew and Mark add in details about Salomé's dance and John's beheading in prison.

Zacharias and his assailant from plate 86, *The Slaying of Zacharias*

John's life became the standard subject for mural cycles decorating baptisteries throughout Italy, while images of Christ's Baptism proliferated as individual scenes, remaining popular through the seventeenth and eighteenth centuries. True to form, Domenico adapted and amended the standard pattern. Zacharias's murder (a rare subject) was followed by a unique funeral, which links the story to the prized relics (Zacharias's body) preserved in the Venetian church of San Zacharias. In Domenico's version, John's naming takes place at his circumcision (ignoring text and visual tradition while forging a link with Jesus's life). Domenico's scene of Elizabeth's flight into the mountains (another unusual subject) establishes a further parallel between John's and Jesus's infancies. Christ's Baptism dominates the chapter with at least four scenes, and John's story ends not only with an unusual portrayal of Elizabeth's death in the desert (paralleling Anna's, at which John was present) but also with a rare scene of John's funeral, which parallels that of his father.

Zacharias's body carried off in a bier, detail of plate 87, *The Funeral of Zacharias*

82. *The Annunciation of the Birth of John to Zacharias*

But the angel said unto him, Fear not, Zacharias: for thy prayer is heard; and thy wife Elizabeth shall bear thee a son, and thou shalt call his name John. (Luke 1:13)

The Altar of Incense of gold, which by God's command was placed over against the vaile hanging before the most holy place, called the Holy of Holiest: Whereon the Priests, every day morning and evening offered unto God sweet savour, Frankincense and sweet perfumes. The Angel Gabriel standing sometime at the right hand of this Altar, told unto Zachary, as he was offering incense, the conception of John Baptist. [*sic*] (Christiaan van Adrichem 1584, Site 80)

Pen and wash, over extensive black chalk, 464 x 360
Signed on the plinth, low right: Dom.o Tiepolo f
Provenance: Jean Fayet Durand (1806–1889)
Literature: Conrad 1996 [29]
Reference: *Vita Christi,* 1570, cap. iv; *Della concettione di Giovanni Battista;* Christiaan van Adrichem 1584, Site 80

Paris, Musée du Louvre, Département des Arts Graphiques, RF 1713bis [11]

In the fifth "annunciation" scene, Gabriel appears to Zacharias in a splendid temple. Like Abraham and Joachim, Zacharias was childless into old age, but he failed to believe the news Gabriel delivered and was struck dumb. Interrupted from his work by Gabriel, Zacharias here has dropped his censer and reacts with surprise as he looks up at the angel. His attitude and dress link him with Joachim, as does the Temple setting. ✹

Although we have encountered Zacharias and Elizabeth already in *The Visitation* (pls. 32–36) and the infant John in "the second visitation" before (pls. 44–46) and after *The Flight into Egypt* (pl. 75), the main story of John the Baptist starts here. The setting here—the interior of the temple, an altar with candles, and the tables of the law— is also used with slight variations for related scenes (pls. 86–87). Zacharias is generally shown with a censer, as "his lot was to burn incense when he went into the temple of the Lord." The location is identified by Christiaan van Adrichem (1584: Site 80), as before the Altar of Incense. One may note that this drawing and the eight that follow appear in the same order in the Louvre Album (pls. 11–19). ❖

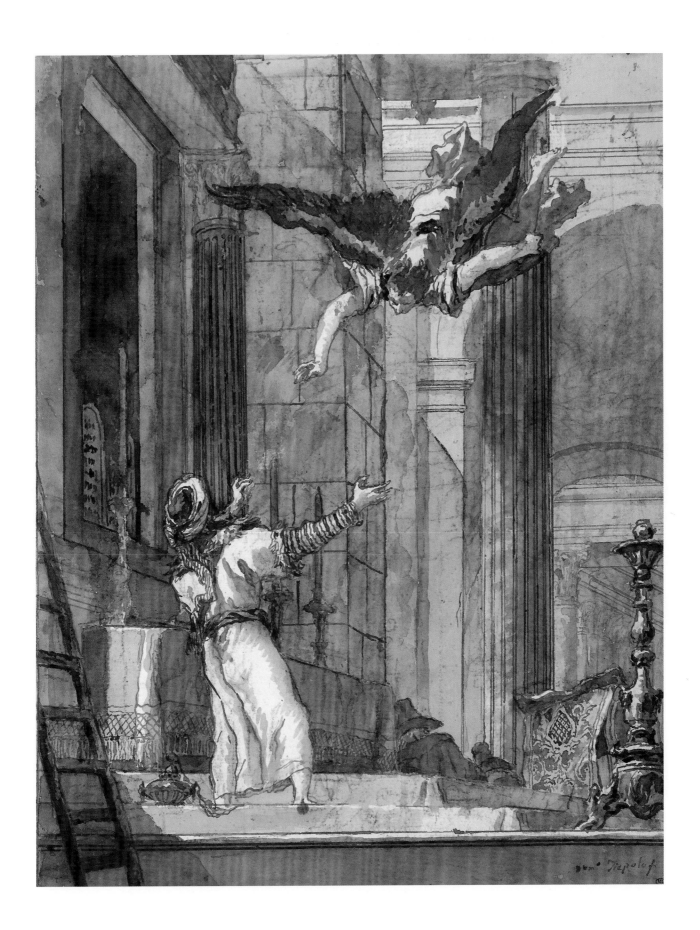

83. *The Circumcision of John the Baptist*

And it came to pass that on the eighth day they came to circumcise the child; and they called him Zacharias after the name of his father. And his mother answered and said, Not so; but he shall be called John. (Luke 1:59–64)

Pen and wash, over black chalk, 470 x 360, image, not trimmed
Signed low left: Dom.o Tiepolo f
Provenance: Roger Cormier, Tours, his sale, Paris, Georges Petit, Apr. 30, 1921, no. 3; Prince Vladimir Argoutinsky-
Dolgoroukoff (Lugt Supp. 2602d), his sale, Sotheby's, Jul. 4, 1923 [19], bt. Ezekial; Tomas Harris; Dr. Rudolf J. Heinemann,
New York
Exhibition: London, Arts Council 1955, pl. 36; New York 1973 [102]
Literature: Conrad 1996 [33]
Reference: *Vita Christi* 1570 cap. vi; Réau 1956, ii/i, 447; Zacharias, *Bibliotheca Sanctorum XII,* 1443–1446; Elizabeth,
Bibliotheca Sanctorum IV, 1079–1093; Ragusa and Green 1961, 25 [19]

New York, The Pierpont Morgan Library, Gift of Mrs. Rudolf Heinemann, in memory of
Dr. Rudolf J. Heinemann, 1996.105

Bypassing the more traditional birth and naming episodes (which show Zacharias writing John's name on a tablet, generally in the room where Elizabeth gave birth), Domenico portrays Zacharias regaining his speech at John's circumcision in the Temple, thus establishing a parallel to Christ's circumcision (pl. 39). In Domenico's version, Zacharias reaches up in thankful prayer to a small angel and receives John's name from the banner it bears, placing less of an accent on Elizabeth's insistence on the unusual (non-family) name of John. Elizabeth stands in the spot where Mary stood earlier, but the number of priests required to read John's service has tripled, while the crowd attending John's ritual is smaller than it was during Christ's Circumcision. ❦

The story of *The Nativity* (not shown by Domenico) and *The Circumcision of the Baptist* find a place as part of the story of *The Visitation* in the *Meditationes vitae Christi* (pls. 32–35). Domenico devotes 22 drawings to the story of John the Baptistl; this compares to fourteen scenes in the baptistery of San Marco and ten scenes in the baptistery in Padua. Here he conceives the scene in somewhat simpler terms than *The Circumcision of Christ* (pl. 39), which is no doubt later in date. He also goes out of his way to make the subject clear, as the putto flies overhead with the identifying little banner. Zacharias and Elizabeth are grouped together on the left. The story of John the Baptist opens with *The Annunciation to Zacharias in the Temple* (pl. 82). Zacharias doubts the message, and is struck dumb. At *The Circumcision,* shown here, Elizabeth insists that the child be called John; Zacharias agrees, and is able to speak again. ⚜

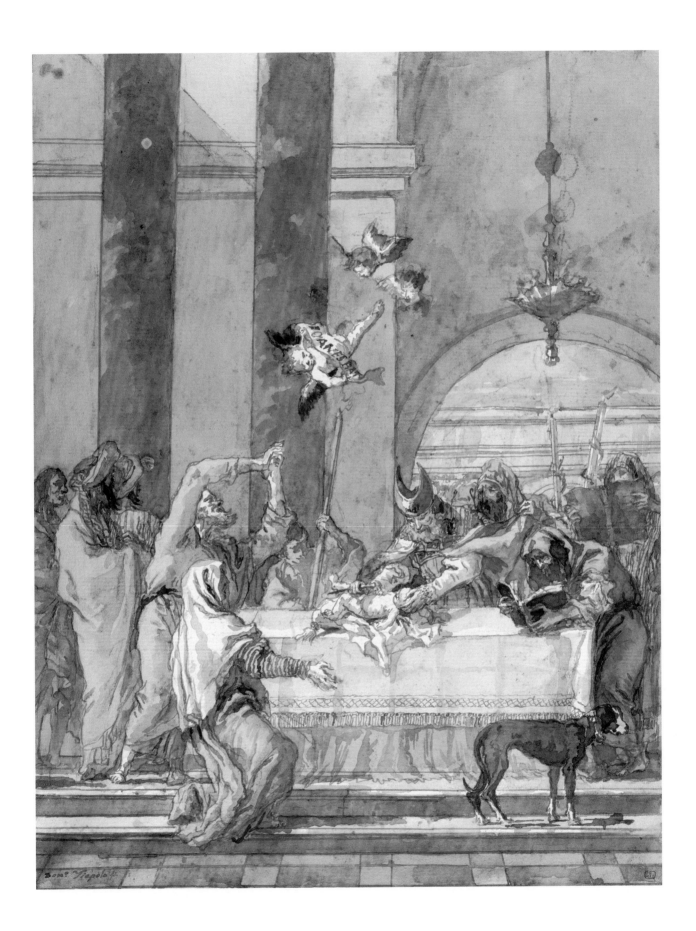

84. *The Flight of Elizabeth into the Wilderness*

But Elizabeth when she heard that they sought for John, took him and went up into the hill country and looked about her where she should hide him: and there was no hiding place. And Elizabeth groaned and said with a loud voice: O mountain of God, receive thou a mother with a child. For Elizabeth was not able to go up. And immediately the mountain clave asunder and took her in. And there was a light shining always for them: for an angel of the Lord was with them, keeping watch over them. (Book of James 22:3)

Pen and wash, over traces of black chalk, 467 x 362, image, untrimmed
Signed twice at low right: Dom.o Tiepolo f
Provenance: Roger Cormier, Tours, his sale. Paris, Georges Petit, Apr. 30, 1921, no.6; Tomas Harris; Dr. Rudolf J. Heinemann, New York
Exhibition: London, Arts Council 1955, pl. 37; New York 1973 [104]
Literature: Guerlain 1921, 47; Conrad 1996 [68]
Reference: Maria de Agreda 1685, iv, 675; James 1924, 48

New York, The Pierpont Morgan Library, Gift of Mrs. Rudolf Heinemann, in memory of
Dr. Rudolf J. Heinemann, 1996.106

Motivated by his interest in marking parallels between Christ's life and John's, Domenico portrays a rarely depicted episode of Herod's soldiers in search of the infant John. The scene stresses the pursuit, rather than the wholesale slaughter found in the earlier massacre scene (pl. 43). Shields held high and swords at the ready, Herod's soldiers rush off in formation to pursue more victims, leaving behind a single corpse. Hidden inside the cloven mountain, Elizabeth, holding her son and guarded by two angels, listens intently to the sound of their departing footsteps. ❧

The scene has something of the character of a *Flight into Egypt* combined with a *Massacre of the Innocents* on the left: Jameson (1899: 232–233) cites the fresco by Pinturicchio in Sant' Onofrio as an example of the two scenes combined. However, the wooden cross and the banner born by the infant John make it clear that the subject here is *The Flight of Elizabeth.* ⚜

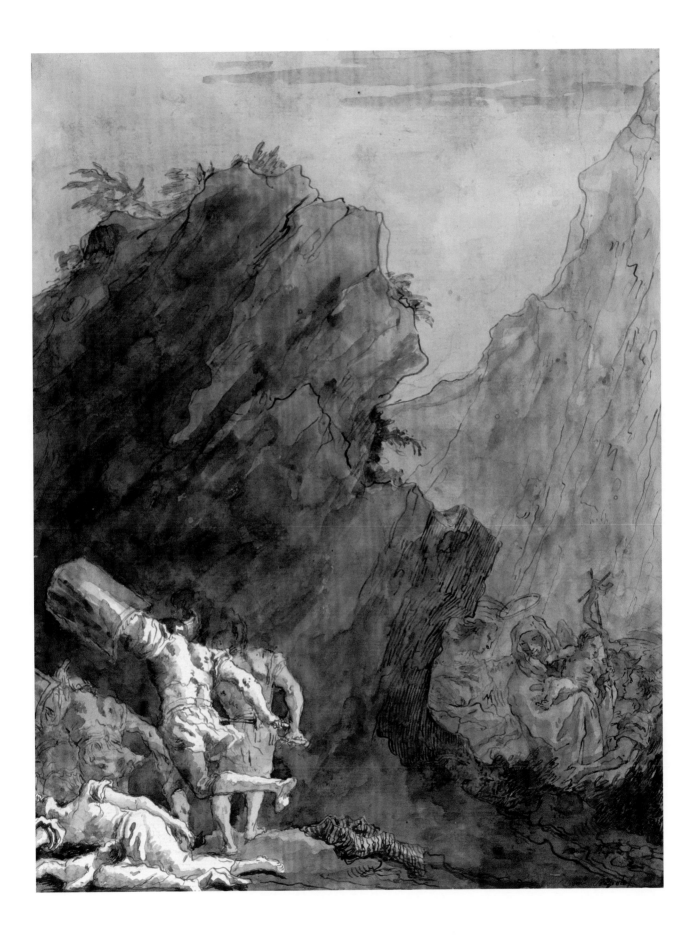

85. *Herod Interrogating Zacharias*

Now Herod sought for John, and sent officers to Zacharias, saying: Where hast thou hidden thy son? And he answered and said unto them: I am a minister of God and attend continually upon the temple of the Lord: I know not where my son is. And the officers departed and told Herod all these things. And Herod was wroth and said: His son is to be king over Israel. And he sent unto him again, saying: say the truth: where is thy son? For thou knowest that thy blood is under my hand. And the officers departed and told him all these things. (Book of James 23:1–2)

Pen and wash, over slight black chalk, 475 x 365, trimmed, very foxed
Signed low right: Dom.o Tiepolo f
Collector's mark: fleur-de-lys—Chantilly
Provenance: Jean-François Gigoux, his sale, Paris, Hôtel Drouot, Mar. 20–23, 1882 [172]; Henri d'Orléans, duc d'Aumale (1822–1897)
Literature: Conrad 1996 [265]
Reference: James 1924, 48

Chantilly, Musée Condé, 177 (158 bis)

Domenico now indulges in an unusually extensive consideration of Zarcharias's final days. This may have been inspired by the fact that one of Venice's oldest relics, the body of Zacharias, was preserved in the church of San Zacharia. Domenico begins with a rare scene of Zacharias's interrogation. A hanging emblazoned with pomegranates underscoring his authority, Herod imperiously demands information. A platoon of soldiers, their pikes at the ready, await further orders. Zacharias, here again seen from the back, refuses to divulge his son John's whereabouts. Sensing danger, his dog slinks away, stage left. ❦

The setting is similar to *The Assembly of Priests in the Palace of Caiaphas* (pl. 177). Zacharias, the father of John the Baptist, is dressed as in *The Slaying of Zacharias,* the drawing which follows (pl. 86). This may suggest that the drawing might represent Herod, improperly dressed as a High Priest, interrogating Zacharias, an event that finds some basis in the passage cited above.

Since the Gigoux sale, the subject has been identified as *Joseph before Pharaoh, Explaining His Dreams,* but there is an obvious problem in identifying the high priest as Pharaoh. An old photograph (Girardon G 7978) shows no foxing. ❦

244

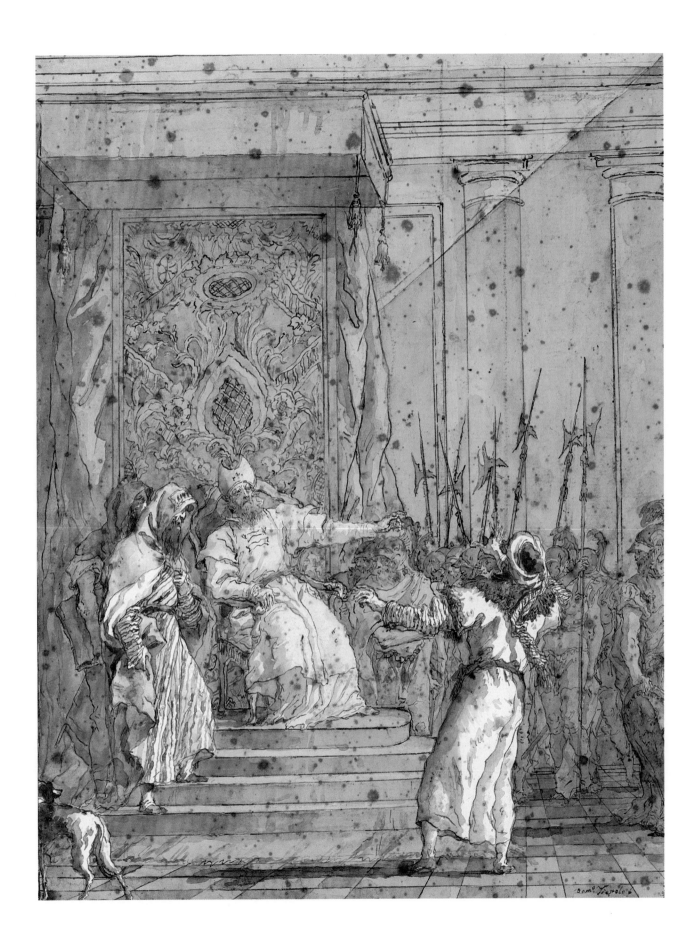

86. *The Slaying of Zacharias*

And Zacharias said: I am a martyr of God if thou sheddest my blood: for my spirit the Lord shall receive, because thou sheddest innocent blood in the forecourt of the temple of the Lord. And about the dawning of the day Zacharias was slain. And the children of Israel knew not that he was slain. But the priests entered in at the hour of salutation, and the blessing of Zacharias met them not according to the manner. And the priests stood waiting for Zacharias, to salute him with the prayer, and to glorify the Most High. Bur as he delayed to come, they were all afraid: and one of them took courage and entered in: and he saw beside the altar congealed blood: and a voice saying: Zacharias hath been slain, and his blood shall not be wiped out until his avenger come. And when he heard that word he was afraid, and went forth and told the priests. And they took courage and went in and saw that which was done: and the panels of the temple did wail; and they rent their clothes from the top to the bottom. And his body they found not, but his blood they found turned into stone. . . . (Book of James 23:3, 24:1–3)

> Pen and wash, over black chalk, 490 x 359
> Signed low left: Dom.o Tiepolo f
> Provenance: Georges Bernier, Paris; Galerie l'Oeil, Paris; G. Wertheimer, Paris 1957; Eugene V. Thaw
> Exhibition: New York 1975 [57]
> Literature: Conrad 1996 [69]
> Reference: Christiaan van Adrichem 1584, Site 98; Maria de Agreda 1685, iv, 675; James 1924, 48; Barb 1948, 35–67; Réau 1956, ii/i. 447

New York, Eugene Victor Thaw

Domenico presents a dramatic murder scene. In a terrible act of desecration, Zacharias is assassinated at the steps of an altar in the Temple. The veiled space containing the tablets of the law is visible above the altar. Reminding us of Herod's brutality against infants, Zacharias lies helpless as his assailant prepares to strike the fatal blow. 🌿

The martyrdom of Zacharias at the order of Herod, for refusing to reveal where Elizabeth had hidden the infant John, follows *The Massacre of the Innocents* in year 1 (pl. 43). The scene here is set before the Holy of Holies, as in plate 14, and in the following drawing. The spot is identified by Christiaan van Adrichem (1584: Site 98). The feast of Zacharias and Elizabeth is celebrated on November 5. The question as to whether Zacharias was stoned or stabbed to death is unclear. Dionysius of Fourna cites both traditions. ⚜

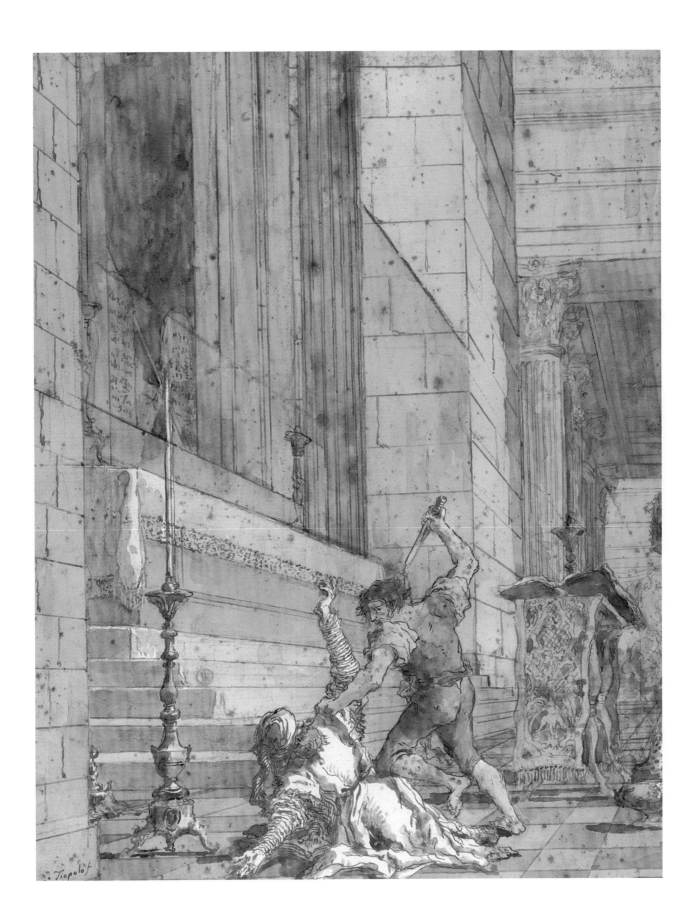

87. The Funeral of Zacharias

. . . And his body they found not, but his blood they found turned into stone. . . . (Book of James 24:3)

> Pen and wash, over slight black chalk, 470 x 371, trimmed close to the image
> Signed on the center column: Dom.o Tiepolo f
> Provenance: Jean-François Gigoux (1806–1894), his bequest, 1894
> Literature: Gernsheim 8141; Conrad 1996 [262], as perhaps *The Funeral of Mary*
> Reference: Christiaan van Adrichem 1584, Site 227

Besançon, Musée des Beaux-Arts et d'Archéologie, 2236

Clearly, the Book of James was not the source for this scene, which must have been inspired by the presence of Zacharias's relics in Venice. As taper-bearing mourners gather at the left and the right, four pallbearers carry the body down the temple steps toward his burial site. Paralleling John's later funeral in many respects, Zacharias's ceremony was attended by a much older group of men. This burial scene is one of several inventions on Domenico's part, which in this chapter forge strong visual connections between Zacharias and his son John. 🖋

The scene is again set before the Holy of Holies, the veiled space containing the tablets of the law in the temple, before which Zacharias had been murdered; thus, it is a close variant of plates 13, 14, 82, and 86. No text describes the funeral of Zacharias, and the Book of James states specifically that "his body was found not." However, his tomb is noted by Christiaan van Adrichem (1584: Site 227), and of course, his relics were a prized possession of the church of San Zaccharia. Zacharias enjoys a special status in Venice, since the Byzantine Emperor Leo V (813–820) presented his relics, together with money and artists, to Venice. Moreover, he and Doge Justinianus (Giustiniano Partecipazio, 827–820) are supposed to have together founded the great church of San Zaccharia, which from the ninth to the twelfth centuries was the burial place of the doges and has always enjoyed a special place in the civic life of the city. ⚜

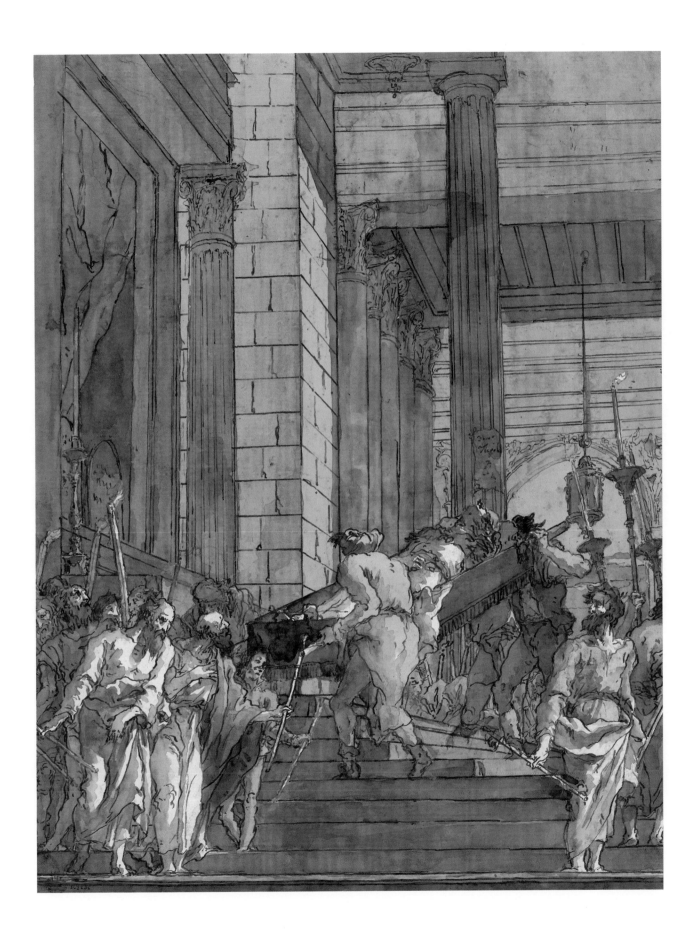

88. *John the Baptist in the Wilderness—ECCE AGNUS DEI*

For this is he that was spoken of by the prophet Esaias, saying, The voice of one crying in the wilderness, Prepare ye the way of the Lord, make his paths straight. (Matt. 3:3)

Pen and wash, 465 x 365, trimmed to the borderline
Not signed
Provenance: Charles Fairfax Murray; J. Pierpont Morgan, 1910
Literature: Conrad 1996 [73]

New York, The Pierpont Morgan Library, Fairfax Murray Collection, IV.151a

From childhood on (as we have seen), having escaped Herod's wrath, John grew up a desert hermit to become the prophet of Jesus. Domenico now shows him as a young mystic, deeply absorbed in his devotions, as a heron takes flight. Last seen when the young saint met Jesus (pl. 75), this bird appears emblematic of those closest to Jesus (Peter is the only other saint featuring the heron, pl. 145). John prays fervently at his makeshift altar, upon which rests a skull. On the ground lie a cloak and a basket. His ever present emblem, the cross with his banner bearing its device ECCE AGNUS DEI, has become the focus of his devotions. The cross also aligns itself emphatically with the evergreen in the foreground and one behind, stressing its role in the future immortality of mankind. John turns away and, absorbed in prayer, is a deliberate "reversal" of such standard interpretations of a handsome young John seated alone and confronting us—the type Leonardo made famous in his early-sixteenth-century masterpiece (Louvre). 🌿

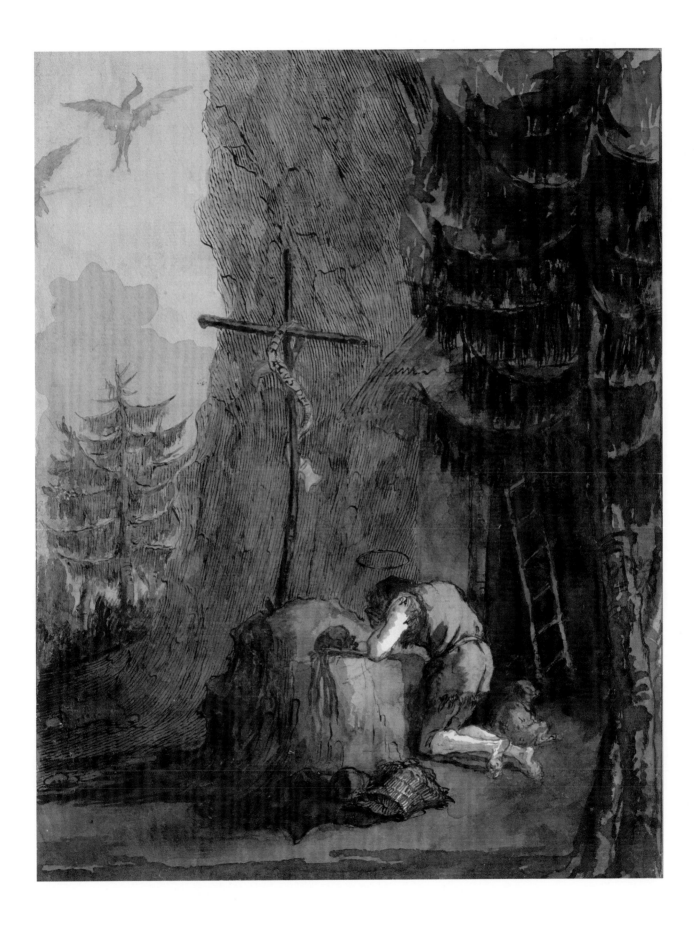

89. *John the Baptist Lying on the Ground, with Angels—ECCE AGNUS DEI MUNDI*

And the same John had his raiment of camel's hair, and a leathern girdle about his loins; and his meat was locusts and wild honey. (Matt. 3:4)

Annas and Caiaphas being the high priests, the word of God came unto John the son of Zacharias in the wilderness. (Luke 3:2)

Pen and wash, over black chalk, 490 x 385
Signed left center: Dom.o Tiepolo f
Marked top left in pencil: 16
Provenance: Roger Cormier, Tours, his sale, Paris, Georges Petit, Apr. 30, 1921, no. 80; Duc de Trévise, Paris, Hôtel Drouot, Dec. 8, 1947, no. 51
Exhibition: Chicago 1938, no. 85; Udine 1996 [111]
Literature: *Revue du Louvre* 1995.2 [26]; Conrad 1996 [74]
Reference: Kaftal 1978, 516

Paris, Musée du Lourve, Département des Arts Graphiques, RF 44311

Clearly determined to add new elements to traditional episodes of John's life, Domenico portrays him receiving his mission in an unusual way. Sleeping on a bed of straw beside his crude hut, John (now bearded and older) clasps his cross to his breast as he reaches for his lamb. Two youthful angels gaze upon him as they descend in a cloud. They are delivering "God's word" in a manner that parallels the way Joachim and Joseph received many of their messages. The scene mixes rude, almost comic rusticity with spiritual radiance. ❦

John lies on the ground with his symbols; on the right stands a ruined hut, and above him hover two angels. One may suppose that this represents a dream or a vision of John, as suggested in Luke 3:2. Kaftal notes: "An angel came to him, and said that he should show the coming of our Lord, and preach penance, and gave him a cloak." ⚜

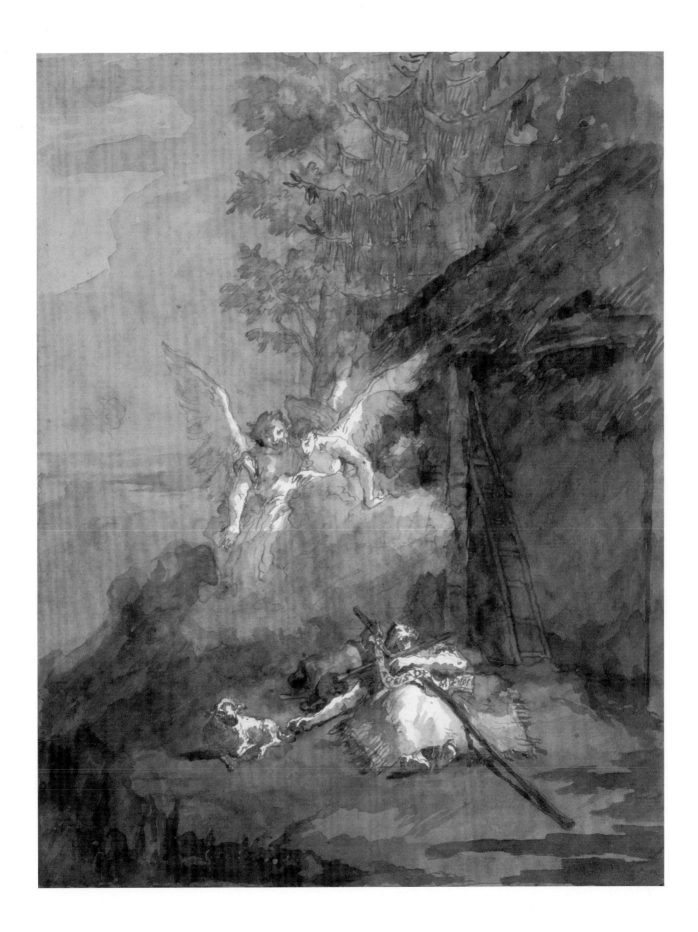

90. *John the Baptist Preaching, I*

And the people asked him, saying, What shall we do then? He answereth and saith unto them, He that hath two coats, let his impart to him that hath none; and he that hath meat, let him do likewise. Then came also publicans to be baptized, and said unto him, Master, what shall we do? And he said unto them, Exact no more than that which is appointed you. And the soldiers likewise demanded of him saying, And what shall we do? And he said unto them, Do violence to no man, neither accuse any falsely: and be content with your wages. (Luke 3:10–14)

Pen and wash, over extensive black chalk, 466 x 363
Not signed
Provenance: Jean Fayet Durand (1806–1889)
Literature: Conrad 1996 [78]
Reference: Réau 1956, ii/i, 448–449

Paris, Musée du Louvre, Département des Arts Graphiques, RF 1713bis [15]

Following his instructions to preach of Christ's coming, John has staked his cross firmly in the ground and delivers a fiery sermon. Energetically pointing heavenward before his rapt audience, he has already produced some converts, who kneel before him while others listen respectfully. Besides peasant girls, patriarchs, and women, Domenico depicts soldiers, one standing in the crowd at the left and another preparing to dismount at the right. Luke, as we know, specifies soldiers in John's audience. Domenico's interpretation suggests that the soldier in the foreground later ignores this advice, since he violates Christ based on false accusations; see *Station VIII,* plate 221. ❧

The presence of simple people, and at least one soldier, suggests that Domenico here follows the text of Luke rather than that of Matthew, which seems more appropriate to the drawing that follows. ❧

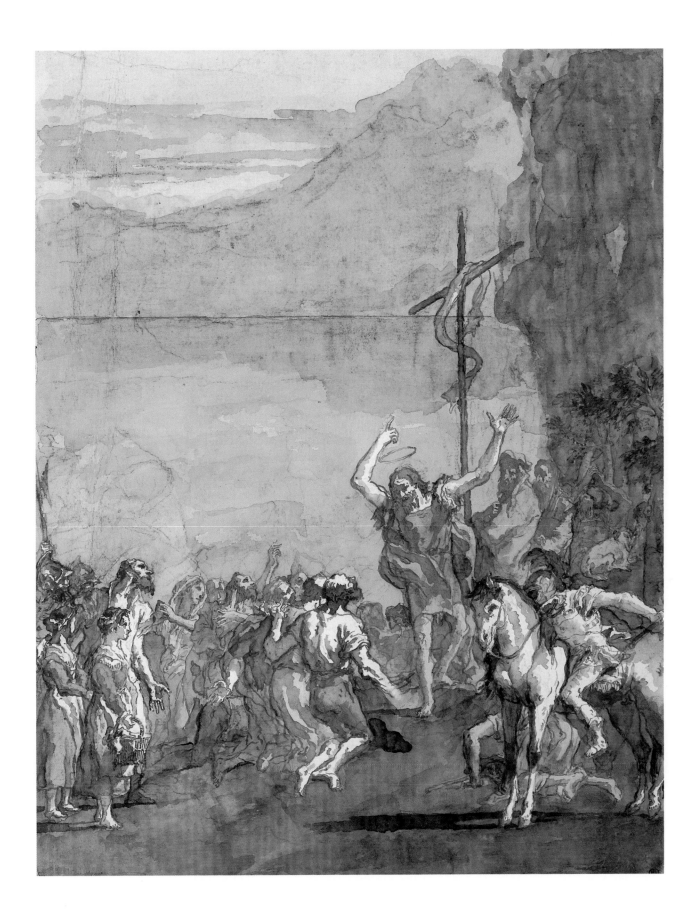

91. *John the Baptist Preaching, II*

In those days came John the Baptist, preaching in the wilderness of Judæa, and saying, Repent ye: for the kingdom of heaven is at hand. For this is he that was spoken of by the prophet Esaias, saying, The voice of one crying in the wilderness, Prepare ye the way of the Lord, make his paths straight. And the same John had his raiment of camel's hair, and a leathern girdle about his loins; and his meat was locusts and wild honey. Then went out to him Jerusalem, and all Judaea, and all the region round about Jordan, and were baptized of him in Jordan, confessing their sins. But when he saw many of the Pharisees and Sadducees come to his baptism, he said unto them, O generation of vipers, who hath warned you to flee from the wrath to come? (Matt. 3:1–7)

> Pen and wash, over black chalk, 470 x 350
> Signed low right: Dom.o Tiepolo f
> Provenance: Jean Fayet Durand (1806–1889)
> Literature: Conrad 1996 [77]

Paris, Musée du Louvre, Département des Arts Graphiques, RF 1713bis [14]

John, still preaching, has attracted an even larger crowd, including the Pharisees and Sadducees mentioned by Matthew. Carefully registering various levels of interest, Domenico has created a diverse audience, exemplified by one absorbed listener who has crossed his bare legs and is lost in concentration. The dark silhouette of the man in the foreground reminds us that John's message was also intended for gentiles and for eighteenth-century audiences. Not surprisingly, the rocky cliff, site of Abraham's sacrifice, returns here to signify the wilderness and to hint at the sacrifice to come. ❧

This is the second treatment of the theme. Here the audience seems to be rather more prosperous, and may refer to Matthew 3:7, making it later than the scene described in Luke. ❧

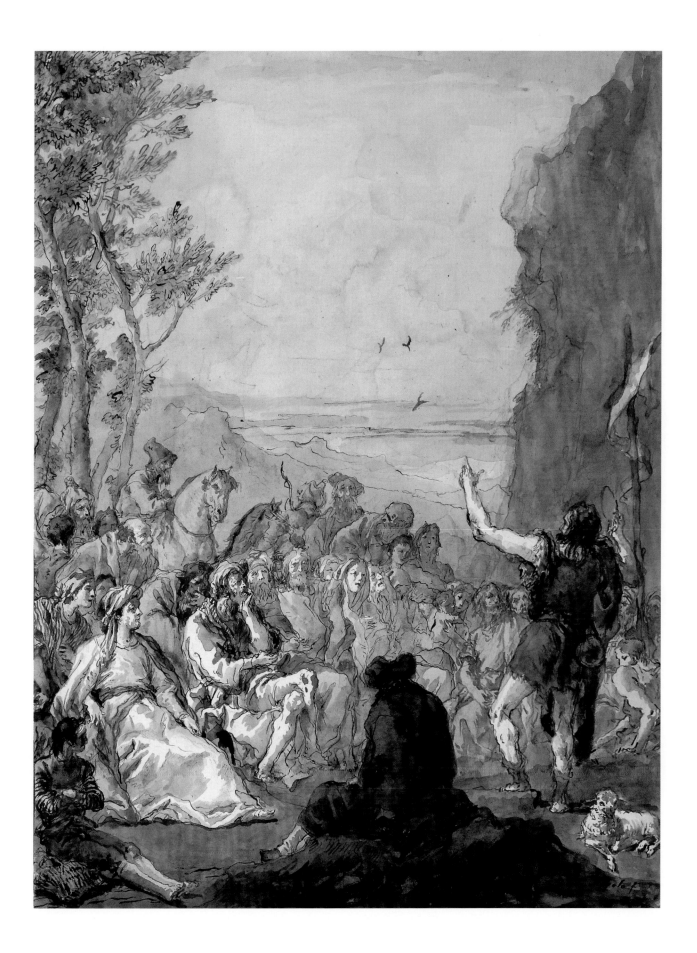

92. *Jesus Coming to Be Baptized—ECCE AGNUS DEI*

Then cometh Jesus from Galilee to Jordan unto John, to be baptized of him. But John forbad him, saying, I have need to be baptized of thee, and comest thou to me? And Jesus answering said unto him, Suffer it to be so now; for thus it becometh us to fulfil all righteousness. Then he suffered him. (Matt. 3:13–15)

The next day John seeth Jesus coming unto him, and saith, Behold the Lamb of God, which taketh away the sin of the world. (John 1:29)

Pen and wash, 460 x 365
Signed low right
Provenance: Paris, Hôtel Drouot, Mar. 13, 1995 [224]
Literature: Conrad 1996 [79]

Unfolding the stages of Christ's baptism over four scenes, Domenico here shows John kneeling in reverence as Jesus arrives to be baptized. As Jesus urges him to rise, the crowd slowly registers a response. A new convert raises his hands in pious recognition, while the cross-legged observer, previously seen listening to John's sermon, rests casually by the riverbank. 🌿

The scene represents the Baptist recognizing Christ, also described in John 1:29–36. Domenico shows a vast crowd, with Jesus standing in the center, his hands clasped in prayer. John bows before him, with his hands across his chest, turning away from another man, about to be baptized. ⚜

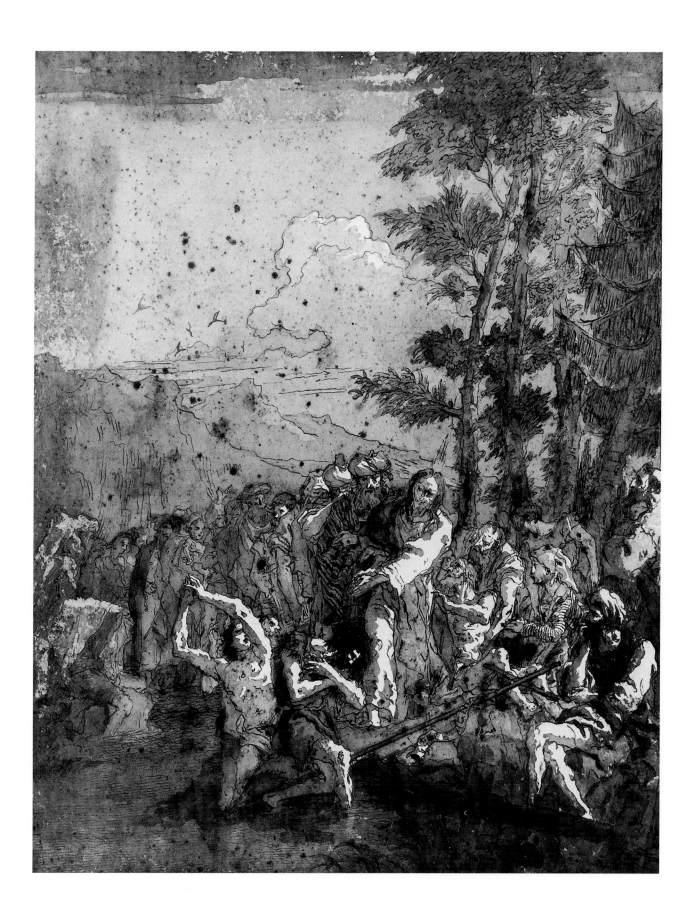

93. *The Baptism of Jesus, I—ECCE AGNUS DEI*

Now when all the people were baptized, it came to pass, that Jesus also being baptized, and praying, the heaven was opened, and the Holy Ghost descended in bodily shape like a dove upon him, and a voice came from heaven, which said, Thou art my beloved Son; in thee I am well pleased. (Luke 3:21–22)

But John forbad him, saying, I have need to be baptized of thee, and comest thou to me? (Matt. 3:14)

> Pen and wash, over extensive black chalk, 470 x 362
> Signed low left: Dom.o Tiepolo f
> Provenance: Jean Fayet Durand (1806–1889)
> Literature: Conrad 1996 [80]
> Reference: Réau 1956, ii/i, 450

Paris, Musée du Louvre, Département des Arts Graphiques, RF 1713bis [13]

Domenico shifts our vantage point to face the river as he presents a complex essay on humility and piety in his scene of sacred baptism. John, partly kneeling, still questions his authority to baptize Jesus. Jesus, having stepped into the water, piously insists that it be so, while an angel (as is traditional) reverently disrobes him. More unusual is the eager convert, unceremoniously pulling off his shirt to receive the rite. Some skeptical patriarchs observe from a distance, while converts, including an ornately robed elder and a man who appears to be Peter, crowd in behind John. ✺

Three or perhaps four drawings in the *New Testament* series deal with aspects of this theme. The first is *Jesus Coming to be Baptized* (pl. 92); the second is this one, again without the Holy Dove, representing perhaps *John Forbidding Christ* (Matt. 3:14); the third depicts *The Baptism of Christ* (pl. 94). Peter's presence in this scene may be Domenico's deliberate extrapolation of the account of John 1:41, which makes Peter's brother Andrew an early follower of John the Baptist. ✺

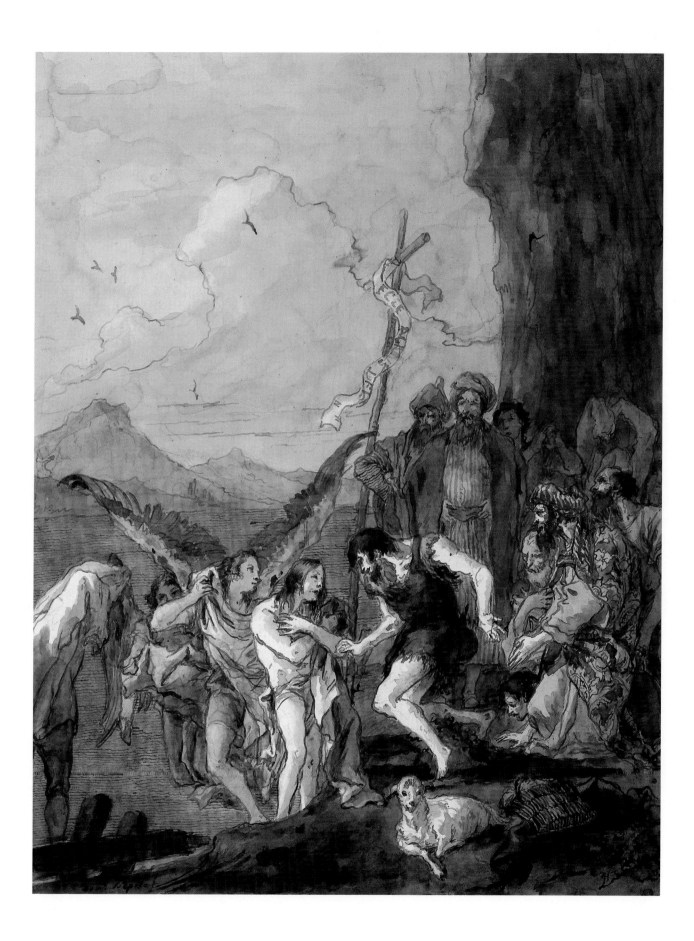

94. *The Baptism of Jesus, II—ECCE AGNUS DEI*

And Jesus, when he was baptized, went up straightway out of the water: and, lo, the heavens were opened unto him, and he saw the spirit of God descending like a dove, and lighting upon him; and lo a voice from heaven, saying, This is my beloved Son, in whom I am well pleased. (Matt. 3:16–17)

> Pen and wash, over black chalk, 460 x 360
> Signed low left
> Provenance: Roger Cormier, Tours, his sale, Paris, Georges Petit, Apr. 30, 1921 [65]; Duc de Trévise, his sale, Paris, Hôtel Drouot, Dec. 8, 1947, no. 45
> Literature: Guerlain 1921 [p.51]; Conrad 1996 [81]
> Reference: Réau II/I 1956, 451; Réau II/II 1957, 295–304

Rotating our vantage point once again, Domenico shows John solemnly pouring baptismal waters on Christ's head, as the crowd of elders observes from the riverbank and the cliff above. Mixing piety with pragmatism, Domenico shows the Holy Ghost descending, while all around ordinary converts are in various states of undress, preparing for baptism. On the other side of the river, a man's bare bottom pokes irreverently out at us. The awkwardly disrobing Christian in the foreground, however, retains his underwear to maintain some decorum.

This event, celebrated in Venetian painting and frequently encountered in the work of Giambattista and Domenico Tiepolo, is said to have occurred in the year 31. It is also treated in plate 93.

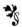

95.** *"Questo e il mio delitto figlio e l'oggetto della mia compiacenza"*

And lo a voice from heaven, saying, This is my beloved Son, in whom I am well pleased. (Matt. 3:17)

> Pen and wash, 460 x 360
> Signed low left
> Provenance: Roger Cormier, Tours, his sale, Paris, Georges Petit, Apr. 30, 1921, no. 19; Duc de Trévise 1947, no. 29

No image.

It seems very possible that this drawing, for which we have no image, may be identified with plate 92 above, even though the signature is said to be on the opposite side and the stated title is a little inexact. The text of the title in the Cormier sale, given in Italian, suggests that the drawing may have borne an inscription.

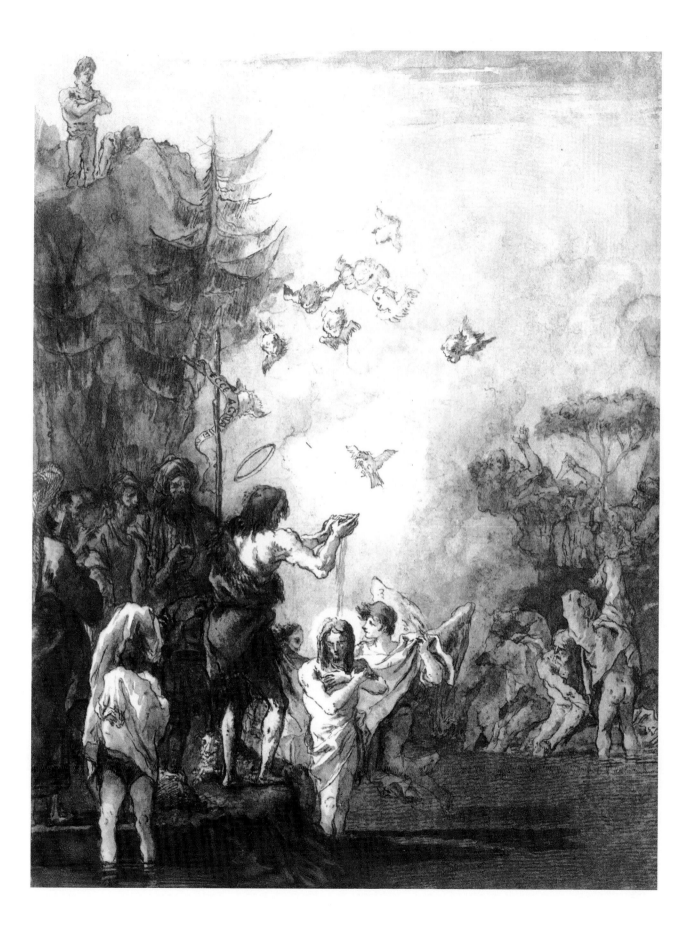

96. *The Death of Elizabeth*

After five years the pious and blessed old mother Elizabeth passed away and the holy John sat weeping over her, as he did not know how to shroud her and bury her, because on the day of her death he was only seven years and six months old.
(The Life of John, according to Serapion)

> Pen and wash, over extensive black chalk, 465 x 358
> Signed low right: Dom.o Tiepolo f
> Provenance: Jean Fayet Durand (1806–1889)
> Literature: Conrad 1996 [70]
> Reference: Maria de Agreda 1685, iv, 676; Hennecke 1963, 414–415

Paris, Musée du Louvre, Département des Arts Graphiques, RF 1713bis [16]

In an inexplicable deviation from text and visual tradition, Domenico shows Elizabeth dying in the desert with her grown son. Kneeling reverently beside her body, John venerates his mother. The angels last seen protecting Elizabeth and her infant son from Herod now mourn her. John's lonely vigil parallels the offices he performed for Anna earlier.

A full account of the death and burial of Elizabeth is given in the *Life of John, according to Serapion,* saying that John at the time was only seven years old. It relates that Jesus, Mary, and Salomé flew on a cloud to John in the desert to comfort him, and that the angels "Michael and Gabriel came down from heaven and dug a grave." It is also found in Maria de Agreda, who places it three years after the death of Zacharias. ❦

The composition is closely related to another similar event, *The Burial of Anna* (pl. 22), where again Domenico represents the adult John the Baptist acting as a mourner. Here he prays by the body of his mother, which rests upon a rush mat, with angels in attendance, thus contradicting the suggestion of an early death for Elizabeth. The setting is a rugged mountainous landscape. ❧

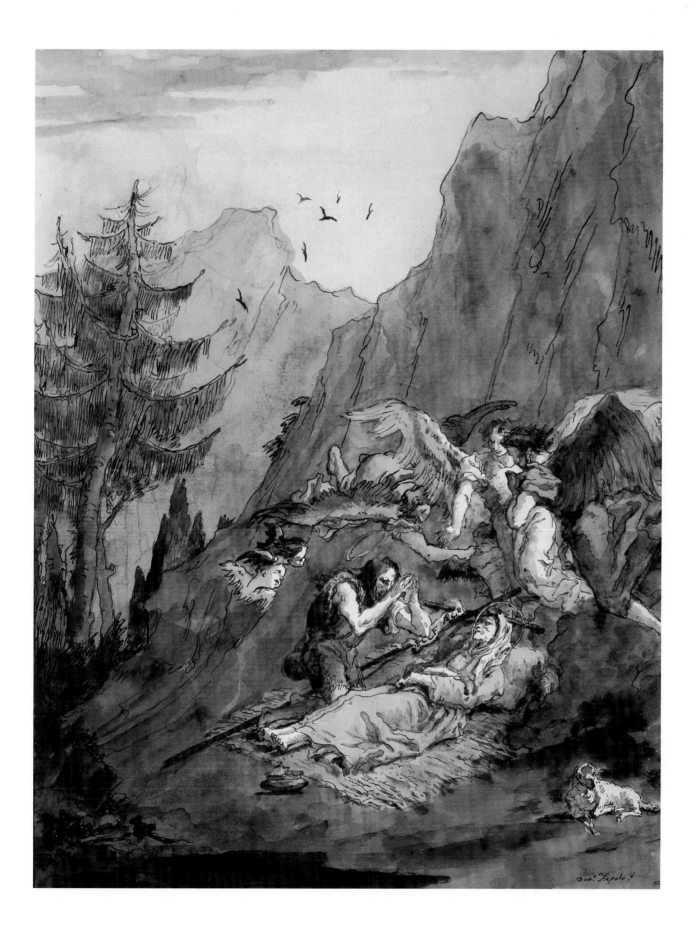

97. *John the Baptist in the Desert,* ECCE AGNUS DEI ECCE

And John was clothed with camel's hair and with a girdle of a skin around his loins; and he did eat locusts and wild honey. (Mark 1:6)

Pen and wash, over extensive black chalk, 468 x 358
Signed low right: Dom.o Tiepolo f
Provenance: Jean Fayet Durand (1806–1889)
Literature: Conrad 1996 [72]
Reference: Réau 1956, ii/i, 448

Paris, Musée du Louvre, Département des Arts Graphiques, RF 1713bis [17]

Still alone in the wilderness, John looks up in a mixture of astonishment and gratitude as angels bring him a basket of refreshments. Adapting his textual sources, Domenico here establishes another parallel between John and Christ's life, besides the earlier Circumcision. When Jesus went into the desert, angels delivered food after his temptation. 🌿

Here John is seated on a bench in the wilderness, and the angels bring food in a basket. We have not encountered a satisfactory prototype or text for this treatment. ⚜

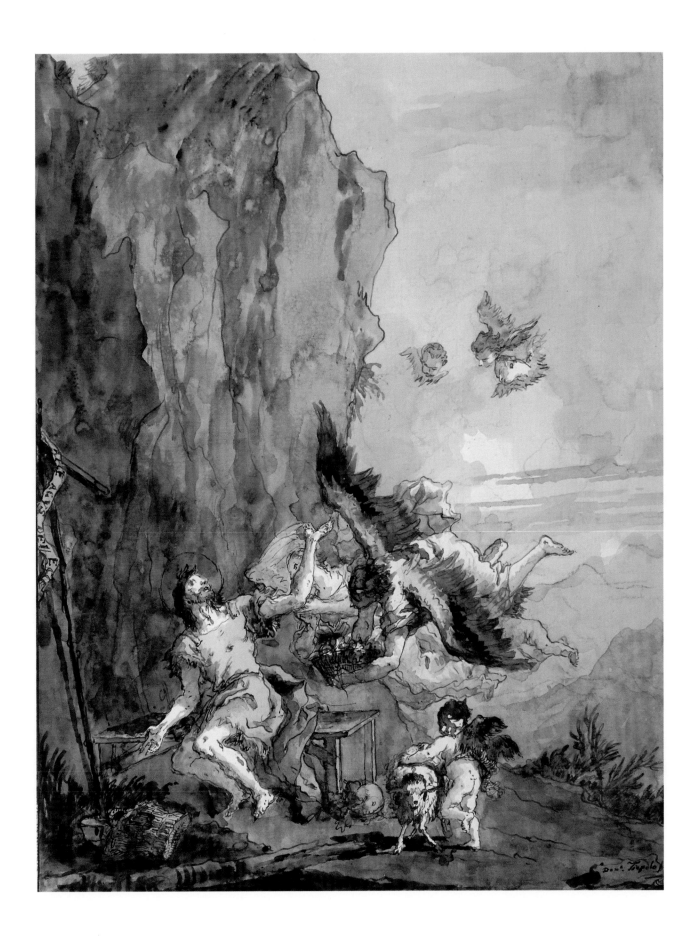

98. *John Reproves Herod*

For John had said unto Herod, It is not lawful for thee to have thy brother's wife. Therefore Herodias had a quarrel against him, and would have killed him; but she could not: for Herod feared John, knowing that he was a just man and an holy, and observed him; and when he heard him, he did many things, and heard him gladly. (Mark 6:18–20)

But Herod the tetrarch, being reproved by him for Herodias his brother Philip's wife, and for all the evils which Herod had done, added yet this above all, that he shut up John in prison. (Luke 3:19–20)

Pen and wash, 465 x 365
Signed low left: Dom.o Tiepolo
Provenance: Paris, Hôtel Drouot, Dec. 14, 1938, lot 11; Michel-Lévy; Mme. A.L.D.; Paris, Drouot-Richelieu, Nov. 21, 2001 [69]
Reference: Christiaan van Adrichem 1584, Site 136; Réau 1956, ii/i, 451, cites Masolino at Castiglione d'Olona; Kaftal 1978, 520

France, private collection

Taking his cue from Mark's account, Domenico elaborates on John's reproval. Empowered by his moral and spiritual superiority, John, pointing an accusing finger at Herod and Herodias, steps upon their raised dais to deliver his reproof. "Caught," literally and visually, between John and Herodias, Herod leans back in fear. Herodias, clutching her husband possessively, glares at John with evident displeasure. The palace dwarf and his dog try to hide behind the throne, while Herod grabs his parrot's leash to prevent its escape. Only the hound seems indifferent. ❦

The figure of the Baptist, though seen from the back, is somewhat reminiscent of the celebrated painting by Titian in the Accademia, then in the church of Sta. Maria Maggiore in Venice (Moschini Marconi 1962 [452]), and may well have been inspired by that model. The Palace of Herod is described by Christiaan van Adrichem (1584: Site 136). ⚜

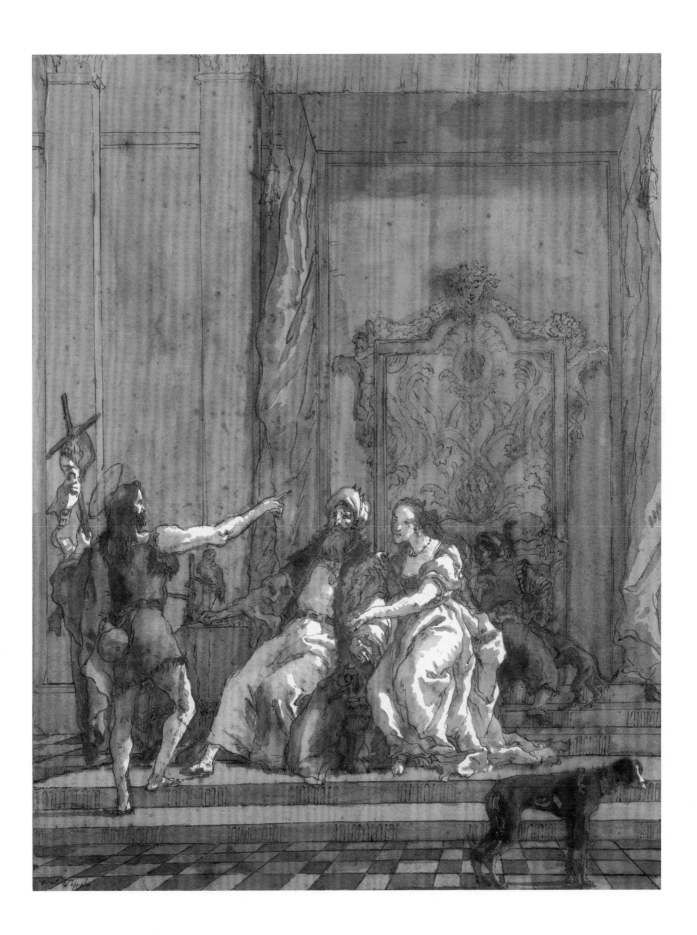

99. *The Beheading of John the Baptist*

And he sent, and beheaded John in the prison. (Matt. 14:10; Mark 6:27)

> Pen and wash, over black chalk, 465 x 367
> Signed on the column, right: Dom. / Tiepolo / f
> Provenance: Jean Fayet Durand (1806–1889)
> Literature: Conrad 1996 [82]
> Reference: *The Golden Legend* 1900, v, 67–78, under August 29; Ribadeneira 1656, i, 616

Paris, Musée du Louvre, Département des Arts Graphiques, RF 1713bis [18]

His hands still clasped in his final act of prayer, John's decapitated body lies upon his cross, as his executioner presents his head to the two official witnesses. While they gaze at John's head, it, in turn looks down upon its own now headless body.[6] Light filters in through the barred windows, barely lifting the gloom, while in the background a figure walks out through an arched portal, offering a contrast to John's imprisonment while perhaps acting as a metaphor for the liberation of his spirit. ❦

Prison scenes seem to have had an extraordinary fascination for the eighteenth-century mind, from Casanova to Piranesi, from Sterne to Beethoven, and Domenico's project offered plenty of opportunities for *scene orride*, particularly in the stories of Peter and Paul. The grand but brutal architecture of prisons, exemplified by the celebrated *Prigioni* of Venice, was irresistible to him; Giambattista too loved a fearsome executioner. ❧

6. This vignette is reminiscent of the arrangement in the church of Notre Dame at Amiens, France, where the relic of John the Baptist's head is placed so that it gazes perpetually upon relief sculptures, including the scene of his execution. Amiens claims to have received the head from Constantinople in 1204.

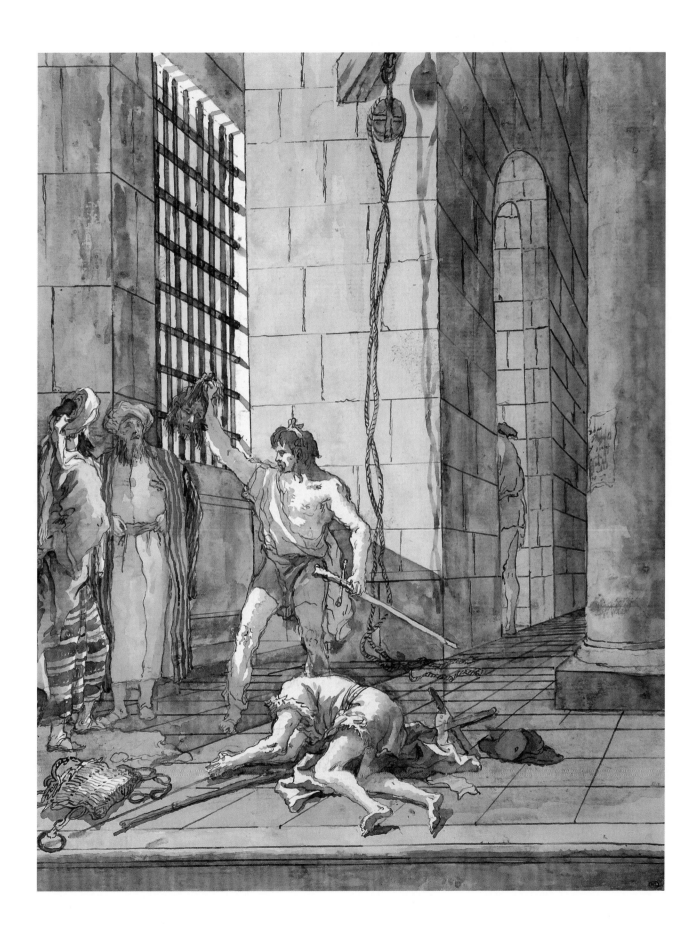

100. *The Head of John Presented to Salomé*

And his head was brought in a charger, and given to the damsel: and she brought it to her mother. (Matt. 14:11)

Pen and wash, over black chalk, 460 x 355
Signed low right: Dom.o Tiepolo f
Provenance: Jacques-Auguste Boussac, b. 1885, his sale, Paris, Petit, May 10–11, 1926 [235], 7,200 frs.; New York, Joseph McCrindle; Hélène Feilchenfeldt, ca. 1970?
Literature: Conrad 1996 [83]
Reference: *The Golden Legend* 1900, v, 67–78; Réau 1956, ii/i, 456; photo: JBS archives

New York, Robert Lehman (formerly)

Skipping, so far as we know, the scene of Salomé's dance on Herod's birthday (which prompted him to promise Salomé anything she wished, thus gaining Herodias her desired execution of John), Domenico focused instead on the sequel. He once more adopted his device of portraying childhood scenes in "secular" or "contemporary" dress, presenting the youthful Salomé as an eighteenth-century fashionplate, thus enhancing the contrast between daintiness and brutality. As Salomé receives the disembodied head she responds with refined displeasure, while her companions register more uninhibited responses of shock and horror. As the kneeling Oriental delivers the platter, his assistant spreads his hands as if to say, "This is what you asked for." ✹

Compared with the preceding drawing (pl. 99), the atmosphere here is quite light-hearted and very contemporary in character. Two gentlemen in Turkish garb present the head on a salver, which Salomé, dressed like a Spanish dancer, willingly receives while the other girls express some shock at the spectacle. ⚜

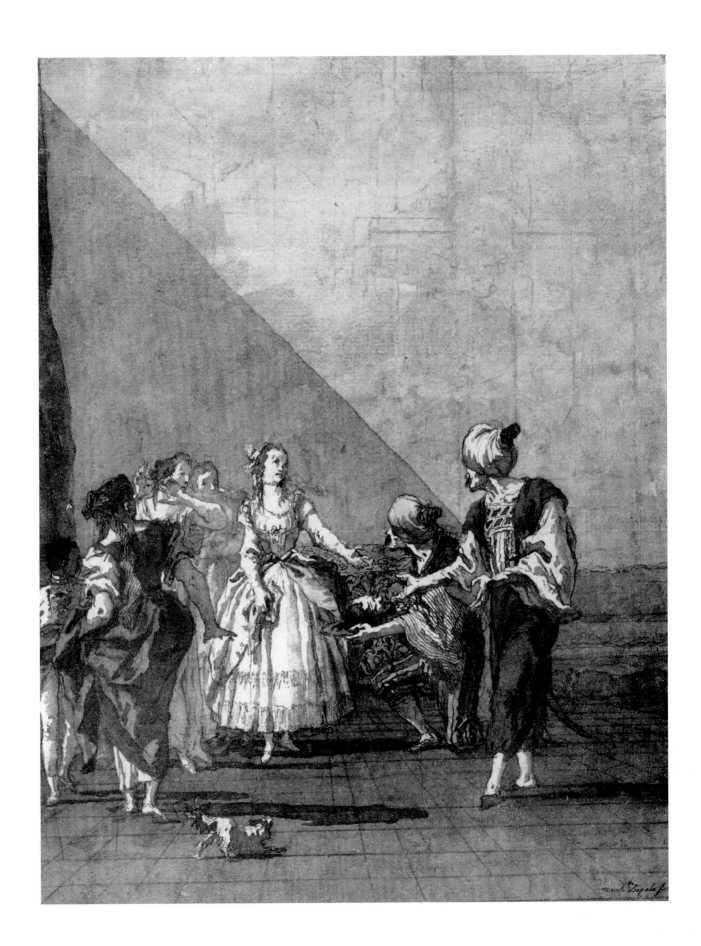

101. *The Banquet of Herod*

And when a convenient day was come, that Herod on his birthday made a supper unto his lords, high captains, and chief estates of Galilee . . . and brought his head in a charger and gave it to the damsel; and the damsel gave it to her mother. (Mark 6:21–28)

Pen and wash, over black chalk, 466 x 356
Signed low left: Dom.o Tiepolo f
Provenance: Jean Fayet Durand (1806–1889)
Literature: de Chennevières 1898 [p. 121]; Conrad 1996 [84]
Reference: *The Golden Legend* 1900, v, 67–78, under August 29; Lippomani iv, 1581, 293

Paris, Musée du Louvre, Département des Arts Graphiques, RF 1713bis [19]

As Herod presides unhappily at his banquet with a childlike Herodias beside him, Salomé arrives with John's head. Domenico lets us anticipate the horrified reaction when she turns to present it just moments later. Oriental elders have assembled in the banquet hall, while one sober man (perhaps he witnessed the execution) waits with crossed arms at the bottom of the stairs. ✹

The Banquet of Herod generally precedes *The Beheading of the Baptist,* but here Salomé is seen on the right with the head of John on the charger. Domenico presents the event as a grand composition in the manner of Veronese that even has some links with Giambattista's Russian *Banquet of Cleopatra* (Paris 1998 [53]). The drawing is unique in that it is unfinished; the arch is indicated in black chalk. ✤

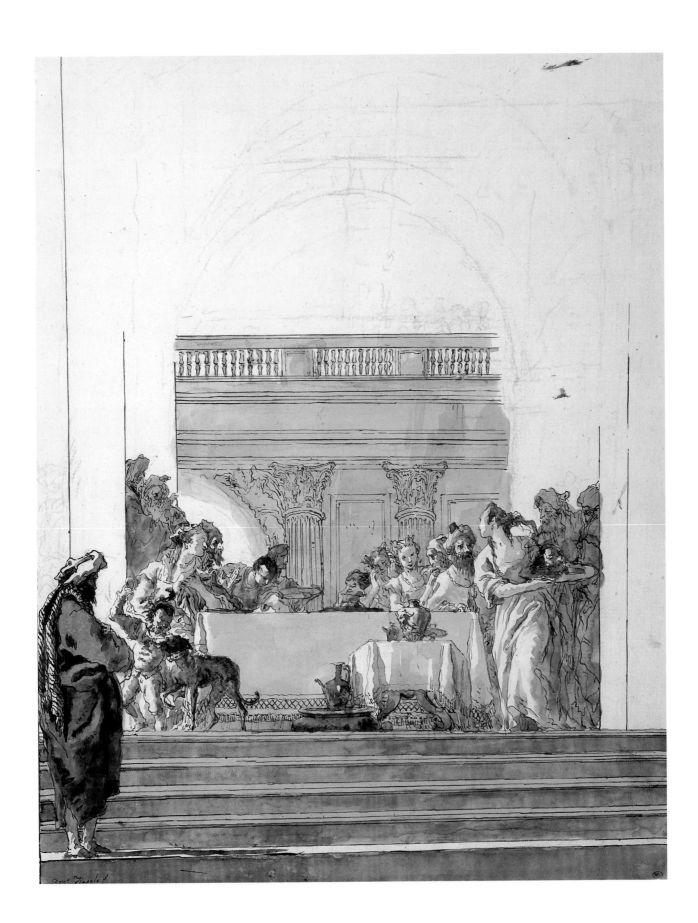

102. *"HERODE D'ANTIPA"—The Funeral of John the Baptist*

And his disciples came, and took up the body, and buried it, and went and told Jesus. (Matt. 14:12)

For when his disciples had borne his body in to the city Sebasten of Palestine, they buried it between Elisoeum and Abdias, and at his tomb many miracles were showed. (The Golden Legend V, 72)

> Pen and wash, over traces of black chalk, 470 x 360
> Signed low left?: Dom.o Tiepolo f
> Provenance: Roger Cormier, Tours, his sale, Paris, Georges Petit, Apr. 30, 1921, no. 81; Paris, Nouveau Drouot, June 24, 1985
> [8], bt. Mme. Bérès
> Literature: Conrad 1996 [85]
> Exhibition: Paris, Eric Coatelem, 2004[nn]
> Reference: *The Golden Legend* 1900, v, 72: Lippomano 1581, iii, 250; Réau 1956, ii/i, 459

New York, private collection

John's head lies just beneath his folded hands as his body is carried past the prison emblazoned with the name of Herod Antipas. Passing by the door (to mark his transition both literally and figuratively), John's funeral procession is placed within historical markers, as will be the scenes of Christ's, Peter's, and Paul's lives and deaths. A group of lads lead the way, perhaps a reminder of John's legacy, the rite of baptism, which is traditionally performed at the start of a child's life. ✺

The Golden Legend offers an expanded account of the burial of John the Baptist: perhaps because, according to Jacopo da Voragine, the relics of John the Baptist are now "worshipped devoutly at Genoa" (*The Golden Legend V,* 72). Ludolf of Saxony also gives an account of the burial of John. His feast day is June 24. As an indication of the structure underlying Domenico's scheme, one may note, *The Funeral of John the Baptist* marks the completion of one-third of his project. ⚜

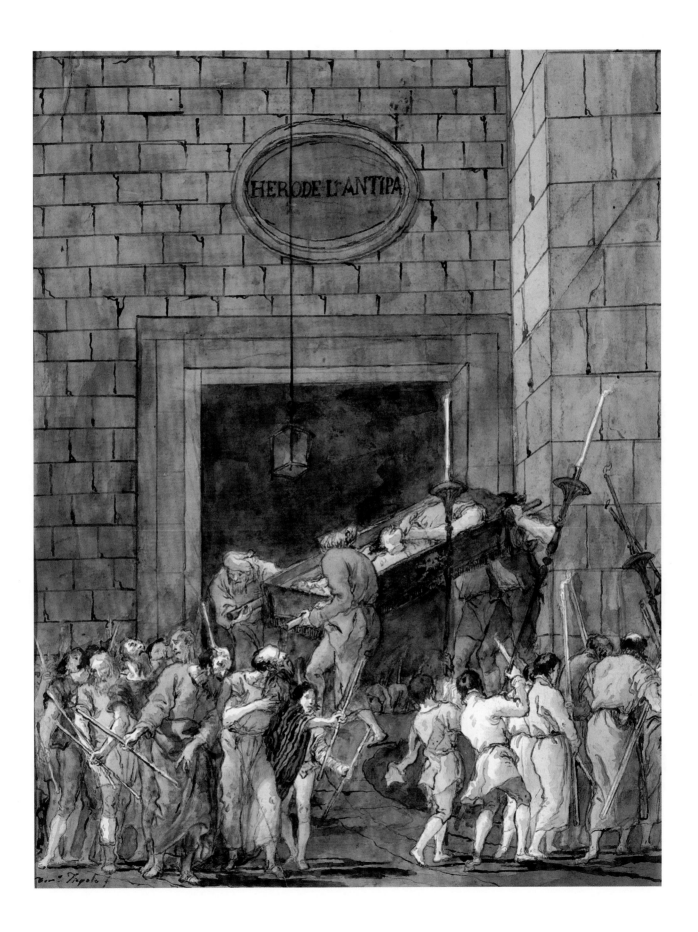

Part V

The Ministry of Jesus, Plates 103–168

Section 1: The Temptation, Plates 103–110

Described at length in Matthew (4:1–11) and Luke (4:1–13), Christ's temptation was briefly noted in Mark (1:12–13), skipped over by John, but much discussed in later devotional literature. After fasting alone for forty days in the wilderness, Jesus was tempted by Satan three times: to turn stones into bread; to leap off the Temple pinnacle to demonstrate God's protection of him; and to worship Satan and gain dominion over this world. Matthew and Luke are in accord as to which came first (stones into bread), but Luke differs as to which came second, making world dominion replace God's protection. Matthew alone concludes the Temptation with angels serving Jesus, while later commentaries such as *The Meditations* and *The City of God* stress the indignity Jesus had to endure on humanity's behalf by permitting Satan to touch him in carrying him up to the Temple. The latter asserts that, in recompense, angels later carried Jesus back to the desert.

The temple from plate 105, *The Devil Sets Jesus on the Pinnacle of the Temple*

Visual tradition generally followed Matthew's sequence regarding the Temptation as demonstrated by the San Marco mosaics, though the Temptation was not standard to pictorial cycles focused on the life of Christ.

The most popular of all Temptations was the first. Once again, Domenico's interpretation departs from the norm. Besides exceptional length (he produced eight drawings), he placed special emphasis on the story's beginning, using a separate drawing to show Jesus entering the desert. That scene, with its accent on Christ's billowing robes, offers a significant parallel to Domenico's later scene of Jesus about to enter Jerusalem (pl. 170). Domenico also stressed the conclusion to Christ's Temptation (showing the angels carrying Jesus back to the desert), both of which are untraditional; and his treatment lends a satisfying sense of completeness to this important episode in Jesus's life. Through sheer numbers of drawings, Domenico makes this initial Temptation parallel Christ's later "temptation" in the Garden of Gethsemane, which also takes up eight drawings. He also inserted the Temple in no fewer than four scenes, thereby linking Christ's Temptation to the future development of the Church (which Domenico takes pains to depict later on in Peter's story).

Christ carried by angels, detail of plate 110, *"He shall give his angels charge concerning thee . . ."—II*

Finally, this is the first but certainly not the last instance in which the Gospels differ as to the sequence of events. Domenico's drawings are striking not only for imbedding visual clues to reflect (rather than gloss over) textual distinctions between Matthew and Luke, but also for imbedding references to later sacred commentaries, notably Maria de Agreda.

103. *Jesus in the Wilderness*

And immediately the spirit driveth him into the wilderness. (Mark 1:12)

Then was Jesus led up of the Spirit into the wilderness to be tempted of the devil. And when he had fasted forty days and forty nights, he was afterward an hungred. (Matt. 4:1–2)

> Pen and wash, . . .
> Signed low left: Dom.o Tiepolo f
> Literature: Guerlain 1921, 53; Conrad 1996 [86]
> Reference: Ragusa and Green 1961, 117–129 [97–107]

Whether the spirit is driving Jesus, as Mark affirms, or is leading him, as Matthew states, is uncertain. What is clear is that Domenico took pains to portray this rarely depicted prelude to Christ's temptation. His eyes cast heavenward, Jesus listens to the spirit and stretches his hand as if to test the winds, as he enters the wilderness to begin his battle with Satan. As he strides forward in this rugged landscape, his cloak flaps in the breeze, suggesting that the spirit is moving him along. Jesus casts a long shadow as he approaches the clump of trees in the foreground, having passed the by now familiar rocky cliff in the background. 🌿

There are at present eight drawings on the theme of the *Temptation of Jesus,* which is described in Matthew 4:1–11. Luke 4:1–13 changes the order of the temptations, placing the one involving the pinnacle of the Temple last. In telling this story, Domenico appears to have been guided by the *Meditationes vitae Christi,* a readily available text then still attributed to S. Bonaventura, which adds much detail to the story. The Paris Ms. Ital. 115 illustrates the narrative with no fewer than eleven miniatures (Ragusa and Green 1961 [97–107]). ✤

104. *The First Temptation of Jesus*

And when the tempter came to him, he said, If thou be the son of God, command these stones be made bread. But he answered and said, It is written, Man shall not live by bread alone, but by every word that proceedeth out of the mouth of God. (Matt. 4:3–4)

Pen and wash, over black chalk, 465 x 360
Not signed
Marked in pencil, top border, right: 8071/1
Provenance: Paris, Palais Galliera, June 13, 1963 [3]; Geneviève Aymonier-Férault;
Prato, private collection;
Exhibition: Paris, Aymonier 1965 [25]; Paris 1971 [109]; London, Heim 1972 [87]
Literature: Conrad 1996 [91]
Reference: Réau 1957, 304–310

Switzerland, private collection

Having seated himself on a rock-like throne, Jesus, high up on a cliff, looks relaxed, though stern, as he gives Satan an audience. Sporting batwings, cloven hooves, a curly tail, horns, and a beard, Domenico's Satan is comical but still threatening as he presents his first temptation. Jesus turns away in distaste, touching the massive stone by which he is seated, as though retorting, "It is written, Man shall not live by bread alone." ❦

It is suggested here that this drawing represents the first of the series of the three temptations as they appear in San Marco (Demus 1985 [103]; *San Marco* 1991 [64/1]). It has much in common with the first, showing the Devil standing on the right, holding the stones, and Jesus seated left. The stones are not in evidence in our drawing, as they are not in the miniature in the *Meditationes vitae Christi* (Ragusa and Green 1961 [99]). Domenico illustrates the first and third temptations in three drawings, all with a very similar setting, but here the figures are set lower, an arrangement not unlike *The Sacrifice of Abraham* (pl. 1), while those representing the third temptation on the high mountain (pls. 107, 108) are set higher. ❖

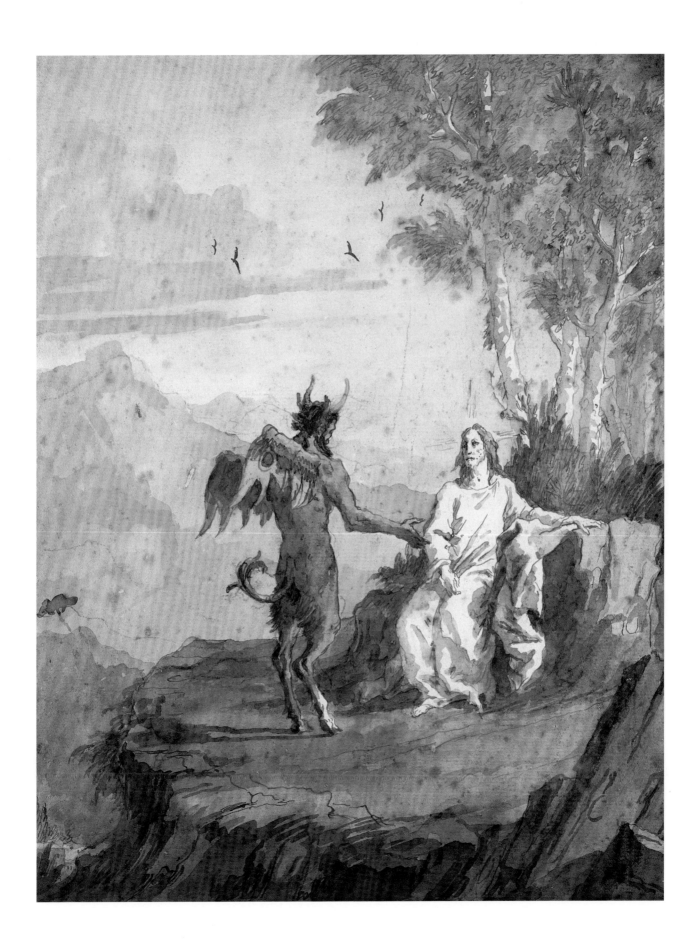

105. *The Devil Sets Jesus on the Pinnacle of the Temple*

Then the devil taketh him up into the holy city and setteth him on a pinnacle of the temple. (Matt. 4:5)

And he brought him to Jerusalem, and set him on a pinnacle of the temple. . . . (Luke 4:9)

> Pen and wash, over black chalk, 466 x 359
> Signed low right center: Dom.o Tiepolo f
> Provenance: Jean Fayet Durand (1806–1889)
> Literature: Conrad 1996 [87]
> Reference: Pigler 1956, i, 266–268

Paris, Musée du Louvre, Département des Arts Graphiques, RF 1713bis [77]

With Jesus firmly in his grasp, Satan flies towards the Temple top, graced by an umbrella pine, whose branches echo Jesus's outstretched arms. Inspired by medieval commentaries that stressed the indignity Jesus thus endured, Domenico invented this unusual scene of Christ's transport, which is traditionally not shown. ❦

This drawing makes a pair with the second temptation of Jesus, depicted in the following drawing (pl. 106), which shows Jesus seated on the pinnacle of the Temple. The Temple is again represented as a classical temple front with Corinthian columns and tympanum, somewhat similar to the façade of the church of Sta. Fosca in Venice, which was adjacent to the Tiepolo home. We have been able to find no prototype showing the devil carrying Jesus in his arms in this way, and it must be considered an original idea of Domenico's. ⚜

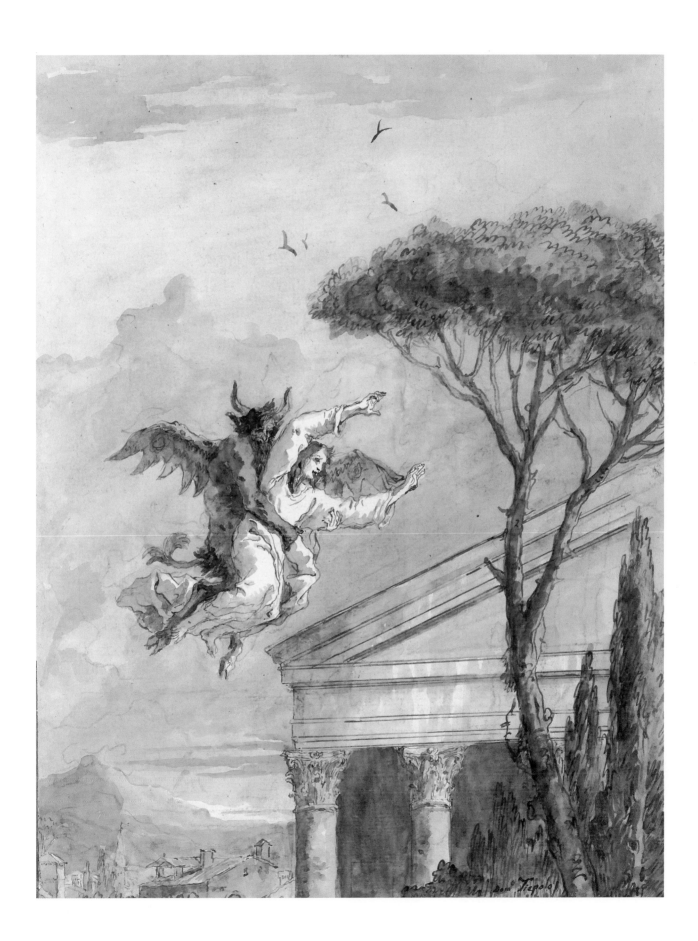

106. *The Second Temptation of Jesus, with the Campanile of San Felice*

Then the devil taketh him up into the holy city, and setteth him on a pinnacle of the temple, and saith unto him, If thou be the son of God, cast thyself down: for it is written, He shall give his angels charge concerning thee: and in their hands they shall bear thee up, lest at any time thou dash thy foot against a stone. (Matt. 4:5–6)

And he brought him to Jerusalem, and set him on the pinnacle of the temple, and said unto him. . . . And Jesus answering said unto him, It is said, Thou shalt not tempt the Lord thy God. (Luke 4:9–12)

Pen and wash, 460 x 360
Signed low left: Dom.o Tiepolo f
Provenance: Roger Cormier, Tours, his sale, Paris, Georges Petit, Apr. 30, 1921 [42]
Exhibition: Dresden 1977, pl. 14; Prague 1977, pl. 44; Nice 1982 [183]
Literature: Guerlain 1921, 54; Guerlain 1921+, 224; Conrad 1996 [88]

Prague, Národní Galerie, DK 4800

His cloak dangling over the Temple's edge, Jesus appears dangerously close to being pushed off by an increasingly angry Satan. With one hand clapped on Christ's shoulder, Satan points to the tower, urging Jesus to take the dare, as Jesus calmly remonstrates him. Luke makes this the third Temptation and Domenico carefully alludes to both texts and sequences in his interpretation. 🖊

Domenico shows the second temptation of Jesus in two scenes. In plate 105 he shows him being carried up to the pinnacle of the Temple, followed by this scene. In both cases the building is shown as a classical temple front with Corinthian columns, again reminiscent of Santa Fosca. The third temptation is continued in Nos. 107 and 108, which show Jesus in the high mountain. The series is completed with two drawings illustrating the text, *"He shall give his angels charge concerning thee"* (pls. 109, 110), which again employ the temple front. ⚜

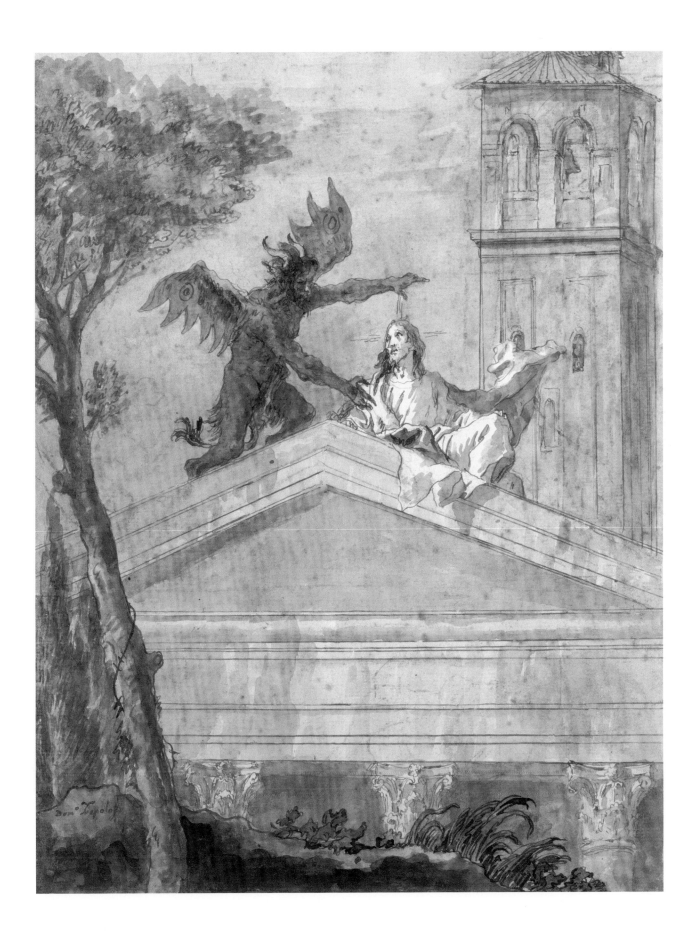

107. *The Third Temptation of Jesus*

Again, the devil taketh him up into an exceeding high mountain, and showeth him all the kingdoms of the world, and the glory of them; And saith unto him, All these things will I give thee, if thou wilt fall down and worship me. Then saith Jesus unto him, Get thee hence, Satan: for it is written, Thou shalt worship the Lord thy God, and him only shalt thou serve. (Matt. 4:8–10)

And the devil . . . shewed unto him all the kingdoms in the world in a moment of time. . . . (Mark 4:5)

Pen and wash, over black chalk,
Signed low right: Dom.o Tiepolo f
Provenance: Paris, Drouot, Dec. 14 1938, pl. 8; Michel-Lévy; Mme. A.L.D.; Paris, Drouot-Richelieu, Nov. 21, 2001 [65],
Reference: Ragusa and Green 1961 [97–197]

Indiana, private collection, on loan to the Indiana University Art Museum

Back on a high mountainside, Christ has returned to his rocky throne while Satan now sits at his feet, reflecting his inferior status and perhaps his diminishing powers. Pointing down, Satan's darkened groveling form is in total opposition to Jesus's erect, brightly lit, upward gesturing, dignified body. A true child of his era, Domenico presents Satan and Jesus almost as eighteenth-century sightseers, who, having climbed up a mountainous promontory, enjoy the view with Satan pointing to a particularly charming vignette. Nonetheless, the sacred message remains clear. 🌿

Here the devil, very unusually, is shown seated somewhat precariously on the edge of the cliff, and appears to be indicating the kingdoms of the world with his hand. Meanwhile, Jesus extends his left arm in a gesture of command, the effect of which is shown in the Louvre drawing of *Jesus Dismisses the Devil* (pl. 108). Both these drawings have a very similar setting that emphasizes the high mountain. ⚜

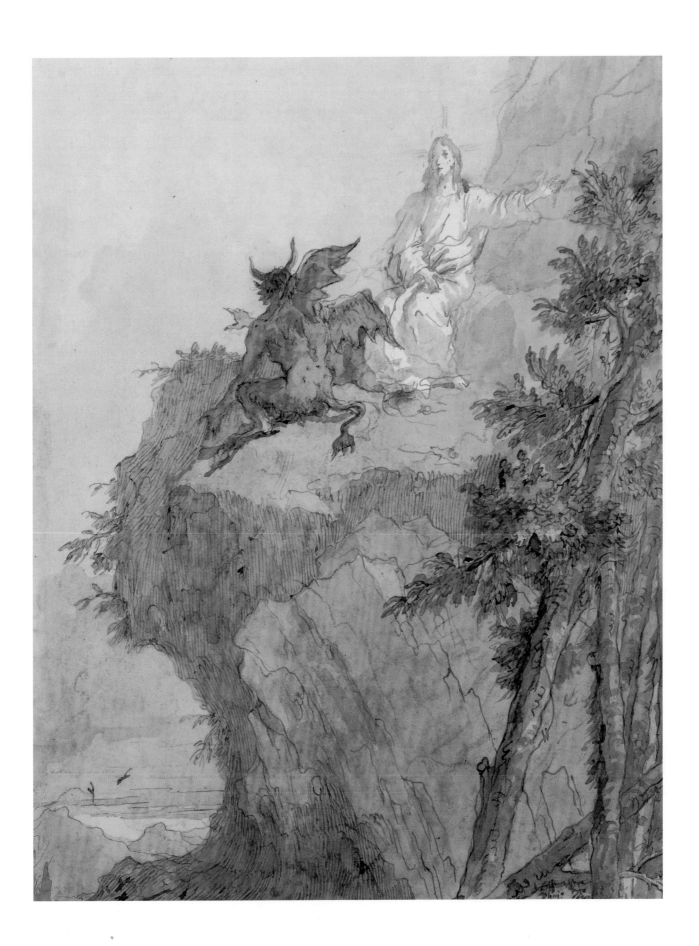

108. *Jesus Dismisses the Devil*

Then Jesus saith unto him, Get thee hence, Satan; for it is written, Thou shalt worship the Lord thy God, and him only shalt thou serve. (Matt. 4:10)

And when the devil ended all the temptation, he departed him for a season. (Luke 4:13)

Pen and wash, over black chalk, 466 x 358
Signed low right: Dom.o Tiepolo f
Provenance: Jean Fayet Durand (1806–1889)
Literature: Conrad 1996 [92]

Paris, Musée du Louvre, Département des Arts Graphiques, RF 1713bis [74]

Satan falling back to hell, frequently off a cliff, was traditional. Domenico embellished this convention with details of his own invention, which also changes his meaning. Stationed higher than Satan to signal his eternal spiritual superiority as well as his current victory, Jesus (with a triumphant smile flickering across his face) dismisses his opponent. "Get thee hence" is ordered with his left (sinister) hand, using a well-known cursing gesture, the *mal occhio,* or evil eye. Threatened by a powerful curse, which in a sense "backfires" on him, Satan hastily leaps out of the way to escape any permanent damage. ❦

This sheet completes the series of five drawings depicting the three temptations of Jesus, closely followed by the setting of the preceding drawing (pl. 107). Domenico's portrayal of Jesus using Satan's own magic against his adversary goes against the spirit of Jesus's own words in Mark 7:22, "Thefts, covetousness, wickedness, deceit, lasciviousness, an evil eye, blasphemy, pride, foolishness: all these things come from within, and defile men." ⚜

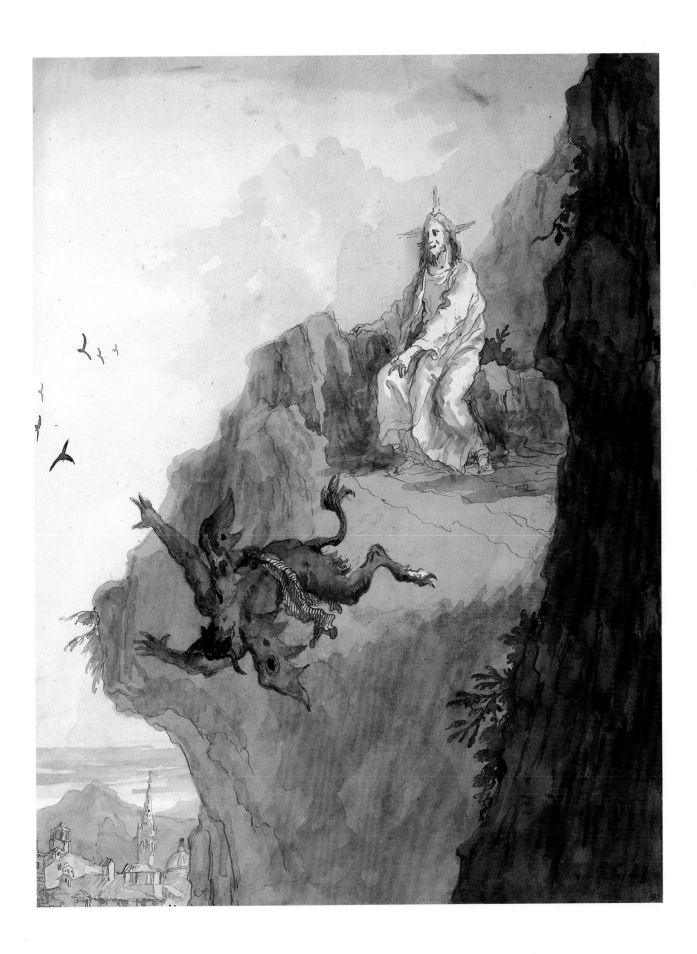

109. *"He shall give his angels charge concerning thee . . ."—I*

Then the devil leaveth him, and, behold, angels came and ministered unto him. (Matt. 4:11)

Pen and wash, over black chalk, 459 x 385
Signed low left: Dom.o Tiepolo f
Provenance: Cailleux; Mrs Drey 1957
Exhibition: Rotterdam 1996 [63]
Literature: Conrad 1996 [89]
Reference: Pigler 1956, i, 268–270; Réau 1957, 309–310, cites nothing Venetian; Ragusa and Green 1961, 427 [104]

Amsterdam, Rijksprentenkabinett 1957.251

Resting on a cloud of glory at the Temple pinnacle, the triumphant Jesus is venerated by a host of angels, several of whom kneel at his feet. One rather companionably offers him refreshment from a basket of food. By placing this scene upon the Temple, Domenico connects Jesus's triumph and the establishment of the Church while reminding us that, according to Luke, the Temple dare was the final temptation. ❧

Domenico here clearly shows the angels bringing food and drink to Jesus, attending to a tradition described at length in the *Meditationes vitae Christi* in the "Instructions" corresponding to the miniature illustrating the scene: "Here how the angels return with the food and set the table; how Jesus sits on the ground with the angels around him." It is curious to note that Domenico here returns to the use of San Felice in the setting, reflecting the order of the temptations as given by Luke, in which "the pinnacle of the temple" comes last. On the other hand Luke does not mention the ministering angels. The following drawing is a companion piece, again showing the tympanum of San Felice. ⚜

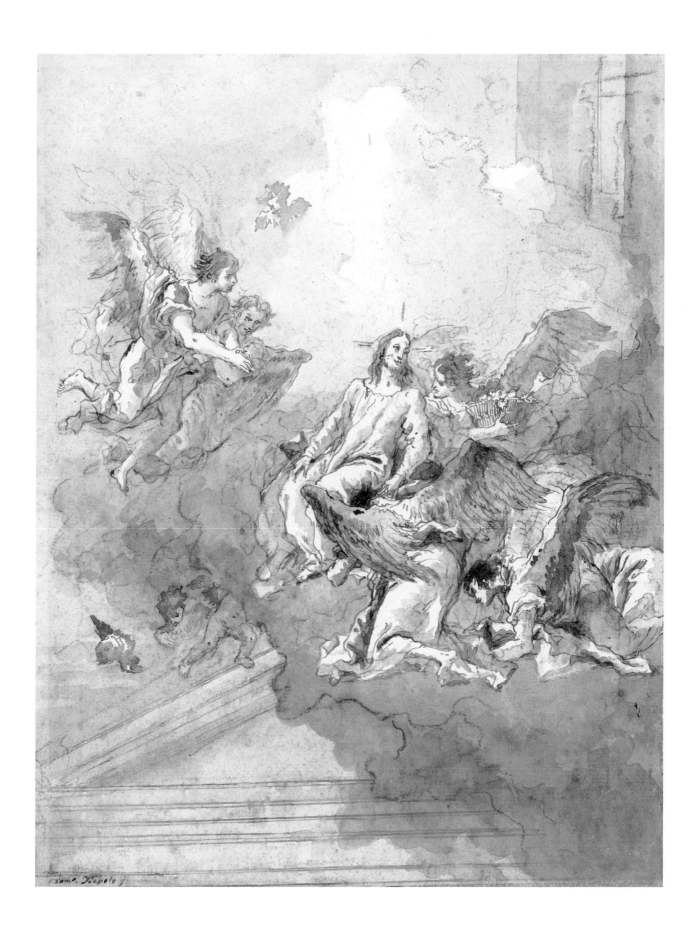

110. *"He shall give his angels charge concerning thee. . . ."—II*

Mid the triumphal songs of a multitude of angels, He was borne back to the desert. They carried him in their hands, although he had not need of their help, since he could make use of his own divine power; but thus service was due to him in recompense for enduring the audacity of Lucifer in carrying to the pinnacle of the temple and the mountain top, the sacred humanity of Christ. (Maria de Agreda, 269)

Pen and wash, over black chalk, 477 x 352
Signed low left: Dom.o Tiepolo f
Provenance: unknown collector, GFA; to the museum in 1912
Exhibition: Berlin 1996 [56]
Literature: Maria de Agreda 1971, 269; Conrad 1996 [90]

Berlin, Staatliche Museen zu Berlin, Preussischer Kulturbesitz, 4589-77-1912

Domenico wraps up this chapter with a suitably celebratory scene. Jesus is carried triumphantly by the angels, and one can almost hear their chorus of Hallelujah! Below, the umbrella pine also stretches its branches broadly. With this scene of his own invention, Domenico establishes a parallel between the conclusion of his Temptation, namely, Christ's triumph over Satan and his later Transfiguration and subsequent Resurrection. ❦

This is a companion to the preceding drawing (pl. 109), again using the tympanum of San Felice as the setting [fig. 106]. The angels are shown here assisting the descent of Jesus, a detail fully described by Maria de Agreda; it is not recorded in the *Meditationes vitae Christi,* though it does have a miniature showing *Jesus Descending from the Mountain Alone* (Ragusa and Green 1961 [107]). ⚜

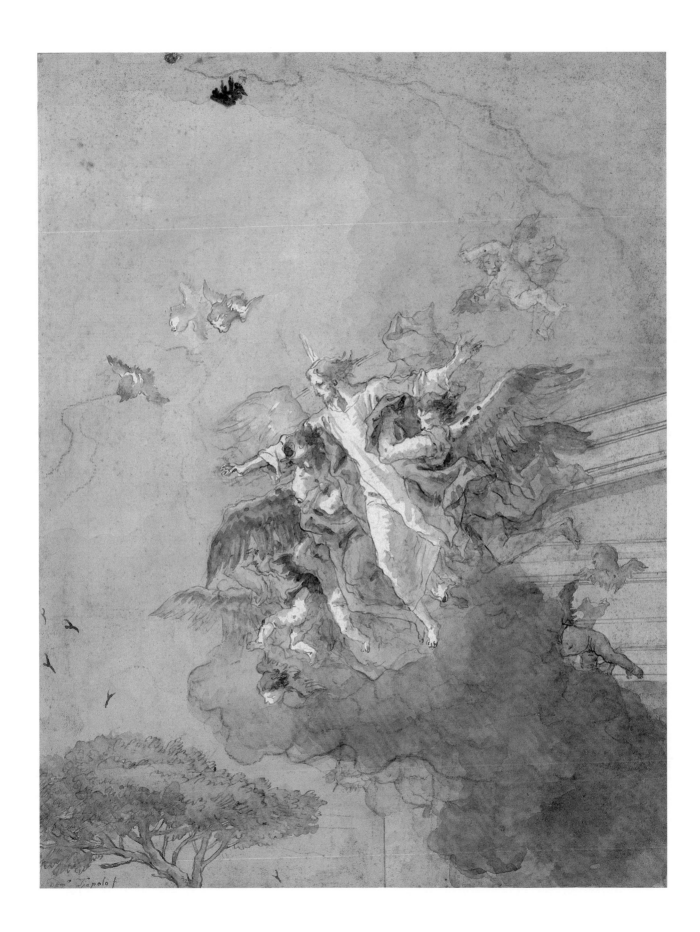

The Ministry of Jesus Continued, Plates 103–168

Section 2: The Calling of Peter to The Transfiguration, Plates 111–138

Accounts of Jesus's early ministry are famously piecemeal and divergent, making the construction of a cohesive narrative somewhat difficult, although some general developments can be ascertained. Jesus began by recruiting disciples, teaching, preaching, and performing miracles. Matthew (4:18–19), Mark (1:16–17), and Luke (5:1–7) concur that Peter and Andrew were the first to be called; Luke describes the miraculous draught of fishes (famous in the visual canon), and John (1:40–41) specifies that Andrew introduced Peter to Jesus. James and John are next, while Matthew (9:9) describes his own conversion in fairly pragmatic terms. Luke (5:27) calls Matthew "Levi" and adds that Jesus later supped with him, which is also how Mark (2:13) accounts for Matthew's recruitment. In the visual tradition, Peter and Matthew's calling have become the most popular recruitment episodes. It is through Matthew (10:2) and Luke (6:13) that we know there were twelve Apostles.

The Gospels vary not only as to which of Christ's miracles are described but in what order. For example, of Christ's numerous cures, the Leper was the first beneficiary, according to Matthew and Luke. They concur that the Centurion's servant was second. These miracles, together with Christ's cure of a palsied man and the cripple at the Pool of Bethesda, have the most extensive visual tradition. Christ's rather private healing of Peter's mother-in-law was his first healing of illness, according to Mark, although he and Luke assert that Christ's first miracle was an exorcism. These events, and Christ's cure of the man with the withered hand, are less often depicted.

Described only by John, Christ's conversion of water into wine at the wedding in Cana was fixed in Catholic tradition as Christ's first public miracle and became immensely important visually. Both Matthew and Mark describe Christ's cure of the Canaanite woman's daughter. Jesus also resurrected two children from the dead: the son of the widow of Nain, mentioned only by Luke, and the daughter of Jairus, described by all but John. These miracles do not have the visual currency of Christ's more celebrated post-Transfiguration resurrection of Lazarus, which is described only by John.

Jesus performed a whole series of "natural miracles" as well. He multiplied loaves and fishes to feed several multitudes, of which his feeding of 5,000 is the only miracle described by all four Gospels. That he walked on water is noted by both Matthew and Mark, but his rescue of Peter (who tried to do the same) is limited to Matthew's account. Christ had earlier calmed a tempest that threatened the boat in which he and his disciples were crossing the sea, and many of these miracles have found their way into pictorial traditions.

Christ expelled numerous demons, but these were less commonly portrayed. Matthew, Mark, and Luke all offer an account of Christ's exorcism of the poor Gadarene man whose demons entered a herd of swine that drowned themselves—a story that, despite its dramatic potential, has limited pictorial currency.

Besides delivering his famous Sermon on the mount, Jesus also preached from boats and occasionally in the Temple. He taught lessons through parables, and during notable encounters. Shortly after raising the son of the Widow of Nain, Christ ate with Simon the Pharisee and taught a lesson about repentance and salvation. Another time, Christ instructed Nicodemus about the kingdom of heaven. Christ revealed such vast knowledge to the woman of Samaria that she brought her townsmen to him and called him "the Christ."

Although the chronology of events must be patched together from divergent accounts, a general development can be determined. During his ministry up to his Transfiguration, Christ called his disciples, revealed his powers, and attracted a large following through his miracles and his teachings. Some events, most notably the Wedding at Cana, became fixtures of the pictorial tradition; others, particularly scenes of exorcism, were less common.

Lengthier than known picture cycles, Domenico's epic uses 29 drawings, which means Domenico encountered more than the usual challenges involved with this first part of Christ's ministry. Here again, Domenico approached his story with an eye to exploring divergences among texts and to placing an accent on unusual topics. Fascinated by recruitment scenes, Domenico illustrated both Matthew's and John's differing accounts of how Peter and Jesus met, and offered an amusingly contemporary vision of Matthew's calling. But his primary focus was Peter. Playing down the miraculous draught of fishes, Domenico emphasized instead Peter's reaction to Jesus in both versions of their meeting, thereby introducing the emphasis on their relationship that continues through Christ's death. Domenico's accent on Peter is evident as well in his choice Christ's cure of Peter's mother-in-law.

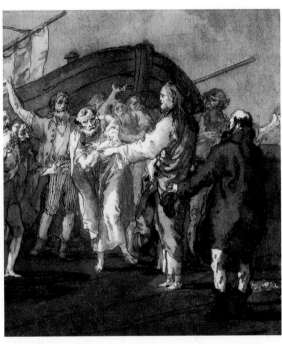

Peter from plate 111, *The Calling of Peter and Andrew*

Domenico portrayed Christ performing fourteen separate miracles that demonstrated the full range of his powers. Beginning with such standard subjects as Christ curing the Leper and the Centurion's servant, Domenico omitted the famous miracle at the Wedding at Cana, but incorporated two exorcism scenes, one interrupted by John's followers and the other involving the demons that fled into the Gadarene swine. Jesus is shown curing the palsied man, stilling a storm, walking on water, rescuing Peter, and feeding the multitude. He is also shown raising the Widow of Nain's dead son. Five of the miracles unfold over two scenes, with the second concentrating on the overawed reaction to what has just taken place. Dramatic and filled with action, Domenico's scenes in this section are (even when paired with a sequel) consciously "self-contained," thereby permitting diverse arrangements to follow various Gospel accounts, a distinctive solution to the problem of sequence. Christ's diverse activities are also stressed in Domenico's hands. Jesus preaches two sermons and teaches a fairly comprehensive list of individuals, including Simon the Pharisee, the woman of Samaria, and Nicodemus. As Domenico approached the canonically significant subject of the Transfiguration, he increasingly stressed Peter, showing him in the foreground of many scenes leading up to this event.

111. *The Calling of Peter and Andrew*

And Jesus, walking by the Sea of Galilee, saw two brethren, Simon called Peter, and Andrew his bother, casting a net into the sea, for they were fishers. And he said unto them, Follow me, and I will make you fishers of men. (Matt. 4:18–19)

Pen and wash
Provenance: Roger Cormier, Tours, his sale, Paris, Georges Petit, Apr. 30, 1921, no. 64, as "Jésus et les pêcheurs"?
Literature: Guerlain 1921, 55; Conrad 1996 [94]
Reference: Réau 1957, 312

Domenico inaugurates Christ's ministry with his calling of disciples, notably Peter and Andrew. Crossing his arms in pious veneration, Peter approaches Jesus in an attitude that reflects his gesture at the earlier *Baptism* (pl. 93). A pile of fish, the man raising his arms in wonder, and the beached boat hint at the (more traditional) miraculous catch of fishes that preceded this moment, while the twelve fishermen remind us that twelve were ultimately chosen. His hat removed, his stockings or boots loose, Andrew stands behind Jesus. ❦

This is the first of the many representations in the series of Peter, who displays his traditional and characteristic features: a round head, a short beard, bald on top with a tuft of hair in the center over the forehead. These are retained quite consistently down to the final scenes of his life: *The Parting of Peter and Paul* and *The Crucifixion of Peter* (pls. 261, 296). It will be noted in due course (pl. 268) that the image of Paul is similarly clearly defined; see also Jameson (1883: I, 185–226). Moreover, one must consider some authoritative images of Peter and Paul in earlier Venetian painting, for example: two polyptychs by Bartolomeo Vivarini in the Accademia: *St. Ambrose Flanked by Peter and Paul,* signed and dated 1477, and *The Annunciation Flanked by Peter and Paul,* from Conversano, signed and dated 1475 (Moschini Marconi I, 1955 [180, 183]); the damaged panel by Crivelli depicting *Peter and Paul* for Camerino; and more importantly, the fine St. Peter by Bellini from the Miracoli (Moschini Marconi I, 1955: [124, 82]). The latter formed the right interior panel of the organ shutters, which, when closed, displayed the Annunciation. The St. Paul, which formed the left interior panel, is missing. One may also note the monumental figures by Dürer in the Alte Pinakothek: *The Four Apostles: John & Peter, Mark & Paul* (*Klassiker der Kunst* 1904: [67]), the two monumental figures by Stefano Cernotto for the Palazzo dei Camerlenghi of 1536 (Moschini Marconi II, 1962: [175, 176]), and the statues by Parodi flanking the high altar in San Giorgio Maggiore. ⚜

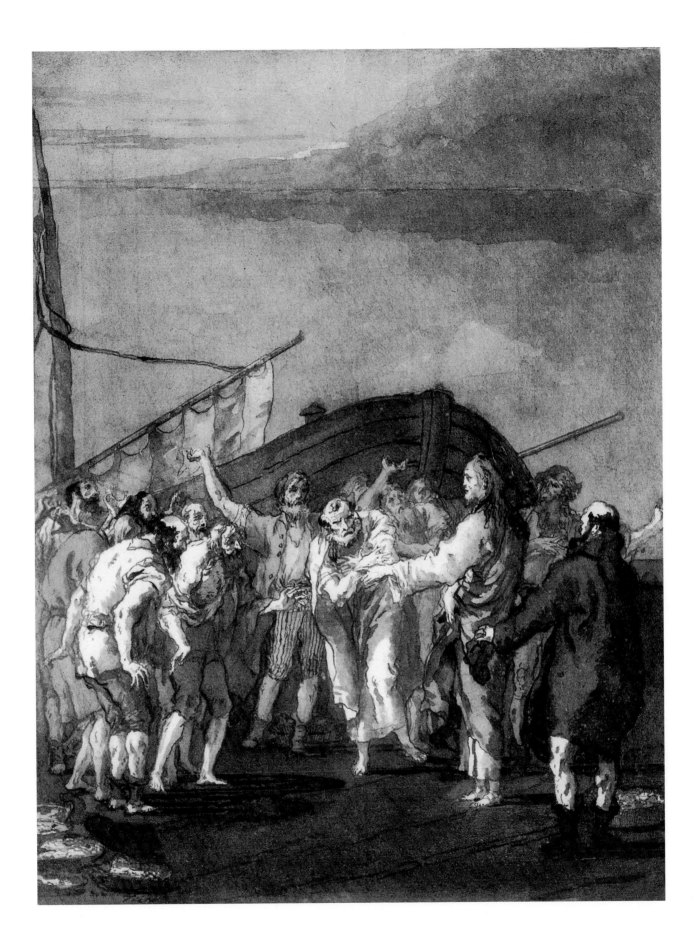

112. *Andrew Brings Peter to Jesus*

And one of the two which heard John speak, and followed him, was Andrew, Simon Peter's brother. He first findeth his own brother Simon, and saith unto him, We have found the Messiah, which is, being interpreted, the Christ. And he brought him to Jesus. And when Jesus beheld him, he said, Thou art Simon the son of Jona: thou shalt be called Cephas, which is by interpretation, A stone. (John 1:40–42)

Pen and wash, over black chalk, 460 x 355
Signed low left: Dom.o Tiepolo f
Provenance: Jean Fayet Durand (1806–1889)
Literature: Conrad 1996 [93]

Paris, Musée du Louvre, Département des Arts Graphiques, RF 1713bis [121]

Evidently interested in the diverse accounts of how Jesus met the disciples, Domenico here shows Andrew bringing Peter to Jesus, as John described. Jesus receives him at the base of a mountain not unlike the one on which he triumphed over Satan. The sheep hint at the flock of Christians whose care would be entrusted to Peter, while the large stone slab beside Jesus reminds us of Peter's designation as "the rock." ❦

At first this drawing was thought to represent the celebrated incident John 21:17, "Feed my sheep," but Conrad suggested that the scene may alternatively be identified as Andrew bringing Peter to Jesus (John 1:42). This seems much more acceptable, although there are certainly some elements, notably the flock of sheep and goats in the lower right corner, that imply some link with the first subject. Jesus is seated in the countryside; by him is a large stone with an illegible inscription, no doubt that referred to by John that brings to mind the famous verse of Matthew 16:18, "And I say unto thee, That thou art Peter, and upon this rock I will build my church; and the gates of hell shall not prevail against it"—for which we have no drawing in the series. Andrew is bald and bearded, dressed in a short tunic with a dark cloak, bare legs, and books, as he is identified in the preceding drawing: Peter has the characteristic tuft of hair over his forehead.

John tells a very different story of the calling of Peter and Andrew to that found in Matthew and Mark, and Luke does not even mention Andrew. We introduce his version of the event between the more familiar events described in the other Gospels. ⚜

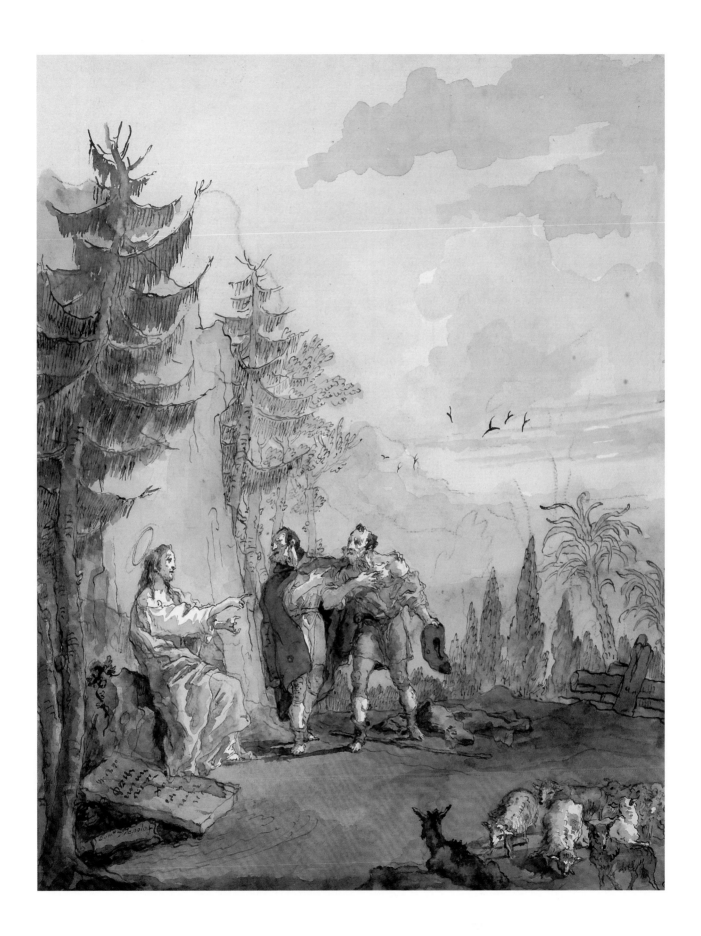

113. *The Calling of the Sons of Zebedee*

And going on from thence, he saw other two brethren, James the son of Zebedee, and John his brother, in a ship with Zebedee their father, mending their nets: and he called them. And they immediately left the ship and their father, and followed him. (Matt. 4:21–22)

> Pen and wash, over black chalk, 460 x 360
> Signed low right: Domo Tiepolo f
> Provenance: Roger Cormier, Tours, his sale, Paris, Georges Petit, Apr. 30, 1921, no. 46; Christie's, Dec. 15, 1992 [136]
> Literature: Guerlain 1921 [p. 57]; Conrad 1996 [104]

Having entered a boat, Jesus points to one man (perhaps James) who reacts with surprise, while another (most likely John) raises his hands in prayer. The growing flock have followed Jesus and intently observe the proceedings. Only the young fisherman is absorbed with mending his net. ❦

This scene follows immediately upon *The Calling of Peter and Andrew* (pl. 111) in Matthew, though we here interpose the scene described in John 1:42: *Andrew brings Peter to Jesus* (pl. 112). Luke 5:1–5 associates this scene with *Jesus Preaching from the Boat* (pl. 129). ❦

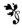

114. *The Baptism of the Virgin*

The most blessed Lady also asked Him for the Sacrament of Baptism, which he had now instituted, and which He had promised Her before. In order that this might be administered with a dignity becoming as well the Son as the Mother, an innumerable host of angelic spirits descended from heaven in visible forms. Attended by them, Christ himself baptized his purest Mother. Immediately the voice of the eternal Father was heard saying: "This is my beloved daughter, in whom I take delight." (Maria de Agreda)

> Pen and wash, 460 x 360
> Signed lower right
> Provenance: Roger Cormier, Tours, his sale, Paris, Georges Petit, Apr. 30, 1921, no. 20; Duc de Trévise, his sale, Paris, Hôtel Drouot, Dec., 8, 1947, pl. 30
> Reference: Maria de Agreda 1685, XXIX; Ragusa and Green 1961, 129, 139 [108]

No image.

The story is told by Maria de Agreda, who places the Baptism of Mary by Jesus soon after the calling of the first five disciples. No prototype has as yet come to light. Maria de Agreda follows Matthew, Mark, and Luke on placing The Baptism of Jesus before the Temptations, but curiously, in the *Meditationes vitae Christi,* it follows them. ❦

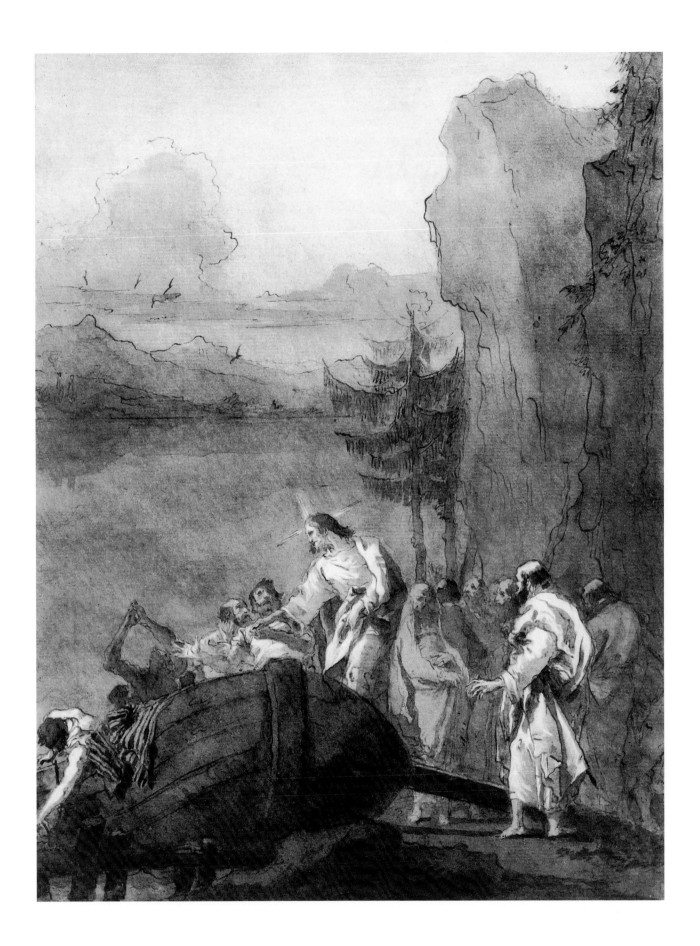

115. *The Sermon on the Mount*

And seeing the multitudes, he went up into a mountain: and when he was set, his disciples came unto him: and he opened his mouth, and taught them, saying, Blessed are the poor in spirit; for theirs is the kingdom of heaven. (Matt. 5:1–3)

Pen and wash, 470 x 365, image, 493 x 387, sheet
Not signed
Provenance: Paris, Hôtel Drouot, Dec. 14, 1938, lot 13; Michel-Lévy; Mme. A.L.D.; Paris, Drouot Richelieu, Nov. 21, 2001 [61]; London, Crispian Riley-Smith
Exhibition: London, Crispian Riley-Smith 2002 [9]
Reference: Réau 1957, 318

Los Angeles County Museum of Art, Gift of Harvey S. Shipley Miller

His arms stretched out expansively toward the assembled crowd, Jesus delivers a powerful sermon. Most listen with rapt attention or deep respect, although one rich merchant (clearly not the "poor in spirit") takes his ease in the foreground, perhaps not a likely candidate for the Kingdom of Heaven. Two patriarchs and a boy stand attentively in the foreground, while the knobby-kneed man who heard John the Baptist preach earlier sits in the middle, absorbed in the sermon. ❦

Domenico here creates a large and various crowd of people, with Jesus standing as an authoritative figure on the right. Three chapters of the Gospel of St. Matthew, 5–7, are devoted to the Sermon on the Mount, which thus constitutes perhaps the most important episode in the ministry of Jesus. Nevertheless, its visual tradition is slim. ⚜

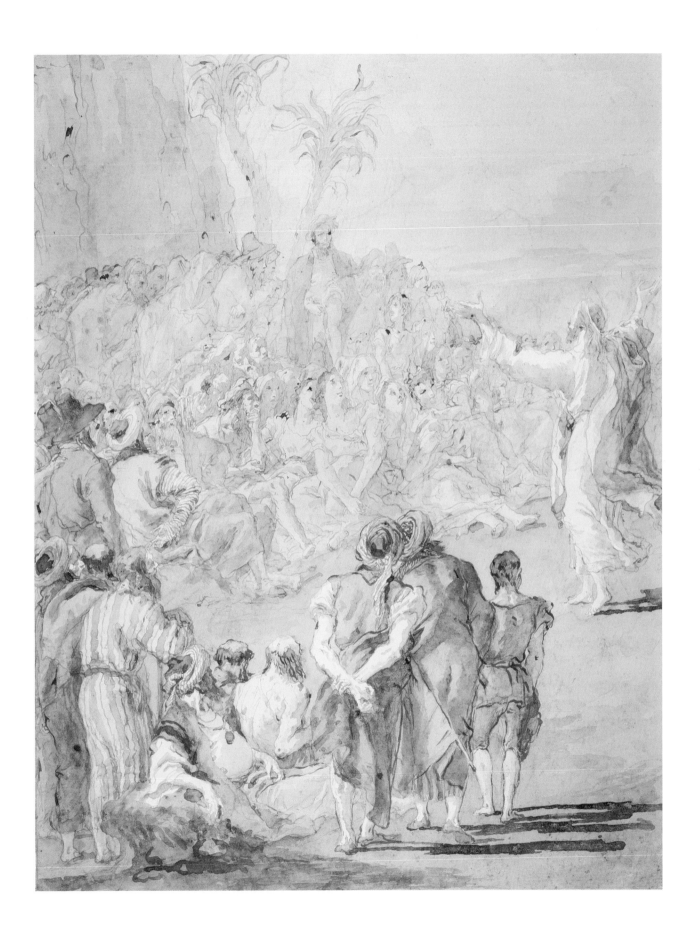

116. *Jesus Healing the Leper*

When he was come down from the mountain, great multitudes followed him. And, behold, there came a leper and worshipped him, saying, Lord, if thou wilt, thou canst make me clean. And Jesus put forth his hand, and touched him, saying, I will; be thou clean. And immediately his leprosy was cleansed. (Matt. 8:1–3)

And there came a leper to him, beseeching him, and kneeling down to him, and saying, If thou wilt, thou canst make me clean. (Mark 1:40)

Pen and wash, 460 x 360
Signed on a plaque on the tower, right: Dom.o Tiepolo f
Provenance: Roger Cormier, Tours, his sale, Paris, Georges Petit, Apr. 30, 1921, no. 71; Paris, Hôtel Drouot, June 24, 1985 [10], bt. Feilchenfeld
Literature: Guerlain 1921, 59; Conrad 1996 [125]
Reference: Réau 1957, 374

Rhinebeck, N.Y., Stephen Mazoh collection

Kneeling with his arms outstretched in supplication (as Mark detailed), the leper makes his plea. Peter, foremost among the disciples, stares over Christ's shoulder. Declaring, "I will, be thou clean," Christ stretches out his hand to cure the leper. In the background, the crowd that had attended Christ's earlier sermon heads back to the city, whose massive battlements become a favorite setting for his ministry. ❧

In Matthew, this story immediately follows the Sermon on the Mount. The mountain may be seen on the left and the great multitude on the right. The leper, with a staff, a bag, and a water bottle, kneels before Jesus with his back to the viewer. Mark 1:40–41 and Luke 5:12–13 tell the story in similar phrases, but do not mention either the mountain or the multitude. ⚜

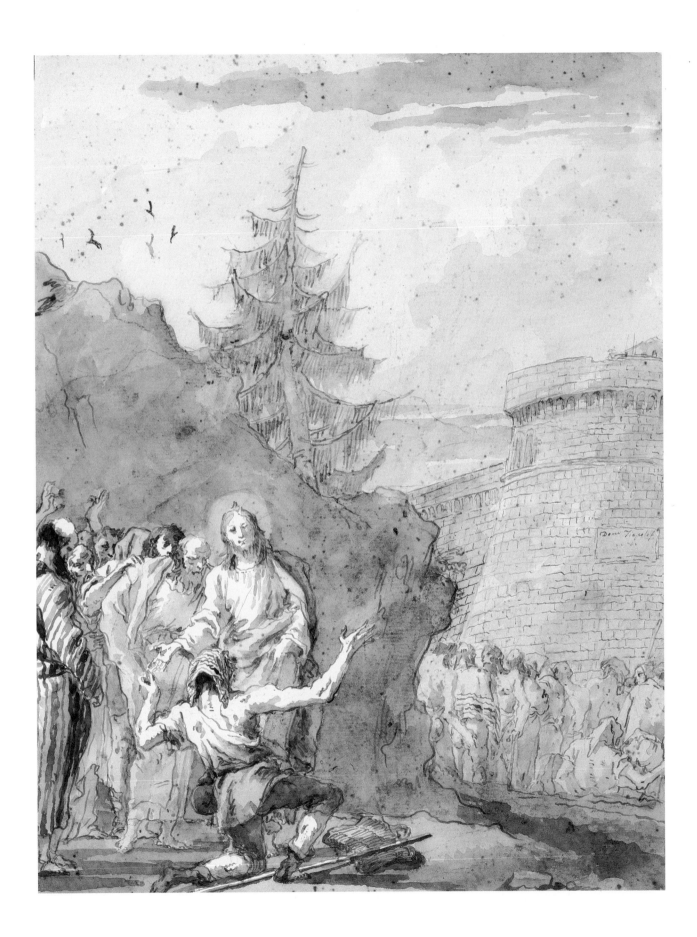

117. *Jesus and the Centurion*

And when Jesus was entered into Capernaum, there came unto him a centurion, beseeching him, and saying, Lord, my servant lieth at home sick of the palsy, grievously tormented. And Jesus saith unto him, I will come and heal him. The centurion answered and said, Lord, I am not worthy that though shouldest come under my roof: but speak the word only, and may servant shall be healed. For I am a man under authority, having soldiers under me: and I say unto this man, Go, and he goeth; and to another, Come, and he cometh; and to my servant, Do this, and he doeth it. When Jesus heard it, he marvelled, and said to them that followed, Verily I say unto you, I have not found so great faith, no, not in Israel. (Matt. 8:5–10)

> Pen and wash, 485 x 385
> Signed center left: Dom.o Tiepolo f
> Provenance: Paris, Hôtel Drouot, Nov. 26, 1919 [148]; Christie's, New York, Jan. 18, 1999 [17]
> Literature: Conrad 1996 [119]
> Exhibition: New York, Colnaghi 2000 [29]
> Reference: Pigler 1956, i, 273–75; Réau 1957, 375

New York, private collection

With Capernaum's battlements looming in the background, the centurion kneels humbly before Jesus, making his plea. Peter is nearly hidden behind Jesus (which may be Domenico's subtle way of noting that Mark does not describe this miracle), while James or John steps up for a closer look. As Jesus declares the power of the centurion's faith, his soldiers await their orders. ❧

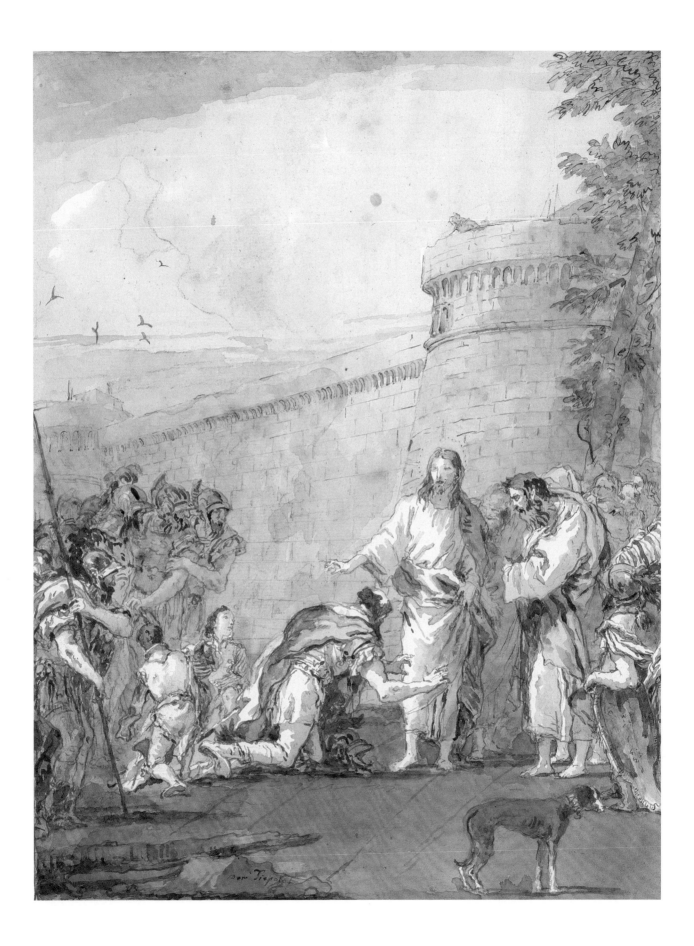

118. *Jesus Heals the Centurion's Servant*

And a certain centurion's servant, who was dear unto him, was sick, and ready to die. And when he heard of Jesus, he sent unto him the elders of the Jews, beseeching him that he would come and heal his servant. (Luke 7:2–3)

Pen and dirty gray wash, over slight black chalk, 467 x 360
Signed low right: Dom.o Tiepolo f
Provenance: Jean Fayet Durand (1806–1889)
Literature: Conrad 1996 [280]

Paris, Musée du Louvre, Département des Arts Graphiques, RF 1713bis [130]

Returning to his servant (or perhaps seeing his illness for the first time), the Centurion approaches his bed, where a priest reads out the service for extreme unction at his bedside. As an elder points to someone (probably Jesus) beyond the picture frame, his divine power is noted by the cross partially visible at the left, thus mixing time frames in this rarely portrayed episode of a cure through faith alone. ✣

In the story according to Luke, this drawing represents the first part of the story of the centurion, whereas it is the second part as told in Matthew 8:5–13 (pl. 117), where Jesus meets the centurion outside the city wall. The essence of the story is Jesus's power to perform a miracle at a considerable distance.

No prototype has been found for this scene, and it appears to be Domenico's own invention. The servant lies in bed, his helmet by his side, in a sort of Venetian infirmary, which also appears to be a chapel, with an altar on the back wall; there is also already a crucifix on the left. He receives extreme unction from a priest attended by an acolyte. The centurion enters from a staircase on the left, and on the right a figure that might be "an elder of the Jews" points urgently off stage. ✣

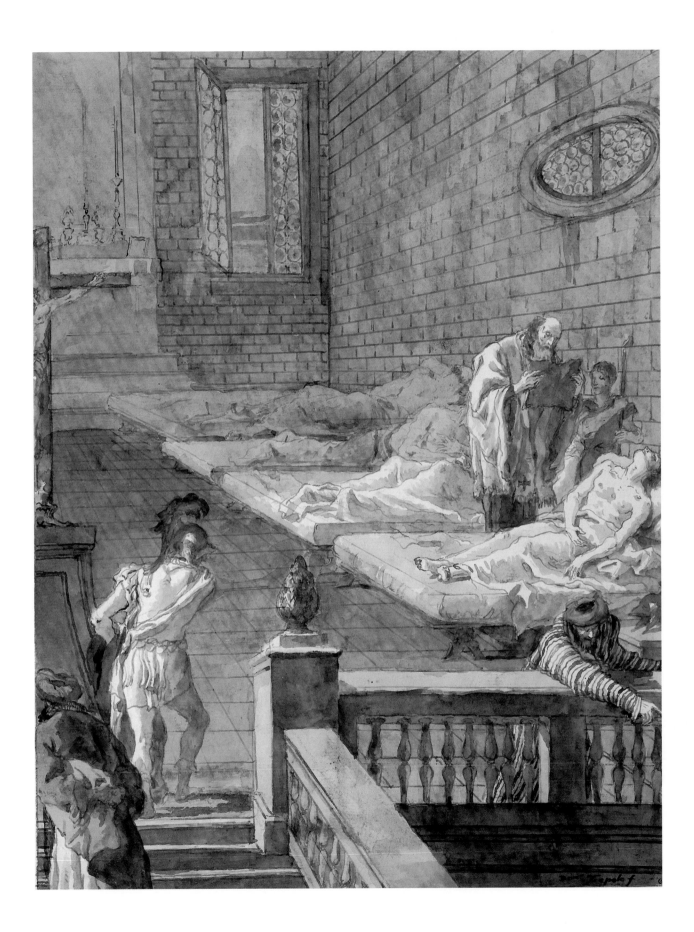

119. *Jesus Curing Peter's Mother-in-Law*

And when Jesus was come into Peter's house, he saw his wife's mother laid, and sick of a fever. And he touched her hand, and the fever left her: and she arose, and ministered unto them. (Matt. 8:14–15)

. . . they entered into the house of Simon and Andrew, with James and John. But Simon's wife's mother lay sick of a fever, and anon they tell him of her. And he came up and took her by the hand and lifted her up, and immediately the fever left her. . . . (Mark 1:29–31)

Pen and wash, over black chalk, 463 x 354, image, untrimmed
Signed low left: Dom.o Tiepolo f
Provenance: Tomas Harris; Dr. Rudolf J. Heinemann, New York
Exhibition: London, Arts Council, 1955, pl. 38; New York 1973 [105]
Literature: Conrad 1996 [120]
Reference: Pigler 1956, i, 300; Réau 1957, 380

New York, The Pierpont Morgan Library, Gift of Mrs. Rudolf J. Heinemann, in memory of Dr. Rudolf J. Heinemann, 1996.107

The first interior featuring Jesus since his infancy is given special meaning. As Jesus confidently prepares a cure, Peter stares at him anxiously. The window brace above their heads is cross-shaped, signifying the bond between them. Both will die on a cross; Peter will found Christ's Church and, within this series, cross-shaped braces will only again grace windows in his fledgling cathedral (see pls. 253, 254). Acknowledging Mark's text, Domenico includes Andrew and James, implying that John is also present. ❧

The setting is not unlike *The Death of Joachim* and *The Death of Joseph* (pls. 20, 80), with a brick-lined interior with peeling plaster and a Venetian beamed ceiling. Peter is shown to the right of Jesus, and once again Andrew is shown in the right foreground, as in plate 111. ❧

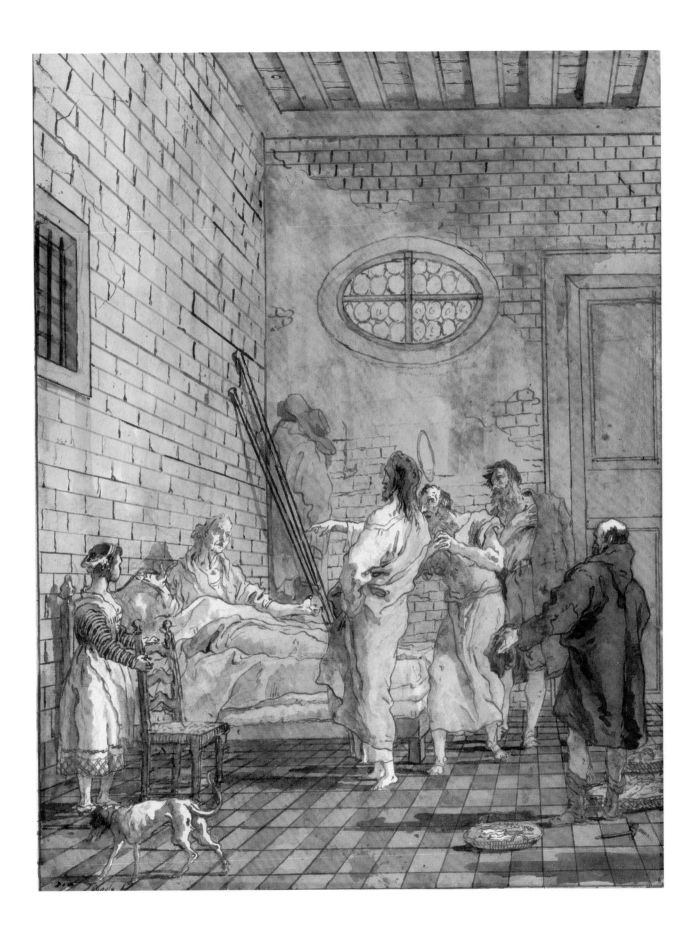

120. *The Resurrection of the Widow's Son*

Now when he came nigh to the gate of the city, behold there was a dead man carried out, the only son of his mother, and she was a widow: and much people of the city was with her. And when the Lord saw her, he had compassion on her, and said unto her, Weep not. And he came and touched the bier; and they that bare him stood still. And he said, Young man, I say unto thee, Arise. (Luke 7:12–14)

Pen and wash, over black chalk, 459 x 350
Signed low right: Dom.o Tiepolo
Provenance: Léon Bonnat [1833–1922]
Literature: Bean 1960 [165]; inv. 1309; Conrad 1996 [134]
Reference: Pigler 1956, i, 306; Réau 1957, 384; Girardon LA 94451

Bayonne, Musée Bonnat, LB 1309

Domenico gave this miracle two frames and paid careful attention to include details from the text. Here, a massive city gate looms in the background as a laborer struggles with the child's heavy bier. Jesus has approached and Domenico stresses his act of touching the bier as he orders the young man to rise. At the left, his mother spreads her arms in surprise and joy. Domenico's choice of the city gate, repeated in his chapter on the Stations (III, pl. 216), here marks the lad's transformation from death to life, while later on it marks Jesus's own transition on his way from life toward death. Luke says that most of the disciples went with him, so we can assume that is Peter looking so earnestly at the widow from the other side of the bier. ❧

The story is told only by Luke, following *Jesus and the Centurion* (pls. 117, 118). Once again, one may note Domenico's use of the open wooden coffin or bier, now covered with a tassled drapery ornamented with the skull and crossbones; the young man is sitting up cheerfully. This drawing and its companion, which follows, show successive phases of the same event, with the same setting, the gate of the city called Nain. ❧

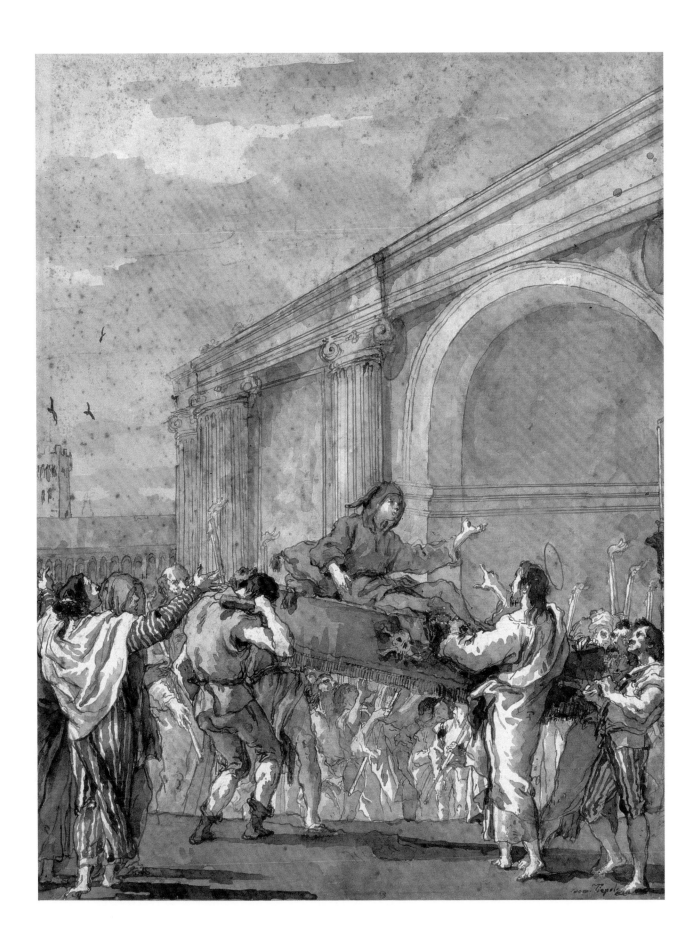

121. *The Widow's Son Restored*

And he that was dead sat up, and began to speak. And he delivered him to his mother. And there came a fear on all.
(Luke 7:15–16)

Pen and wash, over black chalk, 470 x 365, image
Signed on a rock, low right: Dom.o Tiepolo f
Provenance: Paris, Hôtel Drouot, Dec. 14, 1938 [10]; Michel-Lévy; Mme. A.L.D.; Paris, Drouot Richelieu, Nov. 21, 2001 [67]
Literature: Conrad 1996 [135]

Paris, private collection

The bier is now empty, as this widow joyfully receives the son whom Jesus has delivered to her. The ironic parallel between this woman's good fortune and the Virgin Mary (also by now a widow with an only son) cannot be lost on viewers. The widow's friends react with thanks and jubilation, while nearer the gateway a cluster of elders register the astonishment and fear that Luke mentions in verse 16. Jesus, still pointing, is flanked by a disciple dressed as Judas Iscariot, the future traitor (see pl. 181). Luke named Judas the traitor when he listed the twelve disciples a few verses earlier (6:16), so Judas's presence here augments other portents of Christ's death. The city portal will reappear when Christ goes to his execution, as he falls for the first time (Station III, pl. 216). There Jesus falls into the arms of one of his executioners, echoing mother and son seen here. ✴

This drawing follows a companion in the Musée Bonnat, at Bayonne (pl. 120) showing successive phases of the same event, with the same setting: the gate of the city called Nain, which is somewhat reminiscent of Sanmichele's gates of Verona. In the Bayonne drawing one may note Domenico's use of the open wooden coffin or bier, covered with a tasselled drapery ornamented with the skull and crossbones, and the young man sitting up cheerfully. Here the bier is cast aside, and the widow embraces her son. ✤

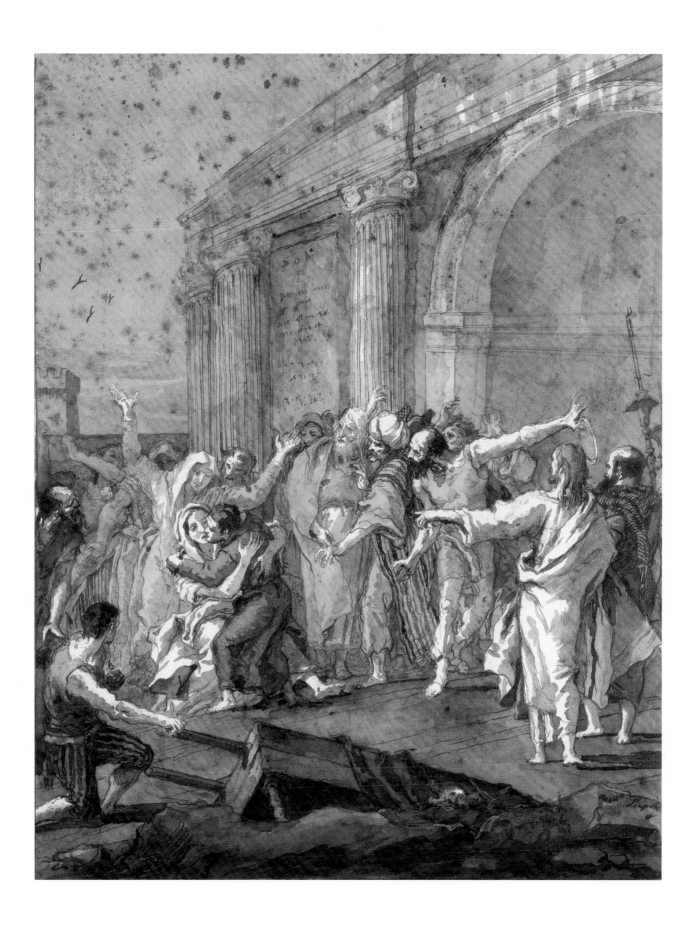

122. *The Feast in the House of Simon, I*

And one of the Pharisees desired him that he would eat with him. And he went into the Pharisee's house and sat down to meat. And, behold, a woman in the city, which was a sinner, when she knew that Jesus sat at meat in the Pharisee's house, brought an alabaster box of ointment, and stood at his feet behind him weeping, and began to wash his feet with tears, and did wipe them with the hair of her head, and kissed his feet, and anointed them with the ointment. (Luke 7:36–38)

> Pen and wash, over traces of black chalk, 450 x 345
> Signed low right: Dom.o Tiepolo f
> Provenance: Paris, Hôtel Drouot, June 10, 1988 [201]
> Literature: Conrad 1996 [143]
> Reference: Christiaan van Adrichem 1584, Site 43; Pigler 1956, i, 314–318; Réau 1957, iii, 326–328

Continuing his allusions to Jesus's upcoming death, Domenico depicts the first feast at which Jesus's feet are anointed with oil. Seated in a manner reminiscent of his earlier temptations, Jesus calmly converses with Simon the Pharisee, as a woman (traditionally identified with the Magdalene) wipes his feet. All the men stare in wonder at these odd proceedings, while a serving lad rushes to refill their plates. The hound has reappeared, perhaps anxious for scraps. This is the first of two such scenes; the second meal with Simon the Leper takes place after the Transfiguration and after Jesus resurrects Lazarus. 🌿

Luke places the story early in the New Testament narrative, in which Simon doubts Jesus for not recognizing that the woman is a sinner, and Jesus responds. The second version of this subject, given in John 12:1–4, is placed toward the very end of Jesus's ministry, six days before the final Passover (pl. 165). The location is indicated by Christiaan van Adrichem (1584: Site 43). The idea that the Feast in the House of Simon should take place in a magnificent setting, and indeed should also be associated with The Last Supper, goes back to Veronese and his *Ultima Cena . . . in ca de Simeon* for the refectory of Ss. Giovanni e Paolo, now in the Accademia (Marini 1968 [164]), altered at the behest of the inquisition into a *Feast in the House of Levi* (Luke 5:29–32); see d'Argaville 1989, who explains the significance of the Palladian setting as deriving from the description of an ancient house by the angel Palladio himself, in Giangiorgio Trissino's *Italia liberata dai Goti*. However, that composition does not include the episode of the woman anointing the feet of Jesus. ⚜

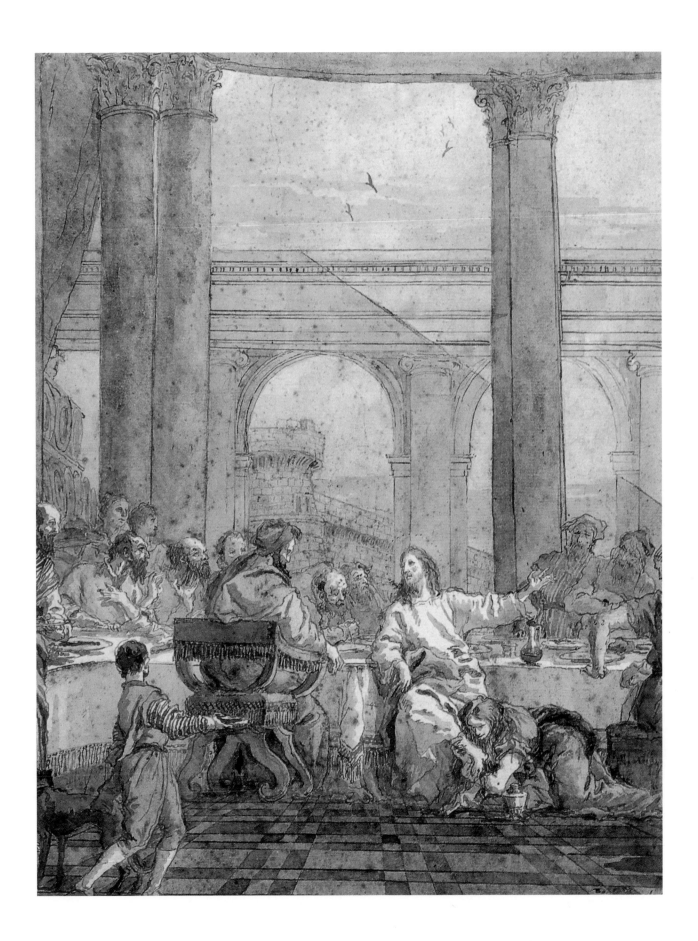

123. *Jesus Calms the Tempest, I*

And when he was entered into a ship, his disciples followed him. And, behold, there arose a great tempest in the sea, insomuch that the ship was covered with the waves: but he was asleep. And his disciples came to him, and awoke him, saying, Lord, save us: we perish. And he saith unto them, Why are ye fearful, O ye of little faith? Then he arose, and rebuked the winds and the sea; and there was a great calm. (Matt. 8:23–26)

Pen and wash, 460 x 360
Signed low left: Dom.o Tiepolo f
Provenance: Roger Cormier, Tours, his sale, Paris, Georges Petit, Apr. 30, 1921, no.41; Duc de Trévise, his sale, Paris, Hôtel Drouot, Dec. 8, 1947, no. 37
Literature: Guerlain 1921, 61; Conrad 1996 [108]
Reference: Pigler 1956, i, 275; Maria de Agreda iii, 315

Luke 8:19–22 mentions that Mary was with him and implies that she joined him on this journey across the Sea of Galilee, something Maria de Agreda asserts. With the city battlements still visible in the distance, Jesus, fully awake, commands the wind to cease as his disciples and Mary look on. An oarsman struggles to steady the boat against the choppy sea. Mark 4:37–40 notes that Jesus first rebuked the winds, then told the sea "Peace, be still." This command should be next. ❦

This scene is also related in Mark 4:38 and Luke 8:23. The pointing figure is Jesus, with Andrew seated by him. He points at the oarsman, who assumes the role of Neptune quelling the tempest at the command of Venus, in Virgil's "Quos ego," following the pose of Bernini's sculpture, recorded by Domenico in the Beauchamp Album, Christie's, June 15, 1965 [142]. It is not impossible that Gustave Doré's composition *La Sainte Bible selon la vulgate* (Doré 1866) was inspired by this drawing. It is followed by plate 124. ✢

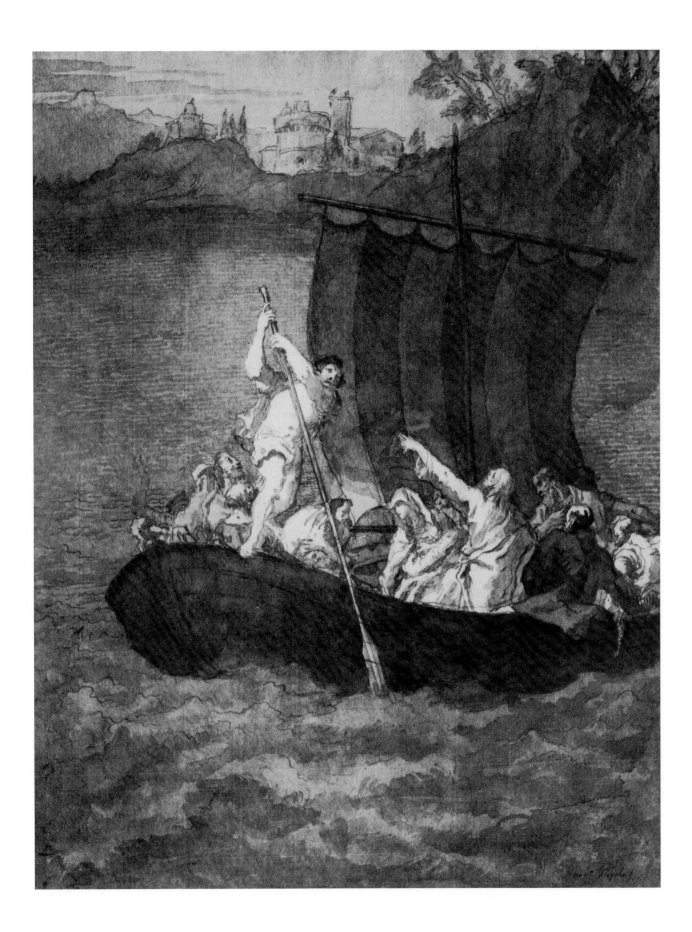

124. *Jesus Calms the Tempest, II*

And he said unto them, Why are ye fearful, O ye of little faith? Then he arose, and rebuked the winds and the sea: and there was a great calm. But the men marvelled, saying, What manner of man is this, that even the winds and the sea obey him! (Matt. 8:26–27)

Pen and wash, over black chalk, 465 x 358
Signed low left: Dom.o Tiepolo f
Provenance: Jean Fayet Durand (1806–1889)
Literature: Conrad 1996 [106]

Paris, Musée du Louvre, Département des Arts Graphiques, RF 1713bis [96]

In this sequel the Virgin is no longer evident, as Domenico concentrates on Jesus addressing his disciples. Rocking slightly, the boat floats on calming waters as Jesus questions his followers about their faith, some of whom still flail their arms in wonder at his power over nature itself. Holding his gown with one hand and making a point with the other was the pose Jesus most often adopted when delivering lessons after or during a miracle. ❦

This drawing is here identified as a sequel to *Jesus Calming the Tempest* (pl. 123). A second story of a storm on the lake is told in Matthew 14:22–33 (pls. 136, 137). ⚜

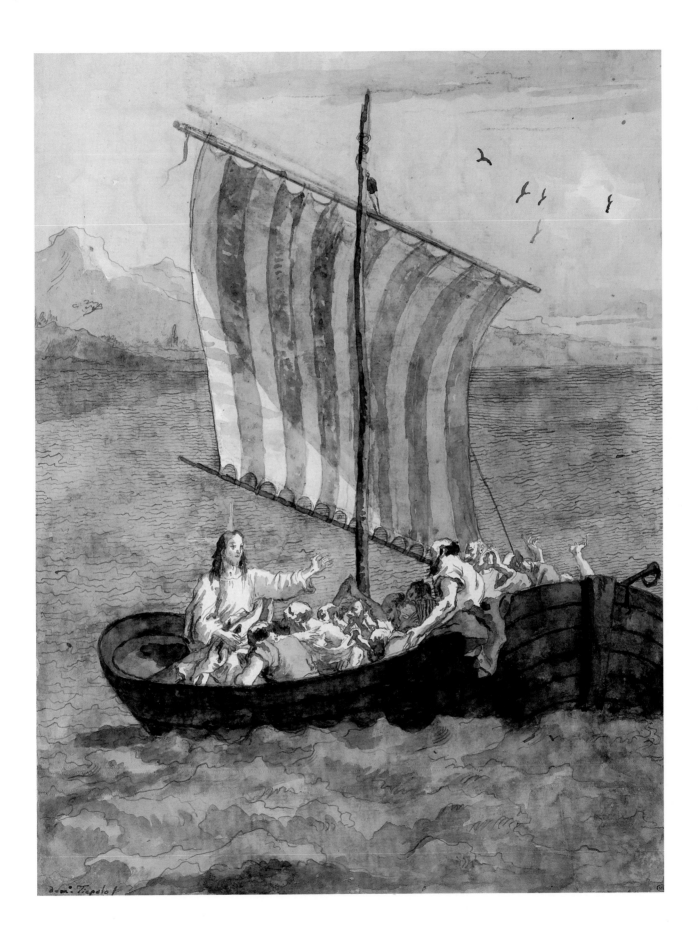

125. *The Gadarene Swine*

And when he was come to the other side of the country of the Gergesenes, there met him two possessed with devils, coming out of the tombs, exceeding fierce, so that no man might pass by that way. And, behold, they cried out saying, What have we to do with thee, Jesus, thou son of God? Art thou come hither to torment us before the time? And there was a good way off from them an herd of many swine feeding. So the devils besought him, saying, If thou cast us out, suffer us to go away into the herd of swine. And he said unto them, Go. And when they were come out, they went into the herd of swine: and, behold, the whole herd of swine ran violently down a steep place into the sea, and perished in the waters. (Matt. 8:28–32)

Pen and wash, over black chalk, 467 x 358
Signed low right: Dom.o Tiepolo f
Provenance: Jean Fayet Durand (1806–1889)
Literature: Conrad 1996 [126]
Reference: Pigler 1956, i, 307; Réau 1957, 378

Paris, Musée du Louvre, Département des Arts Graphiques, RF 1713bis [106]

Mark 5:1–20 goes into the most detail in this story. Both he and Luke 8:26–39 describe the location as Gadarene, both specify one possessed man who, night and day, haunted the mountains and tombs. Having expelled the demons (whom Mark says identified themselves "My name is Legion") from this man, Jesus watches them and explains things to Peter. Swine and demons rush down the "steep place" Mark also describes. Domenico departs from all his sources by showing devils throwing themselves into the sea together with the swine they have inhabited, perhaps feeling that portraying a herd of suicidal pigs would not have been dramatic or clear enough. Standing behind Jesus, Peter points out a particularly interesting demon. Hiding safely behind them both stands the liberated man, still shabby and wild, who happily witnesses the destruction of his tormentors. In the background those that fed the swine prepare to flee into the city. ❦

An unusual element here is that Domenico shows devils intermingled with the swine, placing the latter in the foreground. This is the last drawing in the sequence of the Louvre Album to bear a written note on the verso indicating the subject. ❧

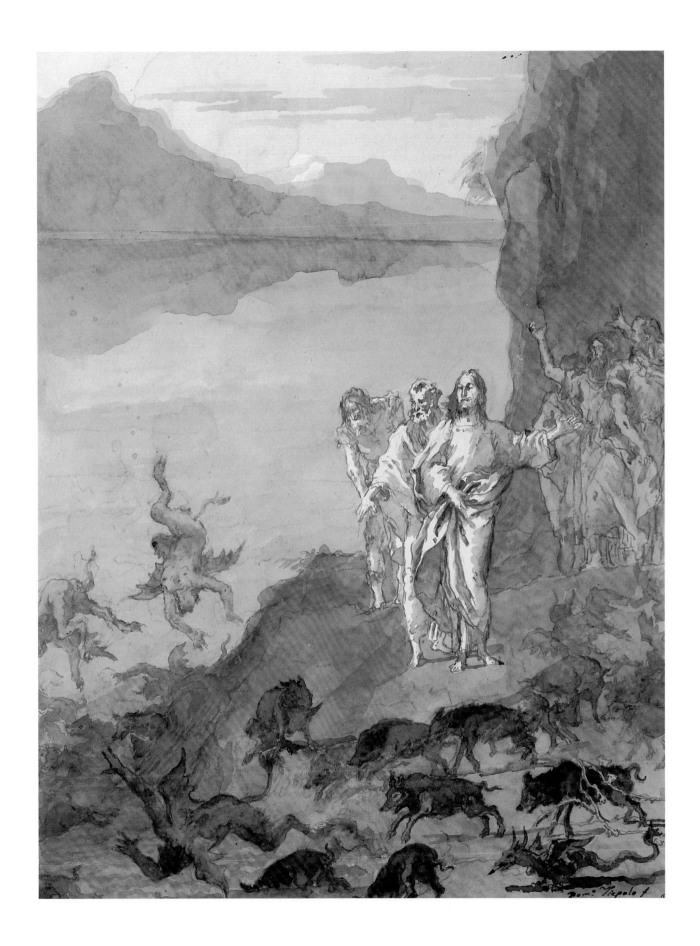

126. *Jesus Healing the Man Sick of the Palsy*

And they come unto him, bringing one sick of the palsy, which was borne of four. And when they could not come nigh unto him for the press, they uncovered the roof where he was; and when they had broken it up, they let down the bed wherein the sick of the palsy lay. When Jesus saw their faith, he said unto the sick of the palsy, Son, thy sins be forgiven thee. But there were certain of the scribes sitting there, and reasoning in their hearts, Why doth this man thus speak blasphemies? Who can forgive sins but God only? (Mark 2:3–7)

Pen and wash, over black chalk, 460 x 360
Signed low left: Dom.o Tiepolo f
Provenance: da Costa; Sotheby's, June 21, 1978 [38], bt. Nathan
Literature: Conrad 1996 [123]
Reference: Pigler 1956, i, 300; Réau 1957, 376; Underwood 1975 [31–33]

Within a brilliantly described crowded room, Jesus deals with the man who has been lowered down to him. He has just instructed the palsied man to rise and the man struggles to obey. Several stern elders at the left may be the scribes who consider Jesus's words regarding sin blasphemous, while those nearer the cripple's bed are less interested in the finer points of theology and far more amazed by the miracle. The central man raises his arms as if to shout Hallelujah! Peter, whose head is just visible in front of Christ's, registers deep concentration. ✎

Domenico creates a fine animated crowd as a complex frieze across the lower part of the design, but on this occasion the upper part also plays an effective role in the telling of the story. ❧

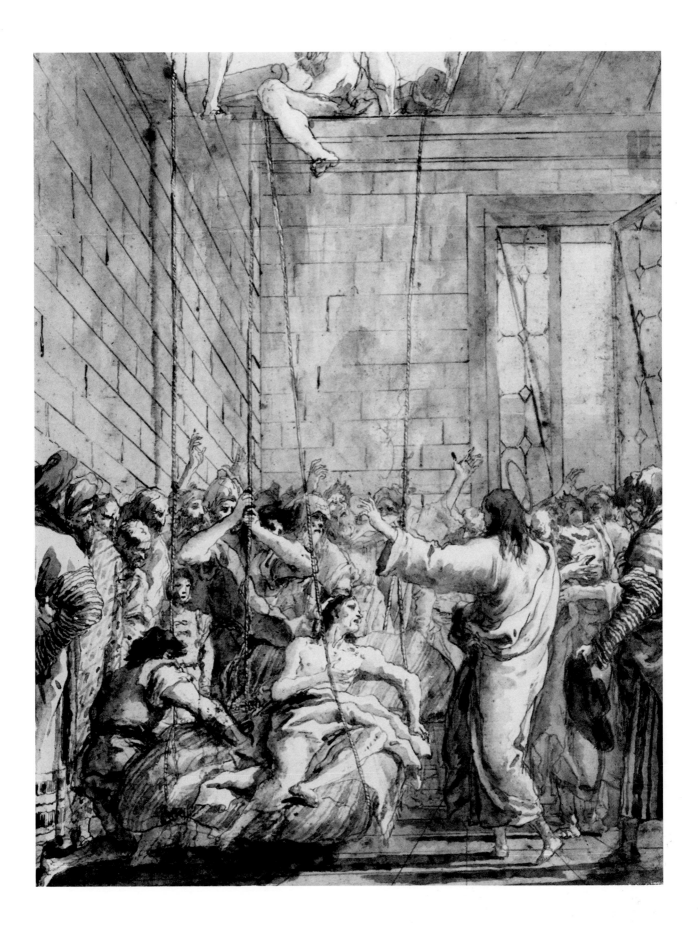

127. *The Calling of Matthew*

And as Jesus passed forth from thence, he saw a man, named Matthew, sitting at the receipt of custom: and he saith unto him, Follow me. And he arose, and followed him. (Matt. 9:9)

Pen and wash, heightened with white gouache, 470 x 365, image
Signed low right: Dom.o Tiepolo
Provenance: Paris, Hôtel Drouot, Dec. 14, 1938, lot 6, as "Jesus chez le peseur d'or"; Michel-Lévy; Mme. A.L.D.; Paris, Drouot Richelieu, Nov. 21, 2001 [60], London, Agnew's

London, The British Museum, National Art Collections Fund gift in honor of Sir Brinsley Ford, 2002

Perhaps in homage to Caravaggioi's famous characterization of this episode in "modern dress," Domenico presents Matthew as a Venetian banker. Jesus has entered to find him counting money. He looks up as Jesus declares "Follow me." Two followers, including Peter, are draped with coats against the Venetian damp and cold. These strange intruders are unnoticed by the local Venetians, who, one assumes, were used to foreigners. Matthew's dog, however, registers his objection to their presence and barks loudly. Mark 2:14 says that Matthew was Levi, the son of Alphaeus, who might be the man sitting at the left. Venice, the city that coined the word "ghetto," was home to a large Jewish community in the eighteenth century. ❧

Domenico shows the scene as the interior of what appears to be a contemporary Venetian banker's office, with a large safe against the wall, a balance, and heaps of money and a ledger on the table. Matthew is seated at the extreme left facing a group of customers across the table, all in modern dress. Jesus and his companions form a somewhat incongruous group on the right. ❧

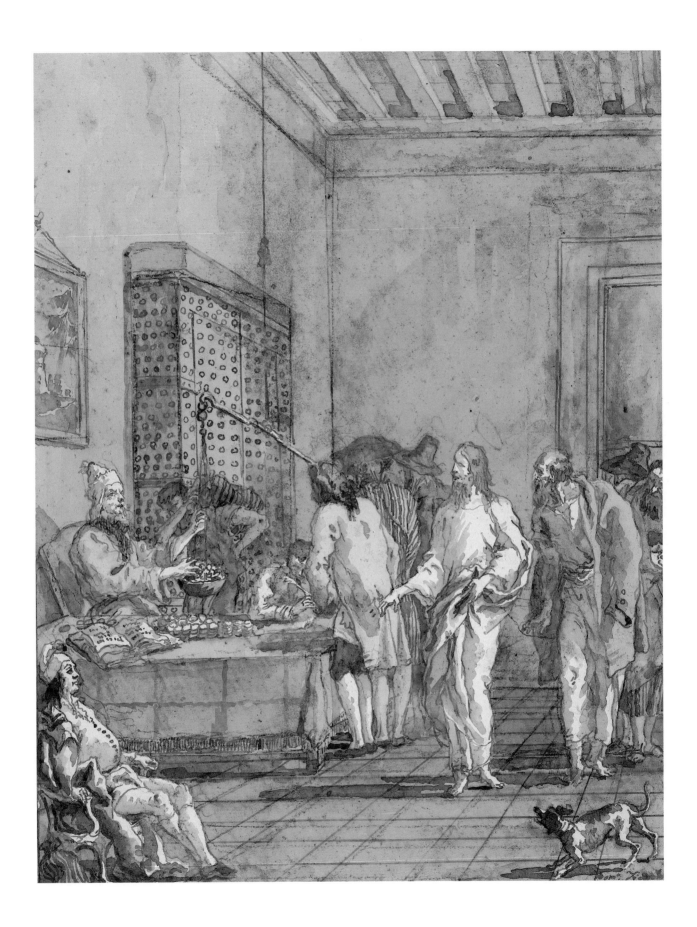

128. *Jesus Receives the Disciples of John the Baptist*

Now when John had heard in the prison the works of Christ, he sent two of his disciples, and said unto him, Art thou he that should come, or do we look for another? (Matt. 11:2–3)

When the men were come unto him, they said, John Baptist hath sent us unto thee, saying, Art thou he that should come? or look we for another? And in that same hour he cured many of their infirmities and plagues, and of evil spirits; and to many that were blind he gave sight. Then Jesus answering said unto them, Go your way, and tell John what things ye have seen and heard; how that the blind see, the lame walk, the lepers are cleansed, the deaf hear, the dead are raised, to the poor the gospel is preached. (Luke 7:20–22)

Pen and wash, over black chalk, 466 x 359
Signed low right: Dom.o Tiepolo f
Watermark: Eagle, as on a Punchinello drawing by Domenico, New York 1971 [281]; illustrated [23]
Provenance: Jean Fayet Durand (1806–1889)
Literature: Conrad 1996 [118]

Paris, Musée du Louvre, Département des Arts Graphiques, RF 1713bis [2]

In the wide open country (perhaps intended to contrast with John's confinement off stage), Jesus receives John's disciples, pointing to the supplicating lepers and those possessed of demons whom he has just cured. As little demons fly away, one victim still writhes in agony. Others, already cured, stand in thankful prayer. ❦

The story of Jesus receiving the messengers from John the Baptist is told both by Matthew 11:2–19 and Luke. The primary element in the scene seems to be Jesus's interlocution with the two rather prosperous-looking men on the right, while with his right hand he indicates the miraculously cured people on the left. ❦

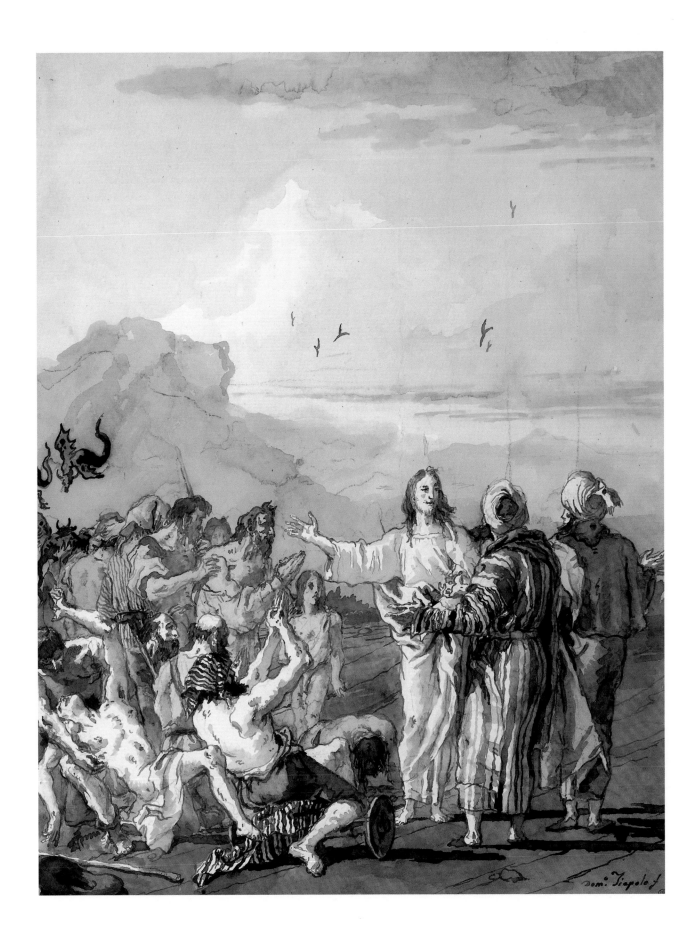

129. *Jesus Preaching on the Lake of Gennesaret*

The same day went Jesus out of the house, and sat by the sea side. And great multitudes were gathered together unto him, so that he went into a ship, and sat; and the whole multitude stood on the shore. (Matt. 13:1–2)

And it came to pass, that, as the people pressed upon him to hear the word of God, he stood by the lake of Gennesaret, and saw two ships standing by the lake: but the fishermen were gone out of them, and were washing their nets. And he entered into one of the ships, which was Simon's, and prayed him that thrust out a little from the land. And he sat down and taught the people out of the ship. (Luke 5:1–3)

> Pen and wash, over extensive black chalk, 465 x 355
> Signed low left: Dom.o Tiepolo f
> Provenance: Jean Fayet Durand (1806–1889)
> Literature: Conrad 1996 [105]
> Reference: Pigler 1956, i, 271–272

Paris, Musée du Louvre, Département des Arts Graphiques, RF 1713bis [7]

As Jesus delivers another sermon, he once again spreads his arms expansively. Peter, seated in the boat, turns to listen, his powerful body presented in one of his characteristic poses. Domenico offers a partial glimpse of the diverse multitude that has gathered to listen. An old peasant leaning on his stick listens respectfully in contrast to two youths sprawling rather casually at his feet, and a woman holds her infant on her lap. Two turbaned elders loom rather threateningly in the background. ❧

Luke 5:1–3 places this scene much earlier, associating it with *The Calling of Peter and Andrew* (pl. 111) and omitting Andrew. ⚜

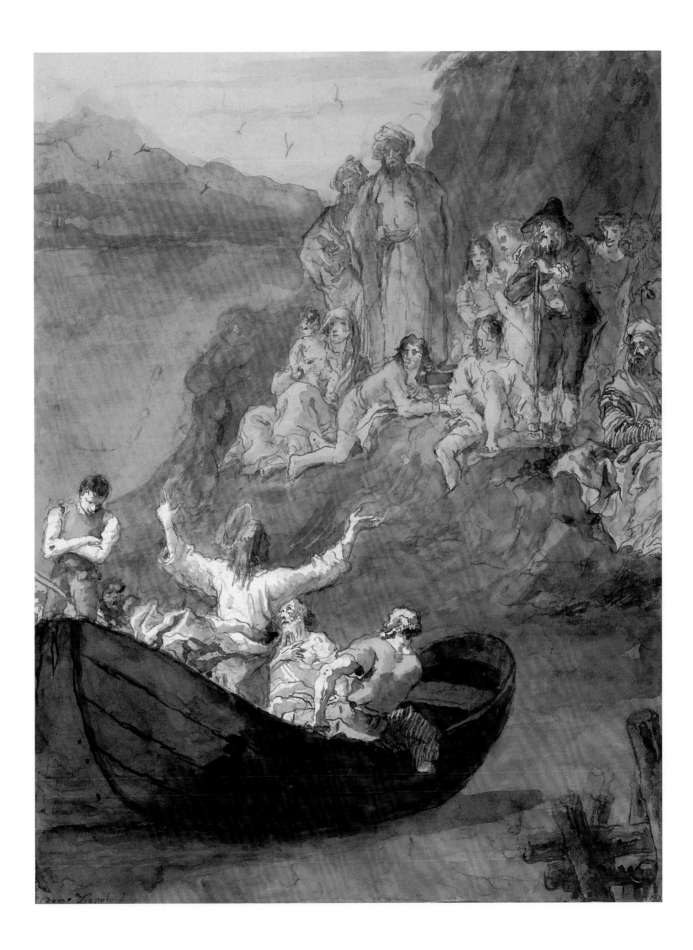

130. *Jesus Instructs Nicodemus*

There was a man of the Pharisees, named Nicodemus, a ruler of the Jews: the same came to Jesus by night, and said unto him, Rabbi, we know that thou art a teacher come from God. . . . Jesus answered and said unto him, Verily, verily, I say unto thee, Except a man be born again, he cannot see the kingdom of God. (John 3:1–3)

> Pen and wash, over black chalk, 466 x 356
> Signed low left: Dom.o Tiepolo f
> Provenance: Jean Fayet Durand (1806–1889)
> Literature: Conrad 1996 [100], suggests Luke 19:5
> Reference: Réau 1957, 312

Paris, Musée du Louvre, Département des Arts Graphiques, RF 1713bis [99]

As one disciple brings up a chair to sit down, Peter and Andrew stand respectfully, listening with rapt attention to Christ admonishing Nicodemus that he must be born again. His hands raised heavenward, Jesus delivers his fateful words regarding the kingdom of God. Nicodemus, facing him and dressed as he would be in *The Lamentation* (pl. 202), concentrates intensely on his words. ❦

There is some question about the identification of this subject. It was at first considered to be *The Calling of Matthew,* which is certainly also found in plate 127. The nineteenth-century inscription on the verso of the drawing identifies it as *Jesus in the House of Zacchaeus* (Luke 19:2–10) and this is followed by Conrad: however, Zacchaeus is characterized as "of little stature," whereas this is clearly a big man. Another possibility is that it may represent Jesus Instructing the Rich Man (Matt. 19:16–24), but it is clearly stated twice that he was a "young man." It is here suggested to represent *Jesus Instructs Nicodemus.*

 The factor that lies against Nicodemus is quite simply that it is not a night scene. Both the text and such representations as that of Virgil Solis and the *Vita Passio et Resurrectio Iesu Christi* emphasize the lamp. Also, they emphasize the point that Jesus and Nicodemus are alone, not surrounded by the twelve Apostles, as here. However, Dionysius of Fourna maintains: "Jesus is seated, behind him are the Apostles. Nicodemus sits before him and asks him" (Dionysius, New York 1963, 84, pl. 225). There is no lamp in the eastern tradition. On the other hand, the second of the prototypes cited above present them both seated as here, but with lamp and book. The prosperous costume also suggests Nicodemus, but does not rule out Matthew. ⚜

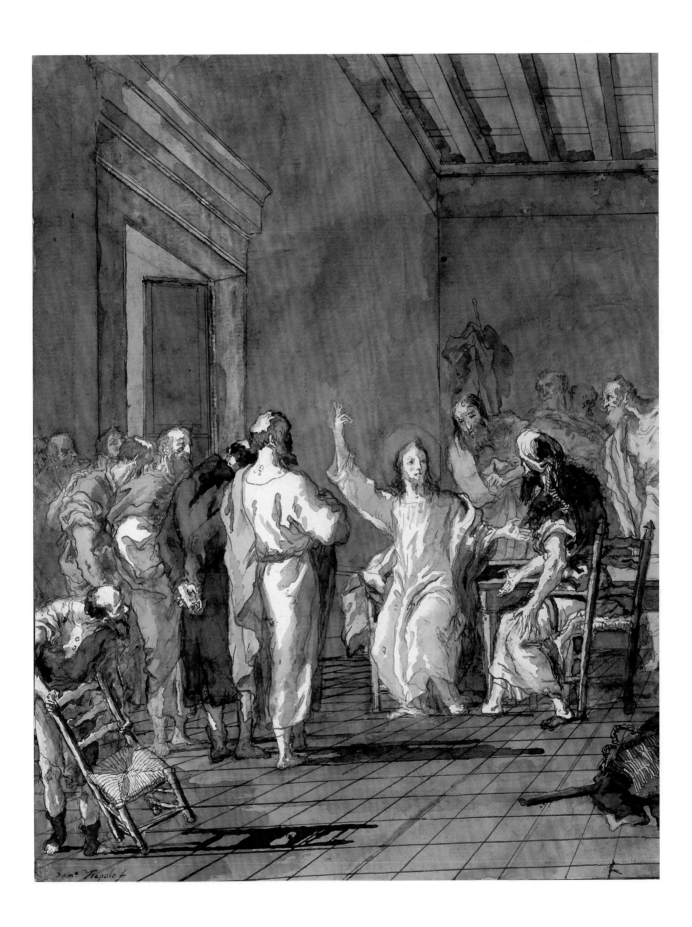

Dom.º Tiepolo f

131. *Jesus and the Woman of Samaria, I*

Now Jacob's well was there. Jesus therefore, being wearied with his journey, sat thus on the well: and it was about the sixth hour. There cometh a woman of Samaria to draw water: Jesus saith unto her, Give me to drink. (For his disciples were gone away unto the city to buy meat.) Then saith the woman of Samaria unto him, How is it that thou, being a Jew, askest drink of me, which am a woman of Samaria? For the Jews have no dealings with the Samaritans. Jesus answered and said unto her: If thou knewest the gift of God, and who it is that saith to thee, Give me to drink; thou wouldest have asked of him, and he would have given thee living water. And the woman saith unto him, Sir, thou has nothing to draw with, and the well is deep; from whence then hast thou that living water? Art thou greater than our father Jacob, which gave us the well, and drank thereof himself, and his children, and his cattle? (John 4:6–12)

Pen and wash, over black chalk, 465 x 364
Signed low left: Dom.o Tiepolo f
Provenance: Jean Fayet Durand (1806–1889)
Literature: Conrad 1996 [95]
Reference: Réau 1957, iii, 322–324

Paris, Musée du Louvre, Département des Arts Graphiques, RF 1713bis [91]

This famous episode of Jesus breaking down a number of traditional barriers (between Jews and Samaritans, whose estrangement extended to their refusal to share utensils and vessels, as well as between the righteous and sinners) unfolds over two scenes. Here Domenico disregards the text that says the disciples went away and ignores the more common tradition (showing the disciples at a distance); instead, he portrays Peter and another disciple watching as Jesus converses with the woman of Samaria at the well. She has brought a particularly ornate pitcher to retrieve her water. Just over Christ's head a lion's head (symbol of Venice and of the Resurrection) spouts water into the well, while the sheep allude to the flock of believers that Peter will later care for. ❧

Domenico tells this popular story in two drawings (pls. 131, 132) and here it is set in an open landscape: the wellhead is a handsome Venetian *vera di pozzo,* with a carved relief. It is found only in John, where it precedes *The Pool of Bethesda.* ⚜

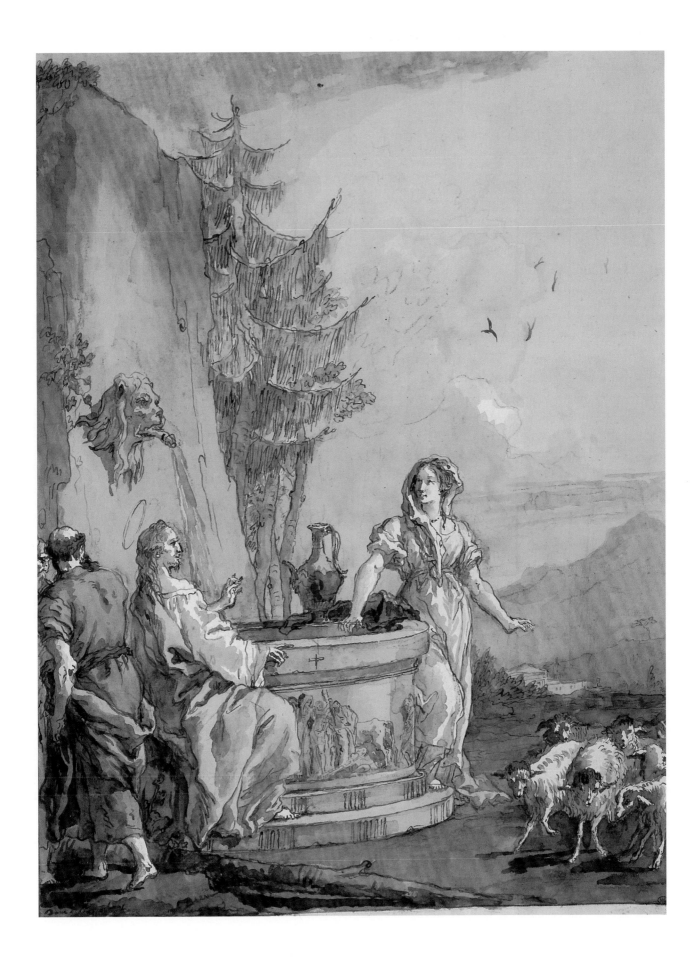

132. *Jesus and the Woman of Samaria, II*

Come, see a man, which told me all things that I ever did: is not this the Christ? (John 4:29)

Pen and wash, over black chalk, 459 x 347
Signed low left: Dom.o Tiepolo f
Provenance: Jean Fayet Durand (1806–1889)
Literature: Conrad 1996 [96]

Paris, Musée du Louvre, Département des Arts Graphiques, RF 1713bis [90]

Peter remains at (or has returned to) the same spot as Christ leans forward to speak with the Samarians the woman has brought. They are led by a bearded peasant, who already speaks to Jesus. The others approach cautiously, staring in wonder. Domenico has now rotated the setting so that Samaria's wall (portrayed in his customary fashion) becomes visible. ❦

This, the second of the two scenes plates 131–132, which follow the story as told in John, offers an interesting example of Domenico following the text very closely. While the left side of the composition, with the Venetian well-head, is similar to plate 131, the rest is no longer open countryside. The reference to the city seems to have prompted the insertion of the city wall. ⚜

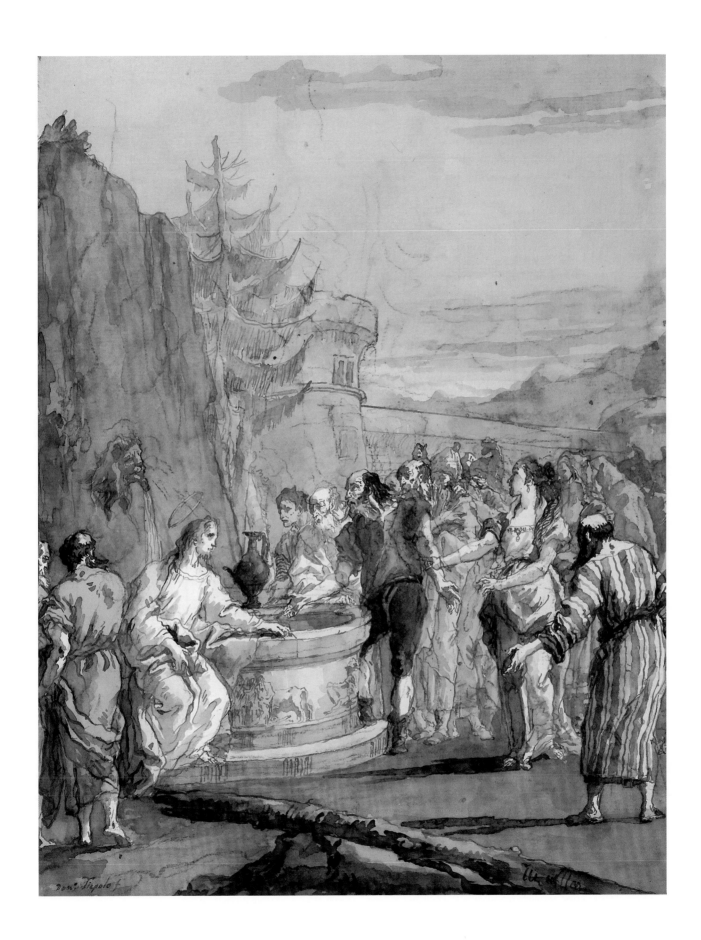

133. *The Pool of Bethesda*

Now there is at Jerusalem by the sheep market a pool, which is called in the Hebrew tongue Bethesda, having five porches. In these lay a great multitude of impotent folk, of blind, halt, withered, wating for the moving of the water. For an angel went down at a certain season into the pool and troubled the water: whosoever then first after the troubling of the water stepped in was made whole of whatsoever disease he had. And a certain man was there, which had an infirmity thirty and eight years. When Jesus saw him lie, and knew that he had been now a long time in that case, he saith unto him, Wilt thou be made whole? The impotent man answered him, Sir, I have no man, when the water is troubled, to put me in the pool: but while I am coming, another steppeth down before me. Jesus saith unto him, Rise, take up thy bed and walk. (John 5:2–8)

Pen and wash, over black chalk, 468 x 363
Signed on the column on the left: Dom / Tiepolo
Provenance: Jean Fayet Durand (1806–1889)
Literature: Conrad 1996 [122]
Reference: Christiaan van Adrichem 1584, Site 61; Pigler 1956, i, 301–304; Réau 1957, 377

Paris, Musée du Louvre, Département des Arts Graphiques, RF 1713bis [110]

Faithful to John's reference to the "five porches," Domenico stages this miracle in a setting rich with colonnades. He departs from his source, however, in his unusual choice of timing. Here, having cured the cripple, Jesus gestures to him while addressing a multitude of kneeling supplicants. Clearly worshipping Jesus as a result of the miracle, these supplicants are not mentioned in John; later sources, notably the *Meditations on the Life of Christ,* imply this reaction. Interestingly, the *Meditations* (Ragusa 1961, 161) discusses the cure of Peter's mother-in-law immediately afterwards, and Domenico places Peter in the scene, showing him observing intently from the far left. ✺

The story, a popular one in all ages, is found only in John, where it follows *Jesus and the Woman of Samaria* (pls. 131–132) and precedes *Jesus Feeding the Multitude* (pl. 135). The Pool of Bethesda, called *La Piscina Probatica* in Italian, is described at length by Christiaan van Adrichem (1584: Site 61). ✣

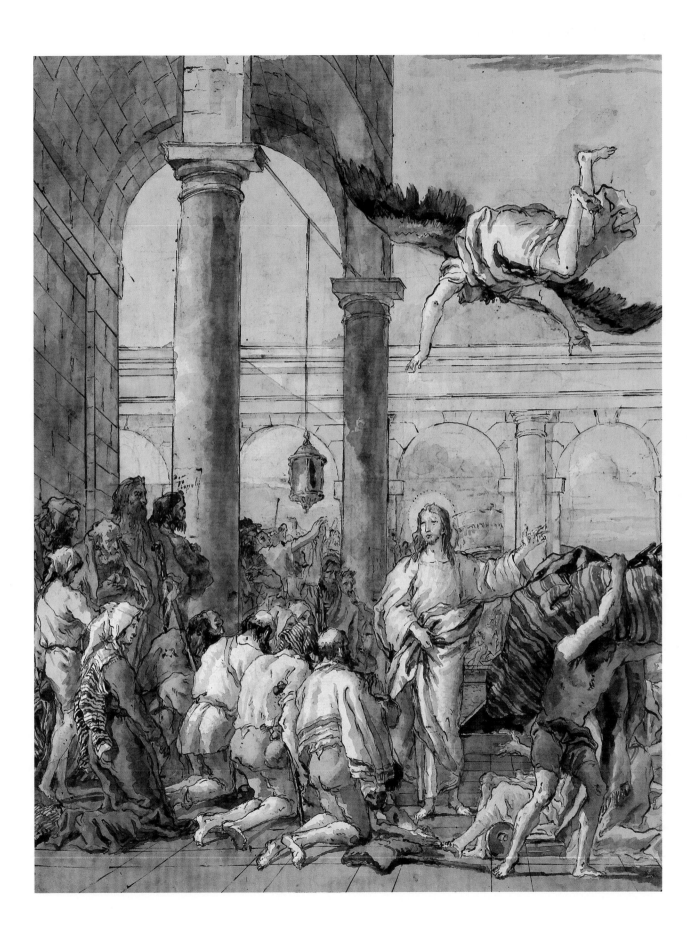

134. *Jesus Blessing the Loaves and Fishes*

And he commanded the multitude to sit down on the grass, and took the five loaves, and the two fishes, and looking up to heaven, he blessed, and brake, and gave loaves to the disciples, and the disciples to the multitude. (Matt. 14:19)

Pen and wash, over black chalk, 464 x 358
Signed low left: Dom.o Tiepolo f
Provenance: Jean Fayet Durand (1806–1889)
Literature: Conrad 1996 [114]
Reference: Pigler 1956, i, 278–283; Réau 1957, 366–367

Paris, Musée du Louvre, Département des Arts Graphiques, RF 1713bis [3]

The only miracle mentioned in all four Gospels involves the five thousand who were fed on the loaves and fishes. Seated at the crown of a hill, Jesus is absorbed in the act of blessing the proliferating baskets of food. In the foreground, Peter, holding bread in both hands, looks up at him in amazement. Addressing several naked supplicants near him whom Jesus had recently cured, Andrew points to Jesus as the source of their miraculous meal. The cloaked seated figure in the foreground and the young boy were last seen listening to John the Baptist (pl. 91). Peter's prominence underscores his increasingly dominant role. The scene echoes Luke's words (9:17–20) that after this miracle Jesus was called John the Baptist by some, but "The Christ of God" by Peter. ❦

The story of Jesus feeding the five thousand is often presented in two phases: *Jesus Blessing the Loaves and Fishes* on the left, and *The Feeding of the Multitude* on the right. Domenico follows a similar pattern: here, although there are baskets, the essential theme seems to be *Jesus Blessing the Loaves and Fishes*. The following scene is shown in the drawing in the Ashmolean Museum (pl. 135). ❦

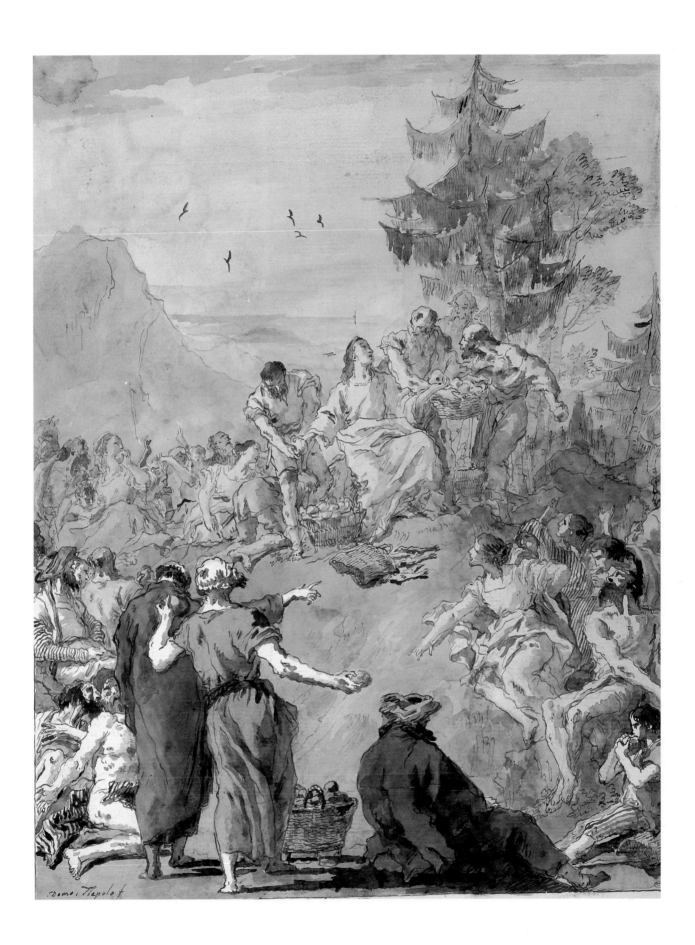

Domo Tiepolo f

135. *Jesus Feeding the Multitude*

And they did all eat, and were filled: and they took up of the fragments that remained twelve baskets full. And they that had eaten were about five thousand men, beside women and children. (Matt. 14:20–21)

One of the disciples, Andrew, Simon Peter's brother, saith unto him, there is a lad here, which hath five barley loaves and two small fishes: but what are they among so many? (John 6:8–9)

> Pen and wash, over traces of black chalk, 486 x 382
> Signed low right: Tiepolo
> Provenance: Brownlow sale, Sotheby's, June 29, 1926 [10]; Sir Karl Parker 1945
> Exhibition: London, Matthiesen 1939 [136]; Venice 1958 [103]
> Literature: Parker 1956, no. 1088 [ccxxxv]; Conrad 1996 [115]
> Reference: Pigler 1956, i, 278–283

Oxford, The Ashmolean Museum, 1086. Presented by Sir Karl T. Parker, 1945

Often interested in small distinctions made by different texts, Domenico here shows Jesus speaking with the lad who presented him with "five barley loaves, and two small fishes" (John 6:9). His disciples go about distributing the miraculously expanded supply of food. Two patriarchs pointing to Jesus in the foreground may refer to those who "would come and take him by force to make him a king" (John 6:15). ❦

The presence of a boy by the side of Jesus may be a reference to the text of John, but the two Apostles in the middle ground are already distributing food. ❦

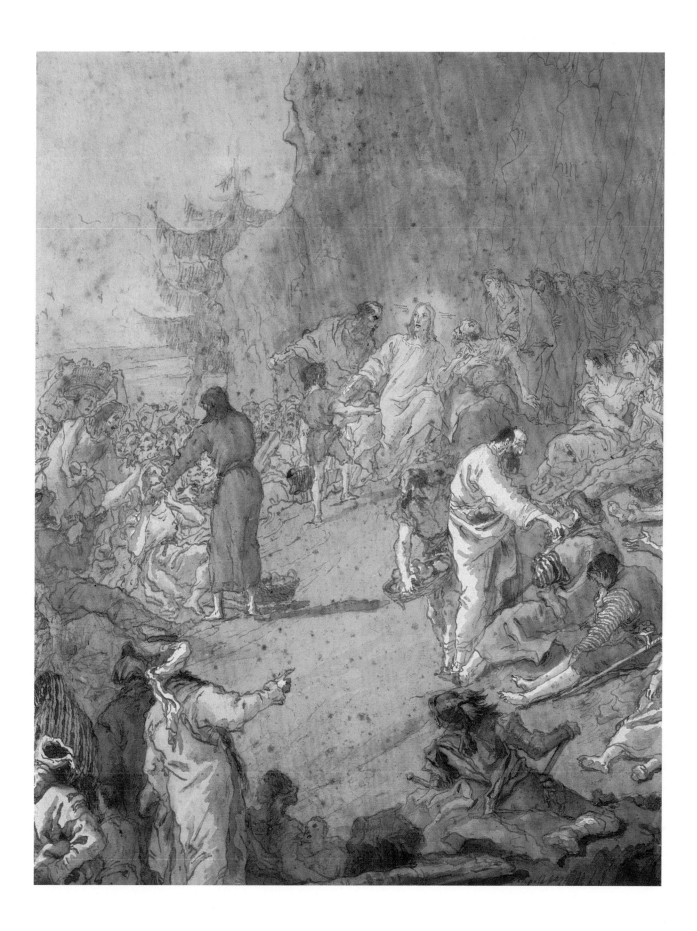

136. *Jesus and Peter Walking on the Waters*

And he said, Come. And when Peter was come down out of the ship, he walked on the water, to go to Jesus. But when he saw the wind boisterous, he was afraid; and beginning to sink, he cried, Lord, save me. And immediately Jesus stretched forth his hand, and caught him, and said unto him, O thou of little faith, wherefore didst thou doubt? (Matt. 14:29–31)

Pen and wash, over black chalk, 466 x 361
Signed low left: Dom.o Tiepolo f
Provenance: Jean Fayet Durand (1806–1889)
Literature: Bacou 1968 [100]; Conrad 1996 [116]
Reference: Pigler 1956, i, 284; Réau 1957, 573

Paris, Musée du Louvre, Département des Arts Graphiques, RF 1713bis [75]

In one of Domenico's most spectacular drawings, Jesus, in a pose that echoes his attitude in Peter's calling, as well as his later resurrection of the Widow of Nain's son, reaches out to save Peter from drowning. As Jesus (the only vertical element in the scene) stands confidently on the water's surface, Peter sinks in. Jesus extends both hands to Peter, unlike the text in Matthew that specifies one hand. Two amazed disciples look on from the boat's edge, while the others are obscured by the billowing sail. Mark (6:48–51) describes Jesus only walking on the water. ✵

The Gospels relate two storms at sea. One, which features Jesus sleeping through the tempest, is related in Matthew 8:24 and repeated in Mark 4:36 and Luke 8:23. This is the subject of plates 123–124. The other, which features Jesus walking upon the waters, is given in Matthew 14:22–33, Mark 6:46–51, and John 6:15–21, but only Matthew tells the story involving Peter. This story is very popular in the West. ⚜

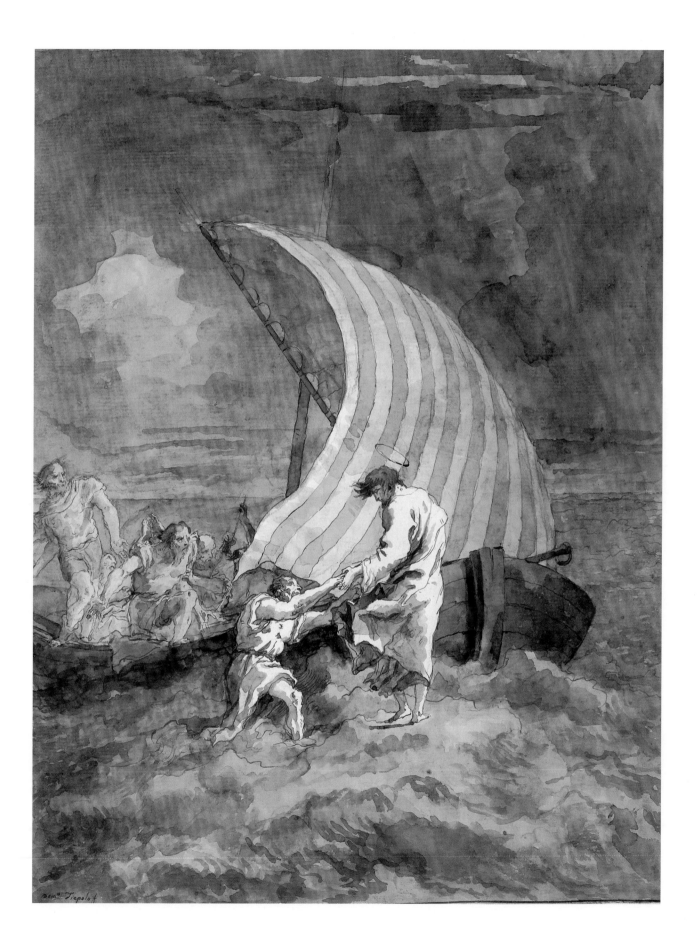

137. *Jesus on the Sea of Galilee*

And when they were come into the ship, the wind ceased. Then they that were in the ship came and worshipped him, saying, Of a truth thou art the son of God. (Matt. 14:32–33)

Pen and wash, with touches of gouache, gray wash on sail, over traces of black chalk, 460 x 361
Signed low right: Dom.o Tiepolo f
Provenance: Jean Fayet Durand (1806–1889)
Literature: Conrad 1996 [107]

Paris, Musée du Louvre, Département des Arts Graphiques, RF 1713bis [97]

Here Andrew stands at the edge of the ship, praising Christ as the Son of God, while the proximity of the boat to the shore may also reflect John's account (6:21), which states that once Christ was back in the boat "the ship was at the land whither they went."

The Gospels relate two storms at sea. One, which features Jesus sleeping through the tempest, is related in Matthew 8:24 and repeated in Mark 4:36 and Luke 8:23. This is the subject of plates 123–124. The other, which features Jesus walking on the waters, is given in Matthew 14:22–33, Mark 6:46–51, and John 6:15–21, but only Matthew tells the story involving Peter. Since Peter is here shown in vigorous communication with Jesus, it is suggested that this drawing is a sequel to plate 136. Again, compared with the subject *Jesus and Peter Walking upon the Waters,* which is so popular, this one is extremely rare.

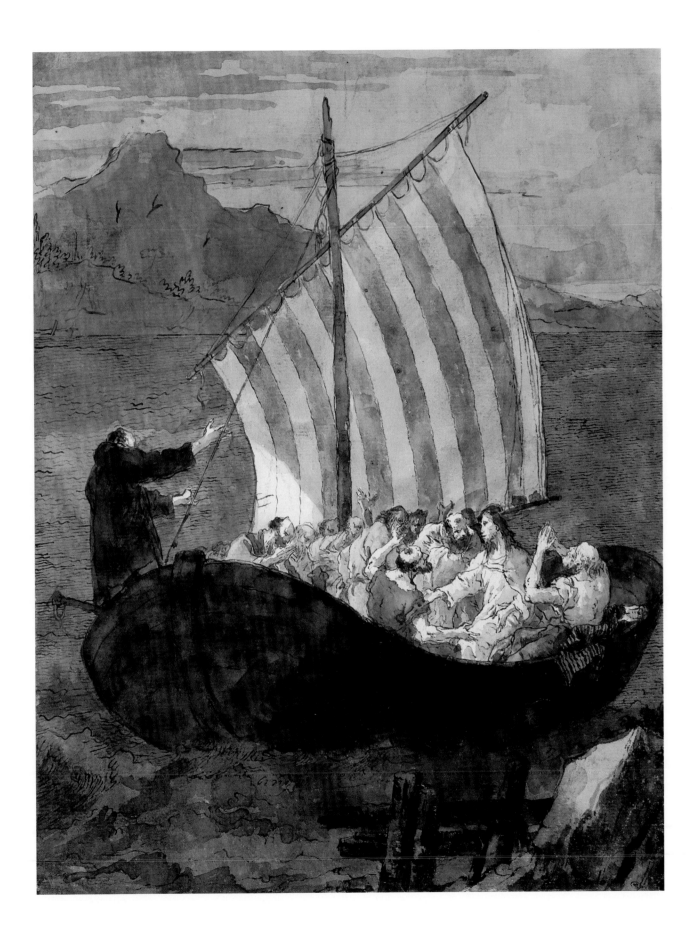

138. *Jesus and the Woman of Canaan*

And, behold, a woman of Canaan came out of the same coasts, and cried unto him, saying, Have mercy on me, O Lord, thou son of David; my daughter is grievously vexed with a devil. . . . Then Jesus answered and said unto her, O woman, great is thy faith: be it unto thee even as thou wilt. (Matt. 15:22–28)

Pen and wash, over black chalk, 463 x 358
Signed low left: Dom.o Tiepolo f
Provenance: Jean Fayet Durand (1806–1889)
Literature: Conrad 1996 [121]
Reference: Pigler 1956, i, 304–306; Réau 1957, 382

Paris, Musée du Louvre, Département des Arts Graphiques, RF 1713bis [94]

Arranging the confrontation between Jesus and the Canaanite Woman much as he had portrayed the earlier meeting with the Centurion, Domenico thus visualizes their thematic connection, namely, the power of faith demonstrated by an outsider and rewarded by Christ. The setting, a barren room, acknowledges Mark 7:24, which specifies that Jesus sought to hide in a room but was found by the woman. The open doorway suggests the outside world, notably the place where her daughter was being healed at that moment. ❦

The scene is described by both Matthew and Mark. Jesus stands in the center, with Peter to the left. Andrew is prominent in the left foregound. ❧

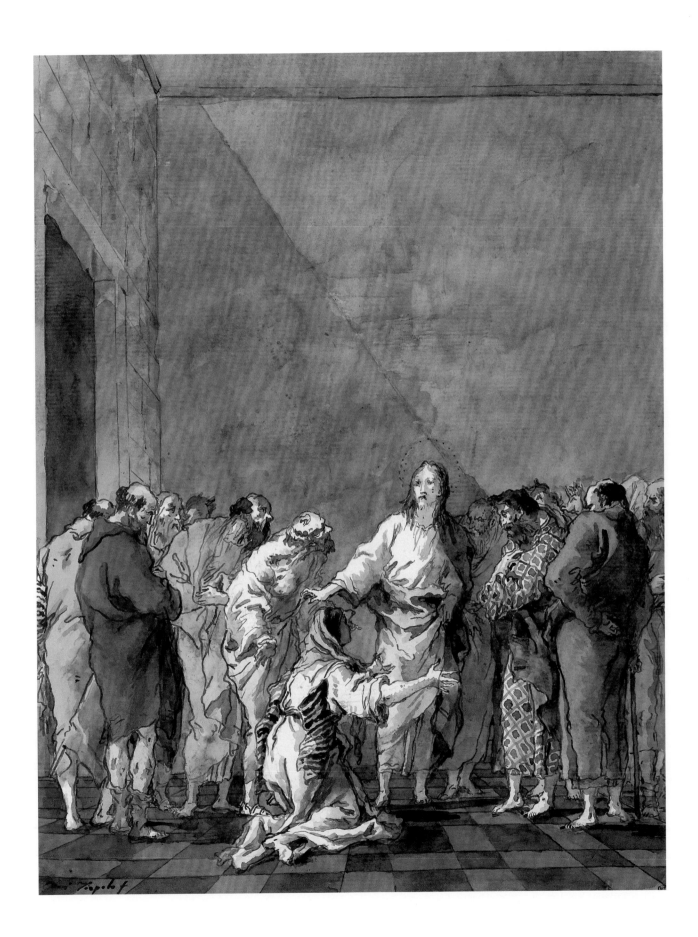

The Ministry of Jesus Continued: The Transfiguration, Plates 139–142

A major turning point in Christ's story, the Transfiguration, revealed Christ's divine nature to Peter, James, and John on a mountain that tradition (not the Gospels) identifies as Mount Tabor. Described by Matthew, Mark, and Luke, the Transfiguration is implied in the mystical chapter of John (6). Luke 9:28 specifies that Jesus went up the mountain to pray, and as he prayed the fashion of his countenance altered—he became white and dazzling. Moses and Elijah appeared at his side and spoke with him, and a cloud flowed in and a voice said, "This is my beloved Son, in whom I am well pleased; hear ye him," whereupon the disciples fell on their faces. Matthew and Mark note that Peter spoke to Jesus as he was transfigured, offering to make three tabernacles. After the Transfiguration, they descended down the mountain and Jesus warned his disciples not to mention what they saw to anyone.

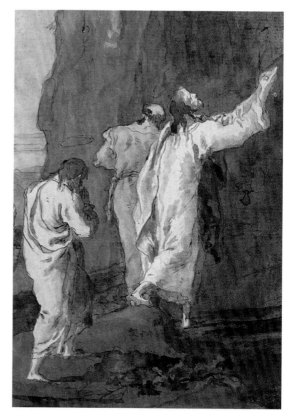

James, Peter, and Jesus ascend the mountain in prayer, detail of plate 139, *Jesus Ascends the High Mountain with Peter, James, and John*

Generally the subject of a single iconic image from the Renaissance on, The Transfiguration unfolds over four detailed scenes in Domenico's narrative, beginning with Jesus's prayerful ascent up the mountain, two visions of the Transfiguration itself, and a final scene as Jesus warns his followers after their descent.

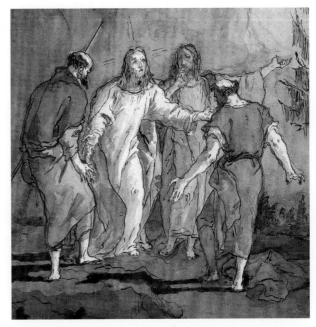

John holding his hand to his lips, signaling his silence, detail of plate 142, *Jesus Descends from the Mountain with Peter, James, and John*

139. *Jesus Ascends the High Mountain with Peter, James, and John*

And after six days Jesus taketh Peter, and James, and John his brother, and bringeth them up into a high mountain apart, and was transfigured before them: and his face did shine as the sun, and his raiment was white as the light. (Matt. 17:1–2)

Pen and wash, over traces of black chalk, Indian ink wash in the figures and in the trees on the left, 459 x 363, image; 479 x 386, paper; trimmed to an outer line

Not signed

Provenance: Roger Cormier, Tours, his sale, Paris, Georges Petit, Apr. 30, 1921, no. 5; Paris, Hôtel Drouot, June 24, 1985 [12]; Paris, Prouté 1987 [34], purchased with funds from the Armand Hammer Foundation

Exhibition: Paris, Prouté, 1987 [34]; Washington 1989, supplement to the 1987 exhibition, as *Jesus Climbing Mount Tabor with Peter, James and John*

Literature: Guerlain 1921, 73; Conrad 1996 [147]

Washington, D.C., National Gallery of Art, The Armand Hammer Collection, 1987.48.2

Assuming the prayerful attitude of his grandmother Anna, Jesus leads Peter, James, and John up Mount Tabor. Stressing Luke's account (9:28–36), which specifies that he went to pray and in so doing his countenance was altered, Domenico visually separates Jesus from the others. Peter is, as usual, closest to him, and looks the other way. Jesus, seen in profile, stares heavenward.

In the Middle Ages the story of The Transfiguration is sometimes represented in three parts: the ascent of the mountain; the Transfiguration, and the descent from the mountain. It appears that Domenico here follows this tradition. ❧

140.** *"Questo e il mio figlio delitto, ascoltatelo"—The Transfiguration, II*

While yet he spake, behold, a bright cloud overshadowed them: and behold a voice out of the cloud, which said, This is my beloved son, in whom I am well pleased; hear ye him. (Matt. 17:5)

Pen and wash, 460 x 360

Signed low left

Provenance: Roger Cormier, Tours, his sale, Paris, Georges Petit, Apr. 30, 1921, no. 34; duc de Trévise 1947, no. 33

No image.

The same subject is represented in plate 141. The fact that the title is given in Italian suggests an inscription. ❧

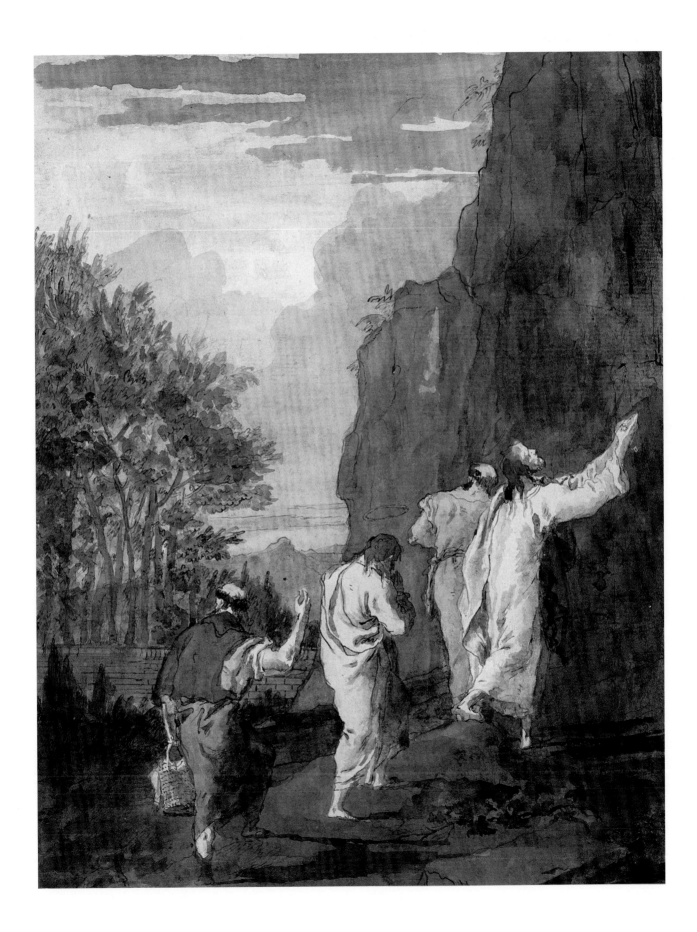

141. *The Transfiguration*

And, behold, there appeared unto them Moses and Elias talking with him. Then answered Peter, and said unto Jesus, Lord, it is good for us to be here: if thou wilt, let us make here three tabernacles; one for thee, and one for Moses, and one for Elias. While he yet spake, behold, a bright cloud overshadowed them; and behold a voice came out of the cloud, which said, This is my beloved Son, in whom I am well pleased; hear ye him. (Matt. 17:3–5)

> Pen and wash, over black chalk, 465 x 360
> Not signed
> Provenance: Jean Fayet Durand (1806–1889)
> Literature: Conrad 1996 [117]
> Reference: Pigler 1956, i, 290–295; Réau 1957, 574–580

Paris, Musée du Louvre, Département des Arts Graphiques, RF 1713bis [78]

Accompanied by angels (an unusual element), Jesus transfigured reminds us of his earlier triumph over Satan. Blending several moments, Domenico portrays two of the disciples falling on their faces as described by Matthew, while Jesus, resplendent in the sky, reveals his divine nature. Peter gazes up at him in rapture, oblivious to the shoe that has fallen off his left foot. Peter's prominence is traditional here, but not in the earlier episode involving the multiplication of loaves and fishes (pl. 135), where Peter's pose is similar. ✠

In the Middle Ages the story of The Transfiguration is sometimes represented in three parts: The ascent of the mountain, the Transfiguration, and the descent from the mountain—such as in the *Meditationes vitae Christi* (Ragusa and Green 1961 [185–187]). Domenico follows this tradition, showing all three scenes in plates 139–142, though we lack the image for the second version of *The Transfiguration,* which is recorded in the Cormier sale. ✠

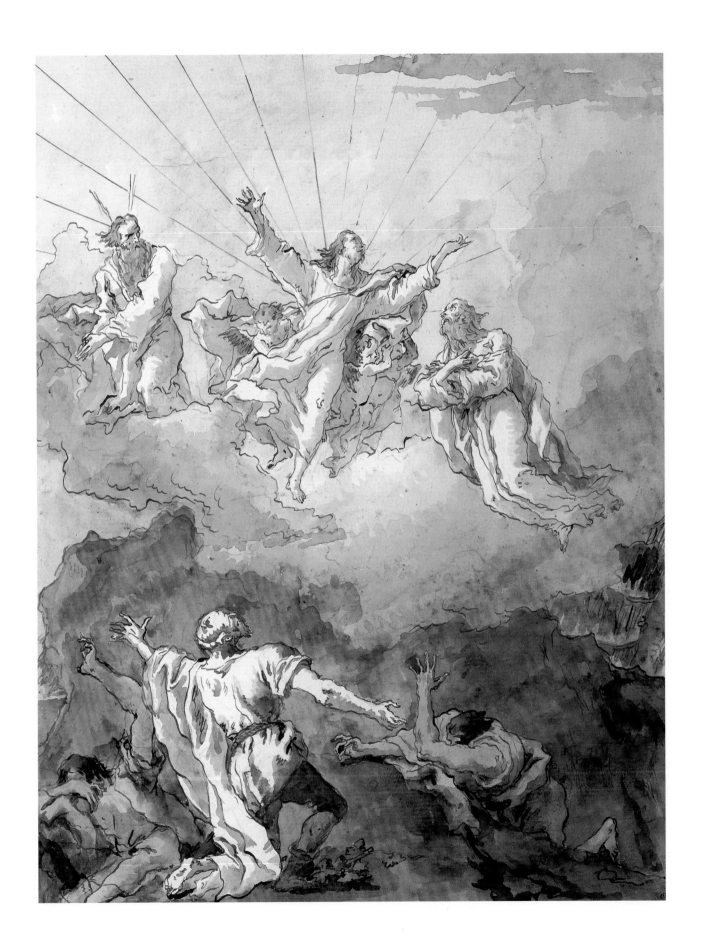

142. *Jesus Descends from the Mountain with Peter, James, and John*

And as they came down from the mountain, Jesus charged them, saying, Tell the vision to no man, until the Son of man be risen from the dead. (Matt. 17:9)

Pen and wash, over extensive black chalk, 452 x 347
Not signed
Provenance: Roger Cormier, Tours, his sale, Paris, Georges Petit, Apr. 30, 1921, no.59; Germain Seligman; Charles E. Slatkin Galleries, 1968; Christie's, Dec. 11, 1990 [50]; Christie's, Apr. 19, 1994 [114]
Exhibition: New York, Seligman 1962 [35]; New York, Seligman 1970 [28]; New York Schab 1987 [23]
Literature: Conrad 1996 [148]

Paris, Paul Prouté, 2002

An abashed Peter accepts Jesus's admonition to tell no one, which counters Peter's earlier suggestion that they build an altar to venerate him. Still shocked by what they experienced, James bows his head, while John holds his hand to his lips, signaling his willing silence on what they just witnessed. Domenico's final essay on The Transfiguration is most unusual and anticipates Peter's later difficulties in the Garden of Gethsemane. ❦

This drawing is here identified as the third part of the triptych illustrating the story of The Transfiguration. The first part is shown in plate 139 and the costume of the three disciples there is clearly the same as is shown here. The second central scene is shown in plate 141, with citations of the use of the central theme; it also appears to have been represented in a second version, plate 140, for which an image is still lacking. The white garment of Jesus suggests The Transfiguration (Luke 9:29): "And as he prayed, the fashion of his countenance was altered, and his raiment was white and glistering." ❧

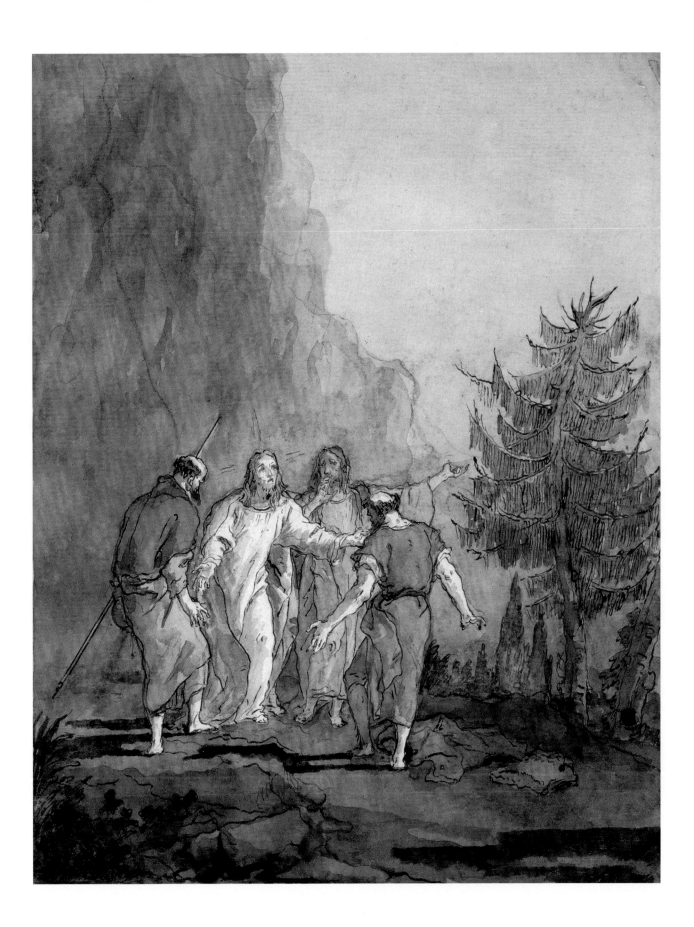

Part VII

The Ministry of Jesus Continued: Post-Transfiguration to His Entry into Jerusalem, Plates 143–168

A careful reading of the Gospels indicates that Christ's ministry underwent a change after his Transfiguration. There were fewer miracles. Matthew begins with Christ's cure of the lunatic son (which involves an issue of faith, 17:14–17), also mentioned by Mark and Luke, and all four Gospels note that Jesus cured the blind. Spending less time performing miracles, Jesus concentrated more on lessons involving faith, civic obedience, compassion, mercy, forgiveness, loving God, and the Kingdom of Heaven. Although he addressed his lessons to many, including Pharisees, publicans, and sinners, much of his attention was focused on his disciples, whom he prepared for what was to come. Peter was often the center of attention, including the miracle of the tribute money, which Jesus directed him to find in the fish (Matt. 17:26–27). Jesus also directed the parable of the Laborer in the Vineyard to him (Matt. 20:1–16). All his disciples received instructions to "Be as children" (Matt. 18:1–6). Children were, in fact, a leitmotif in this part of Jesus' story. Over his disciples' objections, Jesus blessed the children (Matt. 19:15). Luke notes that Jesus taught his disciples how to pray the Lord's Prayer (11:2), and describes many of his most famous parables, including the Good Samaritan (10:30–37), the Prodigal Son (15:12–32), and the Rich Man and Lazarus (16). John placed the strongest accent on the growing tension between Jesus and the Temple elders, which colors such events as Jesus and the Adulteress, which only he relates (8:2–11).

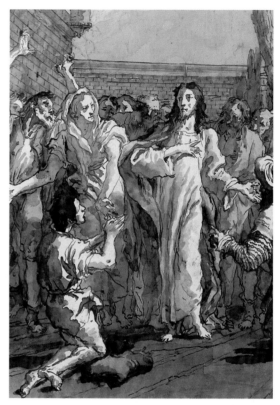

Closeup of Jesus and Mother of Zebedee's children, with one of her sons, detail of plate 158, *Jesus and the Mother of Zebedee's Children*

The Gospels vary as to the final events leading up to Jesus's entry into Jerusalem. Matthew mentions Jesus being confronted by the Mother of Zebedee's children, during which he declares he cannot judge who will sit to his right and left in the Kingdom of Heaven. He then cures two blind men (20:20–34). Mark places Jesus in the house of Simon the Leper where a woman anoints his feet (14:3–9). Luke is the sole source of Jesus's encounter with the publican, Zaccheus, who had climbed a tree to see him (Luke 19:2–7). John alone describes Jesus's most celebrated miracle, his resurrection of Lazarus and his meal in Bethany with Mary and Martha and John thereafter (11:1–45; 12:1–6). This is Christ's final miracle before his Passion begins. Matthew also describes a meal in Bethany but states that it took place in the house of Simon the Leper *after* Jesus had entered Jerusalem (26:1–13). All three accounts note the jar of costly ointment with which a woman (Mary, according to John) anoints Jesus's feet using her hair. John places Judas at the scene, hypocritically protesting its waste when it could have been sold to serve the poor. This story and many others provide portents of Christ's upcoming Passion.

Although many of these events had rich pictorial traditions, they were not necessarily standard parts of picture cycles. No text has been found that stresses the changes in Jesus's ministry after his Transfiguration. Perhaps because he had the freedom to explore Jesus' story in such scope and detail, Domenico was able to

consider these developments, or perhaps he simply intuited them from reading the texts. Certainly his distinctive interpretation shows his sensitivity to such issues. He elects Luke's version of the Lord's Prayer, which concentrates on the disciples alone. He makes a powerful drawing of the Tribute Money (pl. 145) starring Peter alone, and illustrates the Parable of the Master in the Vineyard, which Jesus directed toward Peter. He also placed an accent on children by including numerous scenes of lessons featuring them. Stressing Jesus's role as teacher, he chose to illustrate only those parables that Jesus delivered after the Transfiguration, including the Good Samaritan, the Prodigal Son (which has three scenes), the Rich Man and Lazarus, and the Master in the Vineyard, most of which come from Luke. Here the characters of the actual parable enact the lesson to be learned, placing even greater emphasis on teaching.

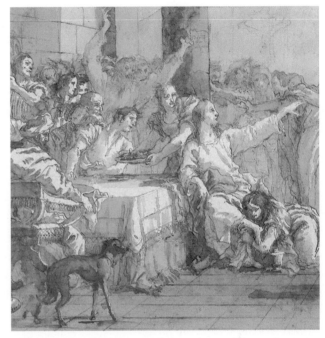

Martha serving the resurrected Lazarus, detail from plate 165, *The Feast in the House of Simon, II*

Domenico alternately followed texts and traditions closely or deliberately violated them in his rich and complex interpretation. He spread the story of Christ and the Adulteress over two frames, omitting the traditional scene of Jesus kneeling and writing on the ground, preferring instead the moment before and immediately after that visually celebrated occasion.

Domenico also took great interest in what each Gospel had to say about the final events before Christ's entry into Jerusalem, placing them all into his story. Jesus explains to the mother of Zebedee's sons that he cannot promise them a place next to his throne in heaven as Matthew and Mark described, then he heals blind men. He resurrects Lazarus as John asserts, but Domenico's interpretation excludes Mary and Martha, whom text and pictorial tradition place there. The women in turn are present in the subsequent feast scene, to honor Lazarus (as John notes), while the seated host hints at the story of the feast in Simon the Leper's house (which both Matthew and Mark place after Christ's entry into Jerusalem) and the stern onlooker at the right could easily be Judas, who complained of the waste of precious oils. Domenico includes three stages of Jesus meeting the publican Zaccheus, who climbed up a tree to see him (as Luke mentioned), placing two of the episodes just outside the city gates. Those gates will next appear as the gate to Jerusalem. Thus, Domenico has knitted the episodes divergently described by various texts into a more cohesive story, while acknowledging the differences with distinctive details.

143. *Jesus Rebukes the Unclean Spirit*

And behold, a man of the company cried out, saying, Master, I beseech thee, look upon my son: for he is mine only child. And, lo, a spirit taketh him, and he suddenly crieth out; and it teareth him that he foamed again, and bruising him hardly departeth from him. And I besought thy disciples to cast him out; and they could not. And Jesus answering said, O faithless generation, how long shall I be with you, and suffer you? Bring thy son hither, And as he was yet a coming, the devil threw him down, and tare him. And Jesus rebuked the unclean spirit, and healed the child, and delivered him again to his father. (Luke 9:38–42)

> Pen and wash, over black chalk, 469 x 353
> Signed low right: Dom.o Tiepolo f
> Provenance: Jean Fayet Durand (1806–1889)
> Literature: Conrad 1996 [127]

Paris, Musée du Louvre, Département des Arts Graphiques, RF 1713bis [76]

Facing a beautiful temple, Jesus expels an unclean spirit with Peter standing by his side. As several men struggle with the writhing youth, the demon flies out, much to the surprise of a young witness. The disciples crowd near Jesus, by now accepting this lastest miracle as a matter of course, while the pagan statue disdains to look. ❦

This story of exorcism is also told in Matthew and Mark, and is the subject of the following drawing (pl. 144), which, however, emphasizes a second aspect of it as told in Matthew 17:15–20—the earlier failure of the disciples to effect the cure. Thus, this may represent the first part of the story and the other the second. It has also been suggested that it may represent the exorcising of the dumb man (Matt. 9:33) but the youth of the patient and the presence of the father seem to argue against this. ❦

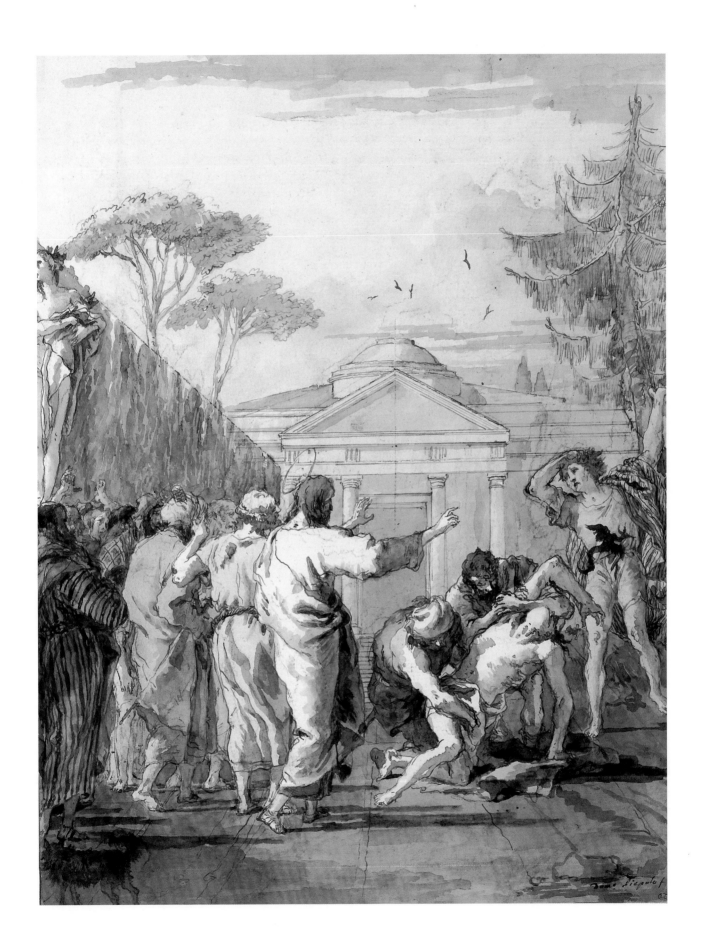

144. *Jesus Demonstrates the Power of Faith*

Lord, have mercy on my son: for he is lunatick, and sore vexed: for ofttimes he falleth into the fire, and oft into the water. And I have brought him to thy disciples, and they could not cure him. Then Jesus answered and said, O faithless and perverse generation, how long shall I be with you? How long shall I suffer you? Bring him hither to me. And Jesus rebuked the devil; and he departed out of him: and the child was cured from that very hour. Then came the disciples to Jesus apart, and said, Why could not we cast him out? And Jesus said unto them, Because of your unbelief: for verily I say unto you, If ye have faith as a grain of mustard seed, ye shall say unto this mountain, Remove hence to yonder space; and it shall remove; and nothing shall be impossible unto you. (Matt. 17:15–20)

Pen and wash, over black chalk, 467 x 360
Signed low right center: Do Tiepolo f / and again on the central column: Dom.o Tieplo
Provenance: Jean Fayet Durand (1806–1889)
Literature: Conrad 1996 [128]

Paris, Musée du Louvre, Département des Arts Graphiques, RF 1713bis [112]

His disciples standing round him, including Peter, Jesus addresses the "faithless generation" as he stands beneath the bust of Tiberius, which hints at his approaching Passion and alludes to the faithless Romans who would ultimately participate in his death. The man confronting Jesus could be the boy's father, who said to Jesus, "Lord, I believe, help thou my unbelief" (Mark 9:24). ❦

This celebrated story of exorcism is also told in Mark and Luke, but only Matthew discusses the failure of the disciples to effect a cure. This is the aspect of the story emphasized here. The father holds the son in his arms on the left, and the devil flies forth; in the center the disciples remonstrate with Jesus. The story is also told in the preceding drawing, plate 143, which simply presents a scene of exorcism, without the intervention of the disciples, as told in Luke. Hence that may be regarded as the first part of the story and this the second. ❦

145. *Peter Finds the Money in the Fish*

Notwithstanding, lest we should offend them, go thou to the sea, and cast an hook, and take up the fish that first cometh up; and when thou hast opened his mouth, thou shalt find a piece of money: take that, and give unto them for me and thee. (Matt. 17:27)

> Pen and wash, heightened with white gouache, 470 x 365, image
> Signed low right: Dom.o Tiepolo f
> Provenance: Paris, Hôtel Drouot, 14 December 1938, lot 12, as *"Saint-Pierre trouvant la monnaie du tribut dans un poisson"*;
> Michel-Lévy; Mme. A.L.D.; Paris, Drouot Richelieu, Nov. 21, 2001 [62]
> Exhibition: New York 2002 [14]

New York, private collection

Offering us a view behind a strange rocky wall (perhaps alluding to the fact that Peter is the rock upon which his Church would be built), Domenico shows Peter in a boat (reminding us that he was a fisherman) triumphantly holding up the coin he found in a fish's mouth, while his other hand searches the rather toothy fish again. A heron (symbol of the obedient son, last seen with John the Baptist) takes flight in the distance. ✥

The question of tribute money is raised twice in Matthew (who was, after all, a tax collector), and not at all in the other gospels. This drawing relates to the first episode. The second, illustrated in plate 175, is found in Matthew 22:19–22. Quite unusually, this scene is here shown with three figures in a boat, off a cliff to the right. Peter holds up the coin in his left hand; the right hand is still thrust into the mouth of the fish. A heron stands on the bank, top left, and another flies off. Two flying herons, one very similar, play a similar role in *Punchinello's Duck Hunt* (Udine 1996 [166]). ✤

146. *The Good Samaritan*

Which now of these three, thinkest thou, was neighbour unto him that fell among the thieves? And he said, He that shewed mercy on him. Then said Jesus unto him, Go, and do thou likewise. (Luke 10:30–37)

Pen and wash, over traces of black chalk, 460 x 358
Not signed
Provenance: MLT, Paris, Hôtel Drouot, June 26, 1913, lot 112; Strolin 1959; Bern, Klipstein & Kornfeld, June 8, 1977 [153]; Sotheby's, Dec. 13, 1973 [64]; de Gamond; Chaikin, July 1981 [75]; Christie's, Apr. 3, 1984 [37]; Thomas le Claire, 1992; Lowell Libson 2002
Exhibition: Udine 1971 [75]; New York 1992 [34]
Literature: Conrad 1996 [109]
Reference: Réau 1957, 331

New York, private collection

Providing a lesson in compassion and charity, the Samaritan (here portrayed as an eighteenth-century cavalier out for a ride) prepares to place the wounded traveler on his waiting horse. With an expression of concern, the Samaritan also presses a cloth to the back of the man's head, perhaps stanching some blood. ☙

Domenico presents the scene as a wooded landscape, with the trees bunched quite thickly. The light falls clearly on the wounded man and the horse. The subject is found only in Luke. ⚜

147. *Jesus in the House of Mary and Martha*

And Jesus answered, and said unto her, Martha, Martha, thou art careful and troubled about many things; but one thing is needful: and Mary hath chosen that good part, which shall not be taken away from her. (Luke 10:38–42)

Pen and wash, over slight black chalk, 467 x 361, trimmed to the borderline, with additional pen work over the wash, for emphasis
Signed low right: Dom.o Tiepolo f
Provenance: Charles Fairfax Murray; J. Pierpont Morgan, 1910
Literature: Charles Fairfax Murray 1912 [IV.151]; Conrad 1996 [97]
Reference: Christiaan van Adrichem 1584, Site 178; Pigler 1956, i, 318–321; Réau 1957, 328

New York, The Pierpont Morgan Library, Fairfax Murray Collection, IV.151

Luke follows the parable of the Good Samaritan with the story of Martha and Mary (traditionally identified as the Magdalen), the sisters (according to John) of Lazarus. Martha, having invited Jesus to her home, complained that Mary preferred to sit at his feet instead of helping in the kitchen. Often a pretext for artists to depict elaborate kitchen still-lifes, the setting here is a stark room, embellished only with an open window. Domenico concentrates on Jesus enlightening Martha about Mary's choice, as the disciples, particularly Peter, listen intently. The kitchen and all Martha's work lie unseen beyond the door to which she gestures so meaningfully. ❧

This scene, which is found only in Luke, is shown here as a rich interior with numerous figures. A small but unusual detail shows the pen work of Mary's right hand added over the drapery of Christ's knee. Christiaan van Adrichem (1584: Site 178) describes the house of Mary and Martha at Bethany, "the which was situated beyond mount Olivet, distant from Jerusalem fifteen furlongs, that is, two Italian miles." ❧

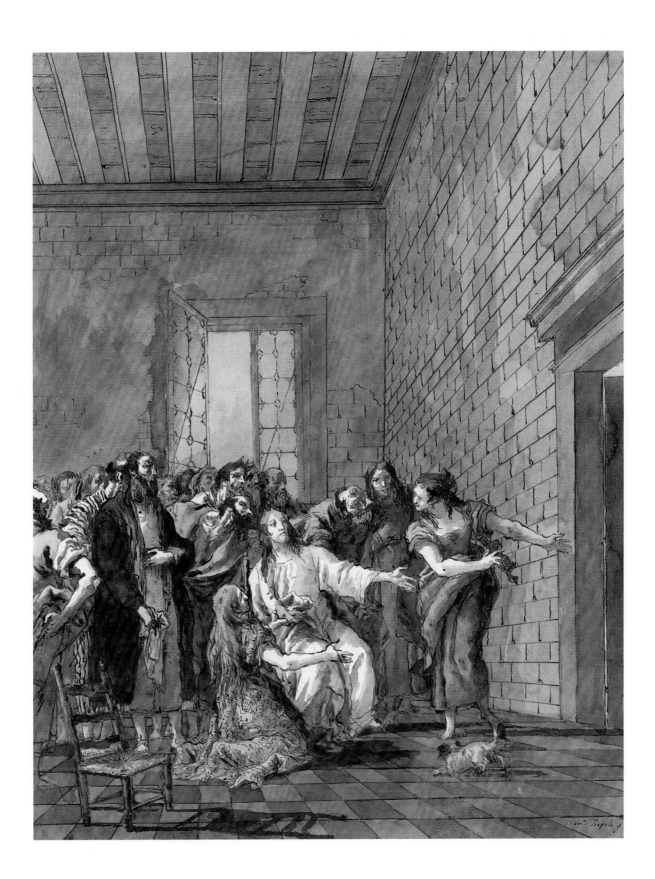

148. *The Lord's Prayer*

And it came to pass that, as he was praying in a certain place, when he ceased, one of his disciples said unto him, Lord, teach us to pray, as John also taught his disciples. And he said unto them, When ye pray, say: Our Father which art in heaven, Hallowed be thy name. Thy kingdom come. Thy will be done, as in heaven, so in earth. . . . (Luke 11:1–2)

Then they returned unto Jerusalem from the mount called Olivet, which is from Jerusalem a sabbath day's journey. And when they were come in, they went up into an upper room, where abode both Peter, and James, and John, and Andrew, Philip, and Thomas, Bartholomew, and Matthew, James the son of Alpheus, and Simon Zelotes, and Judas, the brother of James. These all continued with one accord in prayer and supplication, with the women, and Mary the mother of Jesus, and with his brethren. (Acts 1:12–14)

Pen and wash, 468 x 360
Signed on the central column: Dom.o Tiepolo f
Inscription: *Se Havendo a gli / Apostoli Insegnno / Christo l'Orazione / Domenicale / Maria Vergine é / li predetti Apostoli / più volte la reci=, / tassevi e orando li / servizzio di corona ò / Rosarij con calculi ò / Globuli com noi usiamo*
Provenance: Vicomte Hervé de Cargouet
Reference: photo in the Cailleux archives, June 1964; *Images du Patrimoine*, no. 92, *Inventaire Général* 1991, as *La Pentecôte*

France, private collection

True to his interest in historical roots, Domenico here shows us the origins of the Lord's Prayer as Jesus, once again adopting the prayerful attitude of his grandmother Anne, looks heavenward and leads the assembly in reciting the Lord's Prayer for the first time. As the Virgin Mary looks on, each of the disciples responds with his own personal devotional attitude as he learns this essential prayer. Interestingly, Domenico has added an inscription which relates this moment to future prayerful gatherings such as the one described in Acts, as noted above, but, more importantly, relates the Lord's Prayer to the history of the Rosary, during which the Lord's Prayer is interspersed with prayers to the Virgin Mary. In so doing, Domenico bypasses the traditional interpretation of the Rosary as derived from St. Dominic. Domenico has given eleven of the disciples haloes, omitting, as was traditional, one for Judas, who appears at the far left, also kneeling. ❦

The inscription may be translated: *Christ having himself taught the Apostles the Lord's Prayer, Mary the Virgin and the aforementioned Apostles recited it many times, and praying with the aid of a crown (= a rosary) or Rosaries with beads (in the manner of an abacus), or Globules (little round spheres) as we use (them).* The Lord's Prayer forms a part of the Sermon on the Mount in Matthew 5–7. Domenico here presents the scene as an interior, with a figure on the left, facing the apostles, which might be identified as Jesus. Mary is seated in the center, and there is another woman in the background. A figure that we have identified as Andrew stands in a characteristic pose in the left foreground (compare pls. 111 and 119, now reversed). Twelve haloes can be counted. Neither the very grand setting nor the presence of the Virgin is indicated by the texts of Matthew and Luke, and the inscription suggests that this is a later event, and perhaps out of place here. For this reason it may be preferable to cite Acts 1:12–14, where the setting is specified as an upper room, following *The Ascension of Christ*. This gives the subject a very similar character to *Pentecost* (pl. 230). Although the inscription refers to rosaries, which are associated with the name of St. Dominic and the thirteenth century, none appear in the drawing, suggesting a trace of anachronism. ❧

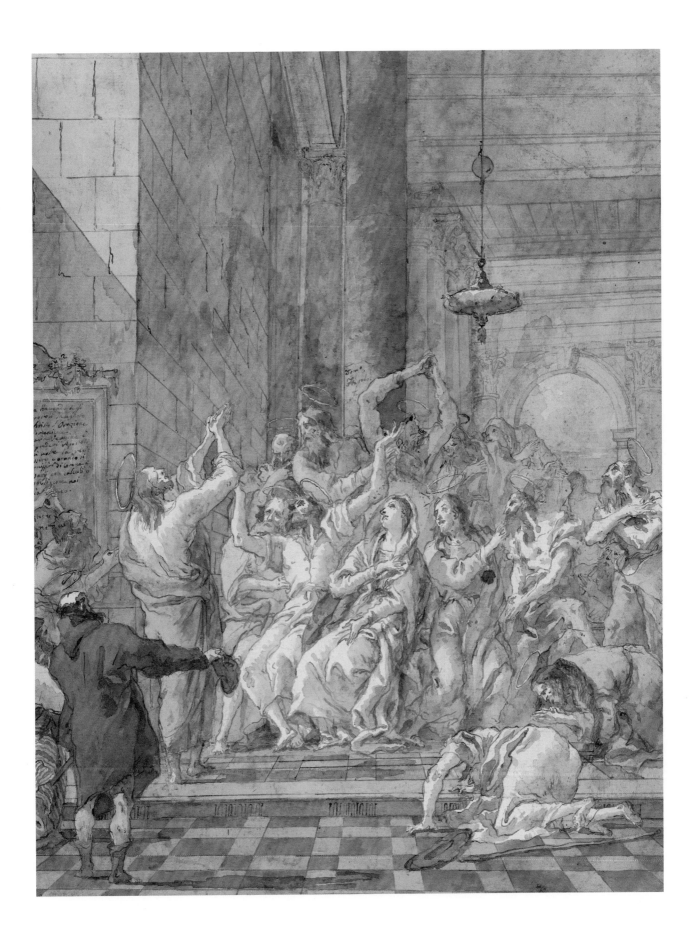

149. *Jesus Heals the Woman with a Spirit of Infirmity*

And he was teaching in one of the synagogues on the sabbath. And, behold, there was a woman which had a spirit of infirmity eighteen years, and was bowed together, and could in no wise lift up herself. And when Jesus saw her, he called her to him, and said unto her, Woman, thou art loosed from thine infirmity. And he laid his hands upon her: and immediately she was made straight, and glorified God. And the ruler of the synagogue answered with indignation, because that Jesus had healed on the sabbath day, and said unto the people, There are six days in which men ought to work; in them therefore come and be healed, and not on the sabbath day. And the Lord then answered him, and said, Thou hypocrite, doth not each one of you on the sabbath loose his ox or his ass from the stall, and lead him away to watering? And ought not this woman, being a daughter of Abraham, whom Satan hath bound, lo, these eighteen years, be loosed from this bond on the sabbath day? (Luke 13:10–16)

Pen and wash, over black chalk, 485 x 380
Signed low right: Dom.o Tiepolo f
Provenance: Paris, Hôtel Drouot, Nov. 23, 1953 [80]; Paris, César de Hauke
Exhibition: St. Louis 1972 [71]
Literature: Conrad 1996 [124]

The St. Louis Art Museum, 113.54

Looking down with compassion upon the infirm woman, Jesus leans slightly toward her as he issues his healing message. All the Apostles, including Peter just by his side, observe this miracle, while one elder in the striped robe registers his complaint about such doings on the Sabbath. It is also a good example of Domenico's habit of encoding stories based on Luke with a stronger than usual element of stripes. ❧

The scene is placed, not in the interior of a synagogue, but in a handsome architectural setting, with "the ruler of the synagogue" protesting on the left, dressed in a striped habit. ❖

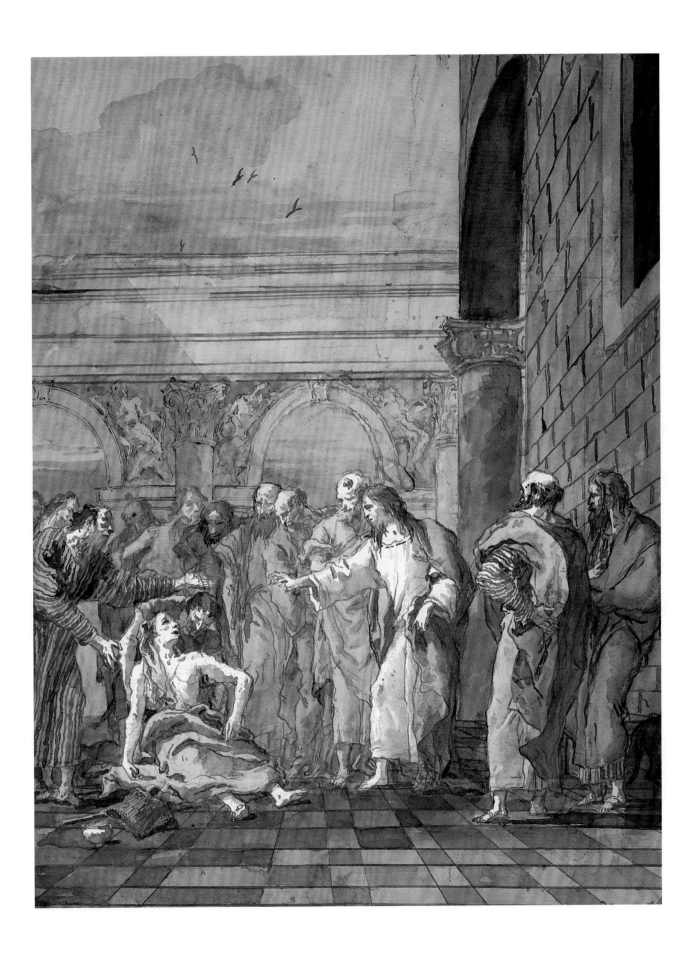

150. *The Prodigal Son Taking His Journey into a Far Country*

And he said, A certain man had two sons; and the younger said to his father, Father, give me the portion of goods that falleth to me. And he divided unto them his living. And not many days after the younger son gathered all together, and took his journey into a far country, and there wasted his substance with riotous living. (Luke 15:11–13)

Pen and wash, over extensive black chalk, 488 x 385, sheet, 447 x 350, image
Signed low right: Dom.o Tiepolo f
Provenance: Roger Cormier, Tours, his sale, Paris, Georges Petit, Apr. 30, 1921, no. 8; Paris, E. Moratilla; London, Paul Wallraf
Exhibition: Venice 1959 [111]

New York, Robert Lehman, on loan to the Lehman Collection, Metropolitan Museum of Art

Switching to a secular mode, Domenico begins the parable of the Prodigal son with his departure from home. Shown as a young cavalier, he sets off excitedly on horseback to begin his adventure. An ox, Luke's symbol, blocks the "high road," sending the Prodigal on the "low road" instead. Above him a goat (long the symbol of lust) makes a prominent appearance, hinting at how the son would squander his fortune. 🌿

This drawing appears to be the only purely secular item in the series. It might be taken to represent the transition in Domenico's interests from *A New Testament* to *The Scenes of Contemporary Life,* a series of perhaps 100 drawings—82 can currently be counted—which occupied him about the year 1791. Byam Shaw devotes a chapter to these drawings, and illustrates sixteen of them (1962, 46–51 [58, 59, 63–76]). Twenty specimens of the series were exhibited at Udine in 1996 [135–154], with discussions on pp. 54–56 and 89–95, and a checklist on pp. 240–243; see Gealt and Knox 2005 for a full account. However, it is here proposed that it may represent the prodigal son setting out on "his journey into a far country," thus preceding plates 151 and 152. The riders certainly have all the confidence of youth, and the landscape is certainly outlandish. Another suggestion that this may represent Saul setting out for Damascus (see pl. 266) is here thought to be less likely. ⚜

151. *The Prodigal Son Among the Swine*

And he went and joined himself to a citizen of that country; and he sent him into his fields to feed swine. And he would fain have filled his belly with the husks that the swine did eat; and no man gave unto him. (Luke 15:15–16)

Pen and wash, over black chalk, 460 x 360
Signed low center?
Provenance: Roger Cormier, Tours, his sale, Paris, Georges Petit, Apr. 30, 1921, no. 53
Literature: Guerlain 1921, 67; Conrad 1996 [111]
Reference: Lieurre 1924, 1109, 1110; Pigler 1956, i, 363; Réau 1957, 333–338

Having squandered his fortune on riotous living, the Prodigal Son is now destitute. Kneeling in abject remorse, he comes to a turning point and, one suspects, decides to return home. The dead trees jutting up by his side signify his unfruitful life, while the swine in the foreground allude not only to his fallen condition but also his unchaste behavior which so degraded him. ❦

The subject, which is found only in Luke, is followed by *The Return of the Prodigal* (pl. 152). Domenico avoids the subject of the Prodigal Son squandering his substance, so popular in the Netherlands. ⚜

152. *The Return of the Prodigal Son*

And the son said to him, Father, I have sinned against heaven, and in thy sight, and am no more worthy to be called thy son. But the father said to his servants, Bring forth the best robe, and put it on him; and put a ring on his finger, and shoes on his feet. And bring hither the fatted calf, and kill it; and let us eat and be merry; for this my son was dead, and is alive again; he was lost and is found. And they began to be merry. (Luke 15:20–24)

 Pen and wash, over black chalk, 467 x 352
 Signed low left: Dom.o Tiepolo f
 Provenance: Jean Fayet Durand (1806–1889)
 Literature: Conrad 1996 [112]; Gealt in Udine 1996, 69
 Reference: Lieurre 1924 [2222] Pigler 1956, i, 360–362

Paris, Musée du Louvre, Département des Arts Graphiques, RF 1713bis [9]

An opulent palace with a raised porch stages the repentant son's return home. As a welcoming party pours out the doorway, the father embraces his son. Kissing his father's hand, the Prodigal ignores his older brother at the right, whose stern expression reveals his displeasure. The larger party appears to include the Apostles, perhaps to remind us that Jesus addressed his disciples with this parable. 🌿

The story of the Prodigal Son is told only by Luke, following the story of the lost sheep; thus it should perhaps follow Matthew 18:12. The detail of the son kissing the father's hand is treated with great tenderness. ⚜

Dopo Tiepolo f.

153. *Lazarus at the Gate*

And there was a certain beggar named Lazarus, which was laid at his gate, full of sores, and desiring to be fed with the crumbs which fell from the rich man's table; moreover the dogs came and licked his sores. (Luke 16:20–21)

Pen and wash, over traces of black chalk, 489 x 382 mm, trimmed close to the image
Signed low left: Dom.o Tiepolo f
Provenance: Jean-François Gigoux [1806–1894], his bequest 1894
Exhibition: Venice 1951, pl. 118; Udine 1971 [74]; Udine 1996 [101]
Literature: Byam Shaw 1962 [33]; Knox 1974 [70]; Conrad 1996 [110]
Reference: Molmenti 1911, 171, note 6; Pigler 1956, i, 369–370; Réau 1957, 348–352

Besançon, Musée des Beaux-Arts et d'Archéologie, D.1659

Leaving us to imagine the celebratory feast that concludes the Prodigal's story, Domenico now invites us to consider the Rich Man's feast. As a pair of guests make their way up the stairs of a stupendous Venetian villa, trays of food are being delivered. Lazarus, heroic in his misery, lies suffering, literally and figuratively at the bottom of the scene. A sphinx-like statue, whose stony breasts provide no milk of kindness or nourishment, sits impassively behind him. Two dogs lick Lazarus's sores rather too eagerly, while a third barks aggressively at them. 🦡

The story appears only in Luke. It is not impossible that Gustave Doré's composition in *La Sainte Bible selon la vulgate* (Doré 1866) may have been inspired by this composition. ❧

154. *The Healing of the Ten Lepers*

And when he saw them, he said unto them, Go shew yourselves to the priests. And it came to pass, that, as they went, they were cleansed. And one of them, when he saw that he was healed, turned back, and with a loud voice glorified God, and fell down on his face at his feet, giving him thanks: and he was a Samaritan. And Jesus answering said, Were there not ten cleansed? but where are the nine? (Luke 17:14–17)

Pen and wash, over black chalk, 460 x 360
Signed low right: Dom.o Tiepolo f
Provenance: Roger Cormier, Tours, his sale, Paris, Georges Petit, Apr. 30, 1921 [79]
Literature: Conrad 1996 [224], as perhaps Acts 19:11, qv
Reference: Fleury 1722, i, VII

Standing once more by a city battlement, Jesus heals the ten lepers, who kneel thankfully before him. Most unusual is the woman who buries her face in the hem of his garment, hinting at the woman with the issue of blood whom Christ also healed (but who is not mentioned in connection with the ten lepers). The disciple to the left of Jesus wears a boldly striped robe, a device Domenico stressed when Luke was his source. ❦

The subject appears only in Luke. The identity of the central figure as Christ has been questioned, and indeed he was identified as Paul in the Cormier sale. Conrad too identifies him as Paul, and cites Acts 19:11; however, two other drawings are linked with this text (pls. 284 and 286). He is the only person with a halo. Some ten crippled men can be counted. The drawing is an excellent example of Domenico's late style: abundant black chalk, the wash applied in three even layers, with some darker notes of emphasis in the foremost figures. ❧

155. *Jesus and the Little Child*

And Jesus called a little child unto him, and set him in the midst of them, and said, Verily I say unto you, Except ye be converted, and become as little children, ye shall not enter the kingdom of heaven. (Matt. 18:2–3)

Pen and wash, over black chalk, 463 x 352
Signed low center: Dom.o Tiepolo f
Provenance: Jean Fayet Durand (1806–1889)
Literature: Conrad 1996 [102]

Paris, Musée du Louvre, Département des Arts Graphiques, RF 1713bis [1]

In one of several episodes involving children in his post-Transfiguration narrative of Christ's life, Domenico shows Jesus delivering yet another lesson about faith, admonishing all his disciples to be as a little child, whom he has emphatically grabbed by the arm. Peter, standing apart and looking on, is singled out again for special attention. ❧

Domenico creates a wide frieze of figures across the page, set back against a matching frieze of buildings in the background that suggest a North Italian town with the Alps beyond. The curious *repoussoir* figure in the left foreground seems to recall the figure of Fabius Maximus in Giambattista's canvas for Ca' Dolfin, *Fabius before the Senate of Carthage* (Morassi 1962 [297]; Venice 1996 [12c]). ✤

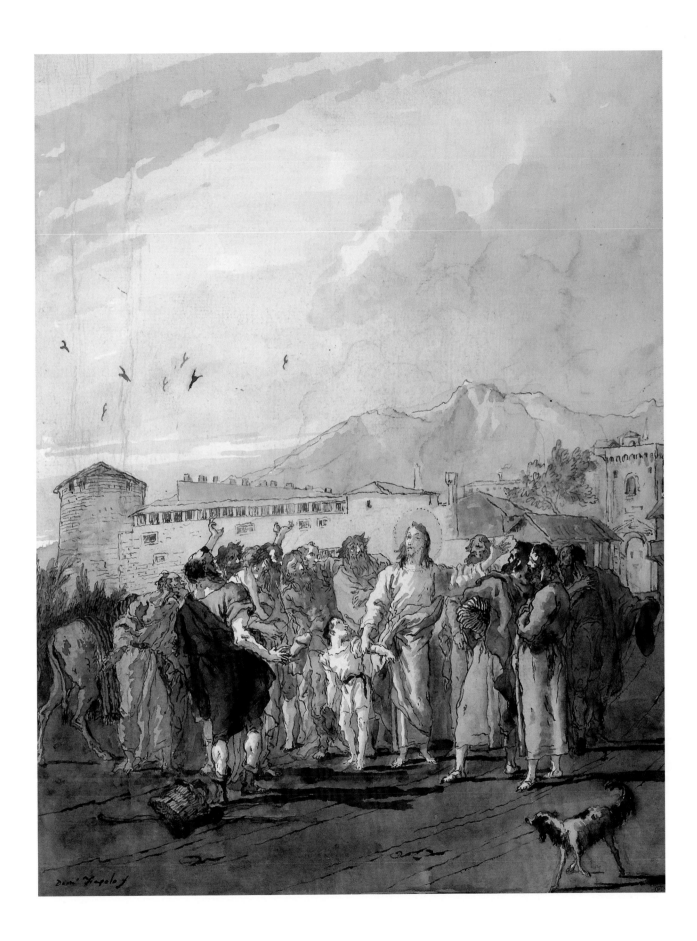

156. *"Suffer little children . . ."*

Then there were brought unto him little children, that he should put his hands upon them, and pray; and the disciples rebuked them. But Jesus said, Suffer little children, and forbid them not, to come unto me: for of such is the kingdom of heaven. (Matt. 19:13–14)

> Pen and wash, over black chalk, 468 x 360
> Not signed
> Provenance: Jean Fayet Durand (1806–1889)
> Literature: Conrad 1996 [129]
> Reference: Pigler 1956, i, 360–362; Réau 1957, 329

Paris, Musée du Louvre, Département des Arts Graphiques, RF 1713bis [117]

Ignoring tradition, which treated this subject as a contemplative moment of blessing, Domenico shows Jesus turning abruptly away from his disciples and greeting the first of the children who have been brought for his blessing. Domenico's interpretation stresses Christ's opposition to his disciples, who rebuked those who brought the children. We also can sense Jesus's emotions reaching a higher pitch as events move toward his Passion. ❦

Domenico here abandons his usual rather static arrangements of figures for an enveloping movement that draws the turning figure of Jesus toward the advancing boy and creates a vortex around a vacant space in the center of the design. One may note that the children now appear to be teenagers. ❦

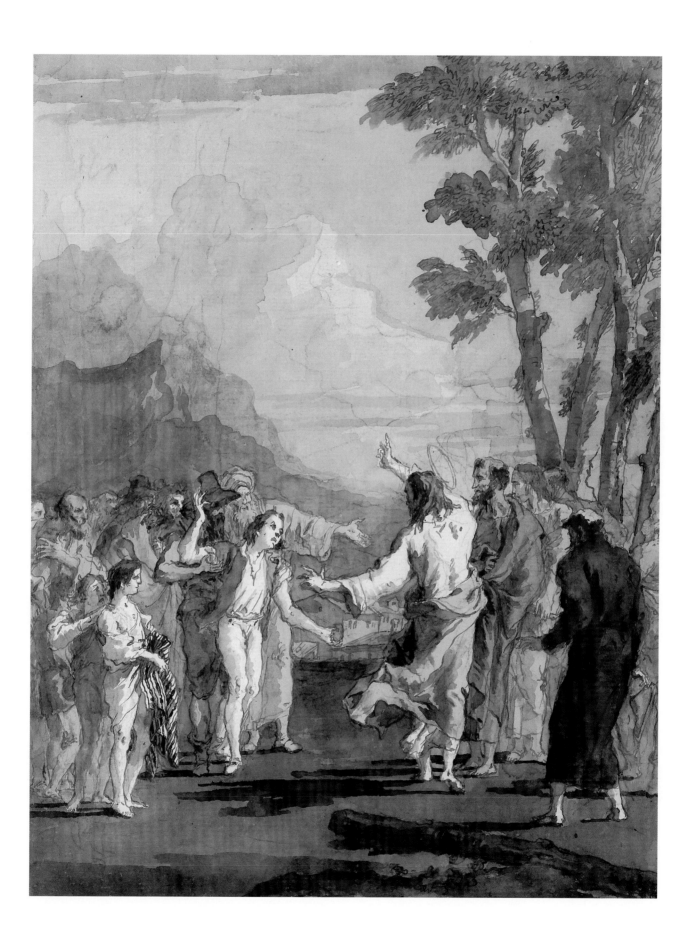

157. *The Master in the Vineyard*

For the kingdom of heaven is like unto a man that is an householder, which went out early in the morning to hire labourers into his vineyard. (Matt. 20:1)

Pen and wash, over black chalk, 465 x 362
Signed low right: Dom.o Tiepolo f
Provenance: Paris, Hôtel Drouot, Apr. 29, 1986 [80], London, Colnaghi; New York, pc
Exhibition: New York 1987 [33]; Udine 1996 [100]
Literature: Conrad 1996 [113]
Reference: Pigler 1956, i, 364–366; Réau 1957, 347

New York, private collection, courtesy of Jean-Luc Baroni

The foppish householder sends the arriving laborers to attend his vineyard. He looks out of place in the rustic barnyard. His elegant dress underscoring his wealth, he appears to earn little respect from the peasants who lean on their shovels to listen. Ignoring the usual tradition, which features the householder issuing the unequal pay, Domenico instead presents the laborers just setting out, leaving us to remember how it all comes out and ending with the famous pronouncement, "The last shall be first." ❦

The parable is told only by Matthew. Domenico portrays the master as a fashionably dressed young man, imperiously addressing his workmen, somewhat in the heroic pose of the Apollo Belvedere, outside the gate of a Venetian farm. ⚜

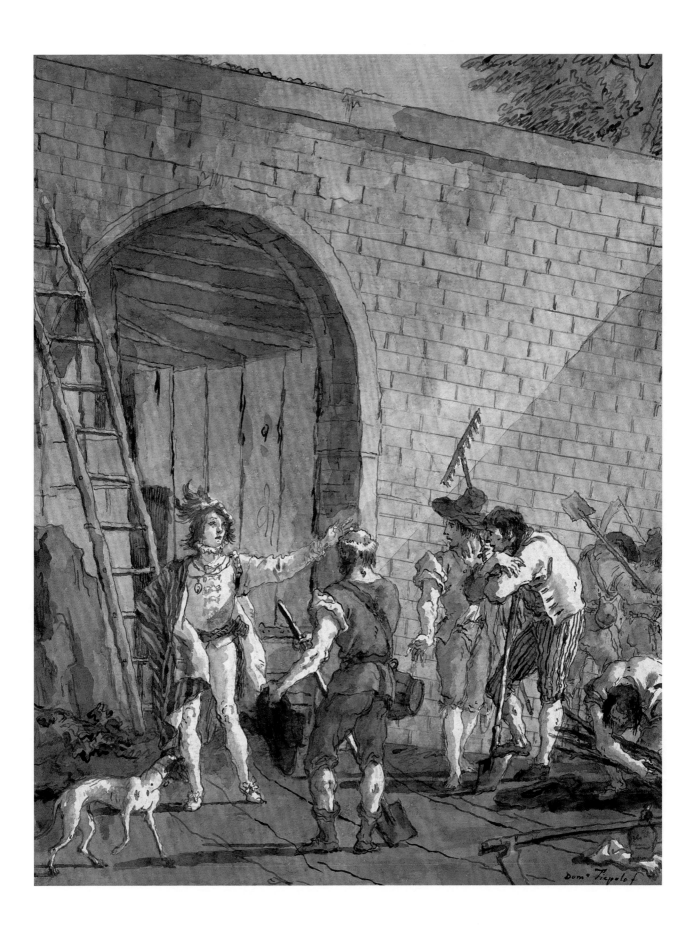

Dom° Tiepolo f

158. *Jesus and the Mother of Zebedee's Children*

Then came the mother of Zebedee's children with her sons, worshipping him, and desiring a certain thing of him. And he said unto her, What wilt thou? She saith unto him, grant that these my two sons may sit, the one on thy right hand, and the other on the left, in thy kingdom. (Matt. 20:20–21)

 Pen and wash, over black chalk, 461 x 351
 Signed on wall, high left, under the clock: Dom.o Tiepolo f
 Provenance: Jean Fayet Durand (1806–1889)
 Literature: Conrad 1996 [136]
 Reference: Pigler 1956, i, 231

Paris, Musée du Louvre, Département des Arts Graphiques, RF 1713bis [137]

Devoting yet another drawing to the theme of the Kingdom of Heaven, Domenico shows Jesus clearly explaining that any placement in the Kingdom of Heaven is "not mine to give." Rarely portrayed, the scene also reveals Domenico's interest in different accounts (here Matthew's) of the final events leading up to Christ's Triumphal Entry into Jerusalem. Giving the palm tree special prominence, Domenico underscores Jericho's designation as the city of palms, while the gateway complete with clock tower offers a clear hint that time is running out before Christ's Passion. ✿

Only one son is shown kneeling in front of his mother, who addresses Jesus. The second son is presumably the boy approaching on the left. In Matthew 4:21 the Apostles James and John are named as the sons of Zebedee, but here in Matthew 20:20–21 the children are not named. In Mark 10:35, James and John make this request as adults, and the mother is not mentioned. ❖

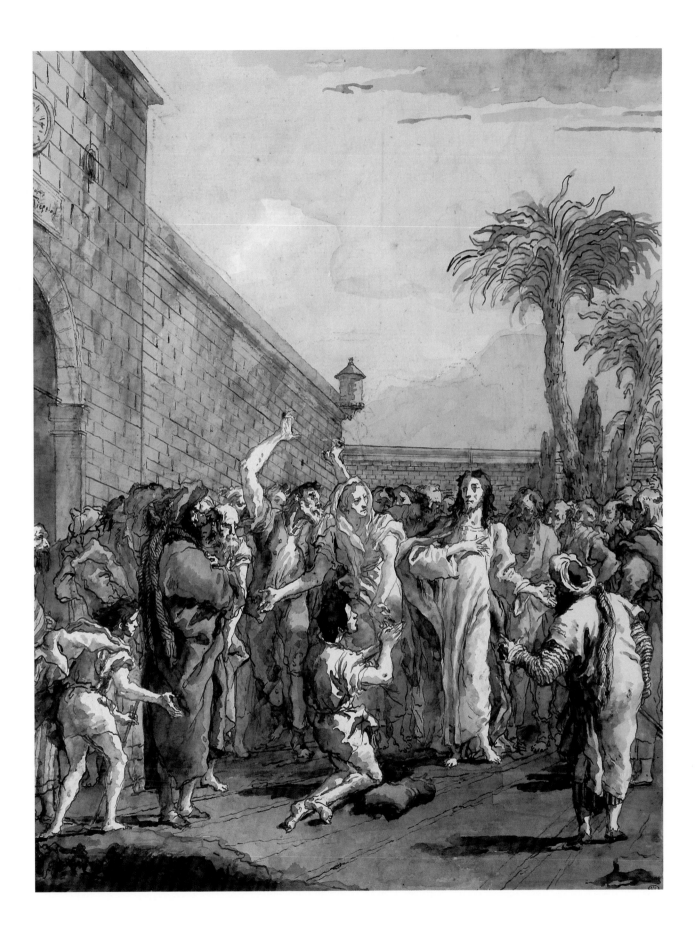

159. *Jesus Heals the Two Blind Men of Jericho*

And, behold, two blind men sitting by the way side, when they heard that Jesus psssed by, cried out, saying, Have mercy on us, O Lord, thou Son of David. And the multitude rebuked them, because they should hold their peace: but they cried out the more, saying, Have mercy upon us, O Lord, thou Son of David. And Jesus stood still, and called them, said, What will ye that I should do unto you? They say unto him, Lord, that our eyes may be opened. So Jesus had compassion on them, and touched their eyes: and immediately their eyes received sight, and they followed him. (Matt. 20:30–34)

Pen and wash, over black chalk, 460 x 360
Not signed
Provenance: Roger Cormier, Tours, his sale, Paris, Georges Petit, Apr. 30, 1921, no. 18
Literature: Guerlain 1921, p. 63; Conrad 1996 [130]; photo: Byam Shaw archives, Fondation Custodia, Paris
Reference: Réau 1957, 373

Milan, Antonio Morassi (formerly)

The city now in the background, Jesus is approached by the two blind men who beg for mercy. Here again, the theme is Christ's compassion over others' objections. As with the little children, whom he blessed, Christ here receives the blind men, in a very similarly conceived scene. This is the final event, according to Matthew, before Jesus goes to Jerusalem. Mark 10:46–52 recalls the same events, but focuses on one man, Bartimaeus, son of Timaeus. ❦

The story of the healing of the two blind men, as told twice in Matthew (9:27 and 20:30–34), must be distinguished from the story of the healing of the single blind man as told in Mark, Luke, and John (pls. 162–163). The setting here seems to correspond better with the second version in Matthew. Once again, Andrew stands in the left foreground, as in plates 111 and 119, in reverse. ⚜

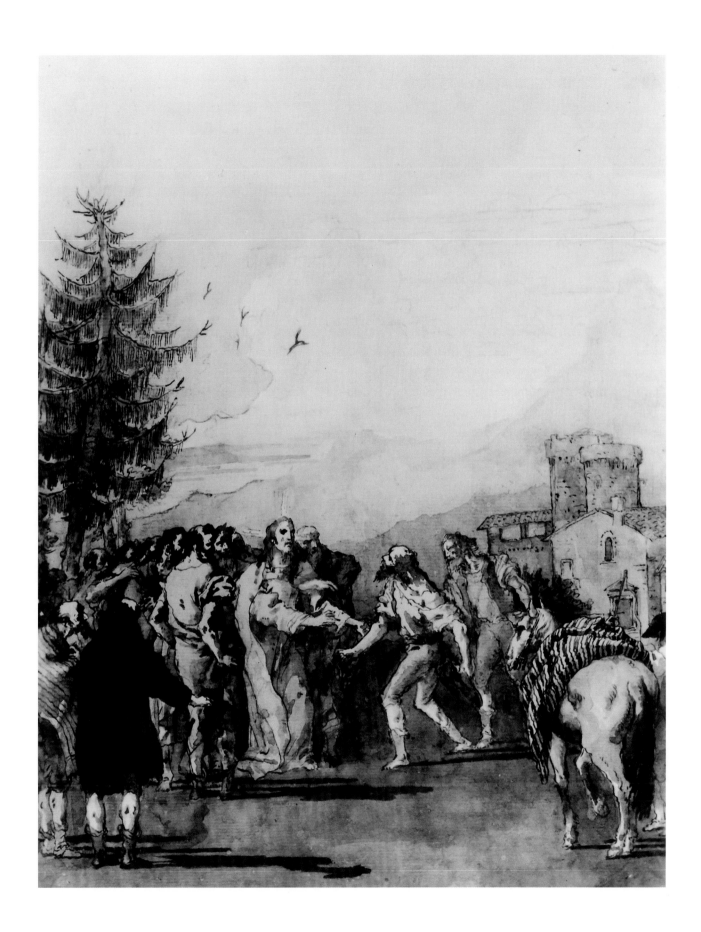

160. *The Woman Taken in Adultery*

So when they continued asking him, he lifted up himself, and said unto them, He that is without sin among you, let him first cast a stone at her. (John 8:7)

Pen and wash, over black chalk, 460 x 360
Signed on the column: Dom.o Tiepolo
Provenance: Roger Cormier, Tours, his sale, Paris, Georges Petit, Apr. 30, 1921, no. 39; Lucerne, Fischer, June 18, 1996 [4037]
Literature: Conrad 1996 [103]
Reference: Christiaan van Adrichem 1584, Site 100; Guerlain 1921, 65, mentions a work by Farinati in Verona, Ss. Nazzaro e Celso; Pigler 1956, i, 309–314; Réau 1957, 324

Zürich, Annette Bühler

Turning to John's account of the last events before Jesus rode into Jerusalem, Domenico begins with the adulterous woman. Spreading his treatment of this famous episode out over two drawings, he shows an unusually chastely clad adulteress brought before Jesus in the Temple. As some patriarchs look on at the left, those behind the woman prepare to mete out punishment, holding their stones aloft. They seem to stare at Jesus in astonishment as he dares any genuine non-sinner to "cast the first stone." A supplicant kneeling behind Jesus may be the blind man whom Jesus will cure later on. 🖌

This story, related only by John, is completed in the following drawing. In earlier times, Jesus is represented standing and remonstrating, but from the sixteenth century onward he is more often shown writing on the ground. In the center, a man is already holding a great rock above his head, as in *The Stoning of Stephen* (pl. 263), and "the ruler of the synagogue" is already making off with the great book under his arm in the left foreground. Christiaan van Adrichem (1584: Site 100) locates this subject in the Court of the Gentiles. ⚜

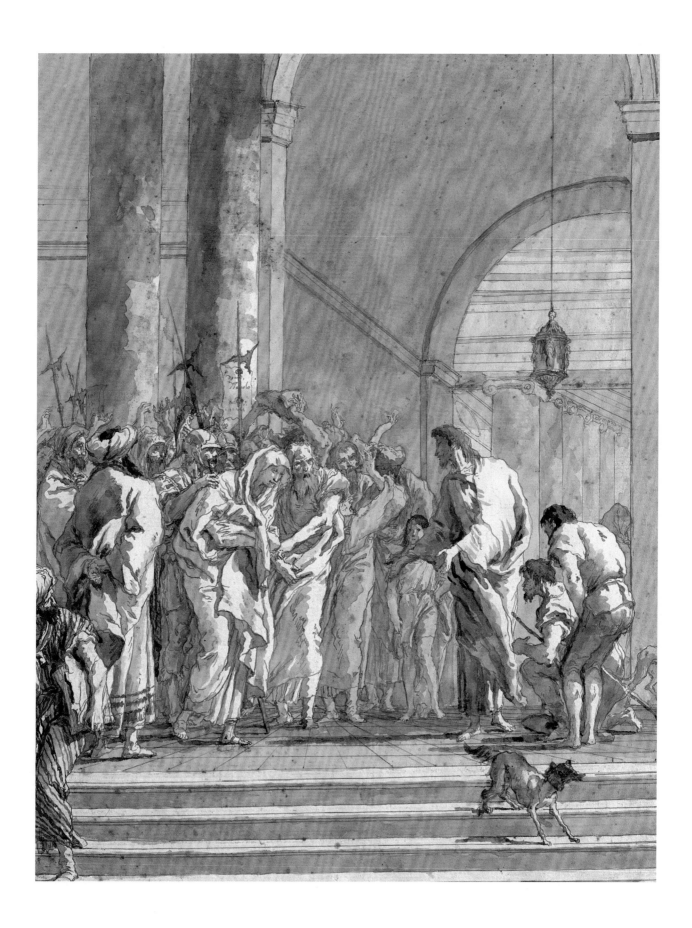

161. *"Go, and sin no more"*

And they which heard it, being convicted by their own conscience, went out one by one, beginning at the eldest, even unto the last: and Jesus was left alone, and the woman standing in the midst. When Jesus had lifted himself, and saw none but the woman, he said unto her, Woman, where are those thine accusers? Hath no man condemned thee? She said, No man, Lord. And Jesus said unto her, Neither do I condemn thee: go, and sin no more. (John 8:9–11)

Pen and wash, traces of black chalk, 485 x 374 / 465 x 350
Signed low left: Dom.o Tiepolo f
Marked, top border, left: 38 right: (2) 30 35
Reference: Christiaan van Adrichem 1584, Site 100; Réau 1957, iii, 325

Paris, Galerie J. Kugel

As the last of the woman's accusers depart, Jesus stands alone with her. Domenico has omitted the traditional scene of Jesus kneeling and drawing in the dirt, preferring this striking aftermath. The lion (seen when Jesus talked with another loose woman in Samaria) is joined by an image of Caesar, which, together with the basin of water, allude to the washing of sins and subsequent events of Christ's Passion. The tension has passed, and the two dogs now feel free to play. ❦

Domenico here completes the story of Jesus and the woman taken in adultery, begun in the preceding drawing. The woman, left, and Jesus, right, stand alone on a platform raised on four steps. Behind them Domenico provides a magnificent architectural setting with a wall, left, bearing the partial inscription: -IUS CESAR. A center column divides the two figures. Some figures can be seen retreating on the right, and two dogs are shown playing. Christiaan van Adrichem (1584: Site 100) locates this scene in the Court of the Gentiles, which could hardly have contained a portrait of Caesar. ⚜

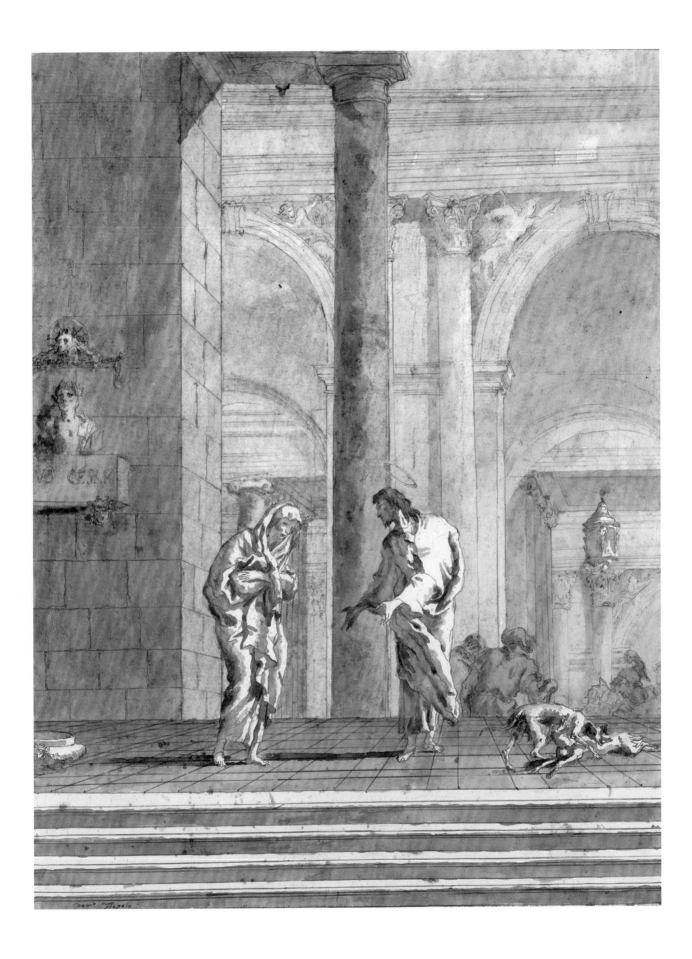

162. *Jesus Heals the Blind Man, I*

And Jesus said unto him, Receive thy sight; thy faith hath saved thee. (Luke 18:42)

When he had thus spoken, he spat upon the ground, and made clay of the spittle, and he anointed the eyes of the man with the clay, and said unto him, Go, wash in the pool of Siloam. . . . He went his way therefore, and washed, and came seeing. (John 9:6–7)

> Pen and wash, over traces of black chalk, 467 x 360
> Signed low right: Dom.o Tiepolo f
> Provenance: Jean Fayet Durand (1806–1889)
> Literature: Conrad 1996 [132]
> Reference: Christiaan van Adrichem 1584, Site 199; Pigler 1956, i, 307–309; Réau 1957, 371

Paris, Musée du Louvre, Département des Arts Graphiques, RF 1713bis [95]

Jesus now turns his attentions to the man blind from birth. With Peter looking over his shoulder and the others watching intently, Jesus applies the clay made of spittle to cure the blind man. All the central characters align with the great vertical pillar of the temple porch, and their postures anticipate Domenico's later dramatic Institution of the Eucharist, plate 181. ✺

The story of the healing of a single blind man is told three times in the Gospels: Mark 10:46–52; Luke 18:35–43, and, in a more elaborate form, John 9:1–7, where the healed man is directed to wash in the pool of Siloam. In both plates 162 and 163 Jesus seems to be anointing the man's eyes, which seems to point to the text of John as the preferred source. The elaborate setting also perhaps derives from John, rather than the other texts. Matthew relates the healing of two blind men twice (9:27–30 and 20:30–34, pl. 159). Christiaan van Adrichem (1584: Site 199) describes "The Fountaine of Siloe, whereto was joyned the Poole of Siloe." ⚜

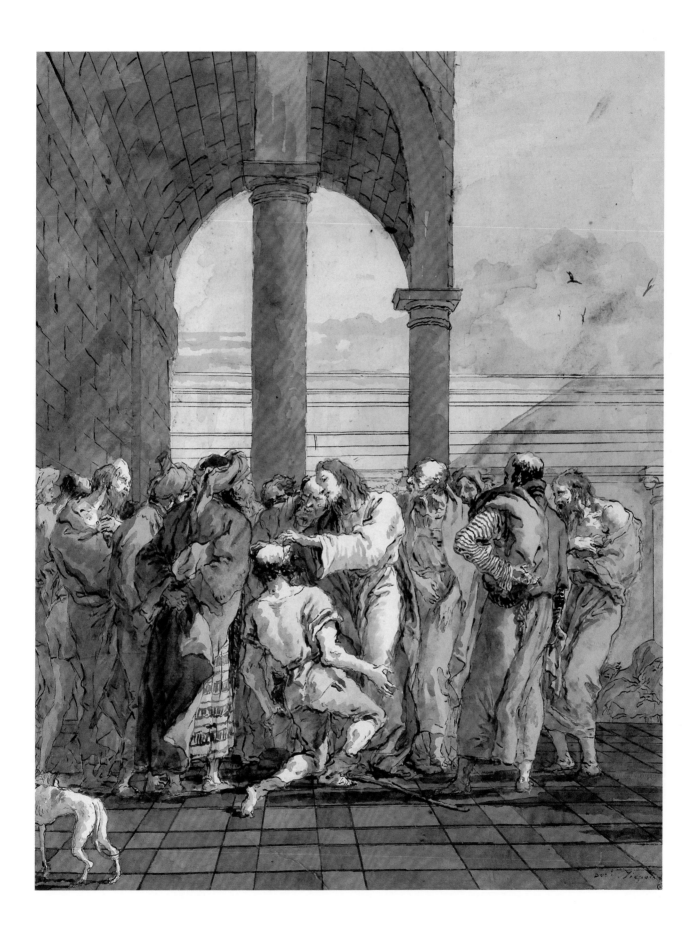

163. *Jesus Heals the Blind Man, II*

And Jesus said unto him, Go thy way; they faith hath made thee whole. And immediately he received his sight, and followed Jesus in the way. (Mark 10:52)

When he had thus spoken, he spat upon the ground, and made clay of the spittle, and he anointed the eyes of the man with the clay, and said unto him, Go, wash in the pool of Siloam. . . . He went his way therefore, and washed, and came seeing. (John 9:6–7)

> Pen and wash, over black chalk, 462 x 357
> Signed low left: Dom.o Tiepolo f
> Provenance: Jean Fayet Durand (1806–1889)
> Literature: Conrad 1996 [131]

Paris, Musée du Louvre, Département des Arts Graphiques, RF 1713bis [6]

Checking the blind man's eyes once more, Jesus instructs him to go to the pool of Siloam. His staff in hand, he prepares to set out. The disciples remain riveted by this cure, while the temple elders stand to one side, their cocked arms registering a mixture of disdain and outrage. ❧

In the note to the preceding drawing (pl. 162) it is argued that the clear gesture of Jesus anointing the eyes of the blind man, and the grandeur of the setting, indicate that the text of John is most appropriate. Here the setting is even grander. In Mark the story precedes *The Ass and Her Colt* (pl. 169). ❦

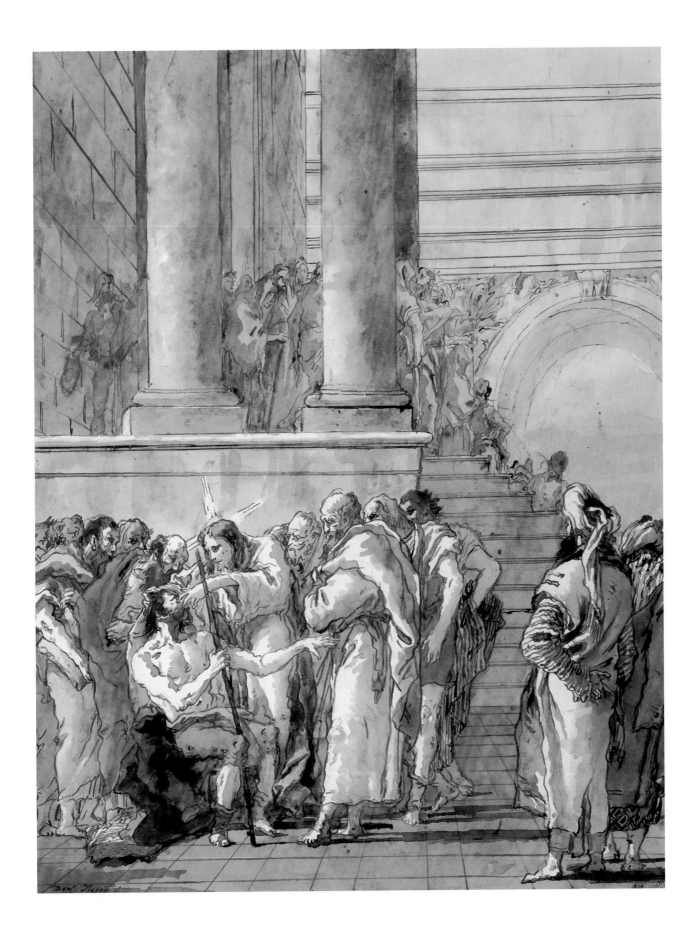

164. *The Raising of Lazarus*

And when he thus had spoken, he cried with a loud voice, Lazarus, come forth. And he that was dead came forth, bound hand and foot with graveclothes; and his face was bound about with a napkin. Jesus said unto them, Loose him, and let him go. (John 11:43–44)

Pen and wash, over black chalk, 463 x 351
Signed on the wall plaque: Dom.o Tiepolo f
Inscription: nonsense
Provenance: Jean Fayet Durand (1806–1889)
Literature: Christiaan van Adrichem 1584, Site 178; Conrad 1996 [133]

Paris, Musée du Louvre, Département des Arts Graphiques, RF 1713bis [93]

According to John, Jesus's final miracle before entering Jerusalem was raising Lazarus from the dead. In a singular interpretation of this famous subject (Lazarus's sisters are notably absent), Domenico maintains continuity with earlier events, reintroducing the lad and the blind man (last seen kneeling behind Jesus with the adulteress in the temple). His sight now restored, he kneels to witness closely as Lazarus struggles out of his tomb. His disciples stare in wonder, while the turbaned patriarch (representing the Jews specifically mentioned in John 11:43) spreads his arms in shock and another man leans away in fear. ✺

This scene is a popular one, though related only in John. It follows the two preceding drawings. Lazarus appears as a somewhat secondary figure, not standing in the traditional manner. The two men on the extreme right derive from *The Woman Taken in Adultery* (pl. 160). Christiaan van Adrichem (1584: Site 178) describes the scene at Bethany: "Here he raised up Lazarus to life, after he had been buried foure days, and began to stink." ✣

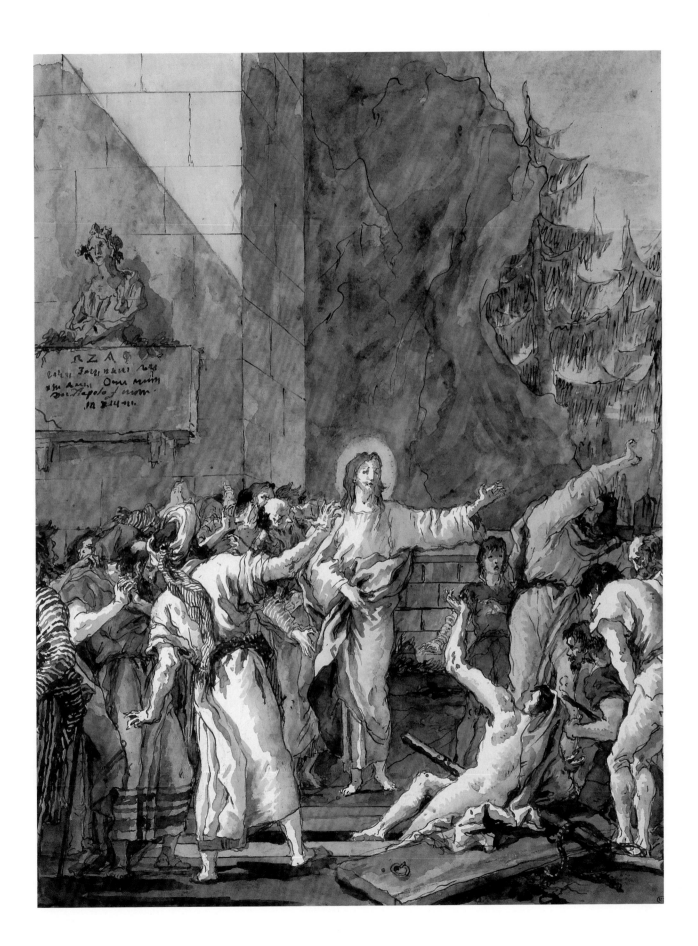

165. *The Feast in the House of Simon, II*

Then Jesus six days before the Passover came to Bethany, where Lazarus was which had been dead, whom he raised from the dead. There they made him a supper; and Martha served: but Lazarus was one of those that sat at the table with him. Then took Mary a pound of ointment of spikenard, very costly, and anointed the feet of Jesus, and wiped his feet with her hair: and the house was filled with the odour of the ointment. Then saith one of his disciples, Judas Iscariot, Simon's son, which should betray him, Why was not this ointment sold for three hundred pence, and given to the poor?
(John 12:1–4)

Pen and wash, over traces of black chalk, 480 x 380
Signed on the central column: Dom.o / Tiepolo / f
Provenance: Paris, Hôtel Drouot, Dec. 14, 1938, lot 9; Michel-Lévy; Mme. A.L.D.; Paris, Drouot Richelieu, Nov. 21, 2001 [68]
Reference: Christiaan van Adrichem 1584, Site 178

Los Angeles, The J. Paul Getty Museum (2001.83)

In Domenico's interpretation, this second feast with Simon the Leper is the banquet in honor of the revived Lazarus. The guest behind Lazarus uses the same gesture of amazement as the woman who witnessed the widow's son restored in plate 121. Several disciples lean over the table to see the source of the wonderful aroma emitting from the ointment, while Jesus points to Judas with great solemnity, as if to say, "Leave her alone: against the day of my burying she hath kept this." ❦

This second version of the subject is hardly less grand than the first (pl. 122) but the setting is more simple, and the frieze of figures more crowded, reflecting the passage in John 12:9: "Much people of the Jews therefore knew that he was there: and they came not for Jesus' sake only, but that they might see Lazarus also, whom he had raised from the dead." It clearly follows the very different story as given in John 12:1–8, showing Martha serving, Lazarus rising from his seat, Judas standing indignantly before Jesus, and Jesus remonstrating with him, while Simon sits calmly in his chair on the left. On the other hand, Mary continues to anoint Jesus's feet, as indicated by Luke and John, rather than his head, as indicated in Matthew 26:6–11 and Mark 14:3–9. Christiaan van Adrichem (1584: Site 178) describes the scene at Bethany: "Here, he sitting in the house of Simon the Leper, at the table together with Lazarus, Martha serving them, Mary anointed him with a most precious ointment." ⚜

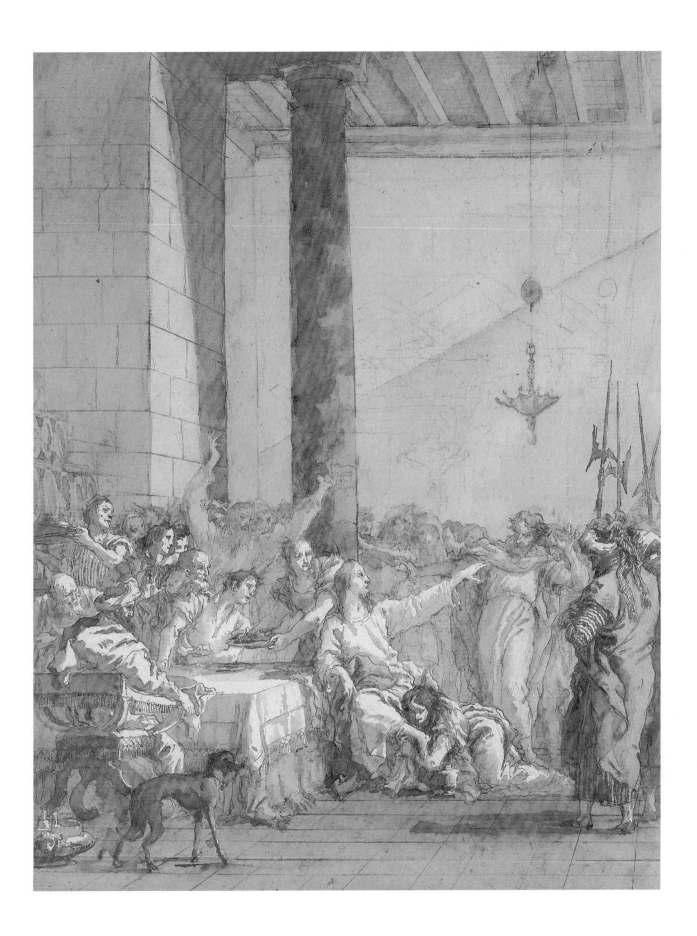

166. *Zacchaeus Climbs the Tree*

And Jesus entered and passed through Jericho. And, behold, there was a man named Zacchaeus, which was the chief among the publicans, and he was rich. And he sought to see Jesus who he was; and could not for the press, because he was of little stature. And he ran before, and climbed up into a sycomore tree to see him; for he was to pass that way.
(Luke 19:2–4)

Pen and wash, over black chalk, 470 x 360
Signed: Dom.o T
Provenance: Roger Cormier, Tours, his sale, Paris, Georges Petit, Apr. 30, 1921, no. 17; Paris, Hôtel Drouot, May 28, 1948 [15]
Literature: Guerlain 1921, 69; Conrad 1996 [98]
Reference: Pigler 1956, i, 322–323

Interested in all the events leading up to Christ's Passion, Domenico now turns to Luke and the story of Zacchaeus, the publican (tax collector) who wanted to see Jesus as he passed through Jericho. Here Zacchaeus has climbed the tree so he can see better. The blind man, Bartimaeus, whom Jesus had cured earlier (pl. 159), is kneeling in the crowd together with a woman, who might be the mother of Zebedee's sons (pl. 158). Both met Jesus in Jericho (pl. 159). 🍂

The story of Zacchaeus, which is described only by Luke, is told by Domenico in three similar drawings (pls. 166–168) and precedes the episode of *The Ass and Her Colt.* This appears to be the first scene, with the town of Jericho spread out in the distance and Jesus surrounded by a considerable crowd of people. Zacchaeus climbs a tall tree with small leaves, very different to the *ficus sycamorus,* shown in the San Marco mosaic, which seems to be clearly bearing figs. ⚜

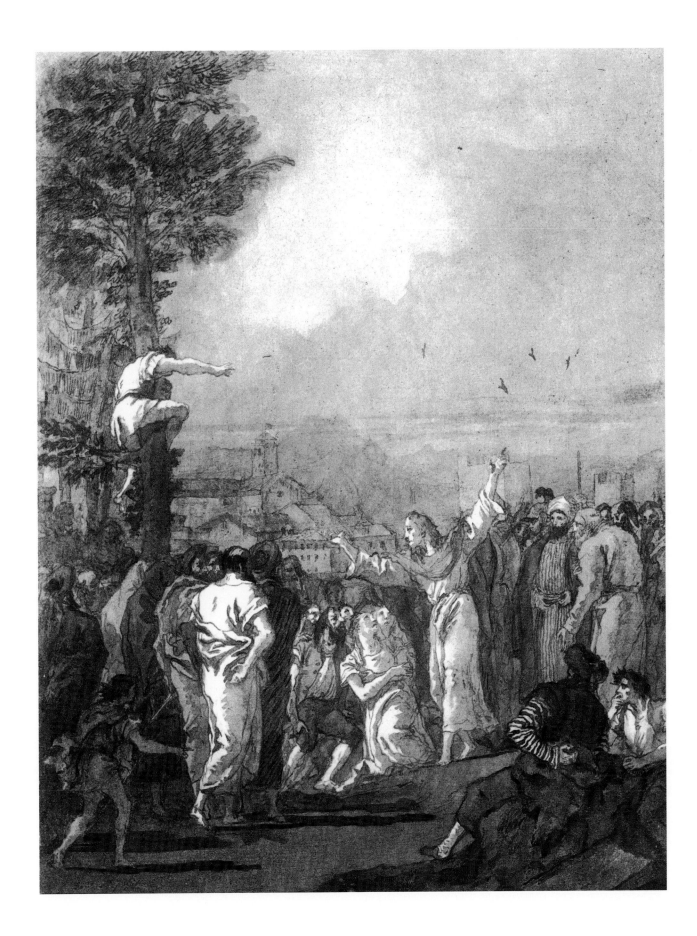

167. *Zacchaeus Climbs Down from the Tree*

And when Jesus came to the place, he looked up, and saw him, and said unto him, Zacchaeus, make haste, and come down; for today I must abide at thy house. And he made haste, and came down, and received him joyfully. (Luke 19:5–6)

> Pen and wash, over extensive black chalk, 454 x 358
> Signed low left center: Dom.o Tiepolo f
> Provenance: Sotheby's, New York, Jan. 9, 1996 [64]

San Francisco, private collection

Zacchaeus is assisted down from what has become a sycamore tree as Jesus beckons him to approach. Several Apostles look at Jesus in evident astonishment as he orders Zacchaeus to make haste because he intends to dine with him. ❦

Here Jesus is clearly addressing Zacchaeus, now a well-dressed man, who is being helped down from the tree, which is now more convincing as a sycamore. Luba Eleen suggests that it may be more properly identified as the *ficus carica,* similar to the common plane tree. The background now depicts the walls of Jericho. The story is told only by Luke. ⚜

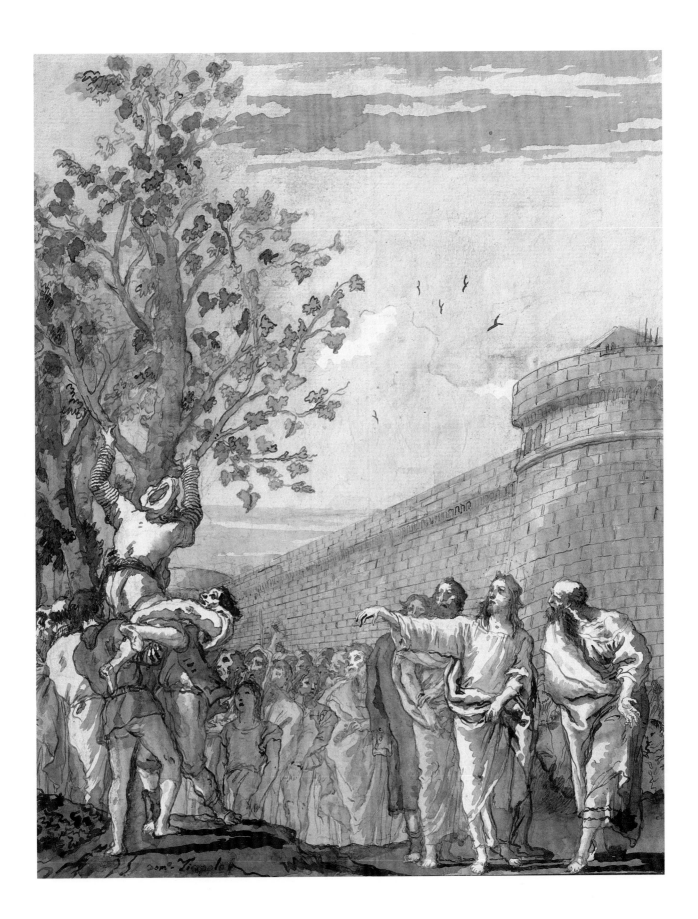

Dom.º Tiepolo

168. *The Meeting of Jesus and Zacchaeus*

And Jesus entered and passed through Jericho. And, behold, there was a man named Zacchaeus, which was the chief among the publicans, and he was rich. And he sought to see Jesus who he was; and could not for the press, because he was of little stature. And he ran before, and climbed up into a sycomore tree to see him; for he was to pass that way. And when Jesus came to the place, he looked up, and saw him, and said unto him, Zacchaeus, make haste, and come down; for today I must abide at thy house. And he made haste, and came down, and received him joyfully. And when they saw it, they all murmured, saying, That he was gone to be guest with a man that is a sinner. (Luke 19:2–7)

Pen and wash, over black chalk, 457 x 355
Signed low right: Dom.o Tiepolo f
Provenance: Roger Cormier, Tours, his sale, Paris, Georges Petit, Apr. 30, 1921, no. 15; Sotheby's, June 21, 1978 [40]; bt. Stein
Literature: Conrad 1996 [99]

Paris, Adolphe Stein

Always sensitive to potential humor, Domenico has fun with the confrontation between the diminutive Zacchaeus and Jesus. As Jesus informs Zacchaeus of his plans, Peter is prominently visible at the picture's edge. *The Golden Legend* helps account for their connection, stating that because of Zacchaeus, Faustinus and Faustus later became followers of Peter (instead of Simon Magus). Interestingly, Domenico leaves out the scene of their meal together (which has limited visual currency) and concludes with a face-to-face encounter between Jesus and Zacchaeus, thereby stressing the "eyewitness" dimensions to Luke's text. ❧

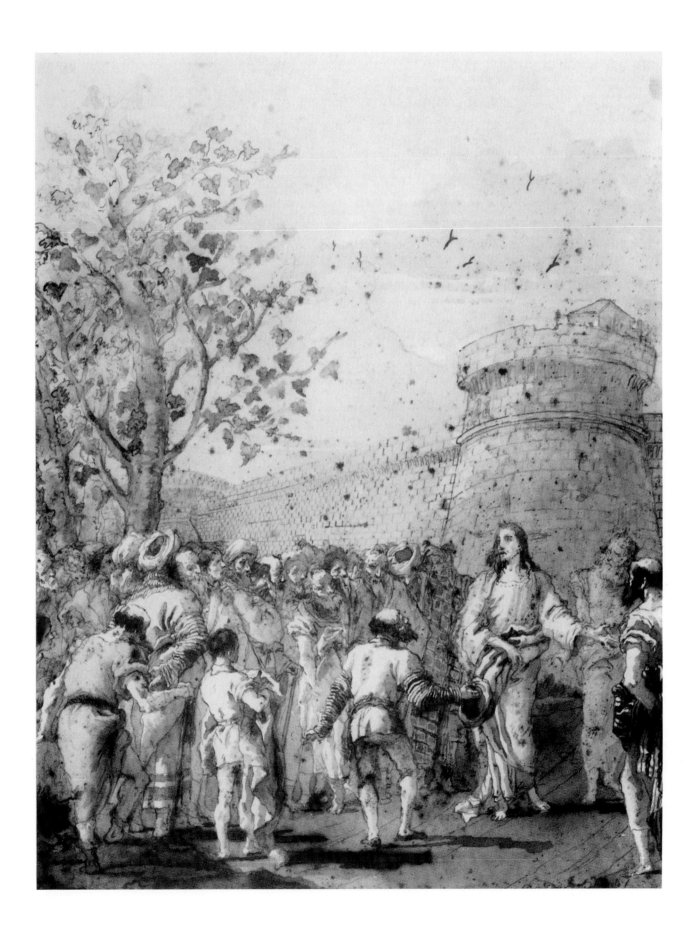

Part VIII

Christ's Passion Begins: His Triumphal Entry to the Last Supper, Plates 169–180

The Gospels provide a fairly full account of how Jesus reentered Jerusalem and what led up to the Last Supper. Matthew, Mark, Luke, and John all relate that Jesus asked his disciples to get an ass and her colt so that he could ride into the city, where he was welcomed by people waving branches (John alone specifies palms) that they spread in his path, together with their clothes. Jesus then drove the money lenders from the Temple and again taught lessons about money ("render unto Caesar"); there also, according to Matthew, he healed the blind and the lame and disputed with the Temple elders over various issues, including the widow with many husbands, which according to Matthew, drove the elders to seek ways to rid themselves of Jesus. John has the Last Supper occur almost immediately after Jesus entered Jerusalem.

Christ's triumphal entry and his cleansing of the Temple were standard episodes in picture cycles, while other events, including Jesus stating "render unto Caesar," were the

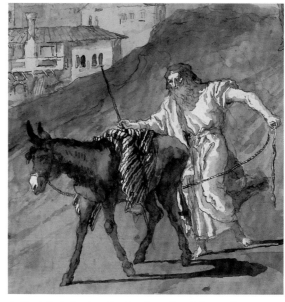

A disciple bringing the donkey, detail from plate 169, *The Disciples Find the Ass and Her Colt*

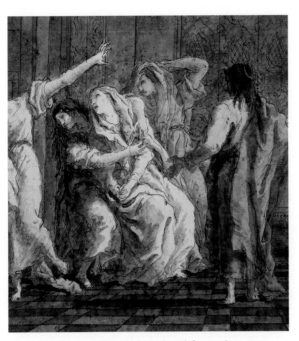
Jesus speaking to his mother, detail from plate 179,
Jesus Taking Leave of His Mother

subject of numerous easel pictures. Domenico expanded his consideration of all these events, incorporating many more scenes than was traditional. He included a rare prelude to Jesus's triumphal entry, the disciples with the ass and colt, followed by two successive frames of his actual entry, electing to show his celebrants waving olive branches (alluding to the Mount of Olives, where Luke 22:39 would say Jesus went to pray) instead of the more traditional palms. Two drawings portray Jesus cleansing the temple; several more consider his disputes and activities around the temple, followed by a rare and dramatic glimpse into the priestly conspiracy and the pact of Judas. Domenico added scenes derived from apocryphal sources, notably Jesus bidding his mother farewell, followed by a unique sequel showing her sorrowfully following after him as he weeps.

169. *The Disciples Find the Ass and Her Colt*

And when they drew nigh unto Jerusalem, and were come to Bethphage, unto the mount of Olives, then sent Jesus two disciples, saying unto them, Go into the village over against you, and straightway you shall find an ass tied, and a colt with her: loose them and bring them unto me. (Matt. 21:2)

And they brought the colt to Jesus and cast their garments on him; and he sat upon him. (Mark 11:7)

> Pen and wash, over black chalk, 460 x 354
> Not signed
> Provenance: Jean Fayet Durand (1806–1889)
> Literature: Conrad 1996 [137]
> Reference: Christiaan van Adrichem 1584, Site 179; Pigler 1956, i, 323; Réau 1957, 398, cites two rare examples

Paris, Musée du Louvre, Département des Arts Graphiques, RF 1713bis [87]

Depicting a rarely portrayed prelude to Christ's triumphal entry, Domenico presents a bearded disciple who appears somewhat inexperienced in handling the donkey Jesus instructed them to find. The donkey has taken the lead, and the disciple prepares to tap it slightly to make it turn in the proper direction. One of the garments has already been laid upon the animal in preparation for Jesus's forthcoming ride into Jerusalem. Domenico has once again inserted a clock tower into the village gate, another allusion to time. ❦

Domenico places in a broad and attractive landscape the story of Jesus rather high-handedly instructing two disciples to commandeer the ass and her colt and to bring them to him. They sensibly have taken control of the mother, whom the colt, watching rather nervously at a distance, will no doubt follow. Bethphage is identified as a little village to the east of Mount Olivet, according to Christiaan van Adrichem (1584: Site 179). ⚜

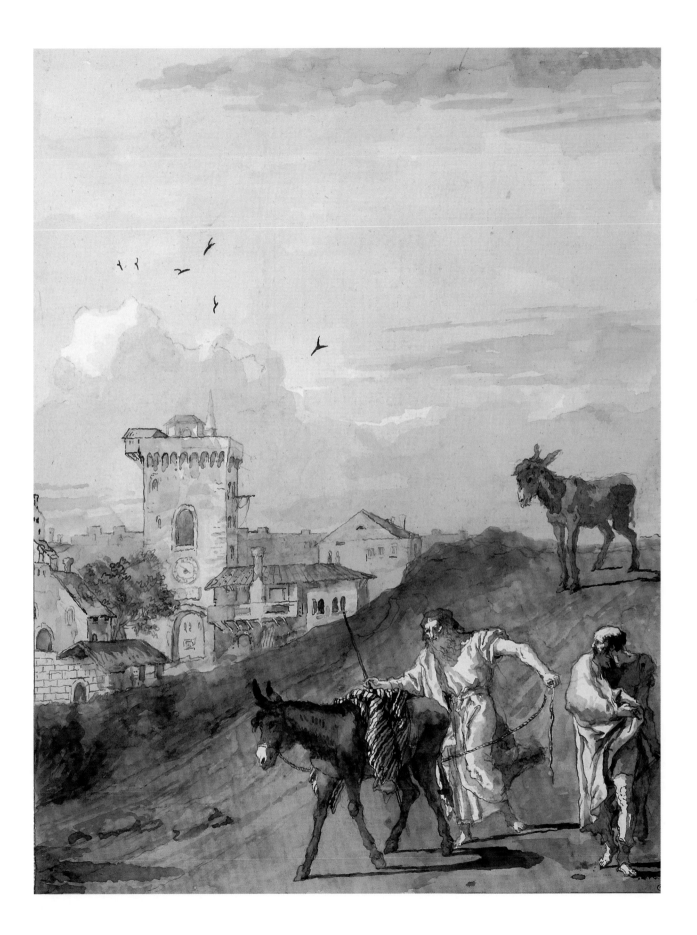

170. *The Entry of Jesus into Jerusalem, I*

On the next day much people that were come to the feast, when they heard that Jesus was coming to Jerusalem, took branches of palm leaves, and went forth to meet him, and cried, Hosanna: Blessed is the King of Israel that cometh in the name of the Lord. And Jesus, when he had found a young ass, sat thereon: as it is written, Fear not, daughter of Sion: behold, thy King cometh, sitting on an ass's colt. (John 12:12–15)

Pen and wash, over black chalk, 470 x 360
Signed low left: Dom.o Tiepolo f
Provenance: Roger Cormier, Tours, his sale, Paris, Georges Petit, Apr. 30, 1921 [7]; Duc de Trévise, his sale, Paris, Hôtel Drouot, Dec. 8, 1947, no. 26
Exhibition: Chicago 1938, pl. 89
Literature: Guerlain 1921 [71]; Conrad 1996 [138]
Reference: Christiaan van Adrichem 1584, Site 15

Strong breezes billow Christ's robes as he hastens to the gates of Jerusalem on his donkey, now led by a much more experienced handler, probably the good thief who escorted the Holy Family out of the farm at a similarly rapid pace (pl. 69). Men wave olive branches (alluding to the Mount of Olives). Some spread their garments as Mark (11:8) indicates. Interestingly, most of the worshippers here are men or boys, reminding us of the passage in Luke 19:37–38, who said that his disciples (to the great vexation of the Pharisees) began to rejoice and praise God for all the mighty works they had seen, saying "Blessed be the King that cometh in the name of the Lord." The lad to the left anticipates the one who assists in Christ's crucifixion (pl. 224). ✺

This scene is popular in all ages. Preceded by the much rarer theme, *The Disciples Find the Ass and Her Colt* (pl. 169), the two themes are often found in various combinations; thus the colt attends his mother in the woodcut by Gustave Doré in his illustration for *La Sainte Bible selon la Vulgate,* Tours 1866 [opp. col. 557]. Christiaan van Adrichem (1584: Site 212) states: "This way came Christ to Jerusalem"; and Site 155: "The Golden Gate . . . By this gate Christ came riding upon an Asse into the City of Jerusalem, at what time men cut down Palmes, & strowed them in his way, crying *Hosanna* before him." John's citation states that "thy King cometh, sitting on an ass's colt." ⚜

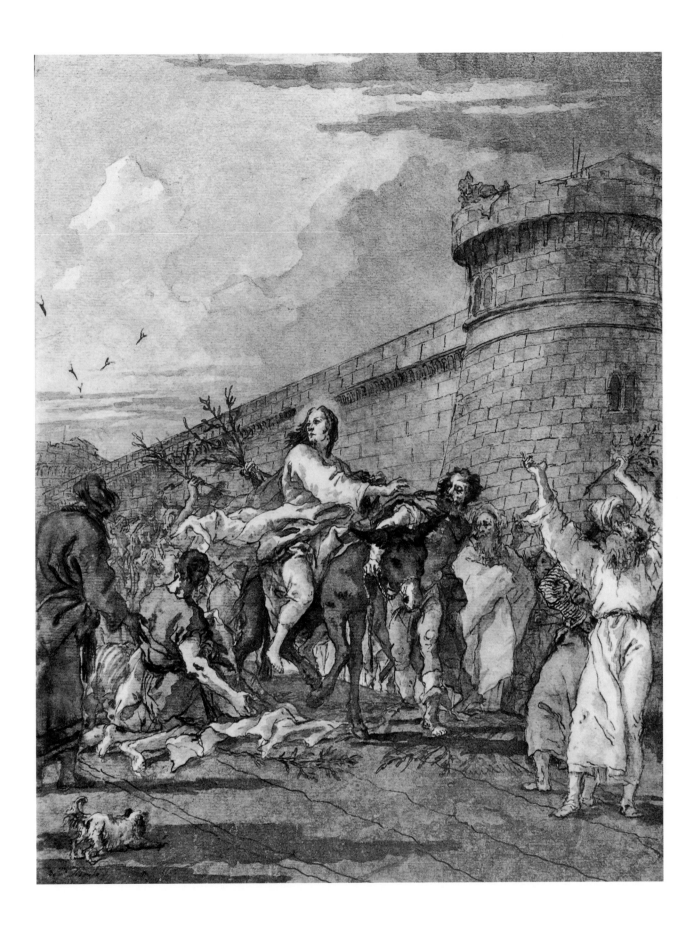

171. *The Entry of Jesus into Jerusalem, II—TIBERIUS CESAR*

And a very great multitude spread their garments in the way: others cut down branches from the trees, and strawed them in the way. And the multitudes that went before, and that followed, cried, saying, Hosanna: Blessed is he that cometh in the name of the Lord; Hosanna in the highest. And when he was come into Jerusalem, all the city was moved, saying, Who is this? (Matt. 21:8–10)

> Pen and wash, over black chalk, 454 x 350
> Signed low left: Dom.o Tiepolo f
> Provenance: Jean Fayet Durand (1806–1889)
> Literature: Conrad 1996 [139]
> Reference: Christiaan van Adrichem 1584, Site 155; Jameson, *History of our Lord,* ii, 1890, 5–11; Pigler 1956, i, 323–325; Réau 1957, 398

Paris, Musée du Louvre, Département des Arts Graphiques, RF 1713bis [89]

Stopped by the crowd as he passes through Jerusalem's gate (unusual timing for this famous subject), Jesus confronts the throng pressing toward him, waving even more olive branches. Above him in the gateway is the profile bust of Tiberius Caesar, under whose authority Jesus would ultimately be tried and convicted. A woman standing near her boy later joins the crowd when Jesus is presented to the people (pl. 195). ✹

Domenico here offers a design that is unusual in that it reads from right to left. It may have been designed to follow plate 171, which is in the traditional arrangement; nevertheless, it shows the spreading of the garments clearly. It also makes great play with the palm leaves that give this occasion the name of Palm Sunday. Christiaan van Adrichem (1584: Site 155), on the Golden Gate: "[B]y this Gate Christ came riding upon an Asse into the City of *Jerusalem,* at what time men cut down Palmes, & strowed them in his way, crying *Hosanna* before him." ⚜

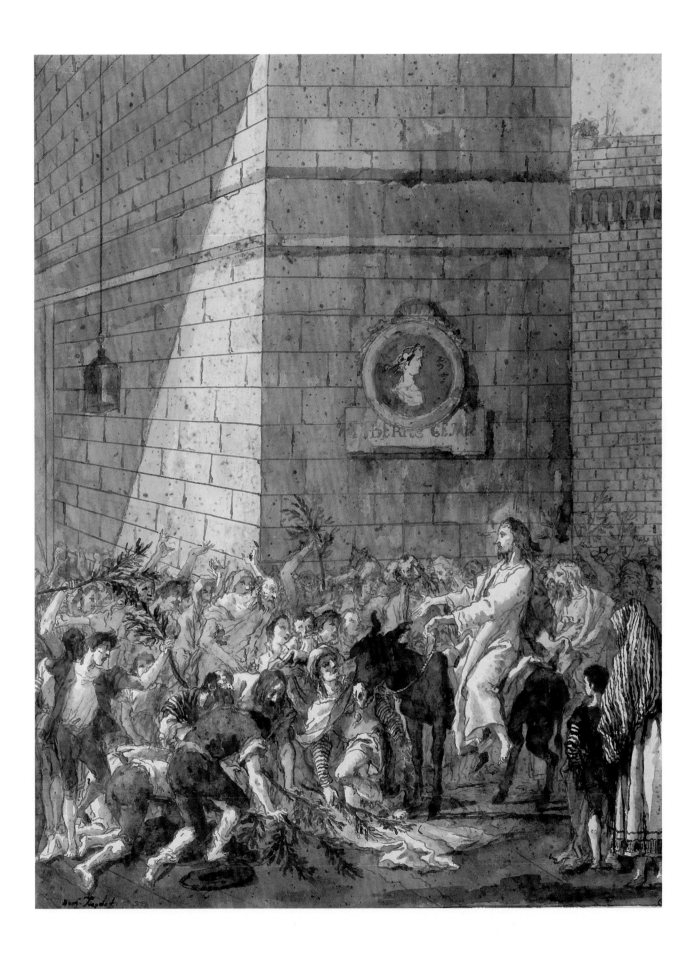

172. *Jesus Cleansing the Temple, I*

And Jesus went into the temple of God, and cast out all them that sold and bought in the temple, and overthrew the tables of the moneychangers, and the seats of them that sold doves. (Matt. 21:12)

> Pen and wash, over black chalk, 457 x 353
> Signed on the column in center: Dom.o Tiepolo f
> Provenance: Jean Fayet Durand (1806–1889)
> Literature: Conrad 1996 [141]
> Reference: Christiaan van Adrichem 1584, Site 100

Paris, Musée du Louvre, Département des Arts Graphiques, RF 1713bis [5]

Liberated doves flutter away as Jesus, having overturned the money changers' tables, vents his fury on one hapless man while his companion hurriedly scoops up the scattered coins. Others gather up their belongings and try to escape. Most likely a second scene (pl. 173) was the intended sequel, which shows Jesus attacking the cattle and sheep (seen here in the background). ❧

This is cited in John 2:15 (pl. 173) and here, with much the same action. However, the setting is now an exterior scene that broadly follows that of *Jesus Healing the Blind Man* (pls. 162–163). One may note that there are again two versions in Ricci 1607: *XX La prima scacciata dal tempio* [Tav. 19] and *CXIV L'entrata di Giesù nel tempio* [Tav. 113], again reflecting the two texts, the differences being quite slight. The design here seems to emphasize the money changers, and the doves are very prominent; hence, Domenico appears to follow the text of Matthew 21:12 rather than John 2:15 (compare pl. 173), in which many examples are cited. Christiaan van Adrichem (1584: Site 100), locates this scene in the Court of the Gentiles: "Here hence it was that Christ did cast out twice the buyers and sellers; and suffered not any man to carry so much as a vessell through the same." ⚜

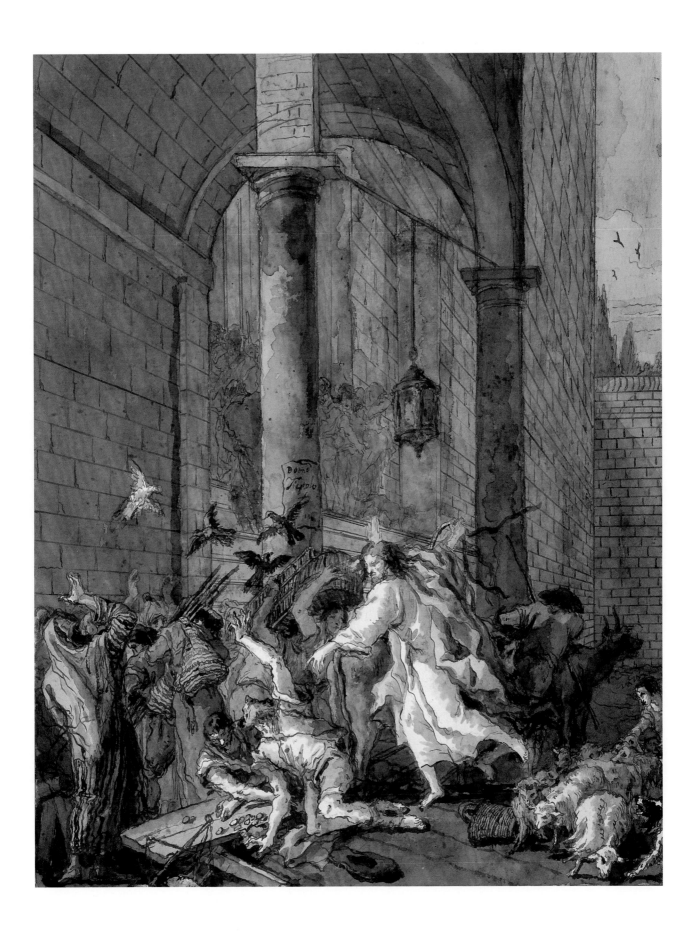

173. *Jesus Cleansing the Temple, II*

And when he had made a scourge of small cords, he drove them all out of the temple, and the sheep and the oxen; and poured out the changers' money, and overthrew the tables. (John 2:15)

Pen and wash, over black chalk, 457 x 365
Signed low left: Dom.o Tiepolo f
Provenance: Jean Fayet Durand (1806–1889)
Literature: Conrad 1996 [140]
Reference: Christiaan van Adrichem 1584, Site 100; Pigler 1956, i, 325–330

Paris, Musée du Louvre, Département des Arts Graphiques, RF 1713bis [4]

Birds escape from their broken cages as a herdsman attempts to protect his huge ox from Jesus's attack. The Temple, whose steps and festooned doorway echo plate 2, is in chaos, though one visitor ascends the step undistracted by the hubbub below him. One youth, whose eggs spill out of his basket, is nearly crushed in the melee. ❧

Domenico depicts this scene twice, but here the sheep and oxen seem to show that he has the text of John before him. Matthew 21:12–13 places this event much later, immediately following the entry of Jesus into Jerusalem (pls. 170–171). In this case the setting broadly follows the view of the Temple in plates 11, 12, 16, and 28. The location is established by Christiaan van Adrichem (1584: Site 100), as the Court of the Gentiles. ⚜

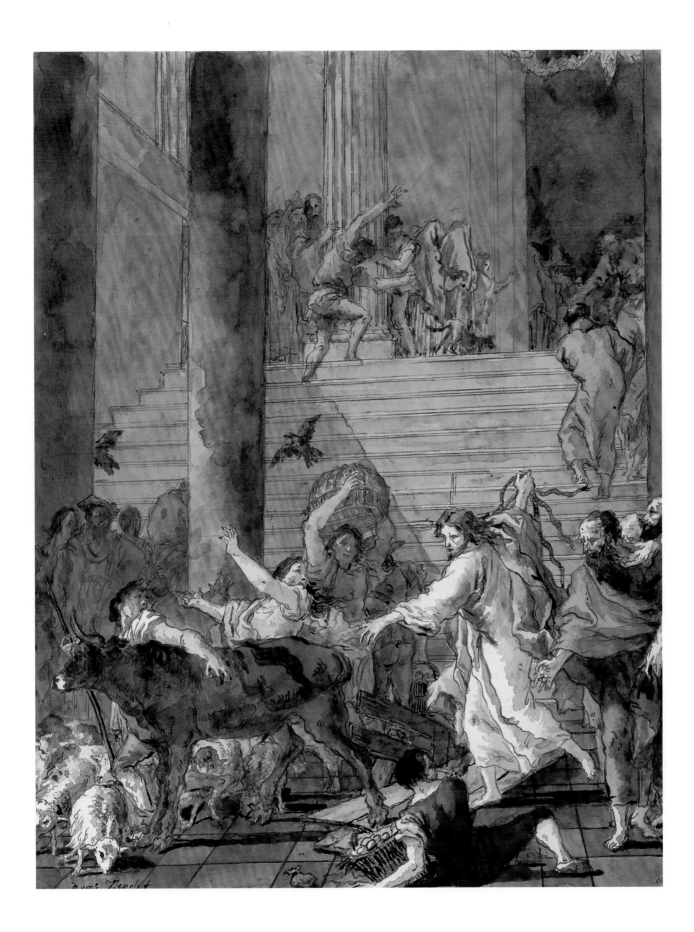

174. *Jesus in the Temple*

And when he was come into the temple, the chief priests and the elders of the temple came unto him as he was teaching, and said, By what authority doest thou these things? And who gave thee this authority? (Matt. 21:23)

Pen and wash, over black chalk, 461 x 355
Signed on column: Dom.o Tiepolo f
Provenance: Jean Fayet Durand (1806–1889)
Literature: Byam Shaw 1962 [30]; Conrad 1996 [142]

Paris, Musée du Louvre, Département des Arts Graphiques, RF 1713bis [100]

Standing atop the grand stairwell of a magnificent Temple, Jesus turns toward his interrogators. His pose and several figures in the group echo the episode of Jesus and the adulteress, and may be Domenico's way of alluding to the questions posed by the elders involving the fate of a much married widow in heaven (Matt. 22:25). The scene makes a grand finale to the Temple and its stairwell, which was so important in the life of Christ, his parents, and his grandparents. 🍂

Domenico's vision of the temple seems to be inspired by the interior of Sta. Maria della Salute, making one of his most elaborate designs. The figure of Jesus and the dog running down the steps is found again in *The Woman Taken in Adultery* (pl. 160) and the figure of Jesus again in *"Go and sin no more"* (pl. 161), establishing a certain relationship between these events. ⚜

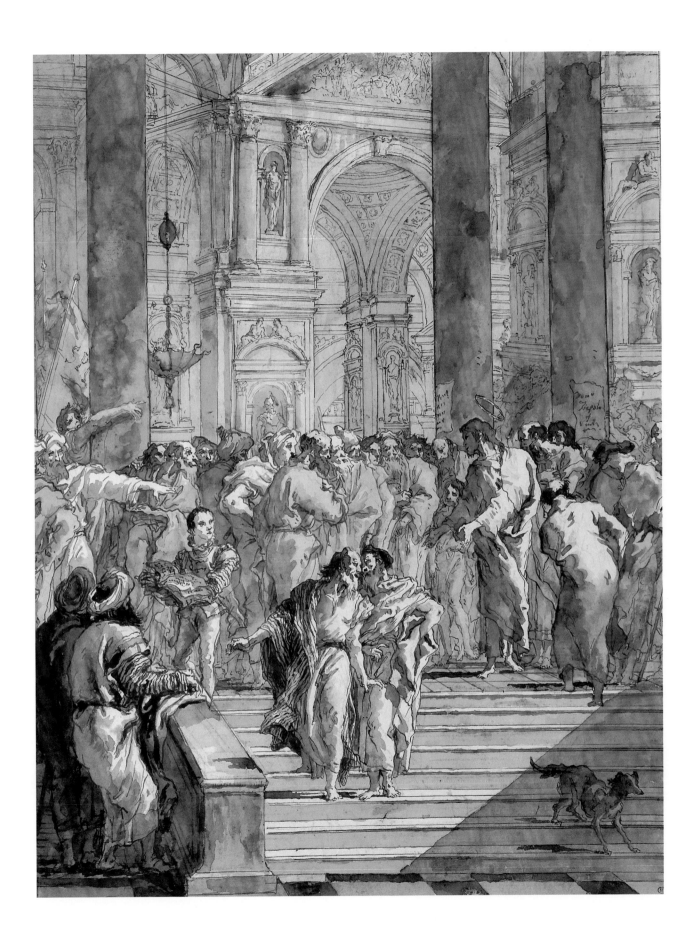

175. *The Tribute Money*

Shew me the tribute money. And they brought unto him a penny. And he saith unto him. Whose is this image and superscription? They say unto him, Caesar's. Then saith he unto them, Render unto Caesar the things that are Caesar's; and unto God the things that are God's. (Matt. 22:19–21)

> Pen and wash, over black chalk, 460 x 354
> Signed on column: Dom.o Tiepolo f
> Provenance: Jean Fayet Durand (1806–1889)
> Literature: Conrad 1996 [101]

Paris, Musée du Louvre, Département des Arts Graphiques, RF 1713bis [92]

The Temple porch is once again the setting for an episode dealing with the elders' attempt to trick Jesus into a false step on the question of paying taxes. Given Matthew's calling (he was a tax collector), his interest in and discussion of this subject are appropriate. The presence of the poor in the foreground may hint at the idea of tax used for general welfare. ❦

The question of tribute money is raised twice in Matthew, and not at all in the other Gospels. This drawing relates to the second episode. The first, illustrated in plate 145, is found in Matthew 17:27. Here the man before Jesus clearly seems to be holding up a coin. The setting broadly follows the same pattern as plates 172–173. ⚜

176.** *"Le Christ, un ange, saint Jean et un autre personnage"*

??And he sent Peter and John, saying, Go and prepare us the passover, that we may eat. (Luke 22:8) *??*

> Pen and wash, 460 x 360
> Signed low right
> Provenance: Roger Cormier, Tours, his sale, Paris, Georges Petit, Apr. 30, 1921, no. 27

No image recorded.

177. *The Chief Priests in the Palace of Caiaphas*

Then assembled together the chief priests, and the scribes, and the elders of the people, unto the palace of the high priest, who was called Caiaphas, and consulted that they might take Jesus by subtilty, and kill him. (Matt. 26:3–4)

Pen and wash, over black chalk, 463 x 355
Signed twice: low left: Dom.o Tiepolo f / on the column: Dom.o Tiepolo f
Provenance: Jean Fayet Durand (1806–1889)
Literature: Christiaan van Adrichem 1584, Site 17; James 1924, 96; Conrad 1996 [264]

Paris, Musée du Louvre, Département des Arts Graphiques, RF 1713bis [131]

In an opulent, windowless room, the chief priests discuss what to do about Jesus. Most have their backs turned toward us, but Domenico shows one priest facing us behind Caiaphas. Consulting his text, he appears to be commenting on the feast days while the chief priest expostulates, registering his reluctance to cause an uproar among the people. ❧

The Gospel of Nicodemus or *The Acts of Pilate* begins the story of the Passion with this scene of the Jews assembled in council as they "came unto Pilate accusing Jesus of many deeds." The very grand setting, with the High Priest enthroned on a dais under a baldachino, is similar to *Herod Interrogating Zacharias* (pl. 85). The characteristic costume of the priesthood as shown here seems to go back at least to the sixteenth century. Titian's and Tintoretto's High Priests in the Accademia *Presentation of Mary in the Temple* of 1534–1538 (Valcanover 1969 [XXI]) and the Madonna del Orto canvas of 1552 (de Vecchi 1970 [94A]) wear a similar costume with a highly colored tassled overgarment, a jewelled breast-plate, and a white undergarment. Domenico seems to favor an entirely white costume. The Palace of Caiaphas is described by Christiaan van Adrichem (1584: Site 17). ❧

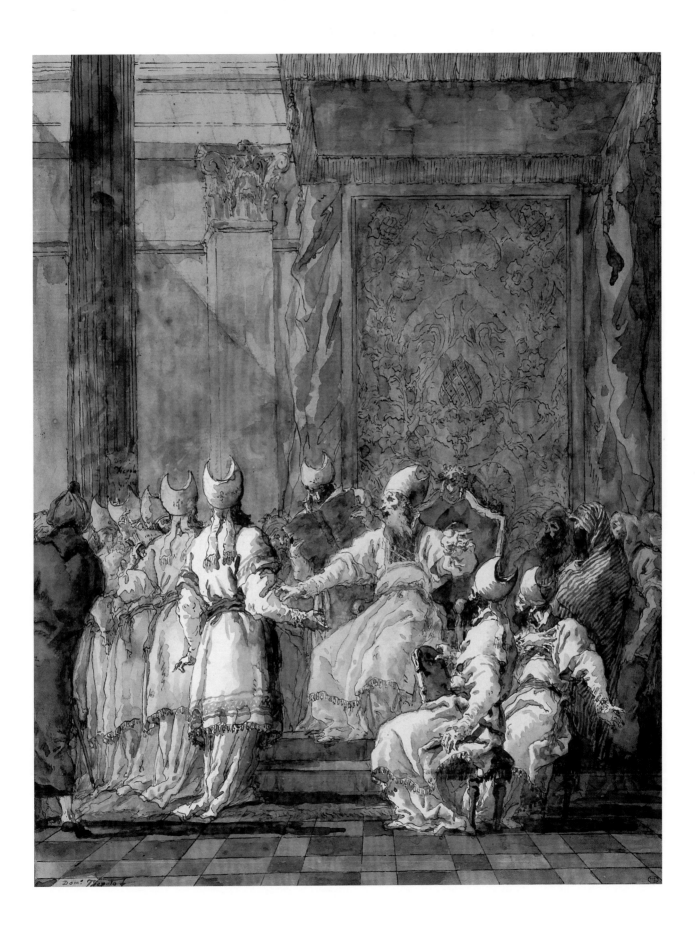

178. *Judas Makes a Covenant with the Priests*

Then one of the twelve, called Judas Iscariot, went unto the chief priests, and said unto them, What will ye give me, and I will deliver him unto you? And they covenanted with him for thirty pieces of silver. (Matt. 26:14–15)

Pen and wash, over slight black chalk, 460 x 355
Signed on column, right: Dom.o Tiepolo f
Provenance: Jean Fayet Durand (1806–1889)
Literature: Conrad 1996 [146]
Reference: Christiaan van Adrichem 1584, Site 17; Réau 1957, 433

Paris, Musée du Louvre, Département des Arts Graphiques, RF 1713bis [116]

With almost operatic drama, Judas and the chief priests stridently point stage right, indicating their agreed-upon terms regarding Jesus's fate. As elders look on with interest, a younger pair of bystanders coolly count up the cost of Judas's fees on their fingers. The turbaned figure pointing at the left reminds us of John's earlier words regarding Lazarus (11:46) that "some of them went their ways to the Pharisees and told them what things Jesus had done." 🖋

Here Domenico abandons the characteristic costume of the priesthood that he established so carefully in the preceding drawing (pl. 177); instead, the twisted figure of Judas seems to be addressing a lay tribunal. The agitation of Judas and the gesture of dismissal of the central seated figure may suggest that the scene represents his attempt to return the pieces of silver. Christiaan van Adrichem (1584: Site 17), locates this episode in the Palace of Caiaphas. ⚜

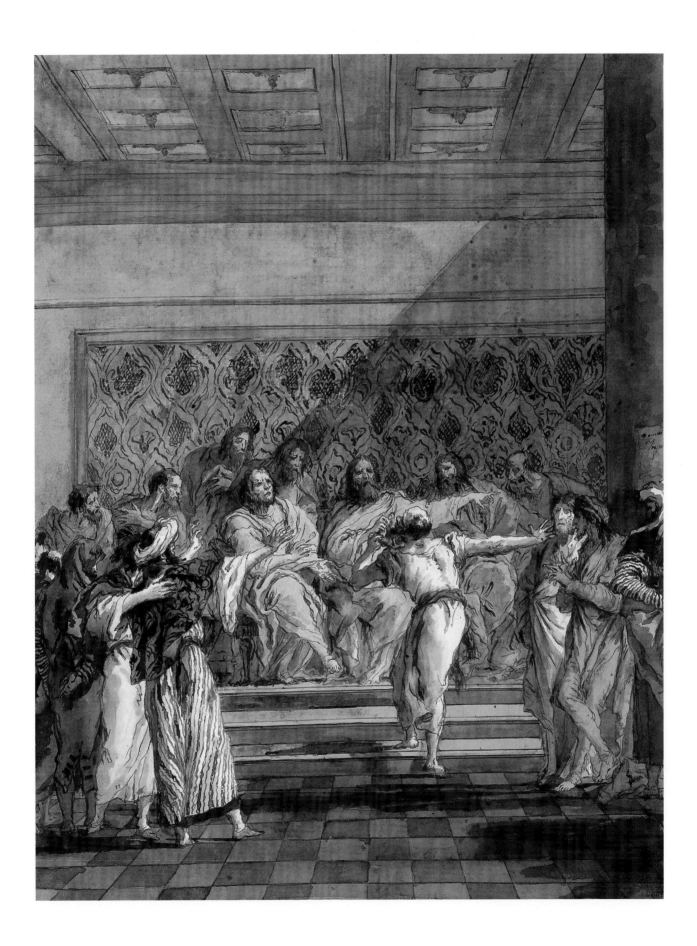

179. *Jesus Taking Leave of His Mother*

Thursday, the eve of the Passion and Death of the Savior, had arrived; at the earliest dawn the Lord called to him his most beloved Mother and She, hastening to prostrate herself at his feet, responded: "Speak, my Lord and Master, for thy servant heareth." (Maria de Agreda 1971, iii, 418–419)

Oh, if you could see the Lady weeping between these words, but moderately and softly, and the Magdalen frantic about her Master and crying with deep sobs. . . . Said the Lord, gently consoling them, "Do not cry. You know that I am bound to obey the Father." (Meditations on the Life of Christ, 308–309)

> Pen and wash, over black chalk, 480 x 382, sheet, 457 x 361, image
> Signed low right: Dom.o Tiepolo f
> Provenance: Roger Cormier, Tours, his sale, Paris, Georges Petit, Apr. 30, 1921, no. 26, as *Jesus et les quatre femmes éplorées;* New York, J. Seligman & Co.
> Literature: Joachim and McCullagh 1979, no. 142 [148], as *Jesus in the House of Jairus;* Conrad 1996 [144]
> Reference: Christiaan van Adrichem 1584, Site 10; Pigler 1956, i, 306; Réau 1957, 385; Ragusa and Green 1961, 308–309; Maria de Agreda 1971, iii, 417–429

The Art Institute of Chicago, Margaret Day Blake Collection, 1960.547

Pomegranates decorate the room that now echoes with the sounds of grief from the sorrowful women. One can almost hear their wails, sobs, and cries. Jesus, his back turned to us, remains calm as he explains to his mother that she shall have her Passover in Bethany while he will follow his Father's command and have his in Jerusalem. Her eyes turned heavenward, Mary may still be hoping for the reprieve she had asked her son to request from God. 🌿

The scene, here identified as *Jesus Taking Leave of His Mother,* does not correspond to any text in the Gospels, though it is described at length in the *Meditationes vitae Christi,* beginning: "Here one may interpolate a very beautiful meditation of which the Scripture does not speak." It is also treated at length by Maria de Agreda. We suggest that it is followed by *Jesus Leaves His Mother's House* (pl. 180), which shows the same group of women by the door of the house as Jesus leaves, weeping. The house of Mary is established by Christiaan van Adrichem (1584: Site 10). ⚜

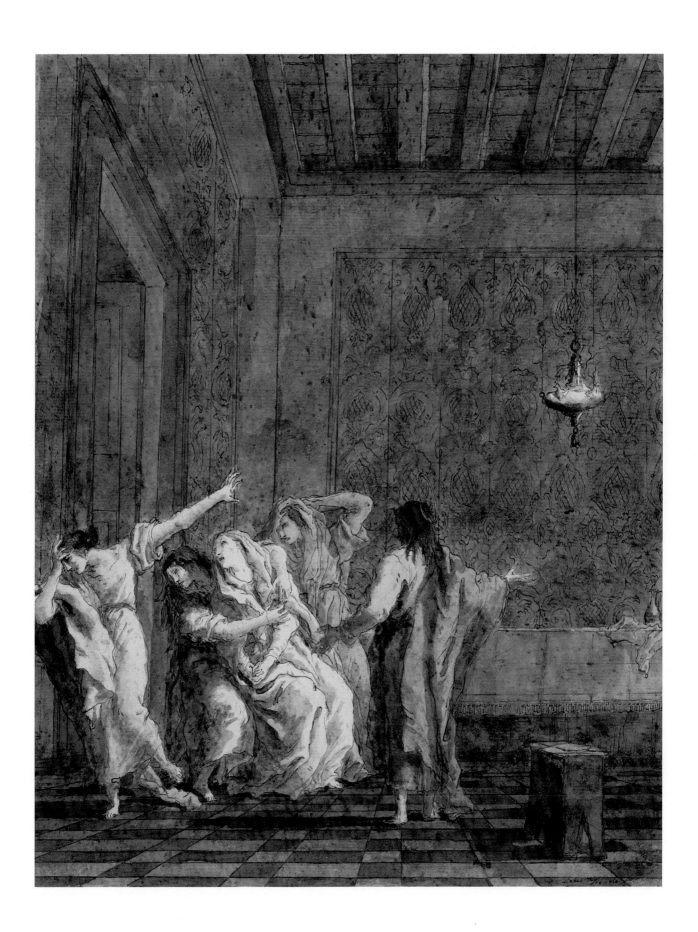

180. *Jesus Leaves His Mother's House*

At the close of this interview the Son of the eternal Father gave his blessing to his beloved Mother and prepared to enter upon that last journey, which led to his suffering and death. (Maria de Agreda 1971, iii, 423)

Pen and wash, over black chalk, 463 x 363
Not signed
Provenance: Jean Fayet Durand (1806–1889)
Literature: Conrad 1996 [186]
Reference: Christiaan van Adrichem 1584, Site 10; *The Golden Legend* 1900, iv, 235; Maria de Agreda 1971, iii, 405–427

Paris, Musée du Louvre, Département des Arts Graphiques, RF 1713bis [60]

Always interested in scenes of departure, Domenico presents a weeping Jesus (a most unusual characterization based on traditional images of John) leaving his mother's house as Mary, nearly collapsed with grief and supported by her companions, follows him. Their mournful gestures indicate their knowledge of and misery over his destiny. ❦

It is here suggested that this scene is a sequel to *Jesus Taking Leave of His Mother* (pl. 179). It shows the Virgin supported by a similar group of women, preceded by a weeping man, who must be identified as Jesus. We have found no text that specifically refers to this suggested event; Maria de Agreda, in her long account of Jesus's last meeting with his mother, does not refer to Jesus leaving the house. The house of Mary is established by Christiaan van Adrichem (1584: Site 10). ⚜

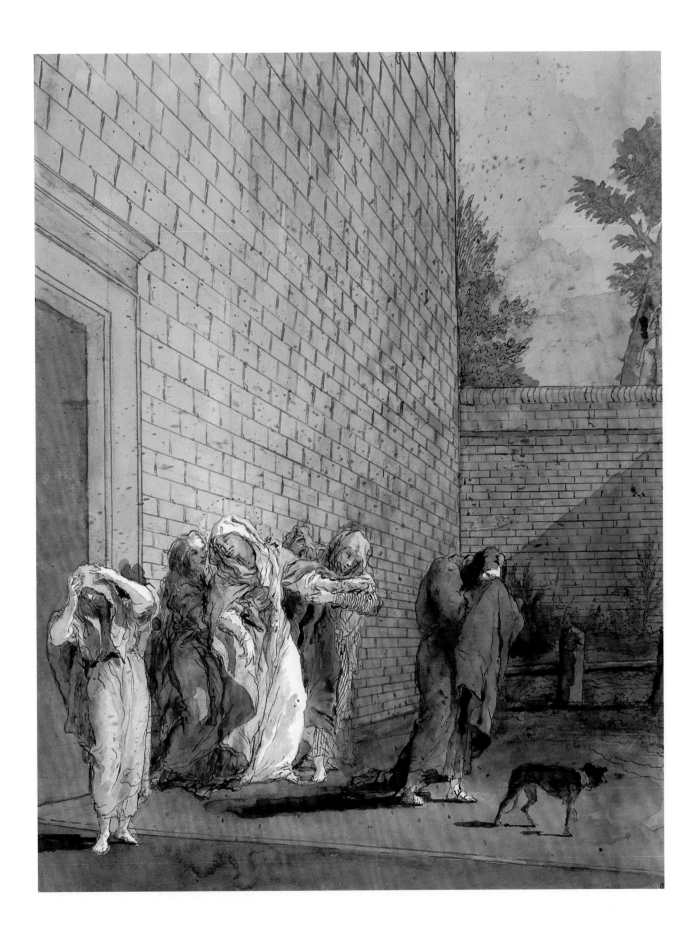

The Institution of the Eucharist, Plate 181

All four Gospels and many later commentaries describe Christ's final Passover meal, known as the Last Supper, which he shared with his twelve disciples. Matthew, Mark, and Luke mention two events taking place during the meal. First, as they ate, Christ announced his imminent betrayal by one of them, eliciting shock from all except Judas. Second, special mention is made of the institution of the Eucharist, in which Jesus first offered the wine and bread to his disciples as the ritual representation of the upcoming sacrifice of his flesh and blood upon the cross.

John alone describes Jesus humbling himself before the meal by washing the disciples' feet, to which Peter objected as too great an act of humility. Traditionally the subject of a single magnificent image, which in Italy was a favorite subject to decorate refectories (dining rooms) of monasteries (with Leonardo's masterpiece in Milan perhaps the most famous example), The Last Supper was occasionally expanded into additional sequences involving the Washing of the Feet and the Institution of the Eucharist. Domenico, in this section, reversed his usual practice: instead of expanding his story, he collapsed it into a single dramatic frame that summarizes past events while offering portents of the future. In this pivotal scene, he concentrates on the key moment of Jesus offering his lead disciple, Peter, the first experience of this inaugural communion.

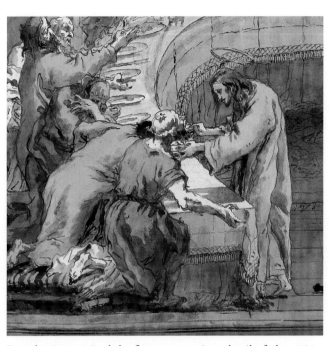

Peter having received the first communion, detail of plate 181,
The Institution of the Eucharist

Moreover, Domenico emphasized the concept of *remembrance* noted in Luke 22:19: "And he took bread, and gave thanks, and brake it, and gave unto them, saying, This is my body which is given for you: this do in remembrance of me." Just as Jesus asked his disciples to "remember" him when taking the Eucharist, Domenico asked his viewers to recall the Last Supper itself, as they pondered this scene portraying the Eucharist's origins. His emphasis on remembrance continues into the Agony in the Garden and Arrest sequences where we are asked to remember well-known episodes which Domenico replaces with less well-known events.

181. *The Institution of the Eucharist*

And as they were eating, Jesus took bread, and blessed it, and brake it, and gave it to the disciples, and said, Take, eat: this is my body. (Matt. 26:26)

> Pen and wash, over black chalk, 463 x 360
> Signed low right center: Dom.o Tiepolo f
> Provenance: Jean Fayet Durand (1806–1889)
> Literature: Conrad 1996 [145]
> Reference: Christiaan van Adrichem 1584, Site 6; Maria de Agreda, iii, 465–466; Réau 1957, 409–420;
> Ragusa and Green 1961, 311

Paris, Musée du Louvre, Département des Arts Graphiques, RF 1713bis [88]

Returning to his emphasis on Peter, Domenico makes him the first recipient of the first Eucharist, as a second disciple prepares to receive it. Other disciples (including the two oldest, Simon and Jude) debate across the table who the traitor could be. Gazing coolly at the assembly from the right, Judas is deliberately cut off by the picture frame to signify his status as an outcast. A Eucharistic lamb with a hauntingly human profile occupies the center spot, together with John, his most beloved disciple, who had fallen asleep earlier. ❦

Domenico here abandons the familiar arrangement of a straight table running across the width of the design, in favour of a table in a great horseshoe shape. He does not follow the detailed description of the table in *Meditationes vitae Christi,* "which was square and consisted of several boards, as I saw in Rome, in the Lateran church, where I measured it." Jesus has left his position at the center of the table, leaving there something of a vacancy, with some Apostles apparently astonished at his sudden disappearance, and stands in the foreground ministering to Peter in a manner that recalls Domenico's earlier treatments of this subject of the Würzburg years (Mariuz 1971 [42, 43]; Knox 1980 [167–173]). The two shadowy figures standing by the door recall the tradition, noted by Maria de Agreda, that the two patriarchs, Enoch and Elias, were present "in their mortal flesh' and participated in the Last Supper. Christiaan van Adrichem (1584: Site 6) locates this event in "the Parlour of Sion." ⚜

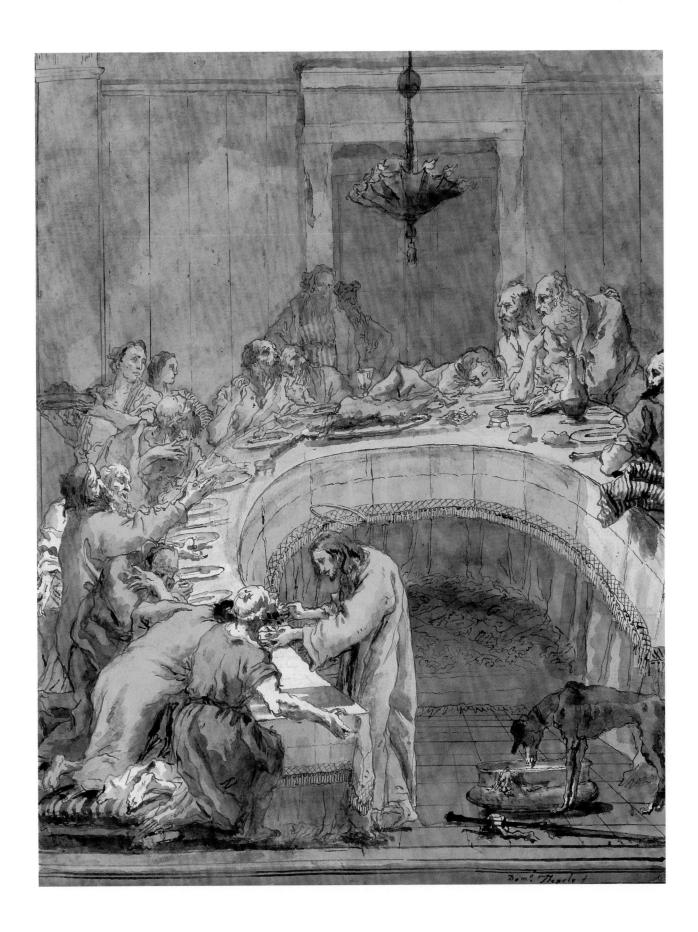

Part X

The Passion Continued: Jesus's Agony in the Garden, Plates 182–189

After the Last Supper, and before he is arrested, Jesus retires to pray. Matthew 26:35 and Mark 14:32 identify the spot as a "place" called Gethsmane, Luke 22:39 calls it the Mount of Olives, and John 18:1 calls the spot a "garden." Thus, by tradition, the spot where Jesus prayed became known as the Garden of Gethsemane (Hebrew for "oil press") which could thus be part of the Mount of Olives. Having taken Peter, James, and John (the same three who witnessed his Transfiguration), Jesus asked them to watch while he prayed. Christ's tormented prayer is detailed. Matthew says Jesus fell on his face; Mark says he fell on the ground. Both concur that each of the three times Jesus went back he found his disciples asleep. All three accounts relate that Jesus's prayer asks, if possible, for this "cup" to be removed. Luke describes one long prayer; he alone uses the word "agony" (22:44), a translation of the Greek meaning "struggle." And only Luke says that as Jesus prayed the angel arrived actually bearing the cup—thus, at one and the same time, offering comfort while sealing Jesus's fate. This scene, the angel bearing the cup, became the iconic image of Christ's

Garden wall with Jesus and Peter, detail from plate 186, *"Could ye not watch with me one hour?"*

agony in the garden, a vigil that ends with Judas arriving with the soldiers. After Judas betrays Jesus with a kiss, the soldiers seize him. One of Herod's servants (Malchus) has his ear cut off by a disciple (Peter), according to John.

Using eight scenes, paralleling the number of drawings he used to describe Christ's earlier Temptation, Domenico once more indulged his love of an expanded narrative that contained untraditional interpretations. His settings alluded to his textual authorities, with a mountainside evident in most scenes, echoing Luke's words, and a garden wall hinting at the Garden of Gethsemane, as noted by John. Domenico followed specific accounts from Matthew and Luke to describe Christ's lonely suffering, including his initial prayer during which he falls on the ground, and his second, more fervent prayer. As with the *Institution of the Eucharist,* in which he implied other better-known events (the

Detail of Peter with clenched fist and Jesus, detail from plate 188, *"Rise, let us be going"*

Last Supper), here too Domenico omits but implies the final prayer in which the angel delivers the cup, which is *the* standard scene in pictorial tradition. He turns instead to a rare final scene with the Apostles in which he once again focuses on Peter, who looks intently at Jesus. Preparing to defend his master, this scene is based on Domenico's imagination and not pictorial tradition. Domenico also omits the traditional "Kiss of Judas," preferring instead the account from Mark that portrays the aftermath of Christ's arrest.

182. *Jesus Warns Peter in the Upper Room*

And the Lord said, Simon, Simon, behold, Satan hath desired to have you, that he may sift you as wheat: but I have prayed for thee, that thy faith fail not: and when thou art converted, strengthen thy brethren. And he said unto him, Lord, I am ready to go with thee, both into prison, and to death. And he said, I tell thee Peter, the cock shall not crow this day, before that thou shalt thrice deny that thou knowest me. (Luke 22:31–34)

Pen and wash, 455 x 358
Signed low left: Dom.o Tiepolo f
Literature: Guerlain 1921, 85; Conrad 1996 [188]
Reference: Pigler 1956, i, 272–273; Réau 1957, 404

Paris, private collection, courtesy of Wildenstein & Co., New York

Jesus prepares to leave and, standing by the doorway, warns his disciples. Peter and another disciple fall to their knees, while the others look stunned and sorrowful. Domenico appears to have taken both John (chs. 14 and 15) and *The Meditations* into account, which describe Jesus delivering a lengthy sermon of admonition and comfort to them. ❧

Domenico clearly establishes that this is a night scene, with the room illuminated by a single lamp, a key factor that might argue in favor of the story of *Jesus Instructs Nicodemus* (pl. 130). On the other hand, Virgil Solis and the *Vita Passio et Resurrectio Iesu Christi* do not show Nicodemus kneeling in this subordinate position. The first shows Nicodemus standing, and in the second, both are seated, with lamp and book. The homely costume of the kneeling man and the presence of numerous figures also argue against Nicodemus. Nor does the scene suggest *The Calling of Matthew*, which is also convincingly represented in plate 127.

It is here suggested that the kneeling figure is Peter, and that the scene represents Jesus warning Peter, as given in Luke 22:31–34. This would account for the night scene and the lamp, the table of the Last Supper, and the presence of the Apostles, since Luke places this scene in the upper room of the Last Supper, before Jesus leads his disciples to the Mount of Olives. In Matthew and Mark it occurs on the Mount of Olives; see plates 183–184. ⚜

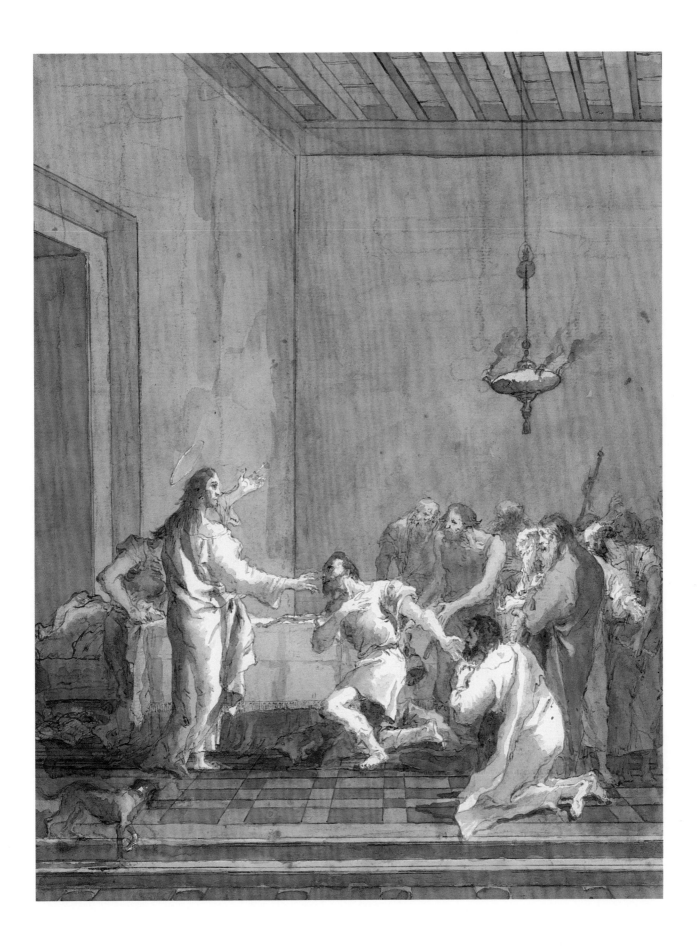

183. *Jesus, Flanked by James and John, Upbraids Peter*

Jesus said unto him, Verily I say unto thee, That this night, before the cock crow, thou shalt deny me thrice. (Matt. 26:34)

Pen and wash, over black chalk, 464 x 353
Not signed
Provenance: Roger Cormier, Tours, his sale, Paris, Georges Petit, Apr. 30, 1921, no. 69; Marignave, Paris; Duc de Trévise, his sale, Paris, Hôtel Drouot, Dec. 8, 1947, lot 47; Paris, Palais Galliera, June 13, 1963 [2]; John Goelet, Paris and Boston
Exhibition: Chicago 1938, pl. 90; New York, Slatkin, 1966 [21]; St. Louis 1972 [72]
Literature: Guerlain 1921, 74; Conrad 1996 [151]

St. Louis, Washington University, Mildred Lane Kempler Museum, 4353

Domenico went into considerable detail regarding the beginning of Christ's trials at Gethsemane, focusing on the warning he gave his disciples. Here we find Jesus confronting them before his prayers begin. The emphasis is naturally on Peter, who appears to be responding: ". . . Although all shall be offended, yet will not I" (Mark 14:29). John the Evangelist appears shocked at the news, while the lateness of the hour has already lulled James to sleep. ❧

Jesus again addresses Peter, who raises his hands in protest, while a standing Apostle on the right expresses surprise and another still sleeps. The composition has a starting point in the obscure figure of a sleeping Apostle, low left. It moves upward and backward through the figure of Peter, to the standing figure of Jesus in the center, supported by the Apostle standing on the right. The arms of the three central figures form a pattern of interlocking horizontals. ⚜

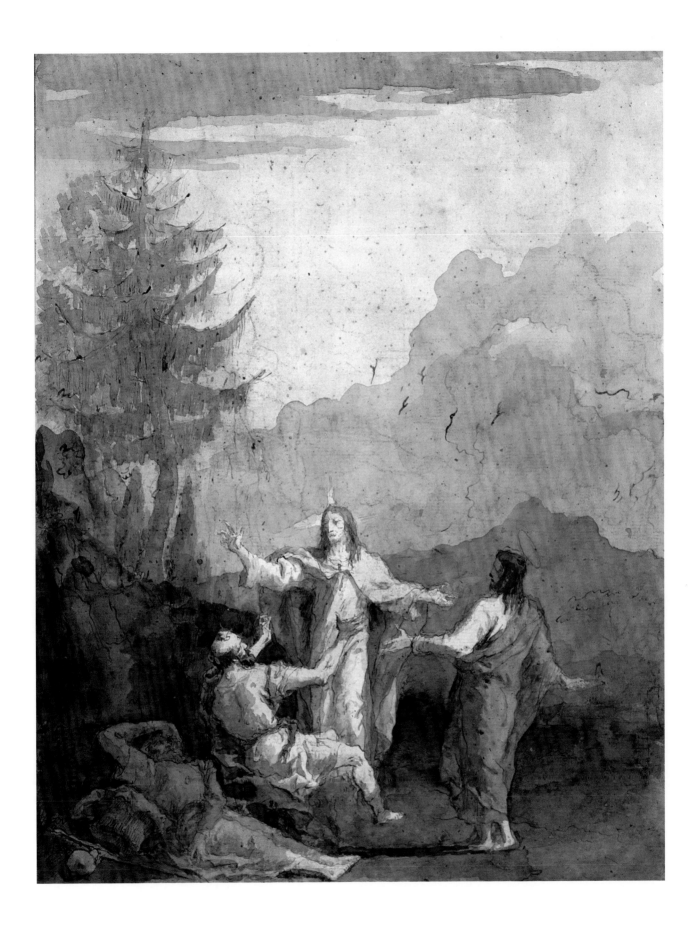

184. *Peter Responds in Protest*

Peter said unto him, Though I should die with thee, yet will I not deny thee. Likewise also said all the disciples.
(Matt. 26:35)

Pen and wash, over traces of black chalk, 470 x 353
Signed low left: Dom.o Tiepolo f
Provenance: Roger Cormier, Tours, his sale, Paris, Georges Petit, Apr. 30, 1921, no. 50; Duc de Trévise, his sale, Paris, Hôtel Drouot, Dec. 8, 1947, no. 39; Emery Reeves; Sotheby's, July 6, 1967 [40], bt. D.C. Collins; William H. Schab; Fort Worth, Kimbell Art Museum, AP 71.9; Sotheby's July 6, 1987 [10], bought in; John O'Brien
Exhibition: New York, Schab, 1968 [165]; Udine 1996 [102]
Literature: Christiaan van Adrichem 1584, Site 186; Conrad 1996 [152]; JBS archives as Seligman, New York, n.d.

Charles Town, West Virginia, John O'Brien

Evidently keeping Luke's as well as Mark's and Matthew's words in mind, Domenico portrays the subsequent exchange between Peter and Jesus. Jesus, having removed himself to the Mount of Olives (Luke 22:39), prepares to pray. Before doing so, he again admonishes Peter about his forthcoming lapses, only to have Peter respond "the more vehemently, If I should die with thee, I will not deny thee in any wise . . ." (Mark 14:31). Peter's exchange with Jesus appears almost secretive, as the others have fallen asleep. Ironically, Peter is braced against a rock (an allusion to Peter's role as the "Rock"), while Jesus looms above him, a white spectral form cast against the dark mountain. As if to remind us of Christ's imminent death, John lies asleep against what appears to be a tomb slab. 🌿

Jesus addresses Peter in the Garden of Gethsemane at the foot of the Mount of Olives, represented as a mountainous landscape. The place is described by Christiaan van Adrichem (1584: Site 186). In this sense the setting is very similar to *Jesus Descends from the Mountain . . .* (pl. 142), but there all three disciples are awake. Here, two disciples are sleeping, and Peter stands abashed. It is even possible that this drawing should be related to *The Transfiguration*. On the other hand, it is also related to the preceding scene, *Jesus, Flanked by James and John, Upbraids Peter* (pl. 183), which is less mountainous and only one Apostle still sleeps, as well as to *"Rise, Let Us Be Going"* (pl. 188). ❧

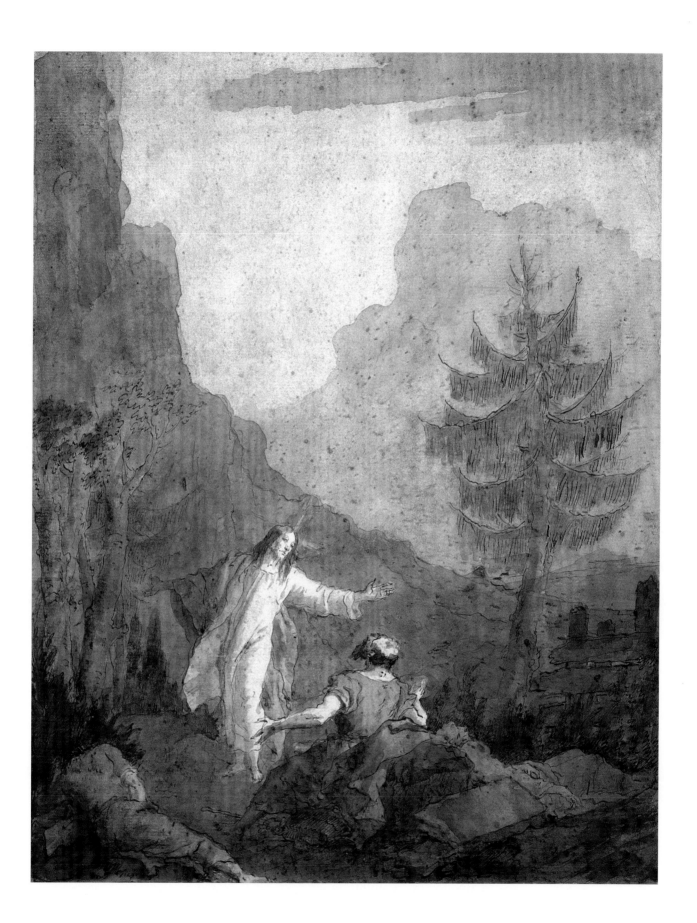

185. *Jesus in the Garden of Gethsemane: The First Prayer*

And he went a little further, and fell on his face, and prayed, saying, O my Father, if it be possible, let this cup pass from me: nevertheless not as I will, but as thou wilt. (Matt. 26:39)

Pen and grey wash, over black chalk: touches of gouache on Jesus's robe, 462 x 363, trimmed to border line
Signed low left: Dom.o Tiepolo f
Provenance: Roger Cormier, Tours, his sale, Paris, Georges Petit, Apr. 30, 1921, no. 40; duc de Trévise, his sale, Paris, Hôtel Drouot, Dec. 8, 1947, no. 36; Galerie l'Oeil, Paris; Eugene V. Thaw
Exhibition: New York 1975 [58]
Literature: New York 1994, 278; Conrad 1996 [149]
Reference: Christiaan van Adrichem 1584, Site 187; Réau 1957, 427

New York, The Pierpont Morgan Library, Thaw Collection

In one of the most moving scenes of his cycle, Domenico shows Jesus prostrate, his hands clasped in prayer. Though he points toward the evergreen, alluding to eternal life, his desolation is profound. Paying homage to the San Marco mosaics, Domenico deliberately ignores the more standard scene of the angel bringing the cup, but pays close attention not only to Matthew but also to Mark, who specified that Jesus "fell on the ground" during the first prayer (14:35). The turbulent sky echoes Jesus's despair and is a portent of its appearance during the Crucifixion (pl. 200). ❦

The Gospels relate that Jesus prayed in the Garden of Gethsemane three times. The treatment here is unusual in that there is no angel with the chalice and no sleeping Apostles are present. He is shown absolutely alone, and although there is nothing to indicate precisely whether this is the first, second, or third prayer, it is here taken to represent the first prayer. Christiaan van Adrichem (1584: Site 187) locates the scene in *The Garden of Olives*. ⚜

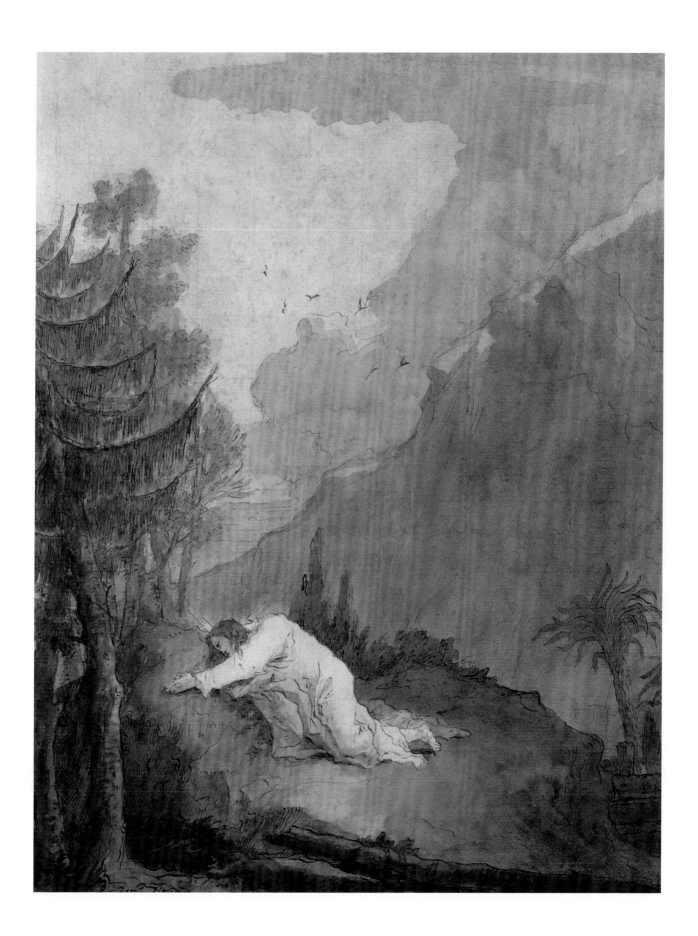

186. *"Could ye not watch with me one hour?"*

And he cometh unto the disciples, and findeth them asleep, and saith unto Peter, What, could ye not watch with me one hour? (Matt. 26:40)

Pen and wash, over black chalk, 463 x 365
Signed low right: Dom.o Tiepolo f
Provenance: Jean Fayet Durand (1806–1889)
Literature: Conrad 1996 [150]

Paris, Musée du Louvre, Département des Arts Graphiques, RF 1713bis [86]

His arms raised high (a gesture echoed by the umbrella pine and hauntingly anticipating the posture of his crucifixion), Jesus confronts Peter, whose response is abject. Two disciples (both too old for one to be John, as described by Matthew and Mark) remain sleeping in the garden-like setting mentioned only by John (18:1). This suggests that here Domenico was leaning more closely on Luke and John's texts, both of which specify that all the disciples were with Jesus (Luke 22:39). ✤

As the text requires, Jesus addresses Peter, who again seems to be protesting, while two other disciples sleep. Although there is a mountain to the right, the setting here has more the character of a garden. ⚜

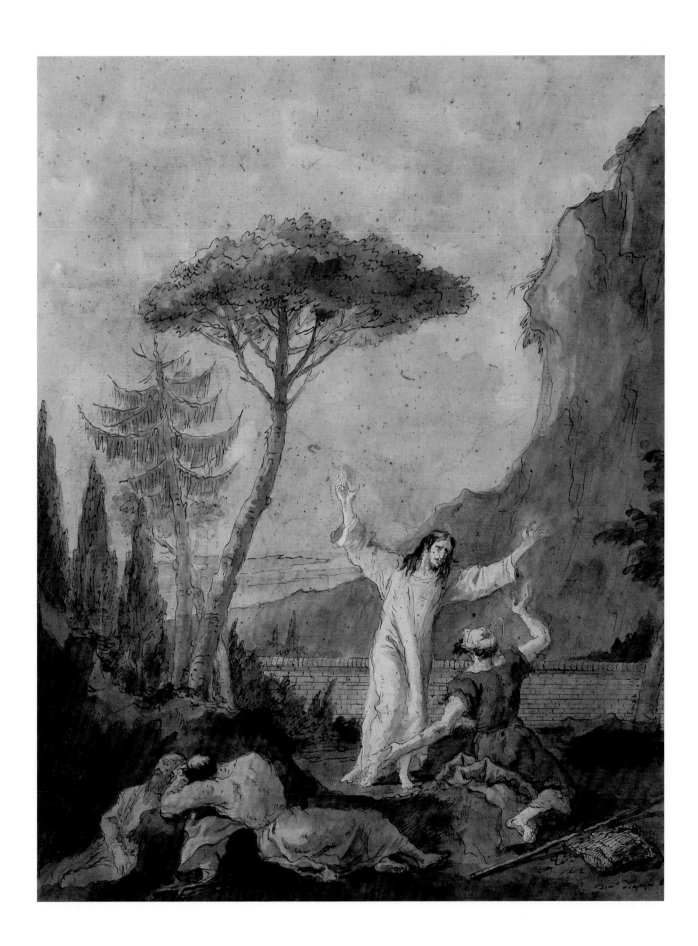

187. *Jesus in the Garden of Gethsemane: The Second Prayer*

He went away again the second time, and prayed, saying, O my Father, if this cup may not pass away from me, except I drink it, thy will be done. (Matt. 26:42)

Pen and wash, 482 x 380
Signed low right: Dom.o Tiepolo
Provenance: Paris, Hôtel Drouot, Dec. 14, 1938, lot 7; Michel Lévy; Mme A.L.D.; Paris, Drouot Richelieu, Nov. 23, 2001 [65]
Exhibition: New York, W. M. Brady, 2003 [15] 23

Indiana, private collection, on loan to the Indiana University Art Museum

No longer prostrate as he was during his first prayer, Jesus, still in his distinctive attitude of prayer, now supplicates God by a rocky outcrop. He pleads "more earnestly" (as noted by Luke 22:44) and his arms are stretched heavenward in fervent supplication. Domenico's sparing depiction of intense spiritual struggle is richly suggestive. Jesus faces the mountainside, evoking not only the specific site of his prayer, the Mount of Olives, but also alluding to the immense and unalterable dimensions of his imminent sacrifice. The scene's timing stimulates remembrance as well as anticipation. According to Luke, the angel arrived to comfort Jesus just before he began to "pray more earnestly" as we see him doing here, leaving us to remember that visually canonical moment, while we, together with Jesus, anticipate subsequent events, including his upcoming betrayal by Judas. ❦

The Gospels relate that Jesus prayed in the Garden of Gethsemane three times. The treatment here is unusual, in that there is no angel with the chalice and no sleeping Apostles are present. He is shown absolutely alone, and as usual there is nothing to indicate whether this is the first, second, or third prayer; it is here taken to represent the second. ⚜

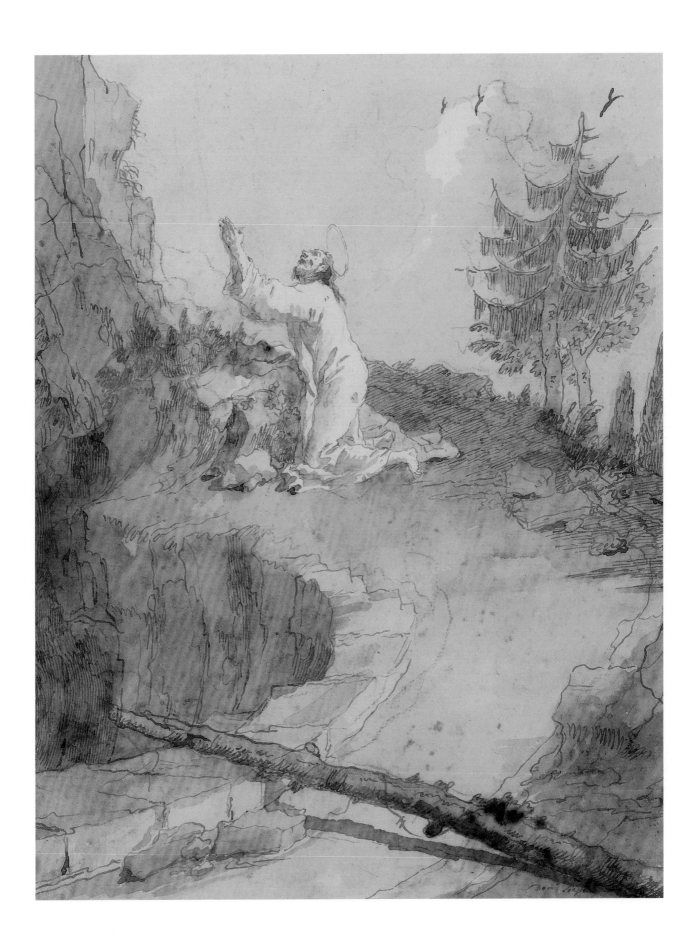

188. *"Rise, let us be going"*

Then cometh he to his disciples, and saith unto them, Sleep on now, and take you rest; behold, the hour is at hand, and the Son of man is betrayed into the hands of sinners. Rise, let us be going: behold, he is at hand that doth betray me. (Matt. 26:45–46)

Pen and wash, over black chalk, 458 x 354
Not signed
Provenance: Jean Fayet Durand (1806–1889)
Literature: Conrad 1996 [153]
Reference: Réau 1957, 429; Schiller 1971 [144]

Paris, Musée du Louvre, Département des Arts Graphiques, RF 1713bis [85]

Domenico evidently follows Mark and bypasses the traditional third prayer, turning instead to a rarely portrayed episode, noted by both Mark (14:42) and Matthew (26:47), who say that while Jesus spoke Judas and the multitude arrived. Peter, his right fist clenched in fury, prepares to defend Jesus who, turning to him, points out the approaching soldiers led by Judas. Once again cut off by the picture, Judas, visually and morally lower than Jesus and his disciples, points to him in this very unusual interpretation of Christ's Passion. John already weeps into his cloak, as he will do at the Crucifixion. ✿

The setting is still the wilderness, reminiscent of *Jesus Descends from the Mountain . . .* (pl. 142) and *Peter Responds in Protest* (pl. 184), but here one must notice the arrival of the soldiers bearing torches, low on the right, led by Judas pointing to Jesus. With his hands Jesus indicates all this, while John the Evangelist weeps. Thus Domenico tells his story, completely and concisely, and we are led on to the drawing that follows. ✤

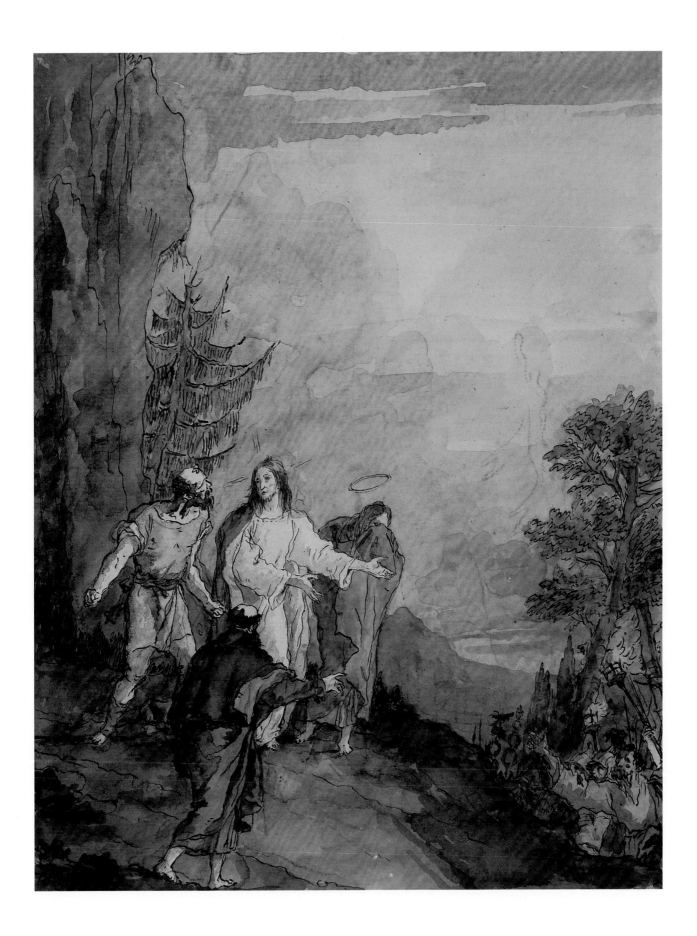

189. *Jesus Arrested in the Garden of Gethsemane*

*And Jesus answered and said unto them, Are ye come out, as against a thief, with swords and with staves
to take me? . . . And there followed him a certain young man, having a linen cloth cast about his naked body;
and the young men laid hold on him: And he left the linen cloth, and fled from them naked.*
(Mark 14:48, 51–52)

Pen and wash, over extensive black chalk, 475 x 370—paper?
Signed low left: Dom.o Tiepolo f
Provenance: Paris, Hôtel Drouot, June 24, 1985 [13]
Exhibition: London, Stein 1986 [74]
Literature: Guerlain 1921, 75; *Apollo,* Apr. 1991; Conrad 1996 [154]
Reference: Christiaan van Adrichem 1584, Sites 205 and 210; Réau 1957, 431–435

London, The British Museum, Department of Prints and Drawings, 1986-7-26-32

Depicting another unusual moment, Domenico selects the story of Christ's arrest as described primarily by Mark,
using details supplied by John. This aftermath to the standard episode of Judas's kiss of betrayal shows a large
troop of Roman officers crowded round Jesus, who is already bound. Just behind him, Malchus, the high priest's
servant, holds a large cloth to the side of his head, stanching the blood from his severed ear—cut off, according
to John 18:10, by Peter. Among the lamps and weapons described in John 18:3, one particularly large torch
illuminates the sky over Jesus's head, ironically reminiscent of his celebrated words in John 8:12: "I am the light of
the world." To the left we see the young man fleeing naked (as Mark describes) while below him Domenico elects
to show Peter, partly cut off by the picture, running away, just as Jesus had predicted. 🌿

The theme here is the arrest of Jesus rather than the more usual betrayal of Jesus. Judas may be represented on the
right, but he is not kissing Jesus. On the other hand, the strange story of the naked young man on the left is given
unusual prominence. Christiaan van Adrichem (1584: Site 205) describes The Way of the Captivity, which begins
at this point and continues until the final scene in the Palace of Pilate, with all the distances involved; Site 210
locates the spot. ⚜

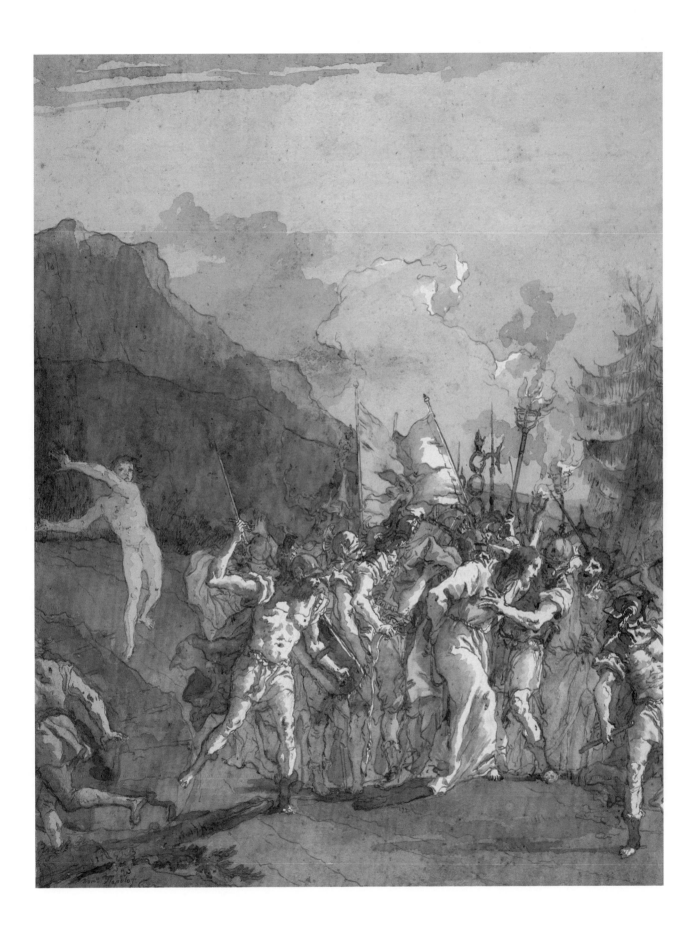

The Passion Continued: The Trial and Condemnation, Plates 190–194

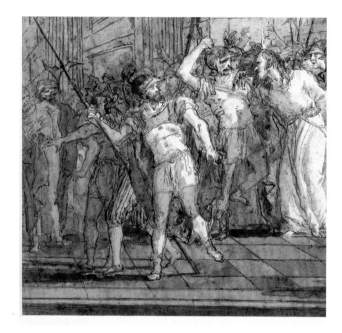

Peter following from "far off," detail of plate 190, *Jesus Sent by Pilate to Herod*

Each Gospel offered diverse details of Jesus's trial, which moved through key stages. John 18:13 asserts that Annas, Caiaphas's son-in-law, was the first to interrogate Jesus, while Matthew 26:57–58 states that Jesus was brought to Caiaphas alone. Declaring himself the Messiah and Son of God, Jesus blasphemed in their opinion, a crime punishable by death, although such a sentence could only be carried out by the occupying Romans. Jesus was thus placed before the Roman governor, Pontius Pilate, who, as Luke notes (23:8–12), handed him over to Herod Antipas, the Tetrarch of Galilee. After abusing Jesus, Herod returned him to Pilate, who, reluctant to condemn a man whom he felt was innocent of any real crime, offered people a choice to release Jesus or the condemned criminal Barabbas. Matthew 27:11–30 gives the lengthiest description, relating that the crowd chose Barabbas. Thereupon Pilate literally and ritually washed his hands of the affair. Jesus was condemned, scourged, mocked, crowned with thorns,

and led off to Calvary. Matthew says the scourging took place in a "common hall," which Mark 15:16 calls a "praetorium." Luke omits this brutal phase, while John 18–19 goes into great detail.

Christ's condemnation by Pilate, beating, and crowning with thorns became iconic phases of his Passion, while scenes of the earlier interrogations were optional. Peter's denial, though a well-known subject, was not commonly part of picture cycles. Domenico made five drawings, including a striking view of Peter's remorseful departure from Caiaphas's palace after hearing the cock crow, preceded by a most unexpected image of Jesus being led from one trial to another, with Peter and Jesus eyeing each other across a dense and threatening crowd of soldiers. Jesus condemned, scourged, crowned with thorns, and presented to the people is largely traditional but includes unusual details of Domenico's own invention.

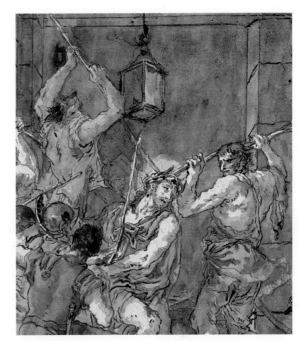

Lamp and head of Jesus, detail of plate 194, *"TIBERIUS CAESAR"—The Crowning with Thorns*

190. *Jesus Sent by Pilate to Herod*

When Pilate heard of Galilee, he asked whether the man were a Galilaean. And as soon as he knew that he belonged unto Herod's jurisdiction, he sent him to Herod, who himself also was at Jerusalem at that time. (Luke 23:6–7)

Pen and wash, over black chalk, 479 x 374
Signed low left?: Dom.o Tiepolo f
Provenance: Roger Cormier, Tours, his sale, Paris, Georges Petit, Apr. 30, 1921, no. 2; Geneva, Durand-Matthiesen 1966; Christie's, Dec. 9, 1986 [103]
Literature: Christiaan van Adrichem 1584, Site 56; Guerlain 1921, 77; James 1924, 98; Conrad 1996 [157]
Reference: Réau 1957, 449

Surrounded by a battalion of heavily armed soldiers, Jesus, his arms still bound, is being led from one judge to another. All eyes, including those of the patriarchal elders who stand by stage right, are fixed on him. Keeping Peter in the drama, Domenico (maintaining his emphasis on the first Pope) elects to show Jesus staring across the crowd at Peter, who peers anxiously back at him from the far left. It should be noted that both Matthew (26:57) and Mark (14:54) mention that Peter followed from "far off" to the palace of the High Priest, and there he later denied Jesus. Here again a lamp hangs suspended over Christ's head, reminding us once more of John 8:12: "I am the light of the world." ❦

The episode of Pilate deciding that Jesus, as a Galilean, was outside his jurisdiction is found only in Luke. Jesus is led away by a large military escort from an imposing hall of justice, glimpsed on the right. The Palace of Pilate is described by Christiaan van Adrichem (1584: Site 56): "The Pallace of Pilate, and of the Lieutenants of Rome, adjoining to the Gallery, which lyeth on the North side of the Castle Antonia; which Pallace was much more large, lofty, and Fayrer, then all the buildings of the City, and had an ascent of mounting of eight and twenty steps of Marble." The setting has the character of a *scena per angolo,* with two *coulisses* receding on either side, though not very clearly constructed, and a grand staircase rising up on the right side, perhaps the one that Christiaan van Adrichem describes. This is apparently a very late and rather confused design, although the main array of figures, mostly soldiers, moves quite evenly across the scene from right to left. ❦

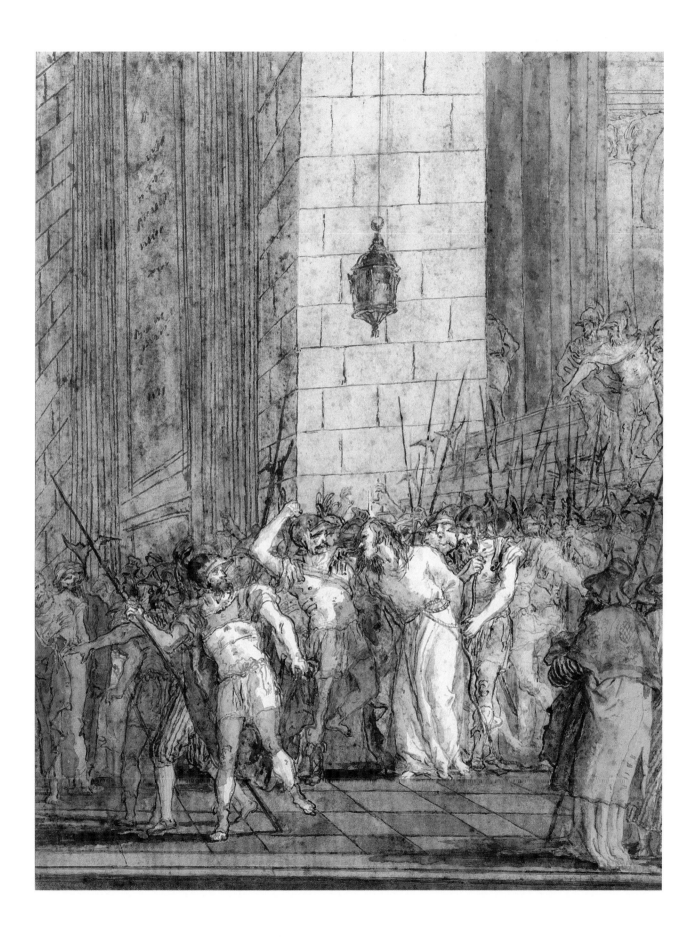

191. *The Denial of Peter*

Then began he to curse and to swear, saying, I know not the man. And immediately the cock crew. And Peter remembered the word of Jesus, which said unto him, Before the cock crow, thou shalt deny me thrice. And he went out, and wept bitterly. (Matt. 26:74–75)

But he denied, saying, I know not, neither understand I what thou sayest. And he went out into the porch: and the cock crew. (Mark 14:68)

Pen and wash, over black chalk, 460 x 360
Signed on the central column: Dom.o Tiepolo f
Provenance: Jean-François Gigoux, his sale, 1882, lot 175; Trotti sale, 1932
Literature: Conrad 1996 [155]
Reference: Christiaan van Adrichem 1584, Site 17; Pigler 1956, i, 333–38; Réau 1957, 438

Having not only run away but denied Jesus three times, Peter, hearing the cock crow, weeps into his cloak and smites his head as he descends the steps to the grand porch that makes up the palace entrance, a location to which Mark's account gives a slightly stronger emphasis. Domenico also consider's Matthew's story, for he alone states that Peter went out and wept bitterly. Giving Peter a starring role, Domenico makes Peter's rueful stance an icon so we can recognize Peter in a subsequent scene where he never traditionally appears: *The Crucifixion* (pl. 200). Jesus, meanwhile, has already exited and only his escorts are visible, including a violent youth brandishing a stick. By staging this moment on a stairwell, Domenico continues its use as a metaphor for transition as well as the place of shame or triumph throughout the series, beginning, most notably, with Joachim's shame in plates 2 and 3. 🌿

Domenico here departs radically from the familiar ways of representing this scene in the Baroque period, where it is generally presented as a crowded composition of accusing people, often consisting of half-length figures. Peter is represented as an isolated figure in a very grand setting. He reappears in very similar form in *The Crucifixion* (pl. 200). Christiaan van Adrichem (1584: Site 17) locates the event in the Palace of Caiaphas. ⚜

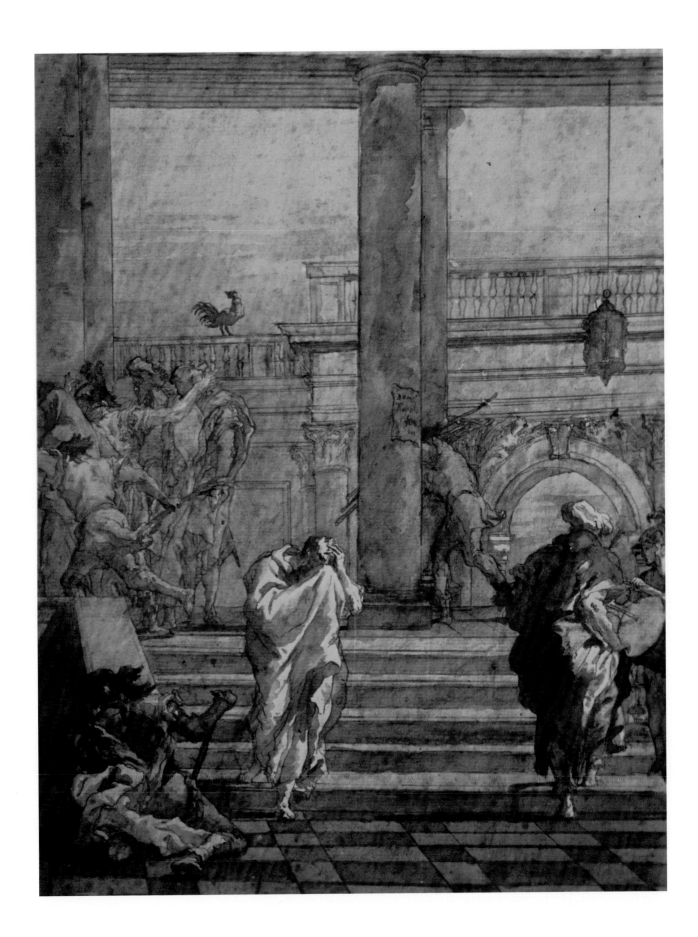

192. *"TIBERIUS CESAR"—Jesus Before Pilate*

When Pilate saw that he could prevail nothing, but that rather a tumult was made, he took water, and washed his hands before the multitude, saying, I am innocent of the blood of this just person: see ye to it. (Matt. 27:24)

Pen and wash, over black chalk, 470 x 366
Signed low left: Dom.o Tiepolo f
Provenance: Jean Fayet Durand (1806–1889)
Literature: Conrad 1996 [159]
Reference: Christiaan van Adrichem 1584, Site 114; Réau 1957, 450

Paris, Musée du Louvre, Département des Arts Graphiques, RF 1713bis [83]

Having endured several trials, Jesus stands in submission before the crowd of elders who cry for his blood. Barabbas, who was spared in Jesus's place, may be the figure kneeling before Jesus. Above him, a laurel-crowned head of Tiberius stares indifferently out into space. Pilate (here looking like an oriental potentate) turns to wash his hands, while the lion head of his armrest glares malevolently at Jesus. The lad who rushes in with the rope heightens the pitch as the crowd cries "His blood be on us and our children." He was last seen carrying a rod as Jesus was led away in plate 189. Jesus already holds the reed, which Matthew 27:29 specifies was later placed in his right hand. ❦

Domenico here develops an extremely grand composition, which owes something to that of Giambattista's *Investiture* fresco at Würzburg. On the left is a bust inscribed *TIBERIUS CESAR*. Christiaan van Adrichem (1584: Site 114) states: "The Tribunall was a public place, set before the house of Pilate, and appointed for Judgement." ⚜

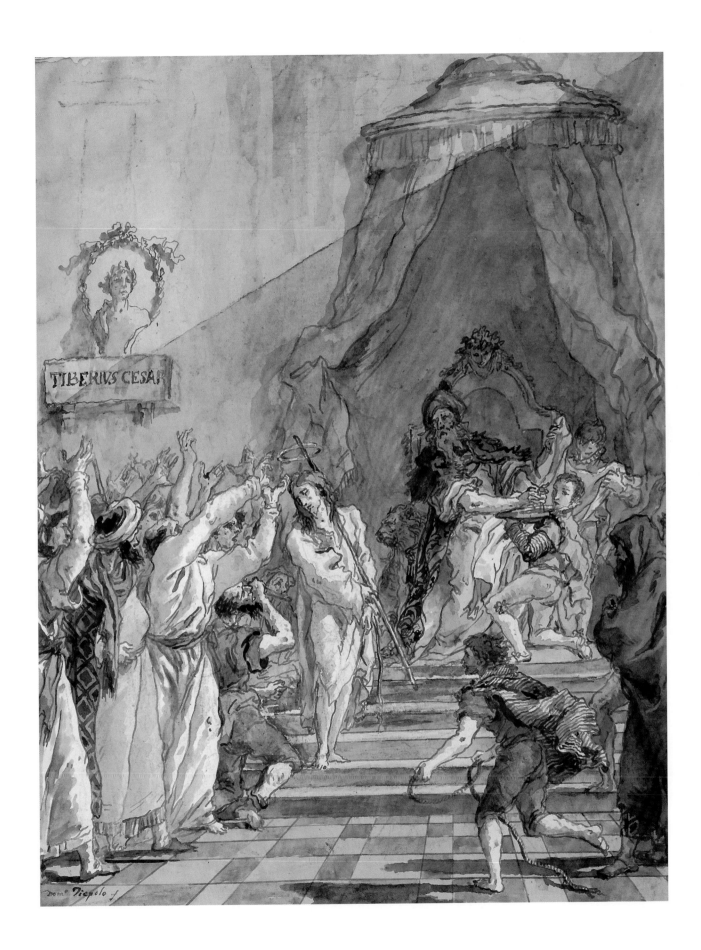

193. *The Flagellation of Jesus*

Then Pilate therefore took Jesus and scourged him. (John 19:1)

Pen and wash, over traces of black chalk, 460 x 360
Signed on the column at right: Dom.o Tiepolo f
Provenance: Geneva, Durand-Matthiesen, 1966; ? Sotheby's, Monaco, Dec. 2, 1989 [22], as 488 x 390
Exhibition: New York 1994 [30]; Udine 1996 [103]
Literature: Guerlain 1921 [79a]; Conrad 1996 [156]
Reference: Christiaan van Adrichem 1584, Site 56; *Burlington Magazine,* ad. May 1955; Réau 1957, 451–456

New York, Estate of Peter Jay Sharp

To this traditional and sacred scene Domenico adds details of his own invention, particularly the boys gathering sticks to replenish those being broken over Jesus's body. Pent-up rage is now vented on the condemned man. As patriarchal elders look on (and one in the right foreground raises his right arm as if commanding the number of lashings), Jesus is beaten so viciously that he is bent down from the blows. Adding to the indignity, one assailant braces his foot against Jesus's leg (a device that has Northern European origins). ❦

The composition is curious in that the figures are crowded together, somewhat in the form of a frieze, filling the lower half of the frame, while the upper half has only the majestic portico of Roman Doric columns. Nevertheless, Jesus does not seem to be bound to any of the columns, as tradition requires. As a young man, Domenico made a series of 23 drawings on the theme of Scenes of the Passion, using pen only, and five of them depict this scene (Stuttgart 1970 [22–26]; Udine 1996 [78, 79]). In painting, Domenico treated this theme only once, in one of the eight scenes painted in 1772 for the church of San Felipe Neri in Madrid, now in the Prado (Mariuz 1971 [233]) for some discussion; see Knox 1980 [267–297]. *The Flagellation* is supposed to have taken place in the Palace of Pilate, as described by Christiaan van Adrichem (1584: Site 56). ❦

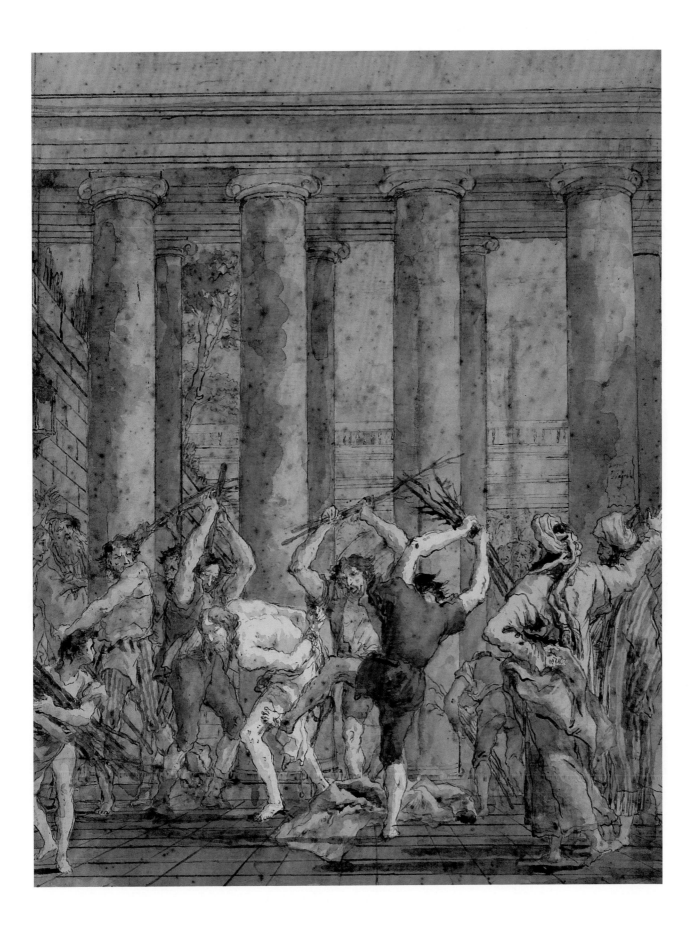

194. "TIBERIUS CESAR"—The Crowning with Thorns

And the soldiers platted a crown of thorns, and put it on his head, and they put on him a purple robe, and said, Hail, King of the Jews! and they smote him with their hands. (John 19:2–3)

Then the soldiers of the goveror took Jesus into the common hall, and gathered unto him the whole band of soldiers. And they stripped him and put on him a scarlet robe. And when they had platted a crown of thorns, they put it upon his head, and a reed in his right hand: and they bowed the knee before him, and mocked him, saying Hail, King of the Jews. And they spit upon him, and took the reed and smote him on the head. (Matt. 27:27–29)

And they smote him on the head with a reed, and did spit upon him, and bowing their knees worshipped him. (Mark 15:19)

> Pen and wash, over black chalk, 461 x 363
> Signed on the step, right: Dom.o Tiepolo f
> Provenance: Roger Cormier, Tours, his sale, Paris, Georges Petit, Apr. 30, 1921 [14]; Lucerne, Fischer Galleries, June 20, 1995 [22]
> Literature: Christiaan van Adrichem 1584, Site 56; Guerlain 1921, p. 79b; ad. *Burlington Magazine,* May 1995; Conrad 1996 [158]
> Reference: Réau 1957, 457–459

Zürich, Annette Bühler

Under Roman authority manifested by Tiberius's bust, the elders continue to orchestrate Jesus's punishment. Already crowned with thorns and still holding the reed found in the previous scene, Jesus receives another thrashing, this time mainly on the head, as Matthew and Mark describe. Here Domenico quotes a famous painting by Titian (Paris, Louvre) but adds a number of his own details. The elder at the left either guides a lad's arm or prepares to take the stick himself to deliver a more forceful blow. To the right, a youth looks for an opportunity to join in. Underscoring man's inhumanity, only the dog (last seen at the Last Supper and perhaps representing fidelity) cannot bear to look. Finally, consistent with the theme of Jesus as the light of the world, which Domenico introduced in the scene of Jesus's arrest (pl. 189), Domenico here stresses the message again by suspending an exceptionally large lamp over Jesus's head, reminding us yet again of John 8:12. ❦

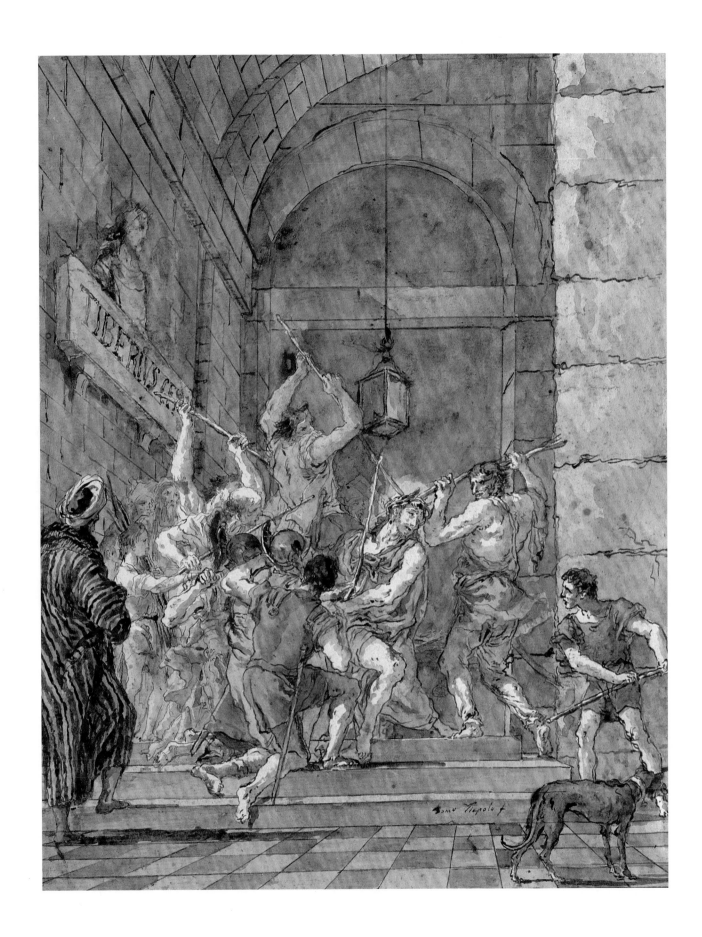

The Passion Continued: From the Ecce Homo *to his Entombment, Plates 195–204*

The final stages of Christ's Passion begin with Pilate showing Jesus to the crowd, whereupon Jesus is forced to take up his cross and carry it to the place of execution. Once he dies, Jesus is buried in a tomb provided for him by Joseph of Arimathea. The canonical Gospels offer diverse details.

John, who was there, uses a whole chapter (19) to tell the story. He takes considerable trouble over Pilate's reluctance to execute Jesus and is our only source for Pilate showing Jesus to the crowd. In John 19:4, Pilate first says "Behold the man" to show that he has found no fault with Jesus. After further discourse, Pilate again shows Jesus, saying, "Behold your king," whereupon the crowd once more demands his execution (John 19:14). Once Jesus reaches the place of execution, the four Gospels provide the same essential accounts with fine distinctions. John 19:17–18 states that Jesus, bearing his cross, went forth (outside the city) to the place of the skull called *Golgotha* in Hebrew (so named in Matthew and Mark as well). Luke 23:33 simply calls it Calvary. Matthew 21:31 and Mark 15:21 add that Simon the Cyrene assisted Jesus in carrying his cross. Luke 23:26 describes a great multitude that followed, including women, to whom Jesus turned and said, "Daughters of Jerusalem weep not for me."

Christ's crucifixion is described in the four Gospels, all of which state that he was crucified between two thieves and beneath a sign that read, "This is Jesus the King of the Jews." John and Luke elaborate that the sign was written in Hebrew, Greek, and Latin (John 19:20; Luke 23:38). All four mention the parting of Jesus's garments and casting of lots, with John 19:23–24 detailing that his seamless tunic was not to be torn so lots were cast for it. Matthew and Mark distinguish those that taunted Jesus for not being saved by God, citing chief priests, scribes and elders, and the two thieves. Luke differentiates between the bad thief who mocked Jesus and the good thief who defended him. John alone describes that he himself (John the Evangelist), Mary Magdalene, and Mary Cleophas were present together with the Virgin. Mark adds Salomé. John 19:25 is the source for Jesus instructing his mother and John from the cross, commending her to John, who "took her into his own home"—words that were the basis for the visual tradition of placing John the Evangelist and the Virgin Mary at the Crucifixion.

Jesus's actual death and final words vary. Matthew 27:45–57 and Mark 15:29–42 offer the fullest account. At the sixth hour there was darkness which lasted until the "ninth hour"; Jesus cried out in a loud voice, "My God, my God, why hast thou forsaken me?" whereupon he was given vinegar upon a sponge to drink. As spectators waited to see if God would save him, Jesus cried again and gave up the ghost. At that point, the veil of the Temple was split into two, "from top to bottom," and the earth quaked, whereupon, according to Mark, the Centurion stationed there was immediately converted and said, "Truly this was the Son of God." Matthew adds further embellishments before the conversion. Luke (23:44) agrees with Matthew and Mark in essentials, but gives Jesus the words: "Father, into thy hands I commend my spirit," after which he "gave up the ghost." John 19:28 has Jesus say "it is finished" and dies. John 19:31–42 adds more details about his burial. Wanting all the victims removed before the Sabbath, the Jews ask Pilate's permission to have all the victims' legs broken to hasten their death. This is done, but Jesus is found to be already dead and his legs are thus spared. His side is lanced, giving out water and blood—proof of death. Joseph of Arimathea then begs the body and, together with Nicodemus, buries Jesus in a new sepulcher in a garden. Matthew and Mark both describe the tomb as hewn from a rock, which Matthew says Pilate ordered to be guarded for three days.

Out of these somewhat differing descriptions a fairly cohesive visual tradition emerges, depicting various stages of Christ's execution, beginning with "Ecce Homo," where Pilate shows Jesus to the people. There follow scenes of Jesus carrying his cross out of the city gate (often looking back at his mother through the crowds);

his later assistance by Simon of Cyrene; his arrival at Golgotha, where he is stripped, nailed to the cross, and then dies upon it, attended by the Virgin, John the Evangelist, and Mary Magdalene. This part of Christ's Passion could be reduced to a single event (the Crucifixion), or expanded to include other images, such as Jesus despoiled, Jesus being nailed to the cross (or in medieval times, climbing up a ladder to be nailed), and Jesus being removed from the cross (the Deposition). Although not described by the Gospels, scenes of Mary and others mourning over the dead body (the so-called Pietá or Lamentation) became immensely popular, much more so than the biblically authorized scene of Jesus removed for burial or entombment.

The lance-bearing soldier, detail of plate 195, *Jesus Shown to the People*

Domenico produces ten drawings that blend conventional and unconventional elements. His "Ecce Homo" (*Jesus Shown to the People,* pl. 195) stresses the crowd clamoring for Jesus's death. A soldier with a lance is stationed in the foreground, hinting at his future role as the one who lances Christ's side. Domenico later has Jesus fall under his cross and Simon the Cyrene coming to his aid (pl. 197) in a scene that anticipates Christ's three falls in the *Fourteen Stations.* Domenico also considers both Mark and John's accounts of Christ's death, alternating between one canonical and one unorthodox version of the Crucifixion. Plate 201, his canonical version, presents the traditional mourners—John the Evangelist, Mary Magdalene, and the Virgin—gathered round the cross, while behind them stand a group of soldiers, including the spear-bearer, later called Longinus who, according to John, pierced Christ's side.[7] A unique yet pivotal scene, plate 200 (in terms of Domenico's emphasis on the saint) places Peter as a key eyewitness at the scene, where tradition has only John. In the foreground at the left, we also find a weeping centurion, whom Mark (15:39) has converting at the moment Jesus dies. Having skipped the traditional Deposition scene (which had less currency in Venice than elsewhere in Italy), Domenico portrays instead a remarkable Lamentation (where Peter is once more untraditionally present), followed by another unusual sequel in which Nicodemus and Joseph of Arimathea struggle with Christ's body as they carry it to the tomb. Domenico concludes with a traditional burial scene located in a rock-hewn cave, as described by both Matthew and Mark.

7. Later christened Longinus, from the Greek word for lance, this soldier is conflated in Christian traditions with the Centurion who converted to Christianity upon Christ's death. According to *The Golden Legend* (Ryan and Ripperger, pl. 191), Longinus was, significantly enough, cured of an *eye* ailment by Christ's blood (again, Domenico is found placing an accent on vision). His feast day became March 15. Butler no longer mentions Longinus.

195. *Jesus Shown to the People*

Then came Jesus forth, wearing the crown of thorns, and the purple robe. And Pilate saith unto them, Behold the man!
(John 19:5)

> Pen and wash, over black chalk, 461 x 357
> Signed center: Dom.o Tiepolo
> Provenance: Jean Fayet Durand (1806–1889)
> Literature: Conrad 1996 [160]
> Reference: Christiaan van Adrichem 1584, Site 119; Réau 1957, 459–460

Paris, Musée du Louvre, Département des Arts Graphiques, RF 1713bis [84]

Standing atop a gateway to Jerusalem (here presented as a Roman triumphal arch), the condemned Jesus is shown to the people.[8] Our vantagepoint behind the vast crowd that includes patriarchs, youths, mothers and their children allows us to judge their actions. The soldier, who is given a prominent role, continues to be an important presence, reminding us that Longinus, among other soldiers, converted to Christianity during Christ's Passion. ❦

The scene is also described in Matthew 27:28–29. This is the second of a series of seven scenes of the Passion of Jesus, which appear in the Louvre Album in the reverse order, plates 84–79. The first is, strictly speaking, the preceding drawing, but the series usually begins with *The Agony in the Garden* and continues through to *The Entombment* in eight or ten scenes, though there is no fixed pattern. Christiaan van Adrichem (1584: Site 119) describes this scene in detail: "Whereas yet an arch of stone is to be seen, and is shewed unto strangers." ⚜

8. *Ecce Homo,* behold the man, gained popularity in the Renaissance with Jesus shown either in a town square or on the balcony of Pilate's *praetorium* or judgment hall.

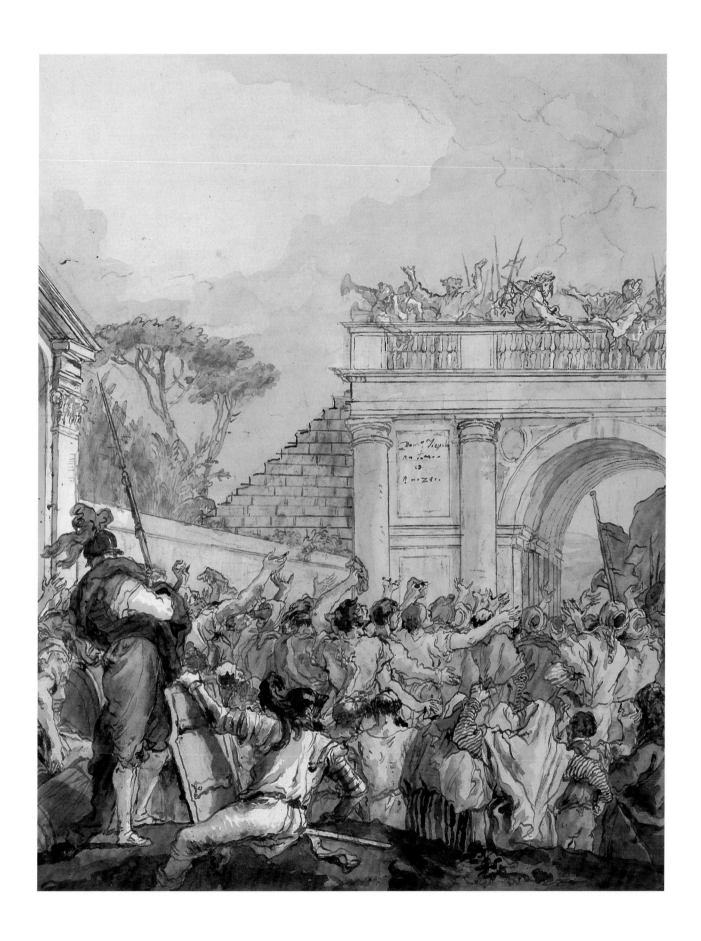

196. *Jesus Carrying the Cross—"GIVLIO CESARE"*

And he bearing his cross went forth into a place called the place of a skull, which is called in the Hebrew Golgotha. (John 19:17)

Pen and Indian ink wash, over slight black chalk, 463 x 363, trimmed close to the image, foxed
Not signed
Provenance: Jean-François Gigoux (1806–1894), his bequest, 1894
Literature: Conrad 1996 [161]
Reference: Christiaan van Adrichem 1584, Site 165; Réau 1957, 463–468

Besançon, Musée des Beaux-Arts et d'Archéologie, 2229

With Jerusalem's massive battlements receding into the distance, Jesus exits the gateway bearing his cross. A youthful drummer beats the death march while an older brute brandishes a whip to goad him along. Several patriarchs observe the procession from their favorite spot, stage right. The inscription referring to Julius Caesar—the first of the Caesars and not mentioned in the Gospels—gives this gateway added antiquity. ❧

The setting shows the procession, led by a boy drummer, leaving the city by an immense gateway, crowned with the inscription *"GIVLIO CESARE."* In scale, the city gate recalls those of Sotinen and Memphis in Egypt (pls. 60, 63, 72, 74), but the man holding a scourge makes a link with Domenico's *Via Crucis II* in San Polo [fig. 234]. Christiaan van Adrichem (1584) describes this gate as "the gate of Judgement" (Site 137), "the Judiciary gate" (Site 143), and "The Old Gate" (Site 174): "Whereupon Christ was led out of the same to be crucified. Of this Gate, there are at this day some old remainders and ruines to be seen." ⚜

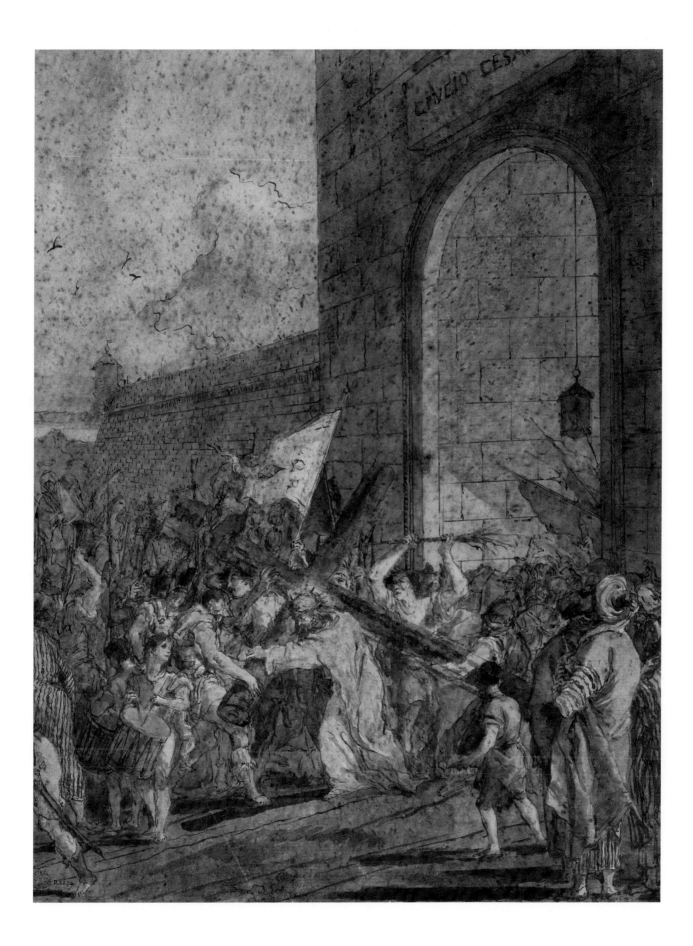

197. *Jesus Led to Calvary*

And there followed him a great company of people, and of women, which also bewailed and lamented him. But Jesus turning unto them said, Daughters of Jerusalem, weep not for me, but weep for yourselves, and for your children. For, behold, the days are coming, in which they shall say, Blessed are the barren, and the wombs that never bare, and the paps that never gave suck. Then shall they begin to say to the mountains, Fall on us; and to the hills, Cover us.
(Luke 23:27–30)

Pen and wash, 480 x 379
Signed: Dom.o Tiepolo f
Provenance: Jean-François Gigoux, his sale, 1882, lot 177: *"Il porte la croix suivi des gens du peuple et des soldats: au premier plan, sainte Madeleine, à genoux et en pleurs, tends les bras vers lui";* Christie's, Paris, Mar. 21, 2002 [269]
Reference: Christiaan van Adrichem 1584, Site 117

Zürich, Arturo Cuellar

Exhausted and wraithlike, Jesus falls to the ground in a pose deliberately echoing his first prayer in Gethsemane (pl. 185). Golgotha looms in the background, while in the foreground the holy women, including the Virgin Mary shrouded in her cloak, stand and watch helplessly at the lower right, replacing the patriarchs who stood there in the previous scene. Simon of Cyrene, whom the Gospels mention as having been compelled to aid Christ, appears to be the bearded man approaching in the center. ❦

The Gospels do not offer any detailed account of the way to Calvary, for which we have to turn, for the most authoritative account, to Christiaan van Adrichem, *Jerusalem sicut Christi tempore floruit,* 1584, Site 117. Luke goes much further than the others and describes the meeting of Jesus with the "Daughters of Jerusalem," and his dire prophesy, but this does not find a place in the traditions of the *Via crucis,* nor indeed does the weeping Magdalene. The verbal description in the Gigoux sale catalogue suggests that the design might have been very close to Giambattista's *Way to Calvary* in Sant'Alvise, which, however, shows St. Veronica in the right foreground. A version of this composition, belonging to Francesco Algarotti, was engraved by Pietro Monaco (1743 [73]; 1763 [72]; Apolloni 2000 [71]) showing perhaps the Virgin in the right foreground. A preliminary drawing was prepared by Domenico ca. 1743. However, the composition here is quite different, with important innovations. Jesus falls under the cross while a soldier and three other men seize the cross and try to raise it up. In the right foregound Domenico places the group of John and the three Marys. The Magdalene kneels and the others remain standing. ⚜

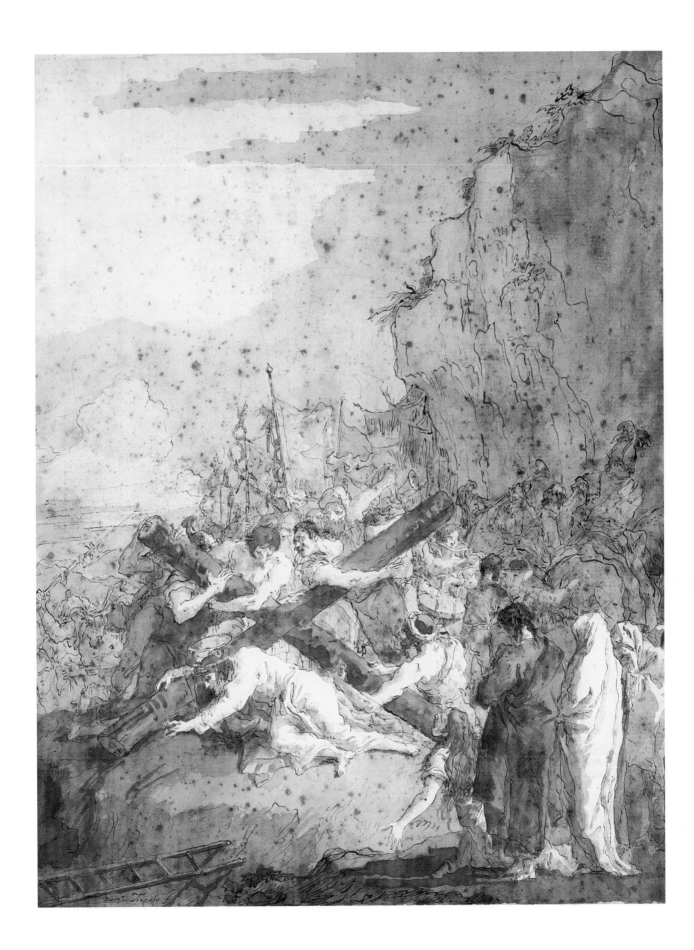

198. *The Despoiling of Jesus*

And after they had mocked him, they took the robe off from him and put his own raiment on him, and led him away to crucify him. (Matt. 27:31)

Here Christ was stript out of his garments, whose body being all torn with whips, could not but be very sore, whereunto his bloody garments cleaving, gave new occasion of pain, when they were violently pulled off. And standing there naked all the while that the Cross was preparing, in the cold and wind, he sate downe at length upon a stone, where he drank Wine mixed with gall and myrrh. (Christiaan van Adrichem 1584, Site 248)

Pen and wash, over black chalk, 460 x 360 image; 479 x 382 paper
Signed low center left: Dom.o Tiepolo f
Provenance: Christie's, New York, Jan. 13, 1993 [62]; Martin Kline
Exhibition: Udine 1996 [104]
Literature: Guerlain 1921, 81; Conrad 1996 [162]
Reference: Christiaan van Adrichem 1584, Site 248

Cleveland Museum of Art, 1999.5

Standing much as he had when Pilate condemned him, Jesus stares down at the kneeling soldier who prepares to nail him to the cross. As several soldiers strip Jesus naked, a trio of patriarchs look on. One points derisively, in a gesture reminiscent of the elder who witnessed Joachim's disgrace so much earlier (pl. 3). The prostrate figure preparing the cross contrasts with the prayerful Joachim who gave thanks at the Temple (pl. 14). ❧

This is apparently one of the drawings illustrated by Guerlain that cannot be traced in the Cormier sale. It is a fine and elaborate design with a strong movement and recession from right to left in the foreground, and a reversed diagonal rising from left to right in the background. Christiaan van Adrichem (1584: Site 248) gives a very moving description of the scene. ⚜

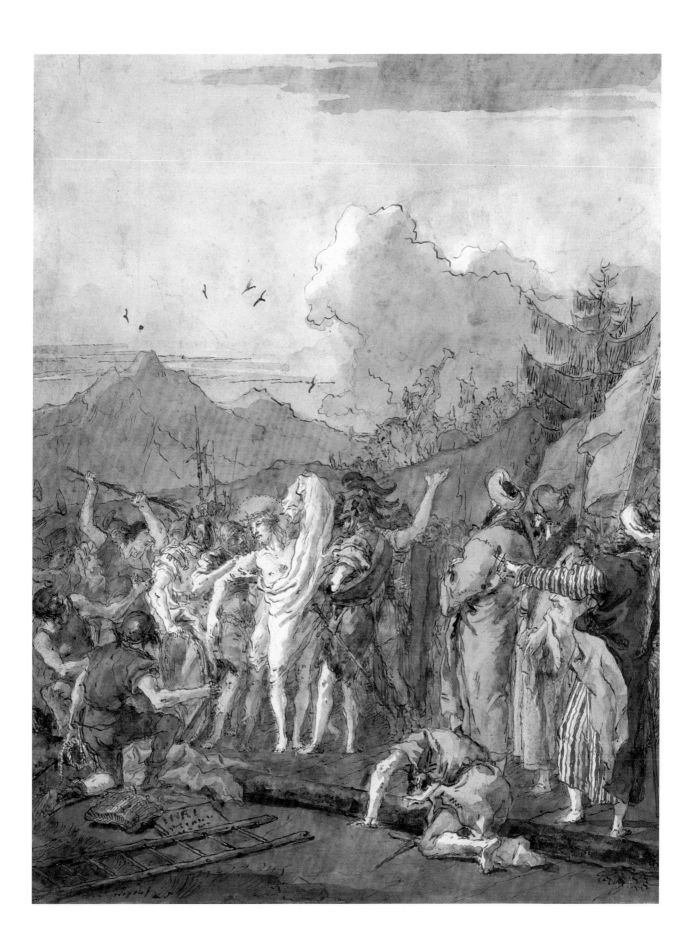

199. *The Nailing of Jesus*

Here Christ being layd on his back on the Cross, & stretched out upon the same, his hands and feet were nailed thereunto with Iron nailes, and his tender members were with such force strained and racked upon the Crosse, that they very arteries and sinews were loosened, and all his bones might be told. (Christiaan van Adrichem 1584, Site 249)

Having bored the three holes into the Cross, the executioners again commanded Jesus the Lord to stretch Himself out upon it in order to be nailed to it. The supreme and almighty King, as the Author of patience, obeyed, and at the will of the hangmen, placed Himself with out stretched arms upon the blessed wood. (Maria de Agreda)

> Pen and wash, over extensive black chalk, 465 x 358
> Signed low left: Dom.o Tiepolo f
> Provenance: Jean Fayet Durand (1806–1889)
> Literature: Conrad 1996 [163]
> Reference: Christiaan van Adrichem 1584, Site 249; Maria de Agreda 1971, vi, 642–665; Réau 1957, 473

Paris, Musée du Louvre, Département des Arts Graphiques, RF 1713bis [82]

Standing before the Roman standards, more elders have gathered to witness Jesus being nailed to the cross. One youth places Jesus in position, while two executioners hammer nails through his feet. As he submits to this sacrifice, Jesus assumes the profile of the paschal lamb portrayed in the Last Supper (pl. 181). Trumpets blare out the news that the execution has begun. ❧

This horrific scene is not described in the Scriptures, but the appalling details are set forth at length by Christiaan van Adrichem (1584: Site 249) and by Maria de Agreda. ⚜

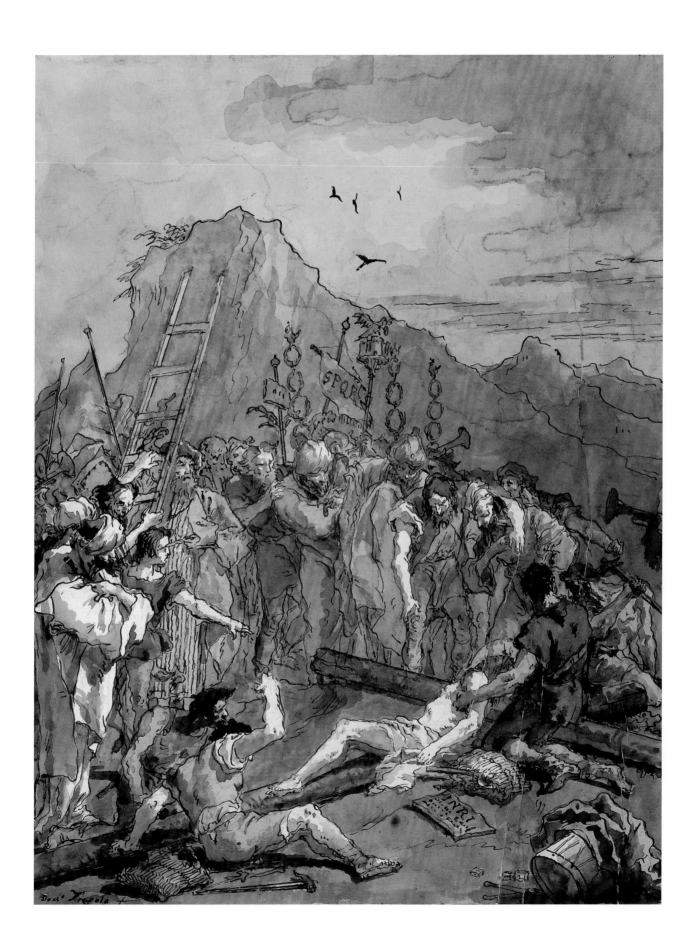

200. *The Crucifixion*

And they crucified him, and parted his garments, casting lots: that it might be fulfilled which was spoken by the prophet, They parted my garments among them, and upon my vesture did they cast lots. (Matt. 27:35)

Pen and wash, over black chalk, 465 x 358
Not signed
Provenance: Jean Fayet Durand (1806–1889)
Literature: Conrad 1996 [165]
Reference: Christiaan van Adrichem 1584, Site 250; Maria de Agreda iii, 653

Paris, Musée du Louvre, Département des Arts Graphiques, RF 1713bis [81]

As clouds close in to shut out the light, Jesus dies on the cross. While John and the Virgin and Mary Magdalene are traditional mourners beneath the cross, the rest of the characters are most unusual. Several saints and women run weeping from the scene, while Peter (who is never shown at The Crucifixion) turns away weeping, his cloak held to his face, echoing his pose of repentance (pl. 191). Given that Domenico's drawing centers on the darkness closing in, his depiction clearly relates to Mark's account, upon which Matthew's was based and which, according to Catholic belief, was dicated by Peter, a scene Domenico illustrates (pl. 253). Hence, Domenico's own internal logic must have led him to introduce Peter in a radically new interpretation of this most traditional of subjects. Two other disciples appear to comfort a remorseful soldier who sits in the foreground. This may be the centurion whom Mark and Matthew (15:39; 27: 54) quote as saying, "Truly this man was the son of God." Mark specifies that his conversion happened immediately after Christ's death. ❦

Domenico responds to the theme with a deeply moving design. The three crosses are set back in the middle distance, beyond the barrier of the three elements in the foreground, distinguished by the figure of the mourning Peter on the right, which is drawn from *The Denial of Peter* (pl. 191). The presence of Peter, as well as the Virgin and John at the foot of the cross, is mentioned in the apocrypha and by Maria de Agreda. The darkening of the sky with heavy clouds is dramatically represented as described in Matthew 27:46: "Now from the sixth hour there was darkness over all the land unto the ninth hour." The scene is described at length by Christiaan van Adrichem (1584: Sites 250, 237–248). ⚜

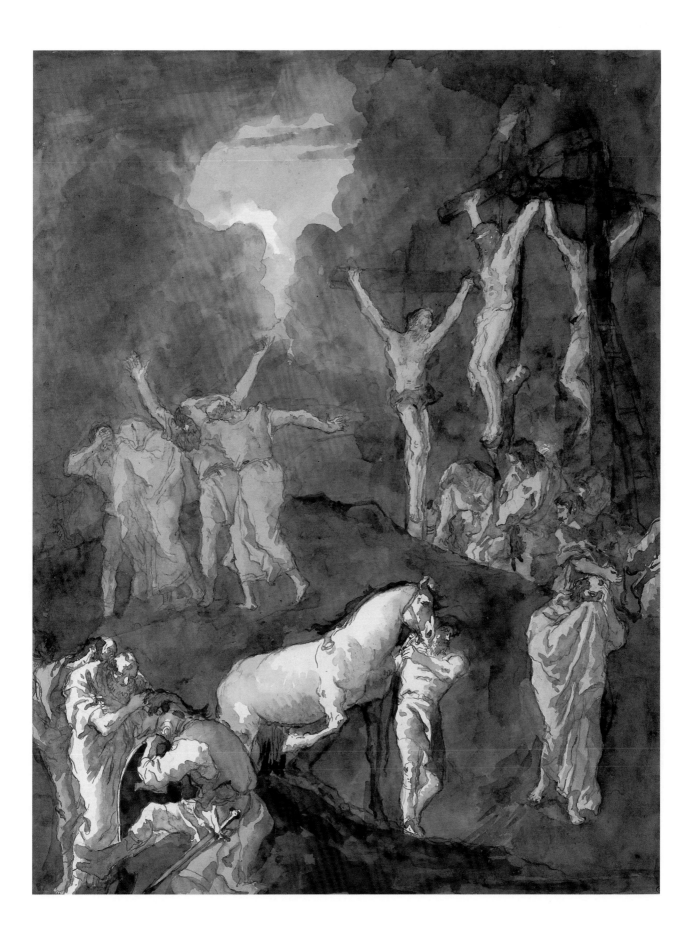

201. *Jesus Crucified Between the Two Thieves*

Then were there two thieves crucified with him, one on the right hand, and another on the left. (Matt. 27:35–38)

Pen and wash, 460 x 350
Signed: Dom.o Tiepolo f
Provenance: Duc de Trévise, his sale, Paris, Hôtel Drouot, Dec. 8, 1947, lot 53
Exhibition: Chicago 1938 [91]
Literature: Middledorf 1938, 102; Conrad 1996 [164]
Reference: Christiaan van Adrichem 1584, Site 233

In a second, more traditional interpretation, Domenico rotates our vantage point to provide a closer view of the mourners. Mary Magdalene embraces the foot of the cross, while the Virgin and John the Evangelist stand to either side. The soldier with his pike awaits orders to pierce Christ's side, which, John later states (19:34), poured forth water and blood, signaling his death. He is by later tradition identified as Longinus (the Greek word for lance), who, according to the other three Gospels, was the centurion who converted at the moment of Christ's death. Behind him others gamble for Christ's garments. 🌿

The scene is described by Christiaan van Adrichem (1584: Site 233): "The Mount of Calvary, a rocky Mountaine of mean height, called in the Hebrew Tongue Golgotha, which was next to the North West part of the City. In which place offenders condemned in open punishment, were put to death. Where at all times, a man might see the bones and bowels of men hanged, or otherwise put to death." ⚜

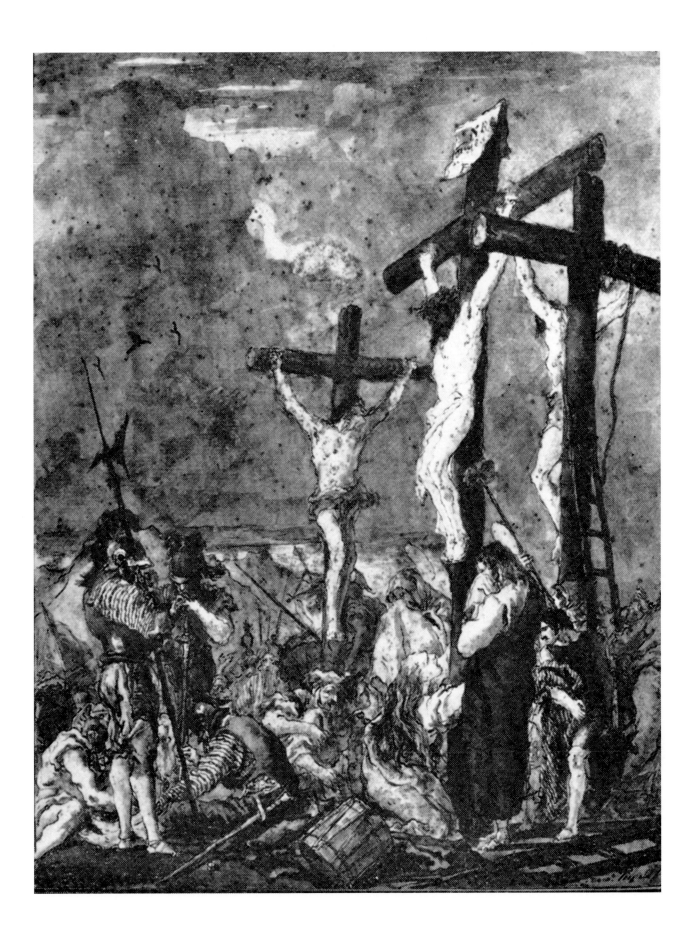

202. *The Lamentation*

You, however, as I have told you elsewhere, attend diligently and carefully to the manner of the Deposition. Two ladders are placed on opposite sides of the cross. Joseph ascends the ladder placed on the right side and tries to extract the nail from His hand——————The nail in the feet pulled out, Joseph descends part way, and all receive the body of the Lord and place it on the ground. The Lady supports the head and shoulders on her lap, the Magdalene the feet at which she had formerly found so much grace. The others stand about, all making a great bewailing over Him: all most bitterly bewail Him, as for a first-born son. (Meditationes vitae Christi 81)

Pen and wash, over black chalk, 460 x 357
Not signed
Provenance: Federigo Madrazo; Tomas Harris; Sir Robert Witt bequest 1952
Exhibition: London, Matthiesen 1939 [137]
Literature: Conrad 1996 [166]
Reference: Réau 1957, 518–521; Ragusa and Green 1961, 341–342; Maris de Agreda 1971, vii, 702

London, Courtauld Institute Galleries, Witt 3181

In an epic mourning scene, the Virgin cradles her son's body on her lap as Mary Magdalene kneels at his feet and others crowd round. Once again Peter, against tradition, is present. One man, perhaps Joseph of Arimathea, prepares to move the ladder that he used to lower Christ's body, while in the foreground a trio of patriarchs, probably including Nicodemus, look on from the left. Longinus, who converted after he speared Jesus with his lance, sits weeping at the left. The only intrusion into this somber and quiet moment is the Roman soldier galloping in from the right, to see what is happening. ❦

The Lamentation is not specifically described in the Gospels, but the account in the *Mediationes vitae Christi* seems to provide most if not all of the traditional elements of the scene. Domenico is even more specific. While Mary "supports the head and shoulders on her lap," she is flanked by Mary Magdalene on the right and the mother of Zebedee's children on the left (Matt. 27:56). Peter is again present, and is shown supporting Mary in his arms, while John stands behind him weeping. Joseph of Arimathea may be identified as the rather well-dressed man standing prominently on the left. Even Longinus with his spear sits weeping in the bottom left corner; his conversion at this time is described by Maria de Agreda. ⚜

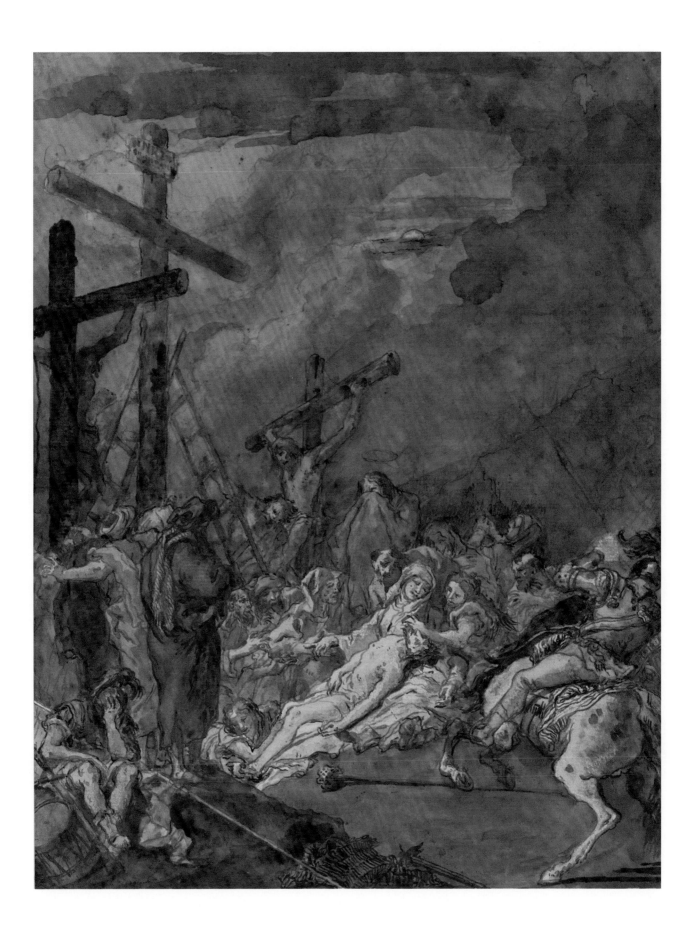

203. *The Removal of the Body of Jesus*

When the even was come, there came a rich man of Arimathea, named Joseph, who also himself was Jesus' disciple. He went to Pilate, and begged the body of Jesus. The Pilate commanded the body to be delivered. (Matt. 27:57–58)

However, the hour growing late, John said, "Lady, let us bow to Joseph and Nicodemus and allow them to prepare and bury the body of our Lord." (Meditationes vitae Christi)

> Pen and wash, over black chalk, 461 x 357
> Signed low left: Dom.o Tiepolo f
> Provenance: Jean Fayet Durand (1806–1889)
> Literature: Ragusa and Green 1961, 342; Conrad 1996 [167]

Paris, Musée du Louvre, Département des Arts Graphiques, RF 1713bis [80]

Having bypassed the traditional Deposition subject, Domenico includes instead a less common scene of Christ's body transported for burial. Mary Magdalene lies prostrate in the foreground, while the Virgin (in shrouded silhouette) watches Christ's body carried to his tomb. Domenico shows his face obscured by his burial cloth, in a haunting and very unusual detail.[9] The patriarchs have now departed, leaving Roman soldiers to oversee the final stages of the thieves' execution. The good thief's sufferings go on as his legs are being broken, while the bad thief's body is being taken away by devils. ❦

This is the last of four drawings depicting the three crosses on Golgotha. The subject is extraordinary in that it shows not only Joseph of Arimathea and Nicodemus, and perhaps again Peter, carrying the body of Jesus away for burial, but also the devil flying off with the body of one of the thieves. This detail, for which few visual prototypes come to mind, is a prominent element in the center of the design. ⚜

9. The only other example of a corpse's covered face that we could find is, interestingly enough, the body of Mark, as depicted in the outer right portal of San Marco. Domenico must have seen this mosaic often.

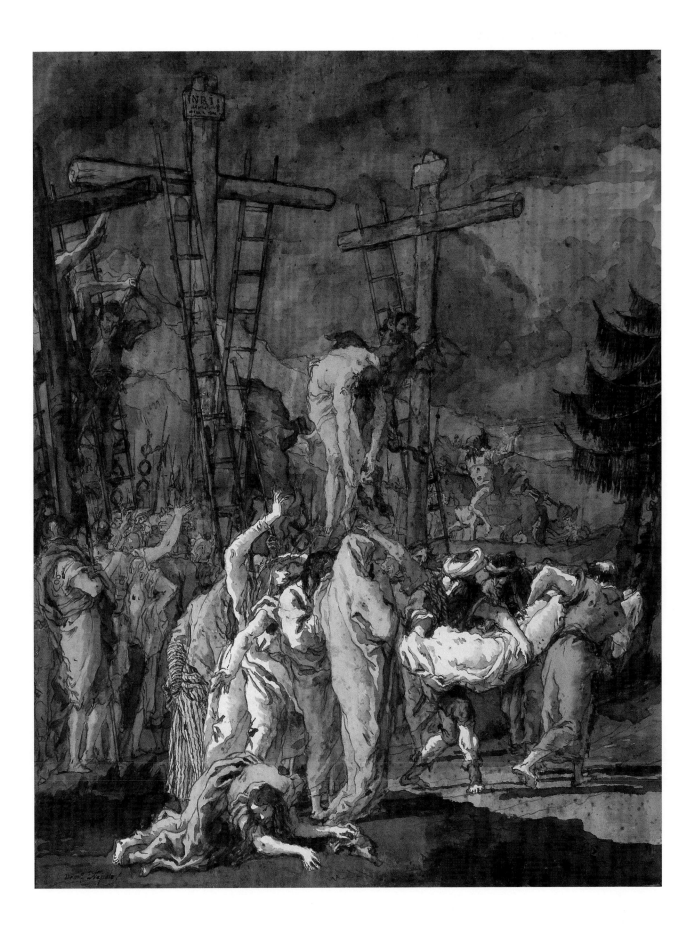

204. *The Entombment of Jesus*

And when Joseph had taken the body, he wrapped it in a clean linen cloth, and laid it in his own new tomb which he had hewn out in the rock . . . (Matt. 27:59–60)

Pen and wash, over extensive black chalk, 462 x 360
Signed low right: Dom.o Tiepolo f
Provenance: Jean Fayet Durand (1806–1889)
Literature: Byam Shaw 1962 [32]; Conrad 1996 [168]
Reference: Christiaan van Adrichem 1584, Site 237; Réau 1957, 521–27; Ragusa and Green 1961, 344; Maria de Agreda 1971, 708–709

Paris, Musée du Louvre, Département des Arts Graphiques, RF 1713bis [79]

Angels, returning for the first time since Christ's Transfiguration, swirl among the clouds as Christ is gently and reverently lowered into his tomb. Joseph and Nicodemus are preoccupied with their sad task while the holy women exhibit various attitudes of grief. The Virgin, nearly fainting, remains standing with the aid of her companion, while the Magdalene vents her fierce sorrow at the base of the tomb. ☙

Domenico follows an ancient tradition in showing the three Marys attending at the entombment, as is described at length in the *Meditationes vitae Christi LXXXII,* by Christiaan van Adrichem (1584: Site 237) and by Maria de Agreda. ✤

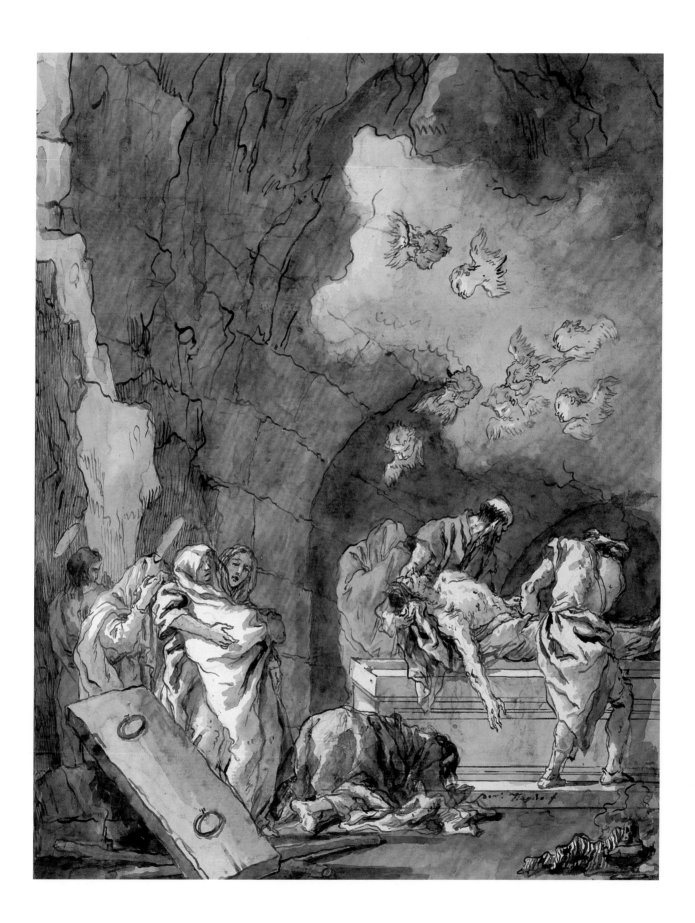

The Resurrection to the Ascension, Plates 205–212

None of the Gospels actually describe the essential aspect of Christian dogma, Christ's Resurrection. The Gospels describe only its aftermath and Christ's later appearances. According to Matthew 27:64–66, Pilate orders Christ's tomb to be sealed by a rock and a guard stationed there to prevent false claims regarding his resurrection. On the third day (first weekday after Sabbath), as Mary and Mary Magdalene come to the sepulcher, there is a mighty earthquake and an angel descends to give them the news that Jesus has arisen (Matt. 28:1–7). Matthew does not mention the Ascension, ending his account with Jesus meeting his eleven disciples on the mountain and anointing them. Mark (16:1–19) tells a similar story with some changes. In his version, the angel greets the arriving women and gives them the news. Christ later appears alone to Mary Magdalene and then to the eleven as they sit at meat; he upbraids them for not believing and ultimately ascends into Heaven.

The incense-bearing angel, detail of plate 205, *The Resurrection of Jesus*

In Luke's version (24:1–53), Peter is the first Apostle to visit the sepulcher and find it empty—an event that, interestingly enough, has gained only limited visual currency. Luke also specifies two "men" in shining garments. According to Luke, two disciples, one called Cleopas, and the other (as he states later on in the story) Simon Peter, go on to Emmaus later and fail to recognize Jesus as the pilgrim who encounters them and who reveals himself later at supper. Mark describes only the journey, not the supper. Luke concludes by saying that outside Bethany, after blessing his disciples, Jesus is carried to heaven. John adds further detail in chapters 20 and 21. Mary Magdalene encounters Jesus; thinking he's a gardener she questions him, and upon recognizing him is told not to touch him since he has not yet ascended to his Father—an event that has become a standard pictorial scene called the "Noli Me Tangere." Jesus later shows himself to his disciples in a room and permits Thomas, who doubts his resurrection, to touch his wound—the famous "Doubting Thomas" scene. According to John, Jesus later appears to his disciples at the Sea of Tiberias, where he arranges another miraculous catch and Peter is so surprised he leaps into the water. John's chapter concludes with Christ's discussions with Peter, which include his instructions to Peter to "feed my sheep" and ends with Jesus telling Peter it is not for him to worry about what would happen to Judas.

The most detailed description of the Ascension actually begins in Acts 1:2–10. Jesus is taken up into heaven in a cloud and the disciples, having gathered, continue to watch the sky until two men in white ask them why they still look to the heavens, affirming that Jesus will indeed come again.

Domenico's eight drawings center on these events, a distinctive mixture of the expected and unexpected. Christ's Resurrection (a standard episode in the pictorial repertoire) follows tradition, although the prominent censors are an unusual element. The angels greeting the women at the open tomb follow early models. Domenico then adds four appearances of Jesus to his disciples, omitting the more traditional "Noli Me Tangere" and the "Doubting Thomas" and choosing instead Jesus appearing to a vast group of followers, first from a distance and then closer up. These appear to follow Matthew 28:16–17, which states that the eleven disciples went away to the mountain where Jesus had appointed them. I Cor. 15:6 reminds us that Christ once appeared to 500 brothers at once. Later commentaries, notably Maria de Agreda, describe 120 persons, including the eleven Apostles, 72 disciples, Mary Magdalene, Lazarus, and the faithful men and women assembled to witness Jesus ascending.[10] Domenico's two drawings have close connections to such

Disciples still watching in the aftermath of Christ's Ascension, detail of plate 212, *The Ascension of Jesus, II*

later descriptions and form a link to his two highly exceptional scenes of Jesus's ascent, which again take into account descriptions beyond the Gospels. Medieval sources and later works like Maria de Agreda say that when Christ ascended he did so with others, including patriarchs and saints, some of whom went as bodies and others as souls.[11]

10. Maria de Agreda, iii, 770*ff.*
11. Maria de Agreda, iii, 801; *The Meditations,* 376–377.

205. *The Resurrection of Jesus*

Lift up your heads, O ye gates; even lift them up, ye everlasting doors; and the King of glory shall come in. Who is this King of glory? The Lord of hosts, he is the King of glory. (Ps. 24:9–10)

Pen and wash, over black chalk, 465 x 364
Signed low left: Dom. Tiepolo f
Provenance: Paris, Hôtel Drouot, Mar. 13, 1995 [223]
Exhibition: New York, Thomas Williams Ltd. and W. M. Brady & Co., 1995 [38]
Literature: ad. *Apollo,* October 1995; Conrad 1996 [184]
Reference: James 1924, 94–146; *The Golden Legend I,* 86–101; Jameson 1890, ii, 263–271; Réau 1957, 547–549

New York, private collection

Using his shield to block Christ's blinding supernatural light, a soldier runs from the stunning apparition of Jesus soaring out of his tomb. His companions have fallen to the ground. One angel spreads incense and another rejoices as Jesus, accompanied by seraphim, glides upward. His lightness reminds us of Maria de Agreda's description, "Agility so freed Him from the weight and slowness of matter, that it exceeded the agility of the immaterial angels, while He himself could move about more quickly than they. . . . In all this glory and heavenly adornment the Savior now rose from the grave."[12] Alluding to immortality, a majestic evergreen stands at the left. ❦

Although the scene of Jesus's resurrection is not directly reported in the New Testament, it is known in art from the sixth century onwards and is described at length in *The Gospel of Nicodemus,* or *Acts of Pilate* of the fourth century, and in *The Golden Legend.* Réau notes that the scene was severely criticized by the Council of Trent, and by Jean d'Ayala as late as 1730; however, it seems to have returned to favor in Venice in the eighteenth century. The present drawing is notable for the extremely brilliant use of the white paper in the handling of light. ⚜

12. Maria de Agreda, *op. cit.,* [727], 729.

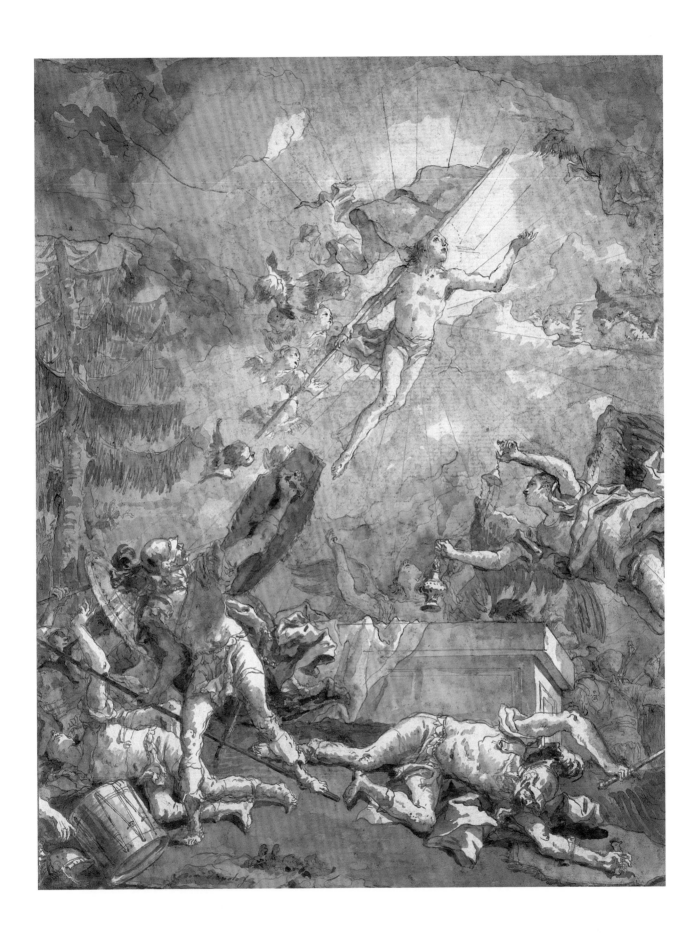

206. *The Three Marys at the Tomb*

And entering the sepulcre, they saw a young man sitting on the right side, clothed in a long white garment; and they were affrighted. And he said unto them, Be not affrighted: Ye seek Jesus of Nazareth, which was crucified: he is risen; he is not here: behold the place where they laid him. (Mark 16:5–6)

And, behold, there was a great earthquake: for the angel of the Lord descended from heaven, and came and rolled back the stone from the door, and sat upon it. His countenance was like lightening, and his raimant white as snow. . . . (Matthew 28: 2–3)

> Pen and wash, over heavy black chalk, touches of white gouache, 470 x 368, image, trimmed
> Signed low right: Dom.o Tiepolo f
> Literature: Ragusa and Green 1961, 361–364; Conrad 1996 [185]

Paris, Musée du Louvre, Département des Arts Graphiques, Réc. 70

Here the angel of the Lord sits astride the empty tomb and, with a face like lightning, gestures aggressively as he declares that Jesus has risen from the dead, clearly frightening Mary Magdalene. He points to her with one hand and to heaven with the other, making his message, strengthened by the empty shroud, abundantly clear. Seated toward the back is a second angel who is mentioned only by Luke (24:4); his presence is unusual in terms of the visual tradition. The other Marys take the news more calmly and kneel reverently before the angel and the empty tomb. ❧

The story is also told in Matthew 28:1–8 at somewhat greater length. The design follows fairly closely on *The Entombment* (pl. 204) and appears to be relatively late in date. One may note, very unusually, that there are two angels, three censers, and four women. The foremost of these, Mary Magdalene, with arms outstretched, has a jar of ointment by her side. The story is told at length in the *Meditationes vitae Christi, 88.* ⚜

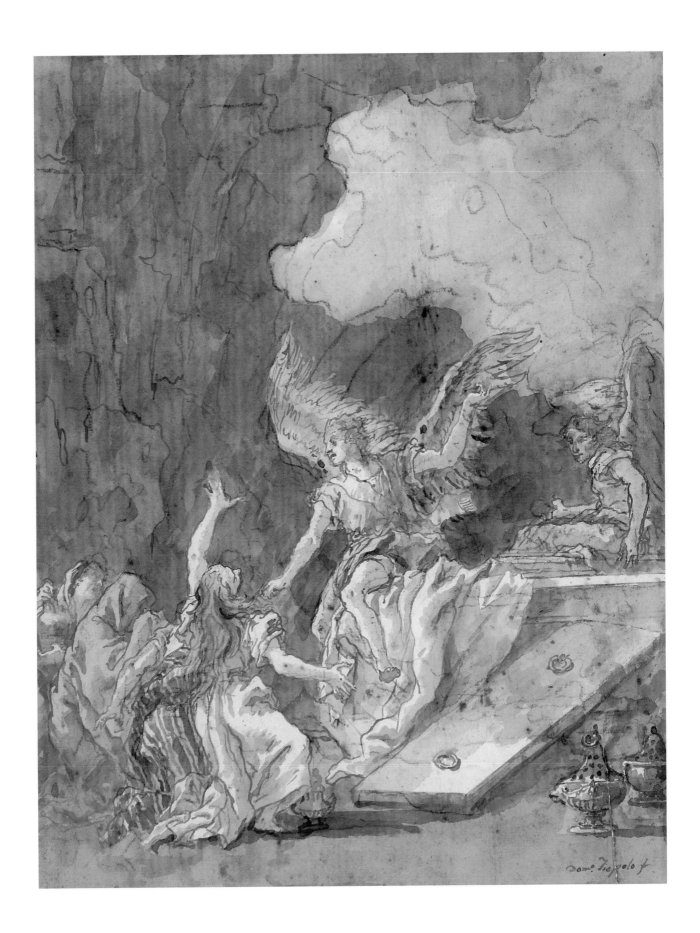

207. *Jesus Appears to His Disciples, I*

Then the eleven disciples went away into Galilee, into a mountain where Jesus had appointed them. And when they saw him, they worshipped him: but some doubted. (Matt. 28:16–17)

Pen and wash, heightened with white gouache, over black chalk, 485 x 385
Signed low right: Dom.o Tiepolo f
Provenance: Paris, Hôtel Drouot, Dec. 14, 1938 [4]; Michel-Lévy; Mme. A.L.D.; Paris, Drouot Richelieu, Nov. 21, 2001 [64]; London, Jean-Luc Baroni; Wildenstein
Literature: Maria de Agreda iii, 779*ff*; Conrad 1996 [190]

New York, private collection, courtesy of Wildenstein & Co.

Once more indulging his interest in unusual events, Domenico shows the resurrected Christ appearing to a vast multitude. Clearly those crowding closest are his disciples, with Peter the figure nearest to him and the holy women in the background, but the outer circle includes a large assembly of Jewish patriarchs with their families. I Cor. 15:6 reminds us that Christ once appeared to 500 brothers at once, an event also mentioned in *The Meditations.* ❧

Two drawings depict Jesus in a mountainous environment in a state of heroic nudity, and surrounded by a vast crowd of people; see the following drawing (pl. 208) recorded in photographs in the Service de Documentation au Musée du Louvre and in the Cailleux archives. The passage in Matthew does not suggest a large crowd. Our drawing may also suggest the story of Doubting Thomas (John 20:24–29) but not very specifically, with a bent figure to the left of Jesus who may perhaps be identified as Peter; moreover, the setting is not appropriate. For this reason we prefer to associate it with the text of Matthew 28. ⚜

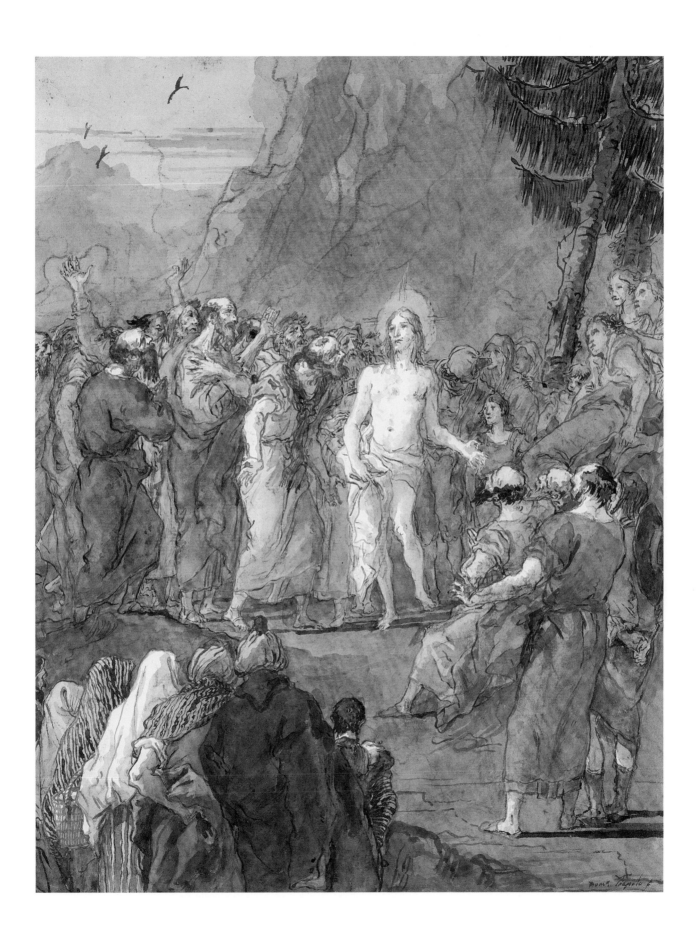

208. *Jesus Appears to His Disciples, II*

Then the eleven disciples went away into Galilee, into a mountain where Jesus had appointed them. And when they saw him, they worshipped him: but some doubted. And Jesus came and spake unto them, saying, All power is given unto me in heaven and in earth. Go ye therefore, and teach all nations, baptizing them in the name of theFather, and of the Son, and of the Holy Ghost . . . (Matt. 28:16–19)

Pen and wash, 470 x 368
Signed low right: Dom.o Tiepolo f
inscribed on verso, in pencil: *Einkl*
Provenance: Roger Cormier, Tours, his sale, Paris, Georges Petit, Apr. 30, 1921, no. 62; Duc de Trévise, his sale, Paris, Hôtel Drouot, Dec. 8, 1947, pl. 44; Cailleux, n.d.
Literature: Conrad 1996 [191]

Repeating his subject of the Resurrected Christ appearing to a vast multitude, here Jesus ascends a small hillock similar to the one from which he will soon ascend (pl. 211). Maria de Agreda mentions that his ascension would take place before a vast assembly of 120 (vol. 3, pp. 770*ff*). 🌿

This drawing shows Jesus as a more commanding figure; it is recorded in photographs in the Service de Documentation au Musée du Louvre and in the Cailleux archives. It treats the scene in an unusually dramatic way, and must be given a relatively late date. ⚜

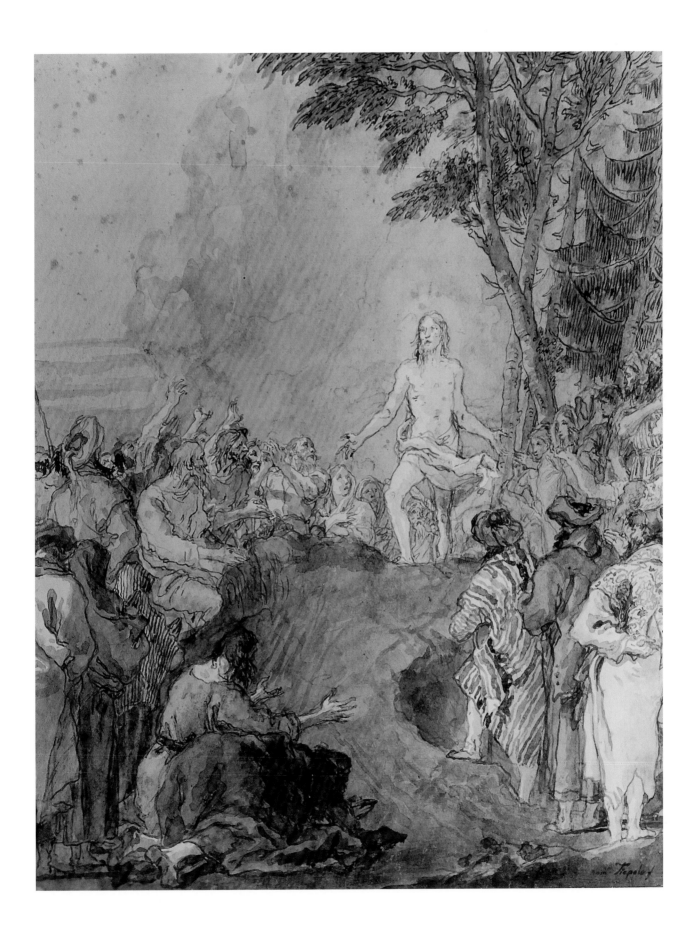

209. *Jesus and the Disciples on the Road to Emmaus*

And, behold, two of them went that same day to a village called Emmaus, which was from Jerusalem about three-score furlongs. And they talked together of all those things which had happened. And it came to pass that, while they communed together and reasoned, Jesus himself drew near, and went with them. But their eyes were holden that they should not know him. (Luke 24:13–16)

The he said unto them, O fools, and slow of heart to believe all that the prophets have spoken. . . . And beginning at Moses and all the prophets, he expounded unto them in all the scriptures the things concerning himself. (Luke 24:25–27)

After that he appeared in another form unto two of them, as they walked, and went into the country. (Mark 16:12)

> Pen and wash, over black chalk, 461 x 362
> Signed low right: Dom.o Tiepolo f
> Provenance: Roger Cormier, Tours, his sale, Paris, Georges Petit, Apr. 30, 1921, no. 33; Dr. Rudolf J. Heinemann, New York
> Exhibition: New York 1973 [111]
> Literature: Guerlain 1921, 83; Conrad 1996 [187]
> Reference: Christiaan van Adrichem 1584, Site 255; Réau 1957, 562; Ragusa and Green 1961, 366–368

New York, The Pierpont Morgan Library, Gift of Mrs. Rudolf J. Heinemann in memory of
Dr. Rudolf J. Heinemann, 1997.77

Now fully clothed (but not, as is traditional, dressed like a pilgrim), the Resurrected Christ appears to two disciples (traditionally identified as Peter and Cleopas) outside Emmaus. They register recognition, which is the way Mark describes this event, though he does not specify Emmaus here defined by its characteristic crenellation. Mark does not mention the subsequent supper, which Domenico also omits. ❦

The scene is set in front of the walls of Emmaus. This may seem odd since the place is described as a village; however, Luke 24:13 as given in the *Vulgate* speaks of a *castellum,* thus giving authority to Emmaus as a walled town. It is interesting to note how Domenico increases the width of the tower in the center of the composition so that it will frame the head of Jesus. In its original form the left edge of the tower would have come down precisely on the center of the head of Jesus, which was clearly felt to be unsatisfactory. The disciple on the right is dressed in the traditional costume of a pilgrim, possibly meant to indicate the Apostle James the Great, of Compostela. The story is told at length in the *Mediatationes vitae Christi CVI,* and more briefly by Christiaan van Adrichem (1584: Site 255). ⚜

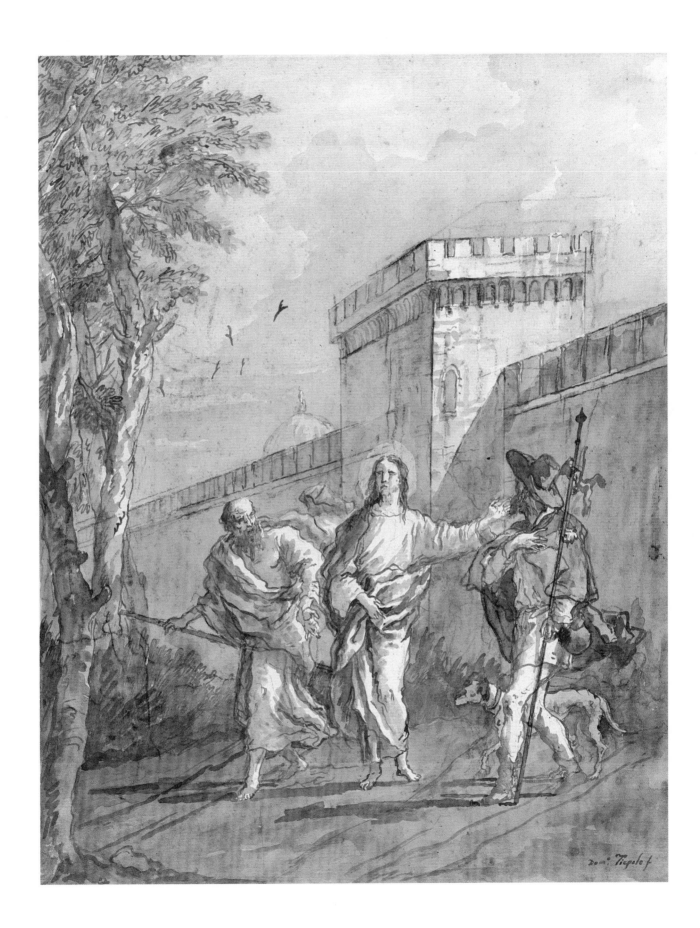

210. *Jesus at the Sea of Tiberias*

But when the morning was now come, Jesus stood on the shore: but the disciples knew not that it was Jesus. Then Jesus saith unto them, Children, have ye any meat? They answered him, pl. And he said unto them, Cast the net on the right side of the ship, and ye shall find. They cast therefore, and now they were not able to draw it for the multitude of fishes. (John 21:1–14)

 Pen and wash, over black chalk, 479 x 373, paper
 Signed low left: Dom.o Tiepolo f
 Provenance: Roger Cormier, Tours, his sale, Paris, Georges Petit, Apr. 30, 1921, no. 31; Christie's, Dec. 15, 1992 [136]
 Literature: Guerlain 1921, 87; Conrad 1996 [189]
 Reference: Pigler 1956, i, 344–346; Réau 1957, 571; Ragusa and Green 1961, 371–373

Flinging up his arms in surprise as he recognizes Christ, Peter has his foot on the ship's edge and prepares to jump in the water, as John's text further states. The others are still absorbed in hauling up the abundant catch Christ has miraculously arranged for them. ✺

The story of the miraculous draught of fishes is told twice in the Gospels. The first is in Luke 5:4–7, where it forms part of the calling of Peter, together with James and John, the sons of Zebedee (pls. 111 and 113). For John it forms one of the stories following the Resurrection, and we suggest that this is the text followed here. This event is described at length in the *Meditationes vitae Christi, XCV.* ⚜

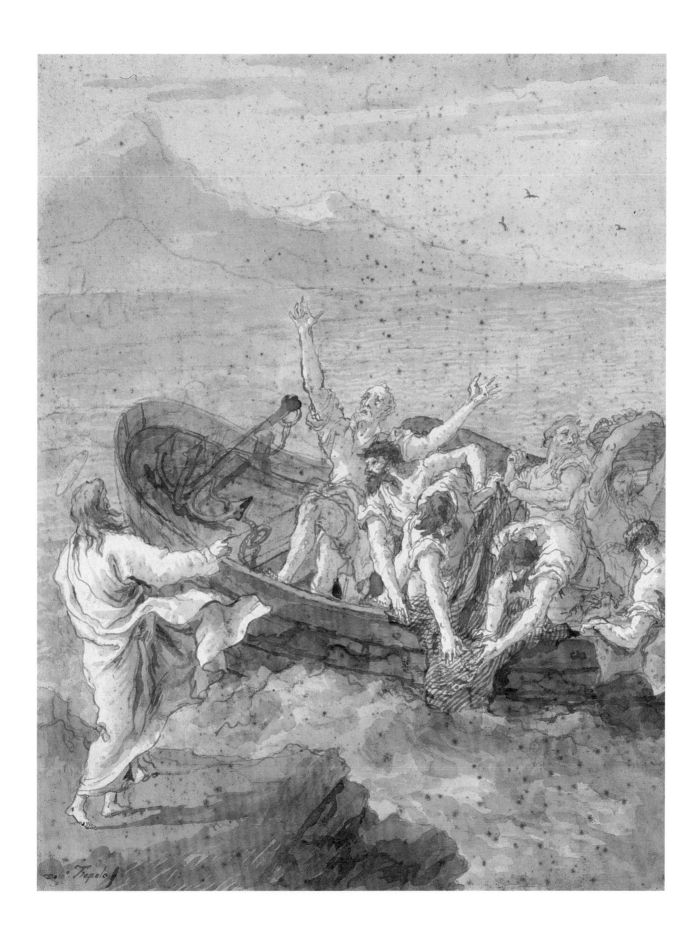

211. *The Ascension of Jesus, I*

And when he had spoken these things, while they beheld, he was taken up; and a cloud received him out of their sight. (Acts 1:9)

Pen and wash, over black chalk . . . ?
Signed low left: Dom.o Tiepolo f
Provenance: M. Luzarche; Roger Cormier, not in sale
Literature: Guerlain 1921, 89; Conrad 1996 [192]
Reference: *The Golden Legend,* 1900, i, 108–122; Réau 1957, 582–590; Ragusa and Green 1961, 374–384

Forty days after he rose from the dead, Christ, resuming the same lithe pose as in his Resurrection (pl. 205), ascends heavenward, drawing a vast company of angels and souls with him into the clouds (in reference to Maria de Agreda, among others). Gathered on the little hillock at the Mount of Olives, his disciples watch him disappear, their faces and bodies conveying a multitude of emotions, including reverence, sadness, mutual affection, and astonishment. Peter, his arms flung wide, has to be restrained, thus conferring upon him a special status in a scene that inaugurates his own prominence in the Book of Acts. ❦

The story of *The Ascension of Jesus* is given in the first chapter of the Acts of the Apostles. An extended account is given in *The Golden Legend.* Here a great crowd of disciples is shown on the ground, and at the top, amid a mass of more or less naked angels, or perhaps souls, the figure of Jesus disappears into a black cloud, with only his legs visible. These elements are reminiscent of Correggio's *Assumption of the Virgin* at Parma. The story is told at length in the *Meditationes vitae Christi, XCVII.* ⚜

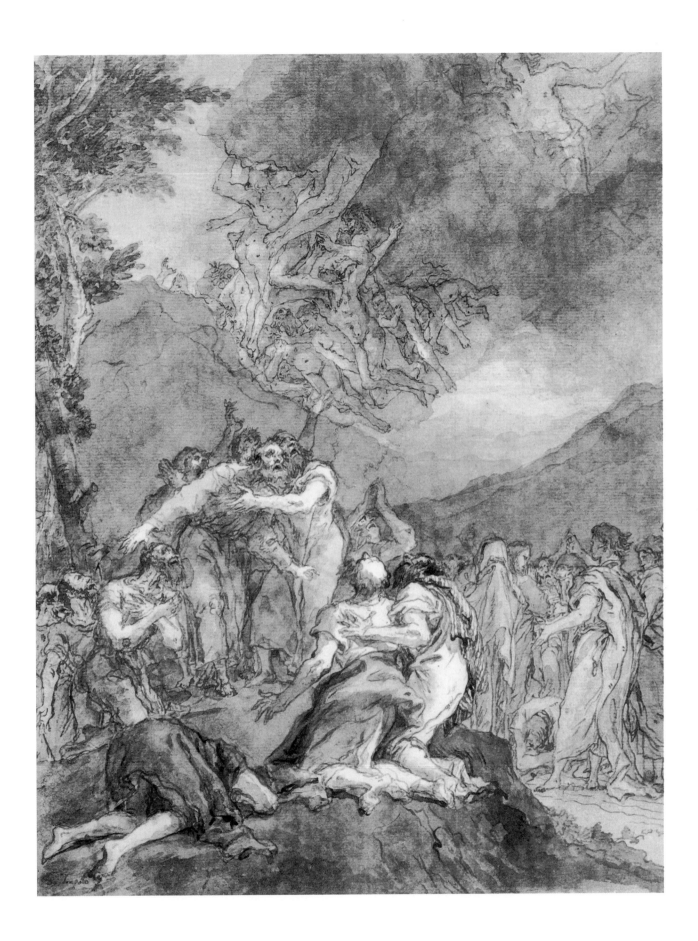

212. *The Ascension of Jesus, II*

And while they looked steadfastly toward heaven as he went up, behold, two men stood by them in white apparel; which also said, Ye men of Galilee, why stand ye gazing up to heaven? this same Jesus, which is taken up from you into heaven, shall so come in like manner as ye have seen him go into heaven. (Acts 1:10–11)

Pen and wash, over slight black chalk, 474 x 373, trimmed close to the image
Signed low left: Dom.o Tiepolo f
Provenance: Jean-François Gigoux (1806–1894), his bequest, 1894
Literature: Conrad 1996 [193]

Besançon, Musée des Beaux-Arts et d'Archéologie, 2231

In this rarely portrayed sequel, Domenico shows the Ascension's aftermath as Christ's disciples continue to search the heavens for a glimpse of him, though only a cloud remains. Peter, posed much as he has been in many earlier scenes, kneels in reverence at the left as the two men in white (here not portrayed as angels, as was tradition), mentioned in Acts, approach to admonish the group. ✺

This design seems to follow plate 211, emphasizing the two men "in white apparel," but otherwise the concept is very different. These two scenes are taken from the first chapter of the Acts of the Apostles. ⚜

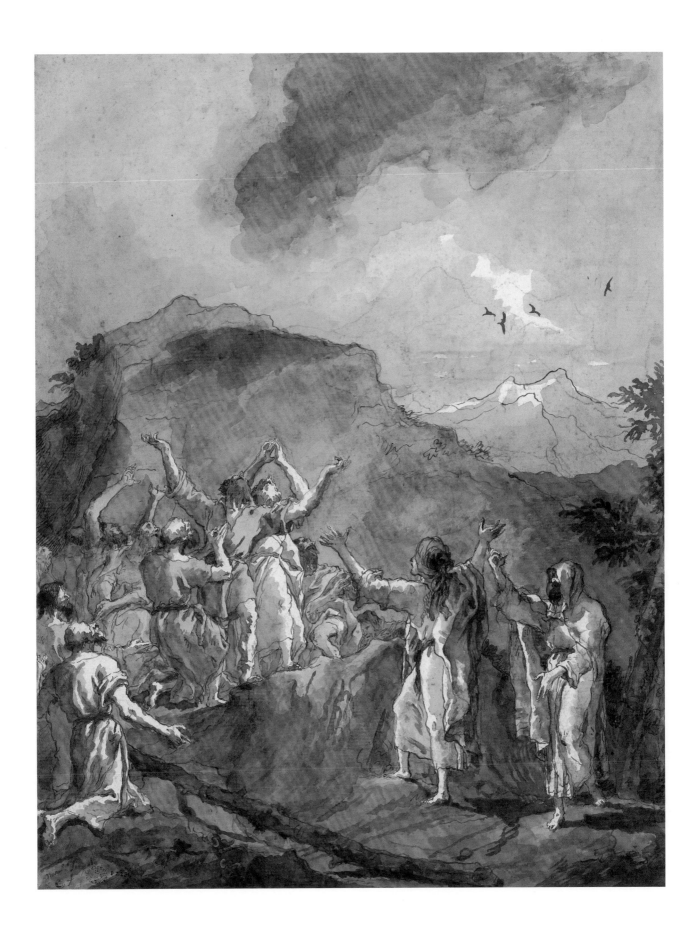

Part XIV

The Via Crucis, or Fourteen Stations of the Cross, Plates 213–227

Based on the devotional exercises performed by pilgrims to the Holy Land, the *Via Crucis* retraced Christ's final steps along the sacred road that led from Pilate's palace to Golgotha. These holy sites were administered by the Franciscan order, and their devotional exercises were codified into fourteen stations by the end of the seventeenth century. Pilate's final condemnation of Christ as he is presented to the people became Station I, and devotions ended with his burial (Station XIV). Other stations include his carrying of the cross out of Jerusalem (Station II), falling three times (Station III, Station VII, Station IX), his encounters with his mother, Veronica, and the Holy Women (Stations IV, VI, and VII), and Simon of Cyrene helping with the cross (Station V). The Fourteen Stations consider three phases of Christ's actual crucifixion, beginning with his despoliation (Station X), nailing (Station XI), and crucifixion (Station XII), followed by the lamentation (Station XIII), and ending with his entombment (Station XIV).

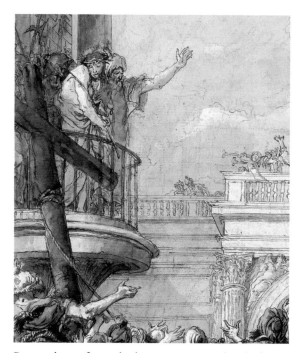

Peter at base of cross looking up at Jesus, detail of plate 214, *Station I: "Ecce homo"—Jesus Presented to the People*

Now a fixture in Catholic churches, the Fourteen Stations were adapted from numerous earlier traditions for portraying stages of Christ's passion, including the important *Sacra Monte* sites in Northern Italy.[13] Clearly proud of his youthful accomplishments as the first Venetian painter to produce a fourteen-station cycle in Venice in 1747 for the church of San Polo, Domenico added a separate chapter on the *Fourteen Stations* to his *New Testament* that

13. Varese and Varallo both have famous Sacro Monte. Varese has fourteen chapels that go from the Annunciation to the Assumption of the Virgin; see Colombo 1982.

recall but deliberately alter his earlier interpretations. Despite their insertion to illustrate how the devotional stations were connected to actual events in Christ's passion, Domenico gave the Stations a greater dramatic impact than his Passion scenes. He brings us closer to the events (perhaps alluding that meditation might have this effect) and accelerates the action, playing it up on and off stage. He goes out of his way to link these events to other parts of his narrative and gives his secondary characters strong roles. He gives Peter an unorthodox presence, including him in Station I, just below the cross, as well as in the lamentation scene, while his Virgin Mary and Mary Magdalene have a much more extensive presence than they traditionally have.

Mary and John the Evangelist watching Jesus' struggle, detail of plate 222, *Station IX: Jesus Falls the Third Time*

213. *Via Crucis—Frontispiece*

Innocent XI in 1686 granted to the Franciscans . . . the right to erect the Stations in all their churches. . . . Innocent XII confirmed the privilege in 1694, and Benedict XIII in 1726 extended it to all the faithful. In 1731 Clement XII extended it still further by permitting the indulgenced Stations to all the churches, provided that they were erected by a Franciscan father with the sanction of the Ordinary. At the same time he definitely fixed the number of Stations at fourteen. Benedict XIV in 1742 exhorted all priests to enrich their churches with so great a treasure. (The Catholic Encyclopedia, xv, 571)

> Pen and wash, over black chalk, 467 x 364
> Signed low right: Dom.o Tiepolo f
> Provenance: Jean Fayet Durand (1806–1889)
> Literature: Conrad 1996 [169]; Gealt in Udine 1996, 76
> Reference: Réau 1957, 465–468, cites nothing Venetian; Knox 1980, 31; Pedrocco 1989–1990, 109–115; Niero 1993, 143

Paris, Musée du Louvre, Département des Arts Graphiques, RF 1713bis [121]

Introducing his drawn version of the *Via Crucis* with less emphasis than his etchings placed on the written title (which is here diminished in scale) and a greater accent on the Passion symbols, Domenico also reinterprets the cross, which in this version is constructed from a rude, unhewn pair of logs, rendering them more hefty and infinitely more cumbersome, and somehow more "original"—perhaps Domenico's way of hinting at his search for the "old time religion." ❦

The cult of the *Via Crucis* is, above all, linked to the name of S. Leonardo da Porto Maurizio (1676–1751), who besides setting up the celebrated series in the Colosseum is said to have erected 571 others in all parts of Italy, while on his different missions. It is not known whether he was in any way involved when, as a very young man of 20 or 21, Domenico painted the fourteen *Stations of the Cross* and other canvases for the Oratorio del Crocefisso in the Venetian church of San Polo. In 1749 he recorded them in a series of etchings, together with a frontispiece, as here. The paintings may be claimed to be the first *Via Crucis* in Venice, though they are not arranged around the walls of the church in the normal fashion but in the adjacent mortuary chapel, which, in the Venetian tradition, was often decorated with *Scenes of the Passion*. In 1750 they were followed by the smaller series by Antonio Zucchi in the Chapel of San Luca in the church of San Giobbe. In 1755 the important series in Santa Maria del Giglio, by the hands of a number of painters, were installed in the now familiar way, around the walls of the church. It may be noticed that this and the fourteen drawings that follow appear in the Louvre Album together and in the correct order (Album pls. 20–34). They often refer back to his series of etchings after the S. Polo *Via Crucis*. ⚜

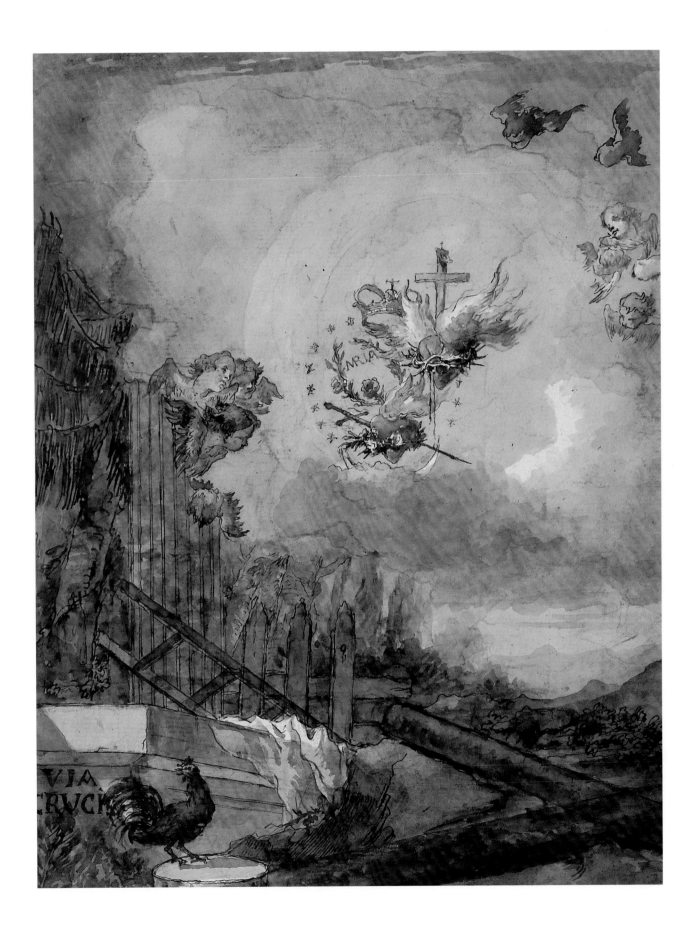

214. *Station I: "Ecce homo"—Jesus Presented to the People*

Whereon Pilate standing, exhibited Jesus to the Princes and people of the Jews to be looked on, being very scourged, spit on, cloathed with a purple cloak, and wearing a sharp crown of thorns upon his head, saying unto them, Behold the man, that he being thus afflicted, they might have compassion on him. But they with confused voyces cryed, Crucifie him, Crucifie him. Where as yet an arch of stone is to be seen, and is shewed unto strangers, with this Inscription, Tolle, Tolle, crucifie—the rest cannot be read, by reason Antiquity hath worn it out. (Christiaan van Adrichem 1584, Site 119)

Pen and wash, over black chalk, 464 x 358
Signed low left: Dom.o Tiepolo f
Inscribed low center: I
Provenance: Jean Fayet Durand (1806–1889)
Literature: Christiaan van Adrichem 1584, Site 119; Conrad 1996 [170]

Paris, Musée du Louvre, Département des Arts Graphiques, RF 1713bis [21]

As Pilate addresses the crowd, Jesus, in Domenico's version, has the first of several private if silent communications with his friends. Here, as he looks down at the cross, he sees Peter, who gestures up to him in anguish, adding a dimension to the Fourteen Stations that no text provides. Domenico deliberately links his treatment of the Stations to his earlier Ministry and Passion cycle (where Peter again was particularly prominent), reminding us that the meditative Stations are based on stages of Christ's Passion. The mob and the vantage point anticipate the construction of Station XII, The Crucifixion, which is the fulfillment of their cries to crucify him. ❦

Domenico here conflates two earlier images of the *Ecce homo,* with reference to the Arch of the Ecce Homo in Jerusalem. A remarkable element in the design is the crowd, pressed down into a series of quarter-length figures, in the lower fifth of the composition. Here begins the description of the *Via Crucis* by Christiaan van Adrichem, *Jerusalem sicut Christi tempore floruit,* 1584, Site 117, which extends over pp. 141–146, with measured distances for the first eleven stations, in the order that later became canonical. We here use the translation by Thomas Thymme, York 1666. He notes: "D. Petrus Folens & M. Matthaeus Svenberck did measure the City of Jerusalem long since, by whose report this Description is made many hundred years after." The three last stations are also described under Sites 250, 253, and 237. This work had a wide distribution, and is considered to be the basic source for the *Via Crucis* as it became later established and known in Domenico's time. Such a precise description of the topography of Jerusalem must have been of great use in visualizing events that took place in the city. Christiaan van Adrichem, 1584, describes the *Ecce homo* under Site 119. ⚜

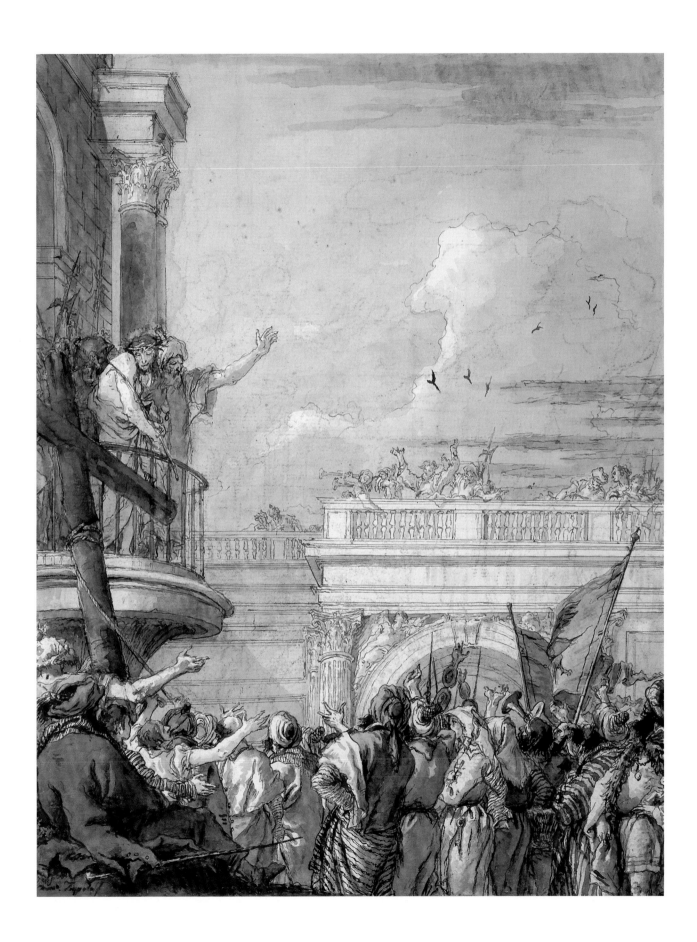

215. *Station II: Jesus Takes the Cross on His Shoulder*

When he is clothed they lead Him outside, so as not to postpone His death any longer, and they place on His shoulders the venerable wood of the long, wide, very heavy cross, which the most gentle lamb patiently takes and carries. (Meditationes vitae Christi)

The Way of the Crosse, by which Christ having received his judgement to be crucified, went forward with painfull and bloody steps to Mount Calvary. For beginning at the Palace of Pilate, he made six and twenty steps (which make threescore and five foot) unto the place where the crosse was laid upon him. (Christiaan van Adrichem 1584, Site 117)

Pen and wash, over black chalk, 471 x 363
Signed low right: Dom.o Tiepolo f
Inscribed low center: II
Provenance: Jean Fayet Durand (1806–1889)
Literature: Christiaan van Adrichem 1584, Site 117; Ragusa and Green 1961, 331; Maria de Agreda 1971, vi, 626; Conrad 1996 [171]

Paris, Musée du Louvre, Département des Arts Graphiques, RF 1713bis [22]

Jesus begins his journey to Calvary in a dramatic yet nuanced visual essay on compassion, indifference, and points of view. Roman soldiers regard Jesus as a condemned prisoner and their leader ferociously jabs his pike, while his subordinates follow suit. One soldier (possibly a future convert) steps out of the crowd and assists with the cross. Perhaps motivated by pity, he looks at Jesus with some compassion. Ignoring his tormentors, Jesus gazes heavenward. Bystanders in the foreground include those inevitably attracted to the spectacle of a public execution, and two youthful participants in it: the drummer boy tapping out the death march and the lad carrying the insignia. They stare fixedly (perhaps with morbid fascination) at Jesus. ❧

In this richly textured drawing, Domenico emphasizes the Roman imperial elements of the scene, the bust of TIB(erius) CAES(ar) on the left, and the banner SPQR in the right center background. The youth on the right, holding the tablet INRI, is outlined in pencil on the verso. Jesus stands erect and still, in contrast to the energetic frenzy of the soldiers, and the boy begins to beat his drum. The scene is described by Christiaan van Adrichem (1584: Site 117). The Cross is described under Site 120: "The Crosse of Christ, which was layd on his shoulder, was fifteen foot long, and eight foot over, as we have received by Tradition of the Elders." ⚜

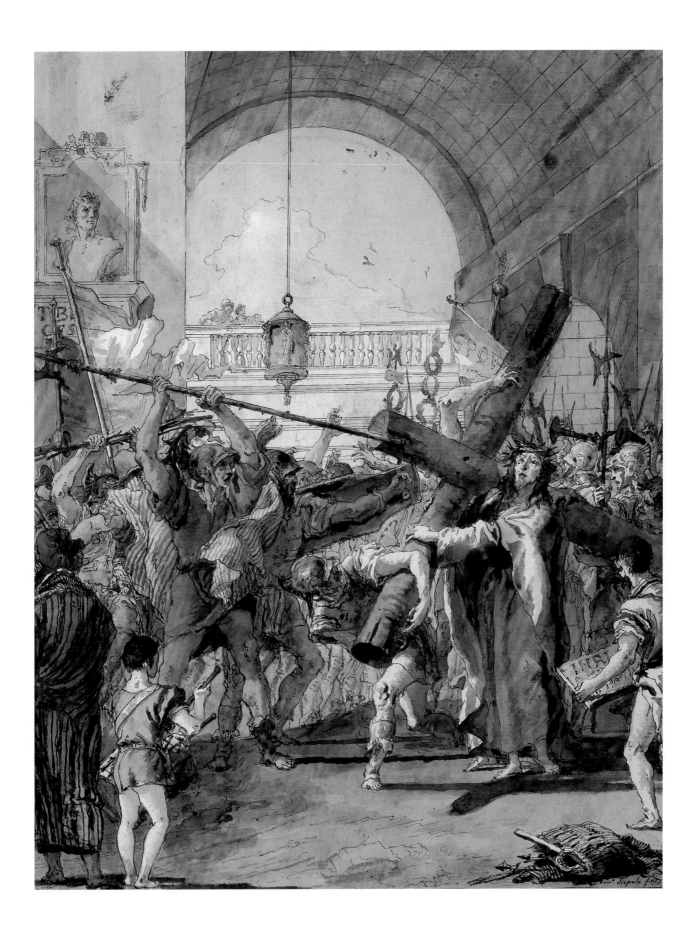

216. *Station III: Jesus Falls Under the Cross the First Time*

From whence (all the City gazing on him) carrying his crosse on his sore shoulders, he came towards the West, or rather North west, fourscore steps, which make two hundred foot, where men say that he fell down under his crosse. (Christiaan van Adrichem 1584, Site 117)

The executioners, bare of all human compassion and kindness, dragged along our Savior Jesus with incredible cruelty and insults. Some of them jerked Him forward by the ropes in order to accelerate his passage, while others pulled from behind in order to retard it. On account of this jerking and the weight of the Cross, they caused Him to sway to and fro and often to fall to the ground. (Maria de Agreda iii, 633)

> Pen and wash, over black chalk, 470 x 370
> Signed low right center: Dom.o Tiepolo f
> Inscribed low center: III
> Provenance: Jean Fayet Durand (1806–1889)
> Literature: Conrad 1996 [172]
> Reference: Christiaan van Adrichem 1584, Site 117; Maria de Agreda iii, 633

Paris, Musée du Louvre, Département des Arts Graphiques, RF 1713bis [23]

A trumpeter blares out the news that Jerusalem's gate has been exited but the procession halts temporarily as Jesus falls for the first time. He collapses into the arms of a sympathetic executioner in a setting and pose deliberately reminiscent of Domenico's earlier restoration of the son of the Widow of Nain (pl. 121), reminding us not only of that widow's gain, but also of his own mother's loss and his own sacrifice. 🖋

The tumultuous procession has left the city gate with trumpets blowing and banners waving. Jesus stumbles, but he and the cross are supported by quite compassionate executioners. Soldiers are not so evident. The scene is described by Christiaan van Adrichem (1584: Sites 117, 121). The city gate in the background is described as "the gate of Judgement" (Site 114), "the Judiciary gate" (Site 143), and "The Old Gate" (Site 165): "It was also called, the Judgement Gate, because in old time, the Judges did sit there in Judgement. For then the Seniors did exercise Justice and Judgement in the Gates of their Cities. And such as were condemned to dye, went out at this gate. Whereupon Christ was led out to be crucified. Of this Gate, there are at this day some old remainders and ruines to be seen." ⚜

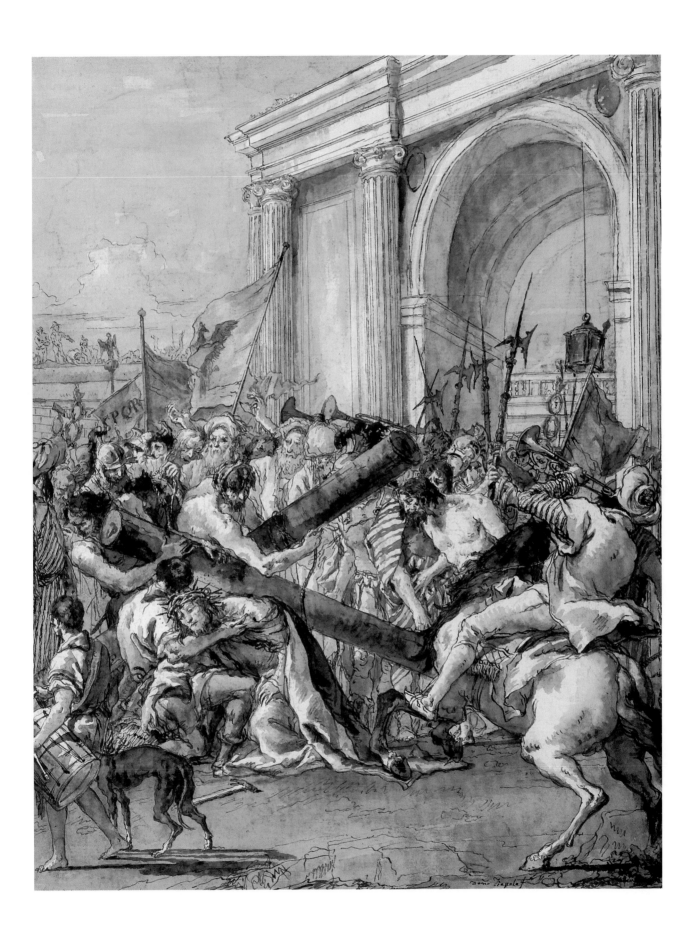

217. *Station IV: Jesus Meets His Mother*

When, however, outside the gate of the city, at a crossroads, she encountered Him, for the first time seeing Him burdened by such a large cross, she was half dead with anguish and could not say a word to Him; nor could He speak to her, He was so hurried along by those who led Him to be crucified. (Meditationes vitae Christi)

From thence going forward by three score steps, and three foot (which makes a hundred fifty and three foot) he came to the place where the Blessed Virgin Mary, with John the Apostle met with him. (Christiaan van Adrichem 1584, Site 117)

Pen and wash, over black chalk, 465 x 365
Signed low right center: Dom.o Tiepolo f
Inscribed low center: IV
Provenance: Jean Fayet Durand (1806–1889)
Literature: Conrad 1996 [173]
Reference: Christiaan van Adrichem 1584, Site 117; Ragusa and Green 1961, 332; Maria de Agreda 1971, vi, 634

Paris, Musée du Louvre, Département des Arts Graphiques, RF 1713bis [24]

The trumpeter signals another stop as Jesus, ignoring the soldiers, stares mutely and almost shyly at his mother, who here confronts him, standing in her familiar tragically silhouetted form. Mary Magdalene (whom Mark 15:40 implies was always with the Virgin) prostrates herself before Jesus in a scene that moves beyond traditional interpretations. ❦

The procession is now in the open countryside, and the mounted trumpeter is still prominent on the right. This device thrusts the figure of Jesus to the left and into the middle distance, making the confrontation with Mary, accompanied by Mary Magdalene and her jar of ointment, more poignant and immediate. The spot is established by Christiaan van Adrichem (1584: Sites 117): "Here also by Tradition of some Fathers, it is said, that the Blessed Virgin Mary, with John, and certain godly women stood, as Christ passed by with his Crosse." ⚜

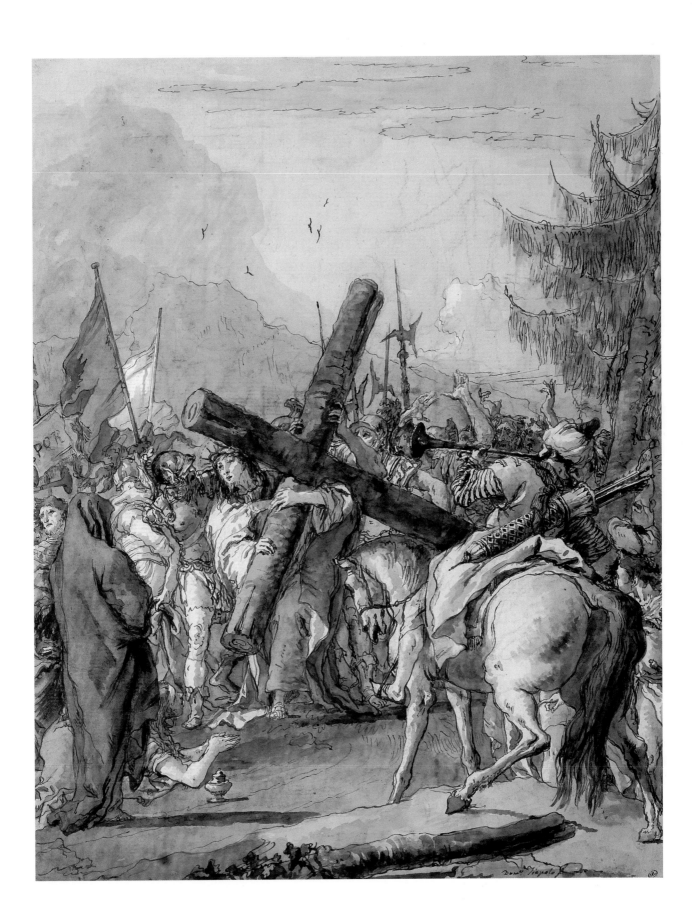

218. Station V: Jesus Assisted by St. Simon of Cyrene

And as they came out, they found a man of Cyrene, Simon by name: him they compelled to bear his cross. (Matt. 27:32)

And they compel one Simon a Cyrenian, who passed by, coming out of the country, the father of Alexander and Rufus, to bear his cross. (Mark 15:21)

And proceeding from thence by threescore and eleven steps, and one foot and a half (which makes a hundred seventy and nine foot) he came unto a certain cross-way, where Simon of Cyrene was compelled to beare the hinder part of the crosse with Christ. (Christiaan van Adrichem 1584, Site 117)

Pen and wash, over black chalk, 470 x 364
Signed low right: Dom.o Tiepolo f
Inscribed low center: V
Provenance: Jean Fayet Durand (1806–1889)
Literature: Conrad 1996 [174]
Reference: Christiaan van Adrichem 1584, Site 117

Paris, Musée du Louvre, Département des Arts Graphiques, RF 1713bis [25]

Embellishing his narrative with small details, Domenico lingers on the mute dialogue between mother and son, begun in the previous scene. Simon of Cyrene is brought in to assist with the cross, shown at its full length for the first time, thus stressing its cumbersome weight. The trumpeter, who has moved beyond the picture plane at the left, blares his trumpet just above Mary's head and orders the procession to move on. ❦

The procession nears Golgotha, which can be seen in the left background. Not only Simon but a Roman soldier assists with the burden of the cross. An interesting innovation is the introduction of the figure of a woman on the left, not unlike Mary in the preceding drawing, to confront the motionless Jesus. The location is established by Christiaan van Adrichem (1584: Site 117): "Christ being come to these two ways, and being wearied with the heavy burden of his Crosse, is said to have fallen. For the which cause, the souldiers and Jews, fearing that he would faint before he could be crucified, took a certain man coming out of the Country, named Simon of Cyren, and compelled him to carry the Crosse after Jesus." ⚜

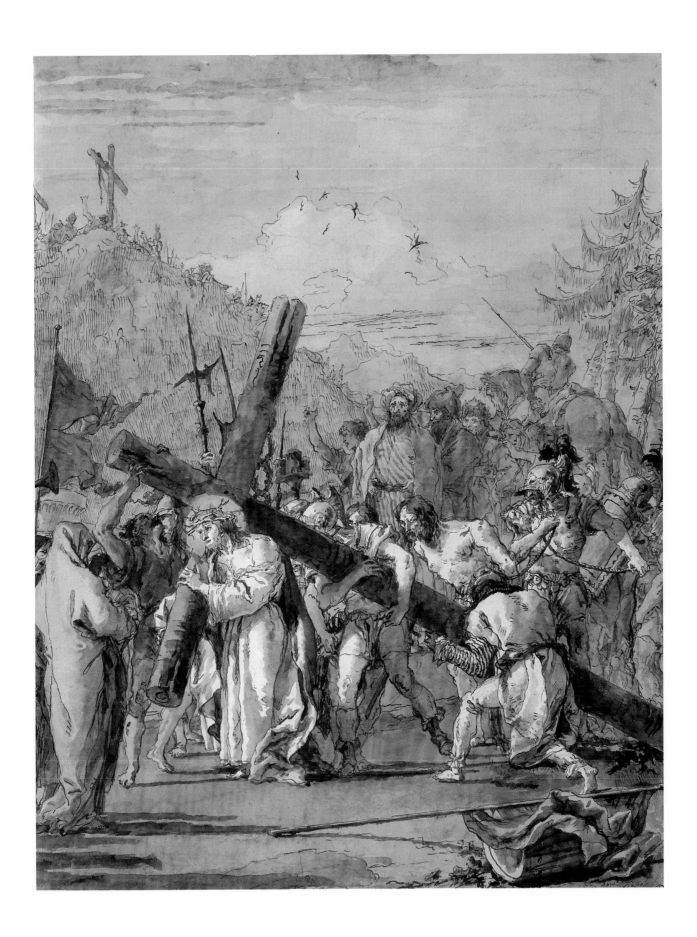

219. *Station VI: Jesus and St. Veronica*

Taking his way hence by one hundred ninety and one step, and half a foot (which commeth to four hundred and seventy foot) he came to the place where a certain Woman met with him. (Christiaan van Adrichem 1584, Site 117)

The print of the holy face of our Saviour on a linen cloth is kept in Saint Peter's church at Rome, with singular veneration. It is mentioned in an ancient ceremonial of that church, dedicated to Celestin II in 1143. . . . It was called Veronica, or true image of our Lord's face, from Vera and Iconica, a word used by St. Gregory of Tours for an image, from the Greek word Icon. Some moderns imagine that it served at the burial of our Lord; others say that a devout woman wiped his face with it, when he was fainting under the load of his cross, going to mount Calvary. . . . Some private writers and churches have given the name of St Veronica to the devout woman, who is said to have presented this linen cloth to our divine Redeemer, but without sufficient warrant. (Butler 1880, i, 54)

Pen and wash, over black chalk, 469 x 363
Signed low left: Dom.o Tiepolo f
Inscribed low center: VI
Provenance: Jean Fayet Durand (1806–1889)
Literature: Christiaan van Adrichem 1584, Site 117; Butler 1880, i, 54, under January 13; Conrad 1996 [175]

Paris, Musée du Louvre, Département des Arts Graphiques, RF 1713bis [26]

Domenico makes this story a subtle essay on looking. Jesus turns to look at Veronica, who holds up her veil to him. The Virgin Mary looks on from the background at the right as the procession makes its inexorable way up to Golgotha. The gentle encounter between Jesus and Veronica contrasts with the brutal treatment of the thieves by the soldiers, who drag them about. A mounted soldier directs traffic from the right. ❧

Notwithstanding Butler's skepticism, the story of Veronica is firmly embedded in the traditions of the *Via Crucis.* The location is established by Christiaan van Adrichem (1584: Site 117), though the woman is not identified as Veronica, nor is it claimed that she wipes the face of Jesus. She bears witness at the trial of Jesus in the fourth-century *Gospel of Nicodemus,* v, 36, identifying herself as the woman with an issue of blood (Matt. 9:20) and again in the *Death of Pilate,* as the woman who heals Tiberius with the linen cloth bearing the image of Jesus that she had received from him (although she did not receive it on the way to Calvary). ⚜

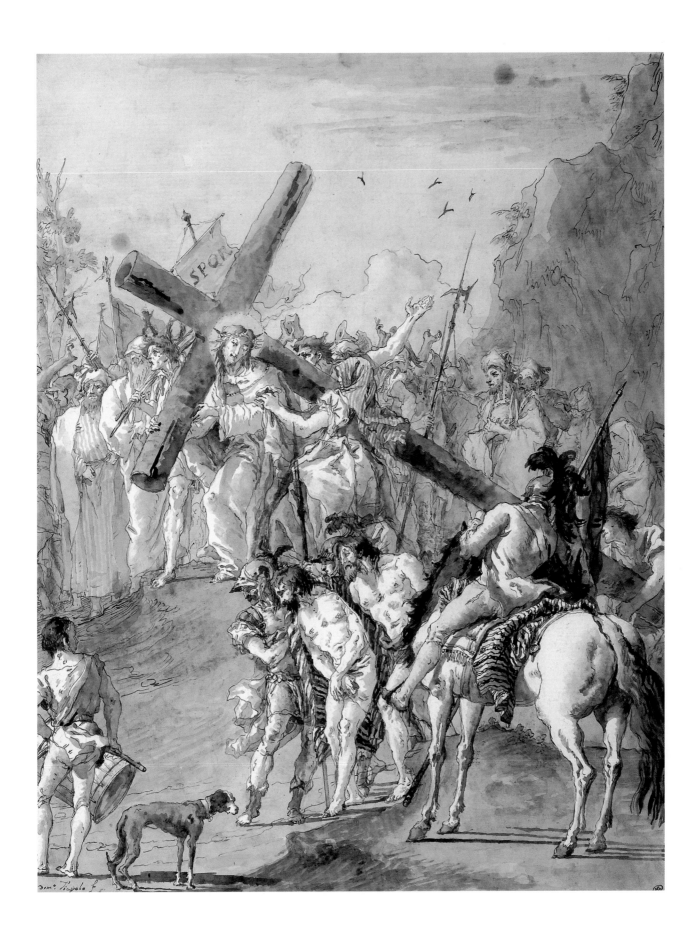

220. *Station VII: Jesus Falls the Second Time*

And from thence going three hundred thirty six steps and two foot (which amount to eight hundred forty and two foot) he came to the Judiciary gate, where once again he fell with his crosse. (Christiaan van Adrichem 1584, Site 117)

Here Christ fell again, according to the Tradition of the Fathers of old. (Christiaan van Adrichem 1584, Site 245)

Pen and wash, over black chalk, 469 x 362
Signed low right: Dom.o Tiepolo f
Inscribed low center: VII
Provenance: Jean Fayet Durand (1806–1889)
Literature: Christiaan van Adrichem 1584, Site 245; de Chennevières 1898, 128; Conrad 1996 [176]; Gealt in Udine 1996, 83

Paris, Musée du Louvre, Département des Arts Graphiques, RF 1713bis [27]

Jesus collapses a second time, perhaps from thirst. Domenico shows him facing a pool of water he cannot reach, while a dog, oblivious to his plight, takes some refreshment. In the commotion, a soldier rushes out of the scene, stage left, as another pushes his captive forward, where he stands, hands bound, waiting for the procession to advance. A quartet of brutish executioners struggle to lift the heavy timbers of the cross and get things moving. ✹

As the procession climbs the hill, Jesus falls again, and once more the executioners gather round and hold the cross. On the left, a motif borrowed from Giambattista, one of the thieves stands as an almost heroic figure. The spot is indicated by Christiaan van Adrichem (1584: Site 117 and, more particularly, Site 245). ✣

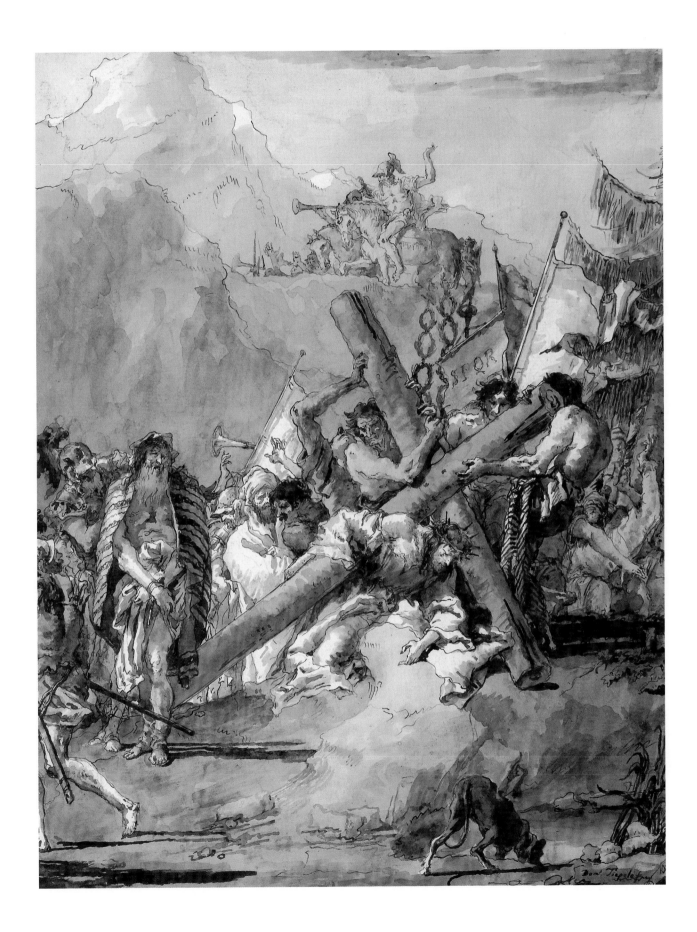

221. *Station VIII: Jesus Meets the Holy Women*

And there followed him a great company of people, and of women, which also bewailed and lamented him, But Jesus turning unto them said, Daughters of Jerusalem, weep not for me, but weep for yourselves, and for your children. For, behold, the days are coming, in which they shall say, Blessed are the barren, and the wombs that never bare, and the paps that never gave suck. Then shall they begin to say to the mountains, Fall on us; and to the hills, Cover us.
(Luke 23:27–30)

From thence he ascending a very hard and stony way towards the North, he gained three hundred forty and eight steps and two feet (the summe eight hundred seventy and two foot) which brought him unto a two-fold way, where certain women weeping spake unto him. (Christiaan van Adrichem 1584, Site 117)

> Pen and wash, over black chalk, 470 x 362
> Signed low left: Dom.o Tiepolo f
> inscribed low center: VIII
> Provenance: Jean Fayet Durand (1806–1889)
> Literature: Christiaan van Adrichem 1584, Site 246; Conrad 1996 [177]

Paris, Musée du Louvre, Département des Arts Graphiques, RF 1713bis [28]

As the Virgin and a weeping John the Evangelist stand at the distant right, a mounted soldier (last seen being told to do no violence by John the Baptist, plate 90, advice he clearly ignored) lifts his baton to break up this conversation between Jesus and the holy women. Several women hold sons (in keeping with Domenico's general emphasis on boys in this story). ✹

This spot is again recorded by Christiaan van Adrichem (1584: Site 246). ✤

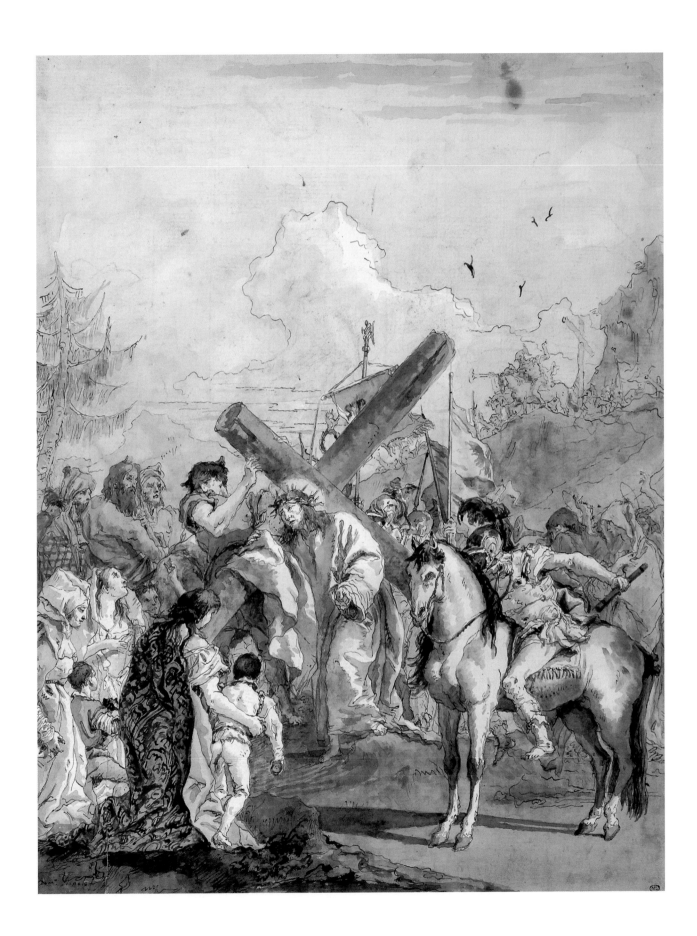

222. *Station IX: Jesus Falls the Third Time*

And from hence labouring forward threescore steps and one, and half a foot (which makes foure hundred and foure foot) he fell down the last time, at the foot of the Mount Calvary. (Christiaan van Adrichem 1584, Site 117)

Here Christ fell down the third time under his crosse, as the Fathers of old have affirmed. (Christiaan van Adrichem 1584, Site 247)

> Pen and wash, over black chalk, 470 x 365
> Signed low right center: Dom.o Tiepolo f
> Inscribed low center: IX
> Provenance: Jean Fayet Durand (1806–1889)
> Literature: Christiaan van Adrichem 1584, Site 247; Conrad 1996 [178]

Paris, Musée du Louvre, Département des Arts Graphiques, RF 1713bis [29]

Last seen escorting the prisoners out of the picture two stations earlier, the soldiers march them briskly back in as Jesus, facing out toward the viewer as he has done in each scene, falls for the third and last time under his cross. As the Virgin, John, and Mary look on with sorrow at the right, the boy bearing the sign has been joined by a patriarch (perhaps Nicodemus). ❦

This is a remarkable example of the care with which Domenico constructed a composition from disparate elements, borrowed from Giambattista and Giulio Romano, and yet welded into a moving and coherent whole. The design is a radical reinterpretation of the etching, moving the figure of Jesus from the foreground to the middle distance. The new composition is a brilliant zigzag pattern, starting at low left with the entrance of the thieves and their escort. The dramatic figure on the right throws the movement back and up to the left, through the great element of the cross, which in turn starts a further diagonal upwards to the right, to underline the somber aspect of Golgotha. The spot is indicated by Christiaan van Adrichem (1584: Site 247). ⚜

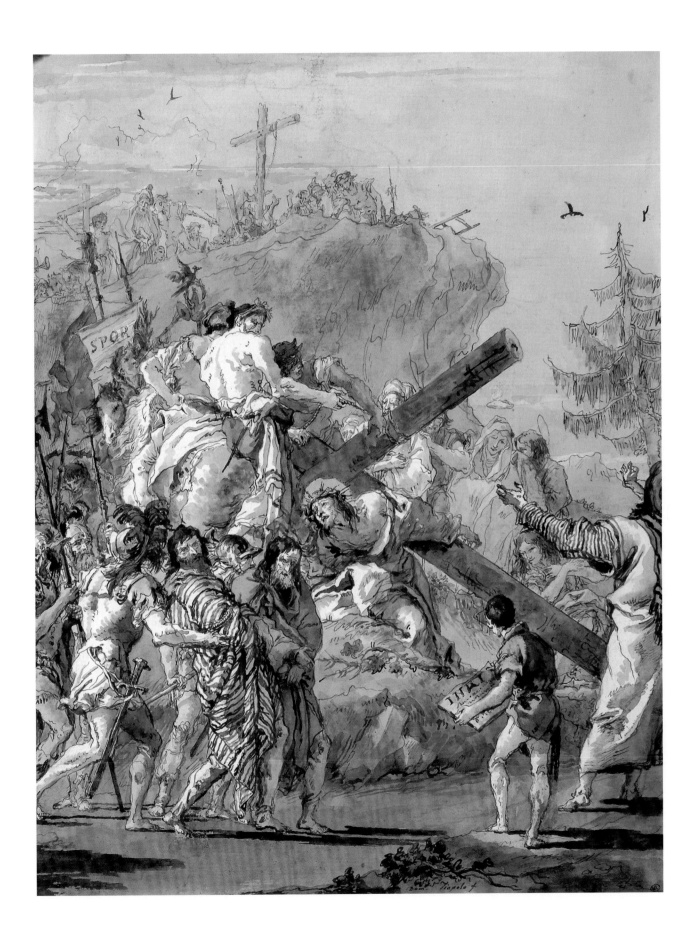

223. *Station X: The Despoiling of Jesus*

With your mind's eye, see some thrusting the cross into the earth, others equipped with nails and hammers, others with the ladder and other instruments, others giving orders about what should be done, and others stripping Him. Again He is stripped, and is now nude before all the multitude for the third time, His wounds reopened by the adhesion of his garments to His flesh. (Meditationes vitae Christi)

From thence he wearily and faintingly went forward eighteen steps, or forty five foot to the place where the Hang-men drew off his cloaths, where they gave him wine mixt with mirrh and gall. (Christiaan van Adrichem 1584, Site 117)

Here Christ was stripped out of his garments, whose body being all torn with whips, could not but be very sore, whereunto his bloody garments cleaving, gave new occasion of pain, when they were violently pulled off. And standing there naked all the while that the Cross was a preparing, in the cold and wind, he sate down at the length upon a stone, where he drank Wine mixed with gall and myrrh. (Christiaan van Adrichem 1584, Site 248)

Pen and wash, over black chalk, 465 x 361
Signed low right: Dom.o Tiepolo f
Inscribed low center: X
Provenance: Jean Fayet Durand (1806–1889)
Literature: Christiaan van Adrichem 1584, Site 248; Ragusa and Green 1961, 333; Maria de Agreda 1971, vi, 645; Conrad 1996 [179]; Gealt in Udine 1996, 84

Paris, Musée du Louvre, Département des Arts Graphiques, RF 1713bis [30]

A deliberate reminder of Station I in which Christ looked down upon his cross, here too Jesus confronts the instrument of his death as soldiers remove his clothing. One executioner kneels before him absorbed in preparing the cross, while the number of attendant patriarchs looking on has increased. ❦

The *Despoiling of Jesus* (see also pl. 198) is not mentioned in the Gospels but is described in the *Meditationes vitae Christi,* and at length in Maria de Agreda. The setting has become a vast mountain wilderness that dwarfs the crowd of people. The spot is indicated by Christiaan van Adrichem (1584: Site 248). It is striking how his text follows the *Meditationes vitae Christi.* ⚜

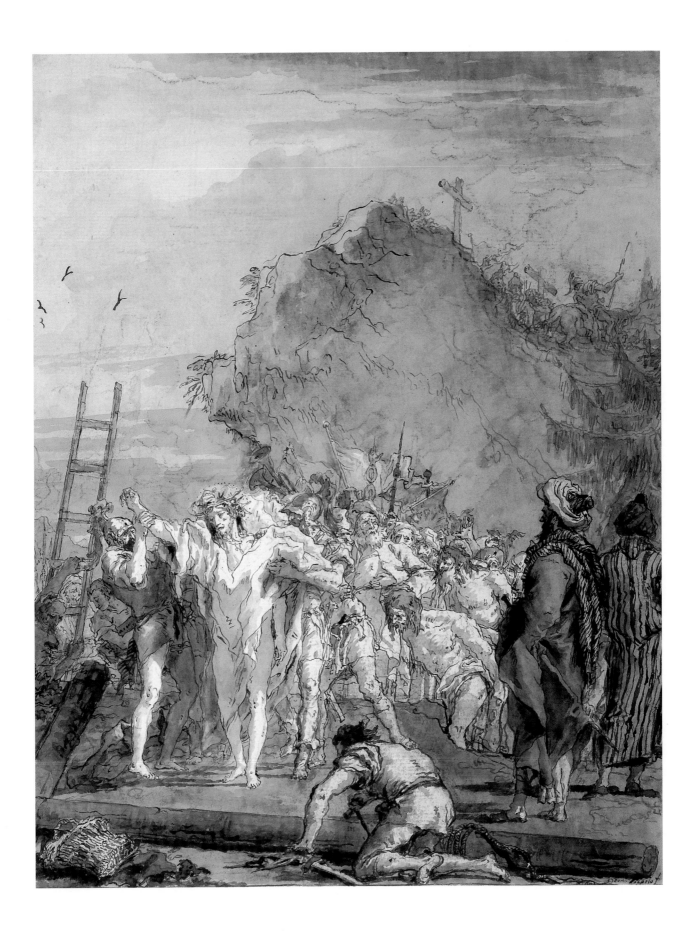

224. *Station XI: The Nailing of Jesus*

Then he went on twelve steps, or thirty foot even to the place where he was nayled on the crosse on Mount Calvary. So that from the Pallace of Pilate, unto the place were Jesus was crucified, the distance is a thousand three hundred and seven steps; or by another account, three thousand two hundred sixty and eight foot. (Christiaan van Adrichem 1584, Site 117)

In order to find the places for the auger-holes on the Cross, the executioners haughtily commanded the Creator of the universe, (O dreadful temerity), to stretch himself out upon it. The Teacher of humility obeyed without hesitation. (Maria de Agreda 1971, vi, 648)

Pen and wash, over black chalk, 468 x 366
Not signed
Inscribed low center: XI
Provenance: Jean Fayet Durand (1806–1889)
Literature: Christiaan van Adrichem 1584, Site 249; Maria de Agreda 1971, vi, 648; Conrad 1996 [180]

Paris, Musée du Louvre, Département des Arts Graphiques, RF 1713bis [31]

The brutality magnifies as a soldier, grasping his prisoner by the hair, marches him into the scene in which Jesus, assuming the profile of the Paschal Lamb that he personified, is nailed to the cross. A vast number of patriarchal onlookers crowds round the scene. In a poignant note, the Virgin, Magdalene, and John look on while the lad who holds Jesus has the same pose (but in reverse) as the youth whose arms caught Jesus as he fell the first time. 🖋

The Gospels do not describe *The Nailing of Jesus,* but Maria de Agreda devotes more than two pages to the appalling details (see also pl. 199). The Magdalene kneels at the head of the Cross to the right. On the left, a soldier runs forward with a prisoner. The spot is also indicated by Christiaan van Adrichem (1584: Site 249): "Here Christ being layd on his back on the Cross, & stretched out upon the same, his hands and feet were nayled thereunto with Iron nailes, and his tender members were with such force strained and racked upon the Crosse, that the very arteries and sinews were loosened, and all his bones might be told."

 This brings us to the end of the *Via Crucis* as described by Christiaan van Adrichem (1584: Site 117): "We have made such exact description and demonstration of the way of the crosse, (as also the way of the Captivity hereafter expressed under the number of two hundred and five) to the end, that every Christian man, in all places, even in the doors of his house, or walking oftentimes in his garden, or being on a journey, or in the Temple, either lying in his bed, may by the imagination of his minde conceive the like way, and with godly affection of the heart, may meditate upon the passion of Christ." ⚜

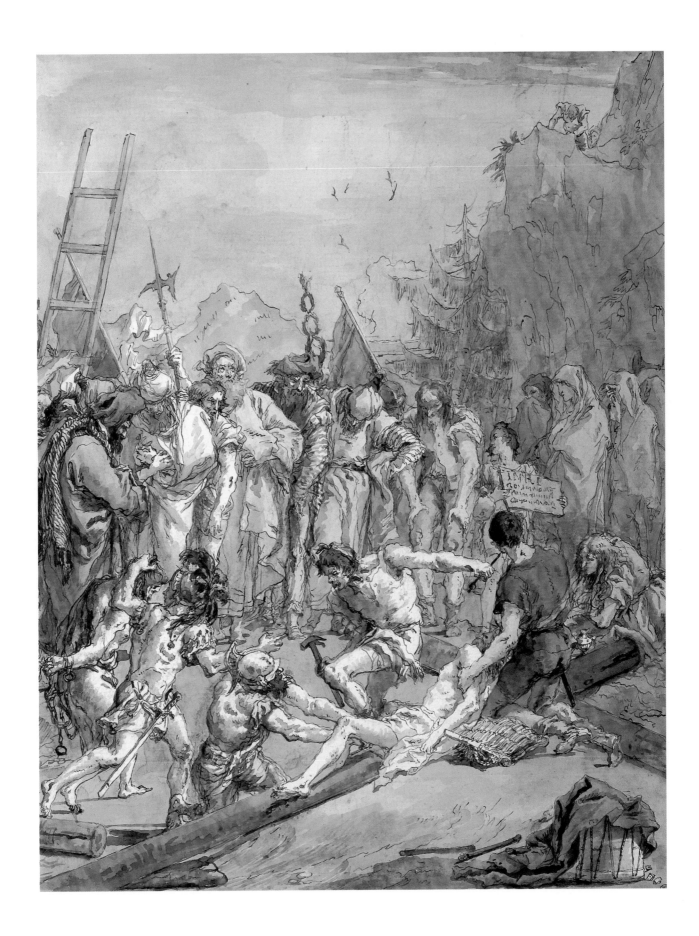

225. *Station XII: The Crucifixion*

And he bearing his cross went forth into a place called the place of a skull, which is called in the Hebrew Golgotha; where they crucified him, and two other with him, one either side one, and Jesus in the midst. And Pilate wrote a title, and put it on the cross. And the writing was JESUS OF NAZARETH THE KING OF THE JEWS. (John 19:17–19)

Pen and wash, over black chalk, 473 x 368
Signed low right center: Dom.o Tiepolo f
Inscribed low center: XII
Provenance: Jean Fayet Durand (1806–1889)
Literature: Byam Shaw 1962 [31]; Pedrocco 1990 [23]; Conrad 1996 [181]
Reference: Christiaan van Adrichem 1584, Site 250

Paris, Musée du Louvre, Département des Arts Graphiques, RF 1713bis [32]

In a scene that fulfills and echoes Station I compositionally and culminates the narrative, Jesus dies on the cross. The patriarchs are prominent spectators both in the group below and on the hilltop above. Only the Virgin and John look away, as does the youth, who, having affixed the sign to the cross's top, makes his way out of the crowd, his face invisible but his attitude registering sadness and resignation. ❦

From first to last, the crucifixion is a Roman political execution, and Domenico seems to sense this. The arrangement of the three crosses is repeated in *The Crucifixion* (pl. 200) and in *Jesus Crucified Between Two Thieves* (pl. 201), but it is presented more centrally. The scene is described at length by Christiaan van Adrichem (1584: Site 250), not as a part of the *Via Crucis* but as a subsequent event. ⚜

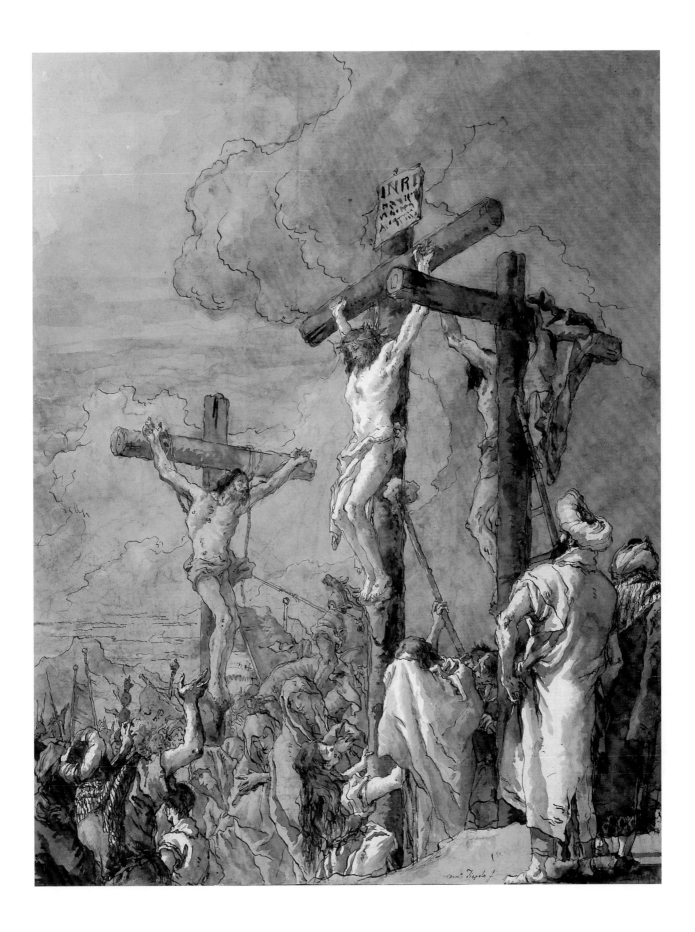

226. *Station XIII: The Descent from the Cross*

There were also women looking on afar off: among whom were Mary Magdalene, and Mary the mother of James the less and of Joses, and Salome; (Who also, when he was in Galilee, followed him, and ministered unto him); and many other women which came up with him to Jerusalem. (Mark 15:40–41)

Here the dead Corps of Christ, being taken down from the Crosse, was delivered to the Blessed Virgin Mary to be buried. (Christiaan van Adrichem 1584, Site 253)

> Pen and wash, over black chalk, 464 x 358
> Signed low right center: Dom.o Tiepolo f
> Inscribed low center: XIII
> Provenance: Jean Fayet Durand (1806–1889)
> Literature: Byam Shaw 1933 [63; fig. 7], as after Rembrandt; New York 1996, 347, note 1; Conrad 1996 [182]
> Reference: Christiaan van Adrichem 1584, Site 253

Paris, Musée du Louvre, Département des Arts Graphiques, RF 1713bis [33]

Called *The Descent from the Cross,* the traditional scene is, in fact, a Lamentation or Pietá. The crowd has thinned to two patriarchs at the left, with a third one departing, as Mary cradles her dead son in her arms. To the traditional mourners (the Magdalene and the other Marys as well as John the Evangelist, who weeps into his cloak) Domenico has added Peter at the far right, who attends with his arms crossed in much the same manner as when he first met Jesus. 🖐

In most essential respects, this design repeats the details noted in *The Lamentation* (pl. 202). The body of Christ is supported in the lap of Mary, who is supported on either side by Peter and two other women. Mary Magdalene is at the feet of Jesus. John weeps, and the mother of Zebedee's children holds Mary's hand. Simon of Cyrene and Joseph of Aramathea stand at the foot of the empty cross. The Symbols of the Passion lie in the foreground. The place is noted by Christiaan van Adrichem (1584: Site 253), not as a part of the *Via Crucis* but as a subsequent event. ⚜

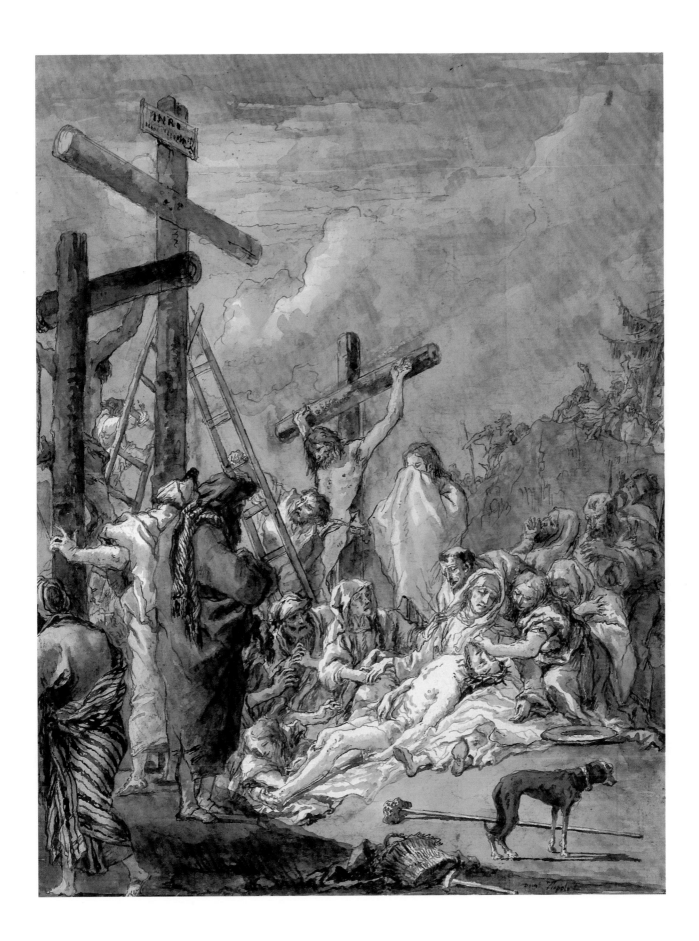

227. *Station XIV: The Entombment of Jesus*

And when Joseph had taken the body, he wrapped it in a clean linen cloth, And laid it in his own new tomb, which he had hewn out in the rock: and he rolled a great stone to the door of the sepulcre, and departed. (Matt. 27:59–60)

Pen and wash, over black chalk, 470 x 365
Signed low left: Dom.o Tiepolo f
Inscribed low center: XIIII
Provenance: Jean Fayet Durand (1806–1889)
Literature: Conrad 1996 [183]
Reference: Christiaan van Adrichem 1584, Site 237

Paris, Musée du Louvre, Département des Arts Graphiques, RF 1713bis [34]

Introducing the first angels in the Stations since the frontispiece, Domenico employs one that makes a meaningful connection to his larger narrative. The angel waving incense repeats the one who urged the Holy Family from their home to escape death from Herod (pl. 47), and here presides over the fulfillment of Christ's destiny. Below the celestial mourners, a man struggling to bury Jesus unself-consciously reveals his rump to John the Evangelist, while Mary and her company stand in dignified sorrow on the other side. Mary Magdalene kneels in a frenzy of grief. ❦

In this second version of *The Entombment* (see also pl. 204), Domenico places the scene within the tomb, looking out toward the entrance on the left. The cave is lit with a glory of light on the right, enveloping the censing angel. The Sepulcre of Christ is described by Christiaan van Adrichem (1584: Site 237), not as a part of the *Via Crucis* but as a subsequent event. ⚜

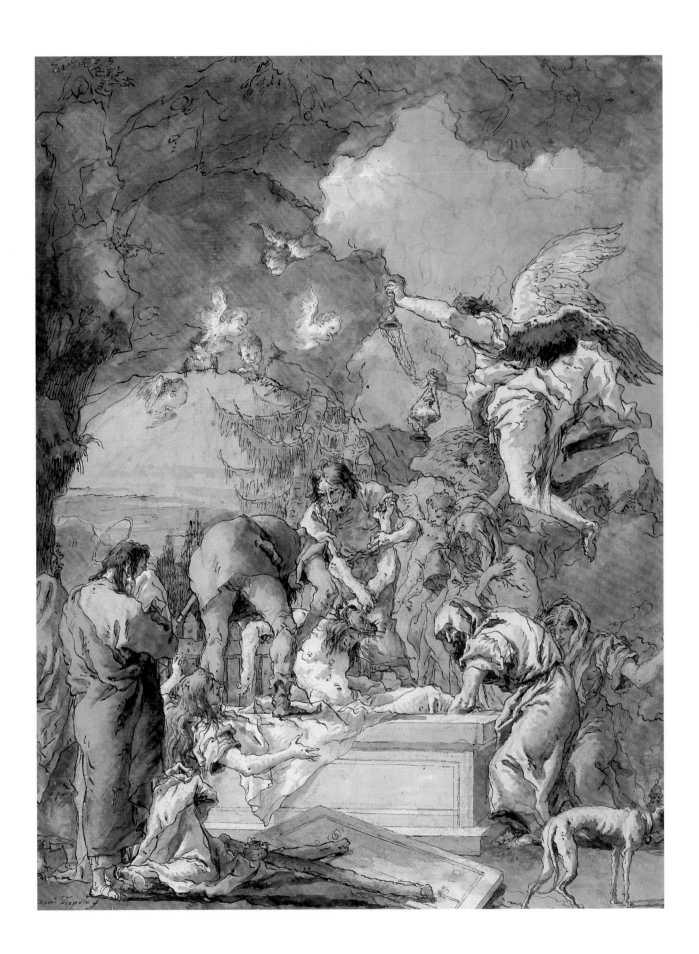

Part XV

The Acts of Peter, Plates 228–262

The Acts of the Apostles and subsequent history emphasize two principle disciples, Paul and Peter. Peter is the venerated founder of the Church, its first Pope, whose leadership was awarded by Jesus himself. Peter's elect status is highlighted in Matthew 16:19, in which Jesus says to Peter, "I will give you the keys to the kingdom." Peter's prominent role continues in the Book of Acts, and is amplified by other sources. Acts 1 mentions Christ's ascension followed by Peter's role in choosing Matthias to replace Judas. Acts 2 describes the Pentecost and Peter's assumption of leadership among the believers, three thousand of whom he baptized. Acts 3 begins with Peter's cure of the lame man outside the beautiful gate of Jerusalem. Acts 4 describes how Peter's movement grew and involved acts of charity, whereupon donations to the church increased. Acts 5 follows with the deaths of Ananias and Sapphira, whose lies about their charity were publicly condemned by Peter. It also provides the story of Peter's deliverance from prison by an angel, and his miraculous cure of the ill with his shadow.

Acts 8 relates Peter's wider mission, including his work with John in Samaria, a place where Philip was also preaching. That chapter also notes Peter's outrage at being offered money by Simon Magus for the secrets to his power. Acts 9 and 10 discuss Peter's continued travels to spread the word, including Joppa, where he resurrected the faithful woman Tabitha, his cure of a cripple in Lydda, followed by his important encounter with the centurion Cornelius, a gentile. Peter's vision of the unclean beasts that prompted him to accept gentiles into the faith was officially accepted in the first Jerusalem council (Acts 15:22–29). Acts 12 describes Peter imprisoned by Herod and once again released by an angel, whereupon he returned to his disciples and was first seen by Rhoda as he knocked on the gate. Peter's authoritative role is reflected in the two instructive letters ascribed to him that are part of the New Testament.

Peter in Cathedra, detail of plate 251, *Peter in Cathedra, Blessing—January 18, AD 43*

Peter's later acts are known from other sources, many of which were assembled in *The Golden Legend*. *The Golden Legend* affirms that Peter assumed the papal chair first at Antioch, which he held for seven years, and later in Rome, where he sat for 25 years as ruler of all Christendom. It also supplies the information that Peter dictated the Gospel to St. Mark and that he ordained his successors, including Clement, who ceded his succession as the next Pope to Linus and Cletus. *The Golden Legend* also describes Peter's martyrdom in Rome, which was preceded by a monumental test of skills with Simon Magus, whom Peter sent crashing to his death. Ambrose is our earliest source of information about the creation of a creed by the Apostles.

Episodes from Peter's life were diversely incorporated into the visual tradition: receiving the keys from Jesus; his miracles; his imprisonment by Herod and release by an angel; his battle with Simon Magus; and his subsequent crucifixion upside-down all became key episodes, while other events, including his encounter with Ananias, his cure

of the sick with his shadow, his resurrection of Tabitha, his assumption of the Cathedra of Antioch (not Rome), and his final encounter with Jesus ("Domine Quo Vadis"), gained more limited visual currency in picture cycles that averaged about eleven episodes.

Domenico made 35 drawings involving Peter's career, blending traditional with unusual subjects. The emphasis on Peter's leadership begins with a rare introductory scene in which his brethren beseech him to select a replacement for Judas, followed by Peter's blessing of Matthias. Peter's well-known cure of the lame man is followed by an unprecedented sequel of the lame man entering the Temple. Domenico has also stretched certain episodes, particularly that of Ananias and Sapphira, to exceptional lengths, and included other uncommon episodes, such as Peter and John blessing believers in Samaria. Peter's encounter with Cornelius, which had limited pictorial currency, is given three drawings. Peter is also given a rare scene of rebuking Simon Magus, after which Domenico, repeating the pattern demonstrated by his treatment of Christ's ministry, takes special interest in portraying the last accounts of Peter in Acts—namely, his last imprisonment under Herod and his release by an angel, followed by his encounter with Rhoda. Domenico then turned to other sources and selected rarely portrayed episodes of Peter's authority, showing Peter assuming the papal chair in Rome, blessing his successors, and reviewing Mark's texts, as well as leading his followers in the creation of a creed. His death and martyrdom are given special attention. Peter has the most opulent and well-attended funeral of the whole series, allowing Domenico to affirm the strength of the Roman Church when Peter died around AD 64.

Peter's bier, detail of plate 262, *The Funeral of Peter*

228. *Peter in the Midst of his Brethren*

And in those days Peter stood up in the midst of the disciples. (Acts 1:15)

> Pen and wash, over black chalk, 467 x 363
> Signed low left: Dom.o Tiepolo f
> Provenance: Jean Fayet Durand (1806–1889)
> Literature: Conrad 1996 [210]
> Reference: *The Golden Legend* 1900, iv, 13–27; Fleury 1722, i, II

Paris, Musée du Louvre, Département des Arts Graphiques, RF 1713bis [138]

Repeating in essentials the room in which Christ warned Peter (pl. 182), Domenico has Peter listening to the elder Simon making an appeal as the others stand by respectfully. A visual "tower of strength," Peter now fulfills his own destiny and assumes leadership of the disciples. His authority is unchallenged and his ministry thus begins. Interestingly, twelve men are present, despite Judas's removal from the group. ✹

The episode of Peter taking charge of the faithful following *The Ascension of Jesus* (pls. 211–212) and proposing the election of an apostle to replace Judas is the starting point of Claude Fleury's *Histoire Ecclesiastique* (Paris, 1722). An Italian edition, translated by Gasparo Gozzi, was published in Venice in 1766–1777.

If, on the other hand, the two figures to the left of Peter may be identified as Paul and Barnabas, then one must suppose that this scene represents the important debate about circumcision in Jerusalem (Acts 15:1–29), in which both Peter and Paul took part. Paul is generally shown at a dominant figure with black hair, sometimes bald and sometimes not. The figure here seems to be an old frail man, bald, with a short beard, and Peter is the extremely dominant figure. ✣

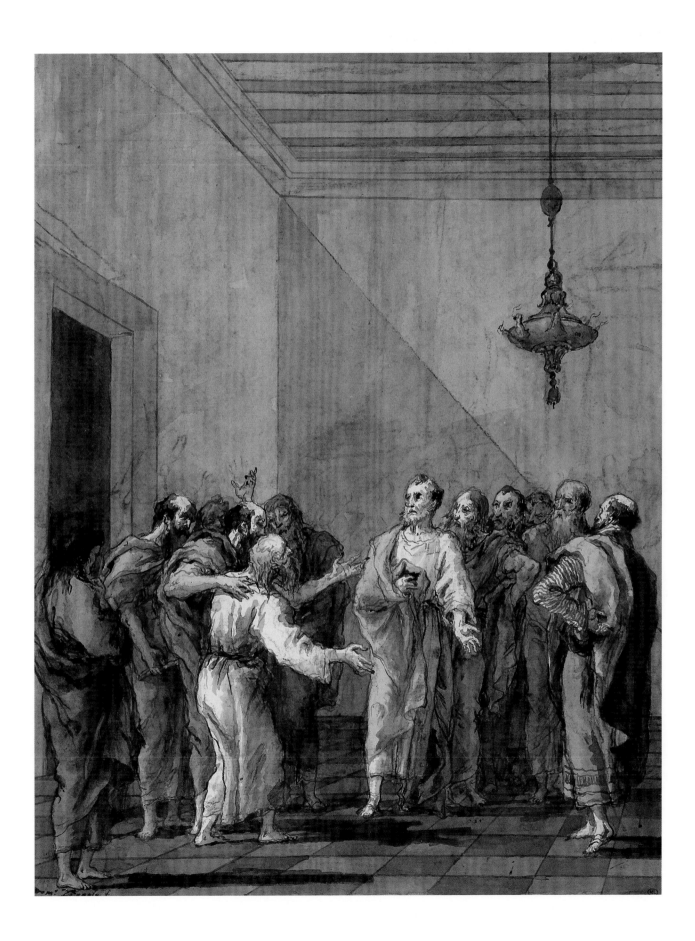

229. *"MATTIA"—Matthias Numbered Among the Apostles*

And they gave forth their lots; and the lot fell upon Matthias; and he was numbered with the eleven apostles. (Acts 1:26)

Pen and wash, over black chalk, 460 x 357
Signed low right: Dom.o Tiepolo f
Provenance: Jean Fayet Durand (1806–1889)
Literature: Conrad 1996 [195]
Reference: Christiaan van Adrichem 1584, Site 6; *The Golden Legend* 1900, iii, 55–60; Fleury 1722, i, II

Paris, Musée du Louvre, Département des Arts Graphiques, RF 1713bis [35]

Rising from his papal throne, Peter confidently blesses Matthias, conferring upon him the spot that Judas had vacated. As this meeting is blessed by the Holy Spirit, Peter, together with the other eleven, now manifest halos. ❦

The scene takes place in an interior with most of the Apostles identified by halos. Peter already stands on a dais before a throne as a symbol of his authority and Matthias kneels before him. The Holy Spirit lends divine authority to the proceedings. Christiaan van Adrichem (1584: Site 6) claims that this event occurred in the "Parlour of Sion," the location proposed for the Last Supper and the Pentecost. ⚜

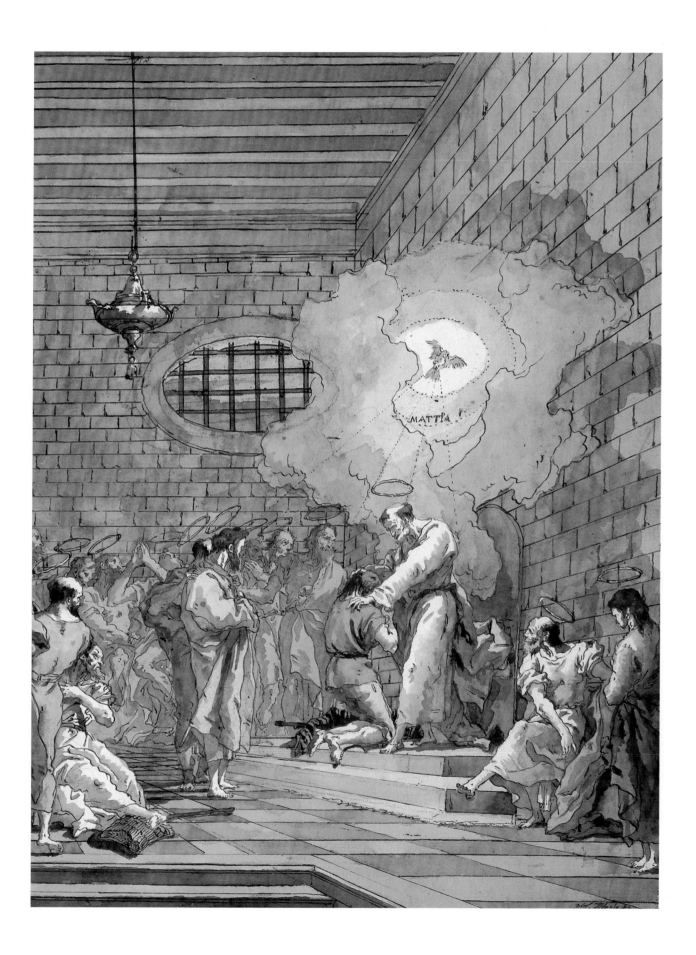

MATTIA

230. *Pentecost*

And there appeared unto them cloven tongues like as of fire, and it sat upon each of them. (Acts 2:3)

Pen and wash, over black chalk, 471 x 352
Signed low right: Dom.o Tiepolo f
Provenance: Jean Fayet Durand (1806–1889)
Literature: Conrad 1996 [196]
Reference: Christiaan van Adrichem 1584, Site 6; *The Golden Legend* 1900, i, 122–141; Fleury 1722, i, III; Pigler 1956, i, 371–379; Réau 1957, 591–596

Paris, Musée du Louvre, Département des Arts Graphiques, RF 1713bis [61]

Seated majestically upon a raised dais, with a portal and lantern similar to those that graced the Institution of the Eucharist (pl. 181), the Virgin joins the disciples to receive the Holy Spirit. Peter, though a visually prominent disciple, is sensitively "subordinated" to this higher power by being placed below the Virgin, and by returning to the posture he adopted during Christ's Ministry, most notably in *The Transfiguration* (pl. 141). ❧

Domenico's composition shows a magnificent interior with three Marys in the center of the composition, raised on three steps. A fourth female figure is shown quite prominently between the columns on the right. The twelve Apostles are loosely scattered about, leaving a clear view of the seated Virgin, with Peter standing on the left. Domenico is very inventive in giving his design a striking energy and tension among its various elements. Christiaan van Adrichem (1584: Site 6) claims that this event occurred in the "Parlour of Sion," the location proposed for the Last Supper and the election of Matthias. ⚜

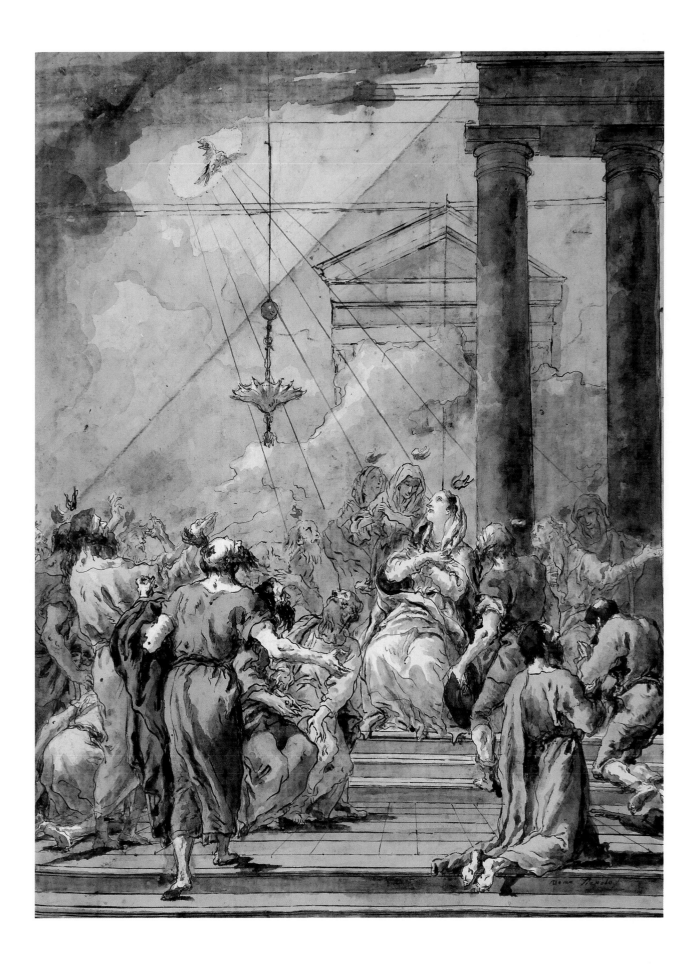

231. *Peter Healing the Lame Man at the Beautiful Gate*

Then Peter said, Silver and gold have I none; but such as I have give I thee: In the name of Jesus Christ of Nazareth rise up and walk. (Acts 3:6)

The East Gate, the which also is called the gate Sur, otherwise Seir; also the Kings gate, and the Beautiful gate, because of all the rest it was the greatest, highest, and fairest, by which also there was the principall enterance into the Temple. This being decayed, was repaired by King Joatham. And neer unto this gate the Apostle Peter with his word (in the name of Jesus Christ) healed the man which was lame from his mother's womb, and sate there begging of almes. (Christiaan van Adrichem 1584, Site 107)

Pen and wash, over black chalk, 465 x 365, trimmed to the border line
Not signed
Provenance: Charles Fairfax Murray; J. Pierpont Morgan, 1910
Exhibition: New York 1938 [71]; New York 1971 [259]; Udine 1996 [107]
Literature: Fairfax Murray 1912 [IV, 150]; Benesch 1947 [fig. 2]; Conrad 1996 [197]
Reference: Christiaan van Adrichem 1584, Site 107; Pigler 1956, i, 370–380; Réau 1959, ii/iii, 1,086; Eleen 1977 [1–10]

New York, The Pierpont Morgan Library, Fairfax Murray Collection, IV.150

Recasting the Temple to differentiate it from Christ's era, Domenico offers us a closeup of the Beautiful Gate, which here is a simple arch set in a wall, thus needing identification. Standing amidst a vast crowd, Peter performs his first miracle by curing the cripple who habitually begged there. His left arm raised very high (indicating both effort as well as surprise), Peter points with his right to the cripple, who is just rising and who echoes the posture Peter himself assumed when he received the Eucharist (pl. 181). ❦

Domenico's design stands in sharp contrast to other treatments of the theme. The background is plain and uncompromising. A plaque proclaims that this is indeed the *PORTA SPECIOSA;* there is nothing particularly beautiful about it, though it is no doubt the same Beautiful Gate at which Joachim met Anna. In fact, the background is curious in that Domenico first drew in a plain stone wall, then roughly superimposed the shape of the gate over it. The diagonal line in black chalk suggests that a shadow was at one time considered. The crowd seems then disposed behind the arch on the left and in front of the arch on the right, denying any logical spatial arrangement. One may wonder whether this primitive spatial setting was intended to convey something of the character of Byzantine art. The gate is described by Christiaan van Adrichem (1584: Site 107), but it is also identified elsewhere as the Golden Gate (Site 155), where Joachim met Anna and where Jesus entered Jerusalem. ⚜

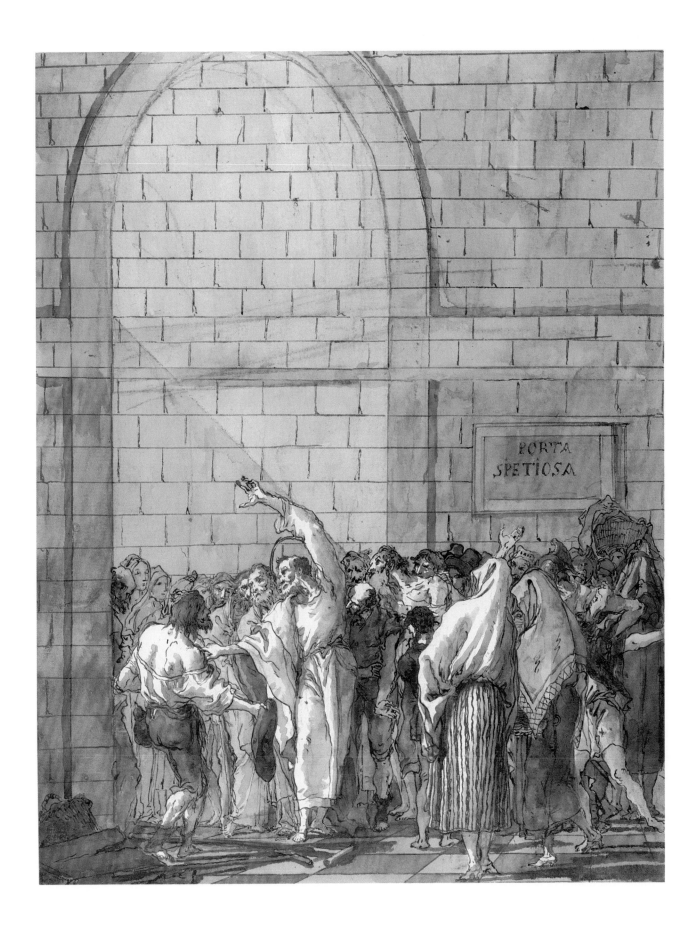

232. *The Lame Man Healed*

And he leaping up stood, and walked, and entered with them into the temple, walking, and leaping, and praising God. And they knew that it was he which sat for alms at the Beautiful gate of the temple: and they were filled with wonder and amazement at that which had happened to him. And as the lame man which was healed held Peter and John, all the people ran together unto them in the porch that is called Solomon's, greatly wondering. (Acts 3:8–11)

Pen and wash, over black chalk, 467 x 359
Signed low left: Dom.o Tiepolo f
Provenance: Roger Cormier, Tours, his sale, Paris, Georges Petit, Apr. 30, 1921, no. 32
Exhibition: Williamstown 1961 [x], as *Nebuchadnezzar Returning to His Palace*
Literature: Havercamp-Begemann 1964 [55]; Conrad 1996 [245]
Reference: Christiaan van Adrichem 1584, Site 86

Williamstown, Massachusetts, The Sterling and Francine Clark Art Institute, 1464

His walking stick abandoned on the steps, the lame man prayerfully and thankfully enters the temple steps escorted by the priests and watched by the crowd that had witnessed the miracle. An extremely rare subject, its deeply recessed archway forms a dramatic contrast with the shallow space of the healing. 🌿

Under a magnificent archway and raised on four steps, a group of priests bring forward a scantily dressed man. On the left stand a man, a boy, and two women; on the right a single cloaked man is seen from the back. The identification of this subject may not be beyond dispute, for the central figure could be identified as the Baptist, though he does not have any of the familiar attributes. It is here identified as the sequel to *Peter Healing the Lame Man at the Beautiful Gate* (pl. 231), and indeed, the two women bystanders are very similar. Again, alternatively, he might be identified as the repentant Judas; he has no halo, and he is certainly surrounded by priests. In that case one may suppose that he has already cast down the pieces of silver and is now being urged to leave by the priests. In the Cormier sale it was rather generally described as *Groups of Priests and the Faithful on the Steps of the Temple;* later it was identified as *Nebuchadnezzar Returning to His Palace* (Daniel 4:36). No prototype for the scene has come to light. The setting of the scene is not unlike that devised by Domenico for *Paul and Silas Prevent the Suicide of the Jailer* (pl. 276), which at first sight might be interpreted as The Suicide of Judas.

Solomon's Porch is described by Christiaan van Adrichem (1584: Site 86): "The Jews Ile, which is also called the Entry, the Hall, the Holy Secular, and Solomon's Porch, being the third part of the Temple. Into which men went up by four steps, whose pavement, checkered with marble of sundry sorts, was open to the aire, and uncovered, & was compassed about with a wall made with three degrees of stone of sundry colours. . . . And Peter when he had healed the lame man, spake unto the people, and converted five thousand men." Domenico appears to have followed the text in providing the four steps. ⚜

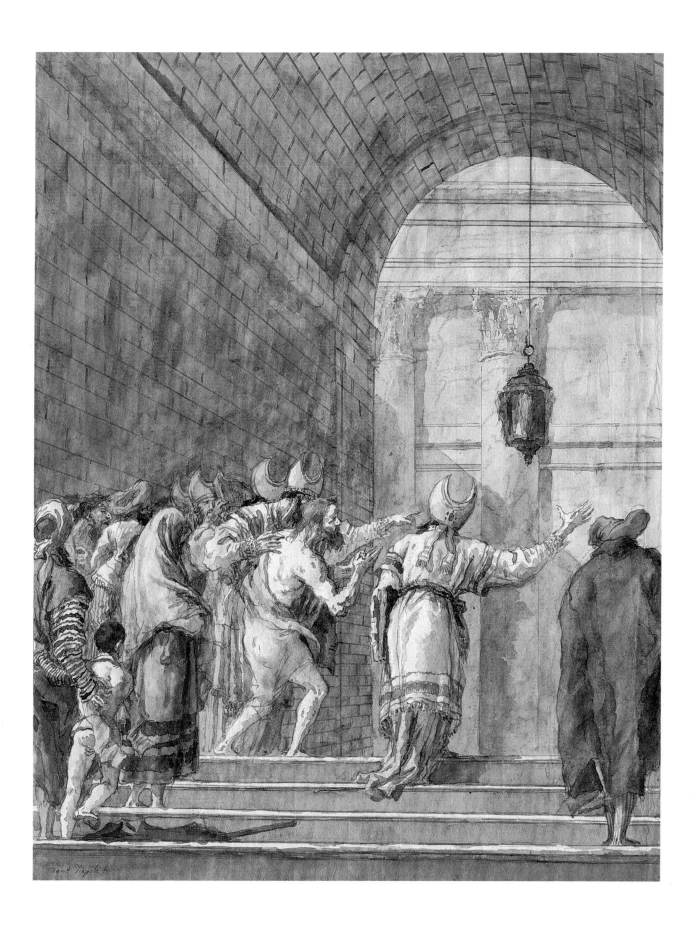

233. Peter and John Before Annas

Be it known to you all, and to all the people of Israel, that by the name of Jesus Christ of Nazareth, whom ye crucified, whom God raised from the dead, even by him doth this man stand before you whole. (Acts 4:10)

Pen and wash, over black chalk, 467 x 362, image trimmed to the borderline
Signed on the column: Dom.o Tiepolo f
Provenance: Paris, Broglio; Tomas Harris; Dr. Rudolf J. Heinemann, New York
Exhibition: London, Arts Council 1955, pl. 40; New York 1973 [107]
Literature: Conrad 1996 [198]
Reference: Christiaan van Adrichem 1584, Site 8

New York, The Pierpont Morgan Library, Gift of Mrs. Rudolf J. Heinemann, in memory of
Dr. Rudolf J. Heinemann, 1996.109

As an elder patriarch and a Roman soldier look on ominously from the right, Peter confronts Annas with the power of Christ. Peter's posture is a more animated variant in reverse of the one he adopted to actually cure the cripple. The altercation between Peter and Annas is most effectively expressed by the gestures of the two protagonists: Peter seems about to strike Annas, and Annas raises his arm in defense. 🌿

The throne of the High Priest refers back to plates 85 and 177. The house of Annas is identified by Christiaan van Adrichem (1584: Site 8). ⚜

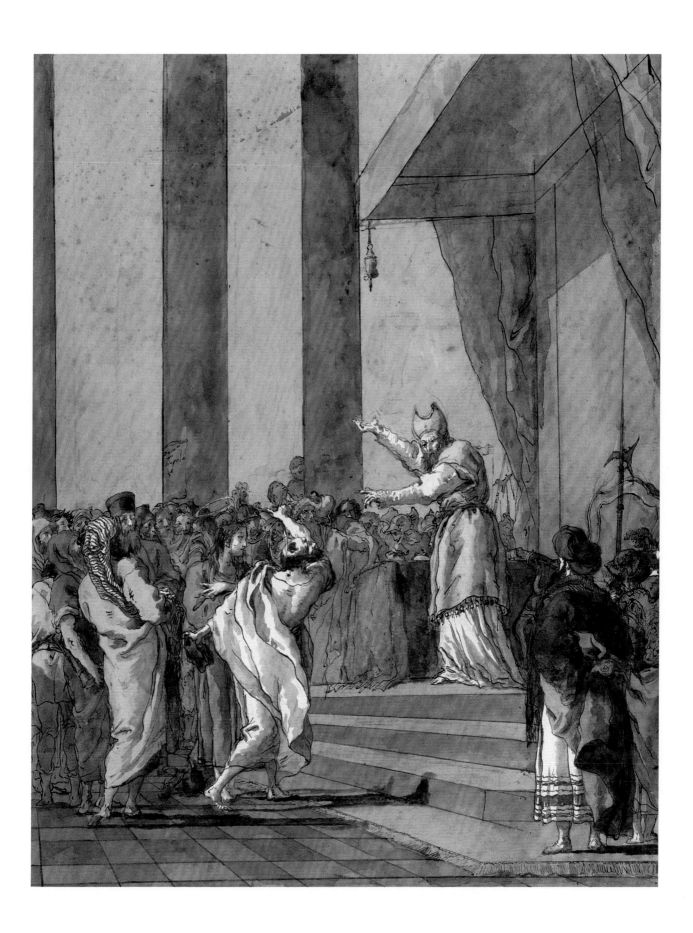

234. *The Death of Ananias*

But Peter said, Ananias, why hath Satan filled thine heart to lie to the Holy Ghost, and to keep back part of the price of the land? Whiles it remained, was it not thine own? and after it was sold, was it not in thine own power? why hast thou conceived this thing in thine heart? thou hast not lied unto men but unto God. And Ananias hearing these words fell down, and gave up the ghost: and great fear came on all them that heard these things. (Acts 5:3–5)

Pen and wash, over black chalk, 466 x 362
Signed low left: Dom Tiepolo f
Provenance: Jean Fayet Durand (1806–1889)
Literature: Conrad 1996 [199]
Reference: Réau 1959, ii/iii, 1,089, giving priority to the Raphael cartoon

Paris, Musée du Louvre, Département des Arts Graphiques, RF 1713bis [136]

His arm raised high again but here in a commanding pose, Peter, standing in an arched tunnel like the one in which the cripple celebrated his cure, delivers the words of death to the deceitful Ananias. As he lies stricken on the floor, his companion, seated on a casket filled with money at the right, reacts with violent shock, while behind Peter his companions respond more soberly to his judgment. Those whom Peter would later heal with his shadow according to the text (Acts 5:14–16) appear here to have already been cured, as one carries away his bedding. ◍

The story of Ananias and Sapphira is illustrated in three drawings of the series, all given more or less the same setting. Here Peter is a commanding figure, standing on four steps on the left, and the dead Ananias seems to be still lying on the ground, and there seems to be a man carrying a coffin in the background. It is followed by plate 235, where the dead body is carried out, and by plate 236, *The Death of Sapphira.* ⚜

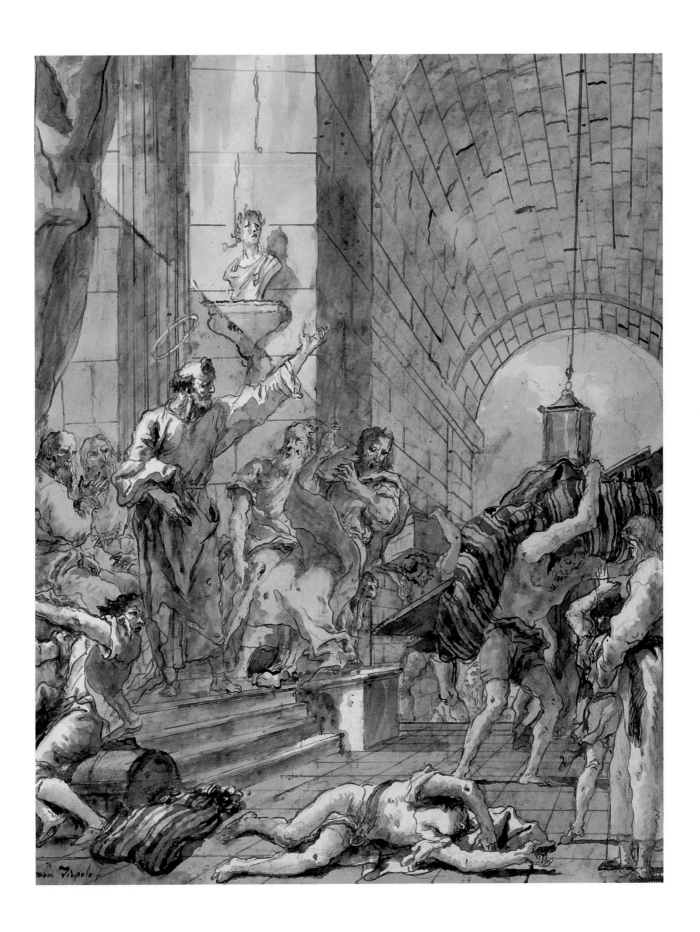

235. *The Burial of Ananias*

And Ananias hearing these words fell down, and gave up the ghost: and great fear came on all them that heard these things. And the young men arose, wound him up, and carried him out, and buried him. (Acts 5:5–6)

Behold, the feet of them that have buried thy husband are at the door, and shall carry thee out. Then fell she down straightway at his feet, and yielded up the ghost: and the young men came in, and found her dead, and, carrying her forth, buried her by her husband. (Acts 5:9–10)

> Pen and wash, over black chalk, 467 x 360
> Signed low left center: Dom.o Tiepolo f
> Provenance: Jean Fayet Durand (1806–1889)
> Literature: Conrad 1996 [201]
> Reference: Pigler 1956, i, 355–356

Paris, Musée du Louvre, Département des Arts Graphiques, RF 1713bis [105]

Peter, still delivering his forceful sermon, watches as the body is carried out, much to the consternation of the dog and the amazement of the onlookers. These include several pairs of patriarchs and the eager lad similar to the one who attended Christ's condemnation. ❧

The same impressive architectural setting, with the massive barrel vault on the right over a descending flight of stairs, is used for the preceding *Death of Ananias* (pl. 234) and for *The Death of Sapphira* (pl. 236). The body is being carried out in the familiar Venetian bier, which has become fantastically elongated. It is a nice question whether the scene represented here is the burial of Ananias or Sapphira. Perhaps the long hair and drapery of the corpse indicate Sapphira. ⚜

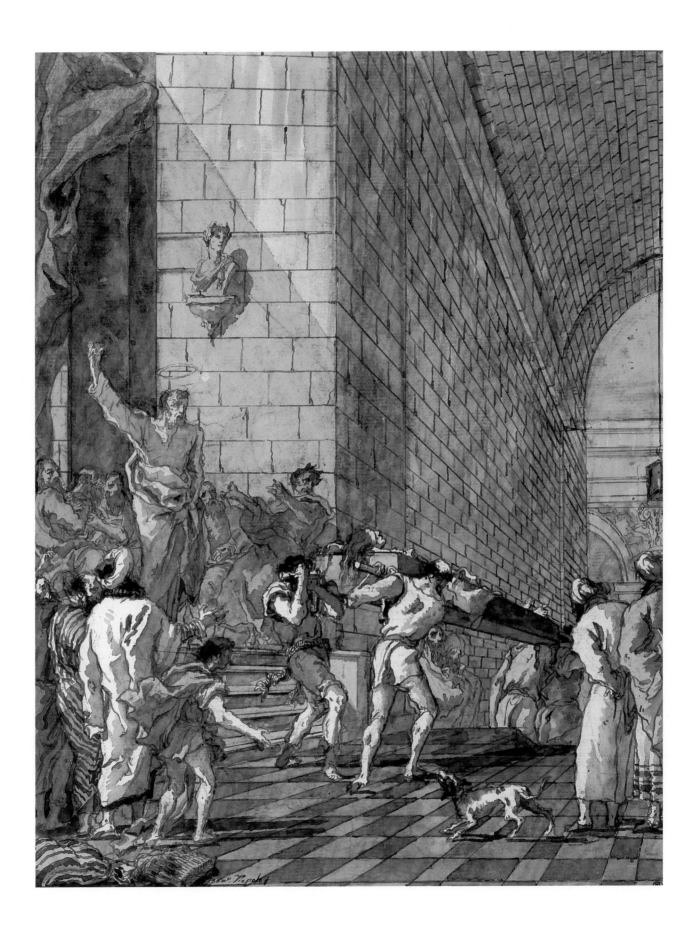

236. The Death of Sapphira

Then Peter said unto her, How is it that ye have agreed together to tempt the Spirit of the Lord? Behold the feet of them which have buried your husband are at the door, and shall carry thee out. Then fell she down straightway at his feet, and yielded up the ghost: and the young men came in, and found her dead, and, carrying her forth, buried her by her husband. (Acts 5:9–10)

Pen and wash, over black chalk, 470 x 360
Signed low right: Dom.o Tiepolo f
Provenance: Roger Cormier, Tours, his sale, Paris, Georges Petit, Apr. 30, 1921, no. 70
Literature: Guerlain 1921, 101; Conrad 1996 [200]
Reference: Pigler 1956, I, 380–81; Réau II/III 1959, 1087

His left arm raised in the fateful gesture once more, Peter now looks down on the stricken Sapphira, whose collapsed body lies at the foot of the steps. This second death provokes a much more violent reaction not only among the bystanders below but also among Peter's followers, who have risen in stunned surprise. Peter, however, remains completely calm in his stern appraisal of the deceitful Sapphira. Acts 5:12–18 goes on to describe the multitude who came to be cured by Peter, which inspired the Sadducees to have the Apostles placed in a "common prison." ❦

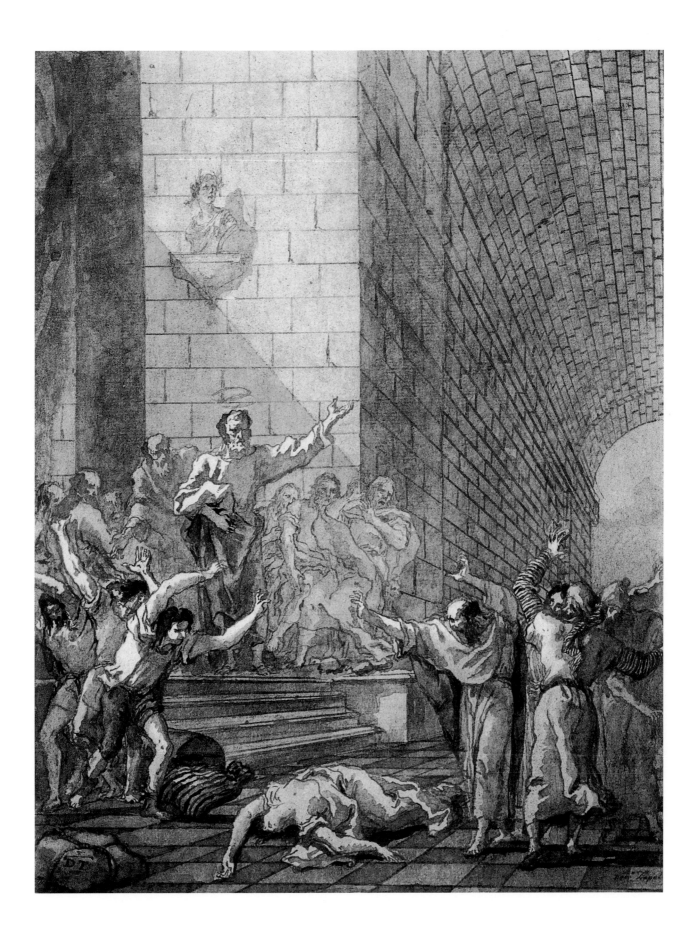

237. *The Apostles Delivered from Prison*

Then the high priest rose up, and all they that were with him (which were the sect of the Sadducees), and were filled with indignation. And laid their hands on the apostles, and put them in the common prison. But the angel of the Lord by night opened the prison doors, and brought them forth, and said, Go, stand and speak in the temple to the people all the words of this life. (Acts 5:17–19)

When they were past the first and the second ward, they came unto the iron gate that leadeth unto the city; which opened to them of his own accord: and they went out, and passed on through one street; and forthwith the angel departed from him. (Acts 12:10)

Pen and wash, over black chalk, 467 x 359
Signed low right: Dom.o Tiepolo f
Provenance: Roger Cormier, Tours, his sale, Paris, Georges Petit, Apr. 30, 1921, no. 43
Exhibition: Williamstown 1961 [ix]
Literature: Guerlain 1921 [113b]; Havercamp-Begemann 1964, pl. 61 [57]; Conrad 1996 [202]

Williamstown, Massachusetts, The Sterling and Francine Clark Art Institute, 1462

Within the sharply receding space of a prison, Peter and John are guided to freedom by an angel. Still reaching upwards, Peter seems to register both thanks and amazement as the angel leads him out the door. The two small hounds in the foreground enhance the sense of new freedom, underscoring the companionship between Peter and John and their faithfulness to Christ. ❦

Several scenes describe the miraculous release of the saints from prison in the Acts of the Apostles. Here the angel leads Peter by the hand, but there is a second youthful figure that one may identify as John, which suggests that the scene illustrates the event described in Acts 5. However, it is also possible that it represents the second part of the story of the release of Peter (Acts 12:10), following plate 249. ⚜

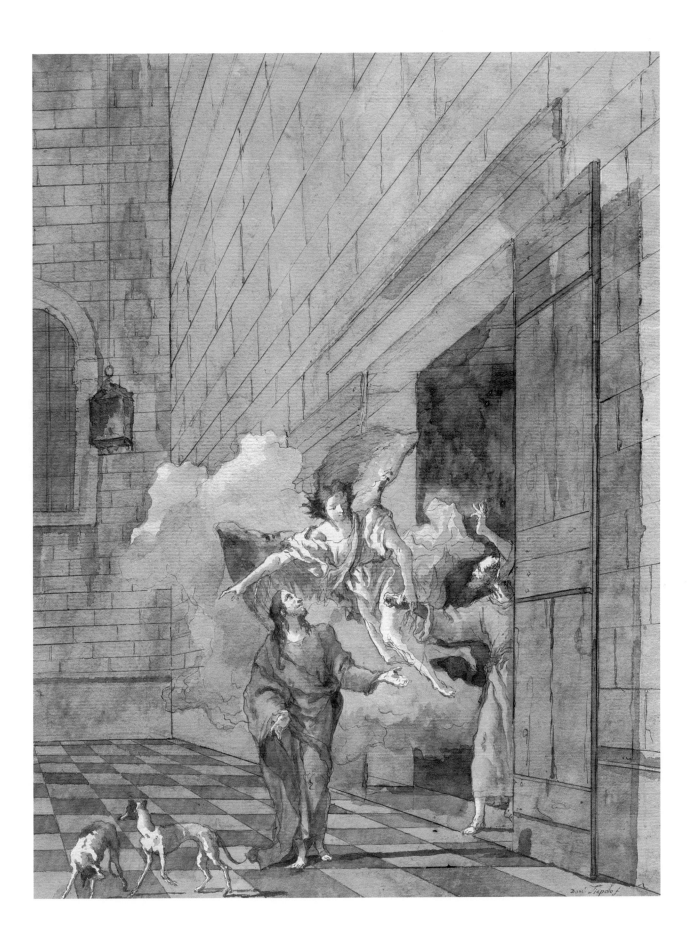

238. *Peter and John in Samaria*

Now when the apostles that were in Jerusalem heard that Samaria had received the word of God, they sent unto them Peter and John: Who, when they were come down, prayed for them, that they might receive the Holy Ghost (for as yet he was fallen upon none of them: only they were baptized in the name of the Lord Jesus). Then they laid their hands on them, and they received the Holy Ghost. (Acts 8:14–17)

Pen and wash, over extensive black chalk, 461 x 355
Signed low left: Dom.o Tiepolo f
Provenance: Jean Fayet Durand (1806–1889)
Literature: Conrad 1996 [205]; Gealt in Udine 1996, 70

Paris, Musée du Louvre, Département des Arts Graphiques, RF 1713bis [103]

The Holy Ghost and several seraphim are manifest as Peter and John lay hands on believers in Samaria. Peter blesses a young woman, and John a young man, who submits rather awkwardly to these unfamiliar attentions, while the rest of the crowd includes men as well as children. All have removed their hats except the standing observer at the far right, arms cocked at his side. ❦

Domenico's composition clearly shows John and Peter laying their hands on the new believers and the Holy Ghost descending between them. This passage follows the martyrdom of Stephen, and "As for Saul, he made havoc of the church, entering into every house, and haling men and women committed them to prison." It also follows immediately upon the introduction of Simon the sorcerer, who allowed himself to be baptized and who, with his wand, may be identified as the watching figure on the right. The drawing forms a pair with *Peter Outraged by Simon Magus* (pl. 239), which illustrates the following verses (Acts 8:18–24). There Simon again carries a wand, while John continues to lay his hands on the new believers and the Holy Ghost hovers above. ⚜

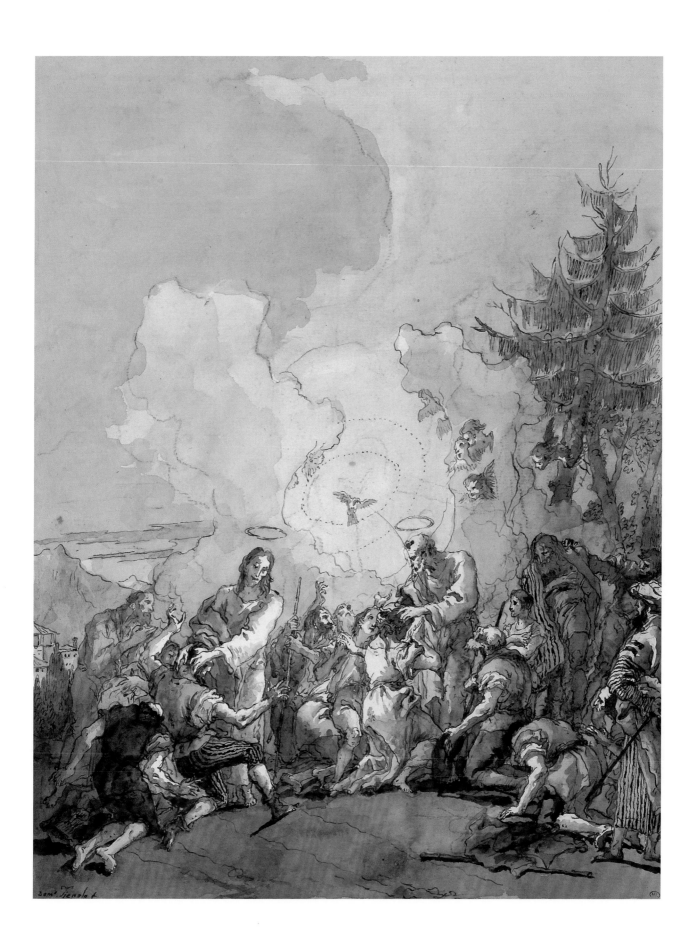

239. *Peter Outraged by Simon Magus*

And when Simon saw that through laying on of the apostles hands the Holy Ghost was given, he offered them money, saying, Give me also this power, that on whomsoever I lay hands, he may receive the Holy Ghost. But Peter said unto him, Thy money perishes with thee, because thou hast thought that the gift of God may be purchased with money. Thou hast neither part nor lot in this matter; for thy heart is not right in the sight of God. (Acts 8:18–21)

> Pen and wash, over extensive black chalk, 455 x 350
> Signed low right: Dom.o Tiepolo f
> Provenance: Roger Cormier, Tours; his sale, Paris, Georges Petit, Apr. 30, 1921, lot 23 : *"Le magicien Simon après sa chute, en accuse saint Pierre";* Sotheby's, June 21, 1978 [39], bt. Stein; Ian Woodner; his sale, Christie's, London, Jul. 2, 1991 [127]; Paris, Drouot-Richelieu, Mar. 27, 1992, as *Christ Appointing the Seventy Disciples* (Luke 10:1–9)
> Literature: Conrad 1996 [204], as *Peter Admonishing Simon Magus*

As the Holy Ghost radiates like the sun, the confrontation between Peter and Simon Magus casts long shadows behind them. His arms again raised in extreme agitation, Peter rejects Simon Magus's offer of money, while behind them John continues to confer blessings upon the new converts. ❧

Sometimes identified as *Christ Appointing the Seventy Disciples* (Luke 10:1–9), this drawing is identified here as lot 23 of the Cormier sale, in spite of the somewhat misleading title. The Holy Ghost is very prominent in the design, and the main action is Peter reacting furiously to the dark figure with his back turned in the center, whom we may identify as Simon Magus carrying his characteristic wand. ⚜

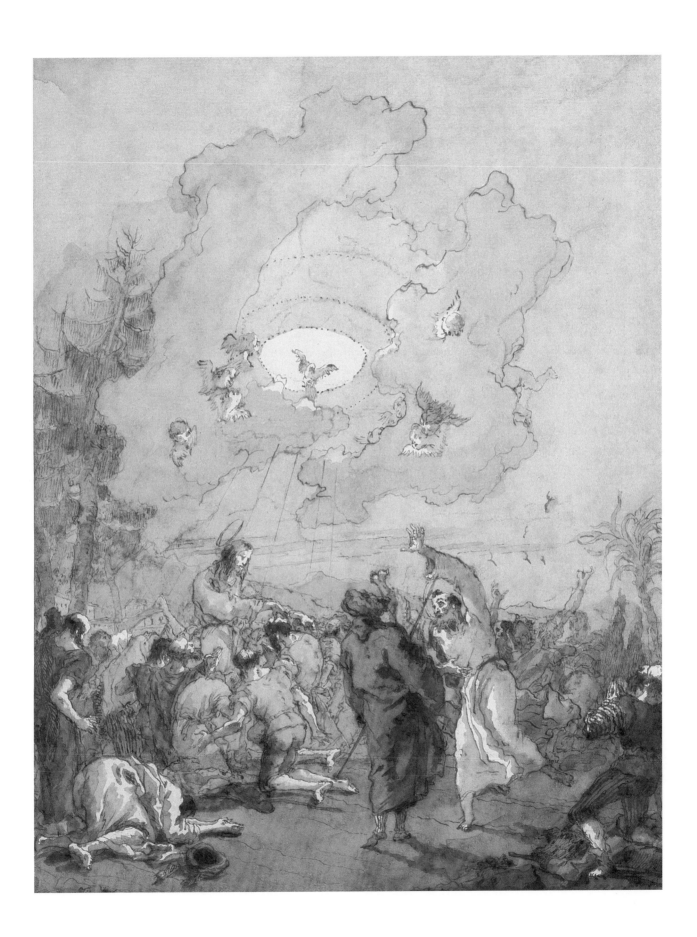

240. *Peter Heals the Palsied Man of Lydda*

And it came to pass, as Peter passed through all quarters, he came down also to the saints which dwelt at Lydda. And there he found a certain man named Aeneas, which had kept his bed eight years, and was sick of the palsy. And Peter said unto him, Aeneas, Jesus Christ maketh thee whole: arise, and make thy bed. And he arose immediately.
(Acts 9:32–35)

Pen and wash, over black chalk, 460 x 360
Signed on the wall plaque: Dom.o Tiepolo f
Provenance: Roger Cormier, Tours, his sale, Paris, Georges Petit, Apr. 30, 1921, no. 10; Duc de Trévise, his sale, Paris, Hôtel Drouot, Dec. 8, 1947, no. 27; Paris, Hôtel Drouot, Mar. 9, 1988 [165]; Kate de Rothschild
Literature: Guerlain 1921, 109; Conrad 1996 [211]

New York, private collection

Peter has entered the paralytic's house and, calmly but with the same authority with which he blessed Matthias earlier, orders the patient to rise, pointing to him with his right hand. His legs clearly withered, the cripple registers his astonishment to find them working, equaling the surprise of the other witnesses. ❦

The subject, which is quite rare, is placed in a simple interior typical of Domenico's compositions, with a lengthy inscription in a plaque on the wall: *"NELLA CITTA DI LIDA RISANO S PIETRO UN PARALITICO CHE ERA OTTO ANNI CHE NON SI ERA LEVATO DI LETTO."* ⚜

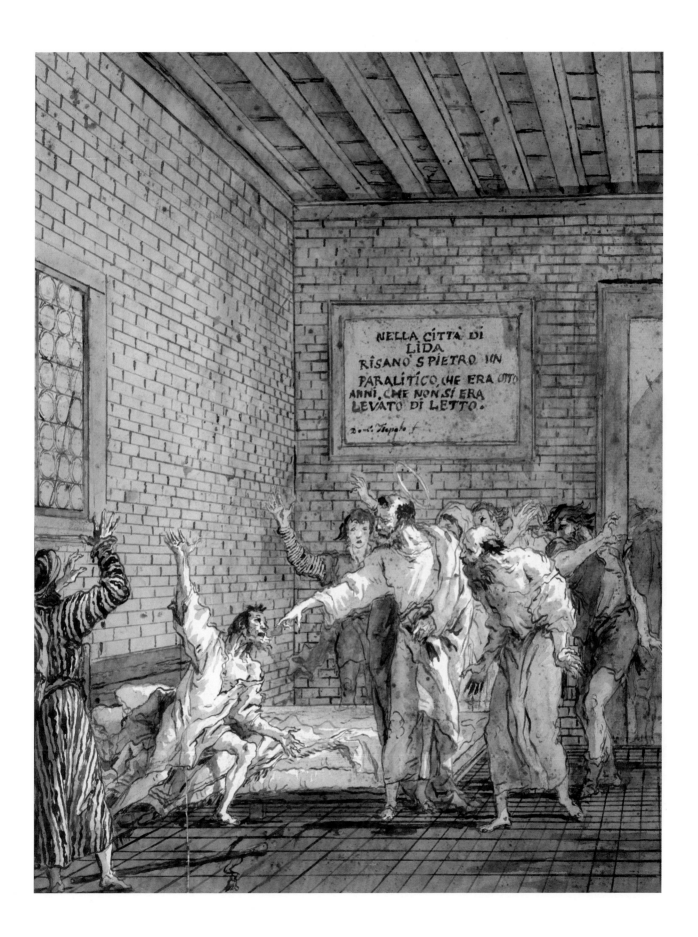

241. *Peter on the High Road to Joppa*

And forasmuch as Lydda was nigh unto Joppa, and the disciples had heard that Peter was there, they sent unto him two men, desiring him that he would not delay to come to them. (Acts 9:38)

Pen and wash, over extensive black chalk, 460 x 360
Signed low right: Dom.o Tiepolo f
Provenance: Paris, Hôtel Drouot, Dec. 3, 1985 [12]; Paris, Drouot-Richelieu, Jun. 17, 1994 [224]

Peter, echoing his forceful determination of the previous scene, stops to converse with two men. He points, along with the disciples behind him, to the town of Joppa below, where Tabitha lies ill. ❧

The scene shows Peter striding along in the countryside with a number of other figures. The subject remains very obscure, although it is quite certainly not *"Domine, Quo Vadis?"* (see pl. 257). It is here tentatively identified as the scene indicated above, which precedes *The Raising of Tabitha* (pl. 242). Everyone seems to be focused on the town in the valley on the left. ❧

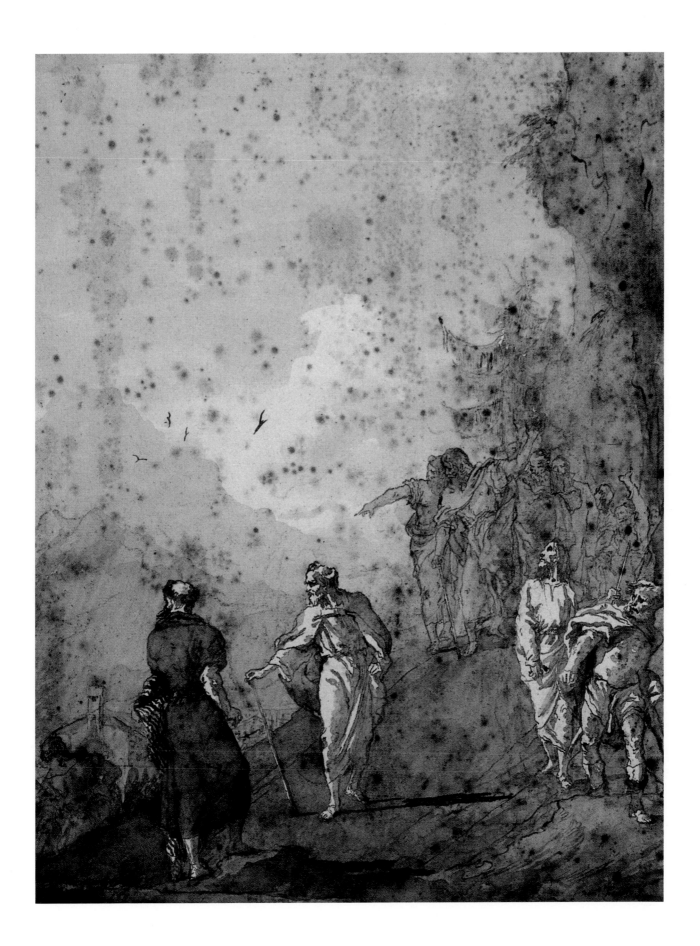

242. *The Raising of Tabitha*

And Peter put them all forth, and kneeled down, and prayed; and turning him to the body said, Tabitha, arise. And she opened her eyes; and when she saw Peter, she sat up. And he gave her his hand, and lifted her up, and when he had called the saints and widows, presented her alive. (Acts 9:40–41)

> Pen and wash, over black chalk, 468 x 362, image; 489 x 380, paper
> Not signed
> Provenance: Roger Cormier, Tours, his sale, Paris, Georges Petit, Apr. 30, 1921, no. 76; Paris, Bruno de Bayser; New York, Ian Woodner
> Exhibition: New York, Schab, Woodner II, 1973 [73]; Munich 1986 [38]; London, R. A. 1987 [35]; New York 1990 [43]; Washington 1995 [95]; Udine 1996 [106]
> Literature: Catherine Whistler, Washington 1995, 334; Conrad 1996 [212]
> Reference: Pigler 1956, i, 386; Réau 1959, iii/iii, 1,089; Eleen 1977 [42–46]

Washington, D.C., The Family Woodner Collections, gift to the National Gallery of Art

Bypassing tradition that placed Tabitha in bed, Domenico shows her on the floor beneath an archway (thus paralleling the site of Peter's first miracle, the cripple healed at the *Porta Spetiosa,* pl. 231). Here with his back turned toward us, Peter commands Tabitha to rise. Her eyes fixed intently upon him, Tabitha responds to this miracle, spreading her arms wide in amazement. The onlookers react too. Some pray, others stare, and still others gesture wildly. Only the two patriarchs, standing in the doorway, are unmoved.

The composition develops in a stage-like space with a backdrop of massive masonry. Catherine Whistler writes, "Domenico's realism is particularly apparent in the expression of Tabitha, who has just sat up (as the biblical text recounts) and whose puzzled features are still appropriately half-shrouded in shadow. It is this sense of empathy with his chosen subject that gives Domenico's biblical series such extraordinary impact."

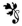

243.** *"Saint Pierre operant une guérison miraculeuse"*

No text yet found.

> Pen and wash, 460 x 360
> Signed low left
> Provenance: Roger Cormier, Tours, his sale, Paris, Georges Petit, 30 Apr. 1921, no. 61

No image recorded.

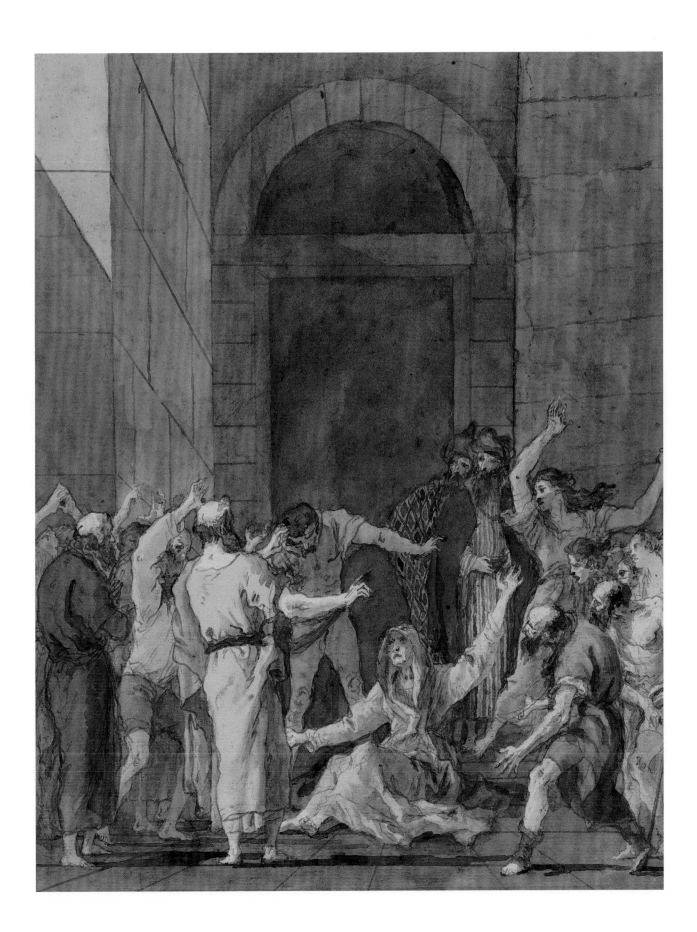

244. *The Angel Appears to Cornelius*

He saw in a vision evidently about the ninth hour of the day an angel of God coming in to him, and saying unto him, Cornelius. And when he looked on him, he was afraid, and said, What is it, Lord? And he said unto him, Thy prayers and thine alms are come up for a memorial before God. (Acts 10:3–4)

Pen and wash, over heavy black chalk, 487 x 379—paper?
Signed: Do Tiepolo
Provenance: Jules Hédou (1833–1905; Lugt 1253), his bequest 1905
Exhibition: Rouen 1970 [81]
Literature: Conrad 1996 [213]

Rouen, Bibliothèque Municipale

In the longest known visual interpretation of this rare episode from Acts, Domenico begins his story of Peter and Cornelius with the angelic visitor. Particularly majestic, his wings spread wide in commanding authority, the angel descends in a cloud of glory to address Cornelius, who looks up from his holy writ. Posed much like Peter himself during holy visitations (see pl. 248, for example), Cornelius is told to send men to Joppa for Simon Peter. 🌿

The scene unfolds in a magnificent interior. The design recalls Evangelist portraits, a familiar part of early gospel manuscripts in which each Gospel has its portrait, specifically, Matthew with his angel. Although Matthew is missing from *The Rockefeller McCormick New Testament,* he is found in Virgil Solis, *Biblische Figuren,* Frankfurt 1565 [103]. Anna Jameson (1883, I, 146) points out that independent depictions of *Matthew and the Angel* are extremely rare, and indeed the only ones that come to mind are the two versions of *St. Matthew* by Caravaggio for San Luigi dei Francesi in Rome (Della Chiesa 1967 [44A, B]). Here Cornelius has the book, a required element in an Evangelist portrait, but he is dressed as a Roman soldier, which seems to justify the identification offered here. ⚜

245. *Peter Receives the Messengers from Cornelius*

While Peter thought on the vision, the Spirit said unto him, Behold, three men seek thee. Arise therefore, and get thee down, and go with them, doubting nothing: for I have sent them. Then Peter went down to the men which were sent unto him from Cornelius; and said, Behold, I am he whom ye seek: what is the cause wherefore ye have come?
(Acts 10:19–21)

Pen and wash, over black chalk, 470 x 360
Not signed
Provenance: Roger Cormier, Tours, his sale, Paris, Georges Petit, Apr. 30, 1921, no. 56; Duc de Trévise, his sale, Paris, Hôtel Drouot, Dec. 8, 1947, no. 41; A. Robaut; Bouasse-Lebel; Paris, Hôtel Drouot, Mar. 9, 1988 [166]; Christie's, New York, Jan. 28, 1999 [17], incorrectly as Cormier 66, Trévise 46
Exhibition: London, Edelstein 1988 [11]
Literature: Guerlain 1921, 113; Conrad 1996 [215]
Reference: Baronius, i, anno 68, cap. XXIV; Pigler 1956, i, 394; Réau 1959, iii/iii, 1,095

Rhinebeck, N.Y., Martin Kline collection

Having guided Cornelius's men to Peter's house, the angel presides over their encounter. Rising from his chair, Peter greets the two soldiers, his arms spread out as he questions them. Unusual for the absence of any doorway or window, Peter's cell-like room renders the appearance of the angel and the soldiers more miraculous. ❧

Domenico shows the angel as still present, hovering on the right. The text mentions three men, though only two are present here, dressed as Roman soldiers. We here follow Conrad in his identification of the scene. The setting is one of Domenico's typical simple interiors, not a prison, so it is unlikely to represent the conversion of the captains of the guard Processus and Martianus as it is recorded during Peter's last imprisonment in Rome; see also Anna Jameson, *Sacred and Legendary Art*, 1899, i, 206. ❧

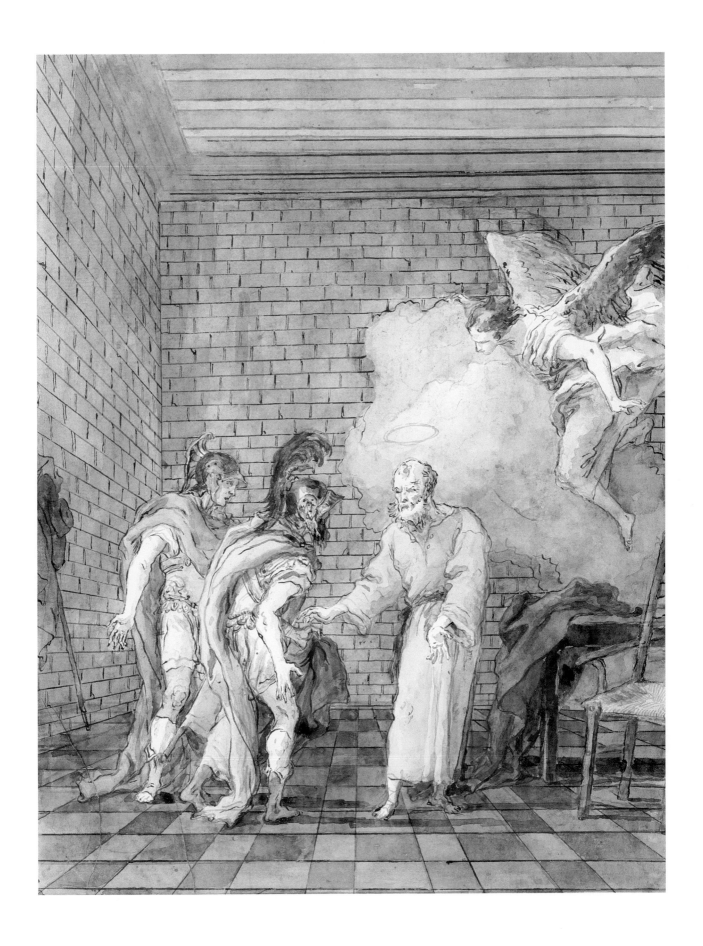

246. *Peter and the Centurion Cornelius*

And the morrow after they entered into Caesarea, And Cornelius waited for them, and had called together his kinsmen and near friends. And as Peter was coming in, Cornelius met him, and fell down at his feet, and worshipped him. But Peter took him up, saying, Stand up; I myself also am a man. (Acts 10:24–26)

> Pen and wash, over black chalk, 468 x 361
> Signed low left: Dom.o Tiepolo f
> Provenance: Jean Fayet Durand (1806–1889)
> Literature: Conrad 1996 [216]
> Reference: Fleury 1722, i, XVII; Pigler 1956, i, 388; Réau 1959, ii/iii, 1,091

Paris, Musée du Louvre, Département des Arts Graphiques, RF 1713bis [119]

Deliberately recalling Christ's earlier encounter with a centurion (pls. 117–118), Peter's meeting is differentiated by his warm embrace of the centurion, whom he urges to rise. Rendering Peter both humble and compassionate, the scene resonates with a touching humanity. The sober crowd of soldiers, patriarchs, and followers look on, while the dog, as is so often the case, ignores the proceedings. ❦

The scene is conceived in very similar terms to the scene in Matthew 8:5–10, *Jesus and the Centurion* (pl. 117), with a similar city wall. The story is continued in the following drawing. ❧

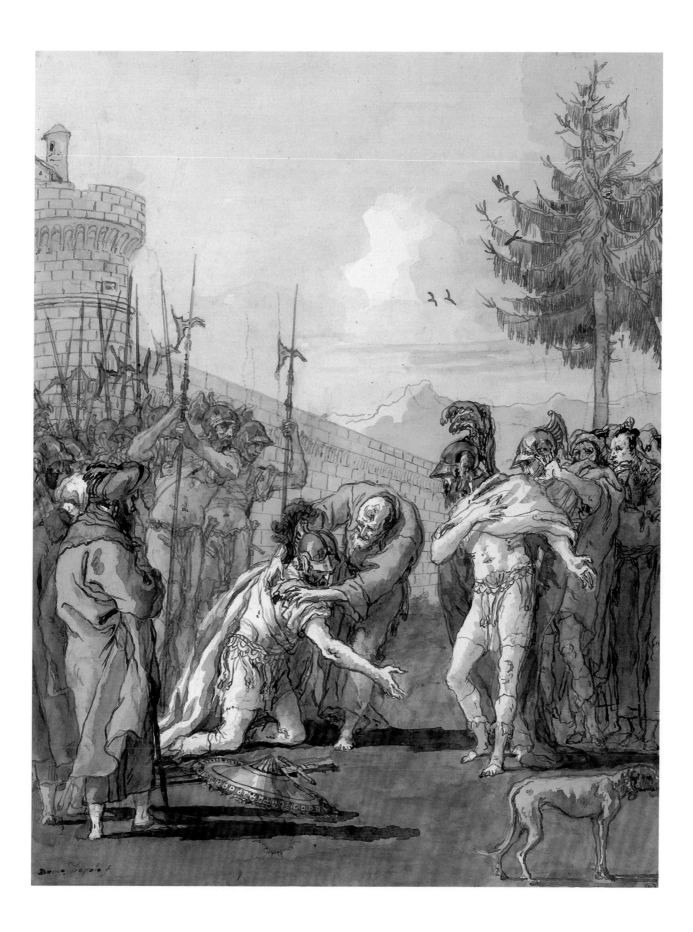

247. *Peter Baptizing the Gentiles*

While Peter yet spake these words, the Holy Ghost fell on all them that heard the word. And they of the circumcision which believed were astonished, as many as came with Peter, because that on the Gentiles also was poured out the gifts of the Holy Ghost. For they heard them speak with tongues, and magnify God. Then answered Peter, Can any man forbid water, that these should not be baptized, which have received the Holy Ghost as well as we? And he commanded them to be baptized in the name of the Lord. Then prayed they him to tarry certain days. (Acts 10: 44–48)

Pen and wash, extensive underdrawing in black chalk, 468 x 360
Signed low left: Do Tiepolo f
Provenance: Jean Fayet Durand (1806–1889)
Literature: Conrad 1996 [217]
Reference: Réau 1959, ii/iii, 1,042

Paris, Musée du Louvre, Département des Arts Graphiques, RF 1713bis [36]

As the Holy Ghost descends upon the group, Peter now baptizes the centurion, still clad as a soldier, his sword at his feet. Surrounding them are gentiles who kneel in anticipation of his blessing. Domenico not only provided an exceptionally expansive commentary on the story of Cornelius, but with this scene he also placed special emphasis on Peter's role with the gentiles, which runs contrary to his traditional role with the Christianized Jews. ✴

Conrad suggests that the scene represents *The Baptism of Cornelius,* an event that is not described in so many words in Acts. Supporting this is the undeniable fact that it is Peter who performs the ceremony. Acts 10, in which the story of Cornelius is told, concludes with the important event *The Baptism of the Gentiles,* which is preceded, as in this drawing, by the descent of the Holy Ghost; this is shown twice, in both cases unfinished.

At first the scene was taken to represent *The Baptism of Paul,* a crucial episode in the Paul cycle, found in the mosaics of the Cappella Palatina (Kitsinger 1960 [fig. 8]) and in those of Monreale (del Giudice 1702 [XXIV.5]). It is also found in *The Rockefeller McCormick New Testament* (1932 [115 verso]) and in the Bible preserved in the Biblioteca Communale at San Daniele del Friuli (folio 228 recto). Here the sword lies on the ground, which seems to indicate the identity of Paul, though he still wears the dress of a Roman soldier. The text does not indicate who performed the baptism of Paul, but it is generally supposed to have been Ananias, whereas the baptist here is clearly Peter, with John standing behind him. ✤

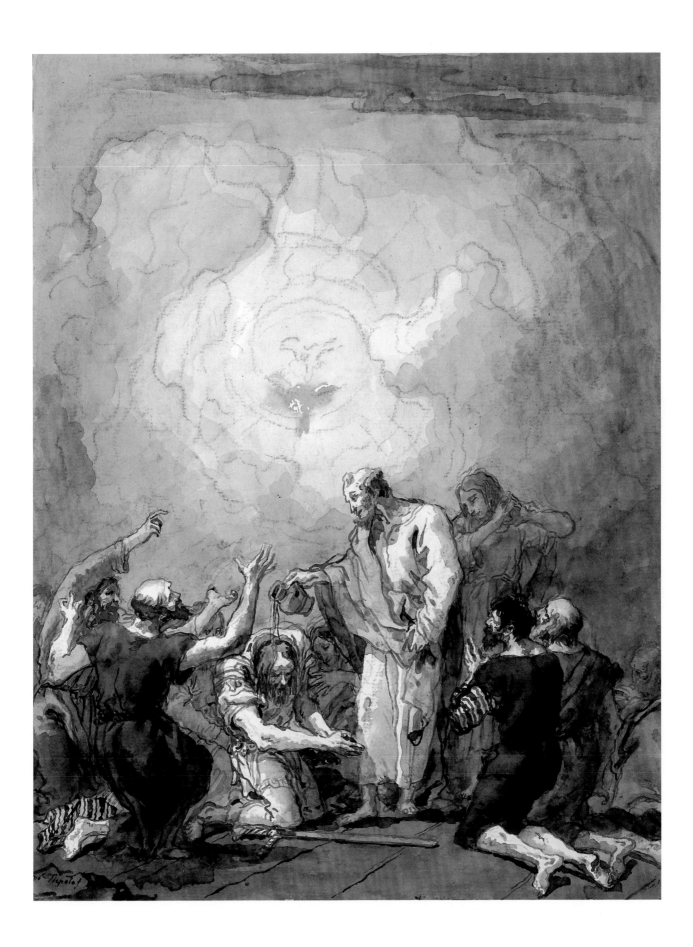

248. *The Vision of Peter*

I was in the city of Joppa praying; and in a trance I saw a vision, A certain vessel descend, as it had been a great sheet, let down from heaven by four corners; and it came even to me: Upon the which when I had fastened mine eyes, I considered, and saw four-footed beasts of the earth, and wild beasts, and creeping things, and fowls of the air. And I heard a voice saying unto me, Arise, Peter; slay and eat. But I said, Not so, Lord: for nothing common or unclean hath at any time entered into my mouth. (Acts 11:5–8)

> Pen and wash, over black chalk, 470 x 360
> Signed low right: Dom.o Tiepolo f
> Provenance: Roger Cormier, Tours, his sale, Paris, Georges Petit, Apr. 30, 1921, no. 4; Duc de Trévise, his sale, Paris, Hôtel Drouot, Dec. 8, 1947, no. 25
> Literature: Guerlain 1921, 111; Conrad 1996 [214]; Eleen 1977 [25–28]
> Reference: Pigler 1956, i, 386–388; Réau 1959, iii/iii, 1090; Eleen 1977 [25–28]

Exhibiting the posture characteristic of his encounter with higher powers, Peter receives the extraordinary vision of unclean beasts. He appears to be in the same room as the one in which he received Cornelius's messengers. Here, a stag, a pig, and a large goose represent the forbidden animals that God instructs Peter to accept. A pigeon, the only live animal, eyes Peter rather cautiously as, seated in the chair, Peter watches this surprising banquet table descend in a cloud of glory. Here again, the theme involves Peter's break with Jewish traditions. ❦

This very rare subject is cited twice in the Acts of the Apostles: in chapter 10 it forms part of the story of Cornelius, the centurion of Caesarea; in chapter 11 it is repeated as a part of the demonstration—"that the Gentiles had also received the word of God." Domenico, rather unusually shows the scene as an interior, whereas Acts 10:9 states clearly that "Peter went up upon the housetop to pray about the sixth hour." He also shows the beasts upon a sort of table with a flat surface instead of "a great sheet knit at the four corners." ❦

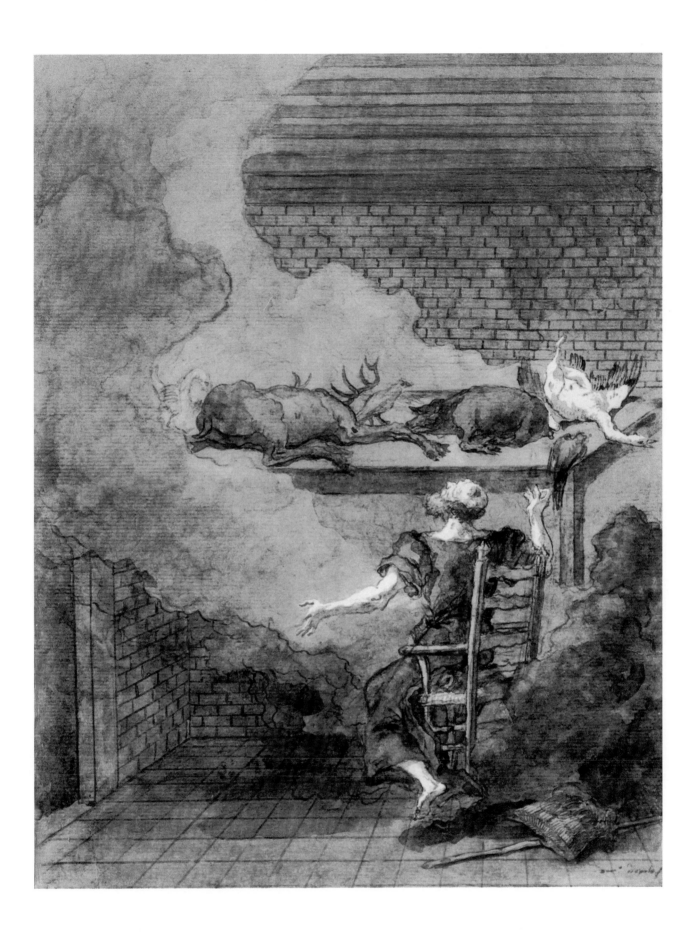

249. *Peter Released by the Angel*

And when Herod would have brought him forth, the same night Peter was sleeping between two soldiers, bound with two chains; and the keepers before the door kept the prison. And behold, the angel of the Lord came upon him, and a light shined in the prison; and he smote Peter on the side, and raised him up, saying, Arise up quickly. And his chains fell off from his hands. (Acts 12:6–10)

> Pen and wash, over black chalk, 468 x 361
> Not signed
> Provenance: Jean Fayet Durand (1806–1889)
> Literature: Conrad 1996 [218]
> Reference: Christiaan van Adrichem 1584, Site 138; *The Golden Legend* 1900, iv, 154–164, under August 1, *S. Pietro in vincoli*
> Ribadeneira 1656, i, 501; Fleury 1722, i, XXIV; Eleen 1977 [29–35]

Paris, Musée du Louvre, Département des Arts Graphiques, RF 1713bis [42]

Acts 12 mentions that Herod the king wished to "vex" the Church, so he killed James and imprisoned Peter in Jerusalem. Peter (again given his characteristic pose that marks his encounter with higher powers) wakes up to the angel rattling his chains. Not only chains but ropes and stony arches and two guards confine him, rendering the miracle of Peter's liberation even more powerful. One of the two sleeping soldiers reminds us of Joachim, who was still sleeping when his angel arrived (pl. 8). ❧

The prison is indicated by Christiaan van Adrichem (1584: Site 138). ⚜

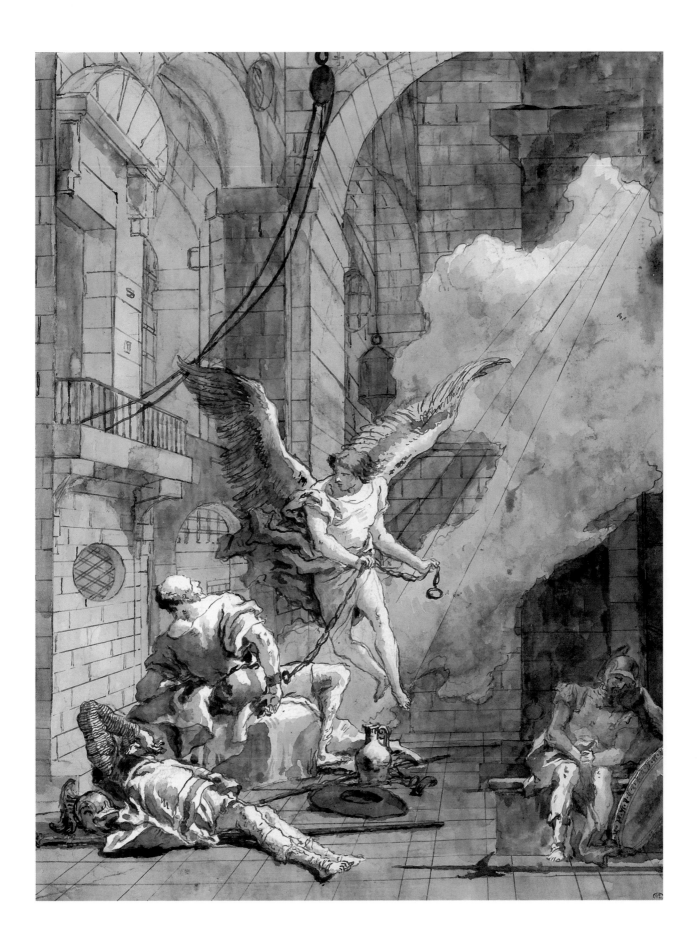

250. *Peter and Rhoda*

And as Peter knocked at the door of the gate, a damsel came to hearken, named Rhoda. And when she knew Peter's voice, she opened not the gate for gladness, but ran in, and told how Peter stood before the gate. (Acts 12:13–14)

Pen and wash, over black chalk, 491 x 381
Signed low left: Dom.o Tiepolo f
Provenance: Roger Cormier, Tours, his sale, Paris, Georges Petit, Apr. 30, 1921, no. 11; Duc de Trévise, his sale, Paris, Hôtel Drouot, Dec. 8, 1947 [28]
Literature: Guerlain 1921, 115; Joachim and McCullagh 1979, no. 143 [147]; Conrad 1996 [219]
Reference: Christiaan van Adrichem 1584, Site 126; Fleury 1722, i, XXIV

The Art Institute of Chicago, 1948.16; gift of Mrs. Potter Palmer, Jr.

Having escaped Herod's prison, Peter has made his way to the House of Mary, the mother of John, surnamed Mark. As the early morning sun casts the shadow of an adjacent house onto her home, Rhoda looks down from her window to see Peter knocking at the door. Given the fact that the first Christian church of the Greeks was reportedly built later on this famous spot, Domenico's loving description of this building takes on particular resonance. The drawing's connection to Mark may explain why Domenico elected to portray this unusual subject. ❦

This completes the series of 22 drawings illustrating the acts of Peter, as they are found in the Acts of the Apostles. The story of Rhoda follows the *Peter Released by the Angel* (pl. 249). The house is identified as that of Mary by Christiaan van Adrichem (1584: Site 126), and here indeed it is not unlike that of Anna: "Where also after the martyrdome of James the Apostle, Peter being cast into Prison by Herod Agrippa, they prayed without ceasing for his deliverance. Who at the last being brought out of Prison by the Angel, and knocking at the door of this house, was by a damsel brought into the same. In which place afterwards a Church was builded, which was the first of the Christian Greeks." ⚜

251. *Peter in Cathedra, Blessing—January 18, AD 43*

The fourth year of Claudius the emperor, Peter came to Rome, and sat there twenty-five years, and ordained two bishops as his helpers, Linus and Cletus, one within the walls, and that other without. (The Golden Legend)

Pen and wash, over black chalk, 460 x 355

Inscription: *d'Antiochio per particol inspirazione / e commando dello Spirito Santo / ando a Roma, qui pose la sua / sedia Pontificale da duravi sino che / il mondo dure; Entro S. Pietro in / Roma l'anno del Signore XLIII. che / da il di Claudio Imperatore alli 18 di / Genaio et in tal giorno si celebra la / Festa della cattedra di Roma si come / di questo di Antiochio, alli 22 di / Febraio perche in tal giorno entro / S. Pietro in questa in questa Città / Stette S. Pietro in Roma questa volta poco piu d'anni tre, poi ritorna in / Gerusaleme, quando Claudio feca / cacciare tutti I Giudai da Roma—/ Gian. Dom.o Tiepolo f*

Provenance: Jean Fayet Durand (1806–1889)

Literature: Conrad 1996 [250]

Reference: *The Golden Legend*, 1900, IV, 16, under June 29; Ribadeneira 1656, i, 129; Fleury 1722, i, XXIV; Butler 1756–1759/1880, ii, 460, under June 29, ii, 82, under January 18

Paris, Musée du Louvre, Département des Arts Graphiques, RF 1713bis [38]

Domenico continues Peter's career using sources other than Acts, and here considers him as first Pope. Peter sits majestic on his throne, flanked by two windows emblazoned with crosses through which light filters into his fledgling church. It is the first such cross to be found since the scene in which Christ cured Peter's mother-in-law (pl. 119). Just whom Peter blesses remains a question. One can suggest Clement, who yielded his place to Linus and Cletus. His twin brothers Faustinus and Faustus, who became Peter's followers because of Zacchaeus, were restored to Clement (together with their mother) by Peter, according to *The Golden Legend* (701). ✱

Butler cites Eusebius, Jerome, and the Old Roman Calendar as authorities for the view that Peter held the see of Rome for 25 years, though there is some slight confusion as to when Peter came there. *The Golden Legend* declares that he arrived in "the fourth year of Claudius the emperor," established the Cathedra of St. Peter in Rome, and held it for 25 years. This would imply that he came to Rome in AD 45, 25 years before his martyrdom. Elsewhere it seems to be agreed that he came in the second year of the Emperor Claudius, whose reign began on the death of Caligula, which took place on January 24, 41. This would justify Domenico in giving the date as "in the year of our Lord 43," on January 18. However, it appears that Peter was also imprisoned by Agrippa in Judaea in that year (see Butler 1880, i, 82, citing many authorities), which might give some support to the later date of *The Golden Legend*. Claudius is said to have expelled the Jews from Rome, following riots, in AD 49.

The throne itself, presented to Pope John VIII by Charles the Bald in 875, was preserved in St. Peter's and used as a papal throne. It is now the centerpiece of Bernini's vast *Cathedra Petri*, completed in 1662 for Alexander VII. Made of ebony with ivory plaques depicting an imperial coronation, it was identified by Baronius as the cathedra that Peter used at Antioch and later at Rome, but this can hardly be the case. The Feast of the Throne of St. Peter at Rome, celebrated on January 18, was reestablished by Paul IV in 1557. The inscription appears to be a quotation from a source that has yet to be identified (Eusebius or Jerome), followed by Ribadeneira (I, 305). The Cathedra is also shown in *The Apostles' Creed* (pl. 254), which is similarly related to the celebrated bronze by Arnolfo in the nave of St. Peter's. It should be remembered that S. Pietro di Castello, Venice, also laid claim to Peter's throne from Antioch. ⚜

252. *Peter Ordaining Linus and Cletus*

The fourth year of Claudius the emperor, Peter came to Rome, and sat there twenty-five years, and ordained two bishops as his helpers, Linus and Cletus, one within the walls, and the other without. (The Golden Legend)

Pen and wash, over black chalk, 469 x 360
Signed low left: Dom.o Tiepolo f
Provenance: Jean Fayet Durand (1806–1889)
Literature: Conrad 1996 [231]
Reference: *The Golden Legend,* 1900, iv, 16, under June 29; Baronius, year 89; Ribadeneira 1656, i, 300;
Lipsius and Bonnet 1959

Paris, Musée du Louvre, Département des Arts Graphiques, RF 1713bis [39]

Here Domenico considers the papal succession, assuring the continuation of the Church. In a less majestic and official setting, Peter, placed before a very dignified portal, administers his blessing with a calm, almost tired authority, offering a subtle hint that his leadership of the Church would soon draw to a close. Most of the disciples observe respectfully, while the oldest is so intent that he braces his arms on his knees, much as Peter himself appeared to do when the mother of Zebedee's children made her plea (pl. 158). Thus, Domenico is hinting that this scene signifies the future of the Church's "kingdom," just as earlier the Kingdom of Heaven was the focus. ❧

The feast day of Linus, who became the "second Pope," after Peter, is celebrated on September 23; he is said to have written an account of the dispute between Peter and Simon Magus and two books on the martyrdom of Peter and Paul, making the seventh volume of *La Bibliothèque des Saints.* Cletus, celebrated on April 26, became the "third Pope." ⚜

253. *Peter Dictating the Gospel to Mark*

As for Mark, then, during Peter's stay in Rome he wrote an account of the Lord's doings, not, however, declaring all of them, not yet hinting at the secret ones, but selecting what he thought most useful for increasing the faith of those who were being instructed. But when Peter died a martyr, Mark came to Alexandria, bringing both his own notes and those of Peter, from which he transferred to his former book the things suitable to whatever makes for proper progress towards knowledge. (The Secret Gospel of St. Mark)

When S. Peter preached there the gospel, the good people of Rome prayed S. Mark that he would put the gospel in writing, like S. Peter had preached. Then he at their request wrote and showed it to his master S. Peter to examine; and when S. Peter had examined it, and saw that it contained the very truth, he approved it and commanded that it should be read at Rome. (The Golden Legend)

> Pen and wash, over very slight black chalk, 464 x 357
> Inscription: *FU PREGAO IN ROMA CHE EGLI DE: / SSE IN SCRITO QUELLO CHE EI PREDI: / CAVA, ET ESSO DIEDE QUEL CARICO A / MARCO SUO DICEPOLO. ET SCRISSE L / VANGELO come PIETRO LO PREDICAVA / havendolo veduto l' Apostolo l'aprovo, e / comando che esse fosse accetato nella chiesa. / Gian. Dom.o Tiepolo f*
> Provenance: Jean Fayet Durand (1806–1889)
> Literature: Conrad 1996 [251]
> Reference: *The Golden Legend,* 1900, iii, 135, under April 25; Ribadeneira 1656, i, 297; Zatta 1761, 46; Fleury 1722, i, LX; Fleury1766, i, XVIII; Butler 1756–1759/1880, ii, 109; Jameson 1883, 149; Barnstone 1984, 341

Paris, Musée du Louvre, Département des Arts Graphiques, RF 1713bis [37]

Once more set in a room with cross-emblazoned windows and a magnificent portal, Peter, seated at a table, calmly reviews Mark's gospel. Mark stands, holding a pen; Peter is seated, reading with approval. The disciples await Peter's verdict and Mark himself is ready to make any necessary corrections, while others go about their business. Two Orientals make their way into the room as one man exits on the left. ❦

Butler cites Paphias and Clement of Alexandria as the authority for the story that Mark wrote his Gospel at the request of the Romans, and that Peter revised the text. Modern scholarship has its reservations about the legend, but there is consensus that Mark's Gospel is the earliest of the four and that it is Petrine in character, but later than the Sack of Jerusalem in AD 70. The inscription may be taken to be a quotation, but the source has not been identified, though the sense follows the text of *The Golden Legend* fairly closely (*cf.* Jerome, *Illustrious Men*). Ribandeneira gives the facts more or less as inscribed above; see also Fleury. ⚜

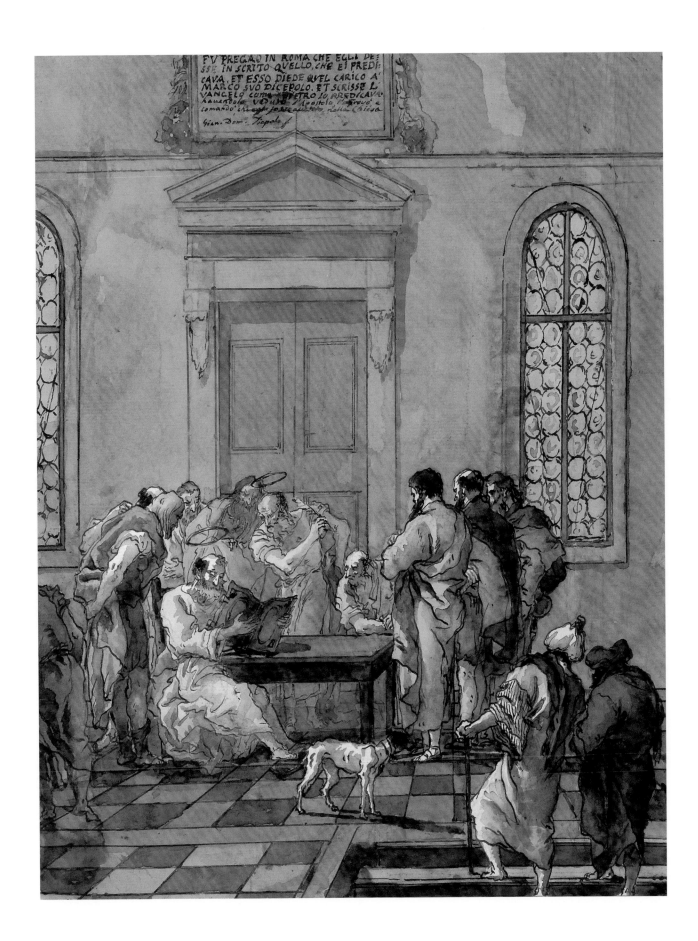

FV PREGAO IN ROMA CHE EGLI DE
SSE IN SCRITO QUELLO, CHE EI PREDI
CAVA, ET ESSO DIEDE QVEL CARICO A'
MARCO SVO DICEPOLO, ET SCRISSE L
VANCELO come PIETRO LO PREDICAVA
hauendolo VDUTO l'Apostolo Paolo, e
comando' che egli fosse aulettato nella Chiesa

Gian. Dom.° Tiepolo f.

254. *The Apostles' Creed*

Inscribed: *SIMBOLO APOSTOLICO / CREDO / IN SEGNO CON IL QUALE SI / CONOCESCESSERO LI FEDELI, ET PER / TENERLO PER UN SOMMARIO BREVE / E COMPENDIOSO DI QUELLO CHE ESSI / DOVEVANO PREDICARE, E CREDERE*

Pen and wash, over heavy black chalk, 466 x 358, image: 473 x 366, paper slightly trimmed to line
Signed on the step, right center: Dom.o Tiepolo f
Provenance: Jean-François Gigoux, Lugt 1164, his sale, Paris, Hôtel Drouot, Mar. 20–23, 1882, pl. 173; Wildenstein, New York; Stephen Mazoh, New York
Exhibition: Venice 1995 [199]; Udine 1996 [112]
Literature: *Lost Books of the Bible,* 1926, 91–93; Conrad 1996 [249]

Washington, D.C., National Gallery of Art, 1991.92.1, gift of Stephen Mazoh & Co., Inc., in Honor of the 50th Anniversary of the National Gallery of Art

Here Domenico considers the origins of the articles of the Catholic faith. Peter, seated upon the papal throne, leads the disciples in the creation of their creed in a manner that echoes Ambrose's description, which says that each Apostle contributed a line. Illuminated by the cross-emblazoned window behind him, one disciple has just stood up as if to deliver his contribution. Perhaps this is Philip, who added the line, "He suffered under Pontius Pilate, was crucified, dead and buried." Positioned just before the cross, this disciple assumes the posture of prayer reserved, until this drawing, for Jesus and his grandmother Anna. 🖋

Archbishop Wake provides a lengthy summary of the debate on the origins and character of the Apostles' Creed. He cites Ambrose as the source of the tradition that the twelve Apostles each contributed a phrase to make up the text of the creed. More recent scholarship suggests that the earliest full account of the origins of the Creed is given by Rufinus of Aquileia (374–410) in his *Commentarius in symbolum Apostolorum,* written in 404. After Pentecost, the Apostles are said to have agreed upon a "creed" or "Symbolum Apostolorum," as may be read here on the wall plaque: *"SIMBOLO APOSTOLICO / CREDO."* However, this term appears a little earlier in a letter, probably written by St. Ambrose in Milan, in 390 (see Kelly 1950: 1–3). The Apostle seated on the bishop's throne in the center is evidently Peter, and the other eleven are grouped on either side. A similar scene, forming a pair, is shown in the drawing *Peter in Cathedra, Blessing, January 18,* AD *43* (pl. 251) but it would appear that this drawing should be located much earlier in the series, after *Pentecost* (pl. 230). However, it has been pointed out that if this is the case, it is strange that the episode is omitted from the Acts. ✤

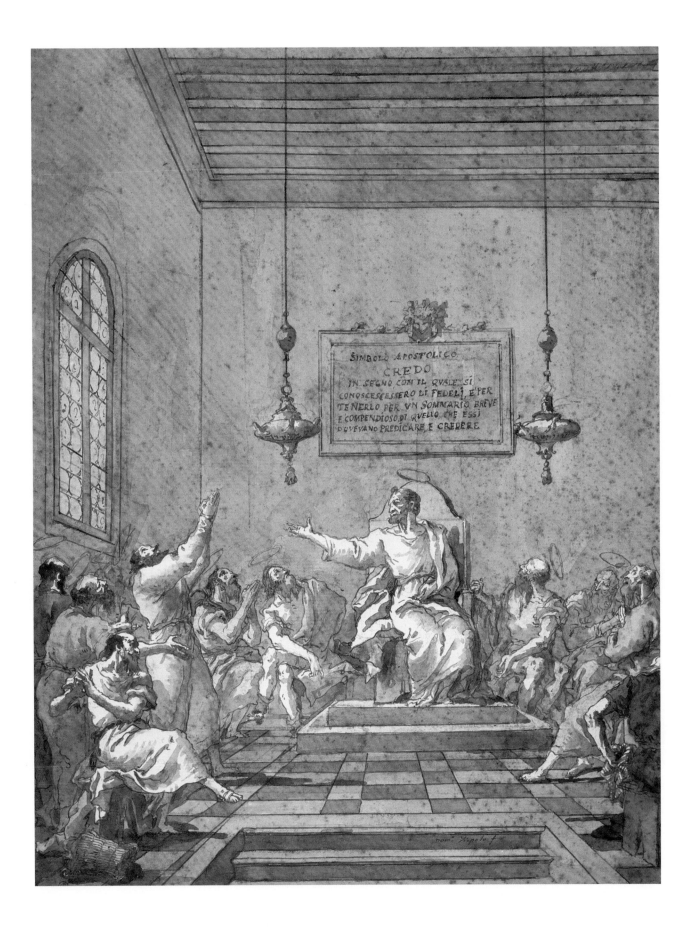

255. *The Fall of Simon Magus, I*

And Peter seeing the strangeness of the sight cried unto the Lord Jesus Christ . . . hasten thy grace O Lord, and let him fall from the height and be disabled; and let him not die but be brought to nought, and break his leg in three places. And he fell from the height and brake his leg in three places. Then every man cast stones upon him and went away home, and thenceforth believed Peter. (Acts of Peter, xxxii)

Then said Peter: I charge and conjure you angels of Sathanas, which bear him in the air, by the name of our Lord Jesus Christ, that ye bare ne sustain him no more, but let him fall to the earth. And anon they let him fall to the ground and brake his neck and head, and he died forthwith. (The Golden Legend, IV, 20)

> Pen and wash, over heavy black chalk, 460 x 360
> Signed low right: ?
> Provenance: Roger Cormier, Tours, his sale, Paris, Georges Petit, Apr. 30, 1921, no. 22; Duc de Trévise, his sale, Paris, Hôtel Drouot, Dec. 8, 1947, lot 31
> Exhibition: Chicago 1938, pl. 93
> Literature: Guerlain 1921, 125; Conrad 1996 [253]
> Reference: *Acts of Peter,* xxxii (James 1924, 331–332); *The Golden Legend,* 1900, iv, 20; Ribadeneira 1656, i, 436; Lenain de Tillement 1701, i, 176; Fleury 1722, ii, XXIII; Pigler 1956, i, 478–481

Domenico offers two views into an arena where people are gathered to watch Simon Magus leave the "unworthy world" and ascend to Heaven. Having leaped off a high tower, Simon was flying until Peter banished the devils holding him up. Here, Simon hurtles to his doom as some spectators rush to get out of the way. Peter stands at the left and calmly observes his fall. Nero, seated upon his throne at the right, is clearly dismayed. The scene takes place in a vast public setting, with the high tower on the left. ❧

The fullest account of the work of Peter following his arrival in Rome is given in the *Acts of Peter,* written no later than AD 200, preserved for us in a Greek manuscript at Vercelli. This relates that Simon Magus only broke his legs in his fall—in the words of Ribadeneira, "so that he who had wished to ascend to heaven was unable to walk upon the earth," although he died the next day at Arriccia. The story of Simon the Magician is told at length in *The Golden Legend* under St. Peter, June 29. Simon appears first in Jerusalem and later in Rome, where Nero became much attached to him. Finally, to demonstrate his powers, he flew from the top of the high tower, and Peter brought him crashing to his death. This scene is followed by plate 256, which shows much the same scene, with a man dressed in a Franciscan habit seated on a bier in the foreground; this remains to be explained. This drawing, which shows Simon with his characteristic wand, appears to be earlier and simpler than plate 256. ❧

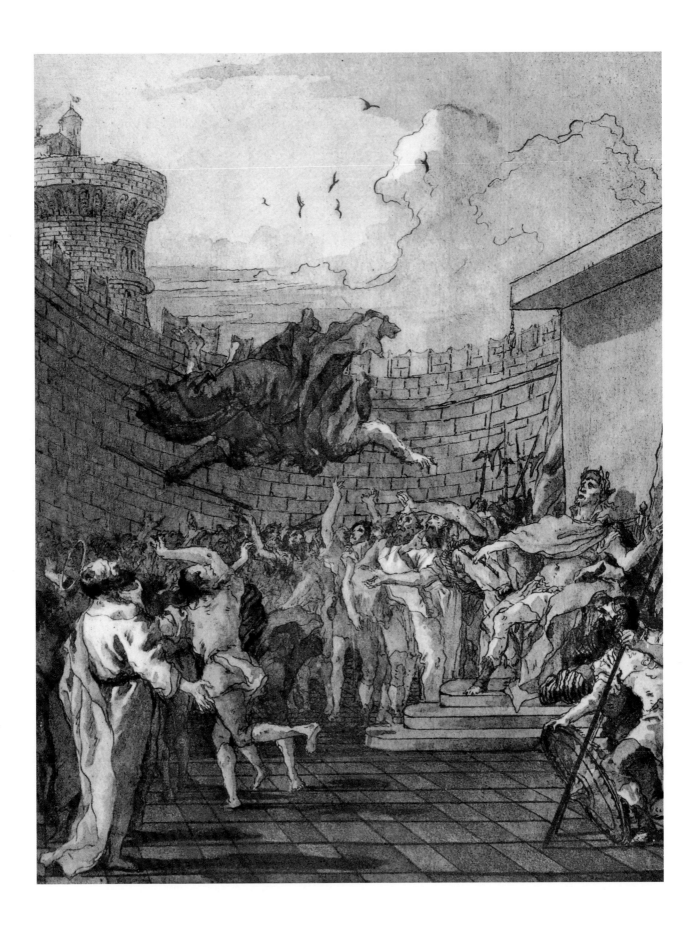

256. *The Fall of Simon Magus, II*

Then said Peter: I charge and conjure you angels of Sathanas, which bear him in the air, by the name of our Lord Jesus Christ, that ye bare ne sustain him no more, but let him fall to the earth. And anon they let him fall to the ground and brake his neck and head, and he died there forthwith. (The Golden Legend)

Pen and wash, over black chalk, 464 x 356
Signed low right: Dom.o Tiepolo f
Provenance: Jean Fayet Durand (1806–1889)
Literature: Conrad 1996 [252]
Reference: Fleury 1722, ii, XXIII; *The Golden Legend* 1900, iv, 20, under 29 June; *The Acts of Peter*—James 1924, 300–336, xxv–xxvii / Barnstone 1984, 439

Paris, Musée du Louvre, Département des Arts Graphiques, RF 1713bis [126]

Rotating our vantage point to the opposite side of the arena, Domenico shows Simon Magus a split-second later, his body twisting, as the flying demons release him at Peter's command. Behind Peter is the golden statue erected to celebrate Simon's divinity after he has staged his own death and resurrection. Below him are a boy and a bier, reminding us that, according to *The Golden Legend,* Simon earlier falsified the boy's resurrection, but Peter actually raised him. 🌿

Apart from *The Golden Legend,* cited above, the apocryphal *Acts of Peter* also gives several accounts of Peter, in contest with Simon in the Forum, reviving several boys from the dead. This must account for the bier in the foreground, and perhaps the boy standing by Peter. The design has a companion piece in plate 255. Simon again holds his characteristic wand. ⚜

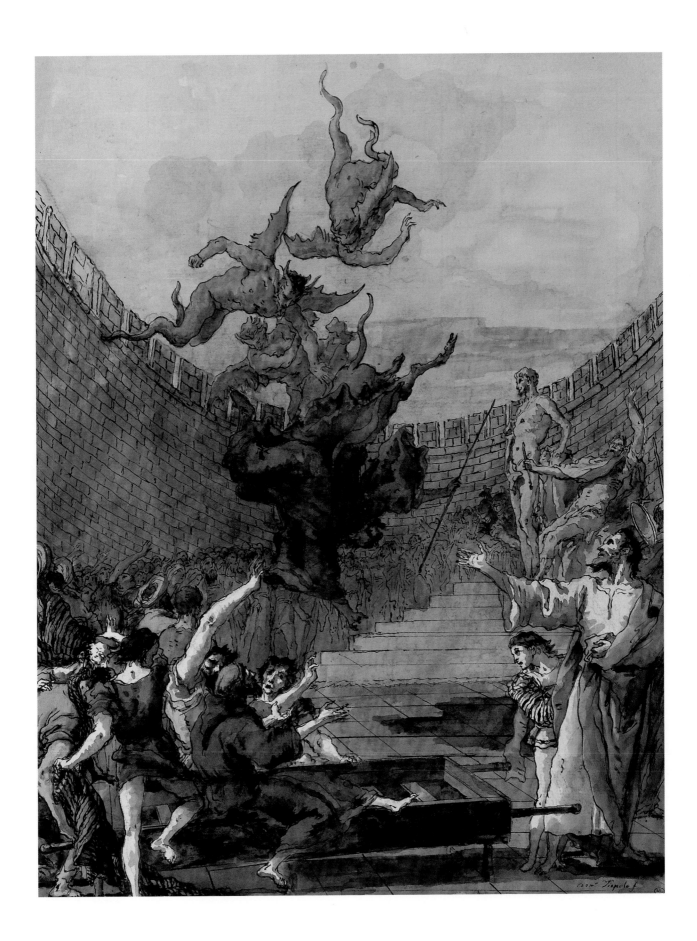

257. *"Domine, quo vadis?"*

And the rest of the brethren, together with Marcellus, besought him to depart. But Peter said unto them: Shall we be runaways, brethren? And they said unto him: Nay, but thou mayest yet be able to serve the Lord. And he obeyed the brethren's voice and went forth alone, saying: Let none of you come forth with me, but I will go forth alone, having changed the fashion of mine apparel. And as he went forth of the city, he saw the Lord entering into Rome. And when he saw him, he said: Lord, wither goest thou thus? And the Lord said unto him: I go into Rome to be crucified. And Peter said unto him: Lord, art thou being crucified again? And he said unto him: Yea, Peter, I am being crucified again. And Peter came to himself: and seeing the Lord ascending up into heaven, he returned to Rome, rejoicing, and glorifying the Lord, for that he said: I am being crucified: the which was about to befall Peter. (Acts of Peter, xxxv)

Pen and wash, 465 x 365, image
Signed low left: Dom.o Tiepolo f
Provenance: Paris, Hôtel Drouot, Dec. 14, 1938, lot 5, as *"Jesus et un disciple près d'une ville";* Michel-Lévy; Mme. A.L.D.; Paris, Drouot Richelieu, Nov. 21, 2001 [66]; New York, W.M. Brady & Co.
Reference: *Acts of Peter,* xxxv (James 1924, 333); *The Golden Legend,* 1900, iv, 21; Baronius, i, 1601, anno 69, cap. VI–VII; Butler 1880, 464

New York, private collection

Having bested Simon Magus, Peter has earned Nero's enmity and, yielding to his brethren's entreaties, quits Rome. Flanked by a magnificent "immortal" evergreen on a country road leading out of Rome that here looks curiously like a North Italian mountain town, Jesus, nude and godlike, appears to Peter. Gazing soberly at him, Jesus has not only surprised but also dismayed his disciple, who now prepares to return to Rome and meet his fate. ❧

The story of *"Domine, quo vadis?"* is first told in the *Acts of Peter,* a Greek text of the late second century that has come down to us in a manuscript at Vercelli. A thousand years later it is found in *The Golden Legend* of Jacobus da Varagine, and four hundred years later it is told by Baronius and Ribadeneira. Visual accounts of it are quite rare. ⚜

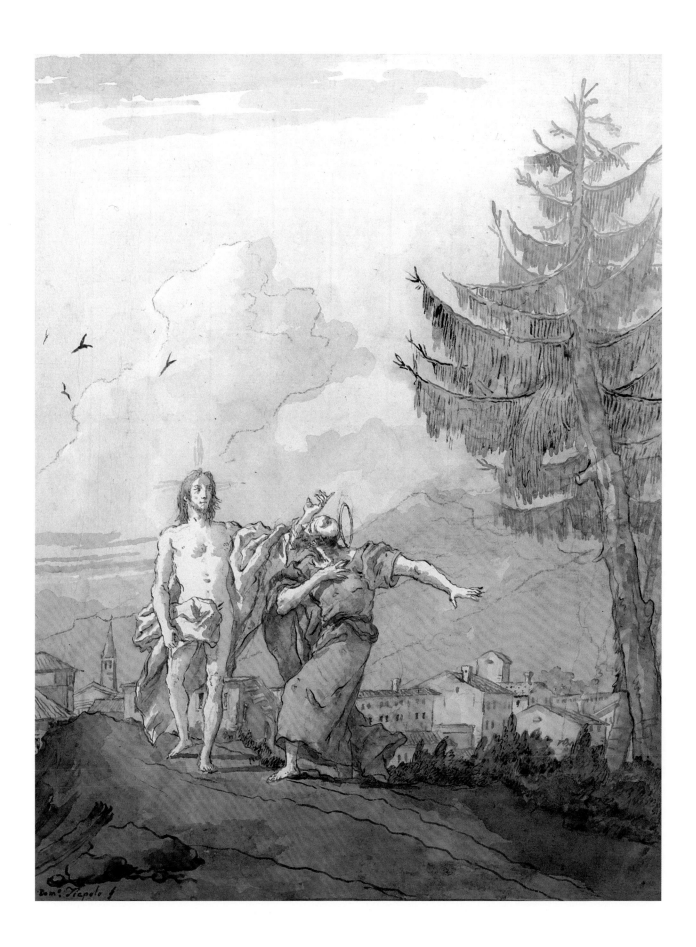

258. *Peter, Having Met Christ, Returns to Rome*

And when Peter understood that our Lord had said to him of his passion, he returned, and when he came to his brethren, he told to them what our Lord had said. (The Golden Legend, IV, 21)

And he went up therefore again unto the brethren and told them that which had been seen by him: and they lamented in soul, weeping and saying: We beseech the Peter, take thought for us that are young. (Acts of Peter, xxxvi)

> Pen and wash, over black chalk, 460 x 360
> Not signed
> Provenance: Jean Fayet Durand (1806–1889)
> Literature: Conrad 1996 [220]
> Reference: *The Golden Legend* 1900, iv, 21

Paris, Musée du Louvre, Département des Arts Graphiques, RF 1713bis [120]

Still touched by his encounter with Jesus, Peter greets his brethren beneath a vaulted arch that hints at his own doom, repeating as it does in essentials the setting for the deaths of Ananias and Sapphira. As his excited followers hear of his miraculous meeting with Jesus, some pray, and others admonish him to escape Herod's wrath. The Virgin, shrouded as she was during Christ's Passion, seems the first to anticipate his upcoming martyrdom. 🍃

This scene is here interpreted as Peter returning to Rome, following the encounter with Christ in *"Domine, quo vadis?"* (pl. 259). Conrad suggests that this scene should follow the story of Peter and Rhoda (pl. 250) (Acts 12:16–17), and the girl on the right could represent Rhoda, but this is not certain. Another possibility is that it represents *Peter and the Gardener's Daughter,* thus identifying the man in the center in a peasant-like costume as the gardener. ⚜

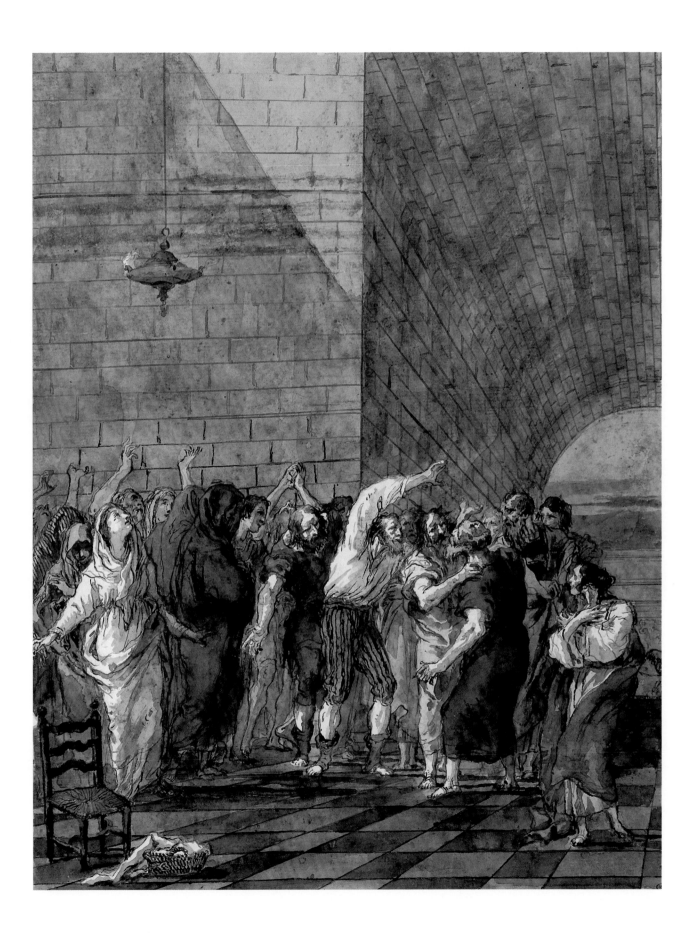

259. *Peter Thrust into Prison by Nero*

And when Nero heard say that Simon was dead, and that he had lost such a man, he was sorrowful, and said to the apostles: Ye have done this in despite of me, and therefore I shall destroy you by right evil example. Then he delivered them to Paulin, and Paulin delivered them unto Mamertin. (The Golden Legend)

Pen and wash, over black chalk, 459 x 356
Not signed
Inscription: *29 di Giugno / La condannazione Pietro e Paulo / a morta l'ultimo anno dall' / Imperio di Nerone*
Provenance: Jean Fayet Durand (1806–1889)
Literature: Conrad 1996 [254]; Gealt in Udine 1996, 63
Reference: *The Golden Legend* 1900, iv, 20, under June 29; Baronius, An. 68; Fleury 1722, ii, VVIII, XXV

Paris, Musée du Louvre, Département des Arts Graphiques, RF 1713bis [40]

A whole platoon of soldiers, one armed with a long spear, goad Peter into the doors of the Mamertine prison, emblazoned with the name of Nero. Several patriarchs number among the onlookers, including the man at the right, who may be identified as the Paulin mentioned in the text. To the left, a young boy rushes forward, reminding us of the lad who earlier witnessed Simon's plunge to his death. 🖌

The plaque on the prison wall records the martyrdom of Peter and Paul in Rome on June 29, AD 64 or 65—not, as stated, in the last year of Nero's reign, who died in AD 68. Peter's day is celebrated June 29, and that of Paul on the following day, June 30. ⚜

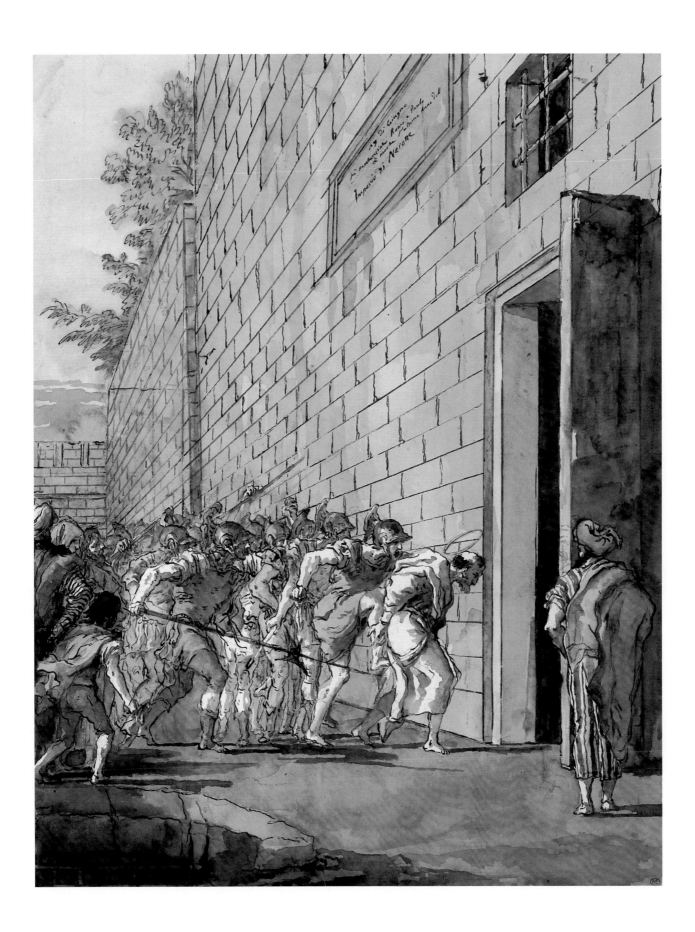

260. *Peter in Prison Baptizing*

Si dice che fosse gli Apostoli custoditi nella prigione di Mamertino posta a pie del campidoglio, a stendervasi sotterna che quivi dimorarono per nove mesi, che due loro custodi Processo e Martiniano maravigliati de la miracoli, si convertirono: anche S. Pietro li battezzo con quaranta sette altri persone ch'eran prigioneri con essi. (unknown)

[Nero] committed them to a high official named Paulinus, who cast them into prison, under the guard of two soldiers, Processus and Martinianus. But they were converted by Peter. . . . (The Golden Legend)

> Pen and wash, over black chalk, 460 x 357
> Signed low left: Dom.o Tiepolo f
> Provenance: Jean Fayet Durand (1806–1889)
> Literature: Conrad 1996 [255]
> References: Baronius, i, An. 68, xiv; Fleury 1722, ii, XXV

Paris, Musée du Louvre, Département des Arts Graphiques, RF 1713bis [41]

Deep in the bowels of the Mamertine prison, Peter reaches through the bars to pour baptismal waters on the converts kneeling at his cell. As those nearest to him receive the Holy Ghost, others, including a prostrate woman and a mother bearing her small child, humbly draw near as one man raises his arms in fervent prayer. ❦

Peter is shown baptizing a kneeling family through the prison bars. Conrad cites Baronius and Fleury as sources for the story of the baptism of Processus and Martinianus in Rome. The figure standing in the center clearly seems to be Andrew, in his short cloak, but with a striped shawl round his shoulders. Paul may be the figure to the left. ❧

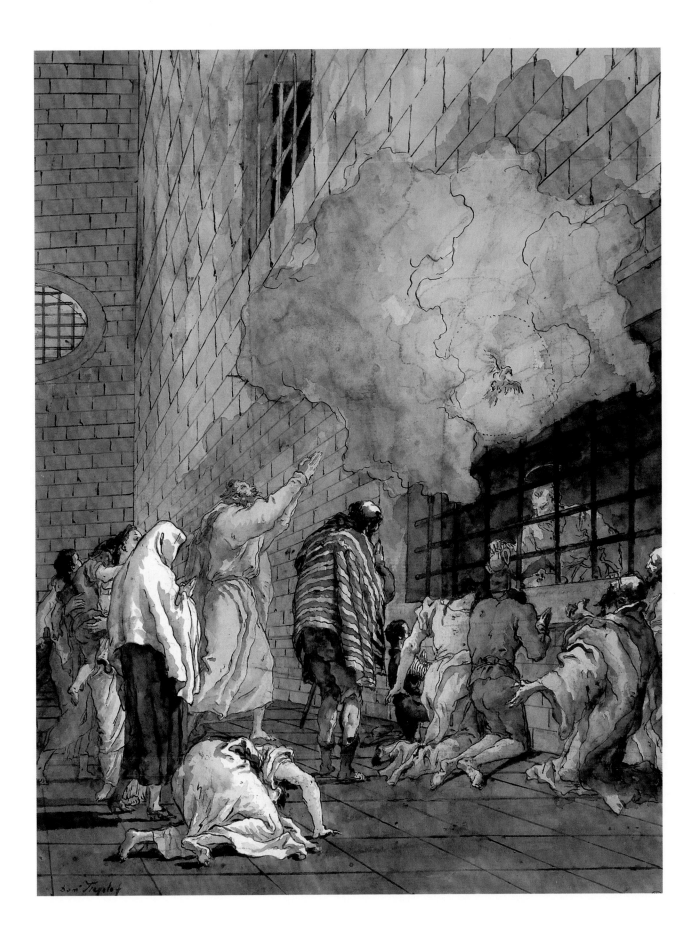

261. *The Crucifixion of Peter*

This saith S. Dionysius, and as Leo the pope and Marcel witness, when Peter came to the cross, he said: When my Lord descended from heaven to the earth he was put on the cross right up, but me whom it pleaseth him to call from the earth to heaven, my cross shall show my head to the earth and address my feet to heaven, for I am not worthy to be put on the cross as my Lord was, therefore turn my cross and crucify me head downward. (The Golden Legend, IV, 22)

Pen and wash, 460 x 360
Signed: Dom.o Tiepolo f
Provenance: Roger Cormier, Tours, his sale, Paris, Georges Petit, Apr. 30, 1921, no. 82; New York 1936, George & Frances Blumenthal; Duc de Trévise, his sale, Paris, Hôtel Drouot, Dec. 8, 1947, no. 52
Exhibition: Chicago 1938, pl. 92
Literature: Guerlain 1921, 127; Conrad 1996 [257]
Reference: *Acts of Peter,* xxxviii (James 1924, 334); *The Golden Legend,* 1900, iv, 22; Baronius, i, an. 69, XIX; Ribadeniera 1656, i, 430, under June 30; Fleury 1722, ii, XXV; Réau 1959, iii/iii, 1,096; Lipsius and Bonnet 1891, i, 10–21

His frail body assuming a profile similar to the crucified Christ, Peter and his large unhewn cross are hastily raised upside-down by a gang of ruffians as a mounted patriarch (not a Roman soldier, as was the case in Christ's execution) presides over his martyrdom. A large crowd of women, children, and older men keep their distance and an argument seems to have broken out between one bystander and the seated soldier who appears much subdued. Just by the Colosseum a completely hooded figure turns away. Maintaining his sense of continuity with the larger narrative, the angel delivering Peter's key and the martyr's palm echoes in basic respects the angel who spared Isaac from his impending sacrifice in the first scene of the epic (pl. 1). Moreover, Domenico thus assigns Peter his traditional symbol upon his death, bypassing the standard scene of Christ giving the keys to Peter, a scene based on Matthew's Gospel. Inaugurated by Titus in AD 80, or 16 years after Peter's death, according to Domenico's inscription (pl. 259), the Colosseum was erected over the ruins of Nero's house. Domenico's choice of Rome's most famous ancient monument may be historically inaccurate, but indelibly fixes Peter's death in the city. ❦

Domenico shows the Colosseum in the background. The story is told in *The Golden Legend,* under St. Peter, June 29, and again by Petrus de Natalibus (Lyons, 1542, iv, cap. xxii). The motive of the angels flying down with the keys seems to be a happy invention of Domenico himself. ❧

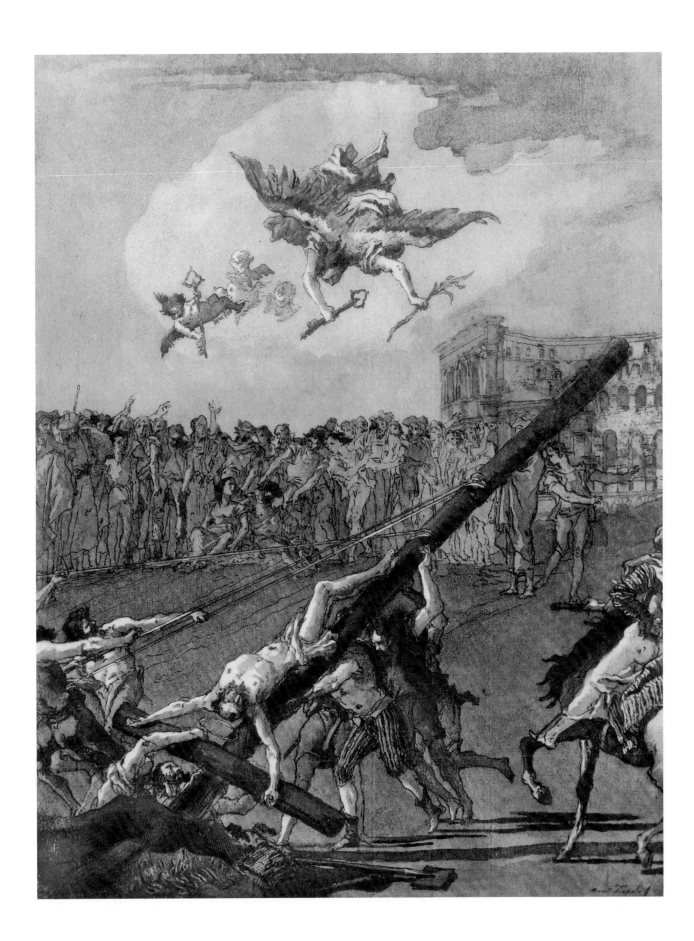

262. *The Funeral of Peter*

And Marcellus not asking leave of any, for it was not possible, when he saw that Peter had given up the ghost, took him down from the cross with his own hands and washed him in milk and wine: and cut fine seven minae of mastic, and of Myrrh and aloes and Indian leaf other fifty, and perfumed his body and filled a coffin of marble of great price with Attic honey and laid it in his own tomb. (Acts of Peter, xl)

The body of Peter was taken with great reverence & devotion by the priest Marcellus, and was solemnly buried with sweet unguents in part of the Vatican, not far from the place where he had been crucified. (Ribadeneira)

Pen and wash, over black chalk, 465 x 358
Signed low right: Dom.o Tiepolo f
Provenance: Jean Fayet Durand (1806–1889)
Literature: Conrad 1996 [259]; Gealt in Udine 1996, 87
Reference: Ribadeneira 1656, i, 437; Fleury 1722, I, XXV; *The Golden Legend,* 1900, iv, 23, under June 29; James 1924, 336

Paris, Musée du Louvre, Département des Arts Graphiques, RF 1713bis [134]

Concluding his chapter on Peter by showing his body carried to his tomb, Domenico links Peter's life with Christ, whom he also showed being carried to his burial. He does not conclude (as he did with Christ's story) with a scene of Peter's actual entombment (leaving that to our imagination), but he does give him a grand and deeply moving funeral procession. The many parishioners of his fledgling but thriving Church accompany his body, reflecting the success of his ministry. The Virgin Mary and other holy women follow behind the disciples and are visible just beneath Peter's bier. His frail body is propped up and his face confronts, but does not see, the host of cherubim bearing his papal insignia, tiara, and martyr's palm upon the cloud. ✹

The burial of Peter is described at length in the *Acts of Peter,* and again very briefly in *The Golden Legend,* under June 29. The body is carried so that all can see it. The cross and ladder lie in the foreground, while the Colosseum and the Arch of Constantine stand in the background, with the papal insignia above the latter. Everyone in the crowd carries a large lighted candle. Domenico forgets that these monuments are later in date than Peter, but he may have recalled that the Colosseum was the site of the most famous series of the Stations of the Cross. ⚜

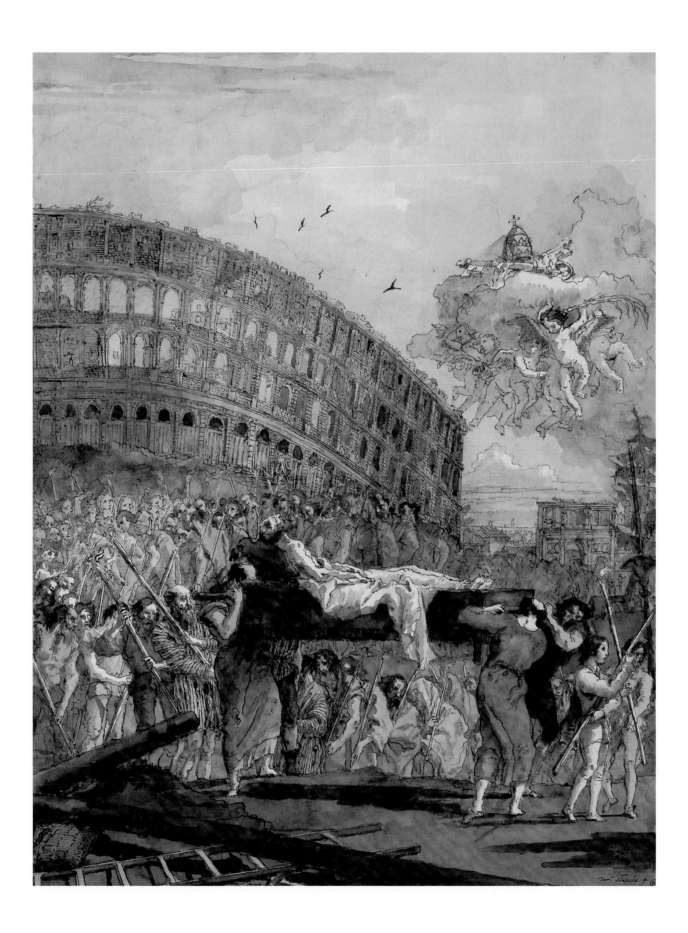

The Acts of Paul, Plates 263–297

Not among the original twelve Apostles, Paul became, with Peter, the cofounder of the Church. A Roman citizen descended from the tribe of Benjamin, Paul was born in Tarsus around AD 10. Given a Greek education, brought up as a Pharisee, and trained in the family textile business, he was, initially, anti-Christian. Present at the stoning of St. Stephen, he "made havoc of the church" (Acts 8:3). As he pursued Christians near Damascus, Paul was struck blind by God, who demanded to know why he persecuted him. Described in Acts 9:1–9, his conversion was instantaneous. Cured of his blindness by Ananias, Paul preached in and later escaped from Damascus (Acts 9:10–25). He went to Jerusalem to meet Peter, and confronted him again at Antioch regarding the issue of Gentile converts and Jewish observances (Galations 2:11–14). Paul's life was one long missionary journey, often in the company of others (including Luke) to faraway places such as Cyprus, Lystra, Iconium, Corinth, Phillippi, Ephesus, and ultimately, Rome. His many letters to his converts in these cities form a significant part of the New Testament, while Acts describes his many adventures.

At Cyprus, Paul (like Peter, who also battled a sorcerer, Simon Magus) struck the sorcerer Elymas blind (Acts 13:6–12). At Lystra, Paul and Barnabas cured a cripple, then had to keep from being worshiped as gods (Acts 14:8–18). At Philippi, Paul and Silas were scourged and thrown into prison after preaching (Acts 16:16–26), whereupon an earthquake freed them. They prevented their jailer's suicide and baptized him. Paul went on to Athens, where he converted Dionysius the Areopagite (Acts 17:16–34). He spent three years at Ephesus (Acts 19:19–41), where his conversion of pagan priests inspired them to cast their magical books into a bonfire (Acts 19:23–24). At Troas, Paul preached for hours into the night, lulling one unfortunate listener, Eutychus, to sleep, causing him to fall from his window to his death, whereupon Paul revived him (Acts 20:9).

Like Peter, Paul had an ecstatic vision (II Cor. 12:1–3) of being borne aloft by angels. He later returned to Jerusalem, where he caused a riot after being accused of bringing Greeks into the Temple and was imprisoned for two years (Acts 21–24). Exercising his right as a Roman, Paul demanded to be tried before the emperor, and was taken to Rome by boat. Caught in a storm, Paul was shipwrecked on Malta, where he performed some of his most famous miracles. After three months, during which he cured many at Malta (Acts 28), he departed on another ship for Rome. Acts 28 concludes with Paul's arrival there, describing his life under house arrest for two years, but making no mention of the trial before the emperor Nero.

Later writers, including Origen and St. Jerome, compiled in *The Golden Legend,* elaborate on Paul's trial and execution under Nero, who ultimately ordered his beheading, which was Paul's right as a Roman citizen. Legend says that Plautilla lent Paul her veil to blindfold his eyes, and that after his head was severed from his body, three jets of blood (symbols of faith, hope, and charity) burst forth. His place of death was traditionally thought to be the *Tre Fontane,* or three fountains. Roughly thirteen episodes of Paul's life joined the visual canon, of which his conversion was the most popular subject. Paul's encounter at Lystra, his preaching at Athens, his activities on Malta, and his farewell from Peter were also frequently portrayed, with numerous examples found in the seventeenth century. Paul's ecstatic vision became a popular Counter-Reformation subject.

Domenico took considerable liberties with Paul's story, which he amplified into 31 drawings. An epic yet traditional conversion follows a less common scene of Paul's oppression of Christians, a logical sequel to Paul's youthful presence at Stephen's martyrdom. Ananias curing Paul's blindness is followed by a scene of Paul's forceful oratory in a Damascus synagogue, which Domenico substitutes for the more common image of Paul preaching at Antioch. Paul's famous encounter at Lystra ignores the traditional ox generally depicted, concentrating instead

on Paul and Barnabas vehemently rejecting the homage paid to them by priests and the crowd. This contrasts with their subsequent treatment at Lystra, where they are violently expelled and stoned—a fairly rare subject that Domenico expands into two split-second sequences.

Domenico also found the story of Paul's circumcision of Timotheus, which has little or no pictorial tradition (Acts 16:3). Fascinated by the story of Paul and Silas's imprisonment at Philippi, he considered the event with five unusual drawings. The jailer's attempted suicide and Paul's righteous indignation with the sergeants and the magistrates, who beg him to leave the prison, are especially original.

Shifting to the more familiar subject of Paul's ministry in Athens, Domenico introduced a rare

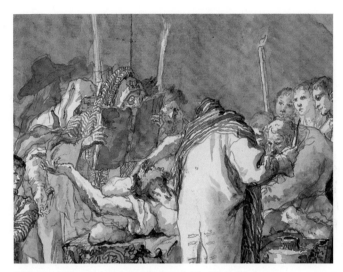

Timotheus's agony, detail of plate 274, *Paul Circumcises Timotheus*

and dramatic scene of his baptism of Dionysius the Areopagite, as well as a homey episode of Paul with his friend Aquila making tents, mentioned in Acts 18:3. Paul's expansive mission in Ephesus involves six drawings, including an impressive scene of the burning of magical books. Paul's unfortunate impact on Eutychus takes three scenes to unfold. Four more drawings take us through to Paul's adventures in Malta, concluded by a most moving interpretation of the well-known farewell between Peter and Paul. This is followed by an especially original conception of Paul's execution on the scaffold. As the series now stands, Paul's trial is omitted.

Domenico went to great pains to distinguish Paul's story from Peter's, omitting the elaborate inscriptions, martyr's palms, angelic presences, and large crowds, which so enriched and elevated Peter's story. Domenico also left out two traditional episodes that formed obvious parallels to Peter's story: the blinding of the sorcerer Elymas, and Paul's vision. Instead, Domenico made Paul unique, stressing his many friends and adventures. Paul's life and death are both more quotidian and less grand or ceremonial than Peter's, but full of split-second action, violent drama, and touching humanity. Yet, like Peter's story, Paul's is given the feeling of an eyewitness account, perhaps inspired by the fact that Luke (who began his Gospel with his affirmation of its eyewitness authority) was the author of Acts.

263. *The Stoning of Stephen*

And they stoned Stephen, calling upon God, and saying, Lord Jesus, receive my spirit. And he kneeled down, and cried with a loud voice, Lord, lay not this sin to their charge. And when he had said this, he fell asleep. And Saul was consenting unto his death. . . . (Acts 7:59–60; 8:1)

And when the blood of thy martyr Stephen was shed, I also was standing by, and consenting unto his death, and kept the raiment of them that slew him. (Acts 22:20)

> Pen and wash, over black chalk, 481 x 380
> Not signed
> Provenance: Roger Cormier, Tours, his sale, Paris, Georges Petit, Apr. 30, 1921, no. 25; J.F. Willumsen, acq. Paris, May 9, 1921
> Exhibition: Fredrikssund 1984 [18]; Udine 1996 [105]
> Literature: Guerlain 1921, 103; Fischer 1984, no. 21 [18]; Conrad 1996 [203]
> Reference: Fleury 1722, i, VI; *The Golden Legend* 1900, ii, 152–161; Réau 1958, iii/i, 452; Eleen 1977 [47–52]

Frederikssund, The J.F. Willumsen Museum, G.S.501

St. Stephen is stoned beneath the walls of Jerusalem as a youthful Paul, sword in hand, holds the clothes of some executioners at the left. On the hill to the right, a group of patriarchs looks on soberly while an angel, again similar to the one that first stopped Abraham's hand (pl. 1), here delivers Stephen's martyr's crown. ❦

The first recorded event in the story of Saul (later Paul) is his presence at the martyrdom of Stephen the Deacon, the first martyrdom suffered by the followers of Christ. Estimated to have occurred in AD 36, this is recalled by Paul in his defense to the people at Jerusalem in Acts 22. The figures in the right background may be interpreted as including Saul, holding "the raiment of them that slew him." The spot is recorded by Christiaan van Adrichem (1584: Sites 164 and 200). ⚜

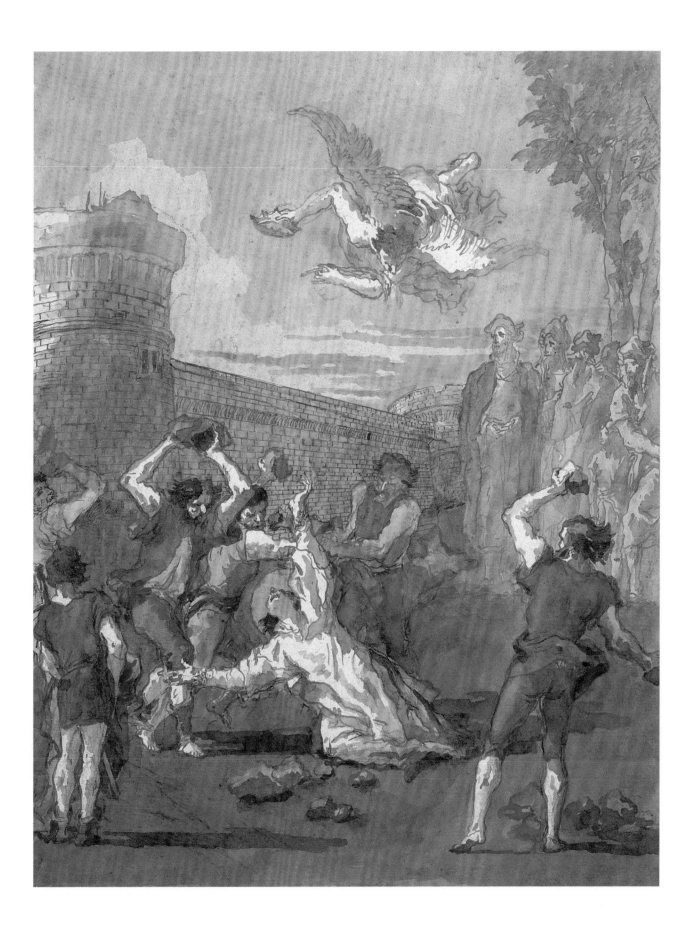

264. *Philip Preaching and Healing in the City of Samaria*

As for Saul, he made havock of the church, entering into every house, and haling men and women committed them to prison. Therefore they that were scattered abroad went every where preaching the word. Then Philip went down to the city of Samaria, and preached Christ unto them. And the people with one accord gave heed unto those things which Philip spake, hearing and seeing the miracles which he did. . . . and many taken with palsies, and that were lame, were healed. (Acts 8:3–7)

> Pen and wash, over black chalk, 472 x 364, image; 481 x 383 paper
> Signed low right: Dom.o Tiepolo f
> Provenance: Arturo Roman, Barcelona; Christie's, Apr. 15, 1980 [121]; photo 942235; Christie's, New York, Jan. 11, 1994 [243]; Zürich, Arturo Cuellar;
> Literature: Conrad 1996 [225], as perhaps Paul at Ephesus, Acts 19:11 (cf. Receuil Luzarche 150)

Indiana, private collection, on loan to the Indiana University Art Museum

In a barren countryside outside the city of Samaria, a huge assembly of the lame, the crippled, and the ill have made their way to Philip. As he raises his arms in blessing, one grateful recipient clasps his arms in prayer in a gesture often seen among Paul's supplicants. ❧

This appears to be the only reference in the Acts to the healing of lame men. If the saint, here identified as Philip, be identified as Paul, there does not seem to be any appropriate text. However, we again place this event under the acts of Paul. It has also been associated with *The Healing of the Ten Lepers* (pl. 154), in which case the main figure would be Jesus. ⚜

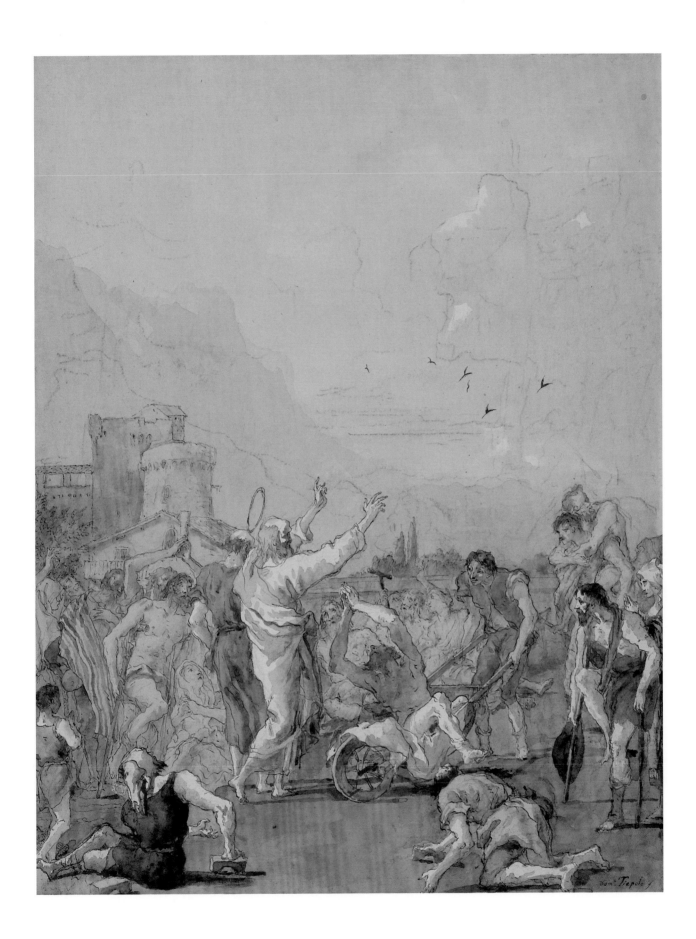

265. *Philip and the Ethiopian Eunuch*

And he arose and went: and, behold, a man of Ethiopia, an eunuch of great authority under Candace queen of the Ethiopians, who had the charge of all her treasure, and had come to Jerusalem for to worship, was returning, and sitting in his chariot read Esaias the prophet. Then the spirit said unto Philip, Go near, and join thyself to this chariot. And Philip ran thither to him, and heard him read the prophet Esaias, and said, Understandest thou what thou readest?
(Acts 8:27–30)

Pen and wash, over heavy black chalk, 470 x 363, image; 488 x 382, paper
Signed low left: Dom.o Tiepolo f
Provenance: Tomas Harris; Dr. Rudolf J. Heinemann, New York
Exhibition: London, Arts Council 1955, pl. 41; New York 1973 [108]
Literature: Griswold 1997 [3]; Conrad 1996 [206]; Gealt in Udine 1996, 75
Reference: Fleury 1722, i, X; Pigler 1956, i, 382–385; Réau 1959, iii/iii, 1,070, cites Bernard Salomon, *Figures du Nouveau Testament;* Eleen 1977 [11–15]

New York, The Pierpont Morgan Library, Heinemann Collection, 1996.110

As an angel hovers over their shoulders (closely resembling the one that attended Christ's burial in the Fourteen Stations, pl. 227), Philip and the Ethiopian eunuch companionably review the text of Esaias, resulting in the eunuch's enlightenment. His chariot draped in opulent tapestries (once again with pomegranate patterns) and his groom finely dressed, the eunuch appears like a great Eastern potentate, bearded and turbaned. ❧

The mission of Philip to Samaria and Gaza, which includes the present scene, follows upon Acts 8:3: "As for Saul, he made havock of the church, entering into every house, and haling men and women committed them to prison." For this reason we place this scene among the acts of Paul. ⚜

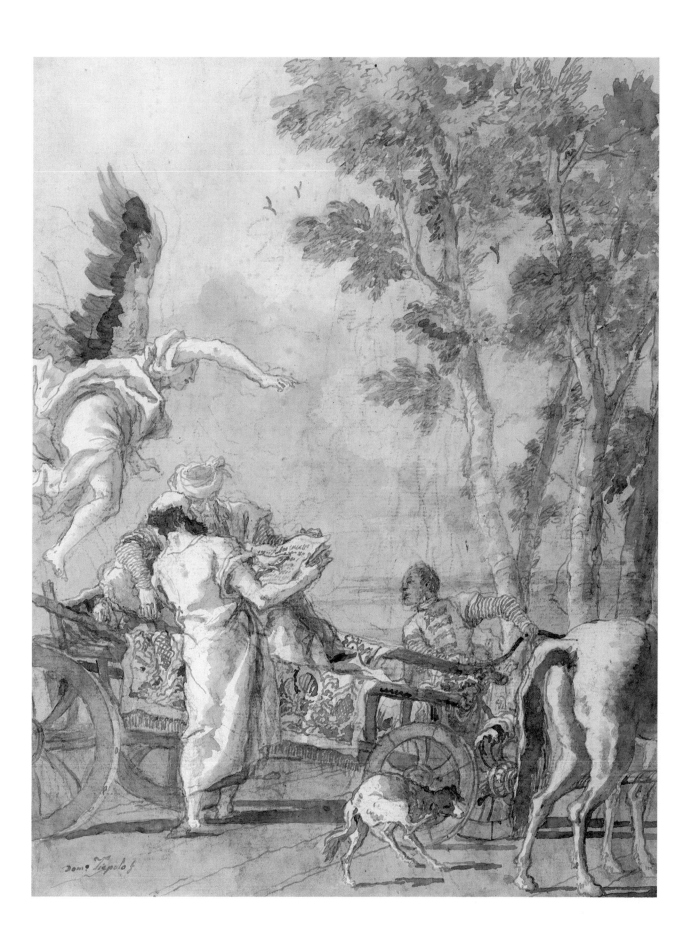

266. *Paul on the Road to Damascus*

And as he journeyed, he came near Damascus: and suddenly there shined round about him a light from heaven.
(Acts 9:3)

Pen and wash, much black chalk, 492 x 385 / 470 x 360
Signed low right: Dom.o Tiepolo
Provenance: Roger Cormier, Tours, his sale, Paris, Georges Petit, Apr. 30, 1921, no. 29, as *Saint Paul, suivi de cavaliers, se dirige vers Damas;* Paris, Hôtel Drouot, June 24, 1985 [11];
Exhibitions: Paris, Paul Prouté 1982 [33]; Paris, Paul Prouté 1987 [33]; Paris 1988; Paris, Hôtel Drouot, Nov. 20, 2000 [101]; Paris, Drouot-Richelieu, June 18, 2002 [46]
Literature: *The Golden Legend*, 1900, IV, 28–46; Conrad 1996 [268]

Sotheby's, London, Jan. 26, 2005 [176]

Returning to Paul's story, Domenico inaugurates two themes important to it: his initial persecution of Christians and his love of travel. As Paul gallops towards Damascus, his sword is drawn, evidently prepared to kill infidel women and children along the way. ❦

A full and accessible account of the life of St. Paul the Apostle is given in *The Golden Legend*. The woman in the left foreground here, with a dead child, obviously suggests a connection with *The Massacre of the Innocents* (pl. 43). However, this link is here taken to refer to the earlier persecution of the Christians by Saul (later Paul) as a parallel to Herod's outrage. ⚜

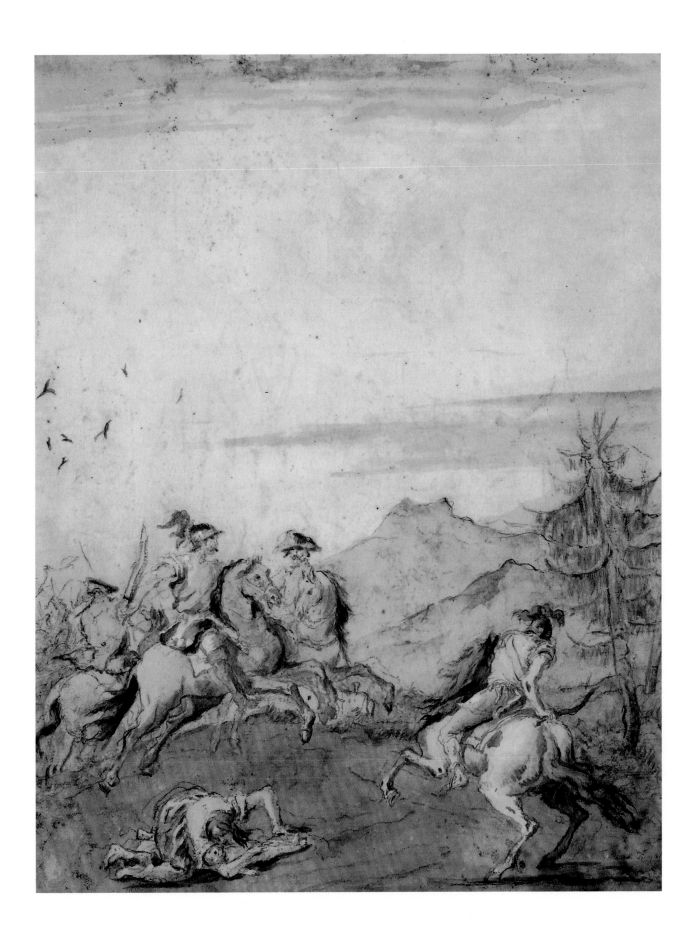

267. *The Conversion of Paul*

And as he journeyed, he came near Damascus: and suddenly there shined round about him a light from heaven; and he fell to the earth, and heard a voice saying to him, Saul, Saul, why persecutest thou me? (Acts 9:3–4)

Pen and wash, over heavy black chalk, 460 x 360
Not signed
Provenance: Roger Cormier, Tours, his sale, Paris, Georges Petit, Apr. 30, 1921, no. 30
Literature: Guerlain 1921, 105; Eleen 1977 [16–22]; Conrad 1996 [207]
Reference: Fleury 1722 i, IX; Réau 1959, iii/iii, 1,041, gives priority to the Raphael cartoon

Domenico's conception of Paul's conversion is unusually epic. Paul has arrived at Damascus with a fairly large platoon of foot soldiers as well as a phalanx of cavalry. Bolts of lightning crackle from the cloud from which God's voice booms, causing Paul's horse to cast off its rider. As Paul is struck blind, soldiers scatter in every direction. Panicked horses stampede away, while foot soldiers react with shock, or are stricken down.

Domenico represents this scene, one of the most popular in religious art, as taking place just outside the walls of Damascus. As so often, the horse is the central element, but Paul seems, rather unusually, to be falling on the far side of it. Above, a vast black cloud indicates the presence of the Almighty.

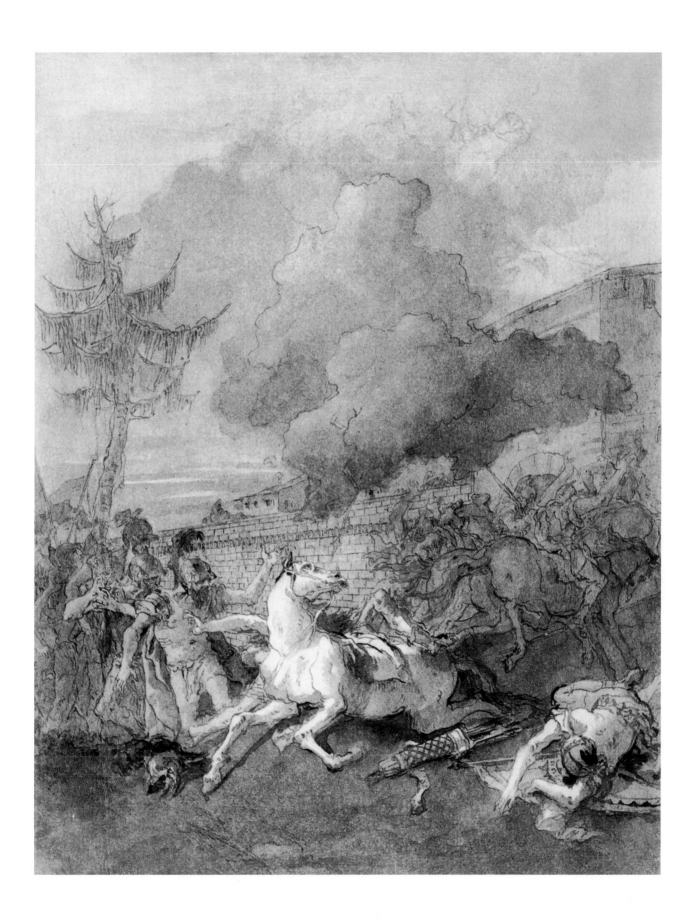

268. *Ananias Restores Paul's Sight*

And Ananias went his way, and entered into the house; and putting his hands on him said, Brother Saul, the Lord, even Lord Jesus, that appeared unto thee in the way as thou camest, hath sent me, that thou mighest receive thy sight, and be filled with the Holy Ghost. And immediately there fell from his eyes as it had been scales: and he received sight forthwith, and arose, and was baptized. (Acts 9:17–18)

Pen and wash, over black chalk, 470 x 360
Signed low left: Dom.o Tiepolo f
Provenance: Roger Cormier, Tours, his sale, Paris, Georges Petit, Apr. 30, 1921, no. 55; Collector's mark: G (Lugt 1237);
Lahman 1937 (Lugt 1656a)
Literature: Guerlain 1921, 107]; Conrad 1996 [208]
Reference: Fleury 1722, i, XI; Pigler 1956, i, 385; Réau 1959, iii/iii, 1,042

Bremen, Kunsthalle, 36/637 (lost during WWII)

Humbly kneeling before Ananias, Paul, still blind, needs his soldier companions to point and explain what is happening. As Ananias prepares his cure, the open window behind the group signals not only the restoration of Paul's vision but the salvation of his soul. ✹

This is the first of the many representations in the series of Paul, who displays his traditional and characteristic features: a long ascetic face, with long hair and a long beard. These are retained quite consistently down to the final scenes of his life, *The Parting of Peter and Paul* and *The Beheading of Paul* (pls. 296–297). ✤

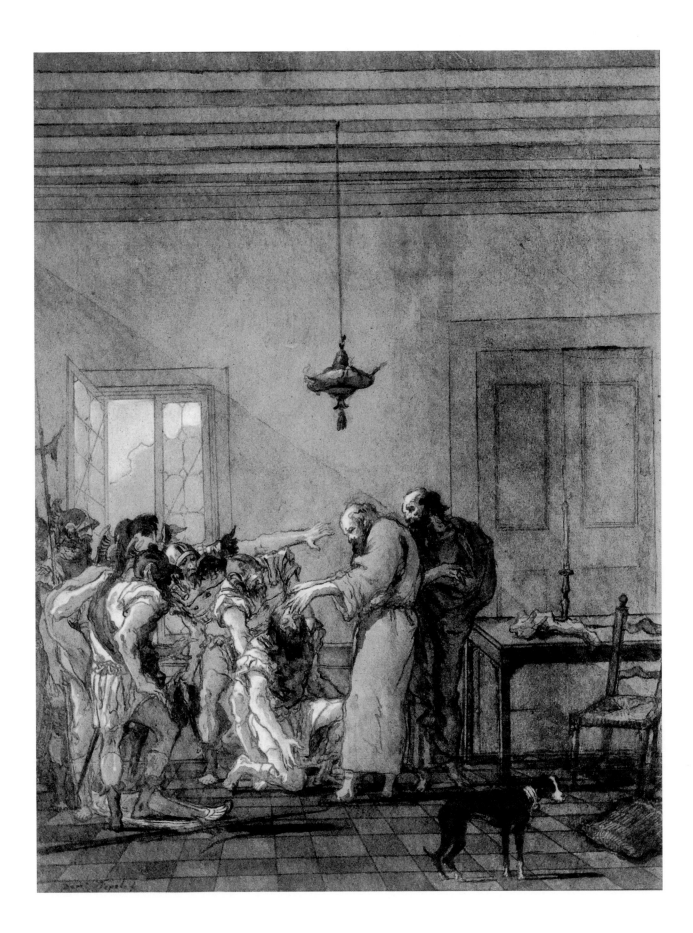

269. *Paul Preaching in the Synagogues at Damascus*

. . . Then was Saul certain days with the disciples that were in Damascus. And straightway he preached Christ in the synagogues, that he is the Son of God. But all that heard him were amazed, and said; Is not this he that destroyed them which called on this name in Jerusalem, and came hither for that intent, that he might bring them bound to the chief priests? (Acts 9:19–21)

But when they departed from Perga, they came to Antioch in Pisidia, and went into the synagogue on the Sabbath day, and sat down. (Acts 13:16–32)

Pen and wash, over black chalk, 489 x 382
Signed low right: Dom.o Tiepolo f
Marked in margin, top right: A XIII (reference to Acts 13?)
Provenance: Roger Cormier, Tours, his sale, Paris, Georges Petit, Apr. 30, 1921, no. 66; Duc de Trévise, his sale, Paris, Hôtel Drouot, Dec. 8, 1947 [46]; Paris, pc; Christie's, June 16, 1960 [323]; Paris, Hôtel Drouot, Mar. 9, 1988 [164]; Christie's, New York, Jan. 9, 1991 [26]
Exhibition: New York, W. M. Brady, May 1989 [11]
Literature: Guerlain 1921, 117; Conrad 1996 [221]

Los Angeles, private collection

Standing in a synagogue with windows similar to those in Peter's chapter but minus the cross, Paul addresses a rabbi the way Peter stood before Annas (pl. 233). Calmly declaring that Christ was the son of God, Paul has the rapt attention of this congregation, who begin to recognize him as the former persecutor of Christians. ❧

It seems likely that this scene is inspired more by Paul's preaching in the synagogues of Damascus than by the later incident in Antioch in Pisidia. Domenico's concept may well be based on an impression of the seventeenth-century Spanish Synagogue in the Ghetto Vecchio in Venice, designed by Longhena. The scene is calm and orderly, in sharp contrast to *Paul at Lystra* (pl. 271). The smart young man on the left might well have stepped out of one of the *Scenes of Contemporary Life*. ⚜

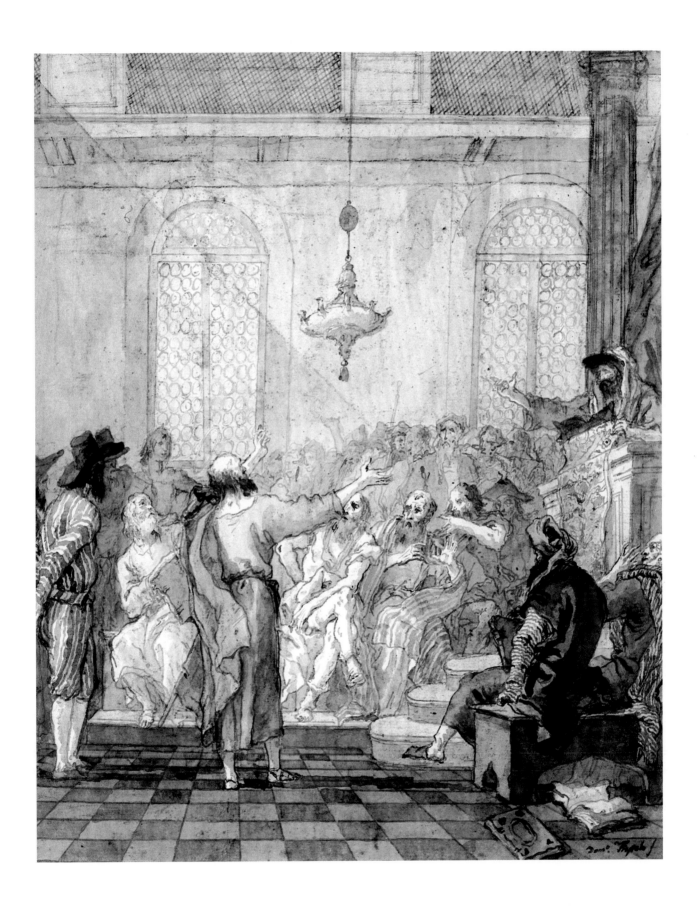

270. *Paul Lowered in a Basket from the Walls of Damascus*

Then the disciples took him by night, and let him down by the wall in a basket. (Acts 9:25)

Pen and wash, over black chalk, 470 x 365
Signed low left: Dom.o Tiepolo f
Provenance: Jean Fayet Durand (1806–1889)
Literature: Conrad 1996 [209]
Reference: Pigler 1956, i, 385–386; Réau 1959, ii/iii, 1,043

Paris, Musée du Louvre, Département des Arts Graphiques, RF 1713bis [66]

Domenico returns to the wall of Damascus (where he showed Paul's conversion taking place) and portrays Paul's famous escape from the city. Now the subject of persecution himself, Paul evades arrest by being lowered in a basket. Domenico stresses the number of Paul's followers and emphasizes Paul's thankful farewell. The widespread arms echo his gesture at the moment of his conversion. ❦

Domenico is careful to render this visually effective theme as a night scene, with no white highlights and two bats flying in the sky. The event can be dated no later than AD 40. ❦

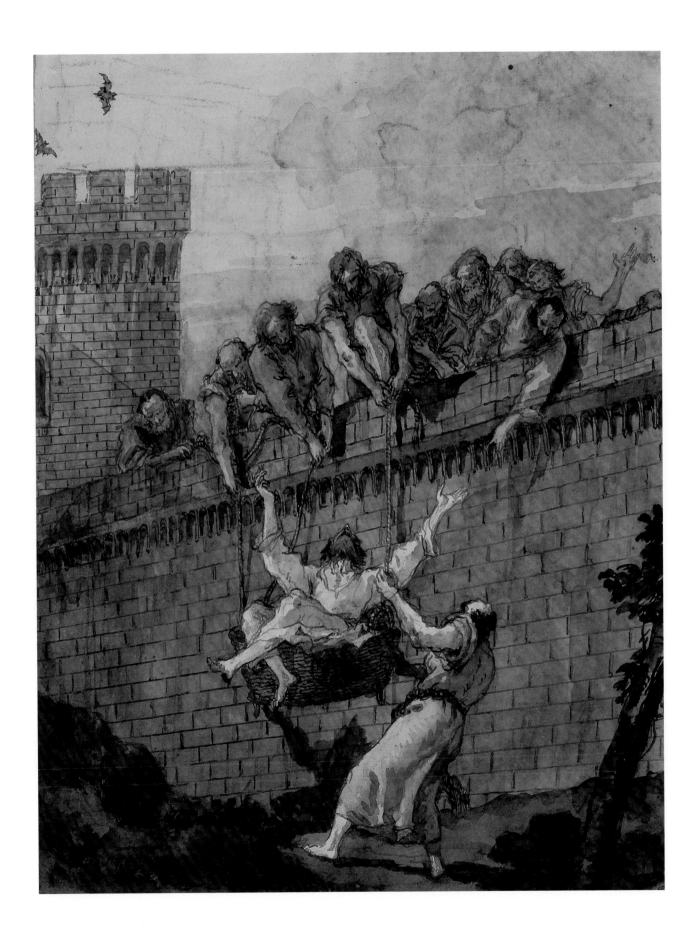

271. *Paul at Lystra*

And there was a certain man at Lystra impotent in his feet, being a cripple from his mother's womb, who never had walked: the same heard Paul speak: who steadfastly beholding him, and perceiving that he had faith to be healed, said with a loud voice, Stand upright on thy feet. And he leaped and walked. And when the people saw what Paul had done, they lifted up their voices, saying in the speech of Lycaonia, the Gods are come down to us in the likeness of men.
(Acts 14:8–11)

Pen and wash, over black chalk 469 x 361, image: 488 x 379, paper
Signed low right: Dom.o Tiepolo f
Provenance: Roger Cormier, Tours, his sale, Paris, Georges Petit, Apr. 30, 1921, no. 77; Galippe sale, Amsterdam, de Vries, Mar. 27–28, 1923 [724]; duc de Trévise, his sale, Paris, Hôtel Drouot, Dec. 8, 1947 [49]; Paris, Broglio; Tomas Harris; Dr. Rudolf J. Heinemann, New York
Exhibition: London, Arts Council 1955, pl. 42; New York 1973 [109]
Literature: Conrad 1996 [227]
Reference: Pigler 1956, i, 388–390; Réau 1959, iii/iii, 1,045, gives priority to the Raphael cartoon, 1515

New York, The Pierpont Morgan Library, Heinemann Collection, 1996.111

Inside the majestic temple at Lystra, Paul and Barnabas try to stop the congregation from worshipping Paul for having healed the cripple. The healed man celebrates his cure with hands clasped fervently heavenward, while Paul, at the far right, appears to go for his sword to stop such a heresy. A young man kneels to embrace Barnabas as a priest waves his censer. In their eagerness to honor him the witnesses have knocked over a lamp in this explosive episode. 🌿

The turbulent scene shows the man leaping from his wheeled pallet on the left, with his crutch lying on the ground. It does not show the more popular episode that followed of the offering of sacrifices, to Paul's consternation. However, this may be reflected in Paul's hands, raised in outrage, the agitated priest with a censer, and the keeling boy with what looks like an overturned tripod. It is this aspect of the incident that is illustrated by the Raphael cartoon and nearly all subsequent treatments of the subject. The setting is extremely grand. ⚜

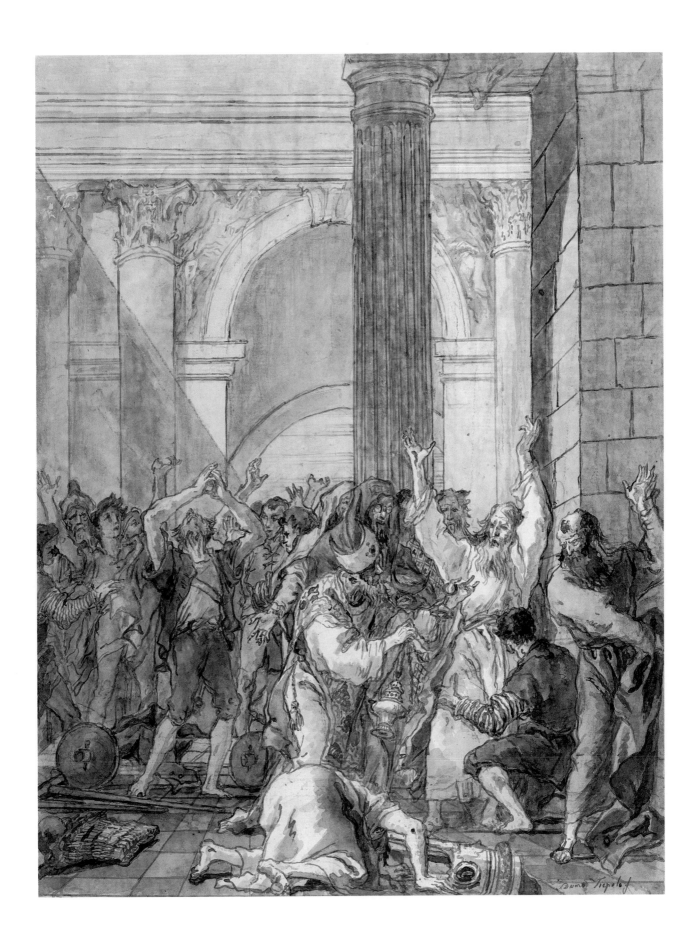

272. *Paul and Barnabas Expelled from Lystra, I*

And there came thither certain Jews from Antioch and Iconium, who persuaded the people, and, having stoned Paul, drew him out of the city, supposing he had been dead. (Acts 14:19)

Pen and wash, over black chalk, 469 x 360
Signed low left: Dom.o Tiepolo f
Provenance: Jean Fayet Durand (1806–1889)
Literature: Conrad 1996 [229]
Reference: Pigler 1956, i, 390

Paris, Musée du Louvre, Département des Arts Graphiques, RF 1713bis [70]

Now subject to the very stoning that he authorized for St. Stephen, Paul flees with Barnabas for his life as a gang of thugs pelt them with rocks. Adding the burlesque of an exposed bottom (last seen in Station 14) during Christ's burial, the figure is no less effective here as he grapples for stones. Domenico used split-second timing to distinguish Paul's chapter. ❦

This dramatic story is told in two scenes outside the walls of the city (see also pl. 273). Here the brutal attack is in progress; in the second the Apostles are left for dead. ✤

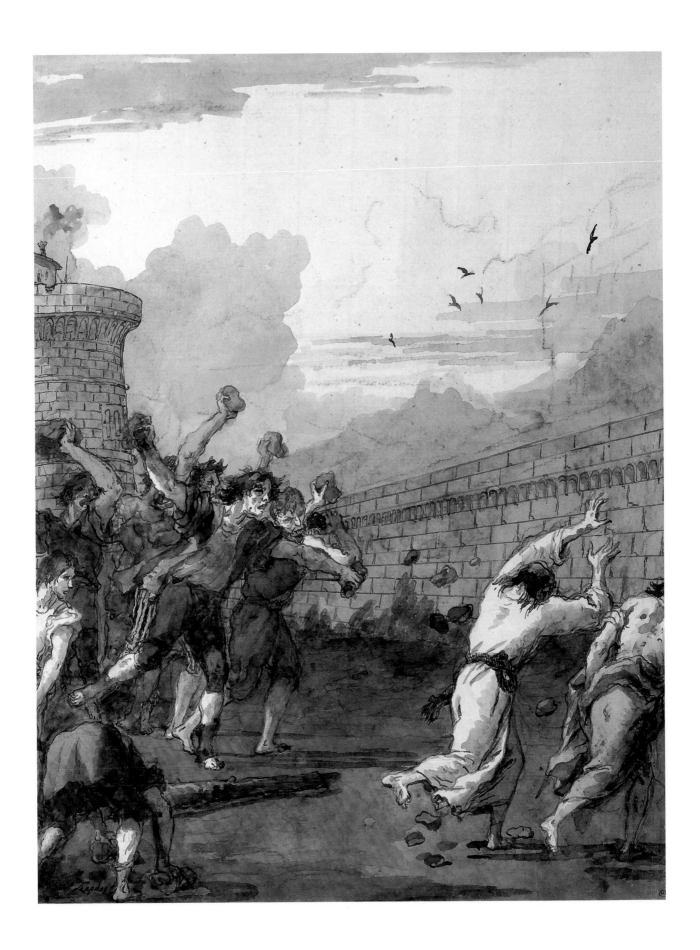

273. *Paul and Barnabas Expelled from Lystra, II*

Howbeit, as the disciples stood round about him, he rose up, and came into the city: and the next day he departed with Barnabas to Derbe. (Acts 14:20)

Pen and wash, over black chalk, 468 x 364
Signed low left: Dom.o Tiepolo f
Provenance: Jean Fayet Durand (1806–1889)
Literature: Conrad 1996 [230]

Paris, Musée du Louvre, Département des Arts Graphiques, RF 1713bis [114]

As the citizens of Lystra jeer and shout over the wall, the last of the assailants exit stage right but look back to ensure that their victims are dead. Above Paul and Barnabas, the great evergreens signal their executioners' mistake, for though they are injured, Paul and Barnabas will survive. ❧

In this scene, a sequel to plate 272, Paul and Silas are left for dead outside the city wall of Lystra, with the hostile crowd on the battlements. Paul is to be identified by the sword lying by his side. ❀

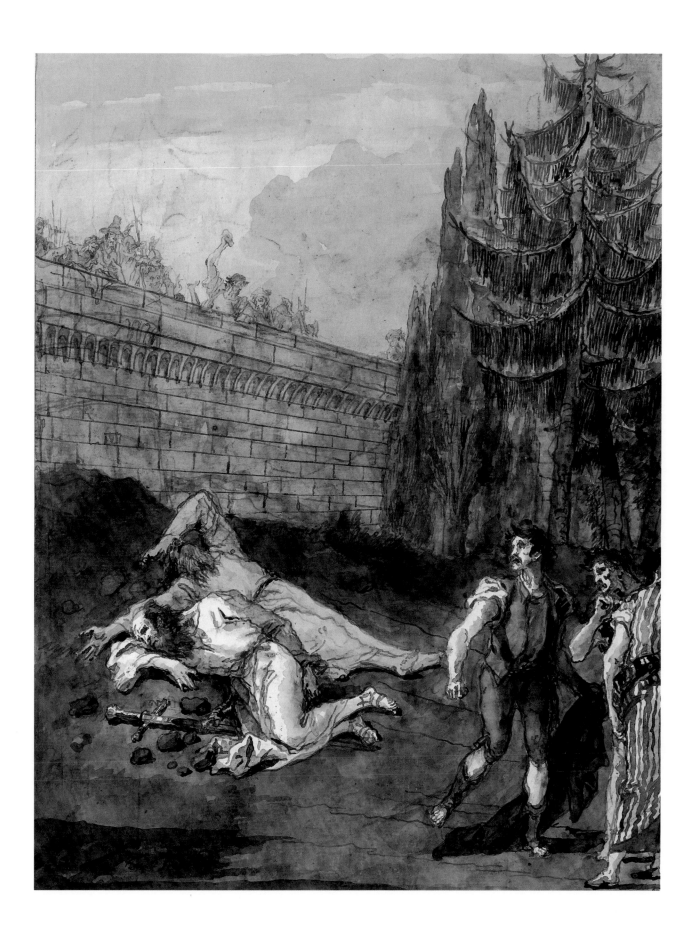

274. *Paul Circumcises Timotheus*

Him would Paul have to go forth with him; and took and circumcised him because of the Jews which were in those quarters: for they knew all that his father was a Greek. (Acts 16:3)

Pen and wash, over black chalk, 469 x 362
Signed low right: Dom.o Tiepolo f
Provenance: Jean Fayet Durand (1806–1889)
Literature: Conrad 1996 [232]
Reference: Fleury 1722, i, XXXIV, calls him "Timothée"

Paris, Musée du Louvre, Département des Arts Graphiques, RF 1713bis [133]

Recumbent upon an altar covered with pomegranate designs, Timotheus writhes in agony as Paul performs the painful circumcision following rituals dictated by the rabbi from his book. Some men cannot bear to watch, but most look on with rapt if morbid fascination. Paul's first act during his second missionary expedition, this rarely portrayed event in his career places an accent on his conversion of Jews. Paul's relation to Jews contrasts with Peter's, whom Domenico (also ignoring convention) emphasized as the converter of gentiles. ❦

The rare subject of this drawing is proposed by Conrad, and in this way all the curious details of the composition are indeed satisfactorily accounted for. ⚜

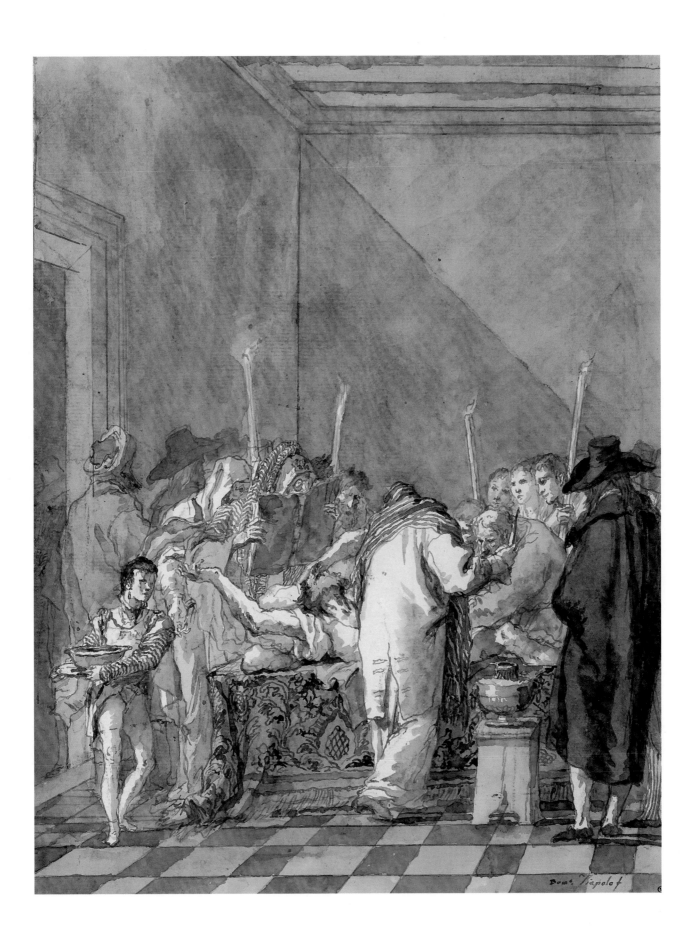

275. *Paul and Silas Beaten and Imprisoned at Philippi*

And the multitude rose up together against them: and the magistrates rent off their clothes, and commanded to beat them. And when they had laid many stripes upon them, they cast them into prison, charging the jailor to keep them safely. (Acts 16:22–23)

> Pen and wash, over black chalk, 460 x 360
> Not signed
> Provenance: Roger Cormier, Tours, his sale, Paris, Georges Petit, Apr. 30, 1921 [72], as *Le Christ entrainé par les soldats*
> Literature: Guerlain 1921, 72; Conrad 1996 [228], as perhaps Acts 14:19 qv
> Reference: Réau 1959, iii/iii, 1046; Eleen 1977 [36–41]

Having exorcised a demon from a woman in Phillipi, Paul and Silas are cast into prison. Prodded and beaten, they stumble down a tunneled corridor (always an ominous setting) toward their cell as one turbaned figure looks on stage left. This might be Luke, the acknowledged author of Acts, who accompanied Paul on a number of journeys, and escaped prison in several instances. ❦

Domenico often uses a dark, barrel-vaulted passage to suggest a dire situation, as in the story of Ananias and Sapphira (pls. 234–236), where it must imply a journey to the grave. Here, the horror of being thrust into prison is most effectively suggested. ⚜

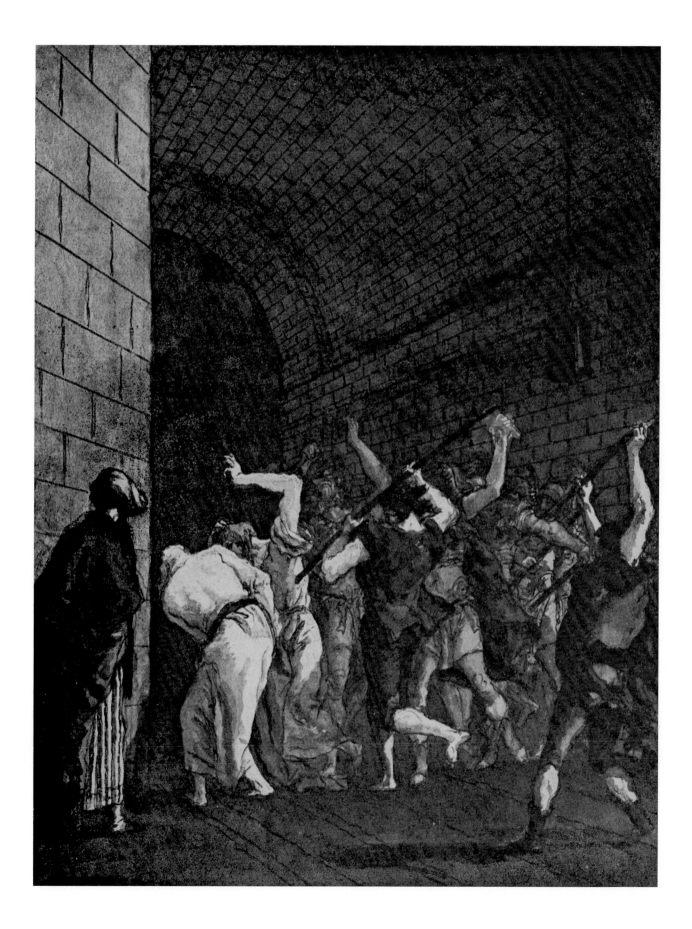

276. *Paul and Silas Prevent the Suicide of the Jailer*

And suddenly there was a great earthquake, so that the foundations of the prison were shaken: and immediately all the doors were opened, and everyone's bands were loosed. And the keeper of the prison awaking out of his sleep, and seeing the prison doors open, he drew out his sword, and would have killed himself, supposing that the prisoners had been fled. But Paul cried out with a loud voice, saying, Do thyself no harm; for we are all here. (Acts 16:27–28)

Pen and wash, over heavy black chalk, 467 x 362, image, untrimmed
Signed low right: Dom.o Tiepolo f
Provenance: Roger Cormier, Tours, his sale, Paris, Georges Petit, Apr. 30, 1921, no. 78; duc de Trévise, Paris, Hôtel Drouot, Dec. 8, 1947, no. 50; Tomas Harris; Dr. Rudolf J. Heinemann, New York
Exhibition: London, Arts Council 1955, pl. 39; New York 1973 [106], as *The Death of Judas*
Literature: Conrad 1996 [233]
Reference: Pigler 1956, i, 338–339; Réau 1957, 441

New York, The Pierpont Morgan Library, Gift of Mrs. Rudolf J. Heinemann, in memory of
Dr. Rudolf J. Heinemann, 1996.108

Now in the cave-like prison, Paul and Silas wave and shout to the jailer to prevent his suicide. Separated from him by a huge pillar, Paul and Silas are ghost-like background figures in contrast to the jailer, who dramatically prepares to fall on his sword. 🌢

Domenico hardly suggests the effect of an earthquake in this scene, but he contrasts the somber architecture of the prison with the vision of daylight and liberty in the right background. The scene has sometimes been identified as *The Death of Judas,* but this presents real problems, and we agree with Conrad that the subject should be correctly identified as Paul and Silas saving the jailer at Philippi. ⚜

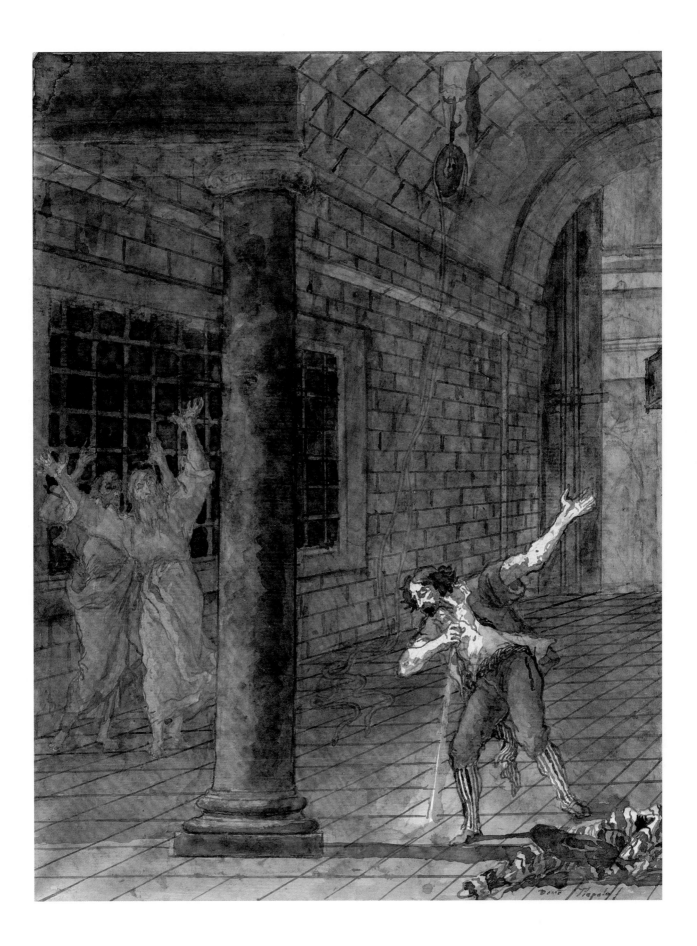

277. *Paul and Silas Baptize the Jailer and His Family*

And they said, Believe on the Lord Jesus Christ, and thou shalt be saved, and thy house. And they spake unto him the word of the Lord, and to all that were in his house. And he took them the same hour of the night, and washed their stripes; and was baptized, he and all his, straightway. (Acts 16:33)

Pen and wash, over black chalk, 474 x 367, trimmed close to the image
Signed low right: Dom.o Tiepolo f
Inscribed on verso in black ink: no 73
Provenance: Roger Cormier, Tours, his sale, Paris, Georges Petit, Apr. 30, 1921 [73]; Paris, Palais Galliera, June 27, 1963 [207]; Adolphe Stein
Exhibition: London 1984 [66]; Paris 1996, pl. 95 [58]; Rotterdam 1996 [62]
Literature: Conrad 1996 [234]

Paris, Fondation Custodia, Institut Néerlandais, Frits Lugt Collection, 1996–T.6

Within the more comfortable environs of the jailer's home, Paul administers baptism to him and his family. Here again the Holy Ghost (reserved for Peter's conversions) is absent. Instead, the more prosaic presence of a window signals his spiritual enlightenment, as it had for Paul himself when his blindness was cured. Silas makes an essential reference to the spirit as he points heavenward and to the hearth where smoke would rise up the chimney. ✸

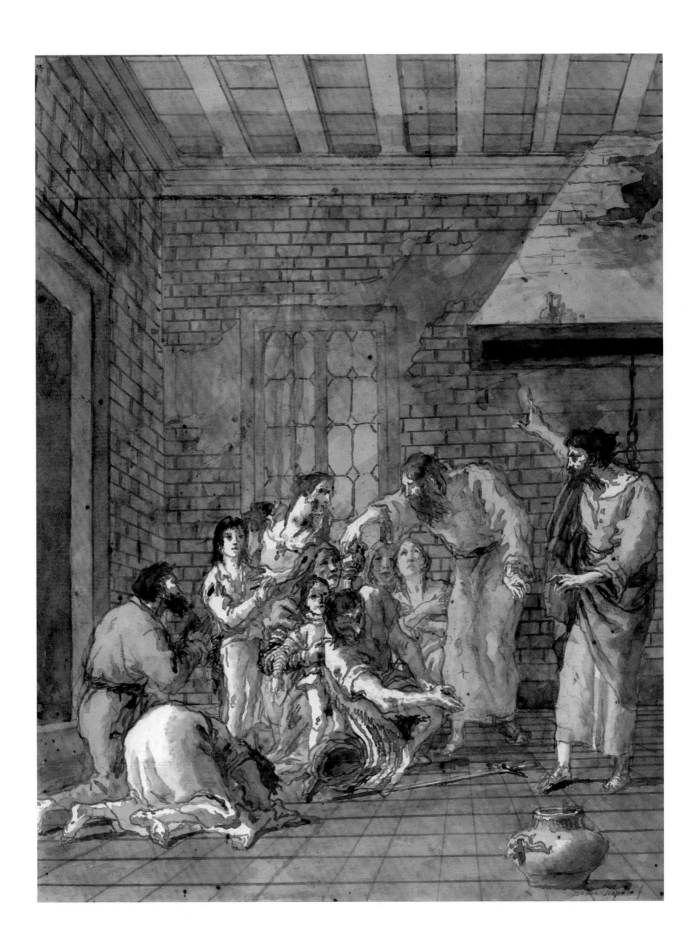

278. Paul and Silas Released from Prison at Philippi

But Paul said unto them, They have beaten us openly uncondemned, being Romans, and cast us into prison; and now do they thrust us out privily; but let them come themselves and fetch us out. And the sergeants told these words unto the magistrates: and they feared, when they heard that they were Romans. And they came and besought them, and brought them out, and desired them to depart from the city. (Acts 16:37–39)

Pen and wash, over black chalk, 465 x 358
Signed low left: Dom.o Tiepolo f
Provenance: Jean Fayet Durand (1806–1889)
Literature: Conrad 1996 [235]

Paris, Musée du Louvre, Département des Arts Graphiques, RF 1713bis [107]

Standing resolutely by the prison door which recedes dramatically into space, Paul declares his indignation at such treatment of a Roman citizen. The keys used to open the prison door lie discarded at the left, together with a hat and striped cloak. Clearly apologetic, one soldier tries to explain that he was only following orders, while behind him his platoon mills restlessly about. Several soldiers are moved by Paul's exhortations and fall to their knees. ❦

Domenico presents this scene as a striking diagonal. Paul addresses a large group of soldiers from an open doorway of which only the right door is open. ❧

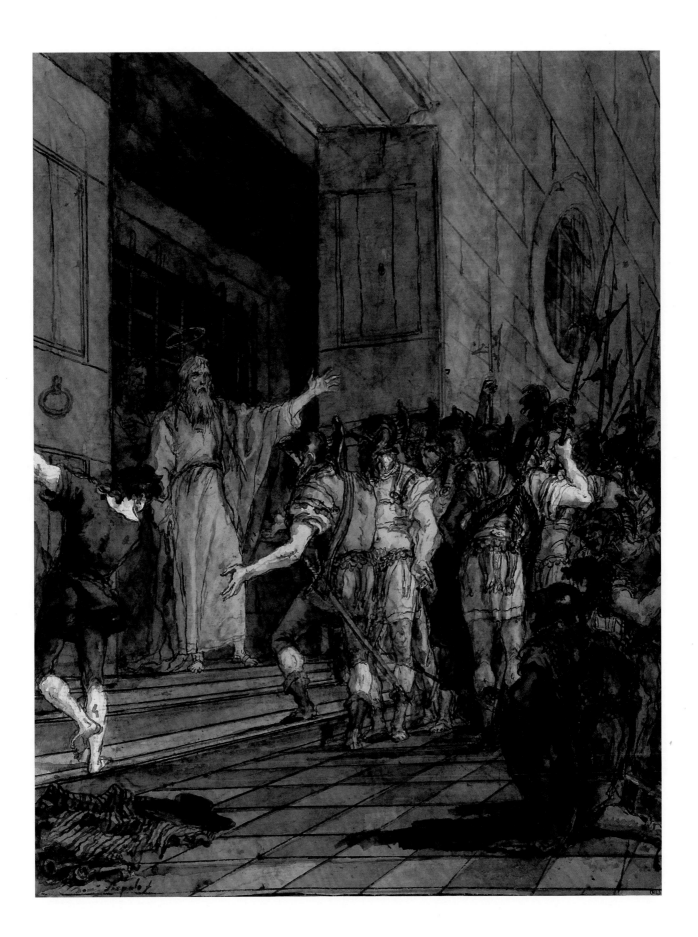

279. *The Magistrates Beseeching Paul and Silas*

And the sergeants told these words unto the magistrates: and they feared, when they heard that they were Romans. And they came and besought them, and brought them out, and desired them to depart from the city. (Acts 16:38–39)

> Pen and wash, over black chalk, 468 x 362
> Not signed
> Provenance: Jean Fayet Durand (1806–1889)
> Literature: Conrad 1996 [237]
> Reference: Fleury 1722, i, XXXVI

Paris, Musée du Louvre, Département des Arts Graphiques, RF 1713bis [101]

Turning our vantage point to front and center, Domenico shows the magistrates pleading with Paul to depart. The soldiers stand back watching negotiations proceed. Pointing to himself and standing with dignified authority, Paul humbles these high civic officers clad in their magnificent robes. Heads bowed, they appear to apologize while to the right a patriarch (the very man who witnessed their imprisonment) looks on. ❦

The entrance of the prison at Philippi is clearly the same as in the preceding drawing (pl. 278), though presented frontally, across the picture plane, rather than diagonally. Both doors now stand open as Paul addresses the magistrates. ⚜

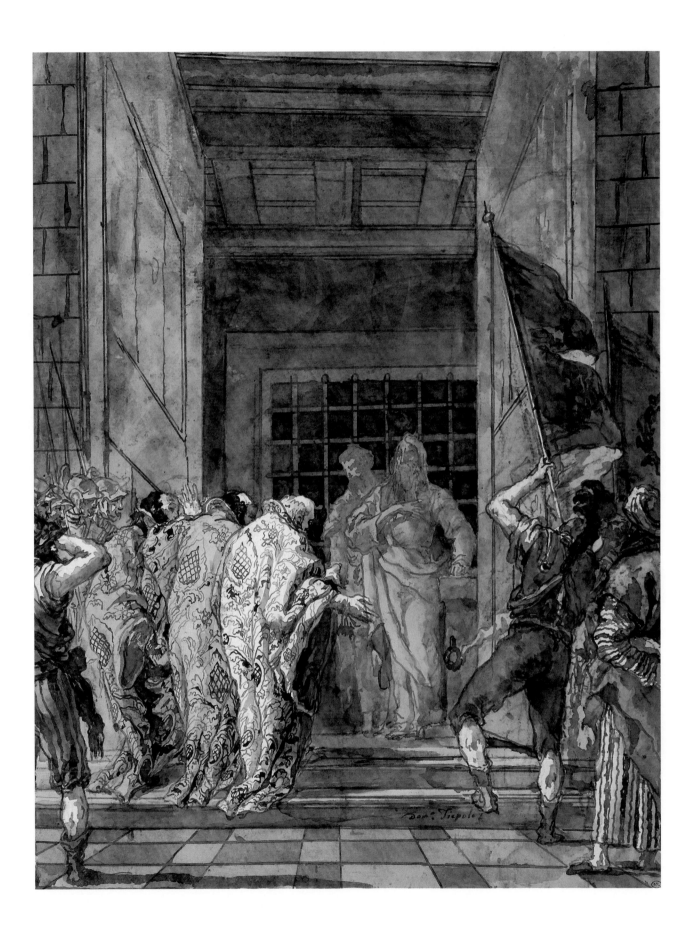

Dom.º Tiepolo

280. *Paul Preaching at Athens*

Because he hath appointed a day, in which he will judge the world in righteousness by that man whom he hath ordained; whereof he hath given assurance unto all men, in that he hath raised him from the dead. And they that heard of the resurrection of the dead, some mocked: and others said, We will hear thee again of this matter.

Then Paul stood in the midst of Mars' hill, and said, Ye men of Athens, I perceive that in all things ye are too superstitious. (Acts 17:13–22)

Pen and wash, over black chalk, 468 x 362
Not signed
Provenance: Jean Fayet Durand (1806–1889)
Literature: Conrad 1996 [237]
Reference: Fleury 1722, i, XXXVI

Paris, Musée du Louvre, Département des Arts Graphiques, RF 1713bis [68]

Having left Phillipi, Paul has journeyed far and wide, landing at Athens where he confronts the philosophers, including Stoics, Epicureans, and Areopagites (whom he ultimately converted). That he has mentioned the resurrection of the dead is suggested by the shocked reaction of the figure in the background. ✺

We agree with Conrad in identifying this scene as *Paul Preaching at Athens,* an event that appears to have taken place in AD 50. It is not clear who Paul's companion may be, but he appears to be Silas. ⚜

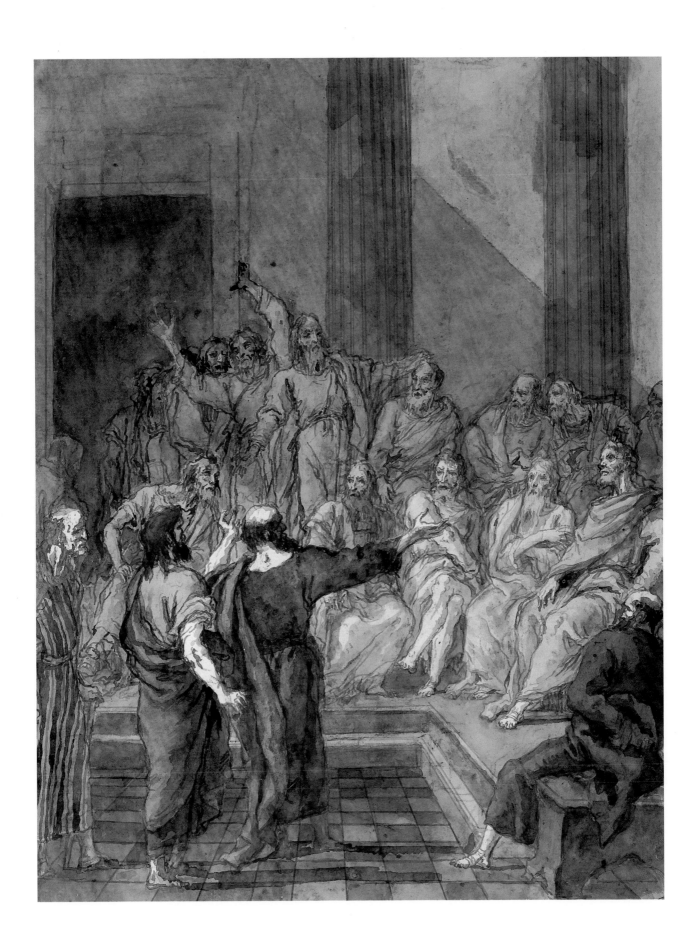

281. *Paul Baptizing Dionysius and Damaris*

Howbeit certain men clave unto them, and believed: among which was Dionysius the Areopagite, and a woman named Damaris, and others with them. (Acts 17:34)

As Dionysius and Paul were exchanging these words, it chanced that a blind man passed before them in the way, and Dionysius straightway said to Paul: "If thou shalt say to this man, 'In the name of my God, receive thy sight,' and he shall see, I shall believe at once. But use no magic words, for perchance thou knowest words which have this power. I shall therefore prescribe a form of words for thee. Say to him, 'In the name of Jesus Christ, born of a virgin, crucified, dead, risen again, and ascended into Heaven, receive thy sight!'" But in order that all suspicion might be averted, Paul commanded Dionysius himself to pronounce these words; and at once the blind man received his sight. Thereupon Dionysius, with Damaris his wife and his whole household, was baptized and made a member of the faith.
(The Golden Legend, under October 9)

> Pen and wash, over black chalk, 468 x 365
> Signed low left: Dom.o Tiepolo f
> Provenance: Jean Fayet Durand (1806–1889)
> Literature: Conrad 1996 [238]
> Reference: Fleury 1722, i, XXXV

Paris, Musée du Louvre, Département des Arts Graphiques, RF 1713bis [71]

Much of Domenico's interpretation comes not from Acts, which barely mentions Dionysius, but from *The Golden Legend,* which gives Dionysius's feast day as October 9 and offers a lengthy account. It describes Paul arriving in Athens and coming to the street of philosophers (who here appear in the background). It mentions Paul witnessing the altar of the Unknown God, whom Dionysius describes to Paul as the "true God," here found at the left of the scene. In their exchange, Dionysius challenges Paul to cure a blind man, whom Paul, in turn, cures through Dionysius himself. This recipient of a miracle appears to be the man raising his hands in grateful prayer at the left, just below the statue. At the center, the whole household is being baptized by Paul, who points heavenward, while a young assistant holds his sword. ❦

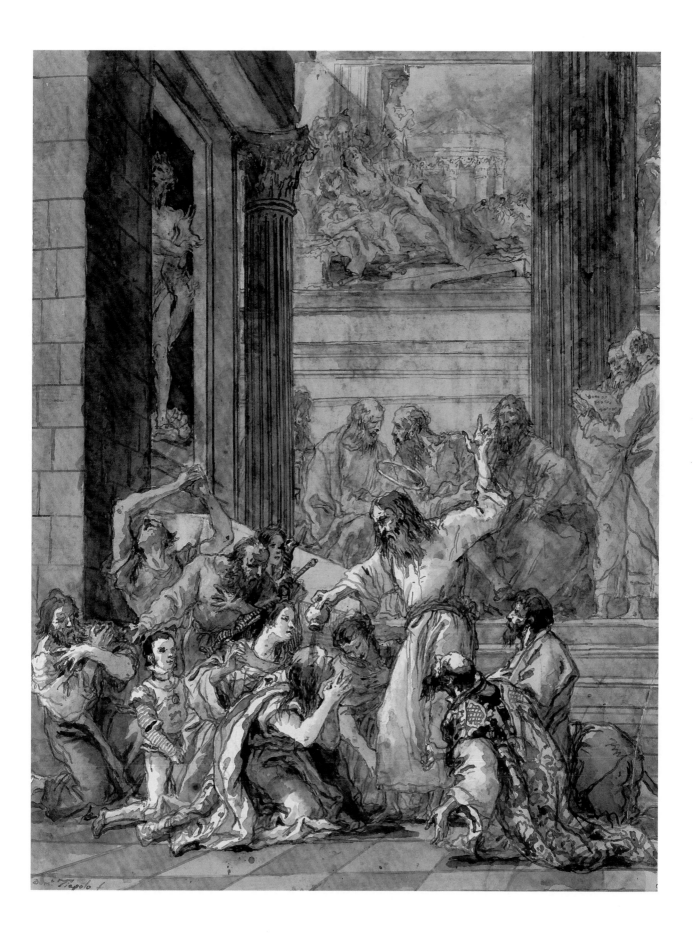

282. *Paul and Aquila as Tentmakers*

After these things Paul departed from Athens, and came to Corinth; and found a certain Jew named Aquila, born in Pontus, lately come from Italy, with his wife Priscilla; (because that Claudius had commanded all Jews to depart from Rome:) and came unto them. And because he was of the same craft, he abode with them, and wrought; for by their occupation they were tentmakers. (Acts 18:1–3)

> Pen and wash, over black chalk, 470 x 361
> Signed low right: Dom.o Tiepolo f
> Initialed on the bale, left: DT
> Provenance: Jean Fayet Durand (1806–1889)
> Literature: Conrad 1996 [239]
> Reference: Fleury 1722, i, XXXVII

Paris, Musée du Louvre, Département des Arts Graphiques, RF 1713bis [67]

Sitting companionably with Aquila, Paul hems the edge of a tent, the top of which, complete with decorated cornice, can be seen at the right. Its gaily striped posts (reminiscent of the striped poles that line Venetian canals) lie in the foreground. Deep in conversation with Aquila, Paul's intimate and informal attitude establishes a homey atmousphere that underscores his friendship with many converts. A bale of cloth awaits their attention at the left. ❦

The date of the expulsion of the Jews from Rome by Claudius is said to be AD 49, and Paul's residence in Corinth is estimated to have lasted eighteen months, from the autumn of AD 50 to the spring of AD 52. ⚜

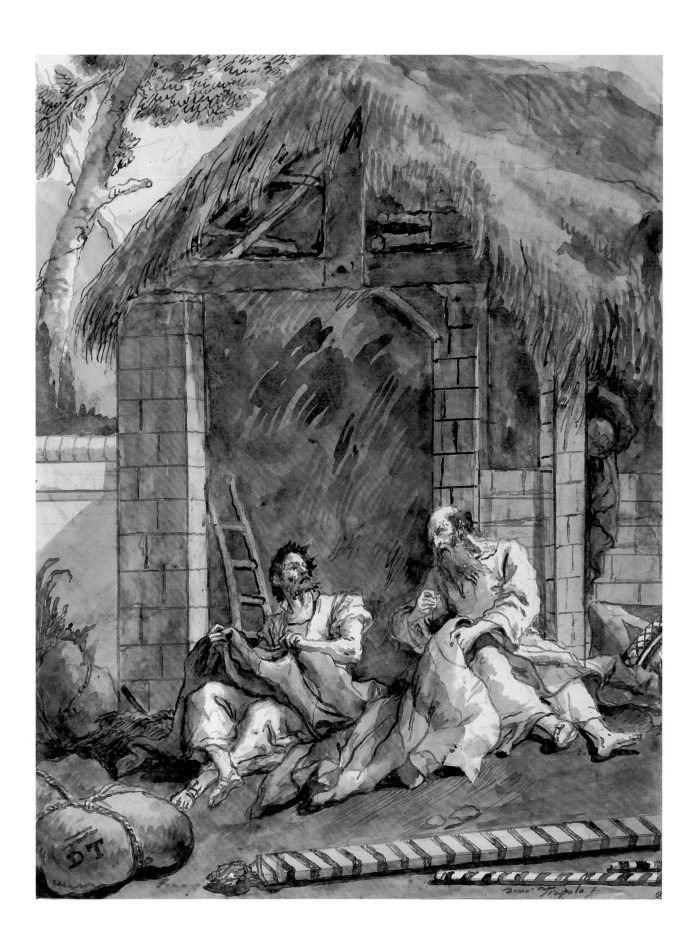

Dom.o Tiepolo f

283. *Paul Baptizing at Ephesus*

Then said Paul, John verily baptized with the baptism of repentance, saying unto the people, that they should believe on him which should come after him, that is, on Jesus Christ. And when they heard this, they were baptized in the name of the Lord Jesus. And when Paul had laid his hands upon them, the Holy Ghost came on them; and they spoke with tongues, and prophesied. (Acts 19:4–6)

Pen and wash, over black chalk, 465 x 360
Signed low left center: Dom.o Tiepolo f
Provenance: Jean Fayet Durand (1806–1889)
Literature: Conrad 1996 [222]
Reference: Fleury 1722, i, XLII

Paris, Musée du Louvre, Département des Arts Graphiques, RF 1713bis [102]

Here Paul, perhaps with Timothy, Paul's most loyal companion, provides the baptism of the Holy Ghost to the inhabitants of coastal Ephesus. Timothy (whose circumcision at Paul's hands Domenico portrayed in pl. 274) became the first Bishop of Ephesus. According to Butler (p. 190) Paul left Timothy in charge of the city in AD 64. The rural setting offers no specific reference to Ephesus, but the number of converts suggests Paul's impact on this early Christian center. The man with clasped hands in the background is most often found in scenes relating to Paul's ministry. ❦

The appearance of the Holy Dove in this scene, with rays coming down to touch the newly baptized and the central figure clearly Paul, serves to establish the subject beyond reasonable doubt. However, the text offers no clue as to the identity of the other saint with a halo, his back turned, on the right. ⚜

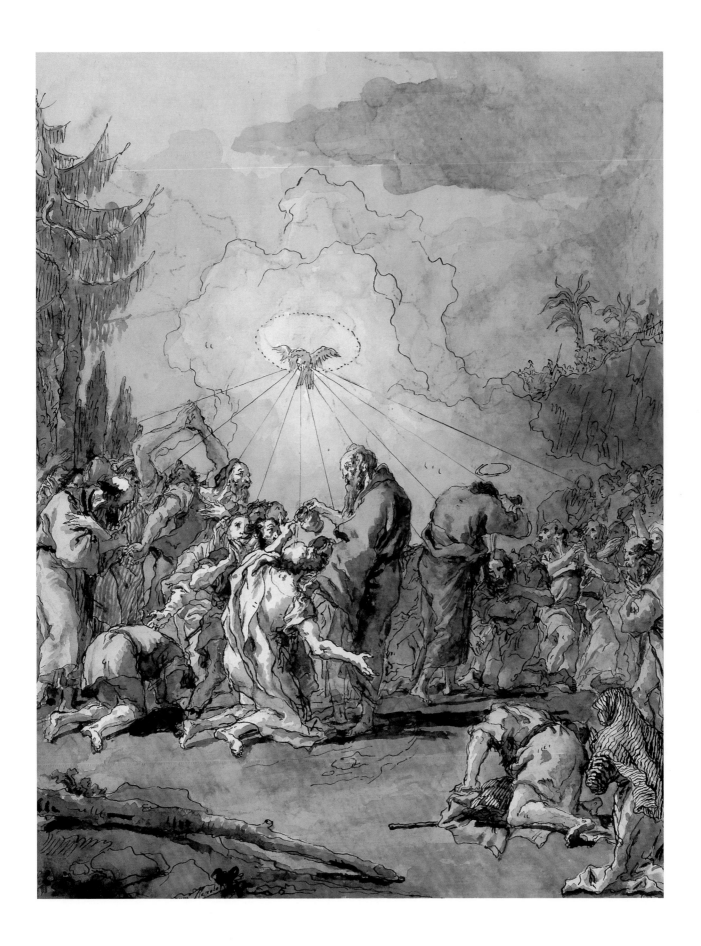

284. *"And God wrought special miracles by the hands of Paul"*

And God wrought special miracles by the hands of Paul: so that from his body were brought unto the sick handkerchiefs, or aprons, and the diseases departed from them, and the evil spirits went out of them. (Acts 19:11–12)

Pen and wash, over heavy black chalk, 460 x 360
Signed low left: Dom.o Tiepolo f
Provenance: Roger Cormier, Tours, his sale, Paris, Georges Petit, Apr. 30, 1921, no. 63; Paris, Hôtel Drouot, Nov. 28, 1962 [43]
Literature: Guerlain 1921 [p. 119]; Conrad 1996 [223], as Acts 14:3

Paris, private collection

Carrying his sword in the center, Paul gives instructions to the man struggling to restrain a man possessed with demons, which he prepares to cast out. To the right, another saint, perhaps Timothy, who traveled with Paul, also casts out demons as a boy writhes in agony on the ground. A single older patriarch looks on from the right. ❦

This is a turbulent scene with demons fleeing and demoniacs still in convulsions, hardly suggested by the text, which implies exorcism at a distance through the undramatic medium of "handkerchiefs and aprons." This passage is followed by the episode of "the vagabond Jews," who attempted to work miracles without success, so that "the evil spirit was leaped on them and overcame them" (Acts 19:13–16). This is represented in the following drawing, *The Vagabond Jews* (pl. 285). The identity of the second saint with a halo, on the left, is not clear. ⚜

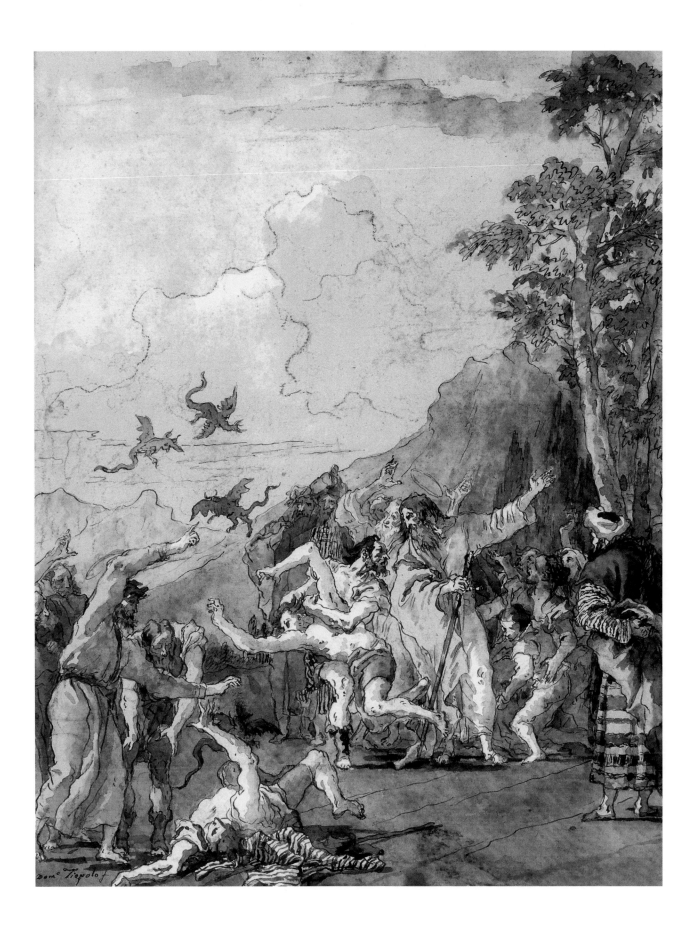

285. *A Young Woman Cured: The Vagabond Jews*

And it came to pass, as we went to prayer, a certain damsel possessed with a spirit of divination met us, which brought her masters much gain by soothsaying. . . . And this she did many days. But Paul, being grieved, turned and said to the spirit, I command thee in the name of Jesus Christ to come out of her. And he came out the same hour. (Acts 16:16–18)

The certain of the vagabond Jews, exorcists, took upon them to call over them that had evil spirits the name of the Lord Jesus, saying, We adjure thee by Jesus whom Paul preacheth. And there were seven sons of one Sceva, a Jew, and chief of the priests, which did so. And the evil spirit answered and said, Jesus I know, and Paul I know; but who are ye? And the man in whom the evil spirit was leaped upon them, and prevailed against them, so that they fled out of that house naked and wounded. (Acts 19:13–16)

Pen and wash, over black chalk, 460 x 360
Signed low right: Dom.o Tiepolo f
Provenance: Roger Cormier, Tours, his sale, Paris, Georges Petit, Apr. 30, 1921 [35]
Literature: Guerlain 1921+, 227; Conrad 1996 [279]; photo, Byam Shaw archives, Fondation Custodia, Paris

Milan, Antonio Morassi (formerly)

In a scene of genuine mayhem, Paul is nearly obscured by the frantic group. He stands near the struggling woman as Sceva delivers some exhortation. Meanwhile, Sceva's sons rush toward them to escape the demons that attack them with clubs. One son has clearly abandoned his shirt, which lies discarded in the foreground. ✹

This drawing may represent a conflation of two rather similar stories described in Acts 16:16–18 and 19:13–16. The damsel seems to relate to the first story, which led to the imprisonment of Paul and Silas at Philippi. The rest is close to the text of the second story, which took place at Ephesus. The rather overdressed man in the center, here identified as the leader of the vagabond Jews, with perhaps six companions, is clearly being attacked vigorously by the evil spirit. ⚜

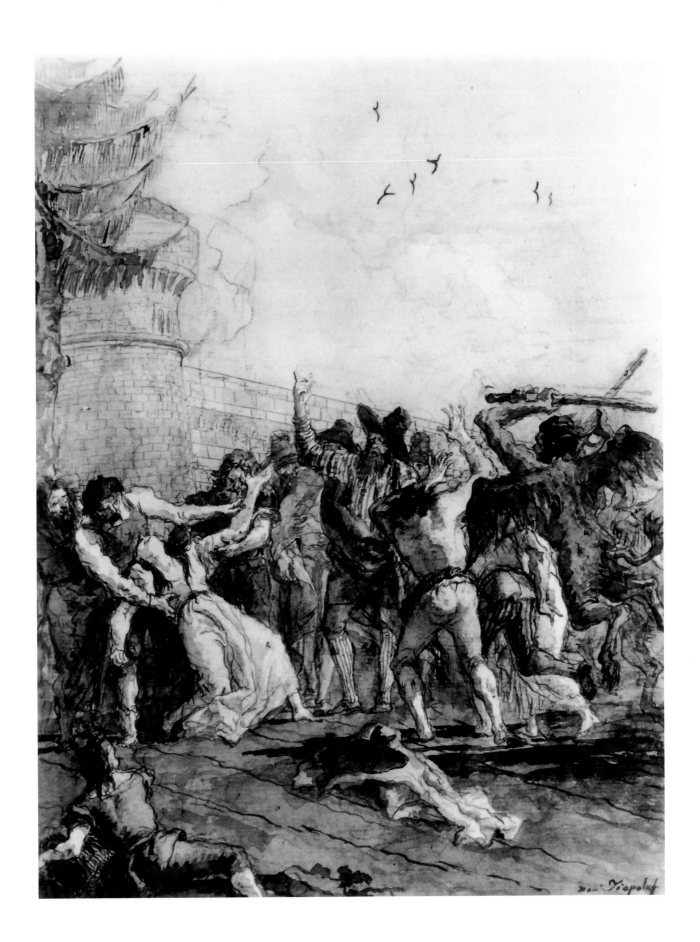

286. *Paul Working Miracles*

And God wrought special miracles by the hand of Paul. (Acts 19:11)

Pen and wash, over black chalk, 465 x 358
Signed on the column: Dom.o Tiepolo f
Provenance: Jean Fayet Durand (1806–1889)
Literature: Conrad 1996 [226]

Paris, Musée du Louvre, Département des Arts Graphiques, RF 1713bis [111]

Less the illustration of a single text than a summary of Paul's impact on the pagan world, this scene shows Paul delivering a fiery sermon at the base of a pagan temple, possibly dedicated to Diana of Ephesus, which may be the goddess above Paul's head. Behind her is another statue of a nude goddess, perhaps Venus. As a massive crowd observes from the porch, Paul heals the sick and infirm gathered in the square. Some already clasp their hands upward in prayerful thanks, while others arrive to receive Paul's blessing. Domenico clearly refers to the general story of Paul's disenfranchisement of the idol makers, who lose business because of his conversions, which is the theme of Acts 19. 🌿

Although this is one of Domenico's most elaborate designs, it is not easy to find a completely satisfactory text for it, and although the subject is obscure, the statue of a goddess, which is here turned frontally, suggests Diana of Ephesus (Acts 19:24–28). A second saint stands behind Paul's left shoulder; the text does not make his identity clear, but he appears to be Timothy. ♣

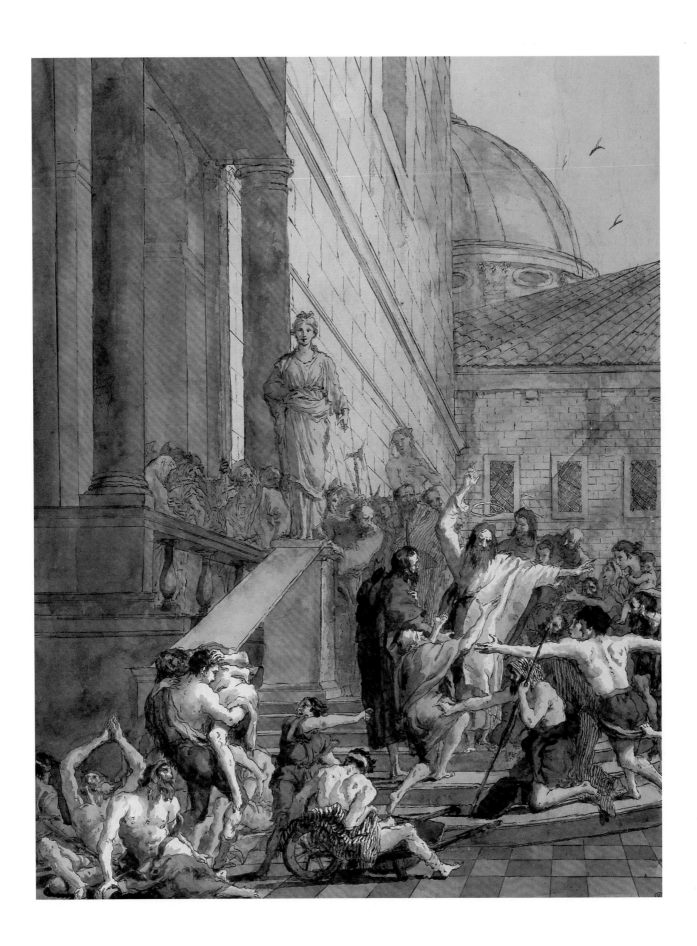

287. *Burning the Books of Magic Arts at Ephesus*

Many of them also which used curious arts brought their books together, and burned them before all men: and they counted the price of them, and found it fifty thousand pieces of silver. (Acts 19:19)

Pen and wash over extensive black chalk, 463 x 360
Not signed
Provenance: Jean Fayet Durand (1806–1889)
Literature: Conrad 1996 [240]
Reference: Fleury 1722, i, XLII

Paris, Musée du Louvre, Département des Arts Graphiques, RF 1713bis [104]

As several elders look on, Ephesians cast their magical books into a huge bonfire blazing in the center of an ancient building. Flames consume one manuscript as another falls into the fire, in yet another dramatic episode involving Paul's ministry. This is one of several dramatic moments through which Domenico gives Paul's chapter a sense of split-second timing. 🌿

Paul's residence at Ephesus is estimated to have covered the years AD 52–55. This drawing, with heavy underdrawing, is held to be late. It appears to have inspired Gustave Doré's woodcut of this subject in *La Sainte Bible selon la Vulgate* (Tours 1866, i [opp. col. 724]). The architectural setting is similar to the Philadelphia *Pool of Bethesda* (Mariuz 1971 [165]). ⚜

288.** *"Saint Paul poursuivis et lapidé par la foule et les vendeurs d'idoles"*

Acts 19:23–41

Pen and wash, 460 x 360
Signed low left
Provenance: Roger Cormier, Tours, his sale, Paris, Georges Petit, Apr. 30, 1921, no. 57

No image.

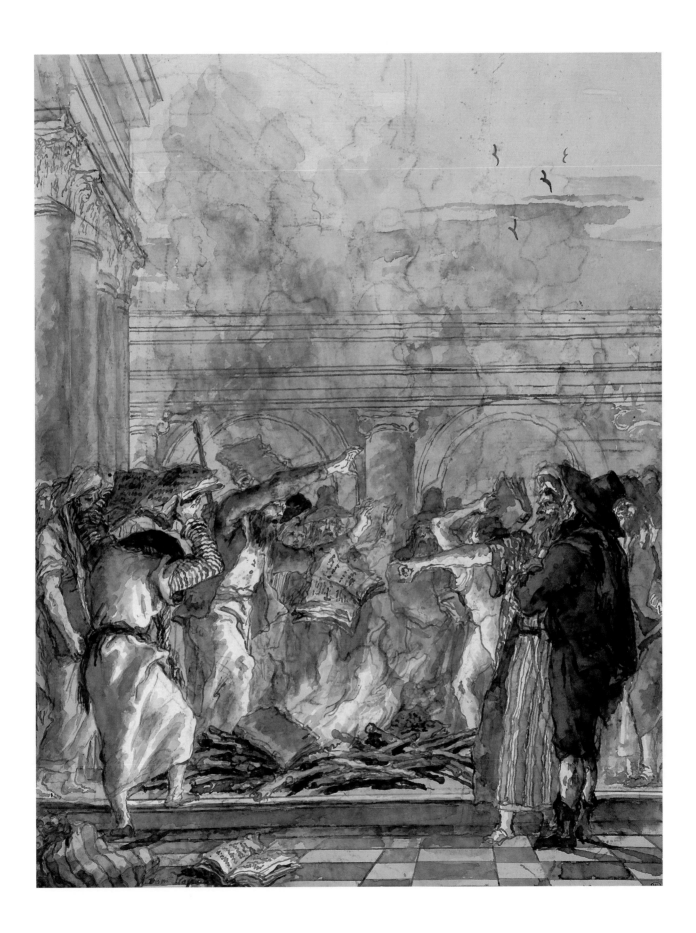

289. *The Fall of Eutychus*

And there sat in the window a certain young man named Eutychus, being fallen into a deep sleep: and as Paul was long preaching, he sunk down with sleep, and fell down from the third loft, and was taken up dead. (Acts 20:9)

Pen and wash, over black chalk, 470 x 360
Not signed
Provenance: Roger Cormier, Tours, his sale, Paris, Georges Petit, Apr. 30, 1921, no. 74
Literature: Guerlain 1921, 121; Conrad 1996 [241]
Reference: Fleury 1722, i, LII

Having left Ephesus, Paul had an interlude at Troas marked by a sermon that lasted twelve hours. Here Eutychus (making an odd parallel with Peter's story that featured Simon Magus falling for very different reasons) falls from the window, after having drifted off to sleep. The shocked bystanders respond with horror; one man (perhaps his father) flails his arms helplessly as he witnesses his son's plunge to his death. In creating his setting, Domenico considered Acts 20:7–8, which notes that Christians had gathered in the upper chamber of a private house to break bread. This early Christian "house church" parallels Domenico's staging for Peter and Rhoda in plate 250, using buildings with a strong Venetian character. ❧

The story of the fall of Eutychus, which occurred at Troas in AD 57, is told in three drawings. Here we see his fall from the window. The following scene (pl. 290) shows him lying on the ground, and the third (pl. 291) shows him restored to life by St. Paul. In each case the setting is the same, with the window from which he fell shown in the top left corner. ❧

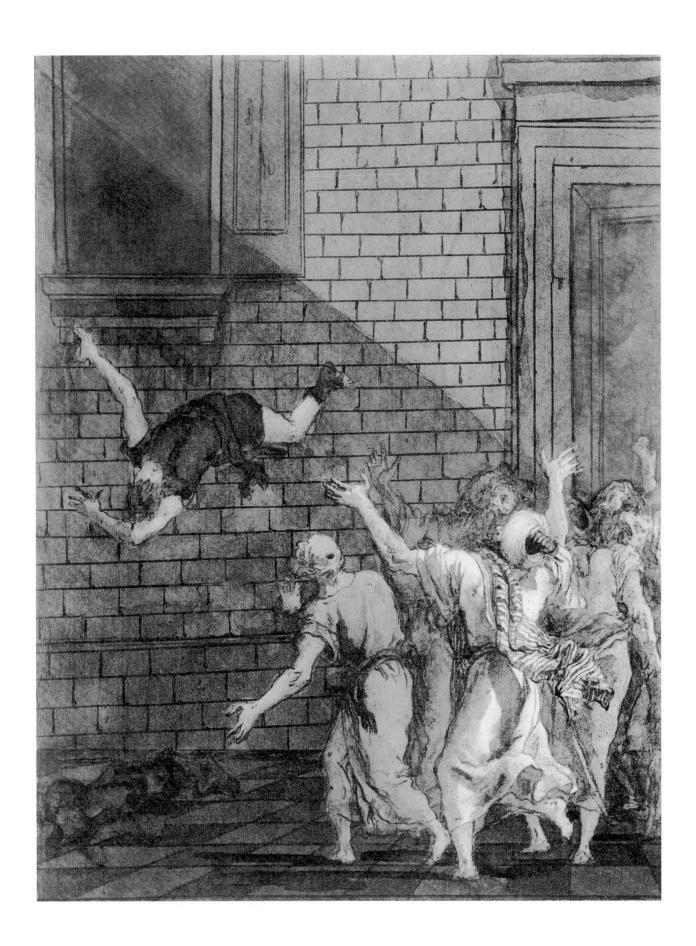

290. *Paul Stands Before the Body of Eutychus*

And Paul went down, and fell on him, and embracing him said, Trouble not yourselves; for his life is in him.
(Acts 20:10)

Pen and wash, over extensive black chalk, 487 x 380
Signed low left: Dom.o Tiepolo f
Marked top left in pencil: 72
Provenance: Roger Cormier, Tours, his sale, Paris, Georges Petit, Apr. 30, 1921, no. 75; Prince Wladimir Nikolaevitch
Argoutinsky-Dolgoroukoff, Lugt 2602d, his sale, Sotheby's, Jul. 4, 1923 [20], bt. Overend; Duc de Trévise, his sale, Hôtel
Drouot, Dec. 8, 1947 [48]
Exhibition: Udine 1996 [108]
Literature: Guerlain 1921, 122; *Revue du Louvre* 1995/2 [25]; Conrad 1996 [242]

Paris, Musée du Louvre, RF 44310

Having moved to the other side, the crowd mourns Eutychus, who lies dead on the ground, looking much larger and more heroic than he did falling from the window. A young man with arms raised seems to reenact the fall as he gazes down at Eutychus. Paul, holding his sword, considers the situation from the right. Crossing herself piously, a young woman has joined the crowd, reminding us that Paul's flock included many female converts, among them Damaris, Priscilla, and Phoebe.

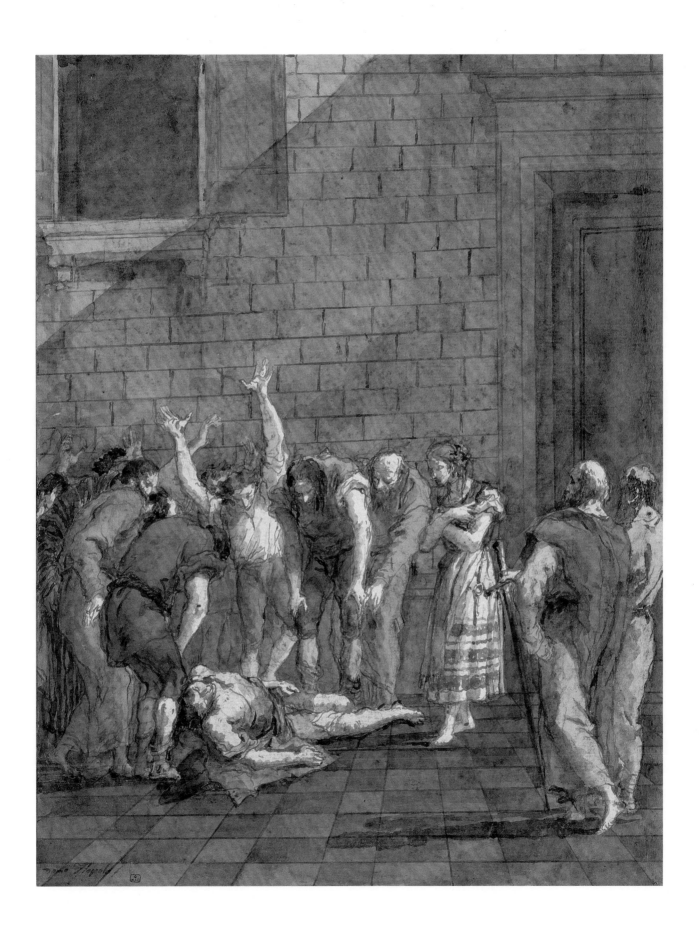

291. *Eutychus Restored to Life*

And there sat in a window a certain young man named Eutychus, being fallen in a deep sleep: and as Paul was long preaching, he sunk down with sleep, and fell down from the third loft, and was taken up dead. And Paul went down and fell on him, and embracing him said, Trouble not yourselves; for his life is in him. . . . And they brought the young man alive, and were not a little comforted. (Acts 20:8–12)

Pen and wash, over black chalk, 466 x 363
Signed low right: Dom.o Tiepolo f
Provenance: Jean Fayet Durand (1806–1889)
Literature: Conrad 1996 [243]

Paris, Musée du Louvre, Département des Arts Graphiques, RF 1713bis [124]

A much more boyish Eutychus now stands resurrected as his father, one arm protectively around him, appears to instruct the young man to thank his benefactor, and behind them all the crowd registers its amazement. An overawed elder raises his hands to rejoice at the left, while Paul's companions observe the proceedings more calmly at the right. ❦

Domenico tells the story of Eutychus, an event that took place in AD 57, in three drawings, the two earlier phases treated in plates 289–290. Here the young man stands before Paul, fully restored, surrounded by his rejoicing friends. ❧

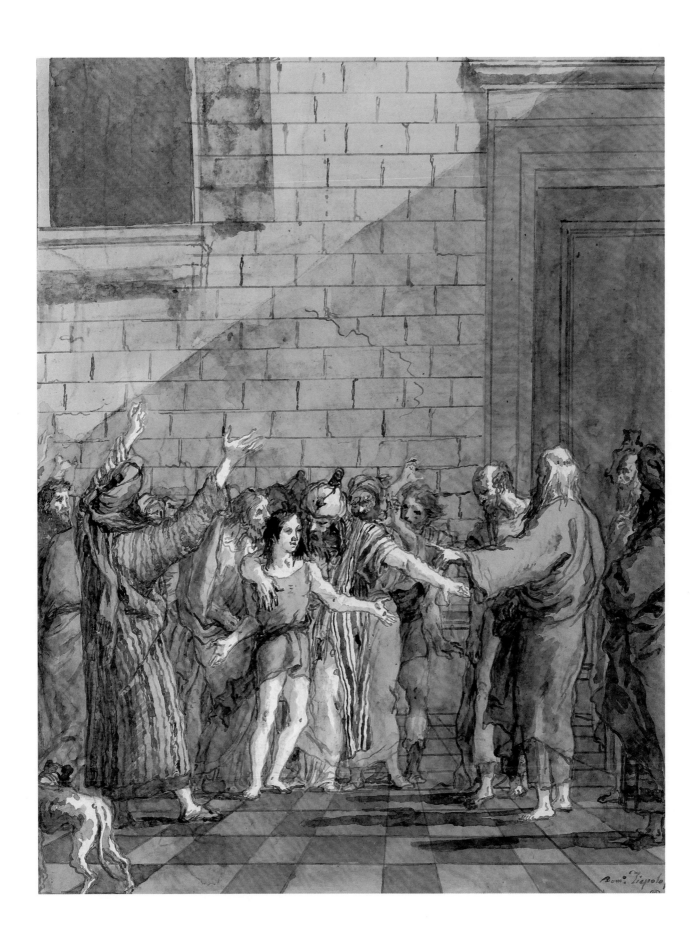

Dom. Tiepolo

292. *Paul Embarks at Ephesus*

And when he had thus spoken, he kneeled down, and prayed with them all. And they all wept sore, and fell on Paul's neck, and kissed him, sorrowing most of all for the words which he spake, that they should see his face no more. And they accompanied him unto the ship. (Acts 20:36–38)

Pen and wash, over extensive black chalk, 476 x 380
Signed low left: Dom.o Tiepolo f
Provenance: Roger Cormier, Tours, his sale, Paris, Georges Petit, Apr. 30, 1921 [21]; Paris, Hôtel Drouot, May 30, 1968 [55]; John Gaines; Paris, Hôtel Drouot, June 17, 1969 [Planche IX]; Sotheby's, Dec. 11, 1974 [44], withdrawn; Christie's, July 6, 1993 [93A]; Kate de Rothschild
Exhibition: London, Kate de Rothschild 1993 [31]
Literature: Guerlain 1921, 123; Conrad 1996 [244]

New York, private collection

Using a rarely illustrated episode in Acts, Domenico imagines Paul's departure from Ephesus. Disciples sadly embrace the departing St. Paul as he prepares to embark on his journey. Eutychus and his father may have followed him and could be the pair standing near the boat, while Paul and his companions are gathered to the left. The bustle of travel animates the background as Paul's sword and a packet are delivered to the ship. Its flag blowing smartly in the breeze, the galleon is tossing in the choppy water, hinting at the stormy weather Paul's ship would soon endure. ❦

In terms of the narrative, this marks the end of Paul's teaching in the Eastern Mediterranean. Domenico completely ignores the seven chapters Acts 21 to 26, one quarter of the entire book, which describe Paul's last visit to Jerusalem, his attack by the local population and rescue by the military, and his stand before Felix and later before Festus, together with Herod and Bernice. As a Roman citizen he appeals unto Caesar and is sent to Rome. Perhaps Domenico did not wish to emphasize this link between Paul and Judaea, and carries his narrative immediately forward to the voyage to Rome and the shipwreck at Malta (pls. 293–295), which feature the same ship (Acts 27 and 28). Paul left Ephesus on his way to Jerusalem in AD 57. ⚜

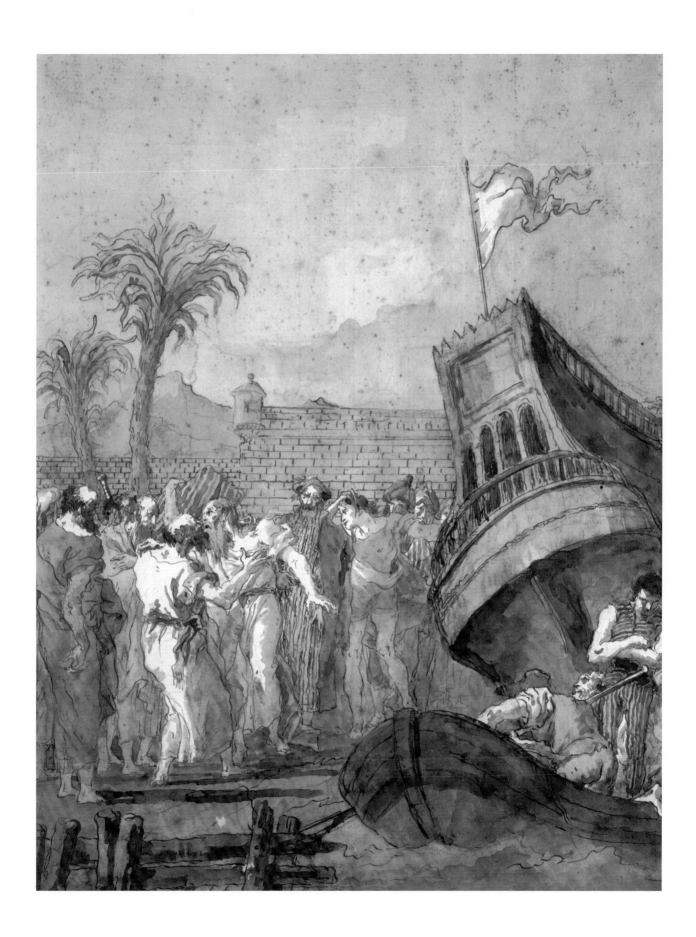

293. *Paul and the Storm at Sea*

But not long after there arose against it a tempestuous wind called Euroclydon, and when the ship was caught, and could not bear up into the wind, we let her drive. (Acts 27:14–15)

Pen and wash, over black chalk, 469 x 360
Not signed
Provenance: Jean Fayet Durand (1806–1889)
Literature: Conrad 1996 [246]
Reference: Fleury 1722, i, LIV

Paris, Musée du Louvre, Département des Arts Graphiques, RF 1713bis [125]

Its sail tearing loose as a giant wave hits its flank, Paul's ship rides out the fierce storm as he (a tiny speck, dwarfed by the boat and the tossing sea) and one companion are visible on the deck. Their presence reminds us that Paul will receive a vision from an angel of God who tells him he will arrive in Rome and that no one will be lost in the storm—a message Paul passes on to the centurion whose prisoner he was. ❧

For this event, which occurred in October–November AD 49, Domenico borrows from a well-established Venetian tradition of storms at sea. One may refer to an example by Giuseppe Zais in the Correr Museum (Pignatti 1960 [393]). The scene follows *Paul Embarks at Ephesus* (pl. 292). It is considered here to be late. ✿

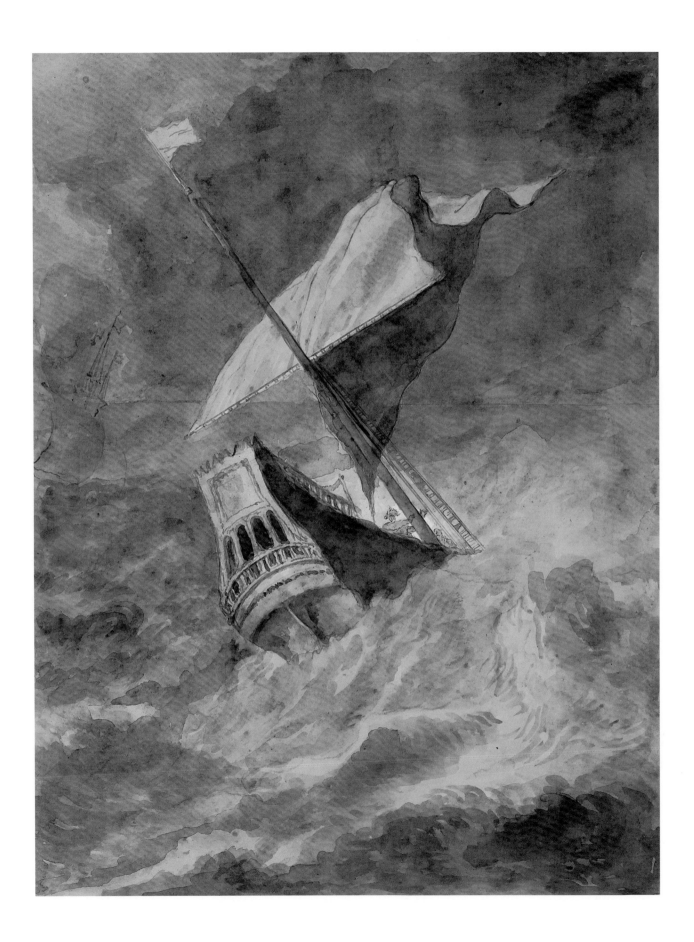

294. *Paul at Malta, with the Serpent*

And when they were escaped, then they knew that the island was called Melita. And the barbarous people shewed us no little kindness: for they kindled a fire, and received us every one, because of the present rain, because of the cold. And when Paul had gathered a bundle of sticks, and laid them on the fire, there came a viper out of the heat, and fastened on his hand. And when the barbarians saw the venomous beast hang on his hand, they said among themselves, No doubt this man is a murderer, whom, though he hath escaped the sea, yet vengeance suffereth not to live. And he shook off the beast into the fire, and felt no harm. (Acts 28:1–5)

Pen and wash, over black chalk, 465 x 360
Signed on the ship: Dom.o Tiepolo f
Provenance: Jean Fayet Durand (1806–1889)
Literature: Conrad 1996 [247]
Reference: Pigler 1956, i, 392–394; Réau 1959, ii/iii, 1047, cites Bernard Picart, *Gravures de la Bible,* 1720

Paris, Musée du Louvre, Département des Arts Graphiques, RF 1713bis [73]

Shipwrecked at Malta, the galleon, though not visibly harmed, is beached on the shore. Her passengers disembark via the smaller boat. Paul, already on shore, is grappling with the viper, which he prepares to cast into the fire. A huge crowd witnesses his struggles with the serpent, and even the boat's passengers point to it. ✺

This is perhaps the most memorable of the acts of Paul. It may be noted that here and in the following drawing (pl. 295) Domenico implies that the ship survived the storm, unlike the narrative in Acts. We are rather surprised to see Andrew, still holding his cap, as in plate 111, standing in the boat under the ship's stern. He is perhaps now no more than a distinctive stock figure. ⚜

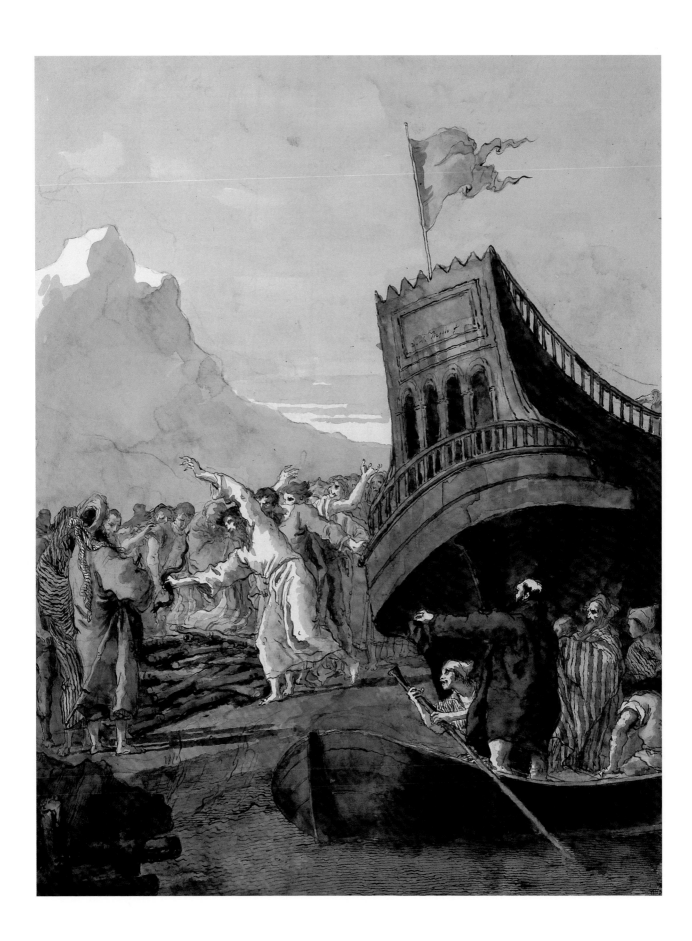

295. *Paul Heals the Sick at Malta*

And it came to pass, that the father of Publius lay sick of a fever and of a bloody flux: to whom Paul entered in and prayed, and laid his hands on him, and healed him. So when this was done, others also that had diseases on the island, came, and were healed. (Acts 28:8–9)

Pen and wash, over black chalk, 464 x 361
Signed low right center: Dom.o Tiepolo
Provenance: Jean Fayet Durand (1806–1889)
Literature: Conrad 1996 [248]

Paris, Musée du Louvre, Département des Arts Graphiques, RF 1713bis [72]

Alluding to the passage of time by placing Paul on the other side of the galleon, Domenico shows him engaged in a final act of healing. A huge multitude of Maltese supplicants crowd round him, including the by now familiar prayerful recipient thanking heaven for his cure. The obligatory patriarch points to the miracles from the boat that is pulling up to shore. ❦

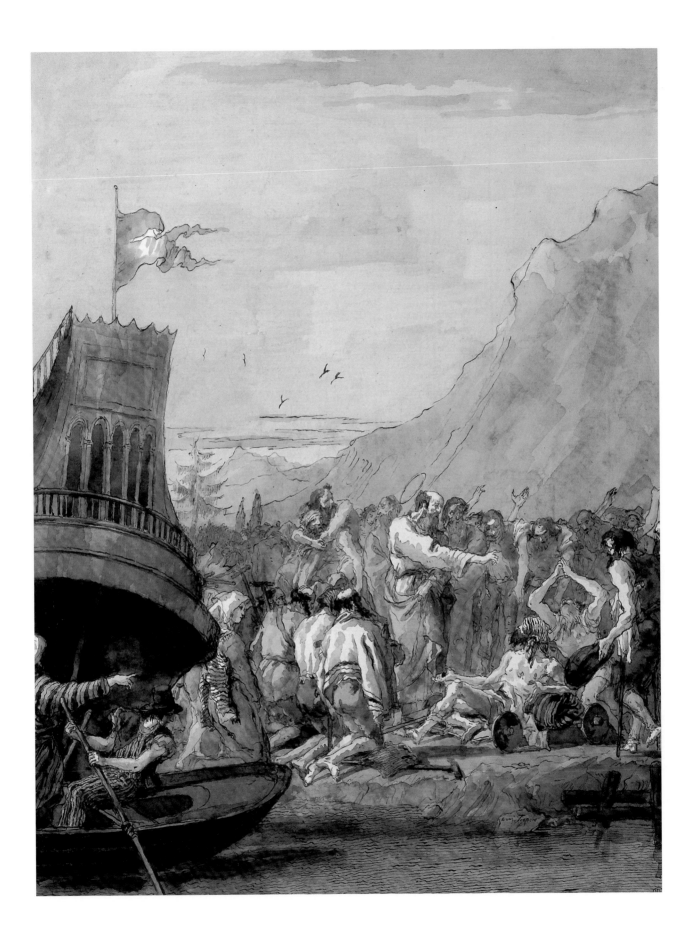

296. *The Parting of Peter and Paul*

Then said S. Paul to S. Peter; Peace be with thee that art foundement of the church and pastor of the sheep and lambs of our Lord. Peter then said to Paul: Go thou in peace, preacher of good manners, mediator, leader, and solace of good people. (The Golden Legend, IV, 22)

Pen and wash over heavy black chalk, 462 x 361, image: 479 x 370, paper, slightly trimmed
Signed low right: Dom.o Tiepolo f
Provenance: Jean-François Gigoux, his sale, Féral, Paris, Mar. 20, 1882, lot 174; Christie's, Dec. 9, 1986 [64]; Kate Ganz; Ian Woodner; Woodner collection, New York
Exhibition: London, Kate Ganz 1987 [34]; New York 1990 [44]; Washington 1995 [94]; Udine 1996 [110]
Literature: *Gazette des Beaux-Arts,* March 1994 [252]; Conrad 1996 [256]
Reference: *The Golden Legend,* 1900, iv, 22; Lippomano 1581, iii, 271; Baronius, i, anno 69, cap. X; Pigler 1956, i, 394–396; Réau 1959, iii/iii, 1096, cites Palermo

Washington, D.C., National Gallery of Art, The Woodner Family Collections, 1993.51.5

Bypassing Paul's further travels and his actions in Rome, Domenico turns to a momentous scene of farewell between the two leading Apostles on the day of their execution. Paul tenderly embraces Peter as they whisper their final words of parting. According to some legends, they were executed on the same day. Peter was condemned to crucifixion, while Paul, a Roman citizen, received the more humane death of beheading by sword. A noisy and massive Roman army reminds us of the large troup that attended Paul's conversion (pl. 267). The scaffolding upon which Paul will be beheaded looms in the background. The swordsman stands upon it at the ready. ❦

Tradition holds that Peter and Paul were martyred in Rome on June 29 and 30, AD 64 or perhaps 65, as shown in the following drawing. Their parting is told in *The Golden Legend* under St. Peter, June 29, immediately after the episode *Quo Vadis.* Domenico seems to have based his conception on that text: "When the order of their separation came, Paul said to Peter: 'Peace be with thee, cornerstone of the Church, shepherd of the lambs of Christ,' and Peter said to Paul: 'Go in peace, preacher of truth and good, mediator of salvation to the just!'" See also Cardinal Cesare Baronius, *Ann. Eccl. I,* anno 69, cap. X. The use of *The Golden Legend* of Jacopo de Voragine at this time is interesting, for the work, though published frequently in the late fifteenth and early sixteenth centuries, then fell out of fashion until the early nineteenth century. No Italian edition appeared between 1613 and 1849. ♣

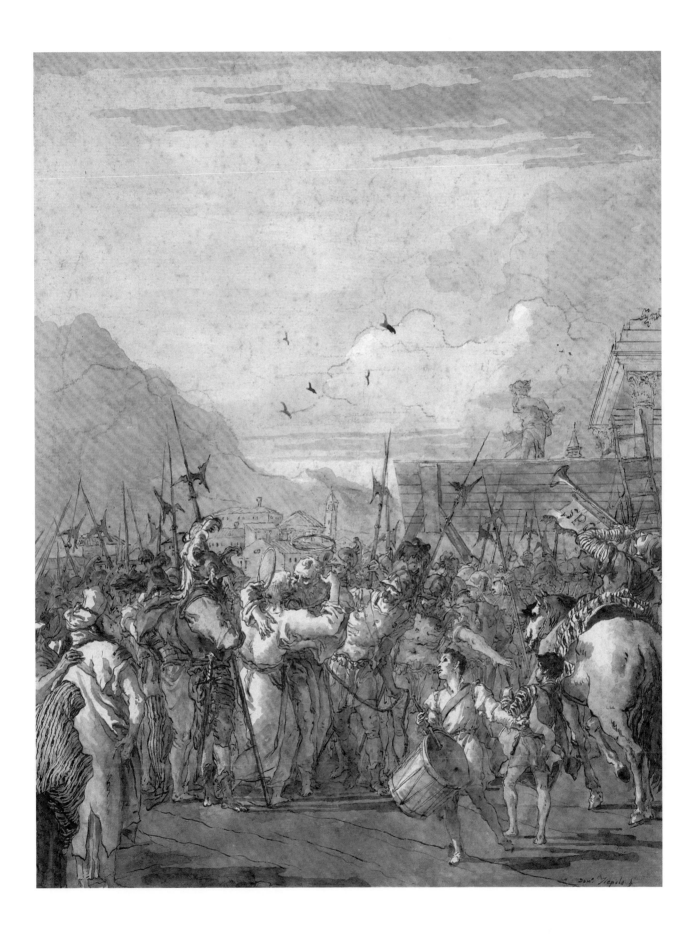

297. *The Beheading of Paul*

Dionysius, in an epistle to Timothy, saith of the death of Paul thus: in that hour full of heaviness, my well beloved brother, the butcher, saying: Paul, make ready thy neck; then blessed Paul looked up into heaven marking his forehead and his breast with the sign of the cross, and then said anon: My Lord Jesu Christ, into thy hands I commend my spirit, etc. And then without heaviness or compulsion he stretched forth his neck and received the crown of martyrdom, the butcher so smiting off his head. (The Golden Legend, IV, 34)

Pen and wash, over black chalk, 460 x 360
Signed?: Dom.o Tiepolo f
Provenance: Roger Cormier, Tours, his sale, Paris, Georges Petit, Apr. 30, 1921, no. 16
Literature: Le Père Giry; Guerlain 1921, 129; Conrad 1996 [258]
Reference: Ribadeneira 1656, i, 448, June 30; Fleury 1722, ii, XXV; *The Golden Legend* 1900, under June 29

Paul's beheading is not portrayed, only its aftermath is shown. Thus, Domenico distinguishes Paul's chapter from Peter's (whose crucifixion upside down is dramatically portrayed). Domenico elects a more prosaic and unusual moment, concentrating on the practical matter of removing Paul's body after his beheading. As Paul's body is lowered from the scaffold, the executioner displays his severed head to the populace. This group, composed primarily of elders and women, appears largely unmoved, save for the youth in the foreground, who spreads his arms as if to catch the body and place it in the bier, which is partially visible in the foreground. Further distinguished from Peter's death by the absence of angels delivering martyr's crowns or palms, Paul's demise promises a funeral procession that is also modest, featuring just a few candle bearers in contrast to the vast number of tapers carried by Peter's extensive flock. 🦋

Domenico often favors the device of the large high wooden scaffold, as in the preceding drawing (pl. 296), which has been traced back to the Lodovico Carracci *Martyrdom of St. Margaret* in San Maurizio at Mantua (Venice 1992 [67]). ⚜

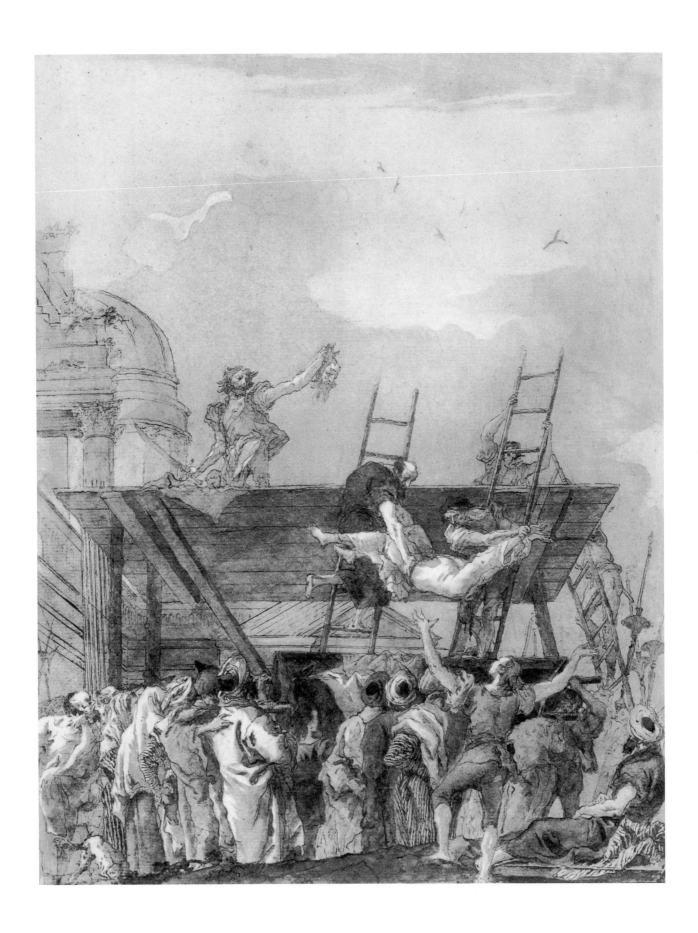

Part XVII

Epilogue, Plates 298–313

The New Testament "ends" with the mystical Book of Revelation, culminating in the image of the Second Coming and the Final Judgment, a subject that has captured the popular imagination and resulted in countless masterpieces featuring fiery furnaces, monstrous beasts, and the prospect of ceaseless torture for the damned. Understandably, this vision has been more easily translated into pictorial language than the ethereal world of eternal bliss that makes up heaven.

Domenico, the product of the enlightenment, does not conclude his story with this traditional image, electing instead to create more original, perhaps personal, and certainly more historical and ecclesiastical ending. He has added two striking images that examine the devotional meaning of Christ's death on the cross. One features angels alone worshipping Jesus, the other is a most striking visual exegesis on the Mass itself, again starring angels as the worshippers.

Angels adoring Jesus, detail of plate 299, *The Exaltation of the Sacrament*

Jerome Emiliani praying beside the Virgin, detail of plate 313,
The Virgin and Child with St. Jerome Emiliani

Domenico then added two scenes centered on worship at an altar, one of which may portray the Mass of Bolsena of 1263. Two drawings involve mystical experiences of St. Anthony of Padua (d. 1231), five drawings appear as a fragmentary reference to an event that took place during the Sack of Rome of 1527, another scene clearly involves an audience before the sixteenth-century Pope Paul IV, yet another depicts the vision of St. Philip Neri (died 1595, founder of the Oratorians), while a final, wonderful drawing depicts the vision of a saint closer to Domenico's own heart, namely Jerome Emiliani, who was beatified in 1747.

298. *Jesus Crucified with Angels*

And Bartholomew said: Lord, when thou wentest to be hanged upon the cross, I followed thee afar off and saw thee hung upon the cross, and the angels coming down from heaven and worshipping thee. (Gospel of Bartholomew 6)

Pen and wash, over slight black chalk, 468 x 363, trimmed close to the image
Signed low right: Dom.o Tiepolo f
Provenance: Jean-François Gigoux (1806–1894), his bequest, 1894
Literature: Conrad 1996 [284]
Reference: Jameson 1890, ii, 172–178; James 1924, 167

Besançon, Musée des Beaux-Arts et d'Archéologie, 2235

Having omitted attending angels in his narrative scenes of Christ's crucifixion, Domenico here shows them alone worshipping him on his cross in his epilogue. Highly unusual for bypassing their traditional action involving the catching of Christ's blood (which legend has it is a relic in Mantua), Domenico focuses instead on the angels' veneration of Christ and his cross, and thus comes close to Bartholomew's text. Fittingly enough, the uppermost angel echoes (but does not repeat exactly) the angel who flew down to interrupt Abraham's sacrifice in the inaugural scene of this epic (pl. 1). ❦

Domenico now adds to the main body of *A New Testament* a series of some seventeen devotional subjects that form a sort of epilogue to the whole. Some deal with themes that are familiar in the Veneto; some present subjects that remain quite obscure.

Anna Jameson, or perhaps rather Lady Eastlake, discusses the frequent depiction of Jesus Crucified with Angels in early Italian art at Assisi and elsewhere. The passage from the *Gospel of Bartholomew,* possibly of the fifth century and possibly earlier, may well be the original textual authority for these numerous representations, and Domenico follows it simply and faithfully. ✤

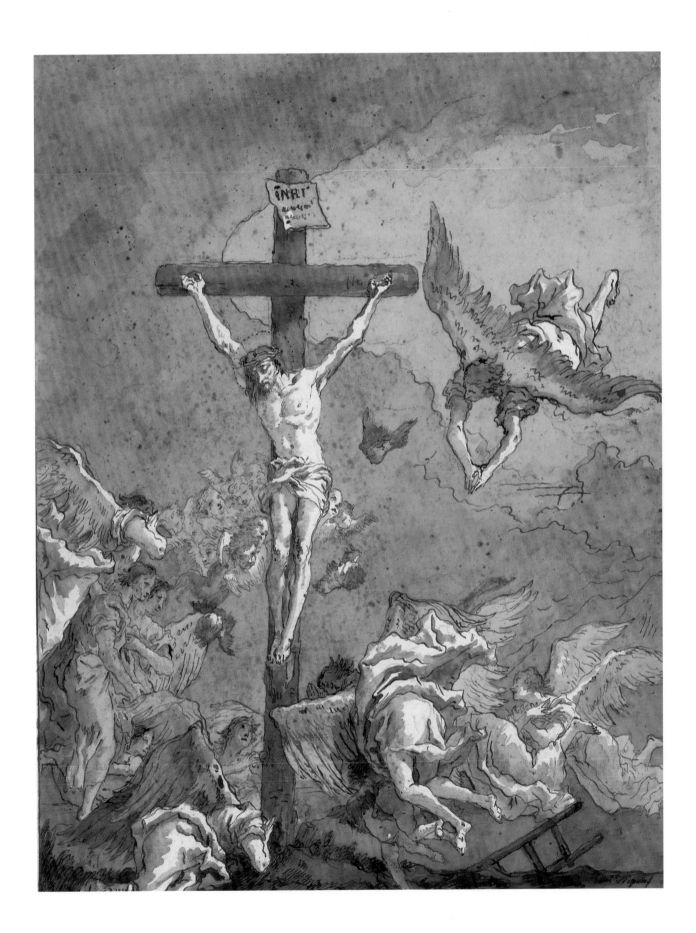

299. *The Exaltation of the Sacrament*

He gave his proper body an offering unto God the Father on the altar of the cross, for our reconciliation, and shed his blood in price and washing our sins. (The Golden Legend)

Pen and wash, over black chalk, 490 x 384
Signed low left: Di Do Tiepolo
Provenance: Jules Hédou (1833–1905; Lugt 1253), his bequest 1905
Exhibition: Rouen 1970 [82]; Paris 1971, pl. 297
Literature: *The Golden Legend* 1900, i, 141; Conrad 1996 [285]

Rouen, Bibliothèque Municipale

In a stunningly complex visual exegesis on the Eucharist, Domenico shows Jesus offering the cup and wafer to God as he kneels upon the instruments of his Passion. Floating on a celestial cloud over an altar, which itself is adorned with a sculpted crucifix, this extraordinary apparition is blessed by the Holy Ghost. Adoring angels swirl about in agitated piety, while from above, appropriately enough, the angel first found in Abraham's sacrifice (pl. 1) bends down with clasped hands. The whole is a visualization of St. John Chrysostom's words, "the whole sanctuary and the space before the altar is filled with heavenly Powers come to honor Him who is present at the altar" (De sac. 6, 4), and the Latin Mass's prayer "Supplice," which notes the holy liturgy of the angels. ❧

Domenico here seems to represent the Feast of the Holy Sacrament as described in *The Golden Legend*. A crucifix placed over an altar is transformed into a vision of the Trinity supported on clouds, with Jesus kneeling before the Almighty, bearing the chalice and wafer of the Sacrament, wearing the crown of thorns, with the scourge of the flagellation by his side. The Feast of Corpus Christi was established by Pope Urban IV in 1264 on the first Thursday after Trinity Sunday in celebration of the Miracle of Bolsena in 1263, also treated here by Domenico (pl. 303). Urban IV also requested St. Thomas Aquinas to compile the Office of the Blessed Sacrament. ✠

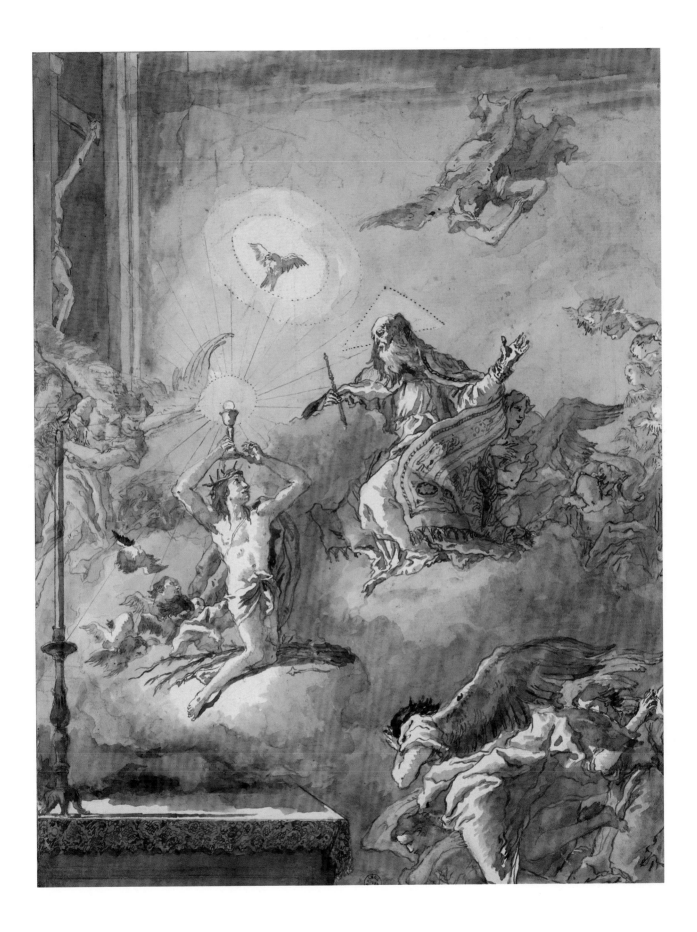

300. *An Apparition of the Virgin Ascending*

John is the narrator. The Virgin called him to listen to a wonderful mystery which had been revealed to her: as she prayed at Golgotha at noon on the sixth day of the week a cloud came and took her to the third heaven. (Ethiopic Apocalypse of the Virgin)

Pen and wash, over black chalk, 468 x 350
Signed low left: Dom.o Tiepolo f
Provenance: Jean Fayet Durand (1806–1889)
Literature: Conrad 1996 [260]
Reference: James 1924, 194–227; 564; *The Golden Legend,* 1900, iv, 234–271, under August 15

Paris, Musée du Louvre, Département des Arts Graphiques, RF 1713bis [65]

Assuming a pose very like that of her son carried aloft during his temptation (pl. 105), Mary ascends past the same temple with the aid of similar angels. A man carrying his bedding (likely the recipient of some divine cure) walks toward her but does not appear to see her, while the walls of a small Italian village peek out from the clouds. ❦

The drawing my be associated with the Festival of the Holy Name of the Virgin Mary, established by Clement X for the whole kingdom of Spain in 1671, and instituted by Innocent III in thanksgiving for the raising of the siege of Vienna in 1683, celebrated on the Sunday next to September 8. Plate 301, *An Apparition of the Virgin Descending,* is a companion drawing. ⚜

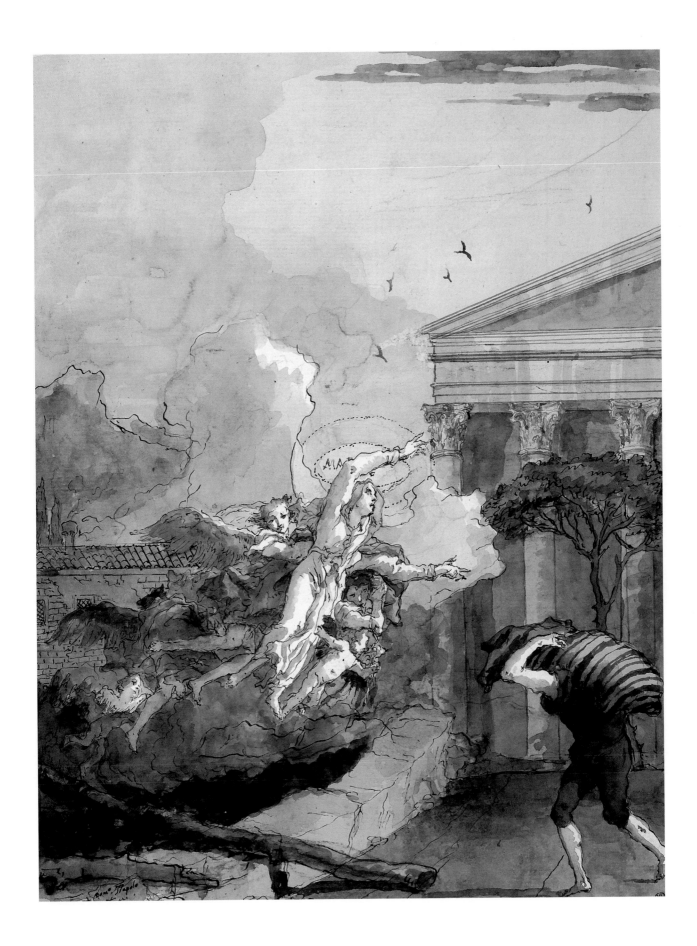

301. *"MARIA": An Apparition of the Virgin Descending*

After the most holy Mary had remained in heaven for three entire days and had enjoyed in body and soul the glory of the right hand of her Son and true God, She departed with the benediction of the blessed Trinity from the highest empyrean and returned, according to her desire, to this nether world of the earth. God ordered an innumerable multitude of angels, selected from all the choirs and from the highest seraphim nearest to his throne, to accompany their Queen. She was enveloped in a cloud or globe of the most resplendent light, which served Her as a couch or reliquary and in which She was borne downward by the seraphim. (Maria de Agreda 1971, IV, 31–32)

> Pen and wash, clouds outlined in ink
> Signed left, on the eves of the house: Dom.o Tiepolo f
> Provenance: Roger Cormier, Tours, his sale, Paris, Georges Petit, Apr. 30, 1921, no. 36, as *La Vierge Marie entourée d'amges;* duc de Trévise, his sale, Paris, Hôtel Drouot, Dec. 8, 1947, no. 34
> Exhibition: Chicago 1938, no. 94
> Literature: Guerlain 1921, 97; Conrad 1996 [261]
> Reference: *The Book of the Passing of the Most Holy Virgin,* M. R. James, Oxford 1924, 194–216; The Apocryphal Gospel of John the Evangelist; *The Golden Legend,* 1900, iv, 234–254, under August 15; Maria de Agreda 1971, iv, I

Mary descends to the very same location, this time accompanied by a larger host of angels. Acting as special escort is the angel who first appeared with Abraham in scene one. Here he holds the lilies usually associated with the Annunciation. ❦

Maria de Agreda tells us that Mary was taken to heaven by Jesus at the time of the Ascension and remained there for three days. The text cited above describes her return to earth. This composition makes a pair with plate 300, also inscribed *MARIA*. In the Louvre drawing she appears to be ascending; here she is descending. Neither shows the conventional scene of Mary rising from the tomb, with the twelve Apostles, treated in a monumental manner by Ricci in the Karlskirche (Knox 1992 [100]), by Piazzetta in the Louvre (Knox 1992 [99]), and by Giulia Lama at Malamocco, [fig. 300]. The latter is associated with the miraculous appearance of the Virgin on the Lido of Pellestrina on August 4, 1716, to the boy Natalino de' Muti, which immediately preceded the relief of Corfu, and which led to the building of the church of Sta. Maria di San Vito at Pellestrina in 1723 (Niero 1993, 127–128, with full references). It could well be that these two drawings relate to that event. One may also note the small painting by Martinelli at Hampton Court (Arslan 1960, 229 [266]) that shows a similar subject with a small church in the background.

It may well be that these designs should be associated with the Feast of the Name of Mary, celebrated on September 15, which was established by Clement X for the whole kingdom of Spain in 1671 and for the whole church in 1683. However, we are unable to cite any visual prototype for this drawing. ⚜

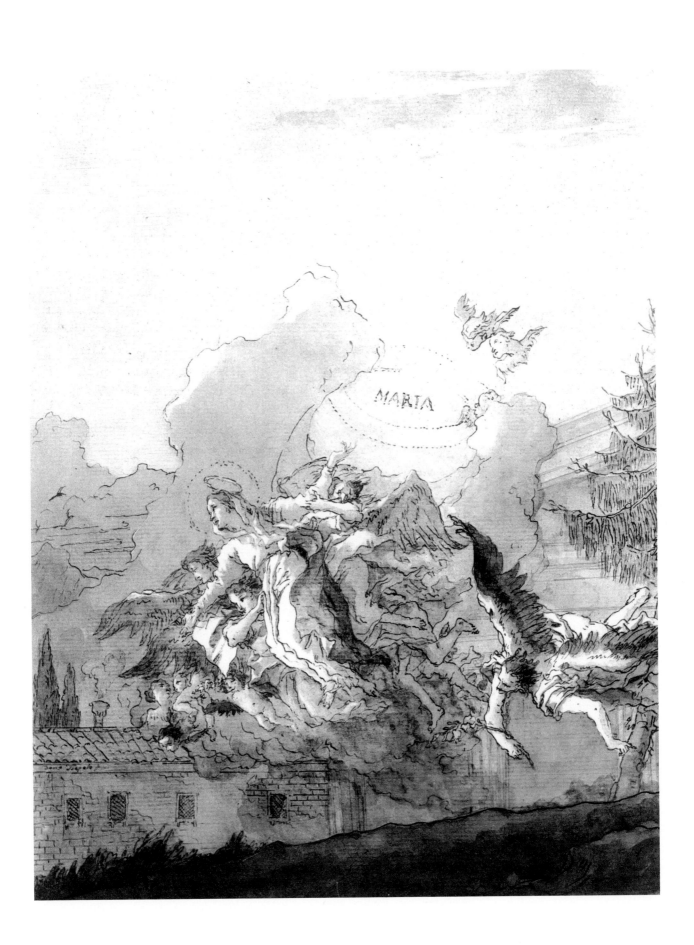

302. *A Miracle of Sta. Agatha: The Sacred Heart*

And for to prove that she had prayed for the salvation of the country, at the beginning of February, the year after her martyrdom, there arose a great fire, and came from the mountain toward the city of Catania and burst the earth and stones, it was so fervent. Then ran the paynims to the sepulcre of S. Agatha and took the cloth that lay upon her tomb, and held it abroad against the fire, and anon on the ninth day after, which was the day of her feast, ceased the fire as soon as it came to the cloth that came from her tomb, showing that our Lord kept the city from the said fire by the merits of S. Agatha. (The Golden Legend, III, 39)

Pen and wash, over extensive black chalk, 468 x 360
Signed low left: Dom.o Tiepolo f
Provenance: Roger Cormier, Tours, his sale, Paris, Georges Petit, Apr. 30, 1921, no. 67;
Milan, Rasini; Sotheby's, Florence, May 18, 1987 [611]; Boston, Jeffery Horwitz
Exhibition: Venice 1951, pl. 113; Paris, Paul Prouté, 1989 [19]
Literature: Morassi 1937 [lxxv]; Conrad 1996 [278]
Reference: *Legendario* 1600, 26; Ribadeneira 1656, i, 197, February 5; *The Golden Legend, 1900, III, 39*; Jameson 1883, 611; Niero 1993, 133–135

Cambridge, Massachusetts, Fogg Art Museum, The Horvitz Collection

An alternative interpretation involves the assembly of devout women who have gathered to celebrate "Candlemas," or the Feast of the Purification, which is celebrated every February 2 in honor of the day that Mary took Jesus to the Temple and was herself purified. This was the moment when Simeon, recognizing Christ, prophesied that Mary would be pierced through the heart. As the worshippers all kneel carrying their customary candles, the priest turns and sees, to his surprise, the flaming hearts descending in a starry cloud, some of which appear to be pierced by small knives. Interestingly, Domenico's *Frontispiece* to his Fourteen Stations features such flaming hearts pierced with knives at the center (or heart) of his design (pl. 213). ❦

St. Agatha was martyred in Catania in the year 251. When eruptions of Etna threatened the city, danger was averted several times by the veil of St. Agatha, taken out of her tomb and carried in procession. The nuns of St. Agatha pray at the altar of the saint in the Duomo, while burning fragments rain down from above. The congregation are mostly women bearing candles, which recalls the Feast of Candlemas, the Purification of the Virgin (February 2), only three days before that of St. Agatha.

It has been suggested that the flying objects are flaming hearts: there may be a link here with the devotion of the Sacred Heart. This originated at Paray-le-Monial in December 1673 with the visions of Margaret Mary Alacoque (1647–1690), canonized by Benedict XV in 1920, shortly after the consecration of that remarkable monument to modern French piety, the Sacré-Coeur on the Butte Montmartre. In Venice a *Compagnia della Sacre Cuore* is noted at San Canciano from 1732 onwards. Clement XII issued a Brief in support of the devotion in 1735. In 1765, Clement XIII Rezzonico granted the Mass and the Office of the Sacred Heart to the Venetian Patriarch, Giovanni Bragadin. The feast of the Sacred Heart falls on the Friday after the octave of the feast of Corpus Domini (see the following drawing). ⚜

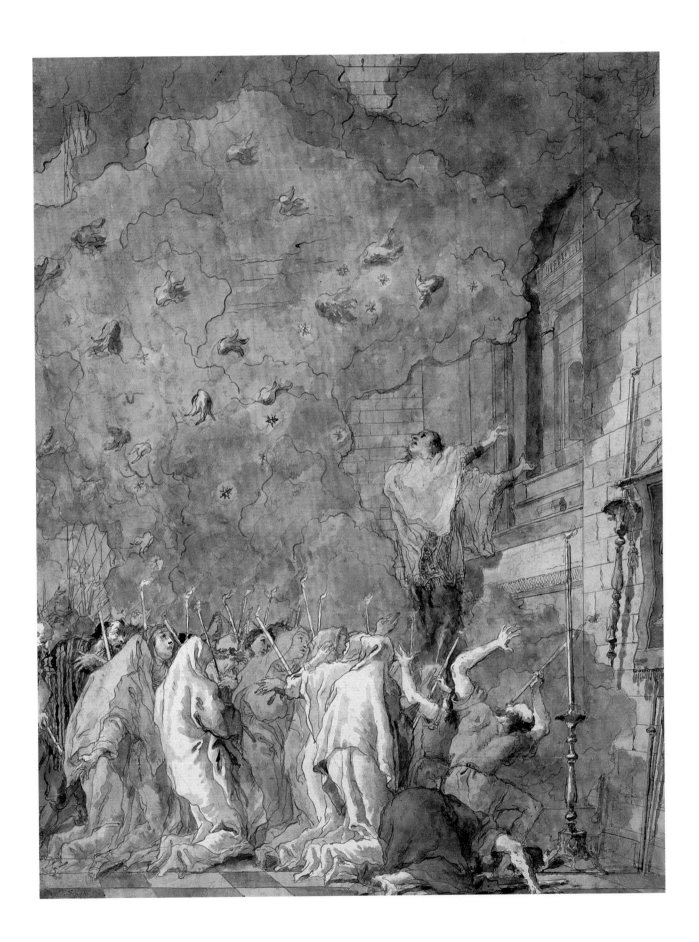

303. *The Mass of Bolsena, 1263*

And because this institution of so noble sacrament may be hallowed more solemnly, the Pope Urban IV, by great affection that he had to this holy sacrament, moved of great devotion, he ordained the feast and remembrance of this holy sacrament the first Thursday after the octaves of Pentecost, for to be hallowed of all good Christian people, to the end that we who use throughout all the year this holy sacrament to our salvation, may do our devoir to this holy institution specially in the time when the Holy Ghost enseigned and teached the hearts of the disciples to know the mystery of this holy sacrament. (The Golden Legend)

Pen and wash, over black chalk, 464 x 358
Signed low right: Dom.o Tiepolo f
Provenance: Jean Fayet Durand (1806–1889)
Literature: *The Golden Legend*, i, 1900, 143; Conrad 1996 [277]

Paris, Musée du Louvre, Département des Arts Graphiques, RF 1713bis [108]

Applying his characteristic blend of prosaic realism to a sacred scene, Domenico lets us join the kneeling worshippers who await the sacrament of the Eucharist. One acolyte removes the consecrated host as another steadies his ladder and the congregation say their prayers. One lady, closest to the altar, has said her rosary (the beads dangle from one hand) and she now turns her attention to the forthcoming Mass. 🌿

This composition shows a priest and an acolyte on a ladder before an altar. The door of the tabernacle is open and the priest is placing or removing something in the tabernacle, in the presence of a large and devout congregation. It is here suggested that the scene may possibly represent the Miracle of Bolsena, in which a skeptical priest and his congregation witnessed a miracle of transubstantiation in the church of Sta. Christina in Bolsena in 1263. To celebrate the miracle, Urban IV instituted the Feast of Corpus Domini in 1264. This falls on the Thursday after Trinity Sunday. The composition is remarkably similar to *The Miracle of Sta. Agatha: The Sacred Heart* (pl. 302). However, this is an early drawing and the other is much later. ⚜

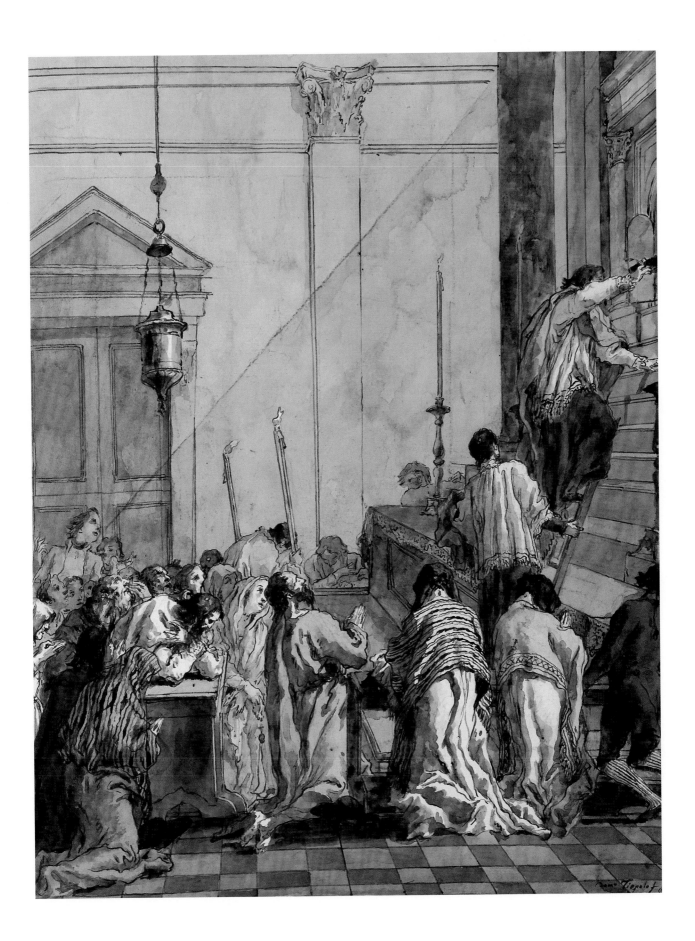

304. St. Anthony Preaching to the Fishes on the Shore at Rimini

St. Anthony being at one time at Rimini, where there were a great number of heretics, and . . . preached to them for several days, and reasoned with them on the faith of Christ. . . . They not only resisted his words, but were hardened and obstinate, refusing to listen to him. At last, St. Anthony, inspired by God, went down to the sea-shore, where the river runs into the sea, and, having placed himself on a bank between the river and the sea, he began to speak to the fishes as if the Lord had sent him to speak to them. (St. Francis of Assisi, The Little Flowers, XL)

Pen and wash, 480 x 360
Signed low right: Dom.o Tiepolo f
Provenance:
Reference: Ribadeneira 1656, i, 389?, June 13; Photograph in the archives of James Byam Shaw, Paris, Fondation Custodia

Milan, Antonio Morassi (formerly)

St. Francis's account goes on to say that the heretics Anthony tried to convert came to see the miracle of the fish and were so impressed by what they saw and heard that they were all converted and threw themselves at St. Anthony's feet. Domenico chooses the transforming moment. A number of heretics already lie at Anthony's feet, while others crowd round him, some gazing down in amazement at the congregation of fish. As the fish listen to Anthony's exhortations, they have their heads out of the water, just as the text described. Unable to resist embellishing the story, Domenico portrays several converts playing in the water, trying to touch or even catch the fish. Characterizing his heretics as Turks, Levantines, and other turbaned Orientals, Domenico selects two of them, a man together with a woman bearing a great pitcher, who are especially attentive to Anthony's words. ❦

Born in Lisbon in 1195, St. Anthony of Padua received the Franciscan habit at the Convent of Santa Croce in Cóimbra (near Lisbon) and eventually made his way to Assisi in 1221. He became a priest for the hermitage of Montepaolo (near Forli) and there his public career as an inspired orator of holy scripture began. St. Francis learned of his gifts and wrote Anthony in 1224 instructing him to teach theology to his brethren. By 1226 Anthony was in the French province of Limousin. St. Francis appeared to him miraculously at Arles. When St. Francis died in 1226, St. Anthony returned to Italy, and in 1230 he returned to the Convent of Padua, where he died in 1231. *The Little Flowers* was written around 1250 and represents an ideal picture of the early days of the Franciscans. ⚜

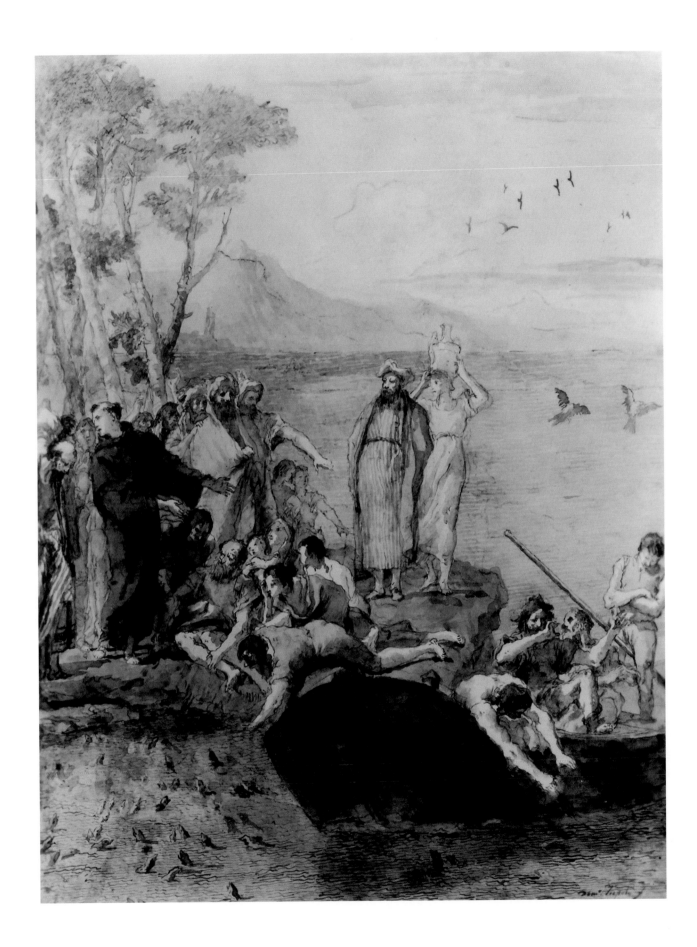

305. *St. Anthony and the Christ Child*

On one occasion, the saint being alone in his room, the host who had received him in his house, passing by, saw a light in his room: he perceived a handsome child on his book and who with great familiarity put himself in the arms of St Anthony, who embraced him, unable to take his eyes off him. The saint later found by divine revelation that his host had witnessed the Infant Jesus with him, and prayed him to speak of it with no one so long as he lived. (Ribadeneira, June 13)

Pen and wash, over heavy black chalk, 488 x 381
Signed low left: Dom.o Tiepolo f
Provenance: Cailleux; Sotheby's, Dec. 13, 1973 [65]; Chaikin; Bern, Klipstein & Kornfeld, June 8, 1977 [152], bt. Gamond;
Zürich, Bruno Meissner; Christie's, July 3, 1990 [90]; Christie's, Mar. 13, 1993; Arturo Cuellar; Albrecht Neuhaus 1995;
Sotheby's, New York, Jan. 26, 2000 [83]
Exhibition: Udine 1971 [77]; Geneva 1978 [134]; Zürich, Bruno Meissner, 1978 [8]
Reference: Ribadeneira 1656, i, 389, June 13; Patrignani 1883, ii, 561

Skipping the more traditional scene of St. Anthony receiving the Christ Child in his room, Domenico instead portrays the pair borne heavenward, much like Mary had been earlier, representing his mystical companionship with Christ on a more celestial plane. ✺

St. Anthony of Padua was born in Lisbon in 1195; he joined St. Francis of Assisi and spent the last ten years of his life in Italy, dying in Padua in 1231. The story of St. Anthony is not told in *The Golden Legend* but its popularity in Venice and even more in Padua was immense; for a summary, see Rotterdam 1996 [56]. His feast day is June 13. The miracle is said to have occurred at Camposanpiero, between Padua and Castelfranco. ⚜

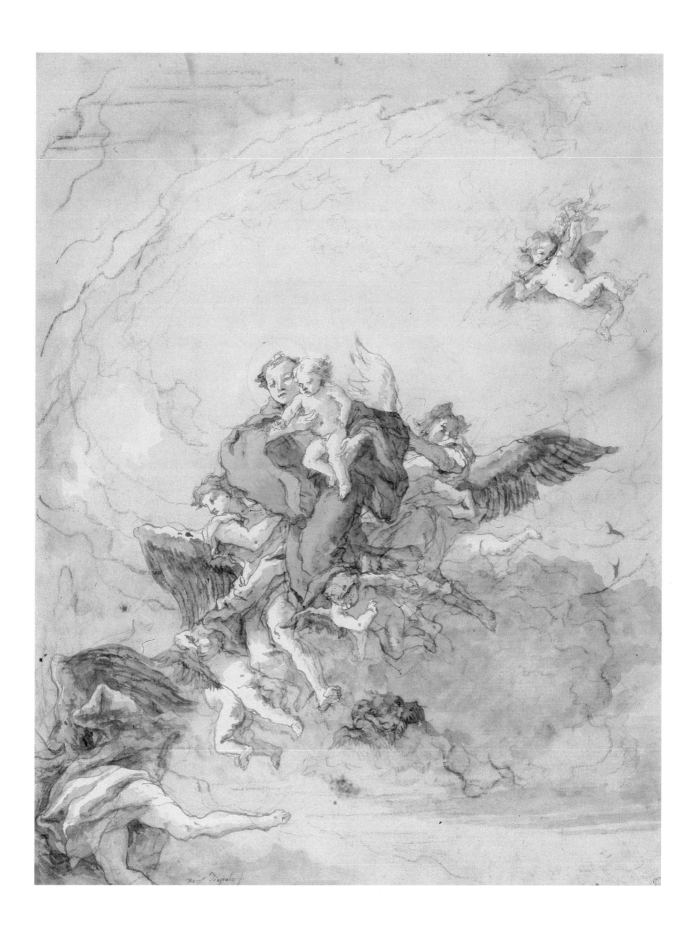

306. *An Army Before the Walls of a City*

No text yet found.

Pen and wash, over black chalk, 468 x 360
Signed low left center: Dom.o Tiepolo f
Provenance: Jean Fayet Durand (1806–1889)
Literature: Conrad 1996 [266]

Paris, Musée du Louvre, Département des Arts Graphiques, RF 1713bis [122]

In a curious scene implying the preparation for a siege of Rome, two soldiers debate their next steps, pointing in the direction of the fortress (here looking like the Castel St. Angelo) as the battalion awaits its next orders. One groom holds a horse at the ready, while behind him a standard bearer proudly holds the emblem, a castle over which flies an eagle. Beyond them, another battalion has begun its siege. ✤

The scene shows an army before a city wall. This and the four following drawings seem to be associated with an unidentified theme that may be associated with the Sack of Rome in 1527. ✤

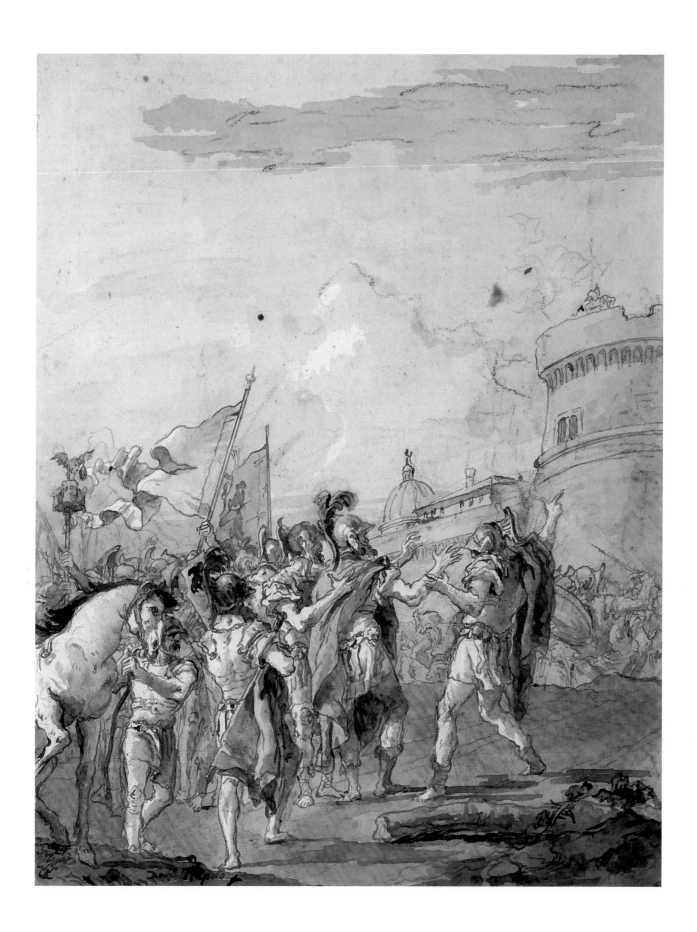

307. *A Soldier Drawing Wine in a Cellar*

No text yet found.

> Pen and wash, over black chalk, 460 x 360
> Signed low left: Dom.o Tiepolo f
> Provenance: Roger Cormier, Tours, his sale, Paris, Georges Petit, Apr. 30, 1921, no. 60; Duc de Trévise, his sale, Paris, Hôtel
> Drouot, Dec. 8, 1947, no. 43; Paris, Nouveau Drouot, Mar. 9, 1988 [163]
> Literature: Conrad 1996 [269]

New York, private collection

If this represents the Sack of Rome in 1527, no published account mentions the invasion of the papal wine cellars, which appears to be what is happening here. With no one on guard, the soldier has tapped one of the casks. ❧

This setting is repeated in three drawings, of which this appears to be the first. It may be preceded by plate 306, showing an army in Roman uniform before a city wall. It is certainly followed by plate 308, which shows the same soldier being driven out of the same cellar by peasants with pitchforks; and this "peasant revolt" may well be followed by plate 309, showing a military execution by firing squad. A third drawing, with the same setting as here (pl. 310), may also be part of the same story. It has been suggested that the cellar may be recognized as that of the Vatican, and that the episode may relate to the Sack of Rome in 1527. ❧

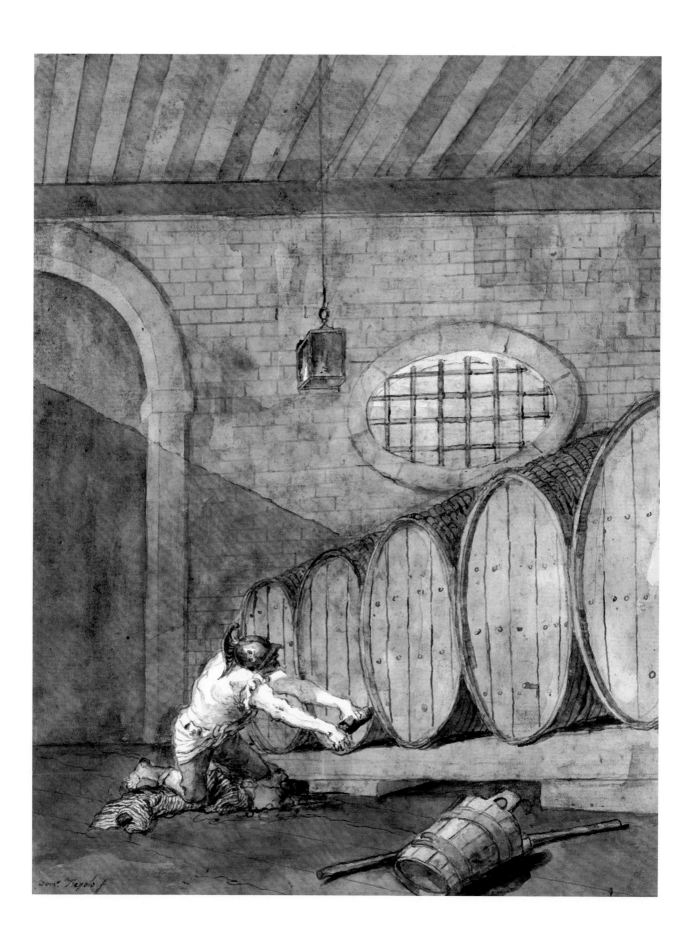

308. *A Soldier Driven Out of a Cellar by Peasants*

No text yet found.

Pen and wash, over slight black chalk, 460 x 353
Signed low right: Dom.o Tiepolo f
Provenance: Jean Fayet Durand (1806–1889)
Literature: Conrad 1996 [270]

Paris, Musée du Louvre, Département des Arts Graphiques, RF 1713bis [129]

Several peasants arrive to chase the soldier from the cellar, threatening him with their pitchforks and overpowering him with their brute strength. Their dog, who likely sounded the alarm, barks furiously at the right. 🖋

This drawing is part of a series of five that appear to illustrate a theme that has yet to be identified. They involve, on the one hand, *An Army Before the Walls of a City* (pl. 306) and *A Military Execution by Firing Squad* (pl. 309), and on the other, *A Soldier Drawing Wine in a Cellar* (pl. 307), the present drawing, and *A Priest Drawing Wine in a Cellar* (pl. 310). ⚜

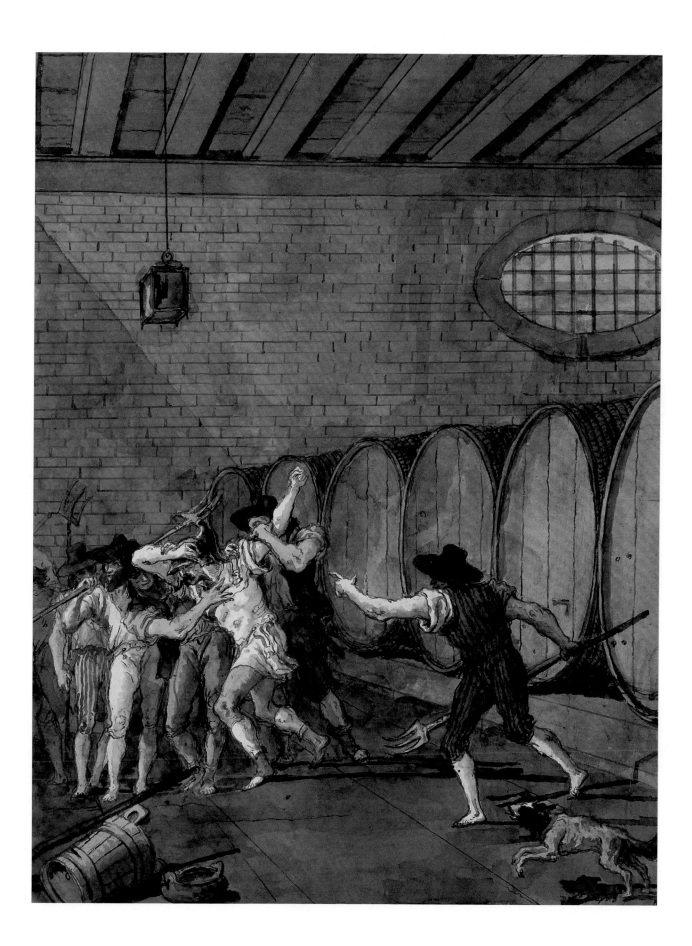

309. *A Military Execution by Firing Squad*

No text yet found.

> Pen and wash, over traces of black chalk, 489 x 387
> Signed low right: Dom.o Tiepolo f
> Provenance: Roger Cormier, Tours, his sale, Paris, Georges Petit, Apr. 30, 1921 [28]; Paris, Hôtel Drouot, Dec. 17, 1942 [11];
> Paris, Hotel Drouot, Feb. 4, 1959 [53]; Bern, Klipstein and Kornfeld, June 16, 1960 [323]; Christie's, New York, Jan. 13, 1993
> [106]; Christie's, New York, Jan. 13, 1993 [106]; D. Feinberg
> Literature: Guerlain (1921+: 226) and Byam Shaw (1962: 62)—note: "surely derived from one of Callot's etchings of *Les misères de la guerre—no. 12*"; Lieurre 1924, no. 1350; Conrad 1996 [267]

As the rider blasts out a signal, soldiers prepare to execute a prisoner. The first two seem to line up their shots before grabbing the rifles held by their assistants behind them. ✺

Although the firing squad are dressed as Roman soldiers, the execution is evidently being carried out with guns. The two foremost soldiers are not actually carrying guns, though they are in a shooting pose; the soldiers standing at ease behind them do carry guns. The victim and the corpse also appear to be Roman soldiers, all of which seems to be an anachronism; however, it could well be that this represents the consequence of the encounter between the soldier and the peasants in the wine cellar, seen in the two preceding drawings.

It is here suggested that this drawing is part of a series that starts with plate 306, continues through plates 307–308, and concludes with plate 310. This design was reused for *Divertimento 97, The Firing Squad* (Gealt 1986 [71]). These may recall some memories of military violence at the time of the League of Cambrai, since they appear to be too early to reflect the French occupation of the Veneto in 1797; moreover, Byam Shaw's suggestion that the theme may be inspired by Callot is very plausible. A connection with the Sack of Rome in 1527 has also been suggested. ❧

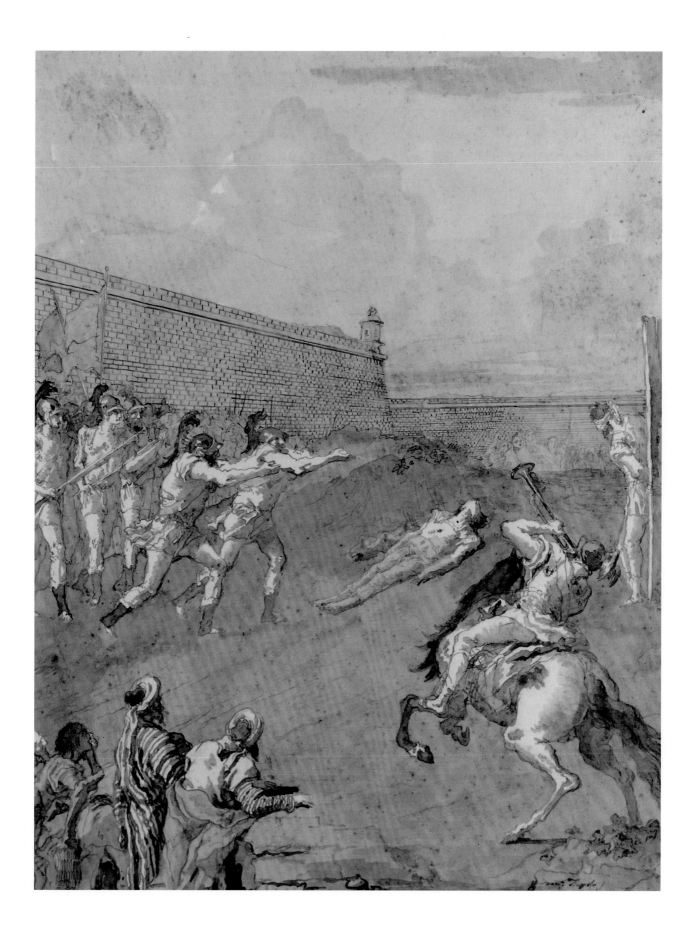

310. *A Priest Drawing Wine in a Cellar*

No text yet found.

 Pen and wash, over black chalk, 489 x 380
 Signed low right: Dom.o Tiepolo f
 Provenance: Roger Cormier, Tours, his sale, Paris, Georges Petit, Apr. 30, 1921, no. 24; Duc de Trévise, his sale, Hôtel Drouot,
 Dec. 8, 1947, no. 32
 Exhibition: Udine 1996 [109]
 Literature: Conrad 1996 [271]

Paris, Musée du Louvre, RF 44308

Meanwhile, back in the cellar, a priest has been called in to check the wine. As he taps one barrel, the peasant seems to be telling him which ones were tampered with. ❦

This scene shows exactly the same cellar as plates 307 and 308 above, and we assume that it must be part of the same story. The door is now half open, and a glimpse of noble architecture can be seen. A connection with the Sack of Rome has been suggested. ❧

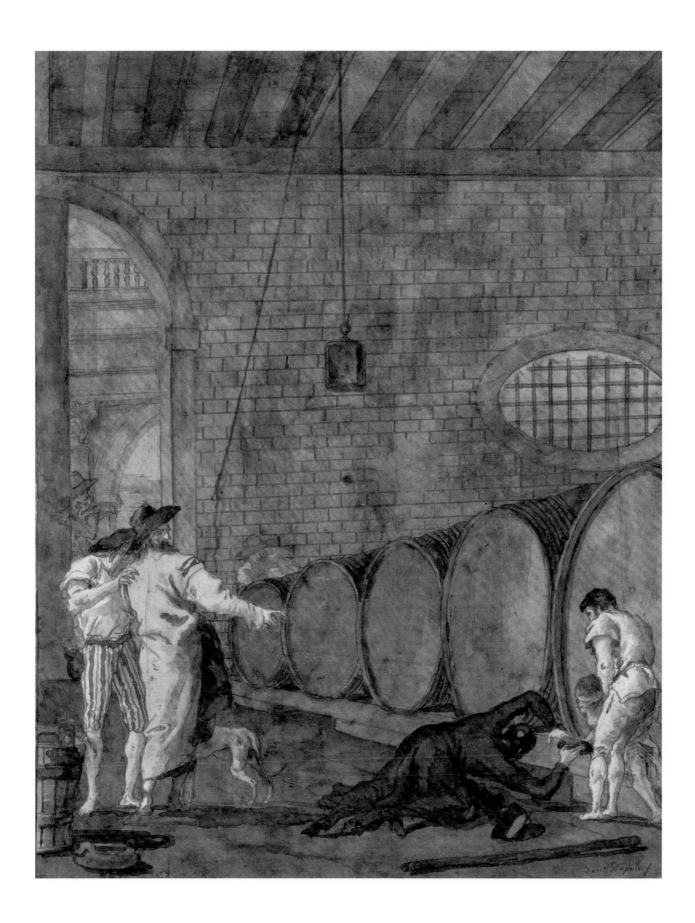

311. *Supplicants Before Pope Paul IV*

No text yet found.

Pen and wash, over black chalk, 490 x 363
Signed low left: Dom.o Tiepolo f
Provenance: Edward Bergson, Lugt 827a; Heck, Vienna; Dan Fellows Platt, 1936
Exhibition: New York and Princeton 1966 [102]; Udine 1996 [113]
Literature: Byam Shaw 1962, 36, note 4; Gibbons 1977 [679]; Conrad 1996 [281]

Princeton University Art Museum, 48-1289

Seated on a splendid throne, Paul IV gives an audience to two supplicants as members of his papal entourage
observe with certain skepticism on the right. Among Paul's accomplishments that are important to Domenico's
story is his reinstitution of the Feast of the Chair of St. Peter. ✿

The Pope is identified as Paul IV Carafa (1555–1559) by the inscription, PAOL / PAPA IV, but the reason
behind the choice of subject remains obscure. One may recall Paul's work on behalf of the Teatini, and the union
of the Teatini and the Somaschi on December 23, 1555 (Pastor 1927, VI, 468–469). On the other hand, one
of the supplicants is a woman, which recalls the role of Maria Carafa, sister of Paul IV, in the foundation of the
Cappuccini. ✤

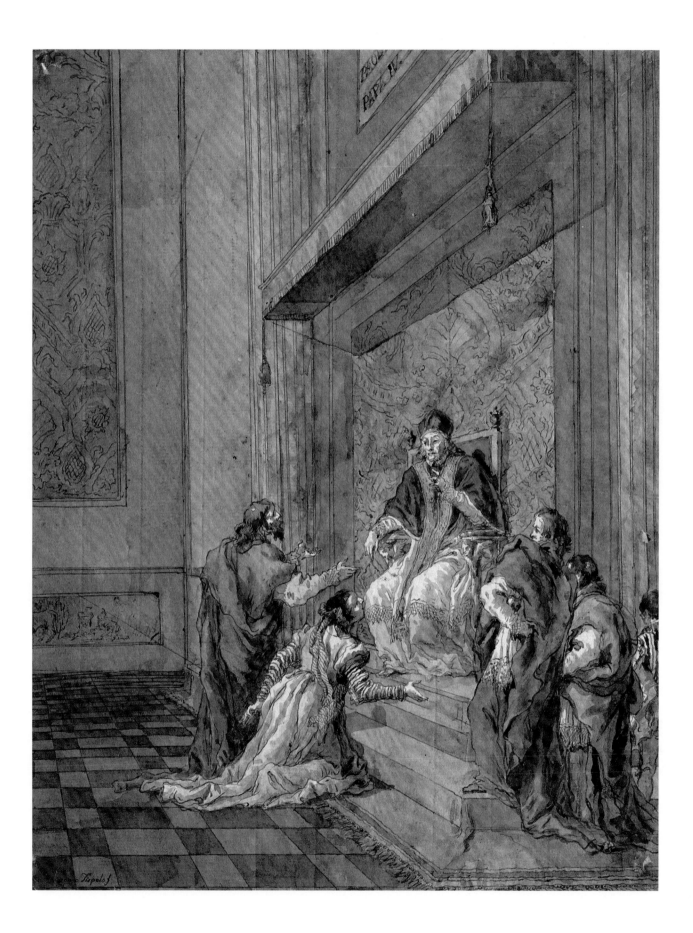

312. *The Vision of St. Philip Neri*

Among other miracles, when he himself lay sick of a fever and his life seemed despaired of, he was suddenly restored to health by a vision of the Blessed Virgin, in which he fell into a wonderful rapture, and cried out, "O most holy Mother of God, what have I done that you should vouchsafe to come to me?" Coming to himself he said unawares to the four physicians that were present: "Did not you see that Blessed Mother of God, who by her visit hath driven away my distemper?" But immediately perceiving that he had discovered his vision, he besought them not to disclose it to anyone. (Butler 1880, i, 275–276)

Pen and wash over black chalk, 485 x 384 / 460 x 355
Signed low right: Dom.o Tiepolo f
Provenance: Roger Cormier, Tours, his sale, Paris, Georges Petit, Apr. 30, 1921, no. 13, as *l'Apparition;* Paris, Dr. and Mme. Etienne Marterel, Paris Hôtel Drouot, Apr. 23, 2001 [12], bt. William Brady
Exhibition: New York, Brady 2002 [9]
Reference: Butler 1880, i, 275–276

New York, private collection

Here we find St. Philip Neri adoring the Virgin and Child, who have appeared to him during his devotions. Besides his piety and his charity (he ran a hospital for the poor), Philip Neri was known for his study of canon law, as indicated by the book lying to the left. ❦

St. Philip Neri (1515–1595), founder of the Oratorians, was canonized by Gregory XV in 1622. His feast is celebrated on May 26. An important biography was published in Venice in 1727. The drawing is said to have come from a collector who had gathered together a mass of material relating to magic and the occult, and who may have been attracted by the title, *l'Apparition,* in the Cormier sale. ⚜

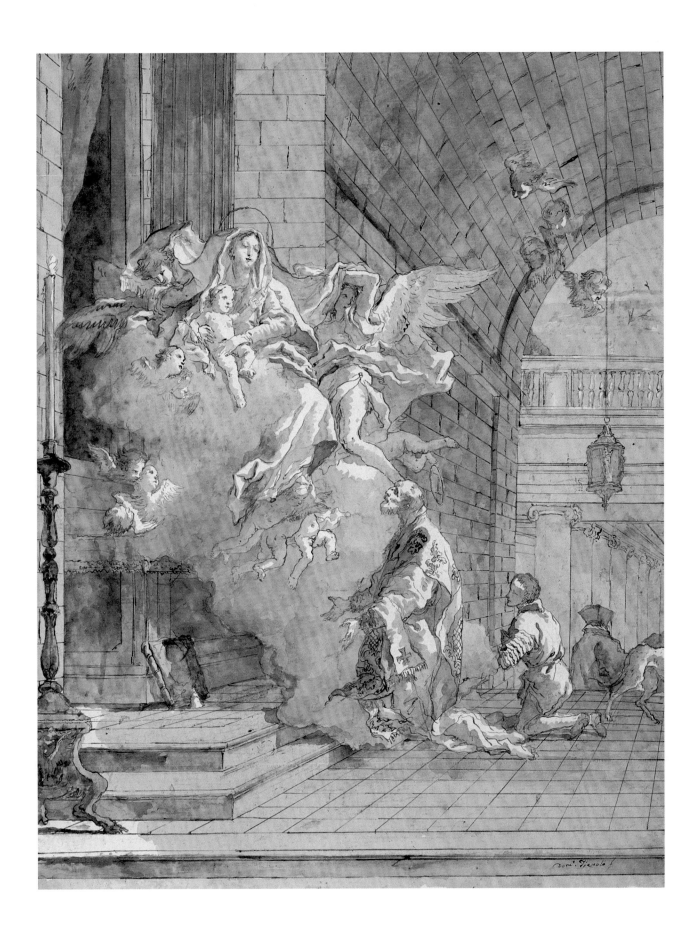

313. *The Virgin and Child with St. Jerome Emiliani*

Whilst he was governor of the new castle in the mountains of Tarviso, he was taken prisoner, cast into a dungeon, and loaded with chains. His sufferings he sanctified by penance and prayer; and being delivered by the marvellous protection of the Mother of God, arriving at Tarviso, he hung up his chains before an altar consecrated to God under the invocation of the Blessed Virgin, and returning to Venice devoted himself to the exercises of prayer and all virtues.
(Butler, Lives of the Saints)

> Pen and wash, over black chalk, 467 x 360
> Signed on step, low right: Dom.o Tiepolo f
> Provenance: Jean Fayet Durand (1806–1889)
> Literature: Conrad 1996 [286]
> Reference: Butler 1880, ii, 115

Paris, Musée du Louvre, Département des Arts Graphiques, RF 1713bis [50]

As Jerome Emiliani kneels and offers the chains and key of his imprisonment at the altar at Treviso, the orphans under his care share in the miracle of this moment. Several of them participate in the service of worship, while one has been honored by being presented with the Christ Child by his mother. Meanwhile, another lad, carrying a basket of refreshments, is stopped in his tracks by this vision. ❦

The Tiepolo family had a special link with Jerome Emiliani and the Somasco Convent in Venice, since Domenico's brother Giuseppe Maria was a priest in the order, which was devoted to education. It is even possible that Domenico's *New Testament* took its inspiration from these educational activities, but a clear link has yet to be found. ⚜

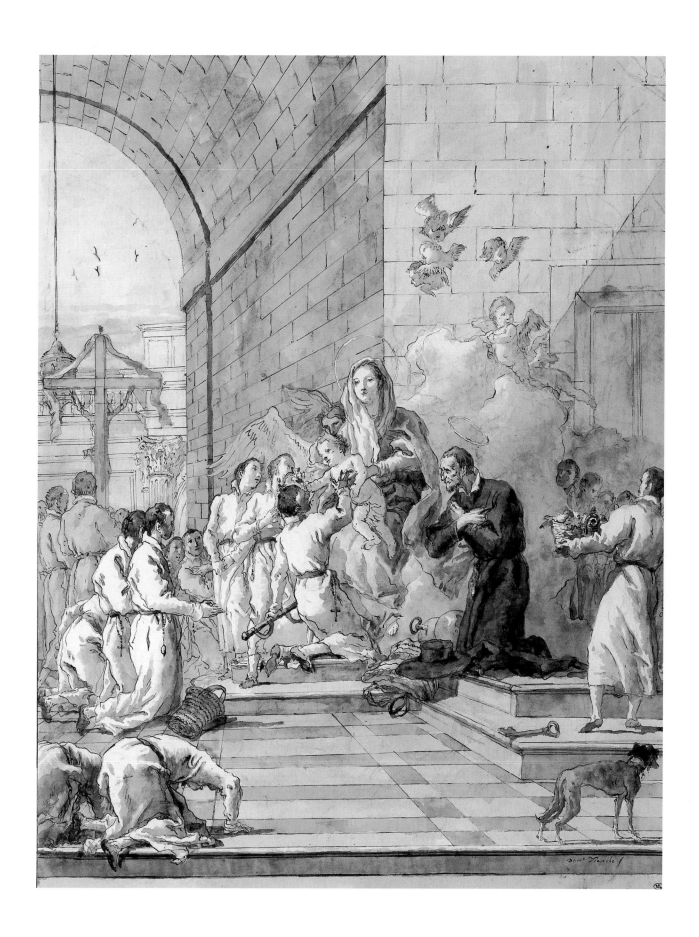

CHAPTER VI.

Traditions and Sources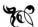

GEORGE KNOX

1. *The Sacrifice of Abraham*

The Sacrifice of Abraham is part of the story of Abraham and Sarah, who were old and childless—as were Joachim and Anna and Zacharias and Elizabeth, as we shall see. God finally granted their wish for a son, but then, to test his faith and obedience, God commanded Abraham to make a sacrifice of Isaac. Only when Abraham had stacked the wood on the altar upon which Isaac was to be burnt as an offering, and was preparing to cut his son's throat, did God relent, sending an angel to stay his hand, satisfied at last that Abraham was obedient. The drawing appears to be relatively early in date but some of its elements establish links with other subjects. The mountain ledge is paralleled in *The Temptation of Christ* (pls. 104 and 108) and the pose of Isaac recalls that of the widow's son (pl. 121) and even that of Christ himself in *Station III* of the *Via Crucis* (pl. 216).

TRADITIONS: With its seminal links to New Testament events, this subject had a lengthy visual history and was, among other celebrated examples, the subject for the famous competition for the Florence Baptistery doors, won by Ghiberti in 1401.

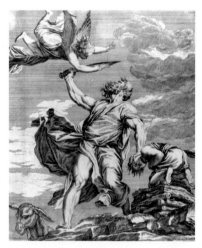

Figure 67. Valentin Lefebre after Titian, *The Sacrifice of Abraham*, from the *Opera Selectiora* (Venice, 1682, [10])

SOURCES: The composition derives from the painting by Titian for the ceiling of Santo Spirito in Isola, now in the Sacristy of Sta. Maria della Salute in Venice (Valcanover 1969: [240A]). This and a second design after Titian, *The Crowning with Thorns* (pl. 194), together with two after Veronese, *The Presentation of Jesus in the Temple* (pl. 41) and *The Feast in the House of Simon, I* (pl. 122), are based on the etchings of Valentin Lefebre, *Opera Selectiora* (1682 [10]); Ruggeri (2001 [1.2]). Here the etching shows the figure of the angel completely redrawn; the altar of logs and the pose of Isaac are also altered [fig. 67].

2. *Joachim's Offering Refused*

TRADITIONS: The earliest treatment of the theme appears in the lowest band of the first column of the Ciborium of San Marco in Venice (Lafontaine-Dosogne 1964: 61–68, [1–3]), which is here accepted, following Weigel (1997), as a Byzantine work of ca. 500. It shows the High Priest behind a table to the right as Reuben is approached by Joachim, followed by his two shepherds with sheep; other figures balance the High Priest on the left. Domenico shows much the same elements in reverse: a priest with a sacrificial axe stands behind the altar on the right as Reuben in the center admonishes Joachim, who is followed by shepherds with sheep on the left. This is the most compelling evidence that Domenico studied the columns of the Ciborium, rather than the treatments of the same theme by Giotto in Padua (Basile 1993: [34a, 36, 37]), where the cycle opens with *Joachim and the High Priest within the Temple* on the left and *The Expulsion of Joachim* on the right. Similarly, the cycle of mosaics of 1310–1320 in the Church of the Chora, the Kariye Djami, in Istanbul (Underwood 1966: [82]) and Albrecht Dürer's series of woodcuts illustrating *The Life of the Virgin* (*The Illustrated Bartsch 10,* 1978: [172]) also start with this scene. It also opened the cycle in the mosaics of San Marco, but here the original work of the twelfth century was replaced in 1690–1691 by Domenico Cigoli, working after a cartoon by Antonio Fumiani (*San Marco* 1991: [97/2]).

The story of Joachim and Anna is found outside Venice in important frescoes by Taddeo Gaddi in Santa Croce and Ghirlandaio in Sta. Maria Novella in Florence, the latter offering the most monumental representation of this scene (Cadogan 2000: 236–243, [71]), as well as in a triptych by Gaudenzio Ferrari (1484–1550) in the Brera, showing *The Rejection of Joachim* on the right.

SOURCES: The man seen from the back in the right foreground derives from a chalk drawing in the Quaderno Gatteri (Lorenzetti 1946: [10]; Knox 1980: C.10), which was also used by Domenico in *Via Crucis VII* and in similar striped costume in the Albertini-Carandini *Separation of Abraham and Lot* (Mariuz 1971: [57]). The old woman standing next to him at extreme right derives from the drawing at Edinburgh [fig. 115].

3. *Joachim Turns from the Temple in Despair*

Domenico devotes 22 sheets to the first phase of his series, depicting the stories of Joachim and Anna and the childhood of Mary. For much of this, he drew, directly or indirectly, upon the Greek *Book of James 1:2* of about AD 200, which tells that Joachim "was a very rich man," but that his offering to the Lord in the Temple was refused because he was childless (hence the link with Abraham, pl. 1). The present drawing is preceded in the sequence by plate 2, which shows Joachim approaching the temple with his offerings and the High Priest rejecting them, in the same setting. Here he turns away in despair. The man with the sheep is also leaving, while the High Priest turns his back on Joachim and retreats into the temple. Maria de Agreda tells the story at great length, describing the marriage of Joachim and Anna and the twenty years during which they remained childless. No earlier modern source for this has been noted.

TRADITIONS: The story appears in San Marco as the first scene on the first column of the Ciborium (Weigel 1997: 265), which is here, following Weigel, taken to be a Byzantine work of the early sixth century (see also Demus 1949: 167; Lafontaine-Dosogne 1964b: 213–219). It also appears as the first scene in Giotto's frescoes in the Arena Chapel at Padua (Basile 1993: [32a]), with Joachim actually leaving the Temple carrying the lamb, which is carried here by a servant. It appears again as the first scene among the mosaics of the Church of the Chora in Istanbul (Underwood 1966: [82]) and as the first scene in the monumental *Life of the Virgin* of 1486–1490 in the choir of Santa Maria Novella by Domenico Ghirlandaio (Cadogan 2000: [71]). More familiar to Domenico would be the opening scene of Albrecht Dürer's *Life of the Virgin* (*The Illustrated Bartsch* 10, 1978: [77]) [fig. 68], who includes Anna in this scene. The same pattern is followed by Israel van Meckenem. It may be noted that Réau, who cites this drawing, indicates it as the only example subsequent to the Dürer woodcut of 1506 and the scene in the left wing of the Quentin Matsys *Triptych of Ste Anne* of 1509 in Brussels (Schiller 1971:

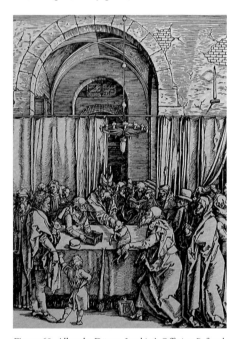

Figure 68. Albrecht Dürer, *Joachim's Offering Refused* (woodcut, 1506)

[481b]). It is also found in the closed right wing of the polyptych by Bernard van Orley in Brussels, matching *The Birth of the Virgin* (Friedländer VIII, 1972, no. 84 [75–77]). Among the mosaics of San Marco, the twelfth-century work is lost and is replaced (Demus 1984: [fig. 48]; *San Marco* 1991: [97/1]) by Cigoli after a cartoon by Antonio Fumiani (1690–1691), among the very last works to be executed, which again includes Anna, who is here omitted. One may also note the treatments of *Joachim Driven from the Temple* by Gaudenzio Ferrari (1484–1550) in the Brera (Newsweek 1970: [61]) and in Turin, in which the High Priest attacks Joachim with his fists. In many of these scenes we find that Anna, the wife of Joachim, is included. But Domenico omits her.

4. *Joachim Withdraws to the Wilderness*

Procopius records the building of a great church dedicated to Anna by Justinian in Constantinople, about the year 550. Her body is said to have been discovered and transferred thither by St. Helena. The veneration of Anna seems

to have been well-established in Venice, with the foundation of the *Fratres Eremitaorum de S. Anna de Castello* in 1284 (Corner 1749: iv, 254; Zorzi 1977, 488–489). The church still stands, though secularized, on the Rio di Sant'Anna, by the southern footbridge leading to San Pietro di Castello. Her feast, it may be noted, was established by Gregory XIII in 1584. Her cult flourished in France in the seventeenth century, promoted by Anne d'Autriche, queen of Louis XIII and mother of Louis XIV. It led to the dedication of the great church of Sainte-Anne-la-Royale, built by Guarino Guarini on the present site of the École des Beaux-Arts and the large chapel attached to the Cathedral at Apt, which contains her relics. Legend relates that her body was hidden in the crypt at Apt in the fourth century and was miraculously rediscovered in the presence of Charlemagne in 801; see also *The Burial of Anna* (pl. 22).

The veneration of Joachim is also found in Venice in close proximity to that of Anna. If one follows the Fondamenta di Sant'Anna along the canal for 100 meters to the west of the church, one comes to the Ponte di S. Gioacchino. Beyond is the Fondamenta di S. Gioacchino, facing that of Sant'Anna, and the Calle di S. Gioacchino, leading to the church, now incorporated in the ancient Ospedale di SS. Pietro e Paolo di Castello (Zorzi 1977: 540).

TRADITIONS: No prototype for this scene has come to light.

SOURCES: The horse and groom in the center are found once more in *Joachim and Anna on the Temple Steps* (pl. 12) and again, reversed, in *Scenes of Contemporary Life 25* (Gealt and Knox 2005: [25]) [fig. 69].

Figure 69. Domenico Tiepolo, *Two Horses with Grooms* (New York, Shickman Gallery)

5. *Joachim in the Wilderness*

TRADITIONS: The fresco by Giotto in the Arena Chapel, *Joachim in the Wilderness with Shepherds and a Flock of Sheep,* though essentially *An Annunciation to Joachim* (Basile 1993: [34a]) provides the most effective prototype for this composition, although there are no other shepherds.

SOURCES: The design derives from an engraving by Pietro Monaco (1763), *Raccolta di cento dodice stampe di pitture della storia sacra* [fig. 70], after a painting by Giovanni Benedetto Castiglione in the Nani collection in Venice, representing *The Miracle of the Bitter Waters Turned Sweet* from Exod. 15:22–26 (Apolloni 2000: [78]). This appears in the first edition of 55 plates (Monaco 1743: [26]) and in the full edition of 112 plates (Monaco 1763: [78]); for a discussion of this publication, see Knox (2000). Mariuz mentions a preparatory drawing by Domenico (Udine 1996: 19) for a second engraving after Castiglione (Monaco 1743: [V]; 1763: [81]; Apolloni 2000: [78]), "his earliest documented work," while two other such drawings have come to light, for engravings after Giambattista (Knox 2000: [2, 3]); hence, it is not impossible that he had made a similar drawing after this

Figure 70. Pietro Monaco, after Castiglione, *The Miracle of the Bitter Waters Turned Sweet* (engraving, 1743)

painting as well. The drawing cuts the composition down on either side and extends it above, leaving only a solitary figure with the animals. The pine tree is also an innovation.

Byam Shaw points out that the flock of sheep is also used more exactly by Domenico for a drawing in the Lehman collection (Byam Shaw and Knox 1987: [153], [fig. 30]). He also points out that the same flock of sheep and the cow appear in *La chasse interrompue* from *Scenes of Contemporary Life 26* (Gealt and Knox 2005: [27]; for a checklist of this series see Udine, 1966, 240–243) and in surviving frescoes in the Villa Tiepolo at Zianigo (Byam Shaw 1959: 391–395).

6. *Joachim Praying in the Wilderness*

TRADITIONS: No strict prototype for this subject has been noted, but the hut is a conspicuous element in Giotto's frescoes in Padua showing *Joachim and the Shepherds* [fig. 71] and *The Dream of Joachim* (Basile 1993: [32b, 34a]) and in the Church of the Chora (Underwood 1966: [84]); the rest of the scene here hardly suggests desert conditions but is redolent of the Venetian countryside. On the other hand, Joachim certainly prayed in the wilderness.

SOURCES: The setting is based on Domenico's drawing at Oxford [fig. 136], which in turn is based on the drawing by Giambattista at Cambridge (Knox 1974: [3]). The landscape background is clearly associated with the drawing at Nottingham (*Scenes of Contemporary Life 10,* Gealt and Knox 2005: [8]), which might imply that this drawing may be the later one. The figure of the kneeling Joachim derives from the Accademia *Abraham and the Angels* (Mariuz 1971: [265]; Udine 1996: 140).

Figure 71. Giotto, *Joachim with the Shepherds* (fresco, 1305, Padua, Arena Chapel)

7. *The Annunciation to Anna*

TRADITIONS: This moving scene appears on the first column of the Ciborium in San Marco (Gabelentz 1903: 9AII), and Giotto shows it as no. 4 of his cycle (Basile 1993: [33a]), representing it, however, as an interior. Jameson points out that this is in the Western tradition, whereas the scene in the garden, as shown here, represents the Eastern tradition. A strikingly similar treatment is found in the celebrated mosaic in the Church of the Chora at Istanbul (Underwood 1966: [85]) [fig. 72] and in the so-called Murano Diptych at Saint Petersburg (Schiller 1971: [496]). The scene also appears in the *Deutsche Bilderbibel* (1960: [Ia]).

Exactly how the tradition represented most magnificently in the Chora survived in this way is unclear, but it may well have been through the Greek community in Venice. They could hardly have been familiar with the Chora itself, which was first noted by Western travelers in 1785, but they could have been aware of the tradition through other examples, such as the celebrated churches in Serbia ornamented with frescoes that descend from it (Lafontaine-Dosogne 1975: [3–9]).

In San Marco the scene is shown in a detail of the mosaic by Cigoli after Fumiani of 1690–1691 (*San Marco* 1991: [97/2]), but nothing of the Greek tradition survives. The story of Joachim and Anna also had a certain currency in late seventeenth-century Verona, represented by five substantial canvases by Giuseppe Lonardi (1661–1729), since the early nineteenth century in the parish church at Breonio, in the hills north of Verona (Verona, 1978, 176–187, [110–114]). The first of these, *The Annunciation to Anna,* presents all the essential elements of Domenico's design, while the others, *The Annunciation to Joachim, The Sacrifice of Joachim, Joachim Meeting Anna,* and *The Nativity of Mary,* are essentially Baroque. Sergio Marinelli notes that "the cult of Anna enjoyed an extraordinary celebrity in the late Seicento, linked directly to that of the Immaculate Conception"; he cites other similar examples in the area that are all lost.

The figure of Anna recalls the two important compositions by Giambattista in which she plays an important role. First is *The Education of the Virgin,* painted for the Church of the Fava in Venice of about 1730 (Gemin and Pedrocco 1993: [128]; New York 1997: [29]). This shows Joachim and Anna and a twelve-year-old Mary in a shimmering white dress that suggests an *Immacolata,* attended by angels. The pose and characteristics of the figure of Anna is reflected in our drawing. Second, and no less relevant, is the altarpiece painted for the nuns of Cividale of 1759, now at Dresden (Gemin and Pedrocco 1993: [489]), which was etched by Lorenzo Tiepolo and described as

Una palla di S. Anna in the invoice sent to Mariette in 1761–1762 (Mirano 1988: 272, [5]). The sketch, now in the Rijksmuseum, was sold by Domenico's widow and her second husband, Domenico's nephew Giambattista Bardese, on May 28, 1808, for 73 lire, and thus belonged to Domenico until his death (Pavanello 1996: 27 and note 45). The composition shows an earthbound Joachim and Anna and a cloud-borne Mary, again perhaps some twelve years old, with the Almighty presiding above. All this is somewhat hard to explain, but Bernard Aikema argues that the scene should be interpreted as an *Immaculate Conception* (Hollstein 1996: [65]).

SOURCES: The angel derives from the painting by Domenico, *Abraham and the Angels,* of 1773 in the Accademia (Mariuz 1971: [265]). The dog derives from Domenico's etching, *Dwarfs and Dogs,* [fig. 93].

Figure 72. *The Annunciation to Anna* (mosaic, 1320, Istanbul, Saint Saviour in the Chora)

8. *The Annunciation to Joachim*

TRADITIONS: The scene appears on the first column of the Ciborium in San Marco (Gabelenz 1902: 9AIII) and is shown by Giotto as *The Dream of Joachim* in the Arena Chapel (Basile 1993: [34a]). It also appears as the second miniature in the *Deutsche Bilderbibel* (1960: [Ib]). Dürer, in the second woodcut of the *Life of the Virgin* (*The Illustrated Bartsch* 10, 1978: 173) presents a landscape setting that is even more heavily populated and lush.

It appears together with *The Annunciation to Anna* in the mosaics of Daphne of the eleventh century, and the two scenes form the central panel of the triptych by Gaudenzio Ferrari in the Brera (Brera 1970: [61]) [fig. 73], with *Joachim's Offering Rejected* on the left wing and *Anna Reproved by Her Servant* on the right. In the Quentin Matsys triptych at Brussels (Silver 1984: [10]), it is found on the interior wing, left, matching *The Death of Anna* on the right. Thereafter, it is somewhat rare in Western art. However, apart from the canvas by Giuseppe Lonardi at Breonio (Verona 1978: [111]), it is found in the first canvas of Luca Giordano's *Life of the Virgin* in Vienna, a series of four fairly large canvases and four smaller ones (*Gemäldegalerie* 1991: [218]), combined with *Joachim and Anna at the Golden Gate.* This is part of a tradition in seventeenth-century Naples. In San Marco, the twelfth-century mosaic was replaced in 1690–1691 by Domenico Cigoli after a cartoon by Gianantonio Fumiani (Demus 1984: [fig. 50]; *San Marco* 1991: [98/1L]).

Figure 73. Gaudenzio Ferrari: *Joachim's Offering Refused; The Annunciation to Anna and to Joachim; Anna*

SOURCES: The reclining boy derives from a drawing by Domenico [fig. 9], which in turn is based on an etching by Cornelis Bloemart [fig. 8]. He is also found again in *Peter Released by the Angel* (pl. 249) and in *Divertimento* 42 and 92. The dog in the left corner also derives from the same drawing. The two cows derive from a drawing in the Lehman Collection (Byam Shaw and Knox 1987: [157]) and the one at extreme left appears again in *Contemporary Life 10.* The signature is quite irregular.

9. *Angels Leading Anna Away from Her House*

TRADITIONS: No prototype for this scene has come to light, but it makes a separated pair with *Anna Returns to Her House* (pl. 15).

SOURCES: The dog scratching itself appears in a number of drawings by Domenico. It derives from Giambattista's etching *Scherzo di Fantasia 22* (Rizzi 1971: [25]) [fig. 74].

Figure 74. Giambattista Tiepolo, *Two Magicians and a Child* (etching, 1743, *Scherzo di Fantasia 22*)

10. *Anna Meets Joachim at the Golden Gate*

A second version, arranged more frontally, is found in plate 11, in which they are clearly shown meeting at the entrance to the temple itself. In neither case are they kissing, which in both the Greek and the Latin tradition indicates the immaculate conception of Mary. Unlike other representations, Domenico shows Joachim's horse and groom on the left, but Anna's donkey, which appears prominently in plate 11, is not shown here. Both are dismounted.

TRADITIONS: The scene appears among Giotto's frescoes in the Arena Chapel (Basile 1993: [34a]), where the kiss is clearly shown. It is found in the *Deutsche Bilderbibel* (1960: [I verso/a]), among the mosaics of the Chora in Istanbul (Underwood 1966: [86]), and in Dürer's *Life of the Virgin* (*The Illustrated Bartsch* 10, 1978: [79]) [fig. 76]. An interesting example from ca. 1500 is the painting by Vittore Carpaccio in the Accademia (Moschini Marconi 1955: [105]), formerly on an altar dedicated to Anna in the church of San Francesco in Treviso, in which an arm of the saint is also preserved. An important example by Bassano from ca. 1575 is in the parish church at Civezzano (Arslan 1960: [175]), which Domenico's composition echoes to some extent.

SOURCES: A woman with a basket of eggs, low left, recalls the Titian *Presentation of the Virgin* in the Accademia; however, it actually derives from Domenico's own etching *The Flight into Egypt 6* (Rizzi 1971: [72]) [fig. 75]. The horse and groom appear to derive from Giambattista's *Alexander and Bucephalus* in the Petit Palais (Paris, 1998, [73]), suggesting that the sketch was still with the Tiepolo family in the 1780s. The group is also found in the Pushkin Museum in Domenico's *Return of the Prodigal Son,* and is used in plates 200 and 306. Byam Shaw (1962: [43]) points out that this motif is used again in *Scenes of Contemporary Life 23.* The small dog in the center derives from

Figure 75. Domenico Tiepolo, *The Flight into Egypt 6* (etching, 1753)

Domenico's etching (Rizzi 1971: [151]), which, along with the adjacent dwarf, is copied from details in the Musée Jacquemart-André *Arrival of Henry III at Mira.* Very similar small dogs are found in plates 7, 35, 47, 100, 147, and 170. It derives from Domenico's etching *Dwarfs and Dogs* [fig. 93].

11. *Anna Meets Joachim Before the Temple*

TRADITIONS: This scene is no. 7 of the Giotto cycle (Basile 1993: [34b]) and appears in the Church of the Chora (Underwood 1966: 96–97, [86]), in the *Deutsche Bilderbibel* (1960: [I verso/a]), and in Dürer's *Life of the Virgin* (*The Illustrated Bartsch 10,* 1978: 174). It also appears as a detail in the central panel of the triptych by Gaudenzio Ferrari in the Brera [fig. 73]. The most memorable treatment in the sixteenth century is Jacopo Bassano's great altarpiece at Civezzano, near Trento, ca. 1575, which is paired with *John the Baptist Preaching* (Arslan 1960: 139–140, [175, 176]). In San Marco, the twelfth-century mosaic was replaced in 1690–1691 by Domenico Cigoli,

after a cartoon by Gianantonio Fumiani (Demus 1984: [fig. 50]; *San Marco* 1991: [98/1R]). It is also the third canvas by Lonardi at Breonio (Verona, 1978, [113]).

SOURCES: The horse and groom on the right derive from a drawing in the Uffizi (Byam Shaw and Knox 1987: [144, fig. 26]).

12. *Joachim and Anna on the Temple Steps*

TRADITIONS: In the Quentin Matsys polyptych at Brussels, *The Offering of Joachim and Anna in the Temple,* precedes *The Rejection of Joachim* (Silver 1984: [8, 9]).

SOURCES: The horse and groom in the lower left corner have already been noticed in plate 4 above; they are used again, reversed, in *Scenes of Contemporary Life 25* (Gealt and Knox 2005: [25]) [fig. 69]. The flying angel in the center derives from *The Flight into Egypt 5,* in reverse [fig. 103]; see also plates 47 and 227.

Figure 76. Dürer, *Joachim and Anna at the Golden Gate* (engraving, 1504, *The Life of the Virgin*)

13. *Joachim and Anna Praying in the Temple, I*

TRADITIONS: No adequate source of inspiration has been found for these subjects. Giotto in Padua (Basile 1993: [33b]) shows *The Sacrifice of Joachim* taking place in the open air, after *The Annunciation to Anna* and before *Joachim's Dream.* Something similar appears in the *Deutsche Bilderbibel* (1960: [IIb]) with the legend *"die opfert anna und joachim in dem tempel."* One of the panels of the Quentin Matsys triptych of Ste Anne of 1509 at Brussels shows *Joachim and Anna Offering Gifts to the High Priest,* [fig. 77].

14. *Joachim and Anna Praying in the Temple, II*

TRADITIONS: The scene appears on the first column of the Ciborium in San Marco (Gabelentz 1903: 9AIV) and in the *Deutsche Bilderbibel* (1960: [11b]) with the inscription *"The Offering of Anna and Joachim in the Temple."* In San Marco, the twelfth-century mosaic was replaced in 1690–1691 by Domenico Cigoli, after a cartoon by Giamantonio Fumiani (*San Marco* 1991: [97/3]). It may be noticed that Domenico seems to have had little interest in these designs, or indeed in that of Giuseppe Lonardi at Breonio (Verona, 1978, [112]).

For a direct representation of the scene as described in the *Book of James,* see the Quentin Matsys panel of 1509 in the Musée Royale des Beaux-Arts in Brussels [fig. 77]. Here there is no High Priest, nor do Joachim and Anna appear to be making an offering.

SOURCES: The crouching figure of Joachim derives perhaps from the similar figure in the Accademia *Institution of the Eucharist* [fig. 204]. Similar figures are found also in plates 148, 204, 208, 211, 239, 251, 260, 271, 278, 302, and 312.

Figure 77. Quentin Matsys, *Joachim and Anna Offering Gifts to the High Priest* (1509, Brussels, Musée Royale des Beaux-Arts)

15. *Anna Returns to Her House*

TRADITIONS: There is no known tradition for this scene.

SOURCES: The horseman appears again in *Paul on the Road to Damascus* (pl. 266) and in *Scenes of Contemporary Life 25A* (Gealt and Knox 2005 [26]) [fig. 78], a drawing newly recognized as being part of that series, in which the dog also appears.

Figure 78. Domenico Tiepolo, *A Cavalry Engagement Between Europeans and Turks* (drawing, location unknown)

16. *The Presentation of Mary in the Temple*

TRADITIONS: The scene appears on the first column of the Ciborium in San Marco, A8 (Weigel 1997: [Falttafel I.1]), among Giotto's frescoes in the Arena Chapel (Basile 1993: [74b]), and among the frescoes by Giusto de' Menabuoi in the Baptistery of the Duomo at Padua, as well as in the polyptych in the same building (Spiazzi 1989: 60.1 [39]; 79.25 [79]), where it appears in each. It is found among the mosaics of the Chora in Istanbul (Underwood 1966: [91]) and the later tradition is discussed by Lafontaine-Dosogne (1975: [17–20]). Among the mosaics in San Marco it appears in a design by Michele Giambono, 1433–1442 (*San Marco* 1990: [156, 157]; 1991: [197/1b]). It also is found in the *Deutsche Bilderbibel* (1960: [IIa]) and in Dürer's *Life of the Virgin* (*The Illustrated Bartsch* 10, 1978: 176). A popular subject in sixteenth-century Venice, it is treated by Carpaccio as the second of the series of six scenes from the life of the Virgin, painted for the Scuola degli Albanesi in or about 1504, now in the Brera (Molmenti and Ludwig 1907: 141–177, [172]; Borean 1994: [7]), in the celebrated canvases by Titian for the Scuola della Carità, and by Tintoretto in Sta. Maria del Orto. There is a second version in San Marco by Cigoli after Fumiani of 1691 on the upper west wall of the south transept (*San Marco* 1990: [164]; 1991: [100/3]).

Molmenti and Ludwig (1907: 156–157) point out that the Carpaccio cycle in the Scuola degli Albanesi was discovered by Giambattista Mingardi on June 1, 1784, and entered on August 29, 1784, in the catalogue of important paintings in Venice started by Anton Maria Zanetti. This new discovery could well have come to the attention of Domenico as President of the Venetian Academy. The same authors (cit. 161*ff*) offer a valuable study of Carpaccio's sources of inspiration for this cycle. Also related to this series are *The Marriage of Mary and Joseph* and *The Visitation* (pls. 27 and 33). It is not impossible that Domenico may also have known the Cima da Conegliano at Dresden, which left Venice in 1743 (*Gemäldegalerie* 1987: 133).

Figure 79. Federico Barocci, *The Presentation of the Virgin in the Temple* (1593–1594, Rome, Sta. Maria in Vallicella)

SOURCES: The general setting may well derive from the celebrated altarpiece of 1593–1594 by Federico Barocci in the left transept of Santa Maria in Vallicella (Olsen 1962: [71]) [fig. 79], which was engraved by Ph. Thomassin in 1615. The old lady with a basket of eggs passed from the small Cima at Dresden to the great canvas of Titian in the Accademia, seated again in left foreground. There is a variant on the same figure in *The Flight into Egypt 6* [fig. 75]. The man standing to her left derives from *Quaderno Gatteri 6* (Knox 1980: C.6) and is also found in *The Suitors Present Their Rods* (pl. 25). Joachim and Anna stand in the right foreground, at the foot of the fifteen steps.

17. *The Preparation for the Drawing of Lots*

TRADITIONS: No prototype for this scene has come to light.

SOURCES: The hound, low right, derives from a drawing by Domenico in the Uffizi [fig. 80].

Figure 80. Domenico Tiepolo, *Hounds* (Florence, Uffizi)

18. *The Seven Virgins Draw Lots*

TRADITIONS: No prototype for this scene has been noticed. However, both the setting and the main characters are found in the following sheet at Williamstown (pl. 19), which plays an established part in the Byzantine tradition.

SOURCES: The setting of the Temple looks rather like the interior of a large Venetian house, with a large Tiepolo painting hanging on the wall, based on the sketch of Giambattista's *Rinaldo and Armida* in Berlin [fig. 81]. This suggests that it was still with the Tiepolo family in the 1780s; it is first recorded as being taken to Russia by the dealer Antonelli in 1817. The statue of Leda on the left derives from a drawing with Kate de Rothschild in 1976 (Christie's, Mar. 29, 1966, [222]). The page on the left is found again in *The Feast in the House of Simon, I* (pl. 122); he derives from Veronese.

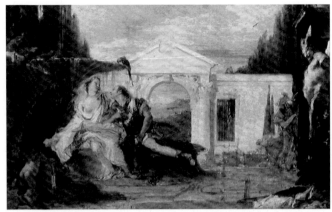

Figure 81. Giambattista Tiepolo, *Rinaldo and Armida in the Garden* (1753, Berlin, Staatliche Museen)

19. *The Young Mary Accepts the Scarlet and the Pure Purple*

TRADITIONS: Here we have prototypes among the twelfth-century mosaics of San Marco (*San Marco* 1991: [78/2]), [fig. 82], and in a mosaic of 1315–1320 in the Church of the Chora in Istanbul (Underwood 1966: [94])—both designs showing Mary receiving the prize from the High Priest and not from Anna, as shown in the present drawing. In San Marco the scene follows *The Annunciation,* shown as taking place outdoors in a garden with a well and a tree, somewhat reminiscent of *The Annunciation to Anna* (pl. 7), while Mary, flanked by three standing men, receives a ceramic pot, presumably holding the purple dye, from the High Priest. In the Chora, the High Priest, left, presents the bundle of purple wool to Mary, center, with the six other virgins, who are shown much older, as here, standing on the right. Two of them hold bundles of white wool. The theme is further discussed by Jacqueline Lafontaine-Dosogne (1975: [21]), who cites a miniature in the Vatican Library *Homilies of the Monk James,* fol. 109, but the subject seems to be completely forgotten in later ages.

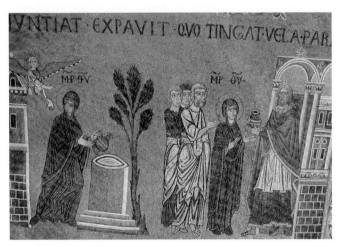

Figure 82. *The Child Mary Accepts the Scarlet and the Pure Purple* (mosaic, 12th century, Venice, San Marco, north transept)

20. *The Death of Joachim*

TRADITIONS: No other representation of this event appears to be recorded. The simple room and the kneeling angel are reminiscent of Giambattista's late painting of the Spanish years, *The Annunciation* (Venice and New York, 1996, [56]). Similar angels are found in plates 21, 52, 75, and 80.

21. *The Death of Anna*

TRADITIONS: The scene is represented here as an interior, with a glory of putti around the inscription that identifies the scene. This is followed by the *SEPOLTURA DI SANTA ANNA* (pl. 22). One may note that

neither scene is recorded in *The Golden Legend.* This is an unusually rich drawing, presumably executed late in the series. It is possible that the concept derives from the type of *The Death of the Virgin,* showing the body arranged across the picture plane. The raised hand might originally have held a candle, but we have found no appropriate prototype. No representation of *The Death of Anna* is found in our regular sources. The most celebrated version, no doubt, is that found in the Saint Anne polyptych of Quentin Matsys of 1509 in Brussels (Silver 1984: [6]) [fig. 83]. However, there is a very important altarpiece representing this subject by Andrea Sacchi of 1649 in the left transept of San Carlo ai Catinari (Harris 1977: [150]) in which Anna is represented on her death bed, surrounded by the Holy Family. Fabrizio Chiari (ca. 1615–1695) painted a further substantial altarpiece on this theme for the church of Regina Coeli in the Trastevere, commissioned by Anna Colonna, together with an *Assumption of the Virgin* by the same artist. The building was swept away in the 1880s to make way for the prison that perpetuates the name. The painting, 264 x 175 cm, reappeared at Sotheby's (New York, Jan. 25, 2001, [197A]). Again, it shows Anna surrounded by the Holy Family and many other figures.

SOURCES: The crouching figure of an angel in the foreground seems to derive from the Stockholm *Institution of the Eucharist* (Mariuz 1971: [63]).

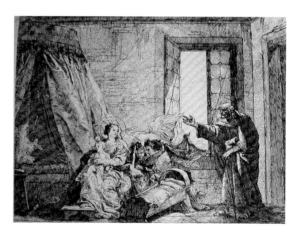

Figure 83. Quentin Matsys, *The Death of Anna* (1509, Brussels, Musée Royale des Beaux-Arts, 299)

22. *The Burial of Anna*

TRADITIONS: No prototype has been noted. One must note the presence of John the Baptist as a grown man, kneeling on the left, while four angels lower Anna into her simple grave, located in a wild mountainous setting. This recalls the death of Elizabeth, as recounted in *The Life of John,* according to Serapion, which records that John was only seven years old at the time, that Jesus, Mary, and Salome flew on a cloud to John in the desert to comfort him, and that the angels Michael and Gabriel came down from heaven and dug a grave. The present scene is preceded by a sheet in the Louvre (pl. 21), which is similarly inscribed *LA MORTE DI S. ANNA.* That collection also contains a somewhat similar scene, also including the Baptist, which may be identified as *The Death of Elizabeth* (pl. 96). Conrad suggests that Domenico's inscription here is an error, and that *The Burial of Elizabeth* is intended.

23. *The Annunciation to the High Priest Zacharias*

TRADITIONS: The scene is found among the mosaics of San Marco (*San Marco* 1991: [78/1L]), but no other prototype has come to light. The motif of the great canopy is reminiscent of *The Dream of Constantine* by Piero della Francesca at Arezzo; closer to home, it is found in the interview between King Maurus and St. Ursula, in the righthand section of *The Arrival of the Ambassadors,* in the St. Ursula cycle by Carpaccio in the Accademia.

SOURCES: The setting derives from *The Flight into Egypt 4* (Rizzi 1970: [70]), [fig. 84]. The flying angels that appear so frequently in this drawing may be compared with similar elements in the mosaics of San Marco (Demus 1984: [237–240]). The dog is found in several other drawings, such as plate 83.

Figure 84. Domenico Tiepolo, *The Flight into Egypt 4* (etching, 1753)

24. *"CONSERVATORIO"*

TRADITIONS: No prototype for this scene has been noted. However, one may note the parallel with *The Virgin's Wedding Procession* by Giotto in the Arena Chapel, particularly in the group on the left.

25. *The Suitors Present Their Rods*

TRADITIONS: The mosaics of San Marco depict *The Rods Placed Upon the Altar* (*San Marco* 1991: [78/1]). The scene is treated by Giotto in the Arena Chapel (Basile 1993: [75a]).

SOURCES: The young man in the center derives from the Pushkin Museum's *Return of the Prodigal Son* [fig. 183] and perhaps ultimately from the page in the foreground of *The Investiture* fresco at Würzburg (Freeden and Lamb 1956: [66]). The man in the foreground on the left with his back turned derives from a study in the *Quaderno Gatteri* (Lorenzetti 1946: [6]; Knox 1980: C.6); it also appears in the same sense from the similar figure reversed in the center foreground of *Via Crucis VII.* The young man with a rod in the left foreground is in the Veronese *Feast in the House of Simon* in the Louvre (Martini 1968: [163]), but reversed, indicating that it derives from the etching by Valentin Lefebre [fig. 161]. An elaborate architectural element in the background is indicated in black chalk, but not completed.

26. *The Betrothal of Mary*

TRADITIONS: The subject is found among the mosaics of San Marco (Demus 1984: [150]; *San Marco* 1991: [78/1]), where two scenes are depicted: on the left, *Zacharias Praying Before the Altar with the Rods Upon It;* on the right, *The Betrothal of the Virgin* [fig. 85]. A similar arrangement is found in the mosaics of the Chora in Istanbul, of 1310–1315 (Underwood 1966: [95, 96]). This scene is also depicted in the *Deutsche Bilderbibel* (1960: [folio II verso/a]).

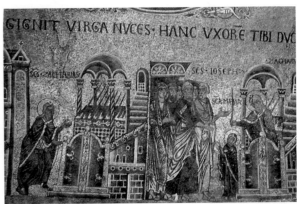

Figure 85. *The Betrothal of the Virgin* (mosaic, 12th century, Venice, San Marco, north transept)

27. *The Marriage of Mary and Joseph*

TRADITIONS: The scene is illustrated by Giotto in Padua (Basile 1993: [76a]) and in a miniature of the fourteenth century *Meditationes vitae Christi* (Ragusa and Green 1961: [10]), in which Joseph is unequivocally putting the ring on Mary's finger. It is found again in the *Deutsche Bilderbibel* (1960: [folio II verso/b]) and in Dürer's *Life of the Virgin* (*The Illustrated Bartsch* 10, 1978: [82]). It was treated by Carpaccio as the third of the series of six scenes from the life of the Virgin, painted for the Scuola degli Albanesi in or about 1504, now in the Brera (Molmenti and Ludwig 1907: 141–177 [182]; Borean 1994 [8]). Pigler notes a painting by Palma Giovane in Venice, Spirito Santo (Santo Spirito in Isola?; see Mason Rinaldi 1984), not traced, and by Zanchi in Sta. Maria della Salute at Este. Verri cites the sculpture by Giuseppe Torretto in Ss. Giovanni e Paolo, one of a series of important marble reliefs of 1730 showing scenes from the infancy of Christ in the Chancel of the Chapel of the Rosary (Guerriero 1994: [21, 22]).

SOURCES: The three central figures seem to derive from the masterpiece by Corrado Giaquinto (1703–1766) for the Sacristy of San Luigi di Palazzo, Naples, now in Pasadena (Detroit, 1982, 108–116 [25a] [fig. 86]; see also the sketch,

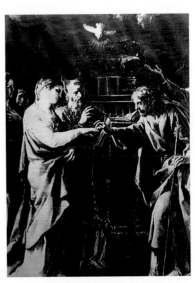

Figure 86. Corrado Giaquinto, *The Marriage of the Virgin* (1764–1765, Pasadena, The Norton Simon Museum)

London, Colnaghi 1967 [33]). The man standing on the right seems to derive from a drawing by Giambattista in the Victoria & Albert Museum (Knox 1960/1975: [158]).

28. *Mary and Joseph Leave the Temple*

TRADITIONS: A comparable scene is found among the mosaics of the Chora in Istanbul (Underwood 1966: [97]) [fig. 87] showing Mary and Joseph and a young man, identified as a son of Joseph, leaving the Temple; however, this may well be associated with the scene that follows.

29. *Mary and Joseph Return to the House*

TRADITIONS: This rare subject seems to be found only among the frescoes of Giotto in Padua (Basile 1993: [76b]), where it completes the upper register of the frescoes. However, the mosaic in the Chora (see the note on the preceding drawing) seems to show a group of three, including Joseph and Mary, leaving the temple and arriving at the house; thus it is possible that Domenico consciously separated two known scenes. The composition here, which is clearly reminiscent of the Giotto, is related to a Punchinello drawing, *Divertimento per li Regazzi 4* (Gealt 1986: [12]; New York, estate of Peter Jay Sharp). The boys that are prominent in the left foreground are sometimes identified as Joseph's four sons (Lafontaine-Dosogne 1975: 186–187).

Figure 87. *Mary and Joseph Leave the Temple* (mosaic, 1310–1315, Istanbul, Church of Saint Saviour in the Chora)

SOURCES: The boy in the left foreground derives, in reverse, from the Pushkin Museum *Return of the Prodigal Son* [fig. 183].

30. *Joseph Taking Leave of Mary*

TRADITIONS: The subject forms a pair with the following drawing using the same setting, as it does among the mosaics of the Chora in Istanbul (Underwood 1966: 148–151, [99]) [fig. 88]. Lafontaine-Dosogne (1975: [16]) draws attention to a similar arrangement in the *Homilies of James* (fol. 108). Hence, this is another instance of Domenico following closely upon the Greek tradition. The scene should logically be followed by *The Annunciation,* which is missing in our series. Conrad points out that there are similar elements in the setting of *The Carpenter's Shop, Divertimento 56* (Gealt 1986: [51]).

Figure 88. *Joseph Leaving Mary; Joseph Scolding Mary* (mosaic, 1310–1315, Istanbul, Church of the Chora)

31. *Joseph Scolding Mary*

TRADITIONS: The subject appears on the second column of the Ciborium in San Marco (Gabelentz 1903: B.I), where it follows *The Annunciation,* as it does among the mosaics of San Marco (Demus 1984: [152]; *San Marco* 1991: [78/3]), inscribed: *Crimina Joseph* [fig. 89]. As noted above, the subject forms a pair with the preceding drawing among the mosaics of the Chora (Underwood 1966: [99]) [fig. 88]. A strict sequence might require this scene to follow *The Visitation.* It also appears

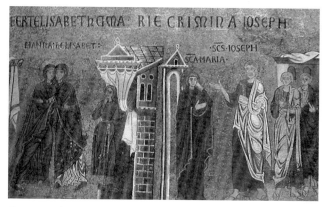

Figure 89. *The Annunciation; Joseph Scolding Mary* (mosaic, 12th century, Venice, S. Marco)

in a miniature in the fourteenth-century *Meditationes vitae Christi* (Ragusa and Green 1961: [21]), but no visual prototype of the sixteenth to eighteenth centuries has come to light.

32. *Mary and Joseph Set Out to Visit Elizabeth*

Christofer Conrad first suggested that, in view of the absence of the Christ child, this scene, together with plates 52, 58, and 59, should be identified, not as *The Flight into Egypt,* but as *Joseph and Mary on the Road to Nazareth.* For the latter scene, see plate 36.

SOURCES: The figures derive from Domenico's etching *The Flight into Egypt 24* (Rizzi 1971: [90]) [fig. 90]; that etching clearly shows the head of the Christ child in Mary's arms, though it is omitted here, as is the basket on Joseph's back. The aureole of angels' heads may be traced to Stefano della Bella (Massar 1971: [11]).

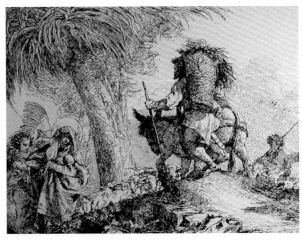

Figure 90. Domenico Tiepolo, *The Flight into Egypt 24* (etching, 1753)

33. *The Visitation*

TRADITIONS: The scene is extremely popular in all ages, being found on the second column of the Ciborium in San Marco (Gabelentz 1903: B.I). It is represented twice in the mosaics of San Marco: in a twelfth-century mosaic that precedes *Joseph Scolding Mary* (*San Marco* 1991: [78/1]), and in a grand architectural setting by Michele Giambono of the fifteenth century (Demus 1984: [152]; *San Marco* 1991: [198/3]). The scene also appears among the mosaics of Monreale (del Giudice 1702: [XVIII.4]) and in *The Rockefeller McCormick New Testament* (1932: folio 57 verso) in Giotto's frescoes in Padua (Basile 1993: [122a]. Among the series of frescoes by Giusto de' Menabuoi in the Baptistery of the Duomo at Padua, and in the polyptych in the same building (Spiazzi 1989: 60.1 [39]; 79.25 [79]), it is treated as an interior with both Joseph and Zacharias. It is treated by Dürer in *The Life of the Virgin* (*The Illustrated Bartsch* 10, 1978: 179) and by Virgil Solis in the *Biblische Figuren* (Solis 1565: [183])—in both cases as an exterior without Joseph. However, Jacob de Bye after Maarten de Vos in the *Vita, Passio et Resurrectio Iesu Christi* (n.d.: [3]) shows it as an exterior with Joseph present. In the fifth of the series of six scenes from the life of the Virgin, painted for the Scuola degli Albanesi in or about 1504, now in the Correr Museum (Molmenti and Ludwig 1907: 141–177, [179]; Mariacher 1957, 66–67; Borean 1994: [10]), Carpaccio treats it as a townscape, with neither Joseph nor Zacharias clearly evident.

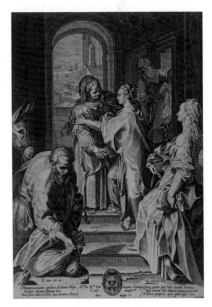

SOURCES: Domenico neglects all these Venetian prototypes. For the main figures, with the exception of Joseph, he follows, as Conrad notes, the celebrated painting of the same subject of 1583–1586 by Federico Barocci in the fourth chapel on the left in the Chiesa Nuova in Rome (Olsen 1962: [59]). This was presumably known to Domenico through one of three engravings, by Gysbert van Veen, 1588 (*Kitto Bible* 1836: 43-7959) [fig. 90], Thomassin (1594), or Philip Galle (*Hollstein 75,* 1996: no. 97). This painting raised San Felipe Neri into a state of ecstasy and became a favorite with the Oratorians, as exemplified by the Amigoni in the Fava (Scarpa Sonino 1994: [35]).

Figure 91. Gysbert van Veen after Federico Barocci, *The Visitation* (etching 1588, San Marino, The Huntington Library)

34. The Magnificat

TRADITIONS: The essential elements of this scene are found in a miniature of the *Meditationes vitae Christi* (Ragusa and Green 1961: [16]), which shows both Elizabeth and Mary, as well as Joseph and Zacharias embracing, with an open door on the right.

For Domenico the most conspicuous modern representations of these themes would have been the painting by Piazzetta, finished by Angeli, over the High Altar of the Venetian church of Sta. Maria della Visitazione, the Pietà (Knox 1992: [121]), showing both Joseph and Zacharias and the donkey at the door of Zacharias's house. Verri cites the sculpture by Luigi and Carlo Tagliapietro in Ss. Giovanni e Paolo, one of a series of important marble reliefs of 1730 showing scenes from the infancy of Christ in the Chancel of the Chapel of the Rosary. This has points of similarity, especially the figure of Zacharias in the door-way on the right, as in the preceding drawing (Semenzato 1966: [201]; Guerriero 1994: [9, 10]).

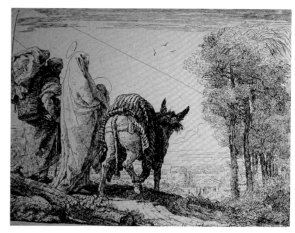

Figure 92. Domenico Tiepolo, *The Flight into Egypt 10* (etching, 1753)

SOURCES: For the donkey at bottom left, see also *The Flight into Egypt 10* (Rizzi 1971: [76]) [fig. 92]. The woman on the right derives from Domenico's *Birth of the Virgin* in the Albertini collection in Rome, in reverse (Mariuz 1971: [60]).

35. Mary and Joseph take leave of Zacharias and Elizabeth

TRADITIONS: Domenico's design seems to be a variation of the familiar theme of *The Visitation* taking place at the entrance of the house of Zacharias. The Dürer woodcut from *The Life of the Virgin* (pl. 9) omits Joseph, as indicated by Luke 1:40 and the *Book of James*. A good example that includes Joseph is plate 3 of the *Vita, Passio et Resurrectio Iesu Christi* (Collaert, n.d.: [3]). Domenico, however, crowds the scene with a number of other figures, suggesting the sorrow of a departure rather than the joy of an arrival.

In eighteenth-century Venice, one may cite important examples, such as the altarpiece by Jacopo Amigoni of 1743 for the Church of the Fava (Scarpa Sonino 1994: [35]) and the High Altar of the Church of the Pietà of 1753–1754, the last work of Giambattista Piazzetta, completed by Giuseppe Angeli (Knox 1992: [121]). Both of these feature Joseph prominently.

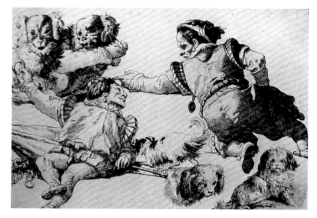

Figure 93. Domenico Tiepolo, *Dwarfs and Dogs* (etching)

SOURCES: The woman standing on the right derives from the drawing at Edinburgh [fig. 115]; see also plates 2, 65, 152, and 214. The dog derives from Domenico's etching, *Dwarfs and Dogs* (Rizzi 1971: [151]) [fig. 93].

36. The Return to Nazareth

TRADITIONS: In the Church of the Chora in Istanbul (Underwood 1966: [100]), the mosaic representing this scene is shown in two parts: on the left, *Joseph Dreaming with an Angel, with Mary and Elizabeth;* on the right, *Mary and Joseph Setting Out for Bethlehem,* showing Mary riding, looking back, and saying farewell to an old man,

perhaps Zacharias. Underwood identifies the three figures as Joseph, Mary, and a son of Joseph. The scene is also recorded in a miniature in the *Meditationes vitae Christi* [fig. 94].

37. *"IN ECELCIS DEO"—The Annunciation to the Shepherds*

TRADITIONS: This scene appears on the second column of the Ciborium in San Marco (Gabelentz 1903: B.II) and among the mosaics of Monreale (del Giudice 1702: [18.8]). In the mosaics of the Church of Saint Saviour in the Chora, Istanbul, *The Nativity* appears on the left and *The Annunciation to the Shepherds* on the right; the latter is not unlike the present design (Underwood 1966: [102]). It is found in the *Deutsche Bilderbibel* (1960: [folio III verso/a]) and in an engraving after Maarten de Vos in the *Theatrum Biblicum* (1674: [6]). In the engraving after Maarten de Vos in the *Vita, Passio et Resurrectio Iesu Christi* (n.d.: [4]), *The Annunciation to the Shepherds* appears in the background of *The Adoration of the Shepherds.* Important Venetian examples are the Jacopo da Ponte in the Accademia di San Luca, Rome, and the related Leandro da Ponte in the Museo Civico, Padua (Arslan 1960: [148, 298]).

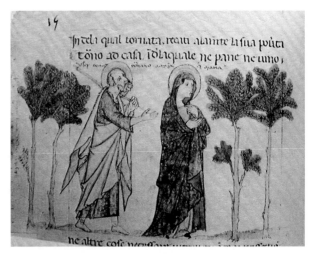

Figure 94. *The Return to Nazareth* (miniature, 14th century, Paris, Bibliothèque Nationale, Ms. Ital. 115)

38. *The Adoration of the Shepherds*

TRADITIONS: *The Adoration of the Shepherds* is often barely distinguishable from *The Nativity of Christ,* as in Giotto in the Arena Chapel (Basile 1993: [122b]; *Deutsche Bilderbibel* 1960, [folio III verso]; Dürer, *The Small Passion 20;* Solis 1565: [107]). Domenico may well have known the large Veronese *Adoration of the Shepherds* in the Crociferi, now in the Cappella del Rosario, Ss. Giovanni e Paolo (Marini 1968: [117]). It is again treated by Jacopo da Ponte in an important altarpiece for the church of San Giuseppe in Bassano, of 1568, now in the Museo Civico (Arslan 1960: [150]), in a pattern that appears to derive from Dürer. The scene is popular with the Antwerp engravers, such as Adrien Collaert after Maarten de Vos, *Vita, Passio et Resurrectio Iesu Christo* (n.d.: [4]), or Wienix after Passeri in the *Evanglicae Historiae Imagines* (1593: [4]), though neither is very helpful. A different design attributed to Maarten de Vos appears in the *Theatrum Biblicum* (1674: [7]).

The subject is a familiar one in eighteenth-century Venice. A fine example is the painting by Antonio Balestra in San Zaccharia of 1704 (Polazzo 1990: [11]). Verri cites the sculpture by Giovanni Bonazza in Ss. Giovanni e Paolo, one of a series of important marble reliefs of 1730 showing scenes from the infancy of Christ in the Chancel of the Chapel of the Rosary. An early drawing by Giambattista at Marseilles, engraved by Pietro Monaco (1763: [22]), owes much to Bassano; other early drawings by Giambattista are known (Knox 1965: [figs. 8, 11, 12]). It is also treated by Domenico in an early drawing in Milan (Udine 1996: [14]) and in a small painting at Stockholm (Mariuz 1971: [63]). None of these are close to the present design, though the peasant woman with a basket of eggs and keys at her belt seems to have found her way in from the Milan drawing.

SOURCES: The curious figure of a shepherd with a staff and a hat on the right, apparently with one leg, derives from a drawing by Giambattista at Washington (London, 1994, [101]) [fig. 95].

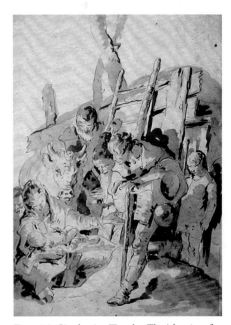

Figure 95. Giambattista Tiepolo, *The Adoration of the Shepherds* (Washington, National Gallery of Art, 1982.39.1)

39. *The Circumcision of Jesus*

TRADITIONS: The scene appears in a miniature in the fourteenth-century *Meditationes vitae Christi* (Ragusa and Green 1961: [59]), in which Mary is shown as performing the ceremony herself. A small canvas by Giovanni Bellini was copied by the young Domenico Tiepolo, now in the Victoria & Albert Museum (Udine 1996: [4]) [fig. 96]. The subject was treated on a monumental scale in the sixteenth century by Francesco da Ponte in 1577 for the Duomo at Bassano (Arslan 1960: [219]) and by Leandro da Ponte in 1582 for the parish church at Rosa (Arslan 1960: [283]). The subject was also enormously popular in print form, appearing in Dürer's *Life of the Virgin,* in the woodcut by Virgil Solis in the *Biblische Figuren* (Solis 1565: [108]), and among the 153 engravings by Wierix after Passeri for the Jesuit book of devotions, *Evangelicae Historiae Imagines* (1593: [5]; Philadelphia, 1996, 95), as well as in an engraving after Maarten de Vos in the *Theatrum Biblicum* (1674: [8]), which is comparable. Domenico may also have been aware of the painting by Barocci in the Louvre, which, before the Napoleonic period, was in Pesaro.

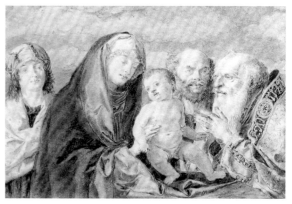

Figure 96. Domenico Tiepolo, after Giovanni Bellini, *The Circumcision* (1743, London, Victoria & Albert Museum, C.A.I. 1044)

An eighteenth-century example, again on a large scale, is the canvas by Giambattista Pittoni from the Servi, now in the Conservatorio Benedetto Marcello (Moschini Marconi 1970: III [168]; Zava Bocazzi 1979: [156, 157]). Domenico would also have known the Nicolo Bambini in the Scuola dei Carmini (Knox 1992: [7]).

SOURCES: The figure of the Virgin derives from *Fugga in Egitto 10* [fig. 92] and is found in reverse in *Fugga in Egitto 16.* It is found again in plate 48, and is repeated in plates 203, 217, and 218. The man on the left derives from *Via Crucis VII.*

40. *The Adoration of the Kings*

TRADITIONS: The theme is found in all the early sources—one may cite the sixth-century mosaics in Ravenna, Sant'Apollinare Nuovo, and two mosaics in San Marco, one of the twelfth century (*San Marco* 1991: [60/2]) and one of the fourteenth (*San Marco* 1991: [184/7]). We may assume that Domenico was also aware, through the engravings published by del Giudice, of the mosaics at Monreale of 1180—on the left, *The Journey of the Magi,* and on the right, *The Adoration of the Kings* (del Giudice 1702: [18.9, 10]). He also no doubt knew the frescoes by Giotto in the Arena Chapel (Basile 1993: [123a]) and Giusto de' Menabuoi in the Baptistery at Padua (Spiazzi 1989: 63.2 [40]).

The subject was popular in Venice in the sixteenth century—recall the great canvases by Veronese in London and Vicenza (Marini 1968: [165, 198])—and again in the eighteenth century: the brilliant painting by Ricci at Hampton Court and the large canvas by Gaspare Diziani in San Stefano (Zugni-Tauro 1971: [19]). Verri cites the sculpture by Giovanni Bonazza in Ss. Giovanni e Paolo, one of a series of important marble reliefs of 1730 showing scenes from the infancy of Christ in the Chancel of the Chapel of the Rosary. The scene is popular with the Antwerp engravers—Adrien Collaert after Maarten de Vos, *Vita, Passio et Resurrectio Iesu Christo* (n.d.: [6]), or by Wierix after Maarten de Vos (Natali 1593: [7])—though neither is very helpful.

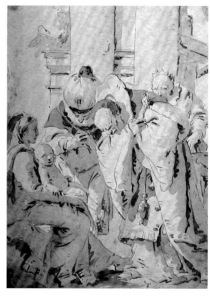

Figure 97. Giambattista Tiepolo, *The Adoration of the Kings* (Paris, Musée du Louvre, MNR, Rec 69)

The subject was treated in numerous drawings by Giambattista Tiepolo, as well as in his largest etching, leading up to the altarpiece now at Munich (Knox 1994: [9, 12, 13, 17]) [fig. 97]. Domenico, however, seems to have avoided these grandiose prototypes. He also would have known the composition by Luca Giordano engraved by Pietro Monaco (1743: no. 46; 1763: no. 42). The setting may be

compared with Dürer's woodcut of the same subject in *The Life of the Virgin* (*The Illustrated Bartsch 10,* 1978: 87, [132]), which Domenico is said to have had in his possession.

SOURCES: The king in the foreground derives from a drawing by Giambattista in the Louvre (Paris, 1998, [104], formerly Hendecourt sale 1929: [269]), and the figure of the Virgin is not unrelated. The young king derives indirectly from *The Adoration of the Kings* of 1504 by Dürer in the Uffizi (*Klassiker der Kunst* 1904: [34]).

41. *The Presentation of Jesus in the Temple*

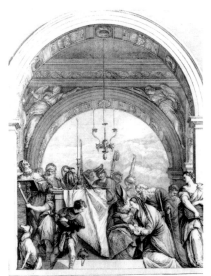

TRADITIONS: The scene appears among the mosaics of Monreale (del Giudice 1702: [XVIII.15]), among Giotto's frescoes in Padua (Basile 1993: [123b]) and those by Giusto de' Menabuoi in the Baptistery of the Duomo at Padua (Spiazzi 1989: 64.3, [40]), in Dürer's *Life of the Virgin* (*The Illustrated Bartsch 10,* 1978: 183), and in the *Biblische Figuren* by Virgil Solis (1565: 117). In San Marco there is a late mosaic by Marini after Tintoretto of 1588–1589 (*San Marco* 1991: [60/3]).

 The subject was painted three times by Domenico (Mariuz 1971: [64–66]). The group of the Holy Family is close to the painting in Dresden (Mariuz 1971: [65]), though in reverse. One may compare the treatment with the large finished drawing by Fontebasso in the Correr Museum (Pignatti 1981: [449]).

SOURCES: It is clear that Domenico studied the celebrated painting by Veronese for the organ of San Sebastiano (Marini 1981: [57A]), from which he took the great arch and the candle, the figure of the Virgin and Child, the lady (here identified as Anna) standing in the left foreground, and several other details. It is not unlikely that Domenico was using the engraving by Valentin Lefebre from the *Opera Selectiora* (1682: [23] [fig. 98]; Ticozzi 1975: [41]; Ruggeri 2001 [I.30]), although this is in reverse. A parallel situation occurs in relation to a similar borrowing from Veronese in *The Feast in the House of Simon, I* (pl. 122). The composition is cut down at the top, which might suggest that Domenico was working from a copy of the Veronese by Lefebre, now at Hollyroodhouse (Levey 1991: [185]), which is also abridged in a similar fashion but in the same sense as our drawing. The standing man with a sword and his back turned, on the extreme right, plays a similar role in plate 232 and in *Divertimento 3.* It derives from a drawing by Giambattista at Stuttgart [fig. 248].

Figure 98. Valentin Lefebre after Paolo Veronese, *The Presentation of the Christ Child in the Temple,* from the *Opera Selectiora* (Venice, 1682, [23])

42. *Herod Consults with the Wise Men and the Priests*

TRADITIONS: The early representations of this scene show Herod seated with advisers on the right and the three kings approaching on the left. Here Domenico shows three priests, left, and Herod, flanked by three kings, right—an interesting modification of the traditional approach. The scene finds a separate pair in *The Chief Priests in the Palace of Caiaphas* (pl. 177). The subject is found on the second column of the Ciborium in San Marco (Gabelentz 1903: B.II) and among the fourteenth-century mosaics in the Baptistery in San Marco (*San Marco* 1991: [184/6]) [fig. 99]. In the Chora the scene is shown in two pendant parts: *The Journey of the Magi,* left, and *The Magi Standing Before Herod Enthroned,* right (Underwood 1966: [103]), followed by

Figure 99. *Herod Consults the Wise Men and the Priests* (mosaic, 14th century, Venice, San Marco, Baptistery)

Herod Consulting Priests and Scribes, mostly missing (Underwood 1966: [104]). In later times one may cite only the engraving by Wierix after Passeri from the *Evangelicae Historiae Imagines* (1593: [5]). One may also note the Ercole Procaccini in the Certosa at Pavia, 1632.

43. *The Massacre of the Innocents*

TRADITIONS: The subject is found in all our basic sources, though not with the Baroque exuberance of our drawing. First, it appears among the mosaics of Monreale as two pendant scenes: *Herod Orders the Massacre,* on the left, and *The Massacre of the Innocents,* on the right (del Giudice 1702: [XVIII.11 and 12]), with a similar arrangement found in the mosaics of the Chora (Underwood 1966: [107]). It also appears among the mid-fourteenth-century mosaics in San Marco, in the Baptistery (*San Marco* 1991: [184/9]), in *The Rockefeller McCormick New Testament* (9 verso), painted by Giotto in the Arena Chapel (Basile 1993: [124b]), among the the series of frescoes by Giusto de' Menabuoi in the Baptistery of the Duomo at Padua (Spiazzi 1989: 61.4, [39]), and in the *Deutsche Bilderbibel* (1960: [IV verso/a]).

The dominant image in the sixteenth century is the celebrated print by Marcantonio Raimondi after Raphael, but it is treated by Virgil Solis in the *Biblische Figuren* (Solis 1565: [176]) and in an engraving by Adrien Collaert after Maarten de Vos in the *Vita, Passio et Resurrectio Iesu Christi* (n.d.: [9]). A large sixteenth-century example is the Bonifacio de Pitati from the Palazzo dei Camerlenghi, now in the Accademia (Moschini Marconi 1962: [62]). It is also treated by Tintoretto in the Scuola di San Rocco, by Liberi in the Ognissanti (lost), and by Zanchi in the Scuola della Misericordia. The motif of the dagger held vertically in the center of the composition finds a parallel in the celebrated Guido Reni in Bologna (Baccheschi 1971: [66]), descending from the celebrated altarpiece by Matteo di San Giovanni in Santa Maria dei Servi, Siena.

Domenico certainly knew the Carpioni, engraved by Pietro Monaco (1743: [L]; 1763: [93]), and he may well have known the fine painting by Luca Giordano, then in the Palazzo Vecchia in Vicenza, and now in the Museo Diocesano in Venice (Ferrari and Scavizzi 1992: A 22, not illus.: *cf.* Fragonard drawing in Pasadena, A 2527). The major treatments of this subject in eighteenth-century Venice are the large Celesti at Dresden, 273 x 436, inv. 1722, the lost canvas by Sebastiano Ricci for the Scuola della Carità (Daniels 1976: [588]), and the two large canvases by Diziani in the Sacristy of San Stefano of 1733 (Zugni-Tauro 1971: [18, 20]). In neither case is there any essential connection. Paintings are also recorded by Bambini in the Frari, by Lazzarini in the Servi, and by Molinari at Noale.

44. *The Holy Family with the Young John the Baptist and Angels*

TRADITIONS: Conrad notes that this scene is related in the *Meditations on the Life of Christ* (Ragusa and Green 1961: 64–65, [54]), though it must be noted that here Zacharias and Elizabeth are not shown. The only early prototype for this scene that has come to light is in the Paris manuscript of the *Meditationes* (Ragusa and Green 1961: [54]). However, beginning with Leonardo da Vinci (National Gallery cartoon) and on through the sixteenth and seventeenth centuries, from Raphael and Andrea del Sarto to Rubens and Poussin (Paris, 1994, [210]), the theme of the Virgin, or the Holy Family, with or without Anna, but including the young John the Baptist together with the Christ child, became enormously popular. Volume 46 of *The Kitto Bible,* folios 8273 to 8442, is devoted to this theme.

SOURCES: The barn in the background derives from the drawing with the Walpole Gallery (London, 1991, [20]). It is also used for *Divertimento per li regazzi* 6 (Udine 1996: [158]). The Virgin and Child derives from *The Holy Family* by Giambattista [fig. 100], formerly in the Talleyrand collection (Morassi 1958: [11]).

Figure 100. Giambattista Tiepolo, *The Holy Family* (formerly Duc de Talleyrand)

45. *The Holy Family Visits Zacharias, Elizabeth, and the Young John*

TRADITIONS: The only early prototype for this scene that has come to light is in the Paris manuscript of the *Meditationes vitae Christi* (Ragusa and Green 1961: [54]). However, beginning with Leonardo da Vinci (National Gallery cartoon) and on through the sixteenth and seventeenth centuries, from Raphael and Andrea del Sarto to Rubens and Poussin (Paris, 1994, [210]), the theme of the Virgin, or the Holy Family, with or without Anna, but including the young John the Baptist together with the Christ child, became enormously popular. Volume 46 of *The Kitto Bible,* folios 8273 to 8442, is devoted to this theme. Giambattista Tiepolo's series of some 110 pen drawings with variations on the theme of *The Holy Family* often include the young John the Baptist [fig. 102], but Domenico here turns his back on this fervent tradition and makes it into a homey scene in which both families, including Zacharias, are present.

Figure 101. Nicolas Poussin, *The Holy Family with Anna and the Infant John the Baptist* (1651, Malibu, J. Paul Getty Museum & Pasadena, Norton Simon Museum)

46. *The Holy Family with Elizabeth, Zacharias, and the Young John*

TRADITIONS: Note the entry on the previous drawing. One may also note a large engraving by Matham after Golzius, with the Holy Family on the right, while Zacharias, Elizabeth, and John approach on the left (*Kitto Bible* 45–8160).

In a discussion of Giambattista's *The Adoration of the Christ Child,* painted for San Zulian in 1732 and now in the Sacristy of San Marco, in which Joseph is once again holding the Christ child (Niero 1999: [243]; see also Catherine Whistler in New York, 1997, [28]), Monsignor Antonio Niero has shown that Giambattista draws heavily on the devotional book by Giuseppe Antonio Patrignani, *La santa infantia del figliuol di Dio,* first published in Florence in 1708 and in a second edition in Venice in 1715–1722. It is possible that this is the more immediate source for this pattern of imagery.

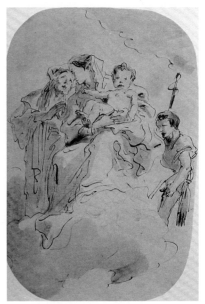

Figure 102. Giambattista Tiepolo, *The Virgin and Child with Elizabeth and the Young John the Baptist* (New York, Pierpont Morgan Library, Heinemann Collection, 1982.97)

47. *The Holy Family Leaves the House*

TRADITIONS: The scene is found is all the early sources, such as in the mosaics of San Marco (*San Marco* 1991: [74/4]). Verri (1991) cites the sculpture by Giovanni Morlaiter in Ss. Giovanni e Paolo, one of a series of important marble reliefs of 1730 showing scenes from the infancy of Christ in the Chancel of the Chapel of the Rosary (Semenzato 1966: [208]).

As a single event, *The Flight into Egypt* enjoyed great popularity from the earliest times down to the period of Domenico himself. In the age of the Baroque, Pigler (1956) lists about 1,000 examples, and Voss (1957) illustrates 48 examples from Veronese to Tiepolo, but these generally display no special interest in the apocryphal stories. The theme has been studied by Sheila Schwarz (1975), who notes groups of miniatures in manuscripts from

Figure 103. Domenico Tiepolo, *The Flight into Egypt 5* (etching, 1753)

England and France of the fourteenth century, notably *The Holkham Bible Picture Book,* which illustrates nineteen scenes from the story (Hassall 1954: [14–15v]). It is the subject of twenty drawings in the *Recueil Luzarche* and of thirteen drawings in the *Recueil Fayet.* Many of them show links with the 24 etchings on this theme, punished by Domenico in Würzburg in 1753: *Idee Pittoresche sopra la Fugga in Egitto* (Rizzi 1971: [67–96]) [fig. 103], including the three title pages, and three additional etchings that were not included in that publication. These appear to have been inspired by material encountered by Domenico in Germany. The etchings broadly do not refer to the events described in the apocryphal gospels, but among the drawings such references are more frequent; indeed, all the salient details of the story are faithfully described.

SOURCES: The Holy Family, the angel, and the donkey all derive from *The Flight into Egypt 5* (Rizzi 1971: [71]).

48. *The Flight into Egypt with the Almighty*

TRADITIONS: While we have not noted any Venetian tradition for including the Almighty so prominently in the Flight into Egypt, there is the Neapolitan tradition of the *Trinitas Terrestris,* in which the Almighty and the Holy Spirit intersect with the Holy Family. One may cite the Luca Giordano at Pontecorvo, *The Almighty with Ss Giuseppe and Teresa,* of 1660 (Spinosa 1984: [71, 224, 440]), and the etchings by Castiglione, *God the Father with Angels Adoring the Christ Child with Mary* (*The Illustrated Bartsch 21,* 1978: 13.7) and *The Holy Family with the Almighty* (*The Illustrated Bartsch 21,* 1978: 15.11; London, British Museum, 1949-10-8-811). One may also note the Maratta at Stourhead (neg. CI B94 116 T.S.) associated with the Maratta decorations in Rome, San Isidoro. There is an impressive print by Francesco Bartolozzi that presents this theme (*Kitto Bible* 32–6130), which may provide a clue.

Figure 92. Domenico Tiepolo, *The Flight into Egypt 10* (etching, 1753)

SOURCES: Here the group of the Holy Family and the donkey derive directly from the etching *Flight into Egypt 10* [fig. 92]. The Almighty appears in slightly different form in *Flight into Egypt 8* (Rizzi 1971: [74]). No exact equivalent has been noticed among the numerous drawings by Domenico on this theme.

49. *The Flight into Egypt on a Mountain Road*

TRADITIONS: The arrangement is somewhat in line with traditional approaches to the subject, for example, the mosaic of the Baptistery in San Marco (*San Marco* 1991: [184/8]), Giotto in Padua (Basile 1993: [124a]), and the *Deutsche Bilderbibel* (folio Ivb).

An interesting variant is shown in the engraving by Adrien Collaert after Maarten de Vos in the *Vita, Passio et Resurrectio Iesu Christo* (n.d.: [8]). This shows Herod's soldiers and the miraculous crop of corn in the background, illustrating a legend noted by Anna Jameson but not by Domenico. It also shows prominently on the right the devil falling out of the tree. The story of the devil dwelling in a tree at the entrance of the city is also told by Maria de Agreda: "When the incarnate word came within sight of this tree, not only was the demon hurled from his seat and cast into hell, but the tree bowed down to the ground." This is seen quite frequently in visual renderings.

SOURCES: The figure of Joseph derives from Domenico's etching *The Flight into Egypt 21* (Rizzi 1971: [87]). The very heavy underdrawing suggests a later date.

50. *The Rest on the Flight into Egypt*

TRADITIONS: For *The Rest on the Flight into Egypt* with a glory of angels (see Cranach: *The Illustrated Bartsch 21,* 1978: 321, 322]), Domenico also would have known the painting by Luca Giordano, engraved by Pietro Monaco (1743: [51]; 1763: [88]). The motif of Joseph carrying the Christ child on *The Flight into Egypt* is shown in the mosaic at Monreale (del Giudice 1702: [XVIII.14]) and in *The Holy Family at Matarea* (pl. 70).

SOURCES: The donkey derives from Domenico's etching *The Flight into Egypt 23* (Rizzi 1971: [89]). The motif of the angel with a basket of flowers appears to derive from a lost portion of Giambattista's *St. Joseph and the Christ Child* for Aranjuez (Knox 1980: [261–262]). The cloud of putti recalls the numerous drawings by Domenico on this theme, but none can be associated with this drawing. The crouching angel at Mary's feet derives from a drawing in the Orloff Album (Petit sale 1920 [83]; Hadeln 1927 [67])[fig. 104].

Figure 104. Giambattista Tiepolo, *An Angel with a Basket of Flowers* (red chalk drawing, Rotterdam, Boymans-van Beuningen Museum)

51. *The Flight into Egypt, after Castiglione*

SOURCES: The Virgin and the donkey are similar, though in reverse, to *Flight into Egypt 8,* which also has a flock of sheep. It is related to the Castiglione etching (*The Illustrated Bartsch 46,* 1978: [12]) [fig. 105] and to the Raggi drawing (Cambridge 1970: [26]), especially in the figure of the Virgin and the barrel behind her. The extensive underdrawing in black chalk may suggest a late dating.

52. *The Flight into Egypt with Angels*

SOURCES: Mary and Joseph derive from *The Flight into Egypt 5* [fig. 103]. The angel and the donkey derive from *The Flight into Egypt 18* (Rizzi 1971: [84]) [fig. 106]. The crouching figure, low left, derives from the Accademia *Institution of the Eucharist* [fig. 204].

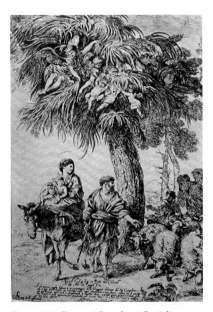

Figure 105. Giovanni Benedetto Castiglione, *The Flight into Egypt* (etching)

53. *The Holy Family Crosses the River*

TRADITIONS: The earliest recorded source of such a theme is an engraving by Johan Sadeler I (1550–1600) after Maarten de Vos (1532–1603), of 1582 [fig. 6], but it is possible that the idea may derive from an engraving of 1559 by Jerome Cock after Hieronymus Bosch (*The Ship of Fools,* Brighton, 2000, [43]). There is also a drawing by Maarten de Vos at Ottawa (*The Flight into Egypt,* Popham and Fenwick 1965: [130]), and the subject is again found in an engraving by Hieronymus Wierix (1548/53–1619) from the *Vita Deiparae Virginis Mariae* (Weirix n.d.: [17]) [fig. 7], but this shows the boat with leeboards being sailed by Joseph, with the Virgin and Child amidships—a prototype for the boat that appears in plates 123, 124, 137, and 138.

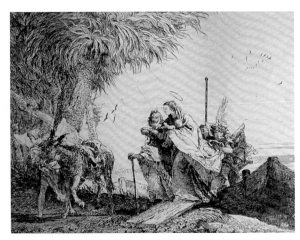

Figure 106. Domenico Tiepolo, *The Flight into Egypt 18* (etching, 1753)

Once established, the theme was treated by Lodovico and Annibale Carracci, Poussin, Castiglione, and Luca Giordano. The Poussin in the Cleveland Museum of Art (Paris, 1960, [52]) may be as early as 1625, and there is another version in the Dulwich Gallery. These are discussed by Charles Mitchell (1938), who suggests an allusion to Charon and the Styx and a prediction of the death of Christ. The Luca Giordano is engraved by Pietro Monaco (1743: [XLIX]; 1763: [89]; Apolloni 2000: [89]) and was therefore known to Domenico; it shows the Holy Family in the boat with the donkey, a putto holding the bridle, and the boatman pushing off. It is also the subject of the fourth etching in the series of six by Sébastien Bourdon (1616–1671), of which Domenico owned four (Stuttgart, 1999, [17.4]); still other examples are cited by Christofer Conrad in the same catalogue ([9, 11]), one by François Perrier.

In the eighteenth century this was a familiar theme in Venice, and the most notable version was the large painting by Diziani in the Sacristy of San Stefano of 1733 (Zugni Tauro 1971: [17]). The small painting on this theme by Sebastiano Ricci at Chatsworth is paired with *The Presentation in the Temple* (Daniels 1976: [288, 289]). The theme is also touched upon by Voss (1957: [16]), who reproduces the Lodovico Carracci in the Tacconi collection in Bologna, without extensive comments, though he does note the "Figur des energisch rudernden Fahrmannes," also an important element in the Diziani (Zugni Tauro 1971: [23]) and in Giambattista's and Domenico's designs, as here.

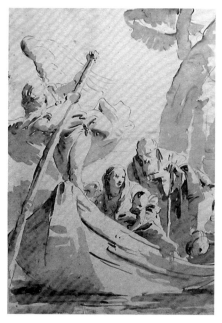

Figure 107. Giambattista Tiepolo, *Crossing the River* (ca. 1735, New York, Mrs. Vincent Astor)

It was treated several times by Giambattista in the drawings of the Orloff Album, two of which were etched by Domenico. It also figures prominently in Domenico's series of etchings on this theme—of the 22 etchings, no fewer than five, *Flight into Egypt 14 to 18,* are devoted to it [fig. 106]. Of the some thirty drawings here representing the Holy Family on the Flight into Egypt, only this one has the scene showing the Holy Family crossing the river.

SOURCES: Based on a drawing by Giambattista in the Orloff Album, one of a group of five, that was also the subject of an etching by Domenico (Rizzi 1971: [66]). This drawing is now in the collection of Mrs. Vincent Astor (New York, 1971, [123]) [fig. 107]. Two swans derive from a drawing in the Heinemann collection (New York, 1973, [116]).

54. *The Holy Family with a Man Digging*

TRADITIONS: "When Adam delved and Eve span" is the theme of plate 2 in the *Historiae Sacrae Veteris et Novae Testamento* (ca. 1670: [2]). The tradition is noted by Anna Jameson (1890: [31, 42]). Domenico seems to be aware of it in the *Divertimento per li regazzi* 43 and 44, *Adam Delving* and *Eve Spinning,* in the Brinsley Ford collection (Gealt 1986: [8, 6]).

SOURCES: The man digging derives from Tintoretto's *Crucifixion* [fig. 108] in the Scuola di San Rocco (de Vecchi 1970: [167]). The Holy Family derives from Domenico's etching *The Flight into Egypt 8* (Rizzi 1971: [74]). Some aspects of this design, a man and his son, a servant digging, and another seated, are remembered in *Divertimento per li regazzi 43,* in the Brinsley Ford collection (Gealt 1986: [8]), although whether this is intended to convey the concept of hope or the dignity of labor is not clear.

Figure 108. Jacopo Tintoretto, *The Crucifixion,* detail (1565, Venice, Scuola di San Rocco)

55. *Jesus and the Dragons*

TRADITIONS: Apart from the reference cited by Réau, we have noticed only the miniature in the Ambrosiana MSS L.58, sup. (Ceriani 1873: [fol. 8 recto]) and the small painting by Giovanni Mansueti (active 1485–1526) in the church of San Martino at Burano, *The Flight into Egypt with Lions and Dragons.*

SOURCES: The donkey low right derives from a drawing by Domenico formerly in the Mangin collection [fig. 110].

56. *The Holy Family with the Bending Palm*

TRADITIONS: *The Bowing Palm* is found in *The Holkham Bible Picture Book* (Hassall 1954: fol. 15, above) and in the Bodleian Library, *Seldon* supra *38,* fol. 5b (James 1923: 37, no. 9). The lions are found in *Seldon,* fol. 4b (37, no. 7) and again in the Ambrosiana MSS (Ceriani 1873: [8 verso, 9 and 10]). The sculpture by Giovanni Morlaiter, *The Flight into Egypt,* in Ss. Giovanni e Paolo shows Joseph receiving fruit (Guerriero 1994: [27]). In spite of its relative rarity, the bending palm is often hinted at in representations of *The Rest on the Flight into Egypt;* one may cite the Veronese at Sarasota (Marini 1969: [121]). None of these, however, show the tree bending so deeply as in Domenico's design here; the miniature of the Limbourg brothers in the *Très Riches Heures* of 1413 comes the closest.

SOURCES: The lion in the center derives from a drawing recorded with Abdy in 1961 (DD03.27). The leopard and the reclining lion on the right derive from two drawings at Princeton (Knox 1964: [82, 83]) [fig. 109]. The leopard with cubs derives from a drawing by Domenico formerly in the Talleyrand collection (Morassi 1958: [45]), copied from a print by Riedinger (Byam Shaw and Knox 1987: [fig. 35]).

57. *The Holy Family Beneath the Great Palm*

TRADITIONS: Veronese drawing.

SOURCES: Conrad notes that the figure of the Virgin derives from *Flight into Egypt 4,* though the pose of the child is altered [fig. 84]. The donkey derives from a drawing in the Mangin collection [fig. 110].

58. *The Holy Family Arrives Within Sight of a City*

SOURCES: The figure of St. Joseph is a close variant on *The Flight into Egypt 20* (Rizzi 1971: [86]); similarly, the figure of the Virgin derives from *The Flight into Egypt 7* (Rizzi 1971: [73]) [fig. 111]. The Egyptian city looks very Italian and derives from a lost drawing by Giambattista of a town of the Veneto, also used in greater detail by Domenico in *Contemporary Life 20* (New York, 1971, [244]; Gealt and Knox 2005 [20]).

Figure 109. Domenico Tiepolo, *A Leopard* (Princeton, The Art Museum, 48–888)

Figure 110. Domenico Tiepolo, *Three Donkeys* (Paris, Mangin Collection)

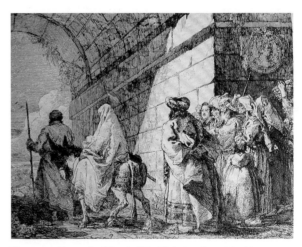

Figure 111. Domenico Tiepolo, *The Flight into Egypt 7* (etching, 1753)

59. *The Holy Family Beholds the Mountains and Cities of Egypt*

SOURCES: The donkey derives from *The Flight into Egypt 10.* The city relates to Domenico Tiepolo's *Sketches of Udine,* 1759, formerly M. le duc de Talleyrand, Saint-Brice-sous-Fôret.

60. *The Holy Family Enters Sotinen*

TRADITIONS: Jacqueline Lafontaine-Dosogne cites two examples of this scene, one in the *Menologium of Basil II,* the other in the Church of the Ascension at Decani (Underwood 1975: [55, 56]). One may also note the miniature in the *Meditations on the Life of Christ* (Ragusa and Green 1961: [59]), which shows the Holy Family approaching the city gate in the foreground and the falling idols in the background (*cf.* pl. 61).

SOURCES: Joseph and the donkey derive from the etching *Flight into Egypt 10* [fig. 92] while the architectural setting is closely related to *Flight into Egypt 27* (Rizzi 1971: [93]) [fig. 112], though the perspective drawing is most peculiar. In both plates 60 and 63, Domenico sets the horizon at mid-page or higher, so that one seems to look down on the figures. This leads to real difficulties in the drawing of the inside wall of the arch. In plate 63, these problems are largely resolved.

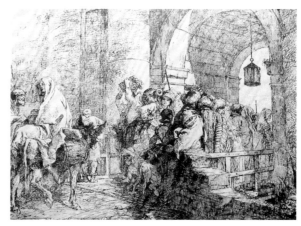

Figure 112. Domenico Tiepolo, *The Holy Family Enters the City Gate* (etching, 1753, *The Flight into Egypt 27*)

61. *The Broken Statues of Sotinen*

TRADITIONS: Among the mosaics of the Chora, *The Flight into Egypt* (largely lost) on the left is paired with *The Falling Idols* on the right (Underwood 1966: [106]), and this is the only miraculous scene shown. It is discussed, with other Greek examples cited, by Lafontaine-Dosogne (Underwood IV, 1975: 228). It is shown in a similar form, with *The Flight into Egypt,* left, and *The Falling Idols,* right, in *The Holkham Bible Picture Book* (Hassall 1954: [folio 15 below]). Among several other examples in medieval manuscripts, it also appears in the Bodleian, *Selden* supra *38,* folio 8a (James 1823: no. 13). It also appears in the background of a miniature in the *Meditationes vitae Christi* (Ragusa and Green 1961: [59]).

The only modern example—and even this is not quite clear—is a painting in the Louvre by Henri Mauperché (Voss 1957: [32]), which seems to show the entire temple at Sotinen wrecked in a rather orderly fashion, with some broken statues. Domenico pairs this scene with plate 62.

Figure 113. Domenico Tiepolo, *A Turkish Rider with a Bowman* (Besançon, Musée Gigoux)

SOURCES: The angel with the donkey derives from *The Flight into Egypt 18* [fig. 106].

62. *Affrodosius Kneels Before the Holy Family*

TRADITIONS: Apart from a miniature in the manuscript *Gesta Infantiae Salvatoris,* Bodleian Library, *Seldon* supra *38,* fol. 81 (James 1923: 37, no. 14), the only example of this theme that has come to light is the canvas by

Federico Macagno in Milan, Istituto di Sant'Ambrogio, 191 x 233, which shows Affrodosius kneeling before the Holy Family (Marco Bona Castellotti, *La pittura lombarda del '700,* Milan, 1986, [411]). The horse and rider are based on a drawing at Besançon [fig. 113].

SOURCES: Conrad identifies the soldier with his back turned as deriving from the etching by Salvator Rosa (Bozzolato 1973: [15]). The page, extreme left, derives from Veronese [fig. 161].

63. *The Holy Family Leaves Sotinen*

No text.

64. *The Holy Family Passes the Falling Idol*

TRADITIONS: The motif is not found in early representations, but becomes quite popular in the Baroque period. The most impressive example is perhaps by Rubens, recorded in an engraving by Paulus Pontius (*Kitto Bible:* 32-6051). A number of interesting examples are noted by Voss. The headless statue in a tempietto is found in a painting by Nicolas Bertin at Munich (Voss 1957: [39]), which is sufficiently close in spirit to Domenico's etching, and to this drawing, as to suggest a direct link with this painting, or another not unlike it. Earlier than this, Pozzoserrato shows a statue of Diana in a tempietto, leaning forward as if in homage to the Holy Family (Voss 1957: [36]), and Poussin shows a headless Roman emperor on a massive plinth, with the head rolling to the Virgin's feet (Voss 1957: [31]). The broken statue in a tempietto is also found in the third engraving of Ottonelli (1652), with the title *CONVERSATIONE FUGGITIVA* (Philadelphia, 1996, 101).

Figure 114. Domenico Tiepolo, The Holy Family Passes the Falling Idol (etching 1753, The Flight into Egypt 22)

These seventeenth-century examples indicate that this episode from *The Arabic Gospel* was familiar before Sike's translation of 1697. As a later example, Voss cites an early Boucher in which the Holy Family is seated under a palm tree watching a group of angels, one engaged in toppling a statue of Apollo (Voss 1957: [35]). The fallen statue is also prominent in the fifth print of Sébastien Bourdon's series (Stuttgart 1999: [17.5]).

SOURCES: The design derives from Domenico's etching, *The Flight into Egypt* 22 (Rizzi 1971: [88]) [fig. 114]. In the etching the head of the idol is shown falling at the foot of the plinth; here it is seen against the foliage to the right of the statue.

65. *The Holy Family Encounters a Group of Gypsies*

SOURCES: The girl in the foreground and the old woman behind her, reversed, derive from the drawing at Edinburgh (Udine 1996: [41]) [fig. 115].

66. *The Holy Family Meets the Robbers*

In *Legends of the Madonna,* Anna Jameson (1852: 234) tells a very different story: that the Holy Family, on their return from Egypt, had passed Jerusalem and were descending into the plains of Syria at Ramla when they encountered certain thieves who fell upon them. One of the thieves spoke up for the family. "And Mary

Figure 115. Domenico Tiepolo, *Two Peasant Girls and an Old Woman in a Landscape* (Edinburgh, National Gallery of Scotland)

said to him, 'The Lord God will receive thee to his right hand, and grant pardon for thy sins!' And it was so, for in after times these two thieves were crucified with Christ, one on the right hand and one on the left; and the merciful thief went with the Saviour into Paradise."

TRADITIONS: *The Arabic Gospel* is said to have been first published by Henry Sike in 1697, but this scene is already found in *The Holkham Bible Picture Book* of 1325–1330 (Hassall 1954: [fol. 14 below]). The subject is treated in a not dissimilar way in two canvases by Giuseppe Maria Crespi (Merriman 1980: [32, 33]) [fig. 116].

67. *The Holy Family Goes with the Robbers*

CONTINUATION OF COMMENTARY: This offers a very different account of *The Flight into Egypt* from the *Liber de Infantia*. In fact, here the journey to Egypt takes no time at all, recording only that "in the length of the journey the girts of the saddle broke." And then immediately we are dealing with the arrival in Egypt and the story of the broken statue (pl. 64), which is told at great length (*Arabic Gospel* 4:6–13). Thereupon the Holy Family decides to leave Egypt, at which point the story of the first encounter with robbers is told (*Arabic Gospel* 5:1–6). The Holy Family then visits several cities and many miraculous events occur, culminating in the second encounter with the robbers, as cited here (*Arabic Gospel* 8:1–7). This is followed by the story of Matarea, after which "they proceeded to Memphis, and saw Pharaoh, and abode three years in Egypt" before they left for Judaea (*Arabic Gospel* 8:12–14). The two drawings might be taken to illustrate either of these two texts, but it is here suggested that both relate to the second story, this one being the later one, which immediately precedes *The Holy Family at Matarea* (pl. 70).

Figure 116. Giuseppe Maria Crespi, *The Holy Family Meets the Robbers* (1740–1744, formerly London, Heim Gallery)

TRADITIONS: This scene is already found in *The Holkham Bible Picture Book* of 1325–1330, British Museum, Add. 47682 (Hassall 1954: [fol. 14 below]) [fig. 117].

SOURCES: The figure of the Virgin derives from the etching *The Flight into Egypt 10* [fig. 92].

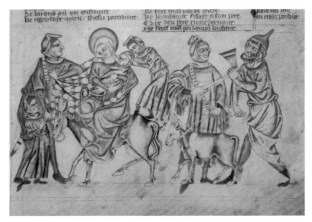

Figure 117. *The Holy Family Meets the Robbers* (1325–1330, London, British Museum, *The Holkham Bible Picture Book*, fol. 14, below)

68. *The Holy Family Arrives at the Robbers' Farm*

CONTINUATION OF COMMENTARY: This scene, showing the Holy Family arriving at a farm gate, and its companion, showing them leaving by the same gate (pl. 69), are quite different from all the other scenes illustrating *The Flight into Egypt*. It is here suggested that they represent the beginning and the end of the robber episode. On both occasions the Holy Family is surrounded by some rough characters, yet it is strange that the farm, which is the subject of some of Giambattista's most charming country scenes and which itself was no doubt well known to Domenico, should have been adapted to the purposes of a robber's den.

TRADITIONS: Gertrud Schiller cites the relief of the later fourteenth century at Thann in Alsace, *The Holy Family and the Robbers* (Schiller 1971: I, 121, [321]), citing the *Vita Christi* of Ludolph von Sachsen as the source.

SOURCES: Here the group of the Virgin and Child derive directly from the etching *The Flight into Egypt 7* [fig. 111]. The setting is a variant of the drawing at Besançon (pl. 69), based on the drawing in the British Museum [fig. 117]. The man standing in the foreground on the right derives from a drawing in the Victoria & Albert Museum (Knox 1960/1975: [133]) [fig. 118].

69. *The Holy Family Leaves the Robbers' Farm*

This drawing is one of nine bequeathed to the museum in 1894. Earlier than this, eight were sold in the Gigoux sale of 1992. Gigoux was evidently a contemporary of Fayet, Luzarche, and even Camille Rogier. He was also a friend of Léon Bonnat. The exact source of his drawings is still obscure, but it is here supposed that they originated in the *Recueil Luzarche*.

SOURCES: Many of these drawings, including the present one, make use of Giambattista's landscape drawings of the late 1750s. The setting here is based on a gateway that was well known to the Tiepolo family, and is recorded in a number of Giambattista's landscape drawings (Knox 1974: [40]; Sotheby's, New York, Jan. 10, 1995) [fig. 119]. The group of the Holy Family and the donkey derive quite directly from Domenico's etching, *The Flight into Egypt 8* (Rizzi 1971: [74]). The striking figure of the man leading the donkey in the right foreground derives from the etching *The Flight into Egypt 25* [fig. 254].

Figure 118. Giambattista Tiepolo, *A Standing Man with a Sword* (London, Victoria & Albert Museum)

70. *The Holy Family at Matarea*

TRADITIONS: The subject is extremely rare in the early sources, being found only in *The Holkham Bible Picture Book* of 1325–1330 (Hassall 1954: [folio 25 verso, upper left]). It is also treated in a print by Francesco Brizio, after Lodovico Carracci (*The Illustrated Bartsch 19,* 1978: 26.5; Diane de Grazia Bohlin, Washington, 1979, 489 [R.1]) [fig. 120]. A rather similar print by Couches after Albani shows Jesus helping Joseph, with angels hanging out the washing on the branch of a tree (*Kitto Bible:* 33-6165). For Joseph holding the Christ child, see the mosaic at Monreale (del Giudice 1702: [XVIII.14]).

Figure 119. Giambattista Tiepolo, *The Gate of a Farm* (London, The British Museum, 1936)

71. *The Holy Family at Hermopolis with Bowing Trees*

TRADITIONS: In this case the general design may be compared to the celebrated etching by Martin Schongauer, *The Flight into Egypt* (*The Illustrated Bartsch 8,* 1978: 220). The subject is also treated several times by the Bassani, for example, the Francesco da Ponte in the Prado (Arslan 1960: [234]) and Adrien Collaert after Maarten de Vos in the *Vita, Passio et Resurrectio Iesu Christo* (n.d.: [8]). This shows Herod's soldiers and the miraculous crop of corn in the background, illustrating a legend noted by Anna Jameson, but not by Domenico. Maria de Agreda tells the story of the devil dwelling in a tree at the entrance of the city: "When the incarnate word came within sight of this tree, not only was the demon hurled from his seat and cast into hell, but the tree bowed down to the ground." This is seen quite frequently in visual renderings.

SOURCES: Many of the drawings in this section make use of material from Domenico's series of etchings, *Idee pittoresche sopra la Fugga in Egitto*. Here the entire group of the Holy Family and the angels derive from the etching *Flight into Egypt 9* (Rizzi 1971: [75]) [fig. 121].

Figure 120. Francesco Brizio, after Lodovico Carracci (?), *The Miraculous Fountain of Matarea* (engraving)

72. *The Holy Family Enters Memphis*

No text.

73. *The Dream of Joseph in Egypt*

Figure 121. Domenico Tiepolo, *The Flight into Egypt 9* (etching, 1753)

TRADITIONS: The scene appears in the mosaics of San Marco (Demus 1984: [155]; *San Marco* 1991: [81/2]) [fig. 123] and again in the mosaics of the Chora, showing *The Dream of Joseph* at left, *The Departure from Egypt* in the center, and *The Arrival at Nazareth* on the right (Underwood 1966: [111]). It also appears in a miniature in the *Meditationes vitae Christi* (Ragusa and Green 1961: [65]. In modern times it appears among the reliefs by Francesco Bonazza in the Chapel of the Rosary in Ss. Giovanni e Paolo, Venice.

SOURCES: The donkey derives from *The Three Donkeys* in the Mangin Collection in Paris [fig. 110].

74. *The Holy Family Leaves Memphis*

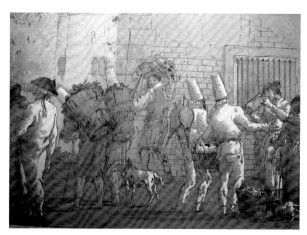

Figure 122. Domenico Tiepolo, *The Pedlars*: (formerly Paris, Richard Owen)

TRADITIONS: The scene is found in a mosaic of San Marco (*San Marco* 1991: [81/3]), which again shows Jesus as an infant in arms, in contrast to the miniature of the *Meditationes vitae Christi* (Ragusa and Green 1961: [66]).

SOURCES: The loaded donkey in the left foreground derives from a drawing by Nicolaes Berchem, dated 1657, in the Pierpont Morgan Library (New York, 1977, [10]) that was also etched (Witt Print Collection, Neg. 1009/17 [29]). It is again used in *Scenes of Contemporary Life 14* (Gealt and Knox 2005: [14]) [fig. 122].

75. *The Holy Family Meets the Young John the Baptist*

TRADITIONS: This treatment comes the closest to the miniature and to the text in the *Meditationes vitae Christi* (Ragusa and Green 1961: [68]), with both children shown as perhaps 8 or 10 years old [fig. 125].

SOURCES: The figure of Joseph reading derives from a drawing, *The Holy Family*, by Giambattista in the Courtauld Institute Galleries (Seilern 1959: no. 159, [119]). This is one of the remarkable series of over 110 drawings on this theme by Giambattista, of which at least 80 originated in the Owen-Savile Album, which contained a written account of its provenance by Edward Cheney, tracing it back to Cigognara and Canova. Pavanello (1996) suggests that this is one of the four albums of drawings by Giambattista sold by Margherita Moscheni, Domenico's widow, to Canova in 1810; he lists 63 items and reproduces 11. The heron at top right is found again in *Divertimento per li regazzi 32*.

Figure 123. *The Dream of Joseph in Egypt* (mosaic, 1100, Venice, San Marco, north transept)

76. *The Holy Family Returns to Nazareth*

TRADITIONS: The theme is found in San Marco on the west wall of the North Transept (Demus 1984: [156]; *San Marco* 1991: [81/3]), set between *The Dream of Joseph* and *Christ Among the Doctors.* However, Jesus is still shown as an infant at the breast. A further example is found in Ottoboni 1652, with the title: *"CONVERSATIONE DELLA TORNATA—accenna l'historia del ritorno di Maria con il Fanciullino e lo Sposo dall'Egitto"* (Philadelphia, 1996, [3: 3]), as well as in the last of the set of etchings on *The Flight into Egypt* by Sébastien Bourdon (Stuttgart 1999: [17.6]). The Christ child in the drawing now seems fully grown, and if the scene indeed belongs to the series of *The Flight into Egypt,* this is the only one that shows the Holy Family on the return journey.

SOURCES: The angel leading the Virgin derives from the etching *The Flight into Egypt 24* (Rizzi 1971: [90]) [fig. 126]. The donkey again appears to derive from the drawing by Nicolaes Berchem, signed and dated 1657, in the Pierpont Morgan Library (New York, 1977, [10]), which was also etched [fig. 124] (Witt Print Collection) [fig. 124].

77. *The Young Jesus Leads His Parents to Jerusalem*

TRADITIONS: The same scene, which is rarely shown, is found in two pendant scenes in the Chora: *The Road to Jerusalem* on the left, and *Jerusalem* on the right (Underwood 1966: [112]) [fig. 127]. It also seems to be the subject of the etching by Rembrandt of 1654 (*The Illustrated Bartsch 50,* 1978: [60]), but it is not clear whether it represents the journey to or from Jerusalem.

78. *Jesus Among the Doctors*

TRADITIONS: The mosaic at Monreale (del Giudice 1702: [XVIII.16]) shows the scene with Mary and Joseph present on the left, as here. It is treated several times: by Giotto in Padua (Basile 1993: [125a]); by Giusto de' Menabuoi in the Baptistery (Spiazzi 1989: 62.6 [39]); in the left panel of the Gentile da Fabriano triptych in the Brera; in the *Deutsche Bilderbibel* 1960: [IV verso/b]); by Dürer in *The Life of the Virgin* (*The Illustrated Bartsch 10,* 1978: [B.91]); by Virgil Solis (1565: [110]); and by Bassano at Oxford (Arslan 1960: [27]).

The scene is popular among the Antwerp engravers: Wierix, *Vita Deiparae Virginis Mariae* (n.d.: [22]); and Wierix and Passeri in *Evanglicae Historiae Imagines* (1593: [9]). A print by Maarten de Vos from the *Theatrum Biblicum* (1674: [9]) shows the essential elements of this composition: Mary and Joseph entering left, Jesus by a table in the center, and the priests seated to the left.

The scene is treated by Sebastiano Ricci in a canvas formerly belonging to Consul Smith (Daniels 1976: [331]) and by Domenico in the Oratorio della Purità at Udine in 1759 (Mariuz 1971: [164]). Verri cites the

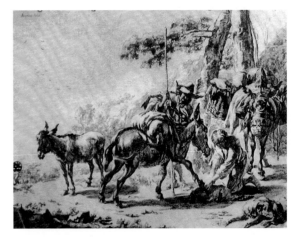

Figure 124. After Nicolaes Berchem, *Shoeing the Mule* (etching, London, Witt Print Collection)

Figure 125. *The Holy Family Meets John the Baptist as a Boy* (miniature, 14th century, Paris, Bibliothèque Nationale, Ms. Ital. 115)

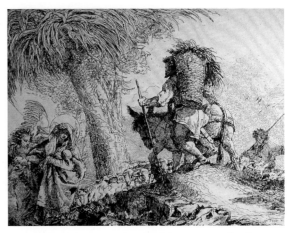

Figure 126. Domenico Tiepolo, *The Flight into Egypt 24* (etching, 1753)

sculpture by Giovanni Morlaiter in Ss. Giovanni e Paolo, one of a series of important marble reliefs of 1730 showing scenes from the infancy of Christ in the Chancel of the Chapel of the Rosary.

SOURCES: The dog at low right derives from a drawing by Domenico in the Heinemann collection [fig. 12], which in turn derives from a print, *The Fall of Man,* by Nicolaes de Bruyn (1571–1656), after Bartolomeus Grondonk (Dorotheum sale, Mar. 30, 2000, Vienna: [226]) [fig. 13]. A reduced version of the print, 405 x 505 mm., showing only one dog, forms Plate 1 of the enormous *Historiae Sacrae Veteris et Novi Testamento,* published by Nicolai Visscher in Amsterdam ca. 1670 [1]. The same dog is found in *Contemporary Life 9.*

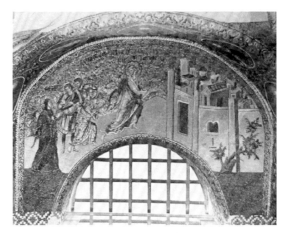

Figure 127. *The Road to Jerusalem: Jerusalem* (mosaic 1310–1315, Istanbul, Saint Saviour in the Chora)

79. *Jesus Leaves the Doctors*

TRADITIONS: The design is found in San Marco (*San Marco* 1991: [81/4]). Compositions showing the young Christ being led away from his encounter with the doctors by his parents are rare; one may cite the Triptych in the Louvre, School of Gentile da Fabriano, with *The Annunciation to Joachim* in the center, flanked by *Christ Among the Doctors* with Joseph and Mary looking in on the left, and *The Nativity of the Virgin* on the right. For these elements, see also the engraving by Jacob de Bye after Maarten de Vos, 185 x 220, from the *Vita, Passio et Resurrectio Iesu Christi* (n.d.: [10]) and the curious engraving by Antonio Hooftmanin with the title *CONVERSATIONE RITROVATA* (Ottolini 1652: [X]; Philadelphia, 1996, [3, 5]). There is a relief by Giovanni Morlaiter in the Cappella del Rosario at Ss. Giovanni e Paolo (Guerriero 1994: [23, 24]).

SOURCES: The faun and fauness are a familiar element in Giambattista's decorative work, but these do not correspond exactly to any recorded examples. They are fairly close to a drawing by Giambattista in the Courtauld Institute Galleries (Seilern 1959: v, no. 380, [LXVII]). The dog, having advanced a few feet from its position in plate 78, derives from a drawing in the Heinemann collection [fig. 12], which in turn derives from a print, *The Fall of Man,* by Nicolaes de Bruyn [fig. 13]. Another version of this print, with one dog only, opens the great folio volume of 150 or so engravings, *Historiae Sacrae Veteris et Novi Testamento,* published by Nicolaes Visscher (ca. 1670 [1]).

80. *The Death of Joseph*

TRADITIONS: While early visual prototypes are lacking, Verri (1971) shows that *The Death of Joseph* was a popular theme in eighteenth-century Venice and earlier, citing numerous examples and invoking the characteristics of a Christian death. The most conspicuous example is the altarpiece by Balestra in San Marziale, 1704 (Polazzo 1990: [10]). There are later examples by Piazzetta (Knox 1992: [67]), by Antonio Guardi (Morassi 1994: [29]), and by Giambattista Tiepolo in the form of an unpublished drawing at Frankfurt (Staedelsches Kunstinstitut 13462).

Domenico also knew the Pittoni engraved by Monaco (1743: no. 25; Zava Bocazzi 1972: [345]), but in every case he avoids the barochetto of these earlier designs in favor of a classical stage-like setting.

SOURCES: The pose of Christ with the head of Joseph is very close to the Guardi at Berlin, in reverse [fig. 128]. The crouching angel in the left foreground, supported on his arms, is a type found frequently among these drawings—see also plates 7, 10, 35, 47, 148, and 171. This figure derives essentially from the Copenhagen *Institution*

Figure 128. Gianantonio Guardi, *The Death of Joseph* (ca. 1730, Berlin, Staatliche Museen)

of the Eucharist of 1752 and the Venice *Institution of the Eucharist* of 1778 [fig. 204]. There is a preparatory drawing for the former in the Hermitage (Knox 1980: [167, 168]).

81. *The Assumption of Joseph*

TRADITIONS: Franco Verri shows that the theme had a certain currency in eighteenth-century Venice. He cites the ceiling by Torri and Ricchi in San Giuseppe di Castello, which also includes the Trinity above (photograph unpublished) and two ceilings by Egidio dall'Oglio in Cison di Valmarino (TV) and Campomolino di Gaiarine (TV) (Verri 1991: 780; Sponza in *Provincia di Venezia 3* 1984: 22–31).

SOURCES: Conrad notes a related drawing with Geneviève Aymonier, exhibited Paris 1968 [20], pen and wash, 203 x 142 (Conrad 1996: [fig. 81]) [fig. 129].

Figure 129. Domenico Tiepolo, *The Assumption of Joseph* (formerly Paris, Geneviève Aymonier)

82. *The Annunciation of the Birth of John to Zacharias*

TRADITIONS: The cycle of New Testament subjects illustrated in the mosaics of Monreale Cathedral of 1180 opens with this important scene on the left, followed by *Zacharias Coming from the Temple* on the right (del Giudice 1702: [XVIII.1 and 2]). We have noticed that del Giudice's engravings may well have been the source through which Domenico became familiar with these mosaics. It is also found in *The Rockefeller McCormick New Testament* (1932: [56 verso]). The scene opens the cycle of the Baptist in the Baptistery in San Marco of the fourteenth century (*San Marco* 1990: [80]; 1991: [189]); similarly, it opens the nine frescoes painted by Giusto de' Menabuoi in the mid-1370s on the north wall of the Baptistery of the Duomo at Padua (Spiazzi 1989: 58.1 [38]). Again, in Giusto's fine polyptych with twelve scenes on the altar in the same building, also of the late fourteenth century (Spiazzi 1989: 79.24 [79]), the cycle opens with *The Annunciation to Zacharias in the Temple* [fig. 130], as does the great fresco cycle depicting *The Life of the Baptist* of 1486–1490 by Domenico Ghirlandaio in the choir of Santa Maria Novella (Cadogan 2000: [72]). Zacharias doubts the message and is struck dumb. Domenico may not have known that cycle, but it is not unlikely that he knew the set of aquatints recording the similar lost cycle by Spinello Aretino in the Carmine in Florence by Thomas Patch (no. 4 of the series made in 1772), at that time attributed to Giotto, following Vasari.

In modern times, the most conspicuous example is the canvas by Andrea Sacchi of ca. 1600, in the Lateran Palace in Rome (Harris 1977: [frontispiece]), one of a series of eight scenes of *The Life of the Baptist* (cat. nos. 54–61, [116–123]). These were engraved in 1769 by Desiderio de Angelis for Pietro Leopoldo, Grand Duke of Tuscany.

Figure 130. Giusto de Menabuoi, *The Annunciation to Zacharias* (fresco, 1380, Padua, Duomo, Baptistery)

83. *The Circumcision of John the Baptist*

TRADITIONS: The scene is shown among the mosaics of the Baptistery of San Marco, *The Naming of the Babe John,* remade in 1628 by L. Ceccato after Gerolamo Pilotto (*San Marco* 1991: [190/1]); it is among the series of frescoes by Giusto de' Menabuoi in the Baptistery of the Duomo at Padua (Spiazzi 1989: 58.3, [38]) and as *The Naming of the Baptist,* and in the polyptych in the same building (Spiazzi 1989:

79.29 [79]) [fig. 131], in which *The Naming of the Baptist* and
The Circumcision appear as separate scenes. It also appears in a
miniature in the fourteenth-century *Meditationes vitae Christi*
(Ragusa and Green 1961: [19]). It is possible that Domenico may
have known the set of prints made by Thomas Patch (1729–1782)
in Florence after the frescoes by Spinello Aretino—then thought
to be by Giotto—in the church of the Carmine, destroyed by fire
in 1771. The scene is also the subject of an engraving, 200 x 266
mm, by Philip Galle after Marten van Heemskerck of 1564 (*The
Illustrated Bartsch 56*, 1978: [103]).

SOURCES: The dog appears in several drawings of the series (*cf.*
pls. 98 and 117).

Figure 131. Giusto de Menabuoi, *The Circumcision of the Baptist*
(polyptych, 1380, Padua, Duomo, Baptistery)

84. *The Flight of Elizabeth into the Wilderness*

TRADITIONS: In the mosaics of the Baptistery in San
Marco, this scene appears as a detail in the upper right corner of
The Massacre of the Innocents (*San Marco* 1991: [184.9]), showing
Elizabeth and the infant John and the mountain opening up.
Elizabeth with the Infant John in the Desert is found in the polyptych
of Giusto de Menabuoi in Padua (Spiazzi 1989: 79/31 [79]).

SOURCES: The soldier running off to the left and the adjacent
figure derive from the oil sketch by Domenico, *The Greeks Entering
Troy*, in Helsinki (Knox 1980: [306]) [fig. 132].

Figure 132. Domenico Tiepolo, *The Greeks Entering Troy* (Helsinki,
Sinebrychoff Museum)

85. *Herod Interrogating Zacharias*

TRADITIONS: The general arrangement of the composition
recalls the mosaic in the Cappella di San Pietro in San Marco
depicting *Herod Interrogating Peter* (*San Marco* 1990: [60, 63]; 1991:
[37/1]) [fig. 133], an event that barely corresponds to Acts 12:1–4.
Although the soldiers on the right play a comparable role and are
mentioned in the text, it is difficult to identify the protagonists in
this drawing as Herod and Peter.

SOURCES: The dog, low right, derives from a drawing in the
Courtauld Institute Galleries (DD04.26).

86. *The Slaying of Zacharias*

Figure 133. *Herod Interrogating Peter* (mosaic, Venice, San Marco,
Cappella di S. Pietro)

TRADITIONS: Lafontaine-Dosogne (Underwood IV 1975: [56])
reports the miniature in the *Homilies of Gregory Nazianzus* (Paris,
Bibl. Nationale [gr 510], fol. 137). Otherwise, the scene has been
found only in the polyptych by Giusto de' Menabuoi in the Baptistery of the Duomo at Padua (Spiazzi 1989: 79.30,
[79, 155]), in which Zacharias is shown as being stoned to death rather than stabbed, as here [fig. 134].

87. *The Funeral of Zacharias*

This design seems to be remembered in *Divertimento per li Regazzi 102* (Udine 1996: [176]) [fig. 135]. All this seems appropriate for the funeral of Zacharias rather than that of Mary, as suggested by Conrad. The bier, the curious open wooden coffin with handles, is a regular part of Domenico's imagery that appears frequently, and may have been a familiar item in Venice; it is found again in similar form in *The Funeral of John the Baptist* (pl. 102); see also plates 120, 121, 234, 235, 256, and 262.

TRADITIONS: No prototype for this scene has been traced.

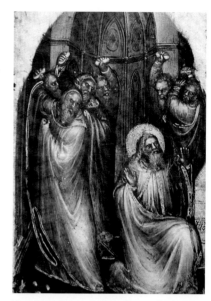

Figure 134. Giusto de' Menabuoi, *The Slaying of Zacharias* (detail of polyptych, 1380, Padua, Duomo, Baptistery)

88. *John the Baptist in the Wilderness—ECCE AGNUS DEI*

TRADITIONS: The San Marco mosaics show the young John the Baptist in the wilderness twice (*San Marco* 1991: [190/2 and 3]), but in the second he is already a bearded man. Zatta (1761: 45) describes in the Cappella del Battistero of San Marco: *"[d]irimpetto alla porta che conduce nella Piazzetta. . . . In un vano quadrato al di sopra in mosaico v'ha il Battetismo del Salvatore, e sopra la porta della Cappella del Cardinal Zeno si vede un'Angiolo, che porge la veste al Battista con queste parole: HIC ANGELUS REPRAESENTAT VESTEM BEATO JOANNI. Alla destra del arco evvi un'altro Angiolo, che lo conduce al Deserto, leggendovisi: HIC ANGELUS DUCIT S. JOHANNEM IN DESERTUM."*

The theme was also certainly familiar to Domenico through two engravings by Pietro Monaco: one after Pittoni (Monaco 1745: [96]; Zava Bocazzi 1979: no. 352), lost, and one after Zuccarelli (Monaco 1743: [LII]; 1745 [14], Apolloni 2000: [14]). It was also treated by Giambattista in a more simple way in the painting in the church of Ss. Massimo e Osvaldo in Padua (Gemin and Pedrocco 1993: [359]). However, Domenico's conception seems to derive rather from the tradition of saints in a landscape, such as Titian's *St. Jerome* in the Brera (Valcanover 1969: [352]).

SOURCES: The vestigial hut on the right derives from a drawing by Giambattista, copied by Domenico (Knox 1974: [3, 21]) [fig. 136].

Figure 135. Domenico Tiepolo, *The Funeral of Punchinello* (London, Thomas T. Solley)

89. *John the Baptist Lying on the Ground, with Angels—ECCE AGNUS DEI MUNDI*

TRADITIONS: A notable representation of this scene appears in the Baptistery of San Marco (*San Marco* 1991: [190.3]).

SOURCES: The figure lying on the ground derives from a drawing by Giambattista in the Orloff Album (sale 1921 [154]; Knox 1961: pl. 40), now in the Fogg Art Museum [fig. 137]. The identity of the saint in that drawing is not quite clear, but

Figure 136. Domenico Tiepolo, *A Barn* (Oxford, The Ashmolean Museum, 1091)

here it is clearly John the Baptist. The hut also derives from a drawing by Giambattista, copied by Domenico [fig. 136].

90. *John the Baptist Preaching, I*

TRADITIONS: The scene is found among the mosaics of the Baptistery of San Marco (*San Marco* 1991: [190/4]) and is shown by Giusto de Menabuoi in the polyptych in the Baptistery in Padua (Spiazzi 1989: [79]) and in the aquatints by Thomas Patch (no. 5 of the series made in 1772, left part) after the lost frescoes of Spinello Aretino in the Carmine in Florence. It is also found in the *Deutsche Bilderbibel* (1960: folio Va). The motif of the mounted soldier on the left is also found in the print by Pietro Monaco after Zuccarelli (Monaco 1763: [14]). One may also note the print by Wierix after Passeri in the *Evanglicae Historiae Imagines* (1593: [10]).

SOURCES: The two girls, one with a basket, derive from the drawing at Edinburgh [fig. 115]. The horse and rider appear in *Station VIII* (pl. 221), which appears to be a much earlier drawing. The horse derives from a drawing in the Huntington Library and Art Gallery (unpublished) [fig. 138].

Figure 137. Giambattista Tiepolo, *An Anchorite Lying on the Ground* (Cambridge, Fogg Art Museum)

91. *John the Baptist Preaching, II*

TRADITIONS: The theme is found among the mosaics of the Baptistery of San Marco (*San Marco* 1991: [190/4]) and in the other early sources, among them the series of frescoes by Giusto de' Menabuoi in the Baptistery of the Duomo at Padua, and the polyptych in the same building (Spiazzi 1989: 58.4 [38]; 80.32 [79]), in which it appears in each. The most memorable treatment in the sixteenth century is Jacopo Bassano's great altarpiece at Civezzano, near Trento, ca. 1575, which is paired with *Joachim and Anna Meeting at the Golden Gate* (Arslan 1960: 139–140, [175, 176]).

One may also note the engraving by Wierix after Passeri from the *Evanglicae Historiae Imagines* (1593: [10]), and one after Maarten de Vos in the *Theatrum Biblicum* (1674: [1]).

The subject, with *The Baptism of Christ* and *The Beheading of the Baptist,* was painted by Giambattista in the Colleoni Chapel at Bergamo in 1733 (Gemin and Pedrocco 1993: [142–144]). The first two compositions were etched by Domenico (Rizzi 1971: [108, 109]) with considerable variations, no doubt after bozzetti. Domenico also developed these themes into two fine paintings of modest size in Treviso and Florence (Mariuz 1971: [304, 305]) that are not far removed from these drawings in date.

SOURCES: The seated figure in the center derives more or less from the first of these. The seated figure at the left and the two adjacent ones derive from Amigoni's *Anzia and Abricone* (Scarpa Sonino 1994: [34]) [fig. 139]. This raises the possibility that the subject should be identified as *John Preaching Before Herod,* a rare subject that is sometimes found.

Figure 138. Domenico Tiepolo, *A Horse* (San Marino, The Huntington Library and Art Gallery)

Figure 139. Jacopo Amigoni, *Anzia and Abricone* (Venezia, Gallerie dell'Accademia)

92. *Jesus Coming to Be Baptized—ECCE AGNUS DEI*

TRADITIONS: The scene is also shown in the mosaics of the Chora (Underwood 1966: [115]), in *The Baptist Recognizing Christ,* mosaic, 1310–1315, Istanbul, Saint Saviour in the Chora.

93. *The Baptism of Jesus, I—ECCE AGNUS DEI*

Figure 140. *The Baptism of Christ* (miniature, 14th century, Paris, Bibliothèque Nationale, Ms. Ital. 115)

TRADITIONS: A mosaic in the Chora at Istanbul is also identified as *John the Baptist Bearing Witness to Christ* (Underwood 1966: [115]).

The theme in general is extremely popular throughout the ages, being found in all the early sources. It appears in a miniature in the *Meditationes vitae Christi* (Ragusa and Green 1961: [96]) in a form that presages in a remarkable way the celebrated composition of Piero della Francesca [fig. 140]. It is also a popular subject in Renaissance Venice, treated in such celebrated works as the Cima in San Giovanni in Bragora and the Bellini in Santa Corona in Vicenza. Moreover, it is the theme of a series of at least 46 drawings by Domenico, many of them with numbers going up to 122, but none of them an exact prototype for this design.

94. *The Baptism of Jesus, II—ECCE AGNUS DEI*

Figure 141. Cima da Conegliano, *The Baptism of Christ* (Venice, San Giovanni in Bragora)

TRADITIONS: The theme is found twice among the mosaics of San Marco: in the Baptistery (*San Marco* 1991: [191/3]) and in a version by Marini after Tintoretto in the east arch of the crossing (1990: [103]; 1991 [60/4]). At Monreale the scene is paired with *The Feast at Cana* (here missing) on the left (del Giudice 1702: [XIX.1 and 2]). It is also treated by Giotto at Padua (Basile 1993: [125b]) and by Giusto de' Menabuoi in the frescoes of the Baptistery of the Duomo at Padua (Spiazzi 1989: 58.5 [38]). The angel holding a garment is frequently shown, as it is in the miniature of the *Deutsche Bilderbibel* (1960: [Vb]). This a popular subject in Venice, treated in such celebrated works as the Cima in San Giovanni in Bragora (Menegazzi 1981: [41]) [fig. 141] and the Bellini in Sta. Corona in Vicenza. One may also note the engraving by Jan Collaert after Maarten de Vos in the *Vita, Passio et Resurrectio Iesu Christi* (n.d.: [11]).

The theme is the subject of a series of at least 46 extant drawings by Domenico, many of them with numbers going up to 122 (*cf.* The Beauchamp Album 1965: [6–18]; Stuttgart, 1970, [44–56]), but none of them is an exact prototype for this design, although the Beauchamp Album ([9]) is quite close. It is also the subject of three or perhaps four drawings in the New Testament series. The first is *Jesus Coming to be Baptized* (pl. 92); the second, again without the Holy Dove, represents perhaps *John Forbidding Christ* from Matthew 3:14 (pl. 93); this is the third; the fourth, which follows plate 95, may be identified with plate 92.

95.** *"Questo e il mio delitto figlio e l'oggetto della mia compiacenza"*

No text.

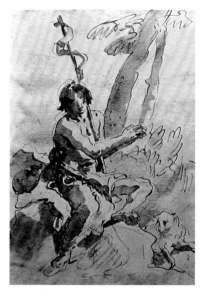

96. *The Death of Elizabeth*

TRADITIONS: No representation of this event has come to light.

97. *John the Baptist in the Desert*

TRADITIONS: The subject is treated by Giambattista in Ss. Maximus and Osvaldo in Padua (Gemin and Pedrocco 1993: [359]) and in a drawing in the Orloff Album (sale 1921 [146]; Knox 1961: pl. 49) [fig. 142].

Figure 142. Giambattista Tiepolo, *John the Baptist in the Desert* (Orloff Album, lot 146)

98. *John Reproves Herod*

TRADITIONS: The only representation of this subject in the vicinity of Venice is in the thirteenth-century fresco cycle in the Baptistery at Parma (Kaftal 1978: [658]). A more celebrated but more distant example by Masolino is found at Castiglione d'Olona, about 25 miles northwest of Milan, near Varese (Roberts 1993: [63]). The subject is treated in Ricci (1607: [22]), a copy of which Domenico owned, and by Mattia Preti in a number of versions: Seville, Museum; Valetta, Cathedral of St. John; London, Cohen (ad. in *Art Quarterly* 1972), and so on.

SOURCES: The parrot on a perch to the left of Herod derives from a drawing by Domenico in the Pushkin Museum (Aosta 1992: [90]). The dog appears in several other drawings of the series, such as plates 83, 98, and 117. John's pose relates to the engraving after Titian [fig. 143].

Figure 143. Valentin Lefebre after Titian, *John the Baptist* (*Opera Selectiora*, no. 7)

99. *The Beheading of John the Baptist*

TRADITIONS: The theme is found twice among the mosaics of San Marco (*San Marco* 1991: [192/1]) [fig. 144]: in the series of frescoes by Giusto de' Menabuoi in the Baptistery of the Duomo at Padua, and in the polyptych in the same building (Spiazzi 1989: 59.9 [38], 80.35 [79]), where it appears in each. It also appears in a miniature in the *Meditationes vitae Christi* (Ragusa and Green 1961: [165]) and in the *Deutsche Bilderbibel* (1960: [13b]).

 The subject is treated by Sebastiano Ricci at Belluno (Daniels 1976: [165]) and by Giambattista in the Capella Colleono at Bergamo (Gemin and Pedrocco 1993: [144]). Domenico's painting in Vicenza (Mariuz 1971: [175]) is more properly *The Vision of the Baptist* and so relates to Piazzetta's great canvas for the Santo in Padua (Knox 1992: [109]). There are also drawings by Giambattista in the Orloff Album (sale 1921 [126, 161]; Knox 1961: pls. 76, 94).

SOURCES: The man standing full-face on the left derives from the drawing at Udine (Rizzi 1970: [37]). The prominent pulley and rope finds a parallel in a print by Molinari after Elisabetta Sirani (*The Illustrated Bartsch 19,* 1978: 157.9).

Figure 144. *The Beheading of the Baptist* (mosaic, 14th century, Venice, San Marco, Baptistery)

100. *The Head of John Presented to Salome*

TRADITIONS: The scene appears among the mosaics of San Marco (*San Marco* 1991: [191/4]), in the series of frescoes by Giusto de' Menabuoi in the Baptistery of the Duomo at Padua (Spiazzi 1989: 60.10, [38]), and in the *Deutsche Bilderbibel* (1960: [13 verso/a]). The design is reminiscent of the Guido Reni at Chicago, *The Head of John the Baptist Presented to Salome,* Chicago, The Art Institute (Baccheschi 1971: [178]) or indeed, the Guido Reni at Sarasota, though in the opposite sense (Baccheschi 1971: [168]).

SOURCES: Salome seems to derive from a figure in the Wrightsman *Minuet* (Mariuz 1971: [86]). The standing woman on the left is not unlike a similar figure in the Albertini *Birth of the Virgin* (Mariuz 1971: [60]). The small dog derives from Giambattista's fresco *Henry III at Mira* and Domenico's etching in [fig. 93].

101. *The Banquet of Herod*

TRADITIONS: The theme is found among the mosaics of the Baptistery of San Marco (*San Marco* 1991: [191/4 center]), among the series of frescoes by Giusto de' Menabuoi in the Baptistery of the Duomo at Padua, and in the polyptych in the same building (Spiazzi 1989: 59.8 [38]; 80.34 [79]). It also appears in a miniature in the *Meditationes Vitae Christi* (Ragusa and Green 1961: [166]) in the *Deutsche Bilderbibel* (1960: [13a]) and the *Biblische Figuren* (Solis 1565: [181]).

SOURCES: The setting owes a good deal to the Melbourne *Banquet of Cleopatra* (Gemin and Pedrocco 1993: [308]) [fig. 145].

Figure 145. Giambattista Tiepolo, *The Banquet of Cleopatra* (1743–1744, Melbourne, National Gallery of Victoria)

102. *"HERODE D'ANTIPA"—The Funeral of John the Baptist*

TRADITIONS: The subject is rare, but it is found in San Marco (*San Marco* 1991: [192/3]), in the lost "Giotto" cycle in the Carmine in Florence, now given to Spinello Aretino, recorded by Thomas Patch (*Kitto Bible:* 40-7360) [fig. 146], in the final scene in the polyptych by Giusto de' Menabuoi in the Baptistery of the Duomo at Padua (Spiazzi 1989: 80.36 [79]), and in the *Deutsche Bilderbibel* (1960: [13 verso/b]). The bier and its bearers appear once more in *The Funeral, Divertimento per li regazzi 102* [fig. 133].

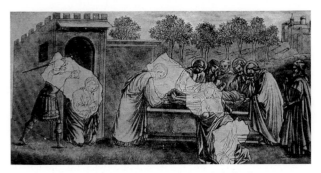

Figure 146. Thomas Patch after Giotto, *The Burial of John the Baptist* (mezzotint, San Marino, The Huntington Library)

103. *Jesus in the Wilderness*

TRADITIONS: *The Temptation of Jesus* is finely represented among the mosaics of San Marco (*San Marco* 1991: [64/1]). However, the only representation of this scene so far noted appears in the *Meditations on the Life of Christ* (Ragusa and Green 1961: [97]), where it is represented in very similar terms [fig. 147].

Figure 147. *Jesus in the Wilderness* (miniature, 14th century, Paris, Bibliothèque Nationale, Ms. Ital. 115)

104. *The First Temptation of Jesus*

TRADITIONS: Apart from San Marco [fig. 148], this
is also very comparable with the mosaics of Monreale (del
Giudice: [XIX.5]). The same series of temptations is found
in the mosaics of the Chora (Underwood 1966: [116]).
The devil may also derive from the small woodcut by Dürer
(*The Illustrated Bartsch 10,* 1978: 547).

 The first temptation, *Jesus Commanded to Turn Stones
into Bread,* is treated by Virgil Solis (1565: [119]) and by
Adrien Collaert after Maarten de Vos in the *Vita, Passio
et Resurrectio Iesu Christi* (Weirix, n.d.: [12]), showing
the devil in very human guise. See also the series of 153
engravings by Wierix after Maarten de Vos illustrating a Jesuit book of devotions by
Hieronymus Nadal (1507–1580), the *Evangelicae Historiae Imagines* (1593: [12]; 2nd ed.
1607). The *Temptation of Jesus* is associated with the first Sunday in Quadragesima, the
first Sunday of the year (Nadal 1594: [12]; Rheinbay 1995: [5]).

Figure 148. *The Temptation of Jesus* (mosaic, ca. 1100, Venice, San Marco, south
vault of the Crossing)

105. *The Devil Sets Jesus on the Pinnacle of the Temple*

TRADITIONS: The second temptation is found among the mosaics of San Marco
(*San Marco* 1991: 64/1) [fig. 149] and in Monreale (del Giudice 1702: [XIX.4]; *Deutsche
Bilderbibel* 1960: [VIa]). The first temptation, *The Devil Commands Jesus to Turn Stones
into Bread,* is treated by Tintoretto in the Scuola di San Rocco (de Vecchi 1970: [223
GG]) and by Wierix after Passeri in the *Evanglicae Historiae Imagines* (1593: [12]), as is
the second temptation (1593: [13]). Botticelli, in his fresco in the Sistine Chapel, follows
Matthew and places the temple in the center of his magnificent composition.

SOURCES: Conrad points out that the house in the distance, low left, derives from a
drawing by Giambattista in the collection of John Nicholas Brown (Knox 1974: [24]).

106. *The Second Temptation of Jesus, with the Campanile of
San Felice*

TRADITIONS: Jesus standing on the pinnacle of the Temple, tempted again by the
Devil, appears as the second scene of temptation in the mosaics of San Marco (*San Marco*
1991: 64/1). It also appears in the mosaics of Monreale (del
Giudice 1702: [XIX.4]), followed by *Jesus Dismissing Satan,* as
well as among those of the Chora (Underwood 1966: [116])
and in a miniature in the *Meditationes Vitae Christi* (Ragusa and
Green 1961: [100]). One may note the engraving by Wierix
after Passeri in the *Evangelicae Historiae Imagines* (1593: [13]).

SOURCES: The campanile of the church clearly follows
that of San Felice, near the Tiepolo apartment in Venice,
recorded in a drawing at Rotterdam (1996, [46]) as
Giambattista, here attributed to Domenico [fig. 150]. The
campanile associated with a similar pediment is noted by
Conrad in the painting by Domenico in the Louvre (Mariuz
1971: [85]).

Figure 149. *The Temptation of Jesus* (mosaic,
1100, Venice, San Marco, south transept)

Figure 150. Domenico Tiepolo, *View of the Church of San Felice* (Rotterdam,
Boymans Van Beuningen Museum)

107. *The Third Temptation of Jesus*

TRADITIONS: While Domenico's treatment of the three temptations of Jesus may be effectively related to the great mosaic of San Marco (*San Marco* 1991: [64/1]), we have not been able to trace any representation that shows the Devil seated familiarly before Jesus as here. However, the relationship between the figures and the mountainous setting here finds an interesting parallel in the miniature of the scene in the *Meditationes vitae Christi* (Ragusa and Green 1961: [101]) [fig. 151].

Figure 151. *The Third Temptation of Jesus* (miniature, 14th century, Paris, Bibliothèque Nationale, Ms. Ital. 115)

108. *Jesus Dismisses the Devil*

TRADITIONS: The scene concludes the great series of mosaics of ca. 1100 depicting *The Temptations of Jesus* on the east side of the arch leading into the south transept of San Marco (*San Marco* 1991: [64/1]) [fig. 152]. It is also found among the mosaics of Monreale (del Giudice 1702: [XIX.5]). Botticelli, in his fresco in the Sistine Chapel, places this scene in the upper right corner, indicating a very similar arrangement.

109. *"He shall give his angels charge concerning thee . . ."—I*

TRADITIONS: In general this theme is rare in the early sources, but the attendant angels may also be noted in the mosaics of San Marco [fig. 148]. On the other hand, it is developed into a considerable story in the fourteenth-century *Meditationes vitae Christi* (Ragusa and Green 1961: [102–106]), describing how *The Virgin Sent Food to Jesus in the Desert, Jesus Blesses the Angels,* and finally *Jesus Descends from the Mountain* (Ragusa and Green 1961: [104]) [figs. 153, 154]. One may also note the late-sixteenth-century engraving by Hieronymus Wierix after Bernardo Passeri from the *Evangelicae Historiae Imagines* (1593: [14]). This subject is also recorded in a drawing by Girolamo Brusaferro in the Civico Museo Correr (Pignatti 1980: [52]).

Figure 152. *Jesus Dismisses the Devil* (mosaic, 1100, Venice, San Marco, south transept)

110. *"He shall give his angels charge concerning thee . . ."—II*

TRADITIONS: The attendant angels may also be noted in the mosaics of San Marco [fig. 148]. The image of Jesus borne by two angels descends essentially from that of the Almighty in Giambattista's great altarpiece at Este of 1758 (Morassi 1955: [75]). It is also developed in a number of drawings by Domenico on the same theme.

111. *The Calling of Peter and Andrew*

The short bald man in the right foreground, with bare legs and boots and wearing a short dark cloak, is here identified as Andrew, Peter's brother. He reappears many times in

Figure 153. *Angels Bringing Food to Jesus* (miniature, 14th century, Paris, Bibliothèque Nationale, Ms. Ital. 115)

association with Peter, sometimes in the same pose (pls. 119 and 148, in reverse) and generally holding a hat.

TRADITIONS: This scene appears on the second column of the Ciborium in San Marco (Gabelentz 1903: B.IV). The subject is also found among the series of frescoes by Giusto de' Menabuoi in the Baptistery of the Duomo at Padua (Spiazzi 1989: 64.4 [40]) and, together with the scene immediately following, *The Calling of James, the Son of Zebedee and John His Brother* (Matt. 4:21), in the *Deutsche Bilderbibel* (1960: [2b and 2 verso/a]). The second scene is also found in the early sixteenth century in the altarpiece by Marco Basaiti of 1510 from Sant'Andrea della Certosa, now in the Gallerie dell'Accademia (Moschini Marconi 1955: [45]. It remains relatively popular in Northern Italy in the seventeenth and eighteenth centuries.

This subject is treated in an engraving by Antonio Wierinck after Maarten de Vos in the *Theatrum Biblicum* (1674: [4]), and in somewhat similar terms by Sebastiano Ricci at Belluno and at Trescore (Daniels 1976: [164], [274]).

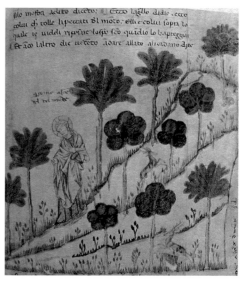

Figure 154. *Jesus Descending from the Mountain Alone* (miniature, 14th century, Paris, Bibliothèque Nationale, Ms. Ital. 115)

112. *Andrew Brings Peter to Jesus*

TRADITIONS: We have found no other representation of this story.

113. *The Calling of the Sons of Zebedee*

This scene follows immediately upon *The Calling of Peter and Andrew* (pl. 111) in Matthew, though here we have interposed the scene described in John 1:42, *Andrew Brings Peter to Jesus* (pl. 112). Luke 5:1–5 associates this scene with Jesus preaching from the boat in *The Lake of Gennesaret* (pl. 129).

TRADITIONS: This scene appears on the third column of the Ciborium in San Marco (Gabelentz 1903: C.IV). One may also note the engraving by Wierix after Passeri from the *Evangelicae Historiae Imagines* (1593: [17]) [fig. 155], which is not dissimilar. It is also found in Venice in the early sixteenth century in the altarpiece by Marco Basaiti of 1510 from Sant'Andrea della Certosa, now in the Gallerie dell'Accademia (Moschini Marconi 1955: [45]).

Figure 155. *The Calling of Peter and Andrew* (carved relief, ca. 500, Venice, San Marco, Ciborium)

114. *The Baptism of the Virgin*

No text.

115. *The Sermon on the Mount*

TRADITIONS: The subject is strangely rare in Venice, which seems to prefer the second great story involving a large crowd, *Jesus Feeding the Multitude* (pl. 135). However, it appears in the fourteenth-century *Meditationes vitae Christi* in three miniatures, showing *The Ascent of the Mountain* (which is identified as Mount Tabor, two miles from Nazareth), *The Sermon* [fig. 156], and *The Descent from the Mountain* (Ragusa and Green 1961: [135, 136, 137]). It is also found in the *Deutsche Bilderbibel* (1960: [6b]). Nadal appropriates it for the fifth Sunday after Pentecost (Nadal 1594: [19]; Rheinbay 1995: [7]).

116. *Jesus Healing the Leper*

TRADITIONS: The subject appears among the mosaics of San Marco (*San Marco* 1991: [75/3]) identified as *The Healing of the Dropsical Man,* among those of Monreale (del Giudice 1702: [XIX.7]), and among those of the Chora (Underwood 1966: [119/139]), as well as in the *Deutsche Bilderbibel* (1960: [VI verso/b]).

Note the engraving by Collaert after Passeri from the *Evangelicae Historiae Imagines* (1593: [26]). Nadal appropriates it to the third Sunday after Epiphany (Nadal 1594: [26]; Rheinbay 1995: [10]).

SOURCES: The tower and city wall on the right derive from *Via Crucis V* [fig. 157] (Rizzi 1971: [45]); see also plates 117, 167, 168, 170, 306, and, in reverse, plates 154, 263, and 309.

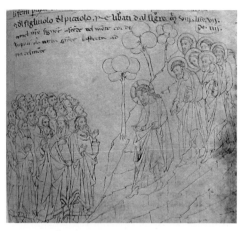

Figure 156. *The Sermon on the Mount* (miniature, 14th century, Paris, Bibliothèque Nationale, Ms. Ital. 115)

117. *Jesus and the Centurion*

TRADITIONS: This scene appears on the second column of the Ciborium in San Marco (Gabelentz 1903: B.VI) and in the mosaics of Monreale (del Giudice 1702: [XIX.6]), followed by *Jesus Heals the Centurion's Servant* (pl. 118). In San Marco the ancient mosaic was replaced in the seventeenth century after a cartoon by Pietro Vecchia (*San Marco* 1991: [73/1]). The subject is treated in the *Deutsche Bilderbibel* (1960: [14 verso/b]) and by Virgil Solis (1565: [112]), which is quite similarly arranged. Domenico would certainly have known the painting by Veronese (one of several versions) in Ca' Grimani until 1747, then passing to Dresden, which was engraved by Pietro Monaco (1743: [LV]; 1763: [67]; Apolloni 2000 [67]). He also would have known the painting by Brusaferro, then in Ss. Cosma e Damiano (which appears to be lost), the Lazzarini in Murano, Sta. Maria degli Angeli (no trace), and the Pittoni in San Zan Degolà (no trace), as well as the relief by Morlaiter of 1754 in the Gesuati (Niero 1979: [11]).

One may also note the engraving by Wierix after Passeri from the *Evangelicae Historiae Imagines* (1593: [27]). There is also a small painting of this subject by Sebastiano Ricci at Naples (Daniels 1976: [472, 473]), which was at Calorno until 1734.

SOURCES: The tower and city wall on the right are to be found in plates 116, 167, 168, 170, 306, and, in reverse, plates 154, 263, and 309.

The drawing derives from *Station V* of the S. Polo *Via Crucis* [fig. 157]. The kneeling page on the left derives from a figure in the marriage fresco of the Kaisersaal at Würzburg (Stuttgart, 1970, [98]) [fig. 158]. The dog has also been noted in several other drawings, such as plates 83 and 98.

Figure 157. Domenico Tiepolo, *Via Crucis V* (etching, 1749)

118. *Jesus Heals the Centurion's Servant*

SOURCES: The man standing, low left, derives from *The Flight into Egypt 7* [fig. 111]; see also plates 25, 160, and 162.

Figure 158. Giambattista Tiepolo, *A Sheet of Studies* (1752, Stuttgart, Staatsgalerie 1474)

119. *Jesus Curing Peter's Mother-in-Law*

TRADITIONS: The theme appears among the mosaics of Monreale (del Giudice 1702: [XIX.13]) [fig. 159] in a design that should be compared with the present drawing, followed by *The Man with the Dropsy* (Luke 14:2), a subject not treated by Domenico. It is also treated in the Chora (Underwood 1966: [136]). In San Marco, the ancient mosaic was replaced in 1670–1680 by Giuseppe Paulutti after a cartoon by Gianantonio Fumiani (*San Marco* 1991: [93/3]); *The Rockefeller McCormick New Testament* (1932: [15]); *Meditationes vitae Christi* (Ragusa and Green 1961: [145]); *Deutsche Bilderbibel* (1960: [VII verso/a & 5 verso/a]). Biancolini (1749) records a painting of this subject by Veronese in San Bernardino, Verona.

One may also note the engraving by Wierix after Passeri from the *Evangelicae Historiae Imagines* (1593: [18]), which is comparable, and Ricci (1607: [29]), which is not dissimilar, as well as an engraving after Maarten de Vos in the *Theatrum Biblicum* (1674).

SOURCES: The girl on the left derives from the figure on the left in a drawing at Edinburgh [fig. 115].

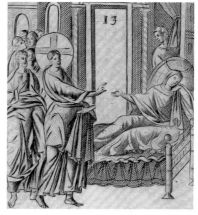

Figure 159. *Jesus Cures Peter's Mother-in-Law* (Monreale Cathedral, after del Giudice 1702)

120. *The Resurrection of the Widow's Son*

TRADITIONS: It is found among the mosaics of Monreale (del Giudice 1702: [XIX.10]) and among those of the Chora (Underwood 1966: [202]). In San Marco the ancient mosaic was replaced in 1567 after a cartoon by Salviati (*San Marco* 1991: [62/1]). It also appears in *The Rockefeller McCormick New Testament* (1932: [66 verso]), in the *Meditationes vitae Christi* (Ragusa and Green 1961: [149, 150]), and in the *Deutsche Bilderbibel* (1960: [VII verso/a & 9a]). Domenico's composition has much in common with that of the Virgil Solis woodcut from the *Biblische Figuren* (Solis 1565: [161]) and with the engraving by Wierix after Passeri from the *Evangelicae Historiae Imagines* (1593: [28; see also Ricci 1607: [53]) and even with the woodcut of the *Biblia Sacra vulgate editionis* (1727: 780). One may also note the engraving after Maarten de Vos in the *Theatrum Biblicum* (1674: [7]). It is treated by the young Antonio Pellegrini in the Cappella del Crocefisso of Sta. Maria del Giglio (Knox 1995: [17]), and this appears to be unique in Venetian painting [fig. 160].

SOURCES: The city gate is somewhat reminiscent of Sanmichele's gates of Verona, but derives from *Station III* of the S. Polo *Via Crucis* [fig. 235].

Figure 160. Antonio Pellegrini, *The Resurrection of the Son of the Widow of Nain* (1698, Venice, Sta, Maria del Giglio, Cappella del Crocefisso)

121. *The Widow's Son Restored*

TRADITIONS: The story is found among the mosaics of Monreale (del Giudice 1702: [XIX.10]) and among those of the Chora (Underwood 1966: [202]). In San Marco the ancient mosaic was replaced in 1567 after a cartoon by Salviati (*San Marco* 1991: [62/1]). It also appears in *The Rockefeller McCormick New Testament* (1932: [66 verso]), in the *Meditationes vitae Christi* (Ragusa and Green 1961: [149, 150]), and in the *Deutsche Bilderbibel* (1960: [VII verso/a, 9a]). Domenico's composition has much in common with that of the Virgil Solis woodcut from the *Biblische Figuren* (Solis 1565: [161]), with the engraving by Wierix after Passeri from the *Evangelicae Historiae Imagines* (1593: [28; see also Ricci 1607: [53]), and even with the woodcut of the *Biblia Sacra vulgate editionis* (1727: 780). One may also note the engraving after Maarten de Vos in the *Theatrum Biblicum* (1674: [7]). It is treated by the young Antonio Pellegrini in the Cappella del Crocefisso of Sta. Maria del Giglio [fig. 160], and this

appears to be unique in Venetian painting. No exact prototype for this scene may be found. In the *Meditationes vitae Christi* (Ragusa and Green 1961: [149, 150]), we see the boy lying on the bier, then sitting up on the bier, then kneeling before Jesus.

SOURCES: The architecture derives from *Station III* of the S. Polo *Via Crucis* [fig. 235].

122. *The Feast in the House of Simon, I*

TRADITIONS: The scene is treated three other times by Paolo Veronese, each including the woman with the box of ointment: first, in a canvas at Turin (Marini 1968: [62]) that was copied by Giambattista in 1761; second, in the great canvas for San Sebastiano, now in the Brera (Marini 1968: [137]); and third, in the canvas for the Servi, now in the Louvre (Marini 1968: [163]).

SOURCES: The setting here seems to derive from the great canvas by Veronese from the Servi, later presented to Louis XIV in 1664, and now in the Louvre. Domenico probably follows the engraving by Valentin Lefebre from the *Opera Selectiora* (Lefebre 1682: [25]), which shows the composition in reverse [fig. 161]. The etching is printed on two sheets glued together; Domenico uses the lefthand sheet only. The engraving may possibly be after a copy by Lefebre at Hampton Court (Levey 1991: [186]), also in reverse. This repeats the situation that arises with respect to *The Presentation of Jesus in the Temple* (pl. 41). Apart from the double columns and the curved architrave, the page in the left foreground (who also appears in *The Seven Virgins Draw Lots,* pl. 18) and the man seated in the large chair derive from the same source. The figure of Jesus

Figure 161. Valentin Lefebre after Veronese, *The Magdalene Washing the Feet of Jesus* (from the *Opera Selectiora*, Venice, 1682)

and the Magdalene follows Domenico's own painting of 1752, for the Neues Speis-Zimmer of the Residenz at Würzburg, or more probably the drawing in Saint Petersburg (Knox 1980: [164, 165]). The painting uses a format similar to the *Deutsche Bilderbibel* (1960: [VIII verso/a & 9 verso/b]) and may owe something to German models. The architectural screen in the background derives from Domenico's *Pool of Bethesda* in the Louvre (Mariuz 1971: [167]), with the same detail seen through the left arch, deriving from *Station V* of the S. Polo *Via Crucis* [fig. 157].

123. *Jesus Calms the Tempest, I*

TRADITIONS: The scene is found among the mosaics of San Marco (*San Marco* 1990: [30]; 1991: [75/2]), which seems to show the figure of Jesus twice: on the left he rebukes the tempest, and on the right he is shown sleeping; perhaps he is also the important figure with arm outstretched, in right center [fig. 162]. The scene is also found in *The Rockefeller McCormick New Testament* (1932: [41 verso]), in the *Meditationes vitae Christi* (Ragusa and Green 1961: [147, 148]), and in the *Deutsche Bilderbibel* (1960: [10a]).

One may also note the woodcut by Virgil Solis from the *Biblische Figuren* (Solis 1565: [116]), the engraving by Wierix after Passeri from the *Evangelicae Historiae Imagines* (1593: [29]), and an engraving after Maarten de Vos in the *Theatrum Biblicum* (1674: [2]). *Jesus Sleeping through the Tempest* is also the subject of a painting by Domenico (Mariuz 1971: [310]).

Figure 162. *Jesus Calms the Tempest* (mosaic, 12th century, Venice, San Marco, north transept)

124. *Jesus Calms the Tempest, II*

SOURCES: The design follows the San Marco mosaic (Demus 1984: [143]) quite closely [fig. 162], though that refers to the other tempest described in Matthew 8:24, Mark 4:38, and Luke 8:23, showing Jesus calming the tempest, a theme that Domenico also treats in plate 123.

125. *The Gadarene Swine*

TRADITIONS: The story, which follows *Jesus Calms The Tempest* (pls. 123–124), is found on the second column of the Ciborium in San Marco (Gabelentz 1903: BV), in *The Rockefeller McCormick New Testament* (1932: [15 verso and 42 verso]), and in the *Deutsche Bilderbibel* (1960: [VIIIa, 10b]).

One may also note the engraving after Maarten de Vos in the *Vita, Passio et Resurrectio Iesv Christi* (n.d., ca. 1580: [20]) [fig. 163]. The seventeenth-century mosaic of San Marco by Paoletti after Fumiani (*San Marco* 1991: [93/1]) seems to be inspired by the design of Maarten de Vos, relegating the swine to the background.

SOURCES: The figure of Jesus derives from the Louvre's *Pool of Bethesda* [fig. 170].

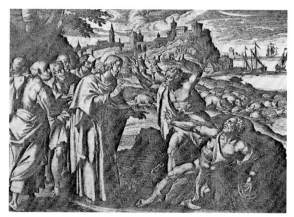

Figure 163. Iacobus de Bye after Maarten de Vos, *The Gadarene Swine* (ca. 1580, from the *Vita, Passio et Resurrectio Iesu Christi*, Antwerp, ca. 1580, [20])

126. *Jesus Healing the Man Sick of the Palsy*

TRADITIONS: The scene is found on the second column of the Ciborium in San Marco (Gabelentz 1903: B.VIII), among the mosaics of San Marco (Demus 1984: color plate 39; *San Marco* 1991: [75/1]), and among those of Monreale (del Giudice 1702: [XX.7]), with which the present design should be compared [fig. 164]. The mosaic of the Chora does not show the breaking open of the roof (Underwood 1966: [124]). It is also found in the *Rockefeller McCormick New Testament* (1932: [16 and 36 verso]); and in the *Deutsche Bilderbibel* (1960: [7 verso/a]). There was also a Lazzarini in the lost church of Sant' Angelo.

One may also note the engraving by Wierix after Passeri from the *Evangelicae Historiae Imagines* (1593: [30]), which makes a useful comparison. Nadal appropriates the subject to the eighteenth Sunday after Pentecost (Nadal 1594: [30]; Rheinbay 1995: [12]; Ricci 1607: [35]). There is also an engraving after Maarten de Vos in the *Theatrum Biblicum* (1674: [4]).

SOURCES: The leg hanging over the masonry, top left, derives from a study by Giambattista for the river-god of the Würzburg Kaisersaal ceiling (Lorenzetti 1946: [43]; Knox 1980: C.43).

Figure 164. *Jesus Healing the Man Sick of the Palsy* (mosaic, 1180, Monreale Cathedral, after del Giudice 1702)

127. *The Calling of Matthew*

TRADITIONS: The scene is found on the third column of the Ciborium in San Marco (Gabelentz 1903: CIII) and among the frescoes of Giusto de' Menabuoi in the Padua Baptistery (Spiazzi 1989: 64.5, [40, 194]). It also appears in the *Meditationes vitae Christi* (Ragusa and Green 1961: [118]) and in the *Deutsche Bilderbibel* (1960: [7a, 7 verso/b]).

In sixteenth-century Venice it appears among the scenes of *The Life of Jesus* by Carpaccio in the Scuola di San Giorgio degli Schiavoni of 1502 (Sgarbi 1979: [19]). Apart from the celebrated Caravaggio in San Luigi dei Francesi,

which Domenico could hardly have known, Anna Jameson refers to a painting by Pordenone at Dresden (Jameson 1883: 146), which we have not been able to trace. A modern example that may be relevant is the Luca Giordano of ca. 1684, hence possibly Venetian, now in the Georgetown University Art Collection, Washington, D.C. (Ferrari and Scavizzi 1992: [997]). There is also a canvas by Diziani in the Tiepolo parish church of San Felice (Zugni-Tauro 1971: [255]).

SOURCES: Many of the elements in this design are found in the drawing dated 1791 by Domenico, *The Pawnbroker* [fig. 165], *Contemporary Life 54* (Gealt and Knox 2005: [55]). However, all of them are shown in reverse: the man in the chair on the left, the balance, and most of the figures round the table. It is a nice question which of these drawings has the priority, but if it is given to *The Pawnbroker,* as we think it must, then the present drawing must be later than 1791.

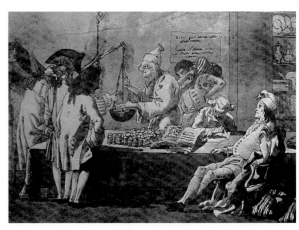

Figure 165. Domenico Tiepolo, *The Pawnbroker* (1791, location unknown)

128. *Jesus Receives the Disciples of John the Baptist*

TRADITIONS: A very comparable arrangement is found in the engraving by Wierix after Passeri from the *Evanglicae Historiae Imagines* (1593: [32]) [fig. 166] and again in Ricci (1607: [54]).

129. *The Lake of Gennesaret*

TRADITIONS: This scene appears on the third column of the Ciborium in San Marco (Gabelentz 1903: CVIII) and in the mosaics of San Marco (*San Marco* 1991: [406]), though it is identified as *The Miraculous Draught of Fishes.* It is also found in *The Rockefeller McCormick New Testament* (1932: [40 verso]), in the *Deutsche Bilderbibel* (1960: [5 verso/b]) [fig. 167], and by Virgil Solis (1565: [150]). The most celebrated sixteenth-century example is the tapestry cartoon by Raphael in the Victoria and Albert Museum.

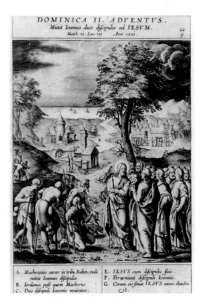

Figure 166. Wierix after Passeri, *Jesus Receives the Disciples of John the Baptist* (from the *Evangelicae Historiae Imagines,* Antwerp, 1593 [32])

SOURCES: The boat is very similar to the one in Domenico's *Jesus Sleeping through the Tempest* (Mariuz 1971: [310]); see also plate 137. The man standing full face, top center, derives from a drawing by Domenico in the Beauchamp Album (Christie's sale 1965: [160]).

130. *Jesus Instructs Nicodemus*

TRADITIONS: The story of Nicodemus is found in the *Deutsche Bilderbibel* (1960: [7b]) and by Virgil Solis (1565: [145]) in the *Biblische Figuren.* A treatment by Tintoretto is recorded in the collection of Hamlet Winstanley (1700–1761) in Le Blanc 12. One may also note the engraving by Jacob de Bye after Maarten de Vos [fig. 168] in the *Vita, Passio et resurrectio Iesu Christi* (n.d.: [16]). Ricci (1607: cap. xxi, [20]) presents a simple indoor scene with Jesus and Nicodemus seated at table with lamp.

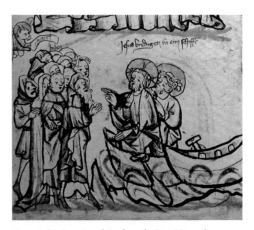

Figure 167. *Jesus Preaching from the Boat* (*Deutsche Bilderbibel,* folio 5 verso/b, Freiburg, University Library)

131. *Jesus and the Woman of Samaria, I*

TRADITIONS: This appears on the second column of the
Ciborium in San Marco (Gabelentz 1903: BV), and among the
mosaics of Monreale (del Giudice 1702: [XX.10]), a single scene
shown in a manner that is very comparable with the present drawing.
The two successive scenes that are represented in plates 132–133 are
also shown together in succession in the San Marco mosaics (Demus
1984: [147]; *San Marco* 1990: [111]; 1991: [89/3, left and right]);
this represents very persuasive evidence that Domenico studied
these mosaics [fig. 169]. The gesture of the woman, indicating the
sheep, seems to confirm her question. The story is also told in eight
miniatures in the *Meditationes vitae Christi* (Ragusa and Green 1961:
[170–177]), and the two scenes are paired in the *Deutsche Bilderbibel*
(1960: [14a, 14 verso a]). One may also note the engraving by Wierix
after Passeri from the *Evanglicae Historiae Imagines* (1593: [35]).

As sixteenth-century examples, Domenico must have known
the engraving by Valentin Lefebre after Veronese in *Opera Selectiora*
(Lefebre 1682); the canvas by Jacopo Bassano, engraved by Pietro
Monaco (Monaco 1743: [LXIII]; 1763: [34]); and later, the small
canvas by Piazzetta, also engraved by Monaco (1743: [LIV]; 1763:
[53]), and several by Sebastiano Ricci, including the overdoor for
Joseph Smith, now at Hampton Court (Daniels 1976: [447]), possibly
through Liotard's engraving.

There is a drawing by Giambattista in the Orloff Album (sale 1920,
[92]; Knox 1961: pl. 42), while Domenico himself treated the subject
more than once (Mariuz 1971: [36, 38]) but in half-length.

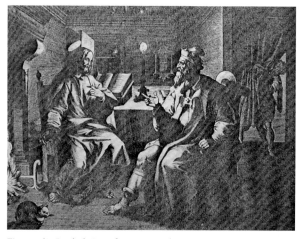

Figure 168. Jacob de Bye after Maarten de Vos, *Jesus Instructs
Nicodemus* (from the *Vita, Passio et Resurrectio Iesu Christi*, Antwerp,
n.d., [16])

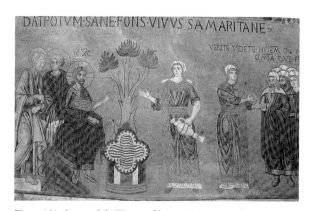

Figure 169. *Jesus and the Woman of Samaria* (mosaic, 12th century,
Venice, San Marco, south transept)

132. *Jesus and the Woman of Samaria, II*

TRADITIONS: The two scenes are shown together in succession in the San Marco mosaics (Demus 1984:
[147]; *San Marco* 1990: [111]; 1991: [89/3, left and right]). The mosaic, which includes the inscription, also treats
the subject in a very similar way. The story is also shown in two scenes in the *Deutsche Bilderbibel* (1960: [14a and
14 verso/a]) and again in engravings by Wierix after Passeri from the *Evanglicae Historiae Imagines* (1593: [35, 36])
and in Ricci (1607: [23, 24]); see [fig. 169].

133. *The Pool of Bethesda*

TRADITIONS: It is found twice among the mosaics of San Marco, in the north transept, twelfth century
(Demus 1984: [142]; *San Marco* 1991: [57, 97]), and in the south transept, seventeenth century (San Marco
1991: [87/2]). It appears among the mosaics of Monreale (del Giudice 1702: [XXI.2]), with the angel above, and
in fragments in the Chora (Underwood 1966: [121]). It is also found in *The Rockefeller McCormick New Testament*
(1932: [89]) and in the *Deutsche Bilderbibel* (1960: [15a]).

Important sixteenth-century examples in Venice include the Tintoretto in the Chiesa di San Rocco (de Vecchi
1970: [132; XX–XXI]), engraved by Valentin Lefebre (1682) and the Veronese formerly in San Sebastiano, now in
the Brera (Marini 1968: [137]). In Domenico's day there was a fine Veronese *Pool of Bethesda* in the Palazzo Grassi,
engraved by Pietro Monaco (1743: [LVI]; 1763: [69]; Apolloni 2000: [69]). Francesco Bartolomeo dal Pozzo (1718:
298) refers to a painting "di figure minori del naturale" by Antonio Fumiani in the collection of Ercole Giusti:
"Christo alla probatica piscina."

One may also note the engraving by Wierix after Passeri from the *Evanglicae Historiae Imagines* (1593: [47]), which is not helpful, and the engraving after Maarten de Vos in the *Theatrum Biblicum* (1674: [10]).

The theme enjoyed some popularity in eighteenth-century Venice, starting with a small painting by Gianantonio Fumiani, recorded in the collection of Ercole Giusti in Verona, followed by the great canvas by Gregorio Lazzarini of 1719 for Sant'Angelo, now in the Fondazione Cini (Moschini Marconi 1970: [81]) and the smaller canvas in the Ospedaletto (Aikema and Meijers 1989: [123]), then followed by the large canvas by Ricci for Joseph Smith (now at Osterley) and a small early canvas by Giambattista Tiepolo in the Accademia and a drawing in the Orloff sale (Paris, 1921, [96]). Finally, it was treated by Domenico in the handsome canvas in the Louvre (Knox 1994: [7, 15, 16, 18]).

Figure 170. Domenico Tiepolo, *The Pool of Bethesda* (1759, Paris, Musée du Louvre)

SOURCES: Virtually all the elements in this design derive from Domenico's painting in the Louvre, *The Pool of Bethesda* (Knox 1980: [243]) [fig. 170]. Other elements from this picture are found in plates 234 and 295.

134. *Jesus Blessing the Loaves and Fishes*

TRADITIONS: The theme, which is a popular one in all ages, appears on the second column of the Ciborium in San Marco (Gabelentz 1903: B.9). In the mosaics of San Marco (*San Marco* 1990: [110] [fig. 171]; 1991: [89/1]) and at Monreale (B: del Giudice 1702: [XX.1]) it appears in two parts, as here. It also appears in a miniature in the *Meditationes vitae Christi* (Ragusa and Green 1961: [183]), in the *Deutsche Bilderbibel* (1960: [15b]), and in *Biblische Figuren* (Solis 1565: [122]).

There is an important version in Venice by Palma Giovane in the chancel of the Carmini, measuring 300 x 860 cm. (Mason Rinaldi 1984: [619]); there was also a large canvas by Leandro da Ponte at Monte Cassino (destroyed) (Arslan 1960: [309]) and one by Zanchi in Sta. Marta (lost).

One may note the engravings by Collaert after Maarten de Vos in the *Vita, Passio et Resurrectio Iesu Christi* (n.d., ca. 1580: [26]), and by Wierix after Passeri in the *Evanglicae Historiae Imagines* (1593: [42]). The scene also appears in the seventeenth-century mosaic of San Marco by Paolutti after Fumiani, in a design that seems to owe something to Maarten de Vos (*San Marco* 1991: [93/2]).

The theme is treated by Molinari in a fine large canvas in the choir of San Pantalon of 1690 (Knox 1992: [10]). But for Domenico, the most magnificent painting on this theme in Venice was the vast canvas by Giambattista Pittoni for Ss. Cosma e Damiano, now with the Fondazione Cini (Zava-Bocazzi 1979: no. 215, [104–111]), and this drawing, in its general layout, seems to owe something to that composition.

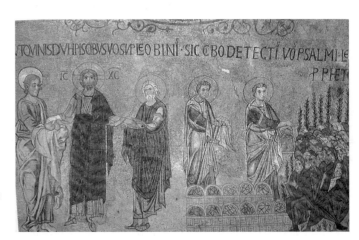

Figure 171. *The Feeding of the Five Thousand* (mosaic, 12th century, Venice, San Marco)

SOURCES: The seated man in the foreground derives from the etching *The Baptism of Jesus* (Rizzi 1971: [109]) in reverse, or more exactly, from the figure in the St. Louis *Crucifixion* (Morassi 1955: [fig. 25]). See also the drawing by Giambattista, formerly with Paul Cassirer in Berlin (Hadeln 1927: [131]; Knox 1980: M.602).

135. *Jesus Feeding the Multitude*

TRADITIONS: The subject is found in San Marco (Demus 1984: [color plate 40]; *San Marco* 1991: [89/1]) in two parts: on the left, *Jesus Blessing the Loaves and Fishes* (see also pl. 135) and on the right, *The Feeding of the Five Thousand*. A similar arrangement is found at Monreale (del Giudice 1702: [XX.1, 2]). In the Chora, only fragments remain (Underwood 1966: [118]). The subject is found in *The Rockefeller McCormick New Testament* (1932: [22 verso]), the *Deutsche Bilderbibel* (1960: [15b, 17 verso/a]), and in the *Biblische Figuren* (Solis 1565: [122, 152]), which has some elements in common with Domenico's design. Two prints by Wierix after Passeri from *Evangelicae Historiae Imagines* (1593: [42, 43]) again show the story in two parts: *The Blessing of the Loaves and Fishes* and *The Feeding of the Five Thousand.*

The most impressive example of the theme in sixteenth-century Venice is the lost Leandro da Ponte, commissioned in 1592 for Monte Cassino, 350 x 580 cm (Arslan 1960: [309]), but perhaps more relevant is the Palma Giovane of ca. 1615 in San Giacomo dell'Orio, which has a similar basic composition (Mason Rinaldi 1984: [564]; Colnaghi, New York, 1999, [8]). One must also note the magnificent canvas by Antonio Molinari in San Pantalon of 1690, measuring some 9 meters square (Knox 1992: [10]) and the Giambattista Pittoni for Ss. Cosma e Damiano on the Giudecca, of 1725, 540 x 830 cm, now at the Fondazione Giorgio Cini (Zava-Bocazzi 1979: [104]).

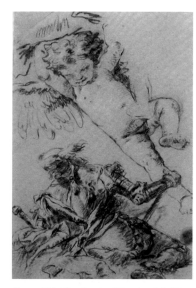

Figure 172. Giambattista Tiepolo, *A Soldier Reclining* (Stuttgart, Staatsgalerie, 1459)

SOURCES: The reclining soldier, lower right edge, derives from a detail of the ceiling of the Kaisersaal at Würzburg, no doubt using the drawing at Stuttgart (1970, [74]) [fig. 172]; see also *The Denial of Peter* (pl. 191).

136. *Jesus and Peter Walking on the Waters*

TRADITIONS: The subject is found among the mosaics of Monreale (del Giudice 1702: [XIX.9]) [fig. 173]. However, the most celebrated example in Western Christendom, though presumably not known directly to Domenico, is the mosaic designed by Giotto, *La Navicella* (Gnudi 1959: [45a]), now in the entrance to St. Peter's. It also appears in a miniature in the *Meditationes vitae Christi* (Ragusa and Green 1961: [188]), with Peter first walking on the water, then sinking. In San Marco, the medieval mosaic has been replaced with work after a cartoon after Pietro della Vecchia (*San Marco* 1991: [87/1]).

One may note the engraving by Wierix after Passeri in *Evanglicae Historiae Imagines* (1593: [44]).

Figure 173. *Jesus and Peter Walking on the Waters* (mosaic, 12th century, Monreale)

SOURCES: The design follows the miniature of the *Deutsche Bilderbibel* (1960: [15a]) quite closely. On the other hand, the figure of Peter, though reversed, is close to the relief by Morlaiter in the Gesuati (Niero 1979: [28]). Much of the composition derives from the painting by Domenico in the Fodor collection (Mariuz 1971: [309]), which shows Peter climbing back into the ship.

137. *Jesus on the Sea of Galilee*

SOURCES: Just as the shape of the ship in plate 136 follows the design of the painting in the Fodor collection (Mariuz 1971: [309]), so here the ship follows the painting *Jesus Sleeping through the Tempest* (London, Agnew, formerly Paris, Strauss; Mariuz 1971: [310]) [fig. 174]. The two images are pendants, dated by Mariuz to the years 1775–1785.

Figure 174. Domenico Tiepolo, *Jesus Sleeping Through the Tempest* (London, Agnew)

138. *Jesus and the Woman of Canaan*

TRADITIONS: This appears on the second column of the Ciborium in San Marco (Gabelentz 1903: B.IX) and among the sixteenth-century mosaics of San Marco (*San Marco* 1991: [62/1]) [fig. 175] in association with *The Resurrection of the Widow's Son,* plates 120–121. Zatta (1761: 33) notes: *"Dirimpetto, vale a dire verso la porta maggiore si sorgano I due miracoli operati dal Salvatore, una della Cananea con queste parole—O MULIER MAGNA EST FIDES TUE—l'atro del figliuolo della vedova con queste—ADOLESCENS TIBI DICO SURGE."* It also appears in a miniature in the *Meditationes vitae Christi* (Ragusa and Green 1961: [190]) in rather a similar arrangement.

There is a treatment of this rare subject by Palma Vecchio in the Gallerie dell'Accademia (Moschini Marconi 1962: [274]). There is also a small painting by Sebastiano Ricci at Naples (Daniels 1976: [457, 474]), which was at the ducal villa at Colorno, near Parma, until 1734.

One may note the engraving by Wierix after Maarten de Vos in the *Evanglicae Historiae Imagines* (1593: [61]), which has some similarities, but the comparison emphasizes the simplicity of Domenico's compositions.

Figure 175. Bianchini, after Salviati, *"O Woman, Great Is Thy Faith"* (mosaic, 1567, Venice, San Marco, left transept)

139. *Jesus Ascends the High Mountain with Peter, James, and John*

TRADITIONS: That this drawing does indeed represent *The Ascent* is made clear by a miniature from *The Rockefeller McCormick New Testament* (1932: [46 verso]), an Imperial Byzantine ms. of about 1260, which shows the four figures in a somewhat similar arrangement. *The Transfiguration,* which appears to be earlier than the other two drawings, is represented in plate 141, and *The Descent* in plate 142. It is not possible as yet to suggest a Venetian prototype for this design that might have been accessible to Domenico; however, a similar set of miniatures is found in the *Meditationes vitae Christi* (Ragusa and Green 1961: [185–187]), though these illustrate the passage in Matthew 14:23, and in each case Jesus is shown alone.

140.** *"Questo e il mio figlio delitto, ascoltatelo"—The Transfiguration, II*

No text.

141. *The Transfiguration*

TRADITIONS: The theme is treated both in the mosaics of the Cappella Palatina and Monreale (del Giudice 1702: [XX.11]), which are quite comparable. In San Marco the early work has been replaced by Marini after a cartoon by Tintoretto of 1588–1589 (*San Marco* 1991: [60/5]). It is also found in *The Rockefeller McCormick New Testament* (1932: [24 verso, 69 verso]), in the frescoes by Giusto de Menabuoi in the Baptistery at Padua (Spiazzi 1989: 65.2 [41]), in the *Deutsche Bilderbibel* (1960: [18b]), and by Dürer (*The Illustrated Bartsch* [80]). The most prominent treatment of this theme in sixteenth-century Venice is the large canvas by Titian, painted ca. 1560 as a cover for the "pala argentea" in the choir of San Salvatore (Valcanover 1969: [417]) [fig. 176]. An example by Antonio Zanchi in the cathedral of Treviso cannot be traced.

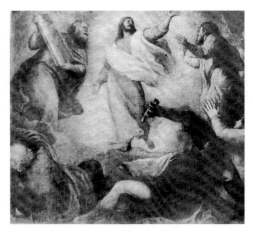

Figure 176. Titian, *The Transfiguration* (ca. 1560, Venice, San Salvatore)

One may note the engraving by Wierix after Passeri in the *Evanglicae Historiae Imagines* (1593: [63]) and another by Wierix after Maarten de Vos in the *Theatrum Biblicum* (1674: [5]).

SOURCES: The figure of the Almighty is broadly based on Giambattista's Este altarpiece of 1758 (Morassi 1955: [75]), though shown in reverse.

142. *Jesus Descends from the Mountain with Peter, James, and John*

TRADITIONS: We have not been able to find an exact treatment of this theme in the familiar sources. However, the fourteenth-century *Meditationes vitae Christi* (Ragusa and Green 1961: [187]) shows Jesus descending the mountain alone [fig. 177].

143. *Jesus Rebukes the Unclean Spirit*

TRADITIONS: This theme appears on the second column of the Ciborium in San Marco (Gabelentz 1903: B.IX) and in the *Deutsche Bilderbibel* (1960: [18 verso/a]). One may also note the engraving by Wierix after Passeri in the *Evanglicae Historiae Imagines* (1593: [45]).

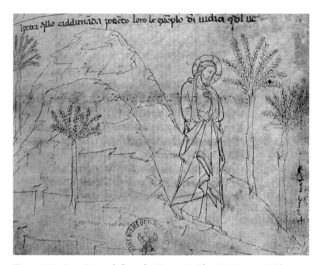

Figure 177. *Jesus Descends from the Mountain Alone* (miniature, 14th century, Paris, Bibliothèque Nationale, Ms. Ital. 115)

SOURCES: The composition here derives from the painting by Domenico in the von Nemes collection (Mariuz 1971: [308]) [fig. 178]. The background, which Conrad relates to Palladio's *Villa Capra*, is reused in *The Hercules Statue* (*Scenes of Contemporary Life 45;* Gealt and Knox 2005: [45]).

144. *Jesus Demonstrates the Power of Faith*

TRADITIONS: This scene appears on the second column of the Ciborium in San Marco (Gabelentz 1903: B.IX) and in the *Deutsche Bilderbibel* (1960: [18 verso/a]). One may also note the engraving by Wierix after Passeri in the *Evanglicae Historiae Imagines* (1593: [45]).

SOURCES: The figure of Jesus derives from the Louvre's *Pool of Bethesda* [fig. 170].

Figure 178. Domenico Tiepolo, *Jesus Rebukes the Unclean Spirit* (Munich, von Nemes collection)

145. *Peter Finds the Money in the Fish*

TRADITIONS: This subject appears in the *Deutsche Bilderbibel* (1960: [24 verso/below]) and as a detail in the celebrated fresco by Masaccio in the Carmine. It is also found in an engraving by Wierix after Passeri in the *Evangelicae Historiae Imagines* (1593: [16]).

146. *The Good Samaritan*

TRADITIONS: The theme does not seem to be favored by the early Venetian tradition, but it is treated by Virgil Solis (1565: [158]) in the *Biblische Figuren.* The trees suggest that Domenico recalled the engraving by

Wierix after Passeri in the *Evangelicae Historiae Imagines* (1593: [33]) [fig. 179]. The subject was treated by Jacopo da Ponte in two fine canvases, at Hampton Court and in the Capitoline Museum (Arslan 1960: [83–88]), which use the motif of the standing horse, also favored here by Domenico. In the early eighteenth century we find it used in five drawings by Molinari and in one early painting by Piazzetta (Knox 1992: 31, note 11, [27]). The main group here is a little reminiscent of Giambattista's studies for *Apollo and Hyacinthus* (Knox 1960/1975: [186 recto]).

SOURCES: The horse may derive from a drawing by Domenico, *A Man Saddling a Horse* (Christie's, June 30, 1984 [132]).

Figure 179. Wierix after Passeri, *The Good Samaritan* (from the *Evangelicae Historiae Imagines,* Antwerp, 1593, [33])

147. *Jesus in the House of Mary and Martha*

TRADITIONS: The subject appears on the third column of the Ciborium in San Marco (Gabelentz 1903: C.IX) in the *Deutsche Bilderbibel* (1960: [19 verso/b]), and in a celebrated Tintoretto at Munich (de Vecchi 1970: [174]) [fig. 180]. One may also note the engraving by Raphael Sadeler (1560/1-1628/32) after Maarten de Vos, dated 1584 (Witt Print Collection), which displays a far more simple design.

SOURCES: The small dog derives from Giambattista's fresco, *Henry III at Mira,* and Domenico's etching [fig. 93].

148. *The Lord's Prayer*

TRADITIONS: No other record of this subject has been noted, unless perhaps in the etching by Georg Frederic Schmidt after Rembrandt of 1757 (*Kitto Bible,* 34-6431).

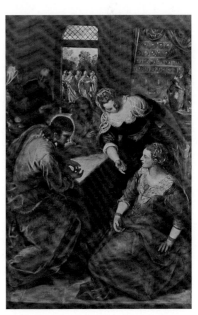

Figure 180. Jacopo Tintoretto, *Christ in the House of Mary and Martha* (Munich, Alte Pinakothek)

149. *Jesus Heals the Woman with a Spirit of Infirmity*

TRADITIONS: The subject, which is found only in Luke, appears among the mosaics of Monreale (del Giudice 1702: [XX.2]) in an arrangement that is very similar to our drawing. In the *Deutsche Bilderbibel* (1960: [20 verso/a]) the miniature is described as "an otherwise unknown representation." In San Marco, the original mosaic was replaced in the seventeenth century by work after a cartoon by Pietro Vecchia (*San Marco* 1991: [73/2]; 1991: [93/4]), though the former may refer to Matthew 9:20: "And, behold, a woman, which was diseased with an issue of blood, came behind him, and touched the hem of his garment."

SOURCES: The design relates to a preparatory drawing by Domenico in the Pierpont Morgan Library (Udine 1996: [44]), in which Jesus reproves the ruler of the synagogue for his objection that such work should not be done on the Sabbath.

Figure 181. *Christ Heals the Woman* (mosaic, 1180, Monreale, Cathedral, after del Giudice 1702)

150. *The Prodigal Son Taking His Journey into a Far Country*

TRADITIONS: The representation of this part of the story of the Prodigal Son is rare, but *The Departure of the Prodigal Son* is found in the set of four scenes by Bazzani in the Kress Collection at Kansas City (Rowlands 1996: [52]) and again in the set of six scenes by Murillo in the Beit Collection at Blessington (Gaya Nuño 1978: [262]). The latter set is said to be based on the set of etchings by Callot (Lieurre 1404–1414), but this scene is not included.

SOURCES: The three ibex derive from a drawing in the Morgan Library, Heinemann Collection (New York, 1973, [118]) [fig. 182], which, as Byam Shaw (1962: 83) noted, derive from a print by J. E. Ridinger; they are used again, more directly, in *Scenes of Contemporary Life 1* (Gealt and Knox 2005: [1]) and again in *Divertimento per li regazzi 59* (Gealt 1986: [98]). The two riders derive from the drawing *Three Horsemen* in a private collection (Udine 1996: [120]), and the foremost one is found again in *Scenes of Contemporary Life 26* (Gealt and Knox 2005 [27]).

Figure 182. Domenico Tiepolo, *Three Ibex* (New York, Pierpont Morgan Library, Heinemann Collection, 1997.69)

151. *The Prodigal Son Among the Swine*

TRADITIONS: The theme does not appear in the early sources. It seems to appear for the first time in Dürer's etching (*The Illustrated Bartsch* X, 1978: [28]); see also the engraving by Collaert after Passeri in the *Evangelicae Historiae Imagines* (1593: [68]). This tradition is also followed in an engraving after Maarten de Vos in the *Theatrum Biblicum* (1674: Witt Print Collection). Conrad finds links with the drawing at Bayonne, *Scenes of Contemporary Life 2* (Gealt and Knox 2005: [2]). There is also an engraving by Pietro Monaco after Jan Lys (Monaco 1763: [35]). It becomes popular in the seventeenth century in sets of etchings by Callot, and in sets of paintings by Murillo and Bazzani—see note to the preceding drawing.

152. *The Return of the Prodigal Son*

TRADITIONS: A useful comparison may be made with the Domenico Feti, one of his series of *Parables* at Dresden (*Gemäldegalerie* 1987: 177), though it is not clear how this series of small paintings could have been known in Venice. One may also note the composition by Jacopo Bassano, engraved by Monaco (1763: Apolloni 2000 [64]).

The subject is engraved by Wierix after Passeri in the *Evanglicae Historiae Imagines* (1593: [69]) and in a print after Maarten de Vos in the *Theatrum Biblicum* (1674: [4]).

SOURCES: The composition apparently derives from *The Return of the Prodigal* in the Pushkin Museum (Mariuz 1971: [301]) [fig. 183]; the arch in the background derives from Domenico's etching after *Station I* of the S. Polo *Via Crucis* (Rizzi 1971: [41]). On the other hand, the composition here seems far more satisfactory than that of the

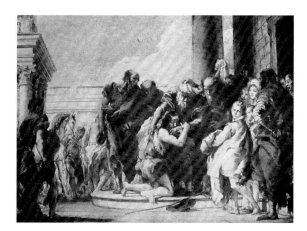

Figure 183. Domenico Tiepolo, *The Return of the Prodigal Son* (ca. 1775, Moscow, Pushkin Museum)

small Moscow canvas. Domenico does away with a building on the left, develops the architectural backcloth, and provides more space in the foreground, turning a crowded and confusion composition into a cool spatial system in which details, such as the tender manner in which the son takes his father's hand and kisses it, read much more clearly and effectively. The old woman in the doorway, extreme right, derives from the drawing at Edinburgh [fig. 115]; see also plates 2 and 35.

153. *Lazarus at the Gate*

TRADITIONS: The most celebrated treatment of the story of Dives and Lazarus is found in Venice in the Bonifacio de Pitati of ca. 1540, now in the Gallerie dell'Accademia (Moschini Marconi 1962: [60]). It was engraved by Pietro Monaco (1743: [LXII]; 1745: [75]), as in the Grimani collection. An interesting woodcut may be noticed in the *Biblia Sacra vulgate editionis* (1748: 494).

The woodcut of Virgil Solis (1565: [146]) is closely related to the Bonifacio, and one may further note the engraving after Maarten de Vos (Witt Print Collection) and by Wierix after Passeri from the *Evangelicae Historiae Imagines* (1593: [73]).

Figure 184. Giambattista Tiepolo, *A Villa* (Malibu, J. Paul Getty Museum)

Byam Shaw notes that "Domenico has set his Lazarus on the steps of a typical villa of the Venetian mainland," and in this at least he follows Bonifacio. However, the design is very different, and it may have been inspired in some degree by the woodcut of Hans Schäufelein (*The Illustrated Bartsch 11,* 1978: [193]).

SOURCES: This sheet was included in the volume on the *vedute* because the original landscape drawing by Giambattista, on which it was based, could not be found. It has since turned up and is now in the J. Paul Getty Museum at Malibu (Goldner 1988: [49]) [fig. 184]. The handling of this design seems to be a little looser than many of the large religious drawings, and it may be one of the first to be executed. The sphinx on the right derives from Domenico's etching of sphinxes and other decorative elements (Rizzi 1971: [154]).

154. *The Healing of the Ten Lepers*

TRADITIONS: The subject is found in Monreale (del Giudice 1702: [XX.3]) in a form that is quite similar to our drawing [fig. 185]. It also has much in common with the fresco at Decani (Underwood 1975: [35]). In San Marco the ancient mosaic was replaced in the seventeenth century with work after a cartoon by Pietro Vecchia (*San Marco* 1991: [72/1]). It is also found in *The Rockefeller McCormick New Testament* (1932: [77 verso]) and in the *Deutsche Bilderbibel* (1960: [9 verso/a, 21a]).

Figure 185. *The Healing of the Ten Lepers* (mosaic, 1180, Monreale, after del Giudice 1702)

One may note the woodcut by Virgil Solis (1565: [159]), which shows the one returning. The engraving by Wierix after Passeri from the *Evangelicae Historiae Imagines* (1594: [81]) is associated by Nadal with the thirteenth Sunday after Pentecost (Nadal 1594: [81]), and the subject is found in an engraving after Maarten de Vos in the *Theatrum Biblicum* (1674: [9]).

SOURCES: The same city wall is to be found in plates 116, 117, 167, 168, 170, 306, and, in reverse, in plates 154, 263, and 309. It derives from *Station V* of the S. Polo *Via Crucis* [fig. 157].

155. *Jesus and the Little Child*

TRADITIONS: The theme is treated in the *Deutsche Bilderbibel* (1960: [19a]). One may note the painting by Giuseppe Bazzani (1690–1769) at Copenhagen.

SOURCES: The buildings on the left derive from a drawing possibly by Domenico (Knox 1974: [31]) [fig. 186], while those on the right derive from a drawing by Domenico after Marco Ricci (Knox 1974: [57]).

156. "Suffer little children . . ."

TRADITIONS: Given the sentimental appeal of the subject, it is remarkably rare. One may cite a large and handsome engraving by Joannes Sadeler (1550–1629) after Iodocus a Winge, Frankfurt 1588 (*Kitto Bible* 41-7453). The subject is treated by Domenico in the Oratorio della Purità at Udine (Mariuz 1971: [163]) [fig. 187]. In the background a tree is indicated on the left.

157. *The Master in the Vineyard*

TRADITIONS: The composition may be compared with the Virgil Solis woodcut from the *Biblische Figuren* (Solis 1565: [115]; *The Illustrated Bartsch 19.1,* 1978: 379]). One may also note the

Figure 186. Domenico Tiepolo, after Marco Ricci, *A City Gate* (formerly M. le duc de Talleyrand, Saint-Brice-sous-fôret)

engraving by Collaert after Passeri from the *Evangelicae Historiae Imagines* (1593: [68]); compare also Ricci (1607: [117]). It is a nice question whether Domenico may have known something of the set of six *Parables* by Domenico Feti at Dresden. *The Master in the Vineyard* (Dresden no. 423; *Gemäldegalerie* 1987: 178; see also London, 1979: [14, 15]) makes an interesting comparison with Domenico's composition, and the man leaning on his spade, though reversed, is very close indeed. See also *The Return of the Prodigal Son* (pl. 152).

SOURCES: Domenico places the parable in a familiar setting in the Venetian countryside, which derives directly from a study of the farm entrance [fig. 188], formerly in the collection of Leo Blumenreich in Berlin (Knox 1974: [44]). The hound, low left, derives from a drawing in the British Museum [fig. 250]. Conrad suggests that the pose of the master derives from the etching by Salvator Rosa (*The Illustrated Bartsch 45,* 1978: [27]; Bozzolato 1973: [6]).

158. *Jesus and the Mother of Zebedee's Children*

TRADITIONS: The subject is treated by Veronese in the altarpiece painted for the church of San Giacomo at Murano, which was purchased in 1768 by the Cecil family and is now at Burghley House, Stamford (Marini 1968: [267]). However, there are no links with the present design.

One may note the engraving by Wierix after Passeri in the *Evanglicae Historiae Imagines* (1593: [82]) [fig. 189] and even wonder whether the palm tree is a direct borrowing.

159. *Jesus Heals the Two Blind Men of Jericho*

TRADITIONS: It is found among the mosaics of Monreale (del Giudice 1702: [XX.4]) and in the Church of the Chora (the Kahrié Djami) at Istanbul (Underwood 1966: [135]), with Jesus and two others standing on the left and the two blind men seated under a tree on the right. It also appears in the *Deutsche Bilderbibel* (1960: [23a]), in Virgil Solis (1565: [118]), and in the engraving by Wierix after Passeri from the *Evangelicae Historiae Imagines* (1593: [83]). A small painting on this theme by Fumiani is recorded in the collection of Ercole Giusti in Verona (dal Pozzo 1718: 298).

Figure 187. Domenico Tiepolo, "*Suffer the Little Children to Come unto Me*" (Udine, Oratorio della Purità)

Figure 188. Giambattista Tiepolo, *A Rustic Gateway* (formerly Berlin, Leo Blumenreich)

SOURCES: The buildings in the right background derive from a study by Giambattista (Knox 1974: [35]) [fig. 190]. The horse without a rider in the right foreground is also found in *The Parting of Peter and Paul* (pl. 296).

160. *The Woman Taken in Adultery*

TRADITIONS: The subject is found on the third column of the Ciborium in San Marco (Gabelentz 1903: C.IX) and among the mosaics of Monreale (del Giudice 1702: [XX.6]), reversed, but not dissimilar. In San Marco, the ancient mosaic was replaced in the seventeenth century after a cartoon by Pietro Vecchia (Demus 1984: [fig. 46]; *San Marco* 1990: [113]; 1991: [72/2]). An untraced painting by Veronese on this theme was engraved by Monaco (1743: [LVIII]; 1745 [70]; Apolloni 2000: [70]), which does, however, show the figure of Jesus standing (Ticozzi 1975: [93]), as here. The subject is also found in the *Deutsche Bilderbibel* (1960: [IXb and 21b]), in Virgil Solis (1565: [123]), and in the engraving by Wierix after Passeri from the *Evangelicae Historiae Imagines* (1593: [53]).

The engraving after Maarten de Vos in the *Vita Passio et Resurrectio Jesu Christi* (n.d.: [23]) and again in the *Theatrum Biblicum* (1674) shows Jesus writing on the ground, as does the painting Jacopo Bassano, at Bassano (Arslan 1960: [11]) and in several canvases by Sebastiano Ricci, among them the large canvas owned by Consul Smith, now at Osterley (Daniels 1976: [453]), as well as in the canvas by Domenico Tiepolo at Paris (Knox 1994: [6, 14, 19]) and in one by Pittoni at Sheffield (Zava-Bocazzi 1979: [230]; Tulsa, 1984, 183, [fig. 4]). None of these resemble the present design.

SOURCES: The design here follows closely on the painting by Domenico in the von Schenk collection (Mariuz 1971: [306]). Both show the figure of Jesus standing [fig. 191]. The San Marco mosaic shows the alternative tradition, with Jesus writing on the ground. The standing figure on the left is a familiar one from *The Suitors Present Their Rods* (pl. 25).

161. *"Go, and sin no more"*

TRADITIONS: The large composition on this theme by Giulio Romano was engraved by Diana Ghisi in 1575 (*The Illustrated Bartsch 31*, 1978: 242). Jesus and the woman are seen alone together in the center of the curved portico of a temple, between two Solomonic columns, with a numerous crowd dispersing on either side. "This print is one of the most beautiful and considerable works of Diana Ghisi" (*Kitto Bible* 52-9459), dated 1633. The two canvases by Veronese at Vienna (Marini 1981: [222a, b]) show the two parts of the story: *The Adulteress Brought Before Jesus* and *"Go, and sin no more."* The second of these shows Jesus and the woman almost alone, with a figure retreating on either side.

SOURCES: The figures of Jesus and the woman are repeated from the preceding drawing (pl. 160) and derive from the Von Shenk painting by Domenico [fig. 191] (Mariuz 1971: [306]). Playing dogs are the subject

Figure 189. Wierix after Passeri, *Jesus and the Mother of Zebedee's Children* (from the *Evangelicae Historiae Imagines*, Antwerp, 1593: [82])

Figure 190. Giambattista Tiepolo, *A Country House Set Against a Fortress* (Crans-sur-Sierre, Adolphe Stein)

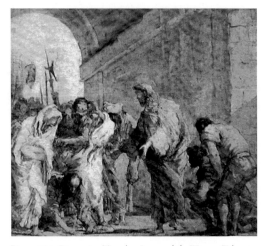

Figure 191. Domenico Tiepolo, *Jesus and the Woman Taken in Adultery* (Landsberg-Lech, Kirsten W. von Schenk)

of numerous drawings by Domenico (see also *Scenes of Contemporary Life 11;* Gealt and Knox 2005: [11]), but this pair has not been noticed elsewhere.

162. *Jesus Heals the Blind Man, I*

TRADITIONS: The scene as it appears on the second column of the Ciborium in San Marco (Gabelentz 1903: B.VII; Weigel 1997: 271) in six niches, and in the mosaic of San Marco (Demus 1984: [148]; *San Marco* 1991: [89/3]), clearly refers to the text of John 9:6–7, where the healed man is directed to wash in the pool of Siloam [fig. 192]. Both show the scene in two parts, with *Jesus Healing the Blind Man* on the left, and *The Man Washing in the Pool of Siloam* on the right. Neither of our drawings hint at this last part of the story, though both show Jesus anointing the eyes of the blind man.

The theme is found in the *Deutsche Bilderbibel* (1960: [X]) and in Virgil Solis (1565: [118]). One may also note the engravings by Wierix after Passeri in the *Evanglicae Historiae Imagines* (1593: [83]) and after Maarten de Vos in the *Theatrum Biblicum* (1674: [11]), where one may discern the Pool of Siloam on the right. A lost treatment of the theme by Lazzarini is recorded in the church of San Gemignano. There is also a small painting by Sebastiano Ricci at Stourhead (Daniels 1976: [407]) that may derive from the collection of Joseph Smith. The sculptural character of the main group may derive from the relief by Morlaiter in the Gesuati (Niero 1979: [13]).

SOURCES: The man on the left is a familiar figure from *The Flight into Egypt 7* [fig. 111]; see also plates 25 and 118.

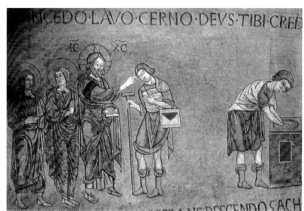

Figure 192. *Jesus Heals the Blind Man* (mosaic, 12th century, Venice, San Marco, south transept)

163. *Jesus Heals the Blind Man, II*

TRADITIONS: An interesting comparison may be made with the El Greco at Dresden (*Gemäldegalerie* 1987: 193), which apparently left Venice in 1741 [fig. 193].

The subject is treated by Domenico in a small painting at Hartford and a sketch formerly in the Bertini collection in Milan (Mariuz 1971: [50, 51]). The scene here is quite different, but the temple in the background, shown with the twelve steps, is required by the previous text (John 8:59).

164. *The Raising of Lazarus*

TRADITIONS: This appears on the second column of the Ciborium in San Marco, B4 (Weigel 1997: [84, 96, 97]), showing Lazarus standing between two youths holding their noses. It is also found among the mosaics of the Cappella Palatina and Monreale (del Giudice 1702: [XXI.1]). In San Marco the old mosaic has been replaced by Zuccati after a cartoon by Pordenone or Salviati of 1549

Figure 193. El Greco, *Jesus Heals the Blind Man* (ca. 1570, Dresden, Gemäldegalerie) v

(*San Marco* 1991: [151/1]). The subject is treated by Giotto in the Arena Chapel (Basile 1993: [126b]), by Giusto de' Menabuoi in the Baptistery at Padua (Spiazzi 1989: 60/11 [38]), and in the *Deutsche Bilderbibel* (1960: [IX verso/a and 22a]).

The most magnificent treatment of the theme is that of Sebastiano del Piombo of 1515 in the National Gallery, but it is found in two important canvases of the 1590s: an altarpiece by Leandro Bassano for the church of the

Carità, now in the Accademia, and a canvas by Carlo Calliari from the Scuola dei Varoteri, now in the Conservatorio Benedetto Marcello (Moschini Marconi 1962: [16, 133]).

One may note engravings by Adrien Collaert after Maarten de Vos in the *Vita, Passio et Resurrectio Iesu Christi* (n.d.: [30]) and by Wierix after Passeri in the *Evanglicae Historiae Imagines* (1593: [78]).

There is also a canvas by Antonio Balestra in the Walker Art Gallery in Liverpool (*cf.* Tulsa, 1994, 182, [fig. 2]) that forms part of a series of seven canvases of Old and New Testament subjects, now scattered, one of them being a *Jesus and the Adultress* by Pittoni; *cf.* plate 161.

SOURCES: For the bust on the wall, left, see a drawing in the Victoria and Albert Museum (Knox 1960: [310]), which must be identified as a bust of Laughter (not, apparently, a bust of Bacchus) by Giusto le Court in the Villa Pisani at Stra (Guerriero 1999: [17]). The figure of Jesus derives from the Louvre's *Pool of Bethesda*, with the head turned to the right [fig. 170]. The figures on the right derive from the von Schenk painting [fig. 191].

165. *The Feast in the House of Simon, II*

TRADITIONS: The great picture by Sebastiano Ricci at Hampton Court, which belonged to Consul Smith (Daniels 1976: no. 158, [141]) and is engraved by Liotard with a specific reference to John 12:3 (*Kitto Bible* 53-9579), illustrates the story as told by John. Judas remonstrates with Jesus on the left, while Mary continues to anoint Jesus's feet.

SOURCES: Instead of following closely on the example of Veronese, this design broadly derives from the painting by Domenico of 1752 for the Neues Speis Zimmer of the Residenz at Würzburg (Mariuz 1971: [41]), though all the figures are quite different. The man seated in a chair and the Magdalene are similar to the preceding drawing, but the general composition recalls the drawing of this subject formerly in the Humphries collection (Udine 1996: [23]) [fig. 194] and again clearly follows the text of John.

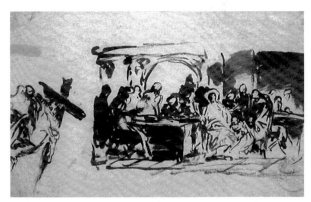

Figure 194. Domenico Tiepolo, *The Magdalene Anointing the Feet of Jesus* (1752, formerly Mrs. Humphries collection)

166. *Zacchaeus Climbs the Tree*

TRADITIONS: Appearing on the second column of the Ciborium in San Marco (Gabelentz 1903: B.VI) and in a miniature (Venice, San Giorgio dei Greci, *Lectionary,* fol. 207 recto), this subject also appears among the San Marco mosaics (Demus 1984: [149]; *San Marco* 1991: [89/4]) [fig. 195] and in the *Deutsche Bilderbibel* (1960: [23b]) [fig. 196]. Domenico's treatment recalls the woodcut of Virgil Solis (1565: [189]; *The Illustrated Bartsch 19.1,* 1978: 379) and an engraving after Maarten de Vos in the *Theatrum Biblicum* (1764), which is not dissimilar. A canvas by Bernardo Strozzi, engraved by Monaco (1743: [57]; 1745: [58]; Apolloni 2000: [58]), must have been known to Domenico.

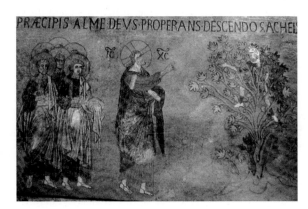

Figure 195. *Zacchaeus in the Tree* (mosaic, Venice, San Marco, south transept)

167. *Zacchaeus Climbs Down from the Tree*

TRADITIONS: This appears among the San Marco mosaics (*San Marco* 1991: [89/4] [fig. 195]). A very similar treatment, part of the old German tradition that seems so fundamental to Domenico's approach to New Testament illustration, is shown in a miniature from the *Deutsche Bilderbibel* (1960: [23b]) [fig. 196], with a little dog barking at the foot of the tree. This and the following drawing form a pair with a very similar setting.

SOURCES: The same city wall is to be found in plates 116, 117, 167, 168, 170, 306, and, in reverse, in plates 154, 263, and 309. It derives from *Station V* of the S. Polo *Via Crucis* [fig. 157].

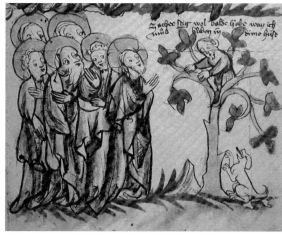

Figure 196. *Zacchaeus Climbs a Tree* (*Deutsche Bilderbibel*, folio 23b, Freiburg, University Library)

168. *The Meeting of Jesus and Zacchaeus*

TRADITIONS: Zacchaeus conversing with Jesus after his descent from the tree is shown in the *Deutsche Biderbibel* (1960: [VIIIb]) [fig. 197].

SOURCES: The same city wall is to be found in plates 116, 117, 167, 168, 170, 306, and, in reverse, in plates 154, 263, and 309. It derives from *Station V* of the S. Polo *Via Crucis* [fig. 157].

169. *The Disciples Find the Ass and Her Colt*

TRADITIONS: Among the prototypes thought to be accessible to Domenico, the theme has been found among the mosaics of Monreale (del Giudice 1702: [XXI.4]) and in the *Deutsche Bilderbibel* (1960: [23 verso/a]). In both cases, the two Apostles are shown bringing the ass and her colt back to Jesus.

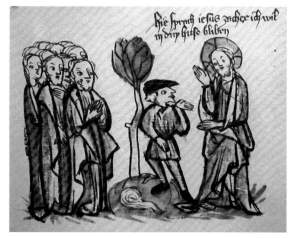

Figure 197. *The Meeting of Jesus and Zacchaeus* (from the *Deutsche Bilderbibel*, New York, Pierpont Morgan Library)

The story appears in the background of the engraving by Wierix after Passeri in the *Evanglicae Historiae Imagines* (1593: [85]), which shows in the foreground *Jesus Setting out for Jerusalem*, riding the ass, with the colt following. Similarly, the two following engravings, *Jesus Arriving in Sight of Jerusalem* and *The Arrival at Jerusalem* (*Evanglicae Historiae Imagines* 1593: [86, 87]) have only the ears of the colt visible. The finding of the ass and her colt is again told in several scenes in the background of the engraving illustrating *The Entry of Jesus into Jerusalem* (Ricci 1607: [112]; Conrad 1996: [fig. 6]).

SOURCES: The buildings in the background derive from a drawing by Domenico, after Marco Ricci ([fig. 186]; Knox 1974: [57]). The colt derives from a drawing of 1657 by Nicolaes Berchem in the Pierpont Morgan Library (New York, 1977: [101]) that was also etched (Witt Print Collection). The laden donkey on the right in the same drawing is used by Domenico in *The Holy Family Leaves Sotinen* (pl. 63) and again in *Contemporary Life 14;* see fig. 124.

170. *The Entry of Jesus into Jerusalem, I*

TRADITIONS: Jesus rides sometimes upon the ass and sometimes upon the ass's "colt," which may be a male animal. However, this complication does not appear on the fourth column of the Ciborium in San Marco

(Gabelentz 1903: D.I) or among the mosaics in San Marco (Demus 1984: [104]; *San Marco* 1990: [107]; 1991: [64/2]) [fig. 198] or those of Monreale (del Giudice 1702: [21.5]). The story as told in Matthew 21:2 makes it clear that the ass is a she-ass, whereas the San Marco mosaic shows a male animal, with the image reading from left to right, as here. It also appears among the Giotto frescoes in Padua (Basile 1993: [127a]), among the series of frescoes by Giusto de' Menabuoi in the Baptistery of the Duomo at Padua (Spiazzi 1989: 62.7 [39]), and in the woodcut by Dürer in *The Small Passion* (*The Illustrated Bartsch 10*, 1978: 117, [22]). Domenico's composition seems to follow the design of the woodcut by Virgil Solis (1565: [170]). The two subjects are found together in the *Deutsche Bilderbibel* (1960: [fig. 60, 61; 23 verso/b]), where we also find the colt accompanying its mother in *The Entry of Jesus into Jerusalem.* The woodcut by Bernard Salomon in the *Biblia Sacra* (1588) again shows the colt in attendance, and three engravings by Wierix after Passeri from the *Evangelicae Historiae Imagines* (1593: [85, 86, 87]) all include the colt.

Figure 198. *The Entry of Jesus into Jerusalem* (mosaic, Venice, San Marco, south vault)

The story is also treated by Domenico in the Cappella della Purità at Udine (Mariuz 1971: [157]; Knox 1980: [236]). The same city wall is to be found in plates 116, 117, 167, 168, 170, 306, and, in reverse, in plates 154, 263, and 309. It derives from *Station V* of the S. Polo *Via Crucis* [fig. 157]. The detail of spreading the garments before the ass is always shown.

SOURCES: The kneeling boy on the left derives from *Via Crucis XI* [fig. 220]. The ass and the man leading it derive from *Flight into Egypt 25* [fig. 254]. The small dog, low left, derives from Giambattista's fresco *Henri III at Mira* and Domenico's etching [fig. 93].

171. *The Entry of Jesus into Jerusalem, II—TIBERIUS CESAR*

TRADITIONS: The theme is found among the mosaics of San Marco (Demus 1984: [104]; *San Marco* 1991: [325]), among those of the Capella Palatina and Monreale (del Giudice 1702: [XXI.5]), and in Giotto's frescoes in the Arena Chapel (Basile 1993: 127). The depiction of the scene in the *Deutsche Bilderbibel* (1960: [23 verso/b]) shows the colt still accompanying its mother, a detail that is also observed by the artist VG in a large woodcut from a Latin Bible (*Kitto Bible* 41-7464), and in Ricci (1607: [112]) the colt is again prominent. This detail is also adopted by Nicolas Poussin, recorded in an engraving by Antoinette Bouzonnet Stella (*Kitto Bible* 36-1677), and by Gustave Doré in his woodcut from *La Sainte Bible.* Anna Jameson illustrates two further examples.

The homely detail of the colt is ignored by Domenico in the Capella della Purità at Udine (Mariuz 1971: [157]) and in the present design. The city gate bears the imperial portrait *TIBERIUS CESAR.* The donkey is very similar to the one in the middle ground of the preceding drawing.

Among the early-eighteenth-century versions in Venice are Zanchi in Sta. Marta and Lazzarini in the Chiesa dell'Assunzione, both lost. The very large canvas by Diziani, 300 x 600 cm, formerly in the Scuola di San Teodoro, now in Murano, Sta. Maria degli Angeli (Zugni-Tauro 1971: [2]) also moves from left to right.

172. *Jesus Cleansing the Temple, I*

TRADITIONS: In San Marco the ancient mosaic has been replaced by mid-seventeenth-century work by Giacomo Pasterini after Pietro Vecchia (*San Marco* 1991: [74.2]). In the *Deutsche Bilderbibel* (1960: [24a]) this scene is paired with the very unusual subject, *Jesus Cursing the Barren Fig Tree,* followed in turn by *The Wilted Fig Tree,* a subject that was used by Giambattista Tiepolo, probably following the woodcut by Urs Graf (*The Illustrated Bartsch,* 1978: 2f [459]) for one of the overdoors at Veitshochheim (Stuttgart, 1970: [5]).

The present design is not unlike the scene in Dürer's *Large Passion 23* (*The Illustrated Bartsch 10,* 1978: 118). One may also note the engraving by Adrien Collaert after Maarten de Vos in the *Vita, Passio et Resurrectio Iesu Christi* (n.d.: [14]) and the etching by Rembrandt of 1635 (*Kitto Bible* 41-7481).

SOURCES: The flock of sheep derives from Castliglione's etching *The Flight into Egypt* (Washington, 1972: [fig. 28]).

173. *Jesus Cleansing the Temple, II*

Figure 199. Pasterini, after Pietro della Vecchia, *Jesus Cleansing the Temple* (mosaic, 1648–1649, Venice, San Marco, left transept)

TRADITIONS: This scene, popular in all ages, appears on the second column of the Ciborium in San Marco (Gabelentz 1903: B.V) and among the mosaics of Monreale (del Giudice 1702: [XX.5]), while in San Marco the old mosaic was replaced in 1646–1648 by G. Pasterini after a cartoon by Pietro della Vecchia (*San Marco* 1991: [74/2]) [fig. 199]. It is shown by Giotto in the Arena chapel, completing the second band of decoration (Basile 1993: [127b]), in the *Deutsche Bilderbibel* (1960: [24a]), and in Dürer's *Large Passion* (*The Illustrated Bartsch 10,* 1978: [23]). Examples in late-seventeenth-century Venice include the Zanchi in the Ateneo Veneto (not traced) and the Fumiani in the church of San Rocco (not traced).

In Domenico's day there was a fine painting on this theme by Luca Giordano in the great room of the Palazzo Vecchia in Vicenza (Ferrari and Scavizzi 1966/1992: [305]), for which Giambattista painted a large ceiling canvas ca. 1750. It was paired with *The Massacre of the Innocents* (Ferrari and Scavizzi 1966: ii, 73, no illus.) and both canvases are now in Venice in the Museo Diocesano Sant'Apollonia. Another version by Luca Giordano is with the Bob Jones University (Tulsa, 1994, [23]). A further large canvas on the theme was painted by Angelo Trevisani in 1732 for Ss. Cosma e Damiano, now at Somaglia, near Lodi, for which there is a sketch in the Accademia (Moschini Marconi 1970: [253]). The subject is treated by Domenico in an overdoor for Veitshochheim of 1752, now in the Thyssen collection (Mariuz 1971: [40]).

SOURCES: The bullock derives from a drawing that is used again in *Scenes of Contemporary Life 9* (Christie's sale, Dec. 4, 1964 [18]; Gealt and Knox 2005: [7]).

174. *Jesus in the Temple*

TRADITIONS: This very rare subject is found among the mosaics of Monreale (del Giudice 1702: [XX.8]) and it is also treated in the *Deutsche Bilderbibel* (1960: [4 verso/b]). One may also note the engravings in Wierix after Passeri in the *Evanglicae Historiae Imagines* (1593: [16, 95]).

SOURCES: Christofer Conrad points out that the background is taken directly from a detail of Plate 1 of Piranesi's *Prima Parte,* with the title *Galleria grande di Statue* (Robison 1986: [2]) [fig. 200]. The figure of Jesus derives from Domenico's *Adulteress Before Jesus* in the Kersten von Schenk collection (Mariuz 1971: [306]).

Figure 200. Giambattista Piranesi, *Galleria Grande di Statue* (engraving, 1743, from the *Prima Parte*)

175. *The Tribute Money*

TRADITIONS: Except for the famous Masaccio in the Brancacci Chapel, the subject seems to be rarely treated on a monumental scale.

One may note the engraving by Collaert after Passeri in the *Evanglicae Historiae Imagines* (1593: [94]), in which the general arrangement is not dissimilar. The Gustave Doré woodcut in *La Sainte Bible selon la Vulgate* (Tours ii, 1866, [opp. col. 560]) displays some broad similarities.

SOURCES: The kneeling woman, bottom left corner, derives from the Louvre's *Pool of Bethesda* [fig. 170].

176.** *Le Christ, un ange, saint Jean et un autre personnage*

No text.

177. *The Chief Priests in the Palace of Caiaphas*

TRADITIONS: This rare subject is found only in the *Deutsche Bilderbibel* (1960: [22b]) and in the engraving by Wierix after Passeri [fig. 201] in the *Evanglicae Historiae Imagines* (1593: [79]). The engraving in Ricci is comparable (Ricci 1607: [108]).

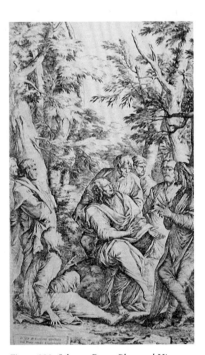

Figure 201. Wierix after Passeri, *The Palace of Caiaphas* (from the *Evangelicae Historiae Imagines*, Antwerp, 1593, [79])

178. *Judas Makes a Covenant with the Priests*

TRADITIONS: Judas's attempt to return the pieces of silver is represented in the Ciborium, Column D4 (Weigel 1997: [Falttafel II.2]). This rare subject is treated by Giotto in the Arena Chapel (Basile 1993: [194a]) and in the *Deutsche Bilderbibel* (1960: [25b]). It is also found as the first of a set of 22 plates after Stradanus depicting the Passion of Jesus in the *Theatrum Biblicum* (1674: [a]).

SOURCES: Conrad points out that the seated priest on the left and the two figures on the right, one leaning against the pillar, derive from the etching by Salvator Rosa, *Plato and His Disciples* (Bozzolato 1973: [82]) [fig. 202].

179. *Jesus Taking Leave of His Mother*

There has been some doubt about the identification of this scene, ever since the Cormier sale. Joachim and McCullagh (1979) identify it as *Jesus in the House of Jairus:* Mark 5 and Luke 8. This is a familiar scene, found regularly in the early cycles: on the third column of the Ciborium in San Marco (Gabelentz 1903: C.VI), among the mosaics of Monreale (del Giudice 1702: [XIX.12]) and those of the Chora (Underwood 1966: [203]), in *The Rockefeller McCormick New Testament* (1932: [43 verso]), and in the *Deutsche Bilderbibel* (1960: [11a]), with the young daughter of Jairus invariably shown sick in bed.

Figure 202. Salvator Rosa, *Plato and His Disciples* (etching)

TRADITIONS: According to Jameson (1852: 281), the earliest representation of this very rare subject is the Dürer woodcut, *Jesus Taking Leave of His Mother* [fig. 203], from *The Life of the Virgin* (*The Illustrated Bartsch 10,*

1978: 92 [132]), a series that Domenico is said to have had in his own collection. Certainly the arrangement of the figures is similar. Both compositions show Mary collapsing, supported by another woman, while a third—and in the case of the Domenico drawing, a fourth—stand by. In this drawing, the extreme youthfulness of Jesus is a little disturbing, suggesting an early stage in his life. The treatment of the walls suggests a substantial residence. The composition by Giuseppe Maria Crespi at Munich (Merriman 1980: [47]) is very different.

180. *Jesus Leaves His Mother's House*

DISCUSSION CONTINUED: Conrad follows the nineteenth-century inscription on the verso of the drawing and suggests that it represents *The Virgin and the Holy Women Leaving the Tomb of Jesus,* though the tomb is usually shown very differently (pl. 205). In this case, the weeping man must be identified as John rather than Jesus. This is not entirely convincing and a better alternative might be a text from *The Assumption of Our Lady* from *The Golden Legend:* "John, my son, remember thee of the word of thy master, by which he made me mother unto thee, and thee a son unto me. Lo! I am called of thy master and my God. I pay now the debt of condition human, and recommend my body unto thy busy care." Something quite similar is found toward the end of Maria de Agreda's account of the life of the Virgin.

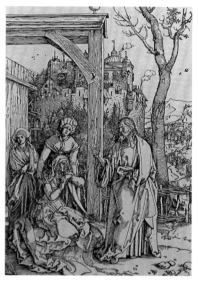

Figure 203. Dürer, *Jesus Taking Leave of His Mother* (woodcut, 1504–1505, from *The Life of the Virgin*)

TRADITIONS: The general setting is similar to the drawing entitled *"CONSERVATORIO"* in the Musée du Louvre (pl. 24). On the other hand, the group consisting of the Virgin supported by women may be compared with *The Entombment of Jesus* (pl. 204). The figure of the weeping John the Evangelist there, found on the extreme left, is a familiar element in many of Domenico's scenes of the *Via Crucis:* plates 225, 226, 227. The present figure may be Crucis compared with a drawing by Domenico, formerly with the Paul Drey Gallery [fig. 243].

181. *The Institution of the Eucharist*

TRADITIONS: The scene is treated on the fourth column of the Ciborium in San Marco (Gabelentz 1903: D.I) In the San Marco mosaics it appears thrice: in twelfth-century work (Demus 1984: [105]; *San Marco* 1991: [64/3]), in an old image replaced by Ceccato after a cartoon by Aliense of 1611–1617 (*San Marco* 1991: [74/3]), and in the north arch of the crossing in a mosaic by Bianchini after Tintoretto of 1567 (*San Marco* 1990: [123]; 1991: [62.2]). The mosaic at Monreale (del Giudice 1702: [XXI.6]) shows a semicircular table with Judas on the near side that may have inspired the present design. The horseshoe shape of the table is unusual and may derive from the Byzantine tradition; note also the image in *The Rockefeller McCormick New Testament* (1932: [31]). The Western tradition is represented by Giotto in the Arena Chapel (Basile 1993: [194b]), by Giusto de Menabuoi in the Baptistery, Padua (Spiazzi 1989: 62.9, [39]), and in the *Deutsche Bilderbibel* (1960: [25 verso/b]).

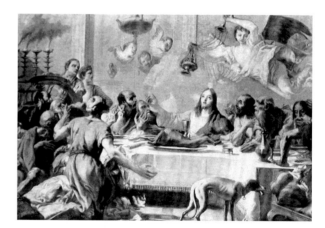

Figure 204. Domenico Tiepolo, *The Institution of the Eucharist* (1775, Venice, La Maddalena)

It is found in one of the 51 plates by Adrien Collaert after Maarten de Vos of the *Vita, Passio et Resurrectio Iesu Christi* (n.d.: [34]) and in three engravings of the *Evanglicae Historiae Imagines* (1593 . . .): showing a round table, all standing ([100]), showing a round table, all seated ([102]), and showing a round table, all seated, with Judas leaving ([103]). Yet another version, by C. van der Broeck after Maarten de Vos, appears in the *Theatrum Biblicum* (1674: [aa]). Note also the woodcut of the du Hamel *Biblia Sacra vulgate editionis* (1748: 504).

SOURCES: Domenico must have known the altarpiece painted by Giambattista Pittoni for Leno near Brescia, engraved by Pietro Monaco (1763: no. 24; Zava Bocazzi 1979: [338, 339]; Apolloni 2000: [24]). Several figures derive from Domenico's own *Last Supper* in the Maddalena in Venice of 1775 (Mariuz 1971: [266]), but Domenico brings the figure of Jesus into the foreground, as in the Pittoni [fig. 204].

182. *Jesus Warns Peter in the Upper Room*

No text.

183. *Jesus, Flanked by James and John, Upbraids Peter*

TRADITIONS: The scene is shown in the mosaics of Monreale (del Giudice 1702: [XXI.8]) [fig. 205] and in the very large mosaic on the south side of the nave in San Marco (*San Marco* 1991: [112/3] [fig. 206]) as part of the story of *The Agony in the Garden,* whereas in the Gospels it is given prior to the entry into Gethsemane; see the discussion on No. 184 below. Demus (1984: 100) states: "The mosaic is one of the best preserved of the entire mosaic decoration of the church"; he dates it 1210–1220 [fig. 206].

184. *Peter Responds in Protest*

TRADITIONS: As in the case of the previous drawing, the subject seems to relate to the arrangement of the scenes in the great San Marco mosaic [fig. 206] (Demus 1984: vol. 4 [1b]; *San Marco* 1990: [120, 121]; 1991: [112/3]), where the exchange between Jesus and Peter is shown as part of *The Agony in the Garden,* and not preceding it.

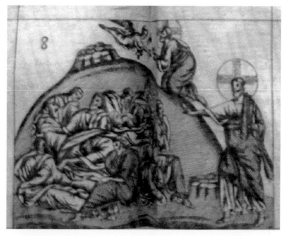

Figure 205. *The Agony in the Garden* (mosaic, 1180, Monreale, after del Giudice 1702)

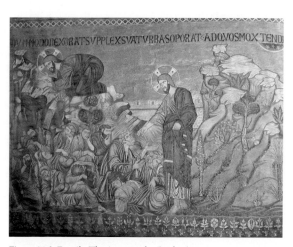

Figure 206. Detail, *The Agony in the Garden* (mosaic, 1210–1220, Venice, San Marco, nave)

185. *Jesus in the Garden of Gethsemane: The First Prayer*

TRADITIONS: This frequently depicted scene appears on the fourth column of the Ciborium in San Marco (Gabelentz 1903: D.II) and among the mosaics of Monreale (del Giudice 1702: [XXI.8]) [fig. 205]. However, in the large mosaic on the south side of the nave in San Marco [fig. 207] (Demus 1984: vol. 4 [color plate 1–2]; *San Marco* 1990: [120–121]; 1991: [112/3]), there is a complete series of scenes depicting *The Agony in the Garden,* viz.: 1. *Jesus Praying the First Time in the Mount of Olives;* 2. *"Could ye not wait with me one hour?";* 3. *Jesus Pleading with His Father the Second Time;* 4. *Jesus and Peter;* 5. *Jesus Praying the Third Time;* and 6. *Jesus and Peter, the Latter Protesting.* This is at variance with the sequence of events in the Gospels, where the exchanges with Peter take place before entering Gethsemane; see the two preceding drawings. If the present drawing relates to the first part of the San Marco series, it would be followed by *"Could ye not watch with me one hour?"* (pl. 186). Demus (1984: 100) notes: "The mosaic is one of the best preserved of the entire mosaic decoration of the church"; he dates it 1210–1220.

The story is also told in the series of frescoes by Giusto de' Menabuoi in the Baptistery of the Duomo at Padua (Spiazzi 1989: 65.7 [40]), in the *Deutsche Bilderbibel* (1960: [28a]), in Dürer's *Large Passion* [6], in the *Small Passion* [26, 54], and in the *Biblische Figuren* (Solis 1565: [126]). One must also recall the paintings by Mantegna and Bellini in the National Gallery.

It is also normally the first subject in a series of the *Scenes of the Passion,* as in the set of nine canvases by Francesco da Ponte for the church of Sant' Antonio Abate in Brescia, dispersed, this one being now in Sarasota (Arslan 1960: 195, 196, [239–246]), and the set by various artists in the Cappella del Crocefisso in San Marcuola, all lost save the Bambini *Deposition* (Knox 1980: 32, note 4), both of which Domenico must have known. It is also the first canvas in Domenico's *Scenes of the Passion* for San Felipe Neri in Madrid, now in the Prado (Mariuz 1971: [232]).

The Agony in the Garden by Giambattista at Hamburg, engraved by Pietro Monaco (1743: [69]; 1763: [71]; Apolloni 2000: [71]), is also recorded in a red chalk drawing, probably by Domenico (Knox 1999: [3]) [fig. 218].

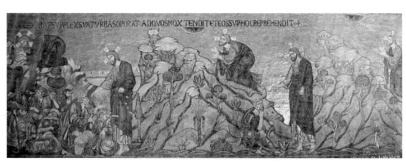

Figure 207. *The Agony in the Garden* (mosaic, 1210–1220, Venice, San Marco, nave)

186. *"Could ye not watch with me one hour?"*

TRADITIONS: A fine mosaic on the right side of the nave in San Marco shows *The Agony in the Garden* in six episodes in a single sequence: *Jesus in Prayer; "Could ye not watch with me one hour?"; Jesus Pleading with His Father in Heaven; Jesus Admonishing Peter; Jesus Praying a Third Time;* and *Peter Responding to Jesus* (*San Marco* 1991: [112–113]) [fig. 208]. The mosaic at Monreale (del Giudice 1702: [XXI.8]) repeats the same pattern. Here we follow the different sequence given in Matthew 26. The second scene of the mosaic is represented. In plates 183 and 184, the fourth and last scenes are found, while plates 185 and 187 are taken to represent the first and second prayer of Jesus. This rare subject is also found in the *Deutsche Bilderbibel* (1960: [27b]).

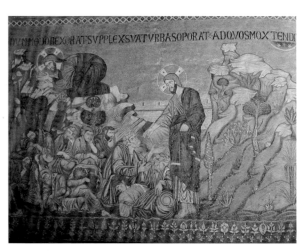

Figure 208. Detail, *The Agony in the Garden* (mosaic, 1210–1220, Venice, San Marco)

187. *Jesus in the Garden of Gethsemane: The Second Prayer*

TRADITIONS: This frequently depicted scene appears on the fourth column of the Ciborium in San Marco (Gabelentz 1903: D.II) and among the mosaics of Monreale (del Giudice 1702: [XXI.8]) [fig. 205]. However, in the large mosaic on the south side of the nave in San Marco (*San Marco* 1990: [120–121]; 1991: [112/3]) [fig. 207], there is a complete series of scenes depicting *The Agony in the Garden,* viz.: 1. *Jesus Praying the First Time in the Mount of Olives;* 2. *"Could ye not wait with me one hour";* 3. *Jesus Pleading with His Father the Second Time;* 4. *Jesus and Peter;* 5. *Jesus Praying the Third Time;* and 6. *Jesus and Peter, the Latter Protesting* [fig. 209]. This is at variance with the sequence of events in the Gospels, where the exchanges with Peter take place before entering Gethsemane; see plates 183 and 184. If the present drawing relates to the first part of the San Marco series, it would be followed by *"Could ye not watch with me one hour"* (pl. 186). According to Demus (1984: 100), "The mosaic is one of the best preserved of the entire mosaic decoration of the church"; he dates it 1210–1220.

The story is also told in the series of frescoes by Giusto de' Menabuoi in the Baptistery of the Duomo at Padua (Spiazzi 1989: 65.7 [40]) in the *Deutsche Bilderbibel* (1960: [28a]), in Dürer's *Large Passion* ([6]), in the *Small Passion* ([26, 54]), and in the *Biblische Figuren* (Solis 1565: [126]). One must also recall the paintings by Mantegna and Bellini in the National Gallery.

It is also normally the first subject in a series of the *Scenes of the Passion,* as in the set of nine canvases by Francesco da Ponte for the church of Sant' Antonio Abate in Brescia, dispersed, this one being now in Sarasota (Arslan 1960: 195, 196, [239–246]), and the set by various artists in the Cappella del Crocefisso in San Marcuola, all lost save the Bambini *Deposition* (Knox 1980: 32, note 4), both of which Domenico must have known. It is also the first canvas

in Domenico's *Scenes of the Passion* for San Felipe Neri in Madrid, now in the Prado (Mariuz 1971: [232]).

The Agony in the Garden by Giambattista at Hamburg, engraved by Pietro Monaco (1743: [LXIX]; 1763: [71]; Apolloni 2000: [71]), is also recorded in a red chalk drawing, probably by Domenico (Knox 1999: [3]).

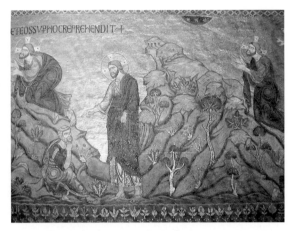

Figure 209. Detail, *The Agony in the Garden* (mosaic, 1210–1220, Venice, San Marco)

188. *"Rise, let us be going"*

TRADITIONS: Schiller cites a tenth-century ivory in London. This rare subject is found again in the *Deutsche Bilderbibel* (1960: [28a]) [fig. 210]. One may also note the sculpture by d'Enrico of 1608, *La sveglia degli apostoli,* in the Sacromonte di Varallo, Cappella 22.

189. *Jesus Arrested in the Garden of Gethsemane*

TRADITIONS: The scene is found on the fourth column of the Ciborium in San Marco (Gabelentz 1903: D.III). Among the mosaics of San Marco, *The Betrayal* is shown together with *The Mocking of Jesus* (Demus 1984: ii, [color plate 66, 330]; *San Marco* 1991: [67/1]), and in Monreale it is again a *Betrayal,* with the kiss of Judas given prominence (del Giudice 1702: [XXI.9]). It is also found in *The Rockefeller McCormick New Testament* (1932: [32]). Giotto in Padua (Basile 1993: [195b]) makes a feature of the kiss of Judas, which is not emphasized here. It is among the series of frescoes by Giusto de' Menabuoi in the Baptistery of the Duomo at Padua (Spiazzi 1989: 65.8 [40]), in the *Deutsche Bilderbibel* (1960: [28b and 28 verso/b]), in Dürer's *Large Passion* ([7]) and *Small Passion* ([28]), and in the *Biblische Figuren* (Solis

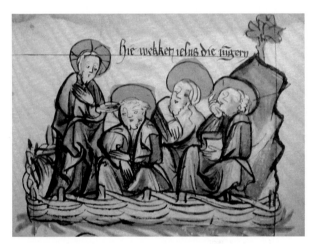

Figure 210. *"Rise, let us be going"* (1420, *Deutsche Bilderbibel,* folio 28a, Freiburg, University Library)

1565: [127]). It is also the second canvas of the series by Francesco da Ponte for the church of Sant'Antonio Abbate in Brescia, now in Cremona (Arslan 1960: [243]).

The drawing closely follows the text of Mark 14:51–52. The ghostly figure on the left must be identified as the "young man, having a linen cloth cast about his naked body; and the young men laid hold on him: And he left the linen cloth, and fled from them naked." This detail, implied on the left side of the Giotto fresco, is also found on a very small scale in Dürer's treatment of the subject in *The Large Passion* (*The Illustrated Bartsch 10,* 1978: 102) [fig. 211], in the woodcut by Virgil Solis, and again prominently in Ricci (1607: [140]).

SOURCES: The man running off on the left seems to derive from the Helsinki *The Greeks Entering Troy* [fig. 132]. The pose of the naked young man may also derive from the same source.

190. *Jesus Sent by Pilate to Herod*

TRADITIONS: The scene may represent Jesus being sent by Pilate to Herod, as is found in the *Deutsche Bilderbibel* (1960: [30 verso/b]) [fig. 212]. This shows Pilate's wife on the left, as required by Matthew 27:19 and by *The Gospel of Nicodemus.*

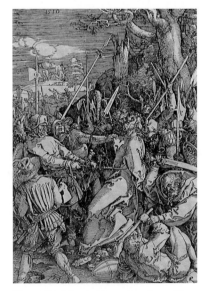

Figure 211. Albrecht Dürer, *Jesus Arrested in the Garden of Gethsemane* (woodcut, *The Large Passion*)

191. *The Denial of Peter*

TRADITIONS: This scene appears on the fourth column of the Ciborium in San Marco (Gabelentz 1903: D.IV) and in the *Deutsche Bilderbibel* (1960: [30 verso/b]). It is hard to find anything comparable in later Venetian painting, except perhaps the small canvas by Lorenzo Lotto, first published by Roberto Longhi in 1946 (Venice, 1953, [40]). This displays a somewhat similar setting and a similar relationship of figures to space. Again, there is a prominent central column with Peter standing in front of it and to the left; behind is an open courtyard, somewhat reminiscent of the *cortile* of the Palazzo Ducale in Venice, with the *Scala dei Giganti,* seen from the *Arco Foscari.* In both cases, the secondary scene of Jesus being hustled away by soldiers from the palace of Caiaphas the High Priest is shown in the background.

SOURCES: The magnificent architectural setting in the background derives from the etching after *Station I* of the S. Polo *Via Crucis* (Rizzi 1971: [41]). The crouching soldier on the left derives from the Würzburg frescoes, and more particularly from the drawing at Stuttgart (1970: [74]); [fig. 172]. The standing man on the right also derives from the Würzburg frescoes, and more particularly from the drawing at Stuttgart (1970, [82]; Knox 1980: M.355) [fig. 213]. It should be noted that the adjacent drummer in that drawing is also included in the present design.

Figure 212. *Jesus Sent by Pilate to Herod* (1420, *Deutsche Bilderbibel,* folio 32 verso/b, Freiburg, University Library)

192. *"TIBERIUS CESAR"—Jesus Before Pilate*

TRADITIONS: The subject is found on the fourth column of the ciborium in San Marco (Weigel 1997: [Falttafel III.1]) and among the mosaics of San Marco. However, those of Monreale (del Giudice 1702: [22.1]) show *Jesus Addressing Pilate the First Time,* followed by *Pilate's Wife Sending a Messenger* (del Giudice 1702: [22.2]). The various meetings between Jesus and Pilate are found in the *Deutsche Bilderbibel* (1960: [35 verso/a]) and in the *Biblische Figuren* (Solis 1565: [129]). The scene showing Pilate washing his hands, with Jesus standing to the left, as here, is found in the *Polyptych of the Passion of Jesus,* by Antonio Vivarini and Giovanni d'Alemagna, from the Convento del Corpus Domini, now in the Ca' d'Oro (Moschini Marconi 1955: [35]). A large but less relevant composition is that by Benedetto Caliari from San Nicolo della Lattuga, in the Gallerie dell'Accademia (Moschini Marconi 962: [127]).

This drawing is here regarded as the first of a series of drawings in the *Recueil Fayet* representing scenes of the Passion (see the note to the following drawing), although perhaps the subject is not usually found in such a series. However, it appeared in a lost canvas by Crosato, part of such a series in San Marcuola, as it does in the polyptych mentioned above.

Figure 213. Giambattista Tiepolo, *A Standing Man, a Drummer* (Stuttgart, Staatsgalerie 1486)

193. *The Flagellation of Jesus*

TRADITIONS: The subject is not found in the early sets of prototypes—the San Marco mosaics, the *Rockefeller McCormick New Testament*—and hence may not be favored by the Byzantine tradition. The Giotto in the Arena Chapel (Basile 1993: [196b]) is perhaps rather *The Mocking of Jesus.* However, it appears in the doors of San Zeno in Verona, in the *Deutsche Bilderbibel* (1960: [34a]), and in the Dürer *Large Passion* [8]; it also appears strongly in Florence in the fifteenth century—Ghiberti's first doors of the Baptistery; Donatello's *Pulpit* in San Lorenzo; and in Piero's *Flagellation* at Urbino—but it is unlikely that these would be known to Domenico. On the other hand,

he might well have known about the celebrated depiction by Sebastiano del Piombo in the Borgherini Chapel in San Pietro in Montorio (Düssler 1942: [35]), which gave rise to other versions, among them an engraving by Agostino Carracci (Washington, 1979, [36]) [fig. 214]. Giambattista's celebrated canvas in Sant'Alvise (New York, 1996, [fig. 69]) also shows Jesus in much the same pose as the Sebastiano del Piombo, except in the inclination of the head; the Jesus in Domenico's *Flagellation* in Madrid again follows Sebastiano closely.

Figure 214. Sebastiano del Piombo, *The Flagellation* (Rome, San Pietro in Montorio)

SOURCES: One may find the figure of Jesus in a similar pose among the drawings at Stuttgart (1970, [23]). The man kicking, to the right of Jesus, is also found in another of the early drawings (Udine 1996: [79]), but it is drawn immediately from the Madrid painting of 1772 (Mariuz 1971: [233]). This figure has an older complex history; one may cite Lodovico Carracci's *Flagellation* at Douai (Fort Worth, 1993, [7]); the Caravaggio at Capodimonte (New York, 1985, [95]); an engraving by Dupuis after Rubens, *The Massacre of the Innocents* (*Kitto Bible* 33-6293, 6294) showing a man with raised foot depicted frontally on the left; and most persuasive of all, an engraving by Stella after Poussin, *The Way to Calvary* (*Kitto Bible* 42-7604) showing Jesus led out of the city gate, with a very similar man kicking from left to right, seen from the back.

194. *"TIBERIUS CESAR"—The Crowning with Thorns*

TRADITIONS: The subject is found among the mosaics of San Marco (*San Marco* 1991: [67/1b]), and Giotto treats it in the Arena Chapel (Basile 1993: [196b]); it also appears in the *Deutsche Bilderbibel* (1960: [34 verso/a]), following *The Flagellation,* and is also treated by Francesco da Ponte for Sant' Antonio Abate in Brescia, now in Milan (Arslan 1960: [240]). *The Crowning with Thorns* is also supposed to have taken place in the Palace of Pilate, as described by Christiaan van Adrichem (1584: Site 56).

Giambattista Tiepolo's canvas in Sant'Alvise, ca. 1736, a pendant to his *Flagellation* (New York, 1996, [31]), is a very different concept, as is his smaller painting in Hamburg ca.1745 (Paris, 1998: [fig. 83]). No fewer than seven of Domenico's early pen drawings on the *Scenes of the Passion* deal with this subject: in Dresden, New York (Byam Shaw and Knox 1987: [120]), linked with the Sant'Alvise composition, Rotterdam, Saint Petersburg (Udine 1996: [78]), Stuttgart (1970: [24]), and Venice. Domenico's *Crowning with Thorns* in Madrid (Mariuz 1971: [234]), his only painting of this subject, displays many of the elements of the early pen drawing in Saint Petersburg and in one formerly with Tomas Harris (Byam Shaw 1962: [19]).

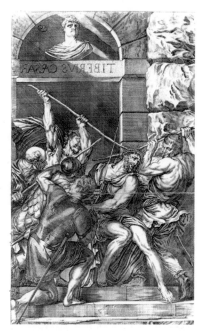

Figure 215. Valentin Lefebre after Titian, *The Crowning with Thorns* (*Opera Selectiora,* 1682, [6])

SOURCES: Domenico bases his design closely on the celebrated painting by Titian, now in the Louvre but, until 1797, in the church of Santa Maria delle Grazie in Milan (Valcanover 1969: [243]; Paris 1993: [171]). Domenico enlarges the composition on all sides and moves the bust of Caesar and the inscription over to the left wall. The most important omission is the extended right leg of Jesus in the painting. Since the design is shown in reverse, it would seem that Domenico made use of the engraving by Valentin Lefebre (1682: [6]; Ruggeri 2001 [1.8]), which is also reversed [fig. 215]. However, he moved the bust and the inscription from the transom of the arch to the left wall. The fine etching by Luigi Scaramuzza of Perugia, 1616–1680 (*Kitto Bible* 42-7649) inscribed *"Tiziano inven et Pinxit Mediolani,"* is not reversed. Another version of the design, now in Munich, remained in Titian's studio until his death, but this does not show the figure in the foreground in a coat of mail, as does the Milanese version, a detail followed closely by Domenico.

195. *Jesus Shown to the People*

TRADITIONS: The subject appears among the mosaics of San Marco (*San Marco* 1990: [131]; 1991: [67.1]) and in the *Deutsche Bilderbibel* (1960: [34 verso/b]). It also appears in the engraving by Wierix after Passeri from the *Evanglicae Historiae Imagines* (1593: [123]).

As a series, one may note the set of eight canvases painted ca. 1583 by the Bassani for the choir of the church of Sant'Antonio Abate in Brescia, now dispersed (Arslan 1960: 195, 196 [239–246]), which, though almost certainly known to Domenico, does not contain this scene. The subject appears in two canvases engraved by Pietro Monaco, by Mattia Preti (Monaco 1743: no. 71; 1763: no. 99; Apolloni 2000: [99]) and by Luca Dolanda (Monaco 1743: no. 70; 1763: no. 43; Apolloni 2000: [43]). Another important series was painted ca. 1730 by Crosato, Camerata, and Bambini for the Capella del Crocefisso of San Marcuola, of which only Bambini's *Deposition* survives (Knox 1980: 32, note 4). Giambattista's three canvases for the church of Sant'Alvise, which followed shortly thereafter, are a sort of truncated set of scenes of the Passion, which we believe must have been intended to decorate the curved wall of the apse of the church, with the windows between the three canvases. It is also treated by Giambattista Tiepolo in the Louvre (Paris, 1998, [72]) and by Domenico at Caen (Paris, 1998, [fig. 110]). The present design is linked with Domenico's etching, *Via Crucis I*. Domenico's set of eight canvases for the church of San Felipe Neri in Madrid followed later in 1772 (Mariuz 1971: [232–239]).

SOURCES: Conrad points out that the prominent soldier standing on the left derives from Salvator Rosa's etching of 1656–1657 (*The Illustrated Bartsch 45*, 1978: 35; Bozzolato 1973: [15]) [fig. 216]; likewise the seated soldier by his side (*The Illustrated Bartsch 45*, 1978: 60; Bozzolato 1973: [40]). These are perhaps the most striking examples of Domenico's use of this source.

Figure 216. Salvator Rosa, *A Standing Soldier* (etching, 1656–1657)

Figure 217. Salvator Rosa, *A Seated Soldier* (etching, 1656–1657)

196. *Jesus Carrying the Cross—"GIVLIO CESARE"*

TRADITIONS: The subject was treated by Giotto in the Arena Chapel (Basile 1993: [197a]), and one may note the similar emphasis on the gate of Jerusalem. It appears in the *Deutsche Bilderbibel* (1960: [36b]), by Virgil Solis (1565: [130]). An important sixteenth-century example is the Veronese, now at Dresden (Marini 1968: [148]), which passed from Modena to Dresden in 1746; it is said to descend from a Schongauer print. It is also treated by Francesco da Ponte for Sant' Antonio Abate in Brescia, later in Paris (Arslan 1960: [244]), but this introduces the element of Sta. Veronica. Domenico also would have known the painting by Rubens, engraved by Pietro Monaco (1743: [73]; 1745: [45]) and perhaps the engraving by Stella after Poussin, also featuring the city gate (*Kitto Bible* 42-7604).

SOURCES: The theme appears in Domenico's work as *Station II* of the San Polo *Via Crucis* (Rizzi 1971: [42]), from which many of the elements of this design are drawn [fig. 234].

197. *Jesus Led to Calvary*

TRADITIONS: This scene appears on the fourth column of the Ciborium in San Marco (Gabelentz 1903: D.VI) and is treated by Giotto in Padua (Basile 1993: [197a]) and in the *Deutsche Bilderbibel* (1960: [36b]).

SOURCES: The figure of John derives from *Station XIII* of the S. Polo *Via Crucis* (Rizzi 1971: [53]). He and Mary Magdalene are repeated in reverse in plate 227, *Station XIV* of the *Via Crucis* (Louvre). A preliminary drawing was prepared by Domenico 1743, Knox 1999 [3], [fig. 218].

Figure 218. Domenico Tiepolo, *The Way to Calvary* (1743, red chalk drawing)

198. *The Despoiling of Jesus*

TRADITIONS: The theme is treated by Francesco da Ponte for Sant' Antonio Abate in Brescia, now in Cremona (Arslan 1960: [242]).

SOURCES: The setting is similar to Giambattista's *Way to Calvary* in Sant'Alvise, but in reverse. Many elements are close to *Station X* of the *Via Crucis* (pl. 223). It is also treated by Domenico in the Passion series in Madrid (Mariuz 1971: [236]) [fig. 219]. Conrad suggests that the soldier to the right of Jesus derives from the etching by Salvator Rosa in reverse (*The Illustrated Bartsch 45,* 1978: [38]; Bozzolato 1973: [18]).

199. *The Nailing of Jesus*

TRADITIONS: Perhaps because it is not specifically described in the Gospels, the scene is not found in the early sources. However, it is treated in the *Deutsche Bilderbibel* (1960: [37b]) and by Dürer in *The Small Passion* (*The Illustrated Bartsch 10,* 1978: [39]); it is also found in one of the series by Gerolamo da Ponte for the church of Sant' Antonio Abate in Brescia, now in Bassano (Arslan 1960: [245]).

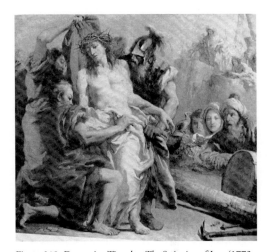

Figure 219. Domenico Tiepolo, *The Stripping of Jesus* (1772, Madrid, Prado)

It appears regularly among the Antwerp engravers: by Collaert after Maarten de Vos in the *Vita, Passio et Resurrectio Iesu Christi* (Hollstein 44, 1996: [46]); in the engraving by Wierix after Passeri from the *Evanglicae Historiae Imagines* (1593: [127]); and in an engraving after Maarten de Vos in the *Theatrum Biblicum* (1674: [1]).

SOURCES: The design is based on the etching *Via Crucis XI* (Rizzi 1971: [51]). The figure of Jesus and the boy holding his arm are found in *Via Crucis XI* (pl. 224) [fig. 220]. It is also quite closely related to an early pen drawing of the same subject by Domenico, shown by Jean-Luc Baroni (New York, May 2002, [24]).

200. *The Crucifixion*

TRADITIONS: This universal subject is found on the fourth column D of the Ciborium in San Marco (Weigel 1997: [Falttafel III.2]) and at Monreale (del Giudice 1702: [XXII.4]). Among the mosaics of San Marco, the subject appears twice, first as a twelfth-century work (*San Marco* 1990: [130]; 1991: [67/2]) that shows Jesus in the center, flanked by figures holding the lance and the sponge, the Virgin and attendants on the left, and John and attendants on the right; second, in a replacement of 1549 (*San*

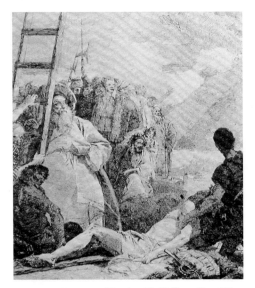

Figure 220. Domenico Tiepolo, *The Nailing of Jesus* (*Via Crucis XI*, Venice, San Polo)

Marco 1991: [151/3]). It is found in *The Rockefeller McCormick New Testament* (1932: [33 verso]) with Giotto at Padua (Basile 1993: [197b]), in the *Deutsche Bilderbibel* (1960: [38a]), and in Virgil Solis (1565: [131]). But for Domenico and all Venetians, the supreme treatment of this theme is the vast canvas by Tintoretto in the Albergo of the Scuola di San Rocco (de Vecchi 1970: [167]). Also noteworthy is the large Pietro della Vecchia from the Ognisanti in the Gallerie dell'Accademia (Moschini Marconi 1970: [254]).

Domenico's design, however, seems to have something more in common with Giambattista's early canvas in San Martino, Burano (Gemin and Pedrocco 1993: [61]). The arrangement of the three crosses follows the pattern of plate 225. Gustave Doré's composition in *La Sainte Bible selon la Vulgate* (Doré 1866: [opp. col. 572]) shows some indication of having been inspired by this drawing.

Figure 221. Giambattista Tiepolo, *Alexander and Bucephalus* (ca. 1760, Paris, Petit Palais)

SOURCES: The horse and groom in the lower central area derive from Giambattista's *Alexander and Bucephalus* in the Petit Palais (Paris, 1998, [73]) [fig. 221]. The group is also used later in *An Army Before the Walls of a City* (pl. 306) and *Anna Meets Joachim at the Golden Gate* (pl. 10), as well as in *Scenes of Contemporary Life 23* (Gealt and Knox 2005: [23]). Christofer Conrad points out that the seated soldier bending over his shield, low left, derives from Salvator Rosa, *A Seated Soldier* (*The Illustrated Bartsch 37,* 1978: [45]; Bozzolato 1973: [17]).

201. *Jesus Crucified Between the Two Thieves*

TRADITIONS: The scene is found among the mosaics of San Marco (Demus 1984: [332]) and among the frescoes by Giusto de' Menabuoi in the Baptistery of the Duomo at Padua (Spiazzi 1989: 66.5 [41]). The scene is shown in three separate miniatures in the *Deutsche Bilderbibel* (1960: [37 verso/b, 38a, b]). The design is somewhat reminiscent of the Veronese of the 1570s in the Louvre (Marini 1968: [158]), but reversed.

SOURCES: The composition derives broadly from the painting in St. Louis Museum of Art (Morassi 1955: [fig. 25]; Knox 1980: 234; etc.). The soldier standing prominently on the left derives from the etching by Salvator Rosa (Bozzolato 1973: [18]; *The Illustrated Bartsch 45,* 1978: [38]) [fig. 222], and Conrad finds two other soldiers that derive from the same source. The weeping John, again prominent on the right, derives from *Via Crucis XIII* (Rizzi 1971: [54]) and ultimately from Mantegna, as does the similar figure in plate 227 [fig. 244].

Figure 222. Salvator Rosa, *Standing Soldier with a Lance* (etching 1656–1657)

202. *The Lamentation*

TRADITIONS: This is treated in the mosaics of Monreale (del Giudice 1702: [XXII.5]), by Giotto in Padua (Basile 1993: 198]), in the *Deutsche Bilderbibel* (1960: [38 verso/b]), and by Virgil Solis (1565: [132]). In the sixteenth century it is treated by Raphael in a design that clearly relates to the text above (Jameson 1890: 221), and there is also a canvas by Veronese at Verona (Marini 1968: [38]).

It is the subject of various paintings by Giambattista and Domenico Tiepolo (Venice, 1996, [58a]; Mariuz 1971: [238]).

SOURCES: This design appears to be a later copy of *Via Crucis XIII* (pl. 226), with the addition of the horse and rider on the right, that essentially derives from a drawing by Domenico at Saint Petersburg (Udine 1996: [122]). As Byam Shaw (1933: [fig. 7]) points out, the composition derives ultimately from the painting by Rembrandt in the National Gallery that belonged to Consul Smith. This was recorded in a chiaroscuro woodcut by J. B. Jackson, dated 1738 (*Kitto Bible* 50-9158) [fig. 223].

203. The Removal of the Body of Jesus

TRADITIONS: The mosaic at Monreale (del Giudice 1702: [XXII.6]) shows the removal of the body, very much as here, with the cave tomb on the right [fig. 224]. Here the head of Jesus is wrapped in a cloth. The *Deutsche Bilderbibel* shows Joseph appealing to Pilate (1960: [folio 38 verso/a]) and preparing the body for burial ([folio 39a]). The woodcut by Urs Graf, *The Crucifixion,* from *The Passion of Christ* (*The Illustrated Bartsch 13,* 1978: [69]), shows an angel taking the soul of the good thief, and a devil taking the soul of the bad thief. *The Entombment* by Antonio Pellegrini in Santa Maria del Giglio (Knox 1995: [18]) shows the body of Christ carried in a somewhat comparable way.

SOURCES: Christofer Conrad points out that the soldier on the extreme left derives from the etching by Salvator Rosa (Bozzolato 1973: [15]); [fig. 222].

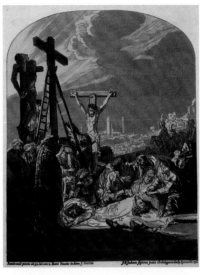

Figure 223. J. B. Jackson, after Rembrandt, *The Deposition* (chiaroscuro woodcut, 1738, San Marino, The Huntington Library)

204. The Entombment of Jesus

TRADITIONS: This is found at San Marco (*San Marco* 1991: [151/4]), by Giotto in Padua (Basile 1993: [198a]), in the *Deutsche Bilderbibel* (1960: [39b]), in Dürer *Small Passion* ([B.44]), as well as in an engraving by Wierix after Passeri from the *Evanglicae Historiae Imagines* (1593: [133]).

It also forms part of Domenico's series of the *Via Crucis, Station XIV* (Mariuz 1971: [18]—see also *Via Crucis XIV,* pl. 227) and of his *Scenes of the Passion* in the Prado (Mariuz 1971: [239]), which owes something to the Titian of 1559 in the Prado (Valcanover 1969: [467]). The weeping John the Evangelist on the extreme left recalls the etching by Mantegna [fig. 244].

SOURCES: The crouching figure in the foreground derives from the drawing by Giambattista at Stuttgart [fig. 252]. The man on the right derives from the San Polo *Via Crucis XIV* (Rizzi 1971: [54]).

Figure 224. *The Removal of the Body of Jesus* (mosaic, 1180, Monreale)

205. The Resurrection of Jesus

TRADITIONS: The earliest notable representation is the celebrated ivory at Munich, a Byzantine work of the sixth century (Jameson 1890: 262]). In San Marco it forms the theme of the central cupola (*San Marco* 1990: [94]; 1991: [50]) and is found again among the mosaics at Monreale (del Giudice 1702: [XXII.7]), showing the risen Jesus with numerous figures. It is also found in the *Deutsche Bilderbibel* (1960: [40a]). However, the prototype here may be Dürer's woodcut in *The Large Passion* and *The Small Passion* (*The Illustrated Bartsch 10,* 1978: [15], [45]). Réau notes that the theme reached its apogee with Tintoretto's canvas of 1580 in San Rocco (de Vecchi 1970: [223Z: 37]). One may also note the small Bassano in the Redentore of 1584–1590.

It is treated twice by Sebastiano Ricci: first in the ceiling from the Oratorio del Crocefisso of San Gimignano (Daniels 1976: [272]), which inspired Domenico for his ceiling in the Oratorio del Crocefisso in San Polo (Knox 1980: [99, 100]), and second in the semi-dome of the apse

Figure 225. The Three Maries at the Empty Tomb (mosaic, 12th century, San Marco, West Vault)

at Chelsea Hospital (Daniels 1976: [327–329]). It was also used by Giambattista Tiepolo for the door of a tabernacle at Udine (Gemin and Pedrocco 1993: [80]). It may also be compared with the large finished drawing by Fontebasso in the Correr Museum (Pignatti 1981: [459]).

SOURCES: The design derives from a drawing by Domenico (Zürich, 1967, [118]; Zürich, 1984, [57]: Stanford, 1969, [43]) [fig. 226]. The censing angel derives, with a change in the pose of the head, from Domenico's canvas in La Maddalena (Knox 1980: [311–314]).

Figure 226. Domenico Tiepolo, *The Resurrection of Jesus* (drawing, 252 x 180, Scherzingen, private collection)

206. *The Three Marys at the Tomb*

TRADITIONS: The scene is found on the fourth column of the Ciborium in San Marco, D6 (Weigel 1997: [Falttafel III.2]), among the San Marco mosaics (Demus 1984: [331]; *San Marco* 1990: [128]; 1991: [67/3]) [fig. 225]. It crowns the arch to the west of the central dome in a design that is not dissimilar except that the three Marys are shown standing; likewise at Monreale (del Giudice 1702: [XXII.8]). It also appears in the *Rockefeller McCormick New Testament* (1932 [54 verso]), among the frescoes by Giusto de' Menabuoi in the Baptistery of the Duomo at Padua (Spiazzi 1989: 68.7 [41]), in the *Deutsche Bilderbibel* (1960: [40b]), and by Solis (1565: [133]). It is related to no fewer than four engravings by Wierix after Passeri in the *Evangelicae Historiae Imagines* (1593: [136, 137, 138, 139]).

207. *Jesus Appears to His Disciples, I*

TRADITIONS: This scene, quite rare, appears in the San Marco mosaics (Demus 1984: [351]; *San Marco* 1991: [68/2]) and again in those of Monreale (del Giudice 1702: [XXIII.6]), in both cases apparently making Doubting Thomas the central element in the design. It also appears in the *Deutsche Bilderbibel* (1960: [43b]) [fig. 227], in Dürer's woodcut from *The Small Passion* (*The Illustrated Bartsch 10,* 1978: 144), in the *Biblische Figuren* (Solis 1565: [135]), and in the engraving by Wierix after Passeri in the *Evangelicae Historiae Imagines* (1593: [146])—sometimes emphasizing the story of Doubting Thomas, which does not appear as such in Domenico's series. However, it is treated by Giambattista in two drawings in the Orloff Album (Paris, Georges Petit, 1920, [107, 108]; Knox 1961: pls. 33, 34) as *Doubting Thomas*.

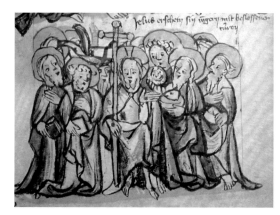

Figure 227. *Jesus Appears to His Disciples* (1420, *Deutsche Bilderbibel*, folio 43b, Freiburg in Breisgau, University Library)

208. *Jesus Appears to His Disciples, II*

TRADITIONS: Once again we must refer to the *Deutsche Bilderbibel* (1960: [44a]) [fig. 228] for a truly comparable prototype.

209. *Jesus and the Disciples on the Road to Emmaus*

TRADITIONS: Among the mosaics of Monreale (del Giudice 1702: [XXIII.1]) the scene is shown together with *The Supper at Emmaus* and *The Disappearance of Jesus* (del Giudice 1702: [XXIII.2 and XXIII.3]), neither of which is treated by Domenico. In San Marco the original work is lost, but the designs are preserved in a drawing made before the work was replaced by Ceccato and Pasterini, after a cartoon by Leandro Bassano, 1617

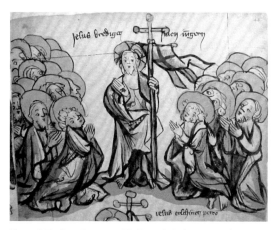

Figure 228. *Jesus Appears to His Disciples* (1420, *Deutsche Bilderbibel*, folio 44a, Freiburg in Breisgau, University Library)

(Demus 1984: [52]). It appears in the *Deutsche Bilderbibel* (1960: [42a]) and in the woodcut by Solis (1565: [134]), where the arrangement of the figures is similar. Also very comparable is the engraving after Maarten de Vos (Witt Print Collection, Neg. 1022/15(12)) [fig. 229]; however, another engraving after Maarten de Vos in the *Theatrum Biblicum* (1674: [2]) is completely different, with a townscape on the left.

Figure 229. After Maarten de Vos, *Jesus on the Road to Emmaus* (engraving, Witt Print Collection)

210. *Jesus at the Sea of Tiberias*

TRADITIONS: In this design, Domenico follows the San Marco mosaic quite faithfully (Demus 1984: [144]; *San Marco* 1991: [75/4]) [fig. 230], and the mosaic at Monreale (del Giudice 1702: [XXIII.7]) more so than in the drawing at Stuttgart (1970, [65]). The *Deutsche Bilderbibel* (1960: [43 verso/b]) tells the story more fully showing "a fire of coals there, and fish laid thereon, and bread"; this is also found in an engraving after Maarten de Vos in the *Theatrum Biblicum* (1674: [4]). In the sixteenth century and later, the theme is dominated by the Raphael cartoon. Domenico was also familiar with the painting by Luca Giordano engraved by Pietro Monaco (1763: [87]; Apolloni 2000; [87]).

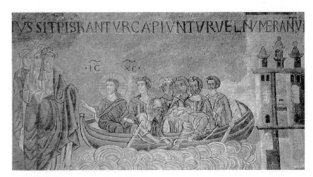

Figure 230. *Miraculous Draught of Fishes* (mosaic, 12th century, Venice, San Marco, north transept)

211. *The Ascension of Jesus, I*

TRADITIONS: This scene appears on the fourth column of the Ciborium in San Marco (Gabelentz 1903: D.VIII). Among the mosaics it is the theme of the Great Dome (*San Marco* 1990: [133]; *San Marco* 1991: [50]) showing the Virgin in the center of the outer ring of figures, flanked by two angels, the two men in white apparel, and the twelve apostles. Among those of Monreale (del Giudice 1702: [23.8]) *The Ascension* appears showing Jesus above, with angels: the Virgin in the center flanked by two angels, the men in white, and a group of figures on either side. In Padua, the scene is found among the frescoes of Giotto (Basile 1993: [199a]); and among those by Giusto de' Menabuoi in the Baptistery of the Duomo (Spiazzi 1989: 68.8 [45]). The design here seems to derive from the *Deutsche Bilderbibel* (1960: [45a]) [fig. 231], rather than from Dürer's woodcut in *The Small Passion* (*The Illustrated Bartsch 10*, 1978: [50]). It is also treated by Virgil Solis (1565: [140]),

SOURCES: The crouching man, low left, derives from a drawing at Stuttgart [fig. 252].

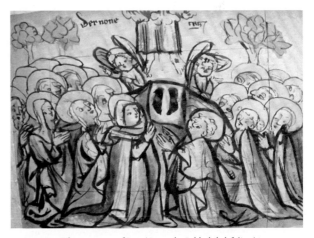

Figure 231. *The Ascension of Jesus* (*Deutsche Bilderbibel*, folio 45a, Freiburg in Breisgau, University Library)

212. *The Ascension of Jesus, II*

TRADITIONS: This scene appears among frescoes of Giotto in Padua (Basile 1933: [199a]) emphasizing the men in white apparel, and in the Baptistery of the Duomo at Padua (Spiazzi 1989: 68.8 [46]). One may note the engraving by Wierix after Passeri in the *Evangelicae Historiae Imagines* (1593: [148]). Tintoretto's canvas

in the Scuola di San Rocco (de Vecchi 1970: [38]) shows the men in white apparel in the middle distance.

213. Via Crucis—*Frontispiece*

TRADITIONS: Domenico's *Via Crucis* belongs to a Venetian tradition that provided a frieze of canvases round the walls of a chapel or *scuola*. This was particularly the case with a mortuary chapel, or Oratorio del Crocefisso, such as that at San Polo, with doors giving access into both the church and the street. Such a chapel also still exists at Santa Maria del Giglio, partly decorated by Antonio Pellegrini 1698–1700 (Knox 1995: [17–19]). A few years later the similar chapel of San Gemignano was decorated by a team of leading painters, again including Pellegrini (Knox 1995: 40) and Sebastiano Ricci, whose *Ascension of Jesus* still survives (Daniels 1976: [350]) and evidently inspired Domenico in his similar ceiling canvas at San Polo. Another example on a larger scale is a mostly vanished series of ten large canvases painted for the Oratory of the Crucifix of San Marcuola ca. 1733.

Figure 232. Domenico Tiepolo, *Via Crucis—Frontispiece* (etching, 1749)

SOURCES: Several of the essential elements derive from Domenico's etched frontispiece for the *Via Crucis* of 1749 (Rizzi 1971: [39]), but here all the symbols of the passion are shown on the ground [fig. 232]. The symbols in the sky represent Mary—"MRIA"—and Joseph, following inventions by Domenico at Stuttgart (1970, [138, 141, 142]).

214. *Station I: "Ecce homo"—Jesus Presented to the People*

TRADITIONS: The general arrangement is not unlike *Le grand Ecce Homo* of Callot (Lieure 1989: [77]).

SOURCES: The architectural background derives from Domenico's etching after *Station I* of the S. Polo *Via Crucis* (Rizzi 1971: [41]), but he makes it far less prominent. The architecture on the left, and the banner on the right, derive from the *Ecce Homo* by Giambattista [fig. 233] in the Louvre (Paris, 1998, [72]) and ultimately from Dürer, *The Large Passion*. The woman in the right center foreground derives from the drawing at Edinburgh [fig. 115].

Figure 233. Giambattista Tiepolo, *Ecce Homo* (ca. 1760, Paris, Musée du Louvre)

215. *Station II: Jesus Takes the Cross on His Shoulder*

SOURCES: The architectural background, the figure of Jesus, and some other details derive from Domenico's etching after *Station II* of the S. Polo *Via Crucis* (Rizzi 1971: [42]) [fig. 234], but he has greatly expanded the foreground. At the same time he has eliminated the seated repoussoir figure in the right foreground and replaced him with the boy carrying the tablet. Jesus becomes a full-length standing figure, bearing an immense cross, and balanced by the drummer-boy in the left foreground.

216. *Station III: Jesus Falls Under the Cross the First Time*

SOURCES: The architectural background, the figure of Jesus, and some other details derive from Domenico's etching after *Station III* of the S. Polo *Via*

Figure 234. Domenico Tiepolo, *Via Crucis II* (etching, 1749)

Crucis (Rizzi 1971: [43]) [fig. 235] but he makes it more magnificent and monumental. This setting, reminiscent of the architecture of Sanmichele, was also used by Domenico for the story of the Widow of Nain (pls. 120–121). He creates a far more animated scene, eliminating a calmly standing man in the right foreground and replacing him with the vigorous figure of a trumpeter on a rearing horse. The horse seems to derive from a drawing in the Hermitage (Udine 1996: [122]). While many of the figures in the etching are used, the static centrality of the etching becomes a strong thrusting movement to the right.

217. *Station IV: Jesus Meets His Mother*

SOURCES: The figure of Jesus derives from Domenico's etching after *Station IV* of the S. Polo *Via Crucis* (Rizzi 1971: [44]) [fig. 236]; however, he eliminates the weary executioner in the right foreground and replaces him with an Oriental horseman blowing a trumpet. The horseman may derive from the drawing at Besançon [fig. 113].

218. *Station V: Jesus Assisted by St. Simon of Cyrene*

SOURCES: The figures of Jesus and St. Simon of Cyrene derive from Domenico's etching after *Station V* of the S. Polo *Via Crucis* (Rizzi 1971: [45]) [fig. 237].

219. *Station VI: Jesus and St. Veronica*

TRADITIONS: The *Sacra Sidone* is sometimes treated as a separate subject, as by Amigoni (Scarpa Sonino 1994: 146, [35, 36]). Veronica figures prominently in the right foreground of the Sant'Alvise *Way to Calvary* by Giambattista (Pallucchini 1968: [21]), but not in the sketch in Berlin (Gemin and Pedrocco 1993: [235a]) or in the engraving by Pietro Monaco [fig. 239].

SOURCES: The figures of Jesus and St. Veronica and other details derive from Domenico's etching after *Station VI* of the S. Polo *Via Crucis* (Rizzi 1971: [46]), but the scene has been radically reconstructed. The main group has been moved from the right foreground to the left middle-distance, and replaced again by a mounted rider. Space is also created in the foreground for the thieves and their escort and for the drummer-boy in the lower left corner. A vast crowd and a rocky wilderness form a backdrop to the scene.

220. *Station VII: Jesus Falls the Second Time*

SOURCES: Here Domenico abandons the example of the etching entirely and takes the essential elements from Giambattista's small painting at Berlin (Gemin and Pedrocco 1993: [235a]), formerly in the collection of Francesco Algarotti, as engraved by Pietro Monaco (Monaco 1743: [73]; 1763: [72]; Apolloni 2000: [72]). A counterproof of a red chalk copy by

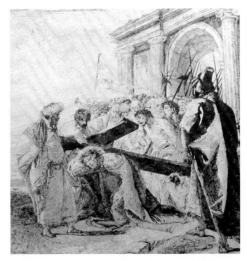

Figure 235. Domenico Tiepolo, *Via Crucis III* (etching, 1749)

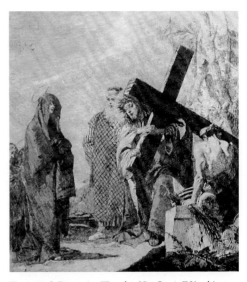

Figure 236. Domenico Tiepolo, *Via Crucis IV* (etching, 1749)

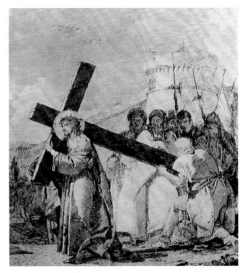

Figure 237. Domenico Tiepolo, *Via Crucis V* (etching, 1749)

Domenico for the engraving is known (Knox 1999: [3]) [fig. 238]. These all relate to Giambattista's great *Way to Calvary* in Sant'Alvise.

221. *Station VIII: Jesus Meets the Holy Women*

SOURCES: Several figures derive from Domenico's etching after *Station VIII* of the S. Polo *Via Crucis* (Rizzi 1971: [48]) [fig. 240], and some of them there may be identified as portraits of members of the Tiepolo family (Knox 1980: 33). Here they are moved to the left, making way for another horse and rider and a vast concourse of people in the background. The same horse and rider appear in the *John the Baptist Preaching* (pl. 90)—evidently a much later drawing than this one. The horse derives from a drawing in the Huntington Library and Art Gallery [fig. 138], also used for *Scenes of Contemporary Life 22.*

222. *Station IX: Jesus Falls the Third Time*

SOURCES: The figure of Jesus and other details derive from Giambattista's *Way to Calvary* (Gemin and Pedrocco 1993: [235a]), painted for Francesco Algarotti and engraved by Pietro Monaco, as shown in a counterproof of a red chalk copy by Domenico (Knox 1999: [3]) [fig. 239]; see also *Via Crucis VII* (pl. 220, above), which shows the group in the same sense as here. The group in the left foreground, a soldier hustling along two prisoners, derives from Giulio Romano's *Triumph of Scipio V,* one of the designs made in Mantua, ca. 1530, for the set of tapestries known as *Le Grand Scipion* (Hartt 1958: [478]). Domenico may have used the engraving by Giorgio Ghisi [fig. 241], which shows the figures moving to the right, as in this drawing (*The Illustrated Bartsch 31,* 1978: 144]). The second prisoner, to the right, and the head of a soldier, also appear in the same engraving, a little to the left.

223. *Station X: The Despoiling of Jesus*

SOURCES: The design derives from drawings at Stuttgart (1970, [27, 28]) [fig. 242]; compare plate 198. The figure on the extreme right derives, reversed, from the Carandini *Separation of Abraham and Lot* (Mariuz 1971: [57]); see also plate 2.

224. *Station XI: The Nailing of Jesus*

SOURCES: Several details derive from Domenico's etching after *Station XI* of the S. Polo *Via Crucis* ([fig. 220]; Rizzi 1971: [51]), but again the scene is greatly enriched. The boy, kneeling by Jesus, is also found in *The Entry into Jerusalem* (pl. 170). The drum and drumsticks are prominent in the right foreground, and the crowd is rather more dominant as it fills the setting from side to side in the middle distance; see figure 220.

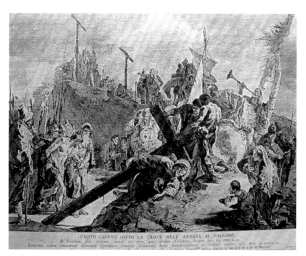

Figure 238. Domenico Tiepolo, *Via Crucis VI* (etching, 1749)

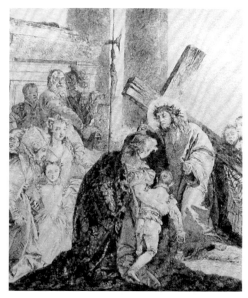

Figure 239. Pietro Monaco, after Giambattista Tiepolo, *The Way to Calvary* (etching)

Figure 240. Domenico Tiepolo, *Via Crucis VIII* (etching, 1749)

225. *Station XII: The Crucifixion*

SOURCES: The figure of John seems to derive from a drawing recorded with the Paul Drey Gallery in New York (Knox 1968: [fig. 6]), also copied by Lorenzo in the Würzburg Second Sketchbook (Knox 1968: [31]; Knox 1980: G.34 and M.89)—hence, a work of the late 1740s [fig. 243].

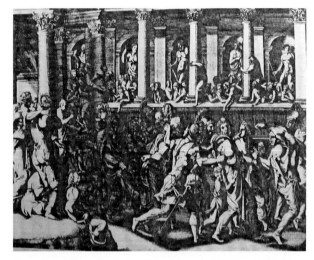

226. *Station XIII: The Descent from the Cross*

SOURCES: Byam Shaw pointed out that the Rembrandt *Descent from the Cross,* now in the National Gallery, was in the collection of Joseph Smith in Venice until it passed to George III in 1762. Thus, Domenico could have known the painting itself, or perhaps more likely the chiaroscuro woodcut by J. B. Jackson of 1738 [fig. 223]. Though not a slavish copy of Rembrandt's composition, this drawing follows it in general

Figure 241. Giorgio Ghisi, after Giulio Romano, *The Triumph of Scipio V* (engraving)

design and in many details. The central figure of the weeping St. John, on the other hand, derives from Giambattista's painting of the Spanish years, *The Deposition,* formerly in the Hausammann collection in Zurich (New York, 1997, [58a]): also there associated with the Rembrandt) and perhaps less directly from the drawing once with the Paul Drey Gallery [fig. 243]; see the preceding drawing (pl. 225). Keith Christiansen points out (New York, 1996, 347) that this figure may be inspired ultimately by Mantegna's engravings: an impression of *La sépulture* is recorded in the 1845 catalogue of material from Domenico's studio, lot 14.

227. *Station XIV: The Entombment of Jesus*

SOURCES: The weeping St. John on the left derives from *Station XIII* of the S. Polo *Via Crucis* (*Rizzi 1971:* [53]), while the figure on the right of the tomb derives from Domenico's etching after *Station XIV* (Rizzi 1971: [54]). Both these figures derive ultimately from Mantegna's engraving, *The Entombment with Four Birds* (London, 1992, [29]) [fig. 244], and here one may refer to lot 14 in the sale catalogue of November 1845 of material *"provenant de la succession de Dominique Tiépolo": Mantegne (André)—La sépulture (3). Bacchanale à la cuve (19). "Quatre*

Figure 242. Domenico Tiepolo, *The Despoiling of Jesus* (Stuttgart, Staatsgalerie, 1537)

morceaux du Triomphe de César, gravés par Andréani." The same elements are found in the Titian of 1559 in the Prado (Valcanover 1969: [467]). The censing angel derives from *The Flight into Egypt V.*

228. *Peter in the Midst of His Brethren*

TRADITIONS: A unique prototype for this scene is found in *The Rockefeller McCormick New Testament* (1932: [106]), and the arrangement of the figures is not dissimilar. The ninety miniatures of that Imperial Byzantine manuscript of 1265 include a set of thirteen illustrating the first fourteen chapters of the Acts of the Apostles. Most of these are also found in Domenico's New Testament, and often represent the only prototype found so far. Thus, is seems evident that Domenico, though he could hardly have known this particular volume, made a careful study of Byzantine manuscript sources.

Illustrations to the Acts of the Apostles are relatively rare until the last quarter of the sixteenth century. In that period one may note especially the *Acta Apostolorum,* a series of 34 prints published in 1575 by Philip Galle (1537–1612) after Marten van Heemskerck (1498–1574) and Stradanus (1523–1605), which passed through

six editions between 1575 and 1655. Also of interest is the *Biblia Sacra* (1588), with 58 woodcuts, possibly after Bernard Salomon, illustrating the Acts.

229. "MATTIA"—*Matthias Numbered Among the Apostles*

TRADITIONS: A unique medieval prototype for this scene is found in *The Rockefeller McCormick New Testament* (1932: [106 verso]). However, in the late sixteenth century it appears as the first engraving by Philip Galle after Marten van Heemskerck in the *Acta Apostolorum* (1582: [1]), 210 x 280. This emphasizes the "upper room" mentioned in Acts 1:13. The first woodcut illustrating the Acts in the *Biblia Sacra* (1588: 1,070]), 75 x 100, shows the Apostles casting lots on the left and the two candidates seated on the right.

230. *Pentecost*

TRADITIONS: The scene is found among the mosaics of Monreale (del Giudice 1702: [XXIII.9]). The celebrated *Cupola of the Pentecost* decorates the western dome over the nave in San Marco (Demus 1984: ii, [4]; *San Marco* 1990: [144]; 1991: [104/1]) and shows the twelve Apostles but not the Virgin. The fresco by Giotto in Padua (Basile 1993: [199b]) completes the third cycle of decoration. It is found in *The Rockefeller McCormick New Testament* (1932: [107]). Giusto de Menabuoi's *Pentecost* fills the dome of the Baptistery in Padua, in similar fashion to San Marco (Spiazzi 1989: 68.9, [47]) but including the Virgin. It is also found in the *Deutsche Bilderbibel* (1960: [45 verso/b]), in the Dürer *Small Passion* (*The Illustrated Bartsch 10,* 1978: 146, [51]), and in the *Biblische Figuren* (Solis 1565: [142]).

For Domenico, the most celebrated painting on this theme in Venice would have been the great altarpiece by Titian for Santo Spirito in Isola, removed to the Salute in 1656 (Valcanover 1969: [387]; Venice 1990: [43]); again, the three Marys dominate the center of the design, with the Virgin seated [fig. 246]. Domenico's composition has a very similar balance and weight. In each case the figure of the Virgin is not quite central. There are other important versions of the theme, one painted by Jacopo da Ponte for the church of San Francesco in Bassano, now in the Museo Civico (Arslan 1960: [122]), and another by Padovanino, for the church of the Spirito Santo in Padua, now in the Gallerie dell'Accademia, Venice (Moschini Marconi 1970: [152]). In both these compositions the Virgin appears alone in the center of the design.

In the late sixteenth century it is found in two engravings in the *Acta Apostolorum* (1582: [3]). The first, after Marten van Heemskerck (Antwerp, 200 x 267) again emphasizes the "upper room" [fig. 245]. The second, after Stradanus, shows at least six Holy Women in the center and Peter kneeling on the left. A woodcut illustrating the Acts in the *Biblia Sacra* (1588: 1,071, 75 x 100), makes an interesting comparison, with the three Marys in the center and a man by a column on the right. It is one of the last engravings of the *Evanglicae Historiae Imagines* (1593: [149]).

SOURCES: The kneeling man in the center foreground derives from a drawing by Domenico in the Beauchamp Album (Christie's, June 15, 1965, [157]); see also *The Mass at Bolsena* (pl. 303).

231. *Peter Healing the Lame Man at the Beautiful Gate*

TRADITIONS: Although this subject is extremely rare in Venice, Luba Eleen notes eleven early examples of it elsewhere. It is found in Palermo, in the Cappella Palatina (Demus 1949: [42A]), where the Beautiful Gate is

Figure 243. Domenico Tiepolo, *The Mourning of St. John* (formerly New York, Paul Drey Gallery)

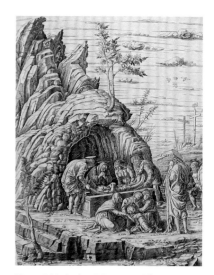

Figure 244. Andrea Mantegna, *The Entombment with Four Birds* (engraving, Vienna, Albertina)

excessively high and narrow, as here, and in the mosaics of Monreale (del Giudice 1702: [25.1]), where it opens the cycle of Peter. Among our standard sources, this subject is found only in *The Rockefeller McCormick New Testament* (1932: [108 verso]). Venice offers nothing comparable to the frescoes of the Brancacci Chapel in the Carmine in Florence, where one finds this subject painted by Masolino, associated with *The Raising of Tabitha* (Roberts 1993: [24]). These would hardly have been known to Domenico, but their design is far more consonant with his principles than the Raphael cartoon of this subject (Fischel 1948: [256]), or indeed the Poussin in the Metropolitan Museum of Art (Paris, 1994–1995, [222]) and many other seventeenth-century examples.

One may note the engraving by Philip Galle after Heemskerck in the *Acta Apostolorum* (1575: [6]). This important and popular work, which went through six editions between 1575 and 1655, offers the finest set of illustrations of the Acts of the Apostles, with 34 plates after Heemskerck and Stradanus.

Pigler (1956) lists an example by Fumiani in the collection of Ercole Giusti, but dal Pozzo (1718: 298) refers to "S. Pietro, ch'illumina il Cieco." No such incident involves Peter, but it might correspond to *Ananias Healing Paul.*

Figure 245. Philip Galle after Marten van Heemskerck, *The Apostles Casting Lots* (engraving from the *Acta Apostolorum*, Antwerp, 1582, [1])

232. *The Lame Man Healed*

TRADITIONS: While extremely rare in Venice, Luba Eleen notes eleven early examples of the subject elsewhere. It is found in Palermo: in the Cappella Palatina-Demus 1949—where the beautiful Gate is excessively high and narrow, as here; and in the mosaics of Monreale-del Giudice 1702 [XXV.1] [fig. 247] where it opens the cycle of Peter.

SOURCES: The standing man with a sword and his back turned, on the extreme right, derives from a drawing by Giambattista at Stuttgart (1996, [22]) [fig. 248]. This figure plays a similar role in *The Presentation of Jesus in the Temple* (pl. 41).

233. *Peter and John Before Annas*

TRADITIONS: In medieval times, this subject is unique to *The Rockefeller McCormick New Testament* (1932: [109 verso]). Peter and John, the latter a youthful figure with a halo, stand in the left center.

Domenico is more likely to have known the engraving by Philip Galle after Marten van Heemskerck in the *Acta Apostolorum* (1575: [6]) [fig. 249], which is actually dated 1558. This has a somewhat similar arrangement.

SOURCES: The man on the right derives from *The Flight into Egypt 7* [fig. 111].

234. *The Death of Ananias*

TRADITIONS: The subject of *The Death of Ananias* is rare, though it appears among the frescoes by Masaccio of the Brancacci Chapel in the Carmine in Florence, of 1425/1427. Réau cites the

Figure 246. Titian, *Pentecost* (1555, Venice, Sta Maria della Salute)

Figure 247. *Peter Healing the Lame Man at the Beautiful Gate* (mosaic, 1180, Monreale)

Raphael cartoon as his first example (Fischel 1948: [251]), which is the prototype for later Baroque treatments.

SOURCES: There is no explanation for the prominent figure of the man carrying his bedding on the right, which is borrowed directly from John 5:8 (*The Pool of Bethesda*, pl. 133) and which derives ultimately from the Louvre *Pool of Bethesda* [fig. 170] (Knox 1980: [243]). A similar episode is described in Acts 9:33–34 (*Peter Heals the Palsied Man of Lydda*, pl. 240), a subject found among the mosaics of Monreale (del Giudice 1702: [XXV.5]). It is possible that this refers to Acts 5:15: "they brought forth the sick into the streets, and laid them on beds and couches, that at the least the shadow of Peter passing by might overshadow some of them"—thus making a contrast with the fate of Ananias.

Figure 248. Giambattista Tiepolo, *A Study of a Standing Man* (Stuttgart, Staatsgalerie, 1454)

235. *The Burial of Ananias*

TRADITIONS: The treatment is remarkable in that it does not actually show *The Death of Ananias,* which is found in *The Rockefeller McCormick New Testament* (1932: [111]) and among the Raphael cartoons (Fischel 1948: [251]), but rather his corpse being carried away for burial. A similar treatment is found in *The Death of Sapphira,* a fifth-century ivory carving on the back cover of the Brescia *Lipsanoteca* (Grabar 1968: [337]), which could have been known to Domenico.

236. *The Death of Sapphira*

TRADITIONS: Again, this subject is found only in our regular sources in *The Rockefeller McCormick New Testament* (1932: [111]). Sapphira is shown standing before Peter in the fifth-century ivory of the Brescia *Lipsanoteca.* However, *The Death of Ananias,* which precedes this scene, is one of the subjects treated by Raphael in the tapestry cartoons. One may wonder whether Domenico may have seen the engraving by Jean Pesne after the painting by Poussin in the Louvre (Paris, 1994, [212C]). Pigler (1956) records an example by Fumiani in Florence, and there is also the Bazzani at Oberlin.

One may also note the engraving by Philip Galle after Marten van Heemskerck in the *Acta Apostolorum* (1575: [6]), which is somewhat similar, though dominated by the influence of Raphael, and the woodcut by Bernard Salomon in the *Biblia Sacra* (1588), which makes a valuable comparison [fig. 249].

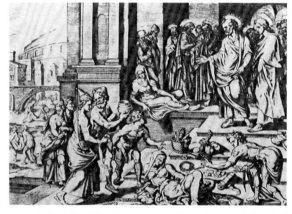

Figure 249. Philip Galle after Marten van Heemskerck, *The Death of Sapphira* (in the *Acta Apostolorum*, Antwerp, 1575, [6])

237. *The Apostles Delivered from Prison*

TRADITIONS: The two scenes are shown in succession among the mosaics of Monreale (del Giudice 1702: [XXV.2 and 3]). One may also note the engraving dated 1572 by Philip Galle after Marten van Heemskerck in the *Acta Apostolorum* (1575: [8]), which shows all twelve Apostles being released—hence, a unique prototype illustrating Acts 5:18–20.

SOURCES: The two hounds derive from a drawing in the British Museum, though here shown reversed (Campbell Dodgson, *Old Master Drawings,* September 1926: [27]) [fig. 250].

Figure 250. Domenico Tiepolo, *Two Hounds in a Landscape* (London, British Museum)

238. *Peter and John in Samaria*

TRADITIONS: The theme is treated in a fine engraving by Philippe Galle after Marten van Heemskerck in the *Acta Apostolorum* (1582: [10]) [fig. 251]. One must also note the large canvas by Antonio Cifrondi (1656–1730) at Brivio, San Leonardo, 350 x 650 cm, ca. 1704 (Marco Bon Castellotti, *La pittura lombarda del 700,* Milan 1896 [195]).

239. *Peter Outraged by Simon Magus*

TRADITIONS: No prototype for this scene has been noted, unless it would be the drawing by Liberale da Verona in the Fitzwilliam Museum, Cambridge (PD21–1961).

SOURCES: The crouching figure in the left foreground with hands clasped in prayer derives broadly from the drawing by Giambattista at Stuttgart (1970, [165]) [fig. 252]; see also plates 204, 211, and 277. The man in the center, here identified as Simon Magus, derives from Domenico's etching, *Via Crucis VII* (Rizzi 1971: [47]). The agitated saint to his right is clearly Peter.

240. *Peter Heals the Palsied Man of Lydda*

TRADITIONS: The scene appears in the mosaics of the Cappella Palatina in Palermo, and those of Monreale (del Giudice 1702: [XXV.5]). It is also treated in the engraving by Philip Galle after Marten van Heemskerck in the *Acta Apostolorum* (1575: [15]) in a design that has some points in common with Domenico's composition [fig. 253].

241. *Peter on the High Road to Joppa*

TRADITIONS: No prototype for this scene has been noted.

SOURCES: The figure in the center derives from the etching *The Flight into Egypt 22* [fig. 114]; see also plate 64. The figure on the right derives from the etching *Flight into Egypt 25* (Rizzi 1971: [91]) [fig. 254]; see also plate 59.

242. *The Raising of Tabitha*

TRADITIONS: The scene is not found in the early Venetian sources, but four examples are cited by Luba Eleen, including the mosaics of the Cappella Palatina (Kitzinger 1960: [fig. 14]) and at Monreale (del Giudice 1702: [XXV.4]) [fig. 255]. She also cites the Giustiniani Codex, fol. 129 verso (Eleen 1977: [42]), recording a lost mosaic from Old St. Peter's and Vatican cod. Chigi A.IV.74, fol. 127 verso (Eleen 1977: [43]). It is

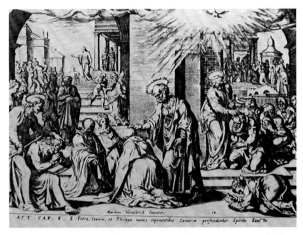

Figure 251. Philip Galle after Marten Van Heemskerck, *Peter and John in Samaria* (Antwerp, 1582, [10])

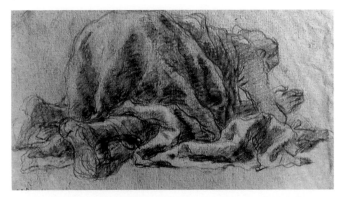

Figure 252. Giambattista Tiepolo, *A Man Thrown to the Ground in Worship* (Stuttgart, Staatsgalerie, 1436)

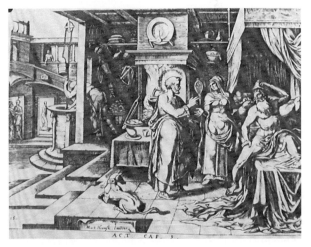

Figure 253. Philip Galle after Marten van Heemskerck, *Peter Heals Aeneas* (from the *Acta Apostolorum,* Antwerp, 1575 [15])

also found in *The Rockefeller McCormick New Testament* (1932: [116 verso]). The outstanding example, though probably not known to Domenico, is the Masolino in the Brancacci Chapel (Roberts 1993: [24]), where it is associated with *Paul Healing the Cripple at the Beautiful Gate*.

One may note the engraving by Philip Galle after Marten van Heemskerck from the *Acta Apostolorum* (1575: [16]) and the painting by Guercino in the Pitti Palace (Salerno, 1988, [45]), which, though quite different, makes a useful comparison as a rare example of the Baroque age. Pigler mentions a painting by Ricci at Urbino (no trace).

243.** *"Saint Pierre operant une guérison miraculeuse"*

No text.

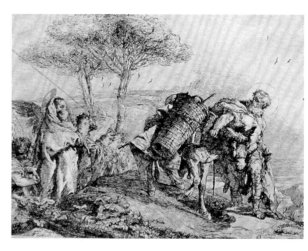

Figure 254. Domenico Tiepolo, *The Flight into Egypt 25* (etching, 1753)

244. *The Angel Appears to Cornelius*

TRADITIONS: The engraving by Philip Galle after Johannes Stradanus from the *Acta Apostolorum* (1575: [19]) seems to be the earliest prototype for this scene [fig. 256]. It also appears in a woodcut by Bernard Salomon in the *Biblia Sacra* (1588: 1,087). For a similar composition one may note the Jacob Backer at Bloomington, Indiana University Art Museum.

SOURCES: Giambattista painted the four Evangelists in the pendentives of the Cappella Sagredo in San Francesco della Vigna, and Domenico made a similar set for the chancel of the church at Meolo (Knox 1980: [230–234]). Here the angel evidently is a reference to the commanding figure in Domenico's canvas in the Accademia, *Abraham and the Angels* (Knox 1980: [298]).

245. *Peter Receives the Messengers from Cornelius*

TRADITIONS: The story of Cornelius is continued in the engraving by Philip Galle after Stradanus from the *Acta Apostolorum* (1575: [20]), a complex design that shows the house of "Simon a tanner" (Acts 10:6), low left, and *The Vision of Peter*, top right.

Figure 255. *The Raising of Tabitha* (mosaic, 1180, Monreale)

246. *Peter and the Centurion Cornelius*

TRADITIONS: A unique medieval prototype for this subject is found in the British Museum manuscript, *The Bible Moralized*, Harley 1526–1527, folio 66 verso, 67 recto (Laborde 1913: iii [537, 538]). In the late sixteenth century it is found in an engraving after Stradanus in the *Acta Apostolorum* (1582: [21], 195 x 270), showing Peter and Cornelius in the foreground, with the scene *Peter Baptizing the Gentiles* in the background, which is shown in plate 247.

SOURCES: The hound derives from a drawing by Domenico at Turin (Gabrielli 1971: [684]).

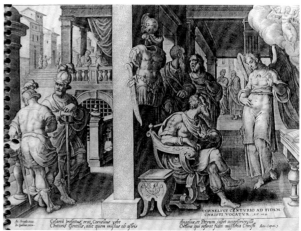

Figure 256. Philip Galle after Johannes Stradanus, *The Angel Appears to Cornelius* (from the *Acta Apostolorum*, Antwerp, 1575, [19])

247. *Peter Baptizing the Gentiles*

TRADITIONS: It is treated by Masaccio in the Brancacci Chapel in Florence and by Federico Zuccaro in the Pauline Chapel in the Vatican. In the late sixteenth century it is found in the background of an engraving after Stradanus in the *Acta Apostolorum* [fig. 258] showing Peter and Cornelius in the foregound and the scene *Peter Baptizing the Gentiles* in the background. Later it is treated by Andrea Procaccini (1671–1734) for San Francesco at Urbino, now at Budapest, and by Pietro Antonio Magatti in San Francesco at Pavia in 1732 (Castellotti 1986: [420]).

SOURCES: Domenico here omits the font and develops the more classical treatment used by Giambattista in the Folzano altarpiece of ca. 1759, *The Baptism of Constantine,* with the use of a ewer, also recorded in an etching of Domenico (Rizzi 1971: [134]) [fig. 259]. The kneeling figure on the left seems to derive from the similar figure *The Last Supper* in the Maddalena of 1775 [fig. 204] with the right arm raised.

248. *The Vision of Peter*

TRADITIONS: Although this subject is unknown in Venice, Luba Eleen cites four early examples, including *The Rockefeller McCormick New Testament* (1932: [117]), Vatican cod. lat. 39 fol. 93 recto; Vatican cod. Chigi A.IV.74 fol. 128 recto; and Abbey Collection cod. 7345 fol. 465 recto. It is also found in another important source of scenes from the Acts, the British Museum manuscript, *Bible Moralized II,* Harley 1526–1527, fol. 66 verso (Laborde 3, 1913: [537]), which we will now have to cite on a number of occasions.

Domenico may have found a prototype in a woodcut designed by Holbein (Hollstein XIVA, 1988: 48i). It is also found in the top right part of the engraving by Philip Galle after Stradanus from the *Acta Apostolorum* (1575 [20]; [fig. 257]), in the woodcut by Bernard Salomon in the *Biblia Sacra* (1588: 1,087), in a drawing by Rembrandt at Munich (Benesch 1973: 1,039 [1321]), and in a painting by Feti in Vienna (*Gemäldegalerie* 1991: [232]).

SOURCES: The stag on the left derives from the drawing by Giambattista for the America section of the Würzburg staircase ceiling in the Hermitage (Knox 1980: A.66), which is copied elsewhere in drawings by Domenico (Byam Shaw and Knox 1987: [149]) [fig. 260]. The reclining pig on the right is also found in a drawing in the Lehman collection (Byam Shaw and Knox 1987: [146]).

249. *Peter Released by the Angel*

TRADITIONS: The scene is found among the mosaics of San Marco in the unique scene from the Acts in the Capella di San Pietro (San Marco 1991: [37.1]) and in the cycle of Peter in the Cappella Palatina (Borsook 1990: [76]) and that at Monreale

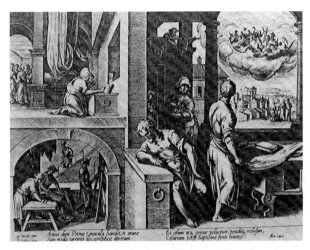

Figure 257. Philip Galle after Stradanus, *The Vision of Peter* (from the *Acta Apostolorum,* Antwerp, 1575, [20])

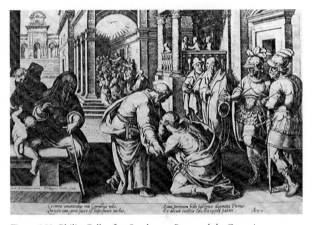

Figure 258. Philip Galle after Stradanus, *Peter and the Centurion Cornelius* (engraving from the *Acta Apostolorum,* Antwerp, 1582, [21])

Figure 259. Domenico Tiepolo, after Giambattista, *The Baptism of Constantine* (etching)

(del Giudice 1702: [XXV.2, 3]). It is also found in *The Rockefeller McCormick New Testament* (1932: [119 verso]). The most celebrated depiction is that of Raphael in the Stanza di Eliodoro, 1512–1514 (Fischel 1948: [110]), which dominates the Baroque era. This evidently inspired the design by Stradanus for the *Acta Apostolorum* (1582: [23]), which also combines two scenes, the visit in the prison on the right and the angel leading Peter out of the prison on the left, with many sleeping soldiers below. See also the woodcut after Bernard Salomon in the *Biblia Sacra* (1588: 1,090]). Domenico would also have known the painting by Bernardo Strozzi, then in Ca' Labia, engraved by Pietro Monaco (1743: [77]; 1763: [6]). One may note the Mattia Preti at Vienna, with a somewhat similar reclining soldier, low left (not traced).

SOURCES: The prison setting, generally reminiscent of the *Carceri* of Piranesi, is actually ingeniously derived from the Piranesi etching, *Parte interiore di Carcere,* plate 2 of the *Prima Parte* (Robison 1986: [3]); this gives a fine monumentality to the design. The main group of figures derives from the fine drawing by Giambattista at Williamstown (Orloff Album 1921: [140]; Knox 1961: pl. 38) [fig. 261]; the angel is also fairly closely related to the drawing by Domenico at Stockholm (Udine 1996: [37]), which itself derives from the painting by Sebastiano Ricci in the parish church at Trescore, near Bergamo, of ca. 1710 (Daniels 1976: [273]). The reclining figure, bottom left, derives from a drawing, formerly Heygate Lambert 1926 [fig. 9]; see also plate 8.

Figure 260. Domenico Tiepolo, *A Stag* (New York, Metropolitan Museum of Art, Lehman Collection, 1975.1.521)

250. *Peter and Rhoda*

TRADITIONS: The subject is of the greatest rarity in art. It has been found only in British Museum manuscript, *Bible Moralized II,* Harley 1526–1527, fol. 69 recto (Laborde 3, 1913: [540]).

SOURCES: The well and the trees on the left derive from a drawing by Giambattista at Rotterdam (Knox 1974: [42]) [fig. 262].

251. *Peter in Cathedra, Blessing—January 18,* AD *43*

More familiar to Domenico would have been the marble throne of Peter in San Pietro di Castello, a gift to the Doge from the Emperor Michael III, 842–867, in its present position in the right aisle since 1752 (Lorenzetti 1926: 311), with an inscription in Arabic from the Koran. It is said to be from Antioch (Corner 1758: 25 and [opp.]).

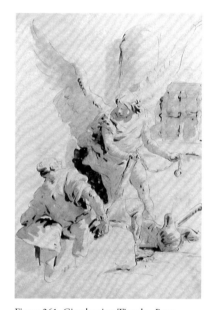

Figure 261. Giambattista Tiepolo, *Peter Visited by the Angel in Prison* (Williamstown, Sterling and Francine Clark Art Institute)

TRADITIONS: Kaftal (Tuscan) [918] cites a dismembered polyptych by Jacopo di Cione. A curious prototype for this scene, showing *Peter Establishing His Cathedra in Antioch,* is found in a woodcut illustrating the *Catalogus Sanctorum* (Petrus de Natalibus 1542: iii, cap. 140, under *XV Kalendae februarii*); however, the same woodcut is used for several other similar scenes: *De sancto Gregorio papa e dottore* (iii, cap 192) and *De sancto Gregorio papa tertio* (x, cap. 118). Note also the Masaccio in the Brancacci Chapel.

SOURCES: The man with his hands on his knees derives from the Louvre *Adulteress Before Christ* [fig. 276].

Figure 262. Giambattista Tiepolo, *A Farmyard Scene* (Rotterdam, Boymans Van Beuningen Museum)

252. *Peter Ordaining Linus and Cletus*

No text.

253. *Peter Dictating the Gospel to Mark*

TRADITIONS: Zatta (1761) describes the scene as found among the mosaics of San Marco: *"e vi si legge: Sanctus Marcus rogatus a fratribus scripsit Evangelium / Sanctus Petrus approbat Evangelium Sancti Marci, & tradit Ecclesiae legendum"* (Demus 1984: vol. 4 [339]; *San Marco* 1991: [181/2]) [fig. 263]. Jameson (1848) cites a number of examples, among them: "Peter and Mark standing together, the former holding a book, the latter a pen, with an inkhorn suspended from his girdle, by Bellini." This may be a rather inaccurate description of the two panels by Lorenzo Veneziano (Moschini Marconi 1955: [8]), signed and dated 1371, from the Ufficio della Seta a Rialto, in which Peter holds a scroll while Mark, gesturing with his hand toward Peter, holds a book.

Figure 263. *Peter Dictating the Gospel to Mark* (mosaic, 1270–1280, Venice, San Marco, Capella Zen)

254. *The Apostles' Creed*

TRADITIONS: No clear prototype has been noticed.

SOURCES: Domenico seems to refer here to the celebrated bronze *St. Peter Enthroned* in the nave of St. Peter's and perhaps to the mosaic of the apse of Sta. Pudenziana, *Christ Enthroned with the Apostles*. Ciampini shows a small and rather inadequate engraved image of the bronze *St. Peter* (Ciampini 1693: [XVI]).

255. *The Fall of Simon Magus, I*

TRADITIONS: An interesting early image is found in the *Sacramentary of Fulda* of ca. 800 (initial D, fol. 48 verso) in the Biblioteca Capitolare at Udine, 76, V/1—"Miniature in Friuli," Udine, Palazzo Communale (1972: 38). It shows, left to right: Nero seated, Peter and Paul, Simon Magus falling headfirst from a tower, and the Crucifixion of Peter.

The theme is found in the Peter cycle in the Cappella Palatina (Borsook 1990: [55]) and at Monreale (del Giudice 1702: [XXV.8]). In monumental terms, it is in a mosaic of 1628–1631, after a cartoon by Palma Giovane and Padovanino, in San Marco, north aisle, the first of a series representing the Acts (*San Marco* 1991: [117/1]), showing *The Fall of Simon Magus* above, and below: *Peter and Paul Before Nero*, left, and *The Crucifixion of Peter* and *The Beheading of Paul*, right [fig. 264].

Figure 264. Pilotti after Palma Giovane and Padovanino, *The Fall of Simon Magus* (mosaic, 1628–1631, Venice, San Marco, north aisle)

256. *The Fall of Simon Magus, II*

TRADITIONS: A series of lost mosaics recording the Acts of Peter, from the Chapel of John VII in Old St. Peter's, are recorded in the Barberini Codex, lat. 2732, 2733; there is a small engraving recording these in Ciampini (1693).

The cycle of the Acts of Peter at Monreale also includes the subject (del Giudice 1702: [XXV.8]), and the original mosaic in the north aisle of the nave of San Marco was replaced in 1619–1620 with a design by Palma Giovane (*San Marco* 1990: [173]; 1991: [117/1]), a monumental composition showing the falling Simon Magus in the upper semicircle, with Nero enthroned and Peter and Paul before him below on the left, and the martyrdom of the saints on the right.

Pigler (1956) mentions paintings by Pordenone at Spilimbergo; by Moretto da Brescia at Brescia, Chiesa del Corpo di Cristo; and by Celesti at Toscolano. For important versions outside Venice one must refer to the fresco by Filippino Lippi in the Brancacci Chapel, though the subject there is *The Dispute before Nero* (Goldner and Bambach 1997: [9]) and the important altarpiece by Francesco Vanni for St. Peter's. One may also note the Lodovico Carracci in the Pinacoteca at Naples; the Solimena in Naples, in the Sacristy of San Paolo Maggiore; the Valerio Castello at Caen; and the Pompeo Batoni in Rome, Santa Maria degli Angeli.

257. *"Domine, quo vadis?"*

TRADITIONS: Raphael's treatment of the subject is recorded in several engravings: by Giulio Bonasone (*The Illustrated Bartsch 28* 1978: 248); Stefania Massari, *Giulio Bonasone* (Rome, 1983: exh. cat. 2 vols.); by Martino Rota, 1568 (le Blanc 1854: 24); by Giovanni Battista Cavalieri (le Blanc 1854: 18); and by Pietro Santi Bartoli (le Blanc 1854: 12). The most celebrated subsequent treatment is the small painting by Annibale Carracci in the National Gallery in London.

SOURCES: The figure of Christ appears to derive, in large part, from the standing figure of the angel in the Accademia *Abraham and the Angels (Mariuz 1971: [265]).* It also appears to owe something to the Apollo Belvedere.

258. *Peter, Having Met Christ, Returns to Rome*

TRADITIONS: In the late sixteenth century a comparable scene is found in two woodcuts illustrating the Acts in the *Biblia Sacra* (1588: 1,086), 75 x 100.

259. *Peter Thrust into Prison by Nero*

SOURCES: Conrad points out the link with Guercino's *Imprisonment of St. Roch* in the Oratorio di San Rocco in Bologna (Bagni 1988: [199]) [fig. 265], which was engraved by Domenico Maria Bonaveri. Apart from this, no prototype is evident.

260. *Peter in Prison Baptizing*

TRADITIONS: Masaccio in the frescoes of the Brancacci Chapel includes two non-biblical subjects, *The Raising of the Son of Theophilus* and *Peter in Prison at Antioch.* We can find no reference to Peter's imprisonment at Antioch, though "he founded the see of Antioch in the year 33, the fifth from Christ's crucifixion, sat there for seven years, and afterwards twenty-five complete years at Rome" (Butler I, 460, under June 29). Peter's imprisonment at Jerusalem under Herod (pl. 249) is said to have occurred in 44 AD (Butler I, 461) on a visit to Judaea from Rome, and there is no record of his baptizing on that occasion. The concept of baptizing through the prison bars recalls Giovanni di San Giovanni, *The Bishop Cirillo Baptizes the Quattro Coronati* in the Quattro Coronati, Rome (Anna Bauta, Giovanni di San Giovanni, Florence 1977).

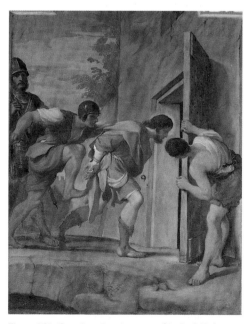

Figure 265. Guercino, *Imprisonment of St. Roch* (Bologna, Oratorio di San Rocco)

261. The Crucifixion of Peter

TRADITIONS: This appears as the last mosaic in the Peter cycle at Monreale (del Giudice 1702: [XXV.9]). In the mosaic of 1624 in San Marco, after a cartoon by Palma Giovane, the two scenes of *The Martyrdom of Peter and Paul* are shown together (Demus 1984: [42]; *San Marco* 1991: [117/3]) [fig. 266]. It is a rare subject in Venice, but one may note the painting by Palma Giovane in the Accademia (Moschini Marconi 1962: [249]) and by Luca Giordano in the Accademia (Moschini Marconi 1970: [314]), signed and dated 1692.

The Martyrdom of St. Peter, crucified upside down at his own request, is frequently treated, one by Filippino Lippi in the Brancacci Chapel (Goldner and Bambach 1997: [9]) and, above all, by Michelangelo in the Pauline Chapel (Camisasca 1966: [77, 78]) where it is paired with *The Conversion of Paul.* The same scenes are juxtaposed by Caravaggio in Sta. Maria del Popolo (Della Chiesa 1967: [44, 47]). One may also note the engraving after Maarten de Vos in the *Theatrum Biblicum* (1674: [2]).

There is also an early drawing on this subject by Giambattista Tiepolo in Munich, Staatliche Graphische Sammlung 1980–1946 (Munich 1982: no. 59 [26]).

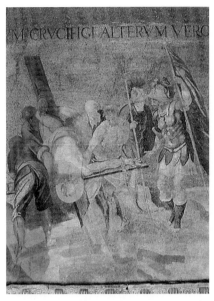

Figure 266. Gaetano after Palma Giovane, *The Crucifixion of Peter* (mosaic, 1624, Venice, San Marco, north aisle)

262. The Funeral of Peter

TRADITIONS: A fresco depicting this event is recorded in Grado, San Piero (*Atti Congresso di Scienze Storici VII* 1905: 241, [6–42]), but otherwise no prototype has been noticed.

SOURCES: The view of the Colosseum derives from the etching by Giambattista Piranesi in the *Vedute di Roma,* shown here reversed (Venice, 1978, [276]) [fig. 267].

263. The Stoning of Stephen

TRADITIONS: Most scenes that are drawn from the Acts of the Apostles are unknown in earlier New

Figure 267. Giambattista Piranesi, *The Colosseum* (etching, from the *Vedute di Roma*)

Testament illustration, but the present one has enjoyed a certain degree of popularity. Luba Eleen (1977) cites six early examples. It is found in *The Rockefeller McCormick New Testament* (1932: [114 verso]), although it appears to be more likely identifiable as *The Conversion of Paul,* and in Virgil Solis (1565: [175]). However, the story may well have been familiar to Domenico through the series of four canvases painted by Carpaccio between 1511 and 1520 for the Scuola di San Stefano, now to be found in Berlin, Paris, Milan and Stuttgart (Molmenti and Ludwig 1907: 178–188, [189–194]), the last of these being *The Stoning of Stephen* at Stuttgart (Sgarbi 1979: [38])[fig. 268]. Perhaps more familiar to Domenico was the large and celebrated canvas by Santo Piatti on the entrance wall of San Moisè and the lost canvas by Pittoni, engraved by Monaco (1745: [27]; Zava Bocazzi 1979: no. 353).

One may also note the Brussels tapestry after the lost Raphael cartoon and the woodcuts of Petrus de Natalibus Venetus, *Catalogus Sanctorum* (1542), as well as in the *Biblia Insigneum Historiarum simulacre* (1542). The story of Stephen is illustrated in two engravings by Philip Galle after Marten van Heemskerck in the *Acta Apostolorum* (1575: [10 and 11]). The first shows *Stephen Before the High Priest,* with the *Stoning of Stephen* in the background: the second shows the *Burial of Stephen.* A further engraving after Heemskerck, *The Stoning of Stephen,* is found in the *Theatrum Biblicum* (1674: [8]).

It was later the subject of a large altarpiece by Domenico himself for Munsterschwarzach in 1754, lately rediscovered in the Berlin Museum (Mariuz 1978: [4]) and long known through his reproductive etching (Rizzi 1971: [121]; Knox 1980: [213, 214]). The Gustave Doré design in *La Sainte Bible selon la Vulgate* (1866: ii, [opp. col. 705]) uses the similar motif of a man holding a large rock above his head.

SOURCES: The angel bearing the crown of martyrdom derives exactly from the etching, as does the man the man holding a stone in each hand immediately above St. Stephen. The upper part of the man holding a large rock in both hands derives from the S. Polo *Martyrdom of St. John Nepomuk* (Knox 1980: [101, 102]). The walls of Jerusalem also derive in some degree from the etching, but they originate in *Station V* of the San Polo *Via Crucis* [fig. 157]. The same city wall is found in plates 116, 117, 167, 168, 170, 306, and, in reverse, plates 154, 285, and 309.

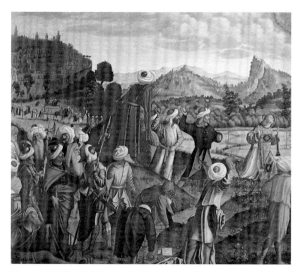

Figure 268. Vittore Carpaccio, *The Stoning of Stephen* (1515, Stuttgart, Staatsgalerie)

264. *Philip Preaching and Healing in the City of Samaria*

TRADITIONS: The only prototype found for this subject is the engraving by Philip Galle after Marten van Heemskerck in the *Acta Apostolorum* (1575: [10]) [fig. 269].

SOURCES: The buildings on the left derive from a landscape drawing by Giambattista (Knox 1974: [35]).

265. *Philip and the Ethiopian Eunuch*

TRADITIONS: This subject is not found in Venice, but Luba Eleen (1997) cites five examples elsewhere: Vatican, cod. gr. 1613, p. 107; Vatican, cod. lat. 39, fol. 97 recto; Vatican, Giustiniani codex, fol. 128 recto, recording a lost mosaic of Old St. Peter's; the Vercelli Rotulus; and a fresco at Decani. Domenico's design is clearly related to the tradition these examples represent, and some link is evident, indicating how closely Domenico followed not only the text before him but an acceptable prototype. The tradition appears to be essentially Roman, and a link with Roman antiquarianism is perfectly possible. Numerous seventeenth-century examples favor the scene *Philip Baptizing the Eunuch,* such as the painting by Salvator Rosa at Norfolk (Salerno 1975: [123]).

The story is told in two engravings by Philip Galle after van Heemskerck in the *Acta Apostolorum* (1575: [13, 14]). The first shows the angel ordering Philip to approach the eunuch; the second shows the baptism, low center, and Philip and the eunuch in the chariot, on the right. Similarly, one finds two woodcuts after Bernard Salomon in the *Biblia Sacra* (1588: [1,083, 1,084]), the first showing *Philip with the Eunuch,* the second *The Baptism of the Eunuch.*

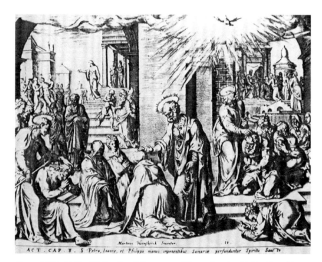

Figure 269. Philip Galle after Marten van Heemskerck, *Philip Preaching and Healing in Samaria* (in the *Acta Apostolorum*, Antwerp, 1575, [10])

Figure 270. Giambattista Tiepolo, *A Farm Cart* (drawing, London, Courtauld Institute Galleries)

SOURCES: The dog scratching itself in the center foreground derives from Giambattista's *Scherzo di Fantasia 22* (Rizzi 1971: [25]). The chariot descends from the drawing of a farm cart by Giambattista in the Courtauld Gallery (Knox 1974: [5]) [fig. 270].

266. *Paul on the Road to Damascus*

TRADITIONS: The cycle of mosaics illustrating the story of Paul in the Cappella Palatina opens with *Paul Commanded to Go to Damascus* (Borsook 1990: [47]); likewise the cycle at Monreale (del Giudice 1702: [XXIV.1]). The *Conversion of Paul,* which follows, is a familiar subject, but this one appears to be unique to Domenico's *New Testament.*

SOURCES: The three horsemen are found later in a drawing by Domenico that has recently come to light, kindly brought to our attention by M. Bruno de Bayser, which we identify as one of the *Scenes of Contemporary Life* (Gealt and Knox 2005 [26]). The horseman in the right foreground is also found in *Anna Returns to Her House* (pl. 15). The two horsemen on the left derive from a drawing at Brno (1969, [128]); however, Domenico, in addition to introducing the woman with a dead child, also significantly changes the headdress of two of the riders from civilian gear into Roman helmets, giving the scene an appropriately military character; see figure 78.

267. *The Conversion of Paul*

TRADITIONS: The story of the conversion of Paul is told fully in the mosaics of the Cappella Palatina (Borsook 1990: [47]) and Monreale (del Giudice 1702: [XXIV.2]) [fig. 271], followed by *Paul Led to Damascus, The Reception of Paul at Damascus,* and *The Baptism of Paul* (Borsook 1990: [47]; del Guidice 1702: [XXIV.3, 4, 5]). The scene appears in *The Rockefeller McCormick New Testament* (1932: [114 verso]), where it is identified as *The Stoning of St Stephen,* then followed by the very rare subject *The Blinded Paul Being Led to Damascus* ([115]), a subject also discussed by Luba Eleen. Paul on horseback is found in some medieval examples associated with the idea of the fall of pride.

In the Renaissance, it is treated by Raphael in the Brussels tapestry, the cartoon being in the Piinacoteca Vaticana; this is followed by many examples, though not one shows the distinctive elements shown here. One must note the fresco by Michelangelo in the Pauline Chapel (Camisasca 1966: [77, 78]), where it is paired with *The Crucifixion of Peter.* The same scenes are juxtaposed by Caravaggio in Sta. Maria del Popolo (Della Chiesa 1967: [46, 47]). An important example in Venice was the Tintoretto painted on the outside of the organ shutters in Santa Maria del Giglio, which disappeared without a trace in the nineteenth century; there is also the large canvas by Veronese in the Hermitage (Marini 1968: [143]).

The engraving by Philip Galle after Marten van Heemskerck in the *Acta Apostolorum* (1575: [16]), 210 x 274, although it places the central emphasis on *The Blind Paul led to Damascus,* also shows *The Conversion of Paul* on the right, with a somewhat similar pose of the horse and the black cloud, indicating that Domenico may have recalled this composition. One may also note the woodcut by Bernard Salomon in the *Biblia Sacra* (1588: 1,085) and the engraving after Thornhill's decoration in the dome of Saint Paul's (*Kitto Bible* 57-10411), again with a similar horse.

Figure 271. *The Conversion of Paul* (mosaic, 1180, Monreale Cathedral)

268. *Ananias Restores Paul's Sight*

TRADITIONS: The subject is found in the mosaics of Palermo and Monreale (del Giudice 1702: [24.4]); thereafter it is rare. One may note the example by Vasari in Rome, San Pietro in Montorio. Domenico shows Paul still surrounded by his entourage of Roman soldiers. For an early authoritative Venetian image of Paul, see figure 272.

269. *Paul Preaching in the Synagogues at Damascus*

TRADITIONS: This rare subject has been found recorded only in the Paul cycles of the Palermo and the Monreale mosaics (del Giudice 1702: [XXIV.8]) [fig. 273].

270. *Paul Lowered in a Basket from the Walls of Damascus*

TRADITIONS: The scene appears in a comparable form both in the Paul cycle of the Cappella Palatina (Kitzinger 1960: [fig. 10]) and of Monreale (del Giudice 1702: [XXIV.7]) [fig. 274]. This seems to prove Domenico's dependence on the engraved record of the Sicilian mosaics. The primitive frontality of the tower on the left may be interpreted as a suggestion of "Byzantinism."

Pigler (1956) notes this subject among a set of twenty engravings, mostly after Raphael, from the Acts, by the monogrammist GDW (Nagler, *Monogrammisten*, 1966: II, 1,013, no. 2882). In the late sixteenth century it is found in the dramatic engraving by Philip Galle after Martin van Heemskerck in the *Acta Apostolorum* (1582: [14]), 200 x 267, showing Paul's flight in the foreground, and the incident of lowering him in the basket in the right background. It also appears as a woodcut illustrating the Acts in the *Biblia Sacra* (1588: 1,086), 75 x 100.

Figure 272. Mantegna, *Peter and Paul*, detail from the San Zeno altarpiece (Verona, San Zeno)

271. *Paul at Lystra*

TRADITIONS: This subject is the last of the series in *The Rockefeller McCormick New Testament* (1932: [122 verso]) and in the engraving by Philip Galle after Stradanus from the *Acta Apostolorum* (1575: [25]), which shows the scene in the open air. Sir James Thornhill, in the dome of Saint Paul's, treats the following part of the story, Acts 14:13–15 (*Kitto Bible* 56-10276). The sale catalogue of Domenico's collection lists an engraving by Blecker of 1738, *Paul and Barnabas at Lystra* (Hollstein 1988: ii, 49, [5]), but this has no bearing on the present design.

Figure 273. *Paul Preaching in the Synagogue at Antioch* (mosaic, 1180, Monreale)

SOURCES: Much of the setting, and the crouching figure at low center, derive from the Accademia *Institution of the Eucharist* (Mariuz 1971: [274]) [fig. 204].

272. *Paul and Barnabas Expelled from Lystra, I*

TRADITIONS: The subject is rare. One may cite the painting by Massimo Stanzione in a private collection in Milan (Schütze and Wilette, *Opera completa di Stanzione*, Naples, 1992, [267]).

SOURCES: The man throwing a large stone, extreme left, derives from Domenico's etching after *The Stoning of St. Stephen* (Mariuz 1971: [68]) [fig. 275].

273. *Paul and Barnabas Expelled from Lystra, II*

TRADITIONS: We have found no prototype for this scene.

SOURCES: The man walking to the right derives from the Louvre *Adulteress before Christ* (Mariuz 1971 [168]). Domenico Tiepolo, *The Adulteress Before Christ,* Paris, Musée du Louvre [fig. 276].

274. *Paul Circumcises Timotheus*

TRADITIONS: Iconclass 7 records engravings from northern Europe.

SOURCES: It seems possible that the figure of Paul, standing with his back turned, may derive from a drawing by Giambattista in the Victoria & Albert Museum (Knox 1960: [159]) [fig. 277].

Figure 274. *Paul Lowered in a Basket from the Walls of Damascus* (mosaic, 1180, Monreale)

275. *Paul and Silas Beaten and Imprisoned at Philippi*

TRADITIONS: Though the subject is unknown in Venice, Luba Eleen cites numerous early examples elsewhere, including a record of the lost mosaic of Old St. Peter's (Eleen 1977: [38]; Codex Giustiniani [fol. 135 verso] [fig. 278]) and a restoration drawing of a fresco in the church at Decani (Eleen 1977: [41]). It is also found in the British Museum manuscript, *Bible Moralized II,* Harley 1526–1527, fol. 75 recto (Laborde 1913: iii [546]) and is treated by Raphael in the tapestry series (the cartoon is lost) and by Bernard Salomon in the woodcut of the *Biblia Sacra* (1588: 1,099).

276. *Paul and Silas Prevent the Suicide of the Jailer*

TRADITIONS: A unique prototype for this scene appears to be the engraving by Philip Galle after Johannes Stradanus from the *Acta Sanctorum* (1575: [27]), 200 x 265 mm, showing the prisoners escaping and the jailer with his sword pointing at his stomach [fig. 279].

Figure 275. Domenico Tiepolo, *The Stoning of St. Stephen* (etching, 1754)

277. *Paul and Silas Baptize the Jailer and His Family*

This very rare scene is shown in a typical Venetian interior, with a fireplace on the right. The jailer has a large family, assembled somewhat in the manner of a group portrait. Characteristically, his sword, almost a badge of office, lies on the ground beside him. Silas stands on the right; neither he nor Paul has a halo in this design.

TRADITIONS: The unique prototype that one may cite is the small scene in the right background of the engraving by Philip Galle after Johannes Stradanus, *Paul and Silas Prevent the Suicide of the Jailer,* from the *Acta Sanctorum* (1575: [27]) [fig. 279]. Thornhill in the decorations of the dome of Saint Paul's (*Kitto Bible* 56-10300 verso) illustrates the preceding scene, Acts 16:30.

Figure 276. Domenico Tiepolo, *The Adulteress Before Christ* (Paris, Musée du Louvre)

SOURCES: The figure prostrate on the ground may derive from the drawing by Giambattista at Stuttgart (1970 [165]) [fig. 252], although, again, the correspondence is not exact. Aikema (Rotterdam, 1996) suggests that the figure of the jailer derives from the moor in the Budapest *Saint James of Compostela* [fig. 280]. This may well be so, although again the similarity is not exact (New York, 1997, [37]).

278. *Paul and Silas Released from Prison at Philippi*

TRADITIONS: There is no prototype for this and the following drawing.

279. *The Magistrates Beseeching Paul and Silas*

TRADITIONS: No prototype has been found for this drawing.

280. *Paul Preaching at Athens*

TRADITIONS: The subject is also found among the Raphael cartoons (Fischel 1948: [261]), but later on the scene is rare. The *Acta Apostolorum* (1582) prefers *Paul Before the Council* [31], *Paul Before Agrippa and Berenice* [32], or *Paul Preaching at Rome* [34]— all of which are comparable, but particularly *Paul Before the Council* [fig. 281]. However, none of these are acceptable here, though the first has points of similarity. *Paul Preaching before King Agrippa* represents a grand occasion that took place in AD 59, attended by many notables, including Berenice, Agrippa's sister, and Festus, Procurator of Palestine. Here neither Berenice nor Festus is evident.

One may note the engraving by Cornelis Bloemart after Cirro Ferri (*Kitto Bible* 57-10318) that has the altar with the inscription "*IGNOTO DEI,*" which is clearly not included in the present design. There is also a canvas by Sebastiano Ricci at Toledo (Daniels 1976: [292]).

281. *Paul Baptizing Dionysius and Damaris*

There seemed to be a possibility that the scene represented the baptism of Lydia and her family; however, this took place "out of the city by a river side" (Acts 16:15). Here is shown the interior of a house, a magnificent neo-classical palace, with a large painting on the wall representing *The Death of Dido,* following the sketch by Giambattista in Moscow, Pushkin Museum (Morassi 1962: [234]) [fig. 282]. There has been some attempt to attribute this composition to Domenico (Gemin and Pedrocco 1993: 508 [41]), but this now seems even less likely.

Beneath it sit a row of grave and reverent signors, and the baptism is shown in the foreground. This led Conrad (1996) to suggest that the drawing represents the baptism of Dionysius the Areopagite and a woman named Damaris, and in this he follows the nineteenth-century written inscription on the back of the drawing. The text of Acts 17:34 does not record their baptism, but it is recorded at length in *The Golden Legend.*

Figure 277. Giambattista Tiepolo, *A Man Standing with His Back Turned* (drawing, London, Victoria & Albert Museum)

Figure 278. *Paul and Silas Beaten at Philippi* (Vatican, Codex Giustiniani, fol. 135 verso)

Figure 279. Philip Galle after Johannes Stradanus, *Paul and Silas Prevent the Suicide of the Jailer* (from the *Acta Sanctorum*, Antwerp, 1575, [27])

TRADITIONS: A unique medieval prototype for this subject is found in the British Museum manuscript, *The Bible Moralized,* Harley 1526–1527, folio 74 verso (Laborde 1913: iii [546]).

In the late sixteenth century it is found as an engraving in the *Acta Apostolorum* (1582: [26]), 200 x 267, showing several scenes: top left, *Paul Speaking to the Damsel Possessed with a Spirit of Divination;* center above, *Paul and Silas Imprisoned at Philippi;* the main scene, *Paul Addressing the Women;* and right, *The Baptism of Lydia and Her Household.*

282. *Paul and Aquila as Tentmakers*

TRADITIONS: The subject, like most from the Acts of the Apostles, seems to be extremely rare. One may note the engraving by Jan Sadeler (1550–ca. 1600) after Joost van Wingen, *Paul at Corinth* (*Kitto Bible* 57-10336), showing an interior with a workshop, Paul writing to the left, women spinning in the center, and a woman with two children sweeping the floor to the right. There is also an engraving by Kraus (*Historische Bilder-Bibel,* Augsburg, 1698–1700); both these designs are utterly different to Domenico's concept.

SOURCES: The familiar setting here derives from a drawing at Oxford (Knox 1974: [21]) [fig. 283]. The same barn is depicted in *Joachim Praying in the Wilderness* (pl. 6).

Figure 280. Domenico after Giambattista Tiepolo, *St. James of Compostela* (etching)

283. *Paul Baptizing at Ephesus*

TRADITIONS: The only prototype that has yet been found for this subject is a drawing by Marten van Heemskerck, dated 1549, Darmstadt, which was also engraved. There is no link with Domenico's concept.

284. *"And God wrought special miracles by the hands of Paul"*

TRADITIONS: It is found in the British Museum manuscript, *Bible Moralized II,* Harley 1526–1527, fol. 80 verso (Laborde 3, 1913: [551]).

SOURCES: The man on the right derives from *The Flight into Egypt 7* [fig. 111].

Figure 281. Philip Galle after Stradanus, *Paul Before the Council* (engraving from the *Acta Apostolorum,* Antwerp, 1582, [31])

285. *A Young Woman Cured: The Vagabond Jews*

TRADITIONS: The only early illustration of this tale we have been able to find is in the British Museum manuscript *The Bible Moralized II,* Harley 1526–1527, fol. 80 verso (Laborde 1913: iii [554]). However, the second episode finds a place among the engravings by Philip Galle after Johannes Stradanus from the *Acta Sanctorum* (1575: [28]), with the story of *Burning the Books of Magic Arts at Ephesus* (pl. 287) shown on a small scale in the top left corner. The same scenes are shown in two woodcuts by Bernard Salomon in the *Biblia Sacra* (1588: 1,098, 1,102).

Figure 282. Giambattista Tiepolo, *The Death of Dido* (Moscow, Pushkin Museum)

SOURCES: The same city wall is to be found in plates 116, 117, 167, 168, 170, 306, and, in reverse, plates 154, 285, and 309. It derives from *Station V* of the S. Polo *Via Crucis* [fig. 157]. The young man reclining in the left foreground is also found in *Christ Cleansing the Temple* (pl. 173).

Figure 283. Domenico Tiepolo, *A Barn* (Oxford, Ashmolean Museum)

286. *Paul Working Miracles*

TRADITIONS: No prototype for this scene has been noted.

SOURCES: As Christofer Conrad (1996) points out, not only the architectural setting but most of the important figures, though re-arranged, derive from the left side of Gregorio Lazzarini's great canvas of 1691 in San Pietro di Castello, *S. Lorenzo Giustiniani Gives Alms to the Poor* (Knox 1992: [8]) [fig. 284]. Paul takes the place of S. Lorenzo Giustinian.

287. *Burning the Books of Magic Arts at Ephesus*

TRADITIONS: A unique medieval prototype for this subject is found in the British Museum manuscript, *The Bible Moralized,* Harley 1526–1527, folio 80 verso (Laborde 1913: iii, [551]). In the late sixteenth century it is found as an engraving in the *Acta Apostolorum* (1575: [28]), 200 x 267, as a small subsidiary scene in the top left corner to the main subject, *The Seven Sons of One Sceva,* Acts 19:14. It is recorded as an etching by Le Sueur (*Kitto Bible* 57-10364), and it is one of the scenes by Thornhill for the interior of the dome of St. Paul's (*Kitto Bible* 57-10365). One may note the ceiling painting by Antonio Zanchi in Venice, Seminario Patriarcale (Donzelli and Pilo 1967: [485]).

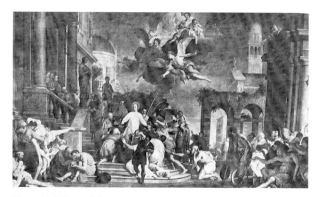

Figure 284. Gregorio Lazzarini, *S. Lorenzo Giustiniani Gives Alms to the Poor* (1691, Venice, San Pietro di Castello)

288.** *"Saint Paul poursuivis et lapidé par la foule et les vendeurs d'idoles"*

No text.

289. *The Fall of Eutychus*

TRADITIONS: The only reference to this story in the early sources refers to a lost cycle of twelfth-century frescoes depicting the Acts in the church of San Eutatius at Vercellae (*The Rockefeller McCormick New Testament* 1932: III, 326). Among later examples, one may note a pair of woodcuts in the *Biblia Insigneum Historiarum simulacre* (1542): *Eutychus Falling* and *Paul Reviving Eutychus.*

Figure 285. Goltzius, after Stradanus, *Paul Reviving Eutychus* (from the *Acta Apostolorum*, Antwerp, 1575, [29])

290. *Paul Stands Before the Body of Eutychus*

TRADITIONS: Again, one may note a pair of woodcuts in the *Biblia Insigneum Historiarum simulacre* (1542): *Eutychus Falling* and *Paul Reviving Eutychus.* The latter subject is again found in the *Biblia Sacra* (1588: 1,105) and in an engraving by the young Goltzius after Stradanus [fig. 285] from the *Acta Apostolorum* (1575: [29]; *The Illustrated Bartsch 4,* 1978: [248]). The scene is depicted by Taddeo Zuccaro in his series of frescoes on the life of Paul in the Cappella Frangipane in San Marcello al Corso (Luchinat 1998: 8, [9]; New York, 1999, [6]) and in an engraving by Agostino Carracci (*The Illustrated Bartsch 39,* 1978: 126).

Figure 286. Hendrik Goltzius after Stradanus, *Paul Restoring Eutychus* (engraving from the *Acta Apostolorum*, Antwerp, 1575, [29])

291. *Eutychus Restored to Life*

TRADITIONS: A unique medieval prototype for this event is found in the British Museum manuscript, *The Bible Moralized,* Harley 1526–1527, folio 81 recto (Laborde 1913: iii [552]). The *Biblia Insigneum Historiarum simulacre* (1542) has a woodcut showing *Eutychus Falling* and *Paul Reviving Eutychus,* and the *Biblia Sacra* (1588: 1,104, 1,105) shows the *Fall of Eutychus* and *Paul Standing Before Eutychus.* It is also found as an early engraving by Hendrik Goltzius (1558–1616) after Stradanus, in the *Acta Apostolorum* [fig. 286] (1582: [29], 200 x 267; *The Illustrated Bartsch 4,* 1978: 248, [159]).

Among Italian examples of the sixteenth century, the scene is depicted by Taddeo Zuccaro in his series of frescoes of the life of Paul in the Cappella Frangipane in San Marcello al Corso (Luchinat 1998: 8 [9]; Colnaghi, New York, 1999, [6]). It is also the subject of an engraving by Agostino Carracci (*The Illustrated Bartsch 39,* 1978: 126]).

Figure 287. Domenico Tiepolo, *A Wall with a Watchtower* (location unknown)

292. *Paul Embarks at Ephesus*

TRADITIONS: No prototype for this scene has come to light.

SOURCES: The wall with a watchtower derives from a landscape drawing by Giambattista (Knox 1974, no. 11; Sotheby's, July 2, 1984 [116]) [fig. 287].

293. *Paul and the Storm at Sea*

TRADITIONS: A prototype for this event is found in the British Museum manuscript, *The Bible Moralized,* Harley 1526–1527, folio 88 recto, 89 verso (Laborde 1913: iii [559, 550]). Luba Eleen finds another specimen in the Vienna codex.

In the *Biblia Sacra* (1588: 1,114) there is a woodcut depicting *The Shipwreck at Malta.*

SOURCES: See figure 288.

Figure 288. Giuseppe Zais, *A Storm at Sea* (Venice, Correr Museum, 141)

294. *Paul at Malta, with the Serpent*

TRADITIONS: A early prototype for this subject is found in the British Museum manuscript, *The Bible Moralized,* Harley 1526–1527, folio 92 verso (Laborde 1913: iii [557, 558]). Luba Eleen cites three other examples in her *Appendix.*

There is a woodcut depicting the subject in the *Biblia Sacra* (1588: 1,115), which is found in an engraving by the young Golzius after Stradanus in the *Acta Apostolorum* (1575: [33]; *The Illustrated Bartsch 4,* 1978: [247]); this also shows the ship in the background, but is otherwise completely different to our design. One may also cite the painting by Adam Elsheimer at Saint Petersburg, and the design used by Sir James Thornhill for the decoration of the dome of St. Paul's (*Kitto Bible* 57-10443). It is also the subject of the great altarpiece by Benjamin West in the Chapel at Greenwich, etched by Francesco Bartolozzi in 1798 (*Kitto Bible* 57-10444).

295. *Paul Heals the Sick at Malta*

TRADITIONS: A unique prototype for this subject is found in the British Museum manuscript, *The Bible Moralized,* Harley 1526–1527, folio 93 recto (Laborde 1913: iii [564]).

SOURCES: The woman by the ship, the three kneeling men near her, and the standing cripple on the right all derive from Domenico's Louvre painting *The Pool of Bethesda* [fig. 170]. The first group is also found in *The Pool of Bethesda* (pl. 133).

296. *The Parting of Peter and Paul*

TRADITIONS: No clear prototype for the scene has come to light, but it may derive from the mosaics in the Cappella Palatina (Borsook 1990: [54]) and at Monreale (del Giudice 1702: [XXV.6]), representing *The Ecstatic Meeting of Peter and Paul,* or a Byzantine miniature such as that found in a Psalter at Athens (*The Rockefeller McCormick New Testament III* 1932: [cxxii]). Somewhat similar embracing figures are found elsewhere (*Divertimento 36*).

There is a German tradition ca. 1500 of panels showing *The Parting of Peter and Paul* and *The Parting or Separation of the Apostles.* Pigler lists a painting by Ricci, formerly Paris, duc de Broglie (no trace).

SOURCES: Conrad notes that the prominent soldier on the left of Paul derives from the etching of Salvator Rosa [fig. 222]. The horse on the right also appears in *Jesus Heals the Two Blind Men of Jericho* (pl. 159).

297. *The Beheading of Paul*

TRADITIONS: This appears as the last scene in the Paul cycle in the mosaics at Monreale (del Giudice 1702: [XXIV.9]; Kitzinger 1960: [fig. 12]) and in the mosaic of 1624 in San Marco, after a cartoon by Palma Giovane (Demus 1984: [42]; *San Marco* 1991: [117/4]) [fig. 289]. Note also the Tintoretto in Santa Maria dell'Orto (de Vecchi 1970: [94C]) and the engraving by the young Hendrik Golzius (1558–1617) after Maarten de Vos (Hollstein 1988: viii, 360). There is a second engraving by Golzius after Stradanus in the *Theatrum Biblicum* (1674: [13]).

SOURCES: One may note the small etching by Callot (*Kitto Bible* 55-9964) which shows a domed building on the left.

Figure 289. Gaetano after Palma Giovane, *The Beheading of Paul* (mosaic, 1624, Venice, San Marco, north aisle)

298. *Jesus Crucified with Angels*

TRADITIONS: Apart from the early painters of Central Italy cited by Anna Jameson—Giunta Pisano, Pietro Cavallini, Duccio, Giotto, Nicolo di Pietro, and Buffalmacco—one may also cite, as closer to the Venetian tradition, the mosaic in San Marco of the twelfth century (*San Marco* 1991: [67/2]) and the fresco by Giusto de Menabuoi in the Baptistery at Padua (Spiazzi 1989: [41]). All these are complex designs with many figures, including angels. One may note that Domenico omits the latter in his treatment of *The Crucifixion* (pl. 200). This subject in a purer form showing only the angels may well derive from the treatment by Dürer (*The Illustrated Bartsch 10,* 1978: 153) [fig. 290].

Figure 290. Albrecht Dürer, *The Crucifixion with Angels* (woodcut)

299. *The Exaltation of the Sacrament*

TRADITIONS: The theme of Jesus returning to the Almighty, bearing various symbols of the Passion, is found in late medieval art; Jameson (1890: ii, 378 [270]) cites a woodcut by Michael Wohlgemuth. Then, after a long interval, it becomes a favorite theme among the numerous drawings by Domenico, depicting *The Almighty* and *The Trinity,* with numbers running up to 141. Note, for example, two drawings in the Heinemann Collection, New York 1973 [91 and 92], or the series of eight sold in the Stefano Bardini sale, New York, 1918, [441].

SOURCES: The design is based on a drawing by Domenico, marked 39, *The Trinity Over an Altar,* Sotheby's sale, Mar. 11, 1964 [168] neg. R.1041 [fig. 291].

Figure 291. Domenico Tiepolo, *The Trinity Over an Altar,* 290 x 199 (location unknown)

300. *An Apparition of the Virgin Ascending*

TRADITIONS: Here Domenico seems to avoid quite deliberately the grandiose tradition of *The Assumption of the Virgin,* as presented by Titian in the Frari, and followed by Ricci in the Karlskirche and by Piazzetta in the Louvre (Knox 1992: [99–101]). It is perhaps a little closer to the *Assunta* by Giulia Lama at Malamocco (Knox 1998: [10–12]) [fig. 292]. The latter is associated with the miraculous appearance of the Virgin on the Lido of Pellestrina on August 4, 1716, to the boy Natalino de' Muti, which immediately preceded the relief of Corfù, and which led to the building of the church of Sta. Maria di San Vito at Pellestrina in 1723 (Niero 1993: 127–128), with full references. It could be that the two drawings relate to this event.

One may also note the small painting by Martinelli at Hampton Court [fig. 293], which shows a similar subject with a small church in the background.

SOURCES: The figure of the Virgin derives from a drawing by Domenico at Besançon (Udine, 1971, [76]).

Figure 292. Giulia Lama, *The Assumption of the Virgin* (ca. 1735, Malamocco, parish church)

301. *"MARIA": An Apparition of the Virgin Descending*

No text.

302. *A Miracle of Sta. Agatha: The Sacred Heart*

TRADITIONS: The devotion in Venice is described by Monsignor Antonio Niero (1993: 144–145), who reproduces the altarpiece of San Canciano by Bartolomeo Letterini of 1742–1745 ([18]). Domenico's concern with the devotion is illustrated by the small early drawing at Stuttgart, *The Heart of Jesus* (Stuttgart, 1970, [141]), following the exact description of the Sacred Heart by Margaret Mary Alacoque. On the other hand, one may perhaps note that Giambattista treated the more familiar subject of *The Martyrdom of St. Agatha* twice: first, in the important altarpiece painted for one of the chapels of the ambulatory of the Santo in Padua in 1734–1737, as part of a series by leading painters of the day (Padua, 1981, [53]); second, in the altarpiece, now at Berlin, that Giambattista painted for the nunnery of Sta. Agatha at Lendinara in 1754–1755 (Venice and New York, 1996, [38]). This was etched by Domenico (Rizzi 1971: [130]) showing the Sacred Heart in the upper part (now lost in the painting).

Figure 293. Luca Martinelli, *An Apparition of Mary in the Sky* (Hampton Court Palace)

SOURCES: The crouching figure, low left, derives from Domenico's *Institution of the Eucharist* of 1778 in the Accademia (Knox 1980: [317–320]); see figure 204.

303. *The Mass of Bolsena, 1263*

TRADITIONS: The supreme and indeed unique representation of this theme is the fresco by Raphael in the Stanza di Eliodoro in the Vatican (Fischel 1948: [104]).

SOURCES: The kneeling man in the center foreground derives from a drawing by Domenico in the Beauchamp Album (Christie's, June 15, 1965 [157]); see also *Pentecost* (pl. 230).

304. *St. Anthony Preaching to the Fishes on the Shore at Rimini*

TRADITIONS: Among the earlier drawings of Domenico we find a series of at least seven quarto-sized pen and wash drawings depicting the story of St. Anthony of Padua. One represents the story of *St Anthony and the Mule* (London, Courtauld Institute Galleries, 2885), while the rest appear to represent *St. Anthony Preaching to the Fishes* (New York, 1973, [84]; Udine 1996 [77]; Stuttgart 1970 [21]; Bellingham Smith sale, Amsterdam, July 5, 1927, [308]; Paris, Hôtel Drouot, May 14, 1936, [110]; Sotheby's, July 15, 1983, [106]).

SOURCES: Of these examples, the closest to the present composition appears to be the first, a drawing from the Heinemann Collection, now in the Pierpont Morgan Library, showing St. Anthony on the left, very much as here, and the boat on the right. A drawing in the Hermitage, hitherto identified as *Christ at the Sea of Galilee* (Udine 1996 [34]) can now be seen to be yet another of the series, with the figure of St. Anthony and the boat disposed in a manner that is very close to the present drawing [fig. 294]. In this drawing we can also discern the man steering the boat on the extreme right, with his arms folded, who is also found, reversed, in *Jesus Preaching from the Boat* (pl. 129).

Figure 294. Domenico Tiepolo, *St. Anthony Preaching to the Fishes* (Saint Petersburg, Hermitage)

305. *St. Anthony and the Christ Child*

TRADITIONS: St. Anthony is a very popular saint in the art of the Veneto. In his early years, Domenico carried out a series of fine pen drawings illustrating the miracles of Anthony of Padua (Udine 1996 [77]), and Giambattista painted an altarpiece at Mirano that was etched by Domenico: yet another shows the present miracle in the proper setting, for the church of San Carlo Borromeo at Aranjuez; see also the drawing formerly at Stuttgart (Stuttgart 1970 [166]).

SOURCES: Domenico created a vast number of small drawings showing Anthony and the Christ child on clouds, with numbers ranging from 12 to 160, and there are many others without numbers. The present design is developed from a drawing in the Heinemann collection (unpublished) [fig. 295].

306. *An Army Before the Walls of a City*

SOURCES: The same city wall is to be found in plates 116, 117, 167, 168, 101, 306, and, in reverse, plates 154, 263, 285, and 309. It derives here from *Station V* of the S. Polo *Via Crucis* [fig. 157]. Part of the upper rim of this is broken. The horse and groom on the left derive from Giambattista's sketch *Alexander and Bucephalus,* in the Petit Palais [fig. 221].

307. *A Soldier Drawing Wine in a Cellar*

TRADITIONS: No prototype has come to light. A somewhat similar range of wine barrels is found in *Scenes of Contemporary Life 57, La Malvasia,* in the Ecole des Beaux-Arts (Gealt and Knox 2005: [58]) [fig. 296].

308. *A Soldier Driven Out of a Cellar by Peasants*

TRADITIONS: No prototype has come to light. A somewhat similar range of wine barrels is found in the *Divertimento per li regazzi 41, La Malvasia,* in a private collection in New York (Gealt 1986: [52]) [fig. 297].

309. *A Military Execution by Firing Squad*

TRADITIONS: No prototype has come to light.

SOURCES: The city wall is familiar: see plates 116, 117, 167, 168, 170, 306, and, in reverse, plates 154, 263, 285, and 309. The horse is very similar to the one in plate 216, which is also found in a drawing in the Hermitage, *A Horseman with Punchinelli* (Udine 1996: [122]), a unique smaller prototype for the Punchinello series [fig. 298]. The pose of the horse is

Figure 295. Domenico Tiepolo, *St. Anthony and the Christ Child* (pen drawing, New York, Pierpont Morgan Library, Heinemann Collection)

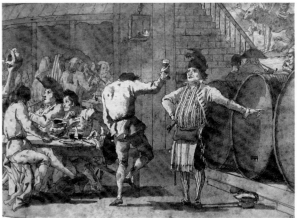

Figure 296. Domenico Tiepolo, *La Malvasia* (drawing, Paris, Ecole des Beaux-Arts, Masson 242)

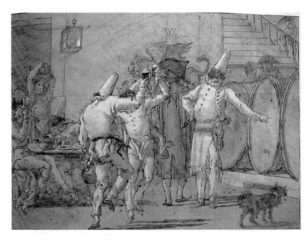

Figure 297. Domenico Tiepolo, *La Malvasia* (drawing, New York, private collection)

a classic one, deriving ultimately from *Le Grand Scipion* (Knox 1992: [19]) and used by Giambattista, reversed, in *The Battle Against the Volsci* for Ca' Dolfin (Knox 1991: [5]).

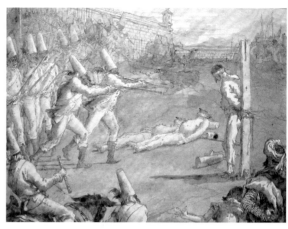

Figure 298. Domenico Tiepolo, *The Firing Squad* (New York, J. N. Street)

310. *A Priest Drawing Wine in a Cellar*

TRADITIONS: No prototype has come to light; Domenico uses similar wine barrels in *Scenes of Contemporary Life 37* (Gealt and Knox 2005: [58]) and *Divertimento 41* (see pls. 307, 308).

311. *Supplicants Before Pope Paul IV*

TRADITIONS: It is perhaps appropriate also to recall the series of drawings by Domenico depicting *St. Gregory the Great Giving Benediction* (Udine 1996: [26, 27]), perhaps relating to the liberation of Rome from the plague and famine after the inundations of the Tiber in 590, and perhaps related to the two paintings by Balestra at San Paulo d'Argon (Polazzo 1990: [54, 55]) [fig. 299].

312. *The Vision of St. Philip Neri*

TRADITIONS: The composition is broadly based on Giambattista's altarpiece for the Oratory at Camerino, 1740 (Gemin and Pedrocco 1993: [238]), which in turn broadly descends from Piazzetta's altarpiece for the Fava, the church of the Oratorians in Venice (Knox 1993: [79–81]); however, there are many variations in every part. Piazzetta's design is evidently inspired by the painting by Guido Reni of 1615 in Santa Maria in Vallicella (Knox 1995: [83]), and it is interesting to note that in the sketch for Giambattista's altarpiece (Gemin and Pedrocco 1993: [238a]) the figure of the saint follows the Reni model exactly.

SOURCES: The composition closely follows the painting by Domenico of 1778 in the Duomo at Padua, but shown in reverse (Mariuz 1971: [279]). The drawing forms a pair with *The Virgin and Child with St. Jerome Emiliani* (pl. 313), which is based on the pendant at Padua [fig. 300].

Figure 299. Domenico Tiepolo, *Gregory the Great Giving Benediction* (Besançon, Musée des Beaux-Arts)

313. *The Virgin and Child with St. Jerome Emiliani*

TRADITIONS: The connection between the Tiepolo family and the Somasco Order was certainly established by 1758, when the chapel in the Tiepolo villa at Zianigo was dedicated to Jerome Emiliani, who was beatified by Benedict XIV in 1747 and canonized by Clement XIII in 1760. The saint also appears in the tondo with the Holy Family over the altar. The tondo is flanked by two frescoes, depicting *Jerome Finding Water* in the manner of Moses and *Jerome Instructing the Rosary*, which bears Domenico's signature and the date 1759 (Mariuz 1971: [153, 155, 156]). But ten years earlier than this is the very moving small canvas, here attributed to Giambattista, depicting *St. Jerome with an Orphan* (Venice, 1979, 66), which now also forms part of the decorations of the room in Ca' Rezzonico that preserves the

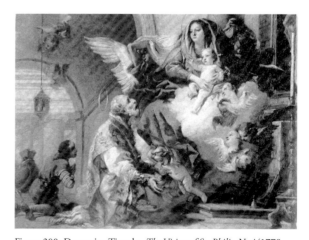

Figure 300. Domenico Tiepolo, *The Vision of St. Philip Neri* (1778, Padua, Duomo)

decorations of the chapel from Zianigo. Jerome Emiliani is also the subject of two early etchings by Domenico (Rizzi 1971: [61, 62]), the first based on a drawing at Besançon (Udine 1996: [16]) and the other recording a lost canvas that was part of the decorations of the Capella del Crocefisso on San Polo (Knox 1980: [118, 119]). He is also the subject of a fine drawing at Bayonne (Udine 1996: [42]) and the painting at Padua of 1778 [fig. 300].

SOURCES: The design derives from the painting in the Duomo in Padua of 1778 (Mariuz 1971: [278]). It forms a pair with *The Vision of St. Philip Neri* (pl. 312), which closely follows the pendant at Padua.

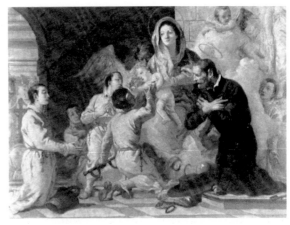

Figure 301. Domenico Tiepolo, *The Virgin and Child with St. Jerome Emiliani* (1778, Padua, Duomo)

Photography Credits

A. Vaquero
The Art Institute of Chicago
Besançon. Musée des Beaux-Arts et d'Archéologie
Board of Trustees, National Gallery of Art, Washington
Camerarts
Charles Choffet
Christie's Images
CIA Photographic and Imaging
The Cleveland Museum of Art
Collection Frits Lugt, Institute Néederlandais, Paris
David A. Loggie
Dean Beasom
Dumbarton Oaks
Florent Duams
Geremy Butler Photography
Jan Dlvls
Jean-Luc Baroni
The John Paul Getty Museum
Joseph Zehavi
Kevin Montague
Kit Weiss
The Metropolitan Museum of Art
Michael Cavanagh
Musée Bonnat, Bayonne
Museum Associates/LACMA
Museum of Fine Arts Boston
Peter Schälchli, Zürich
Ph. Sebert
Photographic Survey, Courtauld Institute of Art
Pierre Guenat
Prudence Cuming Associates Limited, London
Réunion des Musées Nationaux/Art Resource, N.Y.
Rijksmuseum Amsterdam
Schector Lee
Scott Bowron
Sotheby's
Sterling and Francine Clark Art Institute, Williamstown, Massachusetts, USA
Thierry Le Mage
Trustees of Princeton University
The Trustees of The British Museum

Subjects Illustrated and Subjects Omitted

This list offers two essential items: a summary of all the subjects (rare or standard) which Domenico Tiepolo illustrated and (in italics) those standard subjects which he omitted (or which remain unfound), with notable examples cited.

CC = Catalogue of Christofer Conrad—286 items recorded
RF = *Recueil Fayet*—138 items recorded
RL = *Recueil Luzarche*—175 items recorded
** *Recueil Luzarche*—items recorded but without a known image (currently 7 in number)

A1—Joachim and Anna	22 items	
A2—Mary and Joseph	19 items	
A3—*Massacre of Innocents* and the Flight into Egypt	18 items	
A4—The Holy Family in Egypt to *The Death of Joseph*	22 items	
A5—The Story of John the Baptist	21 items	
A6—The Ministry of Jesus to *The Calling of Matthew*	25 items	
A7—From *The Calling of Matthew* to *The Transfiguration*	16 items	
A8—From *The Transfiguration* to *The Feast in the House of Simon*	33 items	
A9—The Passion of Jesus to *The Crucifixion*	25 items	
A10—*The Crucifixion* to *The Ascension*	11 items	
A11—*The Stations of the Cross*	15 items	
A12—The Life of Peter	35 items	
A13—The Life of Paul	35 items	
A14—Epilogue	16 items	Total 313

Apparent Planned Structure

Sections 1–3: 59 items = 20% of narrative: Arrival in Egypt
+ 4 & 5 = 102 items = 33% of narrative: Burial of Baptist
+ 6 & 7
+ 8 & 9 = 200 items = 66 % of narrative: Crucifixion
+ 10 & 11 = 227 items = 75% of narrative: Ascension
+ 12 & 13 = 297 items = 100% of narrative: Peter and Paul
+ 14—Epilogue = 16 items = 313 items total: Epilogue

Key to Textual Source Abbreviations in addition to Four Gospels

A/G = *Arabic Gospel*
Assisi = St. Francis of Assisi, *The Little Flowers*
Butler = Alban Butler, *Lives of the Saints*
Cath. Encyc. = *Catholic Encyclopedia*
CVA = Christiaan von Adrichem (followed by site no.)
Dorlando = Pietro Dorlando
G. Leg. = *The Golden Legend*
G. Nic. = *Gospel of Nicodemus*
MDA = Maria de Agreda
James = *Book of James*
Jameson = Anna Jameson, *Legends of the Madonna*

Joseph = History of Joseph the Carpenter
L/I = *Liber de Infantia*
Life of John = The Life of John, according to Serapion

Sequence with missing subjects are indicated in italics with no number. The plus (+) sign indicates that the two drawings make a "pair."

JOACHIM AND ANNA—22 items

	CC	RF	RL
1. The Sacrifice of Abraham (Gen. 22:2, 22:9–14)	283	1/8	
2. Joachim's Offering Refused (James 1:1–2)	1	2/135	+
3. Joachim Turns from the Temple in Despair (James 1:3)	2	—	1
4. Joachim Withdraws to the Wilderness (James 1:4)	7	3/125	
5. Joachim in the Wilderness (James 1:4)	282	4/124	
6. Joachim Praying in the Wilderness (James 1:4)	3	5/128	
7. The Annunciation to Anna (James 3:1, 4:1)	5	6/62	
8. The Annunciation to Joachim (James 4:2)	4	7/118	
9. Angels Leading Anna Away from Her House (James 4:2, G. Leg.)	6	—	2
10. Anna Meets Joachim at the Golden Gate (G. Leg.)	3	10	3
11. Anna Meets Joachim Before the Temple (James 5:1)	9	8/114	+
12. Joachim and Anna on the Temple Steps (MDA)	11	9/113	
13. Joachim and Anna Praying in the Temple, I (James 5:1)	13	—	4+
14. Joachim and Anna Praying in the Temple, II (James 5:1)	12	10/132	
15. Anna Returns to Her House (James 5:1)	8	5	
Birth of the Virgin (San Marco, Dome of St. Leonard, Domenico Cigola, 1690; Padua, Giotto, Arena Chapel, 1305)			
16. The Presentation of Mary in the Temple (G. Leg.)	6		
Education of the Virgin (Giambattista Tiepolo, Venice, Santa Maria della Fava, 1732)			
17. The Preparation for the Drawing of Lots (James 10:1)	276	7	
18. The Seven Virgins Draw Lots (James 10:1)	274	8	+
19. The Young Mary Accepts the Scarlet and the Pure Purple (James 10:1)	275	—	9
20. The Death of Joachim (Dorlando cap vii, MDA)	14	—	1
21. The Death of Anna (Ribadeneira)	15	11/43	
22. The Burial of Anna (Dorlando vii, Life of John)	70	—	1

MARY & JOSEPH—19 items

The Annunciation to the Virgin makes three appearances in San Marco alone: as part of 12th-century Virgin cycle in west vault of Dome of St. John; part of 15th-century cycle devoted to Life of John the Baptist, Chapel of the Mascoli, back wall; part of 16th-century Nativity cycle in east vault of Dome of the Ascension based on designs by Tintoretto.

	CC	RF	RL
23. The Annunciation to the High Priest Zacharias (James 8:3, Joseph)	263	12	
24. "CONSERVATORIO" (James 8:2)	18	—	13
25. The Suitors Present their Rods (James 9:1)	16	12/127	
26. The Betrothal of Mary (James 9:1, G. Leg.)	17	—	14
27. The Marriage of Mary and Joseph (Matt. 1:18, G. Leg.)	—	—	15
(Matt. 1:19 and Luke 2:5 both note that Mary and Joseph were married)			
28. Mary and Joseph Leave the Temple (MDA)	—	16	+6
29. Mary and Joseph Return to the House (G. Leg., MDA)	20	17	
30. Joseph Taking Leave of Mary (James 9:2)	21	—	18+
31. Joseph Scolding Mary (James 13:1, Matt. 1:19–20)	22	19	
32. Mary and Joseph Set Out to Visit Elizabeth (Med.)	23	20/54	
33. The Visitation (Luke 1:41–42)	30	20	+

Subject			
34. The Magnificat (Luke 1:46–49)	32	21	
35. Mary and Joseph Take Leave of Zacharias and Elizabeth (Luke 1:56)	31	13/45	
36. The Return to Nazareth (Luke 1:56)	28	14/44	

The Nativity (Luke 2:7) not present in San Marco, but a common subject, found in Giotto, Padua, Arena Chapel, 1305.

Subject			
37. The Annunciation to the Shepherds (Luke 2:9)	34	—	22
38. The Adoration of the Shepherds (Luke 2:16–17)	35	15/49	
39. The Circumcision of Jesus (Luke 2:21)	—	—	23
40. The Adoration of the Kings (Matt. 2:11, G. Leg.)	37	16/51	
41. The Presentation of Jesus in the Temple (Luke 2:22)	38	24	

THE MASSACRE & THE FLIGHT INTO EGYPT—18 items

Subject			
42. Herod Consults with the Wise Men and the Priests (Matt. 2:4)		36	29
43. The Massacre of the Innocents (Matt. 2:16)	41	30	
44. The Holy Family with the Young John the Baptist and Angels (Med.) 63			
45. The Holy Family Visits Zacharias, Elizabeth, and the Young John (Med.)	40	31	
46. The Holy Family with Elizabeth, Zacharias, and the Young John (Med.)	39	18/52	19/48
47. The Holy Family Leaves the House (Matt. 2:14)	—	32	
48. The Flight into Egypt with the Almighty (MDA)	50	33	
49. The Flight into Egypt on a Mountain Road (Med.)	52	21/55	
50. The Rest on the Flight into Egypt (MDA)	55	22/57	
51. The Flight into Egypt, after Castiglione (Pseudo-Matthew 19)	54	34	
52. The Flight into Egypt with Angels (MDA)	24	35	
53. The Holy Family Crosses the River (MDA)	51	36	
54. The Holy Family with a Man Digging (L/I)	27	23/58	
55. Jesus and the Dragons (L/I) 18	42	24/46	
56. The Holy Family with the Bending Palm (L/I 20)	43	37	
57. The Holy Family Beneath the Great Palm (L/I 21)	44	38	
58. The Holy Family Arrives Within Sight of a City (L/I 22)	26	39	
59. The Holy Family Beholds the Mountains and Cities of Egypt (L/I 22)	22	40	

THE SOJOURN IN EGYPT to THE DEATH OF JOSEPH—22 items

Subject			
60. The Holy Family Enters Sotinen (L/I 23, Med.)	59	25/64	+RL42
61. The Broken Statues of Sotinen (L/I 23, G. Leg.)	47	26/115	+
62. Affrodosius Kneels Before the Holy Family (L/I 24)	48	41	
63. The Holy Family Leaves Sotinen	61	42	+RF25/64
64. The Holy Family Passes the Falling Idol (A/G 4:10–13)	45	27/56	
65. The Holy Family Encounters a Group of Gypsies (A/G 7:33–35)	56	28/63	
66. The Holy Family Meets the Robbers (A/G 8:1–7)	46	29/59	
67. The Holy Family Goes with the Robbers (A/G 8:1–7)	—	43	
68. The Holy Family Arrives at the Robbers' Farm (G. Nic.)	57	44	+
69. The Holy Family Leaves the Robbers' Farm (G. Nic.)	58	45	
70. The Holy Family at Matarea (A/G 8:9–11)	49	30/47	
71. The Holy Family at Hermopolis with Bowing Trees (G. Leg., Jameson)	—	31/53	
72. The Holy Family Enters Memphis (A/G 8:12)	60	46	+
73. The Dream of Joseph in Egypt (Matt. 2:19–21; Med.)	32/98		
74. The Holy Family Leaves Memphis (Med.)	62	47	
75. The Holy Family Meets the Young John the Baptist (Med.)	64	33/12	
76. The Holy Family Returns to Nazareth (Matt. 2:23)	66	48	
77. The Young Jesus Leads His Parents to Jerusalem (Luke 2:42)	67	49	

THE STORY OF JOHN THE BAPTIST—21 items

THE MINISTRY OF JESUS to THE CALLING OF MATTHEW—25 items

116. Jesus Healing the Leper (Matt. 8:1–3, Mark 1:40)	125	—	75
117. Jesus and the Centurion (Matt. 8:5–10)	119	76	
118. Jesus Heals the Centurion's Servant (Luke 7:2–3)	280	46/130	
119. Jesus Curing Peter's Mother-in-Law (Matt. 8:14–15, Mark 1:29–31)	120	—	77
120. The Resurrection of the Widow's Son (Luke 7:12–14)	134	78	+
121. The Widow's Son Restored (Luke 7:15–16)	135	79	

Jesus transforms water into wine at the Wedding in Cana (John 1:1–12: San Marco, Dome of Ascension, north vault, Bartolomeo Bozza, based on Veronese, 1566–1568)

122. The Feast in the House of Simon, I (Luke 7:36–38)	143	102	
123. Jesus Calms the Tempest, I (Matt. 8:23–26)	108	—	80+
124. Jesus Calms the Tempest, II (Matt. 8:26–27)	106	47/96	
125. The Gadarene Swine (Matt. 8:28–32)	126	48/106	
126. Jesus Healing the Man Sick of the Palsy (Mark 2:3–7)	123	81	

Jesus Heals the Woman with the Issue of Blood (Matt. 9:20, Mark 5:25, Luke 8: 43; San Marco, Dome of St. John, 17th century)

127. The Calling of Matthew (Matt. 9:9)	82	

THE CALLING OF MATTHEW to THE TRANSFIGURATION—16 items

128. Jesus Receives the Disciples of John the Baptist (Matt. 11:2–3, Luke 7:20–22)	118	49/2	
129. The Lake of Gennesaret (Matt. 13:1–2, Luke 5:1–3)	105	50/7	
130. Jesus Instructs Nicodemus (John 3:1–3)	100	51/99	+
131. Jesus and the Woman of Samaria, I (John 4:6–12)	95	52/91	+
132. Jesus and the Woman of Samaria, II (John 4:29)	96	53/90	
133. The Pool of Bethesda (John 5:2–8)	122	54/110	
134. Jesus Blessing the Loaves and Fishes (Matt. 14:19)	114	56/3	
135. Jesus Feeding the Multitude (Matt. 14: 20–21, John 6:8–9)	115	89	
136. Jesus and Peter Walking on the Waters (Matt. 14:29–31)	116	57/75	+
137. Jesus on the Sea of Galilee (Matt. 14:32–33)	107	58/97	
138. Jesus and the Woman of Canaan (Matt. 15:22–28)	121	59/94	

Peter Receives the Keys from Christ; Christ's Charge to Peter (Matt. 16:18–19). Peter is shown numerous times in San Marco and he generally has his keys, but the delivery of those keys to Peter by Christ as portrayed in the celebrated Vatican fresco by Perugino is not found in San Marco and appears to be uncommon in Venetian iconography. A 13th-century fresco cycle in the Archbishop's palace of Bergamo does show this scene; see Kaftal (1978: no. 757).

139. Jesus Ascends the High Mountain with Peter, James, and John (Matt. 17:1–2)	90		+L92
140. *"Questo e il mio figlio delitto, ascoltatelo"*—The Transfiguration, II (Matt. 17:5)	—	91**	
141. The Transfiguration (Matt. 17:3–5)	117	60/78	
142. Jesus Descends from the Mountain with Peter, James, and John (Matt. 17:9)	152	92	+L90

THE TRANSFIGURATION to THE TRIBUTE MONEY—33 items

143. Jesus Rebukes the Unclean Spirit (Luke 9:38–42)	127	61/76	
144. Jesus Demonstrates the Power of Faith (Matt. 17:15–20)	128	62/112	
145. Peter Finds the Money in the Fish (Matt. 17:27)	93		
146. The Good Samaritan (Luke 10:30–37)	109	—	83
147. Jesus in the House of Mary and Martha (Luke 10:38–42)	97	84	
148. The Lord's Prayer (Luke 11:1–2, Acts 1:12–14)	74		
149. Jesus Heals the Woman with a Spirit of Infirmity (Luke 13:10–16)	124	85	
150. The Prodigal Son Taking His Journey into a Far Country (Luke 15:11–13)	—	176	
151. The Prodigal Son Among the Swine (Luke 15:15–16)	111	—	86
152. The Return of the Prodigal Son (Luke 15:20–24)	—	112	55/9

THE PASSION OF JESUS to THE CRUCIFIXION—25 items

THE LAMENTATION to THE ASCENSION—11 items

The Deposition (Matt. 27:38). In Venice, the Lamentation is often called the Deposition, but Christ's removal from the Cross is less common than it appears to be elsewhere in Italy. Notable Depositions include: Perugino and Lippi, ca. 1507, Florence, Accademia, although the celebrated baroque painter Luca Giordano painted a masterful *Deposition* along those lines (Venice, Accademia).

THE FOURTEEN STATIONS OF THE CROSS—15 items

THE ACTS OF PETER—35 items

Exhibitions

Baltimore 1978
Museum of Art, *Old Master Drawings,*
1500–1800

Berlin 1996
Kupferstichkabinett, *Giovanni Battista*
Tiepolo, 1696–1770, und sein Atelier, cat.
Hein-Th. Schultze Altcappenberg

Tübingen 2005
Kunsthalle Tübingen, *Die Kunst des*
Handelns. Meisterwerke des 14. bis
20. Jahrhunderts bei Fritz und Peter
Nathan, ed. Götz Adriani. Ostfildern/
Ruit: Hatje Cantz

Birmingham, Ala. 1978
Museum of Art, *The Tiepolos: Painters*
to Princes and Prelates, cat. Edward F.
Weekes

Bloomington 1997
Indiana University Art Museum,
Domenico Tiepolo, master draftsman, cat.
Adelheid M. Gealt and George Knox

Brighton 2000
Brighton School of Art, *Carnavalesque,*
cat. Roger Malbert

Brno 1969
(Drawing from Brno)

Brussels 1983
Palais des Beaux-Arts, *Masterpieces of*
18th Century Venetian Drawing

Cambridge 1970
Fogg Art Museum, *Tiepolo: A*
Bicentenary Exhibition, 1770–1970, cat.
George Knox

Chicago 1938
Art Institute, Paintings, *Drawings and*
Prints by the Two Tiepolos

Detroit 1982
(Not traced)

Dresden 1977
(Drawings from Prague)

Exeter 1946
Royal Albert Memorial Museum, *Works*
of Art from the Ford Collection

Fort Worth 1993
Kimbell Art Museum (*Lodovico*
Carracci)

Frederikssund 1984
Willumsen Museum, *Italian Drawings*
from the J. F. Willumsen Collection, cat.
Chris Fischer

Geneva 1978
Musée d'art et d'histoire, *L'art vénitien*
en Suisse et Lichtenstein

Gorizia 1986
Palazzo Attems, *Da Carlevaris ai*
Tiepolo, cat. Dario Succi

Hamburg 1987
Thomas le Claire IV, *Zeichnungen und*
Aquarelle, 1500–1900

Hannover 1992
Landesmuseum, *Venedigs Kunst im*
Norden, cat. Hans Werner Grohn

London 1939
Matthiesen Gallery, *Exhibition of*
Venetian Paintings and Drawings of the
18th Century

London 1955
Arts Council, *Drawings and Etchings*
by G.B. and G.D. Tiepolo, cat. Tomas
Harris

London 1963
Colnaghi, *Exhibition of Old Master*
Drawings

London 1969
Colnaghi, *Exhibition of Old Master and*
English Drawings

London 1970
Colnaghi, *Etchings and Drawings by*
GBT and Other Italian Artists of the 18th
Century

London 1972
Heim Gallery

London 1984
Adolphe Stein, *Master Drawings*
Presented by Adolphe Stein

London 1986
Adolphe Stein, *Master Drawings*
Presented by Adolphe Stein

London 1987
Kate Ganz, *Italian Drawings, 1500–1800*

London 1987
Royal Academy of Arts, *Master*
Drawings: The Woodner Collection

London 1988
Hazlitt, Gooden and Fox, *European*
Drawings, Recent Acquisitions

London 1991
Walpole Gallery, *Italian Old Master*
Drawings

London 1992
Heim Gallery, *Venetian Drawings*

London 1992
Royal Academy of Arts, *Andrea*
Manregna, cat. Keith Christiansen

London 1993
Hazlitt, Gooden and Fox, *Eighteenth*
Century Venetian Drawings

London 1993
Kate de Rothschild

London 1994
Royal Academy of Arts, *The Glory of*
Venice, cat. Jane Martineau and
Andrew Robison

London 2002
Crispian Riley Smith

London 2003
Colnaghi, *Master Drawings*

Mirano 1988
Barchessa Villa XXV aprile, *I Tiepolo: virtuosisimo e ironia,* cat. Dario Succi

Munich 1982
Staatliche Graphische Sammlung, *Neuerverbungen*

Munich 1986
Haus de Kunst, *Meisterzeichnungen . . . Woodner*

New York 1938
Metropolitan Museum of Art, *Tiepolo and his Contemporaries*

New York 1962
Jacques Seligman Gallery

New York 1966
Charles E. Slatkin Galleries, *Pastels, Watercolors*

New York 1966–1967
Metropolitan Museum of Art, *Italian Drawings from the Art Museum, Princeton University,* cat. Jacob Bean

New York 1968
The William H. Schab Gallery, *Great Master Drawings and Prints*

New York 1970
Jacques Seligman Gallery, *Master Drawings*

New York 1970
Charles Slatkin Gallery

New York 1971
Metropolitan Museum of Art, *Drawings from New York Collections III: The 18th Century in Italy,* cat. Jacob Bean and Felice Stampfle

New York 1971
William Schab Gallery, *Forty-five Great Master Drawings and Prints*

New York 1973
The Pierpont Morgan Library, *Drawings from the Collection of Rudolf and Lore Heinemann,* cat. Felice Stampfle and Cara Denison

New York 1973
William H. Schab, *Woodner Collection II, Old Master Drawings,* ed. Frederick G. Schab

New York 1975
The Pierpont Morgan Library, *Drawings from the Collection of Mr. and Mrs. Eugene V. Thaw,* cat. Felice Stampfle and Cara Denison

New York 1977
The Pierpont Morgan Library (*Berchem exhibition*)

New York 1981
The Metropolitan Museum of Art, *Eighteenth Century Italian Drawings from the Robert Lehman Collection,* cat. George Szabo

New York 1986
N. G. Stogdon, *Drawings from the 18th to the 20th Century*

New York 1987
Colnaghi, *Old Master Drawings*

New York 1987
William H. Schab Gallery

New York 1989
W. M. Brady, *Master Drawings, 1700–1890*

New York 1990
Metropolitan Museum of Art, *Woodner Collection: Master Drawings*

New York 1992
W. M. Brady, *Thomas le Claire VIII, Master Drawings, 1500–1900*

New York 1994
National Academy of Design, *European Master Drawings from the Collection of Peter Jay Sharp*

New York 1995
Thomas William and W. H. Brady

New York 1996
Colnaghi, *Master Drawings*

New York 1996–1997
The Frick Collection, *Italian Drawings from the Ratjen Foundation*

New York 1997
Metropolitan Museum of Art, *Giambattista Tiepolo 1696–1770,* cat. ed. Keith Christiansen

New York 1999
Colnaghi, *An Exhibition of Master Drawings*

New York 2000
Colnaghi, *An Exhibition of Master Drawings*

New York 2002
Boerner

New York 2002
Jean Luc Baroni, *Master Drawings*

Nice 1982
(Drawings from Prague)

Paris 1952
Galerie Cailleux, *Tiepolo et Guardi dans les collections françaises*

Paris 1960
Musée du Louvre, *Poussin*

Paris, Rotterdam, Haarlem 1962
Institut néerlandais, *Le dessin italien dans les collections hollandais*

Paris 1965
Généviève Aymonier

Paris 1968
Généviève Aymonier

Paris 1971
Orangerie, *Venise au dix-huitième siècle*

Paris 1971
Galerie Heim, *Le dessin vénitien au XVIII, siècle,* cat. Alessandro Bettagno

Paris 1976
Didier Aaron, *Tableaux et dessins anciens*

Paris 1980
Paul Prouté, *Dessins, estampes*

Paris 1982
Paul Prouté, *Dessins, estampes*

Paris 1987
Paul Prouté, *Dessins, estampes*

Paris 1989
Paul Prouté, *Dessins, estampes*

Paris 1994
Grand Palais, *Nicolas Poussin 1594–1663*

Paris 1996
Institut Neerlandais, *Dessins vénitiens de la Collection Frits Lugt*

Paris 1998
Petit Palais, *Giambattista Tiepolo*

Paris 2004
Eric Coatelem, *Oeuvres sur papier*

Passariano 1971
Villa Manin, *Mostra del Tiepolo,* cat. ed.
Aldo Rizzi

Philadelphia 1996
Saint Joseph's University, *The Holy
Family as Prototype of the Civilization
of Love*

Prague 1977
(Drawings from Prague)

Princeton 1967
The Art Museum, *Italian Drawings
from the Art Museum,* ed. Jacob Bean

Rotterdam 1996
Boymans Van Beuningen Museum,
Tiepolo in Holland, cat. Bernard
Aikema and Marguerite Tuijn

Rouen 1970
Bibliothèque Municipale, *Choix de
dessins,* cat. ed. Pierre Rosenberg and
Antoine Schnapper

Stanford 1969
Stanford Art Gallery, *Drawings from
Swiss Collections*

St. Louis 1972
St. Louis Art Museum

Stuttgart 1970
Staatsgalerie, *Zeichnungen von
Giambattista, Domenico und Lorenzo
Tiepolo,* cat. George Knox and Christel
Thiem

Stuttgart 1996
Staatsgalerie, *Tiepolo und die
Zeichenkunst Venedigs im 18,
Jahrhundert,* cat. Corinna Höper and
Ewe Westfehling

Stuttgart 1999
Staatsgalerie

Tulsa 1984
Philbrook Museum of Art, *Botticelli to
Tiepolo,* cat. Richard P. Townsend

Udine 1971
Villa Manin, *Mostra del Tiepolo,* cat. ed.
Aldo Rizzi

Udine 1996
Castello, *Giandomenico Tiepolo: disegni
dal mondo,* cat. Adelheid M. Gealt and
George Knox

Vaduz 1995
Stiftung Ratjen

Vancouver 1980
Vancouver Art Gallery, *Eighteenth
Century Venetian Art in Canadian
Collections,* cat. ed. George Knox

Venice 1951
Giardini, *Mostra del Tiepolo,* cat. ed.
Giulio Lorenzetti

Venice 1958a
Fondazione Giorgio Cini, *Disegni
veneti di Oxford,* cat. K. T. Parker

Venice 1958b
Fondazione Giorgio Cini, *Disegni
veneti in Polonia,* cat. Maria Mrosinska

Venice 1959
Fondazione Giorgio Cini, *Disegni
veneti del 700 nella collezione Paul
Wallraf,* cat. Antonio Morassi

Venice 1964a
Fondazione Giorgio Cini, *Disegni
veneti del Museo di Leningrado,* cat.
Larissa Salmina

Venice 1964b
Fondazione Giorgio Cini, *Disegni
veneti del Museo Correr di Venezia,* cat.
Terisio Pignatti

Venice 1978
Fondazione Giorgio Cini, *Piranesi:
incisioni, libri, rami, ligaturi,
architetturi,* cat. ed. Alessandro
Bettagne

Venice 1980
Fondazione Giorgio Cini, *Disegni
veneti di collezioni inglesi,* cat. ed. Julien
Stock

Venice 1985
Fondazione Giorgio Cini, *Disegni
veneti di collezioni olandesi,* cat. Bernard
Aikema and Bert Meijer

Venice 1988
Fondazione Giorgio Cini, *Disegni
veneti dell'Ecole des Beaux-Arts di Parigi,*
cat. Emmanuelle Brugerolles

Venice 1990
Palazzo Ducale, *Tiziano*

Venice 1995
Ca' Rezzomico, *Splendori del Settecento
Veneziano*

Venice 1996
Ca' Rezzonico, *Giambattista Tiepolo,
1696–1996*

Venice 2004
Fondazione Giorgio Cini, *Tiepolo:
ironia e comico,* cat. Adriano Mariuz
and Giuseppe Pavanello

Verona 1978
Palazzo del Gran Guardia, *La pittura
a Verona tra Sei e Settecento,* cat. ed.
Licisco Magagnato

Washington 1972
National Gallery of Art, *Rare Etchings
by Giovanni Battista and Giovanni
Domenico Tiepolo,* cat. Diane Russell

Washington 1979
National Gallery of Art, *Prints and
Related Drawings by the Carracci Family,*
cat. Diane de Grazia Bohlin

Washington 1989
National Gallery of Art, *Drawings from
the Hammer Collection*

Washington 1995
National Gallery of Art, *The Touch
of the Artist: Master Drawings from
the Woodner Collection,* ed. Margaret
Morgan Grasselli

Williamstown 1961
The Sterling and Francine Clark
Art Institute, *Italian Paintings and
Drawings*

Würzburg 1996
Residenz, *Tiepolo in Würzburg,* ed.
Peter O. Krückmann

Zürich 1967
Kunsthaus, *Handzeichnungen Alter
Meister aus Schweizer Privatbesitz*

Zürich 1978
Bruno Meissner

Zürich 1984
Galerie Meissner, *Hundert Zeichnungen
aus Funf Jahrhunderten*

Bibliography

n.b.: See also Illustrated Bibles, New Testaments, and Vitae listed at end.

Acta Apostolorum 1575–1655
Philip Galle. 34 engravings: 17 after Marten van Heemskerck, some dated 1558; 17 after Stradanus, + frontispiece; six eds.

Acta Sanctorum 1643–1762
Vols. 1–44, January to September. Société Bollandiste, Collegio Saint Michel, Bruxelles. Antwerp.

Adrichem. *See* Christiaan van Adrichem

Agreda. *See* Maria de Agreda

Aikema and Meijers 1989
Bernard Aikema and Dulcia Meijers. *Nel regno dei poveri*. Venice.

Alpago-Novello 1939–1940
Luigi Alpago-Novello. "Gli incisori bellunesi," *Atti del Reale Istituto Veneto di scienze, lettere ed arti* 99: 471–716.

Alvin 1866
L. Alvin. *Catalogue raisonné de l'oeuvre gravé des frères Wierix*. Brussels.

Amalio 1556
Natalino Amalio. *Adunatione dei quattro Evangelisti*. Venice.

Ambrose n.d.
Saint Ambrose. *History of the Fall of Jerusalem* (a manuscript tran. of Josephus).

Ames 1963
Winslow Ames. *Italian Drawings*. New York.

Ante-Nicene Fathers 1951
A. Roberts and J. Donaldson, eds. *Ante-Nicene Fathers,* vol. 8. Grand Rapids; later ed. Peabody 1994.

Apolloni 2000
Davide Apolloni. *Pietro Monaco e la raccolta di cento dodici stampe di storia sacra*. Venice.

Aretino 1539
Pietro Aretino (Partenio Etiro). *Vita di Maria Vergine*. Venice.

Arslan 1960
Edoardo Arslan. *I Bassano*. Milan.

Bacou 1968
Roseline Bacou. *Dessins du Louvre, école italienne*. Paris.

Bacou 1968
Roseline Bacou. *Italian Drawings.* London.

Bacou 1971
Roseline Bacou. *Venise au dix-huitième siècle* (drawings). Paris.

Baier 1977
Walter Baier. "Untersuchungen zu dem Passionsbetrachtungen der *Vita Christi* des Ludolf von Sachsen," in *Analecta Cartusiana,* ed. James Hogg. Salzburg.

Baillet 1703, 1739
Adrien Baillet. *Les vies des saints,* 12 vols.; 10 vols. Paris.

Baillet 1707
Adrien Baillet. *Topographie des saints.* Paris; later ed. 1739

Banti 1977
Anna Banti. *Giovanni di San Giovanni.* Florence.

Barcham 1989
William Barcham. *The Religious Paintings of Giambattista Tiepolo.* Oxford.

Barcham 1993
William Barcham. "Sancta Dei Genetrix," in *La Chiesa di Venezia nel Settecento,* ed. Bruno Bertoli, 249–266. Venice.

Barb 1948
A. A. Barb. "St Zacharias, the prophet and martyr." *Journal of the Courtauld and Warburg Institutes* 11: 35–67.

Barnstone 1984
Willis Barnstone, ed. *The Other Bible.* San Francisco.

Baronio 1738
Cardinal Cesare Baronio. *Annales ecclesiastici.* Italian ed. Lucca.

Bartsch. *See The Illustrated Bartsch*

Basile 1993
Giuseppe Basile. *Giotto: The Arena Chapel.* London.

Baudi de Vesme 1906
A. Baudi de Vesme. *Le peintre-graveur italien.* Milan.

Baudrier 1896–1921
Henri Baudrier. *Bibliographie Lyonnaise.* Lyon.

Bayle 1690, 1702, 1710
Pierre Bayle. *Dictionaire historique et critique.* Amsterdam; Rotterdam; London.

Bayle 1734–1738
Pierre Bayle. *The Dictionary Historical and Critical.* London.

Bean 1960
Jacob Bean. *Les dessins italiens de la collection Bonnat.* Paris.

Benesch 1947
Otto Benesch. "Domenico Tiepolo, draughtsman and painter of architecture," *Art Quarterly* (Winter): 13–17.

Benesch 1973
Otto Benesch. *The Drawings of Rembrandt.* London.

Biancolini 1749; 1771
Giambattista Biancolini. *Notizie storiche delle chiese di Verona,* 10 vols. Verona.

Biblia Sacra 1588
Biblia Sacra. Lyons. *See also list of illustrated Bibles, page 845*

Biblioteca Sanctorum (various dates)
Biblioteca Sanctorum Ed. Instituto
Giovanni XXIII, 14 vols. 1961–1987
(also cited as *Bibliothek der
Kirchenvater,* 28 vols. Kempten,
1875; and *La Bibiothèque des Saints,*
ed. Severin Wenzlowsky; *Library of
Saints*)

Biblische Figuren 1575
Virgin Solis. *Engravings of the Old and
New Testaments.* Frankfurt.

Binetti 1652
S. Binetti. (Etienne Binet). *De i divini
favori di S. Giuseppe e della Famiglia
di Gesù Cristo.* Venezia.

Bodenstedt 1944
Sor M. J. Bodenstedt. *The Vita Christi
of Lodulphus the Carthusian.*
Washington.

Bonaventura 1491, 1492
Saint Bonaventure. *Meditationes vitae
Christi,* eds. with woodcut illus.
Washington, Library of Congress,
Rosenwald Collection 49-38692 and
47-43531

Bonaventura 1751–1756
Sancti Bonaventurae . . . Opere. Venice,
Albrizzi, 1751–1756, 13 vols. in 14
illus.; includes *Meditationes vitae
Christi,* vol. 12, 1756, 379–526.

Borean 1994
Linda Borean. "Nuove proposte . . .
Carpaccio nella Scuola degli
Albanesi," *Saggi e memorie* 19: 21–72.

Borsook 1990
Eve Borsook. *Messages in Mosaic: The
Royal Programmes of Norman Sicily.*
Oxford.

Bosio 1632
Antonio Bosio. *Roma sotterranea.* Rome
(Portland ed. 1972).

Bosque 1975
André de Bosque. *Quentin Matsys.*
Brussels.

Bossuet 1687
Jacques-Bénigne Bossuet. *Elévation sur
les mystères / Histoires des variations.*
Paris.

Bossuet 1736–1757
Jacques-Bénigne Bossuet. *Oeuvres de
messire Jacques-Bénigne Bossuet.*
Albrizzi. Venice.

Bossuet 1862
Jacques-Bénigne Bossuet. *Oeuvres
complètes,* 32 vols. Paris.

Bozzolato 1973
Giampiero Bozzolato. *Le incisioni di
Salvator Rosa.* Padua.

Brown 1988
Patricia Fortini Brown. *Venetian
Narrative Painting in the Age of
Carpaccio.* New Haven.

Burchard 1280, 1896
Burchard (of Mount Sion). *A
Description of the Holy Land.* Trans.
Aubrey Steward. London.

Butler 1756–1759
Alban Butler. *Lives of the Fathers,* 4 vols.
in 7. London; 2nd ed. (as *Lives of the
Saints*), Dublin 1779.

Butler 1880
Alban Butler. *Lives of the Saints.*
Baltimore.

Byam Shaw 1933
James Byam Shaw. "Some Venetian
Draughtsmen of the Eighteenth
Century," *Old Master Drawings*
(March): 47–63.

Byam Shaw 1959
James Byam Shaw. "The remaining
frescoes in the Villa Tiepolo at
Zianigo," *Burlington Magazine* 101
(November): 391–395.

Byam Shaw 1962
James Byam Shaw. *The Drawings of
Domenico Tiepolo.* London.

Byam Shaw and Knox 1987
James Byam Shaw and George Knox.
*The Lehman Collection VI: Italian
Eighteenth-century Drawings.* New
York, Princeton.

Byvanck 1931
Alexander Wilhelm Byvanck. "Les
principaux Manuscrits . . . du
Royaume des Pays-Bas," *Bulletin de
la Société française de Reproductions
de Manuscrits à Peintures* 15: 88*ff.*

Cadogan 2000
Jean Cadogan. *Domenico Ghirlandaio,
Artist and Artisan.* New Haven,
London.

Cailleux 1974
Jean Cailleux. "Centaurs, fauns, female
fauns and satyrs among the drawings
of DT," *Burlington Magazine* 116
(June, adv. supp 31): 2–28.

Calmet 1720–21
Augustin Calmet. *Dictionnaire
historique . . . de la Bible,* 4 vols.
Paris.

Calmet 1726
Augustin Calmet. *Dictionarium
Historicum Criticum, Chronologicum
Sacrae Scriptae,* 2 vols. Venice.

Calmet 1737
Augustin Calmet. *Brevis Chronologia . . .*
Venice.

Calmet 1776
Augustin Calmet. *Dictionarium
manuale biblicum,* 2 vols. Augsburg.

Camisasca 1966
Ettore Camisasca. *L'opera completa di
Michelangelo pittore.* Milan.

Carafa 1749
Giuseppe Maria Carafa. *De Capella
Regis utriusque Siciliae.* Rome.

Ceriani 1873
Antonio Maria Ceriani. *Canonical
Histories and Apocryphal Legends
Relating to the New Testament,* repro.
158 pen drawings ca. 1350 from
Ambrosiana, L.58 sup. Milan.

Chadwick 1981
Owen Chadwick. *The Popes and
European Revolution.* Oxford.

Chaplin 1967
Margaret Chaplin. "The episode of
the robbers in the *Libre dels tres reys
d'orient,*" *Bulletin of Hispanic Studies*
44: 88–95.

Ciampini 1690/1699
Giovanni Giustino Ciampini. *Vetera
monumenta,* 2 vols. Rome.

Ciampini 1693, 1747
Giovanni Giustino Ciampini. *De Sacris
Aedificiis a Constantino Magno
constructis: Synopsis Historica,* 1st and
2nd eds. Rome.

Christiaan van Adrichem 1584
Christiaan van Adrichem
(Adrichomius). *Jerusalem sicut Christi tempore floruit.* Cologne; 2nd ed., 3 vols., Rome 1747.

Christiaan van Adrichem 1590
Christiaan van Adrichem. *Gerusalemme e suoi dintorni* (Italian ed.). Trans. P. F. Toccolo. Verona.

Christiaan van Adrichem 1595
Christiaan van Adrichem. *A Brief Description of Jerusalem* (English ed.). Trans. Thomas Tymme. London. (York 1666, *see* www.lib.com/eebo/image/44942).

Colombo 1982
Silvano Colombo. *Conoscere il Sacromonte.* Varese.

Conrad 1996
Christofer Conrad. *Die grossformatigen religiösen Zeichnungen Giovanni Domenico Tiepolos.* Ph.D. dissertation, Heidelberg University.

Conway 1976
Charles Abbott Conway. "The *Vita Christi* of Ludolf of Saxony," in *Analecta Cartusiana,* ed. James Hogg. Salzburg.

Corner 1749
Flaminio Corner. *Ecclesiae venetae. . . .* 14 vols. Venezia.

Corner 1758
Flaminio Corner. *Notizie storiche delle chiese e monasteri di Venezia . . .* Padova.

Corner 1773
Flaminio Corner. *Hagiologium Italicum.* Bassano, Remondini.

Cradock 1668
Samuel Cradock. *The Harmony of the Four Evangelists. . . .* London: Printed for William Miller, 1670.

Croiset 1723
Jean Croiset. *Le vite dei santi per tutti i giorni dell'anno,* 3 vols. Trans. Selvaggio Canturani. Venice.

Croiset 1725 et al.
Jean Croiset. *Exercizi di pietà sopra tutte le domeniche e feste.* Trans. Selvaggio Canturani. Venice (subs. Trento 1738; Venice 1755, 1762–1763; Parma 1768).

Cullmann 1962
Oscar Cullmann. *Peter: Disciple, Apostle, Martyr.* Philadelphia.

dal Pozzo 1718
Francesco Bartolomeo dal Pozzo. *Le Vite de' Pittori, de gli scultori, et Architetti Veronesi.* Verona.

Daniels 1976
Jeffery Daniels. *L'opera completa di Sebastiano Ricci* Milan.

Daniélou 1976
Jean Daniélou. *The Angels and their Mission, According to the Fathers of the Church.* Trans. D. Heimann. Westminster.

d'Argaville 1989
Brian d'Argaville. "Inquisition & Metamorphosis: Paolo Veronese and the 'Ultima Cena' of 1573," *RACAR* (1989): 43–48.

de Backer. *See* Sommervogel

de Chennevières 1898
Henri de Chennevières. *Les Tiepolo.* Paris.

del Giudice 1702
Michele del Giudice. *Osservazioni sopra le Fabriche e mosaici della Chiesa.* Palermo.

della Chiesa 1967
Angelo Ottino della Chiesa. *Caravaggio.* Milan.

della Pergola 1713
Antonio Maria della Pergola. *Vita di S. Giuseppe.* Treviso.

Demus 1949
Otto Demus. *The Mosaics of Norman Sicily.* London.

Demus 1984
Otto Demus. *The Mosaics of San Marco in Venice.* Chicago.

Deutsche Bilderbibel 1960
Deutsche Bilderbibel aus dem späten Mitelalter, ed. Josef Hermann Beckmann and Ingeborg Schroth. Konstanz.

de Vecchi 1970
Pierluigi de Vecchi. *L'opera completa del Tintoretto.* Milan.

Dictionnaire de la spiritualité 1931–1994
Dictionnaire de la spiritualité. 20 vols. Paris.

Didron 1843
Adolphe-Napoléon Didron. *Iconographie chétienne.* Paris.

Didron 1851
Adolphe-Napoléon Didron. *Christian Iconography.* London.

Dionysius of Fourna 1963
Dionysius of Fourna. *Manuel d'iconographie chrétienne,* ed. Adolphe-Napoléon Didron, trans. Paul Durand. Paris; facsimile ed. New York, 1963.

Donzelli and Pilo 1967
Carlo Donzelli and Giuseppe Maria Pilo. *I pittori del Seicento Veneto.* Florence.

Doré 1866
Gustave Doré. *La Sainte Bible, selon la Vulgate,* 228 plates. Tours; 2nd ed., 230 plates.

Doré 1974
Gustave Doré. *The Bible.* 241 illus. Dover.

Doré 1997
Gustave Doré. *La Bibbia.* Genoa.

Dorlando 1570
Pietro Dorlando. "Vita di Sant'Anna," in *La Vita di Giesu Christo Nostra Redentore,* ed. Ludolfo di Sassonia, trans. Francesco Sansovino. Venice.

Dumesnil 1858
M. J. Dumesnil. *Histoire des plus célèbres amateurs français.* Paris. (Geneva ed., 1973).

Ebersolt 1919
Jean Ebersolt. *Constantinople byzantine et les voyageurs du Levant.* Paris.

Echard 1702
Laurence Echard. *A General Ecclesiastical History.* London.

Eleen 1977
Luba Eleen. "Acts Illustration in Italy and Byzantium," *Dumbarton Oaks Papers* 31: 253–278.

Elliger 1700
Elliger le Jeune. *Histoire de la Bible*, 2 vols. Antwerp; Vol. 2, *Histoire du Nouveau Testament*, 150 engravings.

Eusebius 1740–1741
Eusebius. *Ecclesiasticae Historiae*, illus. Rome.

Eusebius 1965
Eusebius. *Ecclesiastical History*, ed. G. A. Williamson. London.

Evangelicae Historiae Imagines 1593
Evangelicae Historiae Imagines. 154 plates engraved by Wierix, Collaert, etc., listed under Nadal. Antwerp.

Fabricius 1703, 1719
Iohann Albert Fabricius. *Codex apocryphus Novi Testamenti*. Hamburg; 2nd ed., 1719, incl. *Nativity of Mary; Protevangelium of James, Arabic Gospel*.

Fabricius 1962
Iohann Albert Fabricius. *Biblioteca Latina*. Graz.

Facchinetti 1931
Vittorino Facchinetti. *La vie de saint Antoine de Padoue*. Paris.

Fairfax Murray 1912
Charles Fairfax Murray. *J. Pierpont Morgan Collection of Drawings by the Old Masters*, 4 vols. London.

Ferrari and Scavizzi 1966/1992
Oreste Ferrari and Giuseppe Scavizzi. *Luca Giordano*, 1st and 2nd eds. Naples.

Fischel 1948
Oskar Fischel. *Raphael*. London.

Fischer 1984
Chris Fischer. *Italian Drawings in the Willumsen Collection*. Frederikssund.

Fleury 1722
Claude Fleury. *Histoire ecclésiastique*, 34 vols. Paris. 1722–1771.

Fleury 1766–1777
Claude Fleury. *Istoria ecclesiastica*, 26 vols. Trans. Gasparo Gozzi. Venice.

Foakes-Jackson 1957
F. J. (Frederick John) Foakes-Jackson. *The History of the Christian Church from the Earliest Times to AD 461*, 6th. rev. ed. London.

Ford Collection 1998
The Collection of Sir Brinsley Ford. *The Walpole Society*, vol. 40.

Francis of Assisi 1930
St. Francis of Assisi. *The Little Flowers* (ca. 1350). New York.

Frederiksen 1999
Paula Frederiksen. *Jesus of Nazareth, King of the Jews*. New York.

Freeden and Lamb 1956
Max H von Freeden and Carl Lamb. *Das Meisterwerk des Giovanni Battista Tiepolo: die Fresken der Würzburger Residenz*. Münich.

Frend 1996
William Frend. *Archaeology of Early Christianity*. London.

Friedlander 1967–1976
Max J. Friedlander. *Early Netherlandish Painting*, 14 vols. Leiden.

Fussesbrunnen. *See* **Konrad von Fussesbrunnen**

Gabelentz 1903
Hans von der Gabelentz. *Mittelalterliche Plastik in Venedig*. Leipzig.

Gabrielli 1971
Noemi Gabrielli. *Galleria Sabauda: Maestri Italiani*. Turin.

Garavaglia 1967
Niny Garavaglia. *Opera completa del Mantegna*. Milan.

Garber 1918
J. Garber. *Wirkungen. . . .* Berlin, Vienna.

Gaya Nuño 1978
J. A. Gaya Nuño. *L'opera completa di Murillo*. Milan.

Gealt 1986
Adelheid Gealt. *Domenico Tiepolo: The Punchinello Drawings*. New York.

Gealt 1996
Adelheid Gealt. "The Telling Line: Domenico Tiepolo as a Draftsman/Narrator," in *Domenico Tiepolo: Master Draughtsman*, 67–107. Udine/Bloomington.

Gealt 2004
Adelheid Gealt. "Divertimento per li regazzi," in *Tiepolo: ironia e comico*, 183–221. Venice.

Gealt and Knox 2005
Adelheid Gealt and George Knox. 2005. *Gian Domenico Tiepolo: scene de la vita quotidiana a Venezia e nella terra firma (Scenes of Contemporary Life)*. Mirano.

Geerard 1974
Maurice Geerard. *Clavis Apocryphorum Novi Testamenti*. Turnhout.

Gemäldegalerie 1987
Gemäldegalerie Alter Meister Dresden. Dresden.

Gemäldegalerie 1991
Die Gemäldegalerie des Kunsthistorischen Museums in Wien. Vienna.

Gemin and Pedrocco 1993
Massimo Gemin and Filippo Pedrocco. *Giambattista Tiepolo: i dipinti*. Venice.

Gentilucci 1848
Romualdo Gentilucci. *Il Perfetto Leggendario*, 12 vols. in 6. Rome.

Gibbons 1977
Felton Gibbons. *Catalogue of Italian Drawings in the Art Museum*. Princeton: Princeton University Press.

Giry 1683–1685, 1719
Le père Giry. *Les vies des saints*. 2 eds., Paris.

Giry 1878
Le Père Giry. *Les Petits Bollandistes: vies des saints, après le pere Giry*, 7th ed., 17 vols. Bar-le-Duc.

Gnudi 1959
Cesare Gnudi. *Giotto*. Milan.

The Golden Legend 1900
Jacopo da Varagine/Jacobus de Voragine. (*Aurea Legenda*), comp. 1275. As Englished by William Caxton 1483. London.

Goldner 1988
George R. Goldner. *European Drawings, I. The J. Paul Getty Museum*. Malibu.

Goldner and Bambach 1997
George R. Goldner and Carmen C. Bambach. *The Drawings of Filippino Lippi and his Circle*. New York.

Göttlicher 1999
Arvid Göttlicher. *Die Schiffe im Neuen Testament.* Berlin.

Grabar 1968
André Grabar. *Christian Iconography.* London.

Graf 1508
Urs Graf. *Passio Domini Nostri Jesu Christi,* with 25 woodcuts. Strasbourg.

Grandis 1761–1763
P. Domenico Grandis. *Vite, e memorie de' Santi spettanti alla chiese della diocese di Venezia. . . .* 7 vols. Venice.

Grimani Breviary 1971, 1972, 1974
The Grimani Breviary. Ed. Mario Salmi. Venice/London/New York.

Griswold 1997
William M. Griswold. "Lore Heinemann's gift of Tiepolo drawings to the Morgan Library," *Master Drawings* 35(3): 229–233.

Guerlain 1921
Henri Guerlain. *Giovanni Domenico Tiepolo--au temps du Christ.* Tours.

Guerlain 1921+
Henri Guerlain. "Giovanni Domenico Tiepolo: une collection de ses dessins," *Revue de l'art ancien et moderne* 39: 223–230.

Guerriero 1994
Simone Guerriero. "I rilievi marmorei della Capella Rosario ai Santi Giovanni e Paolo," *Saggi e Memorie* 19: 161–169.

Guerriero 1999
Simone Guerriero. "'Di tua Virtù che infonde spirto a i sassi.' Per la prima attività veneziana di Giusto Le Court," *Arte Veneta* 55: 49–72.

Hadeln 1927
Baron von Hadeln Detlev. *Handzeichnungen von G.B. Tiepolo.* Munich.

Hall 1979
James Hall. *Dictionary of Subjects and Symbols in Art,* rev. ed. New York.

Harris 1977
Ann Sutherland Harris. *Andrea Sacchi.* London.

Hartt 1958
Frederick Hartt. *Giulio Romano.* New Haven.

Hassall 1954
W. O. Hassall. *The Holkham Bible Picture Book.* London.

Havercamp-Begemann 1964
Egbert Havercamp-Begemann. *Drawings from the Clark Art Institute.* Williamstown.

Hennecke 1964
E. Hennecke. *New Testament Apocrypha.* Ed. Wilhelm Schneemelcher. London.

Hennecke 1968–1971
E. Hennecke. *Neutestamentliche Apokryphum in deutscher Übersetzung.* Tübingen.

Hetherington 1974
P. Hetherington. *The "Painter's Manual" of Dionysius of Fourna.* London.

Historiae Sacrae Veteris n.d.
Historiae Sacrae Veteris et Novi Testamento. n.d. (ca. 1670?). Nicolai Visscher. 150? engravings, 405 x 505 mm. Amsterdam.

Historiarum 1538
Historiarum veteris Instrumenti Icones ad vivum expressae. Lyons.

Hollstein 1988
F. W. H. Hollstein. *Dutch and Flemish Etchings Engravings and Woodcuts.* Amsterdam.

Hollstein 1996
The New Hollstein. Rotterdam.

Hone 1820
William Hone. *The Apocryphal New Testament.* London.

The Illustrated Bartsch 1978
The Illustrated Bartsch, ed. Walter L. Strauss. New York.

Infelice 1980
Mario Infelice. *I Remondini di Bassano.* Bassano.

Isidor de Isolani 1522
Isidor de Isolani. *Summa de donis S. Josephi.* Pavia.

Jackson n.d.
J. B. Jackson. *The History of the Old & New Testament.* 120 subjects, 24 engravings with 5 subjects on each plate; plates 19–24, New Testament. Venice.

Jacopo da Varagine. *See The Golden Legend*

Jacobus de Voragine 1969 (1941)
The Golden Legend of Jacobus de Voragine. Trans. and adap. from the Latin (*Aurea Legenda*) by Granger Ryan and Helmut Ripperger. New York.

James 1923
M. R. James. "Rare Mediaeval Tiles and Their Story (60 illustrations of the Bodleian *Gesta Infantiae Salvatoris*)," *Burlington Magazine* 42: 32–37.

James 1924
M. R. James. *The Apocryphal New Testament.* Oxford.

James 1927
M. R. James. *Latin Infancy Gospels.* Cambridge.

Jameson 1848
Anna Jameson. *Sacred and Legendary Art,* I, 9th ed. London.

Jameson 1852
Anna Jameson. *Legends of the Madonna.* (New impression 1899). London.

Jameson 1864, 1890
Anna Jameson and Lady Eastlake. *The History of our Lord,* new ed. 1890. London.

Jenkins 2001
Philip Jenkins. *Hidden Gospels: How the Search For Jesus Lost Its Way.* Oxford.

Jerome 1992
Saint Jerome. *Patristic Scholarship,* ed. James Brady and John Olim. Toronto.

Joachim and McCullagh 1979
Harold Joachim and Suzanne Folds McCullagh. *Italian Drawings in the Art Institute of Chicago.* Chicago.

Johannes de Caulibus, *Meditationes vitae Christi. See Ragusa and Green 1961*

John of Hildesheim 1886
John of Hildesheim. *The Three Kings of Cologne,* early English trans. of *Historia Trium Regium,* ed. C. Horstmann. London: Early English Text Society.

Jones 1726
Jeremiah Jones. *A New and Full Method of Setting the Canonical Authorities of the New Testament.* Oxford.

Kaftal 1978
George Kaftal. *Iconography of the Saints in the Painting of North East Italy.* Florence.

Kästner 1985
Manfred Kästner. *Die Icones Hans Holbeins des Jüngeren.* Heidelberg.

Kelly 1950
J. N. D. Kelly. *Early Christian Creeds.* London.

Kessler 1979
Herbert Kessler. "Scenes from the Acts," *Gesta* 18(1): 109*ff.*

Kessler 1994
Herbert Kessler. *Studies in Pictorial Narrative.* London.

Keyes 1955
Frances Keyes. *St. Anne, Grandmother of Our Saviour.* New York.

Killian 1776
Bible illustrations from various sources, engraved by P. A. Killian. Augsburg.

Kitto Bible 1836
The Kitto Bible. The Holy Bible extra illus. by J. Gibbs, 60 vols. Material collected from 1796 to 1836. London.

Kitzinger 1960
Ernst Kitzinger. *I mosaici di Monreale.* Palermo.

Knox 1960
George Knox. *Catalogue of the Tiepolo Drawings in the Victoria & Albert Museum.* (2nd ed. 1975). London.

Knox 1961
George Knox. "The Orloff Album of Tiepolo Drawings," *Burlington Magazine* 103 (June): 269–275.

Knox 1964
George Knox. "Drawings by Giambattista and Domenico Tiepolo at Princeton," *Record of the Art Museum* (Princeton University) 1: 1–28.

Knox 1965
George Knox. "A Group of Tiepolo Drawings Owned and Engraved by Pietro Monaco," *Master Drawings* 3: 389–397.

Knox 1968
George Knox. "A Sketchbook of Lorenzo Tiepolo at Würzburg," *Bollettino dei Musei Civici Veneziani* 13(1): 6–19.

Knox 1974
George Knox. *Un quaderno di vedute di Giambattista e figlio Domenico.* Milan.

Knox 1978
George Knox. "The Tasso Cycles of Giambattista Tiepolo and Gianantonio Guardi," *Museum Studies* (The Art Institute of Chicago) 9: 49–95.

Knox 1980
George Knox. *Giambattista and Domenico Tiepolo: A Study and Catalogue Raisonné of the Chalk Drawings.* Oxford.

Knox 1984
George Knox. "The Punchinello Drawings of Giambattista Tiepolo," in *Interpretazioni veneziane,* ed. David Rosand, 439–446. Venice.

Knox 1992
George Knox. *Giambattista Piazzetta, 1682–1754.* Oxford.

Knox 1994
George Knox. "The paintings of Marco and Sebastiano Ricci for Consul Smith: The suggested location of the large New Testament paintings," *Apollo* (September): 15–23.

Knox 1995
George Knox. *Antonio Pellegrini, 1675–1741.* Oxford.

Knox 1997
George Knox. "Giulia Lama, Antonio Molinari and the young Tiepolo: Problems iconographical," *Arte/Documento* 11: 171–177.

Knox 1999
George Knox. "Giambattista Tiepolo and Pietro Monaco," *Arte/Documento* 13: 264–269.

Koberger 1491
Anton Koberger. *Schatzbehalter* (many full page woodcuts; modern facsimile). Nürnberg.

Koberger 1977
Anton Koberger. *Die Kindheit Jesu* (with notes and illus.), ed. Fromm, Gärtner, Grubmüller, and Kunze. Göppingen.

Konrad von Fussesbrunnen 1973, 1977
Konrad von Fussesbrunnen. *Die Kindheit Jesu,* ed. Hans Fromm and Klaus Grubmüller. Berlin, New York.

Laborde 1911–1927
Alexandre Laborde. *La Bible Moralisée illustrée,* 3 vols. Paris.

Lafontaine-Dosogne 1964a
Jacqueline Lafontaine-Dosogne. *Iconographie de l'enfance de la Vierge dans l'Empire Byzantin et en Occident.* Bruxelles.

Lafontaine-Dosogne 1964b
Jacqueline Lafontaine-Dosogne. "Iconographie de la colonne A du ciborium de Saint-Marc à Venise," *Actes du XIIe Congrès Internationales d'Etudes Byzantines,* 213–219. Beograd.

Lafontaine-Dosogne 1975a
Jacqueline Lafontaine-Dosogne. "Iconography of the Cycle of the Life of the Virgin, in Underwood 1975: 161–194.

Lafontaine-Dosogne 1975b
Jacqueline Lafontaine-Dosogne. "Iconography of the Cycle of the Infancy of Christ," in Underwood 1975: 195–241.

La légende dorée 1902
La légende dorée. Jacobus de Voragine. Trans. Theodor de Wyzewa. Paris.

Lamy 1699
Bernard Lamy. *Commentarius in "Harmoniam sive concordiam quatuor evangelistarum."* Paris.

Lamy 1709
Bernard Lamy. *Apparatus Biblicus.* Paris.

Landolt-Wegener 1961
E. Landolt-Wegener. "Zum Motif der *Infancia Christi,*" *Zeitschrift für schweizerische Archäologie und Kunstgeschichte* 21: 164–170.

Lavin 1990
Marilyn Lavin. *The Place of Narrative: Mural Decoration in Italian Churches, 431–1600.* Chicago.

Le Blanc 1854
Charles Le Blanc. *Manuel de l'Amateur d'Estampes.* Paris.

Lefebre 1682
Valentin Lefebre. *Opera Selectiora.* Venice.

Legendario 1532 et al.
Legendario delle santissime vergini. Venice 1593, 1600, 1611; Remondini, Bassano, Venice, 1731.

Lello 1596
Giovanni Luigi Lello. *Historia della Chiesa di Monreale,* Rome; reprinted Bologna 1967.

Lello and del Giudice 1702
Giovanni Luigi Lello and Michele del Guidice. Lello: *Descrizione de Real Tempio, e Monastero di Sta Maria Nuova di Monreale* (ristampata). del Giudice: *Osservazioni sopra le Fabriche e mosaici della Chiesa.* Palermo.

Lenain de Tillemont 1701–1712
Louis-Sébastien de Tillemont. *Memoires pour servir à l'histoire ecclésiastique,* 16 vols. Paris.

Lessing 1774, 1778
Gotthold Ephraim Lessing. *Von dem Zwecke Jesu und seiner Jünger, nach ein Fragment des Wolfenbüttelschen Ungenannten (Reimarus).* Braunschweig.

Levey 1991
Michael Levey. *The Later Italian Pictures,* 2nd ed. Cambridge.

Lewis 2002
Bernard Lewis. *What Went Wrong? Western Impact and Middle Eastern Response.* Oxford, New York.

Lieure 1924–1929, 1989
Jules Lieure. *Jacques Callot.* Paris; 2nd ed. San Francisco.

Lippomano 1581
Luigi Lippomano. *De Vitis Sanctorum,* 6 vols. Venice.

Lipsius and Bonnet 1891–1903, 1959
Richard Adelbert Lipsius and Richard Bonnet. *Acta Apostolorum Apocrypha, I–III* Hildesheim.

Lorenzetti 1946
Giulio Lorenzetti. *Venezia e il suo estuario.* Milan.

Lorenzetti 1946
Giulio Lorenzetti. *Il Quaderno dei Tiepolo al Museo Correr di Venezia.* Venice.

Lost Books of the Bible 1926
The Lost Books of the Bible. William Hone. Cleveland and New York.

Luchinat 1998
Cristina Acidini Luchinat. *Taddeo e Federico Zucchero.* Milan and Rome.

Ludolph of Saxony 1566
Ludolphus de Saxonia. *Vita Christi.* Venice.

Ludolph of Saxony 1570, 1585, et al.
Ludolfo di Sassonia. *La Vita di Giesu Christo Nostra Redentore.* Trans. Francesco Sansovino. 8 eds. Venice.

Ludolph of Saxony 1544
Ludolfo di Sassonia. *La Grande Vie de Jésus-Christ.* Paris.

Ludolph of Saxony 1642
Ludolfo di Sassonia. *La Grande Vie de Jésus-Christ,* with a life of Sainte-Anne added by Petrum Dorlando. Lyons.

Ludolph of Saxony 1864
Ludolfo di Sassonia. *La Grande Vie de Jesus-Christ.* Trans. Dom M-P Augustin. Paris.

Ludolph von Suchem 1350
Ludolph von Suchem. *Description of the Holy Land, XXX—Of the Garden of Balsam.* Trans. Aubrey Stewart. London, 1895.

Luyken 1732
Jean Luyken. *Histoires les plus remarquables du Nouveau Testament gravé en cuivre par le célèbre Jean Luyken.* Amsterdam.

Macandrew 1980
Hugh Macandrew. *Ashmolean Museum, Oxford: Catalogue of the Collection of Drawings, III.* Oxford.

Macchetta 1885
Blanche Roosevelt Macchetta. *Life and Reminiscences of Gustave Doré.* New York.

Maria de Agreda 1670, 1685
Maria (de Jesus) de Agreda. *Mística ciudad de Dios, y vida de la Virgen.* Madrid, Lisbon (3 vols.).

Maria de Agreda 1712, 1713
Maria (de Jesus) de Agreda. *Mistica città di Dio,* 5 vols. Trento.

Maria de Agreda 1902–1912, 1971
Maria (de Jesus) de Agreda. *Mystical City of God,* 4 vols. Trans. Fiscar Marison. Washington, N.J.

Marini 1968
Remigio Marini. *L'opera completa del Veronese.* Milan.

Mariuz 1971
Adriano Mariuz. *Giandomenico Tiepolo.* Venice.

Mariuz 1978
Adriano Mariuz. "*La Lapidazione di Santo Stefano* ritrovata," *Arte Veneta* 32: 412–417.

Maselli 1610
L. Maselli. *Vita del felicissimo Sposo Santo Giuseppe.* Venezia.

Mason Rinaldi 1984
Stefania Mason Rinaldi. *Palma il Giovane.* Milan.

Massar 1971
Phyllis Dearborn Massar. *Stefano della Bella.* New York.

Mauquoy-Hendrickx 1982
Marie Mauquoy-Hendrickx. *Les estampes des Wierix.* Brussels.

McCarthy 1993
Carmel McCarthy. *Saint Ephraim's Commentary on Tatian's Diatesseron.* Oxford.

***Meditationes vitae Christi* 1761**
Sancti Bonventurae . . . Opere, vol. 12. Venice; *see also* Bonaventura.

Menegazzi 1981
Luigi Menegazzi. *Cima da Conegliano.* Treviso.

Merriman 1980
Mira Pages Merriman. *Giuseppe Maria Crespi.* Milan.

Meschinello 1753
Francesco Meschinello. *Le Chiesa Ducale di S. Marco colle notizie.* Venezia.

Middledorf 1938
Ulrich Middledorf. "Giandomenico's Drawing Technique," *Print Collector's Quarterly* 25: 102–108.

Midelfort 2005
H. C. Erik Midelfort. *Exorcism and Enlightenment.* New Haven.

Millet 1903, 1954
Gabriel Millet. *La peinture du moyen-age en Yougoslavie (Serbie, Macedoine et Montenegro).* Paris.

Millet 1969
Gabriel Millet. *La peinture du moyen âge en Yougoslavie.* Paris

Millet 1960
Gabriel Millet. *Recherches sur l'iconographie de l'évangile aux XIV, XV et XVI siècles,* 2nd ed. Paris.

Mitchell 1938
Charles Mitchell. "Poussin's 'Flight into Egypt,'" *Journal of the Courtauld and Warburg Institutes* 1: 340*ff.*

Molmenti and Ludwig 1907
Pompeo Molmenti and Gustav Ludwig. *The Life and Works of Vittorio Carpaccio.* London.

Monaco 1743
Pietro Monaco. *Raccolta di cinquantacinque storie sacre incise in altrettanti rame.* Venice.

Monaco 1763
Pietro Monaco. *Raccolta di centododici stampe di pitture della storia sacra.* Venice.

Moraldi 1971
Luigi Moraldi. *Apocrifi del Nuovo Testamento.* Torino.

Morassi 1937
Antonio Morassi. *Disegni antichi della Raccolta Rasini.* Milan.

Morassi 1941
Antonio Morassi. "D. Tiepolo," *Emporium* 93: 265–282.

Morassi 1955
Antonio Morassi. *G. B. Tiepolo: His Life and Work.* London.

Morassi 1958
Antonio Morassi. *Dessins vénitiens de dix-huitième siècle de la collection do duc de Talleyrand.* Milan.

Morassi 1962
Antonio Morassi. *A Complete Catalogue of the Paintings of G. B. Tiepolo.* London.

Morassi 1973
Antonio Morassi. *Guardi: i disegni.* Venice.

Moreau 1999
Véronique Moreau. *Peintures du XIXe siècle, 1800–1914.* Tours.

Morigia 1599
Paolo Morigia. *La Santissima Vita del glorioso S. Giuseppe.* Bergamo.

Moschini 1806
Gianantonio Moschini. *Della letteratura veneziana del secolo XVIII. . . .* Venice.

Moschini Marconi 1955
Sandra Moschini Marconi. *Gallerie dell'Accademia di Venezia: opere d'arte dei secoli XIV e XV.* Rome.

Moschini Marconi 1962
Sandra Moschini Marconi. *Gallerie dell'Accademia di Venezia: opere d'arte del secolo XVI.* Rome.

Moschini Marconi 1970
Sandra Moschini Marconi. *Gallerie dell'Accademia di Venezia: opere d'arte dei secoli XVII, XVIII, XIX.* Rome.

Mostafawy 1998
Schoole Mostafawy. *Die Flucht nach Aegypten . . .* Frankfurt.

Musolino, Niero, and Tramontin 1963
Giovanni Musolino, Antonio Niero, and Silvio Tramontin. 1963. *Santi e Beati Veneziani.* Venice.

Nadal 1593
Jérôme Nadal (Hieronymo Natali). *Evangelicae Historiae Imagines . . . ,* with 153 engravings after Wierix, etc. Antwerp.

Nadal 1594
Jérôme Nadal (Hieronymo Natali). *Adnotationes et Meditationes in Evangelia.* Antwerp.

Nadal 1607
Jérôme Nadal (Jeronimo Natali). *Adnotatones et Meditationes in Evangelia . . . ,* with 153 engravings, mostly by the Weirix brothers after Maarten de Vos. Antwerp; reprint Barcelona 1975, Bergamo 1976.

Neander 1564
Soraviensis Neander (Michael Neumann). *Apocrypha: hoc est narrationes de Christo* (incl. editio princeps of "Il vangelio di Giacomo"). Basel.

Newsweek 1970
Gigetta dalli Regoli, Gian Lorenzo Mellini, Licia Ragghianti Collobi, Ranieri Varese Roberto Ciardi, Carlo Ludovico Ragghianti, and editors of ART News. *Brera Milan.* In Newsweek's *Great Museums of the World,* vol. 14. New York.

Niero 1979
Niero, Antonio. *Tre artisti per un tempio.* Venezia.

Niero 1992, 1993
Antonio Niero. "Spiritualità popolare e dotta," in *La Chiesa di Venezia nel Seicento,* ed. Bruno Bertoli, 253–290. Venice; 1993 ed., 127–157.

Niero 1999
Antonio Niero. "Per una lettera iconografica del dipinto di Giovan Battista Tiepolo in basilica di San Marco a Venezia," in *Pittura veneziana,* 241–245. Venice.

Olsen 1962
Harald Olsen. *Federico Barocci.* Copenhagen.

Ottonelli 1652
Gio. Domenico Ottonelli (Odomenigo Lelonotti da Farrano). *Iconologia: cioé Ragionamenti d'Immagini intorno alle Sante Conversatione di Giesu, Maria e Giuseppe.* Florence.

Pächt and Alexander 1973
Otto Pächt and J. J. G. Alexander. *Illuminated Manuscripts in the Bodleian Library.* Oxford.

Paleotti 1582
Gabriel Paleotti. *De sacris et profanis imaginibus libri, V.* Bologna.

Pallucchini 1968
Anna Pallucchini. *L'opera completa di Giambattista Tiepolo.* Milan.

Parker 1956
Karl Parker. *Catalogue of the Collection of Drawings in the Ashmolean Museum.* Oxford.

Patrignani 1705, 1709
Giuseppe Antonio Patrignani. *Il divoto a San Giuseppe,* 2 eds. Florence and Venice.

Patrignani 1715–1722, 1883
Giuseppe Antonio Patrignani. *La santa infantia del figliuol di Dio . . . ,* 4 vols., 2nd. ed., later ed. Venice.

Patrignani 1718
Giuseppe Antonio Patrignani. *Delizie della quotidiana conversazione col divino infante Gesù.* Venice.

Pavanello 1996
Giuseppe Pavanello. *Canova: Collezionista di Tiepolo.* Possagno.

Pedrocco 1989–1990
Filippo Pedrocco. "L'Oratorio del Crocefisso nella Chiesa di San Polo," *Arte Veneta* 43: 109–115.

***Il perfetto legendario. See* Gentilucci 1848**

***Le petit bollandiste. See* Giry 1878**

Petrocchi 1967
Giorgio Petrocchi. *Storia delle spirituale italiane,* ed. Storie e lettere. Rome.

Petrus de Natalibus 1542
Petrus de Natalibus Venetus. *Catalogus Sanctorum.* Lyons.

Pigler 1956
Anton Pigler. *Barockthemen.* Budapest.

Pignatti 1980, 1981
Terisio Pignatti. *Disegni antichi del Museo Correr di Venezia, I, II.* Venice.

Pirro 1716
Rocco Pirro. *Notizia Regiae et Imperialis Capellae Collegiatae Sancti Petri . . . Regii Palatii Panormitani.* Palermo.

Polacco, Scarpa, and Scarpa 1991
Renato Polacco, with Giulia Rossi Scarpa e Jacopo Scarpa. *San Marco: la Basilica d'Oro.* Milano: Berenice.

Polazzo 1990
Marco Polazzo. *Antonio Balestra: pittore veronese del Settecento.* Verona.

Poncelet 1910
Albert Poncelet. "Le Légendier de Pierre Calo," *Analecta Bollendiana* 29: 5–116.

Ragusa and Green 1961
Isa Ragusa and Rosalie Green. *Meditations on the Life of Christ.* Princeton.

Réau 1956–1959
Louis Réau. *Iconographie de l'art chrétien.* Paris.

Reimarus. *See* Lessing

Reinsch 1879
Robert Reinsch. *Die Pseudo-Evangelien von Jesu und Marias Kindheit in der romanischen und germanischen Literatur.* Halle.

Rey 1942
Emile Rey. *L'aieule du Christ: Ste Anne de Jerusalem.* Annecy.

Rheinbay 1995
Paul Rheinbay. *Biblische Bilder für den inneren Weg.* Engelsbach.

Ribadeneyra 1630
Pedro de Ribadeneyra. *Flos Sanctorum.* Madrid.

Ribadeneira 1656/1660
Pedro de Ribadeneira. *Flos Sanctorum* (in Italian). Venice.

Ribadeneira 1657, 1862; 1676
Pedro de Ribadeneira. *Les nouvelles fleurs des vies des saints.* Paris; Rome (reprint 1969).

Ricci 1607, 1610
Bartolomeo Ricci. *Consideratione sopra tutta la vita di N. S. Giesu Christo,* with 160 engravings. 1st and 2nd eds. Rome.

Ripa 1976
Cesare Ripa. *Iconologia.* New York: Garland.

Rizzi 1970
Aldo Rizzi. *I disegni antichi dei Musei Civici di Udine.* Udine.

Rizzi 1971
Aldo Rizzi. *The Etchings of the Tiepolos.* London.

Roberts 1993
Perri Lee Roberts. *Masolino da Panicale.* Oxford.

Robertson 1898
Alex Robertson. *The Bible of St. Mark's Church in Venice.* London.

Robison 1978
Andrew Robison, "Vedute di Roma," in *Piranesi,* exh. cat.: 48–50. Venice.

Robison 1986
Andrew Robison, *Piranesi: Early Architectural Fantasies.* Washington and Chicago.

***Rockefeller McCormick New Testament* 1932**
The Rockefeller McCormick New Testament. Ed. Edgar J. Goodspeed, Donald W. Riddle, and Harold R. Willoughby. Chicago.

Roethlisberger 1992
Marcel G. Roethlisberger. "Bloemart's series of genre prints," *Gazette des Beaux-Arts* 119: 14–30.

Rohault de Fleury 1874
Charles Rohault de Fleury. *L'Évangelie: Etudes iconographiques et archéologiques.* Tours.

Rohault de Fleury 1878
Charles Rohault de Fleury. *La Sainte Vierge: Etudes archaeologiques et iconographiques.* Paris.

Röhrig 1961
Floridus Röhrig. *Miniaturen zum Evangelium von Heinrich Aurhayn.* Klosterneuberg.

Rosier 1997
Bart A Rosier. *The Bible in Print: Netherlandish Bible Illustration in the Sixteenth Century.* Leiden.

Rossetti 1765
G. B. Rossetti. *Descrizione delle pitture . . . di Padova.* Padova.

Rowlands 1996
Eliot W. Rowlands. *Italian paintings, 1300–1800.* Kansas City, Mo.

Ruggeri 2001
Ugo Ruggeri. *Valentin Lefèvre.* Manerbe.

Sack 1910
Eduard Sack. *G.B. und D. Tiepolo.* Hamburg.

Salerno 1975
Luigi Salerno. *L'opera completa di Salvator Rosa.* Milan.

Salerno 1988
Luigi Salerno. *I dipinti del Guercino.* Rome.

Salomon 1556
Bernard Salomon. *Il Nuovo ed Eterno Testamento di Giesu Christo.* Lyons.

Salomon 1558
Bernard Salomon. *Figures du Nouveau Testament.* Lyons.

Salomon 1559
Bernard Salomon. *Figure del Nuovo Testamento.* Lyons.

Salomon 1588
Bernard Salomon. *Biblia Sacra.* Lyons.

Sandini 1731
Antonio Sandini. *Historia Apostolica.* Padua.

Sandini 1734
Antonio Sandini. *Historia Familiae Sacrae.* Padova.

San Marco 1990
San Marco: I mosaici, la storia, l'illuminazione. Texts by Otto Demus, Wladimiro Dorigo, Antonio Niero, Guido Perocco, and Ettore Vio. Milan.

San Marco 1991
San Marco: I mosaici, le inscrizioni, la Pala d'Oro. Texts by Maria Andoloro, Maria da Villa Urbani, Ivette Florent-Goudouneix, Renato Polacco, and Ettore Vio. Milan.

Sansovino 1604
Jacopo Sansovino. *Venezia, città nobilissima,* ed. Stringa (account of San Marco published separately). Venice.

Sansovino 1668
Jacopo Sansovino. *Venezia, città nobilissima,* ed. Martinioni. Venice.

Santifaller 1976
Maria Santifaller. "Domenico Tiepolos *Hl. Joseph mit der Jesuskind* in der Staatsgalerie Stuttgart," *Jahrbuch der Staatliche Kunstsammlungen in Baden-Württemburg* 13: 65–86.

Sanuto Torcellus 1321
Marino Sanuto Torcellus. *Secrets for True Crusaders.* Trans. Aubrey Stewart. London.

Sanuto Torcellus 1611
Marino Sanuto Torcellus. *Liber Secretorum,* with maps. Hanover.

Scarpa Sonino 1994
Annalise Scarpa Sonino. *Jacopo Amigoni.* Soncino.

Schiller 1971
Gertrud Schiller. *Iconography of Christian Art.* London.

Schwarz 1975
Sheila Schwarz. *The Iconography of the Flight into Egypt,* Ph.D. dissertation, New York University.

Schweitzer 1906
Albert Schweitzer. *Von Reimarus zu Wrede: eine Geschichte der Leben-Jesu-Forschung.* Tübingen.

Schweitzer 1910
Albert Schweitzer. *The Quest of the Historical Jesus* (Eng. trans. of preceding). London.

Seilern 1959
Count Antoine Seilern. *Italian Paintings and Drawings at 56 Princes Gate.* London.

Semenzato 1966
Camillo Semenzato. *La scultura veneta del '600 e del '700.* Venice.

Seroux d'Agincourt 1810–1823
Seroux d'Agincourt. *Histoire de l'art par les monuments.* Paris.

Seroux d'Agincourt 1826–1829
Seroux d'Agincourt. *Storia dell'Arte. . . .* Prato.

Sgarbi 1979
Vittorio Sgarbi. *Carpaccio.* Bologna.

Sike 1697
Henry Sike. *Evangelium Infantiae* (The Arabic Gospel). Trajecto ad Rhenum.

Silver 1984
Larry Silver. *The Paintings of Quentin Matsys.* Montclair.

Simon 1689
Richard Simon. *Histoire critique du texte du Nouveau Testament.* Rotterdam.

Solis 1562, 1565
Virgil Solis. *Biblische Figuren des Neüwen Testaments.* Frankfurt.

Sommervogel 1895
Carlos Sommervogel. *Bibliothèque de la Compagnie de Jesus.* Bruxelles/Paris.

Spiazzi 1989
Anna Maria Spiazzi. *Giusto de' Menabuoi nel Battistero di Padova.* Trieste.

Spinosa 1984
N. Spinosa. *La pittura napolitana del '600.* Milan.

Stange 1932
Alfred Stange. "Eine Oesterreichisches Handschrift von 1320 in Schaffhausen," *Jahrbuch des Kunsthistorischessammlung in Wien* 4(6): 55–76.

Steinmann 1897
Ernst Steinmann. *Ghirlandaio.* Bielefeld.

Strachan 1957
James Strachan. *Early Bible Illustration.* Cambridge.

Strauss 1835
David Friedrich Strauss. *Das Leben Jesu.* n.p.

Strauss 1846
David Friedrich Strauss. *The Life of Jesus Critically Examined.* Trans. George Eliot. London.

Succi 1986
Dario Succi. "La 'Iconografia della Ducal Basilica': una raccolta mal attribuita," in Gorizia 1986 (Exhibitions).

Tatian. *See Amalio 1556.*
Text of the Diatessaron 1938
Il Diatessaron in volgare italiano. Vatican. Available at: www. newadvent.org/fathers/1002.htm

Terlinden 1943
Charles Terlinden. *Bernard van Orley.* Brussels.

***Theatrum Biblicum* 1639, 1643, 1674**
Theatrum Biblicum. Engravings by Wierix, etc., after Maarten de Vos. Visscher excudit. Amsterdam.

Thilo 1832
J. C. Thilo. *Codex apocryphus Novo Testamento* (*editio princeps* of the Pseudo-Matthew?). Leipzig.

Ticozzi 1975
Paolo Ticozzi. "Le incisioni da opere del Veronese," *Bollettino dei Musei Civici Veneziani* 20(3.4): 6–89.

Ticozzi 1978–1979
Paolo Ticozzi. *Immagini dal Veronese.* Rome.

Tissot 1896–1897
James Tissot. *La vie de notre Sauveur Jesus Christ,* 2 vols. Tours.

Tissot 1903
James Tissot. *The Life of Our Saviour Jesus Christ: Three hundred and sixty-five compositions from the four Gospels,* 3 vols. New York.

Tortoreto 1630
V. Tortoreto. *Sacellum Regium, hoc est de Capellis et Capellanis Regium Liber singularis, cum notis perpetuis, etc.,* Madrid.

Udine 1996
Domenico Tiepolo: Master Draughtsman. Udine/Bloomington.

Underwood 1966
Paul A Underwood. *The Kariye Djami,* 3 vols. New York.

Underwood 1975
Paul A Underwood. *The Kariye Djami,* vol. 4. Princeton.

Valcanover 1969
Francesco Valcanover. *L'opera completa di Tiziano.* Milan.

Valmy-Baysse 1930
Jean Valmy-Baysse. *Gustave Doré.* Paris.

Van der Waal 1981, 1982
H. Van der Waal. *Iconclass (An Iconographic Classification System of the Bible),* vol. 7. Amsterdam, Oxford, New York.

Venturi 1901
Adolfo Venturi. *Storia dell'Arte Italiana.* Milan.

Vermes 2000
Geza Vermes. *The Changing Face of Jesus.* London.

Verri 1971
Franco Verri. "Iconografia di S. Giuseppe nell'arte medievale veneta," *Cahiers de Joséphologie* 25: 723–734.

Verri 1991
Franco Verri. "S. Giuseppe nell'arte Veneta del Settecento: excursus iconografico," *Cahiers de Joséphologie* 45: 763–788.

Vincent de Beauvais 1624
Vincent de Beauvais. *Speculum historiale,* IV. Douai; reprint Graz 1965.

Visentini 1726
Antonio Visentini. *Iconografia della Ducal Basilica dell' Evangelista S. Marco.* Venezia.

Voss 1957
Hermann Voss. "Die Flucht nach Aegypten," *Saggi e memorie* 1: 27–59.

Waddell 1985
Mag. Brit Waddell. *Evangelicae Historiae Imagines: Entstehungs, Beschelte, und Vorlagen.* Göteborg.

Waetzoldt
Stephan Waetzoldt. 1964. *Die Copien des 17. Jahrhunderts nach Mosaiken und Wandmalerein in Rom.* Vienna.

Weigel 1997
Thomas Weigel. *Die Reliefsäulen des Hauptaltarciboriums: Studien eimer spätantiken Werkgruppe.* Munster.

Whistler 1996
Catherine Whistler. In *Giambattista Tiepolo: 1696–1770,* ed. Keith Christiansen. New York, Metropolitan Museum of Art, exh. cat.

Whistler 2001
Catherine Whistler. "L'occhio critico . . . di Domenico Tiepolo," in *Le metamorfosi di Venezia,* ed. Gino Benzoni, 209–223. Florence.

Wierix n.d.
Hieronymus Wierix. *Vita Deiparae Virginis Mariae,* 30 engravings, "Hieronymus Wierix invenit, incidit & excudit." Antwerp (ca. 1580?).

Yates 1944
Frances Yates. "Paolo Sarpi's *History of the Council of Trent,*" *Journal of the Warburg & Courtauld Institutes* 7: 123–143.

Zatta 1761
Antonio Zatta. *L'Augusta Ducale Basilica dell'Evangelista San Marco. . . .* Venice; reprint Gregg 1964.

Zava Boccazzi 1979
Franca Zava Boccazzi. *Pittoni.* Venice.

Zeri and Gardner 1973
Federico Zeri and Elizabeth Gardner. *Italian Paintings: A Catalogue of the Metropolitan Museum of Art: Venetian School.* New York.

Zorzi 1977
Alvise Zorzi. *Venezia scomparsa.* Venice.

Zuallardo 1587
Giovanni Zuallardo. *Il devotissimo viaggio in Gerusalemme.* Rome.

Zugni-Tauro 1971
A. P. Zugni-Tauro. *Gaspare Diziani.* Venice.

Illustrated Bibles

Biblia cum concordantiis. Lyons 1522.
Biblia Utriusque Testamenti iuxta. sm. fol. Lyons 1538.
Biblia Insigneum Historiarum simulacre. 8 vols. Lyons 1542.

Biblia Sacrosancta. sm. fol. Lyons 1543; reprint Florence 1998, + 16 woodcuts by Holbein, *Historiam Veteres Testamenti Icones.*

Retratos o tablas de las historias del Testamento (Viejo). Lion (Lyons) 1543.

Biblia Sacrosancta. sm. fol. Lyons 1544.

Biblia Sacrosancta. sm. fol. Lyons 1551.

Il Nuovo Testamento (Bernard Salomon). Lyons 1556.

La Bibia. Geneva 1562.

Biblia Sacra. Lyons 1588.

The Bishop's Bible. London 1572.

Icones Historicae Veteris et Novi Testamenti. Geneva 1680.

Historische Bilderbibel. Augsburg 1698–1700.

Holy Bible. Authorized KJV version, family ed. Chicago, New York, 1970, 1969, 1959.

Biblia Sacra vulgate editionis. Venice. 1727 (The Vulgate), ed. A. Martini, Florence 1769–1781.

La Sainte Bible. Ornée de 300 figures, 12 vols. Paris 1789–1804.

La Sacra Bibbia volgarizzato da Nicolo Malerni. Venice. 1481; no illustrations: at end, *Vita di San Josepho,* in four columns; Venice 1490 (386 woodcuts, including 176 illustrating the New Testament); Venice 1567.

Biblia Sacra vulgate editionis. Ed. Io. Baptiste du Hamel. Venice. 1748.

La Sacra Bibbia giunta la volgata in lingua latina e volgare. Venice. 1773–1779.

Le Bible historiale completée (Seznec 1953); notes yearly printed eds. from 1473 to 1526.

New Testaments

Das Neuw Testament. Basel 1522.

Il Nuovo ed Eterno Testamento di Giesu Christo. Lyons 1556.

Figures du Nouveau Testament. Lyons 1558.

Figure del Nuovo Testamento. Lyons 1559.

The Newe Testament of our Saviour Jesus Christ, from *The Bishop's Bible.* London 1568.

Iesu Christi Domino Nostra Novum Testamentum. Th. Bezae annotatum. London 1585.

Novum Iesu Christi Testamentum, ex Typographia Regiam. Paris 1640.

Vitae

Vita Christi. See Ludolph of Saxony

Vita di Sant'Anna. See Dorlando 1570

Vita di S. Antonio di Padova. Venice 1719.

Vita di S. Giuseppe. Bassano, Remondini, n.d.

Francesco Maurolico, *Vita di Christo.* Venice 1555.

Matteo Caldi, *Vita di Christo.* Venice 1556.

Il piu perfetto Leggendario della vita e fatti di N. S. Giesu Christo. Venice 1676.

Vita et Acta Iesu Christo. Ab Apostolo Matthaeo scriptis. Padua 1761.

Vita, Passio et Resurrectio Iesu Christo. n.d. (ca. 1580?). *Variis Iconibus à celeberrimo pictore Martino de Vos expressae ab Adriano Collart nunc primum in aes incisis . . . Ioan Galle excudit Antwerpiae.* 51 plates, 182 x 222.

Vita di S. Gerolamo Emiliani: see Scipio Albani (1600), Andreas Stella (1605), and Aug. Tortosa (1620) in *Acta Sanctorum.*

Index 🪶

Biblical and Apocryphal References Index ❧

❧ Adelheid M. Gealt has been Director of the Indiana University Art Museum since 1989. An internationally recognized expert on Domenico Tiepolo, she is author of *Domenico Tiepolo: The Punchinello Drawings* (Braziller, 1986).

❧ George Knox, Professor Emeritus at the University of British Columbia, is an authority on Venetian art and has published on the works of both Giambattista and Domenico Tiepolo.

Gealt and Knox are co-authors of *Domenico Tiepolo: Master Draftsman* (Indiana University Press, 1997).

Sponsoring Editor
Janet Rabinowitch

Book and Cover Designers
Brian Garvey, Indiana University Art Museum
David Alcorn, Alcorn Publication Design

Copy Editor
Melanie Hunter

Project Editor
Miki Bird

Compositor
David Alcorn, Alcorn Publication Design

Typeface
The Adobe Garamond Family

Printer
Friesens, Manitoba, Canada